Laurie

ART HISTORY

A View of the West

THIRD EDITION

VOLUME ONE

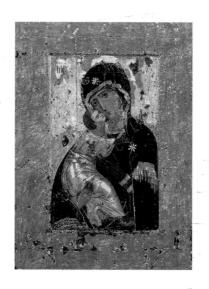

MARILYN STOKSTAD

Judith Harris Murphy Distinguished Professor of Art History Emerita

The University of Kansas

CONTRIBUTORS

Patrick Frank and D. Fairchild Ruggles

Library of Congress Cataloging-in-Publication Data

Stokstad, Marilyn,

Art History: A View of the West / Marilyn Stokstad. —3rd ed.

Stokstad, Marilyn

p. cm.

Includes bibliographical references and index.

ISBN 0-13-156610-5 (alk. paper)

1. Art—History. I. Title.

N5300.S923 2008

709-dc22

2006052795

Editor-in-Chief: Sarah Touborg Sponsoring Editor: Helen Ronan Editorial Assistant: Jacqueline Zea

Editor in Chief, Development: Rochelle Diogenes

Development Editors: Jeannine Ciliotta, Margaret Manos,

Teresa Nemeth, and Carol Peters

Media Editor: Anita Castro

Director of Marketing: Brandy Dawson

Executive Marketing Manager: Marissa Feliberty

AVP, Director of Production and Manufacturing: Barbara Kittle

Senior Managing Editor: Lisa Iarkowski Production Editor: Barbara Taylor-Laino Production Assistant: Marlene Gassler Manufacturing Manager: Nick Sklitsis Manufacturing Buyer: Sherry Lewis Creative Design Director: Leslie Osher

Art Director: Amy Rosen

Interior and Cover Design: Anne DeMarinis

Layout Artist: Gail Cocker-Bogusz

Line Art and Map Program Management: Gail Cocker-Bogusz,

Maria Piper

Line Art Studio: Peter Bull Art Studio

Cartographer: DK Education, a division of Dorling Kindersley, Ltd. Pearson Imaging Center: Corin Skidds, Greg Harrison, Robert Uibelhoer, Ron Walko, Shayle Keating, and Dennis Sheehan

Site Supervisor, Pearson Imaging Center: Joe Conti

Photo Research: Laurie Platt Winfrey, Fay Torres-Yap, Mary Teresa

Giancoli, and Christian Peña, Carousel Research, Inc.

Director, Image Resource Center: Melinda Reo Manager, Rights and Permissions: Zina Arabia Manager, Visual Research: Beth Brenzel

Manager, Cover Visual Research and Permissions: Karen Sanatar

Image Permission Coordinator: Debbie Latronica Manager, Cover Research and Permissions: Rita Wenning

Copy Editor: Stephen Hopkins

Proofreaders: Faye Gemmellaro, Margaret Pinette, Nancy Stevenson,

and Victoria Waters

Composition: Prepare, Inc.

Cover Printer: Phoenix Color Corporation

Printer/Binder: R. R. Donnelley

Maps designed and produced by DK Education, a division of Dorling Kindersley, Limited, 80 Strand London WC2R 0RL. DK and the DK logo are registered trademarks of Dorling Kindersley Limited.

Credits and acknowledgements borrowed from other sources and reproduced, with permission, in this textbook appear on the appropriate page within text or on the credit pages in the back of this book.

Cover Photo:

VIRGIN OF VLADIMIR

Icon, probably from Constantinople. Faces, eleventh-twelfth century; the figures have been retouched. Tempera on panel, height 33" (78 cm). Tretyakov Gallery, Moscow. Scala / Art Resource, NY.

Copyright © 2008, 2005 by Pearson Education, Inc., Upper Saddle River, New Jersey, 07458. All rights reserved. Printed in the United States of America. This publication is protected by copyright, and permission should be obtained from the publisher prior to any prohibited reproduction, storage in a retrieval system, or transmission in any form or by any means, electronic, mechanical, photocopying, recording, or likewise. For information regarding permission(s), write to: Rights and Permissions Department.

Pearson Prentice HallTM is a trademark of Pearson Education, Inc.

Pearson® is a registered trademark of Pearson plc

Prentice Hall® is a registered trademark of Pearson Education, Inc.

Pearson Education LTD.
Pearson Education Australia PTY, Limited
Pearson Education Singapore, Pte. Ltd
Pearson Education North Asia Ltd

Pearson Education, Canada, Ltd Pearson Educación de Mexico, S.A. de C.V Pearson Education—Japan Pearson Education Malaysia, Pte. Ltd

10 9 8 7 6 5 4 3 2

ISBN 0-13-156610-5 ISBN 978-0-13-156610-1

BRIEF CONTENTS

CONTENTS v
PREFACE x
WHAT'S NEW x
TOOLS FOR UNDERSTANDING ART HISTORY xii
FACULTY AND STUDENT RESOURCES FOR ART HISTORY xviii
ACKNOWLEDGEMENTS xix
USE NOTES xxi
STARTER KIT xxiii
INTRODUCTION xxviii

- 1 PREHISTORIC ART IN EUROPE 1
- 2 ART OF THE ANCIENT NEAR EAST 24
- 3 ART OF ANCIENT EGYPT 48
- 4 AEGEAN ART 82
- 5 ART OF ANCIENT GREECE 106
- 6 ETRUSCAN AND ROMAN ART 168
- 7 JEWISH, EARLY CHRISTIAN, AND BYZANTINE ART 232

- 8 ISLAMIC ART 282
- 9 EARLY MEDIEVAL ART OF EUROPE 310
- 1 () ROMANESQUE ART 342
- $11 \quad {}^{\rm GOTHIC\,ART\,OF\,THE\,TWELFTH\,AND}_{\rm THIRTEENTH\,CENTURIES} \quad {}_{382}$
- 12 FOURTEENTH-CENTURY ART IN EUROPE 422

1			

CONTENTS

Preface x

What's New x

Tools for Understanding Art History xii

Faculty and Student Resources for Art History xviii

Acknowledgements xix

Use Notes xxi

Starter Kit xxii

Introduction xxviii

PREHISTORIC ART IN EUROPE I

THE STONE AGE 2

THE PALEOLITHIC PERIOD 2

Shelter or Architecture? 2 Artifacts or Works of Art? 4 Cave Painting 6

THE NEOLITHIC PERIOD 11

Rock-Shelter Art 12 Architecture 13 Sculpture and Ceramics 19

FROM STONE TO METAL 20

The Bronze Age 20 The Proto-Historic Iron Age 21

IN PERSPECTIVE 22 TIMELINE 23

BOXES

THE OBJECT SPEAKS Prehistoric Woman and Man 18

ELEMENTS OF ARCHITECTURE

Post-and-Lintel and Corbel Construction 14

■ TECHNIQUE

Prehistoric Wall Painting 8 Fiber Arts 17 Pottery and Ceramics 20

ART AND ITS CONTEXT

The Power of Naming 5

■ SCIENCE AND TECHNOLOGY

How Early Art Is Dated 13

ART **OF THE ANCIENT** NEAR EAST 24

THE FERTILE CRESCENT AND MESOPOTAMIA 26

The First Cities 26 The Arts 28

SOUTHERN MESOPOTAMIA 29

Sumer 29

Lagash and Gudea 37

Babylon: Hammurabi's Code 37

THE HITTITES OF ANATOLIA 37

LATER MESOPOTAMIAN ART 40

Assyria 4

Neo-Babylonia 42

IN PERSPECTIVE 46

TIMELINE 47

BOXES

THE DBJECT SPEAKS The Code of Hammurabi 38

■ TECHNIQUE

Cuneiform Writing 32 Textiles 44 Coining Money 46

ART AND ITS CONTEXT

Art as Spoils of War-Protection or Theft? 31

ART OF ANCIENT EGYPT 48

THE GIFT OF THE NILE 50

EARLY DYNASTIC EGYPT 50

Manetho's List 51 Religion and the State 51 Artistic Conventions 52 Funerary Architecture 55

THE OLD KINGDOM, c. 2575-2150 BCE 56

Architecture: The Pyramids at Giza 57 Sculpture 59

Tomb Decoration 62

THE MIDDLE KINGDOM, c. 1975- c. 1640 BCE 62

Sculpture: Royal Portraits 63 Tomb Architecture and Funerary Objects 63

Town Planning 66

THE NEW KINGDOM, c. 1539-1075 BCE 67

The Great Temple Complexes 67 The Valley of the Kings and Queens 70 Akhenaten and the Art of the Amarna Period 72 The Return to Tradition: Tutankhamun and Rameses I 75 The Books of the Dead 78

LATE EGYPTIAN ART, c. 715-332 BCE 79

IN PERSPECTIVE 80

TIMELINE 81

BOXES

THE DBJECT SPEAKS The Temples of Rameses II at Abu Simbel 76

■ ELEMENTS OF ARCHITECTURE

Mastaba to Pyramid 56

■ TECHNIQUE

Preserving the Dead 55 Egyptian Painting and Sculpture 64 Glassmaking and Egyptian Faience 70

ART AND ITS CONTEXT

Egyptian Symbols 52 Hieroglyphic, Hieratic, and Demotic Writing 78

AGEAN ART 82

THE BRONZE AGE IN THE AEGEAN 84 THE CYCLADIC ISLANDS 84

THE MINOAN CIVILIZATION ON CRETE 86

The Old Palace Period, c. 1900-1700 BCE 86 The New Palace Period, c. 1700-1450 BCE 86

THE MYCENAEAN (HELLADIC) CULTURE 95

Helladic Architecture 95 Late Minoan Period (c. 1450-1100 BCE) 101 Metalwork 102 Sculpture 103 Ceramic Arts 104

IN PERSPECTIVE 104 TIMELINE 105

BOXES

THE DBJECT SPEAKS The Lion Gate 100

TECHNIQUE Aegean Metalwork 93

ART AND ITS CONTEXT

Pioneers of Aegean Archaeology 88 Homeric Greece 98

> ART ANCIENT

THE EMERGENCE OF GREEK CIVILIZATION 108

OF

GREECE 106

Historical Background 108 Religious Beliefs and Sacred Places 109 Historical Divisions of Greek Art 111

GREEK ART FROM c. 900-c. 600 BCE 112

The Geometric Period 112 The Orientalizing Period 114

THE ARCHAIC PERIOD, c. 600-480 BCE 114

Temple Architecture 117 Architectural Sculpture 119 Freestanding Sculpture 121 Vase Painting 125

THE CLASSICAL PERIOD, c. 480-323 BCE 128

The Canon of Polykleitos 128 The Art of the Early Classical Period, 480-450 BCE 129

THE HIGH CLASSICAL PERIOD, c. 450-400 BCE 135

The Acropolis 136 The Parthenon 136 The Propylaia and the Erechtheion 142 The Temple of Athena Nike 144 The Athenian Agora 145 Stele Sculpture 147 Paintings: Murals and Vases 148

THE LATE CLASSICAL PERIOD, c. 400-323 BCE 148

Architecture and Architectural Sculpture 149 Sculpture 151 The Art of the Goldsmith 155 Wall Painting and Mosaics 155

THE HELLENISTIC PERIOD, 323-31/30 BCE 156

The Corinthian Order in Hellenistic Architecture 158 Hellenistic Architecture: The Theater at Epidauros 158 Sculpture 160 The Multicultural Hellenistic World 164

IN PERSPECTIVE 165 TIMELINE 166

BOXES

THE BJECT SPEAKS The Parthenon 138

■ ELEMENTS OF ARCHITECTURE Greek Temple Plans 116 The Greek Architectural Orders 118

■ TECHNIQUE

Greek Painted Vases 114 The Discovery and Conservation of the Riace Warriors 135

ART AND ITS CONTEXT

Greek and Roman Deities 110 Classic and Classical 128 Who Owns the Art? The Elgin Marbles and the Euphronios Vase 145 Women Artists in Ancient Greece 157

> **ETRUSCAN** AND ROMAN ART 168

THE ETRUSCANS 170

Etruscan Architecture 170 Etruscan Temples and Their Decoration 171 Tomb Chambers 174

Bronze Work 177

THE ROMANS 178

Origins of Rome 179 Roman Religion 179

THE REPUBLIC, 509-27 BCE 179

Sculpture during the Republic 180 Architecture and Engineering 181

THE EARLY EMPIRE, 27 BCE-96 CE 185

Augustan Art 186
The Julio-Claudians 189
The Roman City and the Roman Home 190
Wall Painting 193
The Flavians 199

THE HIGH IMPERIAL ART OF TRAJAN AND HADRIAN 204

Imperial Architecture 205 Mosaics 213 Sculpture 215 Imperial Portraits 216

THE LATE EMPIRE, THIRD AND FOURTH CENTURIES 218

The Severan Dynasty 218
The Third Century: The Soldier Emperors 220
The Tetrarchy 222
Constantine the Great and His Legacy 224

IN PERSPECTIVE 230

TIMELINE 231

BOXES

THE **OBJECT SPEAKS** The Unswept Floor 214

ELEMENTS OF ARCHITECTURE
 Arch, Vault, and Dome 172
 Roman Architectural Orders 174
 Roman Construction 194

■ TECHNIQUE Roman Mosaics 215 Roman Copies 224

ART AND ITS CONTEXT

Roman Writers on Art 179 Color in Roman Sculpture: A Colorized Augustus 186 The Position of Roman Women 198

7

JEWISH, EARLY CHRISTIAN, AND BYZANTINE ART 232

JEWS, CHRISTIANS, AND MUSLIMS 234

Early Jewish Art 234 Early Christian Art 238

IMPERIAL CHRISTIAN ARCHITECTURE AND ART 242

Architecture: The Church and Its Decoration 243
Architecture: Ravenna 247

Sculpture 250

EARLY BYZANTINE ART: THE FIRST GOLDEN AGE 254

The Golden Age of Justinian 254

Objects of Veneration and Devotion 263 Icons and Iconoclasm 266

MIDDLE BYZANTINE ART 267

Architecture and Mosaics 267
The Special Case of Sicily 274

LATER BYZANTINE ART 278

Constantinople 278

Moscow: The Third Rome 278

IN PERSPECTIVE 280

TIMELINE 281

BOXES

THE **OBJECT SPEAKS** The Archangel Michael 276

■ ELEMENTS OF ARCHITECTURE

Basilica-Plan and Central-Plan Churches 242
Pendentives and Squinches 257
Multiple-Dome Church Plans 275

ART AND ITS CONTEXT

Early Forms of the Book 251 Iconography of the Life of Jesus 252

MYTHS AND RELIGION Christian Symbols 238

ISLAMIC ART 282

ISLAM AND EARLY ISLAMIC SOCIETY 284
ART DURING THE EARLY CALIPHATES 285

Architecture 286
Calligraphy 292
Ceramics and Textiles 294

LATER ISLAMIC ART 294

Architecture 295
Portable Arts 300
Manuscripts and Painting 303

THE OTTOMAN EMPIRE 305

Architecture 305
Illuminated Manuscripts and Tugras 306

THE MODERN ERA 307
IN PERSPECTIVE 308
TIMELINE 309

BOXES

THE DISJECT SPEAKS A Mamluk Glass Oil Lamp 296

■ ELEMENTS OF ARCHITECTURE Mosque Plan 289

Arches and Muqarnas 292

TECHNIQUE

Carpet Making 303

■ ART AND ITS CONTEXT
The Five Pillars of Islam 299

EARLY MEDIEVAL ART IN EUROPE 310

THE EARLY MIDDLE AGES 312

THE ART OF PEOPLE ASSOCIATED WITH THE ROMAN EMPIRE 313

The Art of People Outside the Roman Sphere of Influence 314
The Coming of Christianity to the British Isles 316

THE MUSLIM CHALLENGE IN SPAIN 319

Mozarabic Art 319

THE CAROLINGIAN EMPIRE 320

Carolingian Architecture 321
The Scriptorium and Illustrated Books 325
Carolingian Goldsmith Work 327

THE VIKING ERA 329

The Oseberg Ship 329
Picture Stones at Jelling 330
Timber Architecture 331
The End of the Viking Era 334

OTTONIAN EUROPE 334

Ottonian Architecture 334 Ottonian Sculpture 338 Illustrated Books 339

IN PERSPECTIVE 340

TIMELINE 341

BOXES

THE **OBJECT SPEAKS** The Doors of Bishop Bernward 336

ART AND ITS CONTEXT

Defining the Middle Ages 314
The Medieval Scriptorium 318

10

ROMANESQUE ART 342

EUROPE ON THE ROMANESQUE PERIOD 344

Political and Economic Life 344 The Church 345 Intellectual Life 346

ROMANESQUE ART 347

ARCHITECTURE 348

The Early Romanesque Style: The "First Romanesque" 349
The "Pilgrimage Church" 349
The Monastery of Cluny in Burgundy 352
The Cistercians 354

Regional Styles in Romanesque Architecture 355 Secular Architecture: Dover Castle, England 363

THE DECORATION OF BUILDINGS 364

Architectural Sculpture 365 Mosaics and Murals 369

THE CLOISTER CRAFTS 372

Portable Sculpture 372 Metalwork 376 Illustrated Books 377

IN PERSPECTIVE 380

TIMELINE 381

BOXES

THE **OBJECT SPEAKS** The Bayeux Tapestry 374

ART AND ITS CONTEXT

of the Twelfth Century 369

Saint Bernard and Theophilus:
Opposing Views on the Art of Their Time 347
The Pilgrim's Journey 350
Relics and Reliquaries 354
The Role of Women in the Intellectual and Spiritual Life

11

GOTHIC ART OF THE TWELFTH AND THIRTEENTH CENTURIES 382

THE EMERGENCE OF THE GOTHIC STYLE 384

The Rise of Urban Life 384
The Age of Cathedrals 384
Scholasticism and the Arts 384

GOTHIC ART IN FRANCE 385

Early Gothic Architecture 386
From Early to High Gothic: Chartres Cathedral 388
High Gothic: Amiens and Reims Cathedrals 398
High Gothic Sculpture 402
The Rayonnant Style 405
Illuminated Manuscripts 407

GOTHIC ART IN ENGLAND 408

Architecture 409

GOTHIC ART IN GERMANY AND THE HOLY ROMAN EMPIRE 411

Architecture 411 Sculpture 413

GOTHIC ART IN ITALY 417

Sculpture: The Pisano Family 417 Painting 419

IN PERSPECTIVE 420 TIMELINE 421

BOXES

THE DIJECT SPEAKS The Church of St. Francis at Assisi 416

ELEMENTS OF ARCHITECTURE

Rib Vaulting 391 The Gothic Church 392

■ TECHNIQUE

Stained-Glass Windows 398

ART AND ITS CONTEXT

Abbot Suger on the Value of Art 386 Master Builders 395

MYTHS AND RELIGION

The Mendicant Orders: Franciscans and Dominicans 394

12

FOURTEENTH-CENTURY ART IN EUROPE 422

EUROPE IN THE FOURTEENTH CENTURY 424

ITALY 427

Florentine Architecture and Sculpture 427 Florentine Painting 429 Sienese Painting 437

FRANCE 442

Manuscript Illumination 442 Sculpture 443

ENGLAND 445

Embroidery: Opus Anglicanum 445 Architecture 446

THE HOLY ROMAN EMPIRE 448

The Supremacy of Prague 448 Mysticism and Suffering 450

IN PERSPECTIVE 452 TIMELINE 453

BOXES

THE DBJECT SPEAKS The Triumph of Death 426

■ TECHNIQUE

Cennino Cennini (c. 1370-1440) on Painting 434 Buon Fresco 439

ART AND ITS CONTEXT

A New Spirit in Fourteenth-Century Literature 431

Contemporary World Map 455

Glossary 457

Bibliography 467

Credits 483

Index 486

PREFACE

believe that the first goal of an introductory art history course is to create an educated, enthusiastic public for the inspired, tangible creations of human skill and imagination that make up the visual arts—and I remain convinced that every student can and should enjoy her or his introduction to this broad field of study.

This book balances formalist analysis with contextual art history to support the needs of a diverse and fast-changing student population. Throughout the text, the visual arts are treated within the real-world contexts of history, geography, politics, religion, economics, and the broad social and personal aspects of human culture.

So . . . What's New in This Edition?

A Major Revision

I strongly believe that an established text should continually respond to the changing needs of its audience. With this in mind, the Third Edition has been revised in several major ways.

A View of the West: For the first time, this western-only version of the text is offered in response to requests from instructors teaching general survey courses confined to European-based traditions. The text of each of its chapters is identical to the western chapters found in the global version of the new Third Edition of *Art History*.

Significant Restructuring and Rewriting: In response to the evolving requirements of the text's audience—both students and educators—the changes implemented in this edition result in greater depth of discussion, and for

some specific cultures and time periods, a broader scope. I also revamped a number of chapters and sections in a continuing effort to better utilize chapter organization as a foundation for understanding historic periods and to help explain key concepts.

Improved Student Accessibility: New pedagogical features make this book even more readable and accessible than its previous incarnations. Revised maps and chronologies, for example, anchor the reader in time and place, while the redesigned box program provides greater detail about key contextual and technical topics. At the same time, I have worked to maintain an animated and clear narrative to engage the reader. Incorporating feedback from our many users and reviewers, I believe we have succeeded in making this edition the most student-accessible art history survey available.

Enhanced Image Program: Every image that could be obtained in color has been acquired. Older reproductions of uncleaned or unrestored works also have been updated when new and improved images were available. In some instances, details have also been added to allow for closer inspection. (See, for example, figs. 13–21 and 14–37.) The line art program has been enhanced with color for better readability, and there is a new series of color reconstructions and cutaway architectural images. To further assist both students and teachers, we have sought permission for electronic educational use so that instructors who adopt *Art History* will have access to an extraordinary archive of high quality digital images for classroom use. (SEE P. XXI FOR MORE DETAILS ABOUT THE PRENTICE HALL DIGITAL ART LIBRARY).

WHAT'S NEW

Chapter by Chapter Revisions

Chapter 1 includes a focus on the arts and daily life in prehistoric Europe with enhanced coverage of Neolithic paintings and the village of Skara Brae.

Chapter 2 is reorganized to follow a chronological sequence, and the focus on the arts and daily life in this chapter incorporates the sites of Jericho and Catal Huyuk.

Chapter 3 features an aerial view and reconstruction drawing of Karnak, as well as expanded coverage of Abu Simbel.

Chapter 4 now offers aerial views combined with reconstruction drawings for the sites of Knossos and Mycenae, and the "Object Speaks" highlights the Lions' Gate at Mycenae.

Chapter 5 is enhanced by the addition of Exekias' vase, Ajax and Achilles Playing a Dice Game. There also is a clarification of the ownership status of the Death of Sarpedon vase by Euphronios.

Chapter 6 is reorganized to follow a chronological sequence rather an organization by medium. The addition of more "natural" busts such as Pompey and a Middle-aged Flavian Woman broadens the discussion of Roman portrait. A colorized reproduction of the Augustus of Prima Porta is included in a discussion of the use of color in ancient sculpture.

Chapter 7 includes new images of the Old St. Peter's interior and the Hosios Lukas exterior. New examples of Early Christian sculpture are a sarcophagus with Christian themes, and the carved doors of the church of Santa Sabina.

Chapter 8 heightens its emphasis on the exchanges within the Islamic world and between Islam and its neighbors. A new section on the "Five Pillars" of Islamic religious observance is incorporated. Coverage is extended into the modern period.

Chapter 9 is reorganized to clarify the complex styles of migrating peoples in the fifth through seventh centuries as well as the contributions of the Vikings in sculpture and architecture. To allow for a more cohesive discussion, eleventh-and twelfth-century work in wood has been moved to this chapter.

Chapter 10 is reorganized chronologically rather than regionally or by medium. It includes a new focus on secular architecture and Dover Castle. In sculpture, there is enhanced coverage of cloister reliefs, historiated capitals, and bronze work.

Chapter 11 is reorganized in several significant ways. The chapter incorporates early and high Gothic art and ends at about 1300. The origins and development of Gothic art in France have been reworked, the "hall" church has been reinstated, and the coverage of secular architecture continues with Stokesay Castle in England

Chapter 12 is a new chapter that permits a discussion of the fourteenth century as it unfolded across Europe. An aerial view and illustrated drawing of the Cathedral in Florence have been added. A new section on Bohemian art is included.

Chapters 13–16 are a result of a major restructuring. The two chapters formerly devoted to the fifteenth and

sixteenth centuries each have been divided into four chapters.

Chapter 13 continues some of the themes and traditions of Gothic and fourteenth-century art outside Italy. The Ghent Altarpiece has been reinstated with open and closed views. A closed view of Rogier van der Weyden's Last Judgment Altarpiece also is added.

Chapter 14 is devoted to Italian fifteenth-century art. Donatello's St. George is now incorporated, as is the Triumph of Federico and Battista da Montefeltro. The art and architecture of Venice are given greater emphasis.

Chapter 15 features sixteenth-century Italian art. The sculpture discussion is broadened. Illustrations from The Farnese Hours emphasize the continuing tradition of the illuminated manuscript.

Chapter 16 deals with the sixteenth century outside Italy. The "Object Speaks" focuses on Portuguese sculpture and the great Window at Tomar. Secular architecture is expanded to include the Château of Chenonceau and Tudor Hardwick Hall.

Chapter 17 remains regionally organized, but is slightly reordered for better clarity. Spanish colonial sculpture and architecture are moved to chapter 29.

Chapter 18 includes more historical context in the discussion of artists and works. Colonial Latin American objects are moved to this chapter.

Chapter 19 features a section on Orientalism. The interaction of French political history and art is explored in greater detail, and the discussion relating to the definition and causes of Modern art is rewritten and expanded.

Chapter 20 includes an increased exploration of Primitivism in relation to several movements. There is a key new section on Latin American early Modern art, and the segments relating to Kandinsky's abstract art, Dada, and Surrealism are rewritten.

Chapter 21 has a new discussion of cultural factors such as existentialism, John Cage, and the influence of mass media. There is increased coverage of postwar European art and Latin American art. An expanded discussion of the end of Modernism and the beginnings of Postmodernism is incorporated, as well as new sections relating to some dominant trends in Postmodernism.

Tools for Understanding Art History: A View of the West

Art History: A View of the West offers the most student-friendly, contextual, and inclusive survey of art history.

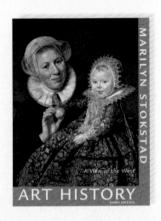

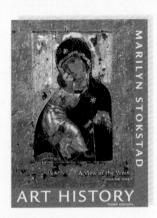

he text provides students with essential historical, social, geographical, political, and religious contexts. It anchors works of art and architecture in time and place to foster a better understanding of their creation and influence. Marilyn Stokstad takes students on a unique journey through the history of art, illustrating the rich diversity of artists, media, and objects.

Key Features of Every Chapter

Art History has always been known for superb pedagogical features in every chapter, many of which have been enhanced for this new edition. These include:

Chapter openers quickly immerse the reader in time and place and set the stage for the chapter. Clear, engaging prose throughout the text is geared to student comprehension.

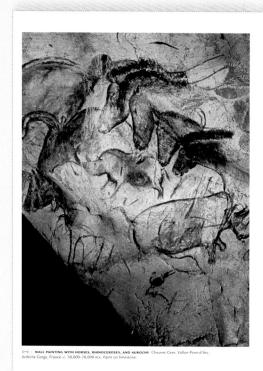

PREHISTORIC ART IN EUROPE

duced. These works are faciniting because they are supremby beautiful and because of what they rifl us about those who beautiful and because of what they rifl us about those who beautiful and because of what they rifl us about those who make them. The wheter arranger and immediately of the images who are left by our early ancostors connect us to them as surely as writer tools agreet to us. The creation of the images we see left by our early ancostors connect us to them as surely as writer. ten records link us to those who came later.

vet Cave, located in a gorge in the Ardeche region of southeastern France (FIG. 1-1) images of horses deer mammoths flanks, powerful legs, and dangerous horns or tusks. Using only

stift you carely accessors connect as to them a sawly a were truched in the stoke who can later.

The first contemporary people to explore the panned day survoid. They were often panned and survoire of terms and Spain entered an almost summinguable cover of france and Spain entered an almost summinguable cover of terms and Spain entered an almost summinguable cover entrance, without access to natural dashight, and which success of through long, narrow undergound pasages, what we extracted and accessed through long, narrow undergound pasages, what we wisted over many years. The walls were not that can vasses but irregular natural look forms. What we perceive as their found automated them and that factorises to the red Collage "art" may how been a matter of necessity to three ancient were constructed.

ring the essence of well-observed animals—meat-bearing structures that survive are only a tiny fraction of what must have

Chapter-at-a-glance feature allows students to see how the chapter will unfold.

God by the biblical patriarch Abraham and long the focus of pilerimage and polytheistic worship. He emptied the shrine reput duting its accumulated pagen idole, while preserving the enignance cubical partners the many critical pagen is a community of the pagen in the preserving the enignance cubical partners media and dockstaming its of dockstaming to food food and the ultimate.

The Kaaba is the symbolic center of the falantic world, the place to which all Muslim prayer is directed and the ultimate tination of Islam's obligatory pilgrimage, the Haji. Each year, huge numbers of Muslims from all over the world travel to Mecca to circumambulate the Kaaba during the month of pilgrimage. The exchange of ideas that occurs during the CHAPTER-AT-A-GLANCE ART DURING THE EARLY CALIPHATES | Architecture | Calligraphy Ce ■ IN PERSPECTIVE ISLAM AND EARLY ISLAMIC SOCIETY ART DURING THE EARLY CALIPHATES

> Easy-to-read color maps use modern country names for ease of reference and point to the sites and locations mentioned in the chapter.

F MODERN ART

Mini chronologies provide small in-text sequencing charts related to historic events and works of art.

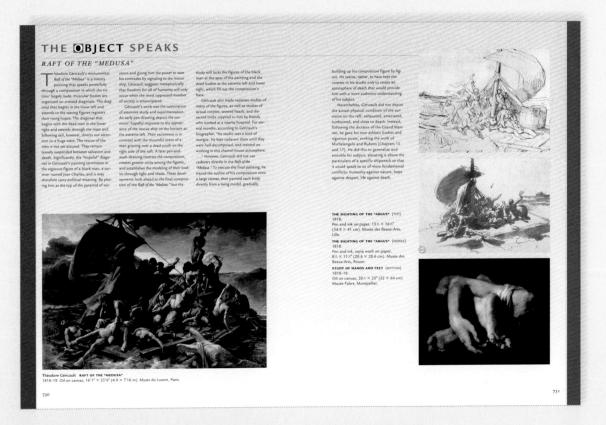

The Object Speaks boxes provide in-depth insights on topics such as authenticity, patronage, and artistic intention.

Box program brings an added layer of understanding to the contextual and technical aspects of the discipline:

- The Object Speaks
- Elements of Architecture
 - Technique
 - Defining Art
- Science and Technology
- Religion and Mythology
 - Art and Its Context

Art and Its Context WOMEN AND ACADEMIES

A history to several soomer over made members of the European andmens of an European the elements of the European andmens of an European E

After the Swin painters May Activate Supplementary and the state of th

ponan Zottany ACADEMICIANS OF THE ROYAL ACADEMY 1771-72. Oil on canvas, 47 ½ × 59 ½ (120.6 × 151.2 cm). The Royal Collection, Windsor Castle, Windsor, England.

590

or soman begin in Para, moved on to southern France to voir a muster of well preserved Roman buildings and moved of the preserved Roman buildings and moved to the preserved Roman and Paragraphic and Paragra

in a troot so trainil times 'trinise.'

Beginning in 17%, extraordinary archaeological discovertees made at two sites men Najdes also excited renewed interest
in closuical art and artifacts. Herculaturum and Pompen, now
prosperson Roman towns hared in 79 c.1 by the sudden vidcanise cruption of Bount Venvirus, editred sensitional new
nuterial for study and speculiation. Numerous allustrated books
on these discoveries crustated throughout Europe and Amer
exa, furling public facination with the ancient world and conrelixing to a track for the Newclosuical Sensition.

Italian Portraits and Views

Most educated Europeans regarded Italy as the wellspring of Western culture, where Roman and Renaissance art flour-held in the past and a great many artists still practiced. The studios of important Italian artists were required stops on the Grand Tour, and collectors avidly bought poteraits and land-scapes that could beaut in Italian artists.

GEREIRA. Whethy northern European sources to the order not for persons by United services. Recalled Carrera (10.55-1872), the leading personance through the first half of the englement country, beginning the first late patterns and pairming ministers persons on the new late patterns and pairming ministers persons on the new late patterns and pairming ministers persons on the new making portrain with patteds, reyonn of pulserated pageness based to a which hose by wear day moverally we are medium-pused can be employed in a sketchy manner to result water and the produce of the produce of the protead water water and the produced image. Carriera's passed, rated water to the produce of the produce of the prosented her homorary membership in Romack Academs of Saint takes in 170%, and the later was admitted to the scalemen in Bologous and Homesce. In 1730 to extract for the residence was been to the produce of the young Loun XV and where the make a partel portrain of the young Loun XV and are decleted to the Royal Academ of Primaging and Sulptore.

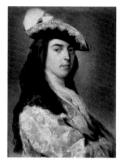

18–13 Rosalba Carriera CHARLES SACKVILLE, 2ND DUKE OF DORSET C. 1730. Pastel on paper, 25 × 19" (63.5 × 48.3 cm

18-14 | Canaletto SANTI GIOVANNI E PAOLO AND THE MONUMEN 1735-38 Oil on canvas 18% × 30% (46 × 78.4 cm) The Royal Co

In Perspective is a concluding synthesis of essential ideas in the chapter.

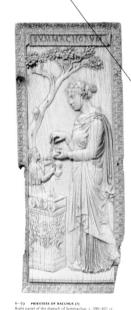

pagan practices. As a result, stories of the ancient gods and heroes entered the secular realm as lively, visually delightful, and even crotic decorative elements.

The style and subject nutree of the art reflect a sociin transition, for even as Roman authority gave way to lorule by powerful "harbarian" tribes in much of the We many people continued to appreciate classical learning a to treasure Greek and Roman art. In the East, classical trations and styles endured to become an important element Myzantine art.

IN PERSPECTIVE

The Romans who supfained the Errucan and the Greeks, appreciated the earlier at of these peoples and adapted it to their own use, but they also had their own uses, but they also had their own uses placed genus for organization. As ophinicated visual propagada, Roman at reverd the state when tracted visual propagada, Roman surpose curvaled and developed the art of portraining the propagada and proper curvaled and developed the art of portraining they also the propagada and proper and propagada and prop

Roman artists covered the walls of private homes wet paintings, too. Sometimes fantastic urban panoramas sur round a room, or painted columns and cornices, weingin garlands, and niches make a wall seem to dissolve. Some artise created the illusion of being on a porto or in a pavision look ing our into an extensive landscape. Such painted surfaces are often like backdown for a therarctic.

Roman architects relied heavily on the round arch an anomary vaulting. Beginning in the second century ice, the also relied increasingly on a new binding material concrete. In contrast to stone, the components of concrete are chose light, and easily transported. Imposing and Isamig concret structures could be built by a large, semiskilled work fore the contrast of the contrast of

Drawing artists impuration from their Eriscan an Greek predecesion and combining this with their own traditions, Romin artists made a distinctive contribution to the history of art, creating works that formed an enduring idea of excellence in the West. And a Roman authority gave we to local rule, the newly powerful "harburan" tribes continue to apprecute and even treasure the Classical learning and at the Roman Jeff Edward.

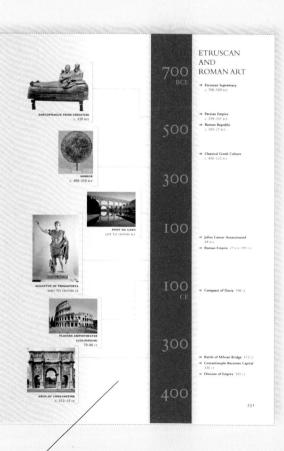

Timelines provide an overview of the chapter time frame.

Elements of Architecture THE SKYSCRAPER The reduction of the deperated on the development of the structural suggests that the development of the structural suggests that the endough specified the structural suggests that the endough specified of the structural suggests that the endough specified of the structural suggests that the endough specified of the structural suggests that the endough specified in the endough

20-16. CAS GIBERT WOOLNOWERH BUILDING

20–56 | Cass Gilbert WOOLWORTH BUILDING New York. 1911-13. C Collection of the New York Historical Society, New York

New York cleans repected the innovative style of Louis Sulfiron and other Chicago architects for the hustorical approach will in favor in the East, as seen in the woodworth moutonee (tite, 20-5), designed by the Minimesta-based Cas Gilbert (1889–1941). When completed, at 792 feer and 55 floors, it was the world's tuller building. In Gothic-style external details, impired by the souring towers of lateracheeal clusters, remotated will with the United States' increasing worship of business. Gilleret explained that he wished to make something "aprimatal" of what others called las "Calmedral of Commerce;"

RT BETWEEN THE WARS

World Wer I had a profound effect on Europe's arms and a arthrens. While the Dalains responded variated we had unprecedented destruction, some sought in the war's although the basis for a new none secure civilization. The onese of the forest Girst Depression in 1929 do metavated many artists to try to for full why to the proposed of the proposed of the proposed of the produced between 1919 and 1919 in Europe and North-America a connected in some way white hope for a better and more just world, rather than primarily serving selfcommont of the uncertainty of self-uncertainty self-units.

Utilitarian Art Forms in Russia

in the 1917 Russian Revolution, the radical socialist Bobbleriks overthrew the czar, took Russia out of the world war, and turned to winning an internal civil war that lasted until 920. Most of the Russian avant-garde enthusiastically supsorred the Bobblewiks, who in turn supported them.

CONTRICTIONS. The case of felexand Roscherko (1891– 1986) is fairly representative. An early associate of Molevich and Poposo (2011 ros.) 28–32, 28–318, Roscherkon immily used durling tools to make abstrat downing. The Supressition phase of the caree columns due is 1921 eighthouse where the downed three large flat, mouse fonematic parisk pattern in relay-globon, and blast, which be tried Lat Primeng (they are unfortunately bad). After making this work, he resourced purputing as a bandaly shifth activity and condemned self-

In the same year he helped launch a group known as the constructions, who were commuted to quiting the stude and going "into the factory, where the real body of he is made." In place of attention dedicated to expering themselve or exploring sewhetic muse, politically committed arms consider care until others and promote has not society to deliberate and the partial good and students of the committee arms of the partial good with Park he was a support of the partial good with Park he that would promote the egilitation ends of the new society society.

ART BETWEEN THE WARS

Diagrams make difficult concepts related to architecture and materials and techniques accessible to students.

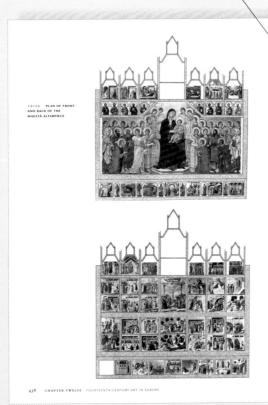

Creating this altarpiece was an arthums undertaking. The central panel alone was 7 by 13.55 forct, and it had to be painted on both from and back, because it was meant to be seen from both sides. The main altar for which it was designed stood beneath the dome in the center of the same-trary. Inscribed on Mary's thones are the smooth, "Holy Mother of God be thou the cause of peace for Siena and, because he painted thee thins, of life for Ducton" (cared in

with also within x₁, pipe (60), angule and the four panel. Many and Christ Albert John Christ Albert John Christ Albert John Christ Albert John Christ John Christ Albert John Christ Jo

Description of the most consistency of the consistency softward. The construction of french Golds. This under bendenning characteristic of French Golds. This under bendenning for northern and southern elements can be seen in the holose quide of anything construction of the construction

In 1721 the alterprice was broken up, and individual pands were side. One pand—the SARTY WHE FROMPIST SHAMM AND EXEMS—in one in Wohington, D.C. Duccor represented the Nativery in the readston of Byzartine scone. Mary lise on a fit mattern within a care bollowed out of a jugged, shydred mountain (rich, 12-21), Joun appears rosec first bying in the manger and then with the misbodie below. However, Daccio followed Western trainen by placing the scene in a shed. Rejoissing angles fift the dsy, and the shep-then, and sheep ald a readine, too dispatch in one paties, which is the state of t

Technique BUON FRESCO

he two techniques used in mural painting are buon ("true") fresco ("fresh"), in which paint is applied with water-based paints on wet plaster, and fresco secce ("dry"), in which paint is applied to a dry

The abuntage of home from is in durability. A chemical cartesion occurs as the painted plaster fiets, which books the pajments into the wall hurder. In from wars, but the painted in the painted of the

In medical and fiencissance Taly, a wall to be frequent with a polymer of the color was free properly with a rough, but co-wifercist of plazars. When this was day, assistance copied the master made any necessary adjustments. These density, a finished passing, which was an immediately and feeshwess lost in the finished passing, but we are immediately and feeshwess lost in other finished passing, but provided in the continuity of major figures and excellent passing and when the was "set" but not day, the arrites worked with freely, thin cost of criving palsars rever the insignal, and when the was "set" but not day, the arrites worked with progress mised with water. Painters worked from the top down to plate drops fit our unfinished portreams. Some arran requiring generic value is all reasons but pellech in the progress in the contract of the contract requiring generic value. It is also that drops fit our unfinished portreams. Some arran requiring generic value is all reasons but pellech gibles ground be added after the wall was day using the firm associated to the residence are made to the progress of the residence and the progress of the progress of

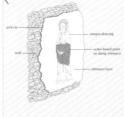

439

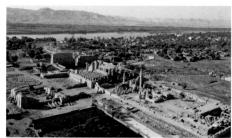

hall and sanctuary. The design was symmetrical and axialthat is, all of its separate elements are symmetrically arranges along a dominant center line, creating a processional path The rooms became smaller, darker, and more exclusive as they neared the sanctuary. Only the pharaoh and the priests entered these inner rooms.

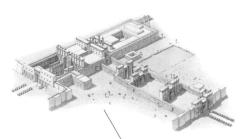

3-23 | RECONSTRUCTION DRAWING OF THE GREAT TEMPLE OF MUN AT KARNAK, EGYPT

68 CHAPTER THREE ART OF ANCIENT 10 VE

Two temple districts consecrated primarily to the worship of Aman, Mut, and Khons arose near Thebes—a huge complex at Karnak to the north and, joined to it by an avenue of sphures.

KANSAK. "At Karrak, temples were built and rebuilt for over 1,500 years, and the remains of the Nex Kingdom additions to the Great Temple of Amin still dominate the landscape (10c. 3–22). Over the nearly 500 years of the New Kingdom, successive kings renovated and expanded the Amin temple until the complex covered about 60 acres, an area as large as a dozen football fields (ric. 3–23).

occers normal trials (Re., 1-21).

Access to the beart of the truple, a sun-tury containing the status of Amin, was from the west (on the left sade of the reconstruction darsaing) through a principal contrapt, a hyposopic half, and a number of smaller halk and courts. Psylons set of each of these separate fermions. Between the Egiferenth and Nineteenth shyansy rogue of Thatmose I (tudied. - 1199-31 mis.), and Ramese II (tudied. - 1299-31 mis.) and Ramese II (tudied. - 1299-31 mis.) and reason of Psylon II through a reason of the complex underwest a gent deal of construction and revealed. They are the problem of the principal missed in Psylon II through the reason of the complex underwest a gent and of construction and revealed. They are the policy missed in the principal missed courts behave the wasternay (modern archaeologues have given the polson numbers) and the half and courts behave the behavior of the principal missed principal

In the suntain, the prices soulded the gold state every morning and delothed in a new gentreal. Homes the gold mentioning and the first in a new gentreal from the grint of food, it has a powder with respect to device morning much twice a day which the temperature of the prices then removed and are themselves. Ordinary people restricted the returple species cody as far as the forecounts of the hyposple fully, where they found themselves surrounded by unscriptions and images of kings and the gold on columns and walls. During religions fortrack, however, they limited the attemption of the processing of

The Guar Hua of Koosoo. Between Pylom II and III a Karnak stands the enormous Bypostyle hall creed in the freigns of the Nuneteenth Dymasy rulers Sery I (rule c. 1290-1279 mx)] and hus son Ramsess II (rule c. 1279-1213 mx). Called the "Temple of the Spain of Sery Beloved of Pah in the House of Annual," it my have been used for royal coronation cremonies. Ramses II referred to a "the Take where the common more level the mane."

his majersy"The hall was 340 feet wide and 170 feet long. Its 134 Gody spaced columns supported a stepped noof of flat stones, the center section of which nose ones 26 feet higher than the rest of the noof (no.5, 3–24, 3–21). The columns supporting this higher part of the noof are 66 feet tail and 12 feet in diameter, with massive fount flower ceptul. On each sub-column with massive flows flower bother columns with home bod capitals seem to maint off flower must the distance. In each of the well will off the habets, in each of the side will off the habets.

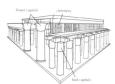

3-24 RECONSTRUCTION DRAWING OF THE HYPOSTYLE HALL, GREAT TEMPLE OF AMUN AT KARNAK

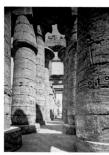

3-25 | FLOWER AND BUD COLUMNS, HYPOSTYLE HALL,

THE NEW KINGDOM: C 1519-1075 ACC

Reconstructions bring partially destroyed and no longer extant sites to life.

THE CRIMINOM. In Florence, the cathedral (homos) (trick, 123-), 12-4) has a long and complex history. The original plan by Armolfo (cathon) (or 123-4-1202), was approved in 123-4 hur political unrest in the 1330- brought construction to a halt until 1335. Several modifications of the design were made, and the cathedral we see today was built between tables and the cathedral we see today was built between tables and the cathedral was to the complex of the state of the s

Giovanni.)

Sculptors and painters rather than masons were ofte responsible for designing Italian architecture, and as the Florence Cathedral reflects, they tended to be more concerne with pure design than with engineering. The long, square

the nave and side aides. Three polygonal apies, each with five radiating chapels, surround the central spice. This symbolic Dome of Heaven, where the main altar is located, stands apart from the worldy realm of the congregation in the nave. But the great ribbed dome, so fundamental to the planners' conception, was not beginn until 1420, where the architect Faljapo Braunelleschi (1377–1446) solved the engineering prob-

THE BAPTISTEY DOORS. In 13.30, Andrea Pisano (c. 1290–1348) was awarded the prestigious commission for a pair of golded bronze doors for the Florentine Baptistry of San Giovanni. (Although his name means "from Pisa," Andrea was not related to Nicola and Giovanni Pisano; The Departer, doors are supported up the program of the Commission of the Commissio

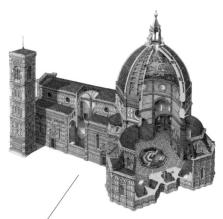

12-3 FLORENCE CYTHEDRAL (DUOMO)
Plan 1294, costruction begun 1296, redisegned 1357 and 1366, drum and dome 1420-36

428 CHAPTER TWELVE FOURTEENTH CENTURY ART IN EUROF

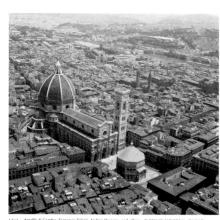

1294 Amoiro di Camoio, Francesco Talento, Andrea Orcagna, and others FLORENCE CATHEDRAL (DUOM 1296-1378; drum and dome by Brunelleschi, 1420-36; bell tower (Campanile) by Giotto, Andrea Pisano, and Francesco Talenti, c. 1334-50.

The Romanesque Baptistry of San Giovanni stands in front of the Duomo.

twenty scenes from the life of John the Baptus (San Giosumn) set above eight personnification of the Vitruss (Sin-Lea-). The reliefs are framed by quartefoils, the four-lobel decorative frames trumbacked at the Charled of Amineus In-France (Gu Fis. 11–21). The figures within the quartefoil are in the monimental, classiving right empired by Giotti their current in Florentine painting, but they also reveal the officiency of the properties of the control of the control officiency, and a quiret dignity of pose particular to Andrea. The individual scenes are eleganfy natural The figures placement, on shellful sease, and their modeling create creativelile distinct of three-dimensionally, but the event

dimensional and decorative, and emphasizes the solidity of the doors. The bronze vine scrolls filled with flowers, fruits, and birds on the lintel and jambs framing the door were added in the mid-fifteenth century.

Florentine Painting

Florence and Stena, rivals in so many ways, each supported fourthing school painting in the fourteenth century. Both grew out of the Halo-Byzantine sayle of the thirteenth century, modified by local traditions and by the presence of individual artists of genius. The Byzantine influence, also referred to a the minima gena ("Greek manner"), was characterized to a the minima gena ("Greek manner"), was characterized by diffauntic publics and complets conography and showed

ITALY 429

Cutaways assist students in understanding the design and engineering of major buildings.

FACULTY AND STUDENT RESOURCES FOR ART HISTORY: A VIEW OF THE WEST

rentice Hall is pleased to present an outstanding array of high quality resources for teaching and learning with Stokstad's *Art History: A View of the West*.

DIGITAL & VISUAL RESOURCES

The Prentice Hall Digital Art Library: Instructors who adopt Stokstad's Art History: A View of the West are eligible to receive this unparalleled resource. Available in a two-DVD set (ISBN 0-13-232211-0) or a 16-CD set (ISBN 0-13-156321-1), The Prentice Hall Digital Art Library contains every image in Art History: A View of the West in the highest resolution (300–400 dpi) and pixellation (up to 3000 pixels) possible for optimal projection and one-click download. Developed with input from a panel of instructors and visual resource curators, this resource features over 1,200 illustrations in jpeg and in PowerPoint, an instant download function for easy import into any presentation software, along with a zoom feature, and a compare/contrast function, both of which are unique and were developed exclusively for Prentice Hall.

VangoNotes: Students can study on the go with VangoNotes—chapter reviews from the text in downloadable mp3 format. Each chapter review contains: Big Ideas—Your "need to know" for each chapter; Key Terms: audio "flashcards" to help you review key concepts and terms; and Rapid Review: A quick drill session—use it right before your test. Visit www.vango.com.

OneKey is Prentice Hall's exclusive course management system that delivers all student and instructor resources in one place.

Powered by WebCT and Blackboard, OneKey offers an abundance of online study and research tools for students and a variety of teaching and presentation resources for instructors, including an easy-to-use gradebook and access to many of the images from the book.

Art History Interactive CD-ROM: 1,000 Images for Study & Presentation is a powerful study tool for students. Images are viewable by title, by period, or by artist. Students can quiz them-

selves in flashcard mode or by answering any number of short answer and compare/contrast questions.

Classroom Response System (CRS) In Class Questions: Get instant, class-wide responses to beautifully illustrated chapter-specific questions during a lecture to gauge student comprehension—and keep them engaged. Visit www.prenhall.com/art.

Companion Website: Visit www.prenhall.com/ stokstad for a comprehensive online resource featuring a variety of learning and teaching modules,

all correlated to the chapters of Art History: A View of the West.

Prentice Hall Test Generator is a commercial-quality computerized test management program available for both Microsoft Windows and Macintosh environments.

PRINT RESOURCES

TIME Special Edition, Art: Featuring stories such as "The Mighty Medici," "When Henri Met Pablo," and "Redesigning America," Prentice Hall's TIME Special Edition contains thirty articles and exhibition reviews on a wide range

of subjects, all illustrated in full color. This is the perfect complement for discussion groups, in-class debates, or writing assignments. With TIME Special Edition, students also receive a 3-month pass to the TIME archive, a unique reference and research tool.

Understanding the Art Museum by Barbara Beall-Fofana: This handbook gives students essential museum-going guidance to help them make the most of their experience seeing art outside of the classroom. Case studies are incorporated into the text, and a list of major museums in the United States and key cities across the world is included. (0-13-195070-3)

OneSearch with Research Navigator helps students with finding the right articles and journals in art history.

Students get exclusive access to three research databases: The New York Times Search by Subject Archive, ContentSelect Academic Journal Database, and Link Library.

Instructor's Manual & Test Item File is an invaluable professional resource and reference for new and experienced faculty, containing sample syllabi, hundreds of sample test questions, and guidance on incorporating media technology into your course. (0-13-232214-5)

To find your Prentice Hall representative, use our rep locator at www.prenhall.com.

ACKNOWLEDGEMENTS AND GRATITUDE

Dedicated to my sister, Karen L. S. Leider, and to my niece, Anna J. Leider

preface gives the author yet another opportunity to thank the many readers, faculty members, and students who have contributed to the development of a book. To all of you who have called, written, e-mailed, and just dropped by my office in the Art History Department or my study in the Spencer Research Library at the University of Kansas, I want to express my heartfelt thanks. Some of you worried about pointing out defects, omissions, or possible errors in the text or picture program of the previous edition. I want to assure you that I am truly grateful for your input and that I have made all the corrections and changes that seemed right and possible. (I swear the Weston photograph in the Introduction is correctly positioned in this edition, and that, no, I was not just being witty by showing only the Gallic trumpeter's back side in Chapter 5—that slip has been corrected!)

Art History: A View of the West represents the cumulative efforts of a distinguished group of scholars and educators. Single authorship of a work such as this is no longer viable. Patrick Frank has reworked the modern material previously contributed by David Cateforis and Bradford R. Collins. Dede Ruggles (Islamic) also has contributed to the third edition.

As ever, this edition has benefited from the assistance and advice of scores of other teachers and scholars who have generously answered my questions, given recommendations on organization and priorities, and provided specialized critiques. I want to especially thank the anonymous reviewers for their advice about reorganizing and revising individual chapters.

In addition, I want to thank University of Kansas colleagues Sally Cornelison, Amy McNair, Marsha Haufler, Charles Eldredge, Marni Kessler, Susan Earle, John Pulz, Linda Stone Ferrier, Stephen Goddard, and Susan Craig for their insightful suggestions and intelligent reactions to revised material. I want to mention, gratefully, graduate students who also helped: Stephanie Fox Knappe, Kate Meyer, and Emily Stamey.

I am additionally grateful for the detailed critiques that the following readers across the country prepared for this third edition: Charles M. Adelman, University of Northern Iowa; Fred C. Albertson, University of Memphis; Frances Altvater, College of William and Mary; Michael Amy, Rochester Institute of Technology; Jennifer L. Ball, Brooklyn College, CUNY; Samantha Baskind, Cleveland State University; Tracey Boswell, Johnson County Community College; Jane H. Brown, University of Arkansas at Little Rock; Roger J. Crum, University of Dayton; Brian A. Curran, Penn State University; Michael T. Davis, Mount Holyoke College; Juilee Decker, Georgetown College; Laurinda Dixon, Syracuse University;

Laura Dufresne, Winthrop University; Dan Ewing, Barry University; Arne Flaten, Coastal Carolina University; John Garton. Cleveland Institute of Art; Rosi Gilday, University of Wisconsin, Oshkosh; Eunice D. Howe, University of Southern California; Phillip Jacks, George Washington University; William R. Levin, Centre College; Susan Libby, Rollins College; Henry Luttikhuizen, Calvin College; Lynn Mackenzie, College of DuPage; Dennis McNamara, Triton College; Gustav Medicus, Kent State University; Lynn Metcalf, St. Cloud State University; Jo-Ann Morgan, Coastal Carolina University; Beth A. Mulvaney, Meredith College; Dorothy Munger, Delaware Community College; Bonnie Noble, University of North Carolina at Charlotte; Leisha O'Quinn, Oklahoma State University; Willow Partington, Hudson Valley Community College; Martin Patrick, Illinois State University; Albert Reischuck, Kent State University; Jeffrey Ruda, University of California, Davis; Diane Scillia, Kent State University: Stephanie Smith, Youngstown State University; Janet Snyder, West Virginia University; James Terry, Stephens College; Michael Tinkler, Hobart and William Smith Colleges; Reid Wood, Lorain County Community College. I hope that these readers will recognize the important part they have played in this new edition of Art History: A View of the West and that they will enjoy the fruits of all our labors. Please continue to share your thoughts and suggestions with me.

Many people reviewed the original edition of Art History and have continued to assist with its revision. Every chapter was read by one or more specialists. For work on the original book and assistance with subsequent editions my thanks go to: Barbara Abou-el-Haj, SUNY Binghamton; Roger Aiken, Creighton University; Molly Aitken; Anthony Alofsin, University of Texas, Austin; Christiane Andersson, Bucknell University; Kathryn Arnold; Julie Aronson, Cincinnati Art Museum; Michael Auerbach, Vanderbilt University; Larry Beck; Evelyn Bell, San Jose State University; Janetta Rebold Benton, Pace University; Janet Berlo, University of Rochester; Sarah Blick, Kenyon College; Jonathan Bloom, Boston College; Suzaan Boettger; Judith Bookbinder, Boston College; Marta Braun, Ryerson University; Elizabeth Broun, Smithsonian American Art Museum; Glen R. Brown, Kansas State University; Maria Elena Buszek, Kansas City Art Institute; Robert G. Calkins; Annmarie Weyl Carr, Southern Methodist University; April Clagget, Keene State College; William W. Clark, Queens College, CUNY; John Clarke, University of Texas, Austin; Jaqueline Clipsham; Ralph T. Coe; Robert Cohon, The Nelson-Atkins Museum of Art:

Bradford Collins, University of South Carolina; Alessandra Comini; Charles Cuttler; James D'Emilio, University of South Florida; Walter Denny, University of Massachusetts, Amherst; Jerrilyn Dodds, City College, CUNY; Lois Drewer, Index of Christian Art; Joseph Dye, Virginia Museum of Art; James Farmer, Virginia Commonwealth University; Grace Flam, Salt Lake City Community College; Mary D. Garrard; Paula Gerson, Florida State University; Walter S. Gibson; Dorothy Glass; Oleg Grabar; Randall Griffey, The Nelson-Atkins Museum of Art; Cynthia Hahn, Florida State University; Sharon Hill, Virginia Commonwealth University; John Hoopes, University of Kansas; Carol Ivory, Washington State University; Reinhild Janzen, Washburn University; Alison Kettering, Carleton College; Wendy Kindred, University of Maine at Fort Kent; Alan T. Kohl, Minneapolis College of Art; Ruth Kolarik, Colorado College; Carol H. Krinski, New York University; Aileen Laing, Sweet Briar College; Janet Le Blanc, Clemson University; Charles Little, The Metropolitan Museum of Art; Laureen Reu Liu, McHenry County College; Loretta Lorance; Brian Madigan, Wayne State University; Janice Mann, Bucknell University; Judith Mann, St. Louis Art Museum; Richard Mann, San Francisco State University; James Martin,; Elizabeth Parker McLachlan, Rutgers University; Tamara Mikailova, St. Petersburg, Russia, and Macalester College; Anta Montet-White; Anne E. Morganstern, Ohio State University; Winslow Myers, Bancroft School; Lawrence Nees, University of Delaware; Amy Ogata, Cleveland Institute of Art; Judith Oliver, Colgate University; Edward Olszewski, Case Western Reserve University; Sara Jane Pearman; John G. Pedley, University of Michigan; Michael Plante, Tulane University; Eloise Quiñones-Keber, Baruch College and the Graduate Center, CUNY; Virginia Raguin, College of the Holy Cross; Nancy H. Ramage, Ithaca College; Ann M. Roberts, Lake Forest College; Lisa Robertson, The Cleveland Museum of Art; Barry Rubin; Charles Sack, Parsons, Kansas; Jan Schall, The Nelson-Atkins Museum of Art; Tom Shaw, Kean College; Pamela Sheingorn, Baruch College, CUNY; Raechell Smith, Kansas City Art Institute; Lauren Soth; Anne R. Stanton, University of Missouri, Columbia; Michael Stoughton; Thomas Sullivan, OSB, Benedictine College (Conception Abbey); Pamela Trimpe, University of Iowa; Richard Turnbull, Fashion Institute of Technology; Elizabeth Valdez del Alamo, Montclair State College; Lisa Vergara; Monica Visoná, University of Kentucky; Roger Ward, Norton Museum of Art; Mark Weil, Washington University, St. Louis; David Wilkins; Marcilene Wittmer, University of Miami

My thanks also to additional expert readers for this new edition including Susan Cahan, University of Missouri-St. Louis; David Craven, University of New Mexico; Marian Feldman, University of California, Berkeley; Dorothy Johnson, University of Iowa; Genevra Kornbluth, University of Maryland; Patricia Mainardi, City University of New York; Clemente Marconi, Columbia University, Tod Marder, Rutgers University; Mary Miller, Yale University; Elizabeth Penton, Durham Technical Community College; Catherine B. Scallen, Case Western University; Kim Shelton, University of California, Berkeley.

I also want to thank Saralyn Reese Hardy, William J. Crowe, Richard W. Clement, and the Kenneth Spencer Research Library and the Helen F. Spencer Museum of Art of the University od Kansas.

Again I worked with my editors at Prentice Hall, Sarah Touborg and Helen Ronan, to create a book that would incorporate effective pedagogical features into a narrative that explores fundamental art historical ideas. Helen Ronan, Barbara Taylor-Laino, Assunta Petrone, and Lisa Iarkowski managed the project. I am grateful for the editing of Jeannine Ciliotta, Margaret Manos, Teresa Nemeth, and Carol Peters. Peter Bull's drawings have brought new information and clarity to the discussions of architecture. Designer Anne Demarinis created the intelligent, approachable design of this book; she was supported by the masterful talents of Amy Rosen and Gail Cocker-Bogusz. Much appreciation goes to Brandy Dawson, Marissa Feliberty, and Sasha Anderson-Smith in marketing and Sherry Lewis the manufacturing buyer, as well as the entire Humanities and Social Sciences team at Prentice Hall.

I hope you will enjoy this third edition of *Art History:* A View of the West and, as you have done so generously and graciously over the past years, will continue to share your responses and suggestions with me.

Marilyn Stokstad
 Lawrence, Kansas

USE NOTES

he various features of this book reinforce each other, helping the reader to become comfortable with terminology and concepts that are specific to art history.

Starter Kit and Introduction The Starter Kit is a highly concise primer of basic concepts and tools. The Introduction is an invitation to the many pleasures of art history.

Captions There are two kinds of captions in this book: short and long. Short captions identify information specific to the work of art or architecture illustrated:

artist (when known)

title or descriptive name of work

date

original location (if moved to a museum or other site) material or materials a work is made of

size (height before width) in feet and inches, with meters and centimeters in parentheses

present location

The order of these elements varies, depending on the type of work illustrated. Dimensions are not given for architecture, for most wall paintings, or for most architectural sculpture. Some captions have one or more lines of small print below the identification section of the caption that gives museum or collection information. This is rarely required reading.

Long captions contain information that complements the narrative of the main text.

Definitions of Terms You will encounter the basic terms of art history in three places:

IN THE TEXT, where words appearing in boldface type are defined, or glossed, at their first use. Some terms are boldfaced and explained more than once, especially those that experience shows are hard to remember.

IN BOXED FEATURES, on technique and other subjects, where labeled drawings and diagrams visually reinforce the use of terms.

IN THE GLOSSARY, at the end of the volume, which contains all the words in boldface type in the text and boxes. The Glossary begins on page 457, and the outer margins are tinted to make it easy to find.

Maps and Timelines At the beginning of each chapter you will find a map with all the places mentioned in the chapter. At the end of each chapter, a timeline runs from the earliest through the latest years covered in that chapter.

Boxes Special material that complements, enhances, explains, or extends the text is set off in three types of tinted boxes. Elements of Architecture boxes clarify specifically architectural features, such as "Space-Spanning Construction Devices" in the Starter Kit (page xxii). Technique boxes (see "Lost-Wax Cast-

ing," page xxvi) amplify the methodology by which a type of artwork is created. Other boxes treat special-interest material related to the text.

Bibliography The bibliography at the end of this book beginning on page 467 contains books in English, organized by general works and by chapter, that are basic to the study of art history today, as well as works cited in the text.

Dates, Abbreviations, and Other Conventions This book uses the designations BCE and CE, abbreviations for "Before the Common Era" and "Common Era," instead of BC ("Before Christ") and AD ("Anno Domini," "the year of our Lord"). The first century BCE is the period from 99 BCE to 1 BCE; the first century CE is from the year 1 CE to 99 CE. Similarly, the second century CE is the period from 199 BCE to 100 BCE; the second century CE extends from 100 CE to 199 CE.

100's	99-1	1-99	100's
second	first	first	second
century BCE	century BCE	century CE	century CE

Circa ("about" or "approximately") is used with dates, spelled out in the text and abbreviated to "c." in the captions, when an exact date is not yet verified.

An illustration is called a "figure," or "fig." Thus, figure 6–7 is the seventh numbered illustration in Chapter 6. Figures 1 through 23 are in the Introduction. There are two types of figures: photographs of artworks or of models, and line drawings. Drawings are used when a work cannot be photographed or when a diagram or simple drawing is the clearest way to illustrate an object or a place.

When introducing artists, we use the words *active* and *documented* with dates, in addition to "b." (for "born") and "d." (for "died"). "Active" means that an artist worked during the years given. "Documented" means that documents link the person to that date.

Accents are used for words in French, German, Italian, and Spanish only.

With few exceptions, names of museums and other cultural bodies in Western European countries are given in the form used in that country.

Titles of Works of Art Most paintings and works of sculpture created in Europe and North America in the past 500 years have been given formal titles, either by the artist or by critics and art historians. Such formal titles are printed in italics. In other traditions and cultures, a single title is not important or even recognized. In this book we use formal descriptive titles of artworks where titles are not established. If a work is best known by its non-English title, such as Manet's *Le Déjeuner sur l'Herbe (The Luncheon on the Grass)*, the original language precedes the translation.

STARTER KIT

rt history focuses on the visual arts—painting, drawing, sculpture, graphic arts, photography, decorative arts, and architecture. This Starter Kit contains basic information and addresses concepts that underlie and support the study of art history. It provides a quick reference guide to the vocabulary used to classify and describe art objects. Understanding these terms is indispensable since you will encounter them again and again in reading, talking, and writing about art, and when experiencing works of art directly.

Let us begin with the basic properties of art. A work of art is a material object having both form and content. It is also described and categorized according to its style and medium.

FORM

Referring to purely visual aspects of art and architecture, the term form encompasses qualities of *line, shape, color, texture, space, mass* and *volume,* and *composition*. These qualities all are known as *formal elements*. When art historians use the term formal, they mean "relating to form."

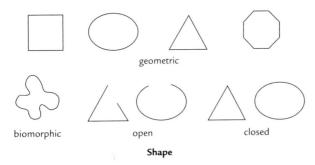

Line and shape are attributes of form. Line is a form—usually drawn or painted—the length of which is so much greater than the width that we perceive it as having only length. Line can be actual, as when the line is visible, or it can be implied, as when the movement of the viewer's eyes over the surface of a work follows a path determined by the artist. Shape, on the other hand, is the two-dimensional, or flat, area defined by the borders of an enclosing *outline*, or *contour*. Shape can be *geometric*, *biomorphic* (suggesting living things; sometimes called organic), *closed*, or *open*. The *outline*, or *contour*, of a three-dimensional object can also be perceived as line.

Color has several attributes. These include *hue, value,* and *saturation.*

Hue is what we think of when we hear the word color, and the terms are interchangeable. We perceive hues as the result of differing wavelengths of electromagnetic energy. The visible spectrum, which can be seen in a rainbow, runs from red through violet. When the ends of the spectrum are connected through the hue red-violet, the result may be diagrammed as a color wheel. The *primary hues* (numbered 1) are red, yellow, and blue. They are known as primaries because all other colors are

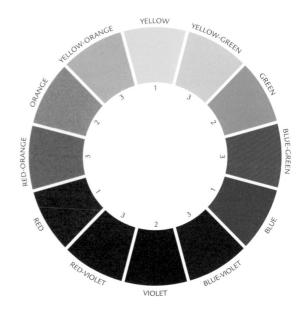

made of a combination of these hues. Orange, green, and violet result from the mixture of two primaries and are known as secondary hues (numbered 2). *Intermediate hues, or tertiaries* (numbered 3), result from the mixture of a primary and a secondary. *Complementary colors* are the two colors directly opposite one another on the color wheel, such as red and green. Red, orange, and yellow are regarded as warm colors and appear to advance toward us. Blue, green, and violet, which seem to recede, are called cool colors. Black and white are not considered colors but neutrals; in terms of light, black is understood as the absence of color and white as the mixture of all colors.

Value is the relative degree of lightness or darkness of a given color and is created by the amount of light reflected from an object's surface. A dark green has a deeper value than a light green, for example. In black-and-white reproductions of colored objects, you see only value, and some artworks—for example, a drawing made with black ink—possesses only value, not hue or saturation.

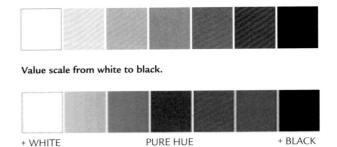

Value variation in red.

Saturation, also sometimes referred to as intensity, is a color's quality of brightness or dullness. A color described as highly saturated looks vivid and pure; a hue of low saturation may look a little muddy or dark.

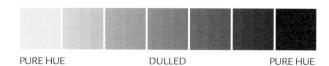

Intensity scale from bright to dull.

Texture, another attribute of form, is the tactile (or touch-perceived) quality of a surface. It is described by words such as *smooth*, *polished*, *rough*, *grainy*, or *oily*. Texture takes two forms: the texture of the actual surface of the work of art and the implied (illusionistically depicted) surface of the object that the work represents.

Space is what contains objects. It may be actual and threedimensional, as it is with sculpture and architecture, or it may be represented illusionistically in two dimensions, as when artists represent recession into the distance on a wall or canvas.

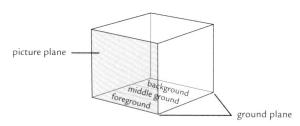

Mass and volume are properties of three-dimensional things.

Mass is matter—whether sculpture or architecture—that takes

up space. Volume is enclosed or defined space, and may be either solid or hollow. Like space, mass and volume may be illusionistically represented in two dimensions.

Composition is the organization, or arrangement, of form in a work of art. Shapes and colors may be repeated or varied, balanced symmetrically or asymmetrically; they may be static or dynamic. The possibilities are nearly endless and depend on the time and place where the work was created as well as the personal sensibility of the artist. *Pictorial depth* (spatial recession) is a specialized aspect of composition in which the three-dimensional world is represented in two dimensions on a flat surface, or *picture plane*. The area "behind" the picture plane is called the *picture space* and conventionally contains three "zones": *foreground, middle ground*, and *background*.

Various techniques for conveying a sense of pictorial depth have been devised by artists in different cultures and at different times. A number of them are diagrammed below. In Western art, the use of various systems of *perspective* has created highly convincing illusions of recession into space. In other cultures, perspective is not the most favored way to treat objects in space.

CONTENT

Content includes *subject matter*, which is what a work of art represents. Not all works of art have subject matter; many buildings, paintings, sculptures, and other art objects include no recognizable

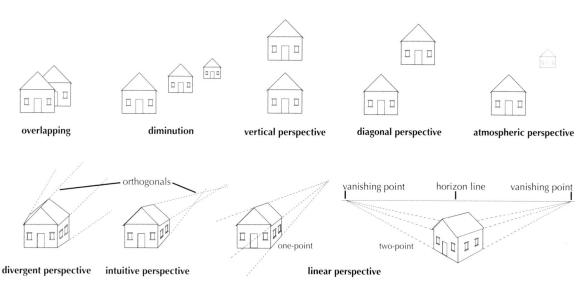

PICTORAL DEVICES FOR DEPICTING RECESSION IN SPACE

The top row shows several comparatively simple devices, including *overlapping*, in which partially covered elements are meant to be seen as located behind those covering them, and *diminution*, in which smaller elements are to be perceived as being farther away than larger ones. In *vertical* and *diagonal perspective*, elements are stacked vertically or diagonally, with the higher elements intended to be perceived as deeper in space. Another way of suggesting depth is through *atmospheric perspective*, which depicts objects in the far distance, often in bluish gray hues, with less clarity than nearer

objects and treats sky as paler near the horizon than higher up. In the lower row, divergent perspective, in which forms widen slightly and lines diverge as they recede in space, was used by East Asian artists. Intuitive perspective, used in some late medieval European art, takes the opposite approach: forms become narrower and converge the farther they are from the viewer, approximating the optical experience of spatial recession. Linear perspective, also called scientific, mathematical, one-point, and renaissance perspective, is an elaboration and standardization of intuitive perspective and was developed

in fifteenth-century Italy. It uses mathematical formulas to construct illusionistic images in which all elements are shaped by imaginary lines called *orthogonals* that converge in one or more vanishing points on a *horizon line*. Linear perspective is the system that most people living in Western cultures think of as perspective. Because it is the visual code they are accustomed to reading, they accept as "truth" the distortions it imposes. One of these distortions is *foreshortening*, in which, for instance, the soles of the feet in the foreground are the largest elements of a figure lying on the ground.

imagery but feature only lines, colors, masses, volumes, and other formal elements. However, all works of art—even those without recognizable subject matter—have content, or meaning, insofar as they seek to convey feelings, communicate ideas, or affirm the beliefs and values of their makers and, often, the people who view or use them.

Content may comprise the social, political, religious, and economic *contexts* in which a work was created, the *intention* of the artist, the *reception* of the work by the beholder (the audience), and ultimately the meanings of the work to both artist and audience. Art historians applying different methods of interpretation often arrive at different conclusions regarding the content of a work of art.

The study of subject matter is *iconography* (literally, "the writing of images"). The iconographer asks, What is the meaning of this image? Iconography includes the study of *symbols* and *symbolism*—the process of representing one thing by another through association, resemblance, or convention.

STYLE

Expressed very broadly, *style* is the combination of form and composition that makes a work distinctive. *Stylistic analysis* is one of art history's most developed practices, because it is how art historians recognize the work of an individual artist or the characteristic manner of several artists working in a particular time or place. Some of the most commonly used terms to discuss *artistic styles* include *period style*, *regional style*, *representational style*, *abstract style*, *linear style*, and *painterly style*.

Period style refers to the common traits detectable in works of art and architecture from a particular historical era. For instance, Roman portrait sculpture created at the height of the Empire is different from sculpture made during the late imperial period, but it is recognizably Roman. It is good practice not to use the words style and period interchangeably. Style is the sum of many influences and characteristics, including the period of its creation. An example of proper usage is "an American house from the Colonial period built in the Georgian style."

Regional style refers to stylistic traits that persist in a geographic region. An art historian whose specialty is medieval art can recognize French style through many successive medieval periods and can distinguish individual objects created in medieval France from other medieval objects that were created in, for example, the Low Countries.

Representational styles are those that create recognizable subject matter. *Realism*, *naturalism*, and *illusionism* are representational styles.

REALISM AND NATURALISM are terms often used interchangeably, and both describe the artist's attempt to describe the observable world. *Realism* is the attempt to depict objects accurately and objectively. *Naturalism* is closely linked to realism but often implies a grim or sordid subject matter. IDEAL STYLES strive to create images of physical perfection according to the prevailing values of a culture. The artist may work in a representational style or may try to capture an underlying or expressive reality. The *Medici Venus* (see Introduction, fig. 7) is *idealized*.

ILLUSIONISM refers to a highly detailed style that seeks to create a convincing illusion of reality. *Flower Piece with Curtain* is a good example of this trick-the-eye form of realism (see Introduction, fig. 2).

IDEALIZATION strives to realize an image of physical perfection according to the prevailing values of a culture. The *Medici Venus* is idealized, (see Introduction, fig. 7).

Abstract styles depart from literal realism to capture the essence of a form. An abstract artist may work from nature or from a memory image of nature's forms and colors, which are simplified, stylized, distorted, or otherwise transformed to achieve a desired expressive effect. Georgia O'Keeffe's *Red Canna* is an abstract representation of nature (see Introduction, fig. 5). *Nonrepresentational art* and *expressionism* are particular kinds of abstract styles.

NONREPRESENTATIONAL (OR NONOBJECTIVE) ART is a form that does not produce recognizable imagery. *Cubi XIX* is nonrepresentational (see Introduction, fig. 6).

EXPRESSIONISM refers to styles in which the artist uses exaggeration of form to appeal to the beholder's subjective response or to project the artist's own subjective feelings. Munch's *The Scream* is expressionistic (see fig 19–71).

Linear describes both style and techniques. In the linear style the artist uses line as the primary means of definition, and modeling—the creation of an illusion of three-dimensional substance, through shading. It is so subtle that brushstrokes nearly disappear. Such a technique is also called "sculptural." Raphael's *The Small Cowper Madonna* is linear and sculptural (fig. 15–5).

Painterly describes a style of painting in which vigorous, evident brushstrokes dominate and shadows and highlights are brushed in freely. Sculpture in which complex surfaces emphasize moving light and shade is called "painterly." Claudel's *The Waltz* is painterly sculpture (see fig. 19–75).

MEDIUM

What is meant by medium or mediums (the plural we use in this book to distinguish the word from print and electronic news media) refers to the material or materials from which a work of art is made.

Technique is the process used to make the work. Today, literally anything can be used to make a work of art, including not only traditional materials like paint, ink, and stone, but also rubbish, food, and the earth itself. Various techniques are explained throughout this book in Technique boxes. When several mediums are used in a single work of art, we employ the term *mixed mediums*. Two-dimensional mediums include painting, drawing, prints, and photography. Three-

dimensional mediums are sculpture, architecture, and many so-called decorative arts.

Painting includes wall painting and fresco, illumination (the decoration of books with paintings), panel painting (painting on wood panels) and painting on canvas, miniature painting (small-scale painting), and handscroll and hanging scroll painting. Paint is pigment mixed with a liquid vehicle, or binder.

Graphic arts are those that involve the application of lines and strokes to a two-dimensional surface or support, most often paper. Drawing is a graphic art, as are the various forms of printmaking. Drawings may be sketches (quick visual notes made in preparation for larger drawings or paintings); studies (more carefully drawn analyses of details or entire compositions); cartoons (full-scale drawings made in preparation for work in another medium, such as fresco); or complete artworks in themselves. Drawings are made with such materials as ink, charcoal, crayon, and pencil. Prints, unlike drawings, are reproducible. The various forms of printmaking include woodcut, the intaglio processes (engraving, etching, drypoint), and lithography.

Photography (literally "light writing") is a medium that involves the rendering of optical images on light-sensitive surfaces. Photographic images are typically recorded by a camera.

Sculpture is three-dimensional art that is *carved, modeled, cast,* or *assembled.* Carved sculpture is subtractive in the sense that the image is created by taking away material. Wood, stone, and ivory are common materials used to create carved sculptures. Modeled sculpture is considered additive, meaning that the object is built up from a material, such as clay, that is soft enough to be molded and shaped. Metal sculpture is usually cast (see "Lost-Wax Casting," page xxvi) or is assembled by welding or a similar means of permanent joining.

Sculpture is either freestanding (that is, not attached) or in relief. Relief sculpture projects from the background surface of which it is a part. High relief sculpture projects far from its background; low relief sculpture is only slightly raised; and sunken relief, found mainly in Egyptian art, is carved into the surface, with the highest part of the relief being the flat surface.

Ephemeral arts include processions and festival decorations and costumes, performance art, earthworks, cinema, video art, and some forms of digital and computer art. All have a central temporal aspect in that the artwork is viewable for a finite period of time and then disappears forever, is in a constant state of change, or must be replayed to be experienced again.

Architecture is three-dimensional, highly spatial, functional, and closely bound with developments in technology and materials. An example of the relationship among technology, materials, and function can be seen in "Space-Spanning Construction Devices" (page xxvi). Several types of two-dimensional schematic drawings are commonly used to enable the visualization of a building. These architectural graphic devices include plans, elevations, sections, and cutaways.

PLANS depict a structure's masses and voids, presenting a view from above—as if the building had been sliced horizontally at about waist height.

ELEVATIONS show exterior sides of a building as if seen from a moderate distance without any perspective distortion.

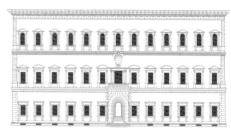

elevation

SECTIONS reveal a building as if it had been cut vertically by an imaginary slicer from top to bottom.

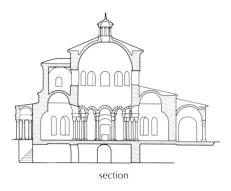

CUTAWAYS show both inside and outside elements from an oblique angle.

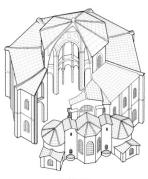

cutaway

Technique

LOST-WAX CASTING

he lost-wax process consists of a core on which the sculptor models the image in wax. A heat-resistant mold is formed over the wax. The wax is melted and replaced with metal, usually bronze or brass. The mold is broken away and the piece finished and polished by hand.

The usual metal for this casting process was bronze, an alloy of copper and tin, although sometimes brass, an alloy of copper and zinc, was used. The progression of drawings here shows the steps used by the Benin sculptors of Africa. A heat-resistant "core" of clay approximating the shape of the sculpture-to-be (and eventually becoming the hollow inside the sculpture) was covered by a layer of wax having the thickness of the final sculpture. The sculptor carved or modeled the details in the wax. Rods and a pouring cup made of wax were attached to the model. A thin layer of fine, damp sand was pressed very firmly

into the surface of the wax model, and then model, rods, and cup were encased in thick layers of clay. When the clay was completely dry, the mold was heated to melt out the wax. The mold was then turned upside down to receive the molten metal, which is heated to the point of liquification. The cast was placed in the ground. When the metal was completely cool, the outside clay cast and the inside core were broken up and removed, leaving the cast brass sculpture. Details were polished to finish the piece of sculpture, which could not be duplicated because the mold had been destroyed in the process.

In lost-wax casting the mold had to be broken and only one sculpture could be made. In the eighteenth century a second process came into use—the piece mold. As its name implies, the piece mold could be removed without breaking allowing sculptors to make several copies (editions) of their work.

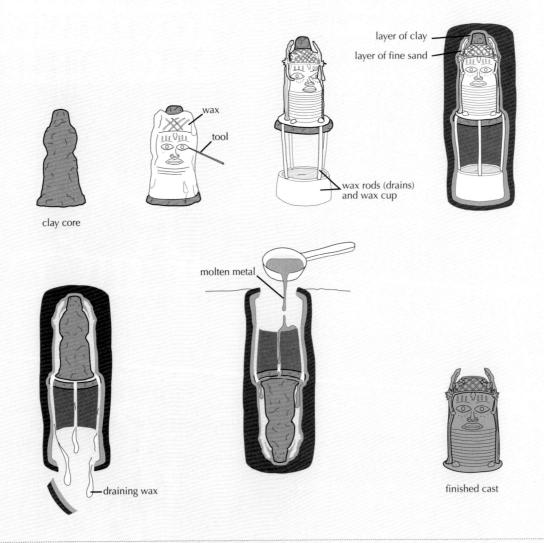

Elements of Architecture

SPACE-SPANNING CONSTRUCTION DEVICES

ravity pulls on everything, presenting great challenges to architects and sculptors. Spanning elements must transfer weight to the ground. The simplest space-spanning device is **post-and-lintel** construction, in which uprights are spanned by a horizontal element. However, if not flexible, a horizontal element over a wide span may break under the pressure of its own weight and the weight it carries.

Corbeling, the building up of overlapping stones, is another simple method for transferring weight to the ground. Arches, round or pointed, span space. Vaults, which are essentially extended arches, move weight out from the center of the covered space and down through the corners. The cantilever is a

variant of post-and-lintel construction. Suspension works to counter the effect of gravity by lifting the spanning element upward. Trusses of wood or metal are relatively lightweight spanners but cannot bear heavy loads. Large-scale modern construction is chiefly steel frame and relies on steel's properties of strength and flexibility to bear great loads. When concrete is reinforced with steel or iron rods, the inherent brittleness of cement and stone is overcome because of metal's flexible qualities. The concrete can then span much more space and bear heavier loads. The balloon frame, an American innovation, is based on post-and-lintel principles and exploits the lightweight, flexible properties of wood.

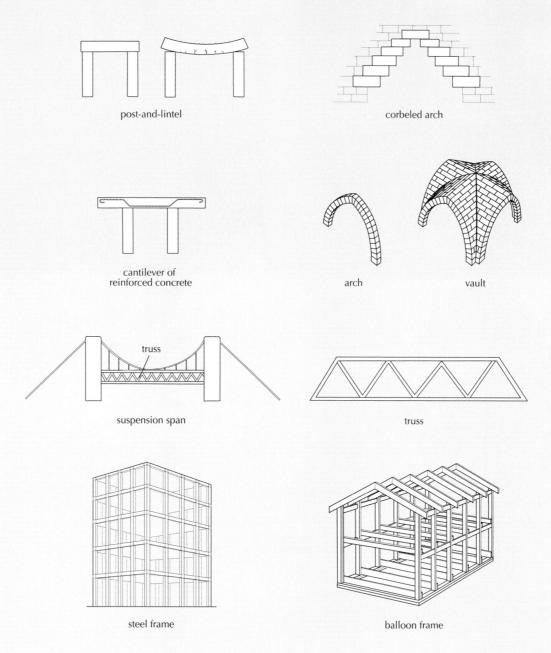

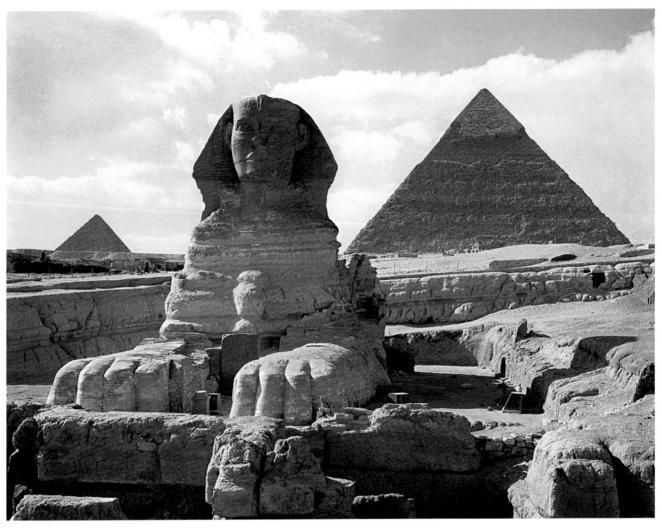

THE GREAT SPHINX, GIZA, EGYPT Dynasty 4, c. 2613-2494 BCE. Sandstone, height approx. 65' (19.8 m).

INTRODUCTION

Crouching in front of the pyramids of Egypt and carved from the living rock of the Giza plateau, the **GREAT SPHINX** is one of the world's best-known monuments (FIG. 1). By placing the head of the ancient Egyptian king Khafre on the body of a huge lion, the sculptors merged human intelligence and animal strength in a single image to evoke the superhuman power of the ruler. For some 4,600 years, the Sphinx has defied the desert sands; today it also must withstand the sprawl of greater Cairo and the impact of air pollution. In its majesty, the Sphinx symbolizes mysterious wisdom and dreams of per-

manence, of immortality. But is such a monument a work of art? Does it matter that the people who carved the Sphinx—unlike today's independent, individualistic artists—obeyed formulaic conventions and followed the orders of priests? No matter what the ancient Egyptians may have called it, today most people would say, "Certainly, it is art." Human imagination conceived this creature, and human skill gave it material form. Combining imagination and skill, the creators have conceived an idea of awesome grandeur and created a work of art. But we seldom stop to ask: What is art?

WHAT IS ART?

At one time the answer to the question "What is art?" would have been simpler than it is today. The creators of the *Great Sphinx* demonstrate a combination of imagination, skill, training, and observation that appeal to our desire for order and harmony—perhaps to an innate aesthetic sense. Yet, today some people question the existence of an aesthetic faculty, and we realize that our tastes are products of our education and our experience, dependent on time and place. Whether acquired at home, in schools, in museums, or in other public places, our responses are learned—not innate. Ideas of truth and falsehood, of good and evil, of beauty and ugliness are influenced as well by class, gender, race, and economic status. Some historians and critics even go so far as to argue that works of art are mere reflections of power and privilege.

Even the idea of "beauty" is questioned and debated today. Some commentators find discussions of aesthetics (the branch of philosophy concerned with The Beautiful) too subjective and too personal, and they dismiss the search for objective criteria that preoccupied scholars in the eighteenth and nineteenth centuries. As traditional aesthetics come under challenge, we can resort to discussing the authenticity of expression in a work of art, even as we continue to analyze its formal qualities. We can realize that people at different times and in different places have held different values. The words "art history" can be our touchstone. Like the twofold term itself, this scholarly discipline considers both art and history—the work of art as a tangible object and as part of its historical context. Ultimately, because so-called objective evaluations of beauty seem to be an impossibility, beauty again seems to lie in the eye of the beholder.

Today's definition of art encompasses the intention of the creator as well as the intentions of those who commissioned the work. It relies, too, on the reception of the artwork by society—both today and at the time when the work was made. The role of art history is to answer complex questions: Who are these artists and patrons? What is this thing they have created? When and how was the work done? Only after we have found answers to practical questions like these can we acquire an understanding and appreciation of the artwork and, answering our earlier question, we can say, yes, this is a work of art.

ART AND NATURE

The ancient Greeks enjoyed the work of skillful artists. They especially admired the illusionistic treatment of reality in which the object represented appears to actually be present. The Greek penchant for realism is illustrated in a story from the late fifth century BCE about a rivalry between two painters named Zeuxis and Parrhasios as to whom was the better painter. First, Zeuxis painted a picture of grapes so accurately that birds flew down to peck at them. But, when Parrhasios

2 Adriaen van der Spelt and Frans van Mieris **FLOWER PIECE WITH CURTAIN** 1658. Oil on panel, $18\% \times 25\%$ (46.5×64 cm). The Art Institute of Chicago. Wirt D. Walker Fund. (1949.585). Photograph © 2005 The Art Institute of Chicago. All rights reserved

took his turn, and Zeuxis asked his rival to remove the curtain hanging over his rival's picture, Parrhasios pointed out with glee that the "curtain" was his painting. Zeuxis had to admit that Parrhasios had won the competition since he himself had fooled only birds, while Parrhasios had deceived a fellow artist.

In the seventeenth century, the painters Adriaen van der Spelt (1630-73) and Frans van Mieris (1635-81) paid homage to the story of Parrhasios's curtain in a painting of blue satin drapery drawn aside to show a garland of flowers. We call the painting simply FLOWER PIECE WITH CURTAIN (FIG. 2). The artists not only re-created Parrhasios's curtain illusion but also included a reference to another popular story from ancient Greece, Pliny's anecdote of Pausias and Glykera. In his youth, Pausias had been enamored of the lovely flowerseller Glykera, and he learned his art by persistently painting the exquisite floral garlands that she made, thereby becoming the most famously skilled painter of his age. The seventeenthcentury people who bought such popular still-life paintings appreciated their classical allusions as much as the artists' skill in drawing and painting and their ability to manipulate colors on canvas. But, the reference to Pausias and Glykera also raised the conundrum inherent in all art that seeks to make an unblemished reproduction of reality: Which has the greater beauty, the flower or the painting of the flower? And which is the greater work of art, the garland or the painting of the garland? So then, who is the greater artist, the garland maker or the garland painter?

MODES OF REPRESENTATION

Many people think that the manner of Zeuxis and Parrhasios, and of van der Spelt and van Mieris—the manner of representation that we call **naturalism**, or **realism**—the mode of

3 CORINTHIAN CAPITAL FROM THE THOLOS AT EPIDAURUS c. 350 BCE. Archaeological Museum, Epidaurus, Greece.

interpretation that seeks to record the visible world—represents the highest accomplishment in art, but not everyone agrees. Even the ancient Greek philosophers Aristotle (384–322 BCE) and Plato (428–348/7 BCE), who both considered the nature of art and beauty in purely intellectual terms, arrived at divergent conclusions. Aristotle believed that works of art should be evaluated on the basis of mimesis ("imitation"), that is, on how well they copy definable or particular aspects of the natural world. This approach to defining "What is art?" is a realistic or naturalistic one. But, of course, while artists may work in a naturalistic style, they also can render lifelike such fictions as a unicorn, a dragon, or a sphinx by incorporating features from actual creatures.

In contrast to Aristotle, Plato looked beyond nature for a definition of art. In his view even the most naturalistic painting or sculpture was only an approximation of an eternal ideal world in which no variations or flaws were present. Rather than focus on a copy of the particular details that one saw in any particular object, Plato focused on an unchangeable ideal—for artists, this would be the representation of a subject that exhibited perfect symmetry and proportion. This mode of interpretation is known as **idealism**. In a triumph of human reason over nature, idealism wishes to eliminate all irregularities, ensuring a balanced and harmonious work of art.

Let us consider a simple example of Greek idealism from architecture: the carved top, or capital, of a Corinthian column, a type that first appeared in ancient Greece during the fourth century BCE. The Corinthian capital has an inverted bell shape surrounded by acanthus leaves (FIG. 3). Although the acanthus foliage was inspired by the appearance of natural vegetation, the sculptors who carved the leaves eliminated blemishes and irregularities in order to create the Platonic ideal of the acanthus plant's foliage. To achieve Plato's ideal images and represent things "as they ought to be" rather than

as they are, classical sculpture and painting established ideals that have inspired Western art ever since.

Like ancient Greek sculptors, Edward Weston (1886–1958) and Georgia O'Keeffe (1887–1986) studied living plants. In his photograph **succulent**, Weston used straightforward camera work without manipulating the film in the darkroom in order to portray his subject (FIG. 4). He argued that although the camera sees more than the human eye, the quality of the image depends not on the camera, but on the choices made by the photographer-artist.

When Georgia O'Keeffe painted RED CANNA, she, too, sought to capture the plant's essence, not its appearance—although we can still recognize the flower's form and color (FIG. 5). By painting the canna lily's organic energy rather than the way it actually looked, she created a new abstract beauty, conveying in paint the pure vigor of the flower's life force. This abstraction—in which the artist appears to transform a visible or recognizable subject from nature in a way that suggests the original but purposefully does not record the subject in an entirely realistic or naturalistic way—is another manner of representation.

Furthest of all from naturalism are pure geometric creations such as the polished stainless steel sculpture of David Smith (1906–65). His Cubi works are usually called **nonrepresentational** art—art that does not depict a recognizable subject. With works such as **CUBI XIX** (FIG. 6), it is important to distinguish between subject matter and content. Abstract art like O'Keeffe's has both subject matter and content, or meaning. Nonrepresentational art does not have subject matter but it does have content, which is a product of the interaction between the artist's

4 Edward Weston

1930. Gelatin silver print, $7\frac{1}{2} \times 9\frac{1}{2}$ " (19.1 \times 24 cm). Center for Creative Photography, The University of Arizona, Tucson.

10 James Hampton THRONE OF THE THIRD HEAVEN OF THE NATIONS' MILLENNIUM GENERAL ASSEMBLY

c. 1950-1964. Gold and silver aluminum foil, colored Kraft paper, and plastic sheets over wood, paperboard, and glass, 10'6" × 27' × 14'6" (3.2 × 8.23 × 4.42 m). Smithsonian American Art Museum, Smithsonian Institution, Washington, D.C.

Gift of Anonymous Donors,

1970.353.1

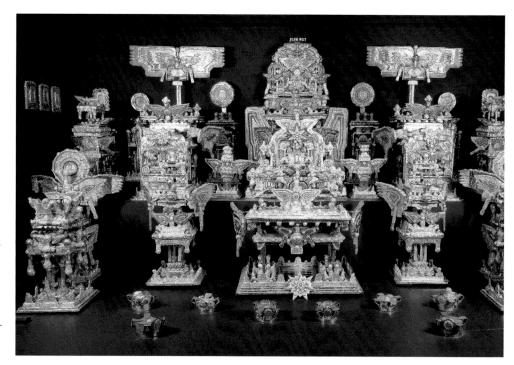

Self-Expression: Art and the Search for Meaning

Throughout history art has played an important part in our search for the meaning of the human experience. In an effort to understand the world and our place in it, we turn both to introspective personal art and to communal public art. Following a personal vision, James Hampton (1909–64) created profoundly stirring religious art. Hampton worked as a janitor to support himself while, in a rented garage, he built throne of the third heaven of the nations' millennium gen-ERAL ASSEMBLY (FIG. 10), his monument to his faith. In rising tiers, thrones and altars have been prepared for Jesus and Moses. Placing New Testament imagery on the right and Old Testament imagery on the left, Hampton labeled and described everything. He even invented his own language to express his visions. On one of many placards he wrote his credo: "Where there is no vision, the people perish" (Proverbs 29:18). Hampton made this fabulous assemblage out of discarded furniture, flashbulbs, and all sorts of refuse tacked together and wrapped in gold and silver aluminum foil and purple tissue paper. How can such worthless materials turn into an exalted work of art? Art's genius transcends material.

In contrast to James Hampton, whose life's work was compiled in private and only came to public attention after his death, most artists and viewers participate in more public expressions of art and belief. Nevertheless, when people employ special objects in their rituals, such as statues, masks, and vessels, these pieces may be seen as works of art by others who do not know about their intended use and original significance.

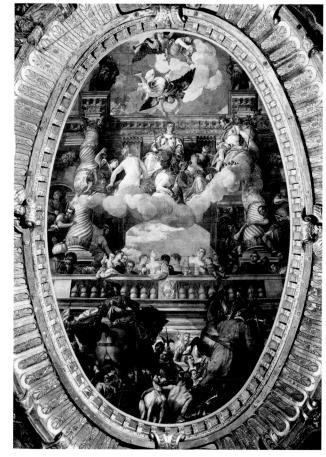

11 Veronese **THE TRIUMPH OF VENICE**Ceiling painting in the Council Chamber, Palazzo Ducale, Venice, Italy. c. 1585. Oil on canvas, 29'8" × 19' (9.04 × 5.79 m).

1506, Michelangelo rushed to watch it being excavated, an astonishing validation of his own ideal, heroic style coming straight out of the earth. The pope acquired it for the papal collection, and it can be seen today in the Vatican Museum.

Like other learned people in the eighteenth century, the German philosopher Lessing knew the story of Laocoön and admired the sculpture as well. In fact, he titled his study of the relationship between words and images "Laocoon: An Essay upon the Limits of Painting and Poetry" (1766). Lessing saw literary pursuits such as poetry and history as arts of time, whereas painting and sculpture played out in a single moment in space. Using words, writers can present a sequence of events, while sculptors and painters must present a single critical moment. Seen in this light, the interpretation of visual art depends upon the viewer who must bring additional knowledge in order to reconstitute the narrative, including events both before and after the depicted moment. For this reason, Lessing argued for the primacy of literature over the visual arts. The debate over the comparative virtues of the arts has been a source of excited argument and even outrage among critics, artists, philosophers, and academics ever since.

Underlying all our assumptions about works of art—whether in the past or the present—is the idea that art has meaning, and that its message can educate and move us, that it can influence and improve our lives. But what gives art its meaning and expressive power? Why do images fascinate and inspire us? Why do we treasure some things but not others? These are difficult questions, and even specialists disagree about the answers. Sometimes even the most informed people must conclude, "I just don't know."

Studying art history, therefore, cannot provide us with definitive answers, but it can help us recognize the value of asking questions as well as the value of exploring possible answers. Art history is grounded in the study of material objects that are the tangible expression of the ideas—and ideals—of a culture. For example, when we become captivated by a striking creation, art history can help us interpret its particular imagery and meaning. Art history can also illuminate the cultural context of the work—that is, the social, economic, and political situation of the historical period in which it was produced, as well as its evolving significance through the passage of time.

Exceptional works of art speak to us. However, only if we know something about the **iconography** (the meaning and interpretation) of an image can its larger meaning become clear. For example, let's look again at *Flower Piece with Curtain* (SEE FIG. 2). The brilliant red and white tulip just to the left of the blue curtain was the most desirable and expensive flower in the seventeenth century; thus, it symbolizes wealth and power. Yet insects creep out of it, and a butterfly—fragile and transitory—hovers above it. Consequently, here flowers also symbolize the passage of time and the fleet-

ing quality of human riches. Informed about its iconography and cultural context, we begin to fathom that this painting is more than a simple still life.

WHY DO WE NEED ART?

Before we turn to Chapter 1—before we begin to look at, read about, and think about works of art and architecture historically, let us consider a few general questions that studying art history can help us answer and that we should keep in mind as we proceed: Why do we need art? Who are artists? What role do patrons play? What is art history? and What is a viewer's role and responsibility? By grappling with such questions, our experience of art can be greatly enhanced.

Biologists account for the human desire for art by explaining that human beings have very large brains that demand stimulation. Curious, active, and inventive, we humans constantly explore, and in so doing we invent things that appeal to our senses—fine art, fine food, fine scents, fine fabrics, and fine music. Ever since our prehistoric ancestors developed their ability to draw and speak, we have visually and verbally been communicating with each other. We speculate on the nature of things and the meaning of life. In fulfilling our need to understand and our need to communicate, the arts serve a vital function. Through art we become fully alive.

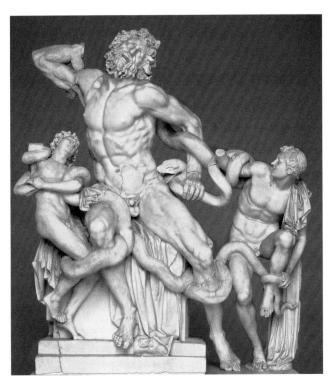

9 Hagesandros, Polydoros, and Athanadoros of Rhodes LAOCOÖN AND HIS SONS

As restored today. Probably the original of 1st century CE or a Roman copy of the 1st century CE. Marble, height 8' (2.44 m). Musei Vaticani, Museo Pio Clementino, Cortile Ottagono, Rome, Italy.

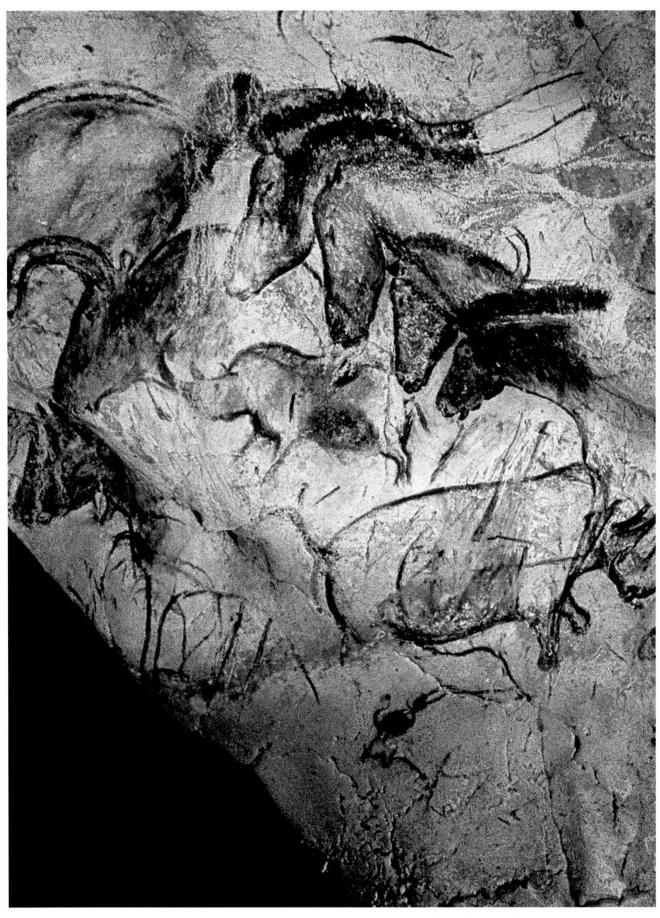

I–I | **WALL PAINTING WITH HORSES, RHINOCEROSES, AND AUROCHS** Chauvet Cave, Vallon-Pont-d'Arc, Ardèche Gorge, France. c. 30,000–28,000 BCE. Paint on limestone.

pher Karl Marx (1818–83) who saw human beings as the products of their economic environment and art as a reflection of humanity's excessive concern with material values. Some social historians see the work of art as a status symbol for the elite in a highly stratified society.

Art historians also study the history of other arts—including music, drama, and literature—to gain a fuller sense of the context of visual art. Their work results in an understanding of the iconography (the narrative and allegorical significance) and the context (social history) of the artwork. Anthropology and linguistics have added yet another theoretical dimension to the study of art. The Swiss linguist Ferdinand de Saussure (1857–1913) developed structuralist theory, which defines language as a system of arbitrary signs. Works of art can be treated as a language in which the marks of the artist replace words as signs. In the 1960s and 1970s structuralism evolved into other critical positions, the most important of which are semiotics (the theory of signs and symbols) and deconstruction. To the semiologist, a work of art is an arrangement of marks or "signs" to be decoded, and the artist's meaning or intention holds little interest. Similarly the deconstructionism of the French philosopher Jacques Derrida (1930-2004) questions all assumptions including the idea that there can be any single correct interpretation of a work of art. So many interpretations emerge from the creative interaction between the viewer and the work of art that in the end the artwork is "deconstructed."

The existence of so many approaches to a work of art may lead us to the conclusion that any idea or opinion is equally valid. But art historians, regardless of their theoretical stance, would argue that the informed mind and eye are absolutely necessary.

As art historians study a wider range of artworks than ever before, many have come to reject the idea of a fixed canon of superior pieces. The distinction between elite fine arts and popular utilitarian arts has become blurred, and the notion that some mediums, techniques, or subjects are better than others has almost disappeared. This is one of the most telling characteristics of art history today, along with the breadth of studies it now encompasses and its changing attitude to challenges such as preservation and restoration.

WHAT IS A VIEWER'S ROLE AND RESPONSIBILITY?

As viewers we enter into an agreement with artists, who in turn make special demands on us. We re-create the works of art for ourselves as we bring to them our own experiences, our intelligence, our knowledge, and even our prejudices. Without our participation, artworks are merely chunks of stone or flecks of paint. But remember, all is change. From extreme realism at one end of the spectrum to entirely non-representational art at the other, artists have worked with varying degrees of naturalism, idealism, and abstraction. For

23 Hendrick Goltzius DUTCH VISITORS TO ROME LOOKING
AT THE FARNESE HERCULES

c. 1592. Engraving, $16 \times 11\frac{1}{2}$ " (40.5 x 29.4 cm). After Goltzius returned from a trip to Rome in 1591–1592, he made engravings based on his drawings. The awe-struck viewers have been identified as two of his Dutch friends.

students of art history, the challenge is to discover not only how those styles evolved, but also why they changed, and ultimately what significance these changes hold for us, for our humanity, and for our future.

Our involvement with art can be casual or intense, naive or sophisticated. At first we may simply react instinctively to a painting or a building or a sculpture (FIG. 22), but this level of "feeling" about art—"I know what I like"—can never be fully satisfying. Like the sixteenth-century Dutch visitors to Rome (FIG. 23), we too can admire and ponder the ancient marble FARNESE HERCULES, and we can also ponder Hendrick Goltzius's engraving that depicts his Dutch friends as they ponder, and we can perhaps imagine an artist depicting us as our glance leaps backwards and forwards pondering art history. Because as viewers we participate in the re-creation of a work of art, its meaning changes from individual to individual, from era to era.

Once we welcome the arts into our lives, we have a ready source of sustenance and challenge that grows, changes, mellows, and enriches our daily experience. This book introduces us to works of art in their historical context, but no matter how much we study or read about art and artists, eventually we return to the contemplation of an original work itself, for art is the tangible evidence of the ever-questing human spirit.

Luckily, Leyland did not destroy the Peacock Room. After Leyland's death, Charles Lang Freer (1854–1919) purchased the room and the painting of *The Princess*. Freer reinstalled the room in his home in Detroit, Michican, and filled the delicate gold shelves with his own collection of porcelain. When Freer died in 1919, the Peacock Room was moved to the Freer Gallery of Art, which he had founded in Washington D.C., where it remains as an extraordinary example of interior design and late nineteenth-century patronage.

Collectors and Museums

From the earliest times, people have collected and kept precious objects that convey the idea of power and prestige. Today both private and public museums are major patrons, collectors, and preservers of art. Curators of such collections acquire works of art for their museums and often assist patrons in obtaining especially desirable pieces, although the idea of what is best and what is worth collecting and preserving often changes from one generation to another.

Charles Lang Freer, mentioned on the previous page, is another kind of patron—one who was a sponsor of artists, a collector, and the founder of the museum that bears his name. Freer

22 THE FARNESE HERCULES
3rd century BCE. Copy of *The Weary Hercules* by
Lysippos. Found in the Baths of Caracalla in 1546; exhibited in the Farnese Palace until 1787. Marble, 10½′ (3.17 m). Signed "Glykon" on the rock under the club. Left arm restored.

was an industrialist in Detroit—the manufacturer of railway cars—who was inspired by the nineteenth-century ideal of art as a means of achieving universal harmony and of the philosophy "Art for Art's Sake." The leading American exponent of this philosophy was James McNeill Whistler. On a trip to Europe in 1890, Freer met Whistler, who inspired him to collect Asian art as well as the art of his own time. Freer became an avid collector and supporter of Whistler, whom he saw as a person who combined the aesthetic ideals of both East and West. Freer assembled a large and distinguished collection of American and Asian art, including the *Peacock Room*. (SEE FIG. 21). In his letter written at the founding the Freer Gallery, donating his collection to the Smithsonian Institution and thus to the American people, he wrote of his desire to "elevate the human mind."

WHAT IS ART HISTORY?

Art history became an academic field of study relatively recently. Many art historians consider the first art history book to be the 1550 publication *Lives of the Most Excellent Italian Architects, Painters, and Sculptors*, by the Italian artist and writer Giorgio Vasari. As the name suggests, art history combines two studies—the study of individual works of art outside time and place (formal analysis and theory) and the study of art in its historical and cultural context (contextualism), the primary approach taken in this book. The scope of art history is immense. As a result, art history today draws on many other disciplines and diverse methodologies.

Studying Art Formally and Contextually

The intense study of individual art objects is known as **connoisseurship**. Through years of close contact with artworks and through the study of the formal qualities that compose style in art (such as the design, the composition, and the way materials are manipulated)—an approach known as formalism—the connoisseur learns to categorize an unknown work through comparison with related pieces, in the hope of attributing it to a period, a place, and sometimes even a specific artist. Today such experts also make use of the many scientific tests—such as x-ray radiography, electron microscopy, infrared spectroscopy, and x-ray diffraction—but ultimately connoisseurs depend on their visual memory and their skills in formal analysis.

As a humanistic discipline, art history adds theoretical and contextual studies to the formal and technical analyses of connoisseurship. Art historians draw on biography to learn about artists' lives; on social history to understand the economic and political forces shaping artists, their patrons, and their public; and on the history of ideas to gain an understanding of the intellectual currents influencing artists' works. Some art historians are steeped in the work of Sigmund Freud (1856–1939), whose psychoanalytic theory addresses creativity, the unconscious mind, and art as an expression of repressed feelings. Others have turned to the political philoso-

19 Lawrence Alma-Tadema PHEIDIAS AND THE FRIEZE OF THE PARTHENON, Athens 1868. Oil on canvas, $29\% \times 42\%$ (75.3 \times 108 cm). Birmingham City Museum and Art Gallery, England

Individual Patrons

People who are not artists often want to be involved with art, and patrons of art constitute a very special audience for artists. Many collectors truly love works of art, but some collect art only to enhance their own prestige, to give themselves an aura of power and importance. Patrons can vicariously participate in the creation of a work by providing economic support to an artist. Such individual patronage can spring from a cordial relationship between a patron and an artist, as is evident in an early fifteenth-century manuscript illustration in which the author, Christine de Pizan, presents her work to her patron Isabeau, the Queen of France (FIG. 20). Christine—a widow who supported her family by writing—hired

20 CHRISTINE DE PIZAN PRESENTING HER BOOK TO THE QUEEN OF FRANCE 1410–15. Tempera and gold on vellum, image approx. $5\% \times 6\%''$ (14 \times 17 cm). The British Library, London.

MS. Harley 4431, folio 3

painters and scribes to copy, illustrate, and decorate her books. She especially admired the painting of a woman named Anastaise, whose work she considered unsurpassed in the city of Paris. While Queen Isabeau was Christine's patron, Christine in turn was Anastaise's patron; and all the women seen in the painting were patrons of the brilliant textile workers who supplied the brocades for their gowns, the tapestries for the wall, and the embroideries for the bed. Such networks of patronage shape a culture.

Relations between artists and patrons are not always necessarily congenial. Patrons may change their minds or fail to pay their bills. Artists may ignore their patron's wishes, or exceed the scope of their commission. In the late nineteenth century, for example, the Liverpool shipping magnate Frederick Leyland asked James McNeill Whistler (1834–1903), an American painter living in London, what color to paint the shutters in the dining room where he planned to hang Whistler's painting *The Princess from The Land of Porcelain* (FIG. 21).

The room had been designed by Thomas Jeckyll with embossed and gilded leather on the walls and finely crafted shelves to show off Leyland's collection of blue and white Chinese porcelain. While Leyland was away, Whistler, inspired by the Japanese theme of his own painting as well as by the porcelain, painted the window shutters with splendid turquoise and gold peacocks, the walls and ceiling with peacock feathers, and then he gilded the walnut shelves. When Leyland, shocked and angry at what seemed to him to be wanton destuction of the room, paid him less than half the agreed on price, Whistler added a painting of himself and Leyland as fighting peacocks. Whistler called the room HARMONY IN BLUE AND GOLD: THE PEACOCK ROOM.

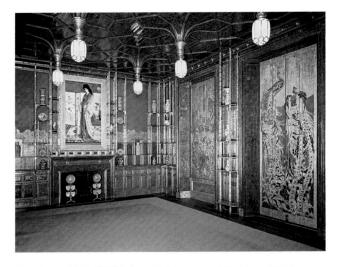

21 James McNeill Whistler HARMONY IN BLUE AND GOLD: THE PEACOCK ROOM northeast corner, from a house owned by Frederick Leyland, London. 1876–1877. Oil paint and metal leaf on canvas, leather, and wood, $13'11\%'' \times 33'2'' \times 19'11\%''$ (4.26 \times 10.11 \times 6.83 m). Over the fireplace, Whistler's *The Princess from The Land of Porcelain*. Freer Gallery of Art, Smithsonian Institution, Washington, D.C. Gift of Charles Lang Freer, (F1904.61)

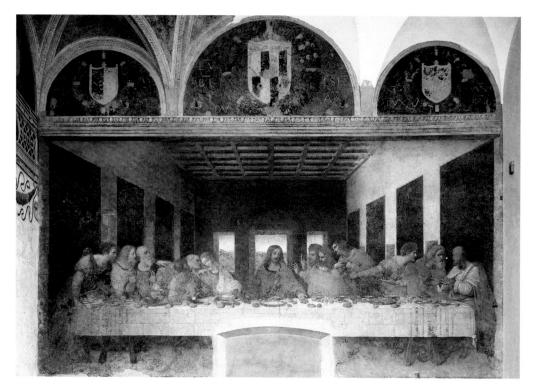

Leonardo da Vinci **THE LAST SUPPER**Wall painting in the refectory, Monastery of Santa Maria delle Grazie, Milan, Italy. 1495–1498. Tempera and oil on plaster, $15'2'' \times 28'10'' (4.6 \times 8.8 \text{m})$.

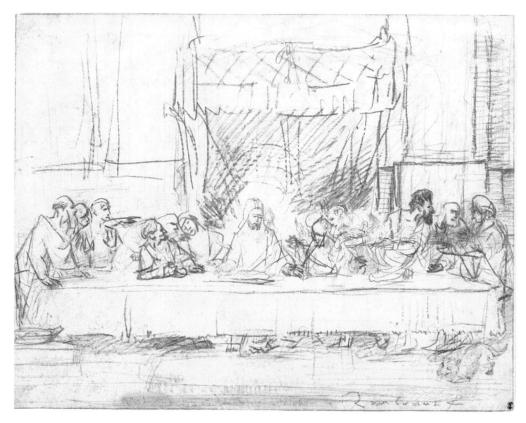

18 Rembrandt van Rijn **THE LAST SUPPER** After Leonardo da Vinci's fresco. Mid-1630s. Drawing in red chalk, $14 \% \times 18 \% \ (36.5 \times 47.5 \ cm). \ The \ Metropolitan \ Museum \ of \ Art, \ New \ York \ Robert \ Lehman \ Collection, 1975 \ (1975.1.794)$

How Does One Become an Artist?

Whether working individually or communally, even the most brilliant artists spend years in study and apprenticeship and continue to educate themselves throughout their lives. In his painting **THE DRAWING LESSON**, Dutch artist Jan Steen (1626–79) takes us into a well-lit artist's studio. Surrounded by the props of his art—a tapestry backdrop, an easel, a stretched canvas, a portfolio, musical instruments, and decorative *objets d'art*—a painter instructs two youngsters—a boy apprentice at a drawing board, and a young woman in an elegant armchair (FIG. 16). The artist's pupil has been drawing from sculpture and plaster casts because women were not permitted to work from nude models. *The Drawing Lesson* records contemporary educational practice and is a valuable record of an artist's workplace in the seventeenth century.

Even the most mature artists learn from each other. In the seventeenth century, Rembrandt van Rijn carefully studied Leonardo's painting of **THE LAST SUPPER** (FIG. 17). Leonardo had turned this traditional theme into a powerful drama by portraying the moment when Christ announces that one of the assembled apostles will betray him. Even though the men react with surprise and horror to this news, Leonardo depicted the scene in a balanced symmetrical composition typical of the Italian Renaissance of the fifteenth and early sixteenth centuries, with the apostles in groups of three on each side of Christ. The regularly spaced tapestries and ceiling panels lead the viewers' eyes to Christ, who is silhouetted in front of an open window (the door seen in the photograph was cut through the painting at a later date).

Rembrandt, working 130 years later in the Netherlands—a very different time and place—knew the Italian master's painting from a print, since he never went to Italy. Rembrandt copied THE LAST SUPPER in hard red chalk (FIG. 18). Then he reworked the drawing in a softer chalk, assimilating Leonardo's lessons but revising the composition and changing the mood of the original. With heavy overdrawing he recreated the scene, shifting Jesus's position to the left, giving Judas more emphasis. Gone are the wall hangings and ceiling, replaced by a huge canopy. The space is undetermined and expansive rather than focused. Rembrandt's drawing is more than an academic exercise; it is also a sincere tribute from one great master to another. The artist must have been pleased with his version of Leonardo's masterpiece because he signed his drawing boldly in the lower right-hand corner.

WHAT ROLE DO PATRONS AND COLLECTORS PLAY?

As we have seen, the person or group who commissions or supports a work of art—the patron—can have significant impact on it. The *Great Sphinx* (SEE FIG. 1) was "designed" following the conventions of priests in ancient Egypt; the mon-

umental statue of *Charles V* was cast to glorify absolutist rule (SEE FIG. 8); the content of Veronese's *Triumph of Venice* (SEE FIG. 11) was determined by that city's government officials; and Chihuly's glassworks (SEE FIG. 15) may be reassembled according to the collector's wishes or whims.

The civic sponsorship of art is epitomized by fifth-century BCE Athens, a Greek city-state whose citizens practiced an early form of democracy. Led by the statesman and general Perikles, the Athenians defeated the Persians, and then rebuilt Athens's civic and religious center, the Acropolis, as a tribute to the goddess Athena and a testament to the glory of Athens. In FIGURE 19, a nineteenth-century British artist, Sir Lawrence Alma-Tadema, conveys the accomplishment of the Athenian architects, sculptors, and painters, who were led by the artist Pheidias. Alma-Tadema imagines the moment when Pheidias showed the carved and painted frieze at the top of the wall of the Temple of Athena (the Parthenon) to Perikles and a group of Athenian citizens—his civic sponsors.

Although artists sometimes work speculatively, hoping afterwards to sell their work on the open market, throughout history interested individuals and institutions have acted as patrons of the arts. During periods of great artistic vigor, enlightened patronage has been an essential factor. Today, museums and other institutions, such as governmental agencies (for example, in the United States, the National Endowment for the Arts), also provide financial grants and support for the arts.

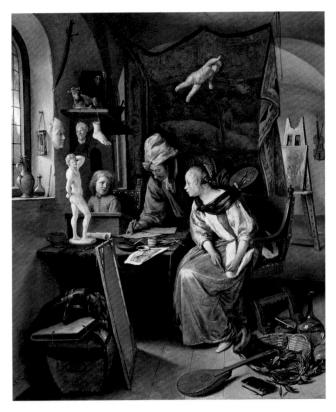

16 Jan Steen THE DRAWING LESSON 1665. Oil on wood, $19\% \times 16\%$ (49.3 \times 41 cm). The J. Paul Getty Museum, Los Angeles, California.

WHO ARE THE ARTISTS?

We have focused so far mostly on works of art. But what of the artists who make them? How artists have viewed themselves and have been viewed by their contemporaries has changed over time. In Western art, painters and sculptors were at first considered artisans or craftspeople. The ancient Greeks and Romans ranked painters and sculptors among the skilled workers; they admired the creations, but not the creators. The Greek word for art, tekne, is the source for the English word "technique," and the English words art and artist come from the Latin word ars, which means "skill." In the Middle Ages, people sometimes went to the opposite extreme and attributed especially fine works of art not to human artisans, but to supernatural forces, to angels, or to Saint Luke. Artists continued to be seen as craftspeople—admired, often prosperous, but not particularly special—until the Renaissance, when artists such as Leonardo da Vinci proclaimed themselves to be geniuses with "divine" abilities.

Soon after the Renaissance, the Italian painter Guercino (Giovanni Francesco Barbieri, 1591-1666) combined the idea that saints and angels have miraculously made works of art with the concept that human painters have special, divinely inspired gifts. In his painting SAINT LUKE DISPLAYING A PAINTING OF THE VIRGIN (FIG. 14), Guercino portrays the Evangelist who was regarded as the patron saint of artists. Christians widely believed that Luke had painted a portrait of the Virgin Mary holding the Christ Child. In Guercino's painting, Luke, seated before just such a painting and assisted by an angel, holds his palette and brushes. A book, a quill pen, and an inkpot decorated with a statue of an ox (Saint Luke's symbol) rest on a table, reminders of his status as the author of a gospel. Guercino seems to say that if Saint Luke is a divinely endowed artist, then surely all other artists share in this special power and status. This image of the artist as an inspired genius has persisted.

Even after the idea of "specially endowed" creators emerged, numerous artists continued to conduct their work as craftspeople leading workshops, and oftentimes artwork continued to be a team effort. Nevertheless, as the one who conceives the work and controls its execution—the artist is the "creator," whose name is associated with the final product.

This approach is evident today in the glassworks of American artist Dale Chihuly (b. 1941). His team of artist-craftspeople is skilled in the ancient art of glass-making, but Chihuly remains the controlling mind and imagination behind the works. Once created, his multipart pieces may be transformed when they are assembled for display; they can take on a new life in accordance with the will of a new owner, who may arrange the pieces to suit his or her own preferences. The viewer/owner thus becomes part of the creative team. Originally fabricated in 1990, VIOLET PERSIAN SET WITH RED LIP WRAPS (FIG. 15) has twenty separate pieces, but the person who assembles them determines the composition.

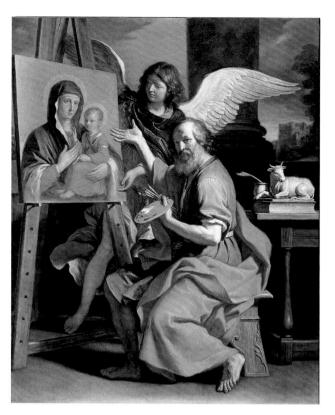

14 Guercino SAINT LUKE DISPLAYING A PAINTING OF THE VIRGIN 1652-1653. Oil on canvas, $7'3'' \times 5'11''$ (2.21×1.81 m). The Nelson-Atkins Museum of Art, Kansas City, Missouri. Purchase (F83-55)

15 Dale Chihuly VIOLET PERSIAN SET WITH RED LIP WRAPS 1990. Glass, $26 \times 30 \times 25''$ ($66 \times 76.2 \times 63.5$ cm). Spencer Museum of Art, The University of Kansas, Lawrence Museum Purchase: Peter T. Bohan Art Acquisition Fund, 1992.2

Social Expression: Art and Social Context

The visual arts are among the most sophisticated forms of human communication, at once shaping and being shaped by their social context. Artists may unconsciously interpret their times, but they also may be enlisted to consciously serve social ends in ways that range from heavy-handed propaganda (as seen earlier in the portrait of Charles V, for example) to subtle suggestion. From ancient Egyptian priests to elected officials today, religious and political leaders have understood the educational and motivational value of the visual arts.

Governments and civic leaders use the power of art to strengthen the unity that nourishes society. In sixteenth-century Venice, for example, city officials ordered Veronese (Paolo Caliari, 1528–88) to fill the ceiling in the Great Council Hall with a huge and colorful painting, THE TRIUMPH OF VENICE (FIG. 11). Their contract with the artist survives as evidence of their intentions. They wanted a painting that showed their beloved Venice surrounded by peace, abundance, fame, happiness, honor, security, and freedom-all in vivid colors and idealized forms. Veronese and his assistants complied by painting the city personified as a mature, beautiful, and splendidly robed woman enthroned between the towers of the Arsenal, a building where ships were built for worldwide trade, the source of the city's wealth and power. Veronese painted enthusiastic crowds of cheering citizens, together with personifications of Fame blowing trumpets and of Victory crowning Venice with a wreath. Supporting this happy throng, bound prisoners and trophies of armor attest to Venetian military prowess. The Lion of Venice—the symbol of the city and its patron, Saint Mark—oversees the triumph. Although Veronese created this splendid propaganda piece to serve the purposes of his patrons, his artistic vision was as individualistic as that of James Hampton, whose art was purely self-expression.

Social Criticism: Uncovering Sociopolitical Intentions

Although powerful patrons have used artworks throughout history to promote their political interests, modern artists are often independent-minded and astute critics of the powers that be. For example, among Honoré Daumier's most trenchant comments on the French government is his print RUE TRANSON-AIN, LE 15 AVRIL 1834 (FIG. 12). During a period of urban unrest, the French National Guard fired on unarmed citizens, killing fourteen people. For his depiction of the massacre, Daumier used lithography—a cheap new means of illustration. He was not thinking in terms of an enduring historical record, but rather of a medium that would enable him to spread his message as widely as possible. Daumier's political commentary created such horror and revulsion among the public that the government reacted by buying and destroying all the newspapers in which the lithograph appeared. As this example shows, art historians sometimes need to consider not just the historical context of a work of art but also its political content and medium to have a fuller understanding of it.

Another, more recent, work with a critical message recalls how American citizens of Japanese ancestry were removed from their homes and confined in internment camps during World War II. In 1978, Roger Shimomura (b. 1939) painted **DIARY**, which illustrates his grandmother's account of the family's experience in one such camp in Idaho (FIG. 13). Shimomura has painted his grandmother writing in her diary, while he (the toddler) and his mother stand by an open door—a door that does not signify freedom but opens on to a field bounded by barbed wire. In this commentary on discrimination and injustice, Shimomura combines two stylistic traditions—the Japanese art of the color woodblock print and American Pop art of the 1960s—to create a personal style that expresses his own dual culture.

12 Honoré Daumier RUE TRANSONAIN, LE 15 AVRIL 1834 Lithograph, $11'' \times 17\%''$ (28 \times 44 cm). Bibliothèque Nationale, Paris

13 Roger Shimomura DIARY (MINIDOKA SERIES #3) 1978. Acrylic on canvas, $4'11\%'' \times 6' (1.52 \times 1.83 \text{ m})$. Spencer Museum of Art, The University of Kansas, Lawrence. Museum purchase, (1979.51)

CHAPTER ONE

PREHISTORIC ART IN EUROPE

Prehistory includes all of human existence before the emergence of writing, but long before that defining moment, people were carving objects, painting images, and creating shelters and other structures. In fact, much of what we

know about prehistoric people is based on the art they produced. These works are fascinating because they are supremely beautiful and because of what they tell us about those who made them. The sheer artistry and immediacy of the images left by our early ancestors connect us to them as surely as written records link us to those who came later.

The first contemporary people to explore the painted caves of France and Spain entered an almost unimaginably ancient world. Hundreds of yards from the entrances and accessed through long, narrow underground passages, what they found astounded them and still fascinates us. In the Chauvet Cave, located in a gorge in the Ardèche region of southeastern France (FIG. 1-1) images of horses, deer, mammoths, aurochs (extinct ancestors of oxen), and other animals that lived 30,000 years ago cover the walls and ceilings. Their forms bulge and seem to shift and move. The images are easily identifiable, for the painters have transformed their memories of active, three-dimensional figures into two dimensions by capturing the essence of well-observed animals-meat-bearing flanks, powerful legs, and dangerous horns or tusks. Using only the formal language of line and color, shading, and contour, these prehistoric painters seem to communicate with us.

Archaeologists and anthropologists study every aspect of material culture, while art historians usually focus on those things that to twenty-first-century eyes seem superior in craft and beauty. But 30,000 years ago our

ancestors were not making "works of art." They were flaking, chipping, and polishing flints into spear points, knives, and scrapers, not into sculptures, however beautiful the forms of these tools appear to us. The creation of the images we see today on the walls of the Chauvet Cave must have seemed a vitally important activity to their makers in terms of every-day survival. They were often painted in areas far from the cave entrance, without access to natural daylight, and which were visited over many years. The walls were not flat canvasses but irregular natural rock forms. What we perceive as "art" may have been a matter of necessity to these ancient image makers.

For art historians, archaeologists, and anthropologists, prehistoric art provides a significant clue—along with fossils, pollen, and artifacts—to understanding early human life and culture. Although specialists continue to discover more about when and how these works were created, they may never be able to tell us why they were made. The sculpture, paintings, and structures that survive are only a tiny fraction of what must have been created over a very long span of time. The conclusions and interpretations drawn from them are only hypotheses, making prehistoric art one of the most speculative areas of art history.

- **THE STONE AGE**
- THE PALEOLITHIC PERIOD | Shelter or Architecture? | Artifacts or Works of Art? | Cave Painting | Cave Sculptures
- THE NEOLITHIC PERIOD | Rock-Shelter Art | Architecture | Sculpture and Ceramics
- FROM STONE TO METAL | The Bronze Age | The Proto-Historic Iron Age
- IN PERSPECTIVE

THE STONE AGE

How and when modern humans evolved is the subject of ongoing lively debate, but anthropologists now agree that the species called *Homo sapiens* appeared about 200,000 years ago, and that the subspecies to which we belong, *Homo sapiens sapiens*, evolved about 120,000 to 100,000 years ago. Based on anthropological and archaeological findings, many scientists now contend that modern humans spread from Africa across Asia, into Europe, and finally to Australia and the Americas. Current evidence suggests that this vast movement of people took place between 100,000 and 35,000 years ago.

Scholars began the systematic study of prehistory only about 200 years ago. Nineteenth-century archaeologists, struck by the wealth of stone tools, weapons, and figures found at ancient sites, named the whole period of early human development the Stone Age. Today, researchers divide the Stone Age into the Paleolithic (from the Greek *paleo*-, "old," and *lithos*, "stone"), and the Neolithic (from the Greek *neo*-, "new") periods. The Paleolithic period itself is divided into three phases: Lower, Middle, and Upper, reflecting the relative position of objects found in the layers of excavation. (Upper is the most recent, lower the earliest.) In some places a transitional, or Paleolithic-Neolithic period—formerly called the Mesolithic (from the Greek meso-, "middle")—can also be identified.

Because the glaciers retreated gradually about 11,000 to 8,000 years ago, the dates for the transition from Paleolithic to Neolithic vary with geography. For some of the places discussed in this chapter, the Neolithic period arrived later and lasted until just 2,800 years ago. Archaeologists mark time in so many years ago, or BP ("before present"). However, to ensure consistent style throughout the book, which reflects the usage of art historians, we will use BCE ("before the Common Era") and CE (the Common Era) to mark time.

Much is yet to be discovered in prehistoric art. In Australia, some of the world's very oldest images have been dated to between 50,000 and 40,000 years ago. Africa, as well, is home to ancient rock art in both its northern and southern regions. In all cases, archaeologists associate the arrival of *Homo sapiens sapiens* in these regions with the advent of image making. This chapter explores the rich traditions of prehistoric European art from the Paleolithic and Neolithic periods into the Bronze and Iron ages (MAP I–I). Later chap-

ters will consider the prehistoric art of other continents and cultures, such as the Near East (Chapter 2).

THE PALEOLITHIC PERIOD

Researchers found that human beings made tools long before they made what today we call "art." *Art*, or image making, is the hallmark of the Upper Paleolithic period. Representational images are seen in the archaeological record beginning around 40,000 years ago in Australia, Africa, and Europe. Before that time, as far back as 2 million years ago during the Lower Paleolithic period in Africa, early humans made tools by flaking and chipping (knapping) flint pebbles into blades and scrapers with sharp edges.

Evolutionary changes took place over time and by 100,000 years ago, during the late Middle Paleolithic period, a well-developed type of Homo sapiens called Neanderthal inhabited Europe. They used many different stone tools and may have carefully buried their dead with funerary offerings. Although Neanderthals survived for thousands of years, Cro-Magnons-fully modern humans like us-overlapped and probably interbred with the Neanderthals and eventually replaced them, probably between 40,000 to 35,000 years ago. Called "Cro-Magnon" after the French site where their bones were first discovered, these modern humans made many different kinds of tools out of reindeer antler and bone, as well as very fine chipped-stone implements. Clearly social beings, Cro-Magnons must have had social organization, rituals, and beliefs that led them to create art. They engraved, carved, drew, and painted with colored ochers, earthy iron ores that could be ground into pigments. These people are our ancestors, and with their sculpture and painting we begin our history of art.

Shelter or Architecture?

The term **architecture** has been applied to the enclosure of spaces with at least some aesthetic intent. Some people object to its use in connection with prehistoric improvisations, but building even a simple shelter requires a degree of imagination and planning deserving of the name "architecture." In the Upper Paleolithic period, humans in some regions used great ingenuity to build shelters that were far

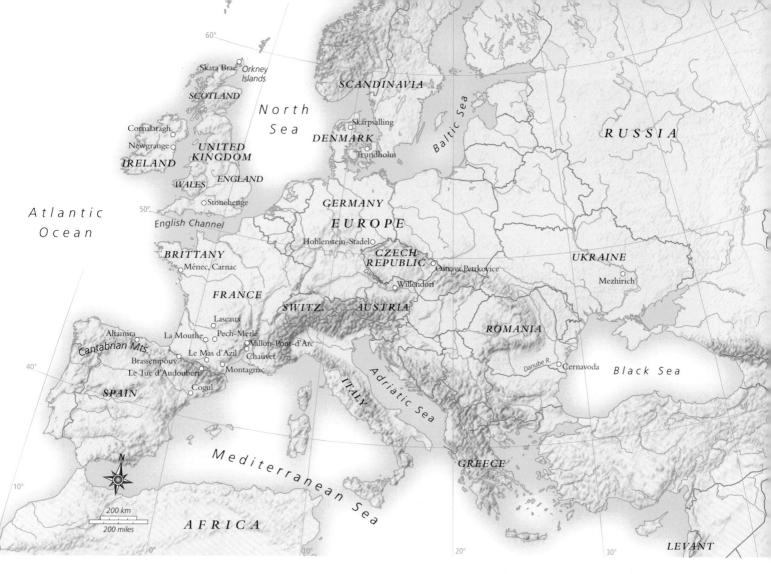

MAP I-I PREHISTORIC EUROPE

As the Ice Age glaciers receded, Paleolithic, Neolithic, Bronze Age, and Iron Age settlements increased from south to north.

from simple. In woodlands, evidence of floors indicates that circular or oval huts of light branches and hides were built. These measured as much as 15 to 20 feet in diameter. (Modern tents to accommodate six people vary from 10 by 11-foot ovals to 14 by 7-foot rooms.)

In the treeless grasslands of Upper Paleolithic Russia and Ukraine, builders created settlements of up to ten houses using the bones of the now extinct woolly mammoth, whose long, curving tusks made excellent roof supports and arched door openings (FIG. 1–2). This bone framework was probably

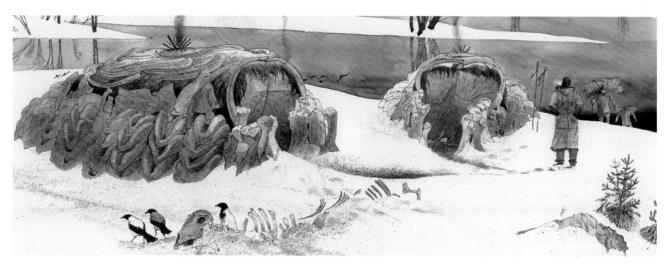

I-2 | RECONSTRUCTION DRAWING OF MAMMOTH-BONE HOUSES Ukraine. c. 16,000-10,000 BCE.

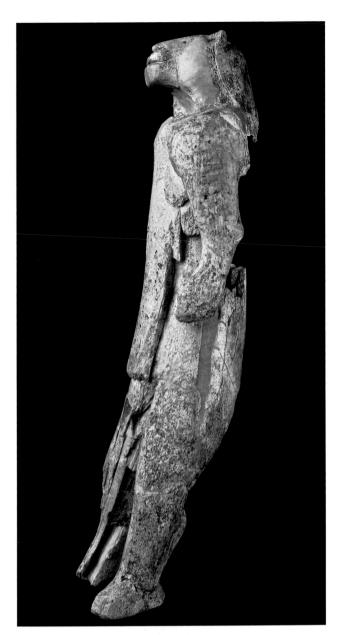

I-3 | LION-HUMAN Hohlenstein-Stadel, Germany. c. 30,000-26,000 BCE. Mammoth ivory, height 11%" (29.6 cm). Ulmer Museum, Ulm, Germany.

covered with animal hides and turf. Most activities centered around the inside fire pit, or hearth, where food was prepared and tools were fashioned. Larger dwellings might have had more than one hearth and spaces set aside for specific uses—working stone, making clothing, sleeping, and dumping refuse. In Mezhirich, Ukraine, archaeologists found fifteen small hearths inside the largest dwelling that still contained ashes and charred bones left by the last occupants. Some people also colored their floors with powdered ocher ranging in color from yellow to red to brown.

Artifacts or Works of Art?

As early as 30,000 BCE small figures, or figurines, of people and animals made of bone, ivory, stone, and clay appeared in Europe and Asia. Today we interpret such self-contained, three-dimensional pieces as examples of sculpture in the round. Pre-historic carvers also produced **relief sculpture** in stone, bone, and ivory. In relief sculpture, the surrounding material is carved away, forming a background that sets off the figure.

THE LION-HUMAN. An early and puzzling example of a sculpture in the round is a human figure—probably male—with a feline head (FIG. 1–3), made about 30,000–26,000 BCE. Archaeologists excavating at Hohlenstein-Stadel, Germany, found broken pieces of ivory (from a mammoth tusk) that they realized were parts of an entire figure. Nearly a foot tall, this remarkable statue surpasses most early figurines in size and complexity. Instead of copying what he or she saw in nature, the carver created a unique creature, part human and part beast. Was the figure intended to represent a person wearing a ritual lion mask? Or has the man taken on the appearance of an animal? One of the few things that can be

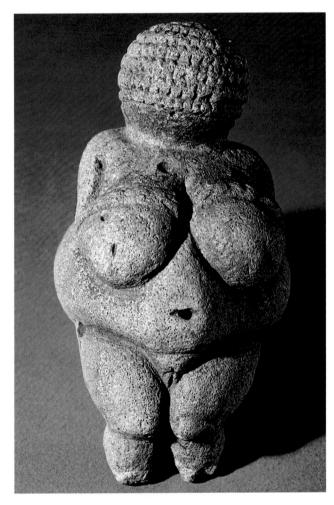

I−4 | **WOMAN FROM WILLENDORF** Austria. c. 24,000 BCE. Limestone, height 4¾″ (11 cm). Naturhistorisches Museum, Vienna.

Art and Its Context

THE POWER OF NAMING

ords are only symbols for ideas. But the very words we invent—or our ancestors invented—reveal a certain view of the world and can shape our thinking. Early people recognized clearly the power of words. In the Old Testament, God gave Adam dominion over the animals and allowed him to name them (Genesis 2:19-20). Today, we still exert the power of naming when we select a name for a baby or call a friend by a nickname. Our ideas about art can also be affected by names, even the ones used for captions in a book. Before the twentieth century, artists usually did not name, or title, their works. Names were eventually supplied by the works' owners or by scholars writing about them and thus may express the cultural prejudices of the labelers or of the times in which they live.

An excellent example of such distortion is provided by the names early scholars gave to the hundreds of small prehistoric

statues of women they found. They called them by the Roman name "Venus." For example, the sculpture in Figure 1–4 was once called the Venus of Willendorf after the place where it had been found. Using the name of the Roman goddess of love and beauty sent a message that this figure was associated with religious belief, that it represented an ideal of womanhood, and that it was one of a long line of images of "classical" feminine beauty. In a short time, most similar works of sculpture from the Upper Paleolithic period came to be known as Venus figures. The name was repeated so often that even scholars began to assume that these had to be fertility figures and mother goddesses, although there is no proof that this was so.

Our ability to understand and interpret works of art creatively is easily compromised by distracting labels. Calling a prehistoric figure a "woman" instead of "Venus" encourages us to think about the sculpture in new and different ways.

said about the **LION-HUMAN** is that it shows highly complex thinking and creative imagination: the ability to conceive and represent a creature never seen in nature.

FEMALE FIGURES. While a number of figurines representing men have been found recently, most human figures from the Upper Paleolithic period are female. The most famous female figure, the **WOMAN FROM WILLENDORF** (FIG. 1–4), from Austria, dates from about 22,000–21,000 BCE (see "The Power of Naming," above). Carved from limestone and originally colored with red ocher, the statuette's swelling, rounded forms make it seem much larger than its actual 4/s-inch height. The sculptor exaggerated the figure's female attributes by giving it pendulous breasts, a big belly with deep navel (a natural indentation in the stone), wide hips, dimpled knees and buttocks, and solid thighs. By carving a woman with a well-nourished body, the artist may be expressing health and fertility, which could ensure the ability to produce strong children, thus guaranteeing the survival of the clan.

Another carved figure, found in the Czech Republic, the **WOMAN FROM OSTRAVA PETRKOVICE** (FIG. 1–5), presents an entirely different conception of the female form. It is less than 2 inches tall and dates from about 23,000 BCE. Archaeologists excavating an oval house stockpiled with flint stone and rough chunks of hematite (iron oxide) discovered the figure next to the hearth. The torso and thighs of a youthful, athletic figure of a woman suggest an animated pose, with one angular hip slightly raised and a knee bent as if she were walking. The marks left by the artist's carving tool are visible.

Another remarkable female image, discovered in the Grotte du Pape in Brassempouy, France, is the tiny ivory head

I-5 | WOMAN FROM OSTRAVA PETRKOVICE
Czech Republic. c. 23,000 BCE. Hematite, height 1¾" (4.6 cm).
Archaeological Institute, Brno, Czech Republic.
© Institute of Archaeology, Academy of Sciences of the Czech Republic, Brno

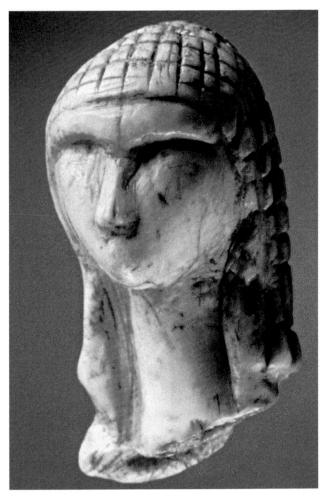

I−6 | **WOMAN FROM BRASSEMPOUY**Grotte du Pape, Brassempouy, Landes, France. Probably c. 30,000 BCE. Ivory, height 1¼″ (3.6 cm). Musée des Antiquités Nationales, St.-Germain-en-Laye, France.

known as the woman from Brassempouy (FIG. 1-6). The finders did not record its archaeological context; however, recent studies declare it to be authentic and date it as early as 30,000 BCE. The carver captured the essence of a head or what psychologists call the memory image—those generalized elements that reside in our standard memory of a human head. An egg shape rests atop a long neck, a wide nose and a strongly defined browline suggest deep-set eyes, and an engraved square patterning may be hair or a headdress. The image is an abstraction (what has come to be known as abstract art): the reduction of shapes and appearances to basic yet recognizable forms that are not intended to be exact replications of nature. The result in this case looks uncannily modern to the contemporary viewer. Today when such a piece is isolated in a museum case or as a book illlustration, we enjoy it as an aesthetic object, but we lose its original cultural context.

Cave Painting

Art in Europe entered a rich and sophisticated phase between about 30,000 and 10,000 BCE, when images were painted on

the walls of caves in central and southern France and northern Spain.

No one knew of the existence of prehistoric cave paintings until one day in 1879, when a young girl, exploring with her father in Altamira in northern Spain, crawled through a small opening in the ground and found herself in a chamber whose ceiling was covered with painted animals (see page 9). Her father, a lawyer and amateur archaeologist, searched the rest of the cave, told authorities about the remarkable find, and published his discovery the following year. Few people believed that these amazing works could have been done by "primitive" people, and the scientific community declared the paintings a hoax. They were accepted as authentic only in 1902, after many other cave paintings, drawings, and engravings had been discovered at other places in northern Spain and in France.

What caused people to paint such dramatic imagery on the walls of caves? The idea that human beings have an inherent desire to decorate themselves and their surroundings—that an aesthetic sense is somehow innate to the human species—found ready acceptance in the nineteenth century. Many believed that people create art for the sheer love of beauty. Scientists now agree that human beings have an aesthetic impulse, but the effort required to accomplish the great cave paintings suggests their creators were motivated by more than simple pleasure. Since the discovery at Altamira, anthropologists and art historians have devised several hypotheses to explain the existence of cave art. Like the search for the meaning of prehistoric female figurines, these explanations depend on the cultural views of those who advance them.

THE MEANING OF CAVE PAINTINGS. Early twentieth-century scholars believed that art fulfills a social function and that aesthetics are culturally relative. They proposed that the cave paintings might be products both of totemistic rites to strengthen clan bonds and increase ceremonies to enhance the fertility of animals used for food. In 1903, French scholar Salomon Reinach suggested that cave paintings were expressions of sympathetic magic (the idea, for instance, that a picture of a reclining bison would insure that hunters found their prey asleep). Abbé Henri Breuil took these ideas further and concluded that caves were used as places of worship and the settings for initiation rites. In the second half of the twentieth century, scholars rejected these ideas and based their interpretations on rigorous scientific methods and current social theory. Andre Leroi-Gourhan and Annette Laming-Emperaire, for example, dismissed the sympathetic magic theory because statistical analysis of debris from human settlements revealed that the animals used most frequently for food were not the ones traditionally portrayed in caves. Their analysis also showed a systematic organization of images.

Researchers continue to discover new cave images and to correct earlier errors of fact or interpretation. A study of the

Altamira cave in the 1980s led Leslie G. Freeman to conclude that these artists faithfully represented a herd of bison during the mating season. Instead of being dead, asleep, or disabled—as earlier observers had thought—the bison were dust-wallowing, common behavior during the mating season.

Although hypotheses that seek to explain cave art have changed and evolved over time, scholars have always agreed that decorated caves must have had a special meaning, because people returned to them time after time over many generations, in some cases over thousands of years. Perhaps Upper Paleolithic cave art was the product of rituals intended to gain the favor of the supernatural. Perhaps because much of the art was made deep inside the caves and nearly inaccessible, its significance may have had less to do with the finished painting than with the very act of creation. Artifacts and footprints (such as those found at Chauvet, below, and Le Tuc d'Audoubert, page 10) suggest that the subterranean galleries, which were far from living quarters, had a religious or magical function. Perhaps the experience of exploring the cave may have been significant to the image makers. Musical instruments, such as bone flutes, have been found in the caves, implying that even acoustical properties may have played a role.

CHAUVET. The earliest known site of prehistoric cave paintings today, discovered in December 1994, is the Chauvet Cave (so called after one of the persons who found it) near Vallon-Pont-d'Arc in southeastern France—a tantalizing trove of hundreds of paintings (SEE FIG. 1–1). The most dramatic of the Chauvet Cave images depict grazing, running, or resting animals. Among the animals depicted are wild horses, bison, mammoths, bears, panthers, owls, deer, aurochs, woolly-haired rhinos, and wild goats (or ibex). Also included are occasional humans, both male and female, many hand-

Sequencing Events PREHISTORIC PERIODS

с. 40,000-8000 все	Upper Paleolithic period; modern man arrives in Europe
с. 10,000 все	Present interglacial period begins
с. 9000-4000 все	Paleolithic-Neolithic overlap (formerly called the Mesolithic period)
с. 6500-1200 все	Neolithic period; farming in Europe
с. 2300-с.800 все	Bronze Age in Europe; trade with Near East increases
с. 1000-50 все	Proto-historic Iron Age in Europe

prints, and hundreds of geometric markings such as grids, circles, and dots. Footprints in the Chauvet Cave, left in soft clay by a child, go to a "room" containing bear skulls. The charcoal used to draw the rhinos has been radiocarbon dated to 32,410 plus or minus 720 years before the present.

PECH-MERLE. A cave site at Pech-Merle, also in southern France, appears to have been used and abandoned several times over a period of 5,000 years. Images of animals, handprints, and nearly 600 geometric symbols have been found in thirty different parts of the underground complex. The earliest artists to work in the cave, some 24,000–25,000 years ago, painted horses (FIG. 1–7) with small, finely detailed heads, heavy bodies, massive extended necks, and legs tapering to almost nothing at the hooves. The right-hand horse's head follows the

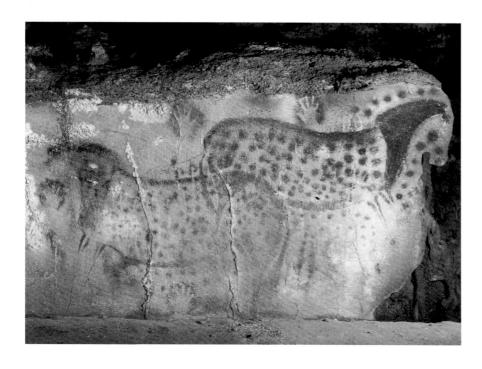

I-7 | SPOTTED HORSES
AND HUMAN HANDS

Pech-Merle Cave, Dordogne, France. Horses 25,000-24,000 BCE; hands c. 15,000 BCE. Paint on limestone, individual horses are over 5' (1.5 m) in length.

Technique

PREHISTORIC WALL PAINTING

n a dark cave, working by the light of an animal-fat lamp, an artist chews a piece of charcoal to dilute it with saliva and water. Then he blows out the mixture on the surface of a wall, using his hand as a stencil. In the drawing, cave archaeologist Michel Lorblanchet is showing us how the original makers of a cave painting at Pech-Merle in France created a complex design of spotted horses.

By turning himself into a human spray can, Lorblanchet can produce clear lines on the rough stone surface much more easily than he could with a brush. To create the line of a horse's back, with its clean upper edge and blurry lower one, he blows pigment below his hand. To capture its angular rump, he places his hand vertically against the wall, holding it slightly curved. To produce, the sharpest lines, such as those of the upper hind leg and tail, he places his hands side by side and blows between them. To create the forelegs and the hair on the horses' bellies, he finger paints. A hole punched in a piece of leather serves as a stencil for the horses' spots. It takes Lorblanchet only 32 hours to reproduce the Pech-Merle painting of spotted horses, his speed suggesting that a single artist created the original (perhaps with the help of an assistant to mix pigments and tend the lamp).

Cro-Magnon artists used three painting techniques the spraying demonstrated by Lorblanchet, drawing with fingers or blocks of ocher, and daubing with a paintbrush made of hair or moss. In some places in prehistoric caves three stages of image creation can be seen—engraved lines using flakes of flint, followed by a color wash of ocher and manganese, and a final engraving to emphasize shapes and details.

shape of the rock. The horse images were then overlaid with bright red dots. Some interpreters see these circles as ordinary spots on the animals' coats, but others see them as representations of rock weapons ritually hurled at the painted horses.

The handprints on the walls at Pech-Merle and other cave sites were almost certainly not idle graffiti or accidental smudges. Some are positive images made by simply coating the hand with color pigment and pressing it against the wall. Others are negative images: The surrounding space rather than the hand shape itself is painted. Negative images were made by placing the hand with fingers spread apart against the wall, then spitting or spraying paint around it with a reed blowpipe or daubing with a paint-covered pad or brush—artist's tools that have been found in such caves (see "Prehistoric Wall Painting," left). In other places, artists drew or incised (scratched) figures onto the cave walls.

LASCAUX. The best-known cave paintings are those found in 1940 at Lascaux, in the Dordogne region of southern France. They have been dated to about 15,000 BCE (FIG. 1–8). Opened to the public after World War II, the prehistoric "museum" at Lascaux soon became one of the most popular tourist sites in France. Too popular, because the visitors brought heat, humidity, exhaled carbon dioxide, and other contaminants. The cave was closed to the public in 1963 so that conservators could battle an aggressive fungus. Eventually they won, but instead of reopening the site, authorities created a facsimile of it. Visitors at what is called Lascaux II may now view copies of the painted scenes without harming the precious originals.

The scenes they view are truly remarkable. The Lascaux artists painted cows, bulls, horses, and deer along the natural ledges of the rock, where the smooth white limestone of the ceiling and upper wall meets a rougher surface below. They also utilized the curving wall to suggest space. Lascaux has about 600 paintings and 1,500 engravings. Ibex and a bear, engraved felines, and a woolly rhinoceros, but no mammoths, have also been found. The animals appear singly, in rows, face to face, tail to tail, and even painted on top of one another. Their most characteristic features have been emphasized. Horns, eyes, and hooves are shown as seen from the front, yet heads and bodies are rendered in profile in a system known as **twisted perspective**. Even when their poses are exaggerated or distorted, the animals are full of life and energy, and the accuracy in the drawing of their silhouettes, or outlines, is remarkable.

Painters worked not only in large caverns, but also far back in the smallest chambers and recesses, many of which are almost inaccessible today. Small stone lamps found in such caves—over 100 lamps have been found at Lascaux—indicate that they worked in flickering light from burning animal fat (SEE FIG. 1–12). (Although 500 grams of fat would burn for 24 hours and animal fat produces no soot, the light created is not as strong as a candle.)

One scene at Lascaux was discovered in a remote setting on a wall at the bottom of a 16-foot shaft that contained a stone

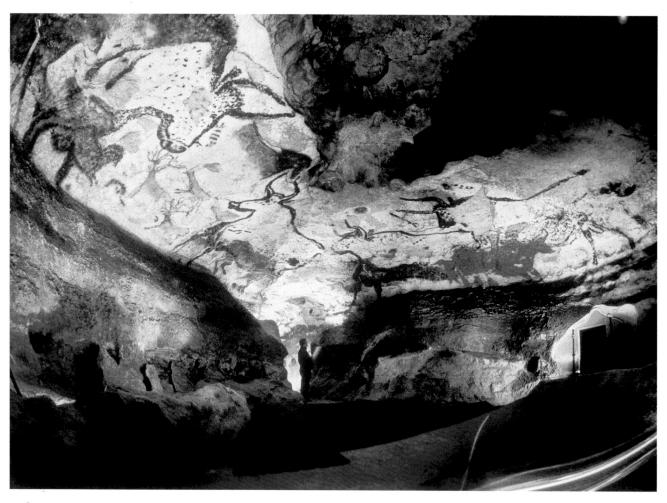

I-8 | HALL OF BULLS Lascaux Cave, Dordogne, France. c. 15,000 BCE. Paint on limestone, length of the largest auroch (bull) 18' (5.50 m).

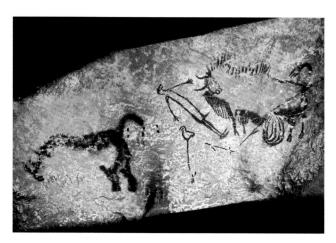

I-9 | BIRD-HEADED MAN WITH BISON Shaft scene in Lascaux Cave. c. 15,000 BCE. Paint on limestone, length approx. 9' (2.75 m).

lamp and spears. The scene is unusual because it is the only painting in the cave complex that seems to tell a story (FIG. 1–9), and it is stylistically different from the other paintings at Lascaux. A figure who could be a hunter, greatly simplified in form but recognizably male and with the head of a bird or wearing a bird's-head mask, appears to be lying on the ground. A great bison looms above him. Below him lie a staff, or baton, and a spear thrower (atlatl)—a device that allowed hunters to throw farther and with greater force—the outer end of which has been carved in the shape of a bird. The long, diagonal line slanting across the bison's hindquarters may be a spear. The bison has been disemboweled and will soon die. To the left of the cleft in the wall a woolly rhinoceros seems to run off.

Why did the artist portray the man as only a sticklike figure when the bison was rendered with such accurate detail? Does the painting illustrate a story or a myth regarding the death of a hero? Is it a record of an actual event? The painting may depict the vision of a *shaman*. Shamans are thought to have special powers, an ability to contact spirits in the form of animals or birds. In a trance they leave their bodies and communicate through spirit guides. The images they use to record their visions tend to be abstract, incorporating geometric

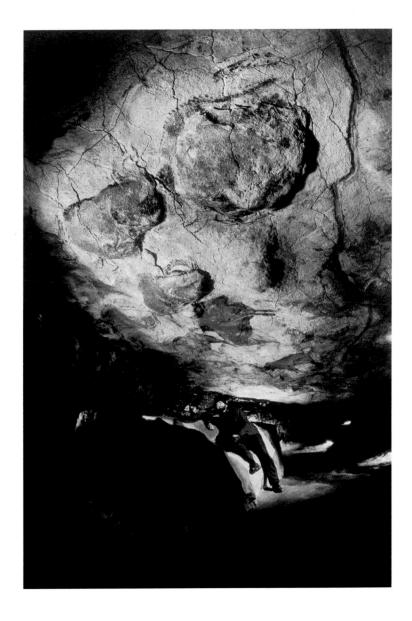

I—IO | BISON Ceiling of a cave at Altamira, Spain. c. 12,500 BCE. Paint on limestone, length approx. 8'3" (2.5 m).

figures and combinations of human and animal forms, such as the bird-headed man in this scene from Lascaux or the lionheaded figure discussed earlier (SEE FIG. 1–3).

ALTAMIRA. The cave paintings at Altamira, near Santander in the Cantabrian Mountains in Spain—the first to be discovered and attributed to the Upper Paleolithic period—have been recently dated to about 12,500 BCE. The Altamira artists created sculptural effects by painting over and around natural irregularities in the cave walls and ceilings. To produce the herd of bison on the ceiling of the main cavern (FIG. 1–10), they used rich red and brown ochers to paint the large areas of the animals' shoulders, backs, and flanks, then sharpened the contours of the rocks and added the details of the legs, tails, heads, and horns in black and brown. They mixed yellow and brown from ochers with iron to make the red tones and derived black from manganese or charcoal.

Cave Sculptures

Caves were sometimes adorned with relief sculpture as well as paintings. At Altamira, an artist simply heightened the resemblance of a natural projecting rock to a similar and familiar animal form. Other reliefs were created by modeling, or shaping, the damp clay of the cave's floor. An excellent example of such work in clay from about 13,000 BCE is preserved at Le Tuc d'Audoubert, south of the Dordogne region of France. Here the sculptor created two bison leaning against a ridge of rock (FIG. 1-11). Although these beasts are modeled in very high relief (they extend well forward from the background), they display the same conventions as in earlier painted ones, with emphasis on the broad masses of the meatbearing flanks and shoulders. To make the animals even more lifelike, their creator engraved short parallel lines below their necks to represent their shaggy coats. Numerous small footprints found in the clay floor of this cave suggest that important group rites took place here.

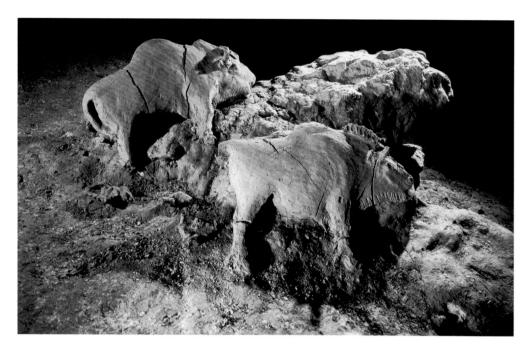

I-II | BISON Le Tuc d'Audoubert, France. c. 13,000 BCE. Unbaked clay, length 25" (63.5 cm) and 24" (60.9 cm).

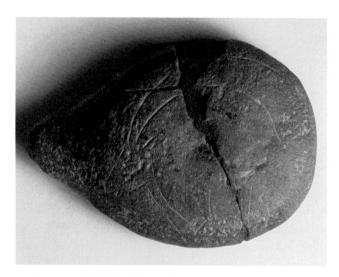

I−I2 | **LAMP WITH IBEX DESIGN**La Mouthe Cave, Dordogne, France. c. 15,000–13,000 BCE. Engraved stone.

An aesthetic sense and the ability to express it in a variety of ways are among the characteristics unique to our subspecies, *Homo sapiens sapiens*. Lamps found in caves provide an example of objects that were both functional and aesthetically pleasing. Some were carved in simple abstract shapes; others were adorned with engraved images, like one found at La Mouthe, France (FIG. 1–12). The maker decorated the underside of this lamp with an ibex. The animal's distinctive head is shown in profile, its sweeping horns reflecting the curved outline of the lamp itself. Objects such as the ibex lamp were made by people whose survival depended upon their skill at hunting animals and gathering wild grains and other edible plants. But a change was already under way that would completely alter human existence.

THE NEOLITHIC PERIOD

Today, advances in technology, medicine, transportation, and electronic communication change human experience in a generation. Many thousands of years ago, change took place much more slowly. In the tenth millennium BCE the world had already entered the present interglacial period, and our modern climate was taking shape. However, the Ice Age ended so gradually and unevenly among regions that people could not have known it was occurring.

To determine the onset of the Neolithic period in a specific region, archaeologists look for evidence of three conditions: an organized system of agriculture, the maintenance of herds of domesticated animals, and permanent, year-round settlements. The cumulative effects of warming temperatures were challenging to a settled way of life. Europe underwent a long and varied intermediary period not only of climate change, but also of cultural development.

At the end of the Ice Age in Europe, rising ocean levels dramatically altered the shorelines of the continent, making islands in some places. About 6000 BCE, the land bridge connecting England with the rest of Europe disappeared beneath the waters of what are now known as the North Sea and the English Channel. Most significantly, the retreating glaciers exposed large temperate regions. The heavily forested Mediterranean basin gave way to grassy plains supporting new, edible plants. Great herds of smaller and quicker animals, such as deer, were lured farther and farther west and north into the open areas and forests of central and northern Europe.

At the same time, people responded to these new conditions by inventing new hunting technologies or improving older ones. Hunters now used the bow and arrow much

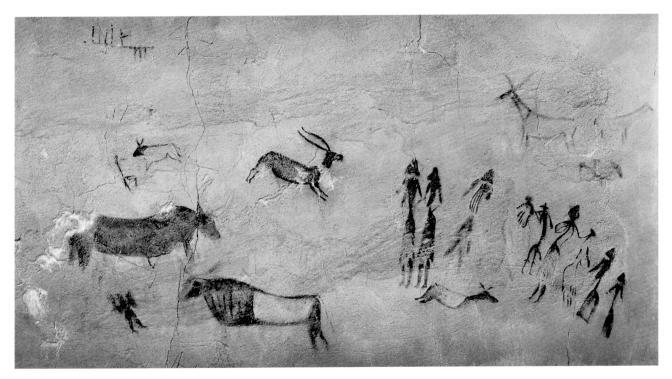

I−I3 | PEOPLE AND ANIMALS

Detail of rock-shelter painting, Cogul, Lérida, Spain. c. 4000–2000 BCE.

more frequently than they did in Paleolithic times. Bows were easier to carry, much more accurate at longer range than spears, and much more effective against the new type of game. The use of dugout boats opened up rich new areas formed by the rising waters of the North Sea for fishing and hunting. Stone tools were now polished to a high gloss instead of being chipped and flaked as in the Paleolithic period. With each advance, the standard of living improved.

The new environment led to a new, more sedentary way of life. Europeans began domesticating animals and cultivating plants. Dogs first joined hunters in Europe more than 10,000 years ago; cattle, sheep, and other animals were domesticated later. Between 10,000 and 5,000 years ago, people along the eastern shore of the Mediterranean began cultivating wild wheat and barley, developing these grasses into productive grains such as bread wheat.

The new farming culture gradually spread across Europe, reaching Spain and France by 5000 BCE. Farmers in the Paris region were using plows by 4000 BCE. As larger numbers of people became farmers, they began to live in villages and produce more than enough food to support themselves—thus freeing some people to attend to other communal needs such as political and military affairs, or ceremonial practices. Over time these early societies became increasingly complex. By the end of the period, villages were larger, trading had developed among distant regions, and advanced building technology had produced awe-inspiring architecture.

Rock-Shelter Art

The period of transition between Paleolithic and Neolithic culture (sometimes called Mesolithic) saw the rise of a distinctive art combining geometric forms and schematic images—simplified, diagrammatic renderings—with depictions of people and animals engaged in everyday activities. Artists of the time preferred to paint and engrave such works on the walls of easily accessible, shallow rock shelters. In style, technique, and subject matter, these rock-shelter images are quite different from those found in Upper Paleolithic cave art. The style is abstract, and the technique is often simple line drawing, with no addition of color. Beginning about 6000 BCE, rock-shelter art appeared in many places near the Mediterranean coast.

At Cogul, in the province of Lérida in Catalonia, the broad surfaces of a rock shelter are decorated with elaborate scenes involving dozens of small figures. The artists now represent men, women, children, animals, even insects, going about daily activities (FIG. 1–13). The paintings date from between 4000 and 2000 BCE (see "How Early Art Is Dated," right). No specific landscape features are indicated, but occasional painted patterns of animal tracks give the sense of a rocky terrain, like that of the surrounding barren hillsides.

In the detail shown here, a number of women are seen strolling or standing about, some in pairs holding hands. The women's small waists are emphasized by skirts with scalloped hemlines revealing large calves and sturdy ankles. All of them have shoulder-length hair. The women stand near several large animals, some of which are shown leaping forward with

legs fully extended. This pose, called a *flying gallop*, has been used to indicate speed in a running animal from prehistory to the present. The paintings are more than a record of daily life: People continued to visit these sites long after their original purpose had been forgotten. Inscriptions in Latin and an early form of Spanish scratched by Roman-era visitors—2,000-year-old graffiti—share the rock wall surfaces with the prehistoric paintings.

Architecture

As humans adopted a settled, agricultural way of life, they began to build large structures to serve as dwellings, storage spaces, and shelters for their animals. After the disappearance of the glaciers in Europe, timber became abundant, and Neolithic people, like their Paleolithic predecessors, continued to construct buildings out of wood and other plant materials. They clustered their dwellings in villages, and built large tombs and ritual centers outside settlements.

DWELLINGS AND VILLAGES. A northern European village of this period typically consisted of three or four long timber buildings, each up to 150 feet long, housing forty-five to fifty people. The structures were rectangular, with a row of posts down the center supporting a ridgepole, a long horizontal beam against which the slanting roof poles were braced (see example 4 in "Post-and-Lintel and Corbel Construction," page 14). The walls were probably made of what is known as wattle and daub, branches woven in a basketlike pattern, then covered with mud or clay. They were probably roofed with thatch, plant material such as reeds or straw tied over a framework of poles. These houses also included large granaries, or storage spaces for the harvest. Similar structures serving as animal shelters or even dwellings can still be seen today. Around 4000 BCE, Neolithic settlers began to locate their communities at defensible sites—near rivers, on plateaus, or in swamps. For additional protection, they also frequently surrounded them with wooden walls, earth embankments, and ditches.

SKARA BRAE. A Neolithic settlement has been wonderfully preserved at Skara Brae in the Orkney Islands off the northern coast of Scotland. It was constructed of stone, which was an abundant building material in this bleak, treeless region. A long-ago storm buried this seaside village under a layer of sand, and another storm brought it to light again in 1850.

Skara Brae presents a vivid picture of Neolithic life in the far north. In the houses, archaeologists found beds, shelves, stone cooking pots, basins, stone mortars for grinding, and pottery with incised decoration. Comparison of these artifacts with objects from sites farther south and laboratory analysis of the village's organic refuse date the settlement to between 3100 and 2600 BCE.

Science and Technology HOW EARLY ART IS DATED

ince the first discoveries at Altamira, archaeologists have developed increasingly sophisticated ways of dating cave paintings and other objects. Today, archaeologists primarily use two approaches to determine an artifact's age. **Relative dating** relies on the chronological relationships among objects in a single excavation or among several sites. If archaeologists have determined, for example, that pottery types A, B, and C follow each other chronologically at one site, they can apply that knowledge to another site. Even if "type B" is the only pottery present, it can still be assigned a relative date. **Absolute dating** aims to determine a precise span of calendar years in which an artifact was created.

The most accurate method of absolute dating is radiometric dating, which measures the degree to which radioactive materials have disintegrated over time. Used for dating organic (plant or animal) materials—including some pigments used in cave paintings—one radiometric method measures a carbon isotope called radiocarbon, or carbon-14, which is constantly replenished in a living organism. When an organism dies, it stops absorbing carbon-14 and starts to lose its store of the isotope at a predictable rate. Under the right circumstances, the amount of carbon-14 remaining in organic material can tell us how long ago an organism died.

This method has serious drawbacks for dating works of art. Using carbon-14 dating on a carved antler or wood sculpture shows only when the animal died or when the tree was cut down, not when the artist created the work using those materials. Also, some part of the object must be destroyed in order to conduct this kind of test—something that is never a desirable procedure to conduct on a work of art. For this reason, researchers frequently test organic materials found in the same context as the work of art rather than in the work itself.

Radiocarbon dating is most accurate for materials no more than 30,000 to 40,000 years old. Potassium-argon dating, which measures the decay of a radioactive potassium isotope into a stable isotope of argon, an inert gas, is most reliable with materials more than a million years old. Two newer techniques have been used since the mid-1980s. Thermo-luminescence dating measures the irradiation of the crystal structure of a material subjected to fire, such as pottery, and the soil in which it is found, determined by the luminescence produced when a sample is heated. Electron spin resonance techniques involve using a magnetic field and microwave irradiation to date a material such as tooth enamel and the soil surrounding it.

Recent experiments have helped to date cave paintings with increasing precision. Radiocarbon analysis has determined, for example, that the animal images at Lascaux are 17,000 years old—to be more precise, 17,070 years plus or minus 130 years.

Elements of Architecture

POST-AND-LINTEL AND CORBEL CONSTRUCTION

f all the methods for spanning space, post-and-lintel construction is the simplest. At its most basic, two uprights (posts) support a horizontal element (lintel). There are countless variations, from the wood structures, dolmens, and other underground burial chambers of prehistory, to Egyptian and Greek stone construction, to medieval timberframe buildings, and even to cast-iron and steel construction. Its

limitation as a space spanner is the degree of tensile strength of the lintel material: the more flexible, the greater the span possible. Another early method for creating openings in walls and covering space is **corbeling**, in which rows or layers of stone are laid with the end of each row projecting beyond the row beneath, progressing until opposing layers almost meet and can then be capped with a stone that rests across the tops of both layers.

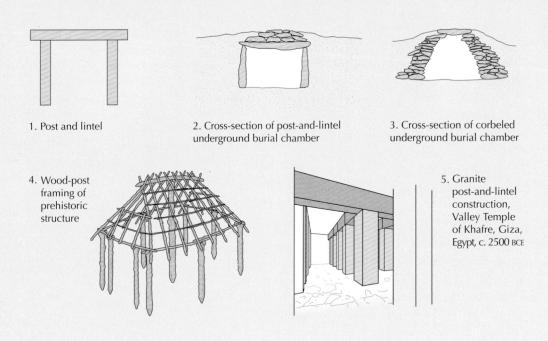

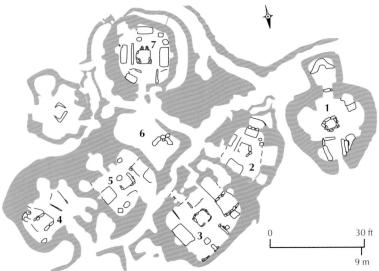

I-I4 | PLAN, VILLAGE OF SKARA BRAE
Orkney Islands, Scotland. c. 3100-2600 BCE. (Numbers refer to individual houses.)

The village consists of a compact cluster of dwellings linked by covered passageways (FIG. I–I4). Each of the houses has a square plan with rounded corners. The largest one measures 20 by 21 feet, the smallest, 13 by 14 feet. Layers of flat stones without mortar form walls, with each layer, or course, projecting slightly inward over the one below. This type of construction is called **corbeling** (see example 3 in "Post-and-Lintel and Corbel Construction," above). In some structures, inward-sloping walls come together at the top in what is known as a **corbel vault**, but at Skara Brae the walls stopped short of meeting, and the remaining open space was covered with hides or turf. There are smaller corbel-vaulted rooms within the main walls of some of the houses that may have been used for storage. One room, possibly a latrine, has a drain leading out under its wall.

The houses of Skara Brae were equipped with space-saving built-in furniture. In the room shown (FIG. 1–15), a large rectangular hearth with a stone seat at one end occupies the center of the space. Rectangular stone beds, some engraved with simple designs, stand against the walls on two sides of the

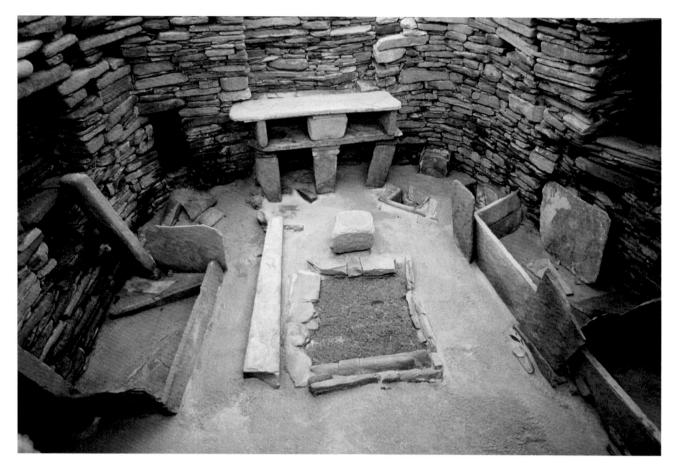

I−I5 HOUSE INTERIOR, SKARA BRAE (House 7 in Fig. 1–14).

hearth. These boxlike beds would probably have been filled with heather "mattresses" and covered with warm furs. In the left corner, a sizable storage room is built into the thick outside wall. Smaller storage niches were provided over each of the beds. A stone tank lined with clay to make it watertight is partly sunk into the floor. This container was probably used for live bait, for it is clear that the people at Skara Brae were skilled fisherfolk. On the back wall is a two-shelf cabinet that is a clear example of what is known as post-and-lintel construction (see "Post-and-Lintel and Corbel Construction," left).

CEREMONIAL AND TOMB ARCHITECTURE. In western and northern Europe, people used huge stones to erect ceremonial structures and tombs. In some cases, they had to transport these great stones over long distances. The monuments thus created are examples of what is known as megalithic architecture, the descriptive term derived from the Greek word roots for "large" (mega-) and "stone" (lithos).

Architecture formed of such massive elements testifies to a complex, stratified society. Powerful religious or political

figures and beliefs were needed to identify the society's need for such structures and dictate their design. Skilled "engineers" were needed to devise methods for shaping, transporting, and aligning the stones. Finally, only strong leaders could have assembled and maintained the labor force required to move the stones long distances.

Elaborate megalithic tombs first appeared in the Neolithic period. Some were built for single burials; others consisted of multiple burial chambers. The simplest type of megalithic tomb was the **dolmen**, built on the post-and-lintel principle. The tomb chamber was formed of huge upright stones supporting one or more tablelike rocks, or *capstones*. The structure was then mounded over with smaller rocks and dirt to form a **cairn** or artificial hill. A more imposing structure was the *passage grave*, which was entered by one or more narrow, stone-lined passageways into a large room at the center.

At Newgrange, in Ireland, the mound of an elaborate passage grave (FIG. 1–16) originally stood 44 feet tall and measured about 280 feet in diameter. The mound was built

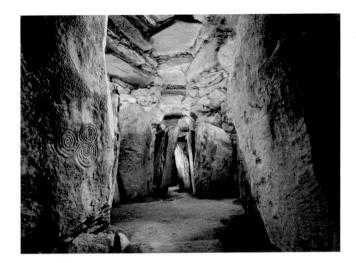

I-I6 | TOMB INTERIOR WITH CORBELING AND ENGRAVED STONES

New Grange, Ireland. c. 3000-2500 BCE.

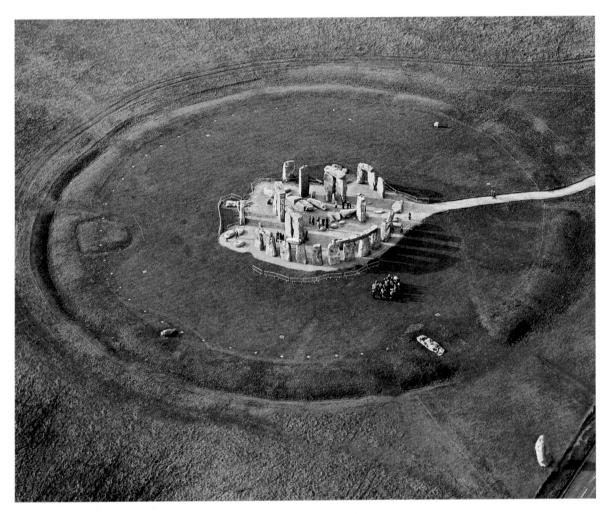

I−I7 | **STONEHENGE**Salisbury Plain, Wiltshire England. c. 2750–1500 BCE.

of sod and river pebbles and was set off by a circle of engraved standing stones around its perimeter. Its passageway, 62 feet long and lined with standing stones, leads into a three-part chamber with a corbel vault rising to a height of 19 feet. Some of the stones are engraved with linear designs, mainly rings, spirals, and diamond shapes. These patterns may have been marked out using strings or com-

passes, then carved by picking at the rock surface with tools made of antlers.

Such large and richly decorated structures did more than honor the distinguished dead; they were truly public architecture that must have fostered communal pride and a group identity. As is the case with elaborate funerary monuments built today, their function was both practical and symbolic.

Technique

FIBER ARTS

eople began working with plant fibers very early. They made ropes, fishing lines, nets, baskets, and even garments using techniques resembling modern macramé and crochet. The actual strings, ropes, and cloth are perishable, but fragments of dried or fired clay impressed with fibers, and even cloth, have been found and dated as early as 25,000 BCE. Fibers were twisted into cording for ropes and strings; netting for traps, fish nets, and perhaps hair nets; knotting for macramé; sprang (a

looping technique similar to making a cat's cradle); and single-hook work or crocheting (knitting with two needles is a relatively modern technique). Work with fibers may have been women's work since women, with primary responsibility for child care, could work with string no matter how frequently they were interrupted by the needs of their families. The creation of strings and nets suggests that women as well as men could hunt for meat; net and trap hunting is common among hunter-gatherers.

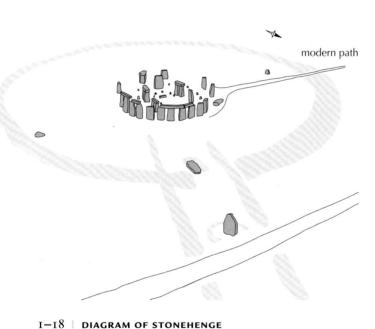

STONEHENGE. Of all the megalithic monuments in Europe, the one that has stirred the imagination of the public most strongly is Stonehenge, on Salisbury Plain in southern England (FIGS. I—17, I—18). A henge is a circle of stones or posts, often surrounded by a ditch with built-up embankments. Laying out such circles with accuracy would have posed no particular problem. Architects likely relied on the human compass, a simple but effective surveying method that persisted well into modern times. All that is required is a length of cord either cut or knotted to mark the desired radius of the circle. A person holding one end of the cord is stationed

in the center; a co-worker, holding the other end and keeping the cord taut, steps off the circle's circumference. By the time of Stonehenge's construction, cords and ropes were readily available.

Stonehenge is not the largest such circle from the Neolithic period, but it is one of the most complex. Stones were brought from great distances during at least four major building phases between about 2750 and 1500 BCE. In the earliest stage, its builders dug a deep, circular ditch, placing the excavated material on the inside rim to form an embankment more than 6 feet high. They dug through the turf to expose the chalk substratum characteristic of this part of England, thus creating a brilliant white circle about 330 feet in diameter. An "avenue" from the henge toward the northeast led well outside the embankment to a pointed sarsen megalith—sarsen is a gray sandstone—brought from 23 miles away. Today, this so-called heel stone, tapered toward the top and weighing about 35 tons, stands about 16 feet high. Whoever stood at the exact center of Stonehenge on the morning of the summer solstice 3,260 years ago would have seen the sun rise directly over the heel stone.

By about 2100 BCE, Stonehenge included all of the internal elements reflected in the drawing shown here (SEE FIG. 1–18). Dominating the center was a horseshoe-shaped arrangement of five sandstone *trilithons*, or pairs of upright stones topped by lintels. The one at the middle stood considerably taller than the rest, rising to a height of 24 feet, and its lintel was more than 15 feet long and 3 feet thick. This group was surrounded by the so-called sarsen circle, a ring of sandstone uprights weighing up to 26 tons each and averaging 13 feet 6 inches tall. This circle, 106 feet in diameter, was capped by a continuous lintel. The uprights were tapered slightly toward the top, and the gently curved lintel

THE OBJECT SPEAKS

PREHISTORIC WOMAN AND MAN

or all we know, the artist who created these figures almost 5,500 years ago had nothing particular in mind—people had been modeling clay figures in southeastern Europe for a long time. Perhaps a woman who was making cooking and storage pots out of clay amused herself by fashioning images of the people she saw around her. But because these figures were found in a grave in Cernavoda, Romania, they suggest to us an otherworldly message.

The woman, spread-hipped and bigbellied, sits directly on the ground, expressive of the mundane world. She exudes stability and fecundity. Her ample hips and thighs seem to ensure the continuity of her family. But in a lively, even elegant, gesture, she joins her hands coquettishly on one raised knee, curls up her toes, and tilts her head upward. Though earthbound, is she a spiritual figure communing with heaven? Her upwardly tilted head could suggest that she is watching the smoke rising from the hearth, or worrying about holes in the roof, or admiring hanging containers of laboriously gathered drying berries, or gazing adoringly at her partner. The man is rather slim, with massive legs and shoulders. He rests his head on his hands in a brooding, pensive pose, evoking thoughtfulness, even weariness or sorrow.

We can interpret the Cernavoda woman and man in many ways, but we cannot know what they meant to their makers or owners. Depending on how they are displayed, we spin out different stories about them. When set facing each other, side by side as they are in the photograph, we tend to see them as a couple—a woman and man in a relationship. In fact, we do not know whether the artist conceived of them in this way, or even made them at the same time. For all their visual eloquence, their secrets remain hidden from us.

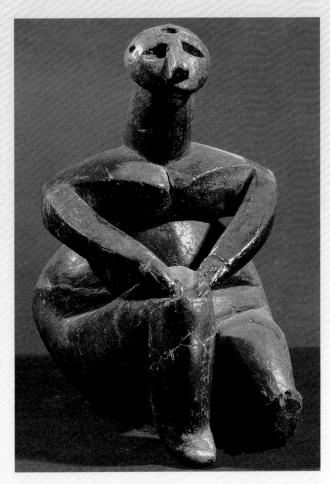

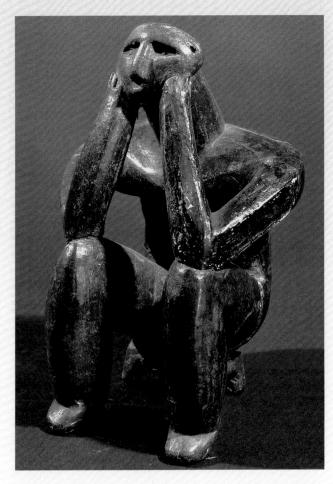

FIGURES OF A WOMAN AND A MAN Cernavoda, Romania. c. 3500 BCE. Ceramic, height 4½" (11.5 cm). National Historical Museum, Bucharest.

sections were secured by mortise-and-tenon joints, that is, joints made by a conical projection at the top of each upright that fits like a peg into a hole in the lintel.

Just inside the sarsen circle was once a ring of bluestones—worked blocks of a bluish stone found only in the mountains of southern Wales, 150 miles away. Why the builders used this type of stone is one of many mysteries about Stonehenge. Clearly the stones were highly prized, for centuries later, about 1500 BCE, they were reused to form a smaller horseshoe (inside the trilithons) that encloses the so-called altar stone. Calling the horizontal stone an altar is yet another example of misnaming (see "The Power of Naming," page 5).

Through the ages, many theories have been advanced to explain Stonehenge. In the Middle Ages, people thought that Merlin, the magician of the King Arthur legend, had built Stonehenge. Later, the site was incorrectly associated with the rituals of the Celtic Druids (priests). Because its orientation is related to the movement of the sun, some people believe it may have been a kind of observatory. The structure must have been an important site for major public ceremonies. Whatever its role may have been, Stonehenge continues to fascinate visitors. Crowds of people still gather there at midsummer to thrill to its mystery. Even if we never learn the original purpose of megalithic structures, we can understand that the technology developed for building them made possible a new kind of architecture.

Sculpture and Ceramics

Besides working in stone, Neolithic artists also commonly used clay. Their ceramics—wares made of baked clay—display a high degree of technical skill and aesthetic imagination. This art required a remarkable conceptual leap. Sculptors created their work out of an existing substance, such as stone, bone, or wood. To produce ceramics, artists had to combine certain substances with clay-bone ash was a common addition—then subject the objects formed of that mixture to high heat for a period of time, hardening them and creating an entirely new material. Among the ceramic figures discovered at a pottery-production center in the Danube River valley at Cernavoda, Romania, are a seated man and woman who form a most engaging pair (see "Prehistoric Woman and Man," left). The artist who made them shaped their bodies out of simple cylinders of clay but managed to pose them in ways that make them seem very true to life.

One unresolved puzzle of prehistory is why people in Europe did not produce pottery vessels much earlier. Although they understood how to harden clay figures by firing them in an oven at high temperatures as early as 32,000 BCE, it was not until about 7000 BCE that they began making vessels using the same technique. Some anthropolo-

Sequencing Works of Art

с. 30,000-26,000 все	Carved mammoth bone sculp- ture of lion-human from Hohlenstein-Stadel, Germany
c. 25,000-17,000 BCE	Earliest known cave paintings at Chauvet, France; first human footprints recorded
с. 4000-2000 все	Rock shelter art at Lérida, Spain
с. 3000-2000 все	Ceramic vessels from Denmark
с. 2700-1500 все	Construction of megalithic ceremonial complex at Stone-henge, England
First century BCE	Openwork Celtic box lid from Ireland

gists argue that clay is a medium of last resort for vessels. Compared with hollow gourds, wooden bowls, or woven baskets, clay vessels are heavy and quite fragile, and firing them requires considerable skill. The earliest pots were round and pouchlike and had built-in loops so that they could be suspended on cords.

Excellence in ceramics depends upon the degree to which a given vessel combines domestic utility, visual beauty, and fine execution (see "Pottery and Ceramics," page 20). A group of bowls from Denmark, made in the third millennium BCE, provides only a hint of the extraordinary achievements of Neolithic artists working in clay (FIG. 1–19).

The earliest pieces in the illustration are the globular bottle with a collar around its neck (bottom center), a form perhaps inspired by eggs or gourd containers, and the flask with loops (top). Even when potters began making pots with flat bottoms that could stand without tipping, they often added hanging loops as part of the design. Some of the ornamentation of these pots, including hatched engraving and stitchlike patterns, seems to reproduce the texture of the baskets and bags that preceded them as containers. It was also possible to decorate clay vessels by impressing stamps into the surface or scratching them with sticks, shells, or toothed implements. Many of these techniques appear to have been used to decorate the flat-bottomed vase with the wide, flaring top (bottom left), a popular type of container that came to be known as a funnel beaker.

The large engraved bowl in FIGURE 1–19, found at Skarpsalling, is considered to be the finest piece of northern Neolithic pottery yet discovered. The potter lightly incised its

Technique

POTTERY AND CERAMICS

he terms pottery and ceramics may be used interchangeably—and often are. Because it covers all baked-clay wares, ceramics is technically a more inclusive term than pottery. Pottery includes all baked-clay wares except porcelain, which is the most refined product of ceramic technology.

Pottery vessels can be formed in several ways. It is possible, though difficult, to raise up the sides from a ball of raw clay. Another method is to coil long rolls of soft, raw clay, stack them on top of each other to form a container, and then smooth them by hand. A third possibility is to simply press the clay over an existing form, a dried gourd for example. By about 4000 BCE, Egyptian potters had developed the potter's wheel, a round, spinning platform on which a lump of clay is placed and then formed with the fingers, making it relatively simple to produce a uniformly shaped vessel in a very short time. The potter's wheel appeared in the ancient Near East about 3250 BCE and in China about 3000 BCE.

After a pot is formed, it is allowed to dry completely before it is fired. Special ovens for firing ceramics, called **kilns**, have been discovered at prehistoric sites in Europe dating from as early as 32,000 BCE. For proper firing, the temperature must be maintained at a relatively uniform level. Raw clay becomes porous pottery when heated to at least 500° centigrade. It then holds its shape permanently and will not disintegrate in water. Fired at 800° centigrade, pottery is technically known as earthenware. When subjected to temperatures between 1,200° and 1,400° centigrade, certain stone elements in the clay vitrify, or become glassy, and the result is a stronger type of ceramic called stoneware.

Pottery is relatively fragile, and new vessels were constantly in demand to replace broken ones, so fragments of low-fired ceramics—fired at the hearth, rather than the higher temperature kiln—are the most common artifacts found in excavations of prehistoric settlements. Pottery fragments, or **potsherds**, serve as a major key in dating sites and reconstructing human living and trading patterns.

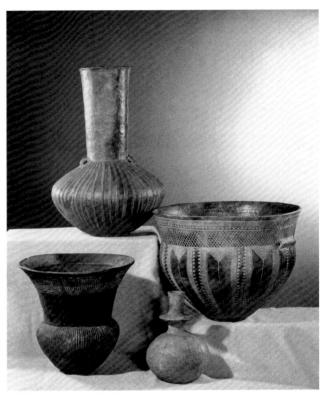

I-19 VESSELS

Denmark. c. 3000-2000 BCE. Ceramic, heights range 5¾" to 12¼" (14.5 to 31 cm). National Museum of Denmark, Copenhagen.

sides with delicate linear patterns, then rubbed white chalk into the engraved lines so that they would stand out against the dark body of the bowl.

FROM STONE TO METAL

The technology of metallurgy is closely allied to that of ceramics. Although Neolithic culture persisted in northern Europe until about 2000 BCE, the age of metals made its appearance in Europe about 2300 BCE. In central and southern Europe, and in the Aegean region, copper, gold, and tin had been mined, worked, and traded even earlier. Smelted and cast copper beads and ornaments dated to 4000 BCE have been discovered in Poland. (Contemporary art from the Mediterranean and ancient Near East and Egypt is discussed in Chapters 2, 3, and 4.)

The Bronze Age

The period that followed the introduction of metalworking is commonly called the Bronze Age. Although copper is relatively abundant in central Europe and in Spain, objects fashioned from it are too soft to be functional. However, bronze—an alloy, or mixture, of tin and copper—is a stronger, harder substance with a wide variety of uses. The introduction of bronze, especially for weapons, changed the peoples of Europe in fundamental ways. Societies dominated

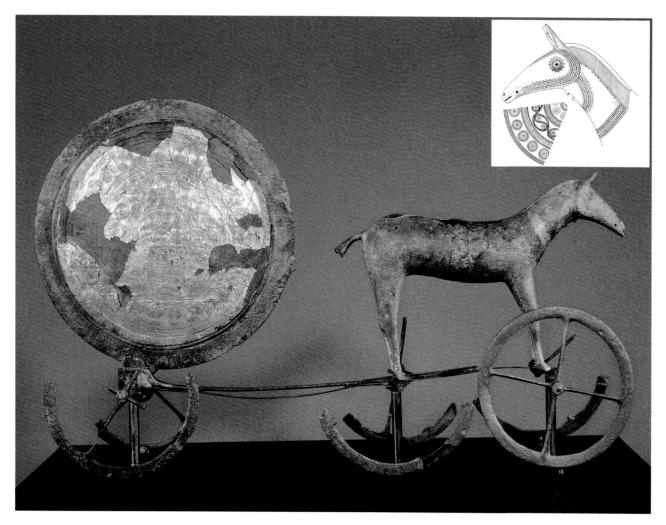

I–20 | HORSE AND SUN CHARIOT AND SCHEMATIC DRAWING OF INCISED DESIGN
Trundholm, Denmark. c. 1800–1600 BCE. Bronze, length 23½" (59.2 cm). National Museum, Copenhagen.

by a strong elite came into existence, and trade and intergroup contacts across the continent and into the Near East increased. Exquisite objects made of bronze are frequently found in the settlements and graves of early northern farming communities.

A remarkable bronze sculpture from between 1500 and 1300 BCE was discovered at what is now Trundholm, in Denmark. It depicts a wheeled horse pulling a cart laden with a large, upright disk commonly thought to represent the sun (FIG. 1–20). Horses had been domesticated in Ukraine by about 4000 BCE, but the first evidence of wheeled chariots and wagons designed to exploit the horse's strength dates from about 2000 BCE. Rock engravings in northern Europe show the sun being drawn through the sky by either an animal or a bird—possibly an indication of a widespread sun cult. This horse and sun cart sculpture could have been rolled from place to place in a ritual reenactment of the sun's passage across the sky.

The valuable materials from which the sculpture was made and the great attention devoted to its details attest to its importance. The horse, cart, and sun were cast in bronze. After two faults in the casting had been repaired, the horse was given its surface finish, and its head and neck were incised with ornamentation. Its eyes were represented as tiny suns. Elaborate and very delicate designs were engraved on its body to suggest a collar and harness. The bronze sun was cast as two disks, both of which were engraved with concentric rings filled with zigzags, circles, spirals, and loops. A thin sheet of beaten gold was then applied to one of the bronze disks and pressed into the incised patterns. Finally, the two disks were joined together by an encircling metal band. The patterns on the horse tend to be geometric and rectilinear, but those on the sun disks are continuous and curvilinear, suggestive of the movement of the sun itself.

The Proto-Historic Iron Age

Although bronze remained the preferred material for luxury items, iron was commonly used for practical items because it was cheaper and more readily available. By 1000 BCE, iron technology had spread across Europe. A hierarchy of metals emerged based on the materials' resistance to corrosion. Gold, as the most permanent and precious metal, ranked first,

I−2I | OPENWORK BOX LID

Cornalaragh County Monaghan, Ireland. La Tène period,
c. 1st century BCE. Bronze, diameter 3" (7.5 cm).

National Museum of Ireland, Dublin.

followed by silver, bronze, and, finally, practical but rusty iron. The blacksmiths who forged the warriors' swords and the farmers' plowshares held a privileged position among artisans, for they practiced a craft that seemed akin to magic as they transformed iron by heat and hammer work into tools and weapons.

During the Iron Age of the first millennium BCE, protohistoric Celtic peoples inhabited most of central and western Europe. The term *proto-historic* implies that they left no written records but that others wrote about them. Most of their wooden buildings and sculptures and their colorful woven textiles have disintegrated, but their protective earthworks, such as embankments fortifying cities, and funerary goods such as jewelry, weapons, and tableware, have survived.

An openwork box lid, in which space is worked into the pattern, illustrates the characteristic Celtic style and the continuing use of bronze during this period (FIG. 1–21). The pattern consists of a pair of expanding, diagonally symmetrical trumpet-shaped spirals surrounded by lattice. The openwork trumpets—the forms defined by the absence of material—catch the viewer's attention, yet at the same time the delicate tendrils of solid metal are equally compelling. Shapes inspired by compass–drawn spirals, stylized vines, and serpentine dragons seem to change at the blink of an eye, for the

artist has eliminated any distinction between figure and background. In Celtic hands, pattern becomes an integral part of the object itself, not an applied decoration.

The Celtic art of the second and first centuries BCE survived well into the Christian era (see Chapter 9) in Ireland, to be reused in the Middle Ages, in folk art, and as a source for Art Nouveau in the nineteenth century.

IN PERSPECTIVE

The paintings and objects that composed the first art made in Europe held great meaning for the people who made them, but without the aid of writing, we cannot know what that meaning was.

Art emerged about 35,000 years ago during the Upper Paleolithic period with the appearance of Cro-Magnon people. These first modern humans constructed houses made of available materials—branches, hides, even mammoth bones. They carved small figures—many of them depicting women—in bone, ivory, and stone. In the caves of southern France and northern Spain, artists painted images of animals and geometric figures with the aid of animal-fat lamps, using a variety of techniques. They took advantage of natural irregularities of the cave walls to create lifelike effects for their figures, and even modeled clay animals in high relief.

In the transition to the Neolithic period, cave art based on observation was replaced by schematic rock-shelter paintings of people engaged in activities that indicated a more settled way of life. Where timber was plentiful, people built long timber houses. In the northern islands they built in stone with stone furniture. This period in northern Europe is also distinguished by the introduction of a wide variety of ceramics, and of dramatic megalithic architecture. Great tomb and ritual centers built on the post-and-lintel system took the efforts of entire communities. At Stonehenge in England, builders overcame great logistical obstacles to move special stones long distances.

Around 2300 BCE, metalworking was introduced into Europe from the Near East. The period that followed is commonly called the Bronze Age and is a time of fundamental change in technology and trade for the peoples of Europe.

The prehistoric period in European art ends with the Celts. Some of what we know about them was recorded by the Greeks and Romans. Fortunately, their art, like that of other prehistoric people, survives as direct evidence of their culture. In later chapters we will study prehistoric and protohistoric art in other areas of the world.

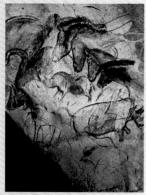

WALL, PAINTING, CHAUVET с. 30,000-20,000 все

PREHISTORIC ART IN EUROPE

■ Upper Paleolithic 40,000-8000 BCE

■ Last Ice Age 18,000-15,000 BCE

■ Neolithic 6500-1200 BCE

■ Farming in Europe c. 5000 BCE

Metallurgy c. 5000 BCE

■ Domestication of Horses c. 4000 BCE

■ Plow in Use c. 4000 BCE

■ Potter's Wheel in Use c. 3250 BCE

■ Invention of Writing c. 3100 BCE

■ Bronze Age c. 2300–800 BCE

■ Iron Age c. 1000 BCE

BCE

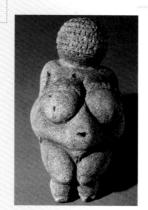

WOMAN FROM WILLENDORF, Austria C. 24,000 BCE

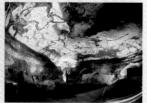

WALL PAINTING, LASCAUX c. 15,000 BCE

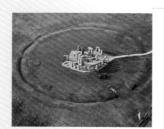

STONEHENGE, с. 2750-1500 все

HORSE AND SUN CHARIOT, с. 1800-1600 все

Denmark

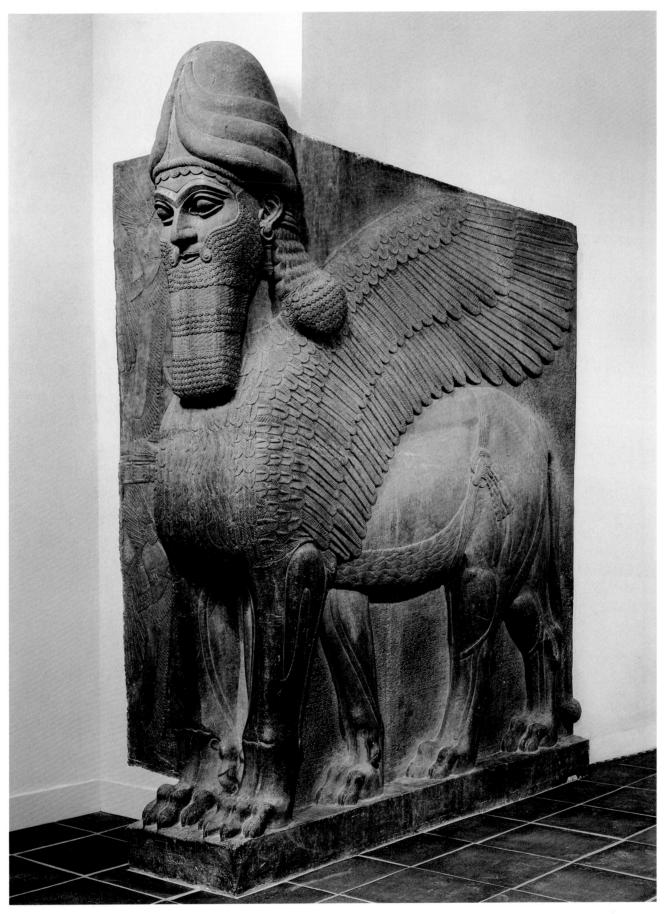

2–I | **HUMAN-HEADED WINGED LION (LAMASSU)** Colossal gateway figure, the palace of Assurnasirpal II, Mesopotamia, Assyria, Kalhu (present-day Nimrud, Iraq). 883–859 BCE. Alabaster, height 10′3½″ (3.11 m). The Metropolitan Museum of Art, New York. Gift of John D. Rockefeller, Jr., 1932 (32.143.1.-2)

CHAPTER TWO

ART OF THE ANCIENT NEAR EAST

Visitors to capital cities like Washington, Paris, and Rome today stroll along broad avenues among huge buildings, dominating gateways, and imposing sculpture. They are experiencing a kind of civic design that rulers—consciously

or not—have used since the third millennium. In the ninth century BCE, the Assyrians, one of the many groups that rose and fell in the ancient Near East, were masters of the art of impressing and intimidating visitors. Emissaries to the city of Kalhu (later called Nimrud), for example, would have encountered breathtaking examples of this ceremonial urbanism, in which the city itself is a stage for the ritual dramas that reinforce and confirm the ruler's absolute power.

Even from a distance, strangers approaching the city would have seen the high walls and imposing gates and temple platforms where the priest-king acted as intermediary between the people and the gods. Important visitors and ambassadors on the way to an audience with the ruler would have passed sculpture extolling the power of the Assyrian armies and then come face-to-face with lamassus, the

extraordinary guardian-protectors of the palaces and throne rooms. These colossal gate-way figures combined the bearded head of a man, the powerful body of a lion or bull, the wings of an eagle, and the horned headdress of

a god (FIG. 2–1) Because they were designed to be viewed frontally and from the side, lamassus seem to have five legs. When seen from the front, two forelegs are placed together and the creatures appear immobile. But when viewed from the side, the legs are shown as vigorously striding (hence the fifth leg). The sheer size of the lamassus—often twice a person's height—symbolizes the strength of the ruler they defend. Their forceful forms and prominent placement contribute to an architecture of domination. On the other hand, the exquisite detailing of their beards, feathers, and jewels testifies to boundless wealth, which also signifies power. These fantastic composite beasts inspired both civic pride and fear. They are works of art with an unmistakable political mission. In the ancient Near East, the arts played an important political role.

- THE FERTILE CRESCENT AND MESOPOTAMIA | The First Cities | The Arts
- SOUTHERN MESOPOTAMIA | Sumer | Akkad | Lagash and Gudea | Babylon: Hammurabi's Code
- **THE HITTITES OF ANATOLIA**
- LATER MESOPOTAMIAN ART | Assyria | Neo-Babylonia
- PERSIA | Empire | Persepolis | Persian Coinage
- **IN PERSPECTIVE**

Well before farming communities appeared in Europe, people in Asia Minor and the ancient Near East domesticated grains. This first occurred in an area known today as the Fertile Crescent (MAP 2-1), the outline of which stretches along the Lebanese mountain range on the Mediterranean and then circles the northern reaches of the Tigris and Euphrates rivers (near the present-day borders of Turkey, Syria, and Iraq), down through the Zagros Mountains. A little later, in the sixth or fifth millennium BCE, agriculture developed in the alluvial plains between the Tigris and Euphrates rivers, which the Greeks called Mesopotamia, meaning the "land between the rivers," now in present-day Iraq. Because of problems with periodic flooding, there was a need for large-scale systems to control the water supply. In a land prone to both drought and flood, this need for a system of water management may have contributed to the development of the first cities.

Between 4000 and 3000 BCE, a major cultural shift seems to have taken place. Agricultural villages evolved into cities simultaneously and independently in both northern and southern Mesopotamia. These prosperous cities joined with their surrounding territories to create what are known as city-states, each with its own gods and government. Social hierarchies—rulers and workers—emerged with the development of specialized skills beyond those needed for agricultural work. To grain mills and ovens were added brick and pottery kilns and textile and metal workshops. With extra goods and even modest affluence came increased trade and contact with other cultures.

Builders and artists labored to construct huge temples and government buildings. Organized religion played an important role, and the people who controlled rituals and the sacred sites eventually became priests. The people of the ancient Near East worshiped numerous gods and goddesses. Each city had a special protective deity, and people believed the fate of the city depended on the power of that deity. (The names of comparable deities varied over time and place—for example, Inanna, the Sumerian goddess of fertility, love, and war, was equivalent to the Babylonians' Ishtar.) Large architectural complexes—clusters of religious, administrative, and

service buildings—developed in each city as centers of ritual and worship and also of government.

Mesopotamia's wealth and agricultural resources, as well as its few natural defenses, made it vulnerable to political upheaval. Over the centuries, the balance of power shifted between north and south and between local powers and outside invaders. First the Sumerians controlled the south. Then they were eclipsed by the Akkadians, their neighbors to the north. When invaders from farther north in turn conquered the Akkadians, the Sumerians regained power locally. The Babylonians were next to dominate the south. Later, the center of power shifted to the Assyrians in the north, then back again to the Babylonians (Neo-Babylonian period). Throughout this time, important cultural centers arose outside Mesopotamia, such as Elam on the plain between the Tigris River and the Zagros Mountains to the east, the Hittite kingdom in Anatolia (present-day Turkey), and beginning in the sixth century BCE, the land of the Achaemenid Persians in present-day Iran. The Persians eventually forged an empire that included the entire ancient Near East.

The First Cities

Agriculture made possible the development of large, sustainable communities that required permanent housing for their residents, means of defense from outsiders, and the development of new technologies to sustain everyday life. The earliest of these settlements, in the Fertile Crescent and southeastern Anatolia, reveal architectural solutions impressive for their variety and use of local materials, sculpture that shows well-developed religious practices, sophisticated decorated pottery, and evidence of crafts based on extensive trade.

JERICHO. Jericho (located in today's West Bank territory)—whose walls and towers became part of folklore when the biblical Joshua fought the battle of Jericho and the walls "came a tumblin' down"—has the earliest stone fortifications discovered to date (FIG. 2–2). People had been living there beside an ever-flowing spring in the ninth millennium, and by about 8000 BCE this agricultural village had grown into a town of mud-brick houses (mud bricks are shaped from clay and dried in the sun). The town covered six to ten acres, and by 7500 BCE it may have had a population of 2,000.

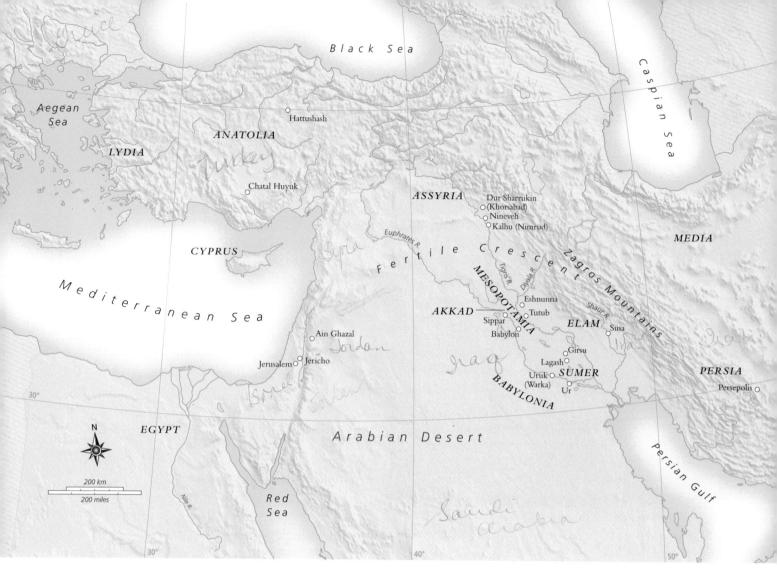

MAP 2-I THE ANCIENT NEAR EAST

Ancient Mesopotamia (present-day Iraq). The Tigris and Euphrates rivers.

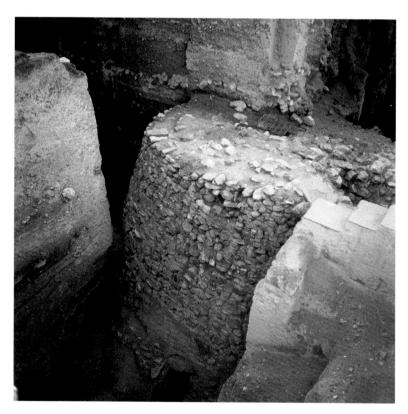

2−2 | WALLS AND TOWER, JERICHO c. 8000–7000 BCE. Mud brick, rubble, stone.

The people of Jericho found they needed protection from their neighbors, or perhaps they were establishing a boundary. For whatever reason, they built a huge brick wall 5 feet thick and nearly 20 feet high, made even higher by a ditch. They also constructed a circular stone tower 28 feet high with a diameter of 33 feet and an inner stair, which required quite sophisticated masonry skills on the part of the builders. Whether this tower was unique or one of several we do not know, but whether one or many, the tower and fortifications of Jericho are a remarkable achievement.

AIN GHAZAL. Another early site, Ain Ghazal ("Spring of Gazelle"), just outside present-day Amman, Jordan, was even larger than Jericho. That settlement, inhabited from about 7200 to 5000 BCE, occupied 30 acres at its maximum extent on terraces stabilized by stone retaining walls. (Its houses, made of stones mortared together with mud, show signs of long occupation, and may have resembled the adobe pueblos built by native peoples in the American Southwest.) The concentration of people and resources in cities such as these was an early step toward the formation of the larger city-states in the ancient Near East.

CHATAL HUYUK. Although agriculture appears to have been the economic mainstay of these new permanent communities, other specialized activities, such as crafts and trade, were also important by about 6500 to 5500 BCE. Chatal Huyuk, a city in Anatolia (present-day Turkey) with a population of about 5,000, developed a thriving trade in obsidian, a rare black volcanic glass that was used from Paleolithic into modern times for sharp blades. The inhabitants of Chatal Huyuk lived in single-story buildings clustered around

shared courtyards, used as garbage dumps. Chatal Huyuk's design, with no streets or open plazas and protected with continuous, unbroken exterior walls, made it easy to defend. Yet the residents could move around freely by crossing from rooftop to rooftop, entering houses through openings in the roofs (FIG. 2–3).

Susa. The strip of fertile plain between the Tigris River and the Zagros Mountains to the east (in present-day Iran), was a flourishing farming region by 7000 BCE. By about 4200 BCE, the city of Susa, later the capital of an Elamite kingdom, was established on the Shaur River. This area, later known as Elam, had close cultural ties to Mesopotamia, but the two regions were often in conflict. For example, in the twelfth century BCE, Elamite invaders did something with which we are all too familiar: They looted art treasures from Mesopotamia and carried them back to Susa (see "Art as Spoils of War—Protection or Theft?" page 31).

The Arts

Among the arts that flourished in these early cities were sculpture, painting, textiles, and pottery.

As in prehistoric art, the sculptures found in these early cities give us hints about the technology and the culture of those who made them. Among the most imposing objects recovered from Ain Ghazal are more than thirty painted plaster figures. Fragments suggest that some figures were nearly life-size (FIG. 2–4). Sculptors molded the figures by applying wet plaster to reed-and-cord frames in human shape. The eyes were inset cowrie shells, and small dots of the black, tarlike substance bitumen—which Near Eastern artists used

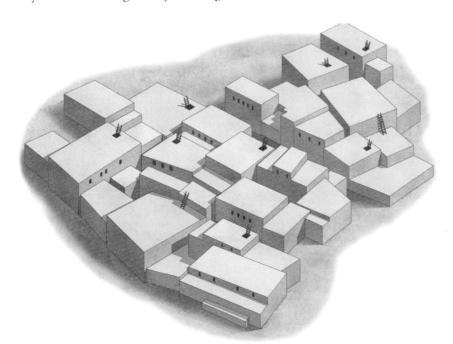

2–3 | COMPOSITE RECONSTRUCTION DRAWING OF CHATAL HUYUK
Anatolia (present-day Turkey).
c. 6500–5500 BCE.

frequently—formed the pupils. The figures probably wore wigs and clothing and stood upright.

At Chatal Huyuk, the elaborately decorated buildings are assumed to have been shrines. Bold geometric designs, painted animal scenes, actual animal skulls and horns, and three-dimensional shapes resembling breasts and horned animals adorned the walls. In one chamber, a leopard-headed woman—portrayed in a high-arched wall area above three large, projecting bulls' heads—braces herself as she gives birth to a ram.

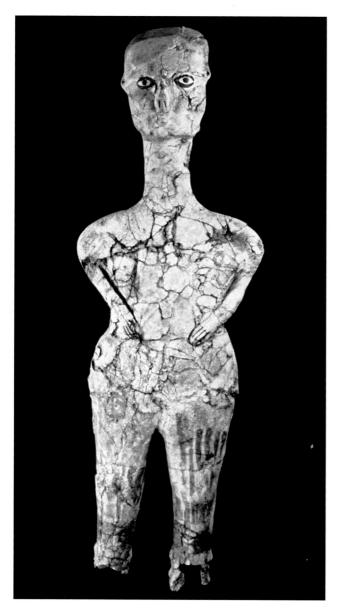

2–4 | **HUMAN FIGURE** Ain Ghazal, Jordan. c. 7000-6000 BCE. Fired lime plaster with cowrie shell, bitumen, and paint, height approx. 35" (90 cm). National Museum, Amman, Jordan.

Although this dramatic image suggests worship of a fertility goddess, any such interpretation is risky because so little is known about the culture. Like other early Near Eastern settlements, Chatal Huyuk seems to have been abandoned suddenly, for unknown reasons, and never reoccupied.

SOUTHERN MESOPOTAMIA

Although the stone-free, alluvial plain of southern Mesopotamia was prone to floods and droughts, it served as a fertile bed for agriculture and successive, interlinked societies. The Sumerians, a people about whose origins little is known, first developed this area. They filled their independent citystates with the fruits of new technology, literacy, and impressive art and architecture. The Sumerian states, marked by constant feuds, were eventually unified by another people, the Akkadians, who united Mesopotamia. The Akkadians embraced Sumerian culture, but the unification they accomplished was, in turn, broken by invaders from the northeast. Only one city-state, Lagash, survived and was revived under the ruler Gudea. Mesopotamia remained in turmoil for several more centuries until order was restored by the Amorites, who had migrated to Mesopotamia from the Syrian desert. Under them and their king, Hammurabi, a new, unified society arose with its capital in the city of Babylon.

Sumer

The cities and city-states that developed along the rivers of southern Mesopotamia between about 3500 and 2340 BCE are known collectively as Sumer. The inhabitants, who had migrated from the north but whose origins are otherwise obscure, are credited with important "firsts." Sumerians may have invented the wagon wheel and the plow, and they created a system of writing—perhaps their greatest contribution to later civilizations. (Recent discoveries indicate that writing developed simultaneously in Egypt; see Chapter 3.)

WRITING. Sumerians pressed cuneiform ("wedge-shaped") symbols into clay tablets with a stylus, a pointed writing instrument, to keep business records (see "Cuneiform Writing," page 32). Thousands of Sumerian tablets document the gradual evolution of writing and arithmetic, another tool of commerce, as well as an organized system of justice and the world's first and best-known literary epic. The origins of the *Epic of Gilgamesh* are Sumerian, but the fullest version, written in Akkadian, was found in the library of the Assyrian king Assurbanipal (ruled 669–c. 627 BCE) in Nineveh (present-day Kuyunjik, Iraq). It records the adventures of Gilgamesh, legendary Sumerian king of Uruk, and his companion Enkidu. When Enkidu dies, a despondent Gilgamesh sets out to find the secret of eternal life from a man

and his wife who are the sole survivors of a great flood sent by the gods to destroy the world, and the only people to whom the gods had granted immortality. Gilgamesh ultimately accepts his mortality, abandons his quest, and returns to Uruk, recognizing the majestic city as his lasting accomplishment.

THE ZIGGURAT. The Sumerians' most impressive surviving archaeological remains are their **ziggurats**, huge stepped structures with a temple or shrine on top. The first ziggurats may have developed from the practice of repeated rebuilding at a sacred site, with rubble from one structure serving as the foundation for the next. Elevating the buildings also protected the shrines from flooding.

Whatever the origin of their design, ziggurats towering above the flat plain proclaimed the wealth, prestige, and stability of a city's rulers and glorified its gods. Ziggurats functioned symbolically too, as lofty bridges between the earth and the heavens—a meeting place for humans and their gods. They were given names such as "House of the Mountain" and "Bond between Heaven and Earth."

URUK. Uruk (present-day Warka, Iraq), the first independent Sumerian city-state, had two large architectural complexes in the 1,000-acre city. One was dedicated to

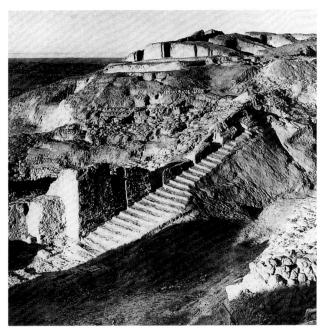

2–5 | RUINS OF THE WHITE TEMPLE
Uruk (present-day Warka, Iraq) c. 3300–3000 BCE.

Many Ancient Near Eastern cities still lie undiscovered. In most cases an archaeological site in a region is signaled by a large mound—known locally as a *tell, tepe,* or *huyuk*—that represents the accumulated debris of generations of human habitation. When properly excavated, such mounds yield evidence about the people who inhabited the site.

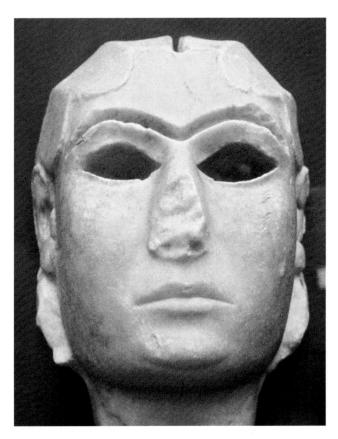

2–6 | FACE OF A WOMAN, KNOWN AS THE WARKA HEAD Uruk (present-day Warka, Iraq). c. 3300–3000 BCE. Marble, height approx. 8" (20.3 cm). Iraq Museum, Baghdad (stolen and recovered in 2003).

Inanna, the goddess of love and war. The Inanna buildings seem to have been an administrative complex as well as serving as temples. The other complex belonged to the sky god Anu. The temple platform of Anu, built up in stages over the centuries, ultimately rose to a height of about 40 feet. Around 3100 BCE, a whitewashed brick temple that modern archaeologists refer to as the White Temple (FIG. 2–5) was erected on top. This now-ruined structure was a simple rectangle oriented to the points of the compass. An off-center doorway on one of the long sides led into a large chamber containing a raised platform and altar; smaller spaces opened off this main chamber.

Statues of gods and donors were placed in the temples. A striking life-size marble face from Uruk may represent a goddess (FIG. 2–6). It could have been attached to a wooden head on a full-size wooden body. Now stripped of its original paint, wig, and inlaid (set-in) brows and eyes, it appears as a stark white mask. Shells may have been used for the whites of the eyes and lapis lazuli for the pupils, and the hair may have been gold. Even without these accessories, the compelling stare and sensitively rendered features attest to the skill of Sumerian sculptors.

Art and Its Context

ART AS SPOILS OF WAR-PROTECTION OR THEFT?

rt has always been a casualty in times of social unrest.

One of the most recent examples is the looting of the head of a woman from Warka, when an angry mob broke into the unguarded Iraq National Museum in April 2003. The delicate marble sculpture was later found, but not without significant damage (compare with FIG. 2-6).

Some of the most bitter resentment spawned by warwhether in Mesopotamia in the twelfth century BCE or in our own time-has involved the "liberation" by the victors of art objects of great value to the people from whom they were taken. Museums around the world hold works either snatched by invading armies or acquired as a result of conquest. Two historically priceless objects unearthed in Elamite Susa, for example-the Akkadian Stele of Naram-Sin (see FIG. 2-14) and the Babylonian Stele of Hammurabi (see "The Code of Hammurabi," page 38)-were not Elamite at all, but Mesopotamian. Both had been brought there as military trophies by an Elamite king, who added an inscription to the Stele of Naram-Sin explaining that he had merely "protected" it. The stele came originally from Sippar, an Akkadian city on the Euphrates River, in what is now Iraq. Raiders from Elam took it there as booty in the twelfth century BCE.

The same rationale has been used in modern times. The Rosetta Stone, the key to deciphering Egyptian hieroglyphics, was discovered in Egypt by French troops in 1799, fell into British hands when they forced the French from Egypt, and ultimately ended up in the British Museum in London (see page 78). In the early nineteenth century, the British Lord Elgin purchased and removed classical Greek reliefs from the Parthenon in Athens with the permission of the Ottoman authorities who governed Greece at the time (see pages 138–139). Although his actions may indeed have protected the reliefs from neglect and damage in later wars, they have remained installed, like the Rosetta Stone, in the British Museum, despite continuing protests from Greece.

The Ishtar Gate from Babylon (see FIG. 2-21) is now reconstructed in Berlin, Germany. Many German collections include

works that were similarly "protected" at the end of World War II and are surfacing now. In the United States, Native Americans are increasingly vocal in their demands that artifacts and human remains collected by anthropologists and archaeologists be returned to them. "To the victor," it is said, "belong the spoils." It continues to be a matter of passionate debate whether this notion is appropriate in the case of revered cultural artifacts.

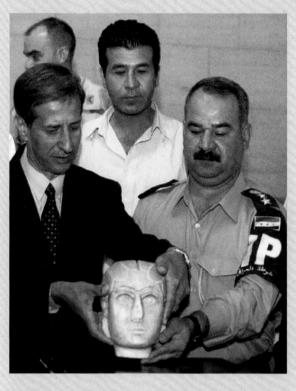

PHOTO OF FACE OF A WOMAN KNOWN AS THE WARKA HEAD, Displayed by Iraqi authorities on its recovery.

A tall, carved alabaster vase found near the temple complex of Inanna at Uruk (FIG. 2–7) shows how Near Eastern sculptors of the time—and for the next 2,500 years—told their stories with great economy and clarity. They organized the picture space into registers, or horizontal bands, and condensed the narrative, much as modern comic-strip artists do. The stylized figures are shown simultaneously with profile heads and legs and with three-quarter-view torsos, making both shoulders visible and increasing each figure's breadth. The lower register of the vase shows the natural world, beginning with water and plants identified as the date palm and barley or the now extinct silphium (identified by medical historians as a plant used by early people to control fertility). Above the plants, alternating rams

and ewes stand on a solid groundline. In the middle register nude men carry baskets of foodstuffs. In the top register, Inanna stands in front of her shrine and storehouse accepting an offering from the priest-king. Through the doorway we see a display of her wealth as well as two devotees.

The scene is usually interpreted as the ritual marriage between the goddess and a human priest-king during the New Year's festival, a ritual meant to ensure the fertility of crops, animals, and people. The riches of the natural world—the date palms, the rams and ewes, the silphium—placed around the base of the vase literally and visually support the human activity in honor of the goddess. The imagery of the alabaster vase attests to the continued survival of Uruk.

Technique

CUNEIFORM WRITING

umerians invented writing around 3100 BCE, apparently as an accounting system for goods traded at Uruk. The symbols were pictographs, simple pictures cut into moist clay slabs with a pointed tool. Between 2900 and 2400 BCE, the symbols evolved from pictures into *phonograms*—representations of syllable sounds—thus becoming a true writing system. During the same centuries, scribes adopted a stylus, or writing tool, with one triangular end and one pointed end. The stylus could be pressed easily and rapidly into a wet clay tablet to create the increasingly abstract symbols, or characters, of cuneiform writing.

This illustration shows examples of the shift from pictograph to cuneiform writing. The drawing of a bowl, which

means "bread" or "food" and dates from about 3100 BCE, was reduced to a four-stroke sign by about 2400 BCE, and by about 700 BCE to a highly abstract arrangement of vertical marks. By combining the pictographs and, later, cuneiform signs, writers created composite signs; for example, a combination of the signs for "head" and "food" meant "to eat."

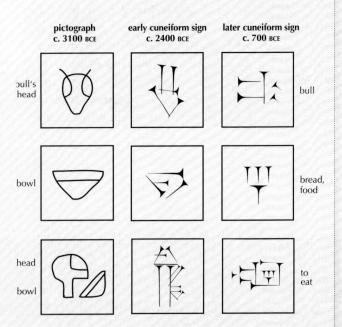

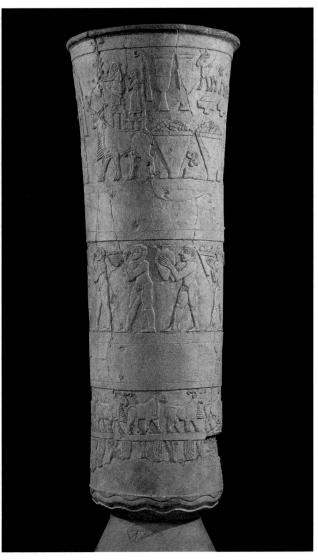

2–7 | CARVED VASE KNOWN AS THE URUK VASE Uruk (present-day Warka, Iraq). c. 3300–3000 BCE. Alabaster, height 36" (91 cm). Iraq Museum, Baghdad (stolen and recovered in 2003).

VOTIVE FIGURES. Limestone statues dated to about 2900–2600 BCE from the Diyala River Valley, Iraq, excavated in 1932–33, reveal another aspect of Sumerian religious art (FIG. 2–8). These **votive figures**—images dedicated to the gods—are an early example of an ancient Near Eastern religious practice: the placement in a shrine of statues of individual worshipers before a larger, more elaborate image of a god. Anyone who was a donor to the temple might commission a representation of him- or herself and dedicate it in the shrine. Many are figures of women. A simple inscription might identify the figure as "One who offers prayers." Longer inscriptions might recount in detail all the things the donor had accomplished in the god's honor. Each sculpture served as a stand-in, at perpetual attention, making eye contact with the god, and chanting its donor's praises.

The sculptors of the votive figures followed the conventions of Sumerian art—that is, the traditional way of repre-

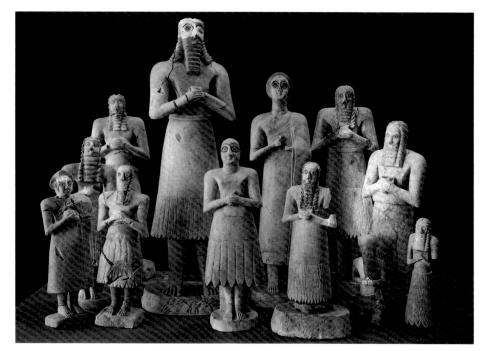

2-8 VOTIVE FIGURES

The Square Temple, Eshnunna (present-day Tell Asmar, Iraq). c. 2900–2600 BCE. Limestone, alabaster, and gypsum, height of largest figure approx. 30" (76.3 cm).

The Oriental Institute of the University of Chicago.

senting forms with simplified faces and bodies, and with clothing that emphasized the cylindrical shape. The figures stand solemnly, hands clasped in respect. The wide-open eyes may be explained by cuneiform texts that reveal the importance of approaching a god with an attentive gaze. As with the face of the woman from Uruk, arched brows are inlaid with dark shell, stone, or bitumen that once emphasized the huge, staring eyes. The male figures, bare-chested and dressed in what appear to be sheepskin skirts, are stocky and muscular, with heavy legs, large feet, big shoulders, and cylindrical bodies. The female figures are as massive as the men. One wears a long sheepskin skirt and the other a calf-length skirt that reveals sturdy legs and feet.

Up.

South of Uruk lay the city of Ur (present-day Muqaiyir, Iraq). About a thousand years after the completion of the temples at Uruk, the people of Ur built a ziggurat dedicated to the moon god Nanna, also called Sin (FIG. 2–9). Although located on the site of an earlier temple, this imposing mud-brick structure was not the accidental result of successive rebuildings. Its base is a rectangle 205 by 141 feet, with three sets of stairs converging at an imposing entrance gate atop the first of what were three platforms. Each platform's walls slope outward from top to base, probably to prevent rainwater from forming puddles and eroding the mud-brick pavement below. The first two levels of the ziggurat and their retaining walls have been reconstructed in recent years.

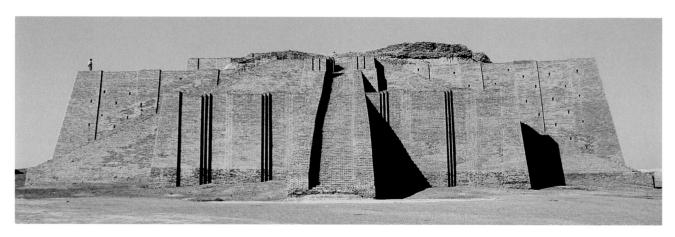

2–9 | **NANNA ZIGGURAT** Ur (present-day Muqaiyir, Iraq). c. 2100–2050 BCE.

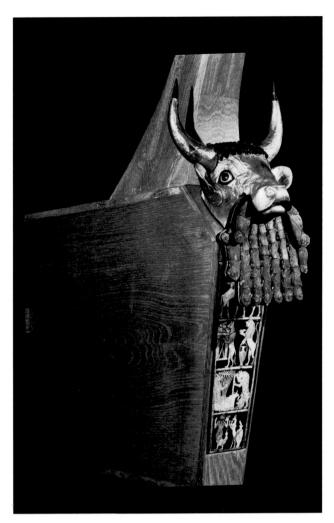

2-IO THE GREAT LYRE WITH BULL'S HEAD Royal Tomb, Ur (present-day Mugaiyir, Iraq). c. 2550-2400 BCE. Wood with gold, silver, lapis lazuli, bitumen, and shell, reassembled in modern wood support; height of head 14" (35.6 cm); height of front panel 13" (33 cm); maximum length of lyre 55½" (140 cm), height of upright back arm 46½" (117 cm). University of Pennsylvania Museum of Archaeology and Anthropology, Philadelphia.

From about 3000 BCE on, Sumerian artisans worked in various precious metals, and in bronze, often combining them with other materials. Many of these creations were decorated with—or were in the shape of—animals or composite animal-human-bird creatures. A superb example of their skill is a lyre—a kind of harp—from a royal tomb (identified as PG789). The harp combines wood, gold, lapis lazuli, and shell (FIG. 2-10). Projecting from the base of the lyre is a sculptured head of a bearded bull, intensely lifelike despite the decoratively patterned blue lapis lazuli beard. (Lapis lazuli, which had to be imported from Afghanistan, is evidence of widespread trade in the region.)

On the front panel of the sound box, four horizontal registers present scenes executed in shell inlaid in bitumen (FIG. 2-11). In the bottom register a scorpion man holds a cylindrical object in his left hand. Scorpion men are associ-

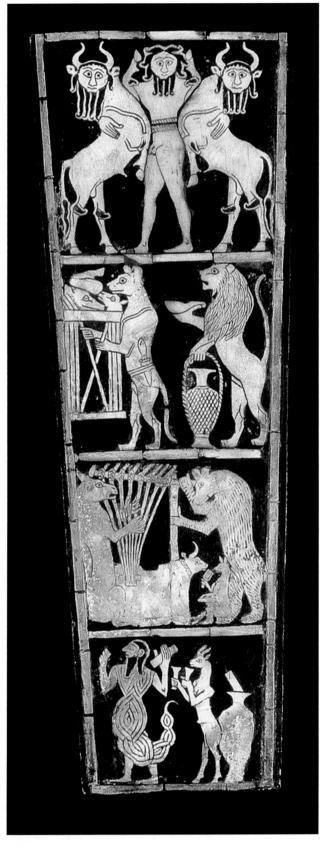

2-II FRONT PANEL, THE SOUND BOX OF THE GREAT LYRE

Ur (present-day Muqaiyir, Iraq). Wood with shell inlaid in bitumen, height $12\frac{1}{4} \times 4\frac{1}{2}$ " (31.1 × 11cm). University of Pennsylvania Museum of Archaeology and Anthropology, Philadelphia.

(T4-29C)

ated with the land of demons, the mountains of sunrise and sunset, which are part of the journey made by the dead. The scorpion man is attended by a gazelle standing on its hind legs and holding out two tall cups, perhaps filled from the large container from which a ladle protrudes. The scene above this one depicts a trio of animal musicians. A seated donkey plucks the strings of a bull lyre—showing how such instruments were played—while a standing bear braces the instrument's frame and a seated animal, perhaps a fox, plays a sistrum (a kind of rattle).

The next register shows animal attendants, also walking erect, bringing food and drink for the feast. On the left a hyena, assuming the role of a butcher with a knife in its belt, carries a table piled high with meat. A lion follows with a large jar and pouring vessel. In the top panel, striding but facing forward, is an athletic man, probably meant to represent the deceased. His long hair and a full beard denote a semidivine status. He is naked except for a wide belt, and he clasps two rearing human-headed bulls. The imagery on the harp may have been inspired in part by the Epic of Gilgamesh, with its descriptions of heroic feats and fabulous creatures like the scorpion man, whom Gilgamesh met as he searched for his friend Enkidu. With the invention of writing we are no longer dealing only with speculation as we did with prehistoric art, and we can begin to study the iconography (the narrative and allegorical meaning) of images.

Because the lyre and others like it were found in royal tombs chambers and were used in funeral rites, the imagery we see here probably depicts a funeral banquet in the realm of the dead. The animals shown are the traditional guardians of the gateway through which the newly dead person had to pass. Cuneiform tablets preserve songs of mourning, which may have been chanted by priests to lyre music at funerals. One begins: "Oh, lady, the harp of mourning is placed on the ground."

Retainers of the deceased ruler seem to have followed them to the tomb, where they committed suicide. In tomb PG789, six soldiers and fifty-seven retainers, mostly women, accompanied the king to the Netherworld. At his death, the legendary Gilgamesh took his wife, child, concubine, minstrel, cup bearer, barber, and courtiers with him into the tomb.

Sequencing Events Ancient Near Eastern Cultures

Uruk (present-day Warka, Iraq)—Sumerian. Settled in c. 5000 BCE; flourished c. 3600-2100 BCE; city occupied until c. 226 CE.

Babylon-Babylonian. First written mention in c. 2200 BCE; capital under Hammurabi (1792-1750 BCE).

Kalhu (present-day Nimrud, Iraq)—Assyrian. Flourished 900–800 BCE; capital under Ashurnarsipal II (ruled 883–859 BCE); sacked c. 614 BCE by the Medes.

Babylon-Neo-Babylonian. Rose to preeminence under Nebuchadnezzar II (ruled 605-562 BCE); declined after 312 BCE.

Persepolis—Persian. Founded c. 515 BCE by Darius I (ruled 521–486 BCE); burned in 330 BCE by Alexander the Great.

CYLINDER SEALS. People in the area of present-day Syria and Turkey first employed simple clay stamps with designs incised (cut) into one surface to stamp textiles or bread. About the time written records appeared, Sumerians developed seals for identifying documents and establishing property ownership. By 3300–3100 BCE, record keepers redesigned the stamp seal as a cylinder. Rolled across soft clay applied to the closure that was to be sealed—a jar lid, the knot securing a bundle, or the door to a room—the cylinder left a raised image of the design. No unauthorized person could then gain access secretly. Sumerian cylinder seals, usually less than 2 inches high, were made of a hard stone, such as marble or lapis lazuli, so that the tiny, elaborate scenes carved into them would not wear away.

The scene in a seal from Ur (FIG. 2–12) includes a human hero protecting rampant bulls from lions in the upper register and five fighting figures in the lower register. Ancient Near Eastern leaders were expected to protect their people from both human and animal enemies, as well as exert control over the natural world. This seal belonged to a queen of Ur named Ninbanda.

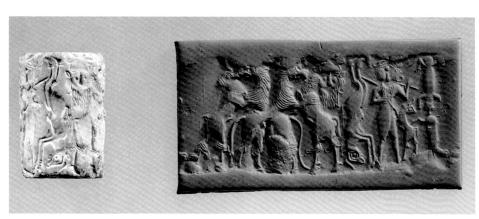

2-I2 CYLINDER SEAL AND ITS IMPRESSION

Ur (present-day Muqaiyir, Iraq). c. 2550-2400 BCE. Lapis lazuli, height, 1%" (4.1 cm). University of Pennsylvania Museum of Archaeology and Anthropology, Philadelphia.

B16852

Akkad

During the Sumerian period, a people known as the Akkadians had settled north of Uruk. They adopted Sumerian culture, but unlike the Sumerians, the Akkadians spoke a Semitic language (the same family of languages that includes Arabic and Hebrew). Under the powerful military and political figure Sargon I (ruled c. 2332–2279 BCE), they conquered most of Mesopotamia. For more than half a century, Sargon, "King of the Four Quarters of the World," ruled this empire from his capital at Akkad, the actual site of which is yet to be discovered.

HEAD OF A RULER. Few artifacts can be identified with Akkad, making a life-size bronze head thought to date from the time of Sargon especially precious (FIG. 2–13). The head is the earliest major work of hollow-cast copper sculpture known in the Ancient Near East.

The facial features and hairstyle probably reflect a generalized male ideal rather than the appearance of a specific individual, although the sculpture was once identified as Sargon. The enormous curling beard and elaborately braided hair (circling the head and ending in a knot at the back) indicate both royalty and the ideal male appearance. This head was found in the northern city of Nineveh. The deliberate damage to the left side of the face and eye suggests that the head was symbolically mutilated to destroy its power. The ears and the inlaid eyes appear to have been deliberately removed; thus the statue could neither hear nor see.

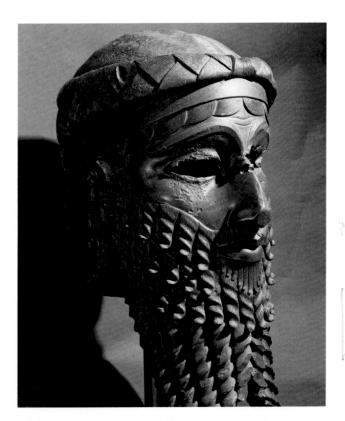

2–13 | HEAD OF A MAN (KNOWN AS AKKADIAN RULER) Nineveh (present-day Kuyunjik, Iraq). c. 2300–2200 BCE. Copper alloy, height 14½" (36.5 cm). Iraq Museum, Baghdad.

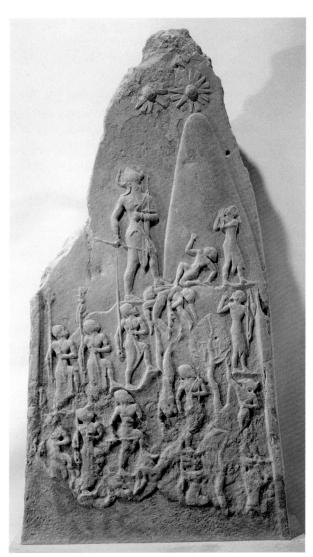

2–14 | STELE OF NARAM-SIN Sippar. Found at Susa. c. 2220–2184 BCE. Limestone, height 6′6″ (1.98 m). Musée du Louvre, Paris.

THE STELE OF NARAM-SIN. The concept of imperial authority was literally carved in stone by Sargon's grandson Naram-Sin (FIG. 2-14). A 6½-foot-high stele (an upright stone slab) memorializes one of Naram-Sin's military victories, and is one of the first works of art created to celebrate a specific achievement of an individual ruler. The inscription states that the stele commemorates the king's victory over the people of the Zagros Mountains. Naram-Sin made himself divine during his lifetime—a new concept requiring new iconography. As god-king, Naram-Sin is immediately recognizable by his size. Size was associated with importance in ancient art, a convention known as hieratic scale. Watched over by three solar deities, symbolized by the rayed suns in the sky, he ascends a mountain wearing the horned helmetcrown associated with deities, which he is now entitled to wear. Naram-Sin's importance is magnified by his position at the dramatic center of the scene, closest to the mountaintop and silhouetted against the sky.

The sculptors used the stele's pointed shape to underscore the dynamic role of the carved mountain in the composition. In a sharp break with visual tradition, they replaced the horizontal registers of Mesopotamian and Egyptian art (see Chapter 3) with wavy groundlines. Soldiers (smaller than the king, as dictated by the convention of hieratic scale) follow their leader at regular intervals, passing conquered enemy forces sprawled in death or begging for mercy. Both the king and his warriors hold their weapons triumphantly upright. (Ironically, although this stele depicts Akkadians as conquerers, they would dominate the region for only about another half century.)

Lagash and Gudea

About 2180 BCE, the Guti, a mountain people from the northeast, conquered the Akkadian Empire. The Guti controlled most of the Mesopotamian plain for a brief time before the Sumerian people regained control of the region. However, one large Sumerian city-state remained independent throughout the period: Lagash, whose capital was Girsu (present-day Telloh, Iraq), on the Tigris River. Gudea, the ruler, built and restored many temples, in which he placed votive statues representing himself as governor and embodiment of just rule. The statues are made of diorite, a very hard imported stone. Perhaps the difficulty of carving diorite prompted sculptors to use compact, simplified forms for the portraits. Twenty of these figures survive, making Gudea's face a familiar one in ancient Near Eastern art.

Images of Gudea present him as a strong, peaceful, pious ruler worthy of divine favor (FIG. 2-15). Whether he is shown sitting or standing, he wears a long garment (which provides ample space for long cuneiform inscriptions). His right shoulder is bare, and he is barefooted. He wears a cap with a wide brim carved with a pattern to represent fleece. In one image, Gudea holds a vessel from which life-giving water flows in two streams, each filled with leaping fish. The text says that he dedicated himself, the statue, and its temple to the goddess Geshtinanna, the divine poet and interpreter of dreams. This imposing statue is only $2\frac{1}{2}$ feet tall. The sculptor emphasizes the power centers of the human body: the eyes, head, and smoothly muscled chest and arms. Gudea's face, below the sheepskin hat, is youthful and serene, and his eyes—oversized and wide open, the better to return the gaze of the deityexpress intense concentration.

Babylon: Hammurabi's Code

For more than 300 years, periods of political turmoil alternated with periods of stable government in Mesopotamia, until the Amorites (a Semitic-speaking people from the Syrian Desert, to the west) reunited the region under Hammurabi (ruled 1792–1750 BCE). Hammurabi's capital city was Babylon and his subjects were called Babylonians. Among Hammurabi's achievements was a written legal code that listed the laws of his realm and the penalties for breaking them (see "The Code of Hammurabi," page 38).

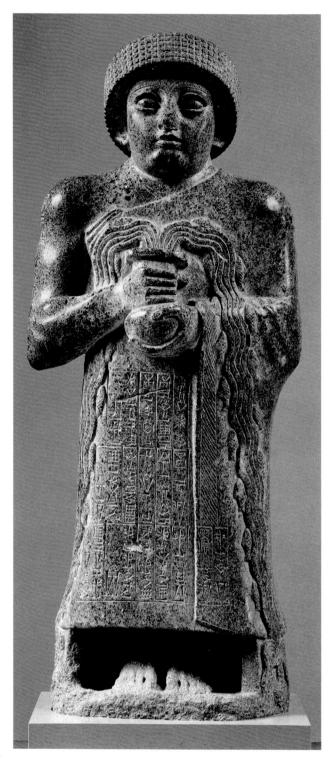

2–15 | VOTIVE STATUE OF GUDEA
Girsu (present-day Telloh, Iraq). c. 2090 BCE. Diorite,
height 29" (73.7 cm). Musée du Louvre, Paris.

THE HITTITES OF ANATOLIA

Outside of Mesopotamia, other cultures developed and flourished in the ancient Near East. Each had an impact on Mesopotamia. Finally one of them, Persia, overwhelmed them all, but the Hittites of Anatolia were among the most influential.

Anatolia (present-day Turkey) had been home to several independent cultures that resisted Mesopotamian domination.

THE OBJECT SPEAKS

THE CODE OF HAMMURABI

ne of Hammurabi's greatest accomplishments was the systematic codification of his people's rights, duties, and punishments for wrongdoing. This code was engraved on the Stele of Hammurabi, and this black diorite stele speaks to us both as a work of art that depicts a legendary event and as a historical document that records a conversation about justice between god and man.

At the top of the stele, we see Hammurabi standing before a mountain where Shamash, the sun god and god of justice, is seated. The mountain is indicated by three flat tiers on which Shamash rests his feet. Hammurabi, standing in an attitude of prayer, listens respectfully. Shamash sits on a backless throne, dressed in a long flounced robe and crowned by a conical horned cap. Rays rise from his shoulders, and he holds additional symbols of his powerthe measuring rod and the rope circle—as he gives the law to the king, his intermediary. From there, the laws themselves flow forth in horizontal bands of exquisitely engraved cuneiform signs. (The idea of god-given laws engraved on stone tablets is a long-standing tradition in the ancient Near East: Moses, the Lawgiver of Israel, received two stone tablets containing the Ten Commandments from God on Mount Sinai [Exodus 32:19].)

A prologue on the front of the stele lists the temples Hammurabi has restored, and an epilogue on the back glorifies him as a peacemaker, but most of the stele was clearly intended to publish the law guaranteeing uniform treatment of people throughout his kingdom. In the long cuneiform inscription, Hammurabi declared that with this code of law he intended "to cause justice to prevail in the land and to destroy the wicked and the evil, that the strong might not oppress the weak nor the weak the strong." Most of the 300 or so entries that follow deal with commercial and property matters. Only sixty-eight relate to domestic problems, and a mere twenty deal with physical assault.

Punishments are based on the wealth, class, and gender of the parties—the rights of the wealthy are favored over the poor, citizens over slaves, men over women. The death penalty is frequently decreed for crimes such as stealing from a temple or palace, helping a slave to escape, or insubordination in the army. Trial by water and fire could also be imposed, as when an adulterous woman and her lover were to be thrown into the water (those who did not drown were deemed innocent) or when a woman who committed incest with her son was to be burned (an incestuous man was only banished). Although some of the punishments may seem excessive today, we recognize that Hammurabi was breaking new ground in his attempt to create a society regulated by laws rather than the whims of rulers or officials.

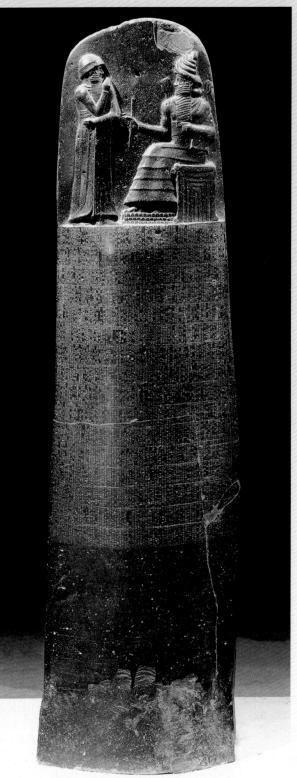

STELE OF HAMMURABI

Susa (present-day Shush, Iran). c. 1792–1750 BCE. Diorite, height of stele approx. 7' (2.13 m); height of relief 28" (71.1 cm). Musée du Louvre, Paris.

The most powerful of them was the Hittite civilization, whose founders had moved into the mountains and plateaus of central Anatolia from the east.

They established their capital at Hattusha (near present-day Boghazkoy, Turkey) about 1600 BCE. (The city was destroyed about 1200 BCE.) Through trade and conquest, the Hittites created an empire that stretched along the coast of the Mediterranean Sea in the area of present-day Syria and Lebanon, bringing them into conflict with the Egyptian Empire, which was expanding into the same region from the south (Chapter 3). They also made incursions into Mesopotamia.

The Hittites may have been the first people to work in iron, which they used for war chariot fittings, weapons, chisels, and hammers for sculptors and masons (see also Chapter 1, page 21). They are noted for the artistry of their fine metalwork and for their imposing palace citadels with double walls and fortified gateways. One of the most monumental of these sites consists of the foundations and base walls of the Hittite stronghold at Hattusha, which date to about 1400–1300 BCE. The lower walls were constructed of stone supplied from local quarries, and the upper walls, stairways, and walkways were finished in brick.

The blocks of stone used to frame doorways at Hattusha were decorated in high relief with a variety of guardian figures—some of them seven feet tall. Some were half-human—half-animal creatures; others were more naturalistically rendered animals like the lions at the Lion Gate (FIG. 2–16). Carved from the building stones, the lions seem

Sequencing Works of Art

с. 8000-7000 все	Early Neolithic—Walls and Towers of Jericho (in present-day Palestine).
с. 3300-2300 все	Sumerian—Votive figures from Eshunna (present-day Tell Asmar, Iraq).
с. 2300-2184 все	Akkadian-Stele of Naramsin.
с. 1400 все	Hittite —Lion Gate at Hattusha, Anatolia (near present-day Borghazkoy, Turkey).
с. 647 все	Assyrian—Assurbanipal and His Queen in the Garden from Nineveh (present-day Kuyunjik, Iraq).
с. 518–460 все	Persian —Apadana of Darius and Xerxes at Persepolis, Iran.

to emerge from the gigantic boulders that form the gate, unlike the later Assyrian guardians (SEE FIG. 2-1) who, while clearly part of the building, seem to stride or stand as independent creatures. The Hittite Lion Gate harmonizes with the colossal scale of the wall. Despite extreme weathering, the lions have endured over the millennia and still possess a sense of both vigor and permanence.

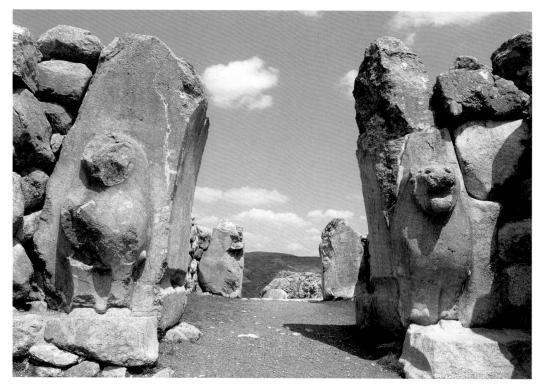

2–16 | LION GATE

Hattusha (near present-day Boghazkoy, Turkey). c. 1400 BCE. Limestone.

LATER MESOPOTAMIAN ART

Assyria

After centuries of struggle among Sumer, Akkad, and Lagash, in southern Mesopotamia, a people called the Assyrians rose to dominance in northern Mesopotamia. They began to extend their power by about 1400 BCE, and after about 1000 BCE started to conquer neighboring regions. By the end of the ninth century BCE, the Assyrians controlled most of Mesopotamia, and by the early seventh century they had extended their influence as far west as Egypt. Soon afterward they succumbed to internal weakness and external enemies, and by 600 BCE their empire had collapsed.

Assyrian rulers built huge palaces atop high platforms inside the different fortified cities that served at one time or another as Assyrian capitals. They decorated these palaces with scenes of battles, Assyrian victories with presentations of tribute to the king, combat between men and beasts, and religious imagery.

KALHU (NIMRUD). During his reign (883–859 BCE), Assurnasirpal II established his capital at Kalhu (present-day Nimrud, Iraq), on the east bank of the Tigris River, and undertook an ambitious building program. His architects fortified the city with mud-brick walls 5 miles long and 42 feet high, and his engineers constructed a canal that irrigated fields and provided water for the expanded population of the city. According to an inscription commemorating the event, Assurnasirpal gave a banquet for 69,574 people to celebrate the dedication of the new capital in 863 BCE.

Most of the buildings in Nimrud were made from mud bricks, but limestone and alabaster—more impressive and durable—were used to veneer walls for architectural decorations. Colossal guardian figures, lamassus, flanked the major portals (SEE FIG. 2-1), and panels covered the walls with scenes

carved in low relief of the king participating in religious rituals, war campaigns, and hunting expeditions.

THE LION HUNT. In a vivid lion-hunting scene (FIG. 2–17), Assurnasirpal II stands in a chariot pulled by galloping horses and draws his bow against an attacking lion that already has four arrows protruding from its body. Another beast, pierced by arrows, lies on the ground. This was probably a ceremonial hunt, in which the king, protected by men with swords and shields, rode back and forth killing animals as they were released one by one into an enclosed area. The immediacy of this image marks a shift in Mesopotamian art away from a sense of timelessness and toward visual narrative.

Dur Sharrukin (Khorsabad). Sargon II (ruled 721–706 BCE) built a new Assyrian capital (FIG. 2–18) at Dur Sharrukin (present-day Khorsabad, Iraq). On the northwest side of the capital, a walled citadel, or fortress, containing several palaces and temples, straddled the city wall. Sargon's palace complex (the group of buildings where the ruler governed and resided) at the rear of the citadel on a raised, fortified platform about 40 feet high, demonstrates the use of art as propaganda to support political power.

Guarded by two towers, it was accessible only by a wide ramp leading up from an open square, around which the residences of important government and religious officials were clustered. Beyond the ramp was the main courtyard, with service buildings on the right and temples on the left. The heart of the palace, protected by a reinforced wall with only two small, off-center doors, lay past the main courtyard. Within the inner compound was a second courtyard lined with narrative relief panels showing tribute bearers that functioned as an audience hall. Visitors would have entered the king's throne room from this courtyard through a stone gate flanked by colossal guardian figures even larger than those at Assurnasirpal (SEE FIG. 2–1).

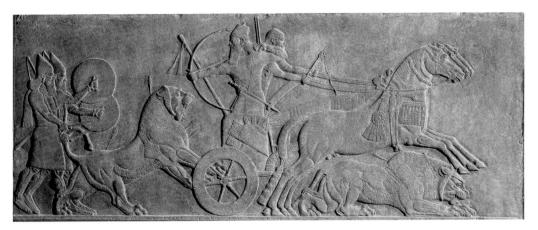

2–17 | ASSURNASIRPAL II KILLING LIONS
Palace complex of Assurnasirpal II, Kalhu (present-day Nimrud, Iraq). c. 850 BCE. Alabaster, height approx. 39" (99.1 cm). The British Museum, London.

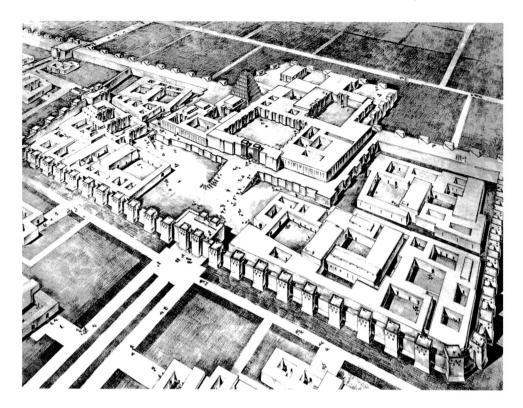

2–18 | RECONSTRUCTION DRAWING OF THE CITADEL AND PALACE COMPLEX OF SARGON II

Dur Sharrukin (present-day Khorsabad, Iraq). c. 721-706 BCE. Courtesy the Oriental Institute of the University of Chicago.

The ziggurat at Dur Sharrukin towered in an open space between the temple complex and the palace, declaring the might of Assyria's kings and symbolizing their claim to empire. It probably had seven levels, each about 18 feet high and painted a different color. The four levels still remaining were once white, black, blue, and red. Instead of separate flights of stairs between the levels, a single, squared-off spiral ramp rose continuously along the exterior from the base.

NINEVEH (KUYUNJIK). Assurbanipal (ruled 669–c. 627 BCE), king of the Assyrians three generations after Sargon II, maintained his capital at Nineveh (present-day Kuyunjik, Iraq).

His palace was decorated with alabaster panels carved with pictorial narratives in low relief. Most show the king and his subjects in battle and hunting, but there are occasional scenes of palace life. An unusually peaceful scene shows the king and queen in a pleasure garden (FIG. 2—19). The king reclines on a couch, and the queen sits in a chair at his feet. Servants arrive with trays of food, while others wave whisks to protect the royal couple from insects.

This apparently tranquil domestic scene is actually a victory celebration. The king's weapons (sword, bow, and quiver of arrows) are on the table behind him, and the severed head of his vanquished enemy hangs upside down from a tree at the far left.

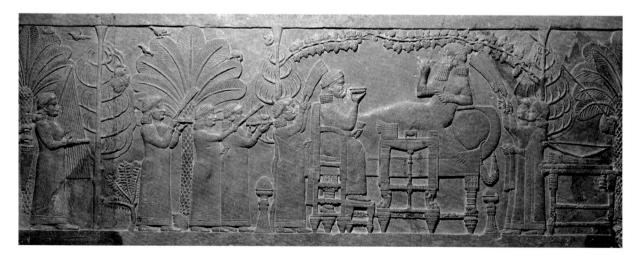

2–19 | ASSURBANIPAL AND HIS QUEEN IN THE GARDEN
The Palace at Nineveh (present-day Kuyunjik, Iraq). c. 647 BCE. Alabaster, height approx. 21"
(53.3 cm). The British Museum, London.

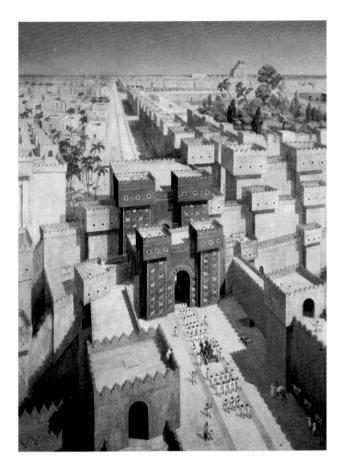

2-20 | RECONSTRUCTION DRAWING OF BABYLON IN THE 6TH CENTURY BCE

Courtesy the Oriental Institute of the University of Chicago.

The palace of Nebuchadnezzar II, with its famous Hanging Gardens, can be seen just behind and to the right of the Ishtar Gate, west of the Processional Way. The Marduk Ziggurat looms in the far distance on the east bank of the Euphrates.

Neo-Babylonia

At the end of the seventh century BCE, the Medes, a people from western Iran, allied with the Babylonians and the Scythians, a nomadic people from northern Asia (present-day Russia and Ukraine) invaded Assyria. In 612 BCE, this army captured Nineveh. When the dust settled, Assyria was no more and the Neo-Babylonians controlled a region that stretched from modern Turkey to northern Arabia and from Mesopotamia to the Mediterranean Sea.

NEBUCHADNEZZAR. The most famous Neo-Babylonian ruler was Nebuchadnezzar II (ruled 605–562 BCE), notorious today for his suppression of the Jews, as recorded in the Hebrew (Old Testament) Book of Daniel, where he may have been confused with the final Neo-Babylonian ruler, Nabonidus. A great patron of architecture, he built temples dedicated to the Babylonian gods throughout his realm and transformed Babylon—the cultural, political, and economic

hub of his empire—into one of the most splendid cities of its day. Babylon straddled the Euphrates River, its two sections joined by a bridge.

The older, eastern sector was traversed by the Processional Way, the route taken by religious processions honoring the city's patron god, Marduk (FIG. 2–20). This street, paved with large stone slabs set in a bed of bitumen, was up to 66 feet wide at some points. It ran from the Euphrates bridge, through the temple district and palaces, and finally through the Ishtar Gate, the ceremonial entrance to the city. Beyond the Ishtar Gate, walls on either side of the route were faced with dark blue glazed bricks. The glazed bricks consisted of a film of colored glass placed over the surface of the bricks and fired, a process used since about 1600 BCE. Against that blue background, specially molded turquoise, blue, and gold-colored bricks formed images of striding lions, symbols of the goddess Ishtar.

THE ISHTAR GATE. The double-arched Ishtar Gate, a symbol of Babylonian power, was guarded by four crenellated towers. (Crenellations are notched walls—the notches are called *crenels*—built as a part of military defenses.) It is decorated with tiers of *mushhushshu* (horned dragons with the head and body of a snake, the forelegs of a lion, and the hind legs of a bird of prey) that were sacred to Marduk, and with bulls with blue horns and tails that were associated with Adad, the storm god.

Now reconstructed inside a Berlin Museum, the Ishtar Gate is installed next to a panel from the throne room in Nebuchadnezzar's nearby palace (FIG. 2–21). In the fragment seen here, lions walk beneath stylized palm trees. Among Babylon's other marvels—none of which have survived—were its fabled terraced and irrigated Hanging Gardens (one of the so-called Seven Wonders of the World), and the Marduk Ziggurat. All that remains of this ziggurat, which ancient documents describe as painted white, black, crimson, blue, orange, silver, and gold, is the outline of its base and traces of the lower stairs.

PERSIA

In the sixth century BCE, the Persians, a formerly nomadic, Indo-European—speaking people, began to seize power in Mesopotamia. From the region of Parsa, or Persis (present-day Fars, Iran), they eventually overwhelmed all of the ancient Near East and established a vast empire. The rulers of this new empire traced their ancestry to a semilegendary Persian king named Achaemenes, and consequently they are known as the Achaemenids.

Empire

The dramatic expansion of the Achaemenids began in 559 BCE with the ascension of a remarkable leader, Cyrus II the Great

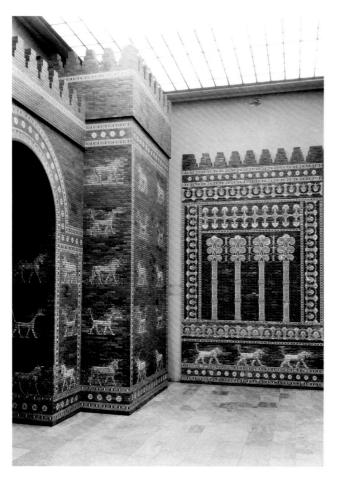

2–21 | ISHTAR GATE AND THRONE ROOM WALL
Reconstructed in a Berlin museum, originally from Babylon
(present-day Iraq) c. 575 BCE. Glazed brick, height of gate
originally 40 feet (12.2 m) with towers rising 100 feet
(30.5 m). Vorderasiatisches Museum, Staatliche Museen zu
Berlin, Preussischer Kulturbesitz.

(ruled 559–530 BCE). By the time of his death, the Persian Empire included Babylonia, Media (which stretched across present-day northern Iran through Anatolia), and some of the Aegean islands far to the west. Only the Greeks stood fastagainst them (see Chapter 5). When Darius I (ruled 521–486 BCE) took the throne, he could proclaim: "I am Darius, great King, King of Kings, King of countries, King of this earth."

An able administrator, Darius organized the Persian lands into twenty tribute-paying areas under Persian governors. He often left local rulers in place beneath the governors. This practice, along with a tolerance for diverse native customs and religions, won the Persians the loyalty of many of their subjects. Darius also developed a system of fair taxation, issued a standardized currency (SEE FIG. 2-25), and improved communication throughout the empire. Like many powerful rulers, Darius created palaces and citadels as visible symbols of his authority. He made Susa his first capital and commissioned a 32-acre administrative compound to be built there.

Persepolis

In about 515 BCE, Darius began construction of Parsa, a new capital in the Persian homeland in the Zagros highlands. Today this city, known as Persepolis, the name the Greeks gave it, is one of the best-preserved and most impressive ancient sites in the Near East (FIG. 2–22). Darius imported materials, workers, and artists from all over his empire for his building projects. He even ordered work to be executed in Egypt and transported to his capital. The result was a new style of art that combined many different cultural traditions, including Persian, Mede, Mesopotamian, Egyptian, and Greek.

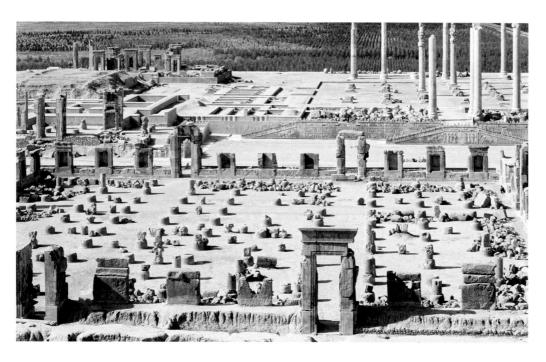

2–22 | AIR VIEW OF THE CEREMONIAL COMPLEX, PERSEPOLIS Iran. 518–c. 460 BCE.

Technique

TEXTILES

extiles are usually a woman's art although men, as shepherds and farmers, often produced the raw materials (wool, flax, and other fibers). And as traveling merchants, men sold or bartered the extra fabrics not needed by the family. Early Assyrian cuneiform tablets preserve correspondence between merchants traveling by caravan and their wives. These astute business women ran the production end of the business back home and often complained to their husbands about late payments and changed orders. The woman shown spinning in the fragment from Susa is important-looking, wearing an elegant hairstyle, many ornaments, and a garment with a patterned border. She sits barefoot and cross-legged on a lionfooted stool covered with sheepskin, spinning thread with a large spindle. A servant stands behind the woman, fanning her, while a fish and six round objects (perhaps fruit) lie on an offering stand in front of her.

WOMAN SPINNINGSusa (present-day Shush, Iran). c. 8th–7th century BCE. Bitumen compound, $3\% \times 5\%''$ (9.2 \times 13 cm). Musée du Louvre, Paris.

The production of textiles is complex. First, fibers gathered from plants (such as flax for linen cloth or hemp for rope) or from animals (wool from sheep, goats, and camels or hair from humans and horses) are cleaned, combed, and sorted. Only then can the fibers be twisted and drawn out under tension—that is, spun—into the long, strong, flexible thread needed for textiles. Spinning tools include a long, sticklike spindle to gather the spun fibers, a whorl (weight) to help rotate the spindle, and a distaff (a word still used to describe women and their work) to hold the raw materials. Because textiles are fragile and decompose rapidly, the indestructible stone or fired-clay spindle whorls are usually the only surviving evidence of thread making.

Weaving is done on a loom. Warp threads are laid out at right angles to weft threads, which are passed over and under the warp. In the earliest vertical looms, warp threads hung from a beam, their tension created either by wrapping them around a lower beam (a tapestry loom) or by tying them to heavy stones. Although weaving was usually a home industry, in palaces and temples slave women staffed large shops, and specialized as spinners, warpers, weavers, and finishers.

Early fiber artists depended on the natural colors of their materials and on natural dyes from the earth (ochers), plants (madder for red, woad and indigo for blue, safflower and saffron crocus for yellow), and animals (royal purple—known as Tyrian purple after the city of its origin—from marine mollusks). They combined color and techniques to create a great variety of fiber arts: Egyptians seem to have preferred white linen, elaborately folded and pleated, for their garments. The Minoans of Crete created multicolored patterned fabrics with fancy borders. Greeks excelled in the art of pictorial tapestries. The people of the ancient Near East used woven and dyed patterns and also developed knotted pile (the so-called Persian carpet) and felt (a cloth made of fibers bound by heat and pressure, not by spinning, weaving, or knitting).

In Assyrian fashion, the imperial complex at Persepolis was set on a raised platform and laid out on a rectangular **grid**, or system of crossed lines. The platform was 40 feet high and measured 1,500 by 900 feet. It was accessible only from a single approach made of wide, shallow steps that allowed horsemen to ride up on horseback. Darius lived to see the completion of a treasury, the Apadana (audience hall), and a very small palace for himself on the platform. The Apadana, set above the rest of the complex on a second terrace (FIG. 2–23), had open porches on three sides and a square hall large enough to hold several thousand people. Darius's son Xerxes I (ruled 485–465 BCE) added a sprawling palace complex for himself, enlarged the treasury building, and began a vast new public reception space, the Hall of 100 Columns.

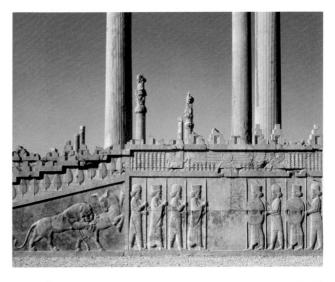

2–23 | APADANA (AUDIENCE HALL) OF DARIUS AND XERXES Ceremonial Complex, Persepolis Iran. 518–c. 460 BCE.

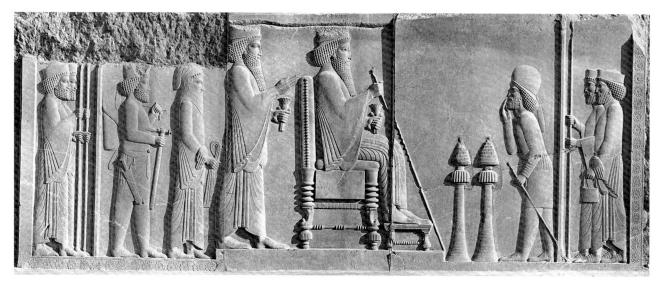

2–24 | **DARIUS AND XERXES RECEIVING TRIBUTE**Detail of a relief from the stairway leading to the Apadana (ceremonial complex), Persepolis, Iran. 491–486 BCE. Limestone, height 8'4" (2.54 m). Courtesy the Oriental Institute of the University of Chicago.

Persian sculpture emphasizes the extent of the empire and its economic prosperity under Persian rule. The central stair of Darius's Apadana displays reliefs of animal combat, tiered ranks of royal guards (the "10,000 Immortals"), and delegations of tribute bearers. Here, lions attack bulls at each side of the Persian generals. These animal combats (a theme found throughout the Near East) emphasize the ferocity of the leaders and their men. Ranks of warriors cover the walls with repeated patterns and seem ready to defend the palace. The elegant drawing, balanced composition, and sleek modeling of figures reflect the Persians' knowledge of Greek art and perhaps the use of Greek artists. Other reliefs throughout Persepolis depict displays of allegiance or economic prosperity. In one example, once the centerpiece, Darius holds an audience while his son and heir, Xerxes, listens from behind the throne (FIG. 2-24). Such panels would have looked quite different when they were freshly painted in rich tones of deep blue, scarlet, green, purple, and turquoise, with metal objects such as Darius's crown and necklace covered in gold leaf (sheets of hammered gold).

Persian Coinage

The Persians' decorative arts—including ornamented weapons, domestic wares, horse trappings, and jewelry—demonstrate high levels of technical and artistic sophistication. The Persians also created a refined coinage, with miniature low-relief portraits of rulers, so that coins, in addition to their function as economic standards, served as propaganda. Persians had learned to mint standard coinage from the Lydi-

ans of western Anatolia after Cyrus the Great defeated Lydia's fabulously wealthy King Croesus in 546 BCE (see "Coining Money," page 46). Croesus's wealth—the source of the lasting expression "rich as Croesus"—had made Lydia an attractive target for an aggressive empire builder like Cyrus.

A Persian coin, the gold daric, named for Darius and first minted during his regime (FIG. 2–25), is among the most valuable coins in the world today. Commonly called an "archer," it shows the well-armed emperor wearing his crown and carrying a lance in his right hand. He lunges forward as if he had just let fly an arrow from his bow.

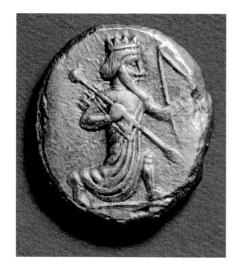

2–25 | DARIC
A coin first minted under Darius I of Persia. 4th century BCE.
Gold. Heberden Coin Room, Ashmolean Museum, Oxford.

Technique

COINING MONEY

ncient people had long used gold, silver, bronze, and copper as mediums of exchange, but each piece had to be weighed to establish its exact value. In the seventh century BCE, the Lydians of western Anatolia began to produce metal coins in standard weights, adapting the seal—a Sumerian invention—to designate their value. Until about 525 BCE, coins bore an image on one side only. The beautiful early coin shown here, minted during the reign of the Lydian king Croesus (ruled 560–546 BCE), is stamped with the heads and forelegs of a bull and a lion in low relief. The reverse has only a squarish depression left by the punch used to force the metal into the mold.

To make two-faced coins, the ancients used a punch and anvil, each of which held a die, or mold, with the design to be impressed in the coin. A metal blank weighing the exact amount of the denomination was placed over the anvil die, containing the design for the "head" (obverse) of the coin. The punch, with the die of the "tail" (reverse) design, was placed on top of the metal blank and struck with a mallet. Beginning in the reign of Darius I, representations of kings appeared on coins, proclaiming the ruler's control of the coin of the realm—a custom that has continued throughout the world in coins. Because we often know approximately when ancient monarchs ruled, coins discovered in an archaeological excavation help to date the objects around them.

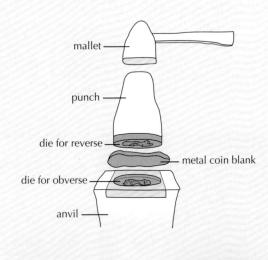

FRONT AND BACK OF A GOLD COIN

First minted under Croesus, king of Lydia. 560-546 BCE. Heberden Coin Room, Ashmolean Museum, Oxford.

At its height, the Persian Empire extended from Africa to India. From the Persians' spectacular capital, Darius in 490 BCE and Xerxes in 480 BCE sent their armies west to conquer Greece. Mainland Greeks successfully resisted the armies of the Achaemenids, however, preventing them from advancing into Europe (Chapter 5). And it was a Greek who ultimately put an end to their empire. In 334 BCE, Alexander the Great of Macedonia (d. 323) crossed into Anatolia and swept through Mesopotamia, defeating Darius III and nearly laying waste the magnificent Persepolis in 330. Although the Achaemenid Empire was at an end, Persia eventually revived and the Persian style in art continued to influence Greek artists (Chapter 5) and ultimately Islamic art (Chapter 8).

IN PERSPECTIVE

In the ancient Near East, people developed systems of recordkeeping and written communication. Thousands of clay tablets covered with <u>cuneiform</u> writing document the gradual evolution of writing in Mesopotamia, as well as an organized system of justice and the world's first epic literature. We know a great deal about this ancient society—both from its records and from modern archaeological exploration and excavation. In <u>Sumer</u>, Akkad, Lagash, and Babylonia, agriculture, including the control of the rivers, was improved. Increased food production then made urban life possible. Population density gave rise to the development of specialized skills. Social hierarchies evolved. Priests communicated with the gods; rulers led and governed; warriors defended the greater community and its fields and villages; and artisans and farmers supplied basic material needs.

Art itself became a means of communication. A distinctive architecture arose as people built colorful stepped ziggurats. Sculptors represented these people as compact cylindrical figures animated only by wide staring eyes. By the ninth century, the Assyrians in northern Mesopotamia had built enormous city palaces and fortresses and placed guardian figures at the gates. The walls of corridors and courtyards were covered with low-relief sculptured narratives that told in vivid detail of the Assyrians' daring exploits in nearly constant warfare. Later, Babylon in the south became a luxurious city, whose hanging gardens were considered one of the wonders of the ancient world, and whose temples and ziggurats, palaces and ceremonial avenues, were lined with brilliantly colored images made of glazed bricks.

Finally, the Achaemenid Persians formed a spectacularly rich and powerful empire. Kings Darius and Xerxes built a huge palace at Persepolis (in present-day Iran) where sculptures extolled their wealth and power. Rulers in western Anatolia (present-day Turkey) invented coinage. These lumps of precious metal, stamped with portraits of rulers and symbols of cities or territories, are in fact miniature works of art.

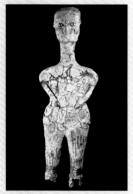

HUMAN FIGURE, AIN GHIZAL C. 7000-6000 BCE

ART OF THE ANCIENT NEAR EAST

- Paleolithic-Neolithic Overlap c. 9000-4000 BCE
- Growth of Jericho
 c. 8000-7500 BCE
- Earliest Pottery c. 7000 BCE
- Neolithic 6500-1200 BCE

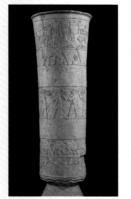

URUK VASE C. 3300–3000 BCE

- **Sumer** c. 3500-2340 BCE
- Potter's Wheel in Use c. 3250 BCE
- Invention of Writing c. 3100 BCE

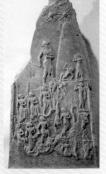

STELE OF NARAM-SIN
C. 2220-2184 BCE

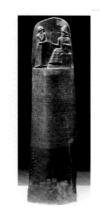

STELE OF HAMMURABI C. 1792–1750 BCE

- **Akkad** c. 2340-2180 BCE
 - Lagash c. 2150 BCE
 - Babylonia, Mari, Hammurabi Ruled c. 1792–1750 BCE
 - Hittite (Anatolia) c. 1600–1200 BCE

- Assyrian Empire c. 1000-612 BCE
- Neo-Babylonia c. 612-539 BCE
- Persia c. 559-331 BCE

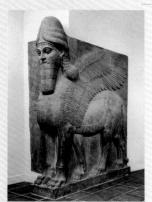

ASSYRIAN GUARDIAN FIGURE C. 883–859 BCE

DARIUS AND XERXES
RECEIVING TRIBUTE
491-486 BCE

300 BCE

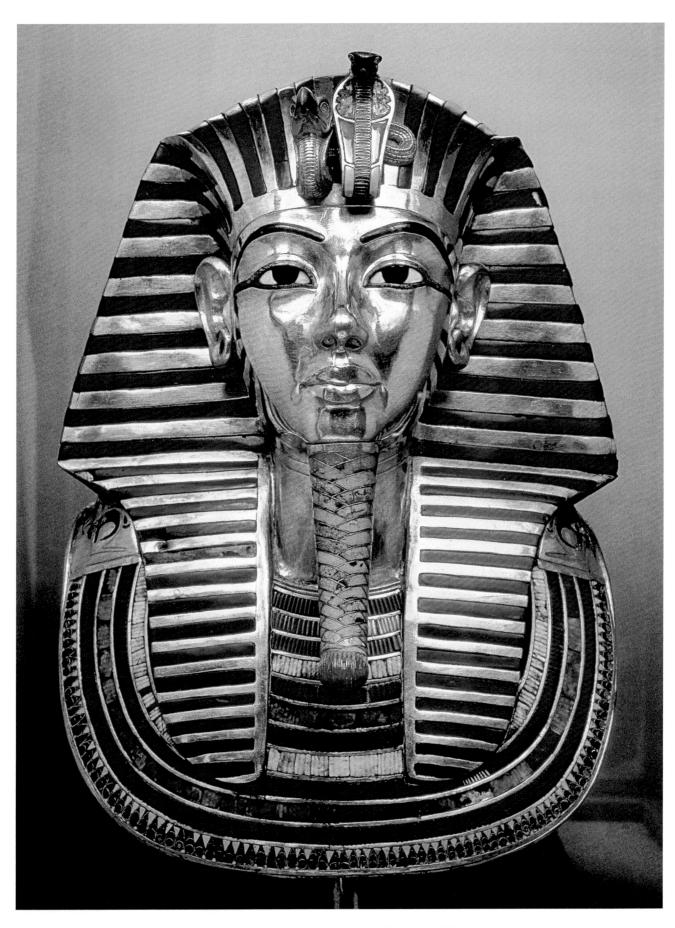

3–I | **FUNERARY MASK OF TUTANKHAMUN** Eighteenth Dynasty (Tutankhamun, ruled 1332–1322 BCE), c. 1327 BCE. Gold inlaid with glass and semiprecious stones. Height 21¼" (54.5 cm). Weight 24 pounds (11 kg). Egyptian Museum, Cairo.

CHAPTER THREE

ART OF ANCIENT EGYPT

On February 16, 1923, the *Times* of London cabled the *New York Times* with dramatic news of a discovery: "This has been, perhaps, the most extraordinary day in the whole history of Egyptian excavation. Whatever one may have

guessed or imagined of the secret of Tut-ankh-Amen's tomb, they [sic] surely cannot have dreamed the truth as now revealed. The entrance today was made into the sealed chamber of the tomb... and yet another door opened beyond that. No eyes have seen the King, but to practical certainty we know that he lies there close at hand in all his original state, undisturbed." And indeed he did. A collar of dried flowers and beads covered the chest, and a linen scarf was draped around the head. A gold funerary mask (FIG. 3–1) had been placed over the head and shoulders of his mummified body, which was enclosed in three nested coffins, the innermost made of gold (SEE FIG. 3–33, and page 75). The coffins were placed in a yellow quartzite box that was itself encased within gilt wooden shrines nested inside one another.

The discoverer of this treasure, the English archaeologist Howard Carter, had worked in Egypt for more than twenty years before he undertook a last expedition, sponsored by the wealthy British amateur Egyptologist Lord Carnarvon, after World War I. Carter, a former chief inspector of Upper Egypt and draftsman for the Egypt Exploration Fund, had a detailed knowledge of the area to be excavated. He was convinced that the tomb of Tutankhamun, the only Eighteenth Dynasty royal burial place then still unidentified,

lay still hidden in the Valley of the Kings. After fifteen years of digging, on November 4, 1922, Carter unearthed the entrance to Tutankhamun's tomb. His workers cleared the way to the antechamber, which was found to contain

unbelievable treasures: jewelry, textiles, gold-covered furniture, a carved and inlaid throne, four gold chariots. In February 1923, they pierced the wall separating the anteroom from the actual burial chamber. Tutankhamun's tomb had been entered, resealed, and hidden, but the burial chamber had not been disturbed.

Since ancient times, tombs have tempted looters; more recently, they also have attracted archaeologists and historians. The first large-scale "archaeological" expedition in history landed in Egypt with the armies of Napoleon in 1798. The French commander, who went to investigate digging a canal between the Mediterranean and Red seas, must have realized that he might find great riches there, for he took with him some 200 French scholars to study ancient sites. The military adventure ended in failure, but the scholars eventually published thirty-six richly illustrated volumes of their findings, unleashing a craze for all things Egyptian that has not dimmed since.

In 1976, the first blockbuster museum exhibition was born when treasures from the tomb of Tutankhamun began a tour of the United States and attracted over 8 million visitors. Major archaeological finds still make newspaper headlines around the world. In 1987, Kent R. Weeks reopened a huge burial complex in the Valley of the Kings. Excavations beginning in 1995 revealed the tomb of Rameses II's fifty-two sons. In September 2000, Egyptian archaeologists again made the front pages when they announced the spectacular discovery of more than a hundred mummies—some from about 500 BCE and most from the time of the Roman occupation of Egypt—in a huge burial site called the Valley of the Golden Mummies, about 230 miles southwest of Cairo. The director of excavations for the government of Egypt, Dr. Zahi Hawass, believes that as many as 10,000 mummies will eventually come to light from the Valley. Meanwhile, in 2006, Dr. Hawass announced the discovery of a tomb containing five sarcophagi in the Valley of the Kings, the first tomb to be found there since Tutankhamun's in 1922.

CHAPTER-AT-A-GLANCE

- **THE GIFT OF THE NILE**
- EARLY DYNASTIC EGYPT | Manetho's List | Religion and the State | Artistic Conventions | Funerary Architecture
- THE OLD KINGDOM, c. 2575–2150 BCE | Architecture: The Pyramids at Giza | Sculpture | Tomb Decoration
- THE MIDDLE KINGDOM, c. 1975-c. 1640 BCE | Sculpture: Royal Portraits | Tomb Architecture and Funerary Objects | Town Planning
- THE NEW KINGDOM, c. 1539–1075 BCE | The Great Temple Complexes | The Valley of the Kings and Queens | Akhenaten and the Art of the Amarna Period | The Return to Tradition: Tutankhamun and Rameses II | The Books of the Dead
- **LATE EGYPTIAN ART, c. 715–332 BCE**
- **IN PERSPECTIVE**

THE GIFT OF THE NILE

The Greek traveler and historian Herodotus, writing in the fifth century BCE, remarked: "Egypt is the gift of the Nile." This great river, the longest in the world, winds northward from equatorial Africa and flows through Egypt in a relatively straight line to the Mediterranean (MAP 3–1). There it forms a broad delta before emptying into the sea. Before it was dammed in 1970 by the Aswan High Dam, the lower (northern) Nile, swollen with the runoff of heavy seasonal rains in the south, overflowed its banks for several months each year. Every time the floodwaters receded, they left behind a new layer of rich silt, making the valley and delta a fertile and attractive habitat.

By about 8000 BCE, the valley's inhabitants had become relatively sedentary, living off the abundant fish, game, and wild plants. Not until about 5000 BCE did they adopt the agricultural village life associated with Neolithic culture (see Chapter 1). At that time, the climate of North Africa grew increasingly dry. To ensure adequate resources for agriculture, the farmers along the Nile cooperated to control the river's flow. As in Mesopotamia (see Chapter 2), this common challenge led riverside settlements to form alliances. Over time, these rudimentary federations expanded by conquering and absorbing weaker communities. By about 3500 BCE, there were several larger states, or chiefdoms, in the lower Nile Valley.

The Predynastic period, from roughly 5000 to 2950 BCE, was a time of significant social and political transition that

preceded the unification of Egypt under a single ruler. (Egyptian history is divided into dynasties—periods in which members of the same family inherited Egypt's throne.) According to later legend, the earliest Kings of Egypt were gods who ruled on earth. By the last centuries of the Predynastic period, after about 3500 BCE, a centralized form of leadership had emerged in which the rulers were considered to be divine. Their subjects expected their leaders to protect them not only from outside aggression, but also from natural catastrophes such as droughts and insect plagues.

The surviving art of the Predynastic period consists chiefly of ceramic figurines, decorated pottery, and reliefs carved on stone plaques and pieces of ivory. A few examples of Predynastic wall painting—lively scenes filled with small figures of people and animals—were found in a tomb at Hierakonpolis, in Upper Egypt, a Predynastic town of mudbrick houses that was once home to as many as 10,000 people.

We begin our discussion with the art of the early dynastic period, from c. 2950 to c. 2575 BCE, and with Manetho's list, the chronology of Egypt's rulers.

EARLY DYNASTIC EGYPT

Sometime about 3000 BCE, Egypt became a consolidated state. According to legend, the country had previously evolved into two major kingdoms—the Two Lands—Upper

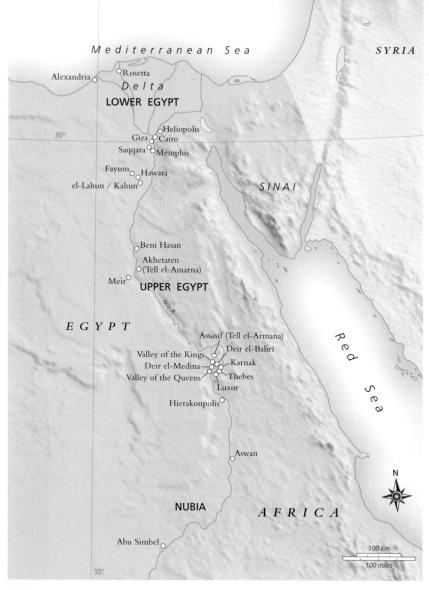

MAP 3-I ANCIENT EGYPT

Upper (southern) Egypt and Lower (northern) Egypt were united about 3100 BCE.

Egypt in the south (upstream on the Nile) and Lower Egypt in the north. But then a powerful ruler from Upper Egypt, referred to in an ancient document as "Menes king-Menes god," finally conquered Lower Egypt.

Manetho's List

In the third century BCE, an Egyptian priest and historian named Manetho used temple records to compile a chronological list of Egypt's rulers since ancient times. He grouped the kings into dynasties and included the length of each king's reign. Although scholars do not agree on all the dates, his chronology is still the accepted guide to ancient Egypt's long history. Manetho listed thirty dynasties that ruled the country between about 3000 and 332 BCE, when Egypt was conquered by Alexander the Great of Macedonia and the Greeks. Egyptologists have grouped these dynasties into larger periods reflecting broad historical developments. The dating system used in this book is that followed by the *Atlas of Ancient Egypt*.

Religion and the State

The Greek historian Herodotus thought the Egyptians the most religious people he had ever encountered. Religious beliefs permeate Egyptian art of all periods. Many of the earliest and most important deities in Egypt's pantheon are introduced in its creation myths.

CREATION MYTHS. One version of the creation myth relates that the sun god Ra—or Ra-Atum—shaped himself out of the waters of chaos, or unformed matter, and emerged sealed atop a mound of sand hardened by his own rays. By spitting—or ejaculating—he then created the gods of wetness and dryness, Tefnut and Shu, who in turn begat the male Geb (earth) and the female Nut (sky). Geb and Nut produced two sons, Osiris and Seth, and two daughters, the goddesses Isis and Nephthys.

Taking Isis as his wife, Osiris became king of Egypt. His envious brother, Seth, promptly killed Osiris, hacked his body to pieces, and snatched the throne for himself. Isis and her sister, Nephthys, gathered up the scattered remains of Osiris

Art and Its Context

EGYPTIAN SYMBOLS

our crowns symbolize kingship: the tall clublike white crown of Upper Egypt (sometimes adorned with two plumes); the flat red cap with rising spiral of Lower Egypt; the double crown representing unified Egypt; and, in the New Kingdom, the blue oval crown, which evolved from a helmet.

A striped gold and blue linen head cloth, known as the nemes headdress, having the cobra and vulture at the center front, was commonly used as a royal headdress. The cobra goddess, Meretseger of Lower Egypt ("she who rears up"), was equated with the sun and with royalty and was often included in headdresses. The queen's crown included the feathered skin of the vulture goddess Nekhbet of Upper Egypt.

The god Horus, king of the earth and a force for good, is represented as a falcon or falcon-headed man. His eyes symbolize the sun and moon; the solar eye is called the *wedjat*. The looped cross, called the **ankh**, is symbolic of everlasting life. The **scarab beetle** (*khepri*, meaning "he who created himself") was associated with creation, resurrection, and the rising sun.

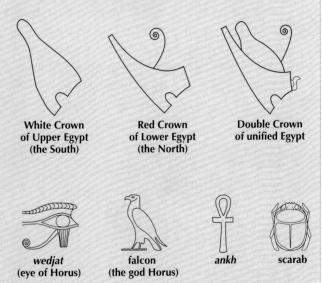

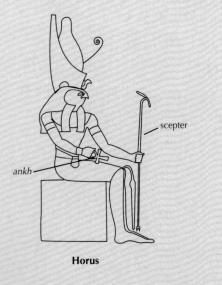

and, with the help of the god Anubis (represented by a jackal), they patched him back together. Despite her husband's mutilated condition, Isis conceived a son—Horus, another power for good, capable of guarding the interests of Egypt. Horus defeated Seth and became king of the earth, while Osiris retired to the underworld as overseer of the realm of the dead (SEE FIG. 3–35).

The myths give different explanations of the creation of human beings. In one, Ra lost an eye but, unperturbed, replaced it with a new one. When the old eye was found, it began to cry, angered that it was no longer of any use. Ra created human beings from its tears. In another myth, the god Khnum created humankind on his potter's wheel.

THE GOD-KINGS. By the Early Dynastic period (2950–2575 BCE), Egypt's kings were revered as gods in human form. A royal jubilee, the *heb sed* or *sed* festival, held in the thirtieth year of the living king's reign, renewed and reaffirmed his power. Kings rejoined their father the sun god Ra at death and rode with him in the solar boat as it made its daily journey across the sky.

To please the gods and ensure their continuing goodwill toward the state, the kings built splendid temples and provided priests to maintain them. The priests saw to it that statues of the gods, placed deep in the innermost rooms of the temples, were never without fresh food and clothing. The many gods and goddesses were depicted in various forms, some as human beings, others as animals, and still others as humans with animal heads. Osiris, for example, regularly appears in human form wrapped in linen as a mummy. His sister-wife, Isis, has a human form, but their son, the sky god Horus, is often depicted as a falcon or falcon-headed man (see "Egyptian Symbols," left).

By the New Kingdom (c. 1539–1075 BCE), Amun (chief god of Thebes, represented as blue and wearing a plumed crown), Ra (of Heliopolis), and Ptah (of Memphis) had become the primary national gods. Other gods and their manifestations included Hathor (cow), goddess of love and fertility; Thoth (ibis), god of writing, science, and law; Maat (feather), god of truth, order, and justice; Anubis (jackal), god of embalming and cemeteries; and Bastet (cat), daughter of Ra.

Egyptian religious beliefs reflect an ordered cosmos. The movements of heavenly bodies, the workings of gods, and the humblest of human activities all were thought to be part of a balanced and harmonious grand design. Death was to be feared only by those who lived in such a way as to disrupt that harmony: Upright souls could be confident that their spirits would live on eternally.

Artistic Conventions

Conventions in art are the customary ways of representing people and the world, generally accepted by artists and patrons. Egyptian artists followed certain well-established conventions: Images are based on memory images and characteristic viewpoints; mathematical formulas determine proportions; importance determines size (hieratic scale); space is represented in horizontal registers; drawing and contours are simplified; and colors are clear and flat. The conventions that govern Egyptian art appear early and continue to be followed, with subtle variations, through its long history.

THE NARMER PALETTE. Being one of the most historically and artistically significant works of ancient Egyptian art, the NARMER PALETTE (FIG. 3–2) was created at the dawn of its history. It is commonly interpreted to announce the unification of Egypt and the beginning of the country's growth as a powerful nation-state. It also exhibits many visual conventions that characterize the art of Egyptian civilization from this point on.

The first king, named Narmer, who may be Menes, is known from this ceremonial palette of green schist found at Hierakonpolis. The ruler's name appears in an early form of hieroglyphic writing at the center top of both sides within a small square representing a palace façade—a horizontal fish (nar) above a vertical chisel (mer). Narmer and his palace are protected by Hathor, depicted as a human face with cow ears and horns and shown on each side of his name.

Palettes, flat stones with a circular depression on one side, were used for grinding eye paint. (Both men and women

Sequencing Events KEY EGYPTIAN PERIODS

c. 5000–2950 BCE Predynastic Period c. 2950–2575 BCE Early Dynastic Period

c. 2575-2150 BCE Old Kingdom

c. 2125-1975 BCE First Intermediate Period

c. 1975-c. 1640 BCE Middle Kingdom

c. 1630-1520 BCE Second Intermediate Period

c. 1630-1520 BCE New Kingdom
c. 715-332 BCE Late Period

painted their eyelids to help prevent infections in the eyes and to reduce the glare of the sun.) The *Narmer Palette*, carved in low relief on both sides, is much larger than most. It was found in the temple of Horus, so it may have had a ceremonial function or been a votive offering.

Narmer dominates the scenes on the palette: Images of conquest proclaim him to be the great unifier, protector, and leader of the Egyptian people. Hieratic scale signals the status of individuals and groups in this highly stratified society; so, as in the *Stele of Naram-Sin* (SEE FIG. 2–14), the ruler is larger than the other human figures. Narmer wears the White

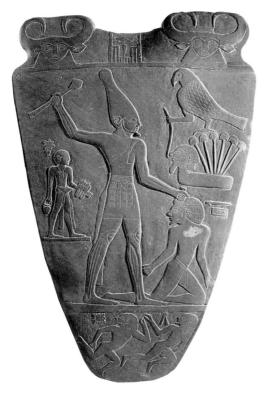

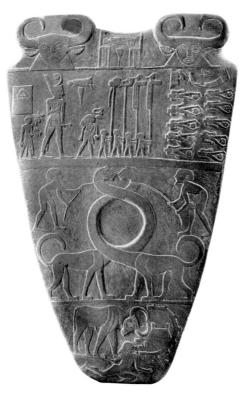

3–2 ↑ **THE NARMER PALETTE**Hierakonpolis. Early Dynastic period, c. 2950–2775 BCE. Green schist, height 25" (64 cm). Egyptian Museum, Cairo.

Crown of Upper Egypt; a ceremonial bull's tail, signifying strength, hangs from his waistband. He is barefoot, and an attendant standing behind him holds his sandals.

He bashes the enemy with a club, and above his kneeling foe, the god Horus—depicted as a falcon with a human hand—holds a rope tied around the neck of a man whose head is attached to a block sprouting stylized papyrus, a plant that grew in profusion along the Nile and was used symbolically to represent Lower Egypt. This combination of symbols makes clear that Narmer has tamed Lower Egypt. At the bottom, below Narmer's feet, two more defeated enemies appear sprawled on the ground.

In the top register on the other side of the palette (FIG. 3–2, right), Narmer wears the Red Crown of Lower Egypt, possibly to indicate he now rules both lands (see "Egyptian Symbols," page 52). With his attendant sandal-bearer, he marches behind his minister of state and four men carrying standards that may symbolize different regions of the country. Before them, under the watchful eye of Horus, decapitated bodies of the enemy are arranged in two neat rows. In the center register, the elongated necks of two feline creatures, each held on a leash by an attendant, curve gracefully around the rim of the cup of the palette. The intertwining of their necks may be another reference to the union of the Two Lands. At the bottom, the king, symbolized as a bull (an animal known for its strength and virility), menaces a fallen foe outside the walls of a fortress.

The images carved on the palette are strong and direct, and although scholars disagree about some of their specific meanings, their overall message is clear: A king named Narmer rules over the unified land of Egypt with a strong hand. For the next 3,000 years, much of Egyptian art was created to meet the demand of royal patrons for similarly graphic and indestructible testimonies to their glory.

TWISTED PERSPECTIVE. Narmer's palette is a very early example of the way Egyptian artists solved the problem of depicting the human form in the two-dimensional arts of relief sculpture and painting. Many of the figures on the palette are shown in poses that would be impossible in real life. By Narmer's time, Egyptian artists, composing their art from memory images (the generic form that suggests a specific object), had arrived at a unique way of drawing the human figure with the aim of representing each part of the body from its most characteristic angle. Heads are shown in profile, to best capture the nose, forehead, and chin. Eyes were rendered frontally. As for the body, a profile head and neck are joined to profile hips and legs by a fully frontal torso. The figure is usually striding to reveal both legs. The result is a formalized version of the twisted perspective we have seen in cave paintings (Chapter 1) and in ancient Near Eastern art (Chapter 2).

This artistic convention was followed especially in the depiction of royalty and other dignitaries. Persons of lesser

social rank engaged in active tasks tend to be represented more naturally (compare the figure of Narmer with those of his standard-bearers).

Similar long-standing conventions governed the depiction of animals, insects, inanimate objects, landscape, and architecture. **Groundlines** establish space as a series of horizontal registers in which the uppermost register is the most distant. A landscape combines the bird's-eye view of a map with the depiction of elements such as trees from the side.

THE CANON OF PROPORTIONS. Egyptian artists also established an ideal image of the human form, following a canon of proportions. The ratios between a figure's height and all of its component parts were clearly prescribed. They were calculated as multiples of a specific unit of measure, such as the width of the closed fist. This unit became the basis of a square grid, the OLD KINGDOM STANDARD GRID (FIG. 3–3). Every body part had its designated place on the grid: Knowing the knee should appear a prescribed number of squares above the groundline, the waist was then x number of squares above the knee, and so on. The whole process was thereby simplified. Since size depended not on the object, but on the amount of space it occupied, even the smallest image possesses the quality of a monumental figure.

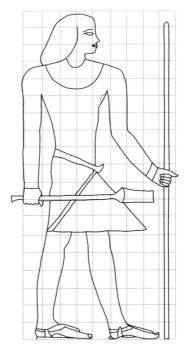

 $3-3 \perp \text{OLD KINGDOM STANDARD GRID-AN EGYPTIAN}$ CANON OF PROPORTIONS FOR REPRESENTING THE HUMAN BODY

This canon sets the height of the male body from heel to hairline at 18 times the width of the fist, which is 1 unit wide. Thus, there are 18 units between the heels and the hairline. The knees align with the fifth unit up, the elbows with the twelfth, and the junction of the neck and shoulders with the sixteenth.

Technique

PRESERVING THE DEAD

gyptians developed mummification techniques to ensure that the ka, or life force, could live on in the body in the afterlife. No recipes for preserving the dead have been found, but the basic process seems clear enough from images found in tombs, the descriptions of later Greek writers such as Herodotus and Plutarch, scientific analysis of mummies, and modern experiments.

By the time of the New Kingdom, the routine was roughly as follows: The body was taken to a mortuary, a special structure used exclusively for embalming. Under the supervision of a priest, workers removed the brains, generally through the nose, and emptied the body cavity through an incision in the left side. They then placed the body and major internal organs in a vat of natron, a naturally occurring salt, to steep for a month or more.

This preservative caused the skin to blacken, so workers often dyed it later to restore some color, using red ocher for a man, yellow ocher for a woman. They then packed the body cavity with clean linen, soaked in various herbs and ointments, provided by the family of the deceased. They wrapped the major organs in separate packets, putting them in special containers called **canopic jars**, to be placed in the tomb chamber.

Workers next wound the trunk and each of the limbs separately with cloth strips, then wrapped the whole body. They wound it in additional layers of cloth to produce the familiar mummy shape. The linen winders often inserted charms and other smaller objects among the wrappings. If the family supplied a copy of the Book of the Dead, it was tucked between the mummy's legs.

Funerary Architecture

Ancient Egyptians believed that an essential part of every human personality is its life force, or spirit, called the ka, which lived on after the death of the body, forever engaged in the activities it had enjoyed in its former existence. The ka needed a body to live in, and a sculpted likeness was adequate. It was especially important to provide a comfortable home for the ka of a departed king, so that even in the afterlife he would continue to ensure the well-being of Egypt.

The Egyptians developed elaborate funerary practices to ensure that their deceased moved safely and effectively into the afterlife. They preserved the bodies of the royal dead with care and placed them in burial chambers filled with all the supplies and furnishings the *ka* might require throughout eternity (see "Preserving the Dead," above). The quantity and value of these grave goods were so great that even in ancient times looters routinely plundered tombs.

THE MASTABA. In Early Dynastic Egypt, the most common tomb structure—used by the upper level of society, the King's family and relatives—was the **mastaba**, a flat-topped, onestory building with slanted walls erected above an underground burial chamber (see "Mastaba to Pyramid," page 56). Mastabas were at first constructed of mud brick, but toward the end of the Third Dynasty (c. 2650–2575 BCE), many incorporated cut stone, at least as an exterior facing.

In its simplest form, the mastaba contained a **serdab**, a small, sealed room housing the *ka* statue of the deceased, and

a chapel designed to receive mourning relatives and offerings. A vertical shaft dropped from the top of the mastaba down to the actual burial chamber, where the remains of the deceased reposed in a **sarcophagus** (a coffin), surrounded by appropriate grave goods. This chamber was sealed off after interment. Mastabas might have numerous underground burial chambers to accommodate whole families, and mastaba burial remained the standard for Egyptian elites for centuries.

THE NECROPOLIS. The kings of the Third Dynasty, such as Djoser, devoted huge sums to the design, construction, and decoration of extensive funerary complexes. These structures tended to be grouped together in a **necropolis**—literally, a "city of the dead"—at the edge of the desert on the west bank of the Nile, for the land of the dead was believed to be in the direction of the setting sun. Two of the most extensive of these early necropolises are at Saqqara and Giza, just outside modern Cairo.

DJOSER'S COMPLEX AT SAQQARA. For his tomb complex at Saqqara, the Third Dynasty King Djoser (c. 2650–2631 BCE) commissioned the earliest known monumental architecture in Egypt (FIG. 3–4). The designer of the complex was Imhotep, the highly educated prime minister who served as one of Djoser's chief advisers. Imhotep is the first architect in history known by name. His name, together with the king's, is inscribed on the base of a statue of Djoser found near the step pyramid.

Elements of Architecture

MASTABA TO PYRAMID

s the gateway to the afterlife for Egyptian kings and members of the royal court, the Egyptian burial structure began as a low rectangular mastaba with an internal *serdab* (the room where the *ka* statue was placed) and chapel. Then a mastaba with attached chapel and *serdab* (not shown) was the custom. Later, mastaba forms of decreasing size were stacked over an underground burial chamber to form the step pyramid. The culmination of the Egyptian burial chamber is the pyramid, in which the actual burial site may be within the pyramid—not below ground—with false chambers, false doors, and confusing passageways to foil potential tomb robbers.

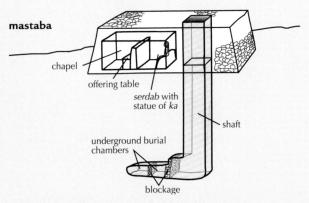

stepped pyramid

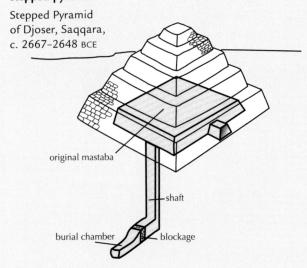

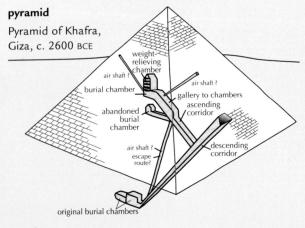

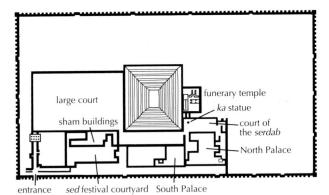

3–4 | PLAN OF DJOSER'S FUNERARY COMPLEX, SAQQARA Third Dynasty, c. 2630–2575 BCE.

Situated on a level terrace, this huge commemorative complex—some 1,800 feet (544 m) long by 900 feet (277 m) wide—was designed as a replica in stone of the wood, brick, and reed buildings of Djoser's actual palace compound. Inside the wall, the step pyramid dominated the complex. Underground apartments copied the layout and appearance of rooms in the royal palace.

It appears that Imhotep first planned Djoser's tomb as a single-story mastaba, then later decided to enlarge upon the concept (FIG. 3–5). In the end, what he produced was a step pyramid formed by six mastaba-like elements of decreasing size placed on top of each other. Although the final structure resembles the ziggurats of Mesopotamia, it differs in both its intention (as a stairway to the sun god Ra) and its purpose (protecting a tomb). A 92-foot shaft descended from the original mastaba enclosed within the pyramid. A descending corridor at the base of the pyramid provided an entrance from outside to a granite-lined burial vault.

The adjacent funerary temple, where priests performed their final rituals before placing the king's mummified body in its tomb, was used for continuing worship of the dead king. In the form of his ka statue, Djoser intended to observe these devotions through two peepholes in the wall between the serdab and the funerary chapel. To the east of the pyramid, buildings filled with debris represent actual structures in which the dead king could continue to observe the sed rituals that had ensured his long reign. In a pavilion near the entrance to the complex in the southeast corner, his spirit could await the start of ceremonies he had performed in life, such as the running trials of the sed festival. These would take place in a long outdoor courtyard within the complex. After proving himself, the king would proceed first to the South Palace and then to the North Palace, to be symbolically crowned once again as ruler of Egypt's Two Lands.

THE OLD KINGDOM, c. 2575-2150 BCE

The Old Kingdom was a time of social and political stability despite increasingly common military excursions to defend the borders. The growing wealth of ruling families of the period is reflected in the size and complexity of the tomb structures they commissioned for themselves. Court sculptors

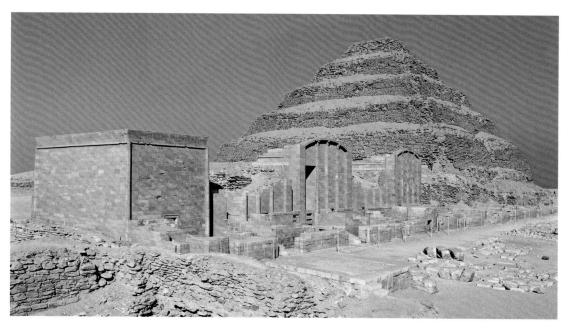

3-5 | THE STEP PYRAMID, AND SHAM BUILDINGS. FUNERARY COMPLEX OF DJOSER, SAQQARA Limestone, height of pyramid 204′ (62 m).

were regularly called on to create life-size, even colossal royal portraits in stone. Kings were not the only patrons of the arts, however. Upper-level government officials also could afford to have tombs decorated with elaborate carvings.

Architecture: The Pyramids at Giza

The architectural form most closely identified with Egypt is the true pyramid with a square base and four sloping triangular faces. The first such structures were erected in the Fourth Dynasty (2575–2450 BCE). The angled sides of the pyramids may have been meant to represent the slanting rays of the sun, for inscriptions on the walls of pyramid tombs built in the Fifth and Sixth dynasties tell of deceased kings climbing up the rays to join the sun god Ra.

Egypt's most famous funerary structures are the three great pyramid tombs at Giza (see Introduction, Fig. 1,; and FIG. 3–6). These were built by the Fourth Dynasty kings Khufu (ruled c. 2551–2528 BCE), Khafre (ruled 2520–2494 BCE), and

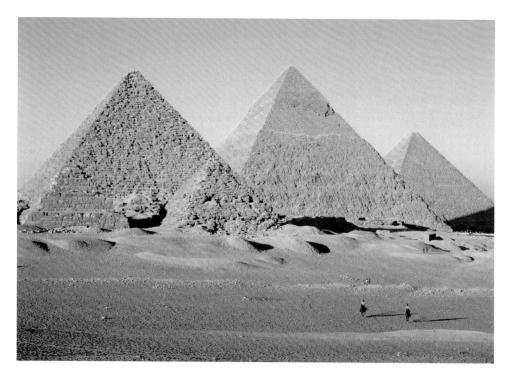

3-6 | GREAT PYRAMIDS, GIZA

Fourth Dynasty, c. 2575-2450

BCE. Erected by (from the left)

Menkaure, Khafre, and Khufu.

Granite and limestone, height of pyramid of Khufu, 450'

(137 m).

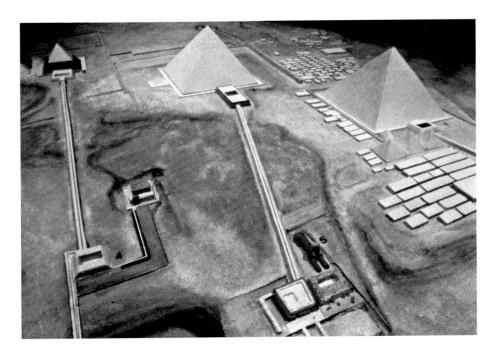

3−7 | MODEL OF THE GIZA PLATEAU

From left to right: the temples and pyramids of Menkaure, Khafre, and Khufu. (Number 4 is the Valley Temple of Menkaure; number 5 is the Valley Temple and Sphinx of Khafre.)

Prepared for the exhibition "The Sphinx and the Pyramids: One Hundred Years of American Archaeology at Giza," held in 1998 at the Harvard University Semitic Museum. Harvard University Semitic Museum, Cambridge, Massachusetts.

Menkaure (ruled c. 2490–2472 BCE). The Greeks were so impressed by these monuments—*pyramid* is a Greek term—that they numbered them among the world's architectural marvels. The early Egyptians referred to the Giza pyramids as" Horizon of Khufu," "Great is Khafre," and "Divine is Menkaure," thus acknowledging the desire of these rulers to commemorate themselves as divine beings.

Khufu and Khafre. The oldest and largest pyramid is that of Khufu, which covers thirteen acres at its base. It was originally finished with a thick veneer of polished limestone that lifted its apex to almost 481 feet, some 30 feet above the present summit. The pyramid of Khafre, the only one of the three that still has a little of its veneer at the top, is slightly smaller than Khufu's. Menkaure's pyramid is considerably smaller than the other two and had a polished red granite base.

The site was carefully planned to follow the sun's east—west path. Next to each of the pyramids was a funerary temple connected by a causeway, or elevated road, to a valley temple on the bank of the Nile (FIG. 3–7). When a king died, his body was embalmed and ferried west across the Nile from the royal palace to his valley temple, where it was received with elaborate ceremonies. It was then carried up the causeway to his funerary temple and placed in its chapel, where family members presented offerings of food and drink, and priests performed rites in which the deceased's spirit consumed a meal. Finally, the body was entombed in a vault deep inside the pyramid.

The designers of the pyramids tried to ensure that the king and his tomb would never be disturbed. Khufu's builders

placed his tomb chamber in the very heart of the mountain of masonry, at the end of a long, narrow, steeply rising passageway, sealed off after the burial with a 50-ton stone block. Three false passageways further obscured the location of the tomb.

Khafre's funerary complex is the best preserved. In the valley temple, massive blocks of red granite form walls and piers supporting a flat roof (FIG. 3–8). Tall, narrow windows act as a clerestory in the upper walls, letting in light which reflects off the polished alabaster floor (see "Post-and-Lintel and Corbel Construction," page 14).

Constructing the Pyramids. The pyramid was a triumph of engineering and design. Constructing one was a formidable undertaking. A large workers' burial ground discovered at Giza attests to the huge labor force that had to be assembled, housed, and fed. Most of the cut stone blocks—each weighing an average of 2.5 tons—used in building the Giza complex were quarried either on the site or nearby. Teams of workers transported them by sheer muscle power, employing small logs as rollers or pouring water on sand to create a slippery surface over which they could drag the blocks on sleds.

Scholars and engineers have various theories about how the pyramids were raised. Some ideas have been tested in computerized projections and a few models on a small but representative scale have been constructed. The most efficient means of getting the stones into position might have been to build a temporary, gently sloping ramp around the body of the pyramid as it grew higher. The ramp could then be dismantled as the stones were smoothed out or slabs of veneer were laid.

3–8 | VALLEY TEMPLE OF KHAFRE
Giza. Old Kingdom, c. 2570–2544 BCE. Limestone and red granite. Commissioned by Khafre.

The architects who oversaw the building of such massive structures were capable of the most sophisticated mathematical calculations. They oriented the pyramids to the points of the compass and may have incorporated other symbolic astronomical calculations as well. There was no room for trial and error. The huge foundation layer had to be absolutely level and the angle of each of the slanting sides had to remain constant so that the stones would meet precisely in the center at the top.

Sculpture

Egyptian artists were adept at creating lifelike threedimensional figures. In contrast to the cylindrical images of early Mesopotamian sculpture, their forms—compact, solid, and blocklike—express a feeling of strength and permanence, and address the practical difficulties of carving hard stone such as diorite.

PORTRAIT OF KHAFRE. As was the custom, Khafre commissioned many portraits of himself. His most famous image is the Great Sphinx, just behind his valley temple: a colossal monument some 65 feet tall that combines his head with the long body of a crouching lion (SEE FIG. 1, Introduction). In an over—life-size statue, one of several discovered inside his valley temple, Khafre was portrayed as an enthroned king (FIG. 3—9). sitting erect on a elegant but simple throne. The falcon god Horus perches on the back of the throne, protectively enfolding the king's head with his wings (FIG. 3—10).

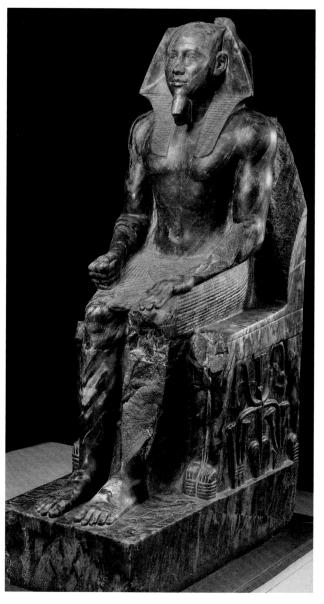

3–9 | KHAFRE Giza, Valley Temple of Khafre. Fourth Dynasty (ruled c. 2520–2494 BCE). Anorthosite gneiss, height 5′ 6½″ (1.68 m). Egyptian Museum, Cairo.

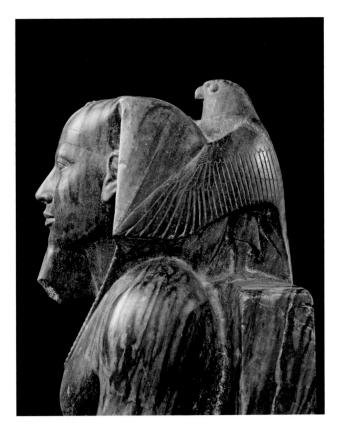

3-10 KHAFRE, DETAIL OF HEAD

Lions—symbols of regal authority—form the throne's legs, and the intertwined lotus and papyrus plants beneath the seat symbolize the king's power over Upper (lotus) and Lower (papyrus) Egypt.

Khafre wears the traditional royal costume: a short, pleated kilt, a linen headdress with the cobra symbol of Ra, and a false beard symbolic of royalty (see "Egyptian Symbols," page 52). He holds a cylinder, probably a rolled piece of cloth. The figure conveys a strong sense of dignity, calm, and above all permanence. The arms are pressed tight to the body, and the body is firmly anchored in the block. The statue was carved in an unusual stone: anorthosite gneiss (related to diorite), imported from Nubia. This stone produces a rare optical effect: In sunlight, it glows a deep blue, the celestial color of Horus. Through skylights in the valley temple, the sun would have illuminated the alabaster floor and the figure, creating a blue radiance.

MENKAURE. Dignity, calm, and permanence also characterize the beautiful double portrait of Khafre's heir King Menkaure and a queen, probably Khamerernebty II, discovered in Menkaure's valley temple (FIG. 3–II). The sculptor's handling of the composition of this work, however, makes it far less austere than Khafre's statue. The couple's separate figures, close in size, are joined by the stone out of which they emerge, forming a single unit. They are further united by the queen's symbolic gesture of embrace. Her right hand comes from behind to lie gently against his ribs, and her left hand rests on his upper arm.

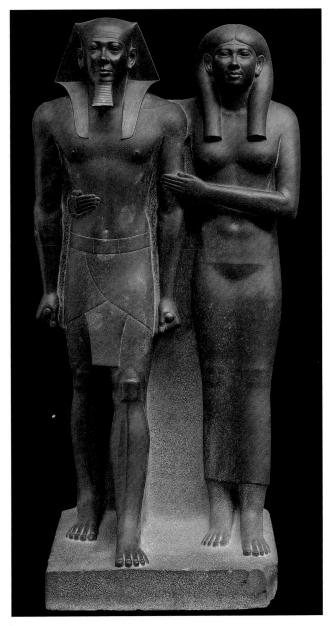

3–II | MENKAURE AND A QUEEN
Perhaps his wife Khamerernebty, from Giza. Fourth
Dynasty (ruled 2490–2472 BCE). Graywacke with traces of red and black paint, height 54½" (142.3 cm). Museum of Fine Arts, Boston.

Harvard University-MFA Expedition

The king, depicted in accordance with the Egyptian ideal as an athletic, youthful figure nude to the waist and wearing the royal kilt and headcloth, stands in a typically Egyptian balanced pose, striding with the left foot forward, his arms straight at his sides, and his fists clenched over cylindrical objects. His equally youthful queen, taking a smaller step forward, echoes his pose. The sculptor exercised remarkable skill in rendering her sheer, close-fitting garment, which clearly reveals the curves of her body. The time-consuming task of polishing this double statue was never completed, indicating that the work may have been undertaken only a few years before Menkaure's death in about 2472 BCE. Traces

of red paint remain on the king's face, ears, and neck (male figures were traditionally painted red), as do traces of black on the queen's hair.

PEPY II AND HIS MOTHER. In the Fifth and Sixth dynasties more generic figures appear, and inscriptions personalize the images. In a statue representing Pepy II (ruled c. 2246–2152 BCE), the king wears the royal kilt and headdress but is reduced to the size of a child seated on his mother's lap (FIG. 3–12). The work pays homage to Queen Ankhnes-meryre, who wears a vulture-skin headdress linking her to the goddess Nekhbet and proclaiming her royal blood. The queen is inscribed "Mother of the King of Upper and Lower Egypt, the god's daughter, the revered one, beloved of Khnum Ankhnesmeryra."

If Pepy II inherited the throne at the age of six, as the Egyptian priest and historian Manetho claimed, then the queen may have acted as regent until he was old enough to rule alone. The sculptor placed the king at a right angle to his mother, thus providing two "frontal" views—the queen fac-

ing forward, the king to the side. In another break with convention, he freed the queen's arms and legs from the stone block of the throne, giving her figure greater independence.

THE SEATED SCRIBE. Old Kingdom sculptors produced figures not only of kings but also of less prominent people. Such works—for example, the *Seated Scribe* from early in the Fifth Dynasty (FIG. 3–13)—are often more lively and less formal than royal portraits. Other early Fifth Dynasty statues found at Saqqara have a similar round head and face, alert expression, and cap of close-cropped hair. This statue was discovered near the tomb of a government official named Kai, and there is some evidence that it may be a portrait of Kai himself.

The scribe's sedentary vocation has made his body a little flabby, a condition that advertised a life freed from hard physical labor. A comment found in a tablet, probably copied from a book of instruction, emphasizes this interpretation: "Become a scribe so that your limbs remain smooth and your hands soft and you can wear white and walk like a man of

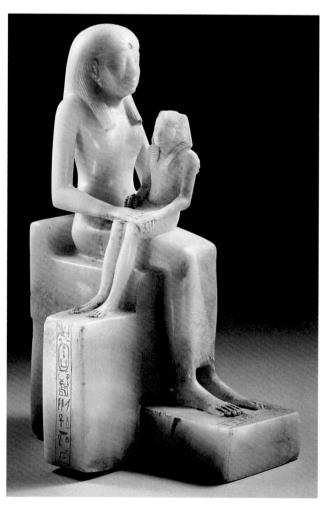

3–12 | PEPY II AND HIS MOTHER, QUEEN ANKHNES-MERYRE Sixth Dynasty, c. 2323–2152 BCE (ruled. c. 2246–2152 BCE). Egyptian alabaster, height $15\% \times 9\%$ (39.2 \times 24.9 cm). The Brooklyn Museum of Art, New York. Charles Edwin Wilbour Fund (39.119)

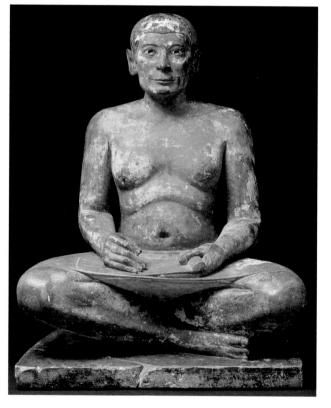

3–I3 | SEATED SCRIBE found near the tomb of Kai, Saqqara. Fifth Dynasty, c. 2450–2325 BCE. Painted limestone with inlaid eyes of rock crystal, calcite, and magnesite mounted in copper, height 21" (53 cm). Musée du Louvre, Paris.

standing whom [even] courtiers will greet" (cited in Strouhal, page 216). He sits holding a papyrus scroll partially unrolled on his lap, his right hand clasping a now-lost reed pen, and his face reveals a lively intelligence. Because the pupils are slightly off-center in the irises, the eyes give the illusion of being in motion, as if they were seeking contact.

A high-ranking scribe with a reputation as a great scholar could hope to be appointed to one of several "houses of life," where lay and priestly scribes copied, compiled, studied, and repaired valuable sacred and scientific texts. Completed texts were placed in related institutions, some of the earliest known libraries.

Tomb Decoration

To provide the *ka* with the most pleasant possible living quarters for eternity, wealthy families often had the interior walls and ceilings of their tombs decorated with paintings and reliefs. Much of this decoration was symbolic or religious, especially in royal tombs, but it could also include a wide variety of everyday events or scenes recounting momentous events in the life of the deceased. Tombs therefore provide a wealth of information about ancient Egyptian culture.

TI AND THE HIPPOPOTAMUS HUNT. A scene in the large mastaba of a Fifth Dynasty government official named Ti—a

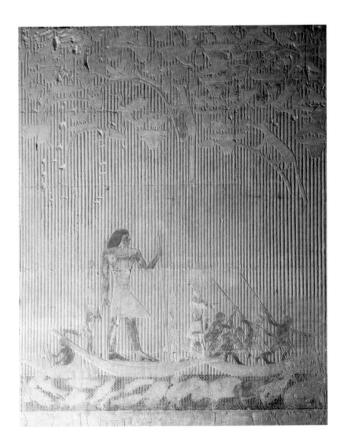

3–14 ↑ **TI WATCHING A HIPPOPOTAMUS HUNT**Tomb of Ti, Saqqara. Fifth Dynasty, c. 2450–2325 BCE.
Painted limestone relief, height approx. 45" (114.3 cm).

commoner who had achieved great power at court and amassed sufficient wealth to build an elaborate home for his immortal spirit—shows him watching a hippopotamus hunt, an official duty of members of the court (FIG. 3–14). It was believed that Seth, the god of darkness, disguised himself as a hippo. Hippos were thought to be destructive: They wandered into fields, damaging crops. Tomb depictions of such hunts therefore illustrated the valor of the deceased and the triumph of good over evil.

The artists who created this painted limestone relief employed a number of established conventions. They depicted the river as if seen from above, rendering it as a band of parallel wavy lines below the boats. The creatures in the river, however—fish, a crocodile, and hippopotami—are shown in profile for easy identification. The shallow boats carrying Ti and his men skim along the surface of the water unhampered by the papyrus stalks, shown as parallel vertical lines, which choke the marshy edges of the river. At the top of the panel, where Egyptian convention placed background scenes, several animals, perhaps foxes, are seen stalking birds among the papyrus leaves and flowers. The erect figure of Ti, rendered in the traditional twisted pose, looms over all. The actual hunters, being of lesser rank and engaged in more strenuous activities, are rendered more realistically (see "Egyptian Painting and Sculpture," page 64).

THE MIDDLE KINGDOM, c. 1975–c. 1640 BCE

The collapse of the Old Kingdom, with its long succession of powerful kings, was followed by roughly 150 years of political turmoil traditionally referred to as the First Intermediate Period. The provinces grew in power, essentially establishing independent rule, and political and military battles dominated the period. About 2010 BCE, three successive kings named Mentuhotep (Eleventh Dynasty, c. 2010–c. 1938? BCE), gained power from Thebes, and the country was reunited under Nebhepetre Menthutop. He reasserted royal power and founded the centralized Twelfth Dynasty.

The Middle Kingdom was another high point in Egyptian history, a period with a powerful, unified government. Arts and writing flourished, and literary and artistic efforts reflect a burgeoning awareness of the political upheaval the country had undergone. During the Middle Kingdom, Egypt's kings also strengthened the military: They expanded the borders and maintained standing armies to patrol these borders, especially in lower Nubia, south of present-day Aswan. By the Thirteenth Dynasty, however, political authority once again became less centralized. A series of short-lived kings succeeded the strong rulers of the Twelfth Dynasty, and an influx of foreigners, especially in the Delta, weakened the King's control over the nation.

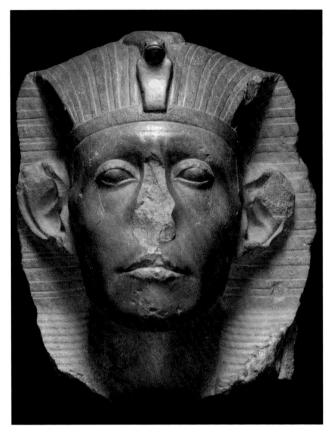

3–15 | HEAD OF SENUSRET III Twelfth Dynasty, c. 1938–1755 BCE (ruled c. 1836–1818 BCE). Yellow quartzite, height $17\frac{1}{4} \times 13\frac{1}{2} \times 17$ " (45.1 \times 34.3 \times 43.2 cm). The Nelson-Atkins Museum of Art, Kansas City, Missouri.

Purchase: Nelson Trust (62-11)

Sculpture: Royal Portraits

Some royal portraits from the Middle Kingdom express a special awareness of the hardship and fragility of human existence. The statue of **SENUSRET III** (FIG. 3–15), a king of the Twelfth Dynasty, who ruled from c. 1836 to 1818 BCE, reflects this new sensibility. Senusret was a dynamic king and successful general who led four military expeditions into Nubia, overhauled the central administration at home, and did much toward regaining control over the country's increasingly independent nobles. His portrait statue seems to reflect not only his achievements, but also something of his personality and even his inner thoughts. He appears to be a man wise in the ways of the world but lonely, saddened, and burdened by the weight of his responsibilities.

Old Kingdom figures such as *Khafre* (SEE FIG. 3–9) gaze into eternity confident and serene, whereas *Senusret III* shows a monarch preoccupied and emotionally drained. Deep creases line his sagging cheeks, his eyes are sunken, his eyelids droop, and his jaw is sternly set. Intended or not, this image betrays a pessimistic view of life, a degree of distrust similar to that reflected in the advice given by Amenemhat I, Senusret

III's great-great-grandfather and the founder of the Twelfth Dynasty, to his son Senusret I (cited in Breasted, page 231):

Fill not thy heart with a brother,

Know not a friend,

Nor make for thyself intimates, . . .

When thou sleepest, guard for thyself thine own heart;

For a man has no people [supporters],

In the day of evil.

Tomb Architecture and Funerary Objects

During the Eleventh and Twelfth dynasties, members of the royal family and high-level officials commissioned a new form of tomb. Rock-cut tombs were excavated in the faces of cliffs, such as those in the necropolis at Beni Hasan on the east bank of the Nile. The chambers and their ornamental columns, lintels, false doors, and niches were all carved out of solid rock (FIG. 3–16). Each one was like a single, complex piece of sculpture that was also usually painted. A typical Beni Hasan tomb included an entrance portico, a main hall, and a shrine with a burial chamber under the offering chapel. Rock-cut tombs at other places along the Nile exhibit variations on this simple plan.

Because the afterlife was always open to danger, ancient Egyptian tombs were equipped with a variety of objects meant to meet not only practical needs—such as actual food, clothing, and furniture—but also reliefs, paintings, and other objects designed to insure the safety and well-being of the individual in perpetuity. Jewelry or amulets with protective or magical functions, figures of deities, and miniature models of buildings, servants, and soldiers all insured that the deceased would experience a life of pleasure and security.

3-16 | ROCK-CUT TOMBS, BENI HASAN Twelfth Dynasty, c. 1938–1755 BCE. At the left is the entrance to the tomb of a provincial governor and the commander-in-chief Amenemhat.

Technique

EGYPTIAN PAINTING AND SCULPTURE

ainting usually relies on color and line for its effect, and relief sculpture usually depends on the play of light and shadow alone, but in Egypt, relief sculpture was also painted. Nearly every inch of the walls and closely spaced columns of Egyptian tombs and temples was adorned with colorful scenes and hieroglyphic texts. Until the Eighteenth Dynasty (c.1539–1292 BCE), the only colors used were black, white, red, yellow, blue, and green. Later, colors were mixed and thinned to produce a wide variety of shades. Modeling might be indicated by overpainting lines in a contrasting color. As more colors were added, the primacy of line was never challenged.

With very few exceptions, figures, scenes, and texts were composed in bands, or registers. Usually the base line at the bottom of each register represented the ground, but determining the sequence of images can be a problem because the registers can run horizontally or vertically.

Surfaces to be painted had to be smooth, so in some cases a coat of plaster was applied. The next step was to lay out the registers with painted lines and draw the appropriate grid (SEE FIG. 3–5). In the unfinished Eighteenth Dynasty tomb of Horemheb in the Valley of the

UNFINISHED RELIEF
Tomb of Horemheb, 18th Dynasty,
Valley of the Kings, west bank of
the Nile, Egypt.

Kings, the red base lines and horizontals of the grid are clearly visible. The general shapes of the hieroglyphs have also been sketched in red. The preparatory drawings from which carvers worked were black.

Egyptian artists

worked in teams,

and each member had a particular skill. The sculptor who executed the carving seen here was following someone else's drawing. Had there been time to finish the tomb, other hands would have smoothed the surface of this limestone relief, and still others would have made fresh drawings to guide the artists assigned to paint it.

When carving a freestanding statue, sculptors approached each face of the block as though they were simply carving a relief. A master drew the image full face on the front of the block and in profile on the side. Sculptors cut straight back from each drawing, removing the superfluous stone and literally "blocking out" the figure. Then the three-dimensional shapes were refined, surface details were added, and finally the statue was polished and details were painted.

3-I7 PECTORAL OF SENUSRET II

Tomb of Princess Sithathoryunet, el-Lahun. Twelfth Dynasty, c. 1938–1755 (ruled c. 1842–1837 BCE). Gold and semi-precious stones, length $3\frac{1}{4}$ " (8.2 cm). The Metropolitan Museum of Art, New York. Purchase, Rogers Fund and Henry Walters Gift, 1916 (16.1.3)

THE SENUSRET PECTORAL. Royal dress, especially jewelry, was very splendid, as shown by a pectoral, or chest ornament (FIG. 3-17) found in the funerary complex of Senusret II at el-Lahun, in the tomb of the king's daughter Sithathoryunet. The design, executed in gold and inlaid with semiprecious stones, incorporates the name of Senusret II and a number of familiar symbols. Two Horus falcons perch on its base, and above their heads is a pair of coiled cobras, symbols of Ra, wearing the ankh, the symbol of life. Between the two cobras, a cartouche—an oval formed by a loop of rope contains the hieroglyphs of the king's name. The sun disk of Ra appears at the top, and a scarab beetle, the hieroglyph khepri (a symbol of Ra and rebirth), is at the bottom. Below the cartouche, a kneeling male figure helps the falcons support a double arch of notched palm ribs, a hieroglyphic symbol meaning "millions of years." Decoded, the pectoral's combination of images yields the message: "May the sun god give eternal life to Senusret II."

THE FAIENCE HIPPO. Middle Kingdom art of all kinds and in all mediums, from official portrait statues to delicate bits of jewelry, exhibits the artists' talent for well-observed, accurate detail. A hippopotamus figurine discovered in the Twelfth Dynasty tomb of a governor named Senbi, for example, has all the characteristics of the beast itself: the rotund body on stubby legs, the massive head with protruding eyes, the tiny ears and characteristic nostrils (FIG. 3–18). The figurine is an example of Egyptian faience, with its distinctive lustrous glaze (see "Glassmaking and Egyptian Faience," page 70).

The artist made the hippo the watery blue of its river habitat, then painted lotus blossoms on its flanks, jaws, and head, giving the impression that the creature is standing in a tangle of aquatic plants. Such figures were often placed in tombs, especially of women, since the goddess Taweret, protector of female fertility and childbirth, was a composite fig-

3–18 | HIPPOPOTAMUS
Tomb of Senbi (Tomb B.3), Meir. Twelfth Dynasty, c. 1938–1755 BCE. Faience, length 71/8" (20 cm). The Metropolitan Museum of Art, New York.
Gift of Edward S. Harkness, 1917 (17.9.1)

ure, with the head of a hippo. However, the hippo could also be a symbol of evil, especially in men's tombs (see the discussion of *Ti Watching a Hippotamus Hunt*, FIG. 3–14).

REPRESENTATIONS OF DAILY LIFE. Funeral offerings represented in statues and paintings would be available for the deceased's use through eternity. On a funeral stele of a man named Amenemhat I (FIG. 3–19), a table heaped with food is watched over by a young woman named Hapi. The family sits together on a lion-legged bench. Everyone wears green jewelry and white linen garments, produced by the women in

Sequencing Events KEY EGYPTIAN RULERS

с. 2650-2631 все	Djoser
с. 2551-2528 все	Khufu
с. 2520-2494 все	Khafre
с. 2490-2472 все	Menkaure
с. 1836–1818 все	Senusret III
с. 1473-1458 все	Hatshepsut
с. 1353-1336 все	Amenhotep IV (Akhenaten)
с. 1332-1322 все	Tutankhamun (Tutankhaten)
с. 1279-1213 все	Rameses II

the household. Amenemhat (at the right) and his son Antef link arms and clasp hands while Iyi holds her son's arm and shoulder with a firm but tender gesture. The hieroglyphs identify everyone and preserve their prayers to the god Osiris.

Tomb art reveals much about domestic life in the Middle Kingdom. Wall paintings, reliefs, and small models of houses and farm buildings—complete with figurines of workers and animals—reproduce everyday scenes. Many of these models survive because they were made of inexpensive materials of no interest to early grave robbers. One from Thebes, made of

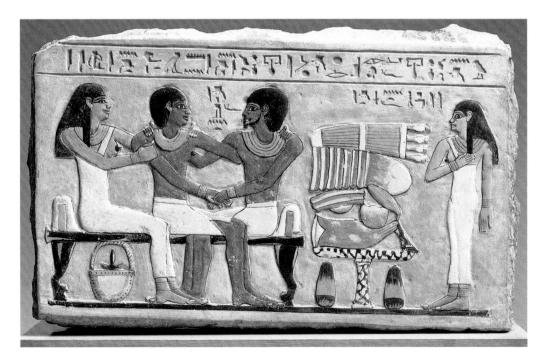

3–19 | STELE OF AMENEMHAT I Assasif. Twelfth Dynasty, c. 1938–1755 (ruled c. 1938–1908 BCE). Painted limestone, $11 \times 15''$ (30×50 cm). Egyptian Museum, Cairo. The Metropolitan Museum of Art, New York. Excavation 1915–16.

wood, plaster, and copper, from about 1975 to 1940 BCE, depicts the home of Meketre, the owner of the tomb (FIG. 3–20). Colorful columns carved to resemble bundles of papyrus support the flat roof of a portico that opens onto a garden. Trees surround a central pool such as only the wealthy could afford. The shade and water provided natural cooling and the pool was probably stocked with fish.

Town Planning

Although Egyptians used durable materials in the construction of tombs, they built their own dwellings with simple mud bricks, which have either disintegrated over time or been carried away for fertilizer by farmers. Only the foundations of these dwellings now remain.

Archaeologists have unearthed the remains of Kahun, a town built by Senusret II (SEE FIG. 3–17) for the many officials, priests, and workers in his court (FIG. 3–21). The plan offers a unique view of the Middle Kingdom's social structure. Parallel streets laid out with rectangular blocks divided into lots for

homes and other buildings reflect three distinct economic and social levels. The houses of priests, court officials, and their families were large and comfortable, with private living quarters and public rooms grouped around central courtyards. The largest had as many as seventy rooms spread out over half an acre. Workers and their families made do with small, five-room row houses built back to back along narrow streets.

A New Kingdom workers' village which was discovered at Deir el-Medina on the west bank of the Nile near the Valley of the Kings, has provided us with detailed information about the lives of the people who created the royal tombs. Workers lived together here under the rule of the king's chief minister. At the height of activity there were forty-eight teams of builders and artists. During a ten-day week, they worked for eight days and had two days off, and also participated in many religious festivals. They lived a good life with their families, were given clothing, sandals, grain, and firewood by the king, and had permission to raise livestock and birds and to tend a garden. The residents had an elected council, and the

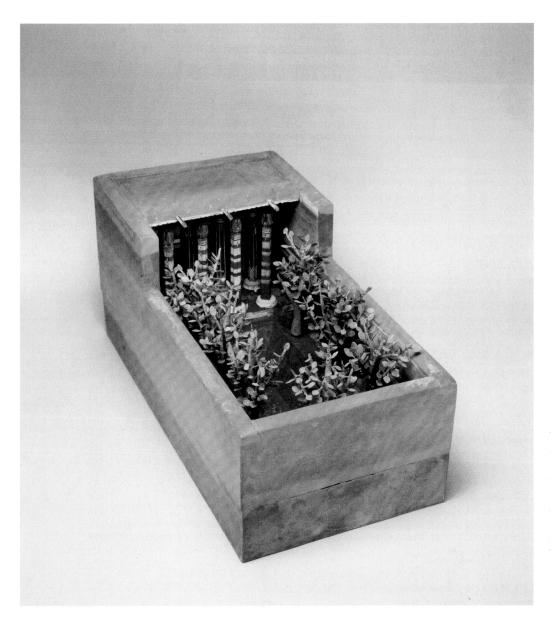

3–20 | MODEL OF A HOUSE AND GARDEN Tomb of Meketre, Deir el-Bahi. Eleventh Dynasty, c. 2125–2055 BCE. Painted and plastered wood and copper, length 33" (87 cm). The Metropolitan Museum of Art, New York.

Purchase, Rogers Fund and Edward S. Harkness Gift, 1920 (20.3.13)

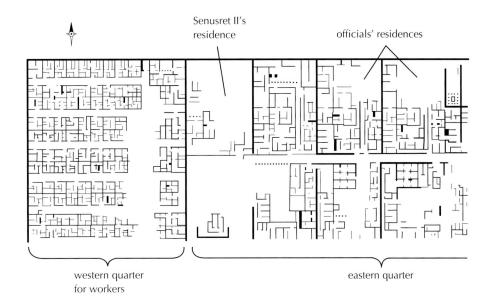

3–21 | PLAN OF THE NORTHERN SECTION OF KAHUN
Built during the reign of Senusret II near Modern el-Lahun. Dynasty 12, c. 1880–1874 BCE.

many written records that survive suggest a literate and litigious society that required many lawyers and scribes. Because the men were away for most of the week working on the tombs, women had a prominent role in the town. The remaining letters, many of which were between women, suggest the women may have been able to read and write.

THE NEW KINGDOM, c. 1539-1075 BCE

During the Second Intermediate period—another turbulent interruption in the succession of dynasties ruling a unified country—an eastern Mediterranean people called the Hyksos invaded Egypt's northernmost regions. Finally, the kings of the Eighteenth Dynasty (c. 1539–1292 BCE) regained control of the entire Nile region from Nubia in the south to the Mediterranean Sea in the north, restoring the country's political and economic strength. Roughly a century later, one of the same dynasty's most dynamic kings, Thutmose III (ruled 1479–1425 BCE), extended Egypt's influence along the eastern Mediterranean coast as far as the region of present-day Syria. His accomplishment was the result of fifteen or more military campaigns and his own skill at diplomacy.

Thutmose III was the first ruler to refer to himself as "pharaoh," a term that literally meant "great house." Egyptians used it in the same way that Americans say "the White House" to mean the current U. S. president and his staff. The successors of Thutmose III continued to use the term, and it ultimately found its way into the Hebrew Bible—and modern usage—as the name for the kings of Egypt.

By the beginning of the fourteenth century BCE, the most powerful Near Eastern kings acknowledged the rulers of Egypt as their equals. Marriages contracted between Egypt's ruling families and Near Eastern royalty helped to forge a generally cooperative network of kingdoms in the region, stimulating trade and securing mutual aid at times of natural disaster and outside threats to established borders. Over time, however, Egyptian influence beyond the Nile diminished, and the power of Egypt's kings began to wane.

The Great Temple Complexes

At the height of the New Kingdom, rulers undertook extensive building programs along the entire length of the Nile. Their palaces, forts, and administrative centers disappeared long ago, but remnants of temples and tombs of this great age have endured. Even as ruins, Egyptian architecture and sculpture attest to the expanded powers and political triumphs of the builders (FIG. 3–22). Early in this period, the priests of the god Amun at Thebes, Egypt's capital city throughout most of the New Kingdom, had gained such dominance that worship of the Theban triad of deities—Amun, his wife Mut, and their son Khons—had spread throughout the country. Temples to these and other gods were a major focus of royal patronage, as were tombs and temples erected to glorify the kings themselves.

THE NEW KINGDOM TEMPLE PLAN. As the home of the god, an Egyptian temple originally had the form of a house—a simple, rectangular, flat-roofed building preceded by a court-yard and gateway. The temples and builders of the New Kingdom enlarged and multiplied these elements. The gateway became a massive pylon with tapering walls; the semipublic courtyard was surrounded by columns (a peristyle court); the temple itself included an outer hypostyle hall (a vast hall filled with columns), and finally inner rooms—the offering

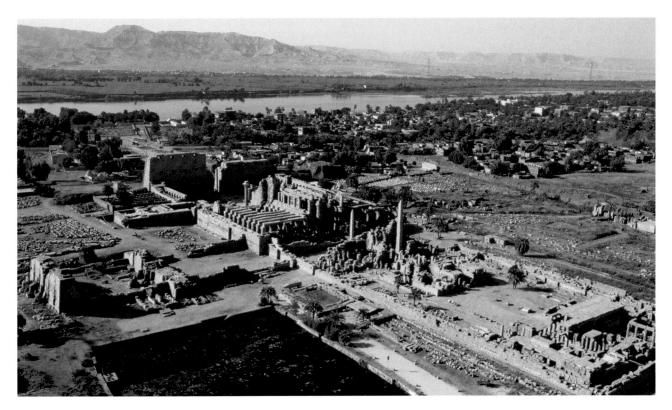

3-22 | THE RUINS OF THE GREAT TEMPLE OF AMUN AT KARNAK, EGYPT

hall and sanctuary. The design was symmetrical and axial—that is, all of its separate elements are symmetrically arranged along a dominant center line, creating a processional path.

The rooms became smaller, darker, and more exclusive as they neared the sanctuary. Only the pharaoh and the priests entered these inner rooms.

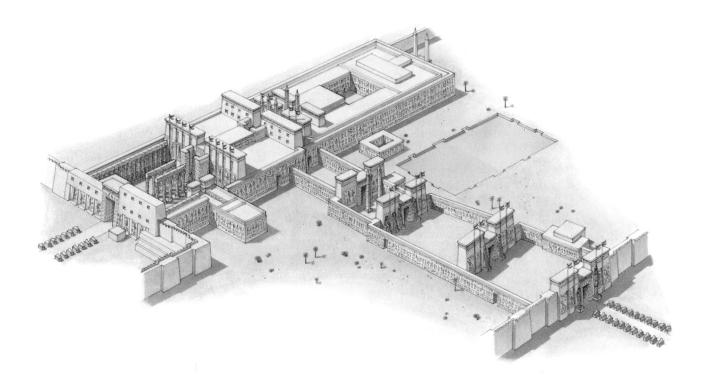

3-23 $\ \$ reconstruction drawing of the great temple of amun at Karnak, egypt New Kingdom, c. 1579–1075 BCE.

Two temple districts consecrated primarily to the worship of Amun, Mut, and Khons arose near Thebes—a huge complex at Karnak to the north and, joined to it by an avenue of sphinxes, a more compact temple at Luxor to the south.

KARNAK. At Karnak, temples were built and rebuilt for over 1,500 years, and the remains of the New Kingdom additions to the Great Temple of Amun still dominate the landscape (FIG. 3–22). Over the nearly 500 years of the New Kingdom, successive kings renovated and expanded the Amun temple until the complex covered about 60 acres, an area as large as a dozen football fields (FIG. 3–23).

Access to the heart of the temple, a sanctuary containing the statue of Amun, was from the west (on the left side of the reconstruction drawing) through a principal courtyard, a hypostyle hall, and a number of smaller halls and courts. Pylons set off each of these separate elements. Between the Eighteenth and Nineteenth dynasty reigns of Thutmose I (ruled c. 1493-? BCE), and Rameses II (ruled c. 1279-1213 BCE), this area of the complex underwent a great deal of construction and renewal. The greater part of Pylons II through VI leading to the sanctuary (modern archaeologists have given the pylons numbers) and the halls and courts behind them were renovated or newly built and embellished with colorful wall reliefs. A sacred lake to the south of the temple, where the king and priests might undergo ritual purification before entering, was also added. In the Eighteenth Dynasty, Thutmose III erected a court and festival temple to his own glory behind the sanctuary of Amun. His great-grandson Amenhotep III (ruled 1390-1353 BCE) placed a large stone statue of the god Khepri, the scarab (beetle) symbolic of the rising sun, rebirth, and everlasting life, next to the sacred lake.

In the sanctuary, the priests washed the god's statue every morning and clothed it in a new garment. Because the god was thought to derive nourishment from the spirit of food, it was provided with tempting meals twice a day, which the priests then removed and ate themselves. Ordinary people entered the temple precinct only as far as the forecourts of the hypostyle halls, where they found themselves surrounded by inscriptions and images of kings and the god on columns and walls. During religious festivals, however, they lined the waterways, along which statues of the gods were carried in ceremonial boats, and were permitted to submit petitions to the priests for requests they wished the gods to grant.

THE GREAT HALL AT KARNAK. Between Pylons II and III at Karnak stands the enormous hypostyle hall erected in the reigns of the Nineteenth Dynasty rulers Sety I (ruled c. 1290–1279 BCE) and his son Rameses II (ruled c. 1279–1213 BCE). Called the "Temple of the Spirit of Sety, Beloved of Ptah in the House of Amun," it may have been used for royal coronation ceremonies. Rameses II referred to it as "the place where the common people extol the name of

his majesty."The hall was 340 feet wide and 170 feet long. Its 134 closely spaced columns supported a stepped roof of flat stones, the center section of which rose some 30 feet higher than the rest of the roof (FIGS. 3–24, 3–25). The columns supporting this higher part of the roof are 66 feet tall and 12 feet in diameter, with massive lotus flower capitals. On each side, smaller columns with lotus bud capitals seem to march off forever into the darkness. In each of the side walls of the higher

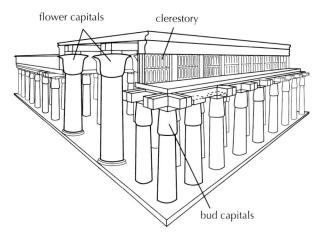

3–24 | RECONSTRUCTION DRAWING OF THE HYPOSTYLE HALL, GREAT TEMPLE OF AMUN AT KARNAK Nineteenth Dynasty, c. 1292–1190 BCE.

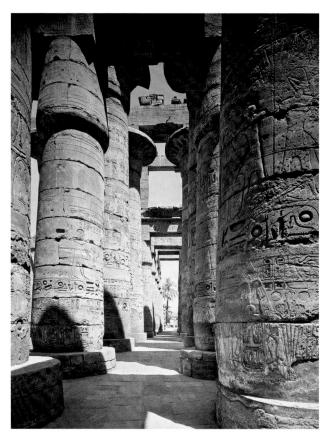

3–25 | FLOWER AND BUD COLUMNS, HYPOSTYLE HALL, GREAT TEMPLE OF AMUN AT KARNAK

Technique

GLASSMAKING AND EGYPTIAN FAIENCE

eating a mixture of sand, lime, and sodium carbonate or sodium sulfate to a very high temperature produces glass. The addition of other substances can make the glass transparent, translucent, or opaque and create a vast range of colors.

No one knows precisely when or where the technique of glassmaking first developed.

By the Predynastic period, Egyptians were experimenting with **faience**, a technique in which glass paste, when fired, produces a smooth and shiny opaque finish. It was used first to form small objects—mainly beads, charms, and color inlays—but later it was used as a colored glaze to ornament pottery wares and clay figurines. The first evidence of all-glass vessels and other hollow objects dates from the early New Kingdom. The first objects to be made entirely of glass in Egypt were produced with the technique known as **core glass** (see Hippopotamus, FIG. 3–18, on page 65).

A lump of sandy clay molded into the desired shape of the finished vessel was wrapped in strips of cloth, then skewered on a fireproof rod. It was then briefly dipped into a pot of molten glass. When the resulting coating of glass had cooled, the clay core was removed through the opening left by the skewer. To decorate the vessel, glassmakers frequently heated thin rods of colored glass and fused them to the surface in elegant wavy patterns, zigzags, and swirls. In the fish-shaped bottle shown here, an example of core glass from the New Kingdom, the body was created from glass tinted with cobalt, and the surface was then decorated with swags resembling fish scales using small rods of white and orange glass.

FISH-SHAPED BOTTLE

Akhetaten (present-day Tell el-Amarna). Eighteenth Dynasty, c. 1353–1336 BCE. Core glass, length 5%" (13 cm). The British Museum, London.

center section, a long row of window openings created what is known as a **clerestory**. These openings were filled with stone grillwork, so they cannot have provided much light, but they did permit a cooling flow of air through the hall. Despite the dimness of the interior, artists covered nearly every inch of the columns, walls, and cross-beams with reliefs.

The Valley of the Kings and Queens

Across the Nile from Karnak and Luxor lay Deir el-Bahri and the Valleys of the Kings and Queens. These valleys on the west bank of the Nile held the royal necropolis, and it was near the Valley of the Kings that the pharaoh Hatshepsut built her funerary temple. The dynamic Hatshepsut (Eighteenth Dynasty, ruled c. 1473–1458 BCE) is a notable figure in a

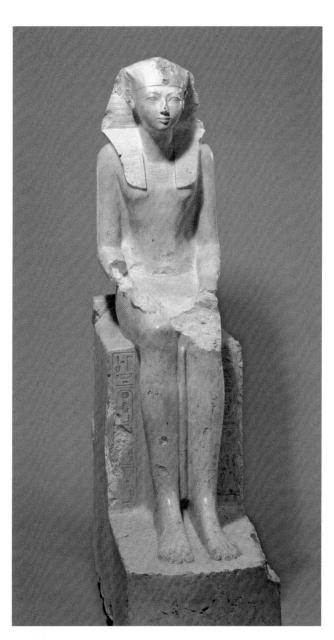

3–26 | HATSHEPSUT ENTHRONED

Deir el-Bahri. Eighteenth Dynasty
(ruled c. 1473–1458 BCE).

The Metropolitan Museum of Art, New York.

period otherwise dominated by male warrior-kings. Besides Hatshepsut, very few women ruled Egypt—they included the little-known Sobekneferu, Tausret, and much later, the notorious Cleopatra VII.

HATSHEPSUT. Of the women rulers who went down in history as "living gods" themselves and not merely "wives of gods," Hatshepsut left the greatest legacy of monuments. Among the reliefs in her funerary temple at Deir el-Bahri, she placed a depiction of her divine birth, just as a male ruler might have done. There she is portrayed as the daughter of her earthly mother, Queen Ahmose, and the god Amun.

The daughter of Thutmose I, Hatshepsut married her half brother, who then reigned for fourteen years as Thutmose II. When he died, she became regent for his underage son—Thutmose III—born to one of his concubines. Hatshepsut had herself declared "king" by the priests of Amun, a maneuver that prevented Thutmose III from assuming the

throne for twenty years. In art, she was represented in all the ways a male ruler would have been, even as a human-headed sphinx, and she was called "His Majesty." Portraits often show her in the full royal trappings; in FIG. 3–26 she wears a kilt, linen headdress, and has a bull's tail hanging from her waist (visible between her legs). In some portraits Hatshepsut even wears the false beard of a king.

HATSHEPSUT'S TEMPLE AT DEIR EL-BAHRI. The most innovative undertaking in Hatshepsut's ambitious building program was her own funerary temple at Deir el-Bahri (FIG. 3–27). The structure was not intended to be her tomb; Hatshepsut was to be buried, like other New Kingdom rulers, in the Valley of the Kings, about half a mile to the northwest. Her funerary temple was magnificently positioned against high cliffs and oriented toward the Great Temple of Amun at Karnak, some miles away on the east bank of the Nile. The complex follows an axial plan (FIG. 3–28).

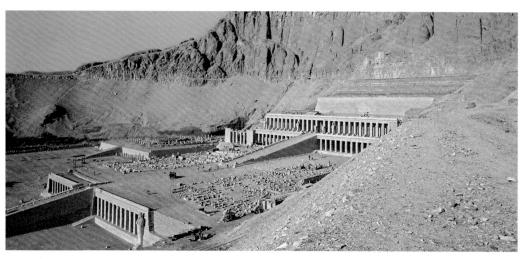

3–27 FUNERARY TEMPLE OF HATSHEPSUT, DEIR EL-BAHRI
Eighteenth Dynasty, c. 1473–1458 BCE. (At the far left, ramp and base of the funerary temple of Mentuhotep III. Eleventh Dynasty, c. 2009–1997 BCE.)

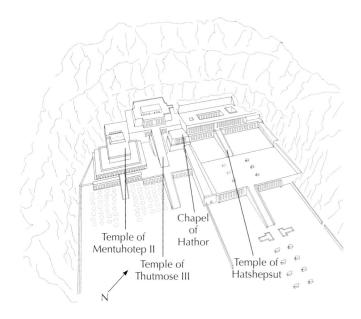

3−28 | PLAN OF THE FUNERARY TEMPLE OF HATSHEPSUT Deir el-Bahri

A raised causeway lined with sphinxes once ran from a valley temple on the Nile to the huge open space of the first court. From there, visitors ascended a long, straight ramp flanked by pools of water to a second court where shrines to Anubis and Hathor occupy the ends of the columned porticos. Relief scenes and inscriptions in the south portico depict Hatshepsut's expedition to the exotic, half-legendary kingdom of Punt (probably located on the Red Sea or the Gulf of Aden), from which rare myrrh trees were obtained for the temple's garden terraces. On the temple's uppermost court, colossal royal statues fronted another colonnade, and behind this lay a large hypostyle hall with chapels dedicated to Hatshepsut, her father, and the gods Amun and Ra-Horakhty—a powerful form of the sun god Ra combined with Horus. Centered in the hall's back wall was the entrance to the innermost sanctuary, a small chamber cut deep into the cliff.

Hatshepsut's funerary temple, with its lively alternating of open garden spaces and grandiose architectural forms, projects an imposing image of authority. Its remarkable union of nature and architecture, with many different levels and contrasting textures—water, stone columns, trees, and cliffs—made it even more impressive in antiquity.

Akhenaten and the Art of the Amarna Period

The most unusual ruler in the history of ancient Egypt was Amenhotep IV, a king of the Eighteenth Dynasty who came to the throne about 1353 BCE. In his 17-year reign (c. 1353–1336 BCE), he radically transformed the political, spiritual, and cultural life of the country. He founded a new religion honoring a single supreme god, the life-giving sun deity Aten (represented by a disk), and changed his own name about 1348 BCE to Akhenaten ("One Who Is Effective on Behalf of Aten"). Abandoning Thebes, the capital of Egypt since the beginning of his dynasty and a city firmly in the grip of the priests of Amun, Akhenaten built a new capital much farther north, calling it Akhetaten ("Horizon of the Aten"). Using the modern name for this site, Tell el-Amarna, historians refer to his reign as the Amarna period.

PORTRAITS OF AKHENATEN. A colossal statue of Akhenaten about 16 feet tall was placed in front of pillars in the new temple to Aten that he built at Karnak when he openly challenged the state gods (FIG. 3–29). He built a huge courtyard (c. 426 by 394 feet) surrounded by porticos, oriented to the movement of the sun. It was here he placed his portraits. The sculpture's strange, softly swelling forms suggest an almost boneless, androgynous figure with long, thin arms and legs, a protruding stomach, swelling thighs, and a thin neck supporting an elongated skull. All the facial features are elongated to the point of distortion. Eyes are slits and slightly downturned, while the nearly smiling and very full lips add to our discomfort. He holds the traditional royal insignia, the flail

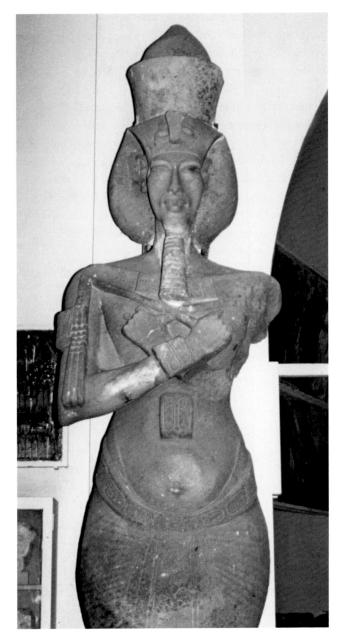

3-29 AKHENATEN, COLOSSAL FIGURE

(symbolizing protection) and the shepherd's crook (the scepter of absolute sovereignty).

The New Amarna Style. The king saw himself as Aten's son, and at his new capital he presided over the worship of Aten as a divine priest. His principal queen, Nefertiti, served as the divine priestess. Temples to Aten were open courtyards, where altars could be bathed in the direct rays of the sun. In art, Aten is depicted as a sun disk sending down long thin rays ending in human hands, some of which hold the *ankh*.

Akhenaten emphasized the philosophical principle of *maat*, or divine truth, and one of his kingly titles was "Living in Maat." Such concern for truth found expression in new artistic conventions. In portraits of the king, artists emphasized his unusual physical characteristics. Unlike his predecessors, and in keeping with his penchant for candor, Akhenaten commanded his artists to portray the royal family in informal situations. Even private houses in the capital city were adorned with reliefs of the king and his family, an indication that he managed to substitute veneration of the royal household for the traditional worship of families of gods, such as

Amun, Mut, and Khons.

A painted relief of Akhenaten, Queen Nefertiti, and three of their daughters exemplifies the new openness and a new figural style (FIG. 3–30). In this sunken relief—where the outlines of the figures have been carved into the surface of the stone, instead of being formed by cutting away the background—the king and queen sit on cushioned thrones playing with their children. The base of the queen's throne is adorned with the stylized plant symbol of a unified Egypt (see the throne of Khafre, FIG. 3–9), which has led some historians to conclude that Nefertiti acted as co-ruler with her husband. The royal couple is receiving the blessings of Aten, whose rays end in hands that penetrate the open pavilion and hold *ankhs* to their nostrils, giving them the "breath of life." Other ray-hands caress the hieroglyphic inscriptions in the center.

SEQUENCING WORKS OF ART

с. 2950 все	Narmer Palette
с. 2551–2472 все	Great Pyramids, Giza
c. 2450-2325 BCE	Seated Scribe
с. 1473-1458 все	Funerary temple of Hatshepsut
с. 1332 все	Funerary mask of Tutankhamun

The king holds one child and lovingly pats her head. The youngest of the three perches on Nefertiti's shoulder and tries to attract her attention by stroking her cheek. The oldest sits on the queen's lap, tugging at her mother's hand and pointing to her father. The children are nude, and the younger two have shaved heads, a custom of the time. The oldest wears the side-lock of youth, a patch of hair left to grow and hang at one side of the head in a braid. The artist has conveyed the engaging behavior of the children and the loving concern of their parents in a way not even hinted at in earlier royal portraiture in Egypt (compare FIG. 3–30 with Pepy II, FIG. 3–12.)

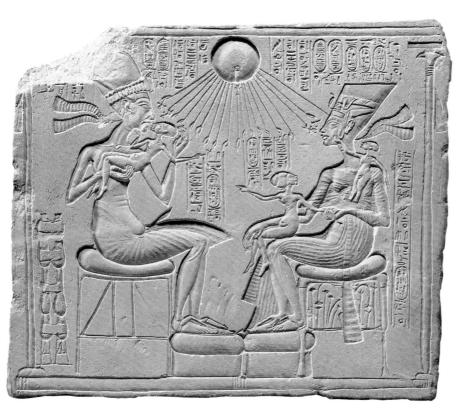

3-30 AKHENATEN AND HIS FAMILY

Akhetaten (present-day Tell el-Amarna). Eighteenth Dynasty, c. 1353–1336 BCE. Painted limestone relief, $12\% \times 15\%$ (31.1 \times 38.7 cm). Staatliche Museen zu Berlin, Preussischer Kulturbesitz, Ägyptisches Museum.

THE PORTRAIT OF TIY. Akhenaten's goals were actively supported not only by Nefertiti but also by his mother, Queen Tiy (FIG. 3–31). She had been the chief wife of the king's father, Amenhotep III (Eighteenth Dynasty, ruled c. 1390–1353 BCE), and had played a significant role in affairs of state during his reign. Queen Tiy's personality emerges from a miniature portrait head that reveals the exquisite bone structure of her dark-skinned face, with its arched brows, uptilted eyes, and slightly pouting lips.

This portrait of Tiy has existed in two versions. In the original, which may been made for the cult of her dead husband, the queen was identified with the funerary goddesses Isis and Nephthys, the sisters of Osiris. She wore a silver headdress covered with gold cobras and gold jewelry. Later, when her son had come to power and established his new religion, the portrait was altered. A brown cap covered with blue glass beads was placed over the funeral headdress. (Blue was the color of Horus, but for Tiy perhaps it was simply royal and a symbol of the sunlit sky.) A plumed crown, perhaps similar to the one worn by Nefertari (SEE FIG. 3–34), rose above the cap (the attachment is still visible). The entire sculpture would have been about one-third lifesize.

THE HEAD OF NEFERTITI. Tiy's commanding portrait contrasts sharply with a head of Nefertiti. The proportions of Nefertiti's refined, regular features, long neck, and heavy-lidded eyes appear almost too ideal to be human (FIG. 3–32). Part of the beauty of this head is the result of the artist's dra-

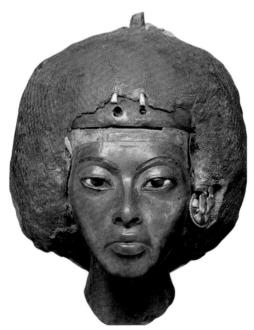

3–31 □ **QUEEN TIY**Kom Medinet el-Ghurab (near el-Lahun). Eighteenth Dynasty, c. 1352 BCE. Boxwood, ebony, glass, silver, gold, lapis lazuli, cloth, clay, and wax; height 3 ¾" (9.4 cm). Staatliche Museen zu Berlin, Preussischer Kulturbesitz, Ägyptisches Museum.

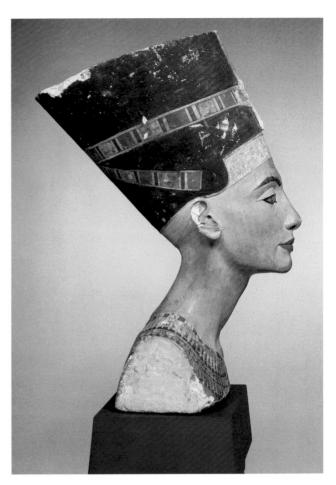

3–32 ↑ **NEFERTITI**Akhetaten (modern Tell el-Amarna). Eighteenth Dynasty, c. 1353–1336 BCE. Painted limestone, height 20" (51 cm). Staatliche Museen zu Berlin, Preussischer Kulturbesitz, Ägyptisches Museum.

matic use of color. The hues of the blue headdress and its colorful band are repeated in the rich red, blue, green, and gold of the jewelry. The queen's brows, eyelids, cheeks, and lips are heightened with color, as they no doubt were heightened with cosmetics in real life. Whether or not Nefertiti's beauty is exaggerated, phrases used by her subjects when referring to her—"Beautiful of Face," "Mistress of Happiness," "Great of Love," or "Endowed with Favors"—tend to support the artist's vision. This famous head was discovered in the studio of the sculptor Thutmose in Akhetaten, the capital city. Because bust portraits were rare in New Kingdom art, scholars believe Thutmose may have made this one as a model for sculptures or paintings of the queen.

AMARNA CRAFTS. The crafts also flourished in the Amarna period. Glassmaking, for example, could only be practiced by artists working for the king, and Akhenaten's new capital had its own glassmaking workshops (see "Glassmaking and Egyptian Faience," page 70). A bottle produced there and

meant to hold scented oil was fashioned in the shape of a fish that has been identified as a bolti, a species that carries its eggs in its mouth and spits out its offspring when they hatch. The bolti was a common symbol for birth and regeneration, complementing the self-generation that Akhenaten attributed to the sun disk Aten.

The Return to Tradition: Tutankhamun and Rameses II

Akhenaten's new religion and revolutionary ideas regarding the conduct and the art appropriate for royalty outlived him by only a few years. His successors had brief and troubled reigns, and the priesthood of Amun quickly regained its former power. His son Tutankhaten (Eighteenth Dynasty, ruled c. 1332–1322 BCE) returned to traditional religious beliefs, changing his name to Tutankhamun. He also turned his back on Akhenaten's new city and moved his court back to Thebes.

TUTANKHAMUN. The sealed inner chamber of Tutankhamun's tomb in the Valley of the Kings was never plundered, and when it was found in 1922 its incredible riches were just as they had been left since his interment. His body lay inside three nested coffins that identified him with Osiris, the god of the dead. The innermost coffin, in the shape of a mummy, is the richest of the three, for it is made of over 240 pounds (110.4 kg) of gold (FIG. 3-33). Its surface is decorated with colored glass and semiprecious gemstones, as well as finely incised linear designs and hieroglyphic inscriptions. The king holds a crook and a flail, symbols that were associated with Osiris and had become a traditional part of the royal regalia. A nemes headcloth with cobra and vulture on his forehead covers his head. A blue braided beard is attached to his chin. His necklace indicates military valor. Nekhbet and Wadjyt, vulture and cobra gods of Upper and Lower Egypt, spread their wings across his body. The king's features as reproduced on the coffin and masks are those of a very young man (FIG. 3-1). Even though they may

not reflect Tutankhamun's actual appearance, the unusually full lips and thin-bridged nose suggest the continued influence of the Amarna style and its realistic portraiture.

RAMESES II AND ABU SIMBEL. By Egyptian standards Tutankhamun was a rather minor king. Rameses II, on the other hand, was both powerful and long-lived. Under Rameses II (Nineteenth Dynasty, ruled c. 1279–1213 BCE), Egypt became a mighty empire. Rameses was a bold military commander and an effective political strategist. He also triumphed diplomatically by securing a peace agreement with the Hittites, a rival power centered in Anatolia (Chapter 2) that had tried to expand to the west and south at Egypt's expense. Rameses twice reaffirmed that agreement later in his reign by marrying Hittite princesses.

In the course of a long and prosperous reign, Rameses II initiated building projects on a scale rivaling the Old Kingdom Pyramids at Giza. Today, the most awe-inspiring of his many architectural monuments are found at Karnak and Luxor and at Abu Simbel in Egypt's southernmost region (see "The Temples of Rameses II at Abu Simbel," pages 76–77). At Abu Simbel, Rameses ordered two large temples to be carved in the living rock.

The temples at Abu Simbel were not funerary monuments. Rameses' and his queen Nefertari's tombs are in the Valleys of the Kings and Queens near Deir el-Bahri. The walls of Nefertari's tomb are covered with some of the most beautiful paintings discovered so far. In one of the many wall paintings, Nefertari offers jars of perfumed ointment to the goddess Isis (FIG. 3–34). The queen wears the vulture-skin headdress indicating her position, a royal collar, and a long, semitransparent white linen gown. Isis, seated on her throne behind a table heaped with offerings, holds a long scepter in her left hand, the *ankh* in her right. She wears a headdress surmounted by the horns of Hathor framing a sun disk, clear indications of her divinity.

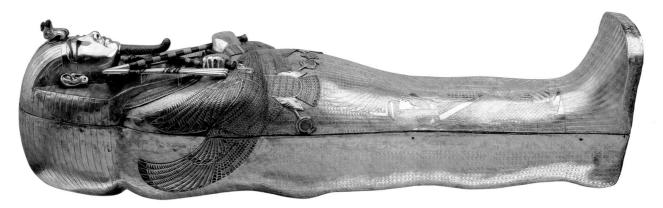

3-33 INNER COFFIN OF TUTANKHAMUN'S SARCOPHAGUS

Tomb of Tutankhamun, Valley of the Kings, near Deir el-Bahri. Eighteenth Dynasty, 1332-1322 BCE. Gold inlaid with glass and semiprecious stones, height 6'%" (1.85 m), weight nearly 243 pounds (110.4 kg). Egyptian Museum, Cairo.

THE OBJECT SPEAKS

THE TEMPLES OF RAMESES II AT ABU SIMBEL

any art objects speak to us subtly, through their beauty or mystery. Monuments such as Rameses II's temples at Abu Simbel, his colossal statues, and his association with the gods also speak across the ages about the religious and political power of this ruler: the king-god of Egypt, the conqueror of the Hittites, the ruler of a vast empire, a virile man with nearly a hundred children. As an inscription he had carved into an obelisk now standing in the heart of Paris says: "Son of Ra: Rameses-Meryamun ['Beloved of Amun']. As long as the skies exist, your monuments shall exist, your name shall exist, firm as the skies."

Rameses built numerous monuments in Egypt, but his choice of Abu Simbel for his

temples proclaims his military and diplomatic success: Abu Simbel is north of the second cataract of the Nile, in Nubia, the ancient land of Kush, which Rameses ruled and which was the source of his gold, ivory, and exotic animal skins. He asserted his divinity in two temples he had carved out of the sacred hills there. The larger temple, carved out of the mountain called Meha, is dedicated to Rameses and the Egyptian gods Amun, Ra, and Ptah. The dominant feature of Rameses' temple is a row of four colossal seated statues of the king himself. At its entrance, four aweinspiring 65-foot statues of Rameses are flanked by relatively small statues of family members, including his principal wife Nefertari, who reaches as high as his leg,

which she affectionately caresses. Inside the temple, eight 33-foot statues of the god Osiris with the face of the god-king Rameses further proclaim his divinity. The corridor they form leads to the seated figures of Ptah, Amun, Rameses II, and Ra. The corridor was oriented in such a way that twice a year the first rays of the rising sun shot through its entire depth to illuminate statues of the king and the four gods placed against the back wall.

About 500 feet away, Rameses ordered a smaller temple to be carved into the mountain called Ibshek, sacred to Hathor, goddess of fertility, love, joy, and music, and to be dedicated to Hathor and to Nefertari. Six statues, 33 feet tall, include two of the queen wearing the headdress

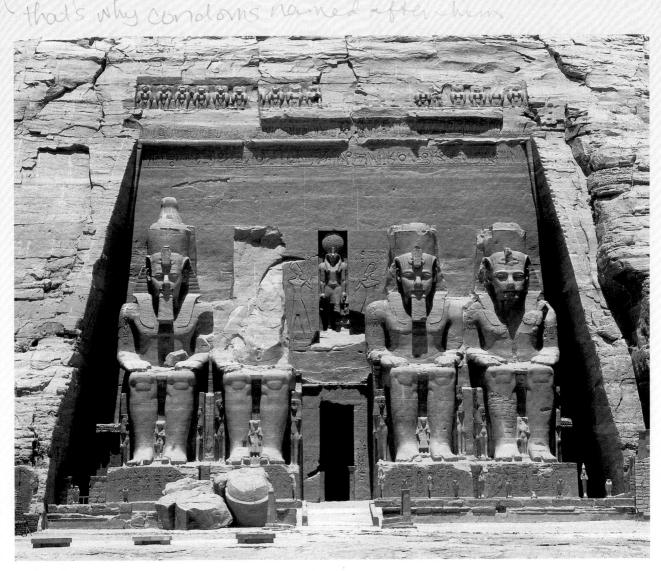

TEMPLE OF RAMESES IIAbu Simbel. Nineteenth Dynasty, c. 1279–1213 BCE.

of Hathor and four of her husband Rameses II. The two temples, together honoring the official gods of Egypt and his dynasty, were oriented so that their axes crossed in the middle of the Nile, suggesting that they may have been associated with the annual life-giving flood.

Ironically, flooding nearly destroyed Rameses' temples at Abu Simbel. Half-buried in the sand over the ages, they were discovered and opened early in the nine-teenth century. But in the 1960s, construction of the Aswan High Dam flooded the Abu Simbel site. Only an international effort and modern technology saved the complex. It was relocated high above the flood levels so that it could continue to speak to us.

TEMPLES OF RAMESES II

(left) and **NEFERTARI** (right) at Abu Simbel. Nineteenth Dynasty, 1279–1213 BCE. (TOP)

DETAIL OF NEFERTARI AND RAMSES'S LEG from Temple of Ramses II. (MIDDLE)

TEMPLE OF RAMESES II, INTERIOR Abu Simbel. Nineteenth Dynasty, c. 1279–1213 BCE. (BOTTOM)

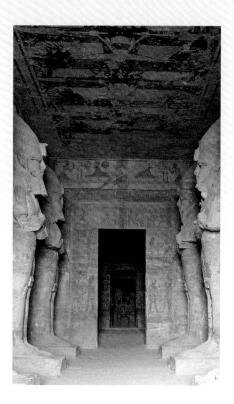

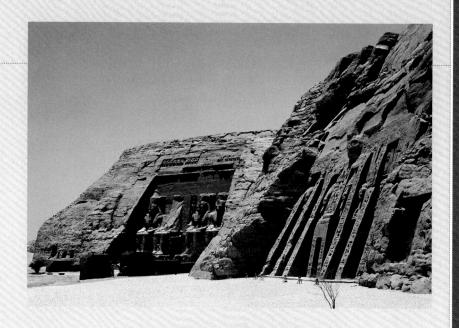

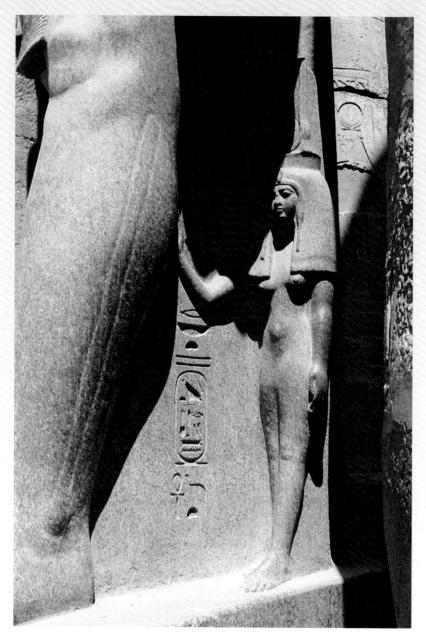

Art and Its Context

HIEROGLYPHIC, HIERATIC, AND DEMOTIC WRITING

ncient Egyptians developed four types of writing that are known today by the names the Greeks gave them. The earliest system employed a large number of symbols called hieroglyphs (from the Greek hieros, "sacred," and glyphein, "to carve"). As their name suggests, the Greeks believed they had religious significance. Some of these symbols were simple pictures of creatures or objects, or pictographs, similar to those used by the Sumerians (Chapter 2). Others were phonograms, or signs representing spoken sounds.

The earliest scribes must also have used this system of signs for record keeping, correspondence, and manuscripts of all sorts. In time, however, they developed simplified hieroglyphs that could be written more quickly in lines of script on papyrus scrolls. This type of writing is called **hieratic**, again derived from the Greek word *hieros*, meaning "sacred." Even after this script was perfected, inscriptions in reliefs or paintings and on ceremonial objects continued to be written in hieroglyph.

The third type of writing came into use only in the eighth century BCE, as written communication ceased to be restricted to priests and scribes. It was a simplified, cursive form of hieratic writing that was less formal and easier to master; the Greeks referred to it as **demotic** writing (from *demos*, "the people"). From this time on, all three systems were in use, each for its own specific purpose: religious documents were written in hieratic, inscriptions on monuments in hieroglyph, and all other texts in demotic script. Once the Greeks began to rule over Egypt, the Egyptians adapted their language to be written with Greek characters in a script known as *Coptic*.

After centuries of foreign rule, beginning with the arrival of the Greeks in 332 BCE, the ancient Egyptian language gradually died out. Modern scholars therefore had to decipher four types

ROSETTA STONE
With its three tiers of writing, from top to bottom: hieroglyphic, demotic, and Greek.
196 BCE. The British Museum, London.

of writing in a long-forgotten language. The key was a fragment of a stone stele, dated 196 BCE, which was called the Rosetta Stone (for the area of the Delta where one of Napoleon's officers discovered it in 1799). On it, a decree issued by the priests at Memphis honoring Ptolemy V (ruled c. 205–180 BCE) had been carved in hieroglyphs, demotic, and Greek.

Even with the Greek translation, the two Egyptian texts were incomprehensible until 1818, when Thomas Young, an English physician interested in ancient Egypt, linked some of the hieroglyphs to specific names in the Greek version. A short time later, French scholar Jean-François Champollion located the names Ptolemy and Cleopatra in both of the Egyptian scripts. With the phonetic symbols for P, T, O, and L in demotic, he was able to build up an "alphabet" of hieroglyphs, and by 1822 he had deciphered the two Egyptian texts.

Hieroglyphic signs for the letters P, T, O, and L, which were Champollion's clues to deciphering the Rosetta Stone, plus M, Y, and S: Ptolmys.

The artists responsible for decorating the tomb worked in a new style diverging very subtly but distinctively from earlier conventions. The outline drawing and use of clear colors reflect traditional practices, but quite new is the slight modeling of the body forms by small changes of hue to increase their appearance of three-dimensionality. The skin color of these women is much darker than that conventionally used for females in earlier periods, and lightly brushed-in shading emphasizes their eyes and lips. The tomb's artists used particular care in placing the hieroglyphic inscriptions in order to create a harmonious overall design.

Noble families also had richly painted tombs. Their paintings give us an insight into daily life, much like the models found in earlier tombs (SEE FIG. 3–20).

The Books of the Dead

By the time of the New Kingdom, the Egyptians had come to believe that only a person free from wrongdoing could enjoy an afterlife. The dead were thought to undergo a last judgment consisting of two tests presided over by Osiris, the god of the underworld, and supervised by the jackal-headed god of embalming and cemeteries, Anubis. After the deceased were questioned about their behavior in life, their hearts—

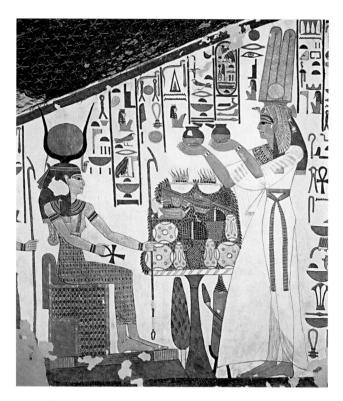

3–34 | QUEEN NEFERTARI MAKING AN OFFERING TO ISIS Wall painting in the tomb of Nefertari, Valley of the Queens, near Deir el-Bahri. Nineteenth Dynasty, 1290–1224 BCE.

which the Egyptians believed to be the seat of the soul—were weighed on a scale against an ostrich feather, the symbol of Maat, goddess of truth, order, and justice.

Family members commissioned papyrus scrolls containing magical texts or spells, which the embalmers placed among the wrappings of the mummified bodies to help the

dead survive the tests. Early collectors of Egyptian artifacts referred to such scrolls, often beautifully illustrated, as "Books of the Dead." The books varied considerably in content. A scene created for a man named Hunefer (Nineteenth Dynasty) shows three successive stages in his induction into the afterlife (FIG. 3–35). At the left, Anubis leads him by the hand to the spot where he will weigh his heart, contained in a tiny jar, against the "feather of Truth." Maat herself appears atop the balancing arm of the scales wearing the feather as a headdress. To the right of the scales, Ammit, the dreaded "Eater of the Dead"—part crocodile, part lion, and part hippopotamus—watches eagerly for a sign from the ibis-headed god Thoth, who prepares to record the result of the weighing

But the "Eater" goes hungry. Hunefer passes the test, and Horus, on the right, presents him to the enthroned Osiris, who floats on a lake of natron (see "Preserving the Dead," page 55). Behind the throne, the goddesses Nephthys and Isis support the god's left arm with a tender gesture, while in front of him his four sons, each entrusted with the care of one of the deceased's vital organs, stand atop a huge lotus blossom rising up out of the lake. In the top register, Hunefer, finally accepted into the afterlife, kneels before the nine gods of Heliopolis—the sacred city of the sun god Ra—and the five personifications of life-sustaining principles.

LATE EGYPTIAN ART, c. 715–332 BCE

The Late Period in Egypt saw the country and its art in the hands and service of foreigners. Nubians, Persians, Macedonians, Greeks, and Romans were all attracted to Egypt's riches and seduced by its art. The Nubians conquered Egypt and

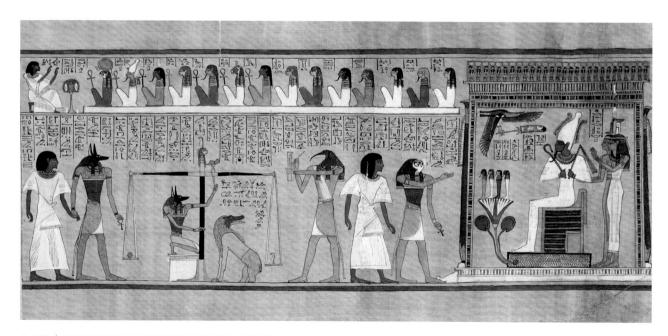

3–35 | JUDGMENT OF HUNEFER BEFORE OSIRIS Illustration from a Book of the Dead. Nineteenth Dynasty, c. 1285 BCE. Painted papyrus, height 15% (39.8 cm). The British Museum, London.

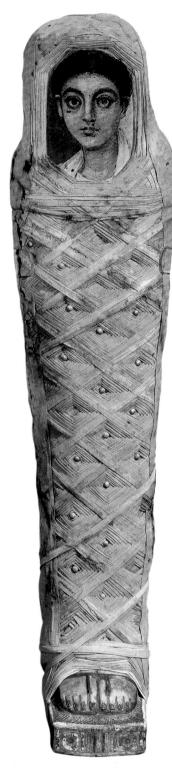

3–36 | MUMMY WRAPPING OF A YOUNG BOY Hawara. Roman period, c. 100–120 CE. Linen wrappings with gilded stucco buttons and inserted portrait in encaustic on wood, height of mummy 53% (133 cm); portrait $9\% \times 6\%$ (24 \times 16.5 cm). The British Museum, London.

re-established capitals at Memphis and Thebes (712–657 BCE). They continued the traditional religious practices and architectural forms, including pyramids.

In 332 BCE the Macedonian Greeks led by Alexander the Great conquered Egypt, and after Alexander's death in 323 BCE, his generals divided up the empire. Ptolemy, a Greek,

took Egypt, declaring himself king in 305. The Ptolemaic dynasty ended with the death of Cleopatra VII (ruled 51–30 BCE), when the Romans succeeded as Egypt's rulers and made it the breadbasket of Europe.

Not surprisingly, painting from this period reflects the conventions of Greek and Roman, not Egyptian, art. The most representative examples of this very late Egyptian art are the so-called Fayum portraits. The tradition of mummifying the dead continued well into Egypt's Roman period. Hundreds of mummies and mummy portraits from that time have been found in the Fayum region of Lower Egypt. The mummy becomes a "soft sculpture" with a Roman-style portrait (FIG. 3–36) painted on a wood panel in encaustic (hot colored wax), inserted over the face in the tradition of the gold mask of Tutankhamun. Although great staring eyes invariably dominate the images, the artists recorded individual features of the deceased. The Fayum portraits link Egyptian art with ancient Roman art (see Chapter 6).

IN PERSPECTIVE

Like the Mesopotamians, the Egyptians brought the prehistoric period to an end when they created hieroglyphic writing (the use of pictures of objects and other signs to represent spoken sounds). They too developed a rich tradition of written history and literature known to us today, thanks to the many surviving texts carved in stone, written on papyrus, and painted on walls.

Egyptian culture included elaborate funerary practices. Rulers devoted huge sums to the design, construction, and decoration of extensive funerary complexes, including the famous pyramids and subterranean tombs. The recovery of this art through the diligent work of archaeologists continues to enlighten and fascinate us.

All cultures have rules for representing both things and ideas, but Egyptian conventions are among the most distinctive in art history. All objects and individual elements are represented from their most characteristic viewpoint, so profile heads are seen on frontal shoulders and stare out at the viewer with eyes drawn in frontal view. Egyptian art is simplified, even geometric, in appearance and often abstract in style.

Egyptian art and history is divided into three principal periods known as the Old, Middle, and New kingdoms. The Old Kingdom was a heroic age of funerary art and architecture whose most famous works—the pyramids and the Great Sphinx—encompass the essence of Egypt to most people. The Middle Kingdom was a slightly decentralized reinstatement of the monarchy with an increase in sensitive and more personal art. In the New Kingdom, rulers devoted extraordinary resources to building temples and expanding the Egyptian empire. During the Eighteenth Dynasty, Akhenaten attempted to change the course of history, religion, and art by introducing a monotheistic religion centered on Aten, the sun. The discovery of the tomb of his successor Tutankhamun ignited an enthusiasm for Egyptian art lasting to this day.

PALETTE OF NARMER
C. 2950-2775 BCE

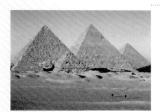

GREAT PYRAMIDS C. 2575–2450 BCE

STELE OF AMENEMHAT I C. 1938–1755 BCE

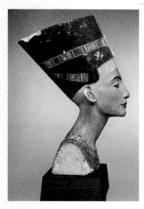

NEFERTITI C. 1353–1336 BCE

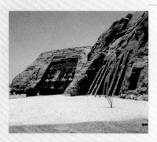

TEMPLE OF RAMESES II
C. 1279–1213 BCE

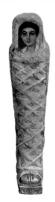

MUMMY WRAPPING
OF A YOUNG BOY
C. 100–120 CE

5500 BCE

3000

2500

2000

1500

1000

500

CE OO

ART OF ANCIENT EGYPT

- Predynastic (Neolithic)c. 5000-2950 BCE
- Early Dynastic c. 2950-2575 BCE
- Old Kingdom c. 2575-2150 BCE
- First Intermediate c. 2125-1975 BCE
- Middle Kingdom c. 1975–1640 BCE
 - Second Intermediate c. 1630-1520 BCE
- New Kingdom c. 1539–1075 BCE
- Amarna c. 1353–1336 BCE
- Third Intermediate c. 1075-715 BCE
- Late Period c. 715-332 BCE
- **Nubian** c. 712-657 BCE
- Ptolemaic c. 323-30 BCE
- Roman c. 30 BCE-395 CE

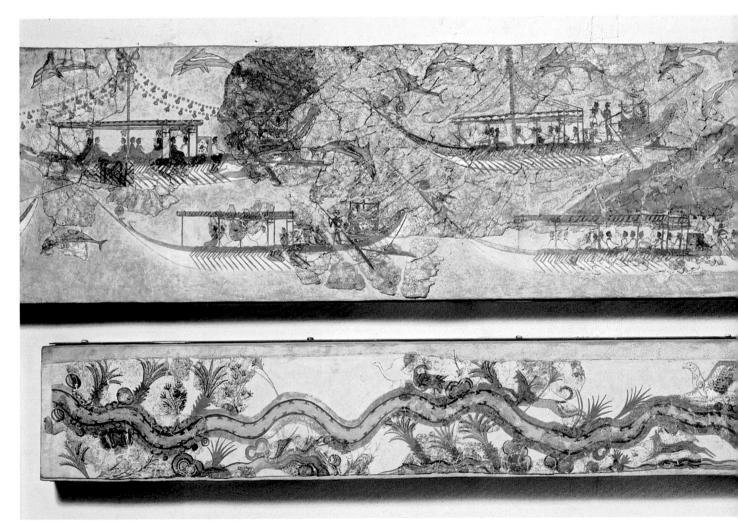

4−I | **"FLOTILLA" FRESCO** from Room 5 of West House, Akrotiri, Thera. New Palace Period, c. 1650 BCE. National Archaeological Museum, Athens.

CHAPTER FOUR

AEGEAN ART

4

Glorious pink, blue, and gold mountains flicker in the brilliant sunlight. Graceful boats glide on calm seas past islands and leaping dolphins. Picturesque villages line

the shore, with people lounging on terraces and rooftops. These words describe the very old painting you see here (FIG. 4–1): the port of Akrotiri on the island of Thera, one of the Cycladic Islands in the southern Aegean Sea. Today, Thera is a romantic and popular tourist destination called Santorini. Akrotiri and the paradise depicted in this painting ended suddenly more than 3,500 years ago, when the volcano that formed the island erupted and blew the top of the mountain off, spewing pumice that filled and sealed every crevice of Akrotiri—fortunately, after the residents had fled.

The discovery of the lost town of Akrotiri in 1967 was among the most significant archaeological events of the second half of the twentieth century, and excavation of the city is still under way. We have much to learn about the cultures that took root on the Cycladic Islands and elsewhere in the Aegean. Every clue helps, especially because only one of the three written languages used there has been decoded. For now, we depend mainly on works of art and architecture like this painting for our knowledge of life in the ancient Aegean world.

Before 3000 BCE until about 1100 BCE, three early European cultures flourished simultaneously in the Aegean region: on a cluster of small islands called the Cyclades, on Crete and

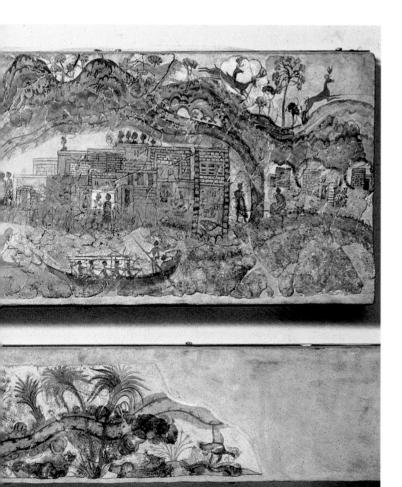

other islands in the eastern Mediterranean, and on the mainland (MAP 4–1). To learn about them, scholars of these cultures have studied shipwrecks, homes and grave sites, and the ruins of architectural complexes. In recent years, archaeologists and art historians have collaborated with researchers in such areas of study as the history of trade and the history of climate change to provide an ever-clearer picture of Aegean society at that time.

CHAPTER-AT-A-GLANCE

- THE BRONZE AGE IN THE AEGEAN
- **THE CYCLADIC ISLANDS**
- THE MINOAN CIVILIZATION ON CRETE | The Old Palace Period, c. 1900–1700 BCE | The New Palace Period, c. 1700–1450 BCE
- THE MYCENAEAN (HELLADIC) CULTURE | Helladic Architecture | Metalwork | Sculpture | Ceramic Arts
- IN PERSPECTIVE

THE BRONZE AGE IN THE AEGEAN

One of the hallmarks of Aegean society during this period was the use of bronze. Bronze, an alloy of copper and tin superior to pure copper for making weapons and tools, gave its name to the period known as the Aegean Bronze Age. (See Chapter 1 for the Bronze Age in Northern Europe.) Using metal ores imported from Europe, Arabia, and Anatolia, Aegean peoples created exquisite objects of bronze that became prized for export.

For the Aegean peoples, the sea provided an important link not only between the mainland and the islands, but also to the world beyond. In contrast to the landlocked civilizations of the Near East, and to the Egyptians, who used river transportation, the peoples of the Aegean were seafarers. So shipwrecks offer vast amounts of information about the material culture of these ancient societies. For example, the wreck of a trading vessel thought to have sunk between 1400 and 1350 BCE and discovered in the vicinity of Ulu Burun, off the southern coast of modern Turkey, carried an extremely varied cargo: metals, bronze weapons and tools, aromatic resins, fruits and spices, jewelry and beads, African ebony, ivory tusks, ostrich eggs, raw blocks of blue glass used for faience, and ceramics from the Near East, mainland Greece, and Cyprus. Among the many gold objects was a scarab associated with Nefertiti, wife of the Egyptian ruler Akhenaten (see Chapter 3). The cargo suggests this vessel cruised from port to port, loading and unloading goods as it went. It also suggests that Egypt and the people of the ancient Near East were especially important trading partners.

The great epics of Homer, the *Iliad* and the *Odyssey*, were both centered on sea voyages, and the places and characters they described roused the interests of two groundbreaking archaeologists of the nineteenth and early twentieth centuries: Heinrich Schliemann located and excavated Homeric Troy in modern western Turkey; Sir Arthur Evans unearthed one of

the great palaces on Crete, and named the civilization Minoan after the mythical king Minos. What archaeologists have since found both substantiates and contradicts Homer.

Probably the thorniest problem in Aegean archaeology is that of dating the finds. Archaeologists have developed a relative dating system for the Aegean Bronze Age, but assigning absolute dates to specific sites and objects continues to be difficult and controversial. One cataclysmic event has helped: A huge volcanic explosion on the Cycladic island of Thera thoroughly devastated Minoan civilization there and on Crete, only 70 miles to the south. Evidence from tree rings from Ireland and California and traces of volcanic ash in ice cores from Greenland put the date of the eruption about 1650-1625 BCE. Outside Thera, archaeologists rely on relative dating, based largely on pottery. Sometimes in this book you will find periods cited without attached dates and in other books you may encounter different dates from those given for objects shown here. You should expect dating to change in the future as our knowledge grows and techniques of dating improve.

THE CYCLADIC ISLANDS

On the Cycladic Islands, late Neolithic and early Bronze Age people had a thriving culture. They engaged in agriculture, herding, some crafts, and trade. They used local stone to build and fortify towns and hillside burial chambers. Because they left no written records and their origins remain obscure, their art is a major source of information about them. From about 6000 BCE on, Cycladic artists used a coarse, poor-quality local clay to make a variety of ceramic objects. Some 3,000 years later, they continued to produce relatively crude but often engaging ceramic figurines of humans and animals, as well as domestic and ceremonial wares. They also produced marble sculptures.

The Cyclades, especially the islands of Naxos and Paros, had ample supplies of a fine and durable white marble. Out of it, sculptors created a unique type of nude figure ranging

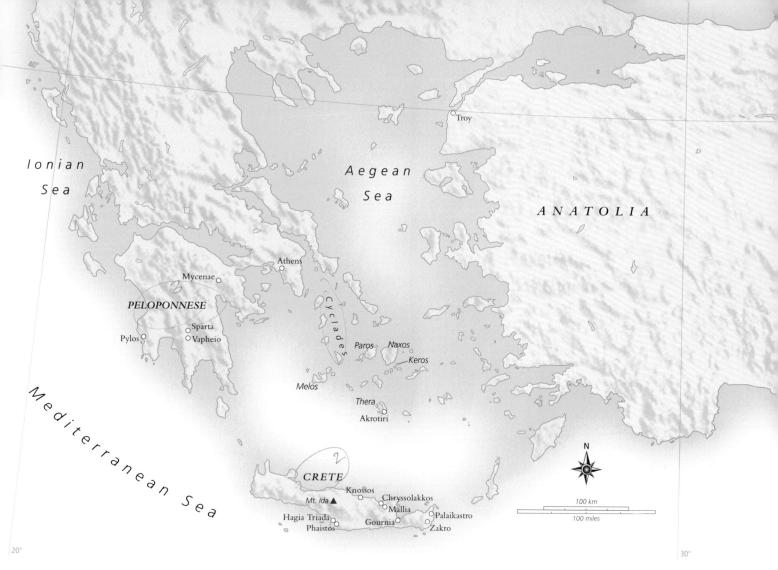

MAP 4-I THE AEGEAN WORLD

The three main cultures in the ancient Aegean were the Cycladic, in the Cyclades; the Minoan, on Thera and Crete; and the Helladic, including the Mycenaean, on the mainland.

from a few inches to about 5 feet tall. The figures are often found lying on graves. To shape the stone, sculptors used scrapers and chisels made of obsidian from the island of Melos and polishing stones of emery from Naxos. The introduction of metal tools may have made it possible for them to carve on a larger scale, but they continued to limit themselves to simple forms, perhaps because the stone fractured easily.

A few male figurines have been found, including depictions of musicians and acrobats, but they are greatly outnumbered by representations of women. The earliest female figures had simple, violinlike shapes. By 2500 BCE a more familiar type had evolved, and it has become the best-known type of Cycladic art (FIG. 4–2). The figures appear as pareddown, elegant renderings of the body. With their simple contours, the female statuettes seem not far removed from the marble slabs out of which they were carved. Tilted-back heads, folded arms, and down-pointed toes suggest that the

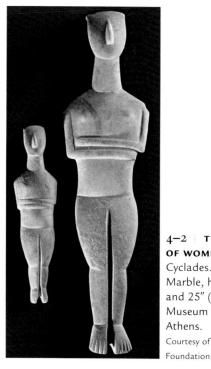

4–2 | TWO FIGURES
OF WOMEN
Cyclades. c. 2500–2200 BCE.
Marble, heights 13" (33 cm)
and 25" (63.4 cm).
Museum of Cycladic Art,
Athens.
Courtesy of the N. P. Goulandris

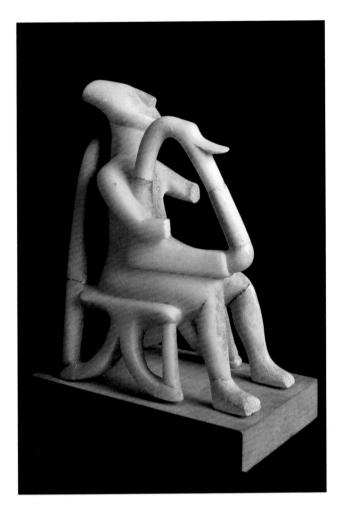

4-3 | SEATED HARP PLAYER Keros, Cyclades. c. 2700-2500 BCE. Marble, height 11½" (29.2 cm). Museum of Cycladic Art, Athens.

figures were intended to lie on their backs, as if asleep or dead. Anatomical detail has been kept to a minimum; the body's natural articulations at the hips, knees, and ankles are indicated by lines, and the pubic area is marked with a lightly incised triangle. These statues originally had painted facial features, hair, and ornaments in black, red, and blue.

The **SEATED HARP PLAYER** is a fully developed sculpture in the round (FIG. 4–3), yet its body shape is just as simplified as that of the female figurines. The figure has been reduced to its geometric essentials, yet with careful attention to elements that characterize an actual musician. The harpist sits on a high-backed chair with a splayed base, head tilted back as if singing, knees and feet apart for stability, and arms raised, bracing the instrument with one hand while plucking its strings with the other. So expressive is the pose that we can almost hear the song.

Although some Cycladic islands retained their distinctive artistic traditions, by the Middle and Later Bronze Age, the art and culture of the Cyclades as a whole was subsumed by Minoan and, later, Mycenean culture.

THE MINOAN CIVILIZATION ON CRETE

By 3000 BCE, Bronze Age people were living on Crete, the largest of the Aegean islands, 155 miles long and 36 miles wide. Crete was economically self-sufficient, producing its own grains, olives and other fruits, and cattle and sheep. But because it lacked the ores necessary for bronze production, its people were forced to look outward. With many safe harbors and a convenient location, Crete became a wealthy sea power, trading with mainland Greece, Egypt, the Near East, and Anatolia.

Between about 1900 BCE and 1375 BCE, a distinctive culture flourished on Crete. Its discoverer, the British archaeologist Sir Arthur Evans, named it Minoan from the legend of Minos, a king who had ruled from the capital, Knossos. According to the legend, a half-man, half-bull monster called the Minotaur was the son of the wife of King Minos and a bull belonging to the sea god Poseidon. It lived at Knossos in a maze called the Labyrinth. To satisfy the Minotaur's appetite for human flesh, King Minos ordered the mainland kingdom of Athens to send a yearly tribute of fourteen young men and women. Theseus, son of King Aegeus of Athens, vowed to free his people from this burden by slaying the monster.

Theseus set out for Crete with the doomed young Athenians, promising his father that on the return he would change the ship's black sails to white ones as a signal if he was victorious. With the help of Crete's princess Ariadne, who gave him a sword and a thread to mark his path through the Labyrinth, Theseus defeated the Minotaur. On his way home with Ariadne and the fourteen Athenians, he stopped at the island of Naxos, where he abandoned Ariadne. As he continued on, he forgot to raise the white sails. When King Aegeus saw the black-sailed ship, he threw himself off a cliff and into the sea that now bears his name, Aegean.

Although a number of written records from the period are preserved, the two earliest forms of Minoan writing, called hieroglyphic and Linear A, continue to defy translation. The surviving documents in a third later script, called Linear B (a very early form of Greek imported from the mainland), have proved to be valuable administrative records and inventories that give an insight into Minoan material culture.

Minoan chronology is divided into two main periods, the Old Palace Period, from about 1900 to 1700 BCE, and the New Palace Period, from around 1700 to 1450 BCE.

The Old Palace Period, c. 1900-1700 BCE

Minoan civilization remained very much a mystery until Sir Arthur Evans discovered the buried ruins of the architectural complex at Knossos, on Crete's north coast, in 1900 CE (FIGS. 4–4, 4–5). The site had been occupied in the Neolithic period, then built over with a succession of Bronze Age buildings.

Evans spent the rest of his life excavating and reconstructing the buildings he had found (see "Pioneers of Aegean

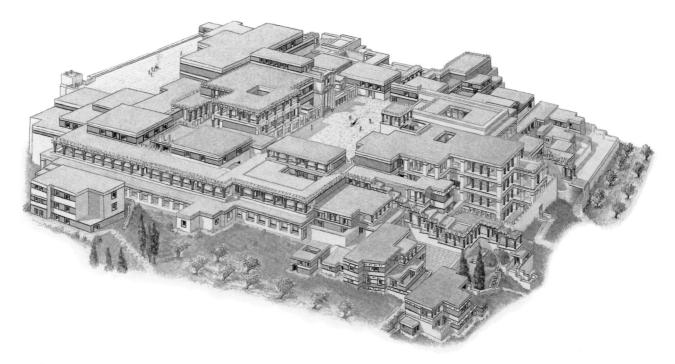

4-4 RECONSTRUCTION OF THE PALACE COMPLEX, KNOSSOS, CRETE

As it would have appeared during the New Palace Period. Site occupied 2000–1375 BCE; complex begun in Old Palace Period (c. 1900–1700 BCE); complex rebuilt after earthquakes and fires during New Palace Period (c. 1700–1450 BCE); final destruction c. 1375 BCE.

Archaeology," page 88). Like nineteenth-century excavators before him, Evans called these great architectural complexes "palaces." But palaces imply kings, and we do not know the sociopolitical structure of the society.

PALACE LAYOUTS. The walls of early Minoan buildings were made of rubble and mud bricks faced with cut and finished

local stone (dressed stone). This was the first use of dressed stone as a building material in the Aegean. Columns and other interior elements were made of wood. Both in palaces and in buildings in the surrounding towns, timber appears to have been used for framing and bracing walls. Its strength and flexibility would have minimized damage from the earthquakes common to the area. Nevertheless, the earthquake at

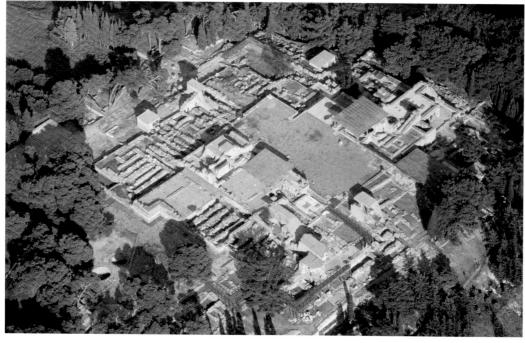

4-5 KNOSSOS, AERIAL PHOTOGRAPH OF THE SITE

Art and Its Context

PIONEERS OF AEGEAN ARCHAEOLOGY

he pioneering figure in the modern study of Aegean civilization was Heinrich Schliemann (1822–90), who was inspired by Homer's epic tales, the *Iliad* and the *Odyssey*. The son of an impoverished German minister and largely selfeducated, he worked hard in America, grew rich, and retired in 1863 to pursue his lifelong dream of becoming an archaeologist. In 1869, he began conducting fieldwork in Greece and Turkey. Scholars of that time considered Homer's stories pure fiction, but by studying the descriptions of geography in the *Iliad*, Schliemann located a multilayered site at Hissarlik, in present-day Turkey, whose sixth level up from the bedrock is now generally accepted as being Homer's Troy.

After this success, Schliemann pursued his hunch that the grave sites of Homer's Greek royal family would be found inside the citadel at Mycenae. But the graves he found were too early to contain the bodies of Atreus, Agamemnon, and their relatives. The discovery of the palace of the legendary King Minos fell to a British archaeologist, Sir Arthur Evans (1851–1941), who led the excavation of the palace at Knossos between 1900 and 1905. Evans gave the name *Minoan* to Bronze Age culture on Crete. He also made a first attempt to establish an absolute chronology for Minoan art, basing his conjectures on datable Egyptian artifacts found in the ruins on Crete and on Minoan artifacts found in Egypt. Later scholars have revised and refined his dating.

the time of the Thera eruption damaged several building sites, including Knossos and Phaistos. The structures were then repaired and enlarged, and the resulting new complexes shared a number of features. Multistoried, flat-roofed, and with many columns, they were designed to maximize light and air, as well as to define access and circulation patterns. Daylight and fresh air entered through staggered levels, open stairwells, and strategically placed air shafts and light wells (FIG. 4–6).

Suites of rooms lay around a spacious rectangular courtvard from which corridors and staircases led to other court-

4–6 KNOSSOS INTERIOR Reconstruction of palace interior staircase.

yards, private rooms and apartments, administrative and ritual areas, storerooms, and baths. Walls were coated with plaster, and some were painted with murals. Floors were plaster, plaster mixed with pebbles, stone, wood, or beaten earth. The residential quarters had many luxuries: sunlit courtyards, richly colored murals, and sophisticated plumbing systems.

Clusters of workshops in and around the palace complexes formed commercial centers. Storeroom walls were lined with enormous clay jars for oil and wine, and in their floors stone-lined pits from earlier structures had been designed for the storage of grain. The huge scale of the centralized management of foodstuffs became apparent when excavators at Knossos found in a single (although more recent) storeroom enough ceramic jars to hold 20,000 gallons of olive oil. There were also workshops that attest to the centralization of manufacturing.

The palace complex itself had a squarish plan and a large central courtyard. Causeways and corridors led from outside to the central courtyard or to special areas such as granaries or storage pits. The complex had a theater or performance area. Around the central court, independent units were made up of eight or nine suites of rooms. Each suite consisted of a forecourt with light well, a hall with a stepped lustral (purification) basin, a room with a hearth, and a series of service rooms. Such suites might belong to a family or serve a special business or government function.

CERAMIC ARTS. During the Old Palace Period, Minoans developed extraordinarily sophisticated metalwork and elegant new types of ceramics, spurred in part by the introduction of the potter's wheel early in the second millennium BCE. One type of ceramic is called Kamares ware, after the cave on Mount Ida overlooking the palace complex at Phaistos, in southern Crete, where it was first discovered. The hallmarks of this select ceramic ware—so sought-after that it was exported as far away as Egypt and Syria—were its extremely

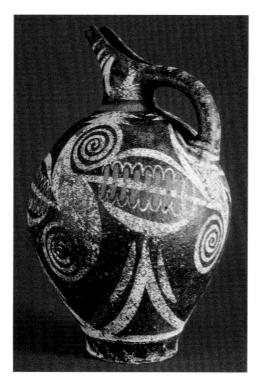

4-7 | KAMARES WARE JUG
Phaistos, Crete. Old Palace Period, c. 2000-1900 BCE.
Ceramic, height 10 %" (27 cm). Archaeological Museum, Iraklion, Crete.

thin walls, its use of color, and its graceful, stylized, painted decoration. An example from about 2000–1900 BCE has a globular body and a "beaked" pouring spout (FIG. 4–7). Decorated with brown, red, and creamy white pigments on a black body, the jug has rounded contours complemented by bold, curving forms derived from plant life.

METALWORK. Matching Kamares ware in sophistication is early Minoan goldwork (see "Aegean Metalwork," page 93). By about 1700 BCE, Aegean metalworkers were producing objects rivaling those of Near Eastern and Egyptian jewelers, whose techniques they may have adopted. For a pendant in gold found at Chryssolakkos (FIG. 4–8), the artist arched a pair of bees (or perhaps wasps) around a honeycomb of gold granules, providing their sleek bodies with a single pair of outspread wings. The pendant hangs from a spiderlike form, with what appear to be long legs encircling a tiny gold ball. Small disks dangle from the ends of the wings and the point where the insects' bodies meet. The simplified geometric patterns and shapes convey the insects' actual appearance.

Cultural and artistic tradition continued unbroken into the New Palace Period when Minoan civilization reached its highest point.

The New Palace Period, c. 1700-1450 BCE

The "old palace" at Knossos, erected about 1900 BCE, formed the core of an elaborate new one built after the Thera eruption in c. 1650–1625 BCE. The Minoans rebuilt at Knossos and elsewhere, inaugurating the New Palace Period and the

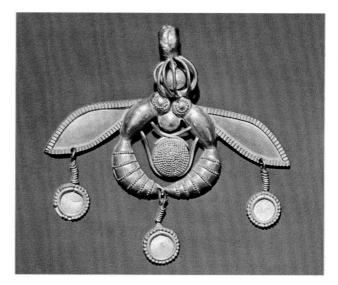

4–8 | PENDANT OF GOLD BEES Chryssolakkos, near Mallia, Crete. Old Palace Period, c. 1700–1550 BCE. Gold, height approx. 111/16" (4.6 cm). Archaeological Museum, Iraklion, Crete.

flowering of Minoan art. In its heyday, the palace complex covered six acres (SEE FIG. 4–5).

THE LABYRINTH AT KNOSSOS. Because double-ax motifs were used in its architectural decoration, the Knossos palace was referred to in later Greek legends as the Labyrinth, meaning the "House of the Double Axes" (Greek *labrys*, "double ax"). The layout of the complex seemed so complicated that the word *labyrinth* eventually came to mean "maze" and became part of the Minotaur legend.

The layout provided the complex with its own internal security system: a baffling array of doors leading to unfamiliar rooms, stairs, and yet more corridors. Admittance could be denied by blocking corridors, and some rooms were accessible only from upper terraces. The building was a warren of halls, stairs, dead ends, and suites. Close analysis, however, shows that the builders had laid out a square grid following predetermined principles, and that the apparently confusing layout was caused in part by earthquake destruction and rebuilding over the centuries.

In typical Minoan fashion, the rebuilt Knossos complex was organized around a large central courtyard. A few steps led from the central courtyard down into the so-called Throne Room to the west, and a great staircase on the east side descended to the Hall of the Double Axes, an unusually grand example of a Minoan hall (Evans gave the rooms their misleading but romantic names; see, for example, FIG. 4–6). This hall and others were supported by the uniquely Minoan-type wood columns that became standard in Aegean palace architecture. The tree trunks from which the columns were made were inverted so that they tapered toward the bottom. The top, supporting massive roof beams and a broad flattened capital, was wider than the bottom.

4–9 YOUNG GIRL GATHERING SAFFRON CROCUS FLOWERS
Detail of wall painting, Room 3 of House Xeste 3, Akrotiri, Thera.
Cyclades before 1630 BCE. Thera Foundation, Petros M. Nomikos, Greece.

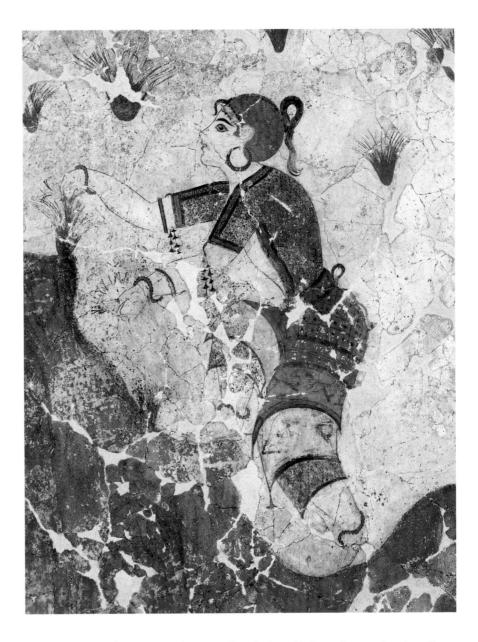

Rooms, following Old Palace tradition, were arranged around a central space rather than along a long axis, as we have seen in Egypt and will see on the mainland. During the New Palace Period, suites functioned as archives, business centers, and residences. Some must also have had a religious function, though the temples, shrines, and elaborate tombs seen in Egypt are not found in Minoan architecture.

WALL PAINTING AT AKROTIRI. Minoan painters worked on a large scale, covering the walls of palace rooms with geometric borders, views of nature, and scenes of human activity. Murals can be painted on a still-wet plaster surface (buon fresco) or a dry one (fresco secco). The wet technique binds pigments to the wall, but forces the painter to work very quickly. On a dry wall, the painter need not hurry, but the pigments tend to flake off in time. Minoans used both techniques. Their preferred colors were red, yellow, black, white, green, and blue. Like Egyptian painters, Minoan artists filled in the outlines of their figures and objects with unshaded areas of pure color.

Minoan wall painting displays elegant drawing, linear contours filled with bright colors, a preference for profile or full-faced views, and a stylization that turns natural forms into decorative patterns. Those conventions can be seen in the vivid murals at Akrotiri, on the Cycladic island of Thera (SEE FIG. 4–1). Along with other Minoan cultural influences, the art of wall painting seems to have spread to both the Cyclades and mainland Greece. Thera, for example, was so heavily under Crete's influence at this time that it was virtually an outpost of Minoan culture.

The paintings in residences at Akrotiri demonstrate a sophisticated decorative sense, both in color selection and in surface detail. Some of the subjects at Akrotiri also occur in the art of Crete, but others are new. One of the houses, for example, has rooms dedicated to young women's initiation ceremonies. In the detail shown here, a young woman picks saffron crocus, valuable for its use as a yellow dye, as a flavoring for food, and as a medicinal plant to alleviate menstrual cramps (FIG. 4–9). The girl wears the typically colorful

Minoan flounced skirt with a short-sleeved, open-breasted bodice, large earrings, and bracelets. She still has the shaved head, fringe of hair, and long ponytail of a child, but the light blue color of her scalp indicates that the hair is beginning to grow out.

In another house, an artist has created a landscape of hills, rocks, and flowers (FIG. 4–10). This mural is unlike anything previously encountered in ancient art, the first pure landscape painting. A viewer standing in the center of the room is surrounded by orange, rose, and blue rocky hillocks sprouting oversized deep red lilies. Swallows, represented by a few deft lines, swoop above and around the flowers. The artist unifies the rhythmic flow of the undulating landscape, the stylized patterning imposed on the natural forms, and the

decorative use of bright colors alternating with darker neutral tones, which were perhaps meant to represent areas of shadow. The colors—pinks, blues, yellows—may seem fanciful to us, but sailors today who know the area well attest to their accuracy: The artist recorded the actual colors of Thera's wet rocks in the sunshine. The impression is one of a celebration of the natural world. How different is this art—which captures a zestful joy of life—from the cool, static elegance of Egyptian painting!

BULL LEAPING AT KNOSSOS. One of the most famous and best-preserved paintings at Knossos depicts bull leaping. The restored panel is one of a group of paintings with bulls as subjects from a room in the palace's east wing (the painting is later

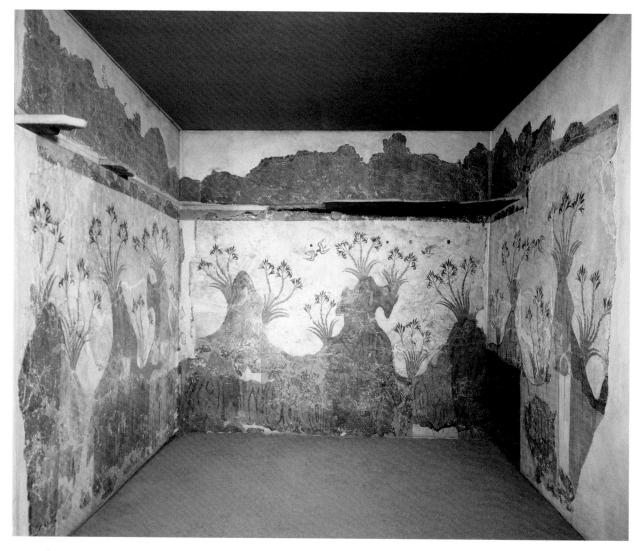

4–10 | LANDSCAPE (SPRING FRESCO)
Wall painting with areas of modern reconstruction, from Akrotiri, Thera Cyclades. Before 1630 BCE.
National Archaeological Museum, Athens.

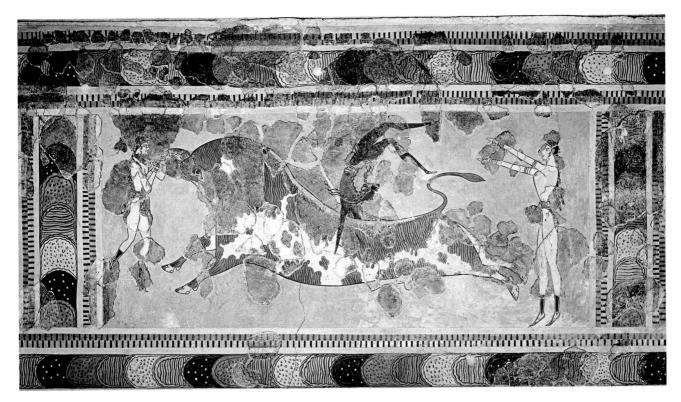

4-II BULL LEAPING

Wall painting with areas of modern reconstruction, from the palace complex, Knossos, Crete. Late Minoan period, c. 1550-1450 BCE. Height approx. 24½" (62.3 cm). Archaeological Museum, Iraklion, Crete.

than the Akrotiri paintings). The action may represent an initiation or fertility ritual. **BULL LEAPING** (FIG. 4–II) shows three scantily clad youthful figures around a gigantic dappled bull, which is charging in the "flying–gallop" pose. The pale-skinned person at the right—probably a woman—is prepared to catch the dark–skinned man in the midst of his leap, and the pale–skinned woman at the left grasps the bull by its horns, perhaps to begin her own vault. The bull's power and grace are masterfully rendered, although the flying–gallop pose is not true to life. Framing the action are overlapping ovals (the so-called chariot–wheel motif) set within striped bands.

SCULPTURE: THE WOMAN WITH SNAKES. Surviving Minoan sculpture consists mainly of small, finely executed work in wood, ivory, precious metals, stone, and faience. Female figurines holding serpents are among the most characteristic images and may have been associated with water, regenerative power, and protection of the home.

The **WOMAN OR GODDESS WITH SNAKES** from the palace at Knossos is intriguing both as a ritual object and as a work of art (FIG. 4–12). This faience figurine was found with other

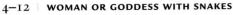

As restored, from the palace complex, Knossos, Crete. New Palace period, c. 1700–1550 BCE. Faience, height 11%" (29.5 cm). Archaeological Museum, Iraklion, Crete.

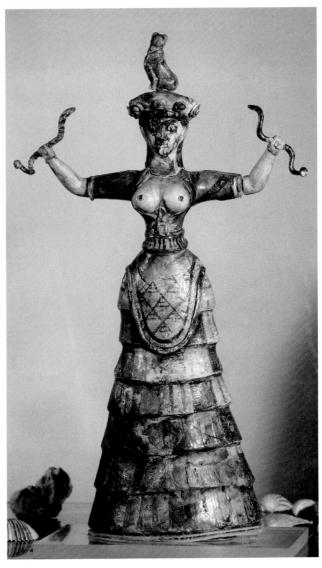

Technique

AEGEAN METALWORK

egean artists created exquisite luxury goods from imported gold. Their techniques included lost-wax casting (see "Lost-Wax Casting," PAGE XXV), inlay, filigree, repoussé (embossing), niello, and gilding. The Vapheio Cup (SEE FIG. 4-16) and the funerary mask (SEE FIG. 4-24) are examples of repoussé, in which the artist gently hammered out relief forms from the back of a thin sheet of gold. Experienced goldsmiths may have done simple designs freehand or used standard wood forms or punches. For more elaborate decorations they would first have sculpted the entire design in wood or clay and then used this form as a mold for the gold sheet.

The artists who created the Mycenaean dagger blade (SEE FIG. 4-25) not only inlaid one metal into another but also

employed a special technique called niello, still a common method of metal decoration. Powdered nigellum—a black alloy of lead, silver, and copper with sulfur—was rubbed into very fine engraved lines in the object being decorated, then fused to the surrounding metal with heat. The lines appear to be black drawings.

Gilding, the application of gold to an object made of some other material, was a technically demanding process by which paper-thin sheets of hammered gold called **gold leaf** (or, if very thin, **gold foil**) were meticulously affixed to the surface to be gilded. This was done with amazing delicacy for the now-bare stone surface of the Harvester Vase (SEE FIG. 4–13) and the wooden horns of the bull's-head rhyton (SEE FIG. 4–14).

ceremonial objects in a pit in one of Knossos's storerooms. Bare-breasted, arms extended, and brandishing a snake in each hand, the woman is a commanding presence. A leopard or a cat (perhaps a symbol of royalty, perhaps protective) is poised on her crown, which is ornamented with circles. This shapely figure is dressed in a fitted, open bodice with an apron over a

typically Minoan flounced skirt. A wide belt cinches the waist. The red, blue, and green geometric patterning on her clothing reflects the Minoan weavers' preference for bright colors, patterns, and fancy borders. Realistic elements combine with formal stylization to create a figure that is both lively and dauntingly, almost hypnotically, powerful—a combination that has led scholars to disagree whether statues such as this one represent deities or their human attendants.

STONE RHYTONS. Almost certainly of ritual significance are the stone vases and **rhytons**—vessels used for pouring liquids—that Minoans carved from steatite (a greenish or brown soapstone). These pieces were all found in fragments. The **HARVESTER VASE** is an egg-shaped rhyton barely $4\frac{1}{2}$ inches in diameter (FIG. 4–13). It may have been covered with **gold leaf**, sheets of hammered gold (see "Aegean Metalwork," above).

A rowdy procession of twenty-seven men has been crowded onto its curving surface. The piece is exceptional for the freedom with which the figures occupy three-dimensional space, overlapping and jostling one another instead of marching in orderly single file across the surface in the manner of Near Eastern or Egyptian art. Also new is the exuberance of this scene, especially the emotions shown on the men's faces. They march and chant to the beat of a sistrum—a rattlelike percussion instrument—played by a man who seems to sing at the top of his lungs. The men have large,

4-13 HARVESTER VASE

Hagia Triada, Crete. New Palace Period, c. 1650–1450 BCE. Steatite, diameter 4½" (11.3 cm). Lower part of vase is reconstructed. Archaeological Museum, Iraklion, Crete.

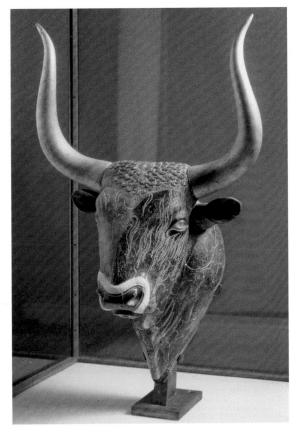

4–I4 | BULL'S-HEAD RHYTON
Palace complex, Knossos, Crete. New Palace Period, c.1550–1450 BCE. Steatite with shell, rock crystal, and red jasper, the gilt-wood horns restored, height 12" (30.5 cm). Archaeological Museum, Iraklion, Crete.

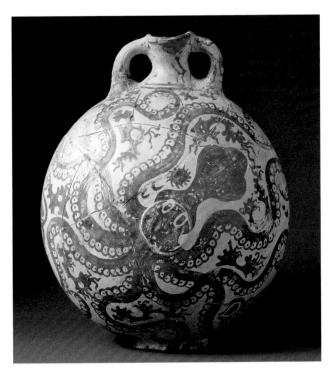

4–15 | OCTOPUS FLASK
Palaikastro, Crete. New Palace Period, c. 1500-1450 BCE.
Marine style ceramic, height 11" (28 cm).
Archaeological Museum, Iraklion, Crete.

coarse features and sinewy bodies so thin that their ribs stick out. Archaeologists have interpreted the scene in many ways—as a spring planting or fall harvest festival, a religious procession, a dance, a crowd of warriors, or a gang of forced laborers.

Rhytons were also made in the form of a bull's head (FIG. 4–14). Bulls often appear in Minoan art, rendered with an intensity not seen since the prehistoric cave paintings at Altamira and Lascaux (Chapter 1). Although many early cultures associated their gods with powerful animals, neither their images nor later myths offer any proof that the Minoans worshiped a bull god. According to later Greek legend, the Minotaur in King Minos's palace was not an object of religious veneration.

The sculptor of a bull's head rhyton found at Knossos used a block of greenish-black steatite to create an image that approaches animal portraiture. Lightly engraved lines, filled with white powder to make them visible, indicate the animal's coat: short, curly hair on top of the head; longer, shaggy strands on the sides; and circular patterns along the neck suggest its dappled coloring. White bands of shell outline the nostrils, and painted rock crystal and red jasper form the eyes. The horns (restored) were made of wood covered with gold leaf. Additionally, liquid could be poured into a hole in the neck and flowed out from the mouth.

Vessels. The ceramic arts, so splendidly demonstrated in Old Palace Kamares ware, continued throughout the New Palace Period. Some of the most striking ceramics were done in what is called the "Marine style," because of the depictions of sea life on their surfaces. In a stoppered bottle of this style known as the OCTOPUS FLASK, made about 1500–1450 BCE (FIG. 4–15), the painter celebrates the sea. Like microscopic life teeming in a drop of pond water, sea creatures float around an octopus's tangled tentacles. The decoration on the Kamares ware jug (SEE FIG. 4–7) reinforces the solidity of its surface, but here the pottery skin seems to dissolve. The painter captured the grace and energy of natural forms while presenting them as a stylized design in harmony with the vessel's spherical shape.

METALWORK. About 1450 BCE, a conquering people from mainland Greece, known as Mycenaeans, arrived in Crete. They occupied the buildings at Knossos and elsewhere until a final catastrophe and the destruction of Knossos about 1375 BCE caused them to abandon the site. But by 1400 BCE, the center of political and cultural power in the Aegean had shifted to mainland Greece.

The skills of Minoan artists, particularly metalsmiths, made them highly sought after in mainland Greece. A pair of magnificent gold cups found in a large tomb at Vapheio, on

the Greek mainland south of Sparta, were made sometime between 1650 and 1450 BCE, either by Minoan artists or by locals trained in Minoan style and techniques. One cup is shown here (FIG. 4–16). The relief designs were executed in repoussé—the technique of hammering from the back of the sheet. The handles were attached with rivets, and the cup was then lined with sheet gold. In the scene that circles the cup, men are depicted trying to capture bulls in various ways. Here, a half-nude man has roped a bull's hind leg. The figures dominate the landscape, which literally bulges with a muscular vitality that belies the cup's small size—it is only $3\frac{1}{8}$ inches tall. The depiction of olive trees could indicate that the scene is a sacred grove, and that these may be illustrations of exploits in some long-lost heroic tale rather than commonplace herding scenes.

THE MYCENAEAN (HELLADIC) CULTURE

Archaeologists use the term *Helladic* (from *Hellas*, the Greek name for Greece) to designate the Aegean Bronze Age on mainland Greece. The Helladic period extends from about 3000 to 1000 BCE, concurrent with the Cycladic and Minoan periods. In the early part of the Aegean Bronze Age, Greekspeaking peoples, probably from the northwest, moved into the mainland. They brought with them advanced techniques for metalworking, ceramicware, and architectural design, and they displaced the local Neolithic culture. When Minoan culture declined after about 1450 BCE, people of a late Helladic mainland culture known as Mycenaean, after the city of

Sequencing Events EGYPTIAN, MYCENAEAN, AND MINOAN CULTURES	
с. 3000 все	Early Bronze Age in the Cyclades
с. 2200 все	First Palaces at Knossos, Crete
с. 2000 все	First pictographic script, Crete
с. 1900 все	Old Palace Period
с. 1650-25 все	Destruction of Thera, earthquakes and volcanic eruption
с. 1600 все	Mycenaeans rise to power
с. 1450 все	Destruction of Minoan palaces; Knossos occupied by Mycenaeans
с. 1400 все	Knossos burned and not rebuilt
с. 1300 все	Mycenaean walls on acropolis in

Mycenae, occupied Crete as well as Greece, and rose to dominance in the Aegean region.

End of Mycenaean dominance

Athens

Helladic Architecture

c. 1100 BCE

Mycenaean architecture was distinct from that of the Minoans. Mycenaeans built strongholds of megaliths called citadels to protect the palaces of their rulers. These palaces contained a characteristic structure called a *megaron* that was axial in plan. The Mycenaeans also buried their dead in magnificent vaulted tombs, round in shape and crafted of cut stone.

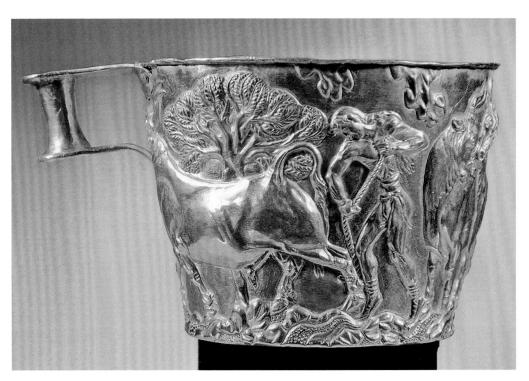

4–16 | VAPHEIO CUP Found near Sparta, Greece. c. 1650–1450 все. Gold, height 3½″ (3.9 cm). Archaeological Museum, Iraklion, Crete.

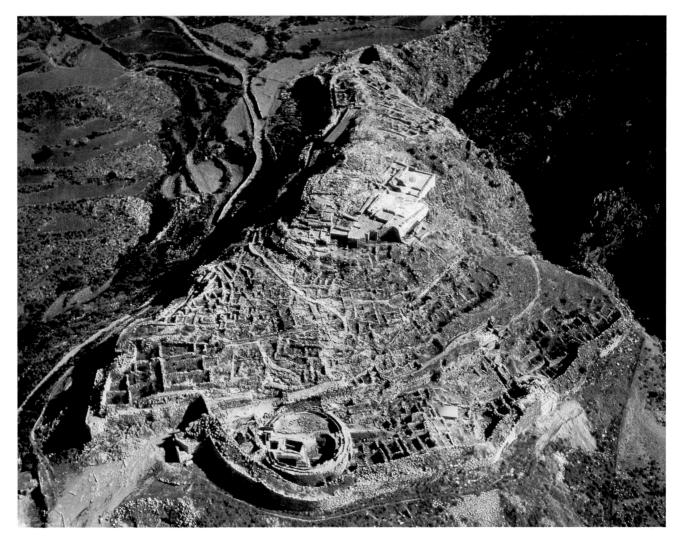

4–17 | CITADEL AT MYCENAE
Greece. Aerial view. Site occupied c. 1600–1200 BCE; walls built c. 1340, 1250, 1200 BCE.

The citadel's hilltop position, the grave circle at the bottom center of the photograph, and the circuit walls are clearly visible. The Lion Gate (see "The Lion Gate," pages 100-101) is at the lower left. The megaron floor and bases of columns and walls are at the top of the hill, at the upper center.

THE CITADEL AT MYCENAE. Later Greek writers called the walled city of Mycenae (FIGS. 4-17, 4-18), located near the east coast of the Peloponnese peninsula in southern Greece, the home of Agamemnon, the leader of the Greek army that conquered the great city of Troy (see "Homeric Greece," page 98). The site has been occupied from the Neolithic period to around 1050 BCE. Even today, the monumental gateway to the citadel at Mycenae is an impressive reminder of the importance of the city. The walls were rebuilt three times—c. 1340 BCE, c. 1250 BCE, and c. 1200 BCE—each time stronger than the last and enclosing more space. The second wall of c. 1250 BCE enclosed the grave circle and was pierced by two gates, the monumental Lion Gate (see "The Lion Gate," pages 100-101) on the west and a small postern gate on the northeast side. The final walls were extended about 1200 BCE to protect the water supply, an underground cistern. These walls were about 25 feet thick and nearly 30 feet high. The drywall masonry is known as **cyclopean**, because it was believed that only the giant Cyclops could have moved such massive stones.

As in Near Eastern citadels, the Lion Gate was provided with guardian figures, which stand above the door rather than in the door jambs. From this gate, the formal entranceway into the citadel, known as the Great Ramp, led up the hillside, past the grave circle, to the king's residence and council room.

The ruler's residence was built on the highest point in the center of the city. Its distinctive feature was a large audience hall called a **megaron**, or "great room." The main courtyard led to a large rectangular building with a porch, a vestibule, and finally the great room—a much more direct approach to the principal room than the complex corridors of a Minoan palace. A typical megaron had a central hearth surrounded by

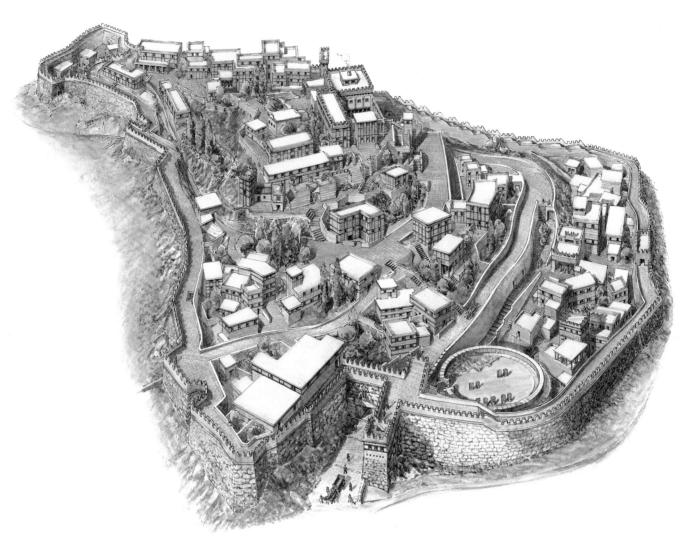

4−18 | RECONSTRUCTION OF CITADEL AT MYCENAE

four large columns that supported the ceiling. The roof above the hearth was raised to admit light and air and permit smoke to escape (FIG. 4–19). Some architectural historians think that the megaron eventually came to be associated with royalty. The later Greeks adapted its form when building temples, which they saw as earthly palaces for their gods.

THE PALACE AT PYLOS. The rulers of Mycenae fortified their city, but the people of Pylos, in the extreme southwest of the Peloponnese, perhaps felt that their more remote and defensible location made them less vulnerable to attack. It may be that the people of Pylos should have taken greater care to protect themselves. Within a century of its construction, the palace at Pylos (c. 1300–1200 BCE) was destroyed by fires, apparently set during the violent upheavals that brought about the collapse of Mycenae.

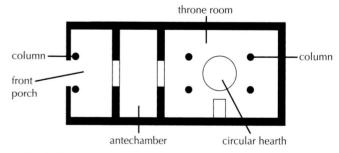

4–19 PYLOS PALACE PLAN c. 1300–1200 BCE.

The palace at Pylos was built on a raised site without fortifications, and it was focused on the ruler's residence and megaron. Set behind a porch and vestibule facing the court-yard, the Pylos megaron was a magnificent display of architectural and decorative skill. The reconstructed view provided

Art and Its Context

HOMERIC GREECE

he legend of the Trojan War and its aftermath held a central place in the imagination of ancient people. Sometime before 700 BCE, it inspired the great epics of the Greek poet Homer—the *Iliad* and the *Odyssey*—and provided later poets and artists with rich subject matter.

According to the legend, a woman's infidelity caused the war. While on a visit to the city of Sparta in the Peloponnese, in southern Greece, young Paris, son of King Priam of Troy, fell in love with Helen, a human daughter of Zeus who was the wife of the Spartan king Menelaus. With the help of Aphrodite, the goddess of love, Helen and Paris fled to Troy, a rich city in northwestern Asia Minor. The angry Greeks dispatched ships and a huge army to bring Helen back. Led by Agamemnon, king of Mycenae and the brother of Menelaus, the Greek forces laid siege to Troy. The two sides were deadlocked for ten years, until a ruse devised by the Greek warrior Odysseus enabled the Greeks to win: The Greeks pretended to give up the siege and built a huge wooden horse to leave behind as a parting gift to the god-

dess Athena. In fact, Greek warriors were hidden inside the wooden horse. After the Trojans pulled the horse inside the gates of Troy, the Greeks slipped out and opened the gates to their comrades, who slaughtered the Trojans and burned the city.

This legend probably originated with a real attack on a coastal city of Asia Minor by mainland Greeks during the late Bronze Age. Tales of the conflict, modified over the centuries, endured in a tradition of oral poetry until finally written down and attributed to Homer.

Archaeologists, including Schliemann, concluded that the remains of the legendary city might be found at the Hissarlik Mound in northwestern Turkey. Excavated first in 1872–90 and again beginning in the 1930s, this relatively small mound—less than 700 feet across—contained the "stacked" remains of at least nine successive cities, the earliest of which dates to at least 3000 BCE. The most recent hypothesis is that so-called Troy 6 (the sixth-level city), which flourished between about 1800 and 1300 BCE, was the Troy of Homeric legend.

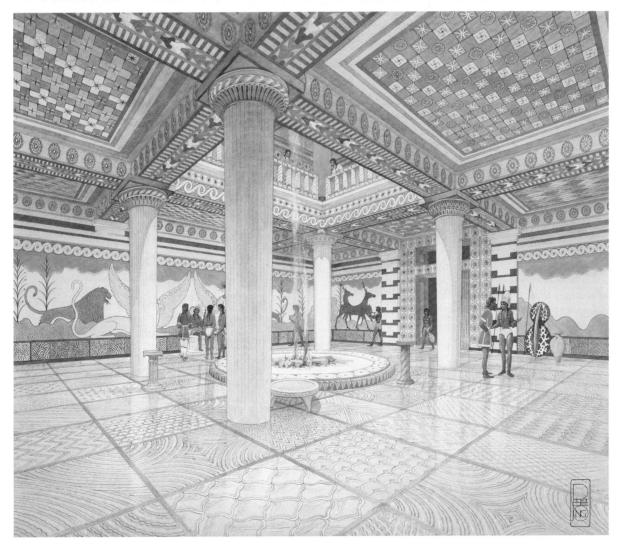

4–20 | **RECONSTRUCTION DRAWING OF THE MEGARON IN THE PALACE AT PYLOS** Greece. c. 1300–1200 BCE. Drawing in Antonopouleion Archaeological Museum, Pylos.

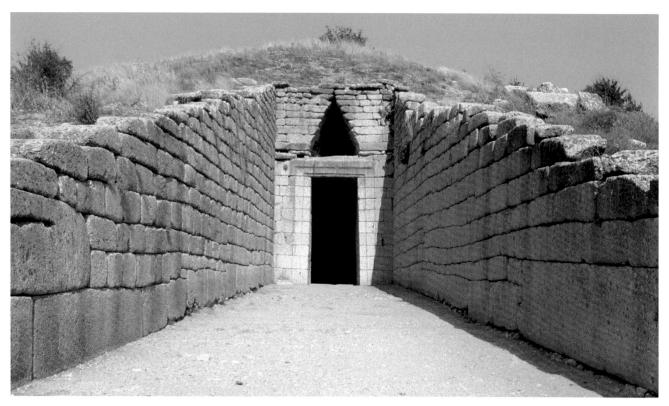

4–21 † THOLOS, THE SO-CALLED TREASURY OF ATREUS Mycenae, Greece. c. 1300–1200 BCE.

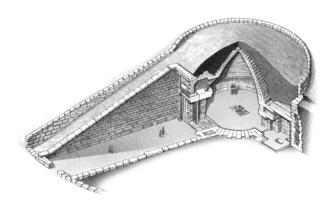

4-22 CUTAWAY DRAWING OF THOLOS

here (FIG. 4–20) shows how the combined throne room and audience hall might have looked. Fluted, upward-swelling Minoan-type columns support heavy ceiling beams. Every inch was painted—floors, ceilings, beams, and door frames were covered with brightly colored abstract designs, and the walls were covered with paintings of large mythical animals and highly stylized plant and landscape forms. The floor was finished with painted plaster.

Clay tablets in Linear B found in the ruins of the palace include an inventory of furnishings that indicates they were as elegant as the architecture. The listing on one tablet reads: "One ebony chair with golden back decorated with birds; and a footstool decorated with ivory pomegranates. One ebony chair with ivory back carved with a pair of finials and

with a man's figure and heifers; one footstool, ebony inlaid with ivory and pomegranates."

MYCENAEAN TOMBS. Tombs were given much greater prominence in the Helladic culture of the mainland than they were by the Minoans, and ultimately they became the most architecturally sophisticated monuments of the entire Aegean period. The earliest burials were in shaft graves, vertical pits 20 to 25 feet deep. In Mycenae, the royal graves were enclosed in a circle of standing stone slabs. In these graves, the ruling families laid out their dead in opulent dress and jewelry and surrounded them with ceremonial weapons (SEE FIG. 4–25), gold and silver wares, and other articles indicative of their status, wealth, and power. It was in shaft grave V that the so-called mask of Agamemnon was found (SEE FIG. 4–24).

By about 1600 BCE, kings and princes on the mainland had begun building large above-ground burial places commonly referred to as **tholos tombs** (popularly known as **bee-hive tombs** because of their rounded, conical shape). More than a hundred such tombs have been found, nine of them in the vicinity of Mycenae. Possibly the most impressive is the so-called **TREASURY OF ATREUS** (FIGS. 4–21, 4–22) which dates from about 1300 to 1200 BCE.

A walled passageway through the earthen mound covering the tomb, about 114 feet long and 20 feet wide and open to the sky, led to the entrance. The original entrance was 34 feet high and the door was $16\frac{1}{2}$ feet high, faced with bronze plaques. It was flanked by engaged, upward-tapering columns

THE OBJECT SPEAKS

THE LION GATE

ne of the most imposing survivals from the Helladic Age is the gate to the city of Mycenae. The gate is today a simple opening, but its importance is indicated not only by the monumental sculptures of guardian beasts, but by the very material of the flanking walls, a conglomerate stone that can be polished to glistening multicolors. Additionally, a corbelled relieving arch above the lintel forms a triangle filled with a limestone panel bearing a grand heraldic composition—a single Minoan column that tapers upward to a large bulbous capital and abbreviated entablature.

An archival photograph shows a group posing jauntily beside, and in, the gate. Visible is Heinrich Schliemann (standing at the left of the gate) and his wife and partner in archeology, Sophia (sitting at the right). Schliemann had already "discovered" Troy, and when he turned his attention to Mycenae, he unearthed graves with rich grave goods, including gold masks (see Fig. 4-24). The grave circle he excavated lay just beyond the Lion Gate.

The Lion Gate has been the subject of much speculation in recent years. What are the animals? What does the architectural feature mean? How is the imagery to be interpreted? The beasts supporting and defending the column are magnificent supple creatures rearing up on hind legs. They once must have faced the visitor, but today only the attachment holes indicate the presence of their heads.

What were they—lions or lionesses? One scholar points out that since the beasts have neither teats nor penises, it is impossible to say. The beasts do not even have to be felines. They could have had eagle heads, which would make them griffins, in which case should they not also have wings? They could have had human heads, and that would turn them into sphinxes. Pausanias, a Greek traveler who visited Mycenae in the second century CE, described a gate guarded by lions. Did he see the now missing heads? Did the "object" not only speak, but roar?

Mixed-media sculpture—ivory and gold, marble and wood—was common. One could imagine that if the creatures had the heads of lions, the heads might have resembled the gold cup in the form of a lion that still survives. Such heads would have gleamed and glowered out at the visitor. And if the sculpture were painted, as most sculpture was, the gold would not have seemed out of place.

A metaphor for power, the lions rest their feet on Mycenaean altars. Between them stands the mysterious column, also on an altar base. What does it mean? Scholars do not agree. Is it a temple? A palace? The entire city? Or the god of the place? The column and capital support a lintel or architrave, which in turn supports the butt ends of logs forming rafters of the horizontal roof, so the most likely theory is that the structure is the symbol of a palace or a temple. But some scholars suggest that by extension it becomes the symbol of a king or a deity (just as we say the "White House" when we mean the government of the United States), and that the imagery of the Lion Gate, with its combination of the guardian beasts and divine or royal palace, serves to legitimize the power of the ruler.

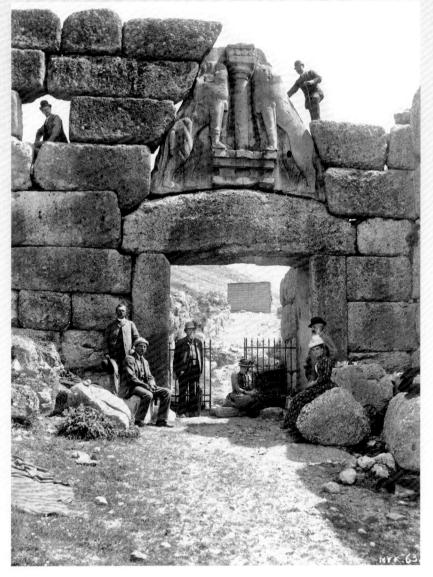

LION GATE, MYCENAE

c. 1250 BCE. Historic photo.

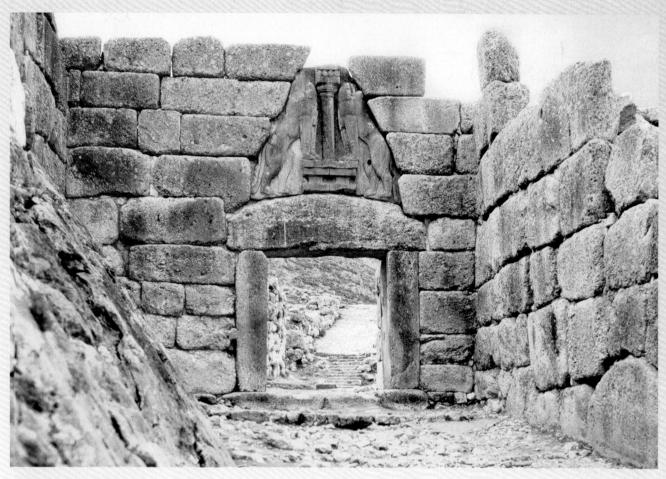

LION GATE, MYCENAE c. 1250 BCE. Limestone relief, height of sculpture approx. 9'6'' (2.9 m).

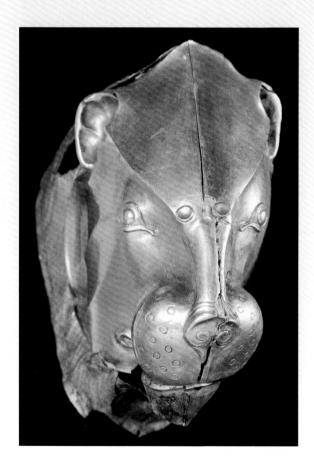

GOLDEN LION'S HEAD RHYTONShaft grave IV, south of Lion gate, Mycenae, sixteenth century BCE.
National Archaeological Museum, Athens.

4–23 | CORBELED VAULT, INTERIOR OF THOLOS Limestone vault, height approx. 43′ (13 m), diameter 47′6″ (14.48 m).

This great beehive tomb was half buried until it was excavated by Christos Stamatakis in 1878. For more than a thousand years, this Mycenaean tomb remained the largest uninterrupted interior space built in Europe. The first European structure to exceed it in size was the Pantheon in Rome (Chapter 6), built in the first century BCE.

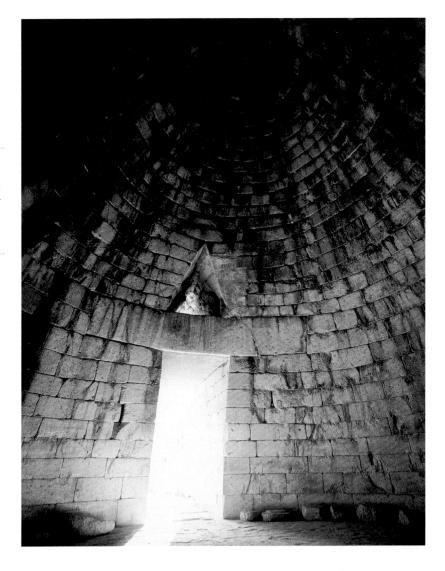

that were carved of green serpentine porphyry found near Sparta and incised with geometric bands and chevrons—inverted Vs—filled with running spirals, a favorite Aegean motif. The section above the lintel had smaller engaged columns on each side, and the relieving triangle was disguised behind a red-and-green engraved marble panel. The main tomb chamber (FIG. 4–23) is a circular room 47½ feet in diameter and 43 feet high. It is roofed with a corbel vault built up in regular courses, or layers, of ashlar—squared stones—smoothly leaning inward and carefully calculated to meet in a single capstone at the peak. Covered with earth, the tomb became a conical hill. It was a remarkable engineering feat.

Metalwork

The tholos tombs at Mycenae had been looted long before archaeologist Heinrich Schliemann began to search for Homeric Greece, but he did excavate the contents of shaft graves (vertical pits 20 to 25 feet deep) at the site. Magnificent gold and bronze swords, daggers, masks, jewelry, and drinking cups were found buried with members of the elite.

Schliemann believed the citadel at Mycenae to be the home of Agamemnon, the commander-in-chief of the Greek

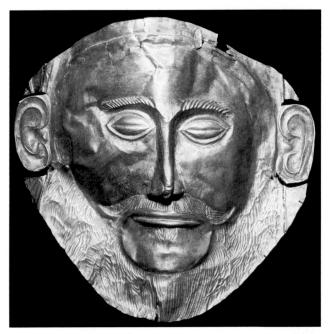

4–24 | "MASK OF AGAMEMNON"
Funerary mask, from the royal tombs, Grave Circle A, Mycenae, Greece. c. 1600–1550 BCE. Gold, height approx. 12" (35 cm). National Archaeological Museum, Athens.

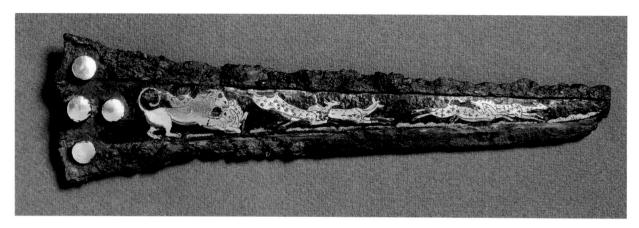

4–25 DAGGER BLADE WITH LION HUNT
Shaft Grave IV, Grave Circle A, Mycenae, Greece. c. 1550–1500 BCE. Bronze inlaid with gold, silver, and niello, length 9½" (23.8 cm). National Archaeological Museum, Athens.

forces against Troy. Among the 30 pounds of gold objects he found in the royal graves were five death masks, and one of these golden treasures (FIG. 4–24) seemed to him to be the face of Homer's hero. We now know this golden mask has nothing to do with the heroes of the Trojan War. Research shows the Mycenae graves are about 300 years older than Schliemann believed, and the burial practices they display were different from those described by Homer. Still, the mask image is so commanding that we sense it is a hero's face. But the characteristics that make it seem so gallant—such as the handlebar moustache and large ears—have caused some scholars to question its authenticity. This mask is significantly different from the others found at the site, and some scholars contend that Schliemann added features to make the mask appear more heroic to viewers of his day.

Among the other objects found in the graves, the gold lion head rhyton (see "The Lion Gate," page 101) and bronze dagger blade (FIG. 4–25), decorated with inlaid scenes, attest to the wealth of a ruling elite. To form the decoration of the dagger, the Mycenaean artist cut shapes out of different-colored metals—copper, silver, and gold—inlaid them in the bronze blade, and then added the fine details in niello (see "Aegean Metalwork," page 93). In the *Iliad*, Homer's epic poem about the Trojan War, the poet describes similar decoration on Agamemnon's armor and Achilles' shield. The decoration on the blade shown here depicts a lion attacking a deer, with four more terrified animals in full flight. Like the bull in the Minoan fresco (FIG. 4–11), the animals spring forward in the "flying-gallop" pose to indicate speed and energy.

Sculpture

Mainland artists saw Minoan art as it was acquired through trade. Perhaps they even worked side by side with Minoan artists brought back by the conquerors of Crete. They adopted Minoan art with such enthusiasm that sometimes experts disagree over the identity of the artists—were they Minoans working for Mycenaeans or Mycenaeans taught by, or copying, Minoans?

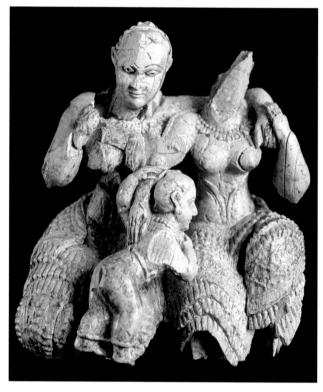

4–26 | TWO WOMEN WITH A CHILD Found in the palace at Mycenae, Greece, c. 1400–1200 BCE. Ivory, height 2¼" (7.5 cm). National Archaeological Museum, Athens.

A carved ivory group of two women and a child (FIG. 4–26), less than 3 inches high and found in the palace shrine at Mycenae, appears to be a product of Minoan-Mycenaean artistic exchange. Dating from about 1400–1200 BCE, the miniature exhibits carefully observed natural forms, an intricately interlocked composition, and finely detailed rendering. The group is carved entirely in the round—top and bottom as well as back and front. It is an object to be held in the hand. Because there are no clues to the identity or the significance of the group, we might easily interpret it as generational—with grandmother, mother, and child. But the figures could just as

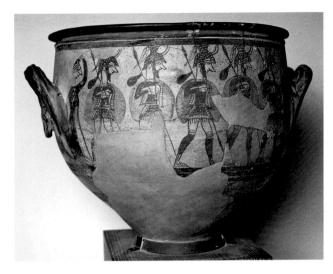

well represent two nymphs or devotees attending a child god. In either case, the mood of affection and tenderness among the three is unmistakable, and, tiny as it is, the sculpture gives an insight into a gentler aspect of Mycenaean art.

Ceramic Arts

In the final phase of the Helladic period, Mycenaean potters created highly refined ceramics. A large **krater**, a bowl for mixing water and wine, used both in feasts and as grave markers, is an example of the technically superior wares being produced between 1300 and 1100 BCE. Decorations could be highly stylized, like the scene of marching men on the **warrior vase** (FIG. 4–27). On the side shown here, a woman at the far left bids farewell to a group of helmeted men marching off to the right with lances and large shields. The vibrant energy of the *Harvester Vase* or the *Vapheio Cup* has changed to the regular rhythm inspired by the tramping feet of disciplined warriors. The only indication of the woman's emotions is the gesture of an arm raised to her head, a symbol of mourning. The men are seemingly interchangeable parts in a rigidly disciplined war machine.

The succeeding centuries, between about 1100 and 900 BCE, were a "dark age" in the Aegean, marked by political, economic, and artistic instability and upheaval. But a new culture was forming, one that looked back to the exploits of the Helladic warrior-kings as the glories of a heroic age, while setting the stage for a new Greek civilization.

IN PERSPECTIVE

The study of the eastern Mediterranean—the Aegean Sea—is, in some senses, the newest of archeological studies. The culture of Mycenae, home of Agamemnon and the setting of the great Homeric tragedies, was discovered only at the end of the nineteenth century, and Knossos on Crete, the home of the Minotaur as well as King Minos, only at the beginning of the twentieth century.

The legends and myths of the Greeks and the epics of Homer—long part of the Western literary tradition—were at last given material form. The architectural complex of Knossos, with its open courts and sweeping stairs, also included living quarters, workrooms, storehouses, and a large performance area, but no grandiose tombs or temples. Relatively secure in its island location, the palace had few outer walls and watchtowers. Minoan art as reconstructed seems open, colorful, and filled with images of nature.

Three parallel geographical groups existed simultaneously, and the groups flourished at different times. Cycladic civilization peaked first in a Bronze Age culture beginning in 3000 BCE and characterized, as far as monuments in the history of art are concerned, by marble figures of women and musicians. On Crete, the Minoan culture had existed since Neolithic times but flourished in the Old and New Palace periods from about 1900 to about 1450 BCE. Minoan art is characterized by elaborate and lightly fortified architectural complexes (which we call palaces), wall painting, and work in precious and semiprecious materials—gold, ivory, bronze, steatite, ceramics, and textiles. On the mainland of Greece, the Mycenaeans rose to dominance about 1600 BCE with fortified citadels, princely burials, and magnificent gold and bronze equipment. The culture continued until about 1100 BCE, but by the year 1000 BCE this Aegean Age comes to an end.

c. 2700-2500 BCE

3000 BCE

AEGEAN ART

- Aegean Bronze Age c. 3000-2000 BCE
- Cycladic Culturec. 3000-1600 BCE
- Bronze Age Culture on Crete c. 3000 BCE
- Helladic Culture 3000-1000 BCE

Cycladic

c. 2000–1900 BCE

2500

2000

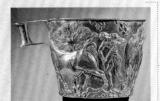

VAPHEIO CUP C. 1650–1450 BCE

Nuncan

plinoan

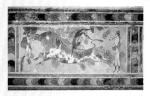

BULL LEAPING C. 1550–1450 BCE

MEGARON IN THE PALACE
OF PYLOS
C. 1300–1200 BCE

1500

IOOO BCE

Minoan Old Palace c. 1900-1700 BCE

✓ Minoan New Palace
 c. 1700-1450 BCE
 1650 ✓ 60 Cano.

Mycenaean Culture c. 1600-1100 BCE

■ Late Minoan c. 1450–1100 BCE

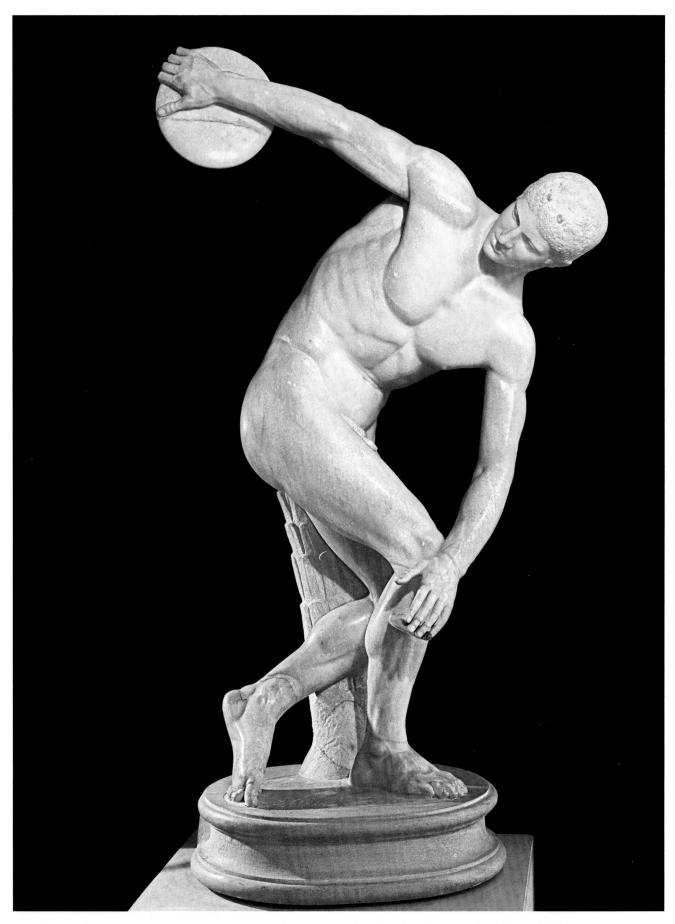

5-I+Myron **DISCUS THROWER (DISKOBOLOS)** Roman copy after the original bronze of c. 450 BCE. Marble, height 5'11'' (1.55 m). National Museum, Rome.

Early classical / aligh classical cusp

CHAPTER FIVE

ART OF ANCIENT GREECE

A sense of awe fills the stadium when the athletes recognized as the best in the world enter. With the opening ceremonies behind them, each has only one goal: to win—to earn recognition as the best, to take home the champi-

onship. This competition began more than 2,500 years ago, but the scene seems familiar. Every four years, then as now, the best athletes came together. Attention would focus on physical competition, on the individual human beings who seemed able to surpass even their own abilities—in such feats as running, wrestling, riding, discus throwing, long jumping, boxing, and javelin hurling—in the glorious pursuit of an ideal. Yet beyond those common elements lie striking differences between the Olympian Games of the past and the Olympic Games of the present.

At those first Olympian Games, the contests had a strong religious aspect. The athletes gathered on sacred ground (near Olympia, in present-day Greece) to pay tribute to the supreme god, Zeus. The first day's ceremonies were religious rituals, and the awards were crowns of wild olive leaves from the Sacred Grove of the gods. The winners' deeds were celebrated by poets long after their victories, and the greatest athletes were idealized for centuries in extraordinary Greek sculpture, such as the **DISCUS THROWER (DISKOBOLOS)**, originally created in bronze by Myron about 450 BCE (FIG. 5–1).

The hero Herakles was believed to be the founder of the Olympian Games. According to the ancients, Herakles drew up the rules and decided the size of the stadium. The Olympian Games came to be so highly regarded that the city-states suspended all political activities while the Games were in progress. The Games may have begun in the

ninth century BCE; a list of winners survives from 776 BCE. Games were held every four years until they were banned in 393 CE by the Christian Roman emperor Theodosius I. They did not resume for centuries: The first modern Olympic Games were held in Athens in 1896. The modern Olympics too begin with the lighting of a flame from a torch ignited by the sun at Olympia and carried by relay to the chosen site for a particular year—an appropriate metaphor for the way the light of inspiration was carried from ancient Greece throughout the Western world. But Olympic Games were not the only contribution the Greeks made to world civilization.

"Man is the measure of all things," concluded Greek sages. Supremely self-aware and self-confident, the Greeks developed a concept of human supremacy and responsibility into a worldview that demanded a new visual expression in art. Artists studied the human figure intensely, then distilled their newfound knowledge to capture the essence of humanity—a term that, by the Greeks' definition, applied only to those who spoke Greek; they considered those who could not speak Greek "barbarians."

Greek customs, institutions, and ideas have had an enduring influence in many parts of the world. Countries

that esteem athletic prowess reflect an ancient Greek ideal. Systems of higher education in the United States and Europe also owe much to ancient Greek models. Many important Western philosophies have conceptual roots in ancient Greece. And representative governments throughout the world today owe a debt to ancient Greek experiments in democracy.

CHAPTER-AT-A-GLANCE

- THE EMERGENCE OF GREEK CIVILIZATION | Historical Background | Religious Beliefs and Sacred Places | Historical Divisions of Greek Art
- GREEK ART FROM c. 900 to 600 BCE | The Geometric Period | The Orientalizing Period
- THE ARCHAIC PERIOD, c. 600–480 BCE | Temple Architecture | Architectural Sculpture | Freestanding Sculpture | Vase Painting
- THE CLASSICAL PERIOD, c. 480–323 BCE | The Canon of Polykleitos | The Art of the Early Classical Period, 480–450 BCE
- THE HIGH CLASSICAL PERIOD, c. 450–400 BCE | The Acropolis | The Parthenon | The Propylaia and the Erechtheion | The Temple of Athena Nike | The Athenian Agora | Stele Sculpture | Painting: Murals and Vases
- THE LATE CLASSICAL PERIOD, c. 400–323 BCE | Architecture and Architectural Sculpture | Sculpture | The Art of the Goldsmith | Wall Painting and Mosaics
- THE HELLENISTIC PERIOD, 323–31/30 BCE | The Corinthian Order in Hellenistic Architecture | Hellenistic Architecture: The Theater at Epidauros | Sculpture | The Multicultural Hellenistic World
- IN PERSPECTIVE

THE EMERGENCE OF GREEK CIVILIZATION

Ancient Greece was a mountainous land of spectacular natural beauty. Olive trees and grapevines grew on the steep hill-sides, producing oil and wine. But with little good farmland, the Greeks turned to commerce to supply their needs. In towns, skilled artisans provided metal and ceramic wares to exchange abroad for grain and raw materials. Greek merchant ships carried pots, olive oil, and bronzes from Athens, Corinth, and Aegina around the Mediterranean Sea. The Greek cultural orbit included mainland Greece with the Peloponnesus in the south and Macedonia in the north, the Aegean Islands, and the western coast of Asia Minor (MAP 5–1). Greek colonies in Italy, Sicily, and Asia Minor rapidly became powerful independent commercial and cultural centers themselves, but they remained tied to the homeland by common language, traditions, religion, and history.

More than 2,000 years have passed since the artists and architects of ancient Greece worked, yet their achievements continue to have a profound influence. Their legacy is especially remarkable given their relatively small numbers, the almost constant warfare that beset them, and the often harsh economic conditions of the time. Greek artists sought a level of perfection that led them continually to improve upon their past accomplishments through changes in style and technique. The history of Greek art contrasts dramatically with that of Egyptian art, where the desire for permanence and continuity induced artists to maintain artistic conventions for

nearly 3,000 years. In the comparatively short time span from around 900 BCE to about 100 BCE, Greek artists explored a succession of new ideas to produce a body of work in every medium—from painting and mosaics to ceramics and sculpture—that exhibits a clear stylistic and technical direction toward representing the visual world as we see it. The periods into which ancient Greek art is traditionally divided reflect the definable stages in this stylistic progression.

Historical Background

Following the collapse of Mycenaean dominance about 1100-1025 BCE, the Aegean region experienced a period of disorganization during which most prior cultural developments, including writing, were destroyed or forgotten. Greeks in the ninth and eighth centuries BCE developed the citystate (polis), an autonomous region having a city—Athens, Corinth, Sparta—as its political, economic, religious, and cultural center. Each was independent, deciding its own form of government, securing its own economic support, and managing its own domestic and foreign affairs. The power of these city-states initially depended at least as much on their manufacturing and commercial skills as on their military might. In the seventh century BCE, the Greeks adopted two sophisticated new tools, coinage from Asia Minor and alphabetic writing from the Phoenicians, opening the way for success in commerce and literature.

Among the emerging city-states, Corinth, located on major land and sea trade routes, was one of the oldest and

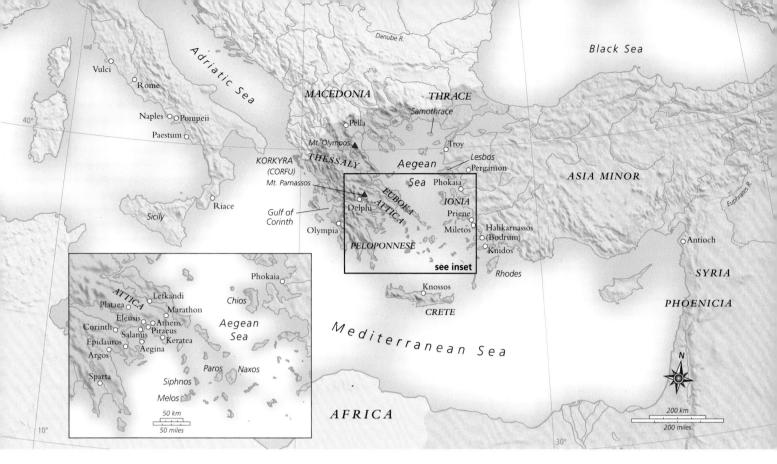

MAP 5-I ANCIENT GREECE

During the Hellenistic period, Greek influence extended beyond mainland Greece to Macedonia, Egypt, and Asia Minor.

most powerful. By the sixth century BCE, Athens, located in Attica on the east coast of the mainland, began to assume both commercial and cultural preeminence. By the end of the sixth century, Athens had a representative government in which every community had its own assembly and magistrates. All citizens participated in the assembly and all had an equal right to own private property, to exercise freedom of speech, to vote and hold public office, and to serve in the army or navy. Citizenship, however, remained an elite male prerogative. The census of 309 BCE in Athens listed 21,000 citizens, 10,000 foreign residents, and 400,000 others—that is, women, children, and slaves. In spite of the exclusive and intensely patriarchal nature of citizenship, the idea of citizens with rights and responsibilities was an important new concept in governance.

Religious Beliefs and Sacred Places

Knowledge of Greek history is important to understanding its arts; knowledge of its religious beliefs is indispensable. According to ancient Greek legend, the creation of the world involved a battle between the earth gods, called Titans, and the sky gods. The victors were the sky gods, whose home was believed to be atop Mount Olympus in the northeast corner of the Greek mainland. The Greeks saw their gods as immortal and endowed with supernatural powers, but more than peoples of the ancient Near East and the Egyptians, they also visualized them in human form and attributed to them human weaknesses and emotions. Among the most important deities were the ruling god and goddess, Zeus and Hera; Apollo, god of healing, arts, and the sun; Poseidon, god of the sea; Ares, god of war; Aphrodite, goddess of love; Artemis, goddess of hunting and the moon; and Athena, the powerful goddess of wisdom who governed several other important aspects of human life (see "Greek and Roman Deities," page 110).

SANCTUARIES. Many sites throughout Greece, called **sanctuaries**, were thought to be sacred to one or more gods. Local people enclosed the sanctuaries and designated them as sacred ground. The earliest sanctuaries had one or more outdoor altars or shrines and a sacred natural element such as a tree, a rock, or a spring. As more buildings were added, a

109

Art and Its Context

GREEK AND ROMAN DEITIES

ccording to legend, twelve major sky gods and goddesses established themselves on Mount Olympos in northeastern Greece after defeating the earth deities (the Titans) for control of the earth and sky. (The Roman form of the name is given after the Greek name.)

THE FIVE CHILDREN OF EARTH AND SKY

- **Zeus** (Jupiter), supreme deity. Mature, bearded man; holds scepter or lightning bolt; eagle and oak tree are sacred to him.
- **Hera** (Juno), goddess of marriage. Sister/wife of Zeus. Mature woman; cow and peacock are sacred to her.
 - **Hestia** (Vesta), goddess of the hearth. Sister of Zeus. Her sacred flame burned in communal hearths.
- **Poseidon** (Neptune), god of the sea. Holds a three-pronged spear; horse is sacred to him.
- **Hades** (Pluto), god of the underworld, the dead, and wealth. His helmet makes the wearer invisible.

THE SEVEN SKY GODS, OFFSPRING OF THE FIRST FIVE

- **Ares** (Mars), god of war. Son of Zeus and Hera. Wears armor; vulture and dog are sacred to him.
- Hephaistos (Vulcan), god of the forge, fire, and metal handicrafts. Son of Hera (in some myths, also of Zeus); husband of Aphrodite. Lame, sometimes ugly; wears blacksmith's apron, carries hammer.
- Apollo (Phoebus), god of the sun, light, truth, music, archery, and healing. Sometimes identified with Helios (the Sun), who rides a chariot across the daytime sky. Son of Zeus and Leto (a descendant of Earth); brother of Artemis. Carries bow and arrows or sometimes lyre; dolphin and laurel are sacred to him.
- Artemis (Diana), goddess of the hunt, wild animals, and the moon. Sometimes identified with Selene (the Moon), who rides a chariot or oxcart across the night sky. Daughter of

- Zeus and Leto; sister of Apollo. Carries bow and arrows, is accompanied by hunting dogs; deer and cypress are sacred to her. Also the goddess of childbirth and unwed young women.
- Athena (Minerva), goddess of wisdom, war, victory, and the city. Also goddess of handcrafts and other artistic skills. Daughter of Zeus; sprang fully grown from his head. Wears helmet and carries shield and spear; owl and olive trees are sacred to her.
- **Aphrodite** (Venus), goddess of love. Daughter of Zeus and the water nymph Dione; alternatively, born of sea foam; wife of Hephaistos. Myrtle, dove, sparrow, and swan are sacred to her.
- Hermes (Mercury), messenger of the gods, god of fertility and luck, guide of the dead to the underworld, and god of thieves and commerce. Son of Zeus and Maia, the daughter of Atlas, a Titan who supports the sky on his shoulders. Wears winged sandals and hat; carries caduceus, a wand with two snakes entwined around it.

OTHER IMPORTANT DEITIES

- **Demeter** (Ceres), goddess of grain and agriculture. Daughter of Kronos and Rhea, Sister of Zeus and Hera.
- **Persephone** (Proserpina), goddess of fertility and queen of the underworld. Wife of Hades; daughter of Demeter.
- **Dionysos** (Bacchus), god of wine, the grape harvest, and inspiration. Shown surrounded by grapevines and grape clusters; carries a wine cup. His female followers are called maenads (Bacchantes).
- Eros (Cupid), god of love. In some myths, the son of Aphrodite. Shown as an infant or young boy, sometimes winged; carries bow and arrows.
- Pan (Faunus), protector of shepherds, god of the wilderness and of music. Half-man, half-goat, he carries panpipes.
- Nike (Victory), goddess of victory. Often shown winged and flying.

sanctuary might become a palatial home for the gods, with one or more temples, several treasuries for storing valuable offerings, various monuments and statues, housing for priests and visitors, an outdoor dance floor or permanent theater for ritual performances and literary competitions, and a stadium for athletic events. The Sanctuary of Zeus near Olympia, in the western Peloponnese, housed an extensive athletic facility with training rooms and arenas for track-and-field events. It was here that athletic competitions, prototypes of today's Olympic Games, were held.

Greek sanctuaries are quite different from the religious complexes of the ancient Egyptians (see, for example, the Temple of Karnak, figs. 3–22, 3–23). Egyptian builders dramatized the power of gods or god-rulers by organizing their

temples along straight, processional ways. The Greeks, in contrast, treated each building and monument as an independent element to be integrated with the natural features of the site. It is tempting to draw a parallel between this manner of organizing space and the way Greeks organized themselves politically. Every structure, like every Greek citizen, was a unique entity meant to be encountered separately within its own environment while being closely allied with other entities in a larger scheme of common purpose.

DELPHI. The temple at Delphi, the sacred home of the Greek god Apollo, was built about 530 BCE on the site of an earlier temple (FIG. 5–2). In this rugged mountain site, according to Greek myth, Zeus was said to have released two

Cantier Cartier

eagles from opposite ends of the earth and they met exactly at the site of Apollo's sanctuary. Here too, it was said, Apollo fought and killed Python, the serpent son of the earth goddess Ge, who guarded his mother's nearby shrine. From very early times, the sanctuary at Delphi was renowned as an *oracle*, a place where the god was believed to communicate with humans by means of cryptic messages delivered through a human intermediary, or *medium* (the Pythia). The Greeks and their leaders routinely sought advice at oracles, and attributed many twists of fate to misinterpretations of the Pythia's statements. Even foreign rulers requested help at Delphi.

Delphi was the site of the Pythian Games which, like the Olympian Games, attracted participants from all over Greece. The principal events were the athletic contests and the music, dance, and poetry competitions in honor of Apollo. As at Olympia, hundreds of statues dedicated to the victors of the competitions, as well as mythological figures, filled the sanctuary grounds. The sanctuary of Apollo included the main temple, performance and athletic areas, treasuries, and other buildings and monuments, which made full use of limited space on the hillside.

After visitors climbed the steep path up the lower slopes of Mount Parnassos, they entered the sanctuary by a ceremonial gate in the southeast corner. From there they zigzagged up the Sacred Way, so named because it was the route of religious processions during festivals. Moving past the numerous treasuries and memorials built by the city-states, they arrived

at the long colonnade of the Temple of Apollo. Below the temple was a stoa, a columned pavilion open on three sides, built by the people of Athens. There visitors rested, talked, or watched ceremonial dancing. At the top of the sanctuary hill was a stadium area for athletic contests.

Historical Divisions of Greek Art

The names of major periods of Greek art have remained in use, even though changing interpretations have led some art historians to question their appropriateness. The primary source of information about Greek art before the seventh century BCE is pottery, and the Geometric period (c. 900–700 BCE) owes its name to the geometric, or rectilinear, forms with which artists of the time decorated ceramic vessels. The Orientalizing period (c. 700-600 BCE) is named for the apparent influence of Egyptian and Near Eastern art on Greek pottery of that time, spread through trading contacts as well as the travels of artists themselves. The name of the third period, Archaic, meaning "old" or "old-fashioned," stresses a presumed contrast between the art of that time (c. 600-480 BCE) and the art of the following Classical period, once thought to be the most admirable and highly developed. It is a view that no longer prevails among art historians.

The Classical period has been subdivided into three phases: the Early Classical period or transitional style from about 480 to 450 BCE; the High Classical period, from about 450 to the end of the fifth century BCE; and the Late

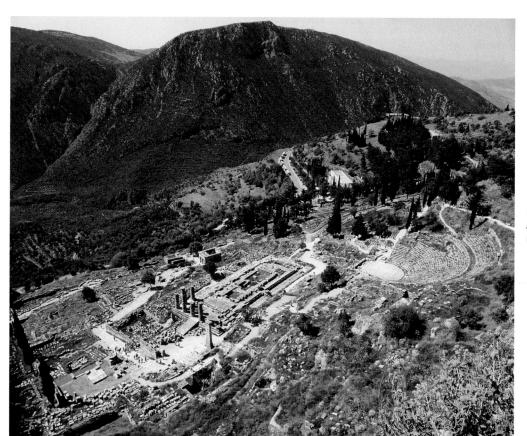

5−2 | SANCTUARY OF APOLLO, DELPHI 6th-3rd century BCE.

Classical, from about 400 to about 323 BCE. High Classical art was once known as the "Golden Age" of Greece. The name of the final period of Greek art, *Hellenistic*, means "Greeklike." Hellenistic art was produced throughout the eastern Mediterranean world as non-Greek people gradually became imbued with Greek culture under Alexander and his successors (323–30 BCE). The history and art of ancient Greece end with the fall of Egypt to the Romans in 31 BCE and the death of Cleopatra one year later.

GREEK ART FROM c. 900 to c. 600 BCE

Around the mid-eleventh century BCE, a new culture began to develop from the ashes of the Mycenaean civilization. A style of ceramic, decorated with organized abstract designs, appeared in Athens and spread to the rest of Greece. This development signaled an awakening that was soon followed by the creation of monumental ceramic vessels embellished with complex geometric designs, the resumption of bronze casting, and perhaps the construction of religious architecture. In this Geometric period, the Greeks, as we now call them, were beginning to create their own architectural forms and were trading actively with their neighbors to the east. By c. 700 BCE, in a phase called the Orientalizing period, they began to incorporate exotic motifs into their native art.

The Geometric Period

The first appearance of a specifically Greek style of vase painting, as opposed to Minoan or Mycenaean, dates to about 1050 BCE. This style—known as Proto-Geometric because it anticipated the Geometric style—was characterized by linear motifs, such as spirals, diamonds, and cross-hatching, rather than the stylized plants, birds, and sea creatures characteristic of Minoan vase painting. The Geometric style proper, an extremely complex form of decoration, became widespread after about 900 BCE in all types of art and endured until about 700 BCE.

CERAMICS. A striking ceramic figure of a half-horse, half-human creature called a centaur dates to the end of the tenth century BCE (FIG. 5–3). This figure exemplifies two aspects of the Proto–Geometric style: the use of geometric forms in painted decoration, and the reduction of human and animal body parts to simple geometric solids, such as cubes, pyramids, cylinders, and spheres. The figure is unusual, however, because of its large size (more than a foot tall) and because its hollow body was formed like a vase on a potter's wheel. The artist added solid legs, arms, and a tail (now missing) and then painted the bold, abstract designs with slip, a mixture of water and clay. The slip fired to dark brown, standing out against the lighter color of the unslipped portions of the figure.

Centaurs, prominent in Greek mythology, had both a good and a bad side and may have symbolized the similar

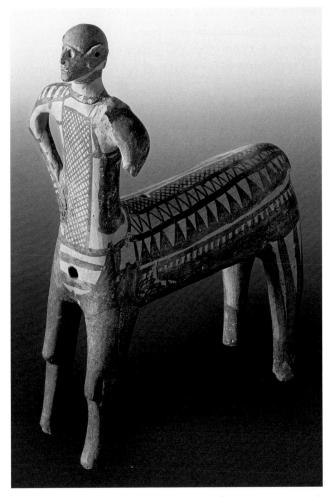

5-3 | CENTAUR
Lefkandi, Euboea. Late 10th century BCE. Ceramic, height
14½" (36 cm). Archaeological Museum, Eretria, Greece.

dual nature of humans. This centaur, discovered in a cemetery, had been deliberately broken into two pieces that were buried in adjacent graves. Clearly, the object had special significance for the people buried in the graves or for their mourners.

Large funerary vases were used as grave markers (FIG. 5-4). The ancient cemetery of Athens just outside the Dipylon Gate, once the main western entrance into the city, contained many vases with the complex decoration typical of the Geometric style proper (c. 900-700 BCE). For the first time, human beings are depicted as part of a narrative. The krater illustrated here, a grave marker dated about 750 BCE, provides a detailed record of the funerary rituals—including the relatively new Greek practice of cremation—for an important person. The body of the deceased is placed on its side on a funeral bier, about to be cremated, as seen on the center of the top register of the vase. Male and female figures stand on each side of the body, their arms raised and both hands placed on top of their heads in a gesture interpreted as expressing anguish—it suggests that the mourners are literally tearing their hair out with grief. In the bottom register, horse-drawn

chariots and foot soldiers, who look like walking shields with tiny antlike heads and muscular legs, form a procession.

The abstract forms used to represent human figures on this pot—triangles for torsos; more triangles for the heads in profile; round dots for eyes; long, thin rectangles for arms; tiny waists; and long legs with bulging thigh and calf muscles—are typical of the Geometric style. Figures are shown in either full-frontal or full-profile views that emphasize flat patterns and outline shapes. No attempt has been made to create the illusion of three-dimensional forms occupying real space. The artist has nevertheless communicated a deep sense of human loss by exploiting the rigidity, solemnity, and strong rhythmic accents of the carefully arranged elements.

Egyptian funerary art reflected the belief that the dead, in the afterworld, could continue to engage in activities they enjoyed while alive. Greek funerary art, in contrast, focused on the emotional reactions of the survivors. The scene of human mourning on this pot contains no supernatural beings, nor any identifiable reference to an afterlife. According to the Greeks, the deceased entered a place of mystery and obscurity that living humans could not define precisely.

Sequencing Events KEY PERIODS IN GREEK ART

с. 1050-900 все	Proto-Geometric Period
с. 900-700 все	Geometric Period
с. 700-600 все	Orientalizing Period
с. 600-480 все	Archaic Period
с. 480-450 все	Early Classical Period
с. 450-400 все	High Classical Period
с. 400-323 все	Late Classical Period
323-31/30 BCE	Hellenistic Period

METAL SCULPTURE. Greek artists of the Geometric period produced many figurines of wood, ivory, clay, and cast bronze. These small statues of humans and animals are similar to those painted on pots. A tiny bronze of this type, MAN AND CENTAUR, dates to about 750 BCE (FIG. 5–5). (Although there were wise and good centaurs, the theme of battling man and centaur is found throughout Greek art.) The two figures

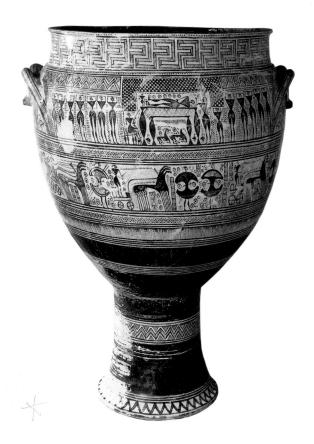

5-4 FUNERARY VASE (KRATER)

Dipylon Cemetery, Athens. c. 750-700 BCE. Attributed to the Hirschfeld Workshop. Ceramic, height 42 1/8" (108 cm). The Metropolitan Museum of Art, New York. Rogers Fund, 1914 (14.130.14)

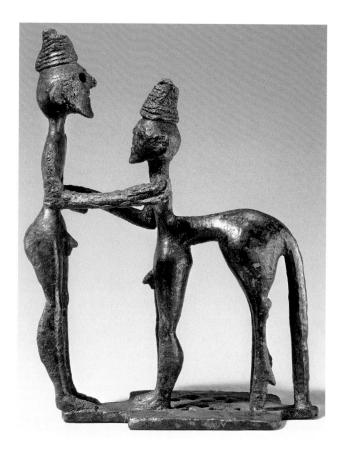

5-5 MAN AND CENTAUR

Perhaps from Olympia. c. 750 BCE. Bronze, height 4%" (11.1 cm). The Metropolitan Museum of Art, New York. Gift of J. Pierpont Morgan, 1917 (17.190.2072)

Technique

GREEK PAINTED VASES

he three main techniques for decorating Greek painted vases were black-figure, red-figure, and white-ground. The painters used a complex procedure that involved preparing a slip (a mixture of clay and water), applying the slip to the vessel, and carefully manipulating the firing process in a kiln (a closed oven) to control the amount of oxygen reaching the ceramics. This firing process involved three stages. In the first stage, oxygen was allowed into the kiln, which "fixed" the whole vessel in one overall shade of red depending on the composition of the clay. Then, in the second (reduction) stage, the oxygen in the kiln was cut back (reduced) to a minimum, turning the vessel black, and the temperature was raised to the point at which the slip partially vitrified (became glasslike). Finally, in the third stage, oxygen was allowed back into the kiln, turning the unslipped areas back to a shade of red. The areas where slip had been applied, which were sealed against the oxygen, remained black. The "reds" varied from dark terra cotta to pale yellow.

In the black-figure technique, artists painted designs—figures, objects, or abstract motifs—with slip in silhouette on the clay vessels. Then using a sharp tool (a **stylus**), they cut through the slip to the body of the vessel, incising linear details within the silhouette. In the red-figure technique, the approach was reversed. Artists painted the background around the figures with the slip and drew details within the figures with the same slip using a brush. In both techniques artists often enhanced their work with touches of white and reddish-purple gloss, pigments mixed with slip. Firing produced the distinctive black (SEE FIG. 5–21) or red (SEE FIG. 5–29) images.

White-ground vases became popular in the Classical period. A highly refined clay slip produced the white ground on which the design elements were painted. After firing the vessel, the artists frequently added details and areas of bright and pastel hues which, because they were added after firing, flaked off easily. Few perfect examples have survived (SEE FIG. 5-46).

confront each other after the man—perhaps Herakles—has stabbed the centaur; the spearhead is visible on the centaur's left side. The centaur must have had a branch or club in his (now missing) right hand. The sculptor reduced the body parts of the figures to simple geometric shapes, arranging them in a composition of solid forms and open, or negative, spaces that makes the piece pleasing from every view. Most such works have been found in sanctuaries, suggesting that they may have been votive offerings to the gods.

THE FIRST GREEK TEMPLES. Greeks worshiped at outdoor altars within sanctuaries where a temple sheltered a statue of a god. Few ancient Greek temples remain standing today. Stone foundations define their rectangular shape, and their appearance has been pieced together largely from fallen columns, broken lintels, and fragments of sculpture lying where they fell centuries ago. Walls and roofs constructed of mud brick and wood have disappeared.

The rectangular building had a door at one end sheltered by a projecting **porch** supported on two sturdy posts. The steeply pitched roof forms a triangular area, or **pediment**, in the **façade**, or front wall that is pierced by an opening directly above the door. The interior followed an enduring basic plan: a large main room called the **cella**, or **naos**, preceded by a small reception area or vestibule, called the **pronaos**.

The Orientalizing Period

By the seventh century BCE, vase painters in major pottery centers in Greece had moved away from the dense linear decoration of the Geometric style. They now created more open

compositions built around large motifs that included real and imaginary animals, abstract plant forms, and human figures. The source of these motifs can be traced to the arts of the Near East, Asia Minor, and Egypt. Greek painters did not simply copy the work of Eastern artists, however. Instead, they drew on work in a variety of mediums—including sculpture, metalwork, and textiles—to invent an entirely new approach to vase painting.

The Orientalizing style (c. 700–600 BCE) began in Corinth, a port city where luxury wares from the Near East and Egypt inspired artists. The new style is evident in a Corinthian olpe, or wide-mouthed pitcher, dating to about 600 BCE, which shows silhouetted creatures striding in horizontal bands against a light background with stylized flower forms called rosettes (FIG. 5–6). An example of the blackfigure pottery style, it is decorated with dark shapes of lions, a serpent, and composite creatures against a background of very pale buff, the natural color of the Corinthian clay (see "Greek Painted Vases," above). The artist incised fine details inside the silhouetted shapes with a sharp tool and added touches of white and reddish purple gloss, or clay slip mixed with metallic color pigments, to enhance the design.

THE ARCHAIC PERIOD, c. 600–480 BCE

During the Archaic period, from c. 600 to c. 480 BCE, the Greek city-states on the mainland, on the Aegean islands, and in the colonies grew and flourished. Athens, which had lagged behind the others in population and economic devel-

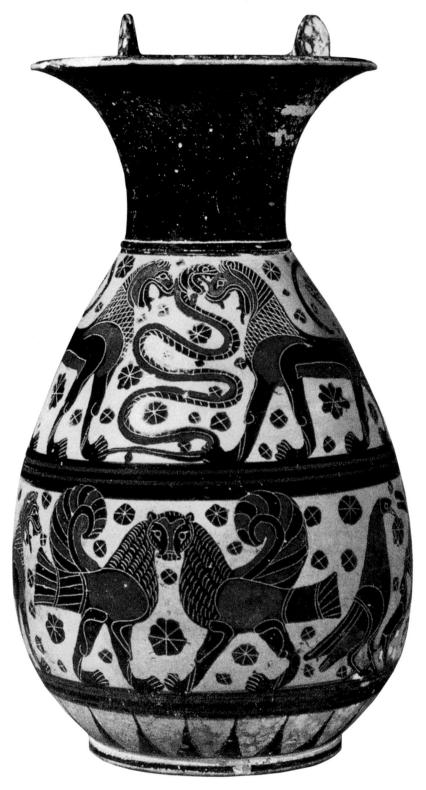

5-6 | PITCHER (OLPE)

Corinth. c. 600 BCE. Ceramic with black-figure decoration, height 11½" (30 cm).

The British Museum, London.

opment, began moving artistically, commercially, and politically to the forefront.

The Greek arts developed rapidly during the Archaic period. In literature, the poet Sappho on the island of Lesbos was writing poetry that would inspire the geographer Strabo, near the end of the millennium, to write: "Never within human memory has there been a woman to compare with her as a poet." On another island, the semilegendary slave Aesop was relating animal fables that became lasting elements in Western culture. Artists shared in the growing prosperity of

Elements of Architecture

GREEK TEMPLE PLANS

he simplest early temples consist of a single room, the cella, or naos. Side walls ending in attached pillars (anta) may project forward to frame two columns in antis (literally, "between the pillars"), as seen in plan (a). An amphiprostyle temple (b) has a row of columns (colonnade) at the front and back ends of the structure, not on the sides, forming porticos, or covered entrance porches, at the front and

back. If the colonnade runs around all four sides of the building, forming a peristyle, the temple is peripteral (c and d). Plan (c), the Temple of Hera I at Paestum, Italy, shows a pronaos and an adyton, an unlit inner chamber. Plan (d), the Parthenon, has an opithodomos, enclosed porch, not an adyton, at the back. The stylobate is the top step of the stereobate, or layered foundation.

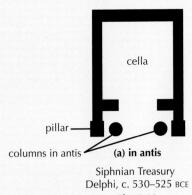

Fig. 5-10

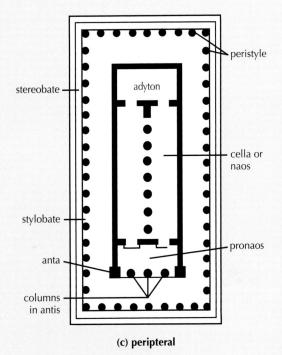

Temple of Hera I, Paestum, Italy, c. 550 BCE Fig. 5-7

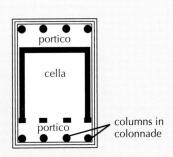

(b) amphiprostyle Temple of Athena Nike Athens, c. 425 BCE

Fig. 5-41

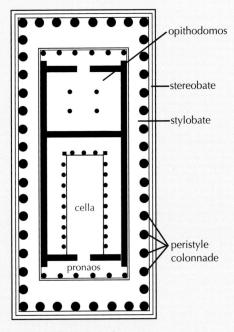

(d) peripteral

Parthenon, Athens, 447-432 BCE

Page 138

the city-states by competing for lucrative commissions from city councils and wealthy individuals, who sponsored the building of temples, shrines, government buildings, monumental sculpture, and fine ceramic wares. During this period, potters and vase painters began to sign their works.

Temple Architecture

As Greek temples grew steadily in size and complexity over the centuries, stone and marble replaced the earlier mudbrick and wood construction. A number of standardized plans evolved, ranging from simple, one-room structures with columned porches to buildings with double porches surrounded by columns (see "Greek Temple Plans," page 116). Builders also experimented with the design of temple elevations—the arrangement, proportions, and appearance of the columns and the lintels, which now grew into elaborate entablatures. Two elevation designs emerged during the Archaic period: the Doric order and the Ionic order. The Corinthian order, a variant of the Ionic order, developed later (see "The Greek Architectural Orders," page 118).

Paestum, the Greek colony of Poseidonia established in the seventh century BCE about 50 miles south of the modern city of Naples, Italy, contains some well-preserved early Greek temples. The earliest standing temple there, built about 550–540 BCE, was dedicated to Hera, the wife of Zeus (FIG. 5–7). It is known today as **HERA I** to distinguish it from a second temple to Hera built adjacent to it about a century later.

Sequencing Works of Art

с. 580 все	Gorgon Medusa, Temple of Artemis
с. 530-525 все	Battle between the Gods and the Giants, Treasury of the Siphnians
c. 515 BCE	Euphronios (painter), Death of Sarpedon, red-figure calyx krater
с. 460 все	Apollo with Battling Lapiths and Centaurs, west pediment, Temple of Zeus
с. 447-432 все	Horsemen, from the Procession frieze, Parthenon

Hera I illustrates the early form of the Doric order temple. A row of columns called the **peristyle** surrounded the main room, the cella. A Doric column has a fluted **shaft** and a **capital** made up of the cushionlike **echinus** and the square **abacus**. These columns support an entablature distinguished by its **frieze**, where flat areas called **metopes** alternate with projecting blocks with three vertical grooves called **triglyphs**. Usually the metopes were either painted or carved in relief and then painted. Fragments of terra-cotta decorations painted in bright colors have also been found in the rubble of Hera I.

The builders of Hera I created an especially robust column, only about four times as high as its maximum diameter,

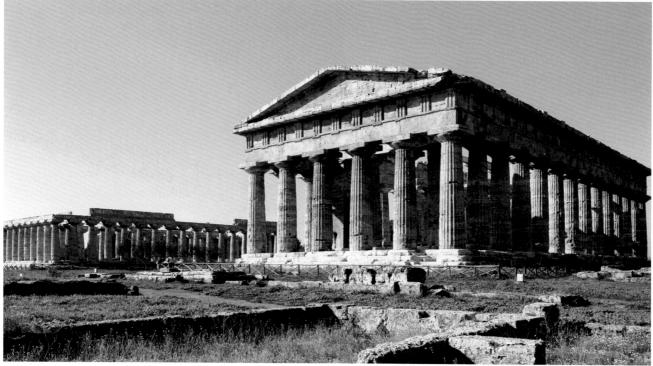

5-7 | TEMPLE OF HERA I, PAESTUM (ancient Poseidonia) and HERA II (in foreground) Italy. c. 550-540 BCE (Hera I) and c. 470-460 BCE (Hera II).

Usually

Elements of Architecture

THE GREEK ARCHITECTURAL ORDERS

he three Classical Greek architectural orders are the Doric, the Ionic, and the Corinthian. Each order is made up of a system of interdependent parts whose proportions are based on mathematical ratios. No element of an order could be changed without producing a corresponding change in other elements.

The basic components of the Greek orders are the **column** and the **entablature**, which function as post and lintel. All types of columns have a **shaft** and a **capital**; lonic and Corinthian also have a **base**. The shafts are formed of round sections, or **drums**, which are joined inside by metal pegs. In Greek temple architecture, columns stand on the **stylobate**, the "floor" of the temple.

The **Doric order** shaft rises directly from the stylobate, without a base. The shaft is **fluted**, or channeled, with sharp edges. The height of the column ranges from five-and-a-half to seven times the diameter of the base. At the top of the shaft and part of the capital is the **necking**, which provides a transition to the

capital. The Doric capital itself has three parts: the necking, the rounded **echinus**, and the tabletlike **abacus**. The entablature includes the **architrave**, the distinctive **frieze** of **triglyphs** and **metopes**, and the **cornice**, the topmost, projecting horizontal element. The roofline may have decorative waterspouts and terminal decorative elements called **acroteria**.

The **lonic order** has more elongated proportions than the Doric, its height being about nine times the diameter of the column at its base. The flutes on the columns are deeper and closer together and are separated by flat surfaces called **fillets**. The **capital** has a distinctive scrolled **volute**; the entablature has a three-panel architrave, continuous sculptured or decorated frieze, and the addition of decorative moldings.

The **Corinthian order** was originally developed by the Greeks for use in interiors but came to be used on temple exteriors as well. Its elaborate capitals are sheathed with stylized **acanthus** leaves that rise from a convex band called the **astragal**.

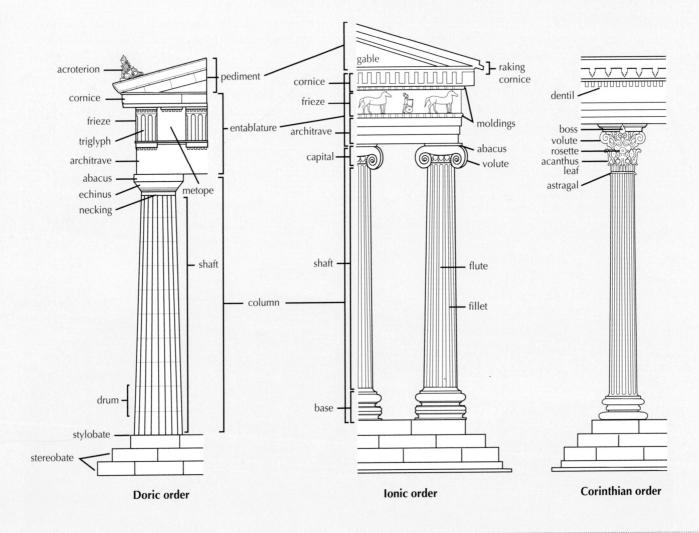

entasis defin

topped with a widely flaring capital. This design creates an impression of great stability and permanence, although it is rather ponderous. As the column shafts rise, they swell in the middle and contract again toward the top, a refinement known as entasis. This adjustment gives a sense of energy and upward lift. Hera I has an uneven number of columns nine—across the short ends of the peristyle, with a column instead of a space at the center of the two ends. The entrance to the pronaos has three central columns, and a row of columns runs down the center of the wide cella to help support the ceiling and roof. The unusual two-aisle, two-door arrangement leading to the small room at the end of the cella proper suggests that the temple had two presiding deities: either Hera and Poseidon (patron of the city), or Hera and Zeus (her consort), or perhaps Hera in her two manifestations (as warrior and protector of the city and as mother and protector of children).

Architectural Sculpture

As Greek temples grew larger and more complex, sculptural decoration took on increased importance. Among the earliest surviving examples of Greek pediment sculpture are fragments of the ruined Doric order **TEMPLE OF ARTEMIS** on the island of Korkyra (Corfu) off the northwest coast of the mainland, which date to about 600–580 BCE (FIG. 5–8). The figures in this sculpture were carved on separate slabs, then installed in the pediment space. They stand in such high relief from the background plane that they actually break through the architectural frame, which was more than 9 feet tall at the peak.

At the center of the pediment is the rampaging snake-haired MEDUSA (FIG. 5–9), one of three winged female monsters with wings called Gorgons. Medusa had the power to turn humans to stone if they should look upon her face, and in this sculpture she fixes viewers with huge glaring eyes as if to work her dreadful magic on them. Ancient Greeks would have seen the image of Medusa at the center of this pediment as both menacing and protecting the temple. The Greek hero Perseus, instructed and armed by Athena, beheaded Medusa while looking only at her reflection in his polished shield. The Medusa head became a popular decoration for Greek armor (see FIG. 5–22, which shows Achilles' and Ajax's shields.)

The much smaller figures flanking Medusa are the flying horse Pegasus on the left (only part of his rump and tail remain) and the giant Chrysaor on the right. These were Medusa's posthumous children (whose father was Poseidon), born from the blood that gushed from her neck after she was beheaded by Perseus. The felines crouching next to them literally bump their heads against the raking cornices of the roof. Dying human warriors lie at the ends of the pediment,

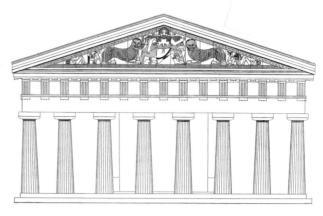

5-8 | RECONSTRUCTION OF THE WEST FAÇADE OF THE TEMPLE OF ARTEMIS, KORKYRA (CORFU)

After G. Rodenwaldt and H. Schleif. c. 600-580 BCF.

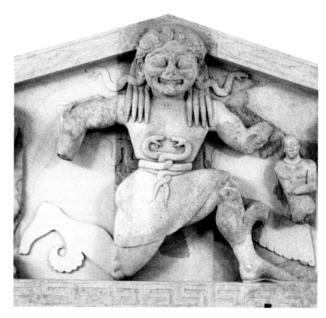

5–9 GORGON MEDUSA

Detail of sculpture from the west pediment of the *Temple of Artemis*, Korkyra. c. 600–580 BCE. Limestone, height of pediment at the center 9'2" (2.79 m). Archaeological Museum, Korkyra (Corfu).

their heads tucked into its corners and their knees rising with its sloping sides. Such changes of scale and awkward positioning are characteristic of Archaic temple sculpture.

TREASURY OF THE SIPHNIANS. An especially noteworthy collaboration between builder and sculptor can still be seen in the small but luxurious TREASURY OF THE SIPHNIANS, built in the sanctuary of Apollo at Delphi between about 530 and 525 BCE and housed today in fragments in the museum at Delphi. Instead of columns, the builders used two caryatids—columns carved in the form of clothed

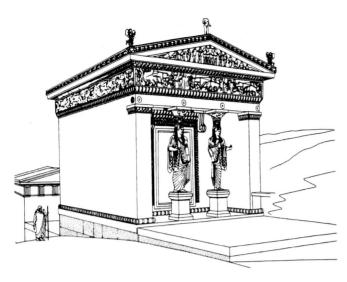

 $5{ extstyle -}10$ | reconstruction drawing of the treasury of the siphnians, delphi

Sanctuary of Apollo, Delphi. c. 530-525 BCE.

This small treasury building at Delphi was originally elegant and richly ornamented. The figure sculpture and decorative moldings were once painted in strong colors, mainly dark blue, bright red, and white, with touches of yellow to resemble gold. The people who commissioned this treasury were from Siphnos, an island in the Aegean Sea just southwest of the Cyclades.

women—(FIG. 5–10). The stately caryatids, with their finely pleated, flowing garments, are raised on pedestals and balance elaborately carved capitals on their heads. The capitals support a tall entablature conforming to the Ionic order, which features a plain, or three-panel, architrave and a continuous carved frieze, set off by richly carved moldings (see "The Greek Architectural Orders," page 118).

Both the continuous frieze and the pediments of the Siphnian Treasury were originally filled with relief sculpture. A surviving section of the frieze from the building's north side, which shows a scene from the legendary battle between the Gods and the Giants, is one of the earliest known examples of a trend in Greek relief sculpture toward a more natural representation of space (FIG. 5–11). To give a sense of three dimensions, the sculptor placed some figures behind others, overlapping as many as three of them and varying the depth of the relief. Countering any sense of deep recession, all the figures were made the same height with their feet on the same groundline.

THE TEMPLE OF APHAIA. The long friezes of Greek temples provided a perfect stage for storytelling, but the triangular pediment created a problem in composition. The sculptor of the east pediment of the Doric TEMPLE OF APHAIA at Aegina (FIG. 5–12), dated about 500–490 BCE, provided a creative

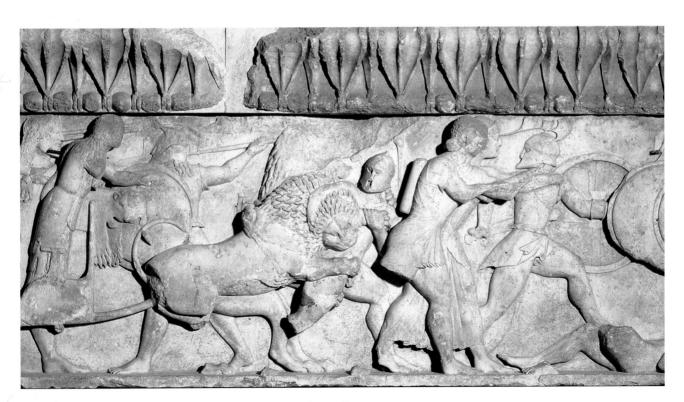

5-II | BATTLE BETWEEN THE GODS AND THE GIANTS (TITANS)

Fragments of the north frieze of the Treasury of the Siphnians, from the Sanctuary of Apollo, Delphi. c. 530-525 BCE. Marble, height 26" (66 cm). Archaeological Museum, Delphi.

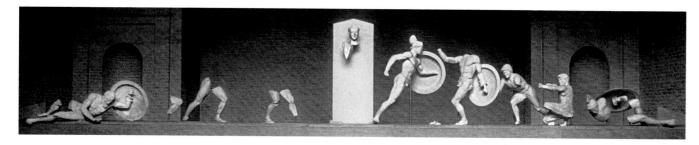

5–12 | EAST PEDIMENT OF THE TEMPLE OF APHAIA, AEGINA c. 490 BCE. Width about 49' (15 m). Surviving fragments as assembled in the Staatliche Antikensammlungen, Munich (early restorations removed).

solution that became a design standard, appearing with variations throughout the fifth century BCE. The subject of the pediment, rendered in fully three-dimensional figures, is an early military expedition against Troy led by Herakles (this is not the Troy of Homer's later epic). Fallen warriors fill the angles at both ends of the pediment base, while others crouch and lunge, rising in height toward an image of Athena as warrior goddess under the peak of the roof. The erect goddess, larger than the other figures and flanked by two defenders facing approaching opponents, dominates the center of the scene and stabilizes the entire composition.

Among the best-preserved fragments from this pediment scene is the **DYING WARRIOR** from the far left corner, a tragic but noble figure struggling to rise, pulling an arrow from his side, even as he dies (FIG. 5–13). This figure originally would have been painted and fitted with authentic bronze acces-

sories, heightening the sense of reality. Fully exploiting the difficult framework of the pediment corner, the sculptor portrayed the soldier's uptilted, twisted form turning in space, capturing his agony and vulnerability. The subtle modeling of the body conveys the softness of human flesh, which is contrasted with the hard, metallic geometry of the shield, helmet, and (now lost) bronze arrow.

Freestanding Sculpture

In addition to decorating temple architecture, sculptors of the Archaic period created a new type of large, freestanding statue made of wood, terra cotta, limestone, or white marble from the islands of Paros and Naxos. Frequently lifesize or larger, these figures usually were standing or striding. They were brightly painted and sometimes bore inscriptions indicating that they had been commissioned

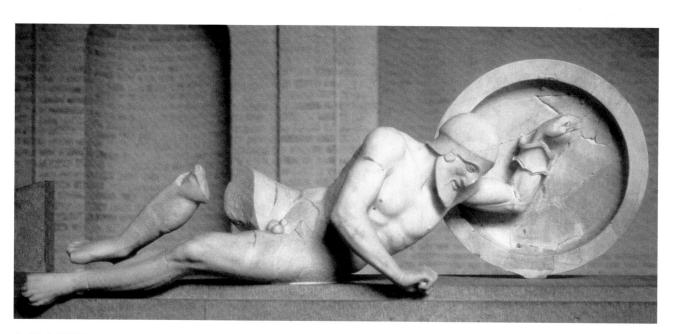

5–13 | DYING WARRIOR

Sculpture from the left corner of the east pediment of the Temple of Aphaia, Aegina. c. 500–490 BCE. Marble, length 6' (1.83 m). Staatliche Antikensammlungen und Glyptothek, Munich.

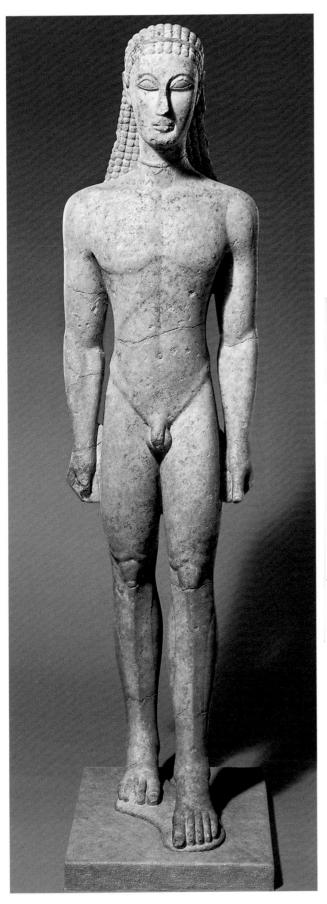

5–14 | STANDING YOUTH (KOUROS)
Attica. c. 600 BCE. Marble, height 6' (1.84 m).
The Metropolitan Museum of Art, New York.
Fletcher Fund, 1932 (32.11.1)

by individual men or women for a commemorative purpose. They have been found marking graves and in sanctuaries, where they lined the sacred way from the entrance to the main temple.

A female statue of this type is called a **kore** (plural, *koraî*), Greek for "young woman," and a male statue is called a **kouros** (plural, *kouroî*), Greek for "young man." Archaic *korai*, always clothed, probably represented deities, priestesses, and nymphs, young female immortals who served as attendants to gods. *Kouroi*, nearly always nude, have been variously identified as gods, warriors, and victorious athletes. Because the Greeks associated young, athletic males with fertility and family continuity, the *kouroi* figures may have symbolized ancestors.

Young Man (Kouros). A kouros dated about 600 BCE (FIG. 5–14) recalls the pose and proportions of Egyptian sculpture. As with Egyptian figures such as the statue of Menkaure (SEE FIG. 3–11), this young Greek stands rigidly upright, arms at his sides, fists clenched, and one leg slightly in front of the other. However, Greek artists of the Archaic period did not share the Egyptian obsession with permanence; they cut away all stone from around the body and introduced variations in appearance from figure to figure. Greek statues suggest the marble block from which they were carved, but they have a notable athletic quality quite unlike Egyptian statues.

Here the artist delineated the figure's anatomy with ridges and grooves that form geometric patterns. The head is ovoid, with heavy features and schematized hair evenly knotted into tufts and tied back with a narrow ribbon. The eyes are relatively large and wide open, and the mouth forms a characteristic closed-lip smile known as the Archaic smile. In Egyptian sculpture, male figures usually wore clothing associated with their status, such as the headdresses, necklaces, and kilts that identified them as kings. The total nudity of the Greek *kouroi*, in contrast, removes them from a specific time, place, or social class.

The powerful, rounded body of a *kouros* known as the **ANAVYSOS** KOUROS, dated about 530 BCE, clearly shows the increasing interest of artists and their patrons in a more lifelike rendering of the human figure (FIG. 5–15). The pose, wiglike hair, and Archaic smile echo the earlier style, but the massive torso and limbs have greater anatomical accuracy suggesting heroic strength. The statue, a grave monument to a fallen war hero, has been associated with a base inscribed: "Stop and grieve at the tomb of the dead Kroisos, slain by wild Ares [god of war] in the front rank of battle." However, there is no evidence that the figure was meant to represent Kroisos.

Young Woman (Kore). The first Archaic korai are as severe and rigid as the male figures. The BERLIN KORE, found in a cemetery at Keratea and dated about 570–560 BCE, stands more than 6 feet tall (FIG. 5–16). The erect, immobile pose and full-bodied figure—accentuated by a crown and thick-

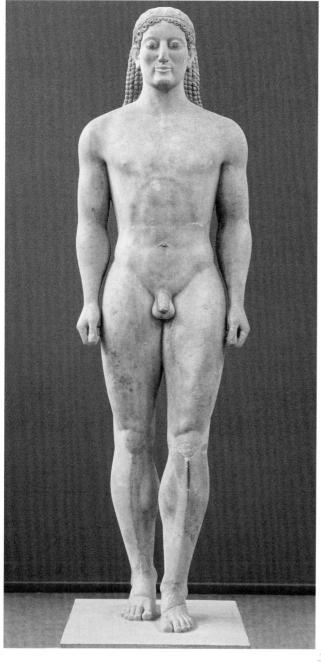

soled clogs—seem appropriate to a goddess, although the statue may represent a priestess or an attendant. The thick robe and tasseled cloak over her shoulders fall in regularly spaced, parallel folds like the fluting on a Greek column, further emphasizing the stately appearance. Traces of red—perhaps the red clay used to make thin sheets of gold adhere—indicate that the robe was once painted or gilded. The figure holds a pomegranate in her right hand, a symbol of Persephone, who was abducted by Hades, the god of the underworld, and whose annual return brought the springtime.

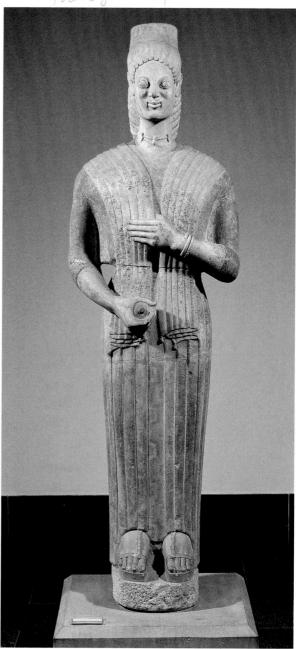

5–16 | BERLIN KORE

Cemetery at Keratea, near Athens. c. 570–560 BCE. Marble with remnants of red paint, height 6'3" (1.9 m). Staatliche Museen zu Berlin, Antikensammlung, Preussischer Kulturbesitz, Berlin.

The PEPLOS KORE (FIG. 5–17), which dates to about 530 BCE, is named for its distinctive and characteristic garment, called a peplos—a draped rectangle of cloth, usually wool, folded over at the top, pinned at the shoulders, and belted to give a bloused effect. The *Peplos Kore* has the same motionless, vertical pose of the earlier *kore*, but is a more rounded, feminine figure. Her bare arms and head convey a greater sense of soft flesh covering a real bone structure, and her smile and hair are somewhat less conventional. The figure once wore a metal crown and earrings and has traces of

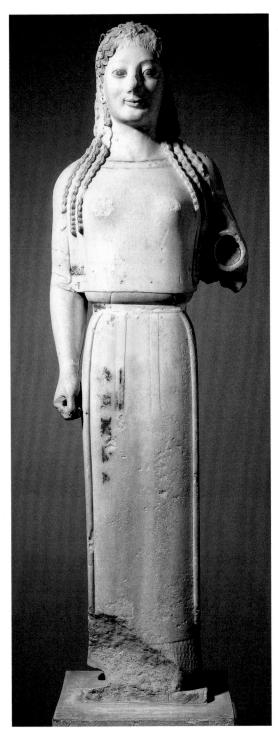

5–17 | PEPLOS KORE Acropolis, Athens. c. 530 BCE. Marble, height 4' (1.21 m). Acropolis Museum, Athens.

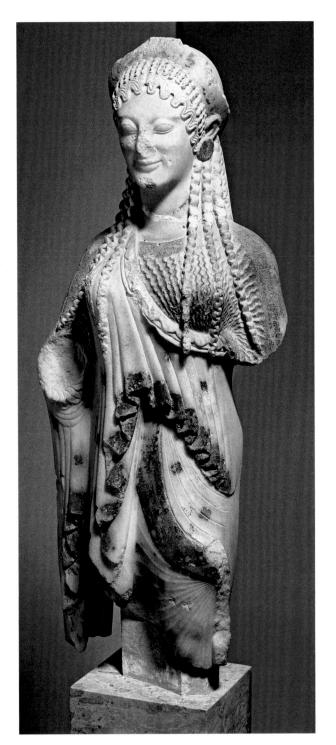

5-18 | KORE Acropolis, Athens (by a sculptor from Chios?). c. 520 BCE. Marble, height 22" (0.55 m). Acropolis Museum, Athens.

encaustic painting, a mixture of pigments and hot wax that left a shiny, hard surface when it cooled. The missing left forearm was made from a separate piece of marble—the socket is still visible—and would have extended forward horizontally. She was probably pouring a libation.

The Peplos Kore was recovered from debris on the Acropolis of Athens, where few of the many votive and

commemorative statues placed in the sanctuary have survived. After the Persians sacked the city in 480 BCE and destroyed the sculptures there, the fragments were used as fill in the reconstruction of the Acropolis the following year.

Another *kore* (FIG. 5–18), dating to about 520 BCE and found on the Athenian Acropolis, may have been made by a

sculptor from Chios, an island off the coast of Asia Minor. Although the arms and legs of this figure have been lost and its face has been damaged, it is impressive for its rich drapery and the large amount of paint that still adheres to it. Like the *Anavysos Kouros* (SEE FIG. 5–15) and the *Peplos Kore*, it reflects a trend toward increasingly lifelike anatomical depiction that would peak in the fifth century BCE.

The *kore* wears a garment called a **chiton**; like the *peplos* but fuller, it was a relatively lightweight rectangle of cloth pinned along the shoulders. It originated in Ionia on the coast of Asia Minor but became popular throughout Greece. Over it, a cloak called a **himation** was draped diagonally and fastened on one shoulder. The elaborate hairstyle and abundance of jewelry add to the opulent effect. A close look at what remains of the figure's legs reveals a rounded thigh showing clearly through the thin fabric of the *chiton*.

Vase Painting

Greek potters created vessels that combine beauty with a specific utilitarian function (FIG. 5–19). The artists who painted the pots, which were often richly decorated, had to accommodate their work to these fixed shapes. During the Archaic period, Athens became the dominant center for pottery manufacture and trade in Greece.

BLACK-FIGURE VASES. Athenian painters adopted the Corinthian black-figure techniques (see "Greek Painted Vases," page 114), which became the principal mode of decoration throughout Greece in the sixth century BCE. At first, Athenian vase painters retained the horizontal banded composition that was characteristic of the Geometric period. Over time, they decreased the number of bands and increased the size of figures until a single scene covered each side of the vessel. A mid-sixth-century BCE amphora—a large, allpurpose storage jar-with bands of decoration above and below a central scene illustrates this development (FIG. 5-20). The decoration on this vessel, a depiction of the wine god Dionysos with maenads, his female worshipers, has been attributed to an anonymous artist called the Amasis Painter. Work in this distinctive style was first recognized on vessels signed by a prolific potter named Amasis.

Two maenads, arms around each other's shoulders, skip forward to present their offerings to Dionysos—a long-eared rabbit and a small deer. (Amasis signed his work just above the rabbit.) The maenad holding the deer wears the skin of a spotted panther (or leopard), its head still attached, draped over her shoulders and secured with a belt at her waist. The god, an imposing, richly dressed figure, clasps a large kantharos (wine cup). This encounter between humans and a god appears to be a joyful, celebratory occasion rather than one of reverence or fear. The Amasis Painter favored strong shapes and patterns, generally disregarding conventions for making figures appear to occupy real space. He emphasized

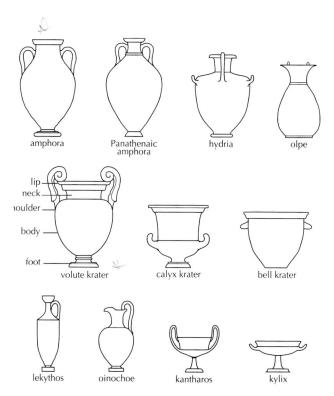

5-19 STANDARD SHAPES OF GREEK VESSELS

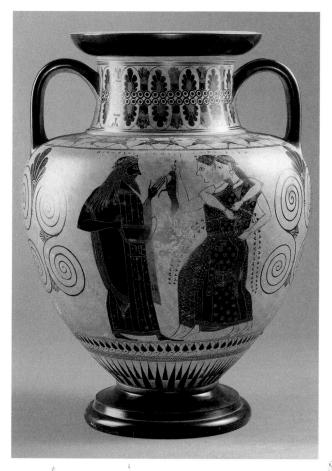

5–20 | Amasis Painter DIONYSOS WITH MAENADS c. 540 BCE. Black-figure decoration on an amphora. Ceramic, height of amphora 13" (33.3 cm). Bibliothèque Nationale de France, Paris.

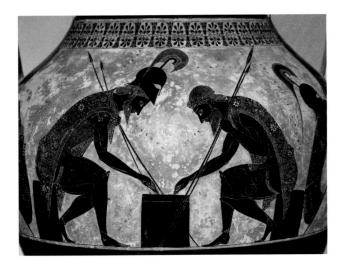

5–21 | Exekias ACHILLES AND AJAX PLAYING A GAME c. 540 BCE. Black-figure decoration on an amphora. Ceramic, height of amphora 2' (61 cm.). c. 540 BCE. Vatican Museums, Rome.

5–22 | Exekias **THE SUICIDE OF AJAX** c. 540 BCE. Black-figure decoration on an amphora. Ceramic, height of amphora 27" (69 cm). Château-Musée, Boulognesur-Mer, France.

fine details, such as the large, delicate petal and spiral designs below each handle, the figures' meticulously arranged hair, and the bold patterns on their clothing.

The finest of all Athenian artists of the Archaic Period, Exekias, signed many of his vessels as both potter and painter. Exekias took his subjects from Greek mythology, which he and his patrons probably considered to be history, such as the hero Achilles and the story of the Trojan War. On the body of an amphora he painted Achilles and his cousin Ajax, a fellow warrior, playing a game of dice (FIG. 5-21). The owner of the amphora knew the story—what had happened and what would happen. Achilles, sulking over an insult, has refused to fight, but eventually returns to battle and is killed. The two men bend over the game board in rapt concentration, wearing their body armor and holding their spears but setting aside their shields. At the moment, Achilles is dominant (he wears his helmet) and is winning the game. He calls "four" to Ajax's "three." (After the battle, Ajax will carry Achilles' lifeless body from the field.) Exekias skillfully matches his painting to the shape of the vase. The triangular shape formed by the two men rises to the mouth of the jar, while the handles continue the line of their shields.

This story continues on another amphora depicting the suicide of Ajax (FIG. 5-22). Ajax was second only to Achilles in bravery, but after the death of Achilles, the Greeks awarded the fallen hero's armor to Odysseus rather than Ajax. Devastated by this humiliation, and mourning his cousin, Ajax killed himself. Other artists showed the great warrior either dying or already dead, but Exekias has captured the story's most poignant moment, showing Ajax preparing to die. He has set aside his helmet, shield, and spear, and he crouches beneath a tree, planting his sword upright in a mound of dirt so that he can fling himself upon it. Two upright elements the tree on the left and the shield on the right-frame and balance the figure of Ajax, their in-curving lines echoing the swelling shape of the amphora and the rounding of the hero's powerful back as he bends forward. The composition focuses the viewer's attention on the head of Ajax and his intense concentration as he pats down the earth to secure the sword. He will not fail in his suicide.

Exekias is a skilled draftsman. He captures both form and emotion, balancing areas of black against fine engraved patterns—for example, the heroes' cloaks and silhouetted figures. These two vessels exemplify the quiet beauty and perfect equilibrium for which Exekias's works are so admired today.

RED-FIGURE VASES. In the last third of the sixth century BCE, while many painters were still creating handsome blackfigure wares, some vase painters turned away from this meticulous process to a new technique called **red-figure** decoration (see "Greek Painted Vases," page 114). This new method,

Desir Just

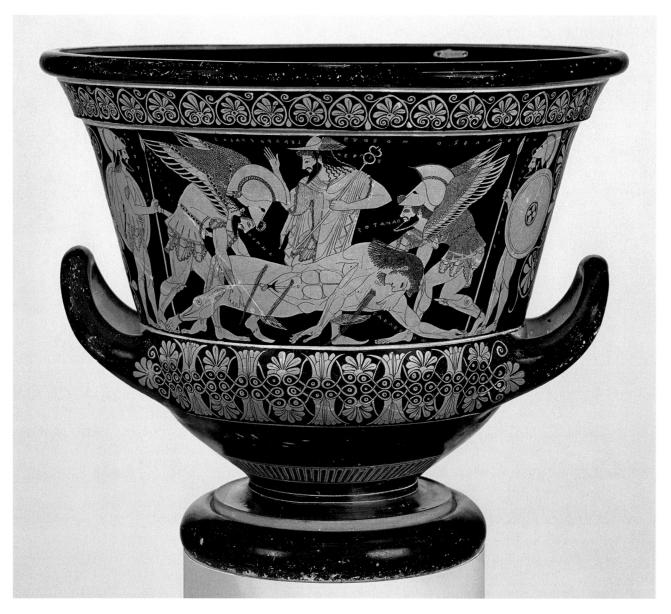

5–23 | Euphronios (painter) and Euxitheos (potter) **DEATH OF SARPEDON**c. 515 BCE. Red-figure decoration on a calyx krater. Ceramic, height of krater 18" (45.7 cm).
The Metropolitan Museum of Art, New York, lent by the Republic of Italy (L.2006.10). Photograph © 1999 The Metropolitan Museum of Art.

The ownership of the Euphronios krater has been the subject of dispute between Italy and the Metropolitan Museum. In 2006 the museum recognized the Italian government's claim.

as its name suggests, resulted in vessels with red figures against a black background, the opposite of black-figure painting. In red-figure wares, the dark slip was painted on as background around the outlined figures, which were left unpainted. Details were drawn on the figures with a fine brush dipped in the slip. The result was a lustrous dark vessel with light-colored figures and dark details. The greater freedom and flexibility of painting rather than engraving the details led artists to adopt it widely in a relatively short time.

One of the best-known artists specializing in the red-figure technique was Euphronios. His rendering of the **DEATH**

OF SARPEDON, about 515 BCE, is painted on a **calyx krater**, so called because its handles curve up like a flower calyx (FIG. 5–23). According to Homer's *Iliad*, Sarpedon, a son of Zeus and a mortal woman, was killed by the Greek warrior Patroclus while fighting for the Trojans. Euphronios shows the winged figures of Hypnos (Sleep) and Thanatos (Death) carrying the dead warrior from the battlefield, an early use of personification. Watching over the scene is Hermes, the messenger of the gods, identified by his winged hat and *caduceus*, a staff with coiled snakes. Hermes is there in another important role, as the guide who leads the dead to the underworld.

Art and Its Context CLASSIC AND CLASSICAL

ur words classic and classical come from the Latin word classis, referring to the division of people into classes based on wealth. Consequently, classic has come to mean "first class," "the highest rank," "the standard of excellence." Greek artists in the fifth century BCE tried to create ideal images based on perfect mathematical proportions. Roman

artists were inspired by the Greeks, so *Classical* refers to the culture of ancient Greece and Rome. By extension, the word may also mean "in the style of ancient Greece and Rome," whenever or wherever that style is used. In the most general usage, a "classic" is something—perhaps a literary work, a car, or a film—of lasting quality and universal significance.

Euphronios has created a perfectly balanced composition of verticals and horizontals that take the shape of the vessel into account. The bands of decoration above and below the scene echo the long horizontal of the dead fighter's body, which seems to levitate in the gentle grasp of its bearers, and the inward-curving lines of the handles mirror the arching backs of Hypnos and Thanatos. The upright figures of the lance-bearers on each side and Hermes in the center counterbalance the horizontal elements of the composition. The painter, while conveying a sense of the mass and energy of the subjects, also portrayed amazingly fine details of their clothing, musculature, and facial features with the fine tip of a brush. Euphronios created the impression of real space around the figures by foreshortening body forms and limbs—Sarpedon's left leg, for example—so that they appear to be coming toward or receding from the viewer.

THE CLASSICAL PERIOD, c. 480–323 BCE

Over the brief span of the next 160 years, the Greeks would establish an ideal of beauty that, remarkably, has endured in the Western world to this day. This period of Greek art, known as the Classical, is framed by two major events: the defeat of the Persians in 480 BCE and the death of Alexander the Great in 323 BCE. Art historians today divide the period into three phases, based on the formal qualities of the art: the Early Classical period or Transitional style (c. 480–450 BCE); the High Classical period (c. 450–400 BCE); and the Late Classical period (c. 400–323 BCE). The speed of change in this short time is among the most extraordinary characteristics of Greek art (see "Classic and Classical," above).

Scholars have characterized Greek Classical art as being based on three general concepts: humanism, rationalism, and idealism. The ancient Greeks believed the words of their philosophers and followed these injunctions in their art: "Man is the measure of all things," that is, seek an ideal based on the human form; "Know thyself," seek the inner signifi-

cance of forms; and "Nothing in excess," reproduce only essential forms. In their embrace of humanism, the Greeks even imagined that their gods looked like perfect human beings. Apollo, for example, exemplifies the Greek ideal: His body and mind in balance, he is athlete and musician, healer and sun god, leader of the Muses.

Yet as reflected in their art, the Greeks valued reason over emotion. Practicing the faith in rationality expressed by the philosophers Sophocles, Plato, and Aristotle, and convinced that logic and reason underlie natural processes, the Greeks saw all aspects of life, including the arts, as having meaning and pattern. Nothing happens by accident. The great Greek artists and architects were not only practitioners but theoreticians as well. In the fifth century BCE, the sculptor Polykleitos (see below) and the architect Iktinos both wrote books on the theory underlying their practice.

Unlike artists in Egypt and the ancient Near East, Greek artists did not rely on memory images. And even more than the artists of Crete, they grounded their art in close observation of nature. Only after meticulous study did they begin to search within each form for its universal ideal, rather than portraying their models in their actual, individual detail. In doing this, they developed a system of perfect mathematical proportions.

Greek artists of the fifth and fourth centuries BCE established a benchmark for art against which succeeding generations of artists and patrons in the Western world have since measured quality.

The Canon of Polykleitos

Just as Greek architects defined and followed a set of standards for ideal temple design, the sculptors of the Classical period selected those human attributes they considered the most desirable, such as regular facial features, smooth skin, and particular body proportions, and combined them into a single ideal of physical perfection.

The best-known theorist of the Classical period was the sculptor Polykleitos of Argos. About 450 BCE he developed a

set of rules for constructing the ideal human figure, which he set down in a treatise called *The Canon (kanon* is Greek for "measure," "rule," or "law"). To illustrate his theory, Polykleitos created a larger-than-lifesize bronze statue of a standing man carrying a spear—perhaps the hero Achilles (FIG. 5–24). Neither the treatise nor the original statue has survived, but both were widely discussed in the writings of his contemporaries, and later Roman artists made copies in stone and marble of the **SPEAR BEARER (DORYPHOROS)**. By studying these copies, scholars have tried to determine the set of measurements that defined the ideal proportions in Polykleitos's canon.

The canon included a system of ratios between a basic unit and the length of various body parts. Some studies suggest that this basic unit may have been the length of the figure's index finger or the width of its hand across the knuckles; others suggest that it was the height of the head from chin to hairline. The canon also included guidelines for *symmetria* ("commensurability"), by which Polykleitos meant the relationship of body parts to one another. In the statue he made to illustrate his treatise, he explored not only proportions, but also the relationship of weight-bearing and relaxed legs and arms in a perfectly balanced figure. The cross-balancing of supporting and free elements in a figure is sometimes referred to as contrapposto.

The marble copy of the *Spear Bearer* illustrated here shows a male athlete, perfectly balanced with the whole weight of the upper body supported over the straight (engaged) right leg. The left leg is bent at the knee, with the left foot poised on the ball of the foot, suggesting preceding and succeeding movement. The pattern of tension and relaxation is reversed in the arrangement of the arms, with the right relaxed on the engaged side, and the left bent to support the weight of the (missing) spear. This dynamically balanced body pose—characteristic of High Classical standing figure sculpture—differs somewhat from that of the *Kritian Boy* (SEE FIG. 5–28) of a generation earlier. The tilt of the *Spear Bearer's* hipline is a little more pronounced to accommodate the raising of the left foot onto its ball, and the head is turned toward the same side as the engaged leg.

The Art of the Early Classical Period, 480-450 BCE

In the early decades of the fifth century BCE, the Greek city-states, which for several centuries had developed relatively unimpeded by external powers, faced a formidable threat to their independence from the expanding Persian Empire. Cyrus the Great of Persia had incorporated the Greek cities of Ionia in Asia Minor into his empire in 546 BCE. At the beginning of the fifth century BCE, the Greek cities of Asia Minor, led by Miletos (SEE FIG. 5–47), revolted against Persia, initiating a period of warfare between Greeks and Persians. In 490 BCE, at the Greek mainland town of Marathon, the Athenians drove off the Persian army. (Today's marathon races still

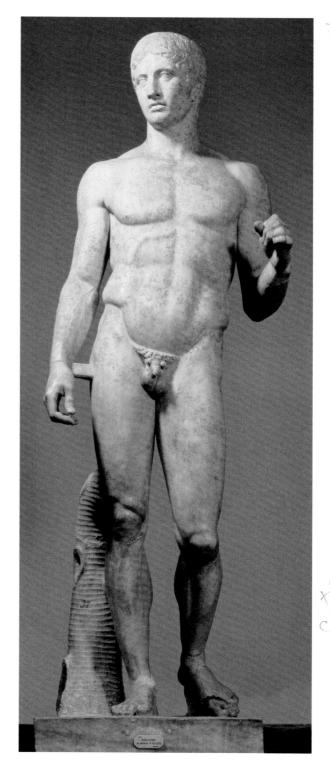

5-24 | Polykleitos | Spear Bearer (Doryphoros), also known as achilles

Roman copy after the original bronze of c. 450-440 BCE. Marble, height 6'11" (2.12 m); tree trunk and brace strut are Roman additions. National Archeological Museum, Naples.

C/T Krifian Bou cusp bles Archaic 5-20 + Early Classical

THE CLASSICAL PERIOD, C. 480-323 BCE

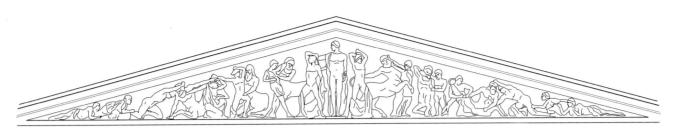

5-25 | RECONSTRUCTION DRAWING OF THE WEST PEDIMENT OF THE TEMPLE OF ZEUS, OLYMPIA c. 470-460 BCE.

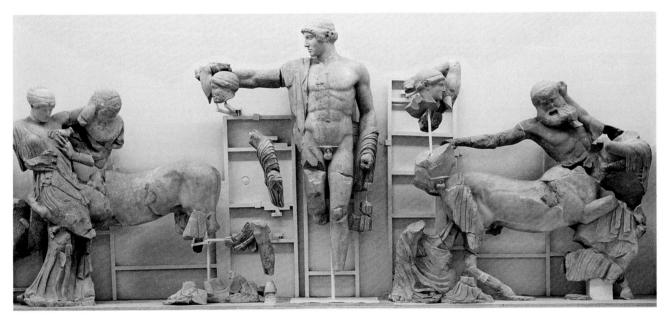

5-26 | APOLLO WITH BATTLING LAPITHS AND CENTAURS Fragments of sculpture from the west pediment of the Temple of Zeus, Olympia. c.470- 460 BCE. Marble, height of Apollo 10'8" (3.25 m). Archaeological Museum, Olympia.

recall the feat of the man who ran the 26 miles from Marathon to Athens with news of victory and then dropped dead from exhaustion as he gasped out his words.)

In 480 BCE, the Persians penetrated Greece with a large force and destroyed many cities, including Athens. In a series of encounters—at Plataea on land and in the straits of Salamis at sea-an alliance of Greek city-states led by Athens and Sparta repulsed the invasion. By 480 BCE, the stalwart armies and formidable navies of the Greeks had triumphed over their enemies.

Athens emerged from the Persian wars as the leader of the city-states. Not all Greeks applauded the Athenians, however. In 431 BCE, a war broke out that only ended in 404 with the collapse of Athens and the victory of the militaristic state of Sparta. In the fourth century BCE, a new force appeared in the north-Macedonia.

Some scholars have argued that their success against the Persians gave the Greeks a self-confidence that accelerated the development of their art, inspiring artists to seek new and more effective ways to express their cities' accomplishments. In any case, the period that followed the Persian Wars, extending from about 480 to about 450 BCE and referred to as the Early Classical period, saw the emergence of a new style.

ARCHITECTURAL SCULPTURE. Just a few years after the Persians had been routed, the citizens of Olympia in the northwest Peloponnese began constructing a new Doric temple to Zeus in the Sanctuary of Zeus. The temple was completed between 470 and 456 BCE. Today the massive temple base, fallen columns, and almost all the metope and pediment sculpture remain, impressive even in ruins. Although the temple was of local stone, it was decorated with sculpture of imported marble, and, appropriately for its Olympian setting, the themes of its artwork demonstrated the power of the gods Zeus, Apollo, and Athena, and metaphorically, the power of Athens and Greece over the Persians.

The freestanding sculpture that once adorned the west pediment (FIG. 5-25) shows Apollo helping the Lapiths, a clan from Thessaly, in their battle with the centaurs. This leg-

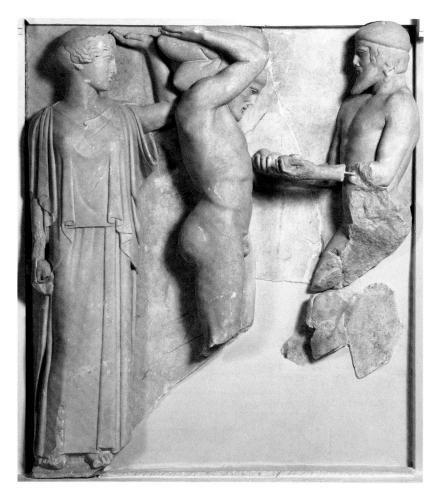

5–27 ATHENA, HERAKLES, AND ATLAS Metope relief from the frieze of the Temple of Zeus, Olympia. c. 460 BCE. Marble, height 5′3″ (1.59 m). Archaeological Museum, Olympia.

Herakles is at the center with the heavens on his shoulders. Atlas, on the right, holds out the gold apples to him. As we can see, and Atlas cannot, the human Herakles is backed, literally, by the goddess Athena, who effortlessly supports the sky with one hand.

endary battle erupted after the centaurs drank too much wine at the wedding feast of the Lapith king and tried to carry off the Lapith women. Apollo stands calmly at the center of the scene, quelling the disturbance by simply raising his arm (FIG. 5–26). The rising, falling, triangular composition fills the awkward pediment space. The contrast of angular forms with turning, twisting poses dramatizes the physical struggle. The majestic figure of Apollo celebrates the triumph of reason over passion, civilization over barbarism, Greece over Persia.

The metope reliefs of the temple illustrated the Twelve Labors imposed by King Eurystheus of Tiryns on Herakles. One of the labors was to steal gold apples from the garden of the Hesperides, the nymphs who guarded the apple trees. To do this, Herakles enlisted the aid of the Titan Atlas, whose job was to hold up the heavens. Herakles offered to take on this job himself while Atlas fetched the apples for him. In the episode shown here (FIG. 5–27), the artist has balanced the erect, frontal view of the heavily clothed Athena, at left, with profile views of the two nude male figures. Carved in high relief, the figures reflect a strong interest in realism. Even the rather severe columnlike figure of the goddess suggests the flesh of her body pressing through the graceful fall of heavy drapery.

FREESTANDING SCULPTURE. In the remarkably short time of only a few generations, Greek sculptors had moved far from the rigid, frontal presentation of the human figure embodied in the Archaic kouroi. One of the earliest and finest extant freestanding marble figures to exhibit more natural, lifelike qualities is the KRITIAN BOY of about 480 BCE (FIG. 5-28). The damaged figure, excavated from the debris on the Athenian Acropolis, was thought by its finders to be by the Greek sculptor Kritios, whose work they knew only from Roman copies. The boy strikes an easy pose quite unlike the rigid, evenly balanced pose of Archaic kouroi. His weight rests on his left leg, and his right leg bends slightly at the knee. A noticeable curve in his spine counters the slight shifting of his hips and a subtle drop of one of his shoulders. The slight turn of the head invites the spectator to follow his gaze and move around the figure, admiring the small marble statue from every angle. The boy's solemn expression lacks any trace of the Archaic smile—at last the sculptors have mastered the subtle planes of the face.

Bronze Sculpture. The obvious problem for anyone trying to create a freestanding statue is to ensure that it will not fall over. Solving this problem requires a familiarity with the ability of sculptural materials to maintain equilibrium under

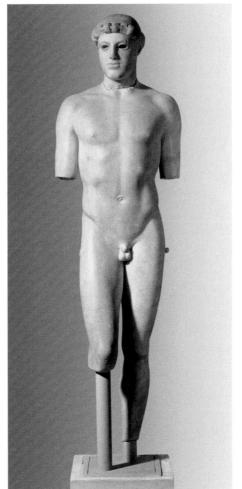

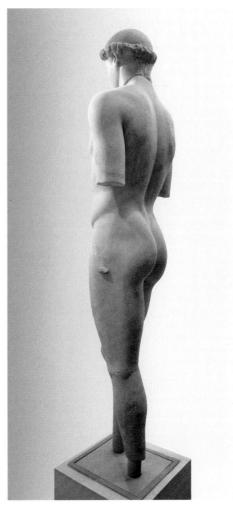

5–28 | KRITIAN BOY From Acropolis, Athens. c. 480 BCE. Marble, height 3'10" (1.17 m). Acropolis Museum, Athens.

c/T wost of.

various conditions. The **hollow-casting** technique created a far more flexible medium than solid marble or other stone and became the medium of choice for Greek sculptors. Although it is possible to create freestanding figures with outstretched arms and legs far apart in stone, hollow-cast bronze more easily permits vigorous and even off-balance action poses. Consequently, after the introduction of the new technique, sculptors sought to craft poses that seemed to capture a natural feeling of continuing movement rather than an arbitrary moment frozen in time.

Athens was as famous for its metalwork as it was for ceramics. A painted kylix, or drinking cup, illustrates the work in a foundry (FIG. 5–29). The artist, called the Foundry Painter, presents all the workings of a contemporary foundry for casting lifesize and monumental bronze figures. The artist organized this scene within the flaring space that extends upward from the foot of the vessel, using the circle that marks the attachment of the foot to the vessel as the groundline for the figures. The walls of the workshop are filled with hanging tools and other foundry paraphernalia and several sketches. The sketches include a horse, human heads, and human figures in different poses.

On the section shown here, a worker wearing what looks like a modern-day construction helmet squats to tend the furnace on the left. The man in the center, perhaps the supervisor, leans on a staff, while a third worker assembles the parts of a leaping figure that is braced against a molded support. The unattached head lies between his feet. This vase painting provides clear evidence that the Greeks were creating large bronze statues in active poses as early as the first decades of the fifth century BCE.

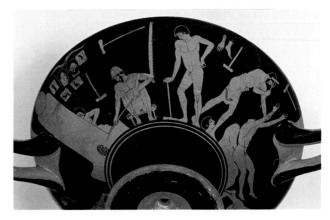

5–29 | Foundry Painter A BRONZE FOUNDRY Red-figure decoration on a kylix from Vulci, Italy. 490–480 BCE. Ceramic, diameter of kylix 12" (31 cm). Staatliche Museen zu Berlin, Preussischer Kulturbesitz, Antikensammlung, Berlin.

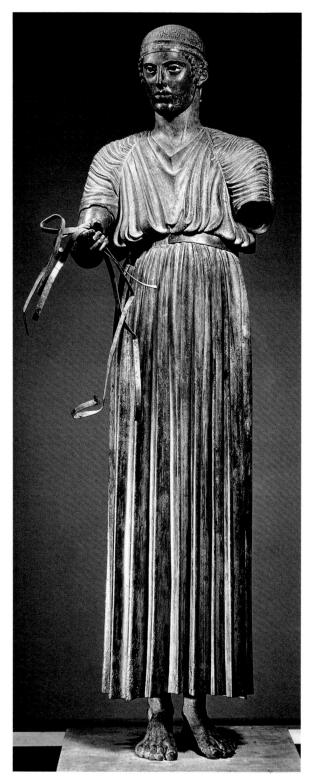

5–30 | CHARIOTEER From the Sanctuary of Apollo, Delphi. c. 470 BCE. Bronze, copper (lips and lashes), silver (hand), onyx (eyes), height 5′11″ (1.8 m). Archaeological Museum, Delphi.

The setting of a work of art affects the impression it makes. Today, the charioteer is exhibited on a low base in the peaceful surroundings of a museum, isolated from other works and spotlighted for close examination. Its effect would have been very different in its original outdoor location, standing in a horse-drawn chariot atop a tall monument. Viewers in ancient times, tired from the steep climb to the sanctuary and jostled by crowds of fellow pilgrims, could have absorbed only its overall effect, not the fine details of the face, robe, and body visible to today's viewers.

THE CHARIOTEER. Unfortunately, foundries began almost immediately to recycle metal from old statues into new works, so few original Greek bronzes have survived. A spectacular lifesize bronze, the **CHARIOTEER** (FIG. 5–30), cast about 470 BCE, was saved only because it was buried after an earthquake in 373 BCE. Archaeologists found it in the sanctuary of Apollo at Delphi, along with fragments of a bronze chariot and horses. According to its inscription, it commemorates a victory by a driver in the Pythian Games of 478 or 474 BCE.

If the Kritian Boy seems solemn, the Charioteer seems to pout. His head turns slightly to one side. His rather intimidating expression is enhanced by glittering, onyx eyes and fine copper eyelashes. The Charioteer stands erect; his long robe with its almost columnar fluting is the epitome of elegance. The folds of the robe fall in a natural way, varying in width and depth, and the whole garment seems capable of swaying and rippling with the charioteer's movement. The feet, with their closely observed toes, toenails, and swelled veins over the instep, are so realistic that they seem to have been cast from molds made from the feet of a living person.

WARRIOR A. The sea as well as the earth has protected ancient bronzes. As recently as 1972, divers recovered a pair of larger-than-life—size bronze figures from the seabed off the coast of Riace, Italy (FIG. 5–31). Known as the RIACE WARRIORS OF WARRIORS A AND B, they date to about 460–450 BCE. Just what sent them to the bottom is not known, but conservators have restored them to their original condition (see "The Discovery and Conservation of the Riace Warriors," page 135).

Warrior A reveals a striking balance between idealized anatomical forms and naturalistic details. The supple musculature suggests a youthfulness belied by the maturity of the face. Minutely detailed touches—the navel, the swelling veins in the backs of the hands, and the strand-by-strand rendering of the hair—are also in marked contrast to the idealized, youthful smoothness of the rest of the body. The sculptor heightened these lifelike effects by inserting eyeballs of bone and colored glass, applying eyelashes and eyebrows of separately cast, fine strands of bronze, insetting the lips and nipples with pinkish copper, and plating the teeth that show between the parted lips with silver. The man held a shield (parts are still visible) on his left arm and a spear in his right hand and was probably part of a monument commemorating a military victory, perhaps against the Persians.

At about the same time, the *Discus Thrower*, reproduced at the beginning of this chapter, was created in bronze by the sculptor Myron (SEE FIG. 5–1). The sculpture is known today only from Roman copies in marble, but in its original form it must have been as lifelike in its details as the *Riace Warriors*. Myron caught the athlete at a critical moment, the breathless instant before the concentrated energy of his body will unwind to propel the discus into space. His muscular torso is

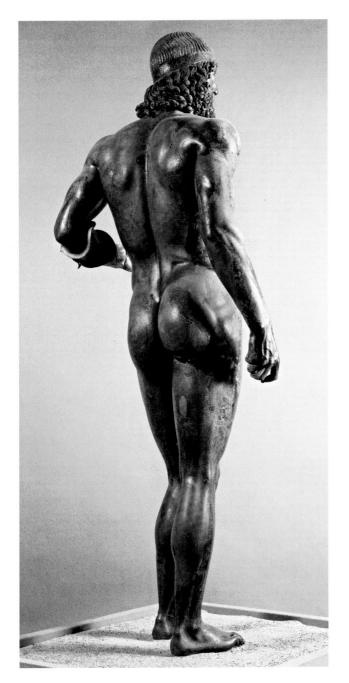

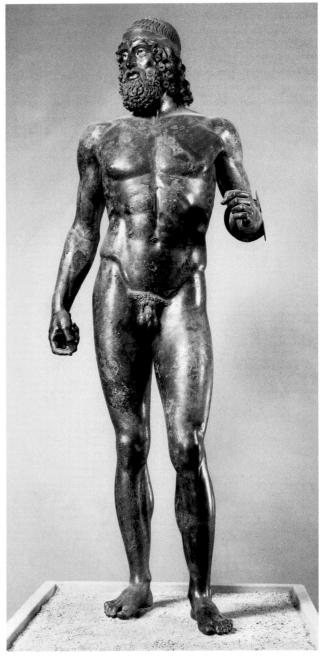

5–31 | WARRIOR A Found in the sea off Riace, Italy. c. 460–450 BCE. Bronze with bone and glass eyes, silver teeth, and copper lips and nipples, height 6′9″ (2.05 m). National Archeological Museum, Reggio Calabria, Italy.

coiled tightly into a forward arch, and his powerful throwing arm is poised at the top of his backswing. Myron earned the adulation of his contemporaries: It is interesting that he was most warmly admired for a sculpture that has not survived—a bronze cow!

PAINTING. Vase painters continued to work with the redfigure technique throughout the fifth century BCE, refining their styles and experimenting with new compositions. Among the outstanding vase painters of the Early Classical period was the prolific Pan Painter, who was inspired by the less heroic myths of the gods to create an admirable body of red-figure works. The artist's name comes from a work involving the god Pan on one side of a bell-shaped krater that dates to about 470 BCE. The other side of this krater shows **ARTEMIS SLAYING ACTAEON (FIG. 5–32).** Actaeon was punished by Artemis for boasting that he was a better hunter than she, or (in another version) for seducing Semele, who was

Technique

THE DISCOVERY AND CONSERVATION OF THE RIACE WARRIORS

n 1972, a scuba diver in the Ionian Sea near the beach resort of Riace, Italy, found what appeared to be a human elbow and upper arm protruding from sand about 25 feet beneath the sea. Taking a closer look, he discovered that the arm was made of metal, not flesh, and was part of a large statue. He soon uncovered a second statue nearby.

Experienced underwater salvagers raised the statues: bronze warriors more than 6 feet tall, complete in every respect, except for swords, shields, and one helmet. But after centuries underwater, the *Warriors* were corroded and covered with accretions. The clay cores from the casting process were still inside the bronzes, adding to the deterioration by absorbing lime and sea salts. To restore the *Warriors*, conservators first removed all the exterior corrosion and lime encrustations using surgeon's

scalpels, pneumatic drills with 3-millimeter heads, and hightechnology equipment such as sonar (sound-wave) probes and micro-sanders. Then they painstakingly removed the clay core through existing holes in the heads and feet using hooks, scoops, jets of distilled water, and concentrated solutions of peroxide. Finally, they cleaned the figures thoroughly by soaking them in solvents, and they sealed them with a fixative specially designed for use on metals.

Since the *Warriors* were put on view in 1980, conservators have taken additional steps to ensure their preservation. In 1993, for example, a sonar probe mounted with two miniature video cameras found and blasted loose with sound waves the clay remaining inside the statues, which was then flushed out with water.

being courted by Zeus. The enraged goddess caused Actaeon's own dogs to mistake him for a stag and attack him. The Pan Painter shows Artemis herself about to shoot the unlucky hunter with an arrow from her bow. The angry god-

dess and the fallen Actaeon each form roughly triangular shapes that conform to the flaring shape of the vessel.

THE HIGH CLASSICAL PERIOD, c. 450–400 BCE

The High Classical period of Greek art, from about 450 to 400 BCE, corresponds roughly to the domination of Sparta and Athens. The two had emerged as the leading city-states in the Greek world in the wake of the Persian Wars. Sparta dominated the Peloponnesus and much of the rest of mainland Greece. Athens dominated the Aegean and became the wealthy and influential center of a maritime empire.

Except for a few brief interludes, Perikles, a dynamic, charismatic leader, dominated Athenian politics and culture from 462 BCE until his death in 429 BCE. Although comedy writers of the time sometimes mocked him, calling him "Zeus" and "The Olympian" because of his haughty personality, he led Athens to a period of great wealth and influence seen later as a "Golden Age." He was a great patron of the arts, supporting the use of Athenian wealth for the adornment of the city and encouraging artists to promote a public image of peace, prosperity, and power.

He brought new splendor to the sanctuaries of the gods who protected Athens and turned the citadel of Athens, the Acropolis, into a center of civic and religious life. Perikles said of his city and its accomplishments: "Future generations will marvel at us, as the present age marvels at us now." It was a prophecy he himself helped fulfill.

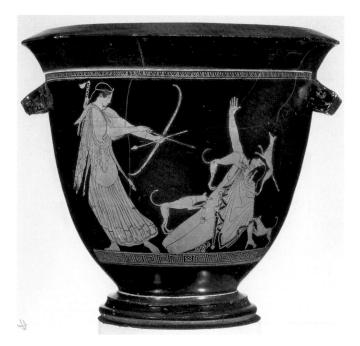

5–32 | Pan Painter ARTEMIS SLAYING ACTAEON c. 470 BCE. Red-figure decoration on a bell krater. Ceramic, height of krater 14%" (37 cm). Museum of Fine Arts, Boston. James Fund and by Special Contribution (10.185).

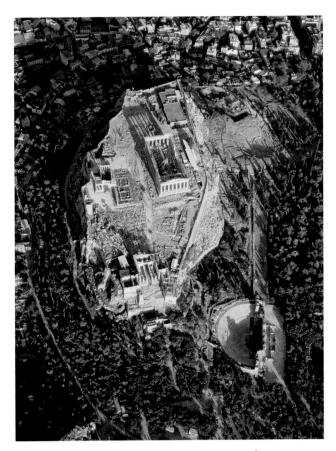

5-33 ATHENS; ACROPOLIS FROM THE AIR

Athens originated as a Neolithic acropolis, or "part of the city on top of a hill" (akro means "high" and polis means "city"). The flat-topped hill that was the original site of the city later served as a fortress and religious sanctuary. As the city grew, the Acropolis became the religious and ceremonial center devoted primarily to the goddess Athena, the city's patron and protector.

The Acropolis

After Persian troops destroyed the Acropolis in 480 BCE, the Athenians vowed to keep it in ruins as a memorial. Later Perikles convinced them to rebuild it (FIG. 5–33). He argued that this project honored the gods, especially Athena, who had helped the Greeks defeat the Persians. But Perikles also hoped to create a visual expression of Athenian values and civic pride that would glorify his city and bolster its status as the capital of the empire he was instrumental in building. He placed his close friend Pheidias, a renowned sculptor, in charge of the rebuilding and assembled under him the most talented artists and artisans in Athens.

The cost and labor involved in this undertaking were staggering. Large quantities of gold, ivory, and exotic woods had to be imported. Some 22,000 tons of marble had to be transported 10 miles from mountain quarries to

city workshops. Perikles was severely criticized by his political opponents for this extravagance, but it never cost him popular support. In fact, many working-class Athenians—laborers, carpenters, masons, sculptors, and the carters and merchants who kept them supplied and fed—benefited from his expenditures.

Work on the Acropolis continued after Perikles' death and was completed by the end of the fifth century BCE (FIG. 5-34). Visitors to the Acropolis in 400 BCE would have climbed a steep ramp on the west side of the hill to the sanctuary entrance, perhaps pausing to admire the small marble temple dedicated to Athena Nike (Athena as the goddess of victory in war), poised on a projection of rock above the ramp. After passing through an impressive porticoed gatehouse called the Propylaia, they would have seen a huge bronze figure of Athena Promachos (the Defender). This statue, designed and executed by Pheidias between about 465 and 455 BCE, showed the goddess bearing a spear. Sailors entering the Athenian port of Piraeus, about 10 miles away, could see the sun reflected off the helmet and spear tip. Behind this statue was a walled precinct that enclosed the Erechtheion, a temple dedicated to several deities.

Religious buildings and votive statues filled the hilltop. A large stoa with projecting wings was dedicated to Artemis Brauronia (the Protector of Wild Animals). Beyond this stoa on the right stood the largest building on the Acropolis, looming above the precinct wall that enclosed it. This was the Parthenon, a temple dedicated to Athena Parthenos (the Virgin). Visitors approached the temple from its northwest corner. The cella of the Parthenon faced east. With permission from the priests, they would have climbed the east steps to look into the cella, seeing a colossal gold and ivory statue of Athena, created by Pheidias and installed and dedicated in the temple in 438 BCE. However, the building was not yet complete and further work on the ornamental sculpture continued until 433/432 BCE.

The Parthenon

Sometime around 490 BCE, Athenians began work on a temple to Athena Parthenos that was still unfinished when the Persians sacked the Acropolis a decade later. Work was resumed in 447 BCE by Perikles, who commissioned the architect Iktinos to design a larger temple using the existing foundation and stone elements. The finest white marble was used throughout, even on the roof, in place of the more usual terra-cotta tiles.

One key to the Parthenon's sense of harmony and balance is an aesthetics of number that was used to determine the perfect proportions—especially the ratio of 4:9, expressing the relationship of breadth to length and also the relationship of column diameter to space between columns. Just as important to the overall effect are subtle refinements of design, including the slightly arched base and entablature, the very subtle swelling of the soaring columns, and the

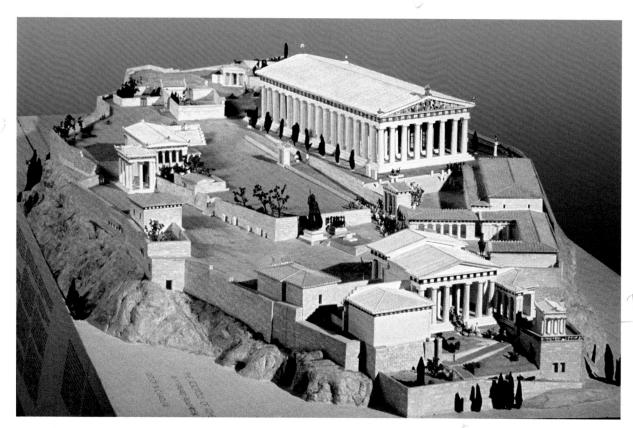

5−34 MODEL OF THE ACROPOLIS, ATHENS c. 447–432 BCE. Royal Ontario Museum, Toronto.

narrowing of the space between the corner columns and the others in the colonnade. This aesthetic control of space is the essence of architecture, as opposed to mere building. The significance of their achievement was clear to its builders—Iktinos even wrote a book on the proportions of his masterpiece.

The planning and execution of the Parthenon required extraordinary mathematical and mechanical skills and would have been impossible without a large contingent of distinguished architects and builders, as well as talented sculptors and painters. The result is as much a testament to the administrative skills as to the artistic vision of Phidias, who supervised the entire project (see plan (d) of "Greek Temple Plans," page 116). The building and statue of Athena Parthenos were dedicated in 438 BCE. Pheidias designed the ivory and gold sculpture, which was executed in his workshop and finished about 432 .

The decoration of the Parthenon strongly reflects Pheidias's unifying vision. A coherent, stylistic whole, the sculptural decoration conveys a number of political and ideological themes: the triumph of the democratic Greek city-states over imperial Persia, the preeminence of Athens thanks to the favor of Athena, and the triumph of an enlightened Greek civilization over despotism and barbarism (see "The Parthenon," page 138).

THE PEDIMENTS. Like the pediments of most temples, those of the Parthenon were filled with sculpture in the round, set on the deep shelf of the cornice and secured to the wall with metal pins. Unfortunately, much has been damaged or lost over the centuries. Using the locations of the pinholes and weathering marks on the cornice, scholars have been able to determine the placement of surviving statues and infer the poses of missing ones. The west pediment sculpture, facing the entrance to the Acropolis, illustrated the contest Athena won over the sea god Poseidon for rule over the Athenians. The east pediment figures, above the entrance to the cella, illustrated the birth of Athena, fully grown and clad in armor, from the brow of her father, Zeus.

The statues from the east pediment are the best preserved of the two groups (FIG. 5–35). Flanking the missing central figures—probably Zeus seated on a throne with the new-born adult Athena standing at his side—were groups of three goddesses followed by single reclining male figures. In the left corner was the sun god Helios in his horse-drawn chariot rising from the sea. In the right corner was the moon goddess Selene descending in her chariot to the sea. The head of her tired horse hangs over the cornice. The reclining male nude, who fits so easily into the left pediment, has been identified as both Herakles with his lion's skin, or Dionysos (god

THE OBJECT SPEAKS

THE PARTHENON

he Parthenon, a symbol of Athenian aspirations and creativity, rises triumphantly above the Acropolis. This temple of the goddess of wisdom spoke eloquently to fifth-century BCE Greeks of independence, self-confidence, and justifiable pride-through the excellence of its materials and craftwork, the rationality of its simple and elegant post-and-lintel structure, and the subtle yet ennobling messages of its sculpture. Today, we continue to be captivated by the gleaming marble ruin of the Parthenon, the building that has shaped our ideas about Greek civilization, about the importance of architecture as a human endeavor, and also about the very notion of the possibility of perfectibility. Its form, even when regarded abstractly, is an icon for democratic values and independent thought.

When the Parthenon was built, Athens was the capital of a powerful, independent city-state. For Perikles, Athens was the model of all Greek cities; the Parthenon was the perfected, ideal Doric temple.

Isolated like a work of sculpture, with the rock of the Acropolis as its base, the Parthenon is both an abstract form—a block of columns—and at the same time the essence of shelter: an earthly home for Athena, the patron goddess. For the ancient Greeks, the Parthenon symbolized Athens, its power and wealth, its glorious victory over foreign invaders, and its position of leadership at home.

Over the centuries, very different people reacting to very different circumstances found that the temple could also express their ideals. They imbued it with meaning and messages that might have shocked the original builders. Over its long life, the Parthenon has been a Christian church dedicated to the Virgin Mary, an Islamic mosque, a Turkish munitions storage facility, an archaeological site, and a major tourist attraction.

To many people through the ages, it remained silent, but in the eighteenth century CE, in the period known as the Enlightenment, the Parthenon found its

voice again. British architects James Stuart and Nicholas Revett made the first careful drawings of the building in the mid-eighteenth century, which they published as The Antiquities of Athens, in 1789. People reacted to the Parthenon's harmonious proportions, subtle details, and rational relationship of part to part, even in drawings. The building came to exemplify, in architectural terms, human and humane values. In the nineteenth century, the Parthenon became a symbol of honesty, heroism, and civic virtue, of the highest ideals in art and politics, a model for national monuments, government buildings, and even homes.

Architectural messages, like any communications, may be subject to surprising interpretations. On a bluff overlooking the Danube River near Regensburg in Germany, a nineteenth-century Parthenon commemorates the defeat of Napoleon, and in Edinburgh, Scotland ("the Athens of the North") the unfinished façade of Doric columns and entablature (the

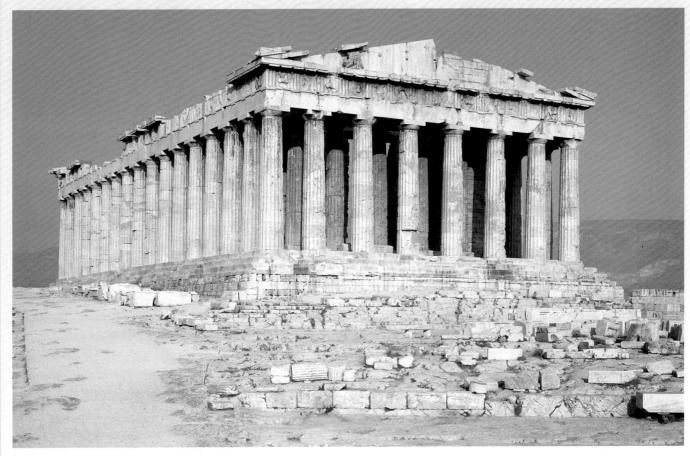

Kallikrates and Iktinos **PARTHENON, ACROPOLIS**Athens. 447–432 BCE. View from the northwest. Pantelic marble.

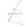

builders ran out of money in 1829) confront the Medieval castle on the opposite hill. Nineteenth century Americans dignified their democratic, mercantile culture by adapting the Parthenon's form to government, business, and even domestic buildings. Not only was the simplicity of the Doric order considered appropriate but it also was the cheapest order to build. In the 1830s and 40s the Greek Revival style spread across the United States, adding a touch of elegance to simple farm houses.

One of the most remarkable reincarnations of the Parthenon can be admired in Nashville, Tennessee, "the Athens of the South." Here a replica of the Parthenon was built for the Centenial exhibition of 1897. So popular was the building that when the structure with its plaster sculpture deteriorated dangerously, the city replaced the building in permanent materials. They rebuilt the Parthenon in concrete on a steel frame. The sculptured pediments were created by the local sculptor Belle Kinney of Nashville, assisted by her husband Leopold Schulz. In 1982 Alan LeQuire created a statue of Athena for the interior. The gigantic figure standing nearly 42 feet tall, made of a compound of gypsum cement and chopped fiberglass supported by a structural steel framework, was unveiled May 20, 1990. In the summer of 2002 the figure was painted to simulate marble and gilded—a sight to behold.

The Athenian Parthenon continues to speak to viewers today. Its columns and pediment have become a universal image, like the Great Pyramids of Egypt, used and reused in popular culture. The Parthenon even has an intriguing half-life in postmodern buildings and decorative arts.

When the notable architect Le Corbusier sought to create an architecture for the twentieth century, he turned for inspiration to the still-vibrant temple of the goddess of wisdom's clean lines, simple forms, and mathematical ratios. Le Corbusier called the Parthenon "ruthless, flawless," and wrote, "There is nothing to equal it in the architecture of the entire world and all the ages . . ." (Le Corbusier, Vers une architecture, 1923).

Alan LeQuire ATHENA, THE PARTHENON, NASHVILLE, TENNESSEE

Recreation of Pheidias's huge gold and ivory figure. 1982–1990. Gypsum concrete and chopped fiberglass on structural steel, height 41' 10". Painted to simulate marble with lapis lazuli eyes by Alan LeQuire and gilded under the direction of master gilder Lou Reed, June 3–Sept. 3, 2002. The ancient sculpture was of ivory and gold.

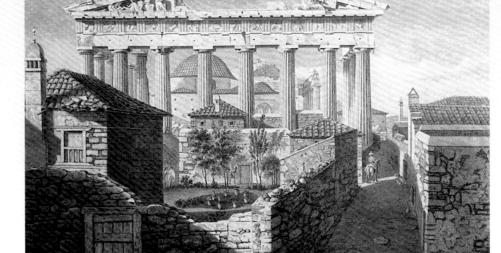

William Pars THE PARTHENON WHEN IT CONTAINED A MOSQUE

Drawing by Nicholas Revett (1765) and published in James Stuart and Nicholas Revett, *The Antiquities of Athens* (London, 1789).

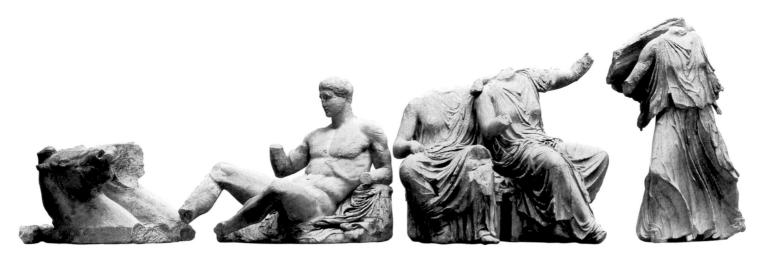

5-35 PHOTOGRAPHIC MOCK-UP OF THE EAST PEDIMENT OF THE PARTHENON

(Using photographs of the extant marble sculpture) c. 447-432 BCE. The gap in the center represents the space that would have been occupied by the missing sculpture. The pediment is over 90 feet (27.45 m) long; the central space of about 40 feet (12.2 m) is missing.

At the beginning of the nineteenth century, Thomas Bruce, the British Earl of Elgin and ambassador to Constantinople, acquired much of the surviving sculpture from the Parthenon, which was being used for military purposes. He shipped it back to London in 1801 to decorate a lavish mansion for himself and his wife. By the time he returned to England a few years later, his wife had left him and the ancient treasures were at the center of a financial dispute. Finally, he sold the sculpture for a very low price. Referred to as the Elgin Marbles, most of the sculpture is now in the British Museum, including all the elements seen here. The Greek government has tried unsuccessfully in recent times to have the Elgin Marbles returned.

of wine) lying on a panther skin. His easy pose conforms to the slope of the pediment without a hint of awkwardness. The two seated women may be the earth and grain goddesses Demeter and Persephone. The running female figure just to the left of center is Iris, messenger of the gods, already spreading the news of Athena's birth.

The three female figures on the right side, two sitting upright and one reclining, were once thought to be the Three Fates, whom the Greeks believed appeared at the birth of a child and determined its destiny. Most art historians now think that they are goddesses, perhaps Hestia (a sister of Zeus and the goddess of the hearth), Dione (one of Zeus's many consorts), and her daughter, Aphrodite. These monumental interlocked figures seem to be awakening from a deep sleep. The sculptor, whether Pheidias or someone working in his style, expertly rendered the female form beneath the fall of draperies. The clinging fabric both covers and reveals, creating circular patterns rippling with a life of their own over torsos, breasts, and knees and uniting the three figures into a single mass.

THE DORIC FRIEZE. The Athenians intended their temple to surpass the Temple of Zeus at Olympia, and they succeeded. The all-marble Parthenon was large in every dimension. It held a spectacular standing statue of Athena, about 40 feet high. It also had two sculptured friezes, one above the outer peristyle and another atop the cella wall inside (Introduction, see Fig. 20). The Doric frieze on the exterior had ninety-two

metope reliefs, fourteen on each end and thirty-two along each side. These reliefs depicted legendary battles, symbolized by combat between two representative figures: a Lapith against a centaur; a god against a Titan; a Greek against a Tro-

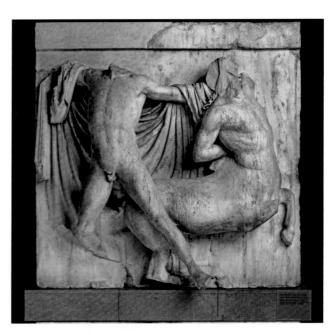

5–36 | LAPITH FIGHTING A CENTAUR

Metope relief from the Doric frieze on the south side of the Parthenon. c. 447–432 BCE. Marble, height 56" (1.42 m).

The British Museum, London.

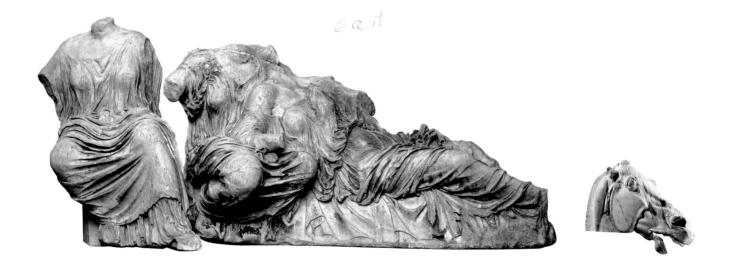

jan; a Greek against an Amazon (Amazons were members of the mythical tribe of female warriors sometimes said to be the daughters of the war god Ares).

Among the best-preserved metope reliefs are those from the south side, including several depicting the battle between the Lapiths and the centaurs. The panel shown here (FIG. 5–36)—with its choice of a perfect moment of pause within a fluid action, its reduction of forms to their most characteristic essentials, and its choice of a single, timeless image to stand for an entire historical episode—captures the essence of High Classical art. So dramatic is the X-shaped composition that we easily accept its visual contradictions.

Like the *Discus Thrower* (SEE FIG. 5–1), the Lapith is caught at an instant of total equilibrium. What should be a grueling tug-of-war between a man and a man-beast appears instead as an athletic ballet choreographed to show off the

Lapith warrior's muscles and graceful movements against the implausible backdrop of his carefully draped cloak. Like Greek sculptors of earlier periods, those of the High Classical style were masters of representing hard muscles but soft flesh.

THE PROCESSIONAL FRIEZE. Enclosed within the Parthenon's Doric peristyle, the body of the temple consists of a cella, opening to the east, and an unconnected auxiliary space opening to the west. Short colonnades in front of each entrance support an entablature with an Ionic order frieze in relief that extends along the four sides of the cella, for a total frieze length of 525 feet. The subject of this frieze is a procession celebrating the festival that took place in Athens every four years, when the women of the city wove a new wool peplos and carried it to the Acropolis to clothe an ancient wooden cult statue of Athena.

North

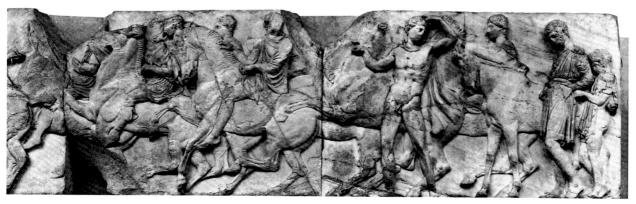

5–37 | **HORSEMEN** Detail of the *Procession*, from the Ionic frieze on the north side of the Parthenon. c. 447–432 BCE. Marble, height 41%" (106 cm). The British Museum, London.

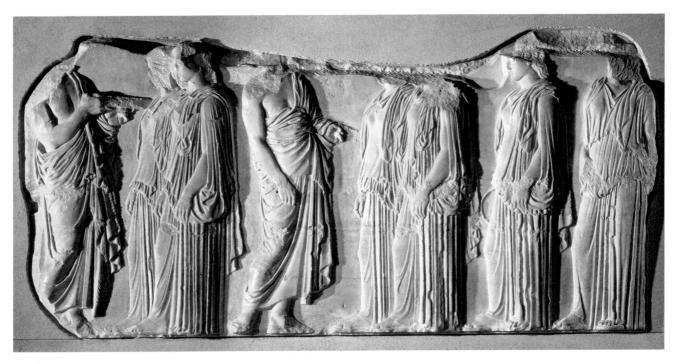

5–38 | MARSHALS AND YOUNG WOMEN

Detail of the *Procession*, from the lonic frieze on the east side of the Parthenon. c. 447–432 BCE. Marble, height 3'6" (1.08 m). Musée du Louvre, Paris.

Gar

The east façade presents a totally integrated program of images—the birth of the goddess in the pediment, her honoring by the citizens who present her with the newly woven *peplos*, and—seen through the doors—the glorious figure of Athena herself.

In Pheidias's portrayal of this major event, the figures—skilled riders managing powerful steeds, for example (FIG. 5–37), or graceful but physically sturdy young walkers (FIG. 5–38)—seem to be representative types, ideal inhabitants of a successful city-state. The underlying message of the frieze as a whole is that the Athenians are a healthy, vigorous people, united in a democratic civic body looked upon with favor by the gods. The people are inseparable from and symbolic of the city itself.

As with the metope relief of the *Lapith Fighting a Centaur*, (SEE FIG. 5–36) viewers of the processional frieze easily accept its disproportions, spatial incongruities, and such implausible compositional features as all the animal and human figures standing on the same groundline, and men and women standing as tall as rearing horses. Carefully planned rhythmic variations—changes in the speed of the participants in the procession as it winds around the walls—contribute to the effectiveness of the frieze: Horses plunge ahead at full gallop; women proceed with a slow, stately step; parade marshals pause to look back at the progress of those behind them; and human-looking deities rest on conveniently placed benches as they await the arrival of the marchers.

In executing the frieze, the sculptors took into account the spectators' low viewpoint and the dim lighting inside the peristyle. They carved the top of the frieze band in higher relief than the lower part, thus tilting the figures out to catch the reflected light from the pavement, permitting a clearer reading of the action. The subtleties in the sculpture may not have been as evident to Athenians in the fifth century BCE as they are now, because the frieze, seen at the top of a high wall and between columns, originally was completely painted (Introduction, see Fig. 20). The background was dark blue and the figures were in contrasting red and ocher, accented with glittering gold and real metal details such as bronze bridles and bits on the horses.

The Propylaia and the Erechtheion

Upon completion of the Parthenon, Perikles commissioned an architect named Mnesikles to design a monumental gatehouse, the Propylaia (SEE FIG. 5–34). Work began on it in 437 and then stopped in 432 BCE, with the structure still incomplete. The Propylaia had no sculptural decoration, but its north wing was originally a dining hall and later it became the earliest known *museum* (meaning "home of the Muses"), the "Pinakotheke" mentioned by Pausanius, which became a gallery built specifically to house a collection of paintings for public view.

The designer of the **ERECHTHEION** (FIG. 5–39), the second important temple erected on the Acropolis under Perikles' building program, is unknown. Work began on the building in 421 BCE and ended in 405 BCE, just before the fall of

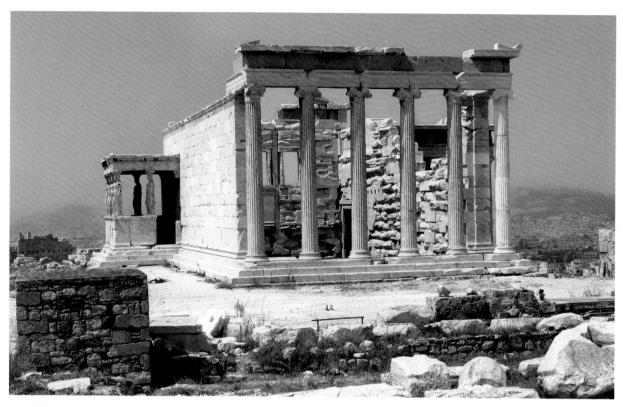

5-39 | ERECHTHEION

Acropolis, Athens. 421–406 BCE. View from the east. Porch of the Maidens at left; north porch can be seen through the columns of the east wall.

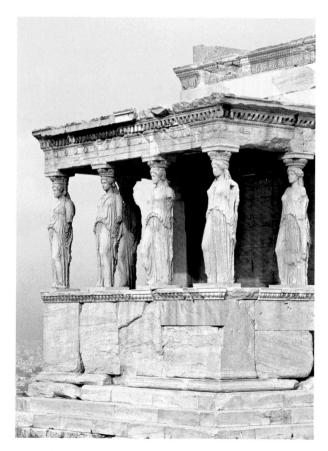

5--40 | porch of the maidens (south porch), erechtheion

Acropolis, Athens. Temple 430s-406 BCE; porch c. 420-410 BCE.

Athens to Sparta. The asymmetrical plan on several levels reflects the building's multiple functions, for it housed many different shrines, and it also conformed to the sharply sloping terrain on which it was located. The building stands on the site of the mythical contest between the sea god Poseidon and Athena for patronage over Athens. During this contest, Poseidon struck a rock with his trident (three-pronged harpoon), bringing forth a spout of water, but Athena gave the olive tree to Athens and won the contest for the city. The Athenians enclosed what they believed to be this sacred rock, bearing the marks of the trident, in the Erechtheion's north porch. The Erechtheion also housed the venerable wooden cult statue of Athena that was the center of the Panathenic festival.

The Erechtheion had porches on the north, east, and south sides. Later architects agreed that the north porch was the most perfect interpretation of the Ionic order, and they have copied the columns and capitals, the carved moldings, and the proportions and details of the door ever since the eighteenth century. The **PORCH OF THE MAIDENS** (FIG. 5–40), on the south side facing the Parthenon, is even more famous. Raised on a high base, its six stately caryatids support simple Doric capitals and an Ionic entablature made up of bands of carved molding. In a pose characteristic of Classical figures, each caryatid's weight is supported on one engaged leg, while the free leg, bent at the knee, rests on the ball of the foot. The three caryatids on the left have their right legs engaged, and

5-41 | THE MONUMENTAL ENTRANCE TO THE ACROPOLIS

The Propylaia (Mnesikles) with the Temple of Athena Nike (Kallikrates) on the bastion at the right.
C. 437-423 BCE.

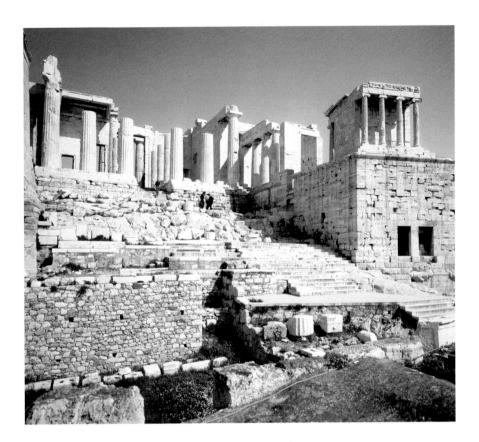

the three on the right have their left legs engaged, creating a sense of closure, symmetry, and rhythm. The vertical fall of the drapery on the engaged side resembles the fluting of a column shaft and provides a sense of stability, whereas the bent leg gives an impression of relaxed grace and effortless support. The hair of each caryatid falls in a loose but massive knot behind its neck, a device that strengthens the weakest point in the sculpture while appearing entirely natural.

The Temple of Athena Nike

The Temple of Athena Nike (victory in war), located south of the Propylaia, was designed and built about 425 BCE, probably by Kallikrates (FIG. 5–41). It is an Ionic temple built on an amphiprostyle plan, that is, with a porch at each end (see plan (c) of "Greek Temple Plans," page 116). Reduced to rubble during the Turkish occupation of Greece in the seventeenth century CE, the temple has since been rebuilt. Its diminutive size, about 27 by 19 feet, and refined Ionic decoration are in marked contrast to the massive Doric Propylaia adjacent to it.

5–42 NIKE (VICTORY) ADJUSTING HER SANDAL Fragment of relief decoration from the parapet (now destroyed), Temple of Athena Nike, Acropolis, Athens. Last quarter of the 5th century (perhaps 410–405) BCE. Marble, height 3'6" (1.06 m). Acropolis Museum, Athens.

Art and Its Context

WHO OWNS THE ART? THE ELGIN MARBLES AND THE EUPHRONIOS VASE

t the beginning of the nineteenth century, Thomas Bruce, the British earl of Elgin and ambassador to Constantinople, acquired much of the surviving sculpture from the Parthenon, which was being used for military purposes. He shipped it back to London in 1801 to decorate a lavish mansion for himself and his wife. By the time he returned to England a few years later, his wife had left him and the ancient treasures were at the center of a financial dispute. Finally, he sold the sculpture for a very low price. Referred to as the Elgin Marbles, most of the sculpture is now in the British Museum, including all the elements seen in figure 5–35 except the torso of Selene, which is in the Acropolis Museum, Athens. The Greek government has tried unsuccessfully in recent times to have the Elgin Marbles returned.

Recently, another Greek treasure has been in the news. In 1972, a krater (a bowl for mixing water and wine), painted by

the master Euphronios and depicting the death of the warrior Sarpedon during the Trojan War, had been purchased by the Metropolitan Museum of Art in New York (FIG. 5–23). Museum officials were told that the krater had come from a private collection, and they made it the centerpiece of the Museum's galleries of Greek vases. But in 1995, Italian and Swiss investigators raided a warehouse in Geneva, Switzerland, where they found documents showing that the vase had been stolen from an Etruscan tomb near Rome. The Italian government wanted the masterpiece back. The controversy—who owns the art—was resolved in 2006. The vase, along with other objects known to have been stolen from other Italian sites, will be returned. Meanwhile, the Metropolitan Museum will display pieces "of equal beauty" on long-term loan agreements with Italy.

Between 410 and 405 BCE, the temple was surrounded by a parapet, or low wall, faced with sculptured panels depicting Athena presiding over her winged attendants, called *nike* (victory) figures, as they prepared for a celebration. The parapet no longer exists, but some of the panels from it have survived. One of the most admired is of **NIKE** (VICTORY) ADJUST-ING HER SANDAL (FIG. 5–42). The figure bends forward gracefully, causing her *chiton* to slip off one shoulder. Her large wings, one open and one closed, effectively balance this unstable pose. Unlike the decorative swirls of heavy fabric covering the Parthenon goddesses or the weighty pleats of the robes of the Erechtheion caryatids, the textile covering this *Nike* appears delicate and light, clinging to her body like wet silk, one of the most discreetly erotic images in ancient art.

The Athenian Agora

In Athens, as in most cities of ancient Greece, commercial, civic, and social life revolved around the marketplace, or agora. The Athenian Agora, at the foot of the Acropolis, began as an open space where farmers and artisans displayed their wares. Over time, public and private structures were erected on both sides of the Panathenaic Way, a ceremonial road used during an important festival in honor of Athena (FIG. 5–43). A stone drainage system was installed to prevent flooding, and a large fountain house was built to provide water for surrounding homes, administrative buildings, and shops. By 400 BCE, the Agora contained several religious and administrative structures and even a small racetrack. The Agora also had the city mint, its military headquarters, and two buildings devoted to court business.

In design, the *stoa*, a distinctively Greek structure found nearly everywhere people gathered, ranged from a simple roof held up by columns to a substantial, sometimes architecturally impressive, building with two stories and shops along one side. Stoas offered protection from the sun and rain, and provided a place for strolling and talking business, politics, or philosophy. While city business could be, and often was, conducted in the stoas, agora districts also came to include buildings with specific administrative functions.

In the Athenian Agora, the 500-member boule, or council, met in a building called the bouleuterion. This structure, built before 450 BCE but probably after the Persian destruction of Athens in 480 BCE, was laid out on a simple rectangular plan with a vestibule and large meeting room. Near the end of the fifth century BCE, a new bouleuterion was constructed to the west of the old one. This too had a rectangular plan. The interior, however, may have had permanent tiered seating arranged in an ascending semicircle around a ground-level podium, or raised platform. Such an arrangement was typical of the outdoor theaters of the time.

Nearby was a small, round building with six columns supporting a conical roof, a type of structure known as a **tholos**. Built about 465 BCE, this *tholos* was the meeting place of the fifty-member executive committee of the *boule*. The committee members dined there at the city's expense, and a few of them always spent the night there in order to be available for any pressing business that might arise.

The Priam Painter has given us an insight into Greek city life as well as a view of an important public building. A water jug (*hydria*) attributed to him depicts a Greek fountain

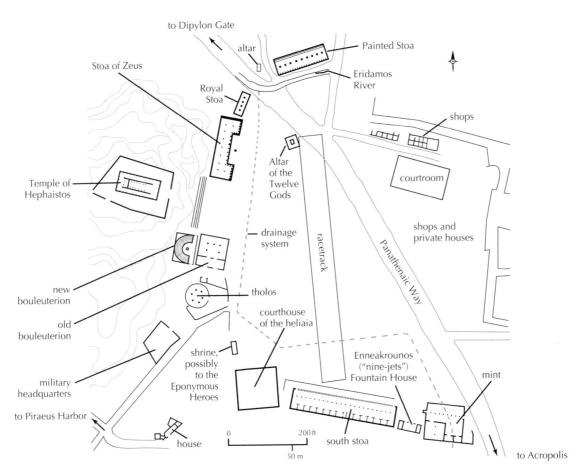

5–43 \dagger Plan of the agora (marketplace) Athens. c. 400 BCE.

house in use (FIG. 5-44). The fountains were truly a public amenity, appreciated by the women and slaves who otherwise would have had to pull up heavy containers from a well. The daily trip to collect water was an important event, since most women in ancient Greece were confined to their homes. At a fountain house, in the shade of a Doric-columned porch, three women fill jugs like the one on which they are painted. A fourth balances her empty jug on her head as she waits, while a fifth woman seems to be waving a greeting to someone. The building is designed like a stoa, open on one side, but having animal-head spigots on three walls. The Doric columns support a Doric entablature with an architrave above the colonnade and a colorful frieze-here black and white blocks replace carved metopes. The circular palmettes (fan-shaped petal designs) framing the main scenes suggest a rich and colorful civic center.

5–44 | Priam Painter **WOMEN AT A FOUNTAIN HOUSE** 520–510 BCE. Black-figure decoration on a hydria. Ceramic, height of hydria 20%" (53 cm). Museum of Fine Arts, Boston. William Francis Warden Fund (61.195)

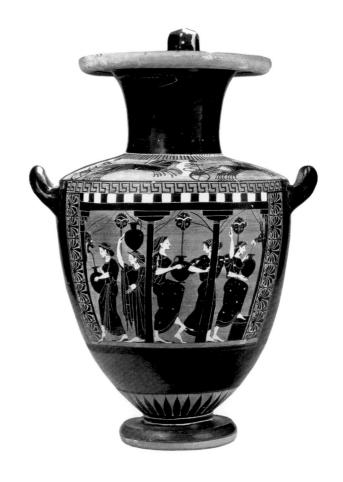

Private houses surrounded the Agora. Compared with the often grand public buildings, houses of the fifth century BCE in Athens were rarely more than simple rectangular structures of stucco-faced mud brick with wooden posts and lintels supporting roofs of terra-cotta tiles. Rooms were small and included a dayroom in which women could sew, weave, and do other chores, a dining room with couches for reclining around a table, a kitchen, bedrooms, and occasionally an indoor bathroom. Where space was not at a premium, houses sometimes opened onto small courtyards or porches.

Stele Sculpture

A freestanding monument that was used in the cemeteries in Greece is an upright stone slab, or **stele** (plural, **stelai**), carved in low relief with the image of the person to be remembered. Instead of images of warriors or athletes used in earlier times, however, the Classical stelai represent departures or domestic scenes that very often feature women. Although respectable

women played no role in politics or civic life, the presence of many fine tombstones of women indicate that they held a respected position in the family.

The **GRAVE STELE OF HEGESO** depicts a beautifully dressed woman seated in an elegant chair, her feet on a footstool (FIG. 5–45). She selects jewels (a necklace indicated in paint) from a box presented by her maid. The composition is entirely inward turning, not only in the gaze and gestures focused on the jewels, but also in the way the vertical fall of the maid's drapery and the curve of Hegeso's chair seem to enclose and frame the figures. Although their faces and bodies are idealized, the two women take on some individuality through details of costume and hairstyle. The simplicity of the maid's tunic and hair, caught in a net, contrasts with the luxurious dress and partially veiled, flowing hair of Hegeso. The sculptor has carved both women as part of the living spectators, space in front of a simple temple-fronted gravestone. The artist does not invade the private world of women: Hegeso's

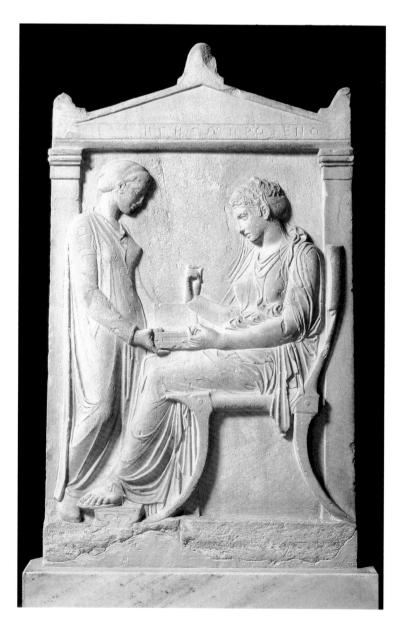

5–45 | GRAVE STELE OF HEGESO c. 410–400 BCE. Marble, height 5′2″ (1.58 m). National Archaeological Museum, Athens.

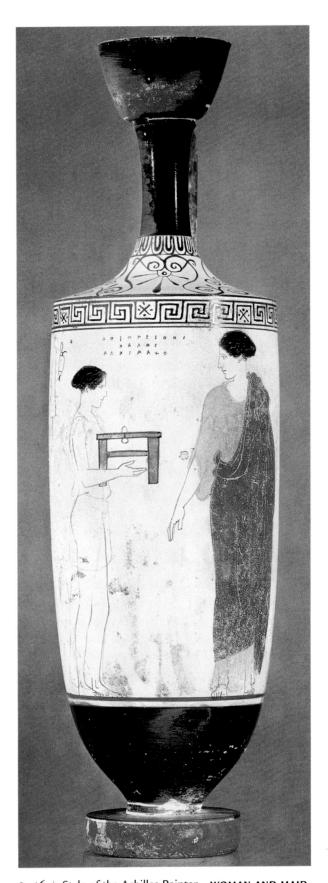

5–46 | Style of the Achilles Painter WOMAN AND MAID c. 450–440 BCE. White-ground lekythos. Ceramic, with additional painting in tempera, height of lekythos 15 1/8" (38.4 cm). Museum of Fine Arts, Boston.

Francis Bartlett Donation of 1912 (13.201)

stele and many others like it could be set up in the public cemetery with no loss of privacy or dignity to its subjects.

Painting: Murals and Vases

The Painted Stoa built on the north side of the Athenian Agora about 460 BCE is known to have been decorated with paintings (hence its name) by the most famous artists of the time, including Polygnotos of Thasos (active c. 475–450 BCE). His contemporaries praised his talent for creating the illusion of spatial recession in landscapes, rendering female figures clothed in transparent draperies, and conveying through facial expressions the full range of human emotions. Ancient writers described his painting, as well as other famous works, enthusiastically, but nothing survives for us to see.

Without mural painting, we turn again to ceramics for information. White-ground vase painting must have echoed the style of contemporary paintings on walls and panels. White ground had been used as early as the seventh century BCE, but white-ground vase painting in the High Classical period was far more complex than earlier efforts (SEE "Greek Painted Vases," page 114). Characterized by outlined or drawn imagery, this style was a specialty of Athenian potters. Artists enhanced the fired vessel with a full range of colors using paints made by mixing tints with white clay and also using tempera, an opaque, water-based medium mixed with glue or egg white. This fragile decoration deteriorated easily and for that reason seems to have been favored for funerary, votive, and other nonutilitarian vessels.

A tall, slender, one-handled white-ground lekythos was used to pour liquids during religious rituals. Some convey grief and loss with a scene of a departing figure bidding farewell. Others depict a grave stele draped with garlands. Still others show scenes of the dead person once again in the prime of life and engaged in a seemingly everyday activity, but the images are imbued with signs of separation and loss. A white-ground lekythos, dated about 450-440 BCE and in the style of the Achilles Painter (an anonymous artist known from his painting of Achilles), shows a young servant girl carrying a stool for a small chest of valuables to a well-dressed woman of regal bearing, the dead person whom the vessel memorializes (FIG. 5-46). Like the Grave Stele of Hegeso, the scene contains no overt signs of grief, but a quiet sadness pervades it. The two figures seem to inhabit different worlds, and their glances just fail to meet.

THE LATE CLASSICAL PERIOD, c. 400–323 BCE

After the Spartans defeated Athens in 404 BCE, they set up a pro-Spartan government so oppressive that within a year the Athenians rebelled against it, killed its leader, Kritias, and restored democracy. Athens recovered its independence and

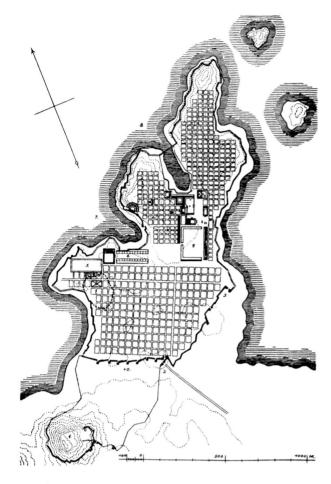

5–47 | PLAN OF MILETOS lonia (present-day Turkey), with original coastline.

its economy revived, but it never regained its dominant political and military status. Although Athens had lost its empire, it retained its reputation as a center of artistic and intellectual life. In 387 BCE, the great philosopher-teacher Plato founded a school just outside Athens, as Plato's student Aristotle did later. Among Aristotle's students was young Alexander of Macedon, known to history as Alexander the Great.

In 359 BCE, a crafty and energetic warrior, Philip II, had come to the throne of Macedonia. In 338, he defeated Athens and rapidly conquered the other Greek cities. When he was assassinated two years later, his kingdom passed to his 20-year-old son, Alexander. Alexander rapidly consolidated his power and then led a united Greece in a war of revenge and conquest against the Persians. In 334 BCE, he crushed the Persian army and conquered Syria and Phoenicia. By 331, he had occupied Egypt and founded the seaport he named Alexandria. The Egyptian priests of Amun recognized him as the son of a god, an idea he readily adopted.

That same year, Alexander reached the Persian capital of Persepolis, where his troops accidentally burned down the palace. He continued east until 326 BCE, when he reached the western part of India—now present-day Pakistan. Finally his troops refused to go any farther. On the way home, Alexander died of fever in 323 BCE. He was only 33 years old.

The work of Greek artists during the fourth century BCE exhibits a high level of creativity and technical accomplishment. Changing political conditions never seriously dampened the Greek creative spirit. Indeed, the artists of the second half of the century in particular experimented widely with new subjects and styles. Although they observed the basic Classical approach to composition and form, they no longer followed its conventions. Their innovations were supported by a sophisticated new group of patrons, including the Macedonian courts of Philip and Alexander, wealthy aristocrats in Asia Minor, and foreign rulers eager to import Greek wares and, sometimes, Greek artists.

Architecture and Architectural Sculpture

Despite the political instability, fourth-century Greek cities undertook innovative architectural projects. Architects developed variations on the Classical ideal in urban planning, temple design, and the design of two increasingly popular structures, the *tholos* and the monumental tomb. In contrast to the previous century, much of this activity took place outside of Athens and even in areas beyond mainland Greece, notably in Asia Minor.

CITY PLANS. In older Greek cities such as Athens, buildings and streets developed according to the needs of their inhabitants and the requirements of the terrain. As early as the eighth century BCE, however, builders in some western Greek settlements began to use a rigid, mathematical concept of urban development based on the orthogonal (or grid) plan. New cities or rebuilt sections in old cities were laid out on straight, evenly spaced parallel streets that intersected at right angles to create rectangular blocks. These blocks were then subdivided into identical building plots.

During the Classical period, Greek architects promoted this system as the ideal city plan (FIG. 5–47). Hippodamos of Miletos, a major urban planner of the fifth century BCE, had views on the city akin to those of the Athenian philosophers (such as Socrates) and artists (such as Polykleitos). He believed that humans could arrive at a model of perfection through reason. According to Hippodamos, the ideal city should be limited to 10,000 citizens divided into three classes—artists, farmers, and soldiers—and divided into three zones—sacred, public, and private. The basic Hippodamian plot was a square 600 feet on each side, divided into quarters. Each quarter was subdivided into six rectangular building plots measuring 100 by 150 feet on a side. (This scheme is still widely used in American and European cities and suburbs today.)

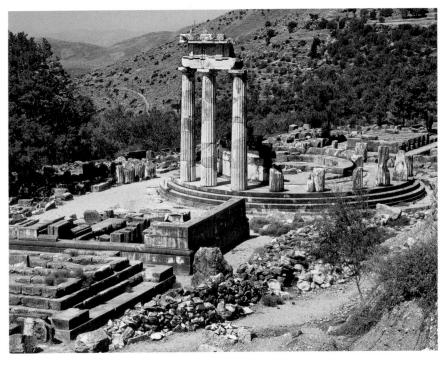

5–48 ↑ THOLOS, SANCTUARY OF ATHENA PRONAIA, DELPHI c. 380–370 BCE.

The term *Pronaia* in this sanctuary name simply means "in front of the temples," referring to the sanctuary's location preceding the Temple of Apollo higher up on the mountainside.

Many Greek cities with orthogonal plans were laid out on relatively flat land. Miletos, an Ionian city in Asia Minor, for example, was redesigned by Hippodamos after its partial destruction by the Persians. Later the orthogonal plan was applied on less hospitable terrain, such as that of Priene, another Ionian city, which lies on a rugged hillside across the plain from Miletos. In this case, the city's planners made no attempt to accommodate their grid to the irregular mountainside, so some streets are in fact stairs.

THOLOI AND TOMBS. While most buildings followed a rectilinear plan, buildings with a circular plan also had a long history in Greece, going back to Mycenaean *tholos* tombs (SEE FIG. 4–21). In later times, various types of *tholoi* were erected. Some were shrines or monuments and some, like the fifth-century BCE *tholos* in the Athens Agora, were administrative buildings. However, the function of many, such as a *tholos* built from about 388 to 370 BCE in the Sanctuary of Athena Pronaia at Delphi, is unknown (FIGS. 5–48, 5–49). Theodoros, the presumed archi-

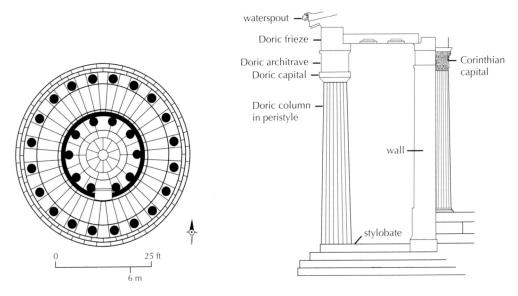

5-49 PLAN AND SECTION OF THE THOLOS, SANCTUARY OF ATHENA PRONAIA, DELPHI.

tect, came from Phokaia in Asia Minor. The exterior was of the Doric order, as seen from the three columns and a piece of the entablature that have been restored. Other remnants suggest that the interior featured a ring of columns with capitals carved to resemble the curling leaves of the acanthus plant (see Introduction, Fig. 3). This type of capital came to be called Corinthian in Roman times (see "The Greek Architectural Orders," page 118). It had been used on roof-supporting columns in temple interiors since the last quarter of the fifth century BCE, but was not used on building exteriors until the Hellenistic period, more than a hundred years later.

Monumental tombs—showy memorials to their wealthy owners—often had circular or square plans. One such tomb was built for Mausolos at Halikarnassos in Asia Minor. Mausolos, whose name has given us the term mausoleum (a large tomb), was the Persian governor of the region. He admired Greek culture and brought the greatest sculptors from Greece to decorate his tomb. The structure was completed after his death in 353 BCE under the direction of his wife, Artemisia, who was rumored to have drunk her dead husband's ashes mixed with wine. The foundation, many scattered stones, and fragments of sculpture are all that remain of Mausolos's tomb.

Sculpture

Throughout the fifth century BCE, sculptors carefully maintained the equilibrium between simplicity and ornament that is fundamental to Greek Classical art. Standards established by Pheidias and Polykleitos in the mid-fifth century BCE for the ideal proportions and idealized forms of the human figure had generally been accepted by the next generation of artists. Fourth-century BCE artists, on the other hand, challenged and modified those standards. The artists of mainland Greece, in particular, developed a new canon of proportions for male figures—now eight or more "heads" tall rather than the six-and-a-half-or seven-head height of earlier works. The calm, noble detachment characteristic of earlier figures gave way to more sensitively rendered images of men and women with expressions of wistful introspection, dreaminess, or even fleeting anxiety. Patrons lost some of their interest in images of mighty Olympian gods and legendary heroes and acquired a taste for minor deities in lighthearted moments. This period also saw the earliest depictions of fully nude women in major works of art/The fourth century BCE was dominated by three sculptors—Praxiteles, Skopas, and Lysippos.

PRAXITELES. Praxiteles was active in Athens from about 370 to 335 BCE or later. According to the Greek traveler Pausanias, writing in the second century CE, Praxiteles carved a "Hermes of stone who carries the infant Dionysos." The sculpture stood in the Temple of Hera at Olympia. Just such a sculpture in marble, depicting the messenger god Hermes teasing the baby Dionysos with a bunch of grapes, was discovered in the ruins of the ancient Temple of Hera in the Sanctuary at Olympia (FIG. 5–50). Archaeologists accepted HERMES AND

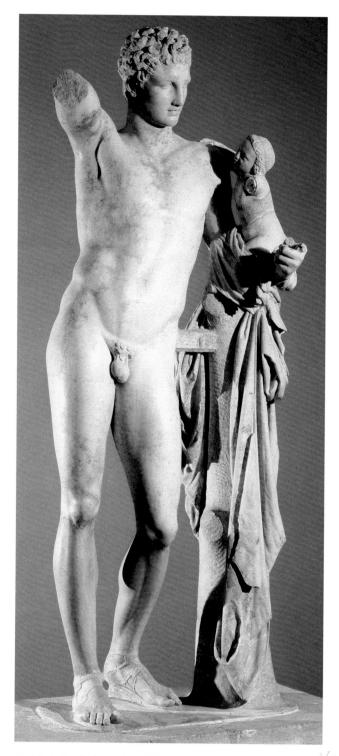

5–50 │ Praxiteles or his followers HERMES AND THE INFANT DIONYSOS

Probably a Hellenistic or Roman copy after a Late Classical 4th-century BCE original. Marble, with remnants of red paint on the lips and hair, height 7'1" (2.15 m). Archaeological Museum, Olympia.

Discovered in the rubble of the ruined Temple of Hera at Olympia in 1875, this statue is now widely accepted as a very good Roman or Hellenistic copy. Support for this conclusion comes from certain elements typical of Roman sculpture: Hermes' sandals, which recent studies suggest, are fourth-century BCE in style; the supporting element of crumpled fabric covering a tree stump; and the use of a reinforcing strut, or brace, between Hermes' hip and the tree stump. Some scholars still attribute the sculpture to Praxiteles.

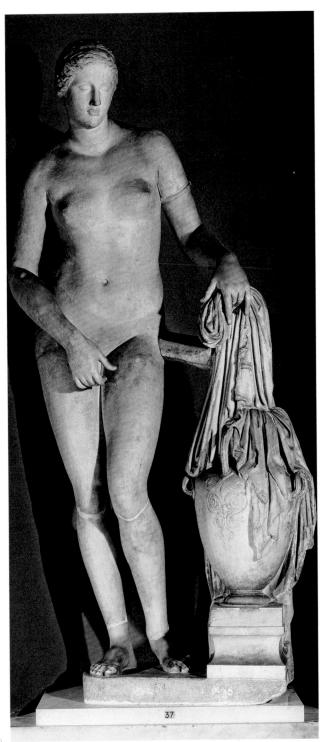

5–51 | Praxiteles APHRODITE OF KNIDOS
Composite of two similar Roman copies after the original marble of c. 350 BCE. Marble, height 6'8" (2.04 m). Vatican Museums, Museo Pio Clementino, Gabinetto delle Maschere, Rome.

The head of this figure is from one Roman copy, the body from another. Seventeenth- and eighteenth-century CE restorers added the nose, the neck, the right forearm and hand, most of the left arm, and the feet and parts of the legs. This kind of restoration would rarely be undertaken today, but it was frequently done and considered quite acceptable in the past, when archaeologists were trying to put together a body of work documenting the appearances of lost Greek statues.

THE INFANT DIONYSOS as an authentic work by Praxiteles until recent studies indicated that it is probably a very good Roman or Hellenistic copy.

The sculpture represents the differences between the fourth and fifth century styles. Hermes has a smaller head and a more youthful body than Polykleitos's Doryphoros (Spear Bearer), his off-balance, S-curve pose, requiring the figure to lean on a post, contrasts clearly with the balance of the earlier work. The sculptor also created a sensuous play of light over the figure's surface. The gleam of the smoothly finished flesh contrasts with the textured quality of the crumpled draperies and the rough locks of hair, even on the baby's head. Praxiteles is also responsible for the humanized treatment of the subject-two gods, one a loving adult and the other a playful child, caught in a moment of absorbed companionship. The interaction of the two across real space through gestures and glances creates an overall effect far different from that of the austere Olympian deities of the fifth century BCE on the pediments and metopes of the Temple of Zeus (SEE FIG. 5-25), near where the work was found.

Around 350 BCE, Praxiteles created a statue of Aphrodite for the city of Knidos in Asia Minor. Although artists of the fifth century BCE had begun to hint boldly at the naked female body beneath tissue-thin drapery, as in *Nike Adjusting Her Sandal* (SEE FIG. 5–42), this **APHRODITE** was apparently the first statue by a well-known Greek sculptor to depict a fully nude woman, and it set a new standard (FIG. 5–51). Although nudity among athletic young men was admired in Greek society, among women it had been considered a sign of low character. The eventual wide acceptance of female nudes in large statuary may be related to the gradual merging of the Greeks' concept of their goddess Aphrodite with some of the characteristics of the Phoenician goddess Astarte (the Babylonian Ishtar), who was nearly always shown nude in Near Eastern art.

In the version of the statue seen here (actually a composite of two Roman copies), the goddess is preparing to take a bath, with a water jug and her discarded clothing at her side. Her right arm and hand extend in what appears at first glance to be a gesture of modesty but in fact only emphasizes her nudity. The bracelet on her left arm has a similar effect. Her well-toned body, with its square shoulders, thick waist, and slim hips, conveys a sense of athletic strength. She leans forward slightly with one knee in front of the other in a seductive pose that emphasizes the swelling forms of her thighs and abdomen. According to an old legend, the sculpture was so realistic that Aphrodite herself made a journey to Knidos to see it and cried out in shock, "Where did Praxiteles see me naked?" The Knidians were so proud of their Aphrodite that they placed it in an open shrine where people could view it from every side. Hellenistic and Roman copies probably

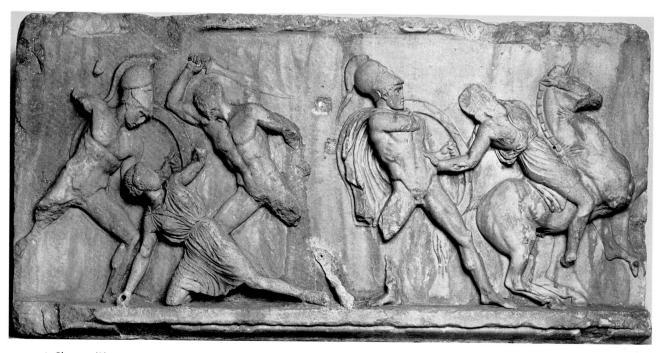

5–52 | Skopas (?) PANEL FROM THE AMAZON FRIEZE, SOUTH SIDE OF THE MAUSOLEUM AT HALIKARNASSOS Mid-4th century BCE. Marble, height 35" (89 cm). The British Museum, London.

numbered in the hundreds, and nearly fifty survive in various collections today (see Introduction Fig. 7).

SKOPAS. According to Pliny, Skopas was one of the sculptors who worked at the mausoleum at Halikarnassos, carving part of the frieze (FIG. 5-52). Skopas was greatly admired in ancient times. He had a brilliant career as both sculptor and architect that took him around the Greek world. Unfortunately, little survives—originals or copies—that can be reliably attributed to him. If literary accounts are accurate, Skopas introduced a new style of sculpture admired in its time and influential in the Hellenistic period. In relief compositions, he favored very active, dramatic poses over balanced, harmonious ones, and he was especially noted for the expression of emotion in the faces and gestures of his figures. The typical Skopas head conveys intensity with its deep-set eyes, heavy brow, slightly parted lips, and a gaze that seems to look far into the future. The squarish heads with deep set eyes, the energetic figures, and the repeated diagonals of the composition all suggest Skopas as the sculptor of the battle scenes of Lapiths against centaurs and Greeks against Amazons.

Lysippos. In contrast to Praxiteles and Skopas, many details of Lysippos's life are known and many copies of his sculpture survive. He claimed to be entirely self-taught and asserted that "nature" was his only model, but he must have received some technical training in the vicinity of his home, near Corinth. He worked from c. 350 to c. 310 BCE. Although he expressed

great admiration for Polykleitos, his own figures reflect a different ideal and different proportions from those of the fifth-century BCE master. For his famous work **THE MAN SCRAPING HIMSELF (APOXYOMENOS)**, known today only from Roman copies (FIG. 5–53), he chose a typical Classical subject, a nude male athlete, but he treated it in an unusual way. Instead of a figure actively engaged in a sport, striding, or standing at ease, Lysippos depicted a young man methodically removing oil and dirt from his body with a scraping tool called a strigil. Judging from the athlete's expression, his thoughts are far from his mundane task. His deep-set eyes, dreamy stare, heavy forehead, and tousled hair may reflect the influence of Skopas.

The Man Scraping Himself, tall and slender with a relatively small head, like Praxiteles' work, makes a telling comparison with Polykleitos's Spear Bearer (SEE FIG. 5-24). Not only does it reflect a different canon of proportions, but the figure's weight is also more evenly distributed between the engaged leg and the free one, with the free foot almost flat on the ground. The legs are also in a wider stance to counterbalance the outstretched arms. The Spear Bearer is contained within fairly simple, compact contours and oriented toward a center front viewer. In contrast, the arms of The Man Scraping Himself break free into the surrounding space, requiring the viewer to move around the statue to absorb its full aspect. Roman authors, who may have been describing the bronze original rather than a marble copy, remarked on the subtle modeling of the statue's elongated body and the spatial extension of its pose.

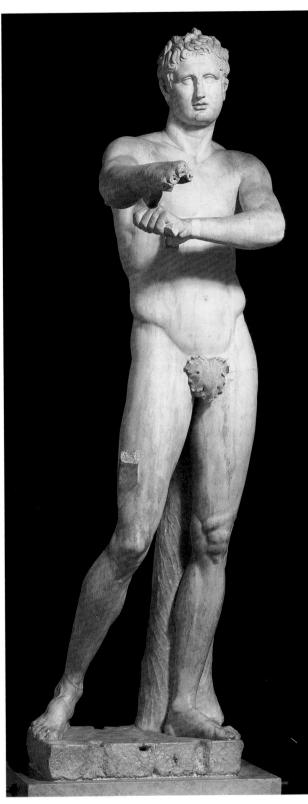

5-53 | Lysippos the man scraping himself (APOXYOMENOS)

Roman copy after the original bronze of c. 350-325 BCE. Marble, height 6'9" (2.06 m). Vatican Museums, Museo Pio Clementino,

Gabinetto dell'Apoxyomenos, Rome.

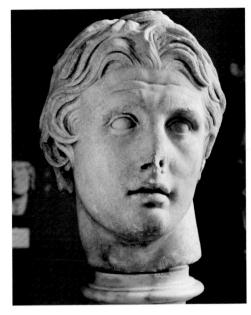

1

5–54 | Lysippos (?) ALEXANDER THE GREAT
Head from a Hellenistic copy (c. 200 BCE) of a statue, possibly after a 4th-century BCE original. Marble fragment, height 16 1/8" (41 cm). Archaeological Museum, Istanbul, Turkey.

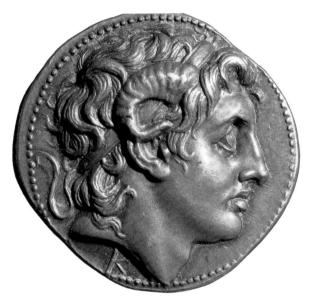

5–55 ALEXANDER THE GREAT
Four drachma coin issued by Lysimachos of Thrace. 306–281
BCE. Silver, diameter 1½" (30 mm). The British Museum, London.

Lysippos was widely known and admired for his monumental statues of Herakles (see Introduction, Fig. 23) and Zeus. The sculpture of Zeus is lost, but the weary Herakles (Hercules), leaning on his club (resting after the last of his Twelve Labors) and holding the apples of the Hesperides, comes down to us in the imposing Hellenistic sculpture known as the Farnese Hercules, a copy in marble, signed by Glykon, of a bronze by Lysippos. Not surprisingly, the Romans admired this heroic figure; the marble copy stood in the Baths of Caracalla. In the Renaissance the sculpture was part of the Farnese collection in

Rome, where it stood in the courtyard of their palace and was studied by artists from all over Europe.

When Lysippos was summoned to do a portrait of Alexander the Great (ruled 336–323 BCE), he portrayed Alexander as a full-length standing figure with an upraised arm holding a scepter, just as he is believed to have posed Zeus. A head found at Pergamon (located in present-day Turkey) that was once part of a standing figure is believed to be from one of several copies of Lysippos's original of Alexander (FIG. 5–54). It depicts a ruggedly handsome, heavy-featured young man with a large Adam's apple and short, tousled hair. The treatment of the hair may be a visual reference to the mythical hero Herakles, who killed the Nemean Lion as his First Labor and is often portrayed wearing its head and pelt as a hooded cloak. Alexander would have felt great kinship with Herakles, whose acts of bravery and strength earned him immortality.

The Pergamon head was not meant to be entirely true to life, although we see here elements of an individual's distinctive appearance. The artist rendered certain features in an idealized manner to convey a specific message about the subject. The deep-set eyes are unfocused and meditative, and the low forehead is heavily lined, as though the figure were contemplating decisions of great consequence and waiting to receive divine advice.

According to the Roman-era historian Plutarch, Lysippos depicted Alexander in a characteristic meditative pose, "with his face turned upward toward the sky, just as Alexander himself was accustomed to gaze, turning his neck gently to one side" (cited in Pollitt, page 20). Because this description fits the marble head from Pergamon and others like it so well, they have been thought to be copies of the Alexander statue. On the other hand, the heads could also be viewed as conventional, idealized "types" created by Lyssipos. A reasonably reliable image of Alexander is found on a coin issued by Lysimachos, who ruled Thrace from 306 to 281 BCE (FIG. 5–55). It shows Alexander in profile wearing the curled ram's-horn headdress that identifies him as the Greek-Egyptian god Zeus-Amun. The portrait has the same low forehead, high-bridged nose, large lips, and thick neck as the Pergamon head.

The Art of the Goldsmith

The work of Greek goldsmiths, which gained international popularity in the Classical period, followed the same stylistic trends and achieved the same high standards of technique and execution found in the other arts. A specialty of Greek goldsmiths was the design of earrings in the form of tiny works of sculpture. They were often placed on the ears of marble statues of goddesses, but they adorned the ears of living women as well. Earrings designed as the youth Ganymede in the grasp of an eagle (Zeus) (FIG. 5–56), dated about 330—300 BCE, are both a charming decoration and a technical tour de force. Slightly more than 2 inches high, they were hollow-cast

5–56 | EARRINGS c. 330–300 BCE. Hollow-cast gold, height $2\frac{1}{8}$ " (6 cm). The Metropolitan Museum of Art, New York. Harris Brisbane Dick Fund, 1937 (37.11.9-10).

using the **lost-wax process**, no doubt to make them light on the ear. Despite their small size, the earrings convey all the drama of their subject. Action subjects like this, with the depiction of swift movement through space, were to become a hallmark of Hellenistic art.

Wall Painting and Mosaics

Roman observers such as Pliny the Elder claimed that Greek painters were skilled in capturing the appearance of the real world. Roman patrons admired Greek murals and commissioned copies, in paintings or mosaic, to decorate their homes. (Mosaics are created from tesserae, small cubes of colored stone or marble. They provide a permanent waterproof surface that the Romans used for floors in important rooms.) Mosaics and red-figure vases are the best evidence for fourth-century BCE painting. They indicate a growing taste for dramatic narrative subjects. A first-century CE mosaic, ALEXANDER THE GREAT CONFRONTS DARIUS III AT THE BATTLE OF ISSOS (FIG. 5–57), for example, copies a painting of about 310 BCE.

Pliny the Elder mentions a painting of Alexander and Darius by Philoxenos of Eretria; but a new theory claims it was by Helen of Egypt (see "Women Artists in Ancient Greece," page 157). Certainly the scene is one of violent action where radical foreshortening draws the viewer into the scene and elicits an emotional response to a dramatic situation. Astride a horse at the left, his hair blowing free and his neck bare, Alexander challenges the helmeted and armored Persian leader, who stretches out his arm in a gesture of defeat and apprehension as his charioteer whisks him back toward safety in the Persian ranks. The mosaicist has created an illusion of solid figures through modeling, mimicking the play of light on three-dimensional surfaces by highlights and shading.

The interest of fourth-century BCE artists in creating a believable illusion of the real world was the subject of anecdotes repeated by later writers. One popular legend

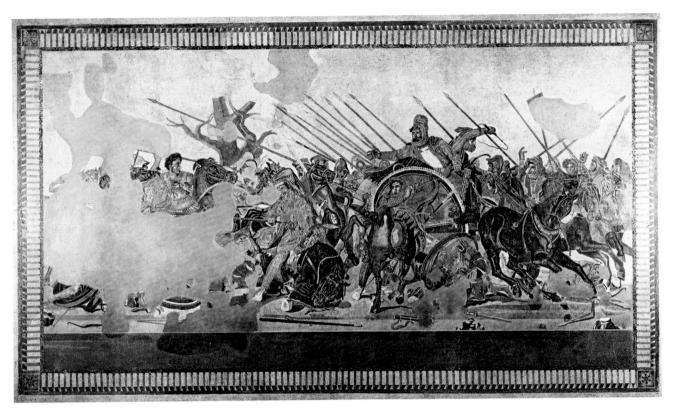

5–57 | ALEXANDER THE GREAT CONFRONTS DARIUS III AT THE BATTLE OF ISSOS Floor mosaic, Pompeii, Italy. 1st-century CE Roman copy of a Greek wall painting of c. 310 BCE, perhaps by Philoxenos of Eretria or Helen of Egypt. Entire panel $8'10'' \times 17'$ (2.7×5.2 m). National Archeological Museum, Naples.

involved a floral designer, a woman named Glykera—widely praised for the artistry with which she wove blossoms and greenery into wreaths, swags, and garlands for religious processions and festivals—and Pausias, the foremost painter of the day. Pausias challenged Glykera to a contest, claiming that he could paint a picture of one of her complex works that would appear as lifelike to the spectator as her real one. According to the legend, he succeeded. It is not surprising, although perhaps unfair, that the opulent floral borders so popular in later Greek painting and mosaics are described as "Pausian" rather than "Glykeran."

A mosaic floor from a palace at Pella (Macedonia) provides an example of a Pausian design. Dated about 300 BCE, the floor features a series of framed hunting scenes, such as the **STAG HUNT** (FIG. 5–58), prominently signed by an artist named Gnosis. Blossoms, leaves, spiraling tendrils, and twisting, undulating stems frame this scene, echoing the linear patterns formed by the hunters, the dog, and the struggling stag.

5-58 | Gnosis STAG HUNT

Detail of mosaic floor decoration from Pella (Macedonia), (present-day Greece). 300 BCE. Pebbles, height 10′2″ (3.1 m). Archaeological Museum, Pella. Signed at top: "Gnosis made it."

The over-life-size human and animal figures are accurately drawn and modeled in light and shade. The dog's front legs are expertly foreshortened to create the illusion that the animal is turning at a sharp angle into the picture. The work is all the more impressive because it was not made with uniformly cut marble in different colors, but with a carefully selected assortment of natural pebbles.

THE HELLENISTIC PERIOD, 323–31/30 BCE

When Alexander died unexpectedly in 323 BCE, he left a vast empire with no administrative structure and no accepted successor. Almost at once his generals turned against one another, local leaders tried to regain their lost autonomy, and the empire began to break apart. The Greek city-states formed a new mutual-protection league but never again achieved significant power. Democracy survived in form but not substance in governments dominated by local rulers.

By the early third century BCE, three of Alexander's generals-Antigonus, Ptolemy, and Seleucus-had carved out kingdoms. The Antigonids controlled Macedonia and mainland Greece; the Ptolemies ruled Egypt; and the Seleucids controlled Asia Minor, Mesopotamia, and Persia. Over the course of the second and first centuries BCE, these kingdoms succumbed to the growing empire centered in Rome. Ptolemaic Egypt endured the longest, almost two and a half centuries. The Ptolemaic capital, Alexandria in Egypt, a prosperous seaport known for its lighthouse (another of the Seven Wonders of the World, according to ancient writers), emerged as a great Hellenistic center of learning and the arts. Its library is estimated to have contained 700,000 papyrus and parchment scrolls. The Battle of Actium in 31 BCE and the death in 30 BCE of Egypt's last ruler, the remarkable Cleopatra, marks the end of the Hellenistic period.

Alexander's lasting legacy was the spread of Greek culture far beyond its original borders, but artists of the Hellenistic period had a vision noticeably different from that of their predecessors. Where earlier artists sought the ideal and the general, Hellenistic artists sought the individual and the specific. They turned increasingly away from the heroic to the everyday, from gods to mortals, from aloof serenity to individual emotion, and from drama to melodramatic pathos. A trend introduced in the fourth century BCE—the appeal to the senses through lustrous or glittering surface treatments and to the emotions with dramatic subjects and poses became more pronounced. Even the architecture of the Hellenistic period largely reflected the contemporary taste for high drama. Building types continued with few changes, but their size and the amount of decoration increased. Greek art continued to influence the art of the Romans, and the Hellenistic style lasted until the Augustan period in the first century CE.

Art and Its Context

WOMEN ARTISTS IN ANCIENT GREECE

Ithough comparatively few artists in ancient Greece were women, there is evidence that women artists worked in many mediums. Ancient writers noted women painters—Pliny the Elder, for example, listed Aristarete, Eirene, Iaia, Kalypso, Olympias, and Timarete. Helen, a painter from Egypt who had been taught by her father, is known to have worked in the fourth century BCE and may have been responsible for the original Greek wall painting of c. 310 BCE of Alexander the Great Confronts Darius III at the Battle of Issos (SEE FIG. 5–57).

Greek women were known to create narrative or pictorial tapestries. They also worked in pottery workshops. The hydria here, dating from about 450 BCE, shows a woman artist in such a workshop, but her status is ambiguous. The composition focuses on the male painters, who are being approached by Nikes (Victories) bearing wreaths symbolizing victory in an artistic competition. A well-dressed woman sits on a raised dais, painting the largest vase in the workshop. She is isolated from the other artists and is not part of the awards ceremony. Perhaps women were excluded from public artistic competitions, as they were from athletics. Another interpretation, however, is that the woman is the head of this workshop. Secure in her own status, she may have encouraged her assistants to enter contests to further their careers and bring glory to the workshop as a whole.

A VASE PAINTER AND ASSISTANTS CROWNED BY ATHENA AND VICTORIES

Composite photograph of the red-figure decoration on a hydria from Athens. c. 450 BCE. Private Collection.

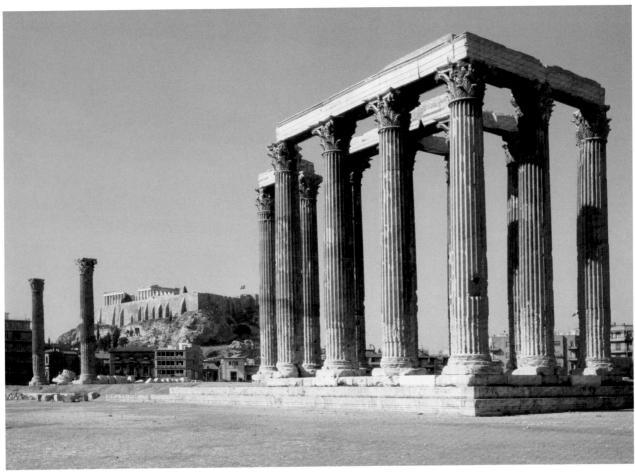

5–59 TEMPLE OF THE OLYMPIAN ZEUS, ATHENS, ACROPOLIS IN DISTANCE
Building and rebuilding phases: foundation c. 520–510 BCE using the Doric order; temple designed by Cossutius, begun 175 BCE, left unfinished 164 BCE, completed 132 CE using Cossutius's design and the Corinthian order (see FIG. 3, Introduction). Height of columns 55′5″ (16.89 m).

The Corinthian Order in Hellenistic Architecture

During the Hellenistic period, a variant of the Ionic order featuring tall, slender columns with elaborate foliate capitals challenged the dominant Doric and Ionic orders. Invented in the late fifth century BCE and called Corinthian by the Romans, this highly decorative column had previously been used only indoors, as in the tholos at Epidaurus (see Introduction, Fig. 2). Today, the Corinthian variant is routinely treated as a third Greek order (see "The Greek Architectural Orders," page 118). In the Corinthian capital, curly acanthus leaves and coiled flower spikes surround a basket-shaped core. Unlike Doric and Ionic capitals, the Corinthian capital has many possible variations; only the foliage is required. Above the capitals, the Corinthian entablature, like the Ionic, has a stepped-out architrave and a continuous frieze. It also has more bands of carved moldings. The Corinthian design became a symbol of elegance and refinement, and it is still used on banks, churches, and court buildings today.

The Corinthian **TEMPLE OF THE OLYMPIAN ZEUS**, located in the lower city of Athens at the foot of the Acropolis, was designed by the Roman architect Cossutius in the second century BCE (FIG. 5–59) on the foundations of an ear-

lier Doric temple. Work on the Cossutius design halted in 164 BCE and was not completed until three centuries later under the patronage of the Roman emperor Hadrian (see Chapter 6). The temple's great Corinthian columns, 55 feet 5 inches tall, may be the second-century BCE Greek originals or Roman replicas. Viewed through these columns, the Parthenon seems modest in comparison. But in spite of its size and luxurious decoration, the new temple followed long-established conventions. It was an enclosed rectangular building surrounded by a screen of columns standing on a three-stepped base. Its proportions and details followed traditional standards. It is, quite simply, a Greek temple grown very large.

Hellenistic Architecture: The Theater at Epidauros

In ancient Greece, the theater was more than mere entertainment; it was a vehicle for the communal expression of religious belief through music, poetry, and dance. In very early times, theater performances took place on the hard-packed dirt or stone-surfaced pavement of an outdoor threshing floor—the same type of floor later incorporated into religious sanctuaries. Whenever feasible, dramas were also presented

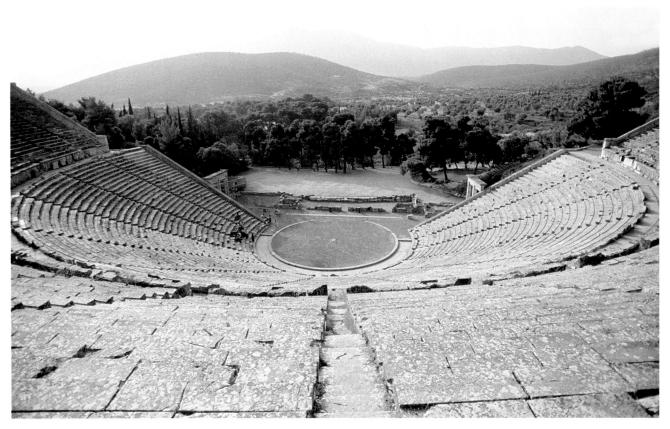

5–60 | THEATER, EPIDAUROS 4^{th} century BCE and later.

facing a steep hill that served as elevated seating for the audience. Eventually such sites were made into permanent openair auditoriums. At first, tiers of seats were simply cut into the side of the hill. Later, builders improved them with stone.

During the fifth century BCE, the plays were usually tragedies in verse based on popular myths and were per-

formed at a festival dedicated to Dionysos. At this time, the three great Greek tragedians—Aeschylus, Sophocles, and Euripides—were creating the dramas that would define tragedy for centuries. Many theaters were built in the fourth century BCE, including those on the side of the Athenian Acropolis and in the sanctuary at Delphi. Because they were

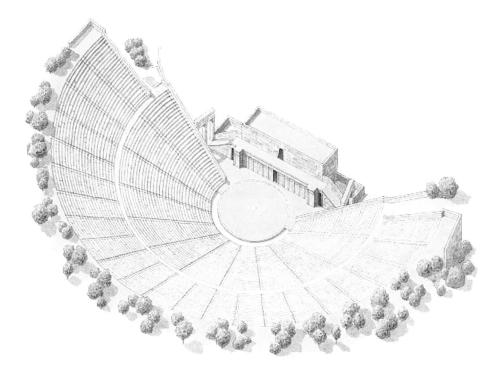

5-61 | RECONSTRUCTION DRAWING OF THE THEATER AT EPIDAUROS

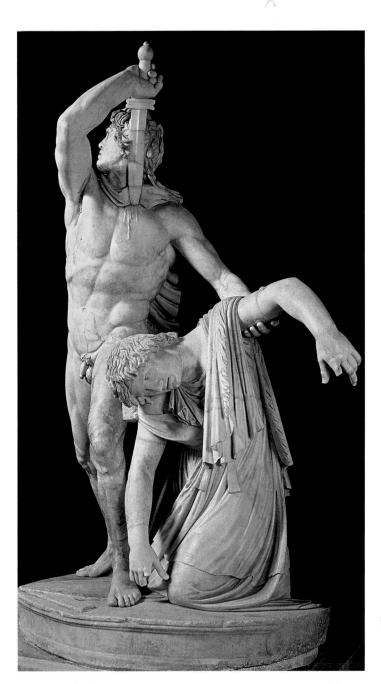

5-62 | GALLIC CHIEFTAIN KILLING HIS WIFE AND HIMSELF Roman copy after the original bronze of c. 220 BCE. Marble, height 6'11" (2.1 m). National Museum, Rome.

used continuously and frequently modified over many centuries, early theaters have not survived in their original form.

The theater at Epidauros, built in the second half of the fourth century, is characteristic (FIGS. 5-60, 5-61). A semicircle of tiered seats built into the hillside overlooked the circular performance area, called the orchestra, at the center of which was an altar to Dionysos. Rising behind the orchestra was a two-tiered stage structure made up of the vertical skene (scene)—an architectural backdrop for performances that also screened the backstage area from view—and the proskenion (proscenium), a raised platform in front of the skene that was increasingly used over time as an extension of the orchestra. Ramps connecting the proskenion with lateral passageways provided access for performers. Steps gave the audience access to the fifty-five rows of seats and divided the seating area into uniform wedge-shaped sections. The tiers of seats above the wide corridor, or gangway, were added at a much later date. This design provided uninterrupted sight lines and good acoustics and allowed for efficient entrance and exit of the 12,000 spectators. No better design has ever been created.

Sculpture

Hellenistic sculptors produced an enormous variety of work in a wide range of materials, techniques, and styles. The period was marked by two broad and conflicting trends. One (sometimes called anti-Classical) led away from Classical models and toward experimentation with new forms and subjects; the other led back to Classical models, with artists selecting aspects of certain favored works by fourth-century BCE sculptors and incorporating them into their own work. The radical anti-Classical style was especially strong in Pergamon and other eastern centers of Greek culture.

PERGAMON. The kingdom of Pergamon, a breakaway state within the Seleucid realm, established itself in the early third century BCE in western Asia Minor. The capital, Pergamon, quickly became a leading center of the arts and the hub of a new sculptural style that had far-reaching influence throughout the Hellenistic period. This new style is illustrated by sculpture from a monument commemorating the victory in 230 BCE of Attalos I (ruled 241–197 BCE) over the Gauls, a Celtic people. The monument extols the dignity and heroism of the defeated enemies and by extension the power and virtue of the Pergamenes.

These figures of Gauls, originally in bronze but known today only from Roman copies in marble, were mounted on a large pedestal. One group depicts the murder-suicide of the Gallic chieftain and his wife (FIG. 5–62) and the slow demise of a wounded soldier-trumpeter (FIG. 5–63). Their wiry, unkempt hair and the trumpeter's twisted neck ring (the Celtic battle dress), identify them as "barbarians." The artist has sought to arouse admiration and pity for his subjects. The chieftain, for example, still supports his dead wife as he plunges the sword

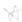

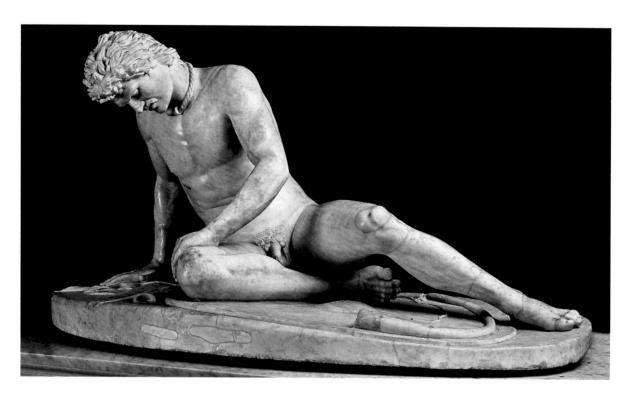

5–63 | Epigonos (?) DYING GALLIC TRUMPETER
Roman copy after the original bronze of c. 220 BCE. Marble, height, 36½" (93 cm). Capitoline Museum, Rome.

The marble sculpture was found in Julius Caesar's garden in Rome. The bronze originals were made for the Sanctuary of Athena in Pergamon. Pliny wrote that Epigonos "surpassed others with his Trumpeter."

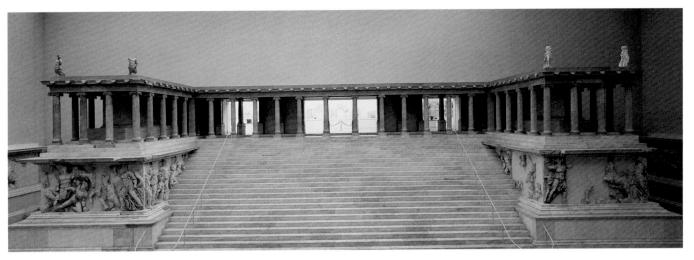

5–64 † RECONSTRUCTED WEST FRONT OF THE ALTAR FROM PERGAMON, TURKEY c. 175–150 BCE. Height of figure 7'7" (2.3 m). Marble. Staatliche Museen zu Berlin, Pergamonmuseum, Preussischer Kutturbesitz, Berlin.

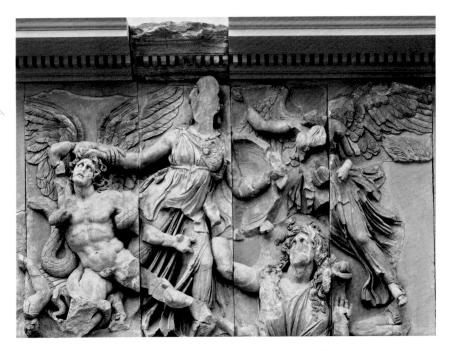

5–65 | ATHENA ATTACKING THE GIANTS Detail of the frieze from the east front of the altar from Pergamon, c. 175–150 BCE. Marble, frieze height 7'7" (2.3 m). Staatliche Museen zu Berlin, Antikensammlung, Pergamonmuseum, Berlin.

into his own breast. The trumpeter, fatally injured, struggles to rise, but the slight bowing of his supporting right arm and his unseeing downcast gaze indicate that he is on the point of death. This kind of deliberate attempt to elicit a specific emotional response in the viewer is known as **expressionism**, and it was to become a characteristic of Hellenistic art.

The marble copies of these works are now separated, but originally they formed part of an interlocked, multifigured group on a raised base that could have been viewed and appreciated from every angle. Pliny the Elder described a work like the *Dying Gallic Trumpeter*, attributing it to an artist named Epigonos. Recent research indicates that Epigonos

probably knew the early fifth-century BCE sculpture of the Temple of Aphaia at Aegina, which included the *Dying War*rior (SEE FIG. 5–13), and could have had it in mind when he created his own works.

The style and approach of the work in the monument became more pronounced and dramatic in later works, culminating in the sculptured frieze on the base of the Great Altar at Pergamon (FIG. 5–64). The wings and staircase to the entrance of the courtyard in which the altar stood have been reconstructed inside a Berlin museum. The original altar complex was a single-story structure with an Ionic colonnade raised on a high podium reached by a monumental

staircase 68 feet wide and nearly 30 feet deep. The running frieze decoration, probably executed during the reign of Eumenes II (197–159 BCE), depicts the battle between the gods and the Giants (Titans), a mythical struggle that the Greeks are thought to have used as a metaphor for Pergamon's victory over the Gauls.

The frieze was more than 7 feet high, tapering along the steps to just a few inches. The Greek gods fight not only human-looking Giants, but also hybrids with snakes for legs emerging from the bowels of the earth. In a detail of the frieze (FIG. 5–65), the goddess Athena at the left has grabbed the hair of a winged male monster and forced him to his knees. Inscriptions along the base of the sculpture identify him as Alkyoneos, a son of the earth goddess Ge, who rises from the ground on the right in fear as she reaches toward Athena, pleading for her son's life. At the far right, a winged Nike rushes to Athena's assistance to crown her with a victor's wreath.

The figures in the Pergamon frieze not only fill the sculptural space, they break out of their architectural boundaries and invade the spectators' space. They crawl out of the frieze onto the steps, where visitors had to pass them on their way up to the shrine. Many consider this theatrical and complex interaction of space and form to be a benchmark of the Hellenistic style, just as they consider the balanced restraint of the Parthenon sculpture to be the epitome of the High Classical style. Where fifth-century BCE artists sought horizontal and vertical equilibrium and control, the Pergamene artists sought to balance opposing forces in three-dimensional space along diagonal lines.

The Classical preference for smooth surfaces reflecting a clear, even light has been replaced by a preference for dramatic contrasts of light and shade playing over complex forms carved with deeply undercut high relief. The composure and stability admired in the Classical style have given way to extreme expressions of pain, stress, wild anger, fear, and despair. In the fifth century, figures stood remote in their own space. In the fourth century BCE, they reached out into their immediate environment, imposing themselves, often forcefully, on the spectator. Whereas the Classical artist asked only for an intellectual commitment, the Hellenistic artist demanded that the viewer empathize.

THE PERGAMENE STYLE: LAOCOÖN AND NIKE. Pergamene artists may have inspired the work of Hagesandros, Polydoros, and Athenedoros, three sculptors on the island of Rhodes named by Pliny the Elder as the creators of the famed *Laocoön and His Sons* (see Introduction, Fig. 10). This work has been assumed by many art historians to be the original version from the second century BCE, although others argue that it is a brilliant copy commissioned by an admiring Roman patron in the first century CE.

The complex sculptural composition illustrates an episode from the Trojan War. The priest Laocoön warned the Trojans not to take the giant wooden horse left by the Greeks

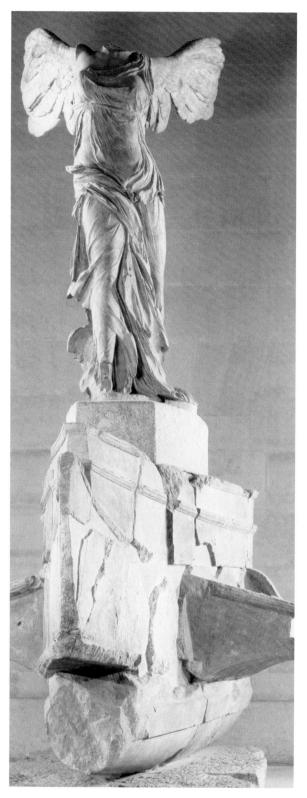

5–66 | NIKE (VICTORY) OF SAMOTHRACE Sanctuary of the Great Gods, Samothrace. c. 180 BCE (?). Marble, height 8'1" (2.45 m). Musée du Louvre, Paris.

The wind-whipped costume and raised wings of this Victory indicate that she has just alighted on the prow of the stone ship that formed the original base of the statue. The work probably commemorated an important naval victory, perhaps the Rhodian triumph over the Seleucid king Antiochus III in 190 BCE. The Nike (lacking its head and arms) and a fragment of its stone ship base were discovered in the ruins of the Sanctuary of the Great Gods by a French explorer in 1863 (additional fragments were discovered later). Soon after, the sculpture entered the collection of the Louvre Museum in Paris.

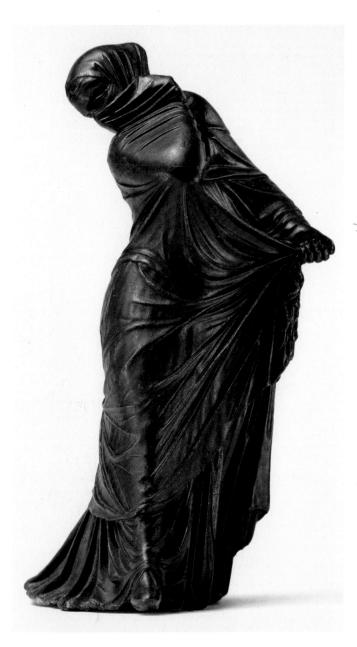

5–67 | VEILED AND MASKED DANCER Late 3rd or 2nd century BCE. Bronze, height 8½" (20.7 cm). The Metropolitan Museum of Art, New York. Bequest of Walter C. Baker, 1971 (1972.118.95)

inside their walls. The gods who supported the Greeks in the war retaliated by sending serpents from the sea to destroy Laocoön and his sons as they walked along the shore. The struggling figures, anguished faces, intricate diagonal movements, and skillful unification of diverse forces in a complex composition all suggest a strong relationship between Rhodian and Pergamene sculptors. Unlike the monument to the conquered Gauls, the *Laocoön* was composed to be seen from the front, within a short distance. As a result, although sculpted in the round, the three figures resemble the relief sculpture on the altar from Pergamon.

The **NIKE** (VICTORY) OF SAMOTHRACE (FIG. 5–66) is even more theatrical than the *Laocoön*. In its original setting—in a hillside niche high above the sanctuary of the Greek gods at Samothrace and perhaps drenched with spray from a fountain—this huge goddess of victory must have reminded visitors of the god in Greek plays who descends from heaven to determine the outcome of the drama. The fact that victory in real life does often seem miraculous makes this image of a goddess alighting suddenly on a ship breathtakingly appropriate for a war memorial. The forward momentum of the Nike's heavy body is balanced by the powerful backward thrust of her enormous wings. The large, open movements of the figure, the strong contrasts of light and dark on the deeply sculpted forms, and the contrasting textures of feathers, fabric, and skin typify the finest Hellenistic art.

Although "huge," "enormous," and "larger-than-life" are terms correctly applied to much Hellenistic sculpture, artists of the time also created fine works on a small scale. The grace, dignity, and energy of the 8-foot-tall *Nike of Samothrace* can also be found in a bronze about 8 inches tall (FIG. 5–67). This figure of a heavily veiled and masked dancing woman twists sensually under the gauzy, layered fabric in a complex spiral movement. The dancer is clearly a professional performer. This bronze would have been costly, but many such graceful figurines were produced in inexpensive terra cotta from molds.

The Multicultural Hellenistic World

In contrast to the Classical world, which was characterized by relative cultural unity and social homogeneity, the Hellenistic world was varied and multicultural. In this environment, artists turned from idealism, the quest for perfect form, to realism, the attempt to portray the world as they saw it. Portraiture, for example, became popular during the Hellenistic period, as did the representation of people from every level of society. Patrons were fascinated by depictions of unusual physical types as well as of ordinary individuals.

An old peasant woman on her way to the agora with three chickens and a basket of vegetables may seem to be an unlikely subject for sculpture (FIG. 5–68). Despite the bunched and untidy way the figure's dress hangs, it appears to be of an elegant design and made of fine fabric. Her hair, too,

bears some semblance of a once-careful arrangement. These characteristics, along with the woman's sagging lower jaw, unfocused stare, and lack of concern for her exposed breasts, have led some to speculate that she represents an aging, dissolute follower of the wine god Dionysos on her way to make an offering. Whether an aging peasant, or a Dionysian celebrant, the woman is the antithesis of the *Nike of Samothrace*. Yet in formal terms, both sculptures stretch out assertively into the space around them, both demand an emotional response from the viewer, and both display technical virtuosity in the rendering of forms and textures. They are closer to each other than either is to the *Nike Adjusting Her Sandal* (SEE FIG. 5–42) or the *Aphrodite of Knidos* (SEE FIG. 5–51).

But not all Hellenistic artists followed the trend toward realism and expressionism that characterized the artists of Pergamon and Rhodes. Some turned to the past, creating an eclectic style by reexamining and borrowing elements from earlier Classical styles and combining them in new ways. Certain popular sculptors looked back especially to Praxiteles and Lysippos for their models. This renewed interest in the style of the fourth century BCE is exemplified by the APHRODITE OF MELOS (better known as the Venus de Milo) (FIG. 5-69), found on the island of Melos by French excavators in the early nineteenth century CE. The sculpture was intended by its maker to recall the Aphrodite of Praxiteles (SEE FIG. 5-51), and indeed the head with its dreamy gaze is very like Praxiteles' work. The figure has the heavier proportions of High Classical sculpture, but the twisting stance and the strong projection of the knee are typical of Hellenistic art. The drapery around the lower part of the body also has the rich, three-dimensional quality associated with the Hellenistic sculpture of Rhodes and Pergamon. The juxtaposition of flesh and drapery, which seems about to slip off the figure entirely, adds a note of erotic tension.

By the end of the first century BCE, the influence of Greek painting, sculpture, and architecture had spread to the artistic communities of the emerging Roman civilization. Roman patrons and artists maintained their enthusiasm for Greek art into Early Christian and Byzantine times. Indeed, so strong was the urge to emulate the great Greek artists that, as we have seen throughout this chapter, much of our knowledge of Greek achievements comes from Roman replicas of Greek artworks and descriptions of Greek art by Roman–era writers.

IN PERSPECTIVE 2005 300

Greek art between the sixth and the fourth centuries BCE reveals that the Greeks had been studying every detail of their surroundings, from an acanthus leaf to the folds of their own clothing. By then, too, builders had evolved standardized temple plans. They had also experimented with the arrangement, proportions, and appearance of their temples until they

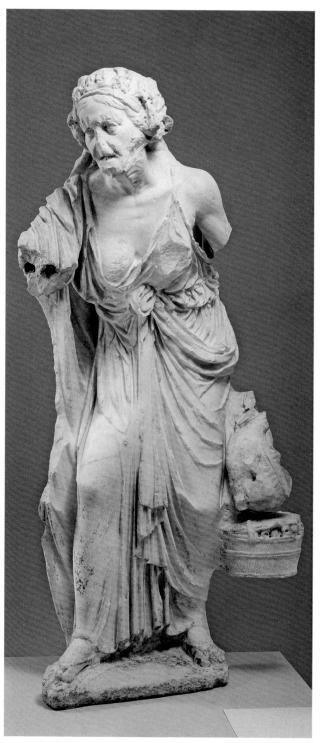

5–68 | OLD WOMAN Roman copy, 1st century CE. Marble, height 49½" (1.25 m). The Metropolitan Museum of Art, New York. Rogers Fund, 1909 (09.39)

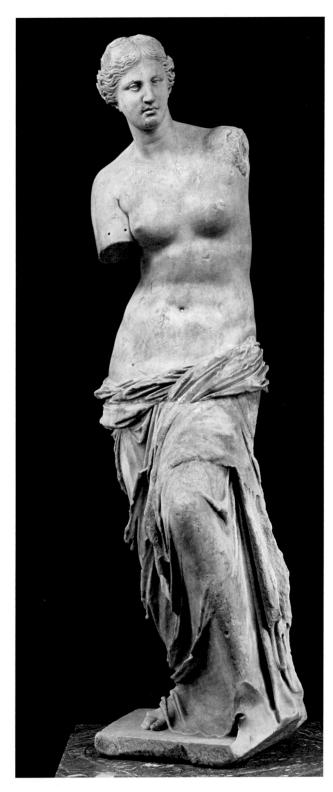

5–69 \perp APHRODITE OF MELOS (ALSO CALLED VENUS DE MILO) c. 150–100 BCE. Marble, height 6'8" (2.04 m). Musée du Louvre, Paris.

The original appearance of this famous statue's missing arms has been much debated. When it was dug up in a field in 1820, some broken pieces (now lost) found with it indicated that the figure was holding out an apple in its right hand. Many judged these fragments to be part of a later restoration, not part of the original statue. Another theory is that Aphrodite was admiring herself in the highly polished shield of the war god Ares, an image that was popular in the second century BCE. This theoretical "restoration" would explain the pronounced S-curve of the pose and the otherwise unnatural forward projection of the knee.

perfected two distinct designs—the Doric order and the Ionic order. The Corinthian order became so popular later that today it too is treated as a standard Greek order.

In the fifth century, the Athenians built the Parthenon, a new temple to the goddess Athena in which architectural design and sculptural decoration established a Classical ideal. The Parthenon's extensive program of decoration strongly reflects the ancient Greek vision of unity and beauty.

Studying human appearances closely, the sculptors of the Classical period selected those attributes they considered most desirable and combined them into a single ideal of perfection. These figures also expressed profound political and ideological themes and ideas: the preeminence of Athens and the triumph of an enlightened Greek civilization over despotism and barbarism.

Although later artists continued to observe the basic Classical approach to composition and form, they no longer adhered rigidly to its conventions. Despite the instability of the fourth century BCE, Greek city-states undertook innovative architectural projects. Architects developed variations on Classical ideals in urban planning, temple design, and the construction of monumental tombs and altars. In contrast to the fifth century, much of this activity took place outside of Athens, notably in Asia Minor.

Earlier Greek artists had sought to capture the ideal and often focused on the heroic. Hellenistic artists sought to represent the specific and turned increasingly to the everyday. Since the fourth century BCE, the appeal to the senses through surface treatments and to the emotions through drama had also become more pronounced. Even the architecture of the Hellenistic period largely reflected the contemporary taste for high drama.

CENTAUR,
LATE 10TH CENTURY BCE

FUNERARY VASE, C. 750–700 BCE

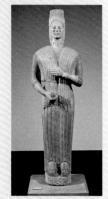

BERLIN CORE, c. 570–560 BCE

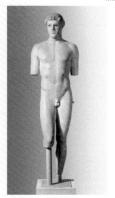

KRITIAN BOY, C. 480 BCE

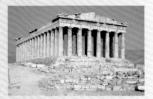

PARTHENON c. 447–432 BCE

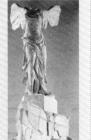

NIKE (VICTORY) OF SAMOTHRACE C. 180

ALEXANDER THE GREAT, c. 306–281 BCE

IOOO

ART OF ANCIENT GREECE

- Proto-Geometric c. 1050–900 BCE
- **Geometric** c. 900–700 BCE

- 750
- Earliest Surviving List of Olympic Game Winners c. 776 BCE
- Orientalizing c. 700-600 BCE
- Archaic c. 600–480 BCE
- Early Classical c. 480–450 BCE
- High Classical c. 450-400 BCE
- Late Classical c. 400–323 BCE

■ Hellenistic c. 323-31 BCE

250

 \prod_{CE}

■ Roman Empire 27 BCE-395 CE

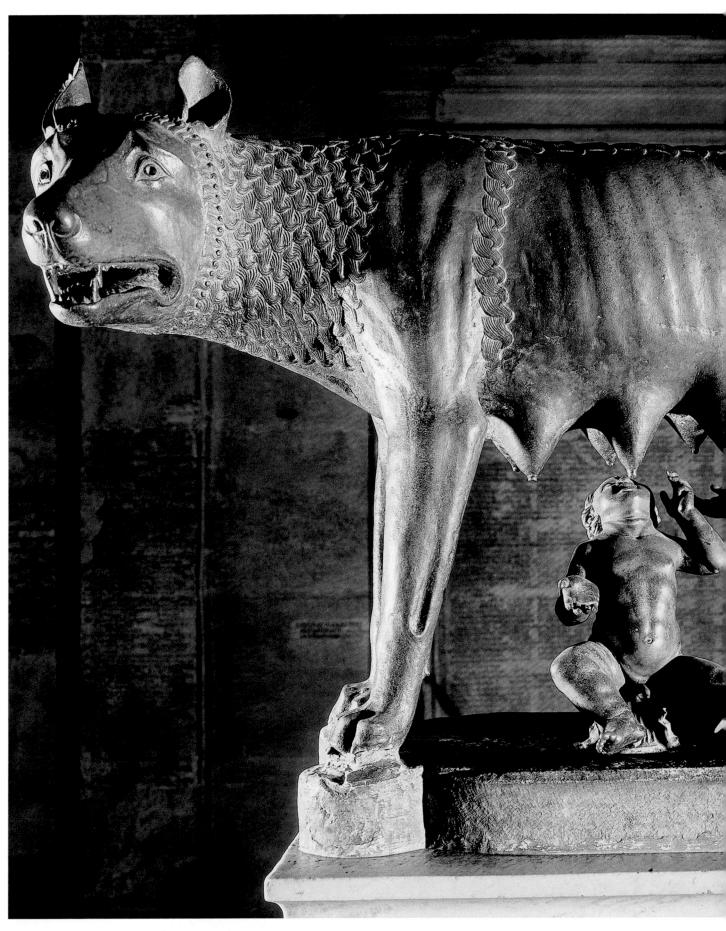

6–I SHE-WOLF c. 500 BCE, or 450-430 BCE with 15th or 16th century additions (the twins). Bronze, glass-paste eyes, height $33\frac{1}{2}$ " (85 cm). Museo Capitolino, Rome.

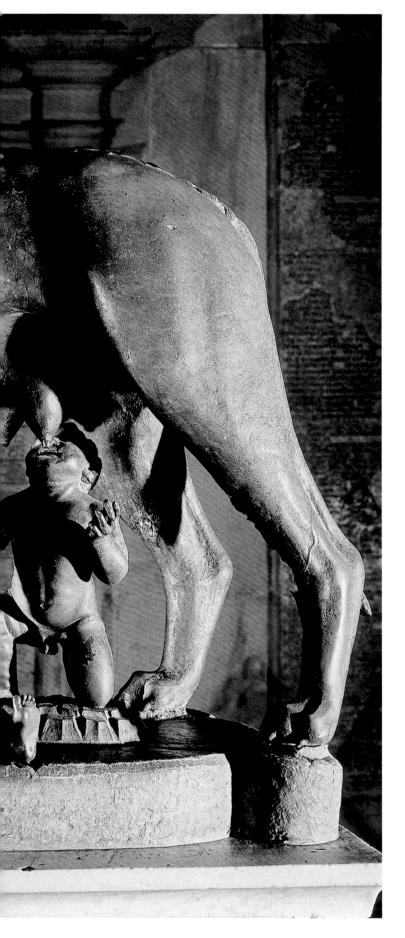

CHAPTER SIX

ETRUSCAN AND ROMAN ART

6

A ferocious she-wolf turns toward us with a vicious snarl. Her tense body, thin flanks, and protruding ribs contrast with her heavy, milk-filled

teats. She suckles two active, chubby little human boys. We are looking at the most famous symbol of Rome, the legendary wolf who nourished and saved the city's founder, Romulus, and his twin brother, Remus (FIG. 6–1). According to a Roman legend, the twin sons, fathered by the god Mars and born of a mortal woman, were left to die on the banks of the Tiber River by their wicked great-uncle. A she-wolf discovered the infants and nursed them in place of her own pups; the twins were later raised by a shepherd. When they reached adulthood, the twins decided to build a city near the spot where the wolf had rescued them, in the year 753 BCE.

This composite sculptural group of wolf and boys suggests the complexity of art history on the Italian peninsula. An early people called Etruscans created the bronze wolf in the fifth century BCE. Later Romans added the sculpture of two children in the late fifteenth or early sixteenth century CE.

We know that a statue of a wolf—and sometimes even a live wolf in a cage—stood on the Capitoline Hill, the governmental and religious center of ancient Rome. But whether the wolf in FIGURE 6—1 is the same sculpture that Romans saw millennia ago is far from certain. According to tradition, the original bronze wolf was struck by lightning

and the damaged figure was buried. The documented history of this statue begins in the tenth century CE, when it was discovered and placed outside the Lateran Palace, the home of the pope. The naturalistic rendering of the wolf's body suggests a mid—fifth-century date and contrasts with the decorative, stylized rendering of the tightly curled, molded, and incised ruff of fur around her neck and along her spine. The glass-paste eyes that add so much to the dynamism of the figure were inserted after the sculpture was finished. At that time, statues of two small men stood under the wolf, personifying the alliance between the Romans and their former enemies from central Italy, the Sabines. In the later Middle Ages, people mistook the figures for children and identified the sculpture with the founding of Rome. During the Renaissance, the Florentine sculptor Antonio del Pollaiuolo (see Chapter 14) added the twins we see here. Pope Sixtus IV (papacy 1471–84 CE) had the sculpture moved from his palace to the Capitoline Hill. Today, the wolf maintains her wary pose in a museum there.

CHAPTER-AT-A-GLANCE

- THE ETRUSCANS Etruscan Architecture Etruscan Temples and Their Decoration Tomb Ghambers Bronze Work
- THE ROMANS Origins of Rome Roman Religion
- THE REPUBLIC, 509–27 BCE Sculpture during the Republic Architecture and Engineering
- THE EARLY EMPIRE, 27 BCE-96 CE Augustan Art The Julio-Claudians The Roman City and the Roman Home Wall Painting
 The Flavians
- THE HIGH IMPERIAL ART OF TRAJAN AND HADRIAN Imperial Architecture Mosaics Sculpture Imperial Portraits
- THE LATE EMPIRE, THIRD AND FOURTH CENTURIES The Severan Dynasty The Third Century: The Soldier Emperors The Tetrarchy Constantine the Great and His Legacy
- **IN PERSPECTIVE**

THE ETRUSCANS

The boot-shaped Italian peninsula, shielded on the north by the Alps, juts into the Mediterranean Sea. At the end of the Bronze Age (about 1000 BCE), a central European people known as the Villanovans occupied the northern and western regions of the peninsula, and the central area was home to a variety of people who spoke a closely related group of Italic languages, Latin among them. Beginning about 750 BCE, Greeks established colonies on the mainland and in Sicily. Between the seventh and sixth centuries BCE, people known as Etruscans, probably related to the Villanovans, gained control of the north and much of today's central Italy, an area known as Etruria.

Etruscan wealth came from fertile soil and an abundance of metal ore. Both farmers and metalworkers, the Etruscans were also sailors and merchants, and they exploited their resources in trade with the Greeks and with other people of the eastern Mediterranean. Etruscan artists knew and drew inspiration from Greek and Near Eastern sources. They assimilated these influences to create a distinctive Etruscan style. Organized into a loose federation of a dozen cities, the

Etruscans reached the height of their power in the sixth century BCE, when they expanded into the Po River valley to the north and the Campania region to the south (MAP 6-1).

Etruscan Architecture

In architecture, the Etruscans used the plans and post-and-lintel structure seen in Greece and elsewhere. Their pattern of building was later adopted by the Romans. The Etruscan city was laid out on a grid plan, like cities in Egypt and Greece, but with a difference: Two main streets—one usually running north-south and the other east-west—divided the city into quarters. The intersection of these streets was the town's business center. We know something about their domestic architecture within these quarters, because the Etruscans created house-shaped funerary urns and also decorated the interiors of tombs to resemble houses. They built their houses around a central courtyard (or atrium) open to the sky, with a pool or cistern fed by rainwater.

Walls with protective gates and towers surrounded the cities. As a city's population grew, its boundaries expanded and building lots were added outside the walls. The third- to

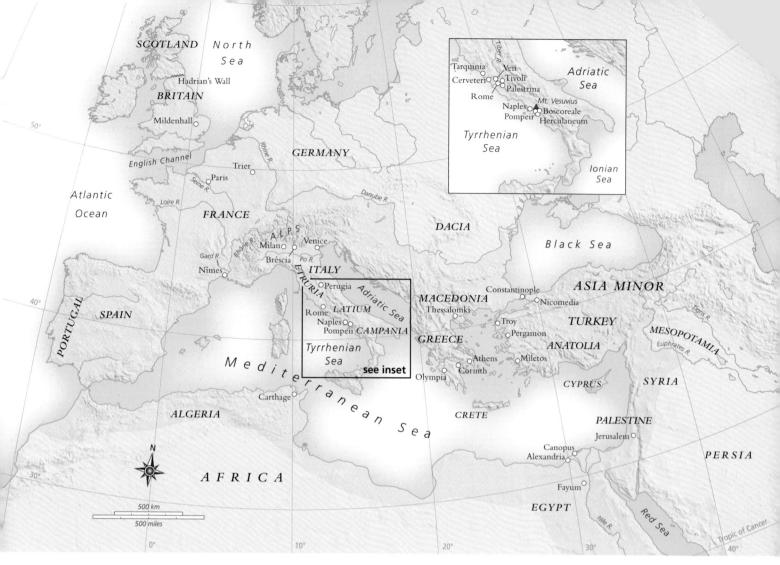

MAP 6-I THE ROMAN REPUBLIC AND EMPIRE

After expelling their Etruscan kings in 509 BCE, Rome became a republic. The Roman Empire, which began in 27 BCE, extended its borders from the Euphrates River to Scotland under Trajan in 106 CE, but was permanently split into the Eastern and Western empires in 395 CE.

second-century BCE city gate of Perugia, called the Porta Augusta, is one of the few surviving examples of Etruscan monumental architecture (FIG. 6–2). A tunnel-like passageway between two huge towers, this gate is significant for anticipating the Roman use of the round arch, which is here extended to create a semicircular barrel vault over the passageway.

The round arch was not an Etruscan or Roman invention, but the Etruscans and Romans were the first to make widespread use of arches and vaults (see "Arch, Vault, and Dome," page 6-6). Unlike the corbel arch, in which overhanging courses of masonry meet at the top, the round arch is formed by precisely cut, wedge-shaped stone blocks called **voussoirs**. In the Porta Augusta, a square frame surmounted by a horizontal decorative element resembling an entablature sets off the arch, which consists of a double row of *voussoirs*

and a molding. The decorative section is filled with a row of circular panels, or roundels, alternating with rectangular, 2 columnlike uprights called pilasters. The effect is reminiscent 3 of the Greek Doric frieze.

Etruscan Temples and Their Decoration

The Etruscans incorporated Greek deities and heroes into their pantheon. They may also have adapted the use of divination to predict future events from the ancient Mesopotamians. Beyond this and their burial practices (revealed by the findings in their tombs, discussed later), we know little about their religious beliefs. Our knowledge of the temples' appearance comes from the few remaining foundations of Etruscan temples, from ceramic votive models, and from the writings of the Roman architect Vitruvius.

arch terms

ements of Architecture

ARCH, VAULT, AND DOME

he first true arch used in Western architecture is the round arch. When extended, the round arch becomes a barrel vault.

The **round arch** displaces most of the weight, or downward thrust (see arrows on diagrams) of the masonry above it to its curving sides. It transmits that weight to the supporting uprights (door or window jambs, columns, or piers), and from there the thrust goes to the ground. Brick or cut-stone arches are formed by fitting together wedge-shaped pieces, called **voussoirs**, until they meet and are locked together at the top center by the final piece, called the **keystone**. These voussoirs exert an outward thrust so arches may require added support, called **buttressing**, from adjacent masonry elements. Until the keystone is in place and the mortar between the bricks or stones dries, an arch is held in place by wooden scaffolding called **centering**. The points from which the curves of the arch rise, called **springings**, are often reinforced by masonry imposts. The wall areas adjacent to the

curves of the arch are **spandrels**. In a succession of arches, called an **arcade**, the space encompassed by each arch and its supports is called a **bay**.

The **barrel vault** is constructed in the same manner as the round arch. The outward pressure exerted by the curving sides of the barrel vault requires buttressing within or outside the supporting walls. When two barrel-vaulted spaces intersect each other at the same level, the result is a **groin vault**. Both the weight and outward thrust of the groin vault are concentrated on the four piers, so only the piers require buttressing. The Romans used the groin vault to construct some of their grandest interior spaces.

A third type of vault brought to technical perfection by the Romans is the **hemispheric dome**. The rim of the dome is supported on a circular wall, as in the Pantheon (SEE FIGS. 6-53, 6-55). This wall is called a **drum** when it is raised on top of a main structure. Sometimes a circular opening, called an **oculus**, is left at the top.

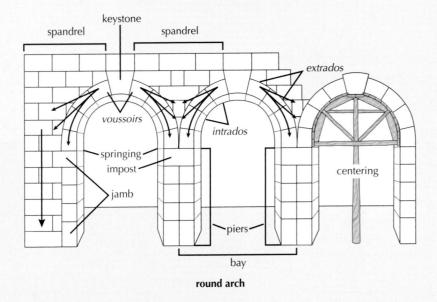

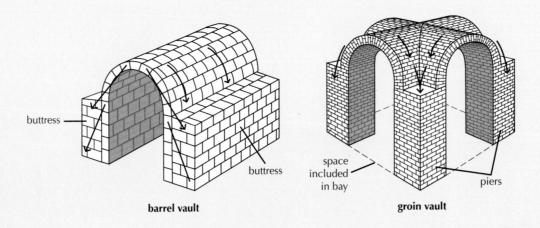

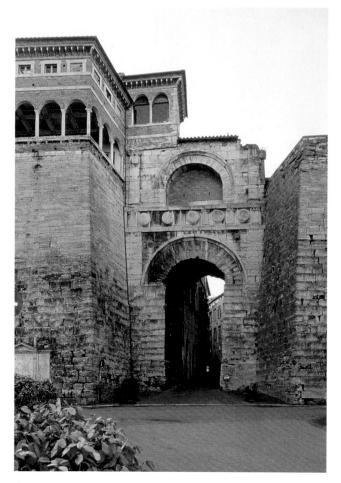

6–2 PORTA AUGUSTAPerugia, Italy. 3rd to 2nd century BCE.

Sometime between 33 and 23 CE, Vitruvius compiled descriptions of Etruscan and Roman architecture (see "Roman Writers on Art," page 179). His account indicates that Etruscan temples (FIG. 6–3) were built on a platform called a podium, and had, starting from a courtyard or open city square, a single flight of steps leading up to a front porch. This new focus and orientation constitutes an important difference from Greek temples. Columns and an entablature supported the section of

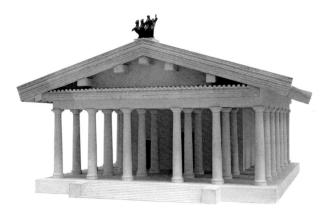

6–3 **RECONSTRUCTION OF AN ETRUSCAN TEMPLE** Based on archaeological evidence and descriptions by Vitruvius. University of Rome, Istituto di Etruscologia e Antichità Italiche.

roof that projected over the porch. The ground plan was almost square and was divided equally between porch and interior space (FIG. 6–4). Often this interior space was separated into three rooms that probably housed cult statues.

Etruscans built their temples with mud-brick walls. The columns and entablatures were made of wood or a quarried volcanic rock called *tufa*, which hardens upon exposure to air. The column bases, shafts (which were sometimes plain), and capitals could resemble those of the Greek Doric or the Greek Ionic orders, and the entablature might include a frieze resembling that of the Doric order (not seen in the model). Vitruvius used the term **Tuscan order** for the variation that resembled the Doric order, with an unfluted shaft and a simplified base, capital, and entablature (see "Roman Architectural Orders," page 174). Although Etruscan temples were simple in form, they were embellished with dazzling displays of painting and terra-cotta sculpture. The temple roof, rather than the pediment, served as a base for large statue groups.

Etruscan artists excelled at making huge terra-cotta figures, a task of great technical difficulty. A splendid example is a life-size figure of **APOLLO** (FIG. 6–5). To make a large clay sculpture such as this one, the artist must know how to construct the figure so that it does not collapse under its own weight while the clay is still wet. The artist must know how to regulate the temperature in a large kiln for a long period of time. Some of the names of Etruscan terra-cotta artists have come down to us, including that of a sculptor from Veii (near Rome) called Vulca, in whose workshop this Apollo may have been created.

Dating from about 510–500 BCE and originally part of a four-figure scene depicting one of the labors of Hercules (the Greek god Herakles), this *Apollo* comes from the temple dedicated to Minerva and other gods in the sanctuary of Portonaccio at Veii. Four figures on the temple's ridgepole depicted Apollo and Hercules fighting for possession of a deer sacred to Diana,

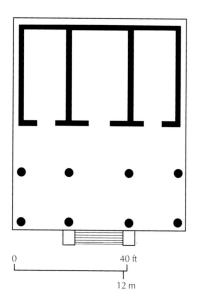

6–4 PLAN OF AN ETRUSCAN TEMPLE Based on descriptions by Vitruvius.

THE ETRUSCANS

ements of Architecture

NOMAN ARCHITECTURAL ORDERS

he Etruscans and Romans adapted Greek architectural orders to their own tastes and uses (see Chapter 5, "The Greek Architectural Orders," page 118). The Etruscans modified the Greek Doric order by adding a base to the column. In this diagram, the two Roman orders are shown on pedestals, which consist of a plinth, a dado, and a cornice. The Romans also created the Tuscan order by adding a base to the Doric column and often leaving the shaft unfluted. They elaborated on the Corinthian order with additional moldings and composite capitals that were a combination of lonic volutes placed on the diagonal of all four corners and Corinthian acanthus foliage. Both the Tuscan and the Composite orders were widely used by later architects.

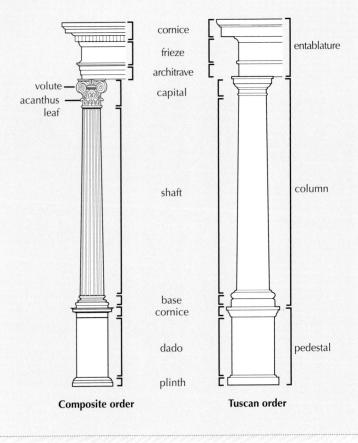

while she and Mercury looked on. Apollo is shown striding forward (to our eyes he seems to have just stepped over the decorative scrolled element that helps support the sculpture). The representation of the god confronting Hercules in vigorous action on the ridgepole of the temple roof defies the logical relationship of sculpture to architecture seen in Greek pediment and frieze sculpture. The Etruscans seemed willing to sacrifice structural logic for lively action in their art.

Apollo's well-developed body and the "Archaic smile" clearly demonstrate that Etruscan sculptors were familiar with contemporary Greek kouroi. Despite those similarities, a comparison of the Apollo and a figure such as the Greek *Anavysos Kouros* (SEE FIG. 5–15) reveals telling differences. Unlike the Greek figure, the body of the Etruscan Apollo is partially concealed by a robe that cascades in knife-edged pleats to his knees. The forward-moving pose of the Etruscan statue also has a vigor that is only hinted at in the balanced stance of the Greek figure. This realistically portrayed energy expressed in purposeful movement is characteristic of Etruscan sculpture and painting.

Tomb Chambers

Like the Egyptians, the Etruscans thought of tombs as homes for the dead. (They did not try to preserve the body but preferred cremation.) The Etruscan cemetery of La Banditaccia at Cerveteri was laid out like a small town, with "streets" running between the grave mounds. The tomb chambers were partially or entirely excavated below the ground, and some were hewn out of bedrock. They were roofed over, sometimes with corbel vaulting, and covered with dirt and stones.

The Etruscan painters had a remarkable ability to suggest that their subjects inhabit a bright, tangible world just beyond the tomb walls. Brightly colored paintings of scenes of feasting, dancing, musical performances, athletic contests, hunting, fishing, and other pleasures decorated the tomb walls. Many of these murals are faded and flaking, but those in the tombs at Tarquinia are well preserved. In a detail of a painted frieze in the **TOMB OF THE TRICLINIUM**, from about 480–470 BCE, young men and women dance to the music of the lyre and double flute (FIG. 6–6). The dancers line the side walls within

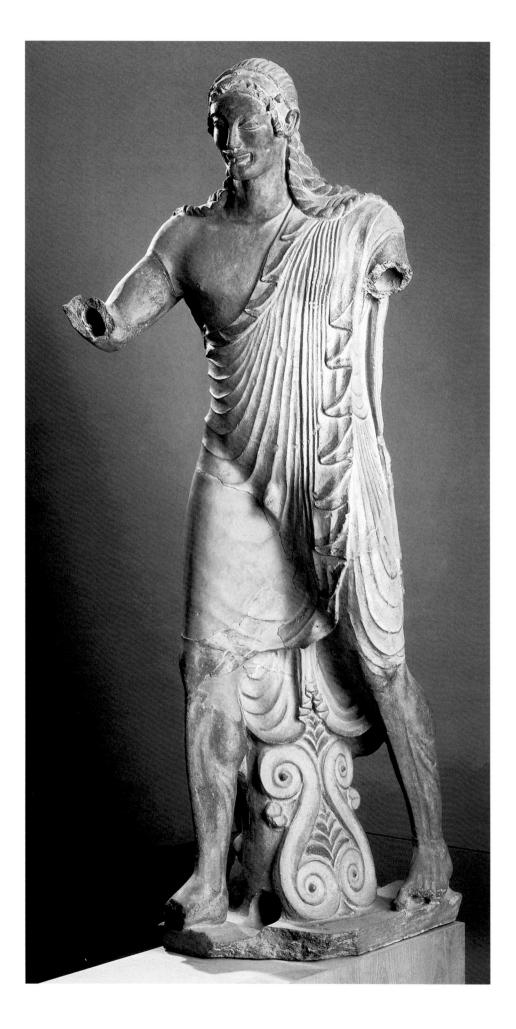

6–5 APOLLO
Temple of Minerva,
Portenaccio, Veii. Master
sculptor Vulca (?).
c. 510–500 BCE. Painted
terra cotta, height 5'10"
(1.8 m). Museo
Nazionale di Villa Giulia,
Rome.

Compact to anny son

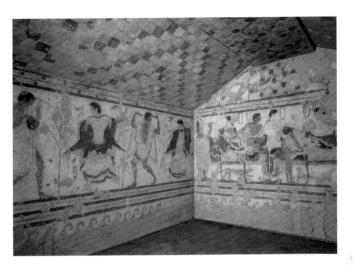

6–6 BURIAL CHAMBER, TOMB OF THE TRICLINIUM, TARQUINIA
c. 480–470 BCE.

a carefully arranged setting of stylized trees and birds, while at the end of the room couples recline on couches as they participate in a funeral banquet. Women are portrayed as active participants in the festivities and ceremonies.

Some tombs were carved out of the rock to resemble rooms in a house. The **TOMB OF THE RELIEFS**, for example, seems to have a flat ceiling supported by square stone posts (FIG. 6–7). Its walls were plastered and painted, and it was fully furnished. Couches were carved from stone, and other furnishings were simulated in **stucco**, a slow-drying type of plaster that can be easily molded and carved. Pots, jugs, robes, axes, and other items were molded and carved to look like real objects hanging on hooks. Rendered in low relief at the bottom of the post just left of center is the family dog.

The deceased were placed in urns or sarcophagi (coffins) made of terra cotta. On the SARCOPHAGUS FROM CERVETERI, from about 520 BCE (FIG. 6–8), a husband and wife are shown reclining comfortably on a dining couch. Their upper bodies are vertical and square shouldered, but their hips and legs seem to sink into the couch Portrait sar-

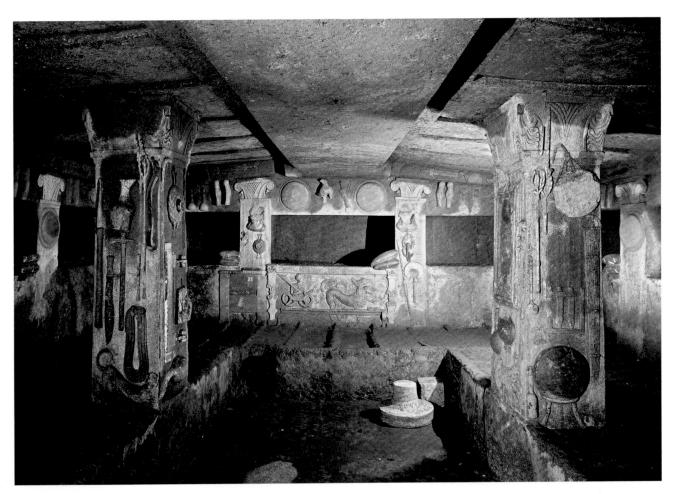

6–7 | **BURIAL CHAMBER, TOMB OF THE RELIEFS** Cerveteri. 3rd century BCE.

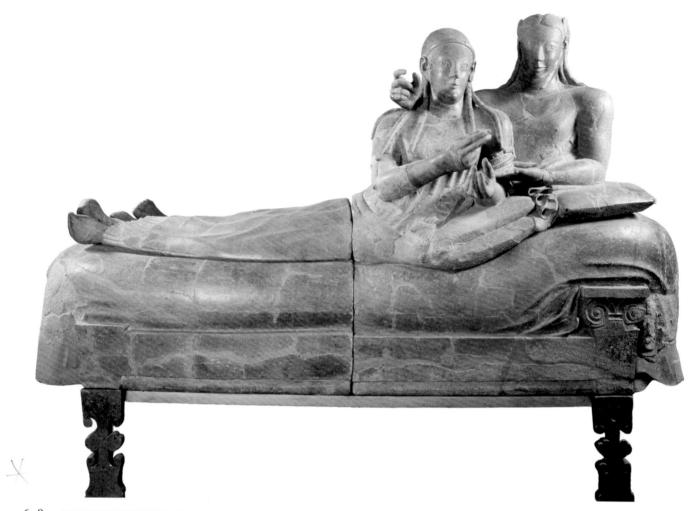

6–8 SARCOPHAGUS FROM CERVETERI c. 520 BCE. Terra cotta, length 6′7″ (2.06 m). Museo Nazionale di Villa Giulia, Rome.

Ony discussed this

cophagi like this one evolved from earlier terra-cotta cinerary jurns with sculpted heads of the dead person whose ashes they held. Rather than seeing a somber memorial to the dead, we find two lively individuals—the man once raised a drinking vessel—rendered in sufficient detail to convey hair and clothing styles. These genial hosts, with their smooth, conventionalized body forms and faces, their uptilted, almond-shaped eyes, and their benign smiles, gesture as if to communicate something important to the living viewer—perhaps an invitation to dine with them for eternity.

As these details suggest, the Etruscans made every effort to provide earthly comforts for their dead, but tomb decorations also sometimes included frightening creatures from Etruscan mythology. On the back wall of the *Tomb of the Reliefs* is another kind of dog—a beast with many heads—that probably represents Cerberus, the guardian of the gates of the underworld, an appropriate funerary image.)

Bronze Work

The most impressive Etruscan metal works are large-scale sculptures in the round like the she-wolf in Figure 6–1.

Etruscan bronze workers created items for both funerary and domestic use, such as a bronze mirror from the early to midfourth century BCE (FIG. 6-9). A mirror had the power to capture an image, hence it was almost magical. Engraved on the back of the mirror is a winged man, identified by the inscription as the Greek priest Calchas, who accompanied the Greek army under Agamemnon to Troy. Here Calchas is shown bending over a table, studying the liver of a sacrificed animal. Greeks, Etruscans, and Romans all believed that the appearance of animal entrails could reveal the future. Perhaps alluding to the legend that Calchas died laughing in his vineyard, the artist has shown him surrounded by grapevines and with a jug at his feet. The complex pose, the naturalistic suggestions of a rocky setting, and the pull and twist of drapery that emphasize the figure's three-dimensionality convey a sense of realism.

Etruscan artists continued to be held in high regard by Roman patrons after the Etruscan cities fell to Rome. Bronze workers and other artists went to work for the Romans, making the distinction between Etruscan and early Roman art difficult. A head that was once part of a bronze statue of a

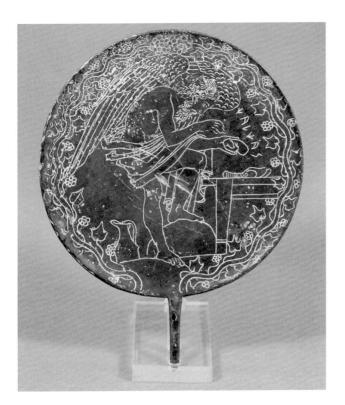

6–9 MIRROR c. 400–350 BCE. Engraved bronze, diameter 6″ (15.3 cm). Musei Vaticani, Museo Gregoriano Etrusco, Rome.

One side of the disc was engraved; the other, highly polished to provide a reflecting surface.

man may be an example of an important Roman commission (FIG. 6–10). Often alleged to be a portrait of Lucius Junius Brutus, a founder and first consul of the Roman Republic, the head traditionally has been dated about 300 BCE (and may even be a more recent work from the first century BCE), long after Brutus's death. Although it may represent an unknown Roman dignitary of the day, it could also be an imaginary portrait of the ancient hero. The rendering of the strong, broad face with its heavy brows, hawk nose, firmly set lips, and wide-open eyes (made of painted ivory) is scrupulously detailed. The sculptor seems also to have sought to convey the psychological complexity of the subject, showing him as a somewhat world-weary man who nevertheless projects strong character and great strength of purpose.

Etruscan art and architectural forms left an indelible stamp on the art and architecture of early Rome that was second only to the influence of Greece. By 88 BCE, when the Etruscans had been granted Roman citizenship, their art had already been absorbed into that of Rome.

THE ROMANS

At the same time as the Etruscan civilization was flourishing, the Latin-speaking inhabitants of Rome began to develop into a formidable power. For a time, kings of Etruscan lineage ruled them, but in 509 BCE the Romans overthrew the kings and formed a republic centered in Rome. Etruscan power was in decline by the fifth century BCE, and they were absorbed by the Roman Republic at the end of the third century, by which time Rome had steadily expanded its territory in many directions. The Romans unified what is now Italy and, after defeating the North African city-state of Carthage, their rival in the western Mediterranean, established an empire that included the entire Mediterranean region (MAP 6–1).

At its greatest extent, in the early second century CE, the Roman Empire reached from the Euphrates River in southwest Asia to Scotland. It ringed the Mediterranean Sea—mare nostrum, or "our sea," the Romans called it. As the Romans absorbed the peoples they conquered, they imposed on them a legal, administrative, and cultural structure that endured for some five centuries—and in the eastern Mediterranean until the fifteenth century CE—and left a lasting mark on the civilizations that emerged in Europe.

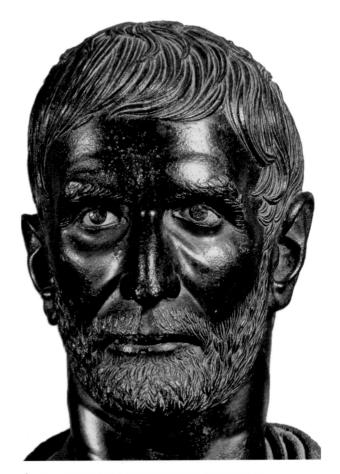

6–IO HEAD OF A MAN (KNOWN AS BRUTUS) c. mid-3rd century BCE. Bronze, eyes of painted ivory, height 12½" (31.8 cm). Palazzo dei Conservatori, Rome.

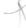

Art and Its Context

ROMAN WRITERS ON ART

nly one book specifically on architecture and the arts survives from antiquity. All our other written sources consist of digressions and insertions in works on other subjects. That one book, Vitruvius's Ten Books on Architecture, written for Augustus in the first century CE, is a practical handbook for builders that discusses such things as laying out cities, siting buildings, and using the Greek architectural orders. His definition of Greek architectural terms is invaluable. Vitruvius argued for appropriateness and rationality in architecture, and he also made significant contributions to art theory, including studies on proportion.

Pliny the Elder (c. 23-79 CE) wrote a vast encyclopedia of "facts, histories, and observations," known as *Naturalis Historia* (*The Natural History*). He often included discussions of art and architecture, and he used works of art to make his points—for example, sculpture to illustrate essays on stones and metals. Pliny's scientific turn of mind led to his death, for he was overcome while observing the eruption of Mount Vesuvius that buried Pompeii. His nephew Pliny the Younger (c. 61–113 CE), a voluminous letter writer, added to our knowledge of Roman domestic architecture with his meticulous description of villas and gardens.

Valuable bits of information can also be found in books by travelers and historians. Pausanias, a second-century CE Greek traveler, wrote descriptions of Greece that are basic sources on Greek art and artists. Flavius Josephus (c. 37–100 CE), a historian of the Flavians, wrote in his *Jewish Wars* a description of the triumph of Titus that includes the treasures looted from the Temple of Solomon in Jerusalem (see Fig. 6–39).

As an iconographical resource, *Metamorphoses* by the poet Ovid (43 BCE-17 CE) provided themes for artists in Ovid's own time, and has done so ever since. Ovid recorded Greek and Roman myths, stories of interactions between gods and mortals, and amazing transformations (metamorphoses)—for example, Daphne turning into a laurel tree to escape Apollo.

Perhaps the best-known—and most pungent—comments on art and artists remain those of the Greek writer Plutarch (c. 46-after 119 CE), who opined that one may admire the art but not the artist, and the Roman poet Virgil (70-19 BCE), who in the *Aeneid* wrote that the Greeks practice the arts, but it is the role of Romans to rule, for their skill lies in government, not art.

Origins of Rome

The Romans saw themselves, not surprisingly, in heroic terms and attributed heroic origins to their ancestors. Two popular legends told the story of Rome's founding: one by Romulus and Remus, twin sons of Mars, the god of war (see the beginning of this chapter); the other, rendered in epic verse by the poet Virgil (70–19 BCE) in the *Aeneid*. In the latter, the Roman people were understood to be the offspring of Aeneas, a Trojan who was the mortal son of Venus. Aeneas and some companions escaped from Troy and made their way to the Italian peninsula. Their sons were the Romans, the people who in fulfillment of a promise by Jupiter to Venus were destined to rule the world.

Archaeologists and historians present a more mundane picture of Rome's origins. In Neolithic times, people settled in permanent villages on the plains of Latium, south of the Tiber River, and on the Palatine, one of the seven hills that would eventually become the city of Rome. The settlements were just clusters of small, round huts, but by the sixth century BCE, they had become a major transportation hub and trading center.

Roman Religion

The Romans adopted the Greek gods and myths as well as Greek art and temple forms. (This chapter uses the Roman form of Greek names.) They assimilated Greek religious beliefs and practices into their state religion. To the Greek pantheon they later added their own deified emperors. Wor-

ship of ancient gods mingled with homage to past rulers, and oaths of allegiance to the living ruler made the official religion a political duty. (As an official religion, it became increasingly ritualized, perfunctory, and distant from the everyday life of the average person.)

Many Romans adopted the more personal religious beliefs of the people they had conquered, the so-called mystery religions. Worship of Isis and Osiris from Egypt, Cybele (the Great Mother) from Anatolia, the hero-god Mithras from Persia, and the single, all-powerful God of Judaism and Christianity from Palestine challenged the Roman establishment. These unauthorized religions flourished alongside the state religion, with its Olympian deities and deified emperors, despite occasional government efforts to suppress them.

THE REPUBLIC, 509–27 BCE

Early Rome was governed by kings and an advisory body of leading citizens called the Senate. The population was divided into two classes: a wealthy and powerful upper class, the *patricians*, and a lower class, the *plebeians*. In 509 BCE, Romans overthrew the last Etruscan king. They established the Roman Republic as an *oligarchy*, a government by the aristocrats. It was to last about 450 years.

By 275 BCE Rome controlled the entire Italian peninsula. By 146 BCE, Rome had defeated its great rival, <u>Carthage</u>, on the north coast of Africa, and taken control of the western

fer nis

THE REPUBLIC, 509-27 BCE

6–II AULUS METELLUS Found near Perugia. c. 80 BCE. Bronze, height 5′11″ (1.8 m). Museo Archeològico Nazionale, Florence.

Mediterranean. By the mid-second century BCE, Rome had taken Macedonia and Greece, and by 44 BCE, it had conquered most of Gaul (present-day France) as well as the eastern Mediterranean (SEE MAP 6–1). Egypt remained independent until Octavian defeated Marc Anthony and Cleopatra in the Battle of Actium in 31 BCE.

During the centuries of the Republic, Roman art reflected Etruscan influence, but territorial expansion brought wider exposure to the arts of other cultures. Like the Etruscans, the Romans admired Greek art. As Horace wrote (*Epistulae II, 1*): "Captive Greece conquered her savage conquerors and brought the arts to rustic Latium." The Romans used Greek designs and Greek orders in their architecture, imported Greek art, and employed Greek artists. In 146 BCE,

for example, they stripped the Greek city of Corinth of its art treasures and shipped them back to Rome. Ironically, this love of Greek art was not accompanied by admiration for its artists. In Rome, as in Greece, professional artists were generally considered to be simply skilled laborers.

Sculpture during the Republic

Sculptors of the Republican period sought to create believable images based on careful observation of their surroundings. The desire to render accurate and faithful portraits of individuals may be derived from Roman ancestor veneration and the practice of making death masks of deceased relatives. Roman patrons in the Republican period clearly admired realistic portraits, and it is not sur-

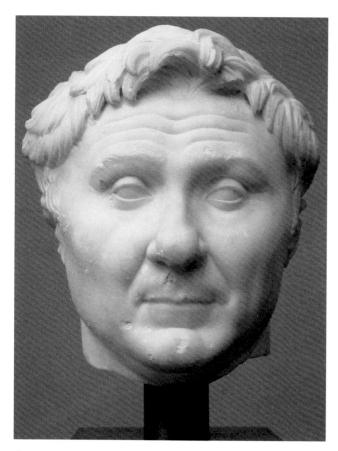

6–12 PORTRAIT OF POMPEY THE GREAT 30 CE. Copy of sculpture of c. 50 BCE. Marble, height $9\frac{1}{4}$ " (24.8 cm). Ny Carlsberg Glyptotek, Copenhagen.

prising that for bronze sculpture they often turned to skilled Etruscan artists.

THE ORATOR. The life-size bronze portrait of AULUS METELLUS—the Roman official's name is inscribed on the hem of his garment in Etruscan letters (FIG. 6–11)—dates to about 80 BCE. The statue, known from early times as *The Orator*, depicts a man addressing a gathering, his arm outstretched and slightly raised, a pose expressive of authority and persuasiveness. The orator wears sturdy laced leather boots and the folded and draped garment called a *toga*, dress characteristic of a Roman official. According to Pliny the Elder, large statues like this were often placed atop columns as memorials.

PORTRAIT OF POMPEY. The PORTRAIT OF POMPEY THE GREAT (106–48 BCE), a general and one of the three-man team—along with Caesar and Crassus—who ruled Rome from 60 to 53 BCE, illustrates the realism demanded by Romans (FIG. 6–12). Pompey's fleshy face, too-small eyes, and warts are recorded for posterity. Such meticulous realism, called verism, combines underlying bone structure with surface detail. In the portrait, however, the elegantly tossed hair suggests a more idealized image. The original sculpture was made during Pompey's lifetime (c. 50 BCE), but about 30 CE

his family commissioned the copy seen here. (A statue, perhaps looking like this one, stood in the Theater of Pompey in Rome. When Caesar was assassinated in 44 BCE, he is supposed to have died at the foot of the statue.)

THE DENARIUS OF JULIUS CAESAR. The propaganda value of portraits was not lost on Roman leaders. In 44 BCE, Julius Caesar issued a denarius (a widely circulated coin) bearing his portrait (FIG. 6–13). Like the monumental images of Etruscan and Roman Republican art, this tiny relief sculpture accurately reproduced Caesar's careworn features and growing baldness. This idea of placing the living ruler's portrait on one side of a coin and a symbol of the country or an image that recalls some important action or event on the other was adopted by Caesar's successors. (In the case of this denarius, Venus was placed on the reverse, a reference to the Julian family's claim that they were descended from Venus through her mortal son, Aeneas. Consequently, Roman coins give us an unprecedented and personal view of Roman history.

Architecture and Engineering

Roman architects had to satisfy the wishes of wealthy and politically powerful patrons who ordered buildings for the public as well as themselves. They also had to satisfy the needs of ordinary people. To do this, they created new building types and construction techniques that permitted them to erect buildings efficiently and inexpensively.

CONSTRUCTION TECHNIQUES. Among the techniques Roman architects relied on were the round arch and vault, and during the empire, concrete. For example, an ample water supply was essential for a city, and the Roman invention to supply water was the aqueduct, built with arches and

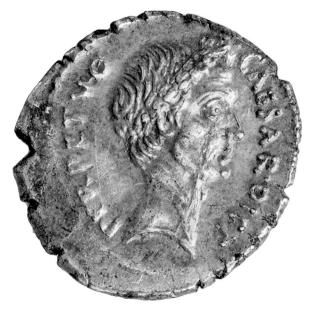

6–13 DENARIUS WITH PORTRAIT OF JULIUS CAESAR 44 BCE. Silver, diameter approximately ¾" (1.9 cm). American Numismatic Society, New York.

181

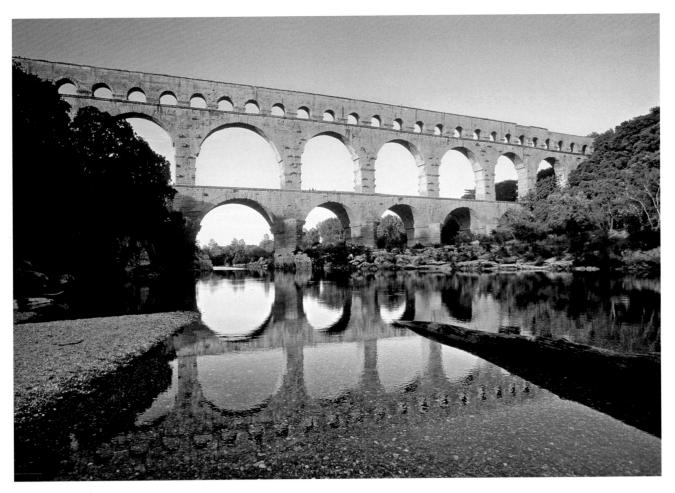

6–14 PONT DU GARDNîmes, France. Late 1st century BCE.

The aqueduct's three arcades rise 160 feet (49 m) above the river. The thick base arcade supports a roadbed approximately 20 feet (6 m) wide. The arches of the second arcade are narrower than the first and are set at one side of the roadbed. The narrow third arcade supports the water trough, 900 feet (274.5 m) long on 35 arches, each of which is 23 feet (7 m) high.

using concrete. The Pont du Gard, near Nîmes, in southern France, carried the water channel of an aqueduct across the river on a bridge of arches (FIG. 6–14) (See "Arch, Vault, and Dome," page 172). It brought water from springs 30 miles to the north using a simple gravity flow, and it provided 100 gallons of water a day for every person in Nîmes. Entirely functional, each arch buttresses its neighbors and the huge arcade ends solidly in the hillsides. The structure conveys the balance, proportions, and rhythmic harmony of a great work of art, and fits naturally into the landscape.

THE USE OF CONCRETE. The Romans were pragmatic, and their practicality extended from recognizing and exploiting undeveloped potential in construction methods and physical materials to organizing large-scale building works. Their exploitation of the arch and the vault is typical of their adaptand-improve approach. Their innovative use of concrete, beginning in the first century BCE, was a technological breakthrough of the greatest importance.

In contrast to stone—which was expensive and difficult to quarry and transport—the components of concrete were cheap, relatively light, and easily transported. Building stone structures required highly skilled masons, but a large, semi-skilled work force directed by a few experienced supervisors could construct brick-faced concrete buildings.

Roman concrete consisted of powdered lime, sand (in particular, a volcanic sand called *pozzolana* found in abundance near Pompeii), and various types of rubble, such as small rocks and broken pottery. Mixing in water caused a chemical reaction that blended the materials, which hardened as they dried into a strong, solid mass. At first, concrete was used mainly for poured foundations, but with technical advances it became indispensable for the construction of walls, arches, and vaults for ever-larger buildings. In the earliest concrete wall construction, workers filled a framework of rough stones with concrete. Soon they developed a technique known as *opus reticulatum*, in which the framework is a diagonal web of small—sish bricks set in a cross pattern. Concrete-based construction

freed the Romans from the limits of right-angle forms and comparatively short spans. With this freedom, Roman builders pushed the established limits of architecture, creating some very large and highly original spaces, many based on the curve.

Concrete's one weakness was that it absorbed moisture, so builders covered exposed surfaces with a **veneer**, or facing, of finer materials, such as marble, stone, stucco, or painted plaster. An essential difference between Greek and Roman architecture is that Greek buildings reveal the building material itself, whereas Roman buildings show only the externally applied surface.

The remains of the **SANCTUARY OF FORTUNA PRIMIGE- NIA**, the goddess of fate and chance, were discovered after
World War II by teams clearing the rubble from bombings of
Palestrina (ancient Praeneste), about 16 miles southeast of
Rome. The sanctuary, an example of Roman Republican
architectural planning and concrete construction at its most
creative (FIG. 6–15), was begun early in the second century
BCE and was grander than any building in Rome in its time.

Its design and size show the clear influence of Hellenistic
architecture, especially the colossal scale of buildings in cities
such as Pergamon (SEE FIG. 5–64).

Built of concrete covered with a veneer of stucco and finely cut limestone, the seven vaulted platforms or terraces of the Sanctuary of Fortuna covered a steep hillside. Worshipers ascended long ramps, then staircases to successively higher levels. Enclosed ramps open onto the fourth terrace, which has a

central stair with flanking colonnades and symmetrically placed **exedrae**, or semicircular niches. On the sixth level, **arcades** (series of arches) and **colonnades** (rows of columns) form three sides of a large square, which is open on the fourth side to the distant view. Finally, from the seventh level, a huge, theaterlike, semicircular colonnaded pavilion is reached by a broad semicircular staircase. Behind this pavilion was a small tholos—the actual temple to Fortuna—hiding the ancient rock—cut cave where acts of divination took place. The overall axial plan—directing the movement of people from the terraces up the semicircular staircase, through the portico, to the tiny tholos temple, to the cave—brings to mind great Egyptian temples, such as that of Hatshepsut at Deir el-Bahri (SEE FIG. 3–28).

THE ROMAN TEMPLE. Roman temples followed the pattern of Etruscan and Greek buildings. The Romans built urban temples in commercial centers as well as in special sanctuaries. In Rome, a small rectangular temple stands on its raised platform, or podium, beside the Tiber River (FIG. 6–16). It is either a second-century temple or a replacement of 80–70 BCE and may have been dedicated to Portunus, the god of harbors and ports. With a rectangular cella and a porch at one end reached by a single flight of steps, the temple combines the Greek idea of a colonnade across the entrance with the Etruscan podium and single flight of steps leading to a front porch entrance. The Ionic columns are freestanding on the porch and engaged (set into the wall) around the cella

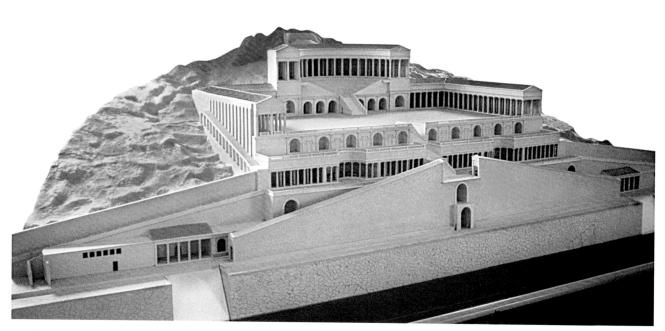

6–15 MODEL OF THE SANCTUARY OF FORTUNA PRIMIGENIA
Palestrina, Italy. Late 2nd century BCE. Museo Archeològico Nazionale, Italy.

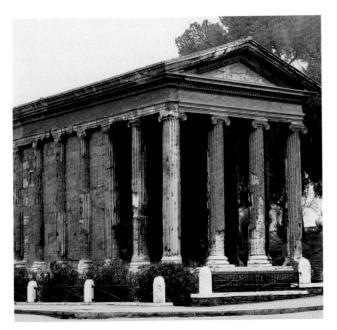

TEMPLE, PERHAPS DEDICATED TO PORTUNUS Forum Boarium (Cattle Market), Rome. Late 2nd century BCE.

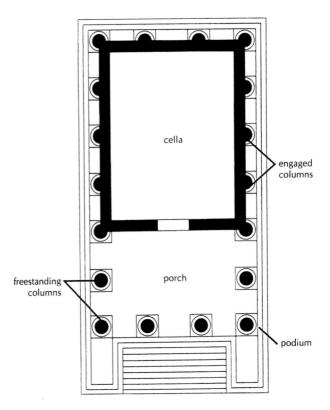

PLAN OF TEMPLE 6 - 17Forum Boarium (Cattle Market), Rome.

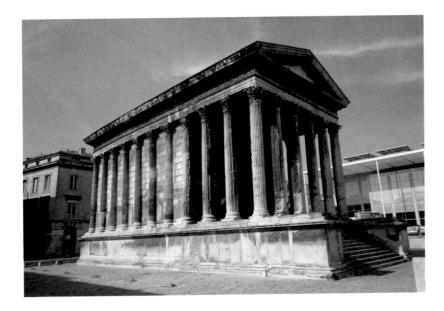

Nîmes, France. c. 20 BCE.

mentus MAISON CARRÉE

(FIG. 6-17). The entablature above the columns on the porch continues around the cella as a decorative frieze. The encircling columns resemble a Greek peripteral temple, but because the columns are engaged, the plan is called pseudo-peripteral. This design, with variations in the orders used with it, is typical of Roman temples.

Early imperial temples, such as the one known as the Maison Carrée (Square House), are simply larger and much more richly decorated versions of the so-called Temple of Portunus. Built in the forum at Nîmes, France, about 20 BCE

and later dedicated to Gaius and Lucius, the adopted heirs of Augustus who died young, the temple was built by their biological father, Marcus Vipsanius Agrippa. The MAISON CAR-RÉE differs from its prototype only in its size and its use of the opulent Corinthian order (FIG. 6-18). The temple summarizes the character of Roman religious architecture: technologically advanced but conservative in design, perfectly proportioned and elegant in sculptural detail, (These qualities appealed to the future American president and amateur architect Thomas Jefferson, who visited Nîmes and was said Montraello

to have found inspiration in the Maison Carrée for his own buildings in the new state of Virginia.)

Although by the first century BCE nearly a million people lived in Rome, the Romans thought of themselves as farmers. In fact, Rome had changed from an essentially agricultural society to a commercial and political power. In 46 BCE, the Roman general Julius Caesar emerged victorious over his rivals, assumed autocratic powers, and ruled Rome until his assassination two years later. The conflicts that followed Caesar's death ended within a few years with the unquestioned control of his grandnephew and heir, Octavian, over Rome and all its possessions. Rome was now an empire.

THE EARLY EMPIRE, 27 BCE-96 CE

The first Roman emperor was born Octavius (Octavian) in 63 BCE. When he was only 18 years old, Octavian was adopted as son and heir by his brilliant great-uncle, Julius Caesar, who recognized qualities in him that would make him a worthy successor. Shortly after Julius Caesar refused the Roman Senate's offer of the imperial crown, early in 44 BCE, he was murdered by a group of conspirators, and the nineteen-year-old Octavian stepped up. Over the next seventeen spectacular years, as general, politician, statesman, and public relations genius, Octavian vanquished warring internal factions and brought peace to fractious provinces. By 27 BCE, the Senate had conferred on him the title of Augustus (meaning "exalted, sacred"). In 12 CE, he was given the title Pontifex Maximus ("High Priest") and so became the empire's highest religious official as well as its political leader.

Assisted by his astute and pragmatic second wife, Livia, Augustus led the state and the empire for nearly sixty years. He proved to be an incomparable administrator who established efficient rule throughout the empire, and he laid the foundation for an extended period of stability, internal peace, and economic prosperity known as the Pax Romana ("Roman Peace"), which lasted over 200 years (27 BCE to 180 CE). When he died in 14 CE, Augustus left a legacy that defined the concept of empire and imperial rule for later Western rulers.

Conquering and maintaining a vast empire required not only the inspired leadership and tactics of Augustus, but also careful planning, massive logistical support, and great administrative skill. Some of Rome's most enduring contributions to Western civilization reflect these qualities—its system of law, its governmental and administrative structures, and its sophisticated civil engineering and architecture.

To facilitate the development and administration of the empire, as well as to make city life comfortable and attractive to its citizens, the Roman government undertook building programs of unprecedented scale and complexity (FIG. 6–19), mandating the construction of central administrative and legal centers (forums and basilicas), recreational facilities (racetracks, stadiums), theaters, public baths, roads, bridges, aqueducts, middle-class housing, and even entire new towns. To accomplish these tasks without sacrificing beauty, efficiency, and human well-being, Roman builders and architects developed rational plans using easily worked but durable materials and highly sophisticated engineering methods. The architect Vitruvius described these accomplishments in his *Ten Books of Architecture* (see "Roman Writers on Art," page 179).

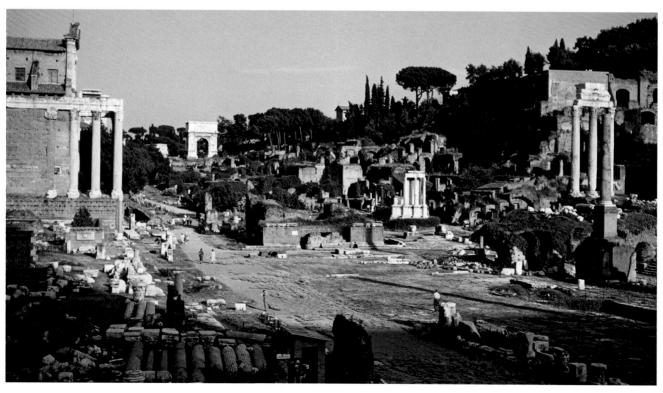

6-19 VIEW OF THE ROMAN FORUM

Art and Its Context

COLOR IN ROMAN SCULPTURE: A COLORIZED AUGUSTUS

ncient sculpture was accentuated by the use of color. A colored reproduction of the Augustus of Primaporta was made based on the research of scholars in the Ny Carlsburg Glyptotek of Copenhagen, Denmark, and the Munich Glyptothek, Germany. In the 1980s, Vincenz Brinkmann of Munich researched the traces of remaining color on ancient sculpture using ultraviolet rays. In addition to aiding the viewer in reading the detailed imagery on Augustus's armor, color also heightens the overall effect of the statue. This painted reproduction may seem shocking to today's viewer, long accustomed to ancient art that has been stripped and scrubbed.

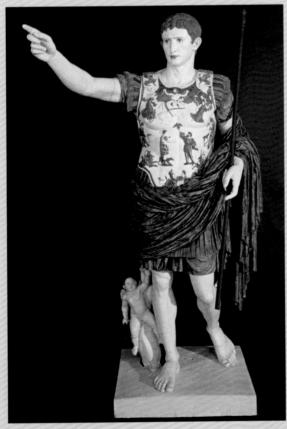

AUGUSTUS OF PRIMAPORTA
A copy with color restored. Vatican Museum, Rome.

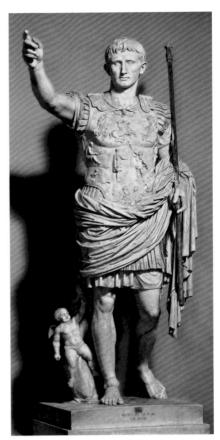

6–20 **AUGUSTUS OF PRIMAPORTA**Early 1st century CE. Perhaps a copy of a bronze statue of c. 20 BCE. Marble, originally colored, height 6'8" (2.03 m). Musei Vaticani, Braccio Nuovo, Rome.

To move their armies about efficiently, to speed communications between Rome and the farthest reaches of the empire, and to promote commerce, the Romans built a vast and complex network of roads and bridges. Many modern European highways still follow the lines laid down by Roman engineers, and Roman-era foundations underlie the streets of many cities. Roman bridges are still in use, and remnants of Roman aqueducts need only repairs and connecting links to enable them to function again.

Augustan Art

Drawing inspiration from Etruscan and Greek art as well as Republican traditions, Roman artists of the Augustan age created a new style—a Roman form of idealism that is grounded in the appearance of the everyday world. They enriched the art of portraiture in both official images and representations of private individuals; they recorded contemporary historical events on arches, columns, and mausoleums erected in public places; and they contributed unabashedly to Roman imperial propaganda.

AUGUSTUS OF PRIMAPORTA. The sculpture known as **AUGUSTUS OF PRIMAPORTA** (FIG. 6–20), discovered in Livia's villa at Primaporta, near Rome, demonstrates the creative assimilation of earlier sculptural traditions into a new context. In its idealization of a specific ruler and his prowess, the sculpture also illustrates the use of imperial portraiture for propaganda. The sculptor of this larger-than-life marble statue adapted the orator's gesture of

Aulus Metellus (SEE FIG. 6–11) and combined it with the pose and ideal proportions developed by the Greek Polykleitos and exemplified by the Spear Bearer (SEE FIG. 5–24). To this combination the Roman sculptor added mythological imagery that exalts Augustus's family. Cupid, son of the goddess Venus, rides a dolphin next to the emperor's right leg, a reference to the claim of the emperor's family, the Julians, to descent from the goddess Venus through her human son Aeneas. Although Augustus wears a cuirass (torso armor) and may have held a commander's baton or the Parthian standard, his feet are bare, suggesting to some scholars his elevation to divine status after death.

This imposing statue creates a recognizable image of Augustus, yet it is far removed from the intensely individualized portrait style that was popular during the Republican period. Augustus was in his late seventies when he died, but in his portrait sculpture he is always a vigorous young ruler. Whether depicting Augustus as a general praising his troops or as a peacetime leader speaking words of encouragement to his people, the sculpture projects the image of a benign ruler, touched by the gods, who governs by reason and persuasion, not autocratic power.

THE ARA PACIS. The ARA PACIS AUGUSTAE, OR ALTAR OF AUGUSTAN PEACE (FIG. 6–21), begun in 13 BCE and dedicated in 9 BCE, commemorates Augustus's triumphal return to Rome after establishing Roman rule in Gaul and Hispania. In its original location, in the Campus Martius (Plain of Mars), the Ara Pacis was aligned with a giant sundial that had an Egyptian obelisk as its pointer, suggesting that Augustus controlled time itself. A walled rectangular enclosure surrounded the altar. Its decoration is a thoughtful union of portraiture and allegory, religion and politics, the private and the public. On the inner walls, garlands of flowers are suspended in swags, or loops, from ox skulls. The ox skulls symbolize sacrificial offerings, and the garlands, which unrealistically include flowering plants from every season, signify continuous peace.

Decorative allegory gives way to Roman realism on the exterior side walls, where sculptors depicted the just-completed procession with its double lines of senators and magistrates (on the north) and Augustus, priests, and imperial family members (on the south). Here recognizable people wait for

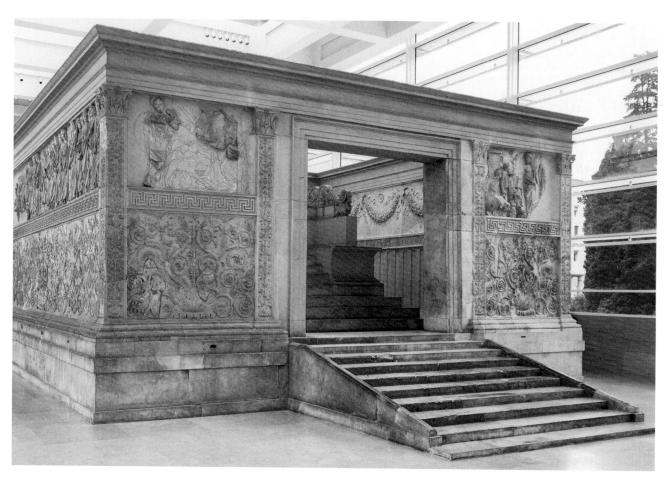

6–21 ARA PACIS AUGUSTAE (ALTAR OF AUGUSTAN PEACE)
Rome. 13–9 BCE. Marble, approx. 34'5'' (10.5 m) \times 38' (11.6 m). View of west side.

At the time of the fall equinox (the time of Augustus's conception), the shadow of the obelisk pointed to the open door of the altar's enclosure wall, on which sculptured panels depicted the first rulers of Rome—the warrior-king Romulus and Numa Pompilius. Consequently, the Ara Pacis celebrates Augustus as both a warrior and a peacemaker. The monument was begun when Augustus was 50 (in 13 BCE) and was dedicated on Livia's 50th birthday (9 BCE).

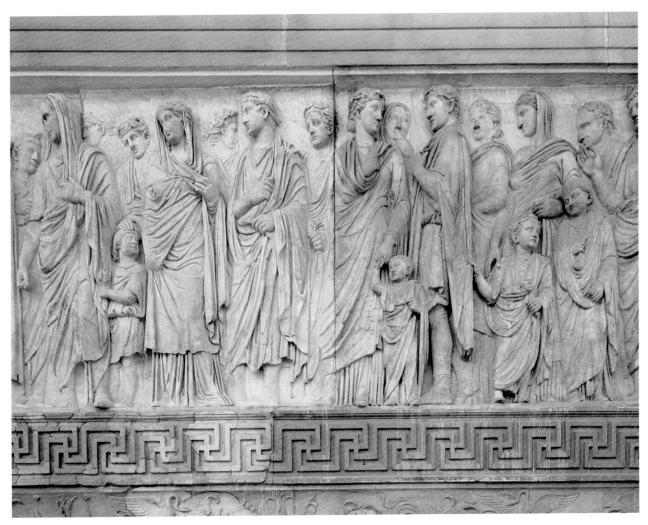

6–22 IMPERIAL PROCESSION

Detail of a relief on the south side of the Ara Pacis. Height 5'2" (1.6 m).

The middle-aged man with the shrouded head at the far left is Marcus Agrippa, who would have been Augustus's successor had he not died in 12 CE. The bored but well-behaved youngster pulling at Agrippa's robe—and being restrained gently by the hand of the man behind him—is probably Agrippa's son Gaius Caesar. The heavily swathed woman next to Agrippa on the right may be Augustus's wife, Livia, followed by Tiberius, who would become the next emperor. Behind Tiberius is Antonia, the niece of Augustus, looking back at her husband, Drusus, Livia's younger son. She grasps the hand of Germanicus, one of her younger children. Behind their uncle Drusus are Gnaeus and Domitia, children of Antonia's older sister, who can be seen beside them. The depiction of children in an official relief was new to the Augustan period and reflects Augustus's desire to promote private family life as well as his potential heirs.

other ceremonies to begin. At the head of the line on the south side of the altar is Augustus (not shown), with members of his family waiting behind him (FIG. 6–22). Unlike the Greek sculptors who created an ideal procession for the Parthenon frieze (SEE FIG. 5–38), the Roman sculptors of the Ara Pacis depicted actual individuals participating in a specific event at a known time. To suggest a double line of marchers in space, they varied the height of the relief, with the closest elements in high relief and those farther back in increasingly lower relief. They draw spectators into the event by making the feet of the nearest figures project from the architectural groundline into the viewers' space.

Moving from this procession, with its immediacy and naturalness, to the east and west ends of the enclosure wall, we find panels of quite a different character, an allegory of Peace and War in two complementary pairs of images. On the west front

6–23 ALLEGORY OF PEACE
Relief on the east side of the Ara Pacis. Height 5'2" (1.6 m).

(SEE FIG. 6–21) are Romulus and (probably) Aeneas. On the east side are personifications (symbols in human form) of Roma (the triumphant empire) and Pax (the goddess of peace).

In the best-preserved panel, the **ALLEGORY OF PEACE** (FIG. 6–23), the goddess Pax, who is also understood to be Tellus Mater, or Mother Earth, nurtures the Roman people, represented by the two chubby babies in her arms. She is accompanied by two young women with billowing veils, one seated on the back of a flying swan (the land wind), the other reclining on a sea monster (the sea wind). The sea wind, symbolized by the sea monster and waves, would have reminded Augustus's contemporaries of Rome's dominion over the Mediterranean; the land wind, symbolized by the swan, the jug of fresh water, and the vegetation, would have suggested the fertility of Roman farms. The underlying theme of a peaceful, abundant Earth is reinforced by the flowers and foliage in the background and the domesticated animals in the foreground.

Although the inclusion in this panel of features from the natural world—sky, water, rocks, and foliage—represents a Roman contribution to monumental sculpture, the idealized figures themselves are clearly drawn from Greek sources. The artists have conveyed a sense of three-dimensionality and volume by turning the figures in space and wrapping them in revealing draperies. The scene is framed by Corinthian pilasters

supporting a simple entablature. A wide molding with a Greek key pattern (meander) joins the pilasters and divides the wall into two horizontal segments. Stylized vine and flower forms cover the lower panels. More foliage overlays the pilasters, culminating in the acanthus-covered capitals. The delicacy and the minute detail with which even the ornamental forms are rendered are characteristic of Roman decorative sculpture.

The Julio-Claudians

After his death in 14 CE, the Senate ordered Augustus to be venerated as a god. Augustus's successor was his stepson Tiberius (ruled 14–37 CE), and in acknowledgment of the lineage of both—Augustus from Julius Caesar and Tiberius from his father, Tiberius Claudius Nero, Livia's first husband—the dynasty is known as the Julio-Claudian (14–68 CE). Although the family produced some capable administrators, its rule was marked by suspicion, intrigue, and terror. The dynasty ended with the reign of the despotic, capricious Nero. A brief period of civil war followed Nero's death in 68 CE, until an astute general, Vespasian, seized control of the government in 69 CE.

Exquisite skill characterizes the arts of the first century. A large onyx cameo (a gemstone carved in low relief) known as the **GEMMA AUGUSTEA** glorifies Augustus as triumphant over barbarians and as the deified emperor (FIG. 6–24).

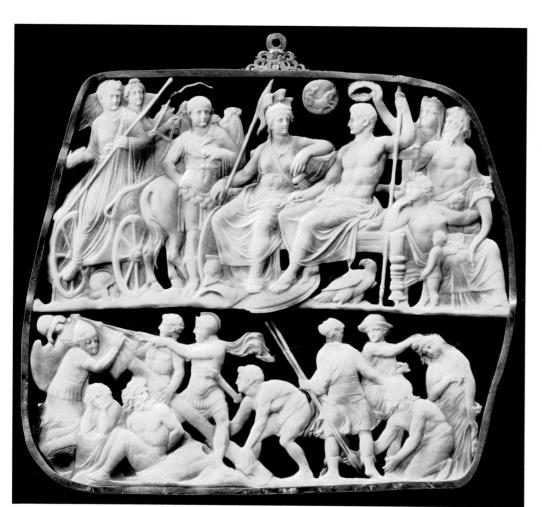

6-24 GEMMA AUGUSTEA Early 1st century CE. Onyx, $7\frac{1}{2} \times 9^{\prime\prime}$ (19×23 cm). Kunsthistorisches Museum, Vienna.

The emperor, crowned with a victor's wreath, sits at the center right of the upper register. He has assumed the identity of Jupiter, the king of the gods; an eagle, sacred to Jupiter, stands at his feet. Sitting next to him is a personification of Rome that has Livia's features. The sea goat in the roundel between them may represent Capricorn, the emperor's zodiac sign.

Tiberius, as the adopted son of Augustus, steps out of a chariot at the left. Returning victorious from the German front, he assumes the imperial throne. Below this realm of godly rulers, Roman soldiers are raising a post or standard on which armor captured from the defeated enemy is displayed. The cowering, shackled barbarians on the bottom right wait to be tied to this post. The artist of the *Gemma Augustea* brilliantly combines idealized, heroic figures characteristic of Classical Greek art with recognizable Roman portraits, the dramatic action of Hellenistic art with Roman realism.

The Roman City and the Roman Home

In good times and bad, individual Romans—like people everywhere at any time—tried to live a decent or even comfortable life with adequate shelter, food, and clothing. Despite their urbanity, as we have noted, Romans liked to portray themselves as simple country folk who had never

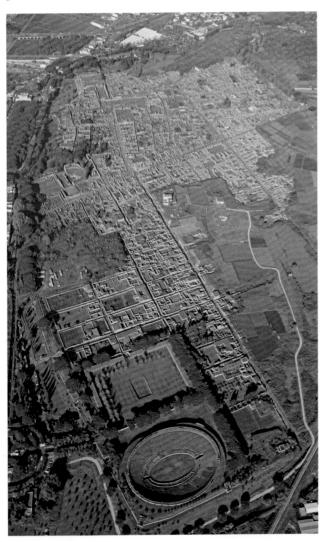

lost their love of nature. The middle classes enjoyed their gardens, wealthy city-dwellers maintained rural estates, and Roman emperors had country villas that were both functioning farms and places of recreation. Wealthy Romans even brought nature indoors by commissioning artists to paint landscapes on the interior walls of their homes. Through the efforts of the modern archaeologists who have excavated them, Roman cities and towns, houses, apartments, and country villas evoke the ancient Roman way of life with amazing clarity.

ROMAN CITIES. Roman architects who designed new cities or who expanded and rebuilt existing ones based the urban plan on the layout of the army camp. These camps were laid out in a grid, but unlike Greek cities such as Miletos, two main streets crossed at right angles dividing the camp—or the city—into quarters. The commander's headquarters, or in a city, the forum and other public buildings, were located at this intersection.

Much of the housing in a Roman city consisted of brick apartment blocks called *insulae*. These apartment buildings had internal courtyards, multiple floors joined by narrow staircases, and occasionally overhanging balconies. City-

6-25 **AERIAL VIEW OF THE CITY OF POMPEII** 79 CE.

dwellers—then as now—were social creatures who lived much of their lives in public markets, squares, theaters, baths, and neighborhood bars. The city-dweller returned to the insulae to sleep, perhaps to eat. Even women enjoyed a public life outside the home—a marked contrast to the circumscribed lives of Greek women.

The affluent southern Italian city of Pompeii, a thriving center of between 10,000 and 20,000 inhabitants, gives a vivid picture of Roman city life. In 79 CE Mount Vesuvius erupted, burying the city under more than 20 feet of volcanic ash and preserving it until its recovery began in the seventeenth century and rediscovery in the eighteenth century. An ancient village that had grown and spread over many centuries, Pompeii lacked the gridlike regularity of newer, planned Roman cities, but its layout is typical of cities that grew over time (FIG. 6-25). Temples and government buildings surrounded a main square, or forum; shops and houses lined straight paved streets; and a protective wall enclosed the heart of the city. The forum was the center of civic life in Roman towns and cities, as the agora was in Greek cities. Business was conducted in its basilicas and porticoes, religious duties performed in its temples, and speeches presented in its

Sequencing Works of Art		
13-9 все	Ara Pacis Augustae	
с. 10-30 се	Gemma Augustea	
с. 40-60 се	Wall painting, House of M. Lucretius Fronto	
с. 62–79 се	Peristyle Garden, House of the Vetii, Pompeii	
c. 81 CE	Spoils from the Temple of Solomon, Jerusalem, from the Arch of Titus	
70-80 ce	Flavian Amphitheater (Colosseum)	

open square. For recreation, people went to the nearby baths or to events in the theater or amphitheater.

The people of Pompeii lived in houses behind or above rows of shops (FIG. 6–26). Even the gracious private residences with gardens often had street-level shops. If there was no shop, the wall facing the street was usually broken only by a door, for the Romans emphasized the interior rather than the exterior in their domestic architecture.

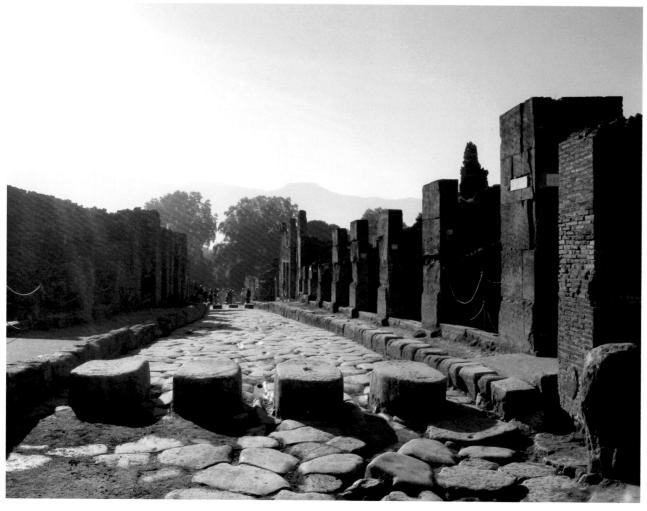

6-26 STREET IN POMPEII

6-27 PLAN OF THE VILLA OF THE MYSTERIES

Pompeii, early second century BCE.

- 1) entrance foyer, 2) peristyle,
- 3) atrium, 4) pool (water basin),
- 5) tablinium (office, official reception room), 6) room with paintings of mysteries, 7) terrace,
- 8) bedroom

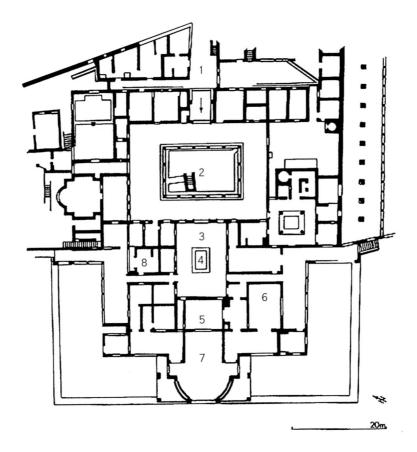

THE ROMAN HOUSE. A Roman house usually consisted of small rooms laid out around one or two open courts, the atrium and the peristyle (FIG. 6-27). The atrium was a large space with a pool or cistern for catching rainwater. The peristyle was a planted interior court enclosed by columns. The formal reception room or office was called the tablinum, and here the head of the household conferred with clients. Portrait busts of the family's ancestors might be displayed there or in the atrium. Rooms were arranged symmetrically. The private areas-such as the family sitting room and bedrooms and the service areas such as the kitchen and servants' quarters—usually were entered from the peristyle. In Pompeii, where the mild southern climate permitted gardens to flourish yearround, the peristyle was often turned into an outdoor living room with painted walls, fountains, and sculpture, as in the mid-first-century CE remodeling of the second-century BCE HOUSE OF THE VETTII (FIG. 6–28). The Villa (a country house) combined family living with facilities required by the farm.

THE URBAN GARDEN. The nature-loving Romans softened the regularity of their homes with beautifully designed and planted gardens. Fruit- and nut-bearing trees and occasionally olive trees were arranged in irregular rows. Some houses had both peristyle gardens and separate vegetable gardens. Only the great luxury villas had the formal landscaping and topiery work (fanciful clipped shrubbery) praised by ancient writers.

Little was known about these gardens until the archaeologist Wilhelmina Jashemski began the excavation of the peristyle in the House of G. Polybius in Pompeii in 1973. Earlier archaeologists had usually destroyed evidence of gardens, but Jashemski developed a new way to find and analyze the layout and the plants cultivated in them. Workers first removed layers of debris and volcanic material to expose the level of the soil as it was before the eruption in 79 CE. They then collected samples of pollen, seeds, and other organic material and carefully injected plaster into underground root cavities. When the surrounding earth was removed, the roots, now in plaster, enabled botanists to identify the types of plants and trees cultivated in the garden and to estimate their size.

The garden in the house of Polybius was surrounded on three sides by a portico, which protected a large cistern on one side that supplied the house and garden with water. Young lemon trees in pots lined the fourth side of the garden, and nail holes in the wall above the pots indicated that the trees had been espaliered—pruned and trained to grow flat against a support—a practice still in use today. Fig, cherry, and pear trees filled the garden space, and traces of a fruit-picking ladder, wide at the bottom and narrow at the top to fit among the branches, was found on the site. This evidence suggests that the garden was a densely planted orchard similar to the one painted on the dining-room walls of the villa of Empress Livia in Primaporta (SEE FIG. 6–31).

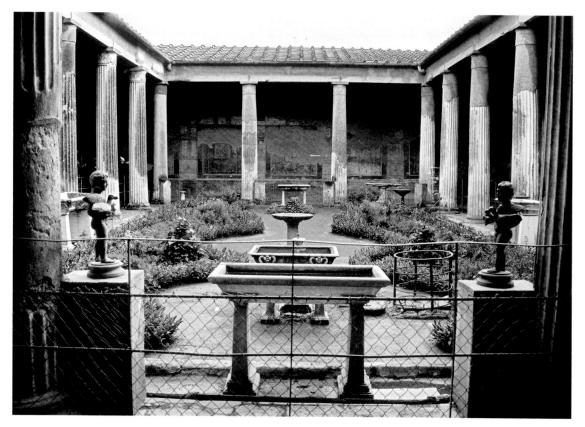

6–28 **PERISTYLE GARDEN, HOUSE OF THE VETTII** Pompeii. Rebuilt 62–79 CE.

An aqueduct built during the reign of Augustus eliminated Pompeii's dependence on wells and rainwater basins and allowed residents to add pools, fountains, and flowering plants that needed heavy watering to their gardens. In contrast to earlier, unordered plantings, formal gardens with low, clipped borders and plantings of ivy, ornamental boxwood, laurel, myrtle, acanthus, and rosemary-all mentioned by writers of the time-became fashionable. There is also evidence of topiary work, the clipping of shrubs and hedges into fanciful shapes. Sculpture and purely decorative fountains became popular. The peristyle garden of the House of the Vettii, for example, had more than a dozen fountain statues jetting water into marble basins (SEE FIG. 6-28). In the most elegant peristyles, mosaic decorations covered the floors, walls, and even the fountains. Some of the earliest wall mosaics, such as the one from a wall niche in a Pompeian garden, were created as backdrops for fountains (FIG. 6-29).

Wall Painting

The interior walls of Roman houses were plain, smooth plaster surfaces with few architectural features. On these invitingly empty spaces, artists painted decorations using pigment in a solution of lime and soap, sometimes with a little wax. After the painting was finished, they polished it with a special metal, glass, or stone burnisher and then buffed the surface with a cloth. Many fine wall paintings have come to light

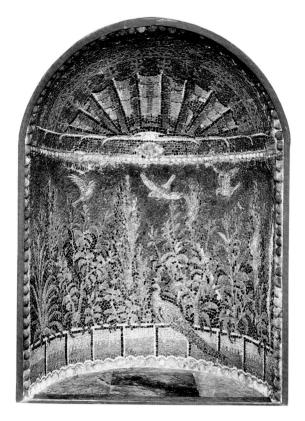

6–29 FOUNTAIN MOSAIC Wall niche, from a garden in Pompeii. Mid-1st century CE. Mosaic, $43\frac{1}{4} \times 31\frac{1}{2}$ " (111 \times 80 cm). Fitzwilliam Museum, University of Cambridge, England.

through excavations, first in Pompeii and other communities surrounding Mount Vesuvius, near Naples, and more recently in and around Rome.

In the earliest paintings (200–80 BCE), artists attempted to produce the illusion of thin slabs of colored marble covering the walls, which were set off by actual architectural moldings and columns. By about 80 BCE, they began to extend the space of a room visually with painted scenes of figures on a shallow "stage" or with a landscape or cityscape. Architectural details such as columns were painted rather than made of molded plaster.

ROMAN REALISM: CREATING AN ILLUSION OF THE WORLD. One of the most famous painted rooms in Roman art is in the socalled **VILLA OF THE MYSTERIES** just outside the city walls of Pompeii (FIG. 6–30; SEE PLAN IN FIG. 6–27). The rites of mystery religions were often performed in private homes as well as in special buildings or temples, and this room, at the corner of a suburban villa, must have been a shrine or meeting place for such a cult. The murals depict initiation rites—probably into the cult of Bacchus, who was the god of vegetation and fertility as well as wine. Bacchus (or Dionysus) was one of the most important deities in Pompeii.

The entirely painted architectural setting consists of a "marble" dado (the lower part of a wall) and, around the top of the wall, an elegant frieze supported by pilasters. The action takes place on a shallow "stage" along the top of the dado, with a background of brilliant, deep red—now known as Pompeian red. This red was very popular with Roman

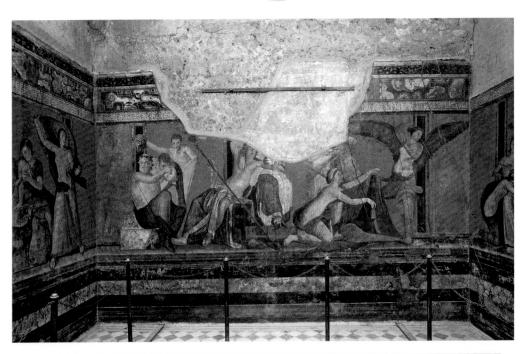

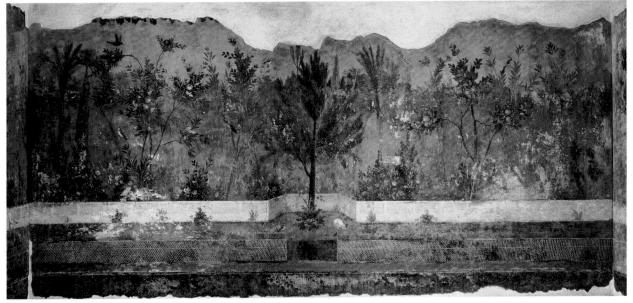

6–31 GARDEN SCENE

Detail of a wall painting from the dining room of the Villa of Livia at Primaporta, near Rome. Late 1st century BCE.

Museo Nazionale Romano, Rome.

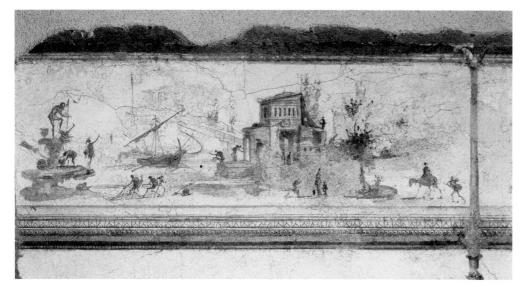

6-32 SEASCAPE AND COASTAL TOWNS
Detail of a wall painting from Villa Farnesina,
Rome. Late 1st century CE.

painters. The scene unfolds around the entire room, perhaps depicting a succession of events that culminate in the acceptance of an initiate into the cult.

The dining-room walls of Livia's Villa at Primaporta exemplify yet another approach to creating a sense of expanded space (FIG. 6–31). Instead of rendering a stage set, the artist "painted away" the wall surfaces to create the illusion of being on a porch or pavilion looking out over a low wall into an orchard of heavily laden fruit trees. These and the flowering shrubs are filled with a variety of wonderfully observed birds.

In such paintings, the overall effect is one of an idealized view of the world, rendered with free, fluid brushwork and delicate color. A painting from the Villa Farnesina, found in excavations in Rome (FIG. 6–32), depicts the *locus amoenus*, the "lovely place" extolled by Roman poets, where people lived effortlessly in union with the land. Here two conventions create the illusion of space: Distant objects are rendered proportionally smaller than near objects, and the colors become slightly grayer near the horizon, an effect called *atmospheric perspective*—that is, the tendency of distant objects to appear hazy and lighter in color.

ELEGANT FANTASIES: BOSCOREALE AND POMPEII. The walls of a room from a villa at Boscoreale near Pompeii (reconstructed in the Metropolitan Museum of Art in New York) open onto a fantastic urban panorama (FIG. 6–33). The wall

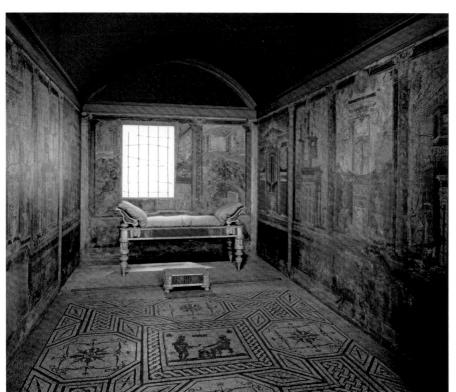

6–33 RECONSTRUCTED BEDROOM House of Publius Fannius Synistor, Boscoreale, near Pompeii. Late 1st century BCE, with later furnishings. The Metropolitan Museum of Art, New York.

Rogers Fund, 1903 (03.14.13)

Although the elements in the room are from a variety of places and dates, they give a sense of how the original furnished room might have looked. The wall paintings, original to the Boscoreale villa, may have been inspired by theater scene painting. The floor mosaic, found near Rome, dates to the second century CE. At its center is an image of a priest offering a basket with a snake to a cult image of Isis. The luxurious couch and footstool, inlaid with bone and glass, date from the first century CE.

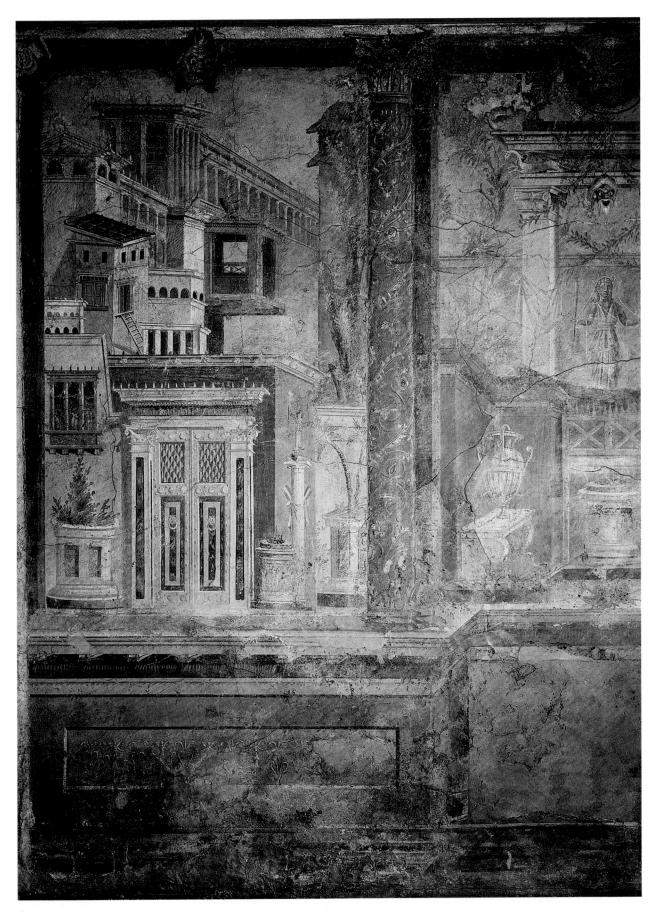

6–34 CITYSCAPE

Detail of a wall painting from a bedroom in the House of Publius Fannius Synistor, Boscoreale.

Late 1st century CE. The Metropolitan Museum of Art, New York.

Rogers Fund, 1903 (03.14.13)

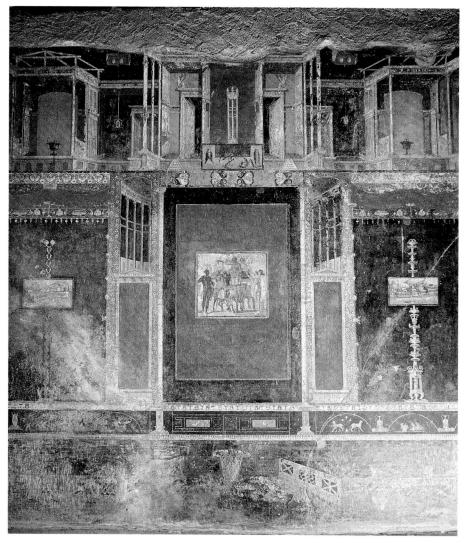

6–35 **DETAIL OF A WALL PAINTING IN THE HOUSE OF M. LUCRETIUS FRONTO** Pompeii. Mid-1st century CE.

surfaces seem to dissolve behind columns and lintels, which frame a maze of floating architectural forms creating purely visual effects, like the backdrops of a stage. Indeed, the theater may have inspired this kind of decoration, as details in the room suggest. For example, on the rear wall, next to the window, is a painting of a grotto, the traditional setting for satyr plays, dramatic interludes about the half-man, half-goat followers of Bacchus. On the side walls, paintings of theatrical masks hang from the lintels.

As one looks more closely, the architecture becomes a complex jumble of buildings with balconies, windows, arcades, and roofs at different levels, as well as a magnificent colonnade (FIG. 6–34). By using an intuitive perspective, the artist has created a general impression of real space. In intuitive perspective, the architectural details follow diagonal

lines that the eye interprets as parallel lines receding into the distance, and objects meant to be perceived as far away from the surface plane of the wall are shown slightly smaller than those intended to appear nearby. The orderly focus of a single point of view, however, is lacking.

As time passed, this painted architecture became increasingly fanciful. Solid-colored walls were decorated with slender, whimsical architectural and floral details and small, delicate vignettes. In the **HOUSE OF M. LUCRETIUS FRONTO** in Pompeii, from the mid-first century CE (FIG. 6–35), the artist painted a room with panels of black and red, bordered with architectural moldings. These architectural elements have no logic, and for all their playing with space, they fail to create any significant illusion of depth. Rectangular pictures seem to be mounted on the black and red panels.

Art and Its Context

THE POSITION OF ROMAN WOMEN

f we were to judge from the conflicting accounts of Roman writers, Roman women were either shockingly wicked and willful, totally preoccupied with clothes, hairstyles, and social events, or they were well-educated, talented, active members of family and society. In ancient Rome, as in the contemporary world, sin sold better than saintliness, and for that reason written attacks on women by their male contemporaries must be viewed with some reservation. Roman women were far freer and more engaged in society than their Greek counterparts (however, to judge from art, so were women in Egypt and Crete). Many women received a formal education, and a well-educated woman was admired. Although many women became physicians, shopkeepers, and even overseers in such male-dominated businesses as shipbuilding, education was valued primarily for the desirable status it imparted.

Ovid (43 BCE-17 CE) advised all young women to read both the Greek classics and contemporary Roman literature, including of course, his own. Women conversant with political and cultural affairs and with a reputation for good conversation enjoyed the praise and admiration of some male writers. A few women even took up literature themselves. Julia Balbilla was respected for her poetry. Another woman, Sulpicia, a writer of elegies, was accepted into male literary circles. Her works were recommended by the author Martial to men and women alike. The younger Agrippina, sister of the emperor Caligula and mother of Nero, wrote a history of her illustrious family.

Women were also encouraged to become accomplished singers, musicians, and even dancers—as long as they did not perform publicly. Almost nothing appears in literature about women in the visual arts, no doubt because visual artists were not highly regarded.

The scene with figures in the center is flanked by two small simulated window openings protected by grilles. The two pictures of villas in landscapes appear to float in front of intricate bronze easels.

ROMAN REALISM IN DETAILS: STILL LIFES AND PORTRAITS.

In addition to landscapes and city views, other subjects that appeared in Roman art included historical and mythological scenes, exquisitely rendered still lifes (compositions of inanimate objects), and portraits. A still-life panel from Herculaneum, a community in the vicinity of Mount Vesuvius near Pompeii, depicts everyday domestic objects—still-green peaches just picked from the tree and a glass jar half filled with water (FIG. 6–36). The items have been carefully arranged on two shelves to give the composition clarity and balance. A strong, clear light floods the picture from right to left, casting shadows, picking up highlights, and enhancing the illusion of real objects in real space.

Portraits, sometimes imaginary ones, also became popular. A first-century tondo (circular panel) from Pompeii contains the portrait YOUNG WOMAN WRITING (FIG. 6–37). The sitter has regular features and curly hair caught in a golden net. As in a modern studio portrait photograph, with its careful lighting and retouching, the young woman may be somewhat idealized. Following a popular convention, she nibbles on the tip of her stylus. Her sweet expression and clear-eyed but unfocused and contemplative gaze suggest that she is in the throes of composition.

The paintings in Pompeii reveal much about the lives of women during this period (see "The Position of Roman

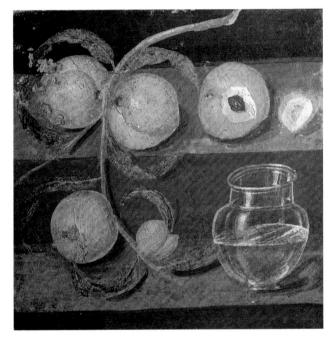

6–36 STILL LIFEDetail of a wall painting from House of the Stags (Cervi), Herculaneum. Before 79 CE. Approx. $1'2'' \times 1' \frac{1}{2}''$ (35.5 \times 31.7 cm). Museo Nazionale, Naples.

Women," above). Some, like Julia Felix, were the owners of houses where paintings were found. Others were the subjects of the paintings. They are shown as rich and poor, young and old, employed as business managers and domestic workers.

The Flavians

The Julio-Claudian dynasty ended with the suicide of Nero in 68 CE, to be replaced by the Flavians, practical military men who restored confidence and ruled for the rest of the first century. They restored the imperial finances and stabilized the frontiers, but during the autocratic reign of the last Flavian, Domitian, intrigue and terror returned to the capital.

THE ARCH OF TITUS. Among the most admirable official commissions during the Flavian dynasty is a distinctive Roman structure, the triumphal arch. Part architecture, part sculpture, the freestanding arch commemorates a triumph, or formal victory celebration, during which a victorious general or emperor paraded through the city with his troops, captives, and booty. When Domitian assumed the throne in 81 CE, for example, he immediately commissioned a triumphal arch to honor the capture of Jerusalem in 70 CE by his brother and deified predecessor, Titus (FIG. 6-38). THE ARCH OF TITUS, constructed of concrete and faced with marble, is essentially a freestanding gateway whose passage is covered by a barrel vault. The arch served as a giant base, 50 feet tall, for a statue of a four-horse chariot and driver, a typical triumphal symbol. Applied to the faces of the arch are columns in the Composite order supporting an entablature. The inscription on the attic story declares that the Senate and the Roman people erected the monument to honor Titus.

Titus's capture of Jerusalem ended a fierce campaign to crush a revolt of the Jews in Palestine. The Romans sacked and

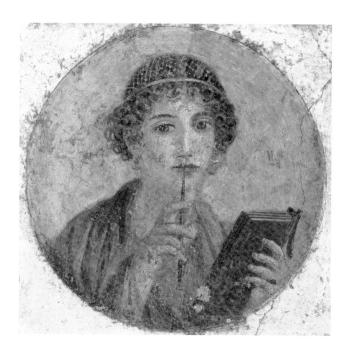

Sequencing Events REIGNS OF NOTABLE ROMAN EMPERORS

The Early Empire	27 BCE-96 CE ≠
Augustus good	27 все-14 се
The Julio-Claudians	14-69 CE
Tiberius good	14-37 се
Caligula	37-41 CE
Claudius	41-54 CE
Nero Laa	54-68 CE
The Flavians	69-96 CE
Vespasian Josef	69-79 CE
Titus	79-81 CE
Domitian	81-96 CE
The High Empire	96-192 CE ❖
Nerva	96-98 CE
Trajan g Mol	98-117 CE
Hadrian	117-138 се
The Antonines	138-192 CE
Antoninus Pius	138-161 CE
Marcus Aurelius	161-180 CE
Commodus OLAZU	180-192 CE
The Late Empire	192-476 CE ₩
Septimius Severus	193-211 CE
Caracalla bala	211-217 CE
Alexander Severus	222-235 CE
Diocletian	284-305 CE
The Tetrarchy (Rule of Four)	293-305/312 CE
Constantine I 900 A	312-337 се
Death of Romulus	
Augustus (last emperor in the West)	476 CE
in the vvest)	4/ 0 CE

6-37 YOUNG WOMAN WRITING

Detail of a wall painting, from Pompeii. Before 79 CE. Diameter 14%" (37 cm). Museo Archeològico Nazionale, Naples.

The fashionable young woman seems to be pondering what she will write about with her stylus on the beribboned writing tablet that she holds in her other hand. Romans used pointed styluses to engrave letters on thin, wax-coated ivory or wood tablets in much the way we might use a hand-held computer. Errors could be easily smoothed over. When a text or letter was considered ready, it was copied onto expensive papyrus or parchment. Tablets like these were also used by schoolchildren for their homework.

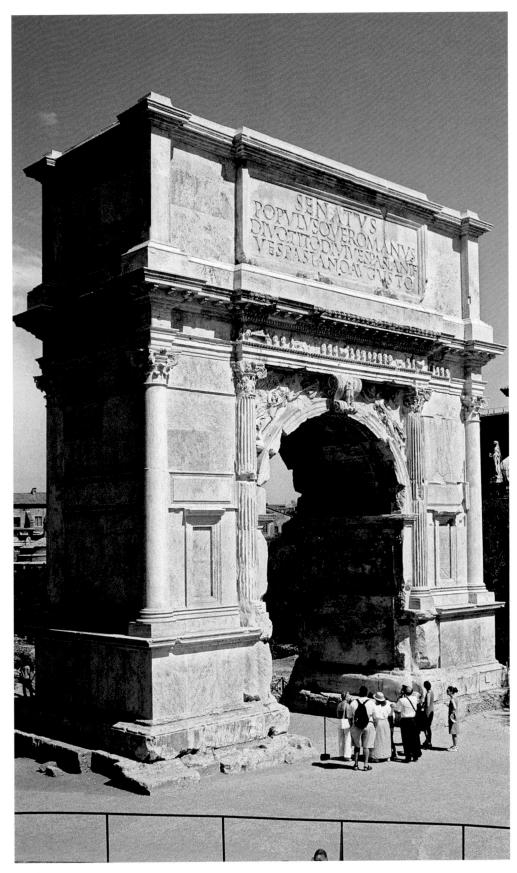

6--38 $\,$ THE ARCH OF TITUS Rome. c. 81 CE (Restored 1822-24). Concrete and white marble, height 50' (15 m).

The dedication inscribed across the tall attic story above the arch opening reads: "The Senate and the Roman People to the Deified Titus Vespasian Augustus, son of the Deified Vespasian." The perfectly sized and spaced Roman capital letters meant to be read from a distance and cut with sharp terminals (serifs) to catch the light established a standard that calligraphers and alphabet designers still follow.

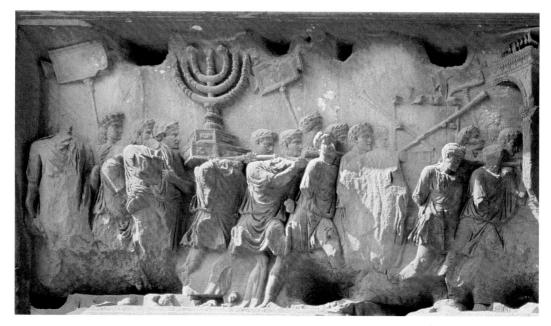

6–39 **SPOILS FROM THE TEMPLE OF SOLOMON**Relief in the passageway of the Arch of Titus. Marble, height 6'8" (2.03 m).

destroyed the Second Temple in Jerusalem, carried off its sacred treasures (FIG. 6–39), then displayed them in a triumphal procession in Rome (FIG. 6–40). The reliefs on the inside walls of the arch, capturing the drama of the occasion, depict Titus's soldiers flaunting this booty as they carry it through the streets of Rome. The viewer can sense the press of that boisterous, disorderly crowd and might expect at any moment to hear soldiers and onlookers shouting and chanting.

The mood of the procession depicted in these reliefs contrasts with the relaxed but formal solemnity of the procession portrayed on the Ara Pacis (SEE FIG. 6–21). Like the sculptors of the Ara Pacis, the sculptors of the Arch of Titus

showed the spatial relationships among figures, varying the height of the relief by rendering nearer elements in higher relief than those more distant. A menorah, or seven-branched lampholder from the Temple of Jerusalem, dominates one scene; Titus riding in his chariot as a participant in the ceremonies, the other. Reflecting their concern for representing objects as well as people in a believable manner, the sculptors rendered this menorah as if seen from the low point of view of a spectator at the event, and they have positioned the arch on the right through which the procession is about to pass on a diagonal. On the vaulted ceiling, an eagle carries Titus skyward to join the gods.

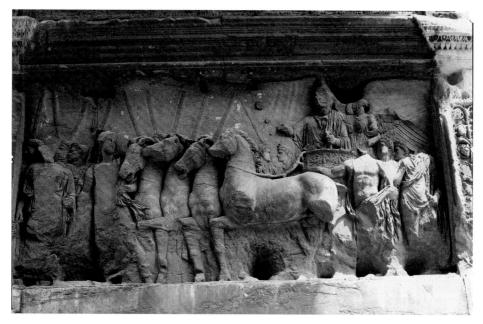

6–40 **TRIUMPHAL PROCESSION, TITUS IN CHARIOT**Relief in the passageway of the Arch of Titus. Marble, height 6'8" (2.03 m).

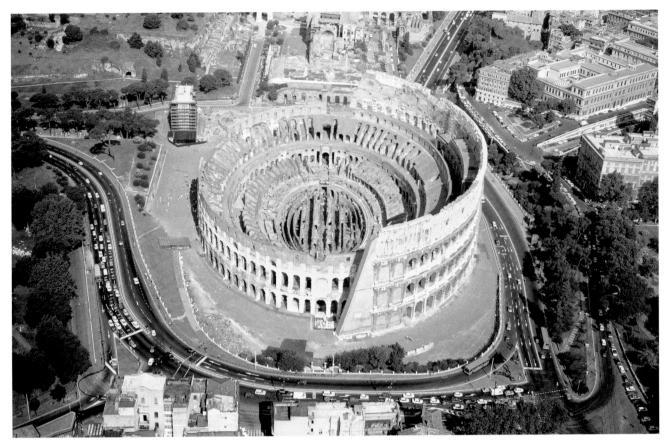

6-41 FLAVIAN AMPHITHEATER (COLOSSEUM) From the air. Rome. 70–80 CE.

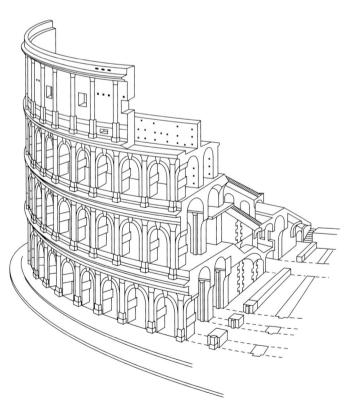

6–42 **FLAVIAN AMPHITHEATER** Drawing showing vaulted construction.

THE FLAVIAN AMPHITHEATER. In a way, Romans were as sports-mad as modern Americans, and the Flavian emperors catered to their tastes by building splendid facilities. Construction of the FLAVIAN AMPHITHEATER, Rome's greatest arena (FIG. 6-41), began under Vespasian in 70 CE and was completed under Titus, who dedicated it in 80 CE. The Flavian Amphitheater came to be known as the "Colosseum," because a gigantic statue of Nero called the Colossus stood next to it. But "Colosseum" is a most appropriate description of this enormous entertainment center. It is an oval, measuring 615 by 510 feet, with a floor 280 by 175 feet. Its outer wall stands 159 feet high. Roman audiences watched a variety of athletic events and spectacles, including animal hunts, fights to the death between gladiators or between gladiators and wild animals, performances of trained animals and acrobats, and even mock sea battles, for which the arena would be flooded. The opening performances in 80 CE lasted 100 days, during which time it was claimed that 9,000 wild animals and 2,000 gladiators died for the amusement of the spectators.

The floor of the Colosseum was laid over a foundation of service rooms and tunnels that provided an area for the athletes, performers, animals, and equipment. This floor was covered by sand, *arena* in Latin, hence the English term

"arena" for a building of this type. Some 50,000 spectators could move easily through the seventy-six entrance doors to the three levels of seats and the standing area at the top. Each had an uninterrupted view of the spectacle below. Stadiums today are still based on this efficient plan.

The Romans took the form of the Greek theater and enlarged upon it (see Chapter 5, page 159). They constructed freestanding amphitheaters by placing two theaters facing each other to create a central oval-shaped performance area. The amphitheater is a remarkable piece of planning with easy access, perfect sight lines for everyone, and effective crowd control. Ascending tiers of seats were laid over barrel-vaulted access corridors and entrance tunnels that connect the rings of corridors to the ramps and seats on each level (FIG. 6-42). The intersection of the barrel-vaulted entrance tunnels and the ring corridors created groin vaults (see "Arch, Vault, and Dome," page 172). The walls on the top level of the arena supported a huge awning that could shade the seating areas. Sailors who had experience in handling ropes, pulleys, and large expanses of canvas worked the apparatus that extended the awning.

The curving, outer wall of the Colosseum consists of three levels of arcades surmounted by a wall-like attic (top) story. Each arch in the arcades is framed by engaged columns. Entablature-like friezes mark the divisions between levels (FIG. 6–43). Each level also uses a different architectural order, increasing in complexity from bottom to top: the plain Tuscan order on the ground level, Ionic on the second level, Corinthian on the third, and Corinthian pilasters on the fourth. The attic story is broken by small, square windows, which originally alternated with gilded bronze shield-shaped ornaments called cartouches, supported on brackets that are still in place and can be seen in the illustration. Engaged Corinthian pilasters above the Corinthian columns of the third level support another row of corbels beneath the projecting cornice.

All these elements are purely decorative. As we saw in the Etruscan Porta Augusta (SEE FIG. 6–2), the addition of post-and-lintel decoration to arched structures was an Etruscan innovation. The systematic use of the orders in a logical succession from sturdy Tuscan to lighter Ionic to decorative Corinthian follows a tradition inherited from

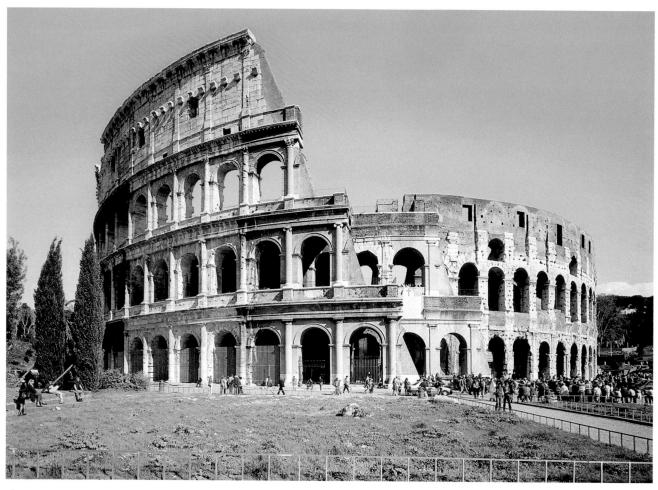

6–43 FLAVIAN AMPHITHEATER, OUTER WALL Rome. 70–80 ce.

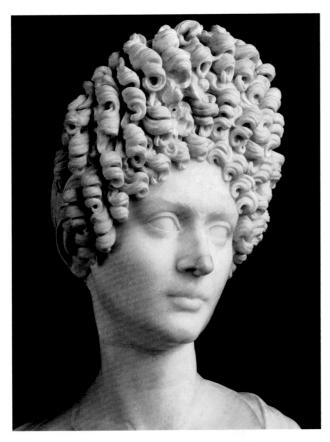

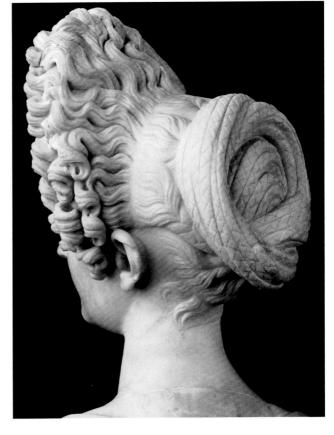

6–44 A YOUNG FLAVIAN WOMAN c. 90 CE. Marble, height 25" (65.5 cm). Museo Capitolino, Rome.

Hellenistic architecture. This orderly, dignified, and visually satisfying way of organizing the façades of large buildings is still popular. Unfortunately, much of the Colosseum was dismantled in the Middle Ages as a source of marble, metal fittings, and materials for buildings such as churches.

PORTRAIT SCULPTURE. Roman patrons continued to demand likenesses in their portraits, but the portrait, A YOUNG FLAVIAN WOMAN (FIG. 6-44), exemplifies the current Roman ideal. Her well-observed, recognizable features—a strong nose and jaw, heavy brows, deep-set eyes, and a long neck—contrast with the smoothly rendered flesh and soft, full lips. (The portrait suggests the retouched fashion photos of today.) Her hair is piled high in an extraordinary mass of ringlets in the latest court fashion. Executing the head required skillful chiseling and drillwork, a technique for rapidly cutting deep grooves with straight sides, as was done here to render the holes in the center of the curls. The overall effect, from a distance, seems very lifelike. The play of natural light over the more subtly sculpted surfaces gives the illusion of being reflected off real skin and hair, yet closer inspection reveals a portrayal too perfect to be real.

A bust of an older woman (FIG. 6–45), reflects a revival of the veristic portraiture popular in the Republican period. The subject of this portrait, though she too wore her hair in the latest style, was apparently not preoccupied with her appearance. The work she commissioned shows her just as she appeared in her own mirror, with all the signs of age recorded on her face.

THE HIGH IMPERIAL ART OF TRAJAN AND HADRIAN

Domitian was assassinated in 96 CE and succeeded by a senator, Nerva (96–98), who designated as his successor Trajan, a general born in Spain and commander of troops in Germany. For nearly a century, the empire was under the control of brilliant administrators. Instead of depending on the vagaries of fate (or genetics) to produce intelligent heirs, the emperors Nerva (96–98), Trajan (98–117), Hadrian (117–138), and Antoninus Pius (138–161) (but not Marcus Aurelius [161–180]) each selected an able administrator to follow him and each thereby "adopted" his successor. Italy and the provinces flourished, and official and private patronage of the arts increased.

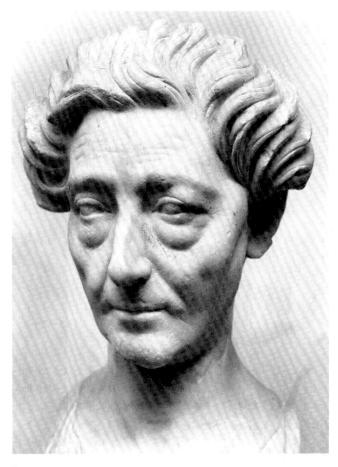

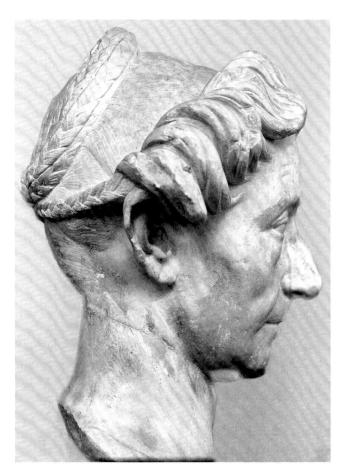

6–45 MIDDLE-AGED FLAVIAN WOMAN Late 1st century CE. Marble, height 9½" (24.1 cm). Musei Vaticani, Museo Gregoriano Profano, ex-Lateranese, Rome.

Under Trajan, the empire reached its greatest extent. By 106 CE Romans had conquered Dacia, roughly present-day Romania (SEE MAP 6–1). The next emperor, Hadrian, then consolidated the empire's borders and imposed far-reaching social, governmental, and military reforms. Hadrian was well educated and widely traveled, and his admiration for Greek culture spurred new building programs and art patronage throughout the empire. Unfortunately, Marcus Aurelius broke the tradition of adoption and left his son, Commodus, to inherit the throne. Within twelve years, Commodus (180–192) destroyed the government his predecessors had so carefully built.

Imperial Architecture

The Romans believed their rule extended to the ends of the Western world, but the city of Rome remained the nerve center of the empire. During his long and peaceful reign, Augustus had paved the city's old Republican Forum, restored its temples and basilicas, and followed Julius Caesar's example by building an Imperial Forum. These projects marked the beginning of a continuing effort to transform the capital itself into a magnificent monument to imperial rule. While Augustus's claim of having turned Rome into a city of marble is

exaggerated (like most politicians he was speaking metaphorically, not literally), he certainly began the process of creating a monumental civic center. Such grand structures as the Imperial Forums, the Colosseum, the Circus Maximus (a track for chariot races), the Pantheon, and aqueducts stood amid the temples, baths, warehouses, and homes in the city center.

The Forum of Trajan. A model of Rome's city center makes apparent the dense building plan (FIG. 6–46). The last and largest Imperial Forum was built by Trajan about 107–113 and finished under Hadrian about 117 CE on a large piece of property next to the earlier forums of Augustus and Julius Caesar (FIG. 6–47). For this major undertaking, Trajan chose a Greek architect, Apollodorus of Damascus, a military engineer. A straight, central axis leads from the Forum of Augustus through a triple-arched gate, surmounted by a bronze chariot group, into a large, colonnaded square with a statue of Trajan on horseback at its center. Closing off the courtyard at the north end was the Basilica Ulpia, dedicated in c. 112 CE, and named for the family to which Trajan belonged.

A basilica was a large, rectangular building with a rounded extension, called an apse, at each end. A general-purpose administrative structure, it could be adapted to

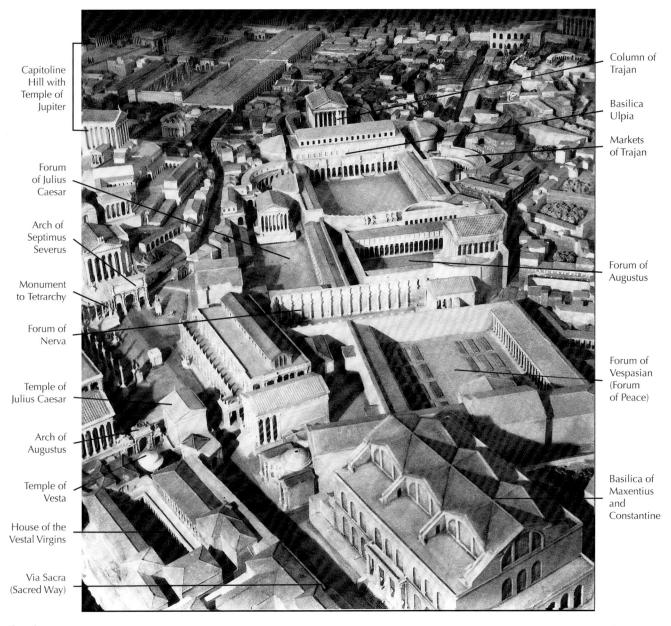

6--46 $\,$ model of the forum romanum and imperial forums Rome. c. 325 ce.

many uses. The Basilica Ulpia was a court of law, but other basilicas served as imperial audience chambers, army drill halls, and schools. The basilica design provided a large interior space whose many doors on the long sides provided easy access (FIG. 6–48). The Basilica Ulpia was 385 feet long (not including the apses) and 182 feet wide. The interior space consisted of a large central area (the nave) flanked by double colonnaded aisles surmounted by open galleries or by a clerestory, an upper nave wall with windows. The cen-

tral space was taller than the surrounding galleries and was lit directly by an open gallery or clerestory windows. The timber truss roof had a span of about 80 feet. The two apses, one at each end of the building, provided imposing settings for judges when the court was in session.

During the site preparation for the forum, part of a commercial district had to be razed and excavated. To make up for the loss, Trajan ordered the construction of a handsome public market (FIG. 6–49). The market, comparable in size to a large

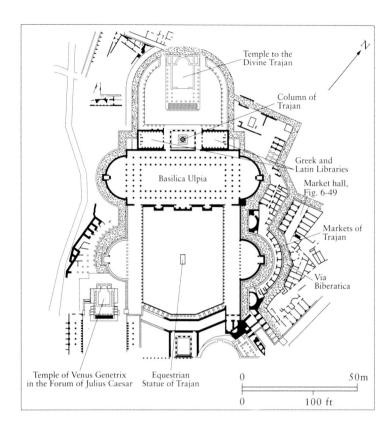

6–47 **PLAN OF TRAJAN'S FORUM** c. 110–113 CE.

6--48 $\,$ restored perspective view of the central hall

Basilica Ulpia, Rome. c. 112 CE. Drawn by Gilbert Gorski. Trajan's architect was Apollodorus of Damascus.

The building may have had clerestory windows instead of the gallery shown in this drawing. The column of Trajan can be seen at the right.

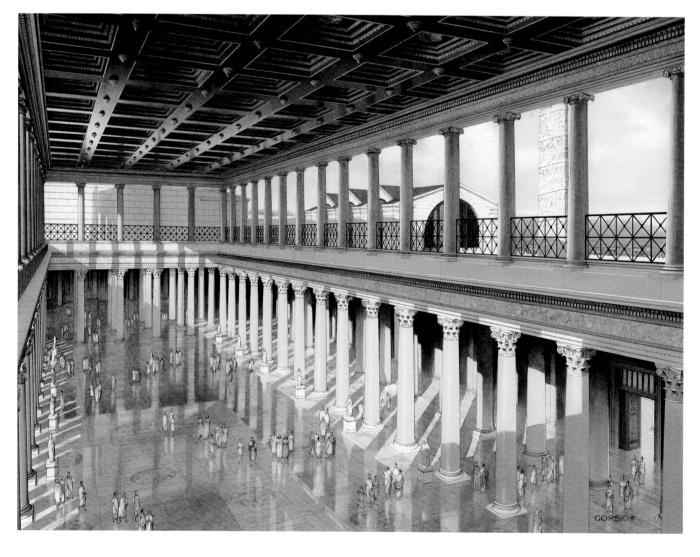

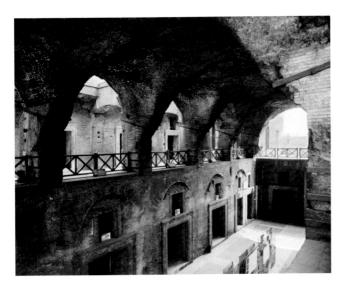

6–49 MAIN HALL, MARKETS OF TRAJAN Rome. 100–12 CE.

modern shopping mall, had more than 150 individual shops on several levels and included a large groin-vaulted main hall. In compliance with a building code that was put into effect after a disastrous fire in 64 CE, the market, like all Roman buildings of the time, had masonry construction—brick-faced concrete, with only some detailing in stone and wood.

Behind the Basilica Ulpia stood twin libraries built to house the emperor's collections of Latin and Greek manuscripts. These buildings flanked an open court and the great spiral column that became Trajan's tomb (Hadrian placed his predecessor's ashes in the base). The column commemorated Trajan's victory over the Dacians and was erected either with the Basilica Ulpia about 113 CE or by Hadrian after Trajan's death in 117 CE. The Temple of the Divine Trajan stands opposite the Basilica Ulpia, forming the fourth side of the court and closing off the end of the forum. Hadrian ordered the temple built after Trajan's death.

THE COLUMN OF TRAJAN. The relief decoration on the COLUMN OF TRAJAN spirals upward in a band that would stretch almost 625 feet if unfurled. Like a giant version of the scrolls housed in the libraries next to it, the column is a continuous pictorial narrative of the Dacian campaigns of 102–103 and 105–106 CE (FIG. 6–50). The remarkable sculpture includes more than 2,500 individual figures linked by landscape, architecture, and the recurring figure of Trajan. The artist took care to make the scroll legible. The narrative band slowly expands from about 3 feet in height at the bottom, near the viewer, to 4 feet at the top of the column, where it is farther from view.

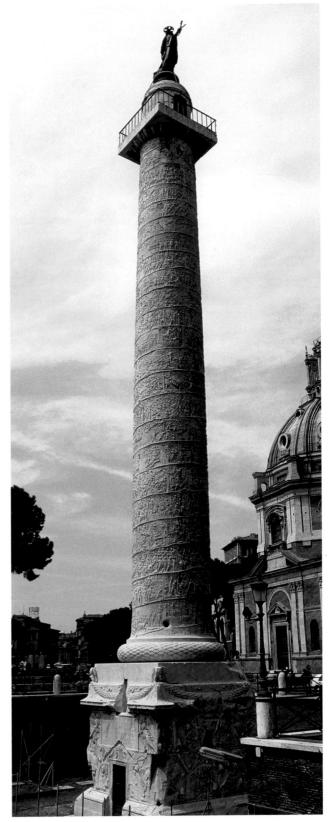

6–50 **COLUMN OF TRAJAN**Rome. 113–16 or after 117 CE. Marble, overall height with base 125' (38 m), column alone 97'8" (29.77 m); relief 625' (190.5 m) long.

The height of the column, 100 Roman feet (97'8", 30 m) may have recorded the depth of the excavation required to build the Forum of Trajan. The column had been topped by a gilded bronze statue of Trajan that was replaced in 1588 CE by order of Pope Sixtus V with the statue of Saint Peter seen today. Trajan's ashes were interred in the base in a golden urn.

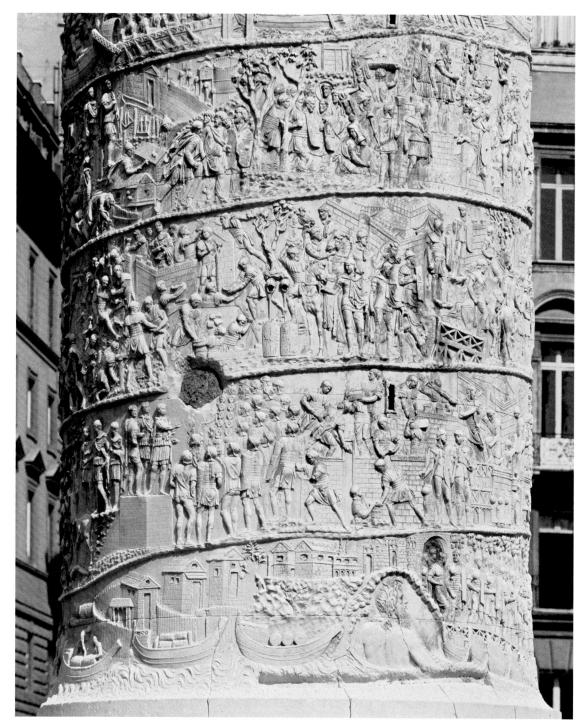

6–51 ROMANS CROSSING THE DANUBE AND BUILDING A FORT

Detail of the lowest part of the Column of Trajan. 113–16 CE, or after 117. Marble, height of the spiral band approx. 36" (91 cm).

The natural and architectural elements in the scenes have been kept small to emphasize the important figures.

On the Column of Trajan, sculptors refined the art of pictorial narrative seen on the Arch of Titus (SEE FIGS. 6–39, 6–40). The scene at the beginning of the spiral, at the bottom of the column, shows Trajan's army crossing the Danube River on a pontoon bridge as the first Dacian campaign of

101 gets under way (FIG. 6–51). Soldiers construct a battle-field headquarters in Dacia from which the men on the frontiers will receive orders, food, and weapons. In this spectacular piece of imperial propaganda, Trajan is portrayed as a strong, stable, and efficient commander of a well-run army, and his barbarian enemies are shown as worthy opponents of Rome.

6–52 **PANTHEON** Rome c. 118–128 CE.

The approach to the Pantheon is very different today. A huge fountain dominates the square in front of the building. Built in 1578 by Giacomo della Porta, today it supports an Egyptian obelisk placed there in 1711 by Pope Clement XI.

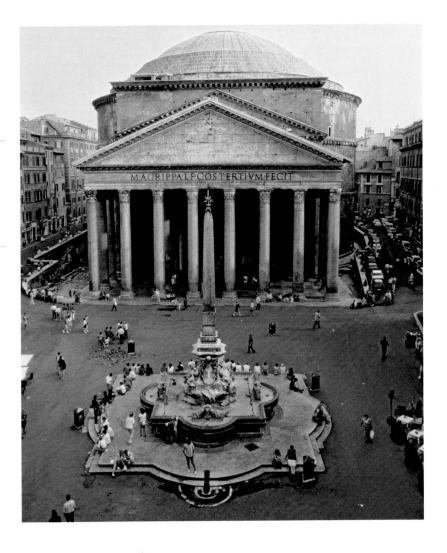

THE PANTHEON. Perhaps the most remarkable ancient building surviving in Rome—and one of the marvels of architecture in any age—is a temple to the Olympian gods called the PANTHEON (literally, "all the gods") (FIG. 6-52). Originally the Pantheon stood on a podium and was approached by stairs from a colonnaded square. (The difference in height of the street levels of ancient and modern Rome can be seen at the left side of the photograph.) Although this magnificent monument was designed and constructed entirely during the reign of the emperor Hadrian, the long inscription on the architrave states that it was built by "Marcus Agrippa, son of Lucius, who was consul three times." Agrippa, the son-in-law and valued adviser of Augustus, was responsible for building on this site in 27-25 BCE. After a fire in 80 CE, Domitian built a new temple, which Hadrian then replaced in 118-128 CE with the Pantheon.

Hadrian, who must have had a strong sense of history, placed Agrippa's name on the façade in a grand gesture to the memory of the illustrious consul, rather than using the new building to memorialize himself. Septimius Severus (see page 218) restored the Pantheon in 202 CE.

The approach to the temple gives little suggestion of its original appearance. Centuries of dirt and street construction

hide its podium and stairs. Attachment holes in the pediment indicate the placement of sculpture, perhaps an eagle within a wreath, the imperial Jupiter. Nor is there any hint of what lies beyond the entrance porch, which resembles the façade of a typical Roman temple. Behind this porch is a giant rotunda with 20-foot-thick walls that rise nearly 75 feet. The walls support a bowl-shaped dome that is 143 feet in diameter and 143 feet from the floor at its summit (FIG. 6-53). Standing at the center of this hemispherical temple (FIG. 6-54), the visitor feels isolated from the outside world and intensely aware of the shape and tangibility of the space itself. The eye is drawn upward over the circular patterns made by the sunken panels, or coffers, in the dome's ceiling to the light entering the 29-foot-wide oculus, or central opening. The sun pours through this opening on clear days; rain falls on wet ones, then drains off as planned by the original engineer; and the occasional bird flies in. The empty, luminous space gives the feeling that one could rise buoyantly upward and escape the spherical hollow of the building to commune with the gods.

The simple shape of the Pantheon's dome belies its sophisticated design and engineering (FIG. 6–55). Marble veneer disguises the internal brick arches and concrete structure. The interior walls, which form the drum that both

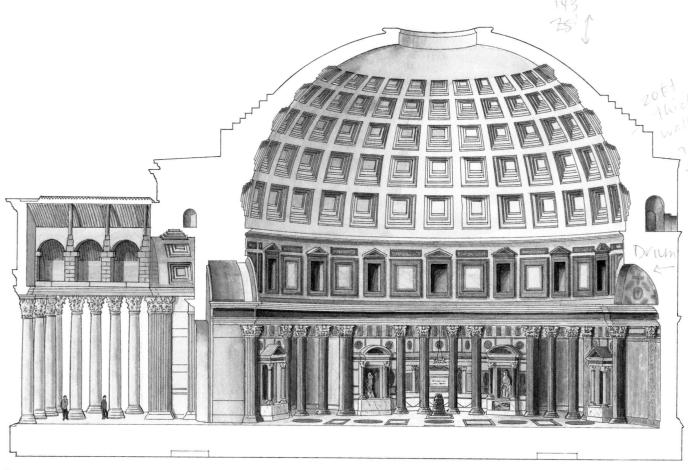

6-53 reconstruction drawing of the pantheon

Ammianus Marcellinus described the Pantheon in 357 CE as being "rounded like the boundary of the horizon, and vaulted with a beautiful loftiness." Although the Pantheon has inspired hundreds—perhaps thousands—of faithful copies, inventive variants, and eclectic borrowings over the centuries, only recently have the true complexity and the innovative engineering of its construction been fully understood.

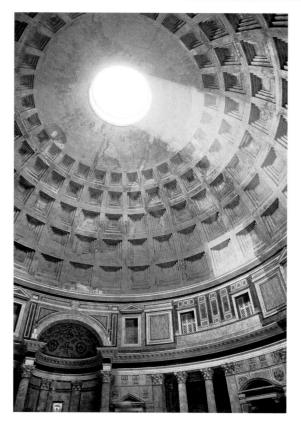

6-54 dome of the pantheon

With light from the oculus on its coffered ceiling. 125–128 CE. Brick, concrete, marble, veneer, diameter of dome 143′ (43.5 m).

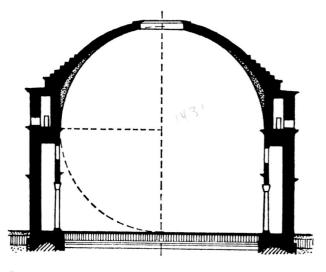

6-55 CIRCLE SECTION OF THE PANTHEON

supports and buttresses the dome, are disguised by two tiers of architectural detail and richly colored marble. More than half of the original decoration—a wealth of columns, pilasters, and entablatures—survives. The wall is punctuated by seven exedrae (niches)—rectangular alternating with semicircular—that originally held statues of gods. This simple repetition of square against circle is found throughout the building. The square, boxlike coffers inside the dome, which help lighten the weight of the masonry, may once have contained gilded bronze rosettes or stars suggesting the heavens. In 609 CE, Pope Boniface IV dedicated the Pantheon as the Christian church of Saint Mary of the Martyrs, thus ensuring its survival through the Middle ages.

HADRIAN'S VILLA AT TIVOLI. To imagine Roman life at its most luxurious, one must go to Tivoli, a little more than 20 miles from Rome. Hadrian's Villa was not a single building but an architectural complex of many buildings, lakes, and gardens spread over half a square mile. Each section had its own inner logic, and each took advantage of natural land formations and attractive views. Hadrian instructed his architects to re-create his favorite places throughout the empire. In his splendid villa, he could pretend to enjoy the Athenian Grove of Academe, the Painted Stoa from the Athenian Agora, and buildings of the Ptolemaic capital of Alexandria, Egypt.

Landscapes with pools, fountains, and gardens turned the villa into a place of sensuous delight. An area with a long reflecting pool, called the **CANOPUS** after a site near Alexandria, was framed by a colonnade with alternating semicircular and straight entablatures (FIG. 6–56). It led to an outdoor dining room with concrete couches facing the pool. Copies of famous Greek statues, and sometimes even the originals, filled the spaces between the columns. So great was Hadrian's

love of Greek sculpture that he even had the caryatids of the Erechtheion (SEE FIG. 5–40) replicated for his pleasure palace.

The individual buildings were not large, but they were extremely complex. Roman builders and engineers exploited to the fullest the flexibility offered by concrete and vaulted construction. Walls and floors had veneers of marble and travertine or exquisite mosaics and paintings.

ARCHITECTURE THROUGHOUT THE EMPIRE. Hadrian traveled widely, since the emperor's appearance in distant lands reinforced his authority there. Hadrian also seemed to be genuinely interested in people and places. The emperor did more than copy his favorite cities at his villa; he also added to them. In Athens, for example, he finished the Temple of the Olympian Zeus and dedicated it in 131/132 CE (SEE FIG. 5–59). He also built a library, a stoa, and an aqueduct for the Athenians, and according to Pausanias, placed a statue of himself inside the Parthenon.

At the other end of the empire he engaged in the construction of functional architecture. During a visit to Britain in 122 CE as part of a review of the western provinces, Hadrian ordered the building of a defensive wall (FIG. 6–57) across the northernmost boundary of the empire.

Hadrian's Wall was built of stone and turf by legionaries and garrisoned by as many as 24,000 auxiliaries from conquered territories. Forts, and fortified towers at mile intervals, were built along its 73-mile length. It was defended by natural sharp drop-offs in the terrain and by a ditch on the north side and a wide open space that allowed easy movement of the troops on the south. Seventeen large camps housed forces ready to respond to any trouble. The wall created a symbolic as well as a physical boundary between Roman territory and that of the "barbarian" Picts and Scots to the north.

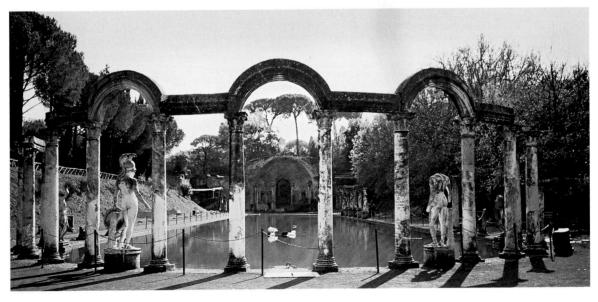

6–56 CANOPUS, HADRIAN'S VILLA Tivoli. c. 130–35 ce.

6-57 HADRIAN'S WALL Great Britain. 2nd century CE. View from near Housesteads, England.

Mosaics

Pictorial mosaics covered the floors of fine houses, villas, and public buildings throughout the empire. Working with very small *tesserae* (cubes of glass or stone) and a wide range of colors, mosaicists achieved remarkable effects (see "Roman Mosaics," page 215). The panels from a floor mosaic from

Hadrian's Villa at Tivoli illustrate extraordinary artistry (FIG. 6–58). In a rocky landscape with only a few bits of greenery, a desperate male centaur raises a large boulder over his head to crush a tiger that has attacked and severely wounded a female centaur. Two other felines apparently took part in the attack—the white leopard on the rocks to the left

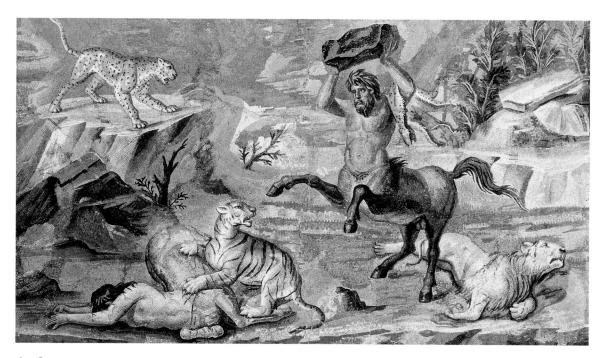

6–58 BATTLE OF CENTAURS AND WILD BEASTS Hadrian's Villa, Tivoli. c. 118–28 CE. Mosaic, $23\times36''$ (58.4×91.4 cm). Staatliche Museen zu Berlin, Preussischer Kulturbesitz, Antikensammlung, Berlin.

This floor mosaic may be a copy of a much-admired painting of a fight between centaurs and wild animals done by the late fifth-century BCE Greek artist Zeuxis.

THE OBJECT SPEAKS

THE UNSWEPT FLOOR

n his first-century CE work Satyricon, the comic genius and satirist Petronius created one of the all-time wild dinner parties. In Trimalchio's Feast (Cena Trimalchionis, Book 15), the newly rich Trimalchio entertains his friends at a lavish banquet. He shows off his extraordinary wealth, but also exposes his boorish ignorance and bad manners. Unlike the Greeks, whose banquets were private affairs, Romans such as Trimalchio used such occasions to display their possessions. When dishes are broken, Trimalchio orders his servants to sweep them away with the rubbish on the floor.

In The Unswept Floor mosaic, the remains of fine food from a party such as Trimalchio's—from lobster claws to cherry pits—seem to litter the floor. In the dining room where this segment was found, mosaics cover almost the entire floor.

Because Romans arranged their dining rooms with three-person couches on three sides of a square table, the family and guests would have seen these fictive remains of past gourmet pleasures under their couches. Such a festive Roman dinner might have had as many as seven courses, including a whole roasted pig (or ostrich, crane, or peacock), veal, and several kinds of fish; the final course may have been snails, nuts, shellfish, and fruit.

If art speaks to and of the ideals of a society, what does it mean that wealthy Romans commemorated their table scraps in mosaics of the greatest subtlety and skill? Is this a form of conspicuous consumption, proof that the owner of this house gave lavish banquets and hosted guests who had the kind of sophisticated humor that could appreciate satires like *Trimalchio's Feast*?

The Romans did in fact place a high value on displaying their wealth and taste in the semipublic rooms and gardens of their houses and villas, and they did so through their possessions, especially their art collections. The Unswept Floor is but one of a very large number of Roman copies of Greek mosaics and paintings, such as Alexander the Great Confronts Darius III (SEE FIG. 5–57).

In the case of *The Unswept Floor*, Herakleitos, a second-century CE Greek mosaicist living in Rome, made this copy of an original work by the renowned second-century BCE artist Sosos. Pliny the Elder, in his *Natural History*, mentions a mosaic of an unswept floor and another of doves that Sosos made in Pergamon. The guests reclining on their banquet couches could have displayed their knowledge of the notable precedents for the mosaic on the floor.

THE UNSWEPT FLOOR Mosaic variant of a 2nd-century BCE painting by Sosos of Pergamon. 2nd century CE. Signed by Herakleitos. Musei Vaticani, Museo Gregoriano Profano, Rome.

Technique

ROMAN MOSAICS

osaics were used widely in Hellenistic times and became enormously popular for decorating homes in the Roman period. **Mosaic** designs were created with pebbles (see Fig. 5-58), or with small, regularly shaped pieces of colored stone and marble, called **tesserae**. The stones were pressed into a kind of soft cement called *grout*. When the stones were firmly set, the spaces between them were also filled with grout. After the surface dried, it was cleaned and polished. At first, mosaics were used mainly as durable, water-resistant coverings on floors. They were done in a narrow range of colors depending on the natural color of the stone—often earth tones or black or some other dark color on a light background. When

mosaics began to be used on walls (see Fig. 6-29), a wide range of colors—and sometimes colored glass—was employed. Some skilled mosaicists even copied well-known paintings. Employing a technique in which very small tesserae, in a wide range of colors, were laid down in irregular, curving lines, they effectively imitated painted brushstrokes.

Mosaic production was made more efficient by the use of **emblemata** (the plural of *emblema*, "central design"). These small, intricate mosaic compositions were created in the artist's workshop in square or rectangular trays. They could be made in advance, carried to a work site, and inserted into a floor decorated with an easily produced geometric pattern.

and the dead lion at the feet of the male centaur. The mosaicist rendered the figures with three-dimensional shading, fore-shortening, and a great sensitivity to a range of figure types, including human torsos and powerful animals in a variety of poses.

Artists created these fine mosaic image panels, called emblemata, in their workshops. The emblemata were then set into a larger area already bordered by geometric patterns in mosaic. The mosaic floor in the reconstructed room in the Metropolitan Museum of Art in New York (SEE FIG. 6–33) shows a typical floor with a small image panel and many abstract designs in black and white. Image panels in floors

usually reflected the purpose of the room. A dining room, for example, might have an Unswept Floor (see "The Unswept Floor," page 214), with table scraps re-created in meticulous detail, even to the shadows they cast, and a mouse foraging among them.

Sculpture

Hadrian also used monumental sculpture to publicize his accomplishments. Several large, circular reliefs, or **roundels** (originally part of a monument that no longer exists and now reused in the Arch of Constantine) contain images designed to affirm his imperial stature and right to rule (FIG. 6–59). In the

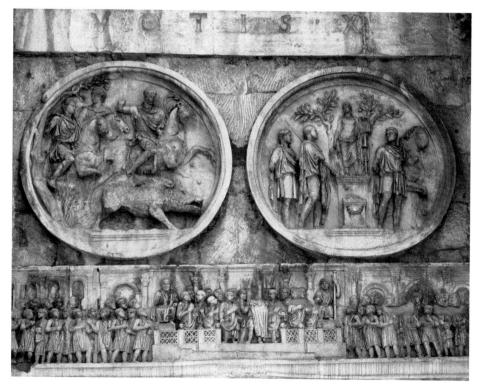

6-59 HADRIAN HUNTING BOAR AND SACRIFICING TO APOLLO

Roundels made for a monument to Hadrian and reused on the Arch of Constantine. Sculpture c. 130–38 CE. Marble, roundel diameter 40" (102 cm). Horizontal panel by Constantinian sculptors 312–315 CE.

In the fourth century CE, Emperor Constantine had the roundels removed from a Hadrianic monument, had Hadrian's head recarved with his own or his father's features, and placed them on his own triumphal arch (SEE FIG. 6-74).

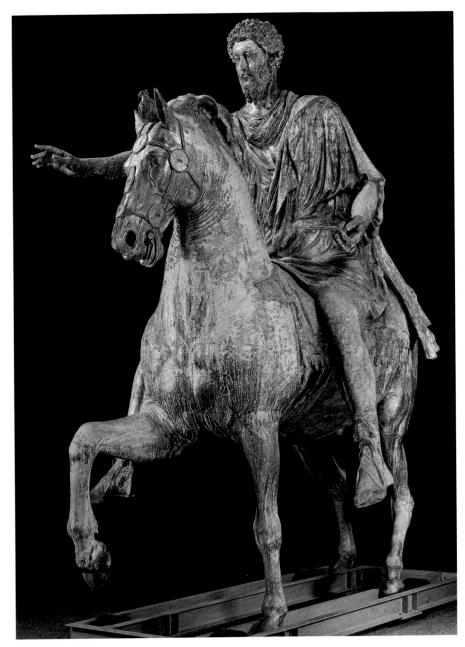

6–60 EQUESTRIAN STATUE OF MARCUS AURELIUS c. 176 CE. Bronze, originally gilded, height of statue 11′6″ (3.5 m). Museo Capitolino, Rome.

Between 1187 and 1538, this statue stood in the piazza fronting the palace and church of Saint John Lateran in Rome. In January 1538, Pope Paul III had it moved to the Capitoline Hill. After being removed from its base for cleaning and restoration in recent times, it was taken inside the Capitoline Museum to protect it from air pollution, and a copy has replaced it in the piazza.

scene on the left, he demonstrates his courage and physical prowess in a boar hunt. Other roundels, not included here, show him confronting a bear and a lion. At the right, in a show of piety and appreciation to the gods for their support for his endeavors, Hadrian makes a sacrificial offering to Apollo at an outdoor altar.

Like the sculptors of the Column of Trajan, the sculptors of these roundels included elements of a natural land-scape setting but kept them relatively small, using them to frame the proportionally larger figures. The idealized heads, form-enhancing drapery, and graceful yet energetic move-

ment of the figures owe a distant debt to the works of Praxiteles and Lysippos (Chapter 5). The well-observed details of the features and the bits of landscape are characteristically Roman. Much of the sculpture of the mid-second century CE shows the influence of Hadrian's love of Greek art, and for a time Roman artists achieved a level of idealized figural depiction close to that of Classical Greece.

Imperial Portraits

Imperial portraits contained an element of propaganda. Marcus Aurelius, like Hadrian, was a successful military commander who was equally proud of his intellectual attainments. In a lucky error—or twist of fortune—a gilded bronze equestrian statue of the emperor (FIG. 6–60) came mistakenly to be revered as a statue of Constantine, known in the Middle Ages as the first Christian emperor, and consequently the sculpture escaped being melted down. The emperor is dressed as a military commander in a tunic and short, heavy cloak. The raised foreleg of his horse once trampled a crouching barbarian.

Marcus Aurelius's head, with its thick, curly hair and full beard (a style that was begun by Hadrian) resembles the traditional "philosopher" portraits of the Republican period. The emperor wears no armor and carries no weapons; like Egyptian kings, he conquers effortlessly by the will of the gods. And like his illustrious predecessor Augustus, he reaches out to the people in a persuasive, beneficent gesture. It is difficult to create an equestrian portrait in which the rider stands out as the dominant figure without making the horse look too small. The sculptor of this statue found a balance acceptable to viewers of the time and, in doing so, created a model for later artists.

Marcus Aurelius was succeeded as emperor by his son Commodus, a man without political skill, adminis-

trative competence, or intellectual distinction. The emperor Commodus was not just decadent—he was probably insane. During his unfortunate reign (180-92 CE), he devoted himself to luxury and frivolous pursuits. He claimed at various times to be the reincarnation of Hercules and the incarnation of the god Jupiter. When he proposed to assume the consulship dressed and armed as a gladiator, his associates, including his mistress, arranged to have him strangled in his bath by a wrestling partner. Commodus did, however, attract some of the finest artists of the day for his commissions. A marble bust of the emperor posing as Hercules reflects his character (FIG. 6-61). In this portrait, the emperor is shown adorned with references to the hero's legendary labors: Hercules's club, the skin and head of the Nemean Lion, and the golden apples from the garden of the Hesperides.

The sculptor's sensitive modeling and expert drillwork exploit the play of light and shadow on the figure and bring out the textures of the hair, beard, facial features, and drapery. The portrait conveys the illusion of life and movement, but it

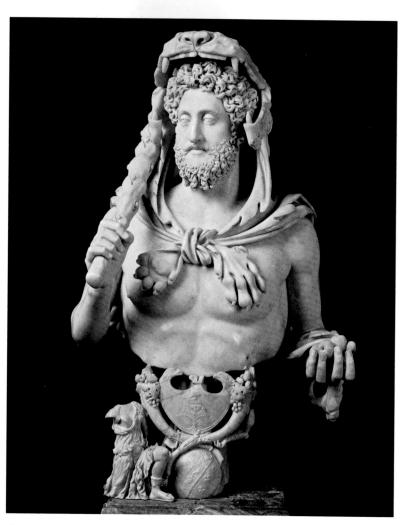

6–61 **COMMODUS AS HERCULES**Esquiline Hill, Rome. c. 191–92 CE. Marble, height 46½" (118 cm).
Palazzo dei Conservatori, Rome.

also captures its subject's weakness. The foolishness of the man comes through in his pretentious assumption of the attributes of Hercules.

THE LATE EMPIRE, THIRD AND FOURTH CENTURIES

The comfortable life suggested by the wall paintings in Roman villas was, within a century, to be challenged by hard times. The reign of Commodus marked the beginning of a period of political and economic decline. Barbarian groups had already begun moving into the empire in the time of Marcus Aurelius. Now they pressed on Rome's frontiers. Many crossed the borders and settled within them, disrupting provincial governments. As perceived threats spread throughout the empire, imperial rule became increasingly authoritarian. Eventually the army controlled the government, and the Imperial Guards set up and deposed rulers almost at will, often selecting candidates from among poorly educated, power-hungry provincial leaders in their own ranks.

The Severan Dynasty

Despite the pressures of political and economic change, at least the arts continued to flourish under the Severan emperors (193–235 CE) who succeeded Commodus. Septimius Severus (ruled 193–211 CE), who was born in Africa, and his Syrian wife, Julia Domna, restored public buildings, commissioned official portraits, and made some splendid additions to the old Republican Forum, including the transformation of the House of the Vestal Virgins, who served the Temple of Vesta, goddess of hearth and home, into a large, luxurious residence. Their sons, Geta and Caracalla, succeeded Septimus Severus as co-emperors in 211 CE. In 212 CE, Caracalla murdered Geta, and then ruled alone until he in turn was murdered in 217 CE.

THE FAMILY OF SEPTIMIUS SEVERUS. A portrait of the family of Septimius Severus provides insight into both the history of the Severan dynasty and early third-century CE painting (FIG. 6–62). The work is in the highly formal style of the Fayum region in northwestern Egypt (SEE FIG. 3–36), and it may be a souvenir of an imperial visit to Egypt. The emperor, clearly identified by his distinctive divided beard and curled moustache, wears an enormous crown. Next to him is the empress Julia Domna, portrayed with similarly recognizable features—full face, large nose, and masses of waving hair. Their two sons, Geta (whose face has been scratched out) and Caracalla, stand in front of them. Perhaps because we know that he grew up to be a ruthless dictator, little Caracalla looks like a disagreeable child.

After murdering his brother, perhaps with Julia Domna's help, Caracalla issued a decree to abolish every reference to Geta. Clearly the owners of this painting complied. The work emphasized the trappings of imperial wealth and power—crowns, jewels, and direct, forceful expressions—rather than

6–62 SEPTIMIUS SEVERUS, JULIA DOMNA, AND THEIR CHILDREN, GETA AND CARACALLA
Fayum, Egypt. c. 200 CE. Painted wood, diameter
14" (35.6 cm). The face of Geta has been obliterated.
Staatliche Museen zu Berlin, Preussischer Kulturbesitz,
Antikensammlung.

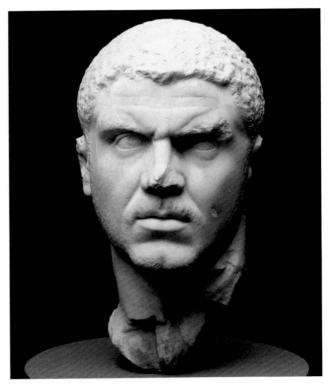

6–63 CARACALLAEarly 3rd century CE. Marble, height 14½" (36.2 cm). The Metropolitan Museum of Art, New York.
Samuel D. Lee Fund, 1940 (40.11.1A)

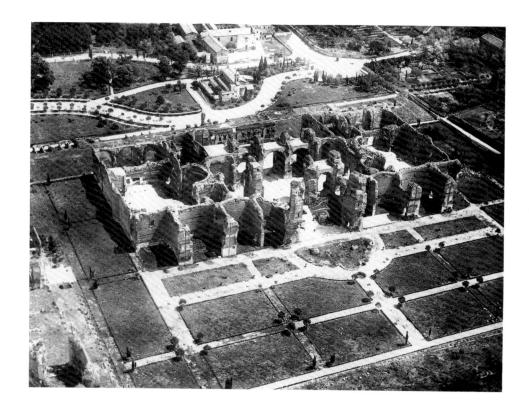

6–64 BATHS OF CARACALLA Rome. c. 211–17 CE.

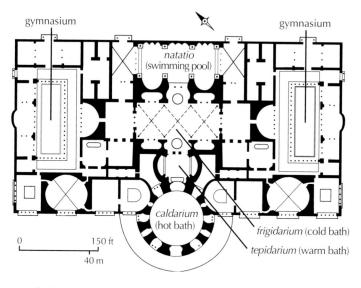

6-65 plan of the baths of caracalla

attempting any psychological study. The rather hard drawing style, with its broadly brushed-in colors, contrasts markedly with the subtlety of earlier portraits, such as the *Young Woman Writing* (SEE FIG. 6–37).

Emperor Caracalla emerges from his adult portraits as a man of chilling and calculating ruthlessness. In the example shown here (FIG. 6–63), the sculptor has enhanced the intensity of the emperor's expression by producing strong contrasts of light and dark with careful chiseling and drillwork. Even the marble eyes have been drilled and engraved to catch the light in a way that makes them glitter. The contrast between this style and that of the portraits of Augustus is a telling

reflection of the changing character of imperial rule. Augustus presented himself as the first among equals: Caracalla revealed himself as a no-nonsense ruler of iron-fisted determination.

THE BATHS OF CARACALLA. The year before his death in 211 CE, Septimius Severus had begun a popular public works project: the construction of magnificent new public baths on the southeast side of Rome. Caracalla completed and inaugurated the baths in 216-17 CE, and they are known by his name. For the Romans, baths were recreational and educational centers in which the brick and concrete structure was hidden under a sheath of colorful marble and mosaic. Even in ruins the great halls soar over the heads of the visitors. The builders covered the space with groin and barrel vaults, which allow the maximum space with the fewest possible supports. (In the early years of the twentieth century, the halls provided architects with the models for major train stations in American cities.) * The groin vaults also made possible large windows in every bay. Windows were important, since the baths depended on natural light and could only be open during daylight hours.

The **BATHS OF CARACALLA** (FIG. 6–64) were laid out on a strictly symmetrical plan. The bathing facilities were grouped in the center of the main building to make efficient use of the below-ground furnaces that heated them and to allow bathers to move comfortably from hot to cold pools and then finish with a swim (FIG. 6–65). Many other facilities—exercise rooms, shops, latrines, and dressing rooms—were housed on each side of the bathing block. The bath buildings alone covered five acres. The entire complex, which included gardens, a stadium, libraries, a painting gallery, auditoriums, and huge water reservoirs, covered an area of 50 acres.

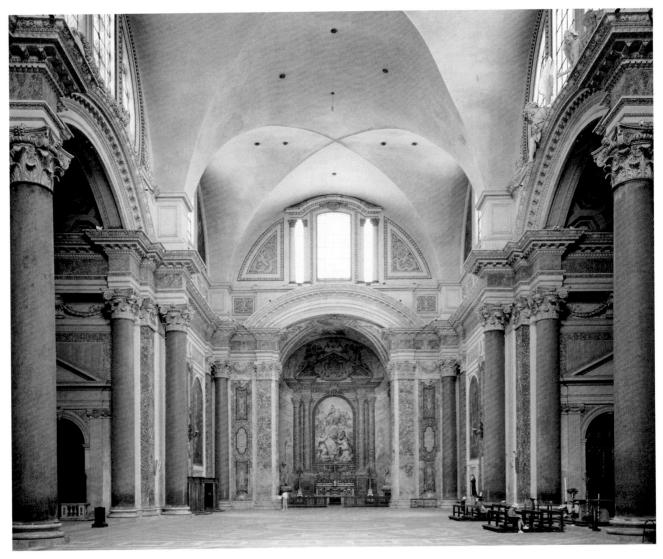

6–66 CHURCH OF SANTA MARIA DEGLI ANGELI (BATHS OF DIOCLETIAN, c. 298–306) Converted into a church by Michelangelo in 1563.

The luxury of these imperial establishments can still be seen in the **CHURCH OF SANTA MARIA DEGLI ANGELI** in Rome (FIG. 6–66), where Michelangelo converted the *frigidarium* of the Baths of Diocletian into a church, thus preserving it. Marble veneers and huge Corinthian columns and pilasters disguise the structural concrete of the building, although the vaults have lost their decoration.

The Third Century: The Soldier Emperors

The successors of the Severan emperors—the more than two dozen so-called soldier-emperors who attempted to rule the empire for the next seventy years—continued to favor the style of Caracalla's portraits. The sculptor of a bust of **PHILIP THE ARAB** (ruled 244–49 CE), for example, only modeled the broad structure of the emperor's head, then used both chisel and drill to deepen shadows and heighten the effects of light in the furrows of the face and the stiff folds of the drapery

(FIG. 6–67). Tiny flicks of the chisel suggest the texture of hair and beard. The overall impact of the work depends on the effects of light and the imagination of the spectator as much as on the carved stone itself.

This portrait does not convey the same malevolent energy as Caracalla's portraits. Philip seems tense and worried, suggesting that this is the portrait of a troubled man in troubled times. What comes through from Philip's twisted brow, sidelong upward glance, quizzical lips, and tightened jaw muscles is a sense of guile, deceit, and fear. Philip had been the head of the Imperial Guard, but he murdered his predecessor and was murdered himself after only five years.

ENGRAVED GOLD-GLASS. During the turmoil of the third century CE, Roman artists emphasized the symbolic or general qualities of their subjects and expressed them in increasingly simplified, geometric forms. Despite this trend toward

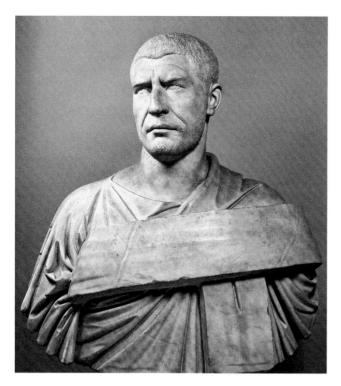

6–67 PHILIP THE ARAB Ruled 244–49 CE. Marble, height 26″ (71.1 cm). Musei Vaticani, Braccio Nuovo, Rome.

abstraction, the earlier tradition of slightly idealized but realistic portraiture was slow to die out, probably because it showed patrons as they wanted to be remembered. In the engraved gold-glass image of a woman with her son and daughter, the so-called **FAMILY OF VUNNERIUS KERAMUS** (FIG. 6–68), the subjects are rendered as individuals, although the artist has emphasized their great almond-shaped eyes. The work seems to reflect the advice of Philostratus who, writing in the late third century CE, commented:

The person who would properly master this art [of painting] must also be a keen observer of human nature and must be capable of discerning the signs of people's characters even though they are silent; he should be able to discern what is revealed in the expression of the eyes, what is found in the character of the brows, and, to state the point briefly, whatever indicates the condition of the mind. (Quoted in Pollitt, pages 224–25)

The Family Group portrait was engraved and stippled on a sheet of gold leaf sealed between two layers of glass. This fragile, delicate medium, often used for the bottoms of glass bowls or cups, seems appropriate for an age of material insecurity and emotional intensity. The portrait was inserted by a later Christian owner as the central jewel in a Lombard cross (SEE FIG. 9–3).

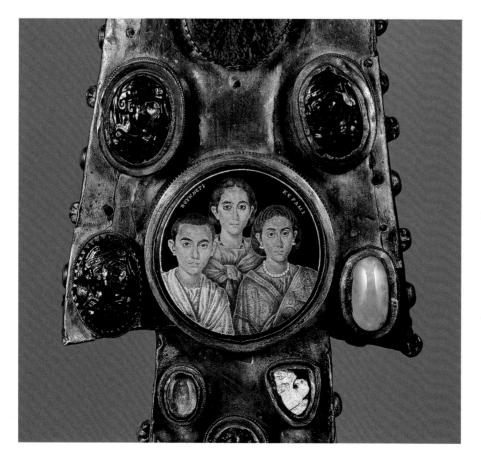

6–68 FAMILY GROUP,
TRADITIONALLY CALLED THE FAMILY OF VUNNERIUS KERAMUS
c. 250 CE. Engraved gold leaf sealed between glass, diameter 2%" (6 cm).
Museo Civico dell'Età Cristiana,
Brescia.

This gold-glass medallion of a mother, son, and daughter could have been made in Alexandria, Egypt, at any time between the early third and the mid-fifth centuries CE. The medallion was later placed in a Lombard cross (SEE FIG. 9-3).

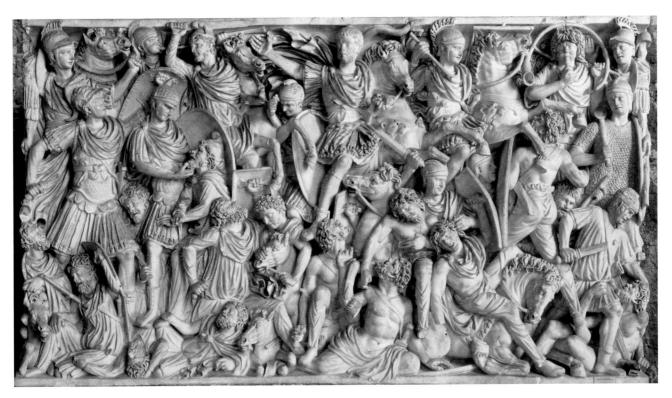

6–69 BATTLE BETWEEN THE ROMANS AND THE BARBARIANS, DETAIL OF THE LUDOVISI BATTLE SARCOPHAGUS Found near Rome. c. 250 CE. Marble, height approx. 5′ (1.52 m). Museo Nazionale Romano, Rome.

FUNERARY SCULPTURE. Although portraits and narrative reliefs were the major forms of public sculpture during the second and third centuries CE, a shift from cremation to burial led to a growing demand for funerary sculpture. Wealthy Romans commissioned elegant marble sarcophagi. Workshops throughout the empire produced thousands of them, carved with reliefs that ranged in complexity from simple geometric or floral ornaments to scenes involving large numbers of figures.

A figured sarcophagus known as the LUDOVISI BATTLE SARCOPHAGUS (after a seventeenth-century owner) dates to about 250 CE (FIG. 6-69) and depicts Romans triumphing over barbarians. The imagery and style has roots in the sculptural traditions of Hellenistic Pergamon (Chapter 5). In contrast to the carefully crafted illusion of earlier Roman reliefs like the Arch of Titus, where figures move in and through naturalistic surroundings, the artist of the Ludovisi squeezed his figures into the allotted space with no attempt to create a realistic environment. The Romans, packed together in orderly rows at the top of the panel, efficiently dispatch the barbarians—clearly identifiable by their heavy, twisted locks of hair and scraggly beards—who fall, dying, or beaten into an unorganized heap at the bottom. The bareheaded young Roman commander with his gesture of victory, who occupies the center top of the composition, recalls the Equestrian Statue of Marcus Aurelius (SEE FIG. 6-60).

The Tetrarchy

The half century of anarchy, power struggles, and inept rule by the soldier-emperors that had begun with the death of Alexander Severus (ruled 222–235 CE), the last in the Severan line, ended with the rise to power of Diocletian (ruled 284–305 CE). This brilliant politician and general reversed the empire's declining fortunes, but he also began an increasingly autocratic form of rule, and the social structure of the empire became increasingly rigid.

To divide up the task of defending and administering the empire and to assure an orderly succession, in 286 CE Diocletian divided the empire in two parts. According to his plan, with the title of "Augustus" he would rule in the East, while another Augustus, Maximian, would rule in the West. Then, in 293 CE, he devised a form of government called a tetrarchy, or "rule of four," in which each Augustus designated a subordinate and heir, who held the title of "Caesar."

PORTRAIT OF THE TETRARCHS. Sculpture depicting the tetrarchs, about 300 CE, documents a turn in art toward abstraction and symbolic representation (FIG. 6–70). The four figures—two with beards, probably the senior Augusti, and two clean-shaven, probably the Caesars—are nearly identical. Dressed in military garb and clasping swords at their sides, they embrace each other in a show of imperial unity, proclaiming a kind of peace through concerted strength and

vigilance. As a piece of propaganda and a summary of the state of affairs at the time, it is unsurpassed.

The sculpture is made of porphyry, a purple stone from Egypt reserved for imperial use. The hardness of the stone, which makes it difficult to carve, may have contributed to the extremely abstract style of the work. The most striking features of **THE TETRARCHS**—the simplification of natural forms to geometric shapes, the disregard for normal human proportions, and the emphasis on a message or idea—appear often in Roman art by the end of the third century. The sculpture may have been made in Egypt and moved to Constantinople after 330 CE. Christian Crusaders who looted Constantinople in 1204 CE took the statue to Venice and placed it on the Cathedral of Saint Mark, where it can still be seen.

THE BASILICA AT TRIER. The tetrarchs had ruled the empire from administrative headquarters in Milan, Italy; Trier, Germany; Thessaloniki, in Greece; and Nicomedia, in present-day Turkey. These four capital cities all had imposing buildings. In Trier, for example, Constantius Chlorus (Augustus, 293–306 CE) and his son Constantine fortified the city with walls and a monumental gate which still stand. They built public

6-70 THE TETRARCHS

c. 300 CE. Porphyry, height of figures 51'' (129 cm). Brought from Constantinople in 1204, installed at the corner of the façade of the Cathedral of Saint Mark, Venice.

amenities, such as baths, and a palace with a huge audience hall, later used as a Christian church (FIGS. 6–71, 6–72). This early fourth-century CE basilica's large size and simple plan and structure exemplify the architecture of the tetrarchs: imposing buildings that would impress their subjects.

The audience hall is a large rectangular building, 190 by 95 feet (200 by 100 Roman feet), with a strong directional focus given by a single apse opposite the door. Brick walls, originally stuccoed on the outside and covered with marble veneer inside, are pierced by two rows of arched windows. The flat roof, nearly 100 feet above the floor, covers both the nave and the apse. In a

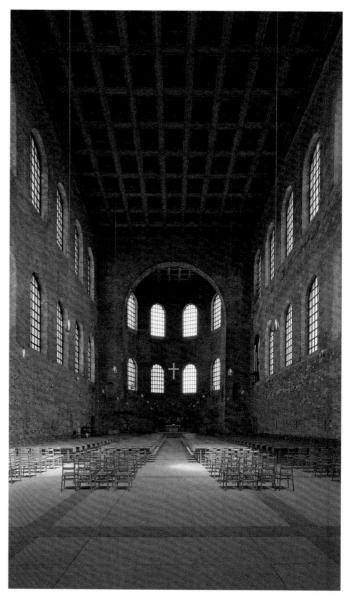

6-71 AUDIENCE HALL OF CONSTANTINE CHLORUS (NOW KNOWN AS THE BASILICA)

Interior. Trier, Germany. Early 4th century. View of the nave. Height of room 100′ (30.5 m).

Only the left wall and apse survive from the original Roman building. The hall became part of the bishop's palace during the medieval period.

Technique

ROMAN COPIES

Oth bronze and marble sculpture was often copied in marble (recall the Roman copies of Greek sculpture in Chapter 5). The Romans developed a method of making nearly exact copies using a technique known as "pointing." A stonecutter transferred "points" on the original sculpture to a three-dimensional grid that was used to rough out the form.

Then master sculptors finished the work.

Marble copies of bronze sculpture required extra bracing, such as a tree trunk or column beside a leg or a strut to support an arm. These copies vary considerably in quality, depending on the skill of the copyists.

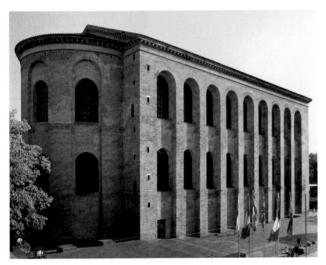

6–72 AUDIENCE HALL (NOW KNOWN AS THE BASILICA) Exterior. Trier, Germany. Early 4th century.

concession to the northern climate, the building was centrally heated with hot air flowing under the floor (a technique used in Roman baths). The windows of the apse create an interesting optical effect. Slightly smaller and set higher than the windows in the hall, they create the illusion of greater distance, so that the tetrarch enthroned in the apse would appear larger than life.

Constantine the Great and His Legacy

In 305 CE, Diocletian abdicated and forced his fellow Augustus, Maximian, to do so too. The orderly succession he had hoped for failed to occur, and a struggle for position and advantage followed almost immediately. Two main contenders emerged in the western empire: Maximian's son Maxentius and Constantine I, son of Tetrarch Constantius Chlorus. Constantine was victorious in 312, defeating Maxentius at the Battle of the Milvian Bridge at the entrance to Rome.

According to tradition, Constantine had a vision the night before the battle in which he saw a flaming cross in the sky and heard these words: "In this sign you shall conquer."

The next morning he ordered that his army's shields and standards be inscribed with the monogram XP (the Greek letters *chi* and *rho*, standing for *Christos*; see "Christian Symbols," page 238). The victorious Constantine then showed his gratitude by ending the persecution of Christians and recognizing Christianity as a lawful religion. (He may also have been influenced in that decision by his mother, Helen, a devout Christian—later canonized.) Whatever his motivation, in 313 CE, together with Licinius, who ruled the East, Constantine issued the Edict of Milan, a model of religious toleration.

The Edict granted freedom to all religious groups, not just Christians. Constantine, however, remained the Pontifex Maximus of Rome's state religion and also reaffirmed his devotion during his reign to the military's favorite god, Mithras, and to the Invincible Sun, Sol Invictus, a manifestation of Helios Apollo, the sun god. In 324 CE Constantine defeated Licinius, his last rival; he ruled as sole emperor until his death in 337. He made the port city of Byzantium the new Rome and renamed it Constantinople (present-day Istanbul, in Turkey). After Constantinople was dedicated in 330, Rome, which had already ceased to be the seat of government in the West, further declined in importance.

PORTRAITURE. Portraiture continued to be an important aspect of imperial propaganda. Constantine commissioned a colossal, 30-foot statue of himself for his new basilica (FIG. 6–73). To create the colossal figure, the sculptor used white marble for the head, chest, arms, and legs, and sheets of bronze for the drapery, all supported on a wooden frame. This statue became a permanent stand-in for the emperor, representing him whenever the conduct of business legally required his presence. The head combines features of traditional Roman portraiture with the abstract qualities evident in *The Tetrarchs* (SEE FIG. 6–70). The defining characteristics of Constantine's face—his heavy jaw, hooked nose, and jutting chin—have been incorporated into a rigid, symmetrical pattern in which other features, such as his eyes, eyebrows, and hair, have been simplified into repeated geometric arcs. The

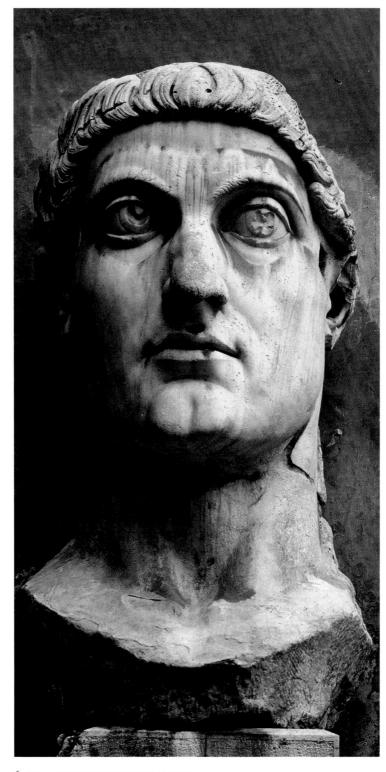

6–73 CONSTANTINE THE GREAT Basilica of Maxentius and Constantine, Rome. 325–26 CE. Marble, height of head 8'6'' (2.6 m). Palazzo dei Conservatori, Rome.

result is a work that projects imperial power and dignity with no hint of human frailty or imperfection. Similar portraits appear in relief sculpture on Constantine's triumphal arch. THE ARCH OF CONSTANTINE. In Rome, next to the Colosseum, the Senate erected a memorial to Constantine's victory over Maxentius (FIG. 6–74), a huge, triple arch that dwarfs the

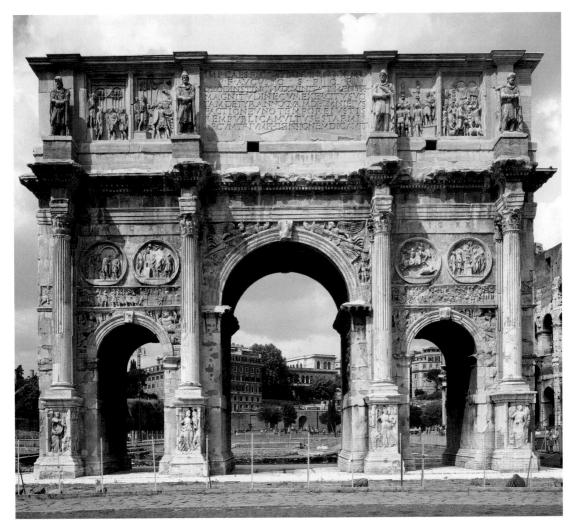

6–74 ARCH OF CONSTANTINE Rome. 312–15 CE (dedicated July 25, 315).

This massive, triple-arched monument to Emperor Constantine's victory over Maxentius in 312 CE is a wonder of recycled sculpture. On the attic story, flanking the inscription over the central arch, are relief panels taken from a monument celebrating the victory of Marcus Aurelius over the Germans in 174 CE. On the attached piers framing these panels are large statues of prisoners made to celebrate Trajan's victory over the Dacians in the early second century CE. On the inner walls of the central arch (not seen here) are reliefs commemorating Trajan's conquest of Dacia. Over each of the side arches are pairs of large roundels taken from a monument to Hadrian (SEE FIG. 6-59). The rest of the decoration is 4th century, contemporary with the arch.

nearby Arch of Titus (SEE FIG. 6–38). Its three barrel-vaulted passageways are flanked by columns on high pedestals and surmounted by a large attic story with elaborate sculptural decoration and a traditional laudatory inscription: "To the Emperor Constantine from the Senate and the Roman People. Since through divine inspiration and great wisdom he has delivered the state from the tyrant and his party by his army and noble arms, [we] dedicate this arch, decorated with triumphal insignia." The "triumphal insignia" were in part looted from earlier monuments made for Constantine's illustrious predecessors, Trajan, Hadrian (SEE FIG. 6–59), and Marcus Aurelius. The reused items visually transferred the old Roman virtues of strength, courage, and piety associated with

these earlier "good" emperors to Constantine. New reliefs made for the arch recount the story of Constantine's victory and symbolize his power and generosity.

Although these new reliefs reflect the long-standing Roman affection for depicting important events with realistic detail, they nevertheless represent a significant change in style, approach, and subject matter. They are easily distinguished from the reused elements in the arch. The stocky, frontal, look-alike figures are compressed by the buildings of the forum into the foreground plane. The arrangement and appearance of the uniform participants below the enthroned Constantine clearly isolate the new emperor and connect him visually with his illustrious predecessors on each side.

This two-dimensional, hierarchical approach and abstract style are far removed from the realism of earlier imperial reliefs. This style, with its emphasis on authority, ritual, and symbolic meaning, was adopted by the emerging Christian Church. Constantinian art thus bridges the art of the Classical world and the art of the Middle Ages (approximately from 476 to 1453 CE).

THE BASILICA NOVA. Constantine's rival Maxentius, who controlled Rome throughout his short reign (ruled 306–12), ordered the repair of many buildings there and had others built. His most impressive undertaking was a huge new basilica, just southeast of the Imperial Forums, called the Basilica Nova, or New Basilica. Now known as the Basilica of Maxentius and Constantine, this was the last important imperial government building erected in Rome. Like all basilicas, it functioned as an administrative center and provided a magnificent setting for the emperor when he appeared as supreme judge.

Earlier basilicas, such as Trajan's Basilica Ulpia (SEE FIG. 6–48), had been columnar halls, but Maxentius ordered

his engineers to create the kind of large, unbroken, vaulted space found in public baths. Such solid masonry construction was less vulnerable to fire, an important consideration in troubled times. The central hall was covered with groin vaults, and the side aisles were covered with lower barrel vaults. These vaults acted as buttresses, or projecting supports, for the central vault and allowed generous window openings in the clerestory areas over the side walls.

Three of these brick-and-concrete barrel vaults still loom over the streets of present-day Rome (FIG. 6–75). The basilica originally measured 300 by 215 feet and the vaults of the central nave rose to a height of 114 feet. A groin-vaulted porch extended across the short side and sheltered a triple entrance to the central hall. At the opposite end of the long axis of the hall was an apse of the same width, which acted as a focal point for the building (FIGS. 6–76, 6–77). The directional focus along a central axis from entrance to apse was adopted by Christians for use in churches.

Constantine, seeking to impress the people of Rome with visible symbols of his authority, put his own stamp on projects Maxentius had started. He may have changed the orientation

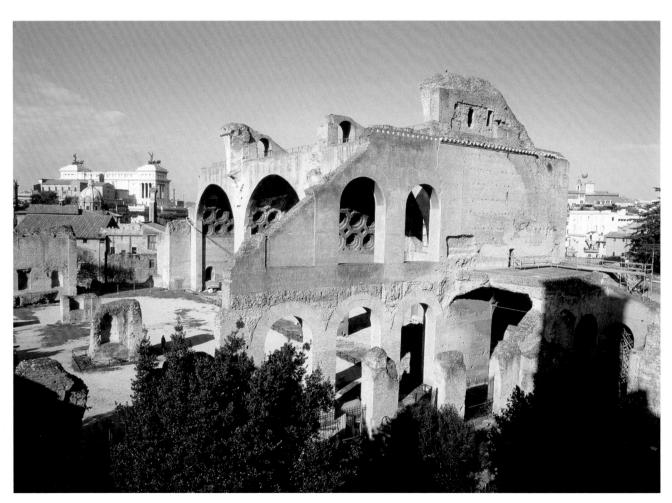

6–75 BASILICA OF MAXENTIUS AND CONSTANTINE (BASILICA NOVA)
Rome. 306–13 CE.

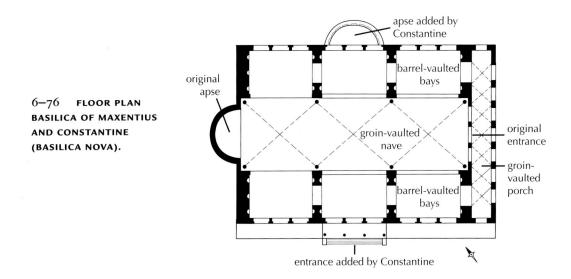

of the Basilica Nova by adding an imposing new entrance in the center of the long side facing the Via Sacra and a giant apse facing it across the three aisles. (A new theory suggests that the building was designed and built as a single project.)

ROMAN ART AFTER CONSTANTINE. Although Constantine was baptized only on his deathbed in 337, Christianity had become the official religion of the empire by the end of the fourth century CE, and non-Christians had become tar-

gets of persecution. Many people resisted this shift and tried to revive Classical culture. A large silver platter dating from the mid-fourth century CE shows how themes involving Bacchus continued to provide artists with the opportunity to create elaborate figural compositions displaying the nude or lightly draped human body in complex, dynamic poses (FIG. 6–78).

The Bacchic revelers whirl, leap, and sway in a dance to the piping of satyrs around a circular central medallion. In the

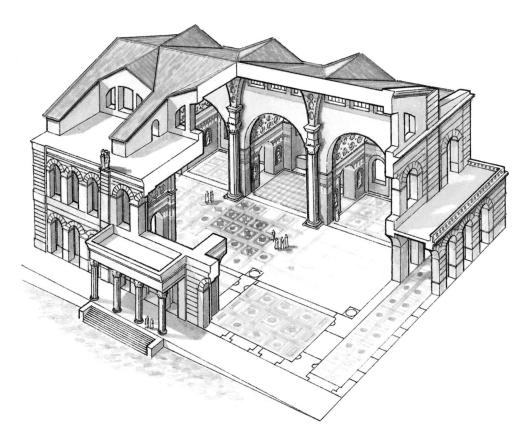

6-77 RECONSTRUCTION OF THE BASILICA OF MAXENTIUS AND CONSTANTINE (BASILICA NOVA).

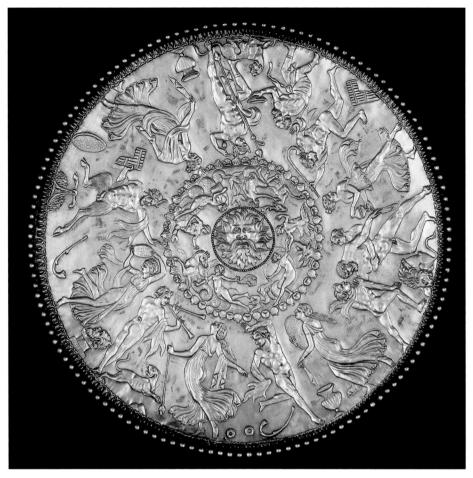

6–78 DISH
From Mildenhall, England. Mid-4th century CE. Silver, diameter approx. 24" (61 cm). The British Museum, London.

centerpiece, the head of the sea god Oceanus is ringed by nude females frolicking in the waves with fantastic sea creatures. In the outer circle, Bacchus is the one stable element. With a bunch of grapes in his right hand, a krater at his feet, and one foot on the haunches of his panther, he listens to a male follower begging for another drink. Only a few figures away, the pitifully drunken hero Hercules has lost his lion-skin mantle and collapsed in a stupor into the supporting arms of two satyrs. The detail, clarity, and liveliness of this platter reflect the work of a skillful artist. Deeply engraved lines emphasize the contours of the subtly modeled bodies, echoing the technique of undercutting used to add depth to figures in stone and marble reliefs and suggesting a connection between silver working and relief sculpture. The platter was found in a cache of silver near Mildenhall, England. (Such opulent items were often hidden or buried to protect them from theft and looting, a sign of the breakdown of the long Roman peace.)

Among the champions of paganism were the Roman patricians Quintus Aurelius Symmachus and Virius Nicomachus Flavianus. A famous ivory diptych—a pair of panels attached with hinges—attests to the close relationship

between their families, perhaps through marriage, as well as to their firmly held beliefs. One family's name is inscribed at the top of each panel. On the panel inscribed *Symmachorum* (FIG. 6–79), a stately, elegantly attired priestess burns incense at a beautifully decorated altar. On her head is a wreath of ivy, sacred to Bacchus. She is assisted by a small child, and the event takes place out of doors under an oak tree, sacred to Jupiter. The Roman ivory carvers of the fourth century were extremely skillful, and their wares were widely admired. For conservative patrons like the Nicomachus and Symmachus families, they imitated the Augustan style effortlessly. The exquisite rendering of the drapery and foliage recalls the reliefs of the Ara Pacis (SEE FIG. 6–21).

Classical subject matter remained attractive to artists and patrons, and imperial repression could not immediately extinguish it. Even such great Christian thinkers as the fourth-century CE bishop Gregory of Nazianzus (a saint and father of the Orthodox church) spoke out in support of the right of the people to appreciate and enjoy their classical heritage, so long as they were not seduced by it to return to

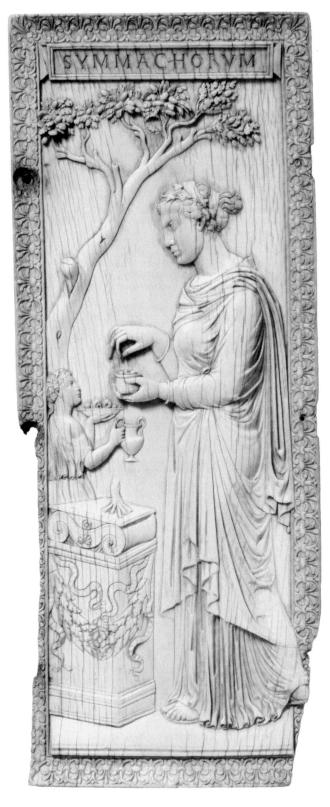

6–79 PRIESTESS OF BACCHUS (?) Right panel of the diptych of Symmachus. c. 390–401 CE. Ivory, $11\frac{1}{4}\times4\frac{1}{4}$ " (29.9 \times 12 cm). Victoria & Albert Museum, London.

pagan practices. As a result, stories of the ancient gods and heroes entered the secular realm as lively, visually delightful, and even erotic decorative elements.

The style and subject matter of the art reflect a society in transition, for even as Roman authority gave way to local rule by powerful "barbarian" tribes in much of the West, many people continued to appreciate classical learning and to treasure Greek and Roman art. In the East, classical traditions and styles endured to become an important element of Byzantine art.

IN PERSPECTIVE

The Romans, who supplanted the Etruscans and the Greeks, appreciated the earlier art of these peoples and adapted it to their own uses, but they also had their own strengths, such as efficiency and a practical genius for organization. As sophisticated visual propaganda, Roman art served the state and the empire. Creating both official images and representations of private individuals, Roman sculptors enriched and developed the art of portraiture. They also recorded contemporary historical events on commemorative arches, columns, and mausoleums.

Roman artists covered the walls of private homes with paintings, too. Sometimes fantastic urban panoramas surround a room, or painted columns and cornices, swinging garlands, and niches make a wall seem to dissolve. Some artists created the illusion of being on a porch or in a pavilion looking out into an extensive landscape. Such painted surfaces are often like backdrops for a theatrical set.

Roman architects relied heavily on the round arch and masonry vaulting. Beginning in the second century BCE, they also relied increasingly on a new building material: concrete. In contrast to stone, the components of concrete are cheap, light, and easily transported. Imposing and lasting concrete structures could be built by a large, semiskilled work force directed by one or two trained and experienced supervisors.

Drawing artistic inspiration from their Etruscan and Greek predecessors and combining this with their own traditions, Roman artists made a distinctive contribution to the history of art, creating works that formed an enduring ideal of excellence in the West. And as Roman authority gave way to local rule, the newly powerful "barbarian" tribes continued to appreciate and even treasure the Classical learning and art the Romans left behind.

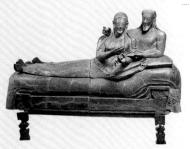

SARCOPHAGUS FROM CERVETERI C. 520 BCE

MIRROR c. 400–350 BCE

AUGUSTUS OF PRIMAPORTA
EARLY 1ST CENTURY CE

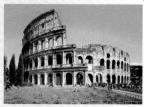

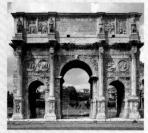

ARCH OF CONSTANTINEC. 312–15 CE

100

PONT DU GARD
LATE 1ST CENTURY BCE

IOO

300

400

)

ETRUSCAN AND ROMAN ART

- Etruscan Supremacyc. 700–509 BCE
- Persian Empire
 c. 559-331 BCE
- Roman Republic c. 509-27 BCE
- Classical Greek Culture
 c. 450–323 BCE

Par Rimore

- Julius Caesar Assassinated 44 BCE
- Roman Empire 27 BCE-395 CE

■ Conquest of Dacia 106 CE

Constantine

- Battle of Milvian Bridge 312 CE
- Costantinople Becomes Capital 330 CE
- Division of Empire 395 CE

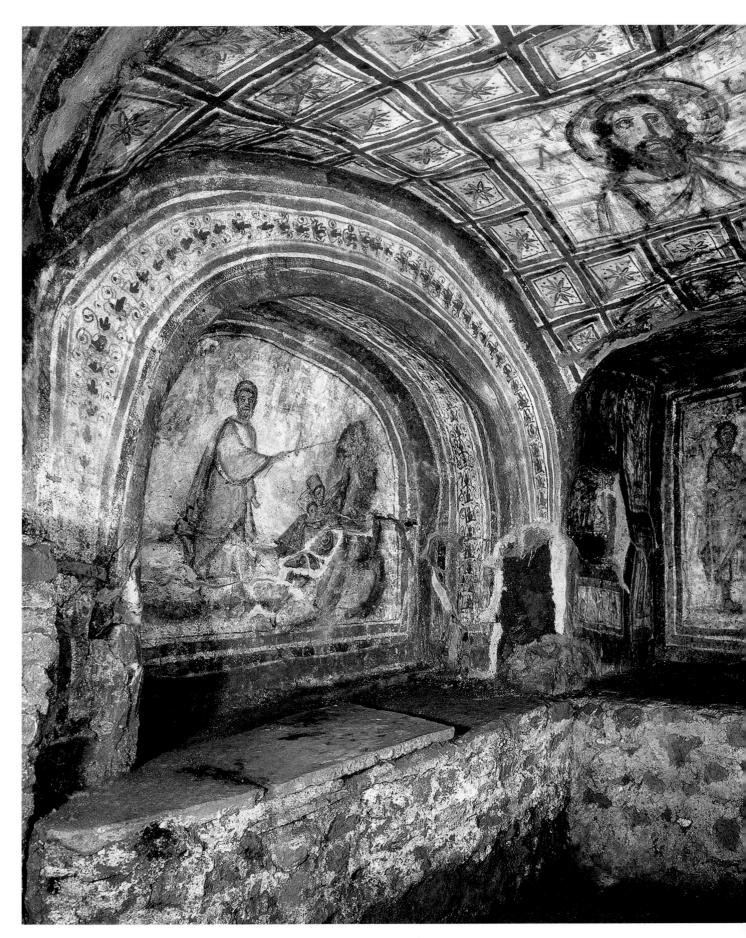

7-i | **CUBICULUM OF LEONIS, CATACOMB OF COMMODILLA** Near Rome. Late 4th century.

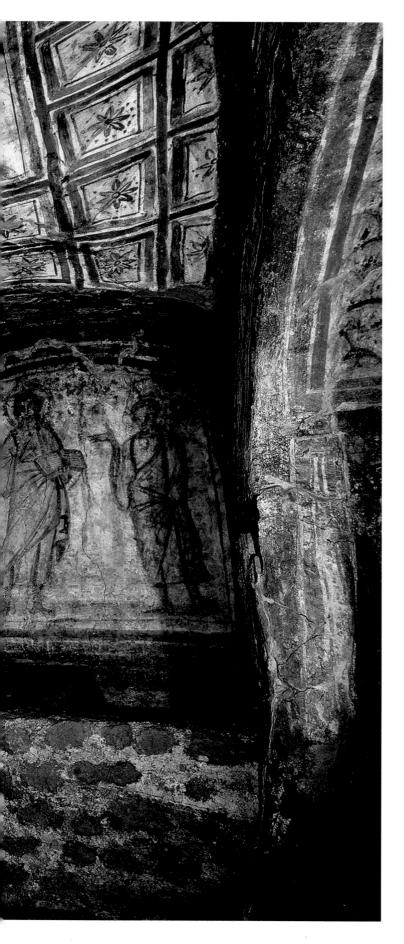

CHAPTER SEVEN

JEWISH, EARLY CHRISTIAN, AND BYZANTINE ART

7

In ancient Rome, gravediggers were the architects of the underground. Where subsoil conditions were right, they tunneled out streets and

houses in a city of the dead—a **necropolis**—with as many as five underground levels. Working in dark, narrow galleries as much as 70 feet below the surface, they dug out corridors, shelves, and small burial rooms to create **catacombs**. Aboveground, the gravediggers acted as guards and gardeners. Some of them may have been artists too, for even the earliest catacombs contained paintings—initially very simple inscriptions and symbols.

Burials were always outside the city walls, so that the dead would not defile the city. Catacombs were not secret nor were they ever used as hiding places—such stories spring from the imaginations of nineteenth-century romantic writers. Burial in catacombs became common in the early third century CE and ended by about 500. Although Rome's Christian catacombs are the most famous today, people of other faiths—Jews, devotees of Isis, followers of Bacchus and other mystery religions, pagan traditionalists—were interred in their own communal catacombs, which were decorated with symbols of their faith.

In the third century CE, Christian catacombs were painted with images of salvation based on prayers for the dead. By the fourth century, painting had become even more

elaborate, as in this catacomb which depicts saints having a particular connection to Rome (FIG. 7–1). In the center of a small burial room's ceiling—between alpha and omega—the Greek letters signifying the beginning and end—the head of Christ appears in a circle (a halo). Facing the door is Christ with the Roman martyrs Felix (d. 274) and Adauctus (d. 303). At the right, a painting depicts Peter in the hours before the cock crowed, when he denied that he knew Jesus (Matthew 26:74–75). On the left, Peter miraculously brings forth water from a rock in Rome's Mamertine Prison to baptize his fellow prisoners and their jailers. Here the painter has copied the traditional Jewish scene of Moses striking water from the rock (Exodus 17:1–7). Were it not for the painting's Christian context, it would be indistinguishable from Jewish art.

CHAPTER-AT-A-GLANCE

- JEWS, CHRISTIANS, AND MUSLIMS Early Jewish Art Early Christian Art
- IMPERIAL CHRISTIAN ARCHITECTURE AND ART Architecture: The Church and Its Decoration Architecture: Ravenna Sculpture
- EARLY BYZANTINE ART: THE FIRST GOLDEN AGE The Golden Age of Justinian Objects of Veneration and Devotion
- MIDDLE BYZANTINE ART Architecture and Mosaics Objects of Veneration and Devotion The Special Case of Sicily
- LATE BYZANTINE ART Constantinople Moscow: The Third Rome
- IN PERSPECTIVE

JEWS, CHRISTIANS, AND MUSLIMS

Three religions that arose in the Near East dominate the spiritual life of the Western world today: Judaism, Christianity, and Islam. All three are monotheistic-followers hold that only one god created and rules the universe. Jews believe that God made a covenant, or pact, with their ancestors, the Hebrews, and that they are God's chosen people. They await the coming of a savior, the Messiah, "the anointed one." Christians believe that Jesus of Nazareth was that Messiah (the name Christ is derived from the Greek term meaning "Messiah"). They believe that God took human form, preached among men and women, suffered execution, then rose from the dead and ascended to heaven after establishing the Christian Church under the leadership of the apostles (his closest disciples). Muslims, while accepting the Hebrew prophets and Jesus as divinely inspired, believe Muhammad to be the last and greatest prophet of God (Allah), the Messenger of God through whom Islam was revealed some six centuries after Jesus's lifetime.

All three are "religions of the book," that is, they have written records of God's will and words: the Hebrew Scriptures; the Christian Bible, which includes the Hebrew Scriptures as its Old Testament as well as the Christian New Testament; and the Muslim Qur'an, believed to be the Word of God as revealed in Arabic directly to Muhammad through the archangel Gabriel.

Both Judaism and Christianity existed within the Roman Empire, along with various other religions devoted to the worship of many gods. The variety of religious buildings found in present-day Syria at the abandoned Roman outpost of Dura-Europus, a Hellenistic fortress taken over by the Romans in 165 CE, illustrates the cosmopolitan character of Roman society, as well as places of worship, in the second and third centuries. Although Dura-Europus was destroyed in 256-57 CE by the Sassanid Persians, important parts of the stronghold have been excavated, including a Jewish house-synagogue, a Christian house-church, shrines to the Persian gods Mithras and Zoroaster, and temples to Greek and Roman gods, including Zeus, Artemis, and Adonis. The Jewish and Christian structures were preserved because they had been built beside the wall of the southwest rampart. When the desperate citizens attempted to strengthen this fortification in futile preparation for the final attack, they buried these buildings. The entire site was later abandoned and rediscovered in 1920 by a French army officer.

This chapter concentrates on the religions of the Roman Empire: We consider Jewish and Early Christian and Byzantine art, including some of the later art of the Eastern Orthodox Church.

Early Jewish Art

The Jewish people trace their origin to a Semitic people called the Hebrews, who lived in the land of Canaan. Canaan, known from the second century CE by the Roman name Palestine, was located along the eastern edge of the Mediterranean Sea (MAP 7–1). According to the Torah, the first five books of the Hebrew Scriptures, God promised the patriarch

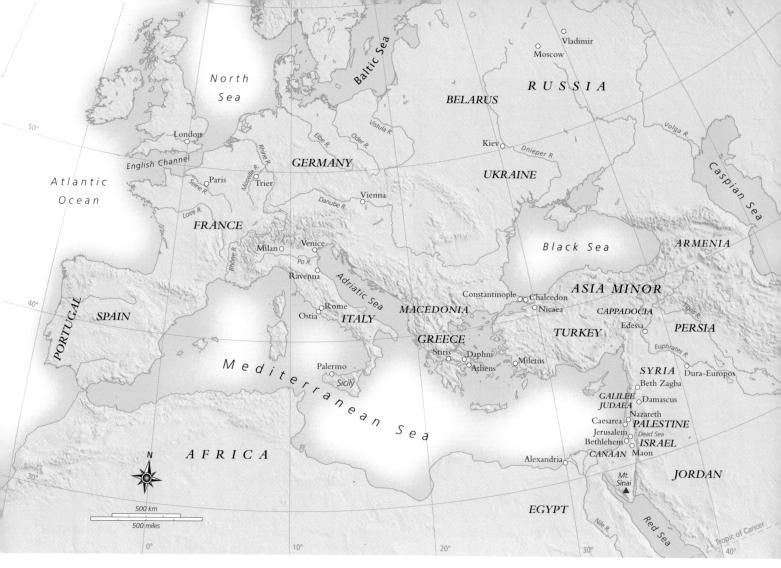

MAP 7-I | JEWISH, EARLY CHRISTIAN, AND BYZANTINE WORLDS

The eastern Mediterranean lands of Canaan and Judaea were centers of Jewish settlement. Rome was a major center of early western Christianity. Byzantine culture took root in Constantinople and flourished throughout the Eastern Roman, or Byzantine, Empire and extended into northern areas such as Russia and Ukraine.

Abraham that Canaan would be a homeland for the Jewish people (Genesis 17:8), a belief that remains important among Jews to this day.

Jewish settlement of Canaan probably began sometime in the second millennium BCE. According to Exodus, the second book of the Torah, the prophet Moses led the Hebrews out of slavery in Egypt to the promised land of Canaan. At one crucial point during the journey, Moses climbed alone to the top of Mount Sinai, where God gave him the Ten Commandments, the cornerstone of Jewish law. The commandments, inscribed on tablets, were kept in a gold-covered wooden box, the Ark of the Covenant.

Jewish law forbade the worship of idols, a prohibition that often made the representational arts—especially sculpture in the round—suspect. Nevertheless, artists working for Jewish patrons depicted both symbolic and narrative Jewish subjects; and as they did so they looked to both Near Eastern and classical Greek and Roman art for inspiration.

SOLOMON: THE FIRST TEMPLE IN JERUSALEM. In the tenth century BCE, the Jewish king Solomon built a temple in Jerusalem to house the Ark of the Covenant. He sent to nearby Phoenicia for cedar, cypress, and sandalwood, and for a superb artisan to supervise construction of the Temple, later known as the First Temple (2 Chronicles 2:2–15). The Temple was the spiritual center of Jewish life. It consisted of courtyards, two bronze pillars, an entrance hall, a main hall, and the Holy of Holies, the innermost chamber that housed the Ark and its guardian cherubim, or attendant angels (perhaps resembling the winged guardians of Assyria, seen in FIG. 2–1).

In 586 BCE, the Babylonians, under King Nebuchadnezzar II, conquered Jerusalem. They destroyed the Temple, exiled the Jews, and carried off the Ark of the Covenant. When Cyrus the Great of Persia conquered Babylonia in 539 BCE, he permitted the Jews to return to their homeland (Ezra 1:1–4) and rebuild the Temple, which became known as the Second Temple. When Canaan became part of the Roman Empire,

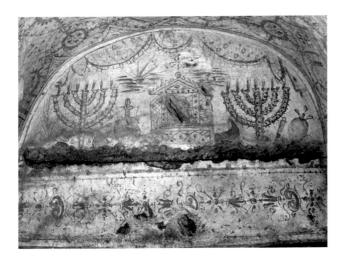

7–2 | MENORAHS AND ARK OF THE COVENANT Wall painting in a Jewish catacomb, Villa Torlonia, Rome. 3rd century. $3'11'' \times 5'9''$ (1.19 \times 1.8 m).

The menorah form probably derives from the ancient Near Eastern Tree of Life, symbolizing for the Jewish people both the end of exile and the paradise to come.

Herod the Great (the king of Judaea, 37–4 BCE), restored the Second Temple. In 70 CE, Roman forces led by the general and future emperor Titus destroyed the Second Temple and all of Jerusalem, an exploit the Romans commemorated on the Arch of Titus (SEE FIG. 6–39). The conspicuous representation of the menoral looted from the Second Temple kept the

memory of the Jewish treasures alive. The site of the Second Temple, the Temple Mount, is also an Islamic holy site, the Haram al-Sharif, and is now occupied by the shrine called the Dome of the Rock (SEE FIGS. 8–2, 8–3).

JEWISH CATACOMB ART IN ROME. Most of the earliest surviving examples of Jewish art date from the Hellenistic and Roman periods. Six Jewish catacombs, discovered in the outskirts of Rome and in use from the first to fourth centuries CE, display wall paintings with Jewish themes. In one example, from the third century CE, two *menorahs* (seven-branched lamps), flank the long-lost Ark of the Covenant (FIG. 7–2).

Synagogues. Judaism has always emphasized religious learning. Jews gather in synagogues for study and worship, so a synagogue can be any large room where the Torah scrolls are kept and read publicly. Some synagogues were located in private homes or in buildings originally constructed like homes. The first Dura-Europus synagogue consisted of an assembly hall, a separate alcove for women, and a courtyard. After a remodeling of the building, completed in 244–45 CE, men and women shared the hall, and residential rooms were added. Two architectural features distinguished the assembly hall: a bench along its walls and a niche for the Torah scrolls (FIG. 7–3).

Scenes from Jewish history and the story of Moses, as recorded in Exodus, unfold in a continuous narrative around

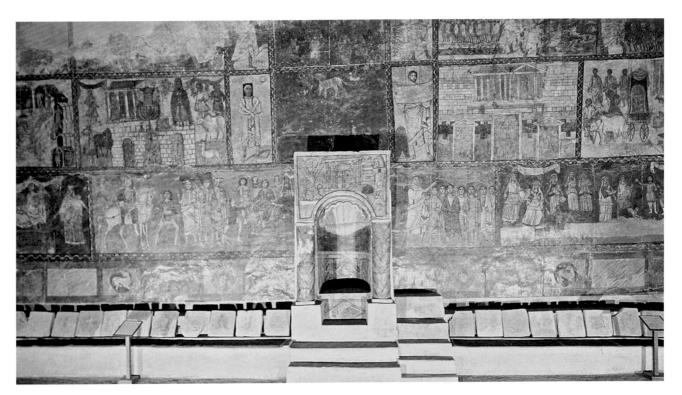

7–3 | WALL WITH TORAH NICHE
From a house-synagogue, Dura-Europos, Syria. 244–45. Tempera on plaster, section approx. 40′ (12.19 m) long.
Reconstructed in the National Museum, Damascus, Syria.

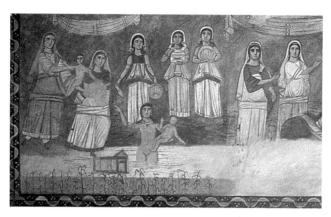

7–4 | THE FINDING OF THE BABY MOSES

Detail of a wall painting from a house-synagogue, Dura-Europos, Syria. 244–45. Copy in tempera on plaster.

Dura-Europos Collection. Yale University Art Gallery,

New Haven, Connecticut.

the room. This vivid depiction of events follows the Roman tradition of historical narrative. In **THE FINDING OF THE BABY MOSES** (FIG. 7–4), Moses's mother has set him afloat in a reed basket in the shallows of the Nile in an attempt to save him from the pharaoh's decree that all male Jewish infants be put to death (Exodus 1:8–2:10). The pharaoh's daughter finds him and claims him as her own child.

The painting shows the story unfolding in a narrow foreground space. At the right, the princess sees the child hidden in the bulrushes; at the center, she or a servant wades nude into the water to save him; and at the left, she hands him to a nurse (actually his own mother). Individual paintings are inspired by Near Eastern sources. They are done in a style in which static, two-dimensional figures seem to float against a neutral background. The frontal poses, strong outlines, and flat colors are also features of later Byzantine art, an art perhaps derived from the same sources that inspired these images.

In addition to house-synagogues, Jews built synagogues designed on the model of the ancient Roman basilica. A typical basilica synagogue had a central nave; an aisle on both sides, separated from the nave by a line of columns; a semicircular apse in the wall facing Jerusalem; and perhaps an atrium and porch, or narthex. A very grand synagogue might have a mosaic floor.

A fragment of a mosaic floor from a sixth-century synagogue at the site of ancient Menois (present-day Maon) features traditional Jewish symbols along with a variety of stylized plants, birds, and animals (FIG. 7–5). Two lions of Judah flank a menorah. Beneath it is the ram's horn (*shofar*), blown on ceremonial occasions, and three citrons (*etrogs*) used to celebrate the harvest festival of Sukkot. Other Sukkot emblems—including palm trees and the *lulav*, a sheaf of palm, myrtle, and willow branches, and an *etrog*—symbolize the bounty of the earth and unity of all Jews. The variety of

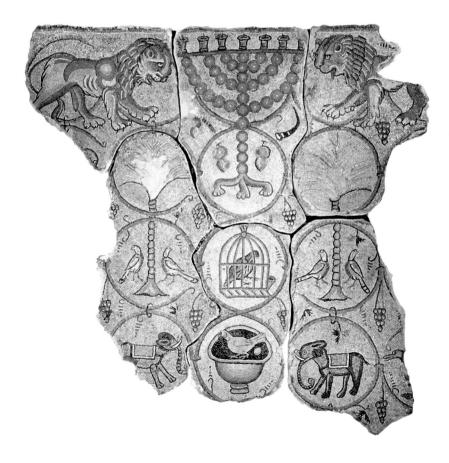

7−5 | **SYNAGOGUE FLOOR**Maon (ancient Menois). c. 530. Mosaic.
The Israel Museum, Jerusalem.

Myth and Religion

CHRISTIAN SYMBOLS

ymbols have always played an integral role in Christian art. Some were devised just for Christianity, but most were borrowed from pagan and Jewish traditions and adopted for Christian use. The Old Testament dove is a symbol of purity, representing peace when it is shown bearing an olive branch. In Christian art, a white dove is the symbolic embodiment of the Holy Spirit. The fish was one of the earliest symbols for Jesus Christ. The first letters of Jesus Christ, Son of God, Savior, spelled "fish" in Greek. Because of its association with baptism in water, it came to stand for all Christians. The lamb, an ancient sacrificial animal, symbolizes Jesus's sacrifice on the Cross as the Lamb of God. A flock of sheep represents the apostles-or all Christians-cared for by their Good Shepherd, Jesus Christ. The Evangelists, who were believed to have written the New Testament Gospels, are traditionally associated with the following creatures: Saint Matthew, a man (or angel); Saint Mark, a lion; Saint Luke, an ox; and Saint John, an eagle.

THE CROSS. The primary Christian emblem, the cross, symbolizes the suffering and triumph of Jesus's Crucifixion and Resurrection. It also stands for Jesus Christ himself, as well as the Christian religion as a whole. Crosses have taken various forms; the two most common are the Latin cross and the Greek cross.

MONOGRAMS. Alpha (the first letter of the Greek alphabet) and omega (the last) signify God as the beginning and end of all things. This symbolic device was popular from Early Christian times through the Middle Ages. The initials I and X are the first letters of Jesus and Christ in Greek. The Greek letters XP, known as the *chi rho*, were the first two letters of the word Christos. These emblems are sometimes enclosed by a halo or wreath of victory.

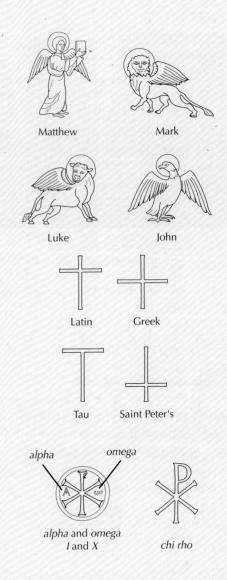

placid animals may represent the universal peace prophesied by Isaiah (11:6–9; 65:25). The pairing of images around a central element—as in the birds flanking the palm trees or the lions facing the menorah—is characteristic of Near Eastern art.

Early Christian Art

Christians believe in one God manifest in three persons: the Trinity of Father (God), Son (Jesus Christ), and Holy Spirit. According to Christian belief, Jesus was the Son of God by a human mother, the Virgin Mary. At the age of 30, Jesus gathered a group of disciples, male and female, and began to preach love and charity, a personal relationship with God, the forgiveness of sins, and the promise of life after death. After his ministry on earth, he was crucified (and after three days he rose from the dead). The core of Christian belief was formalized at the first ecumenical council of the Christian Church, called by Constantine I at Nicaea (present-day Iznik, Turkey) in 325.

THE CHRISTIAN BIBLE. The Christian Bible has two parts: the Old Testament (the Hebrew Scriptures), and the New Testament. The life and teachings of Jesus of Nazareth were recorded between about 70 and 100 CE in the New Testament books attributed to the Four Evangelists: Matthew, Mark, Luke, and John, the order arranged by Saint Jerome, an early Church father who made a translation of the books into Latin. They are known as the Gospels (from an Old English translation of a Latin word derived from the Greek *evangelion*, meaning "good news").

In addition to the Gospels, the New Testament includes an account of the Acts of the Apostles and the epistles, twenty-one letters of advice and encouragement to Christian communities in cities and towns in Greece, Asia Minor, and other parts of the Roman Empire. Thirteen of these letters are attributed to a Jewish convert, Saul, who took the Christian name Paul. The final book is the Apocalypse (the Revelation), a series of enigmatic visions and prophecies concern-

ing the eventual triumph of God at the end of the world, written about 95 CE.

THE EARLY CHURCH. Jesus limited his ministry primarily to Jews; the twelve apostles, as well as followers such as Paul, then took his teachings to non-Jews. Despite sporadic persecutions, Christianity persisted and spread throughout the Roman Empire. The government formally recognized the religion in 313 CE, and Christianity grew rapidly during the fourth century. As well-educated, upper-class Romans joined the Christian Church, they established an increasingly elaborate organizational structure along with ever more sophisticated doctrine.

Christian communities were organized by geographical units, called *dioceses*, along the lines of Roman provincial governments. Senior church officials called *bishops* served as governors of dioceses made up of smaller units, *parishes*, headed by priests. A bishop's church is a *cathedral*, a word derived from the Latin *cathedra*, which means "chair" but took on the meaning "bishop's throne." The bishop of Rome eventually became head of the Western church, with the title *pope*. The bishop of Constantinople became the head, or *patriarch*, of the Eastern church.

In spite of tensions between East and West, the Church remained united until 1054, when the Western pope and Eastern patriarch declared one another to be in error. The Church split in two, with the pope becoming the supreme authority in the Western or Catholic church, and the patriarch, with his metropolitans (equivalent to archbishops), governing the Eastern or Orthodox church.

Communal Christian worship focused on the central "mystery," or miracle, of the Incarnation of Jesus Christ and the promise of salvation. At its core was the ritual consumption of bread and wine, identified as the Body and Blood of Christ, which Jesus Christ had inaugurated at the Last Supper, a Passover meal with his disciples. Around these acts developed an elaborate religious ceremony, or *liturgy*, called the Eucharist (also known as Holy Communion or the Mass). Christians adopted the grapevine and grape cluster of the Roman god Bacchus to symbolize the wine of the Eucharist, and the Blood of Christ (see "Christian Symbols," page 238).

CATACOMB PAINTINGS. Christian rites prompted the development of special buildings—churches and baptistries—as well as specialized equipment. Christians began to use the visual arts to instruct worshipers as well as to glorify God. Almost no examples of specifically Christian art exist before the early third century, and even then it drew its styles and imagery from Jewish and classical traditions.

In this process, known as **syncretism**, artists assimilate images from other traditions and give them new meanings. The borrowings can be unconscious or quite deliberate. For example, **orant** figures—worshipers with arms outstretched—can be pagan, Jewish, or Christian, depending on the context in which they occur. Perhaps the most important

Sequencing Works of Art

244-45	Wall with Torah niche, from a house- synagogue, Dura-Europos
c. 270	Sarcophagus from Santa Maria Antiqua
Late 300s	Cubiculum of Leonis, Catacomb of Commodilla
c. 422-32	Church of Santa Sabina
c. 530	Synagogue floor, Maon

6 Good Shepher

of these syncretic images is the Good Shepherd. In pagan art, he was Apollo, or Hermes the shepherd, or Orpheus among the animals. He became the Good Shepherd of the Psalms and Gospels to the Jews and Christians.

Christians, like Jews, used catacombs for burials and funeral services even before Constantine I granted their religion official recognition. In the Christian Catacomb of Commodilla, dating from the fourth century, long rectangular niches in the walls, called *loculi*, each held two or three bodies. Affluent families created small rooms, or *cubicula*, off the main passages to house sarcophagi (SEE FIG. 7–1). The cubicula were hewn out of tufa, soft volcanic rock, then plastered and painted with imagery related to their owners' religious beliefs. The finest Early Christian catacomb paintings resemble murals in houses such as those preserved at Rome and Pompeii (SEE FIGS. 6–34, 6–35). However, the aesthetic quality of the paintings is secondary to the message they convey.

One fourth-century Roman catacomb contained remains, or relics, of Saints Peter and Marcellinus, two third-century Christians martyred for their faith. Here, the ceiling of a cubiculum is partitioned by a central **medallion**, or round ornament, and four **lunettes**, semicircular wall areas framed by an arch (FIG. 7–6). At the center is a Good

7–6 | **GOOD SHEPHERD, ORANTS, AND STORY OF JONAH** Painted ceiling of the Catacomb of Saints Peter and Marcellinus, Rome. Late 3rd-early 4th century.

Shepherd, whose pose has roots in classical sculpture. In its new context, the image was a reminder of Jesus's promise "I am the good shepherd. A good shepherd lays down his life for the sheep" (John 10:11), as well as the Good Shepherd of the Psalms (Psalm 23:1).

The semicircular compartments at the ends of the arms of the cross tell the Old Testament story of Jonah and the sea monster (Jonah 1–2), in which God caused Jonah to be thrown overboard, swallowed by a monster, and released, repentant and unscathed, three days later. Christians reinterpreted this story as a parable of Christ's death and resurrection—and hence of the everlasting life awaiting true believers—and it was a popular subject in Christian catacombs. On the left, Jonah is thrown from the boat; on the right, the monster spits him up; and at the center, Jonah

reclines in the shade of a vine, a symbol of Paradise. Orant figures stand between the lunettes.

Sculpture. Sculpture that is clearly Christian from before the time of Constantine is even rarer than painting. What there is consists mainly of sarcophagi and small statues and reliefs, many of them Good Shepherd images. A remarkable set of small marble figures, probably made in the third century in Asia Minor, depicts the Good Shepherd (FIG. 7–7). Because it was found with sculptures depicting Jonah, it is probably from a Christian home.

Large workshops devoted to carving tomb chests existed in most urban centers. The sculptors worked on special orders and also kept a supply of finished sarcophagi carved with subjects suitable for a variety of beliefs (FIG. 7–8). Figures of the

7–7 | THE GOOD SHEPHERD Eastern Mediterranean, probably Anatolia (Turkey). Second half of the 3rd century. Marble, height 19¾" (50.2 cm), width 16" (15.9 cm). The Cleveland Museum of Art. John L. Severance Fund, 1965.241

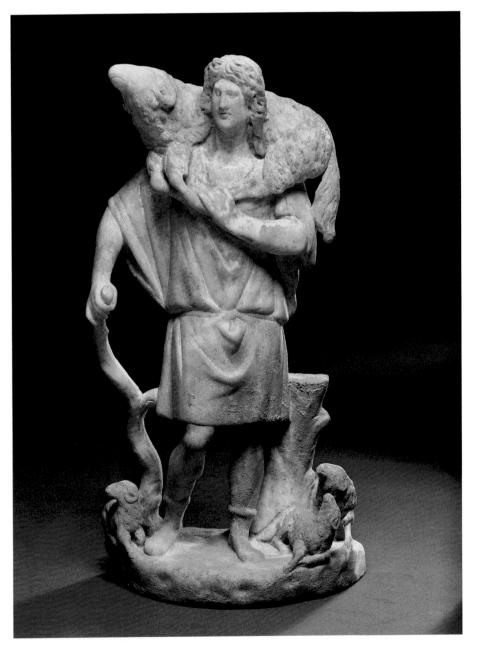

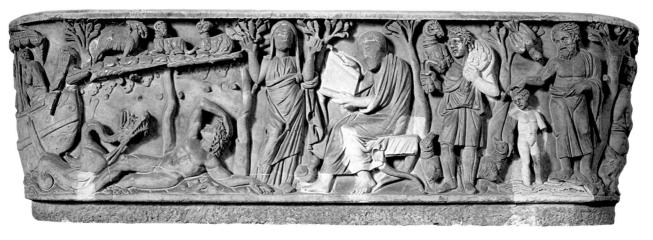

7-8 | SARCOPHAGUS OF THE CHURCH OF SANTA MARIA ANTIQUA Rome. c. 270. Marble. $1'11/4'' \times 7'2''$ (5.45 \times 2.2 m).

deceased needed only to have the individual face carved to complete the work. On the sarcophagus found in the Roman Church of Santa Maria Antiqua the natural poses of the figures, the solid modeling of the figures, and the revealing drapery all indicate the sculpture's classical roots.

The subject of the sculpture would be appropriate for either a pagan or Christian family. In the center stands a figure with hands raised in the age-old gesture of prayer. At one side a bearded man reads a scroll (a teacher or philosopher), a shepherd brings in a sheep, and an older man places his hand on the head of a youth who stands in a river. On the other side, a youth, menaced by a monster, lies under an arbor in the standard classical pose of sleep. Three sheep fill out the landscape, and a ship sails off at the far left. Nothing represented here could offend pagan sensibilities. But to the informed Christian, the orant is the Christian soul, the seated man is the teaching Christ, followed by Christ the Good Shepherd and a scene of baptism. The sleeping youth is Jonah, resting after his ordeal, and the monster is in the classical form of a dog-headed serpent.

HOUSE-CHURCHES. At first, Christians, like Jews, gathered in the homes of members of the community. In Dura-Europus, a house-church stands only about 300 yards from the house-synagogue (SEE FIG. 7–3). The building was a typical Roman house, with rooms around a courtyard and a second-floor apartment for the owner. A small red cross painted above the main entrance alerted Christians that the building was a gathering place. Two of the five ground-floor rooms—a large assembly hall and a room with a water tank—were adapted for Christian use.

The water tank indicates a baptistry, a special place for the baptismal rite. (Baptism washes away sin, leaving the initiate reborn as a member of the community of the faithful.) One end of the room had a niche equipped with a water basin, above which were images of the Good Shepherd and of Adam and Eve (FIG. 7–9). These murals reminded new Christians that humanity fell from grace when the first man and woman disobeyed God and ate fruit from the tree of knowledge, but the Good Shepherd (Jesus Christ) came to earth to carry his sheep (Christians) to salvation and eternal life.

7–9 MODEL OF WALLS AND BAPTISMAL FONT
Baptistry of a Christian house-church, Dura-Europos, Syria.
c. 240, destroyed 256. Dura-Europos Collection.
Yale University Art Gallery, New Haven, Connecticut.

Elements of Architecture

BASILICA-PLAN AND CENTRAL-PLAN CHURCHES

he forms of early Christian buildings were based on two classical prototypes: rectangular Roman basilicas (SEE FIG. 6-48) and round-domed structures—rotundas—such as the Pantheon (SEE FIGS. 6-52, 6-53).

As in Old Saint Peter's in Rome (SEE FIG. 7–10), basilica-plan churches are characterized by a forecourt, the **atrium**, leading to a porch, the **narthex**, which spans one of the building's short ends. Doorways—known collectively as the church's **portal**—lead from the narthex into the **nave**. Rows of columns separate the high-ceilinged nave from the **aisles** on either side. The nave is lit by windows of the **clerestory**, which rises above the side aisles' roofs. At the opposite end of the nave from the narthex is a semicircular **apse**. The apse functions as the building's focal point, where the altar, raised on a platform, is located. Sometimes there is also a **transept**, a wing that crosses the nave in front of the

apse, making the building T-shaped (SEE FIG. 7-10); this is known as the *tau* plan. When additional space (a choir) comes between the transept and the apse, the plan is known as a Latin cross.

Central-plan buildings were first used by Christians as tombs, baptism centers, and shrines to martyrs. The Greek-cross plan, in which two similarly sized "arms" intersect at their centers, is a type of central plan (FIG. 7-44). Like basilicas, central-plan churches generally have an atrium, a narthex, and an apse. But instead of the longitudinal axis of basilica-plan churches, which draws worshipers forward toward the apse, central-plan churches such as Ravenna's San Vitale (SEE FIGS. 7-28, 7-29) have a more vertical axis. This makes worshipers focus on the dome, the symbolic "vault of heaven." The space where the liturgy is performed, containing the central dome, sanctuary, and apse, is called the naos.

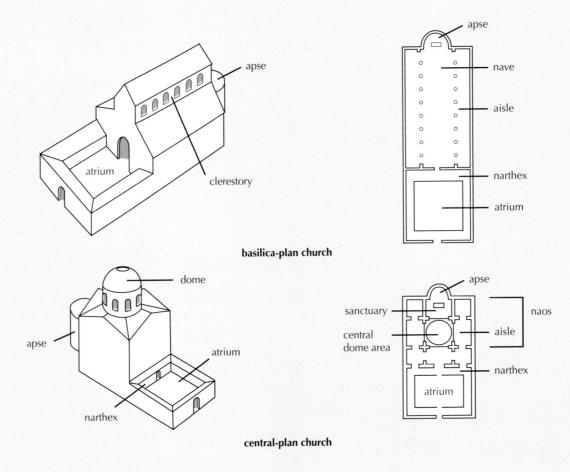

IMPERIAL CHRISTIAN ARCHITECTURE AND ART

In 313, Constantine I issued the Edict of Milan, granting all people in the Roman Empire freedom to worship whatever god they wished. This religious toleration, combined with Constantine's active support, allowed Christianity to enter a

new phase. In the fourth and fifth centuries, a sophisticated philosophical and ethical system developed, using many ideas from Greek and Roman thought. Church scholars edited and commented on the Bible, and the papal secretary who would become Saint Jerome (c. 347–420) undertook a new translation from Hebrew and Greek versions into Latin, the language of the Western church.

rch.

Completed about 404, this so-called Vulgate became the official version of the Bible. (The term *Vulgate* has the same root as the word *vulgat*, the Latin *vularis*, meaning "common" or "popular.") Christians also gained political influence in this period. The Christian writer Lactantius, for example, tutored Constantine I's son. Eusebius, bishop of Caesarea, was a trusted imperial adviser from about 315 to 339. These transformations in the philosophical and political arenas coincided with a dramatic increase in the size and splendor of Christian architecture.

Architecture: The Church and Its Decoration

The Christian community had special architectural needs. A Greek or Roman temple served as the house and treasury of the god and formed a backdrop for ceremonies that took place at altars in the open air. In Christianity, as in some of the Mystery religions (SEE FIG. 6–27), the entire community gathered inside the building to participate in the rites. Christians also needed places or buildings for activities such as education, the initiation of new members, private prayer, and burials. The pagan basilica provided a model for the congregational church and the tholos tomb provided a model for the baptistry and martyr's shrine.

THE BASILICA CHURCH. Christian congregations needed large, well-lit spaces for worship, and the Roman basilica provided a perfect model (see "Basilica-Plan and Central-Plan Churches," page 242). But rather than an entrance through

the long side of the building into a columnar hall, with an apse at each end (see the basilica Ulpia, FIG. 6–48), the early Christian basilica had its entrance from an atrium on the short side of the building and a single apse at the opposite end, like the contemporary secular hall in Trier (SEE FIG. 6–71). The place where the altar stood was the place that in a pagan basilica was reserved for the judge or presiding official. The nave with aisles on the two long sides created an ample central space for processions and a place for the congregation. If the clergy needed to partition space, they used screens or curtains around the altar or in the side aisles.

In Rome, Constantine and his family sponsored a vast building program for the Church. For the bishop of Rome (the pope), Constantine built a residence on the site of the imperial Lateran palace as well as a baptistry and a basilican church. The Church of Saint John Lateran remains the cathedral of Rome to this day, although the pope's residence has been the Vatican since the thirteenth century. Perhaps as early as 320, the emperor also ordered the construction of a large new basilica to replace the humble monument marking the place where Christians believed Saint Peter was buried (c. 64 CE).

OLD SAINT PETER'S CHURCH. The new basilica—now known as Old Saint Peter's because it was replaced by a new building in the sixteenth century—would protect the tomb of Peter, and make the site accessible to the faithful (FIG. 7–10). Our knowledge of Old Saint Peter's is based on written descriptions, drawings made before and while it was

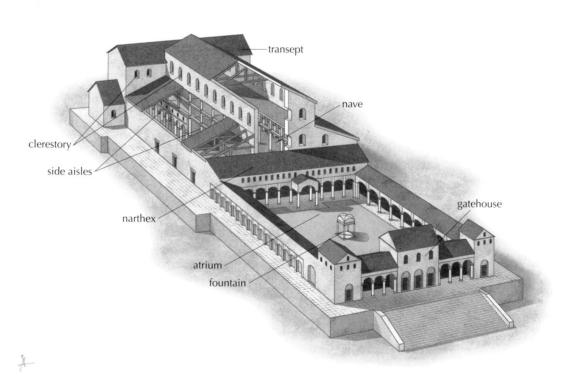

7-IO RECONSTRUCTION DRAWING OF OLD SAINT PETER'S BASILICA

Rome. c. 320-27; atrium added in later 4th century. Approx. 394' (120 m) long and 210' (64 m) wide.

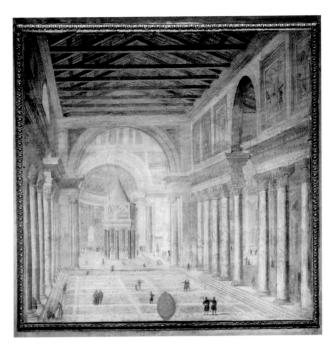

7—II OLD ST. PETER'S, PAINTING OF THE INTERIOR Painting in San Martino ai Monte, Rome. 16th century.

being dismantled, the study of other churches inspired by it, and modern archaeological excavations at the site (FIG. 7–11).

Old Saint Peter's was an unusual basilica church in having double side aisles instead of one aisle on each side of the nave. A narthex across the width of the building provided a place for people who had not yet been baptized. Five doorways—a large, central portal into the nave and two portals on each side—gave access to the church. Columns supporting an entablature lined the nave, forming what is called a nave colonnade. However, the columns dividing the double side aisles supported round arches. In turn, these arches carried the open wood rafters roofing the

nave and aisles. Sarcophagi and tombs also lined the side aisles.

Constantine's architects devised a new element for the basilica plan. At the apse end of the nave, they added a **transept**, a large hall that crossed in front of the apse. It created a T form that anticipated the later Latin-cross church plan, seen in the reconstruction in FIGURE 7–10. This area provided additional space for the large number of clergy serving the church, and it also accommodated pilgrims visiting the tomb of Saint Peter. Transept windows lit the high altar directly.

Saint Peter's bones supposedly lie below the altar, marked by a permanent, pavilionlike structure supported on four columns, called a *ciborium*. A Roman cemetery, partly destroyed and covered by the foundations of Constantine's basilica, lay beneath the church. Eventually a large *crypt*, or underground vault, giving access to the tomb of Peter and providing additional space for important burials, was built on the site. It is still used today for the burial of the popes.

Old Saint Peter's thus served a variety of functions. It was a burial site, a pilgrimage shrine commemorating Peter's martyrdom and containing his relics, and a congregational church. It could hold at least 14,000 worshipers, and it remained the largest Christian church until the eleventh century.

SANTA SABINA. Most early Christian churches have been rebuilt, some many times, but the Church of Santa Sabina in Rome, constructed by Bishop Peter of Ilyria between 422 and 432, appears much as it did in the fifth century (FIG. 7–12). The basic elements of the basilica church are clearly visible inside and out: a nave lit by clerestory windows, flanked by side aisles, and ending in a rounded apse. (Compare the Audience Hall at Trier; SEE FIG. 6–71.)

Santa Sabina's exterior is the typical simple brickwork. In contrast, the church's interior displays a wealth of marble

7—12 CHURCH OF SANTA SABINA
Rome. Exterior view from the Southeast.
c. 422–32.

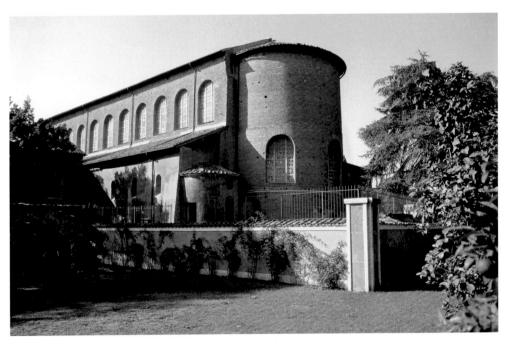

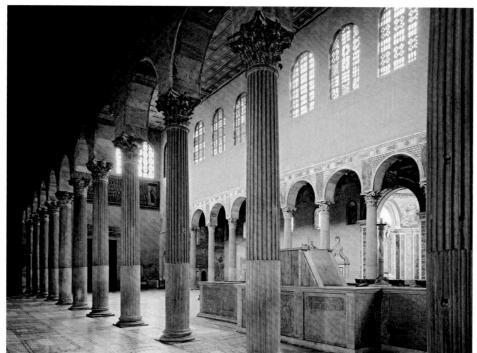

7—13 | INTERIOR, CHURCH OF SANTA SABINA
View from the south aisle near the sanctuary to the entrance.

nove areade

c. 422-32.

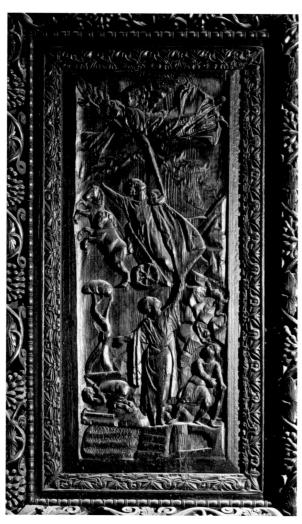

7-I4 | THE ASCENSION OF ELIJAH
Panel from the doors of the Church of Santa Sabina.
420s. Cypress wood.

veneer and twenty-four fluted marble columns with Corinthian capitals acquired from a second-century building (FIG. 7–13). (Material reused from earlier buildings is known as *spolia*, Latin for "spoils.") The columns support round arches, creating a <u>nave arcade</u>, in contrast to the nave colonnade in Saint Peter's. The spandrels are inlaid with marble images of the *chalice* (the wine cup) and *paten* (the plate that holds the bread)—the essential equipment for the Eucharistic rite that took place at the altar. The blind wall between the arcade and the clerestory typically had paintings or mosaics with scenes from the Old Testament or the Gospels. The decoration of the upper walls is lost, and a paneled ceiling covers the rafter roof.

Sheltered by the narthex, the principal entrance to the church still has its fifth-century wooden doors (FIG. 7–14), which were in place for the consecration of the church by Pope Sixtus III (432–40 CE). Framed panels are carved with scenes from the Old and New Testaments. Only eighteen out of twenty-eight panels survive, making any analysis of the iconography highly speculative, but some relationship between Old and New Testament themes seems to have been intended. The Ascension of Elijah (2 Kings 2:11) could have been related to the Ascension of Christ, for example. The prophet soars upward in the chariot of fire sent for him by God and guided by an angel, to the amazement of his followers. An angel with a long wand guides his ascent.

SANTA MARIA MAGGIORE. Another kind of decoration, mosaic panels, still survives in the Church of Santa Maria Maggiore, which was built between 432 and 440. The church was the first to be dedicated to the Virgin Mary after the Council of Ephesus in 431 declared her to be Theotokos,

"Bearer of God." The mosaics of the Church of Santa Maria Maggiore reflect a renewed interest in the earlier classical style of Roman art that arose during the reign of Pope Sixtus III. The mosaics along the nave walls, in framed panels high above the worshipers, illustrate Old Testament stories of the Jewish patriarchs and heroes—Abraham, Jacob, Moses, and Joshua—whom Christians believe foretold the coming of Christ and his activities on earth. These panels were not simply intended to instruct the congregation. Instead, as with most of the decorations in great Christian churches from this time forward, they were also meant to praise God through their splendor, to make churches symbolic embodiments of the Heavenly Jerusalem that awaits believers in the afterlife.

Some of the most effective compositions are those in which a few large figures dominate the space, as in the PART-ING OF LOT AND ABRAHAM (FIG. 7–15), a story told in the first book of the Old Testament (Genesis 13:1–12). The people of Abraham and his nephew Lot, dwelling together, had grown too numerous, so the two agreed to separate and lead their followers in different directions. On the right, Lot and his daughters turn toward the land of Jordan, while Abraham and his wife stay in the land of Canaan. Abraham was the founder of Israel and an ancestor of Jesus. (Judaism, Christianity, and Islam are sometimes referred to as Abrahamic religions.)

The toga-clad men share a parting look as they gather their robes about them and turn decisively away from each other. The space between them in the center of the composition emphasizes their irreversible decision to part. Clusters of heads in the background represent their followers, an artistic convention used effectively here. The earlier Roman realistic style can be seen in the solid three-dimensional rendering of foreground figures, the hint of perspective in the building, and the landscape setting, with its flocks of sheep, bits of foliage, and touches of blue sky. To Roman stone and marble mosaics, Christian artists added tesserae of colored glass and clear glass in which gold leaf was embedded. The use of graduated colors creates shading from light to dark, producing three-dimensional effects that are offset by strong outlines. These outlines, coupled with the sheen of the gold tesserae, tend to flatten the forms and emphasize a quality of otherworldly splendor.

SANTA COSTANZA. A second type of ancient building—the *tholos*, a round structure with a central plan and vertical axis—also served Christian builders as a model for tombs, martyrs' churches, and baptistries (see "Basilica-Plan and Central-Plan Churches," page 242). One of the earliest surviving central-plan Christian buildings is the mausoleum of Constantina, the daughter of Constantine. The tomb was built outside the walls of Rome just before 350 (FIG. 7–16). The mausoleum was consecrated as a church in 1256 and is now dedicated to Santa Costanza (the Italian form of Constantina). The building consists of a tall rotunda with an

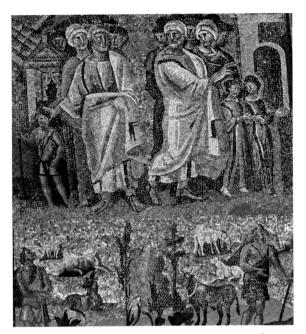

7–15 | PARTING OF LOT AND ABRAHAM

Mosaic in the nave arcade of the Church of Santa Maria Maggiore, Rome. 432–40. Panel approx. 4'11" × 6'8" (1.2 × 2 m).

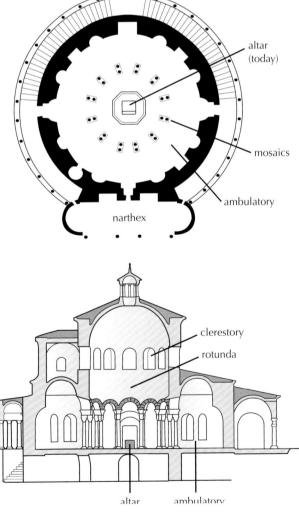

7-16 | plan and section, church of Santa Costanza Rome. c. 350.

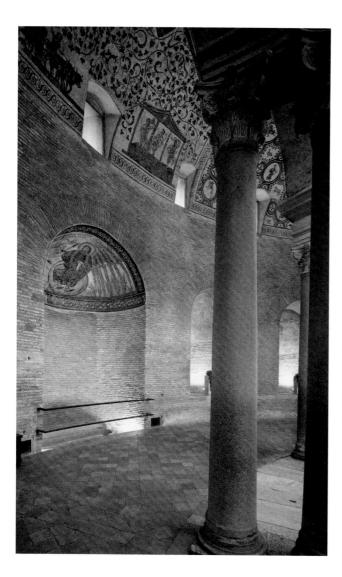

encircling barrel-vaulted passageway called an ambulatory (FIG. 7-17). A double ring of paired columns with Composite capitals and richly molded entablature blocks supports the arcade and dome. Originally, the interior was entirely sheathed in mosaics and fine marble.

Mosaics in the ambulatory vault recall the syncretic images in the catacombs. One section, for example, is covered

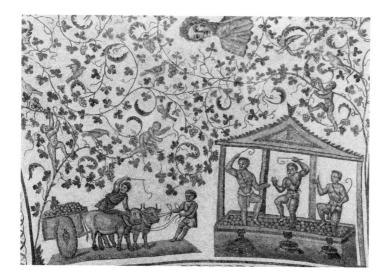

7-17 CHURCH OF SANTA COSTANZA

Rome. c. 350. Ambulatory with harvesting mosaic (see Fig. 7-18). Niche at left with mosaic of Christ. In the apse, the Lord handing over the tablets of the law to Moses (mosaic, later 4th century). Canali Photobank, Capriolo (BS)

with a tangle of grapevines filled with putti-naked male child-angels, or cherubs, derived from classical art—who vie with the birds to harvest the grapes (FIG. 7-18). Along the bottom edges on each side, putti drive wagonloads of grapes toward pavilions housing large vats in which more putti trample the grapes into juice. The technique, subject, and style are Roman, but the meaning has been altered. The scene would have been familiar to the pagan followers of Bacchus, but in a Christian context, the grape juice becomes the wine of the Eucharist. Constantina's pagan husband, however, may have appreciated the double allusion. Nel 556/250

Architecture: Ravenna

As Rome's political importance dwindled, that of the northern Italian cities of Milan and Ravenna grew. In 395, Emperor Theodosius I split the Roman Empire into eastern and western divisions, each ruled by one of his sons. Heading the Western Roman Empire, Honorius (ruled 395-423) first established his capital at Milan. When Germanic settlers laid siege to Milan in 402, Honorius moved his government to Ravenna on the east coast. Its naval base, Classis (present-day Classe), had been important since the early days of the empire. In addition to military security, Ravenna offered direct access by sea to Constantinople. Ravenna flourished, and when Italy fell in 476 to the Ostrogoths, the city became one of their headquarters. It still contains a remarkable group of well-preserved fifth- and sixth-century buildings.

THE MAUSOLEUM OF GALLA PLACIDIA. One of the earliest * surviving Christian structures in Ravenna is a funerary chapel that was once attached to the narthex of the church of the imperial palace (now Santa Croce, meaning "Holy Cross"). Built about 425-26, the chapel was constructed when

7-18 HARVESTING OF GRAPES Ambulatory vault, Church of Santa Costanza, Rome. c. 350. Mosaic.

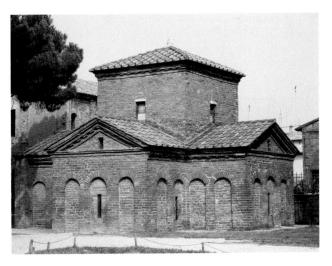

7–19 MAUSOLEUM OF GALLA PLACIDIA Ravenna. c. 425–26.

Honorius's half-sister, Galla Placidia, ruled the West (425–c. 440) as regent for her son. The chapel came to be called the **MAUSOLEUM OF GALLA PLACIDIA** because she and her family were once believed to be buried there (FIG. 7–19).

This small building is **cruciform**, or cross-shaped; a barrel vault covers each of its arms, and a **pendentive dome**—a dome continuous with its pendentives—covers the space at the intersection of the arms (see "Pendentives and Squinches," page 257). The interior of the chapel contrasts markedly with the unadorned exterior, a transition designed to simulate the passage from the real world into a supernatural one (FIG. 7–20). The worshiper looking from the western entrance across to the eastern bay of the chapel sees a brilliant, abstract pattern of mosaic that suggests a starry sky filling the barrel vault. Panels of veined marble sheathe the walls below. Bands of luxuriant foliage and floral designs derived from funerary garlands cover the four central arches, and the walls above them are filled with the figures of standing apostles, gesturing like orators. Doves flanking a small fountain between the apostles symbolize eternal life in heaven.

In the lunette below, a mosaic depicts the third-century martyrdom of Saint Lawrence, to whom the building may have been dedicated. The saint holds a cross and gestures toward the fire and metal grill on which he was literally roasted (thereby becoming the patron saint of bakers). At the left stands a tall cabinet containing the Gospels, signifying the faith for which he died (see a detail showing the contents of the cabinet in "Early Forms of the Book," page 251).

Opposite Saint Lawrence, in a lunette over the entrance portal, is a mosaic of the Good Shepherd (FIG. 7–21). A comparison of this version with a fourth-century depiction of the

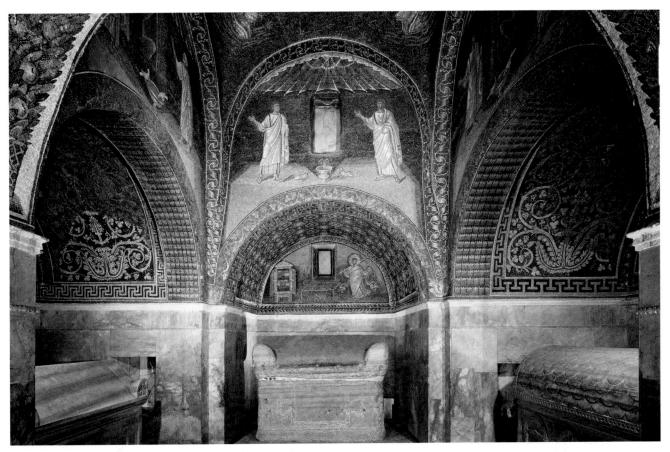

7–20 | MAUSOLEUM OF GALLA PLACIDIA

Ravenna. View from entrance, barrel-vaulted arms housing sarchophagi, lunette mosaic of the Martyrdom of Saint Lawrence. c. 425–26.

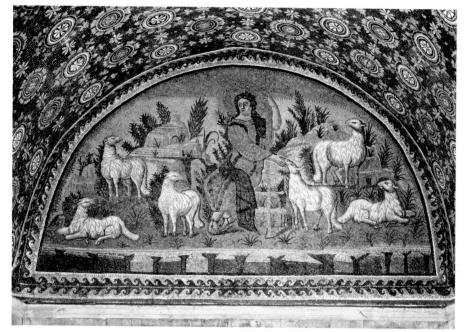

7-21 GOOD SHEPHERD Lunette over the entrance, Mausoleum of Galla Placidia. c 425-26. Mosaic.

tallan.

dong there yers

**same subject (SEE FIG. 7–6) reveals significant changes in content and design. The Ravenna mosaic contains many familiar classical elements, such as shading suggesting a single light source acting on solid forms, cast shadows, and a hint of land-scape in rocks and foliage. The conception of Jesus the Shepherd, however, has changed.

In the fourth-century painting, he was a simple shepherd boy carrying an animal on his shoulders. In the Ravenna mosaic, he is a young adult with a golden halo, wearing imperial robes of gold and purple and holding a long golden staff that ends in a cross instead of a shepherd's crook. The stylized elements of a natural landscape are arranged more rigidly than before. Individual plants at regular intervals fill the spaces between animals, and the rocks are stepped back into a shallow space that rises from the foreground plane and ends in foliage. The rocky band at the bottom of the lunette scene, resembling a cliff face riddled with clefts, separates the divine image from worshipers.

BAPTISTRY OF THE ORTHODOX. Just as the political role of Ravenna changed in the fourth and fifth centuries, so did the religious beliefs of its leaders. The early Christian Church faced many philosophical and doctrinal controversies, some of which resulted in serious splits, called *schisms*, within the Church. When this happened, Church leaders gathered in councils to decide on the orthodox, or official, position, while denouncing other positions as heretical. For example, they rejected Arianism, an early form of Christianity that questioned the doctrine of the Trinity and held that Jesus was not fully divine. The first church council, called by Constantine at Nicaea in 325, made the doctrine of the Trinity the official Christian belief. In 451, the Council of Chalcedon.

near Constantinople, declared Jesus to be of two natures—human and divine—united in one.

In Ravenna, two baptistries, orthodox and Arian, still stand as witness to these disputes. The Baptistry of the Orthodox, constructed next to the cathedral of Ravenna in the early fourth century, is the more splendid of the two. It was renovated and refurbished between 450 and 460 when the original wooden ceiling was replaced with a dome and splendid interior decoration added in marble, stucco, and mosaic (FIG. 7–22). On the clerestory level, a blind arcade frames figures of Old Testament prophets in stucco relief. This arcading suggests that the domed ceiling is a huge canopy tethered to the columns.

In the dome itself, concentric rings of decoration draw the eye upward to a central image: the baptism of Jesus by John the Baptist. The lowest ring depicts fantastic architecture, similar to that seen in ancient secular wall painting. Eight circular niches contain alternating altars holding gospel books and empty thrones that symbolize Christ's Second Coming (Matthew 25:31-36). In the next ring, toga-clad apostles stand holding crowns, the rewards of martyrdom. Stylized golden plant forms divide the deep blue ground between them. Although the figures cast dark shadows on the pale green grass, their cloudlike robes, shot through with golden rays, give them an otherworldly presence. The landscape setting of the Baptism of Jesus in the central tondo—a circular image—exhibits classical roots, and the personification of the Jordan River recalls pagan imagery. The background, however, is not the blue of the earthly sky but the gold of paradise. Already in the mid-fifth century, artists working for the Christian Church had begun to reinterpret and transform Roman realism into an abstract style better suited to their patrons' spiritual goals.

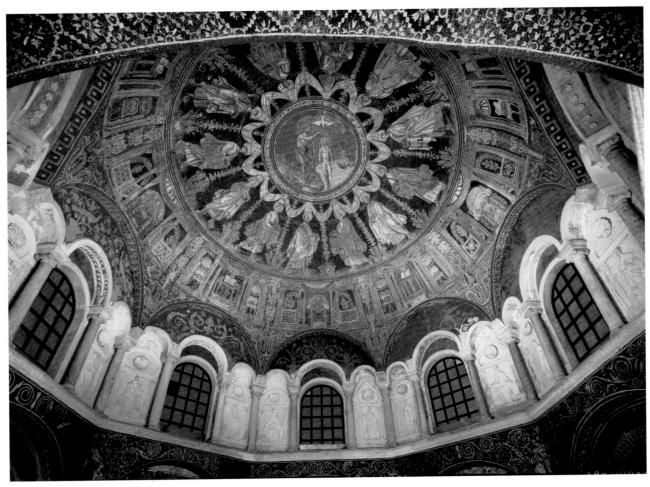

7–22 CLERESTORY AND DOME BAPTISM OF CHRIST AND PROCESSION OF APOSTLES, GOSPELS AND THRONES, THE PROPHETS. BAPTISTRY OF THE ORTHODOX Ravenna. Italy. Early 5th century; dome remodeled c. 450–60.

Sculpture

In sculpture, as in architecture, Christians adapted Roman forms for their own needs, especially monumental stone sarcophagi such as the elaborately carved **SARCOPHAGUS OF JUNIUS BASSUS** (FIG. 7–23), as imposing as the pagan Roman Battle Sacarphogus (SEE FIG. 6–69). Junius Bassus was a Roman official who, as the inscription here tells us, was "newly baptized" and died on August 25, 359, at the age of 42. On the front panel, columns, entablatures, and gables divide the space into individual scenes. Details of architecture, furniture, and foliage suggest the earthly setting for each scene.

In the center of both registers, columns carved with putti producing wine frame the triumphal Christ. In the upper register, he appears as a teacher-philosopher flanked by Saints Peter and Paul. In a reference to the pagan past, Christ rests his feet on the head of Aeolus, the classical god of the winds, who also represents the Cosmos (shown with a veil billowing behind him). To Christians, Aeolus personified the

skies, so that Christ is meant to be seen as seated in heaven. He is giving the Christian law to his disciples, imitating the Hebrew Scriptures' account of God dispensing the Law to Moses. In the bottom register, the earthly Jesus makes his triumphal entry into Jerusalem like a Roman emperor entering a conquered city. However, he rides on a humble animal.

The earliest Christian art, such as that in catacomb paintings and on the *Sarcophagus of Junius Bassus*, unites the imagery of Old and New Testaments in elaborate allegories; Old Testament themes foreshadow and illuminate events in the New Testament. On the top left, Abraham passes the test of faith and need not sacrifice his son Isaac. Christians saw in this story a sign of God's sacrifice of his son, Jesus, on the cross. Under the triangular gable on the lower right, the Old Testament story of Daniel saved by God from the lions prefigures Christ's Resurrection. The figure of Daniel has been replaced. Originally nude, he balanced the nude Adam and Eve. In the lower left frame on the far left, God tests the faith of Job, who provides a model for the sufferings of Christian

Art in Its Context

EARLY FORMS OF THE BOOK

ince people began to write some 5,000 years ago, they have kept records on a variety of materials, including clay or wax tablets, pieces of broken pottery, papyrus, animal skins, and paper. Books have taken two forms: scroll and codex.

Scribes made **scrolls** from sheets of papyrus glued end to end or from thin sheets of cleaned, scraped, and trimmed sheep- or calfskin, a material known as **parchment** or, when softer and lighter, **vellum**. Each end of the scroll was attached to a rod; the reader slowly unfurled the scroll from one rod to the other. Scrolls could be written to be read either horizontally or vertically.

At the end of the first century CE, the more practical and manageable **codex** (plural, *codices*)—sheets bound together like the modern book—replaced the scroll. The basic unit of the codex was the eight-leaf **quire**, made by folding a large sheet of parchment twice, cutting the edges free, then sewing the sheets together up the center. Heavy covers kept the sheets of a codex flat.

Until the invention of printing in the fifteenth century, all books were manuscripts—that is, written by hand. Manuscripts often included illustrations, called **miniatures**, from *minium*, the Latin word for a reddish lead pigment. Manuscripts decorated with gold and colors were said to be **illuminated**.

The thickness and weight of parchment and vellum made it impractical to produce a very large manuscript, such as an entire Bible, in a single volume. As a result, individual sections were made into separate books. These weighty tomes were stored flat on shelves in cabinets like the one holding the Gospels shown here and visible in the mosaic of Saint Lawrence in the Mausoleum of Galla Placidia.

BOOKCASE WITH THE GOSPELS IN CODEX FORM Detail of a mosaic in the eastern lunette, *Mausoleum of Galla Placidia*, Ravenna (FIG. 7-20).

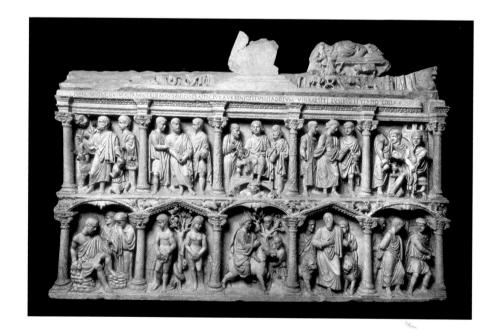

7–23 | SARCOPHAGUS OF JUNIUS BASSUS Grottoes of Saint Peter, Vatican, Rome. c. 359. Marble, $4\times8'$ (1.2 \times 2.4 m).

Myth and Religion

ICONOGRAPHY OF THE LIFE OF JESUS

conography is the study of subject matter in art. It involves identifying both what a work of art represents—what it depicts—and the deeper significance of what is represented—its symbolic meaning. Stories about the life of Jesus, grouped in "cycles," form the basis of Christian iconography. What follows is an outline of those cycles and the main events of each.

The Incarnation Cycle and the Childhood of Jesus

Events surrounding the conception and birth of Jesus.

The Annunciation: The archangel Gabriel informs the Virgin Mary that God has chosen her to bear his son. A dove represents the Incarnation, her miraculous conception of Jesus through the Holy Spirit.

The Visitation: The pregnant Mary visits her older cousin Elizabeth, pregnant with the future Saint John the Baptist. Elizabeth is the first to acknowledge the divinity of Mary's child.

The Nativity: Jesus is born to Mary in Bethlehem. The Holy Family—Jesus, Mary, and her husband, Joseph—is shown in a house, a stable, or, in Byzantine art, a cave.

The Annunciation to the Shepherds and the Adoration of the Shepherds: An angel announces Jesus's birth to humble shepherds who hurry to Bethlehem to honor him.

The Adoration of the Magi: Wisemen from the "East" follow a bright star to Bethlehem to honor Jesus as King of the Jews. They present him with precious gifts: gold (kingship), frankincense (divinity), and myrrh (death). In the European Middle Ages, the Magi were identified as three kings.

The Presentation in the Temple: Mary and Joseph bring the infant Jesus to the Temple in Jerusalem, where he is presented to the high priest. It is prophesied that Jesus will redeem humankind and that Mary will suffer great sorrow.

The Massacre of the Innocents and the Flight into Egypt: An angel warns Joseph that King Herod—to eliminate the threat of a newborn rival king—plans to murder all the male infants in Bethlehem. The Holy Family flees to Egypt.

Jesus among the Doctors: In Jerusalem to celebrate Passover, Joseph and Mary find the twelve-year-old Jesus in serious discussion with Temple scholars, a sign of his coming ministry.

The Public Ministry Cycle

In which Jesus preaches and performs miracles (signs of God's power).

The Marriage at Cana: Jesus turns water into wine at a wedding feast, his first public miracle. Later the event was interpreted as prefiguring the Eucharist.

The Cleansing of the Temple: Jesus, in anger, drives money changers and animal traders from the Temple.

The Baptism: At age thirty, Jesus is baptized by John the Baptist in the Jordan River. He sees the Holy Spirit and hears a heavenly voice proclaiming him God's son. His ministry begins.

Jesus and the Samaritan Woman at the Well: Jesus rests by a spring called Jacob's Well. Jews and Samaritans did not associate, but Jesus asks a local Samaritan woman for water.

The Miracles of Healing: Jesus performs miracles of healing the blind, the possessed (mentally ill), the paralytic, and lepers. He also resurrects the dead.

The Miraculous Draft of Fishes: At Jesus's command Peter lowers the nets and catches so many fish that James and John have to help him bring them into the boat. Jesus promises that they soon will be "fishers of men."

Jesus Walking on the Water; Storm at Sea: The apostles, in a storm-tossed boat, see Jesus walking toward them on the water. Peter tries to go out to meet Jesus, but begins to sink, and Jesus saves him.

The Calling of Levi (Matthew): Passing the customhouse, Jesus sees Levi, a tax collector, and says, "Follow me." Levi complies, becoming the apostle Matthew.

Raising of Lazarus: Jesus brings his friend Lazarus back to life four days after his death. Lazarus emerges from the tomb wrapped in his shroud.

Jesus in the House of Mary and Martha: Mary, representing the contemplative life, sits listening to Jesus while Martha, representing the active life, prepares food. Jesus praises Mary.

The Transfiguration: Jesus reveals his divinity in a dazzling vision on Mount Tabor in Galilee, as his closest disciples—Peter, James, and John—look on. A cloud envelops them, and a heavenly voice proclaims Jesus to be God's son.

The Tribute Money: Challenged to pay the temple tax, Jesus sends Peter to catch a fish, which has the required coin in its mouth.

The Delivery of the Keys to Peter: Jesus designates Peter as his successor, symbolically turning over to him the keys to the kingdom of heaven.

The Passion Cycle

Events surrounding Jesus's death and Resurrection. (*Passio* is Latin for "suffering.")

Entry into Jerusalem: Jesus, riding an ass, and his disciples enter Jerusalem in triumph. Crowds honor them, spreading clothes and palm fronds in their path.

The Last Supper: During the Passover meal, Jesus reveals his impending death to his disciples. Instructing them to drink wine (his Blood) and eat bread (his Body) in remembrance of him, he lays the foundation for the Christian Eucharist (Mass).

Jesus Washing the Apostles' Feet: After the Last Supper, Jesus washes the apostles' feet to set an example of humility. Peter, embarrassed, protests.

The Agony in the Garden: In the Garden of Gethsemane on the Mount of Olives, Jesus struggles between his human fear of pain and death and his divine strength to overcome them (agon is Greek for "contest"). The apostles sleep nearby, oblivious.

Betrayal (The Arrest): Judas Iscariot, a disciple, accepts a bribe to point Jesus out to his enemies. Judas brings an armed crowd to Gethsemane and kisses Jesus (a prearranged signal). Peter attempts to defend Jesus from the Roman soldiers who seize him.

The Denial of Peter: Jesus is taken to the Jewish high priest, Caiaphas, to be interrogated for claiming to be the Messiah. Peter follows, and there he three times denies knowing Jesus, as Jesus had predicted.

Jesus before Pilate: Jesus is taken to Pontius Pilate, the Roman governor of Judaea, and charged with treason for calling himself King of the Jews. He is sent to Herod Antipas, ruler of Galilee, who scorns him. Pilate proposes freeing Jesus but is shouted down by the mob, which demands that Jesus be crucified. Pilate washes his hands before the mob to signify that Jesus's blood is on their hands, not his.

The Flagellation (The Scourging): Jesus is whipped by his Roman captors.

Jesus Crowned with Thorns (The Mocking of Jesus):
Pilate's soldiers torment Jesus. They dress him in royal robes,
crown him with thorns, and kneel before him, sarcastically hailing him as King of the Jews.

The Bearing of the Cross (Road to Calvary): Jesus bears the cross from Pilate's house to Golgotha, where he is executed. This event and its accompanying incidents came to be called the Stations of the Cross: (1) Jesus is condemned to death; (2) Jesus picks up the cross; (3) Jesus falls; (4) Jesus meets his grieving mother; (5) Simon of Cyrene is forced to help Jesus carry the cross; (6) Veronica wipes Jesus's face with her veil; (7) Jesus falls again; (8) Jesus admonishes the women of Jerusalem; (9) Jesus falls a third time; (10) Jesus is stripped; (11) Jesus is nailed to the cross; (12) Jesus dies on the cross; (13) Jesus is taken down from the cross; (14) Jesus is entombed.

The Crucifixion: The earliest representations of the Crucifixion show either a cross alone or a cross and a lamb. Later

depictions include some or all of the following details: two criminals (one penitent, the other not) are crucified alongside Jesus; the Virgin Mary, John the Evangelist, Mary Magdalen, and others mourn at the foot of the cross; Roman soldiers torment Jesus—one extends a sponge on a pole with vinegar instead of water for him to drink, another stabs him in the side with a spear, and others gamble for his clothes; a skull identifies the execution ground as Golgotha, "the place of the skull," where Adam was buried, symbolizing the promise of redemption.

The Descent from the Cross (The Deposition): Jesus's followers take his body down from the cross. Joseph of Arimathea and Nicodemus wrap it in linen with myrrh and aloe. Also present are the grief-stricken Virgin, John the Evangelist, and (in some accounts) Mary Magdalen, other disciples, and angels.

The Lamentation (Pietà): Jesus's sorrowful followers gather around his body. An image of the Virgin mourning alone with Jesus across her lap is known as a pietà (from the Latin pietas, "compassion").

The Entombment: Jesus's mother and friends place his body in a nearby sarcophagus, or rock tomb. This is done hastily because the Jewish Sabbath is near.

The Descent into Limbo (The Harrowing of Hell/Anastasis): No longer in mortal form, Jesus, now called Christ, descends into limbo, or hell, to free deserving souls, among them Adam, Eve, and Moses.

The Resurrection: Three days after his death, Christ walks from his tomb while the soldiers guarding it sleep.

The Marys at the Tomb (The Holy Women at the Sepulcher): Christ's female followers—usually including Mary Magdalen and Mary the mother of the apostle James—discover his empty tomb. An angel announces Christ's Resurrection. The soldiers guarding the tomb look on terrified.

Noli Me Tangere ("Do Not Touch Me"), The Supper at Emmaus, and Doubting Thomas: Christ makes a series of appearances to his followers in the forty days between his Resurrection and his Ascension. He first appears to Mary Magdalen as she weeps at his tomb. She reaches out to him, but he warns her not to touch him. Christ tells her to tell the Apostles of his Resurrection. At Emmaus, Christ and his disciples share a meal. Christ invites Thomas, who doubts his Resurrection, to touch the wound in his side in order to convince him.

The Ascension: Christ ascends to heaven from the Mount of Olives, disappearing in a cloud. His disciples, often accompanied by the Virgin, watch.

martyrs. Next, Adam and Eve have set in motion the entire Christian story. Lured by the serpent, they have eaten the forbidden fruit, have become conscious of their nakedness, and are trying to hide their genitals with leaves. This fall from grace will be redeemed by Christ.

On the upper right side are two scenes from Christ's Passion (see "Iconography of the Life of Jesus," page 252), his arrest and his appearance before Pontius Pilate, who is about to wash his hands, symbolizing that he denies responsibility for Jesus's death. The Crucifixion is not represented: It rarely was in early Christian art. After the death of Jesus, the apostle Peter is arrested for preaching. In the last frame, Paul is arrested. The images in the upper central frame are of Paul and Peter, whose martyrdoms in Rome represented the continuing power of Christ and his disciples, and also symbolized the power of the Roman Church.

EARLY BYZANTINE ART: THE FIRST GOLDEN AGE

Byzantine art can be thought of broadly as the art of Constantinople (whose ancient name, before Constantine renamed it after himself, was Byzantium) and the regions under its influence. In this chapter, we focus on Byzantine art's three "golden ages." The Early Byzantine period, most closely associated with the reign of Emperor Justinian I (527-65), began in the fifth century CE and ended in 726, the onset of the iconoclast controversy that led to the destruction of religious images. The Middle Byzantine period began in 843, when Empress Theodora (c. 810-67) reinstated the veneration of icons. It lasted until 1204, when Christian Crusaders from the West occupied Constantinople. The Late Byzantine period began with the restoration of Byzantine rule in 1261 and ended with the empire's fall to the Ottoman Turks in 1453. Russia succeeded Constantinople as the "Third Rome" and the center of the Eastern Orthodox Church. Late Byzantine art continued to flourish into the eighteenth century in the Ukraine, Russia, and much of southeastern Europe.

The Golden Age of Justinian

During the fifth and sixth centuries, while invasions and religious controversy wracked the Italian peninsula, the Eastern Empire prospered. Byzantium became the "New Rome." The city of Constantine was called Constantinople (present-day Istanbul). Constantine had chosen the site of his new capital city well. The small Greek port of Byzantium lay at the crossroads of the overland trade routes between Asia and Europe and the sea route connecting the Black Sea and the Mediterranean.

In the sixth century, Byzantine political power, wealth, and culture reached its height under Emperor Justinian I and his wife, Theodora. Imperial forces held northern Africa, Sicily, much of Italy, and part of Spain. Ravenna became the

Eastern empire's administrative capital in the West. Rome remained under nominal Byzantine control until the eighth century, and the pope remained head of the Western Church. But the pope rejected the Byzantine policy of *caesaropapism*, whereby the emperor was head of both church and state, and the pope was thereby required to pay homage to the powers in Constantinople. As Slavs and Bulgars moved into the Balkan peninsula in southeastern Europe, they too came under Constantinople's influence. Only on the frontier with the Persian Empire to the east did Byzantine armies falter, and there Justinian bought peace with tribute.

Control of land and sea routes between Europe and Asia made many people wealthy. The patronage of the affluent citizenry, as well as that of the imperial family, made the city an artistic center. Greek literature, science, and philosophy continued to be taught in its schools. Influences from the regions under the empire's control—Syria and Palestine—gradually combined to create a distinctive Byzantine culture.

CONSTANTINOPLE: THE WALLS. The secret of Byzantine success was its invulnerable capital. At the beginning of the fifth century, during the reign of Theodosius II, the Byzantines built a new defensive system consisting of a moat and double walls with huge towers (FIG. 7–24). The walls were about $4\frac{1}{2}$ miles long along the city's only vulnerable stretch of land, and the defensive system about 180 feet deep.

An enemy approaching the city encountered a 60-foot stone-lined **moat** (a water-filled ditch), then a towered wall, a terrace, and finally the powerful inner wall, 36 feet high and

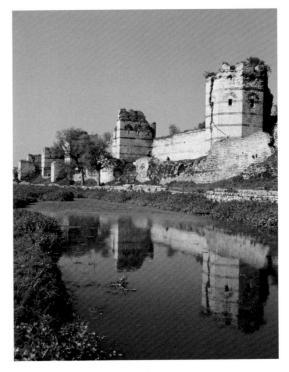

7–24 | LAND WALLS OF CONSTANTINOPLE Begun 412–13. Photo: Josephine Powell, Rome

16 feet wide. The inner wall was high enough that defenders could shoot over the heads of those on the outer wall and even reach the moat with their missiles. The builders used both stone (for strength) and brick (for flexibility) in leveling and bonding the facing to a solid core of rubble and concrete. This masonry created stripes of different colors and textures, an effect that was used decoratively by later builders who copied the walls. Ninety-six huge towers, each an independent unit, defended the inner wall. Double towers flanked the few gateways into the city. For more than a thousand years—from 412–13 to 1453—the people of Constantinople lived secure behind their walls.

CONSTANTINOPLE: HAGIA SOPHIA. Justinian and Theodora embarked on a building and renovation campaign in Constantinople that overshadowed any in the city since the reign of Constantine two centuries earlier. Their massive undertaking would more than restore the city, half of which had been destroyed by rioters in 532. But little now remains of their architectural projects or of the old imperial capital itself.

A magnificent exception is the **CHURCH OF HAGIA SOPHIA**, meaning "Holy Wisdom" (FIG. 7–25). It replaced a fourth-century church destroyed when crowds, spurred on by Justinian's foes, set the old church on fire. The empress Theodora, a brilliant, politically shrewd woman, is said to have goaded Justinian to resist the rioters by saying "Purple makes a fine shroud"—meaning that she would rather die an empress (purple was the royal color) than flee for her life. Taking up her words as a battle cry, imperial forces crushed the rebels and restored order in 532.

To design a church that embodied imperial power and Christian glory, Justinian chose two scholar-theoreticians, Anthemius of Tralles and Isidorus of Miletus. Anthemius was a specialist in geometry and optics, and Isidorus a specialist in physics who had also studied vaulting. They developed a daring and magnificent design. And they had a trained and experienced work force to carry out their ideas. Builders had refined their masonry techniques building the towers and domed rooms within them that were part of the city's defenses. So when Justinian ordered the construction of domed churches, and especially Hagia Sophia, master masons with a trained and experienced work force stood ready to give permanent form to the architects' dreams.

The new Hagia Sophia was not constructed by the miraculous intervention of angels, as was rumored, but by mortal builders in only five years (532–37). The architects, engineers, and masons who built it benefited from the accumulated experience of a long tradition of great architecture. Procopius of Caesarea, who chronicled Justinian's reign, claimed poetically that Hagia Sophia's gigantic dome seemed to hang suspended on a "golden chain from Heaven." Legend has it that Justinian himself, aware that architecture can be a potent symbol of earthly power, compared his accomplish-

ment with that of the legendary builder of the First Temple in Jerusalem, saying "Solomon, I have outdone you."

Hagia Sophia is based on a central plan with a dome inscribed in a square (FIG. 7–26). To form a long nave for

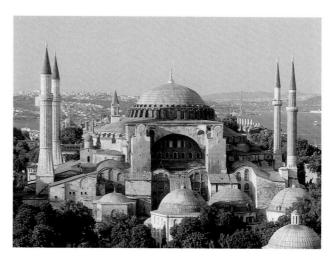

7-25 Anthemius of tralles and isidorus of miletus. Church of hagia sophia

Istanbul. 532-37. View from the southwest.

The body of the original church is now surrounded by later additions, including the minarets built after 1453 by the Ottoman Turks. Today the building is a museum.

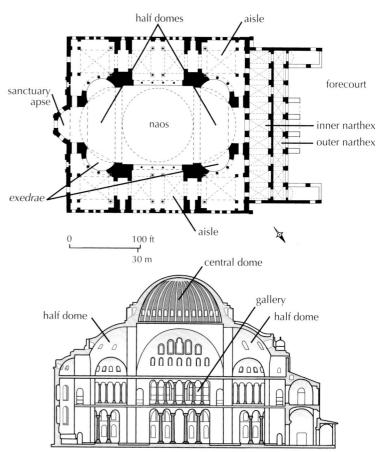

7-26 | PLAN AND SECTION OF THE CHURCH OF HAGIA SOPHIA

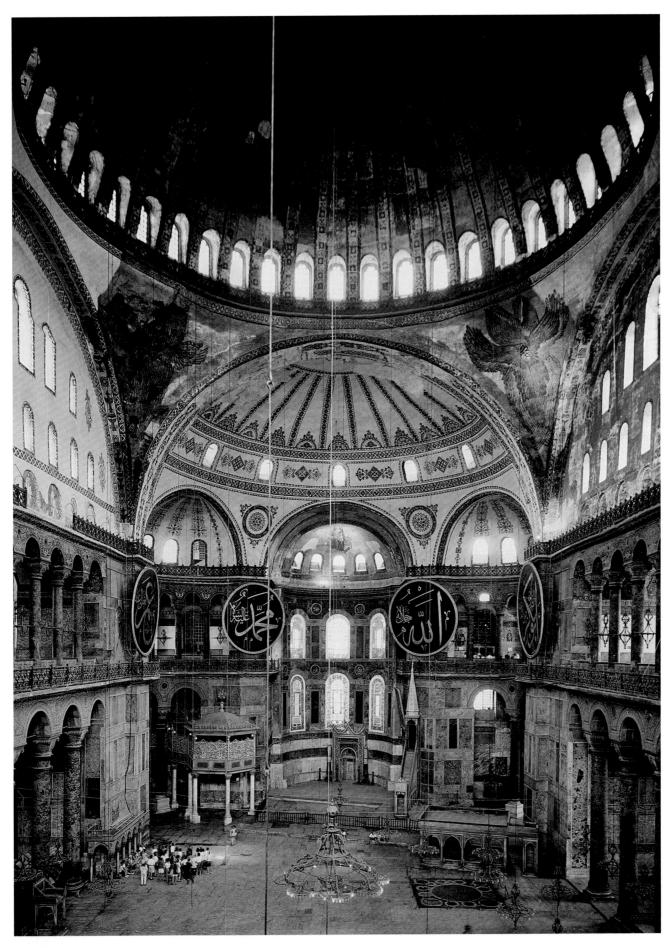

7-27 CHURCH OF HAGIA SOPHIA. INTERIOR

Elements of Architecture

PENDENTIVES AND SQUINCHES

endentives and squinches are two methods of supporting a round dome or its drum over a square space. They convert the square formed by walls or arches into a circle. Pendentives are spherical triangles between arches that rise to form openings on which a dome rests (SEE FIG. 7–44).

Squinches are lintels placed across the upper corner of the wall and supported by an arch or a series of corbeled arches that

give it a nichelike or trumpet shape. Because squinches create an octagon, which is close in shape to a circle, they provide a solid base for a dome. A **drum** (a circular wall) may be inserted between the squinches and the dome or between the pendentives and the dome. Byzantine builders used both pendentives and squinches. Western Europeans and Muslims usually used squinches.

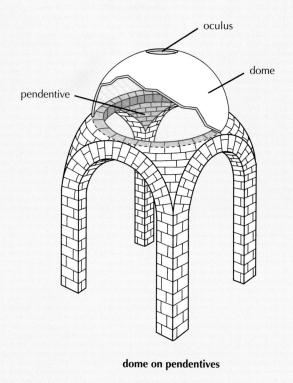

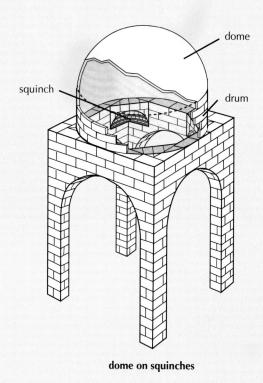

processions, half domes expand outward from the central dome to connect with the narthex on one end and the half dome of the sanctuary apse on the other. Side aisles flank this central core, called the **naos** in Byzantine architecture; **galleries**, or stories open to and overlooking the naos, are located above the aisles. The main weight-bearing interior supports in the Hagia Sophia are the piers, which are pushed back into the darkness of the aisles. The massiveness of both piers and walls is minimized by covering them with mosaics and marble veneers. Exterior buttresses give additional support, invisible in the interior.

The main dome of Hagia Sophia is supported on pendentives, triangular curving vault sections built between the

four huge arches that spring from piers at the corners of the dome's square base (see "Pendentives and Squinches," above). The Church of Hagia Sophia represents the earliest use of the dome on pendentives in a major building. Here two half domes flanking the main dome rise above **exedrae** with their own smaller half domes at the four corners of the nave.

Unlike the Pantheon's dome, which rises uninterrupted from the walls to an oculus at the top (SEE FIG. 6–53), Hagia Sophia's dome has a band of forty windows around its base. This daring concept challenged architectural logic by apparently weakening the masonry support, but it created the all-important circle of light that makes the dome appear to float (FIG. 7–27). The architects stretched the building materials to

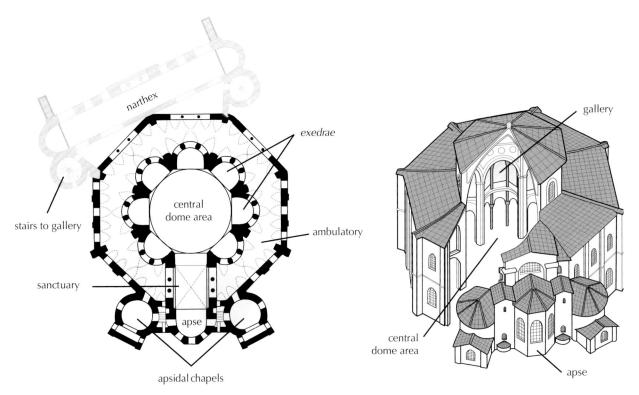

7--28 \mid PLAN AND CUTAWAY DRAWING, CHURCH OF SAN VITALE Ravenna. Under construction from c. 520; consecrated 547; mosaics, c. 546–48.

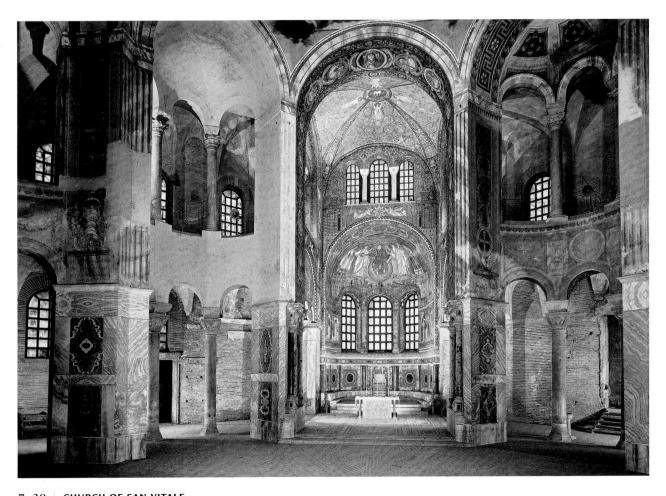

7–29 CHURCH OF SAN VITALE

Ravenna. Interior view across the central space toward the sanctuary apse with mosaic showing Christ enthroned, flanked by Saint Vitalis and Bishop Ecclesius. Consecrated 547.

their physical limits, denying the physicality of the building in order to emphasize its spirituality. In fact, when the first dome fell in 558, it did so because a pier and pendentive shifted and because the dome was too shallow and exerted too much outward force at its base, not because of the windows. Confident of their revised technical methods, the architects designed a steeper dome that raised the summit 20 feet higher. They also added exterior buttressing. Although repairs had to be made in 869, 989, and 1346, the church has since withstood numerous earthquakes.

As in a basilica, worshipers moved along a central axis as they entered Hagia Sophia through a forecourt and outer and inner narthexes. Once through the portals, their gaze was drawn upward by the succession of curving spaces to the central dome and then forward to the distant sanctuary. The dome of the church provided a vast, golden, light-filled canopy high above a processional space for the many priests and members of the imperial court who assembled there to celebrate the Eucharist. With this inspired design, Anthemius and Isidorus had reconciled an inherent conflict in church architecture between the desire for a soaring heavenly space and the need to focus attention on the altar and the liturgy.

The liturgy used in Hagia Sophia in the sixth century has been lost, but it presumably resembled the rites described in detail for the church in the Middle Byzantine period. The celebration of the Mass took place behind a screen—at Hagia Sophia a crimson curtain embroidered in gold, in later churches an iconostasis, a wall hung with devotional paintings called icons (meaning "images" in Greek). The emperor was the only layperson permitted to enter the sanctuary; men stood in the aisles and women in the galleries. Processions of clergy moved in a circular path from the sanctuary into the nave and back five or six times during the ritual. The focus of the congregation was on the iconostasis and the dome rather than the altar and apse. This upward focus reflects the interest of Byzantine philosophers, who viewed meditation as a way to rise from the material world to a spiritual state. Worshipers standing on the church floor must have felt just such a spiritual uplift as they gazed at the mosaics of saints, angels, and, in the golden central dome, heaven itself.

RAVENNA: SAN VITALE. In 540, Byzantine forces captured Ravenna from the Arian Christian Ostrogoths who had taken it from the Romans in 476. Much of our knowledge of the art of this turbulent period comes from the well-preserved monuments at Ravenna.

In 526, Ecclesius, bishop of Ravenna, commissioned two new churches, one for the city and one for its port, Classis, as well as other churches and baptistries. Construction began on a central-plan church dedicated to the fourth-century Roman martyr Saint Vitalis (FIG. 7–28) in the 520s, but it was

not finished until after Justinian had conquered Ravenna and established it as the administrative capital of Byzantine Italy.

The design of San Vitale is basically a central-domed octagon extended by exedralike semicircular bays, surrounded in turn by an ambulatory and gallery, all covered by vaults. A rectangular sanctuary and semicircular apse project from one of the sides of the octagon, and in typical Byzantine fashion circular rooms flank the apse. A separate oval narthex, set off-axis, joined church and palace and also led to cylindrical stair towers that gave access to the second-floor gallery. This sophisticated design has distant roots in Roman buildings such as Santa Costanza (SEE FIG. 7–16).

The floor plan of San Vitale only hints at the effect of the complex interior spaces of the church, an effect that was enhanced by the offset narthex, with its double sets of doors leading into the church. People entering from the right saw only arched openings, whereas those entering from the left approached on an axis with the sanctuary, which they saw straight ahead of them. Eight large piers frame the exedrae and the sanctuary. These two-story exedrae open through arches into the outer aisles on the ground floor and into galleries on the second floor. Squinches rather than pendentives support the dome.

The round dome, hidden on the exterior by an octagonal shell and a tile-covered roof, is a light, strong structure ingeniously created out of interlocking ceramic tubes mortared together. The interior is light and airy, a sensation reinforced by the liberal use of gold tesserae in the mosaic surface decoration. The structure seems to dissolve into shimmering light and color (FIG. 7–29).

In the half dome of the sanctuary apse, an image of Christ enthroned is flanked by SaintVitalis and Bishop Ecclesius, who presents a model of the church to Christ (FIG. 7–30). The other sanctuary images relate to its use for the celebration of the Eucharist. Pairs of lambs flanking a cross decorate blocks above the intricately interlaced carving of the marble column capitals. The lunette on the south wall shows an altar table set with a chalice for wine and two patens, to which the high priest Melchizedek on the right brings an offering of bread, and Abel, on the left, carries a sacrificial lamb. Their identities are known from the inscriptions above their heads.

The prophets Isaiah (right) and Moses (left) appear in the spandrels. Moses is shown twice: The lower image depicts the moment when, while tending his sheep, he heard the voice of an angel of God coming from a bush that was burning with a fire that did not destroy it. Just above, Moses is shown reaching down to remove his shoes, a symbolic gesture of respect in the presence of God or on holy ground. In the gallery zone of the sanctuary the Four Evangelists are depicted, two on each wall, and in the vault the Lamb of God, supported by four angels, appears in a field of vine scrolls.

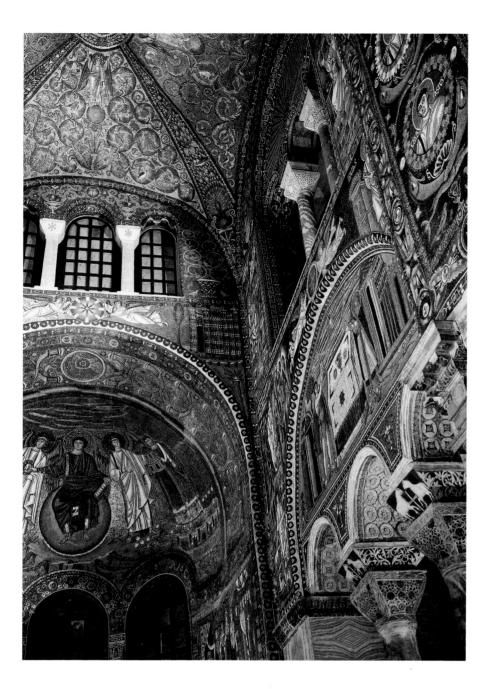

7–30 CHURCH OF SAN VITALE, SOUTH WALL OF THE SANCTUARY Abel and Melchizedek shown in the lunette (at right), and Christ enthroned, flanked by Saint Vitalis and Bishop Ecclesius in the half dome. Consecrated 547.

Justinian and Theodora did not attend the dedication ceremonies for the Church of San Vitale, conducted by Archbishop Maximianus in 547. They may never have set foot in Ravenna, but two large mosaic panels that face each other across its apse still stand in their stead. Justinian (FIG. 7–31), on the north wall, carries a large golden paten for the Host and stands next to Maximianus, who holds a golden, jewelencrusted cross. The priestly celebrants at the right carry the Gospels, encased in a golden, jeweled book cover, symbolizing the coming of the Word, and a censer containing burning incense to purify the altar prior to the Mass.

On the south wall, Theodora, standing beneath a fluted shell canopy and singled out by a gold halolike disk and elaborate crown, carries a huge golden chalice studded with jewels (FIG. 7–32). She presents the chalice both as an offering for the Mass and as a gift of great value for Christ. With it she emulates the Magi (see "Iconography of the Life of Jesus," page 252), depicted in embroidery at the bottom of her purple cloak, who brought valuable gifts to the infant Jesus. A

courtyard fountain stands to the left of the panel and patterned draperies adorn the openings at left and right. Theodora's huge jeweled and pearl-hung crown nearly dwarfs her delicate features, yet the empress dominates these worldly trappings by the intensity of her gaze.

The mosaic decoration in the Church of San Vitale combines imperial ritual, Old Testament narrative, and Christian liturgical symbolism. The setting around Theodora—the implied shell form, the fluted pedestal, the open door, and the swagged draperies—are classical illusionistic devices, yet unlike the ancient Romans, the mosaicists deliberately avoid making them space-creating elements. Byzantine artists accepted the idea that objects exist in space, but they no longer conceived pictorial space the way Roman artists had, as a view of the natural world seen through a "window." In Byzantine art, invisible rays of sight joined eye and image so that pictorial space extended forward from the picture plane to the eye of the beholder and included the real space between them. Parallel lines

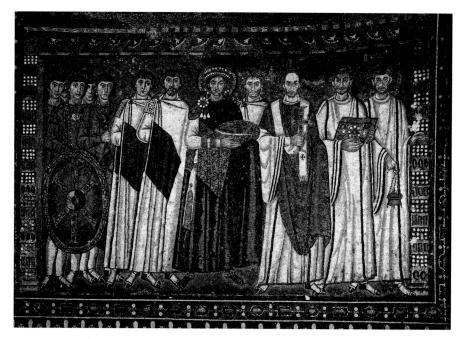

7-31 | EMPEROR JUSTINIAN AND HIS ATTENDANTS, NORTH WALL OF THE APSE Church Of San Vitale. Consecrated 547. Mosaic, $8'8'' \times 12'$ (2.64 \times 3.65 m).

As head of state, Justinian wears a huge jeweled crown and a purple cloak; as head of church, he carries a large golden paten to hold the Host, the symbolic body of Jesus Christ. The church officials at his left hold a jeweled cross and a Gospel book symbolizing Christ and his Church. Justinian's soldiers stand behind a shield decorated with the *chi rho*, the Greek letter monogram for "Christ." On the opposite wall, Empress Theodora, also dressed in royal purple, offers a golden chalice for the liturgical wine (SEE FIG. 7-32).

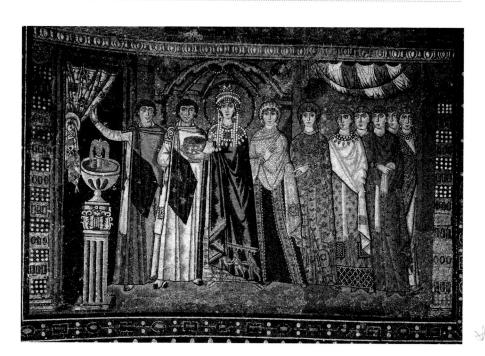

7-32 | EMPRESS THEODORA AND HER ATTENDANTS, SOUTH WALL OF THE APSE Church Of San Vitale. Consecrated 547. Mosaic 8'8" \times 12' (2.64 \times 3.65 m).

The mosaic suggests the richness of Byzantine court costume. Both men and women dressed in layers, beginning with a linen or silk tunic, over which men wore another tunic and a long cloak fastened on the right shoulder with a *fibula* (brooch) and decorated with a rectangular panel (tablion). Women wore a second, fuller long-sleeved garment over their tunics. Over all their layers, women wore a large rectangular shawl, usually draped over the head. Justinian and Theodora wear imperial purple cloaks with gold-embroidered tablions held by fibulae. Embroidered in gold at the hem of Theodora's cloak is the scene of the Magi bringing gifts to Jesus. Her elaborate jewelry includes a wide collar of embroidered and jeweled cloth worn on the shoulders. A pearled crown, hung with long strands of pearls (thought to protect the wearer from diseases) frames her face. Theodora died not long after this mosaic was completed.

appear to diverge as they get farther away and objects seem to tip up in a representational system known as **reverse perspective**.

THE MOSAICS OF SANT'APOLLINAIRE—IN CLASSE. At the same time he was building the Church of San Vitale, Bishop Ecclesius ordered a basilica-plan church in the port of Classis dedicated to Saint Apollinaris, the first bishop of Ravenna. As usual, the basilica's brick exterior gives no hint of the richness within. Nothing interferes visually with the movement forward from the entrance to the raised sanctuary (FIG. 7–33), which extends directly from a triumphal-arch opening into the semicircular apse.

The apse mosaic depicts the Transfiguration—Jesus's revelation of his divinity. An array of men and sheep stand in a

Sequencing Events KEY BYZANTINE PERIODS

526-726	Early Byzantine Period
726-843	Period of Iconoclasm
843-1204	Middle Byzantine Period
1261-1453	Late Byzantine Period

stylized landscape below a jeweled cross with the face of Christ at its center. The hand of God and the Old Testament figures Moses and Elijah appear in the heavens to legitimize the new religion and attest to the divinity of Christ. The apostles Peter, James, and John, who witness the event, are

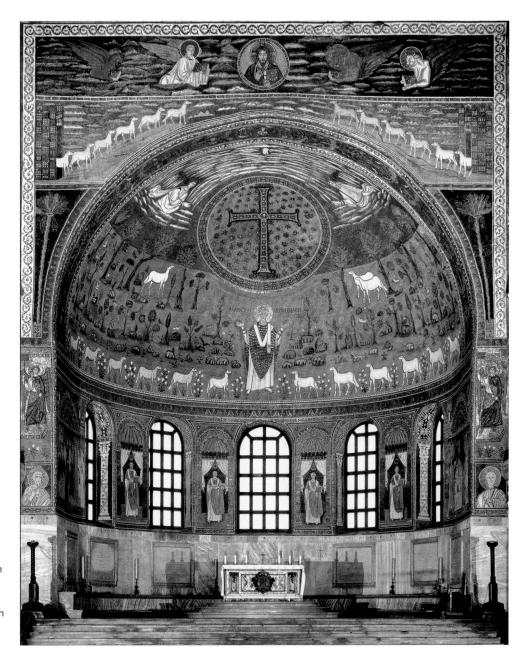

7–33 THE
TRANSFIGURATION OF
CHRIST WITH
SANT'APOLLINARE, FIRST
BISHOP OF RAVENNA
Church of Sant'Apollinare in
Classe. Consecrated 549.
Mosaics: apse, 6th century;
wall above apse, 7th and 9th
centuries; side panels, 7th
century.

represented here by the three sheep with raised heads. Below the cross, Bishop Apollinaris raises his hands in prayer and blessing, flanked by twelve lambs who represent the apostles. Stalks of blooming lilies, along with tiny trees and other plants, birds, and oddly shaped rocks, fill the green mountain landscape. Unlike the landscape in the Good Shepherd lunette of the Mausoleum of Galla Placidia (SEE FIG. 7–21), these highly stylized forms bear little resemblance to nature. The artists eliminated any suggestion of a naturalistic landscape by making the trees and lambs at the top of the golden sky larger than those at the bottom.

In the mosaics on the wall above the apse, which were added in the seventh and ninth centuries, Christ, now portrayed as a man with a cross inscribed in his halo and flanked by symbols representing the Four Evangelists, blesses and holds the Gospels. Sheep (the apostles) emerge from gateways and climb golden rocks toward their leader and teacher.

The formal character of the Transfiguration of Christ mosaic reflects an evolving approach to representation that began with imperial Roman art of the third century. As the character of imperial rule changed, the emperor became an increasingly remote figure surrounded by pomp and ceremony. In official art such as the Arch of Constantine (SEE FIG. 6–74), abstraction displaced the naturalism and idealism of the Greeks. The Roman interest in capturing the visual appearance of the material world gave way in Christian art to a new style that sought to express essential religious meaning rather than exact external appearance. Geometric simplification of forms, an expressionistic abstraction of figures, use of reverse perspective, and standardized conventions to portray individuals and events characterized the new style.

Objects of Veneration and Devotion

The court workshops of Constantinople excelled in the production of gold work, carved ivory, and textiles. The Byzantine elite also sponsored major **scriptoria** (writing rooms for **scribes**—professional document writers) for the production of **manuscripts** (handwritten books).

THE ARCHANGEL MICHAEL DIPTYCH. The commemorative ivory diptych—two carved panels hinged together—originated with Roman politicians elected to the post of consul. The new consuls sent notices of that event to friends and colleagues inscribed in wax on the inner sides of a pair of carved ivory panels. Christians adapted the practice for religious use, inscribing a diptych with the names of people to be remembered with prayers during Mass.

The panel depicting the archangel Michael was half of a diptych (FIG. 7–34). In his beauty, physical presence, and elegant setting, the archangel is comparable to the priestess of Bacchus in the Symmachus panel (SEE FIG. 6–79). His relation to the architectural space and the frame around him, how-

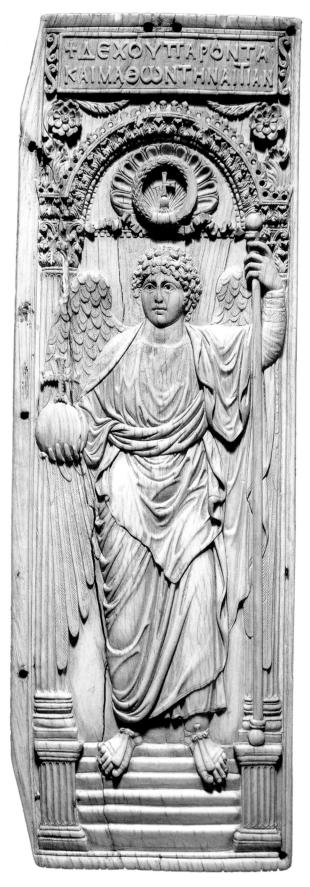

7–34 ARCHANGEL MICHAEL
Panel of a diptych, probably from the court workshop at Constantinople. Early 6th century. Ivory, 17 × 15½" (43.3 × 14 cm). The British Museum, London.

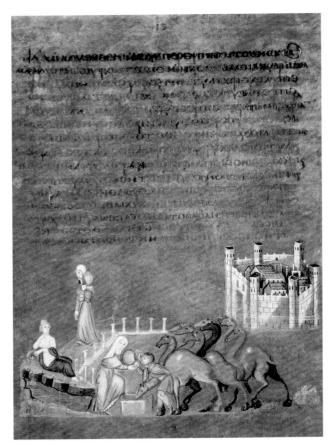

7–35 | REBECCA AT THE WELL Page from the Book of Genesis (known as *The Vienna Genesis*). Syria or Palestine. Early 6th century. Tempera, gold, and silver paint on purple-dyed vellum, $13\frac{1}{2} \times 9\frac{1}{8}$ " (33.7 × 25 cm). Österreichische Nationalbibliothek, Vienna.

ever, has changed. His heels rest on the top step of a stair that clearly lies behind the columns and pedestals, but the rest of his body projects in front of them.

The angel is shown here as a divine messenger, holding a staff of authority in his left hand and a sphere symbolizing worldly power in his right, a message reinforced by repetition: Within the arch is a cross-topped orb, framed by a wreath, against the background of a scallop shell. This image floats in an indefinite space, unrelated to either the archangel or the message. The lost half of this diptych would have completed the Greek inscription across the top, which reads: "Receive these gifts, and having learned the cause . . ." Perhaps the other panel contained the portrait of the emperor or another high official who presented the panels as a gift to an important colleague, acquaintance, or family member.

THE BOOK OF GENESIS. Byzantine manuscripts were often made with very costly materials. Sheets of purple-dyed vellum (a fine writing surface made from calfskin) and gold and silver inks were used in a book known as the VIENNA GENESIS (FIG. 7–35). It was probably made in Syria or Palestine, and the purple vellum indicates that it may have been done for an imperial patron (costly purple dye, made from the shells of murex mollusks, was usually restricted to imperial use). The Vienna Genesis is in codex form and is written in Greek (see "Early Forms of the Book," page 251). Illustrations appear below the text at the bottom of the pages.

The illustration of the story of Rebecca at the Well (Genesis 24) shown here appears to be a single scene, but it actually mimics the continuous narrative of a scroll. Events that take place at different times in the story follow in succession. Rebecca, the heroine of the story, appears at the left walking away from the walled city of Nahor with a large jug on her shoulder to fetch water. She walks along a miniature colonnaded road toward a spring, personified by a reclining pagan water nymph who holds a flowing jar. In the foreground, Rebecca, her jug now full, encounters a thirsty camel driver and offers him water to drink. The man is Abraham's servant, Eliezer, in search of a bride for Abraham's son Isaac. Her generosity leads to her marriage with Isaac. Although the realistic poses and rounded, full-bodied figures in this painting reflect an earlier Roman painting tradition, the unnatural purple of the background and the glittering metallic letters of the text remove the scene from the everyday world.

THE RABBULA GOSPELS. An illustrated Gospel book, signed by a monk named Rabbula and completed in February 586 at the Monastery of Saint John the Evangelist in Beth Zagba, Syria, illustrates a different approach to religious art. Church murals and mosaics may have inspired its illustrations, which are intended not only to depict biblical events, but also to present the Christian story through complex, multileveled symbolism.

A full-page illustration of the Crucifixion provides a detailed picture of Christ's death and the Resurrection (FIG. 7–36). He appears twice, on the cross in the center of the upper register and with the two Marys—the mother of James and Mary Magdalen—at the right in the lower register. In Byzantine art of this period Christ is a living king who triumphs over death. He is shown as a mature, bearded figure, not the youthful shepherd depicted in the catacombs (SEE FIG. 7–6). Even on the cross he is dressed in a long, purple robe that signifies his royal status. (In many Byzantine images he also wears a jeweled crown.)

At his sides are the repentant and unrepentant thieves who were crucified with him. Beside the thief at the left stand the Virgin and John the Evangelist; beside the thief at the right are the holy women. Beneath the cross soldiers

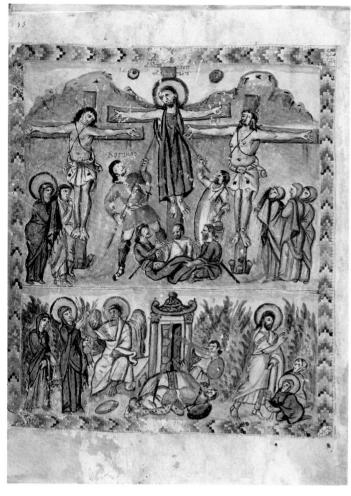

7–36 † THE CRUCIFIXION AND RESURRECTION Page from the *Rabbula Gospels*, from Beth Zagba, Syria. 586. 13½ \times 10½" (33.7 \times 26.7 cm). Biblioteca Medicea Laurenziana, Florence.

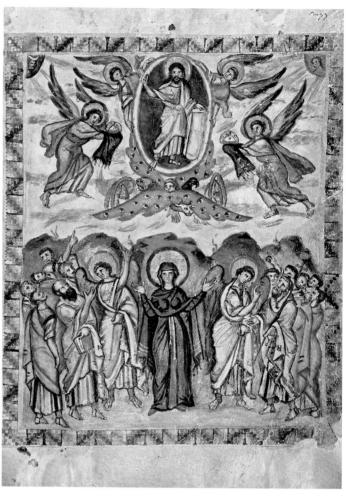

7–37 | THE ASCENSION Page from the *Rabbula Gospels*, from Beth Zagba, Syria. 586. $13\frac{1}{2} \times 10\frac{1}{2}$ " (33.7 \times 26.7 cm). Biblioteca Medicea Laurenziana, Florence.

throw dice for Jesus's clothes. A centurion stands on either side of the cross. One of them pierces Jesus's side with a lance; the other gives him vinegar to drink from a sponge. The small disks in the heavens represent the sun and moon.

In the lower register, directly under Jesus on the cross, stands his tomb, with its open door and stunned or sleeping guards. The angel reassures the holy women at the left, and Christ himself appears to them at the right. All these events (described in Matthew 28) take place in an otherworldly setting indicated by the glowing bands of color in the sky. The bare mountains behind the crosses give way to the lush foliage of the garden around the tomb.

Another page shows the Ascension of Christ into heaven (FIG. 7–37), which the New Testament describes this way: "[A]s they [his apostles] were looking on, he was lifted up, and a cloud took him from their sight" (Acts of the Apostles 1:9). But now the cloud has been transformed

into an almond-shaped area of light called a mandorla supported by two angels. Two other angels hold victory crowns in fringed cloths. The image directly under the mandorla combines fiery wheels and the four creatures seen by the Hebrew prophet Ezekiel in a vision (Ezekiel 1). Those four, which also appear in the Book of Revelation, are associated with the Four Evangelists: Matthew, an angel; Mark, a lion; Luke, an ox; and John, an eagle. Below this imagery, the Virgin Mary stands calmly in the pose of an orant, while angels at her side confront the astonished apostles. One angel gestures at the departing Christ and the other appears to be offering an explanation of the event to attentive listeners (Acts of the Apostles 1:10-11). The prominence accorded Mary here can be interpreted as a result of her status of Theotokos, God-bearer. She may also represent the Christian community on earth, that is, the Church.

Icons and Iconoclasm

Eastern Christians prayed to Christ, Mary, and the saints while looking at images of them on icons (from the Greek eikon, meaning "image") that were thought to have miraculous powers. The first miraculous image was believed to have been a portrait Jesus sent to King Abgar of Edessa and was known as the Mandylion. It was in Constantinople in the tenth century, and was taken to the West by Crusaders. Later it became identified with the scarf with which Saint Veronica wiped Christ's face as he carried the cross to the execution ground.

Church doctrine toward the veneration of icons was ambivalent. Christianity, like Judaism and Islam, has always been uneasy with the power of religious images. Key figures of the Eastern Church, such as Basil the Great of Cappadocia (c. 329–79) and John of Damascus (c. 675–749), distinguished between idolatry—the worship of images—and the veneration of an idea or holy person depicted in a work of art. The Eastern Church prohibited the worship of icons but accepted them as aids to meditation and prayer, as intermediaries between worshipers and the holy personages they depicted. They were often displayed in churches on a screen called the iconostasis.

Discomfort about the rituals associated with the icons grew into a major controversy in the Eastern Church, and in 726 Emperor Leo III launched a campaign of iconoclasm ("image breaking"). In the decades that followed, Iconoclasts undertook widespread destruction of devotional pictures. Those who defended these images were persecuted. Then in 843 Empress Theodora, widow of Theophilus, last of the iconoclastic emperors, reversed her husband's policy. But it was too late for much of the art: Most early icons were destroyed in the iconoclasm, making those that have survived especially precious.

A few very beautiful examples were preserved in the Monastery of Saint Catherine on Mount Sinai, among them the VIRGIN AND CHILD WITH SAINTS AND ANGELS (FIG. 7-38). As Theotokos, Mary was viewed as the powerful, everforgiving intercessor, appealing to her divine son for mercy on behalf of repentant worshipers. She was also called the Seat of Wisdom, and many images of the Virgin and Child, like this one, show her holding Jesus on her lap in a way that suggests that she represents the throne of Solomon. The Christian warrior-saints Theodore (left) and George (right)—both legendary figures said to have slain dragons, representing the triumph of the Church over the "evil serpent" of paganism-stand at each side. Angels behind them look heavenward. The Christ Child, the Virgin, and the angels were painted with a Roman-derived technique and are almost realistic. The male saints are much more stylized than the other figures; the richly patterned textiles of their cloaks barely hint at the bodies beneath.

Kievan Rus artists (see page 268) copied and recopied icons brought from Constantinople. The revered icon of Mary and Jesus known as the **VIRGIN OF VLADIMIR** (FIG. 7–39) was such a painting. This distinctively humanized image suggests the growing desire for a more immediate and personal religion. Paintings of this type, known as the Virgin of Compassion, show Mary and the Christ Child pressing their cheeks together and gazing tenderly at each other. It was widely believed that St. Luke was the first to paint such a portrait following a vision he had of the Nativity.

Almost from its creation (probably in Constantinople), the *Virgin of Vladimir* was thought to protect the people of the city where it resided. It arrived in Kiev sometime between

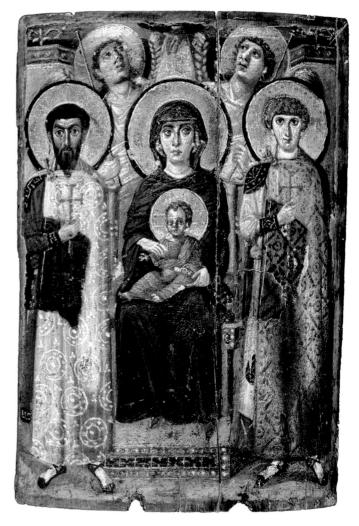

7–38 \parallel VIRGIN AND CHILD WITH SAINTS AND ANGELS Icon. Second half of the 6th century. Encaustic on wood, 27 \times 18%" (69 \times 48 cm). Monastery of Saint Catherine, Mount Sinai, Egypt.

7–39 VIRGIN OF VLADIMIR
Icon, probably from Constantinople. Faces,
11th-12th century; the figures have been
retouched. Tempera on panel, height approx.
31" (78 cm). Tretyakov Gallery, Moscow.

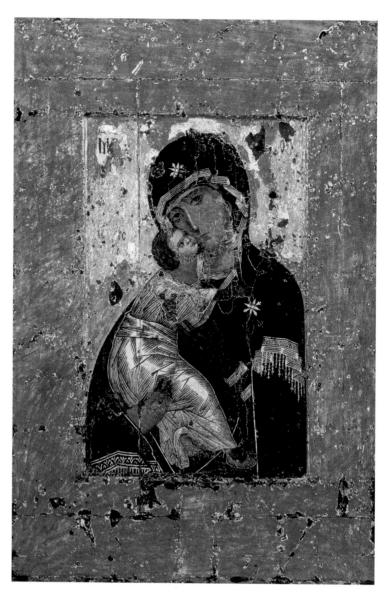

1131 and 1136 and was taken to the city of Suzdal and then to Vladimir in 1155. In 1480 it was moved to the Cathedral of the Dormition in the Moscow Kremlin. Today, even in a museum, it inspires prayers.

MIDDLE BYZANTINE ART

The *Virgin of Vladimir* belongs to the period now called Middle Byzantine. Early Byzantine civilization had been centered in lands along the rim of the Mediterranean Sea that had been within the Roman Empire. During the Middle Byzantine period, Constantinople's scope was reduced to present-day Turkey and other areas by the Black Sea, as well as the Balkan peninsula, including Greece, and southern Italy. The influence of Byzantine culture also extended into Russia and Ukraine, and to Venice, Constantinople's trading partner in northeastern Italy, at the head of the Adriatic Sea.

Under the Macedonian dynasty (867–1056) initiated by Basil I, the empire prospered and enjoyed a cultural rebirth. Middle Byzantine art and architecture, visually powerful and stylistically coherent, reflect the strongly spiritual focus of the period's autocratic, wealthy leadership. From the mideleventh century, however, other powers entered Byzantine territory. The empire stabilized temporarily under the Comnenian dynasty (1081–1185), extending the Middle Byzantine period well into the time of the Western Middle Ages. Then, in 1204, Western Christian Crusaders seized and looted Constantinople.

Architecture and Mosaics

Comparatively few Middle Byzantine churches in Constantinople have survived intact, but many central-plan domed churches, favored by Byzantine architects, survive in

Ukraine, to the northeast, and in Sicily, to the southwest. These structures reveal the builders' taste for a multiplicity of geometric forms, verticality, and rich decorative effects both inside and out.

KIEVAN RUS: SANTA SOPHIA IN KIEV. Outside Constantinople, the rulers of Ukraine, Belarus, and Russia adopted Orthodox Christianity and Byzantine culture. These lands had been settled by Eastern Slavs in the fifth and sixth centuries, but later were ruled by Scandinavian Vikings who had sailed down the rivers from the Baltic to the Black Sea. In Constantinople, the Byzantine emperor hired the Vikings as his personal bodyguards. In the ninth century, Viking traders established a head-quarters in the upper Volga region and in the city of Kiev, which became the capital of the area under their control, known as Kievan Rus.

The first Christian member of the Kievan ruling family was Princess Olga (c. 890–969), who was baptized in Constantinople by the patriarch himself, with the Byzantine emperor as her godfather. Her grandson Grand Prince

Sequencing Events KEY BYZANTINE EMPERORS 527-65 Justinian I: First Byzantine Emperor 717-41 Leo III: Launches campaign of Iconoclasm in 726 867-86 Basil I: Initiates Macedonian Dynasty

Michael VIII Palaeologus: Retakes Constantinople from Crusaders in 1261

Constantine XI Palaeologus: Last

Vladimir (ruled 980–1015) established Orthodox Christianity as the state religion in 988. Vladimir sealed the pact with the Byzantines by accepting baptism and marrying

Byzantine Emperor

Anna, the sister of the powerful Emperor Basil II (ruled 976–1025).

1259-82

1449-53

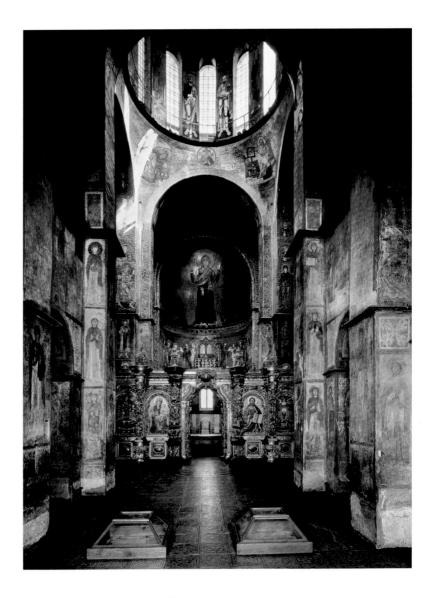

7-40 INTERIOR, CATHEDRAL OF SANTA SOPHIA

Kiev. 1037-46. Apse mosaic: Orant Virgin and Communion of the Apostles.

7–41 | MONASTERY CHURCHES AT HOSIOS LOUKAS
Greece (view from the east); Katholikon (left) early 11th century, and Church of the
Theotokos Cristy. Late 10th century.
Henri Stierlin, Geneva

Vladimir's son Grand Prince Yaroslav (ruled 1036–54) founded the Cathedral of Santa Sophia in Kiev. The church originally had a typical Byzantine multiple-domed cross design, but the building was expanded with double side aisles, leading to five apses. It culminated in a large central dome surrounded by twelve smaller domes. The small domes were said to represent the twelve apostles gathered around the central dome, representing Christ the Pantokrator, Ruler of the Universe. The central domed space of the crossing focuses attention on the nave and the main apse. Nonetheless, the many individual bays create an often confusing and compartmentalized interior.

The walls glow with lavish decoration: Mosaics glitter from the central dome, the apse, and the arches of the crossing. The remaining surfaces are painted with scenes from the lives of Christ, the Virgin, the apostles Peter and Paul, and the archangels.

The Kievan mosaics established a system of iconography that came to be followed in all Russian Orthodox churches. The Pantokrator fills the center of the dome (not visible above the window-pierced drum in FIG. 7–40). At a lower level, the apostles stand between the windows of the drum, with the Four Evangelists in the pendentives. The Virgin Mary, an orant, seems to float in a golden heaven, filling the half dome and upper wall of the apse. In the mosaic on the wall below the Virgin, Christ appears not once, but twice, to offer bread and wine. He celebrates Mass at an altar under a canopy, a theme known as the Communion of the Apostles. Accompanied by angels who act as deacons, he distributes

communion to the apostles, six on each side of the altar. With this extravagant use of costly mosaic, Prince Yaroslav made a powerful political declaration about his own—and the Kievan church's—wealth and importance.

GREECE: HOSIOS LOUKAS. Although an outpost, Greece lay within the Byzantine Empire in the tenth and eleventh centuries and its architecture and art followed the trends toward multiplicity and intricacy seen in the capital. The KATHOLIKON OF THE MONASTERY OF HOSIOS LOUKAS, built a few miles from the village of Stiris, Greece, in the eleventh century, is an excellent example of the architecture of the Middle Byzantine age. It stands next to the ear lier Church of the Theotokos (FIG. 7–41). The church has a compact central plan with a dome, supported by squinches, rising over an octagonal core (see "Basilica-Plan and Central-Plan Churches," page 242, and "Pendentives and Squinches," page 257). On the exterior, the rising forms of apses, walls, and roofs disguise the vaults of the interior.

Outside and in, the buildings revolve around a lofty, central, tile-covered dome on a tall drum. Alternating courses of brick and stone, seen in the defensive walls of Constantinople, bond the wall surface and create an intricate masonry pattern. The Greek builders added to the decorative effect by outlining the stones with bricks set both vertically and horizontally. Ornamental courses of bricks set diagonally form saw-toothed moldings that also enhance the decorative quality rather than the supporting function of the walls. Inside the churches, the high central space of the dome carries the eye

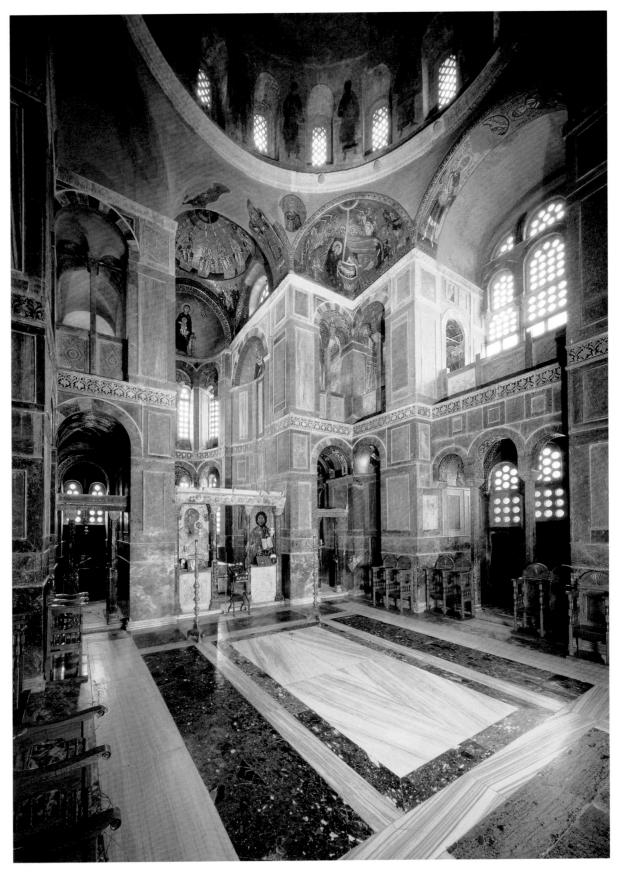

7–42 │ CENTRAL DOMED SPACE AND APSE (THE NAOS), KATHOLIKON Monastery of Hosios Loukas. Near Stiris, Greece. Early 11th century and later.

Visible are mosaics of the Virgin and Child Enthroned in the apse; apostles in the sanctuary dome; the Nativity and several standing saints in the vaults. The iconostasis held large paintings of the Virgin and Child (left) and Christ (right). The icons were stolen and have been replaced.

of the worshiper upward into the main dome, which soars above a ring of tall arched windows (FIG. 7–42).

Unlike Hagia Sophia, with its clear, sweeping geometric forms, the Katholikon has a complex variety of forms, including domes, groin vaults, barrel vaults, pendentives, and squinches, all built on a relatively small scale. The barrel vaults and tall sanctuary apse with flanking rooms further complicate the space. Single, double, and triple windows create intricate and unusual patterns of light, illuminating a painting (originally a mosaic) of *Christ Pantokrator* in the center of the main dome. The secondary, sanctuary dome of the Katholikon is decorated with a mosaic of the *Lamb of God* surrounded by the *Tivelve Apostles*, and the apse half dome has a mosaic of the *Virgin and Child Enthroned*. Scenes from the Old and New Testaments and figures of saints fill the interior with brilliant color and dramatic images.

GREECE: MOSAICS OF THE CHURCH OF THE DORMITION AT DAPHNI. Eleventh-century mosaicists in Greece looked with renewed interest at models from the past. They conceived their compositions in terms of an intellectual rather than a physical ideal. While continuing to represent the human figure and narrative subjects, artists eliminated all details to focus on the essential elements of a scene to convey its mood and message.

The mosaics of the Church of the Dormition at Daphni, near Athens, provide an excellent example of this moving but elegant style. (Dormition, meaning "sleep," refers to Mary's bodily assumption into heaven.) The mosaic of the CRUCIFIXION (FIG. 7-43), like the Virgin of Vladimir, illustrates the emotional appeal to individuals in Middle Byzantine art: Jesus is shown with bowed head and sagging body, his eyes closed in death. Gone is the alert, living figure in a royal robe seen in the sixth-century Rabbula Gospels (SEE FIG. 7-36); now a nearly nude figure hangs on the cross. Also unlike the earlier scene, where a crowd reacts with anguish, indifference, or hostility, this image shows just two isolated mourning figures, Mary and the young apostle John, to whom Jesus had entrusted the care of his mother. The simplification of contours and the reduction of forms to essentials add to the emotional power of the image. The figures inhabit an otherworldly space, a golden universe anchored to the material world by a few flowers, which suggest the promise of new life.

This interpretation of the Crucifixion unites the Old and New Testaments. The mound of rocks and the skull at the bottom of the cross represent Golgotha, the "place of the skull," the hill outside ancient Jerusalem where Adam was thought to be buried and where the Crucifixion was said to have taken place. To the faithful, Jesus Christ was the new Adam sent by God to save humanity through his own sacrifice from the sins brought into the world by Adam and Eve. The arc of blood and water springing from Jesus's side refers to the rites of the

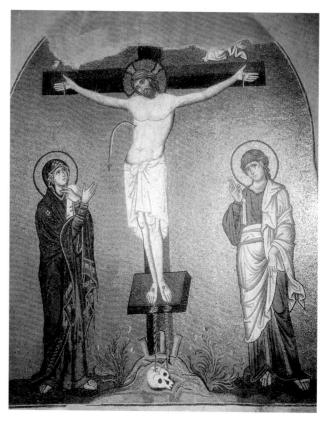

7-43 | CRUCIFIXION Church of the Dormition, Daphni, Greece. East wall of the north arm, Late 11th century. Mosaic.

Eucharist and the Baptism. As Paul wrote in his First Letter to the Corinthians: "For just as in Adam all die, so too in Christ shall all be brought to life" (1 Corinthians 15:22). The timelessness and simplicity of this image were meant to aid the Christian worshiper seeking to achieve a mystical union with the divine through prayer and meditation.

VENICE: THE CATHEDRAL OF SAINT MARK. The northeastern Italian city of Venice, set on the Adriatic at the crossroads of Europe and Asia Minor, was a major center of Byzantine art in Italy. Venice had been subject to Byzantine rule in the sixth and seventh centuries. Until the tenth century, the city's ruler, the *doge*, had to be ratified by the emperor. (*Doge* means "Duke" in the Venetian dialect.) At the end of the tenth century, when Constantinople granted Venice a special trade status that allowed its merchants to control much of the commerce between East and West, the city became very wealthy. Increased exposure to Eastern cultures is reflected in its art and architecture.

Venetian architects looked to the Byzantine domed church for inspiration in 1063, when the doge commissioned a church to replace the palace chapel, which had

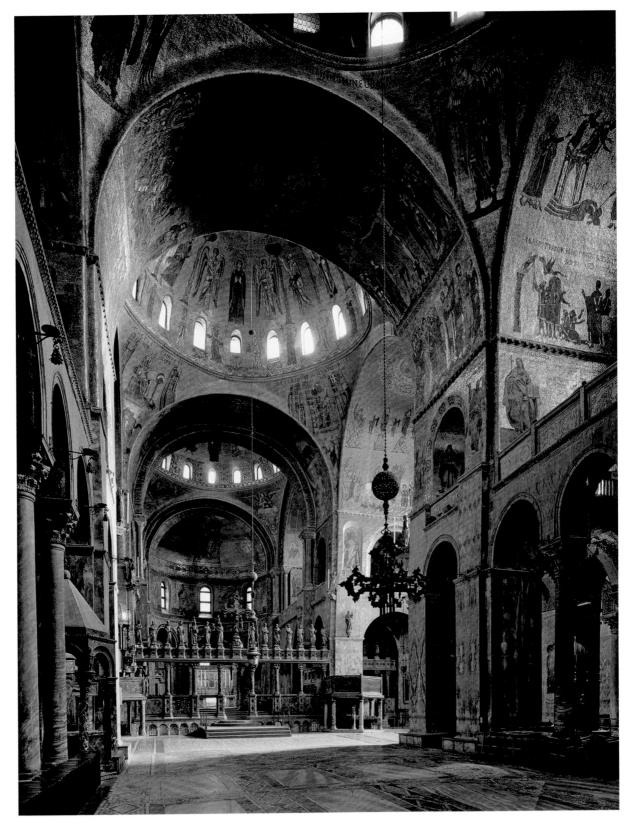

7-44 CATHEDRAL OF SAINT MARK

Venice. Present building begun 1063. View looking toward apse.

This church is the third one built on the site. It was both the palace chapel of the doge and the burial place for the bones of the patron of Venice, Saint Mark. The church was consecrated as a cathedral in 1807. Mosaics have been reworked continually to the present day.

served since the ninth century to hold the relics of Saint Mark the Apostle. The relics had been brought to Venice from Alexandria in 828/29. The Cathedral of Saint Mark has a Greek-cross plan, each square unit of which is covered by a dome, that is, five great domes in all, separated by barrel vaults and supported by pendentives. (See "Multiple-Dome Church Plans," page 275). Unlike Hagia Sophia in Constantinople, where the space seems to flow from the narthex up into the dome and through the nave to the apse, Saint Mark's domed compartments produce a complex space in which each dome has its own separate vertical axis (FIG. 7-44). Marble veneer covers the lower walls, and golden mosaics glimmer above on the vaults, pendentives, and domes. The dome seen in FIGURE 7-44 depicts the Pentecost, the descent of the Holy Spirit on the apostles. A view of Saint Mark's as it would have appeared in premodern times can be seen in a painting by the fifteenth-century Venetian artist Giovanni Bellini (FIG. 14–14).

Objects of Veneration and Devotion

During the second Byzantine golden age, artists of great talent and high aesthetic sensibility produced small luxury items of a personal nature for members of the court as well as for the church. Many of these items were commissioned by rulers and secular and church functionaries as official gifts for one another. They had to be portable, sturdy, and exquisitely refined. In style these works tended to combine classical elements with iconic compositions, successfully joining simple beauty and religious meaning. Ivory carving, gold and enamel work, and fine books were especially prized.

THE HARBAVILLE TRIPTYCH. Dating from the mid-eleventh century, the small ivory devotional piece known as the HAR-BAVILLE TRIPTYCH represents Christ flanked by Mary and Saint John the Baptist, a group known as THE DEËSIS (FIG. 7-45). Deesis means "entreaty" in Greek, and here Mary and John intercede for the people, pleading with Christ for forgiveness and salvation. The Deesis was an important new theme in keeping with personalized religious art. Directly below Christ, Saint Peter stands gesturing toward him. Inscriptions identify Saints James, John, Paul, and Andrew. The figures in the outer panels are military saints and martyrs. All the figures exist in a neutral space given definition only by the small bases under their feet. Although conceived as essentially frontal and rigid, the figures have rounded shoulders, thighs, and knees that suggest physical substance beneath their linear, decorative drapery.

METALWORK. The refined taste and skillful work that characterize the arts of the tenth through twelfth centuries were also expressed in precious materials such as silver and gold. A silver-gilt and enamel icon of the archangel Michael was one of the prizes the Crusaders took back to Venice in 1204, after sacking Constantinople (see "The Archangel Michael," page 276). The icon was presumably made in the late tenth or early eleventh century in an imperial workshop. The archangel appears here in essentially the same frontal pose and with the same idealized and timeless youthfulness with which he was portrayed in a sixth-century ivory panel (SEE FIG. 7–34). His head and hands, executed in relief, are surrounded by intricate relief and enamel decoration. Halo, wings, and garments

7–45 | **HARBAVILLE TRIPTYCH** Mid-11th century. Ivory, closed $11 \times 9 \%$ " (28 × 24.1 cm); open 11×19 " (28 × 48.2 cm). Musée du Louvre, Paris.

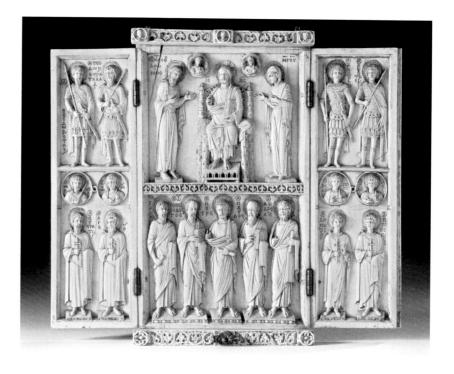

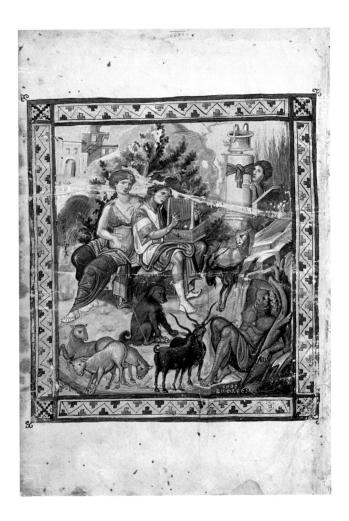

7–46 | DAVID THE PSALMIST Page from the *Paris Psalter*. Second half of the 10th century. Paint and gold on vellum, sheet size $14 \times 10 \frac{1}{2}$ " (35.6 × 26 cm). Bibliothèque Nationale, Paris.

are in jewels, colored glass, and delicate **cloisonné**. (Cloisonné enamel is produced by soldering fine wires in the desired pattern to a metal plate and then filling the resulting spaces, the cells—the *cloisons*—with powdered colored glass. When the plate is heated, the glass powder melts and fuses onto the surface to create small, jewel-like sections.) The outer frame, added later, is inset with enamel roundels.

THE PARIS PSALTER. As was true of the artists who decorated church interiors, the illustrators of luxuriously illustrated manuscripts combined intense religious expression, aristocratic elegance, and a heightened appreciation of rich decoration.

The PARIS PSALTER from the second half of the tenth century was a luxurious production with fourteen full-page paintings (FIG. 7–46). About a third of the Old Testament was written in poetry, and among its most famous poems are those in the Book of Psalms. According to ancient tradition, the author of the Psalms was Israel's King David, who as a young shepherd and musician saved the people by killing the giant Goliath. In Christian times, the Psalms were copied into a book called a psalter, used for private reading and meditation. The words "psalm" and "psalter" refer to the song sung to the harp or to the action of playing a stringed instrument.

Like the earlier *Rabbula Gospels* (SEE FIGS. 7–36, 7–37), the *Paris Psalter* artist framed his scenes on pages without text. The first of the full-page illustrations depicts David seated in a land-

scape playing his harp. The massive, idealized figures occupy a spacious landscape filled with lush foliage, a meandering stream, and a distant city. The image seems to have been transported directly from an ancient Roman wall painting. The ribbon-tied memorial column is a convention in Greek and Roman funerary art, and in the ancient manner, the illustrator has personified abstract ideas and landscape features: Melody, a female figure, leans casually on David's shoulder, while another woman, perhaps the nymph Echo, peeks out from behind the column. The reclining youth in the lower foreground is a personification of Mount Bethlehem, as we learn from his inscription. The image of the dog watching over the sheep and goats while his master strums the harp suggests the classical subject of Orpheus charming wild animals with music. The subtle modeling of forms, the integration of the figures into a threedimensional space, and the use of atmospheric perspective all enhance the classical flavor of the painting.

The Special Case of Sicily

A unique mixing of Byzantine, classical Greek and Roman, Muslim, and western Christian culture took place during this period on the island of Sicily. Sicily had been a Greek colony and then part of the Roman Empire. Muslims had ruled it from 827 to the end of the eleventh century, when it fell to the Normans, descendants of the Viking settlers of northern France. The Norman Roger II was crowned King of Sicily in

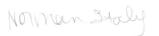

Elements of Architecture

MULTIPLE-DOME CHURCH PLANS

he construction of a huge single dome, such as Hagia Sophia's (SEE FIGS. 7-26, 7-27), presented almost insurmountable technical challenges. Byzantine architects found it more practical to cover large interior spaces with several domes. Justinian's architects devised the fivedome Greek-cross plan, which was copied in the West at Saint Mark's in Venice, (a) and see FIGURE 7-44. Middle Byzantine builders preferred smaller, more intricate spaces, and multiple-dome churches were very popular. The five

domes of the Greek cross would often rise over a nine-bay square (b). The most favored plan was the **quincunx**, or cross-in-square, in which barrel vaults cover the arms of a Greek cross around a large central dome, with domes or groin vaults filling out the corners of a nine-bay space (c). Often the vaults and secondary domes are smaller than the central dome. Any of these arrangements can be made into an expanded quincunx (d) by additional domed aisles, as at the Cathedral of Saint Sophia in Kiev (SEE FIG. 7-40).

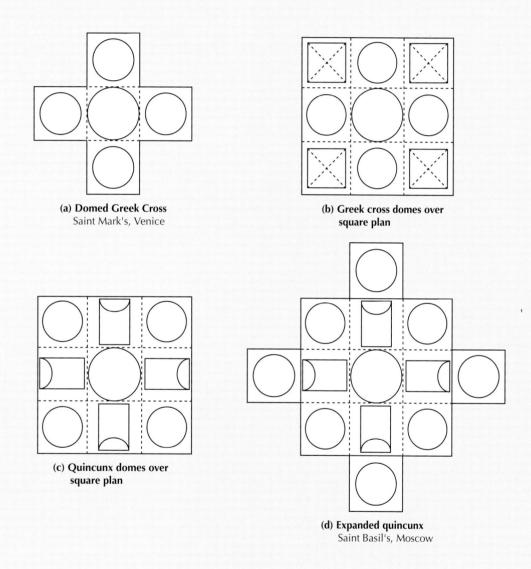

Palermo in 1130 and ruled until 1154. The pope, who assumed ecclesiastical jurisdiction over Sicily for "God and Saint Peter," was forced to endorse his rule while held captive. In the twelfth century, Sicily was one of the wealthiest and most enlightened kingdoms in Europe. Roger extended

religious toleration to a diverse population, which included Western Europeans, Greeks, Arabs, and Jews. He involved all factions in his government, permitted everyone to participate equally in the kingdom's economy, and issued official documents in Latin, Greek, and Arabic.

THE OBJECT SPEAKS

THE ARCHANGEL MICHAEL

cons speak to us today from computer screens—tiny images leading us from function to function in increasingly sophisticated hierarchies. Allusive images formed of light and color, these present-day icons—as with the religious icons (meaning "images" in Greek) that came before—speak to those who almost intuitively understand their suggestive form of communication.

The earliest icons had a mostly religious purpose—they were holy images that mediated between people and their God. Icons in the early Church were thought to be miracle workers, capable of defending petitioners from evil. One icon made more than a thousand years ago, possibly from the front and back covers of a book, depicts the archangel

Michael. The Protector of the Chosen, who defends his people from Satan and conducts their souls to God, Michael is mentioned in Jewish, Christian, and Islamic scriptures. On the front of this icon, Michael blesses petitioners with upraised hand; on the back is a relief in silver of the Cross, symbolizing Christ's victory over death.

When it was created, this icon would have spoken to believers of how archangels and angels mediate between God and humans—as when they announced Jesus's birth or mourned his death. They are not matter: They occupy no space, and their presence is felt, not seen. They are known intuitively, not by human reason.

Intuitive understanding is the core of Christian mysticism, according to the

sixth-century theologian Dionysus the Pseudo-Areopagite. As he explained, humans may, in stages, leave their sensory perception of the material world and rational thought and move to a mystical union with God. In icons, enamels, mosaics, and stained glass, artists tried to convey a sense of the divine with colored light. For them, matter becomes pure color and light as it becomes pure spirit. Believers thus would have interpreted the archangel Michael icon as an image formed by the golden light of heaven-it is his presence that is felt, not his body. When believers then and now behold icons like the archangel Michael, they intuit the image of the Heavenly Jerusalem.

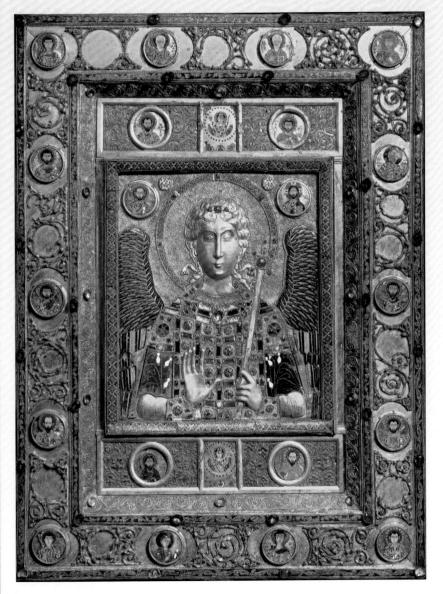

7–43 | ARCHANGEL MICHAEL Icon. Late 10th or early 11th century. Silver gilt with enamel, $19 \times 14''$ (48×36 cm). Treasury of the Cathedral of Saint Mark, Venice.

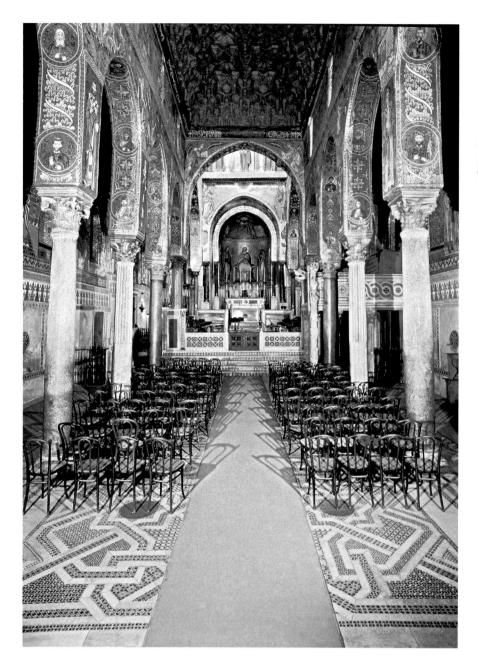

7–47 | PALATINE CHAPEL
Palermo, Sicily. Mid-12th century.
View toward the east.

A rich mixture of influences from East and West define art and architectural forms under his rule. He overtly emulated the culture of Byzantine empire, and his artistic patrimony offers a partial clue to the lost glory of imperial Constantinople in the twelfth century.

PALERMO: THE PALATINE CHAPEL. Roger's court in his capital of Palermo was a brilliant cultural mixture as reflected in the Palatine ("Palace") Chapel. The Western basilica-plan church has a Byzantine dome on squinches over the crossing, and an Islamic timber *muqarnas* ceiling in the nave. Its lower walls and floor are of inlaid marble, and the upper walls are decorated with mosaic. Christ holding an open book fills the half dome of the apse; a Christ Pantokrator surrounded by angels, the dome; the Annunciation, the arches of the crossing. The mosaics in the transept have scenes from the Gospels. The tall, well-proportioned figures are clothed in form-defining garments whose jagged, flying ends bear no relation to gravity. The artists often relied on strong juxtapositions of light and

dark areas instead of modeling forms with subtle tonal gradations. All these elements combine into a colorful, exotic whole (FIG. 7–47).

Palermo: King Roger's Chamber. A room in the Norman Palace at Palermo, made for William I (ruled 1154–66), known as King Roger's chamber, gives an idea of secular Byzantine art (FIG. 7–48). The floor, lower walls, and door frames have individual marble panels framed by strips inlaid with geometric patterns of colored stones. Mosaics cover the upper walls and vault. Against a continuous gold surface are two registers of highly stylized trees and paired lions, leopards, peacocks, centaurs, and hunters. The mosaics in the vault combine Islamic geometric patterns with very stylized vine scrolls and imperial symbols—lions, eagles, and griffons. The interior glistens with reflected light and color. The idea of a garden room, so popular in Roman houses, remains, but the artists have turned it into a stylized fantasy on nature—a world as formalized as the rituals that had come to dominate life in the imperial and royal courts.

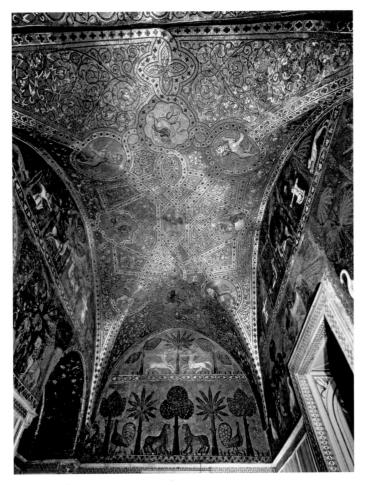

7–48 | **CHAMBER OF KING ROGER, NORMAN PALACE** Palermo, Sicily. Mid-12th century.

The Palermo palace is especially important because the loss of buildings makes the study of Byzantine domestic architecture almost impossible. Byzantine palaces must have been spectacular. Descriptions of the imperial palace in Constantinople tell of extraordinarily rich marbles and mosaics, silk hangings, and golden furniture, including a throne surrounded by mechanical singing birds and roaring lions. Palaces and houses evidently followed the pattern established by the Romans—a series of rooms around open courts. The great palace of the Byzantine emperors may have resembled Hadrian's Villa, with different buildings for domestic and governmental functions set in gardens, which were walled off from the city.

LATE BYZANTINE ART

The third great age of Byzantine art began in 1261, after the Byzantines expelled the Christian Crusaders who had occupied Constantinople for nearly sixty years, and it lasted until the city fell to the Turks in 1453. Although the empire had been weakened and its realm decreased to small areas of the Balkans and Greece, its arts underwent a resurgence. The

patronage of emperors, wealthy courtiers, and the Church stimulated renewed church building. In this new work, the physical requirements of the clergy and the liturgy took precedence over costly interior decorations. Nevertheless, the buildings reflect excellent construction skills as well as elegant and refined design.

Constantinople

In Constantinople, many small, existing churches were expanded with new ambulatory aisles, narthexes, and side chapels. Among these is the former Church of the Monastery of Christ in Chora, now the Kariye Camii Museum in Istanbul. The expansion of this church was one of several projects that Theodore Metochites, a humanist poet and scientist, and the administrator of the Imperial Treasury at Constantinople, sponsored between c. 1316 and 1321. To its church he added a two-story annex on the north side, two narthexes on the west side, and a funerary chapel on the south side. These structures contain the most impressive interior decorations remaining in Constantinople from the Late Byzantine period.

The funerary chapel is entirely painted with themes appropriate to such a setting (FIG. 7–49). For example, the Last Judgment is painted on the vault of the nave, and the Anastasis, Christ's descent into limbo to rescue Adam, Eve, and other virtuous people from Satan, is depicted in the half dome of the apse. Large figures of the church fathers (a group of especially revered early Christian writers of the history and teachings of the Church), saints, and martyrs line the walls below. Sarcophagi, surmounted by portraits of the deceased, once stood in side niches. Trompe l'oeil ("fool the eye") painting simulates marble paneling in the dado.

In the **ANASTASIS** (FIG. 7–50), Christ appears as a savior in white, moving with a force that is captured by his star-studded mandorla. He has trampled down the doors of hell; tied Satan into a helpless bundle; and shattered locks, chains, and bolts, which lie scattered over the ground. He drags the elderly Adam and Eve from their open sarcophagi with such force that their bodies seem airborne. Behind him are Old Testament prophets and kings, as well as his cousin John the Baptist.

Moscow: The Third Rome

In the fifteenth and sixteenth centuries, architecture of the Late Byzantine style flourished outside the borders of the empire in regions that had adopted Eastern Orthodox Christianity. After Constantinople's fall to the Ottoman Turks in 1453, leadership of the Orthodox Church shifted to Russia, whose rulers declared Moscow to be the "Third Rome" and themselves the heirs of Caesar (the czar).

The practice of venerating icons continued in Russia. A remarkable icon from this time is **THE OLD TESTAMENT TRIN- ITY (THREE ANGELS VISITING ABRAHAM)**, a large panel created sometime between 1410 and 1420 by the famed

artist-monk Andrey Rublyov (FIG. 7–51). It was commissioned in honor of the abbot Sergius of the Trinity-Sergius Monastery, near Moscow. This icon clearly illustrates how Late Byzantine artists relied on mathematical conventions to create ideal figures, as did the ancient Greeks. But unlike the Greeks, who based their formulas on close observation of nature, Byzantine artists invented an ideal geometry and depicted human forms and features accordingly.

Here, as is often the case, the circle forms the underlying geometric figure, emphasized by the form of the haloed heads. Despite the formulaic approach, talented artists like Rublyov managed to create a personal, expressive style. Rublyov relied on typical conventions—simple contours, elongation of the body, and a focus on a limited number of figures—to capture the sense of the spiritual in his work, yet distinguished his art by imbuing it with a sweet, poetic ambience. In this artist's hands, the Byzantine style took on new life.

The Byzantine tradition would continue in the art of the Eastern Orthodox Church and is carried on to this day in Greek and Russian icon painting. But in Constantinople, the three golden ages of Byzantine art—and the empire itself—came to an end in 1453. When the forces of the Ottoman sultan Mehmed II overran the capital, the Eastern Empire became part of the Islamic world, with its own very rich aesthetic heritage.

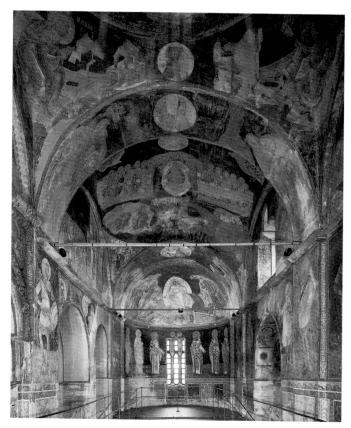

7-49 FUNERARY CHAPEL, CHURCH OF THE MONASTERY
OF CHRIST

In Chora, Constantinople. (Present-day Kariye Mazesi, Istanbul, Turkey.) c. 1310-21.

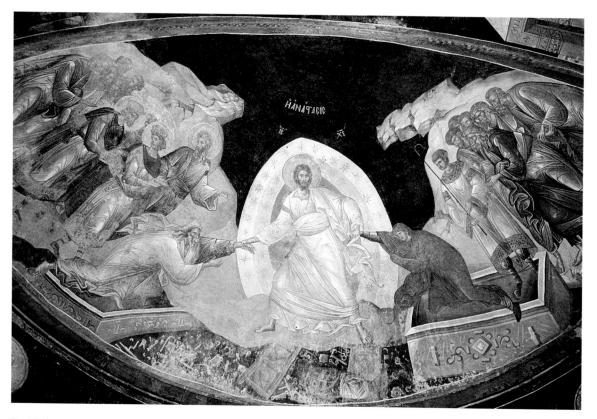

7–50 | ANASTASIS

Apse of the funerary chapel, Church of the Monastery of Christ in Chora. Painting.

Getty Research Library, Los Angeles. Wim Swaan Photograph Collection, 96.P.21

7–51 | Andrey Rublyov THE OLD TESTAMENT TRINITY (THREE ANGELS VISITING ABRAHAM) Icon. c. 1410–25. Tempera on panel, 55½ × 44½" (141 × 113 cm).

Representing the dogma of the Trinity—one God in three beings—was a great challenge to artists. One solution was to depict God as three identical individuals. Rublyov used that convention to illustrate the Old Testament story of the Hebrew patriarch Abraham and his wife, Sarah, who entertained three divine messengers in the guise of three strangers.

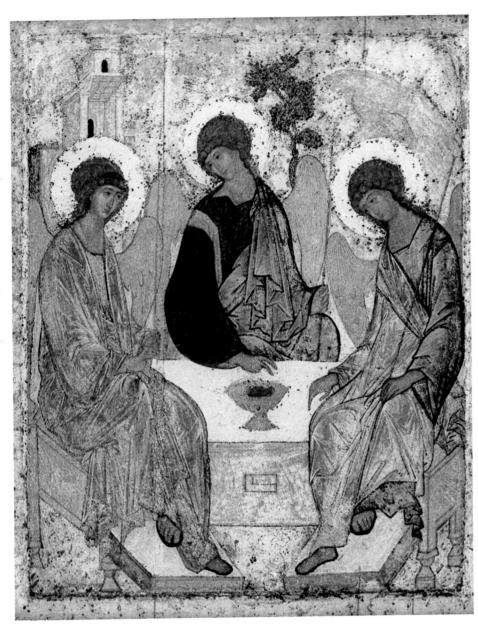

IN PERSPECTIVE

People in widely different times and places have sought answers to the fundamental questions of life and death, and in so doing they have tried to explain their relationship to a spiritual world. The arts reflect such searches for eternal truths. Artists appropriate, adapt, or reject earlier styles as they seek new modes of visual expression appropriate to their beliefs.

Jews, Christians, and Muslims believe in a single god. Jewish law, however, forbade the worship of idols—a prohibition that often made the representational arts suspect. Nevertheless, artists working for Jewish patrons depicted both symbolic and narrative Jewish subjects, and they looked to Near Eastern and classical Greek and Roman art for inspiration. Christians adopted the Jewish Scriptures as their Old Testament. Believing that God came to earth as a man in Jesus

Christ, they created a powerful figurative art using human beings as expressive symbols. Early Christians were Romans, x and their art and architecture were essentially Roman in style and technique.

Byzantine art—the art of the Orthodox Church—was centered in Constantinople (present-day Istanbul) and lasted for a thousand years. The Byzantine elite sponsored major scriptoria, or writing rooms, where scribes produced handwritten books, along with workshops for the production of ivory carvings and painted icons. Architects of the Byzantine era perfected churches in which glittering domes formed vast, light-filled canopies. Regardless of a building's appearance, the final product in each case is a reflection and an expression both of the spiritual beliefs and the worldly aspirations of the people who oversaw its construction and who gathered within its walls.

SYNAGOGUE DURA EUROPAS 244-45

GOOD SHEPHERD MOSAIC C. 425-6

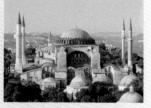

ANTHEMIUS OF TRALLES AND ISIDORUS OF MILETUS, HAGIA SOPHIA 532-37

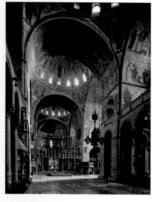

CATHEDRAL OF SAINT MARK 1063

OLD TESTAMENT TRINITY

c. 1410-25

JEWISH, EARLY CHRISTIAN AND BYZANTINE ART

- Destruction of Jerusalem 70 CE
- Early Christian 100-6th century CE

- Imperial Christian 313-476 CE
- Council of Nicaea 325 CE
- Early Byzantine c. 5th century-726 CE
- End of WesternRoman Empire 476 CE
- Justinian Emperor 527-65 CE

- Iconoclastic Controversy 726-843 CE
- Middle Byzantine 843-1204 CE
- Russia Becomes Christian 988 CE
- Division of Christian Church into Catholic and Orthodox 1054 CE
- Crusades Begin 1095 CE
- Western Rule of Constantinople 1204-61 CE
- Late Byzantine 1261-1453 CE
- ▼ Fall of Constantinople to Turks 1453 CE

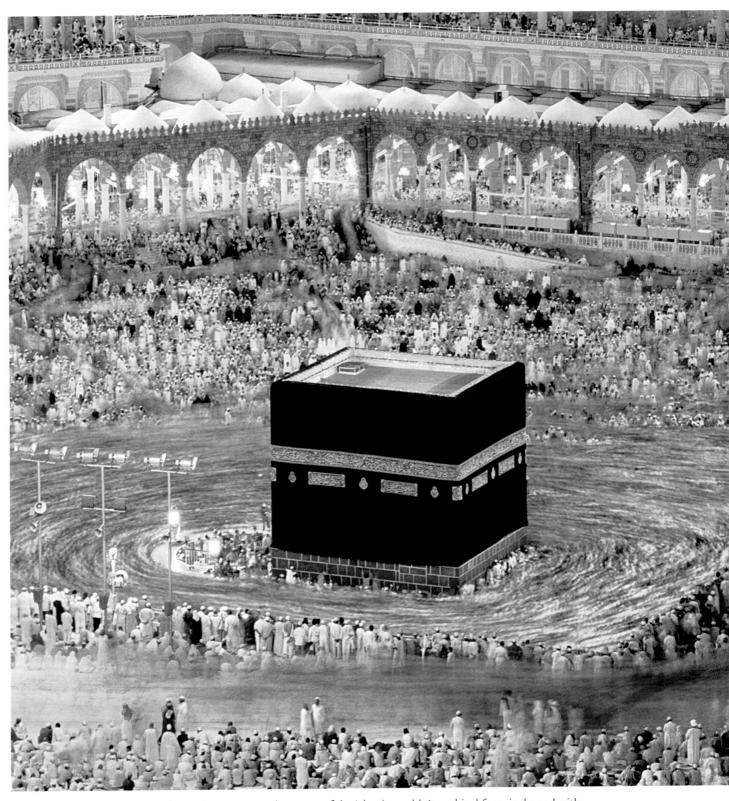

8-1 | **THE KAABA, MECCA** The Kaaba represents the center of the Islamic world. Its cubical form is draped with a black textile that is embroidered with a few Qur'anic verses in gold.

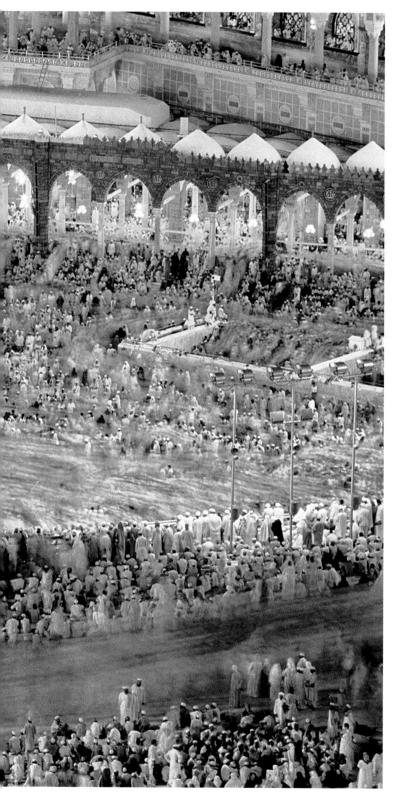

CHAPTER EIGHT

ISLAMIC ART

8

In the desert outside of Mecca in 610 CE, an Arab merchant named al-Amin sought solitude in a cave. On that night, which Muslims call "The

Night of Destiny," an angel appeared to al-Amin and commanded him to recite revelations from God (Allah). In that moment, al-Amin became Muhammad ("Messenger of God"). His revelations form the foundation of the religion called Islam ("submission to God's will"), whose adherents are Muslims ("those who have submitted to God"). For the rest of his life, Muhammad recited revelations in cadenced verses to his followers who committed them to memory. After his death, they transcribed the verses and organized them in chapters called *surahs*, thus compiling the holy book of Islam: the Qur'an ("Recitation").

The first person to accept Muhammad as God's Prophet was his wife, Khadija, followed soon thereafter by other family members. But many powerful Meccans were hostile to the message of the young visionary, and he and his companions were forced to flee in 622. Settling in an oasis town, later renamed Medina ("City"), Muhammad built a house that became a gathering place for the converted and thus the first Islamic mosque.

In 630, Muhammad returned to Mecca with an army of ten thousand, routed his enemies, and established the city

as the spiritual capital of Islam. After his triumph, he went to the Kaaba (FIG. 8–1), a cubical shrine said to have been built for God by the biblical patriarch Abraham and long the focus of pilgrimage and polytheistic worship. He emptied the shrine, repudiating its accumulated pagan idols, while preserving the enigmatic cubical structure itself and dedicating it to God.

The Kaaba is the symbolic center of the Islamic world, the place to which all Muslim prayer is directed and the ultimate destination of Islam's obligatory pilgrimage, the Hajj. Each year, huge numbers of Muslims from all over the world travel to Mecca to circumambulate the Kaaba during the month of pilgrimage. The exchange of ideas that occurs during the intermingling of these diverse groups of pilgrims has been a primary source of Islamic art's cultural eclecticism.

CHAPTER-AT-A-GLANCE

- **ISLAM AND EARLY ISLAMIC SOCIETY**
- ART DURING THE EARLY CALIPHATES | Architecture | Calligraphy | Ceramics and Textiles
- LATER ISLAMIC ART | Architecture | Portable Arts | Manuscripts and Painting
- THE OTTOMAN EMPIRE | Architecture | Illuminated Manuscripts and Tugras
- **THE MODERN ERA**
- IN PERSPECTIVE

ISLAM AND EARLY ISLAMIC SOCIETY

Seemingly out of nowhere, Islam arose in seventh-century Arabia, a land of desert oases with no cities of great size, sparsely inhabited by tribal nomads. Yet, under the leadership of its founder, the Prophet Muhammad (c. 570–632 CE), and his successors, Islam spread rapidly throughout northern Africa, southern and eastern Europe, and much of Asia, gaining territory and converts with astonishing speed. Because Islam encompassed geographical areas with a variety of longestablished cultural traditions, and because it admitted diverse peoples among its converts, it absorbed and combined many different techniques and ideas about art and architecture. The result was a remarkable eclecticism and artistic sophistication.

Muslims date their history as beginning with the hijira ("emigration"), the flight of the Prophet Muhammad in 622 from Mecca to Medina. In less than a decade Muhammad had succeeded in uniting the warring clans of Arabia under the banner of Islam. Following his death in 632, four of his closest associates in turn assumed the title of caliph ("successor").

Muhammad's act of emptying the Kaaba of its pagan idols confirmed the fundamental concept of aniconism (avoidance of figural imagery) in Islamic art. Following his example, the Muslim faith discourages the representation of figures, particularly in religious contexts. Instead, Islamic artists elaborated a rich vocabulary of nonfigural ornament, including complex geometric designs and scrolling vines

sometimes known as **arabesques**. Islamic art revels in surface decoration, in manipulating line, color, and especially pattern, often highlighting the interplay of pure abstraction, organic form, and script.

According to tradition, the Qur'an assumed its final form during the time of the third caliph, Uthman (ruled 644–56). As the language of the Qur'an, the Arabic language and script have been a powerful unifying force within Islam. From the eighth through the eleventh centuries, Arabic was the universal language among scholars in the Islamic world and in some Christian lands as well. Inscriptions frequently ornament works of art, sometimes written clearly to provide a readable message, but in other cases written as complex patterns simply to delight the eye.

The accession of Ali as the fourth caliph (ruled 656–61) provoked a power struggle that led to his assassination and resulted in enduring divisions within Islam. Followers of Ali, known as Shi'ites (referring to the party or *shi'a* of Ali), regard him alone as the Prophet's rightful successor. Sunni Muslims, in contrast, recognize all of the first four caliphs as "rightly guided." Ali was succeeded by his rival Muawiya (ruled 661–80), a close relative of Uthman and the founder of the Umayyad dynasty (661–750).

Islam expanded dramatically. In just two decades, seemingly unstoppable Muslim armies conquered the Sasanian Persian Empire, Egypt, and the Byzantine provinces of Syria and Palestine. By the early eighth century, under the Umayyads, they had reached India, conquered northern

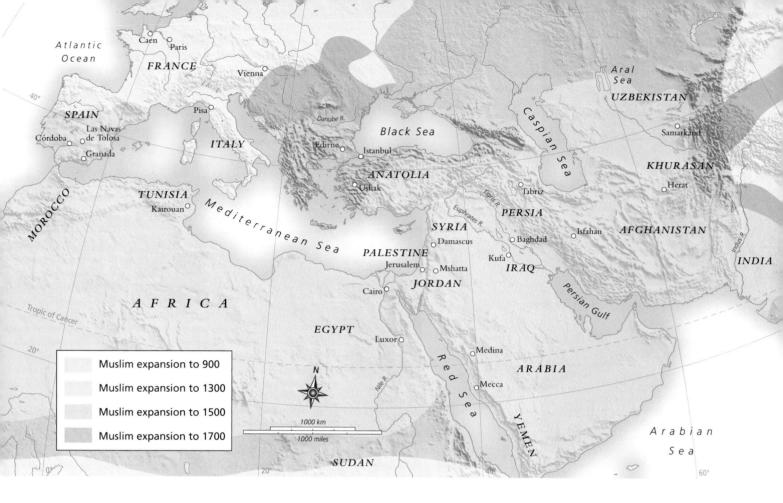

MAP 8-I THE ISLAMIC WORLD

Within 200 years after 622 CE, the Islamic world expanded from Mecca to India in the east, and to Morocco and Spain in the west.

Africa and Spain, and penetrated France to within 100 miles of Paris before being turned back (MAP 8–1). In these newly conquered lands, the treatment of Christians and Jews who did not convert to Islam was not consistent, but in general, as "People of the Book"—followers of a monotheistic religion based on a revealed scripture—they enjoyed a protected status. However, they were also subject to a special tax and restrictions on dress and employment.

Muslims participate in congregational worship at a mosque (masjid, "place of prostration"). The Prophet Muhammad himself lived simply and instructed his followers in prayer at a mud-brick house, now known as the Mosque of the Prophet, where he resided in Medina. This was a square enclosure that framed a large courtyard. Facing the courtyard along the east wall were small rooms where Muhammad and his family lived. Along the south wall, a thatched portico supported by palm-tree trunks sheltered both the faithful as they prayed and Muhammad as he spoke from a low platform. This simple arrangement inspired the design of later mosques.

Lacking an architectural focus such as an altar, nave, or dome, the space of this prototypical mosque reflected the founding spirit of Islam in which the faithful pray directly to God without the intermediary of a priesthood.

ART DURING THE EARLY CALIPHATES

The caliphs of the Umayyad dynasty (661–750), which ruled from Damascus in Syria, built mosques and palaces throughout the Islamic Empire. These buildings projected the authority of the new rulers and reflected the growing acceptance of Islam. In 750 the caliphs of the Abbasid dynasty replaced the Umayyads in a coup d'etat, ruling until 1258 in the grand manner of the ancient Persian emperors. Their capital was Baghdad in Iraq, and their art patronage reflected Persian and Turkic traditions. Their long and cosmopolitan reign saw achievements in medicine, mathematics, the natural sciences, philosophy, literature, music, and art. They were generally

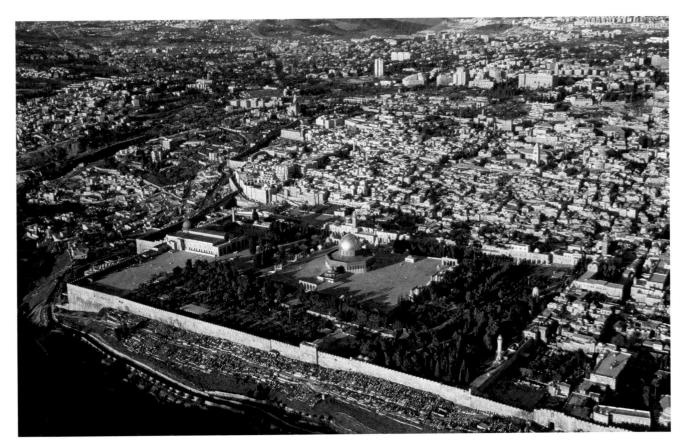

8-2 | AERIAL VIEW OF HARAM AL-SHARIF, JERUSALEM

The Dome of the Rock occupies a place of visual height and prominence in Jerusalem and, when first built, strikingly emphasized the arrival of Islam and its community of adherents in that ancient city.

tolerant of the ethnically diverse populations in the territories they subjugated, and they admired the past achievements of Roman civilization and the living traditions of Byzantium, Persia, India, and China, freely borrowing artistic techniques and styles from all of them.

Architecture

While Mecca and Medina remained the holiest Muslim cities, under the Umayyad caliphs the political center moved away from the Arabian peninsula to the Syrian city of Damascus. Here, inspired by the Roman and Byzantine architecture of the eastern Mediterranean, the Muslims became enthusiastic builders of shrines, mosques, and palaces. The simple congregational mosque with hypostyle columns eventually gave way to new types, such as cruciform and centrally planned mosques. Although tombs were officially discouraged in Islam, they proliferated from the eleventh century onward, in part due to funerary practices imported from the Turkic northeast, and in part due to the rise of Shi'ism with its emphasis on genealogy and particularly ancestry through Muhammad's daughter, Fatima. The Umayyads launched the practice of building both urban palaces and rural estates; under later dynasties such as the Abbasids, the Spanish Umayyads, and

their successors, these were huge, sprawling complexes with an urban infrastructure of mosques, bathhouses, reception rooms, kitchens, barracks, gardens, and road networks.

THE DOME OF THE ROCK. The Dome of the Rock is the first great monument of Islamic art. Built in Jerusalem, it is the third most holy site in Islam. In the center of the city rises the Haram al-Sharif ("Noble Sanctuary") (FIG. 8-2), a rocky outcrop from which Muslims believe Muhammad ascended to the presence of God on the "Night Journey" described in the Qur'an. Jews and Christians variously associate the same site with Solomon's Temple, the site of the creation of Adam, and the place where the patriarch Abraham prepared to sacrifice his son Isaac at the command of God. In 691-2, the Umayyads had completed the construction of a shrine over the rock (FIGS. 8-3, 8-4) using Syrian artisans trained in the Byzantine tradition. By appropriating a site holy to the Jewish and Christian faiths, the Dome of the Rock is the first architectural manifestation of Islam's view of itself as completing the prophecies of those faiths and superseding them.

Structurally, the Dome of the Rock imitates the centrally planned form of Early Christian and Byzantine martyria. However, unlike its models, with their plain exteriors, it is

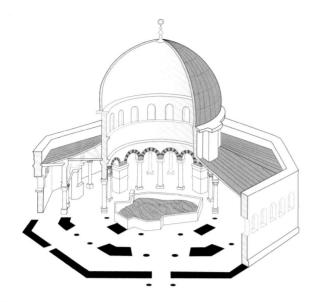

8-3 CUTAWAY DRAWING OF THE DOME OF THE ROCK

crowned with a golden dome that dominates the Jerusalem skyline, and it is decorated with opulent marble veneer and mosaics inside its exterior tiles. The dome, surmounting an octagonal drum pierced with windows and supported by

arcades of alternating piers and columns, covers the central space containing the rock (FIG. 8-3). These arcades create concentric aisles (ambulatories) that permit devout visitors to circumambulate the rock. Inscriptions from the Qur'an interspersed with passages from other texts, including information about the building itself, form a frieze around the inner wall. As the pilgrim walks around the central space to read the inscriptions in brilliant gold mosaic on turquoise green ground, the building communicates both as a text and as a dazzling visual display. These passages of text are especially notable because they are the oldest surviving written Qur'an verses and the first use of monumental Our'anic inscriptions in architecture. Below the frieze are walls covered with pale marble, the veining of which creates abstract symmetrical patterns, and columns with shafts of gray marble and gilded capitals. Above the calligraphic frieze is another mosaic frieze depicting thick, symmetrical vine scrolls and trees in turquoise, blue, and green, embellished with imitation jewels, over a gold ground. The mosaics are variously thought to represent the gardens of Paradise and trophies of Muslim victories offered to God. The decorative program is extraordinarily rich, but remarkably enough, the focus of the building is neither art nor architecture but the plain rock within it.

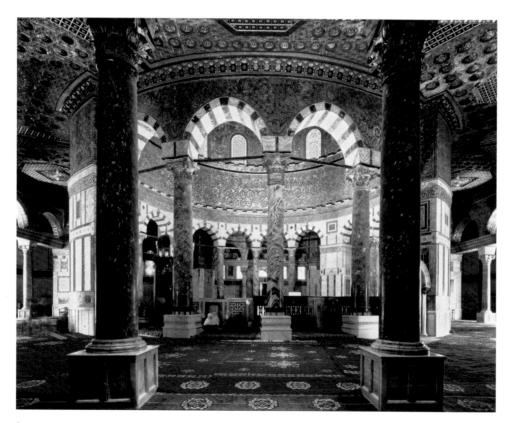

8–4 ↑ **DOME OF THE ROCK, JERUSALEM** 691–2. Interior.

The arches of the inner and outer face of the central arcade are encrusted with golden mosaics. The carpets and ceiling are modern but probably reflect the original patron's intention.

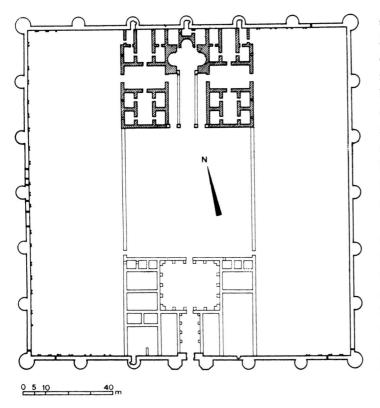

 $8-5 \pm \text{plan of the palace at mshatta, Jordan}$ 743-4.

MSHATTA PALACE. The Umayyad caliphs built profusely decorated palatial hunting retreats on the edge of the desert where local chieftains could be entertained and impressed. One such palace was built at Mshatta, near present-day Amman, Jordan (probably in 743–4). Although the east and west sides of Mshatta seem never to have been completed, this square, stone-walled complex is nevertheless impressively monumental (FIG. 8–5). It measured 472 feet on each side, and its outer walls and gates were guarded by towers and bastions reminiscent of a Roman fort. Inside, around a large central court, were a mosque, a domed audience hall, and private apartments.

Unique among surviving palaces, Mshatta was decorated with a frieze that extended in a band about 16 feet high across the base of its façade. This frieze was divided by a zigzag molding into triangular compartments, each punctuated by a large rosette carved in high relief (FIG. 8–6). The compartments were filled with intricate carvings in low relief that included interlacing scrolls inhabited by birds and other animals, urns, and candlesticks. Beneath one of the rosettes, two facing lions drink at an urn from which grows the Tree of Life, an ancient Persian motif. However, where the frieze runs across the outer wall of the mosque, to the right of the entrance, animal and bird imagery is conspicuously absent, in close observance of the strictures against icons.

THE GREAT MOSQUE OF KAIROUAN. Mosques provide a place for regular public worship. The characteristic elements of the **hypostyle** (multicolumned) mosque developed during

the Umayyad period (see "Mosque Plans," right). The Great Mosque of Kairouan, Tunisia (FIG. 8–7), built in the ninth century, reflects the early form of the mosque but is elaborated with new additions. Its large rectangular plan is divided between a courtyard and a flat-roofed hypostyle prayer hall oriented toward Mecca. The system of repeated bays and aisles can easily be extended as the congregation grows in size—one of the hallmarks of the hypostyle plan. New is the huge tower (the minaret, from which the faithful are called to prayer) that rises from one end of the courtyard and that stands as a powerful sign of Islam's presence in the city.

The qibla wall, marked by a centrally positioned mihrab niche, is the wall of the prayer hall that is closest to Mecca. In the Great Mosque of Kairouan, the qibla wall is given heightened importance by a raised roof, a dome over the mihrab, and an aisle that marks the axis that extends from the mihrab to the minaret. The mihrab belongs to the tradition of niches that signify a holy place—the shrine for the Torah scrolls in a synagogue, the frame for the sculpture of a god or ancestor in Roman architecture, the apse in a church.

The magsura, an enclosure in front of the militab for the

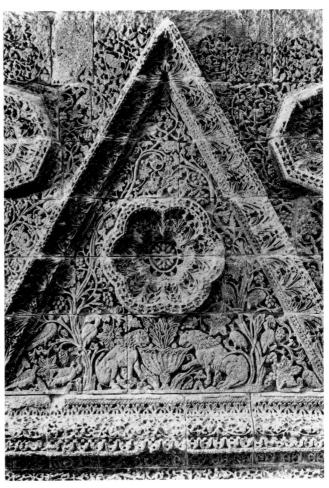

 $8-6 \ | \$ frieze, detail of façade of the palace at mshatta

Stone. Staatliche Museen zu Berlin, Preussischer Kulturbesitz, Museum für Islamische Kunst.

Elements of Architecture MOSQUE PLANS

ollowing the model of the Mosque of the Prophet in Medina, the earliest mosques were columnar **hypostyle halls**. The Great Mosque of Cordoba (SEE FIG. 8–8) was approached through an open courtyard, its interior divided by rows of columns leading, at the far end, to the *mihrab* niche of a *qibla* wall indicating the direction of Mecca.

A second type, the **four-iwan mosque**, such as the Masjid-i Jami at Isfahan, was developed in Iran. The *iwans*—huge barrel-vaulted halls with wide-open, arched entrances—faced each other across a central courtyard; the inner façade of this courtyard was thus given cross-axial emphasis, height, and greater monumentality (SEE FIG. 8-14).

Centrally planned mosques, such as the Sultan Selim Mosque at Edirne (SEE FIG. 8–27), were strongly influenced by Byzantine church plans, such as the Hagia Sophia (SEE FIG. 7–26) and are typical of the Ottoman architecture of Turkey. The interiors are dominated by a large domed space uninterrupted by structural supports. Worship is directed, as in other mosques, toward a *qibla* wall and *mihrab* opposite the entrance.

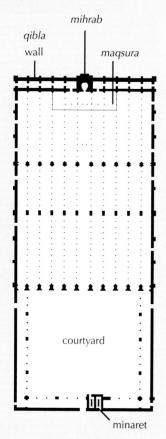

hypostyle mosque Great Mosque, Cordoba, after extension by al-Hakam II

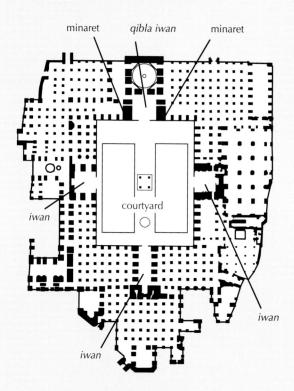

four-iwan mosque Congregational Mosque, Isfahan

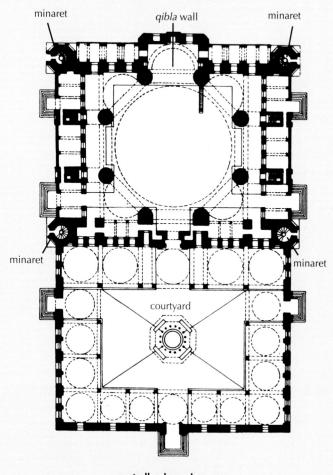

centrally-planned mosque Sultan Selim Mosque, Edirne

(Plans are not to scale)

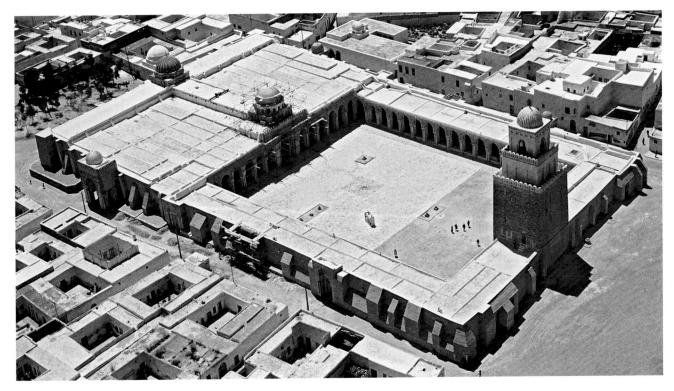

8-7 \perp the great mosque, Kairouan, Tunisia 836-75.

ruler and other dignitaries, became a feature of the principal congregational mosque after an assassination attempt on one of the Umayyad rulers. The minbar, or pulpit, stands by the *mihrab* as the place for the prayer leader and as a symbol of authority (for a fourteenth-century example of a *mihrab* and a *minbar*, SEE FIG. 8–16).

THE GREAT MOSQUE OF CORDOBA. When the Abbasids overthrew the Umayyads in 750, a survivor of the Umayyad dynasty, Abd al-Rahman I (ruled 756–88), fled across North Africa into southern Spain (known as al-Andalus in Arabic) where, with the support of Muslim settlers, he established himself as the provincial ruler, or emir. While the caliphs of the Abbasid dynasty ruled the eastern Islamic world from Baghdad for five centuries, the Umayyad dynasty ruled in Spain from their capital in Cordoba (756–1031). The Umayyads were noted patrons of the arts, and one of the finest surviving examples of Umayyad architecture is the Great Mosque of Cordoba (see "Mosque Plans," page 289).

In 785, the Umayyad conquerors began building the Cordoba mosque on the site of a Christian church built by the Visigoths, the pre-Islamic rulers of Spain. The choice of site was both practical—for the Muslims had already been borrowing space within the church—and symbolic, an appropriation of place (similar to the Dome of the Rock) that affirmed their presence. Later rulers expanded the building three times, and today the walls enclose an area of

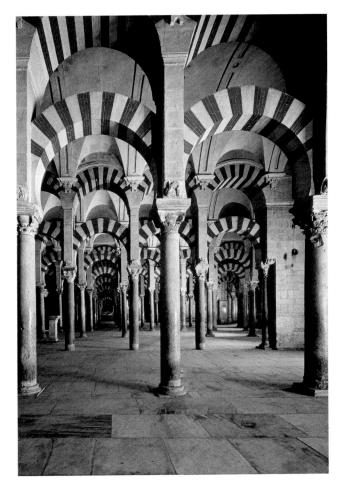

8–8 | prayer hall, great mosque, cordoba, spain. Begun 785–86.

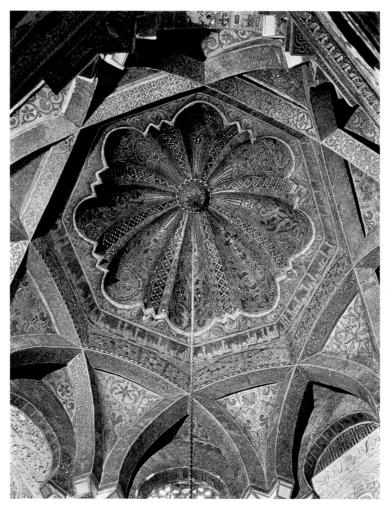

8-9 | dome in front of the *mihrab*, great mosque 965.

about 620 by 460 feet, about a third of which is the courtyard. This patio was planted with fruit trees beginning in the early eighth century; today orange trees seasonally fill the space with color and scent. Inside, the proliferation of pattern in the repeated columns and double flying arches is colorful and dramatic. The marble columns and capitals in the hypostyle prayer hall were recycled from the Christian church that had formerly occupied the site, as well as from classical buildings in the region, which had been a wealthy Roman province. FIG. 8–8 shows the mosque's interior with columns of slightly varying heights. Two tiers of arches, one over the other, surmount these columns; the upper tier springs from rectangular posts that rise from the columns. This double-tiered design effectively increases the height of the interior space and provides excellent air circulation as well as a sense of monumentality and awe. The distinctively shaped horseshoe arches—a form known from Roman times and favored by the Visigoths—came to be closely associated with Islamic architecture in the West (see "Arches and Mugarnas," page 292). Another distinctive feature of these arches, also adopted from Roman and Byzantine precedents, is the alternation of white stone and red brick voussoirs forming the curved arch.

In the final century of Umayyad rule, Cordoba emerged as a major commercial and intellectual hub and a flourishing center for the arts, surpassing Christian European cities economically and also in science, literature, and philosophy. As a sign of this new prestige and power, Abd al-Rahman III (ruled 912-61) boldly reclaimed the title of caliph in 929. He and his son al-Hakam II (ruled 961-76) made the Great Mosque a focus of patronage, commissioning costly and luxurious renovations such as a new mihrab with three bays in front of it. The melon-shaped, ribbed dome over the central bay seems to float upon a web of criss-crossing arches (FIG. 8-9). The complexity of the design, which differs from the geometric configuration of the domes to either side, reflects the Islamic interest in mathematics and geometry, not purely as abstract concepts but as sources for artistic inspiration. Lushly patterned mosaics with inscriptions, geometric motifs, and stylized vegetation clothe both this dome and the mihrab below in brilliant color and gold. These were installed by a Byzantine master who was sent by the emperor in Constantinople, bearing boxes of the small glazed ceramic and glass pieces (tesserae). Such artistic exchange is emblematic of the interconnectedness of the medieval Mediterraneanthrough trade, diplomacy, and competition.

Elements of Architecture

ARCHES AND MUQARNAS

slamic builders explored structure in innovative ways. They explored the variations and possibilities of the horseshoe arch (SEE FIG. 8–8) (which had a very limited use before the advent of Islam) and the pointed arch (SEE FIG. 8–14). There are many variations of each, some of which disguise their structural function beneath complex decoration.

Unique to Islam, *muqarnas* are small nichelike component that is usually stacked and used in multiples as interlocking, successive, non-load-bearing, vaulting units. Over time they became increasingly intricate (and non-structural) so that they dazzled the eye and confused the rational mind (SEE FIG. 8–18). They are frequently used to fill the hoods of *mihrabs* and portals and, on a larger scale, to vault domes, softening or even masking the transition from the vertical plane to the horizontal.

horseshoe arch

pointed arch

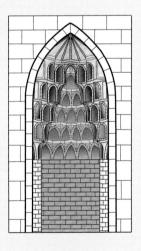

muqarnas

Calligraphy

Muslim society holds calligraphy (the art of fine hand lettering) in high esteem. Since the Qur'an is believed to reveal the word of God, its words must be written accurately, with devotion and embellishment. Writing was not limited to books and documents but was displayed on the walls of buildings, on metalwork, textiles, and ceramics. Since pictorial imagery developed relatively late in Islamic art (and there was no figural imagery at all in the religious context), inscription became the principal vehicle for visual communication. The written word thus played two roles: It could convey verbal information about a building or object, describing its beauty or naming its patron, while also delighting the eye in an entirely aesthetic sense. Arabic script is written from right to left, and each letter usually takes one of three forms depending on its position in a word. With its rhythmic interplay between verticals and horizontals, the system lends itself to many variations. Formal Kufic script (after Kufa, a city in Iraq) is blocky and angular, with strong upright strokes and long horizontals. It may have developed first for carved or woven inscriptions where clarity and practicality of execution were important.

Most early Qur'ans had large Kufic letters and only three to five lines per page, which had a horizontal orientation. The visual clarity was necessary because one book was often shared by multiple readers simultaneously. A page from a ninth-century Syrian Qur'an exemplifies the style common from the eighth to the tenth century (FIG. 8–10). Red diacritical marks (pronunciation guides) accent the dark brown ink; the *surah* ("chapter") title is embedded in the burnished ornament at the bottom of the sheet. Instead of page numbers, the brilliant gold of the framed words and the knoblike projection in the left-hand margin are a distinctive means of marking chapter breaks.

Calligraphers enjoyed the highest status of all artists in Islamic society. Included in their numbers were a few princes and women. Apprentice scribes had to learn secret formulas for inks and paints; become skilled in the proper ways to sit, breathe, and manipulate their tools; and develop their individual specialties. They also had to absorb the complex literary traditions and number symbolism that had developed in Islamic culture. Their training was long and arduous, but unlike other craft practitioners who were generally anonymous in the early centuries of Islam, outstanding calligraphers received public recognition.

By the tenth century, more than twenty cursive scripts had come into use. They were standardized by Ibn Muqla (d. 940), an Abbasid official who fixed the proportions of the letters in each and devised a method for teaching the calligraphy that is still in use today. The Qur'an was usually written on parchment (treated animal skin) and vellum (calfskin or a fine parchment). Paper was first manufactured in Central Asia during the mid-eighth century, having been

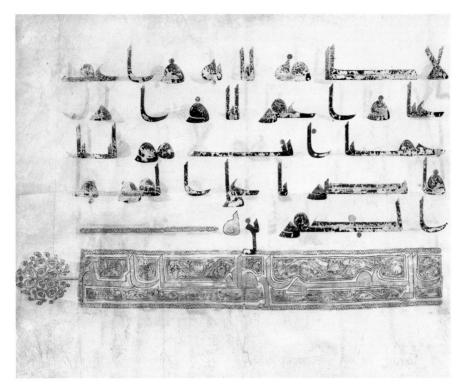

8–10 | PAGE FROM THE QUR'AN (Surah II: 286 and title Surah III) in Kufic script, from Syria, 9th century. Black ink pigments, and gold on vellum, $8\frac{1}{8} \times 11\frac{1}{8}$ " (21.8 \times 29.2 cm). The Metropolitan Museum of Art, New York.

Rogers Fund, 1937 (37.99.2)

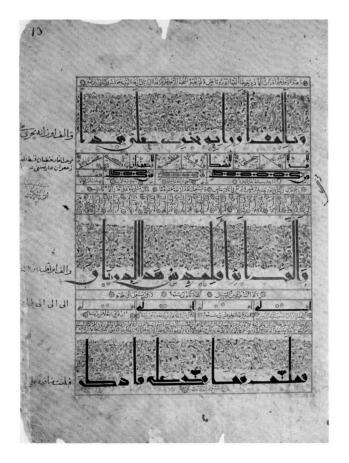

8–II | ARABIC MANUSCRIPT PAGE
Attributed to Galinus. Iraq. 1199.
Headings are in ornamental Kufic
script with a background of scrolling
vines, while the text—a medical treatise—is written horizontally and vertically in Naskhi script.
Bibliothèque Nationale, Paris.

introduced earlier by Buddhist monks. Muslims learned how to make high-quality, rag-based paper, eventually establishing their own paper mills. By about 1000, paper had largely replaced the more costly parchment, encouraging the proliferation of increasingly elaborate and decorative cursive scripts, which generally superseded Kufic by

the thirteenth century. Of the major styles, one extraordinarily beautiful form, known as *naskhi*, was said to have been revealed and taught to scribes in a vision. Even those who cannot read Arabic can enjoy the flowing beauty of its lines, which are often interlaced with swirling vine scrolls (FIG. 8–11).

Ceramics and Textiles

On objects made of ceramics, ivory, and metal, as well as textiles, calligraphy was prominently displayed. It was the only decoration on a type of white pottery made in the ninth and tenth centuries in and around the region of Khurasan (also known as Nishapur, in present-day northeastern Iran) and Samarkand (in present-day Uzbekistan). Now known as Samarkand ware, these elegant pieces are characterized by the use of a clear lead glaze applied over a black inscription on a white slip-painted ground. In FIG. 8–12 the script's horizontals and verticals have been elongated to fill the bowl's rim. The inscription translates: "Knowledge: the beginning of it is bitter to taste, but the end is sweeter than honey," an apt choice for tableware and appealing to an educated patron. Inscriptions on Samarkand ware provide a storehouse of such popular sayings.

A Kufic inscription appears on a tenth-century piece of silk from Khurasan (FIG. 8–13): "Glory and happiness to the Commander Abu Mansur Bukhtakin. May God prolong his prosperity." Such good wishes were common in Islamic art, appearing as generic blessings on ordinary goods sold in the marketplace or, as here, personalized for the patron. Texts can sometimes help determine where and when a work was made, but they can also be frustratingly uninformative when little is known about the patron, and they are not always

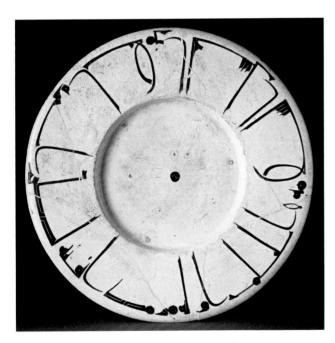

8–12 | BOWL WITH KUFIC BORDER
Samarkand, Uzbekistan. 9th-10th century. Earthenware with slip, pigment, and lead glaze, diameter 14½" (37 cm).
Musée du Louvre, Paris.

The white ground of this piece imitated prized Chinese porcelains made of fine white kaolin clay. Both Samarkand and Khurasan were connected to the Silk Road, the great caravan route to China, and were influenced by Chinese culture.

truthful. Stylistic comparisons—in this case with other textiles, with the way similar subjects appear in other mediums, and with other Kufic inscriptions—sometimes reveal more than the inscription alone.

This silk must have been brought from the Near East to France by knights at the time of the First Crusade. Known as the Shroud of Saint Josse, the silk was preserved in the Church of Saint-Josse-sur-Mer, near Caen in Normandy. Textiles were an actively traded commodity in the medieval Mediterranean region and formed a significant portion of dowries and inheritances. Because of this, textiles were an important means of disseminating artistic styles and techniques. This fragment shows two elephants with rich ornamental coverings facing each other on a dark red ground, each with a mythical griffin between its feet. A caravan of two-humped Bactrian camels linked with rope moves up the left side, part of the elaborately patterned borders. The inscription at the bottom is upside-down, suggesting that the missing portion of the textile was a fragment from a larger and more complex composition. The weavers used a complicated loom to produce repeated patterns. The technique and design derive from the sumptuous pattern-woven silks of Sasanian Iran (Persia). The Persian weavers had, in turn, adapted Chinese silk technology to the Sasanian taste for paired heraldic beasts and other Near Eastern imagery. This tradition, with modifications—the depiction of animals, for example, became less naturalistic—continued after the Islamic conquest of Iran.

LATER ISLAMIC ART

The Abbasid caliphate began a slow disintegration in the ninth century, and thereafter power in the Islamic world became fragmented among more or less independent regional rulers. During the eleventh century, the Saljuqs, a Turkic people, swept from north of the Caspian Sea into Khurasan and took Baghdad in 1055, becoming the virtual rulers of the Abbasid Empire. The Saljuqs united most of Iran and Iraq, establishing a dynasty that endured from 1037/38 to 1194. A branch of the dynasty, the Saljuqs of Rum, ruled much of Anatolia (Turkey) from the late eleventh to the beginning of the fourteenth century. The Islamic world suffered a dramatic rift in the early thirteenth century when the nomadic Mongols-non-Muslims led by Genghiz Khan (ruled 1206-27) and his successors-attacked northern China, Central Asia, and ultimately Iran. The Mongols captured Baghdad in 1258 and encountered weak resistance until they reached Egypt. There, the young Mamluk dynasty (1250-1517), founded by descendants of slave soldiers (mamluk means "slave"), firmly defeated the Mongols. In Spain, the borders of Islamic territory were gradually pushed back by Christian forces and Muslim rule ended altogether in 1492.

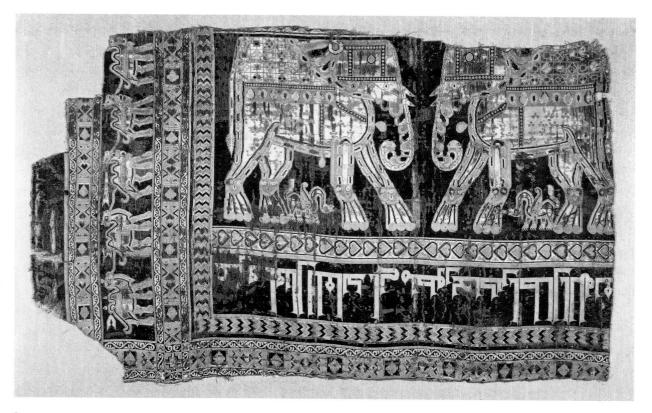

8-13 | TEXTILE WITH ELEPHANTS AND CAMELS

Known today as the Shroud of Saint Josse, from Khurasan or Central Asia. Before 961. Dyed silk, largest fragment $20\frac{1}{2} \times 37$ " (94 \times 52 cm). Musée du Louvre, Paris.

Silk textiles were both sought-after luxury items and a medium of economic exchange. Government-controlled factories, known as *tiraz*, produced cloth for the court as well as for official gifts and payments. A number of fine Islamic fabrics have been preserved in the treasuries of medieval European churches, where they were used for priests' ceremonial robes, altar cloths, and to wrap the relics of Christian saints.

Although the religion of Islam remained a dominant and unifying force throughout these developments, the history of later Islamic society and culture reflects largely regional phenomena. Only a few works have been selected here to characterize the art of Islam, and they by no means provide a comprehensive history of Islamic art.

Architecture

The Saljuq Dynasty and its successors built on a grand scale, expanding their patronage from mosques and palaces to include new functional buildings, such as tombs, madrasas (colleges for religious and legal studies), public fountains, urban hostels, and remote caravanserais (inns) for traveling merchants in order to encourage long-distance trade. They developed a new mosque plan organized around a central courtyard framed by four large *iwans* (large vaulted halls with rectangular plans and monumental arched openings); this four-*iwan* plan was already being used for schools and palaces.

Furthermore, they amplified the social role of architecture so that multiple building types were combined in large and diverse complexes, supported by perpetual endowments that funded not only the building, but its administration and maintenance. Increasingly, these complexes included the patron's own tomb, thus giving visual prominence to the act of individual patronage and the expression of personal identity.

THE GREAT MOSQUE OF ISFAHAN. The Masjid-i Jami ("Congregational mosque") of Isfahan (the Saljuq capital in Iran) was modified in this period from its original form as a simple hypostyle mosque to a more complex plan. Specifically, two great brick domes were added in the late eleventh century, one of them marking the *mihrab*, and in the twelfth century the mosque was reconfigured as a four-*iwan* plan. The massive *qibla iwan* on the southwest side is a twelfth-century structure to which a vault filled with muqarnas (stacked niches) was added in the fourteenth-century (see "Arches and Muqarnas," page 292). Its twin minarets and the façade of brilliant blue, glazed tile that wraps around the entire

THE OBJECT SPEAKS

A MAMLUK GLASS OIL LAMP

ade of ordinary sand and ash, glass is the most ethereal of materials. The Egyptians produced the first glassware during the second millennium BCE, yet the tools and techniques for making it have changed little since then. During the thirteenth and fourteenth centuries CE, glassmakers in Syria, Egypt, and Italy derived a new elegant thinness through blowing and molding techniques. Mamluk glassmakers especially excelled in the application of enameled surface decoration in gold and various colors.

This mosque lamp was suspended from chains attached to its handles,

although it could also stand on its high footed base. Exquisite glass was also used for beakers and vases, but lamps, lit from within by oil and wick, must have glowed with special richness. A mosque required hundreds of lamps, and there were hundreds of mosques—glassmaking was a booming industry in Egypt and Syria.

Blue, red, and white enamel and gilding cover the surface of the lamp in vertical bands that include swirling vegetal designs and cursive inscriptions interrupted by roundels containing iconic emblems. The inscription on the vessel's flared neck is a Qur'anic quotation (Surah 24:35) commonly found on mosque lamps: "God is the light of the heavens and the earth. His light is as a niche wherein is a lamp, the lamp in a glass, the glass as a glittering star." The emblem, called a blazon, identifies the patron-on this cup, it is the sign of Sayf al-Din Shaykhu al-'Umari, who built a mosque and a Sufi lodge in Cairo. The blazon resembles European heraldry. It was a "symbolic/emblematic language of power [that] passed to Western Europe beginning in the early twelfth century as the result of the Crusades, where it evolved into the genealogical system we know as heraldry" (Redford "A Grammar of Rūm Seljuk Ornament," Mésogeois 25-26 [2005]: 288). These emblems, which appear in Islamic glass, metalwork, and architecture, reflect an increasing interest in figural imagery that coincided with the increased production of illustrated books.

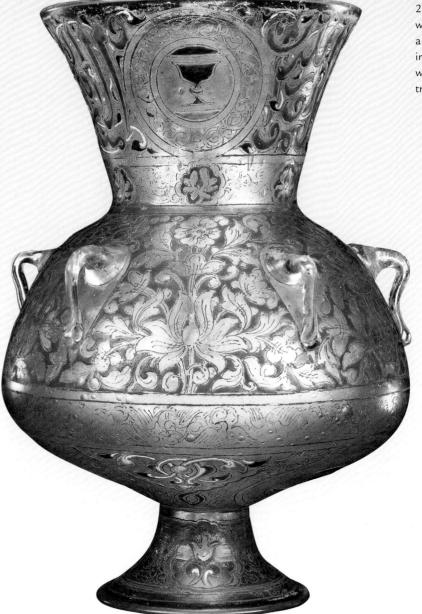

MAMLUK GLASS OIL LAMP

Syria or Egypt. c. 1355. Glass, polychrome enamel, and gold, height 12" (30.5 cm). Corning Museum of Glass, Corning, New York. (52.1.86)

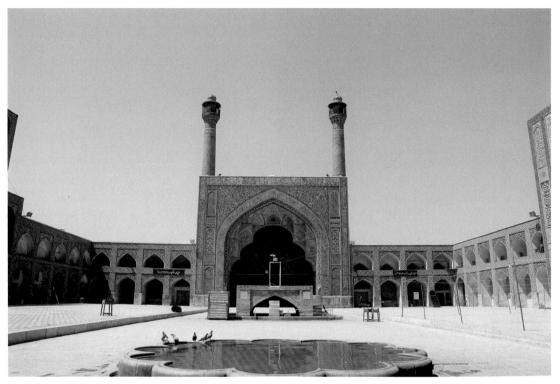

8–14 | **COURTYARD, MASJID-I JAMI, ISFAHAN** Iran 11th–18th century. 14th-century *iwan* vault, 17th-century minarets.

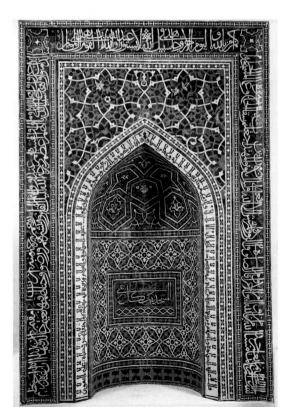

courtyard belong to the seventeenth century (FIG. 8–14). The many changes made to this mosque reflect its ongoing importance to the community it served.

A TILE MIHRAB. A fourteenth-century tile *milnab*, originally from a *madrasa* in Isfahan but now in the Metropolitan Museum of Art in New York, is one of the finest examples of early architectural ceramic decoration in Islamic art (FIG. 8–15). More than 11 feet tall, it was made by painstakingly cutting each individual piece of tile, including the pieces making up the letters on the curving surface of the niche. The color scheme—white against turquoise and cobalt blue with accents of dark yellow and green—was typical of this type of decoration, as were the harmonious, dense, contrasting patterns of organic and geometric forms. The cursive inscription of the outer frame quotes Surah 9, verses 18–20, from the Qur'an, reminding the faithful of their duties. It is rendered in elegant white lettering on a blue ground, while the Kufic inscription bordering the pointed arch reverses these colors for a pleasing contrast.

8-15 TILE MOSAIC MIHRAB

Madrasa Imami, Isfahan, Iran. Founded 1354. Glazed and cut tiles, $11'3''\times7'6''$ (3.43 \times 2.29 m). The Metropolitan Museum of Art, New York. Harris Brisbane Dick Fund (39.20)

This *mihrab* has three inscriptions: the outer inscription, in cursive, contains Qur'anic verses (Surah 9) that describe the duties of believers and the Five Pillars of Islam. Framing the niche's pointed arch, a Kufic inscription contains sayings of the Prophet. In the center, a panel with a line in Kufic and another in cursive states: "The mosque is the house of every pious person."

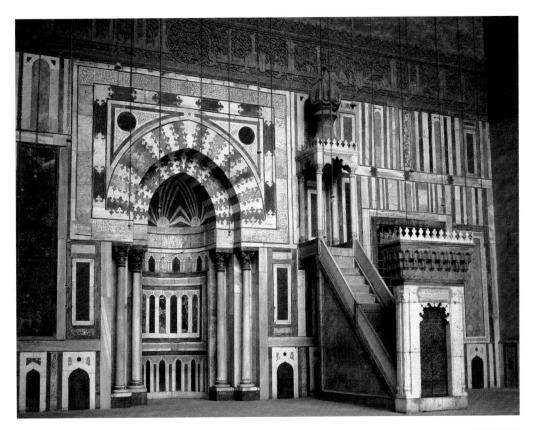

8-16 \mid QIBLA WALL WITH MIHRAB AND MINBAR, SULTAN HASAN MADRASA-MAUSOLEUM-MOSQUE COMPLEX

Main iwan (vaulted chamber) in the mosque, Cairo, Egypt. 1356-63.

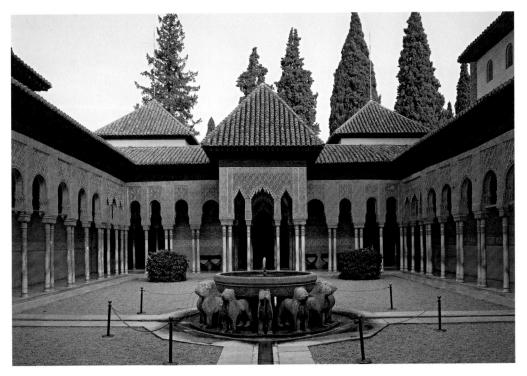

 $8\mathbf{-17} \perp \text{court of the lions, alhambra, granada, spain.} 1354-91.$

An ample water supply had long made Granada a city of gardens. This fountain fills the courtyard with the sound of its life-giving abundance, while channel-lined walkways form the four-part *chahar bagh*. Channeling water has a practical role in the irrigation of the garden, and here it is raised to the level of an art form.

THE MADRASA-MAUSOLEUM-MOSQUE IN CAIRO. Beginning in the eleventh century, Muslim rulers and wealthy individuals endowed hundreds of charitable complexes, including many madrasas. These were public displays of piety as well as personal wealth and status. The combined madrasa-mausoleummosque complex established in mid-fourteenth-century Cairo by the Mamluk Sultan Hasan (FIG. 8-16) is such an example. With a four-iwan plan, each iwan served as a classroom for a different branch of study, the students housed in a multistoried cluster of tiny rooms around each one. Standing just beyond the qibla iwan, the patron's monumental domed tomb attached his identity ostentatiously to the architectural complex. The sumptuous gibla iwan served as the prayer hall for the complex. Its walls are ornamented with colorful marble paneling, typical of Mamluk patronage, that culminates in a doubly recessed militab framed by slightly pointed arches on columns. The marble blocks of the arches are ingeniously joined in interlocking pieces of alternating colors called joggled voussoirs. The paneling is surmounted by a wide band of Kufic inscription in stucco set against a background of scrolling vines. Next to the mihrab stands an elaborate thronelike minbar. The Sultan Hasan complex is excessive in its vast scale and opulent decoration, but money was not an object: The project was financed by the estates of victims of the bubonic plague that had raged in Cairo in 1348-50.

THE ALHAMBRA. Muslim architects also created luxurious palaces set in gardens. The Alhambra in Granada, in southeastern Spain, is an outstanding example of beautiful and refined Islamic palace architecture. Built on the hilltop site of a pre-Islamic fortress, this palace complex was the seat of the Nasrids (1232-1492), the last Spanish Muslim (Moorish) dynasty, Islamic territory having shrunk from most of the Iberian Peninsula to the region around Granada. To the conquering Christians at the end of the fifteenth century, the Alhambra represented the epitome of luxury. Thereafter, they preserved the Alhambra as much to commemorate the defeat of Islam as for its beauty. Literally a small town extending for about half a mile along the crest of a high hill overlooking Granada, it included government buildings, royal residences, gates, mosques, baths, servants' quarters, barracks, stables, a mint, workshops, and gardens. Most of what one sees at the site today was built in the fourteenth century or in later centuries by Christian patrons.

The Alhambra was a sophisticated citadel whose buildings offered dramatic views to the settled valley and snow-capped mountains around it, while enclosing gardens within its court-yards. One of these is the Court of the Lions which stood at the heart of the so-called Palace of the Lions, the private retreat of Sultan Muhammad V (ruled 1354–59 and 1362–91). The Court of the Lions is divided evenly into four parts by cross-axial walkways that meet at a central marble fountain held aloft on the backs of twelve stone lions (FIG. 8–17). An Islamic garden divided thus into quadrants is called a *chahar bagh*. The

Art and Its Context

THE FIVE PILLARS OF ISLAM

slam emphasizes a direct, personal relationship with God. The Pillars of Islam, sometimes symbolized by an open hand with the five fingers extended, enumerate the duties required of Muslims by their faith.

- The first pillar (shahadah) is to proclaim that there is only one God and that Muhammad is his messenger.
 While monotheism is common to Judaism, Christianity, and Islam, and Muslims worship the god of Abraham, and also acknowledge Hebrew and Christian prophets such as Musa (Moses) and Isa (Jesus), Muslims deem the Christian Trinity polytheistic and assert that God was not born and did not give birth.
- The second pillar requires prayer (salat) to be performed by turning to face the Kaaba in Mecca five times daily: at dawn, noon, late afternoon, sunset, and nightfall. Prayer can occur almost anywhere, although the prayer on Fridays takes place in the congregational mosque. Because ritual ablutions are required for purity, mosque courtyards usually have fountains.
- The third pillar is the voluntary payment of annual tax or alms (zakah), equivalent to one-fortieth of one's assets. Zakah is used for charities such as feeding the poor, housing travelers, and paying the dowries of orphan girls. Among Shi'ites, an additional tithe is required to support the Shi'ite community specifically.
- The fourth pillar is the dawn-to-dusk fast (*sawm*) during the month of Ramadan, the month when Muhammad received the revelations set down in the Qur'an. The fast of Ramadan is a communally shared sacrifice that imparts purification, self-control, and kinship with others. The end of Ramadan is celebrated with the feast day 'Id al-Fitr (Festival of the Breaking of the Fast).
- For those physically and financially able to do so, the fifth pillar is the pilgrimage to Mecca (hajj), which ideally occurs at least once in the life of each Muslim. Among the extensive pilgrimage rites are donning simple garments to remove distinctions of class and culture; collective circumambulations of the Kaaba; kissing the Black Stone inside the Kaaba (probably a meteorite that fell in pre-Islamic times); and the sacrificing of an animal, usually a sheep, in memory of Abraham's readiness to sacrifice his son at God's command. The end of the hajj is celebrated by the festival 'Id al-Adha (Festival of Sacrifice).

The directness and simplicity of Islam have made the Muslim religion readily adaptable to numerous varied cultural contexts throughout history. The Five Pillars instill not only faith and a sense of belonging, but also a commitment to Islam in the form of actual practice.

courtyard is encircled by an arcade of stucco arches supported on single columns or clusters of two and three. Second-floor miradors—windows that frame specifically intentioned views—look over the courtyard, which was planted with aromatic citrus and flowers. From these windows, protected by latticework screens, it is quite likely that the women of the court, who did not appear in public, would watch the activities of the men below. At one end of the Palace of the Lions, a particularly magnificent *mirador* looks out onto a large, lower garden and the plain below. From here, the sultan literally oversaw the fertile valley that was his kingdom.

On the south side of the Court of the Lions, the lofty Hall of the Abencerrajes was designed as a winter reception hall and music room. In addition to having excellent acoustics, its ceiling exhibits dazzling geometrical complexity and exquisitely carved stucco (FIG. 8–18). The star-shaped vault is formed by a honeycomb of clustered *muqarnas* arches that alternate with corner squinches that are filled with more *muqarnas*. The square room thus rises to an eight-pointed star, pierced by eighteen windows, that culminates in a burst of *muqarnas* floating high overhead, perceived and yet ultimately unknowable, like the heavens themselves.

Portable Arts

Islamic society was cosmopolitan, with pilgrimage, trade, and a well-defined road network fostering the circulation of marketable goods. In addition to the import and export of basic foodstuffs and goods, luxury arts brought particular pleasure and status to their owners and were visible signs of cultural refinement. These art objects were eagerly exchanged and collected from one end of the Islamic world to the other, and they were sought by European patrons as well.

METAL. Islamic metalworkers inherited the techniques of their Roman, Byzantine, and Sasanian predecessors, applying this heritage to new forms, such as incense burners and water pitchers in the shape of birds and animals. An example of this delight in fanciful metalwork is an unusually large and stylized griffin, perhaps originally used as a fountain (FIG. 8–19). Now in Pisa, Italy, it is probably Fatimid work from Egypt, and it may have arrived as booty from Pisan victories over the Egyptian fleet in 1087. The Pisans displayed it atop their cathedral from about 1100 to 1828. Made of cast bronze, it is decorated with incised representations of feathers, scales, and silk trappings. The decoration on the mighty creature's thighs includes animals in medallions; the bands across its chest and back are embellished with Kufic lettering and scale and circle patterns.

The Islamic world was administered by educated functionaries who often commissioned personalized containers for their pens, ink, and blotting sand. One such container, an inlaid brass box, belonged to the grand vizier, or chief minister, of Khurasan in the early thirteenth century (FIG. 8–20). The artist cast, engraved, embossed, and inlaid the box with consummate

8–18 | muqarnas dome, hall of the abencerrajes, palace of the lions, alhambra Built between 1354–91.

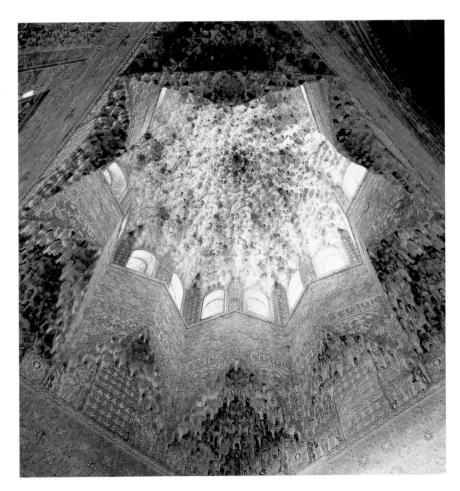

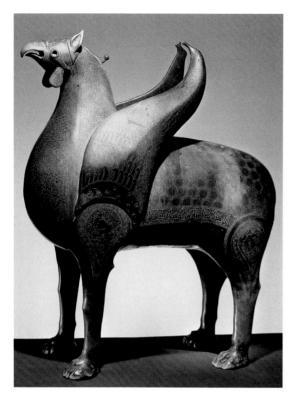

8-19 GRIFFIN

Islamic Mediterranean, probably Fatimid, Egypt. 11th century. Bronze, height 42%" (107 cm). Museo dell' Opera del Duomo, Pisa.

skill. Scrolls, interlacing designs, and human and animal figures enliven its calligraphic inscriptions. A silver shortage in the midtwelfth century prompted the development of inlaid brasswork like this that used the more precious metal sparingly. Humbler brassware was also available to those of lesser rank than the vizier.

8-20 PEN BOX

By Shazi, from Iran or Afghanistan. 1210–11. Brass with inlaid silver, copper, and black organic material; height 2", length 12%", width 2%" (5 \times 31.4 \times 6.4 cm). Freer Gallery of Art, Smithsonian Institution, Washington, D.C. (F1936.7)

The inscriptions on this box include some twenty honorific phrases extolling its owner, al-Mulk. The *naskhi* script on the lid calls him the "luminous star of Islam." The largest inscription, written in animated *naskhi* (an animated script is one with human or animal forms in it), asked twenty-four blessings for him from God. Shazi, the designer of the box, signed and dated it in animated Kufic on the side of the lid, making it one of the earliest signed works in Islamic art. The owner enjoyed his box for only ten years; he was killed by Mongol invaders in 1221.

CERAMICS. In the ninth century, potters developed a technique to produce a lustrous metallic surface on their ceramics. They may have learned the technique from Islamic glassmakers who had produced luster-painted vessels a century earlier. First the potters applied a paint laced with silver, copper, or gold oxides to the surface of already fired and glazed tiles or vessels. In a second firing with relatively low heat and less oxygen, these oxides burned away to produce a reflective shine. The finished lusterware resembled precious metal. At first the potters covered the entire surface with luster, but soon they began to use luster to paint dense, elaborate patterns using geometric design, foliage, and animals in golden brown, red, purple, and green. Lusterware tiles, dated 862–3, decorated the *mihrab* of the Great Mosque at Kairouan.

The most spectacular lusterware pieces are the double-shell fritware, in which an inner solid body is hidden beneath a densely decorated and perforated outer shell. A jar in the Metropolitan Museum of Art known as **THE MACY JUG** (after a previous owner) exemplifies this style (FIG. 8–21). The black

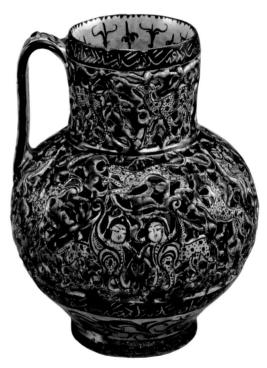

8-21 THE MACY JUG

Iran. 1215–16. Composite body glazed, painted fritware and incised (glaze partially stained with cobalt), with pierced outer shell, $6\% \times 7\%$ (16.8 \times 19.7 cm). The Metropolitan Museum of Art, New York.

Fletcher Fund, 1932 (32.52.1)

Fritware was used to make beads in ancient Egypt and may have been rediscovered there by Islamic potters searching for a substitute for Chinese porcelain. Its components were one part white clay, ten parts quartz, and one part quartz fused with soda, which produced a brittle white ware when fired. The colors on this double-walled ewer and others like it were produced by applying mineral glazes over black painted detailing. The deep blue comes from cobalt and the turquoise from copper. Luster, a thin, transparent glaze with a metallic sheen, was applied over the colored glazes.

underglaze-painted decoration represents animals and pairs of harpies and sphinxes set into an elaborate "water-weed" pattern. The outer shell is covered with a turquoise glaze, enhanced by a deep cobalt-blue glaze on parts of the floral decoration and finally a luster overglaze that gives the entire surface a metallic sheen. An inscription includes the date AH 612 (1215–16 CE).

TEXTILES. The tradition of silk weaving that passed from Sasanian Persia to Islamic artisans in the early Islamic period (SEE FIG. 8–13) was kept alive in Muslim Spain. Spanish designs reflect a new aesthetic, with an emphasis beginning in the thirteenth century on forms that had much in common with architectural ornament. An eight-pointed star forms the center of a magnificent silk and gold banner (FIG. 8–22). The calligraphic panels continue down the sides and a second panel crosses the top. Eight lobes with gold crescents and white

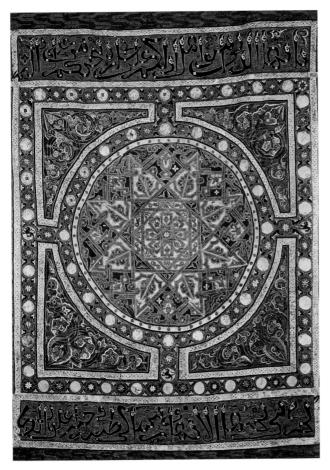

8–22 | BANNER OF LAS NAVAS DE TOLOSA Detail of center panel, from southern Spain. 1212–50. Silk tapestry-weave with gilt parchment, 10'9 $\%'' \times 7'2 \%''$ (3.3 \times 2.2 m). Museo de Telas Medievales, Monasterio de Santa María la Real de Las Huelgas, Burgos, Spain.

This banner was a trophy taken by the Christian king Ferdinand III, who gave it to Las Huelgas, the Cistercian convent outside Burgos, the capital city of Old Castile and the burial place of the royal family. This illustration shows only a detail of the center section of the textile. The calligraphic panels continue down the sides, and a second panel crosses the top.

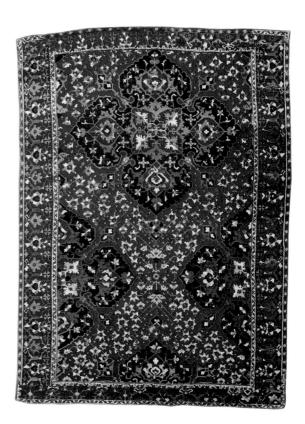

8–23 | MEDALLION RUG, VARIANT STAR USHAK STYLE Anatolia (present-day Turkey). 16th century. Wool, $10'3'' \times 7'6 \, \%'' \, (313.7 \times 229.2 \, cm)$. The St. Louis Art Museum. Gift of James F. Ballard.

inscribed parchment medallions form the lower edge of the banner. In part, the text reads: "You shall believe in God and His Messenger. . . . He will forgive you your sins and admit you to gardens underneath which rivers flow, and to dwelling places goodly in Gardens of Eden; that is the mighty triumph."

The Qur'an describes paradise as a shady garden with four rivers, and many works of Islamic art evoke both paradisiac and garden associations. In particular, Persian and Turkish carpets were often embellished with elegant designs of flowers and shrubs inhabited by birds. Laid out on the floor of an open-air hall and perhaps set with bowls of ripe fruit and other delicacies, such carpets brought the beauty of nature indoors. Written accounts indicate that elaborate patterns appeared on Persian carpets as early as the seventh century. In one fabled royal carpet, garden paths were rendered in real gold, leaves were modeled with emeralds, and highlights on flowers, fruits, and birds were created from pearls and jewels.

A carpet from Ushak in western Anatolia (Turkey), created in the first half of the sixteenth century, retains its vibrant colors (FIG. 8–23). Large, deeply serrated quatrefoil medallions establish the underlying star pattern but arabesques flow in every direction. This "infinite arabesque," as it is called (the pattern repeats infinitely in all directions), is characteristic of Ushak carpets. Carpets were usually at least three times as long as they were wide; the asymmetry of this carpet may indicate that it was cut and shortened.

Technique

CARPET MAKING

ecause textiles are made of organic materials that are destroyed through use, very few carpets from before the sixteenth century have survived. There are two basic types of carpets: flat-weaves and pile, or knotted, carpets. Both can be made on either vertical or horizontal looms.

The best-known flat-weaves today are kilims, which are typically woven in wool with bold, geometric patterns and sometimes with brocaded details. Kilim weaving is done with a tapestry technique called slit tapestry (see diagram a).

Knotted carpets are an ancient invention. The oldest known example, excavated in Siberia and dating to the fourth or fifth century BCE, has designs evocative of Achaemenid art, suggesting that the technique may have originated in Central Asia. In knotted carpets, the pile-the plush, thickly tufted surface-is made by tying colored strands of yarn, usually wool but occasionally silk for deluxe carpets, onto the vertical elements (the warp) of a yarn grid (see diagram b or c). These knotted loops are later trimmed and sheared to form the plush pile surface of the carpet. The weft strand (crosswise threads) are shot horizontally, usually twice, after each row of knots is tied, to hold the knots in place and to form the horizontal element common to all woven structures. The weft is usually an undyed yarn and is hidden by the colored knots of the warp. Two common knot tying techniques are the asymmetrical knot, used in many carpets from Iran, Egypt, and Central Asia (formerly termed the Sehna knot), and the symmetrical knot (formerly called the Gördes knot) more commonly used in Anatolian Turkish carpet weaving. The greater the number of knots, the shorter the pile. The finest carpets can

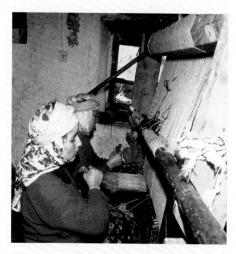

have as many as 2,400 knots per square inch, each one tied separately by hand.

Although royal workshops produced luxurious carpets (SEE FIG. 8–23), most knotted rugs have traditionally been made in tents and homes. Either women or men, depending on local custom, wove carpets. The photograph in this box shows two women, sisters in Çanakkale province in Turkey, weaving a large carpet in a typical Turkish pattern. The woman in the foreground pushes a row of knots tightly against the row below it with a wood comb called a beater. The other woman pulls a dark red weft yarn against the warp threads before tying a knot. Working between September and May, these women may weave five carpets, tying up to 5,000 knots a day. A Çanakkale rug will usually have only 40–50 knots per square inch. Generally, an older woman works with a young girl, who learns the art of carpet weaving at the loom and eventually passes it on to the next generation.

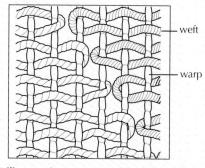

a. Kilim weaving pattern used in flat-weaving

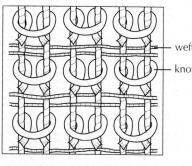

b. Symmetrical knot, used extensively in Iran

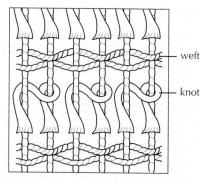

c. Asymmetrical knot, used extensively in Turkey

Rugs have long been used for Muslim prayer, which involves repeatedly kneeling and touching the forehead to the floor before God. While individuals often had their own small prayer rugs, with representations of niches to orient the faithful in prayer, many mosques were furnished with woolpile rugs received as pious donations (see, for example, the rugs on the floor of the Sultan Selim Mosque in FIG. 8–28). In Islamic houses, people sat and slept on cushions and thick mats laid directly on the floor, so that cushions took the place of the fixed furnishings of Western domestic environments.

From the late Middle Ages to today, carpets and textiles are one of the predominant Islamic arts, and the Islamic art form best known in the West. Historically, rugs from Iran, Turkey, and elsewhere were highly prized among Westerners, who often displayed them on tables rather than floors.

Manuscripts and Painting

The art of book production flourished from the first century of Islam. Islam's emphasis on the study of the Qur'an promoted a high level of literacy among both women and men, and calligraphers were the first artisans to emerge from anonymity and achieve individual distinction and recognition for their skill. Books on a wide range of secular as well as religious subjects were available, although hand-copied books—even on paper—always remained fairly costly. Libraries, often associated with *madrasas*, were endowed by members of the educated elite. Books made for royal patrons had luxurious bindings and highly embellished pages, the result of workshop collaboration between noted calligraphers and illustrators. New scripts were developed for new literary forms.

The manuscript illustrators of Mamluk Egypt (1250–1517) executed intricate nonfigural geometric designs for the Qur'ans they produced. Geometric and botanical ornamentation contributed to unprecedented sumptuousness and complexity. As in architectural decoration, the exuberant ornament was underlaid by strict geometric organization. In an impressive frontispiece originally paired with its mirror image on the facing left page, the design radiates from a sixteen-pointed starburst, filling the central square (FIG. 8-24). The surrounding ovals and medallions are filled with interlacing foliage and stylized flowers that provide a backdrop for the holy scripture. The page's resemblance to court carpets was not coincidental. Designers worked in more than one medium, leaving the execution of their efforts to specialized artisans. In addition to religious works, scribes copied and recopied famous secular texts—scientific treatises, manuals of all kinds, stories, and especially poetry. Painters supplied illustrations for these books and also created individual small-scale paintings-miniatures—that were collected by the wealthy and placed in albums.

THE HERAT SCHOOL. One of the great royal centers of miniature painting was at Herat in western Afghanistan. A school of painting and calligraphy was founded there in the early fifteenth century under the highly cultured patronage of the Timurid dynasty (1370-1507). In the second half of the fifteenth century, the leader of the Herat school was Kamal al-Din Bihzad (c. 1450–1514). When the Safavids supplanted the Timurids in 1506-7 and established their capital at Tabriz in northwestern Iran, Bihzad moved to Tabriz and briefly resumed his career there. Bihzad's paintings, done around 1494 to illustrate the Khamsa (Five Poems), written by Nizami, demonstrate his ability to render human activity convincingly. He set his scenes within complex, stagelike architectural spaces that are stylized according to Timurid conventions, creating a visual balance between activity and architecture. In THE CALIPH HARUN AL-RASHID VISITS THE TURKISH BATH (FIG. 8-25), the bathhouse, its tiled entrance leading to a high-ceiling dressing room with brick walls, provides the structuring element. Attendants wash long, blue towels and hang them to dry on overhead clotheslines. A worker reaches for one of the towels with a long pole, and a client prepares to wrap himself discreetly in a towel before removing his outer garments. The blue door on the left leads to a room where a barber grooms the caliph while attendants bring water for his bath. The asymmetrical composition

depends on a balanced placement of colors and architectural ornaments within each section.

An illustrated copy of the Khamsa (FIG. 8-26) from Herat in slightly earlier period shows a romantic scene in a landscape setting. The painting shows the gold-crowned princess Shirin at the moment when she sees a portrait of Khusrau hanging in a tree and falls in love with him. She is shown at the moment of discovery, holding the portrait before her, as one of her dismayed attendants grabs her cloak as if to hold her back from destiny. The background consists of an ochre-colored arid landscape that rises to two ranges of hills from which emerge two trees. Almost hidden in the upper left, a man observes the scene. This is Shapur, the painter of Khusrau's portrait and his friend, but at the same time the inclusion of this figure makes witty reference to the painter of the manuscript page. In contrast to the plain background, in the foreground, a rockbordered stream—its silvery surface now tarnished to gray winds its way through a meadow of flowers and a tree. Overhead, a cloud painted in a Chinese style seems to reflect the agitation in her heart. By the beginning of the seventeenth century, this manuscript was in the hands of the Mughal rulers of India, evidence of the enduring appreciation for Timurid painting and of the cultural exchanges that took place as both artists and art moved to new courts and collections.

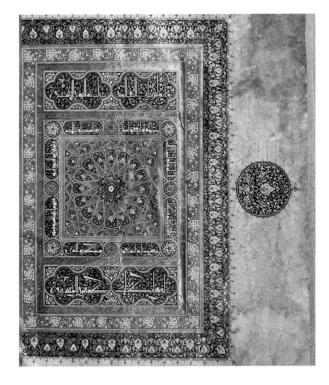

8–24 \perp **QUR'AN FRONTISPIECE (RIGHT HALF OF TWO-PAGE SPREAD)** Cairo, Egypt. c. 1368. Ink, pigments, and gold on paper, 24 \times 18" (61 \times 45.7 cm). National Library, Cairo.

The Qur'an to which this page belonged was donated in 1369 by Sultan Shaban to the *madrasa* established by his mother. A close collaboration between illuminator and scribe can be seen here and throughout the manuscript.

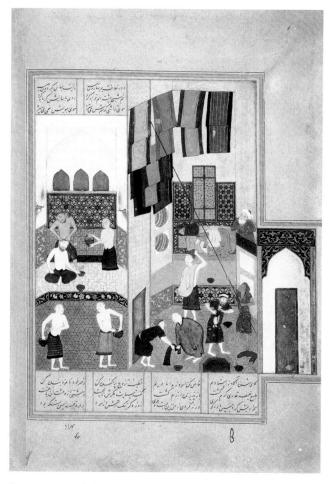

From a copy of the 12th-century *Khamsa* (*Five Poems*) of Nizami. Herat, Afghanistan. c. 1494. Ink and pigments on paper, approx. $7 \times 6''$ (17.8 \times 15.3 cm). The British Library, London. Oriental and India Office Collections (Ms. Or. 6810, fol. 27v)

Despite early warnings against it as a place for the dangerous indulgence of the pleasures of the flesh, the bathhouse (hammam), adapted from Roman and Hellenistic predecessors, became an important social center in much of the Islamic world. The remains of an eighth-century hammam still stand in Jordan, and a twelfth-century hammam is still in use in Damascus. Hammams had a small entrance to keep in the heat, which was supplied by steam ducts running under the floors. The main room had pipes in the wall with steam vents. Unlike the Romans, who bathed and swam in pools of water, Muslims preferred to splash themselves from basins, and the floors were slanted for drainage. A hammam was frequently located near a mosque, part of the commercial complex provided by the patron to generate income for the mosque's upkeep.

THE OTTOMAN EMPIRE

With the breakdown of Saljuq power in Anatolia at the end of the thirteenth century, another group of Muslim Turks seized power in the early fourteenth century in the northwestern part of that region, having migrated there from their homeland in Central Asia. Known as the Ottomans, after an early leader named Osman, they pushed their territorial boundaries westward and, in spite of setbacks inflicted by the Mongols, ulti-

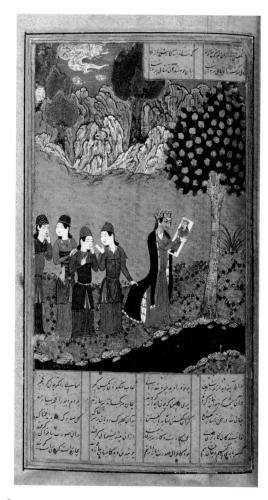

8–26 | SHIRIN SEES KHUSRAU'S PORTRAIT
From a copy of the 12th-century *Khamsa (Five Poems)* of Nizami.
Herat, Afghanistan, 1442. Ink, pigments, and gold on paper.
The British Library, London.

mately created an empire that extended over Anatolia, western Iran, Iraq, Syria, Palestine, western Arabia (including Mecca and Medina), northern Africa (excepting Morocco), and part of eastern Europe. In 1453, they captured Constantinople, ultimately renaming it Istanbul, and brought the Byzantine Empire to an end. The Ottoman Empire lasted until 1918.

Architecture

Upon conquering Istanbul, the rulers of the Ottoman Empire converted the great Byzantine church of Hagia Sophia into a mosque, framing it with two graceful Turkish-style minarets in the fifteenth century and two more in the sixteenth century (SEE FIG. 7–25). In conformance with Islamic aniconism, the church's mosaics were destroyed or whitewashed. Huge calligraphic disks with the names of God, Muhammad, and the early caliphs were added to the interior in the mid-nineteenth century (SEE FIG. 7–27). At present, Hagia Sophia is neither a church nor a mosque but a state museum.

THE ARCHITECT SINAN. Ottoman architects had already developed the domed, centrally planned mosque (see

"Mosque Plans," page 289), but this great Byzantine structure of Hagia Sophia inspired them to strive for a more ambitious scale. For the architect Sinan (c. 1489–1588) the development of a monumental centrally planned mosque was a personal quest. Sinan began his career in the army and served as engineer in the Ottoman campaign at Belgrade, Vienna, and Baghdad. He rose through the ranks to become, in 1528, chief architect for Suleyman "the Magnificent," the tenth Ottoman sultan (ruled 1520-66). Suleyman's reign marked the height of Ottoman power, and the sultan sponsored a building program on a scale not seen since the days of the Roman Empire. Serving Suleyman and his successor, Sinan is credited with more than 300 imperial commissions, including palaces, madrasas and Qur'an schools, tombs, public kitchens and hospitals, caravanserais, treasure houses, baths, bridges, viaducts, and 124 large and small mosques.

Sinan's crowning accomplishment, completed about 1579, when he was over 80, was a mosque he designed in the provincial capital of Edirne for Suleyman's son Selim II (ruled 1566-74) (FIG. 8-27). The gigantic hemispheric dome that tops this structure is more than 102 feet in diameter, larger than the dome of Hagia Sophia, as Sinan proudly pointed out. The dome crowns a building of extraordinary architectural coherence. The transition from square base to the central dome is accomplished by corner half-domes that enhance the spatial plasticity and openness of the vast interior of the prayer hall (FIG. 8-28). The eight massive piers that bear the dome's weight are visible both within and without—on the exterior they resolve in pointed towers that encircle the main dome revealing the structural logic of the building and clarifying its form. In the arches that support the dome and span from one pier to the next-and indeed at every level-light pours from windows into the interior, a space at once soaring and serene. In addition to the mosque, the complex housed a *madrasa* and other educational buildings, a cemetery, a hospital, and charity kitchens, as well as the income-producing covered market and baths. Framed by the vertical lines of four minarets and raised on a platform at the city's edge, the Selimiye mosque dominates the skyline.

The interior was clearly influenced by Hagia Sophia—an open expanse under a vast dome floating on a ring of light—but it lacks Hagia Sophia's longitudinal pull from entrance to sanctuary. The Selimiye mosque is truly centrally planned structure and a small fountain covered by a platform (visible in the lower right of FIG. 8–28) emphasizes this centralization.

Illuminated Manuscripts and Tugras

A combination of abstract setting with realism in figures and details characterizes Ottoman painting. Ottoman painters adopted the style of the Herat school (as influenced by Timurid conventions) for their miniatures, enhancing its decorative aspects with an intensity of religious feeling. At the Ottoman court of Sultan Suleyman in Istanbul, the imperial workshops produced even more remarkable illuminated manuscripts.

Following a practice begun by the Saljuqs and Mamluks, the Ottomans put calligraphy to political use, developing the design of imperial ciphers—tugras—into a specialized art form. Ottoman tugras combined the ruler's name and title with the motto "Eternally Victorious" into a monogram denoting the authority of the sultan and of those select officials who were also granted an emblem. Tugras appeared on seals, coins, and buildings, as well as on official documents called firmans, imperial edicts supplementing Muslim law. Suleyman issued hundreds of edicts, and a high court official supervised specialist calligraphers and illuminators who produced the documents with fancy tugras (FIG. 8–29).

8–27 | MOSQUE OF SULTAN SELIM, EDIRNE

Turkey. 1568-75.

The minarets that pierce the sky around the prayer hall of this mosque, their sleek, fluted walls and needle-nosed spires soaring to more than 295 feet, are only 12½ feet in diameter at the base, an impressive feat of engineering. Only royal mosques were permitted multiple minarets, and having more than two was unusual.

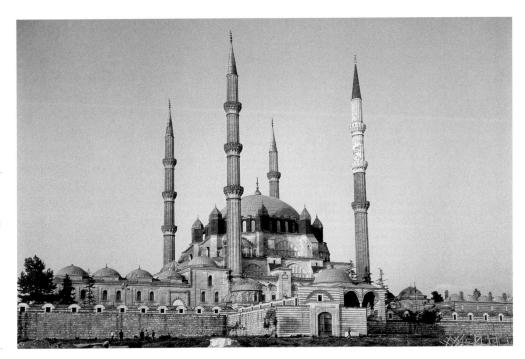

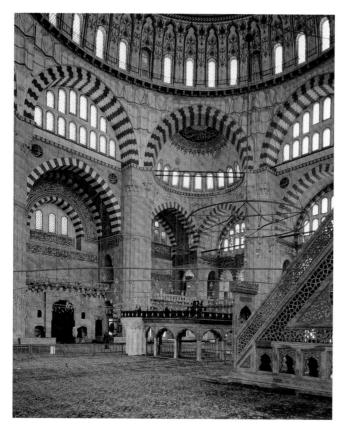

8-28 | interior, mosque of sultan selim

Tugras were drawn in black or blue with three long, vertical strokes (tug means "horsetail") to the right of two concentric horizontal teardrops. Decorative foliage patterns fill the space. Fill decoration became more naturalistic by the 1550s and in later centuries spilled outside the emblems' boundary lines. The rare, oversized tugra in FIG. 8-29 has a sweeping, fluid line drawn with perfect control according to set proportions. The color scheme of the delicate floral inter-

lace enclosed in the body of the *tugra* may have been inspired by Chinese blue-and-white ceramics; similar designs appear on Ottoman ceramics and textiles.

THE MODERN ERA

For many years the largest and most powerful political entity in the Islamic World, the Ottoman Empire lasted until the end of World War I. It was not until 1918 that modern Turkey was founded in Anatolia, the former heart of the empire. The twentieth century saw the dissolution of the great Islamic empires and the formation of smaller nation-states in their place. The question of identity and its expression in art changed significantly as Muslim artists and architects sought training abroad and participated in an international movement that swept away many of the visible signs that formerly expressed their cultural character and difference. The abstract work of the architect Zaha Hadid (SEE FIG. 21-80), who was born in Baghdad and studied and practiced in London, is exemplary of the new internationalism. But earlier, when architects in Islamic countries were debating whether modernity promised opportunities for new expression or simply another form of Western domination, the Egyptian Hasan Fathy (1900-89) asked whether abstraction could serve the cause of social justice. He revived traditional, inexpensive, and locally obtainable materials such as mud brick and forms such as wind scoops (an inexpensive means of catching breezes to cool a building's interior) to build affordable housing for the poor. For architects around the world, Fathy's New Gourna Village (designed 1945-47) in Luxor, Egypt, was a model of environmental sustainability realized in pure geometric forms that resonated with references to Egypt's architectural past (FIG. 8-30). In their simplicity, his watercolor paintings are as beautiful as his buildings.

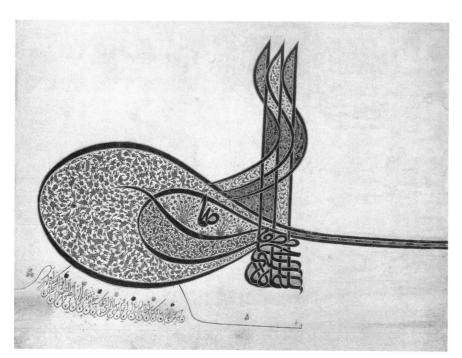

8-29 ILLUMINATED TUGRA OF SULTAN SULEYMAN

Istanbul, Turkey. c. 1555-60. Ink, paint, and gold on paper, removed from a firman and trimmed to $20\% \times 25\%$ " (52 \times 64.5 cm). The Metropolitan Museum of Art, New York. Rogers Fund, 1938 (38.149.1).

The tugra shown here is from a document endowing an institution in Jerusalem that had been established by Suleyman's wife, Hurrem.

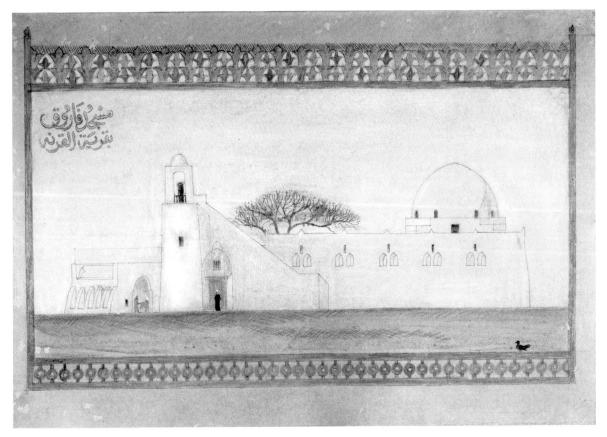

8–30 | **HASAN FATHY MOSQUE AT NEW GOURNA** Luxor, Egypt, 1945–47. Gouache on paper, $22\frac{1}{2} \times 17\frac{8}{8}$ (52.8 \times 45.2 cm). Collection: Aga Khan Award for Architecture, Geneva, Switzerland.

One of many buildings designed for the Egyptian Department of Antiquities for a village relocation project. Seven thousand people were removed from their village near pharaonic tombs and resettled on agricultural land near the Nile. Fathy's emphasis on both the traditional values of the community and the individualism of its residents was remarkably different from the abstract and highly conformist character of other modern housing projects of the period.

IN PERSPECTIVE

In Islamic art, a proscription against figural imagery in religious contexts gave rise instead to the development of a rich vocabulary of ornament and pattern using abstract geometrical figures and botanically inspired design. Motifs readily circulated in the Islamic world via portable objects in the hands of pilgrims and traveling merchants. Textiles and carpets especially were widely traded both within the Islamic world and between it and its neighbors. The resulting eclecticism of motif and technique is an enduring characteristic of Islamic art.

As with geometric and floral ornament, writing played a central role in Islamic art. Since the lessons of the Qur'an were not to be presented pictorially, instead the actual words of the Qur'an were incorporated in the decoration of buildings and objects to instruct and inspire the viewer. As a result, calligraphy

emerged as the most highly valued form of art, maintaining its prestige even after manuscript painting grew in importance under court patronage from the thirteenth century onward.

Architecture also played an important role in Islam and reveals the flexibility and innovation of Islamic culture. The mosque began as a simple space for congregational gathering and prayer but grew in complexity. The individual mosque, whether hypostyle, domical, or four-iwan, was eventually combined with other functional types (such as schools, tombs, and public fountains), culminating with the vast complexes of the Ottoman era. The Islamic world's awareness of history is especially evident in its architecture, as for instance in the Mosque of Selim II—an homage to the Hagia Sophia—or as seen in Hasan Fathy's self-conscious evocation of vernacular Egyptian architecture.

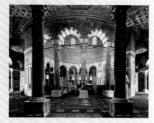

DOME OF THE ROCK BEGUN 691-92

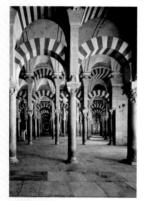

PRAYER HALL, GREAT MOSQUE CORDOBA, BEGUN 785-86

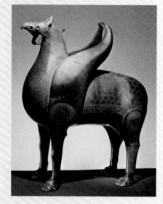

GRIFFIN 11TH CENTURY

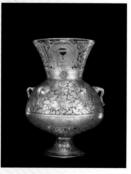

MAMLUK GLASS LAMP с. 1355

ILLUMINATED TUGRA OF SULTAN SULEYMAN c. 1555-60

800

1000

ISLAMIC ART

- Founding of Islam 622 CE
- Early Caliphs 633-61 CE
- Umayyad Dynasty c. 661-750 CE
- Abbasid Dynasty c. 750–1258 CE
- Spanish Umayyad Dynasty c. 756-1031 CE

- Fatimid Dynasty c. 909-1171 CE
- Saljuq Dynasty с. 1037-1194 СЕ
- Saljuq Dynasty of Rum late 11th-early 14th century CE

- Spanish Nasrid Dynasty c. 1232-1492 CE
- Egyptian Mamluk Dynasty c. 1250-1517 CE
- Ottoman Empire c. 1281-1918 CE
- Timurid Dynasty c. 1370-1507 CE
- Fall of Constantinople to Ottoman Turks 1453 CE
- Modern Turkey Founded 1918 CE

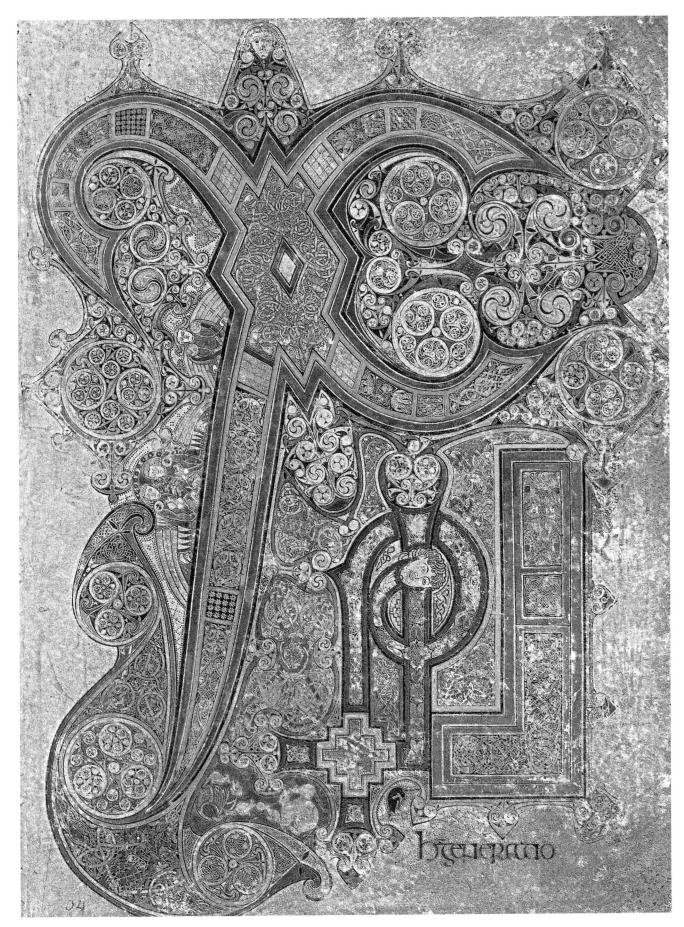

9–I $\,$ CHI RHO IOTA PAGE FROM THE BOOK OF KELLS Matt. 1:18. Probably made at Iona, Scotland. Late 8th or early 9th century. Oxgall inks and pigments on vellum, $12\frac{1}{4} \times 9\frac{1}{2}$ " (325 \times 24 cm). The Board of Trinity College, Dublin.

MS 58, fol. 34r.

CHAPTER NINE

EARLY MEDIEVAL ART IN EUROPE

According to legend, the Irish prince Colum Cille (c. 521–97), scholar, scribe, and churchman, who was canonized as Saint Columba, caused a war by secretly copying a psalter (psalm book). After King Finnian, the owner of the original, found out

and petitioned for possession of the copy, and even after the king ruled, "To every cow its calf, to every book its copy," Colum Cille still refused to relinquish it. Instead he incited his kinsmen to fight for the precious book. Whether fleeing from his enemies or to atone for his actions (the legend is unclear), Colum Cille left Ireland forever in self-imposed exile in 563. He established a monastery on Iona, an island off the western coast of Scotland.

As described by the eighth-century Anglo-Saxon historian Bede, such remote monasteries stood "among craggy and distant mountains, which looked more like lurking places for robbers and retreats for wild beasts than habitation for men." Nevertheless, they became centers of Celtic Christendom—their monks as famous for writing and copying books as for their missionary fervor. But, wealthy, isolated, and undefended, they fell victim to Viking attacks beginning at the end of the eighth century. Only the stormy seas could save the treasures of the monasteries. As one monk wrote:

Bitter is the wind tonight, It tosses the ocean's white hair: Tonight I fear not the fierce warriors of Norway Coursing on the Irish Sea.

(translated by Kuno Meyer, Selections from Ancient Irish Poetry. London: Constable, 1959 [1911])

In 806, the monks, fleeing Viking raids on Iona, established a refuge at Kells on the Irish mainland. They may have brought with them the Gospel book now known as the **BOOK OF KELLS** (FIG. 9–1). To produce this illustrated

version of the Gospels entailed a lavish expenditure: Four scribes and three major illuminators worked on it (modern scribes take about a month to complete a page comparable to the one illustrated here), 185 calves were slaughtered to make the vellum, and the colors for the paintings came from as far away as Afghanistan.

Throughout the Middle Ages monasteries were the centers of art and learning. While religious services remained their primary responsibility, some talented monks and nuns also spent many hours as painters, jewelers, carvers, weavers, and embroiderers. These arts, used in the creation of illustrated books and liturgical equipment, are often called the "cloister crafts." Few cloisters could claim a work of art like the *Book of Kells*.

The twelfth century priest Gerald of Wales aptly described just such a Gospel book when he wrote:

Fine craftsmanship is all about you, but you might not notice it. Look more keenly at it, and you will penetrate to the very shrine of art. You will make out intricacies, so delicate and subtle, so exact and compact, so full of knots and links, with colors so fresh and vivid, that you might say that all this was the work of an angel, and not of a man.

(cited in Henderson, page 195)

- THE EARLY MIDDLE AGES | The Art of People Associated with the Roman Empire | The Art of People Outside the Roman Sphere of Influence |
 The Coming of Christianity to the British Isles
- THE MUSLIM CHALLENGE IN SPAIN | Mozarabic Art
- THE CAROLINGIAN EMPIRE | Carolingian Architecture | The Scriptorium and Illustrated Books | Carolingian Goldsmith Work
- THE VIKING ERA | The Oseberg Ship | Picture Stones at Jelling | Timber Architecture | The End of the Viking Era
- OTTONIAN EUROPE | Ottonian Architecture | Ottonian Sculpture | Illustrated Books
- **IN PERSPECTIVE**

THE EARLY MIDDLE AGES

As the Roman Empire declined in the fourth century and came to an end in the fifth, its authority was supplanted by "barbarians," people from outside the empire who could only "barble" Greek or Latin.

At this point we have seen these "barbarians" only through Greek and Roman eyes—as the defeated Gauls at Pergamon (FIG. 5–63), on the Gemma Augustea (FIG. 6–24), or on the Ludovisi Sarcophagus (FIG. 6–69). Trajan's Column (FIG. 6–50) shows only Roman triumphs in the barbarians' homeland beyond the Danube River. Hadrian's Wall (FIG. 6–57), built to defend the northern frontier in Britain, marks the extent of the empire. But by the fourth century many Germanic tribes were allies of Rome. In fact, most of Constantine's troops in the decisive battle with Maxentius (page 226) were Germans.

A century later the situation was entirely different. In 410 the Visigoths under Alaric besieged and captured Rome. The adventures of the Byzantine princess Galla Placidia, whom we have met as a patron of the arts (FIG. 7-19), bring the situation vividly to life. She had the misfortune to be in Rome when Alaric and the Visigoths sacked the city (the emperor and pope were living safely in Ravenna). Carried off as a prize of war by the Goths, Galla Placidia had to join their migrations through France and Spain and eventually married the Gothic king, who was soon murdered. Back in Italy, married and widowed yet again, Galla Placidia ruled the Western Empire as regent for her son from 425 to 437/8. She died in 450, before having to endure yet another sack of Rome, this time by the Vandals, in 455. The fall of Rome shocked the Christian world, although the wounds were more psychological than physical. Saint Augustine was inspired to write The City of God, a cornerstone of Christian philosophy, as an answer to people who claimed that the Goths represented the vengeance of the pagan gods on people who had abandoned them for Christianity.

Who were these people living outside the Mediterranean orbit? Their wooden architecture is lost to fire and decay, but their metalwork and use of animal and geometric ornament is well established. The people were hunters and

fishermen, shepherds and farmers living in villages with a social organization based on extended families and tribal loyalties. They engaged in the essential crafts—pottery, weaving, woodwork—and they fashioned metals into weapons, tools, and jewelry. We saw examples of Bronze and Iron Age (Celtic) art in Chapter 1.

The Celts controlled most of Europe, and the Germanic people—Goths and others—lived around the Baltic Sea. Increasing population evidently forced the Goths to begin to move south, into better lands and climate around the Mediterranean and Black Seas, but the Romans had extended the borders of their empire across the Rhine and Danube rivers. Seeking the relative security and higher standard of living they saw in the Roman Empire, the Germanic people crossed the borders and settled within the empire.

The tempo of migration speeded up in the fifth century when the Huns from central Asia swept down on western Europe. Only the death of their leader Attila in 453 saved Europe. The Arian Ostrogoths (Eastern Goths) moved into Italy, and in 476 they deposed the last Roman emperor. They made Ravenna their capital until they were in turn defeated by the Byzantines. The Visigoths (Western Goths) ended their wanderings in Spain. The Burgundians settled in Switzerland and eastern France; the Franks in Germany, France, and Belgium. Meanwhile the Vandals moved through France and Spain, crossed over into Africa, making Carthage their headquarters, and then returned back to Italy, sacking Rome in 455.

At first Christianity was not a unifying force. As early as 345 the Goths adopted Arian Christianity, beliefs considered heretical by the Church in Rome. Not until 589 did they accept Roman Christianity. In contrast to the Arian Goths, the Franks under Clovis (ruled 481–511), influenced by his Burgundian wife Clotilda, converted to Roman Christianity in 496, beginning a fruitful alliance between French rulers and the popes.

Bewildering as the period seems, the Europe we know today was beginning to take shape. Relationships of patronage and dependence between powerful men and their retainers remained important, ultimately giving rise to a political and economic system based on family and clan ties, on

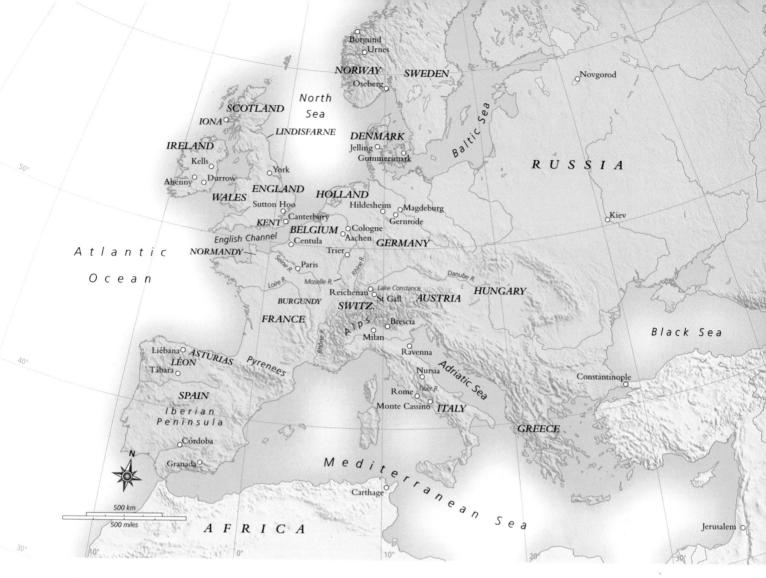

MAP 9-I | EUROPE OF THE EARLY MIDDLE AGES

On this map, modern names have been used for medieval regions in northern and western Europe to make sites of artworks easier to locate.

personal loyalty and mutual support, and on the exchange of personal service and labor for protection. This system became formalized as *feudalism*.

Mutual support also developed between secular and religious leaders. Kings and nobles defended the claims of the Roman Church, and the pope, in turn, validated their authority. As its wealth and influence increased throughout Europe, the Church emerged as the principal patron of the arts to fulfill growing needs for buildings and liturgical equipment, including altars, altar vessels, crosses, candlesticks, containers for the remains of saints (reliquaries), vestments (ritual garments), images of Christian figures and stories, and copies of sacred texts such as the Gospels.

The Art of People Associated with the Roman Empire

As Christianity spread north beyond the borders of what had been the Western Roman Empire, northern artistic traditions similarly worked their way south. Out of a tangled web of themes and styles originating from inside and out of the empire, from pagan and Christian beliefs, from urban and rural settlements, brilliant new artistic styles were born.

THE VISIGOTHS. Among the many people who had lived outside the Roman Empire and then moved within its borders, the Visigoths migrated across southern France and by the sixth century had settled in Spain, where they became an elite group ruling the indigenous population. They adopted Latin for writing, and in 589 they accepted Roman Christianity. Saint Isidore, patron saint of historians (including art historians), was a Visigothic bishop.

Following the same late—Roman-Germanic tradition they shared with other Gothic peoples, the Visigoths were superior metalworkers and created magnificent colorful jewelry. In the eagle brooch (FIG. 9-2), the artist rendered the bird in flight with outspread wings and tail, profile head with curved beak, and large round eye. This brooch displays a rich assortment of gems. Besides the red garnets interspersed with blue and green stones, the circle that represents the eagle's body has a *cabochon* (polished but unfaceted) crystal

Art and Its Context

DEFINING THE MIDDLE AGES

he roughly 1,000 years of European history between the collapse of the Western Roman Empire in the fifth century and the Italian Renaissance in the fifteenth are known as the Middle Ages, or the medieval period. These terms reflect the view of Renaissance humanists who regarded the period that preceded theirs as a "dark age" of ignorance, decline, and barbarism, standing in the *middle* and separating their own "golden age" from the golden ages of ancient Greece and Rome. Although we now recognize the Middle Ages as a period of great richness, complexity, and innovation, the term has endured.

Art historians commonly divide the Middle Ages into three periods: Early Medieval (ending in the early eleventh century), Romanesque (eleventh and twelfth centuries), and Gothic (extending from the mid-twelfth into the fifteenth century). We shall look at only a few of the many cultures that make up the Early Medieval period. For convenience, we will use modern geographical names (MAP 9-1)—in fact, the nations we know today did not yet exist.

9–2 | EAGLE BROOCH One of a pair. Spain. 6th century. Gilt, bronze, crystal, garnets, and other gems. Height 5% (14.3 cm). The Walters Art Museum, Baltimore.

at the center. Round amethyst in a white meerschaum frame forms the eye. Pendant jewels originally hung from the bird's tail. The eagle remained one of the most popular motifs in Western art, owing in part to its continuing significance—first as an ancient sun symbol, then as a symbol of imperial Rome, and later as the emblem of Saint John the Evangelist.

THE LOMBARDS. Among those who established kingdoms in the heart of what had been the Roman Empire in Italy were

the Lombards. The Lombards had moved from their northern homeland into the Hungarian plain and then traveled west into Italy, where they became a constant threat to Rome. Like other migrating people, the Lombards excelled in fine metalwork. The huge jeweled cross in Brescia (east of Milan) shows their skillful use of precious metals and spectacular jewels (FIG. 9-3). The cross has a Byzantine form—equal arms widening at the ends joined by a central disc with a relief figure of Christ enthroned in a jeweled mandorla, indicating divine light emanating from the figure. More than 200 jewels, engraved gems, antique cameos, and glass pseudo-cameos adorn the cross. At the bottom of the cross is a gold glass Roman portrait medallion (SEE FIG. 6-68). According to tradition, the last Lombard king, Desiderius (ruled 757-74), gave the cross to the Church of Santa Giulia in Brescia. Scholars cannot agree on its date; they place the cross somewhere between the late seventh and early ninth centuries.

The patron who gathered this rich collection of jewels and ordered the cross to be made intended it to glorify God with glowing color and was evidently not concerned that nearly all the engraved gems and cameos have pagan subjects. The cross typifies this turbulent period in the Western European history of art. Made for a Western Christian church but having the form associated with the Byzantine East and using engraved jewels and cameos from the ancient world (even when they had to fake some in glass), the makers of the cross achieve an effect of extraordinary splendor.

The Art of People Outside the Roman Sphere of Influence

In Scandinavia (present-day Denmark, Norway, and Sweden), which was never part of the Roman Empire, people spoke variants of the Norse language and shared a rich mythology with other Germanic peoples. In the British Isles, where the Romans had built Hadrian's Wall to mark the boundaries between civilization and the wilds of Scotland, the ancient Celtic culture flourished.

9–3 | cross Church of Saint Giulia, Brescia, Italy. Late 7th-early 9th century. Gilded silver, wood, jewels, glass, cameos, and gold-glass medallion of the third century, 50 \times 39" (126 \times 99 cm). Museo di Santa Giulia, Brescia.

At the beginning of the fifth century the Roman army abandoned Britain. The economy faltered, and large towns lost their commercial function and declined as Romanized British leaders vied for dominance with the help of Germanic mercenary soldiers from the Continent.

THE NORSE. Scandinavian artists had exhibited a fondness for abstract patterning from early prehistoric times. During the first millennium BCE, trade, warfare, and migration had brought a variety of jewelry, coins, textiles, and other portable objects into northern Europe. The artists incorporated the solar disks and stylized animals on these objects into their already rich artistic vocabulary (SEE FIG. 1–20).

By the fifth century CE, the so-called **animal style** dominated the arts, displaying an impressive array of serpents, four-legged beasts, and squat human figures, as can be seen in

their metalwork. The **GUMMERSMARK BROOCH** (FIG. 9–4), for example, is a large silver gilt pin dating from the sixth century CE in Denmark. This elegant ornament consists of a large, rectangular panel and a medallionlike plate covering the safety pin's catch connected by an arched bow. The surface of the pin seethes with human, animal, and geometric forms. An eye-and-beak motif frames the rectangular panel; a man is compressed between dragons just below the bow; and a pair of monster heads and crouching dogs with spiraling tongues frame the covering of the catch.

Certain underlying principles govern works with animal style design: The compositions are generally symmetrical, and artists depict animals in their entirety either in profile or from above. Ribs and spinal columns are exposed as if they had been x-rayed; hip and shoulder joints are pear-shaped; tongues and jaws extend and curl, and legs end in large claws.

9–4 | GUMMERSMARK BROOCH
Denmark. 6th century. Silver gilt, height 5¾" (14.6 cm).
Nationalmuseet, Copenhagen.

The northern jewelers carefully crafted their molds to produce a glittering surface on the cast metal, turning a process intended to speed production into an art form of great refinement.

THE CELTS AND ANGLO-SAXONS. After the Romans departed, Angles and Saxons from Germany and the Low Lands and Jutes from Denmark crossed the sea to occupy southeastern Britain. Gradually they extended their control northwest across the island. Over the next 200 years, the arts made a brilliant recovery as the fusion of Celtic, Romanized British, Germanic, and Norse cultures generated a new culture and style of art, known as Hiberno-Saxon (from the Roman name for Ireland, *Hibernia*). Anglo-Saxon literature is filled with references to splendid and costly jewelry and weapons made of or decorated with gold and silver.

The Anglo-Saxon epic *Beowulf,* composed perhaps as early as the seventh century, describes its hero's burial with a hoard of treasure in a grave mound near the sea. Such a burial site was discovered near the North Sea coast in Suffolk at a site called Sutton Hoo (*hoo* means "hill" or "headland"). The

grave's occupant had been buried in a ship whose traces in the earth were recovered by the careful excavators. The wood—and the hero's body—had disintegrated, and no inscriptions record his name. He has sometimes been identified with the ruler Redwald, who died about 625. The treasures buried with him confirm that he was, in any case, a wealthy and powerful man.

The burial ship at Sutton Hoo was 90 feet long and designed for rowing, not sailing. In it were weapons, armor, other equipment to provide for the ruler's afterlife, and many luxury items, including Byzantine silver bowls. Also found was a large purse filled with coins. Although the leather of the pouch and the bone or ivory of its lid have disintegrated, the gold and garnet fittings survive (FIG. 9–5). The artist, using the cloisonné technique (cells formed from gold wire to hold shaped pieces of garnet or glass), frequently seen in Byzantine enamels, created figures of gold, garnets, and blue-checkered glass (known as *millefiore glass*). Polygons decorated with purely geometric patterns flank a central plaque of four animals with long interlacing legs and jaws. Below, large hawks attack ducks, and men are spread-eagled between two rampant beasts.

Themes, techniques, and styles from many places are represented on the purse cover. The motif of a human being flanked by a pair of animals is widespread in ancient Near Eastern art and in the Roman world (as is the motif of the predator vanquishing the prey). The hawks with rectangular eyebrows and curving beaks, twisted wings and square tails are Norse in style, and the interlacing four-legged, long-jawed animals characterize the Germanic animal style. The use of bright color—especially red and gold—reflects an Eastern European tradition. All in all, the purse displays the rich blend of motifs that marks the complex Hiberno-Saxon style that flourished in Britain and Ireland during the seventh and eighth centuries.

The Coming of Christianity to the British Isles

Although the Anglo-Saxons who settled in Britain had their own gods and myths, Christianity survived the pagan onslaught. Monasteries flourished in the Celtic north and west, and Christians from Ireland founded influential missions in Scotland and northern England. Cut off from Rome, these Celtic Christians developed their own liturgical practices, church calendar, and distinctive artistic traditions. Then, in 597, Pope Gregory the Great (ruled 590-604) dispatched missionaries from Rome to the Anglo-Saxon king Ethelbert of Kent, whose Christian wife Bertha was sympathetic to their cause. The head of this successful mission, the monk Augustine (Saint Augustine, d. 604), became the archbishop of Canterbury in 601. The Roman Christian authorities and the Irish monasteries, although allied in the effort to Christianize the British Isles, came into conflict over their divergent practices. The Roman Church eventually triumphed and brought British Christians under its authority. Local traditions, however, continued to influence their art.

9-5 PURSE COVER, FROM THE SUTTON HOO BURIAL SHIP

Suffolk, England. First half of 7th century. Cloisonné plaques of gold, garnet, and checked millefiore glass, length 8" (20.3 cm). The British Museum, London.

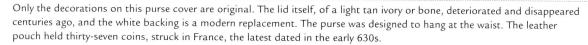

ILLUSTRATED BOOKS. Among the richest surviving artworks of the period were the beautifully written, illustrated, and bound manuscripts, especially the Gospel books. Gospel books were essential for the missionary activities of the Church throughout the early Middle Ages, not only for the information they contained—the "good news" of Christianity—but also as instruments to glorify the Word of God. Often bound in gold and jeweled covers, they were placed on the altars of churches and carried in processions. Thought to protect parishioners from enemies, predators, diseases, and all kinds of misfortune, these books were produced by monks in local monastic workshops called *scriptoria* (see "The Medieval *Scriptorium*," page 318).

One of the many elaborately decorated Gospels of the period is the **GOSPEL BOOK OF DURROW**, dating to the second half of the seventh century (FIG. 9–6). The format and text of the book reflect Roman Christian models, but its paintings are an encyclopedia of contemporary design. Each of the four Gospels is introduced by a page with the symbol of its evangelist author, followed by a page of pure ornament and finally the decorated letters of the first words of the text (the incipit).

9–6 | PAGE WITH MAN, GOSPEL BOOK OF DURROW Gospel of Saint Matthew. Probably made at Iona, Scotland, or northern England, second half of 7th century. Ink and tempera on parchment, $9\% \times 6\%$ (24.4 \times 15.5 cm). The Board of Trinity College, Dublin. MS 57 fol, 21v.

Art in Its Context

THE MEDIEVAL SCRIPTORIUM

oday books are made with the aid of computer software that can lay out pages, set type, and insert and prepare illustrations. Modern presses can produce hundreds of thousands of identical copies in full color. In Europe in the Middle Ages, however, before the invention there of printing from movable type in the mid-1400s, books were made by hand, one at a time, with ink, pen, brush, and paint. Each one was an important, time-consuming, and expensive undertaking. Medieval books were usually made by monks and nuns in a workshop called a scriptorium (plural scriptoria) within the monastery. As the demand for books increased, lay professionals joined the work, and great rulers set up palace workshops supervised by well-known scholars. Books were written on animal skin-either vellum, which was fine and soft, or parchment, which was heavier and shinier. (Paper did not come into common use in Europe until the early 1400s.) Skins for vellum were

cleaned, stripped of hair, and scraped to create a smooth surface for the ink and water-based paints, which themselves required time and experience to prepare. Many pigments—particularly blues and greens—had to be imported and were as costly as semiprecious stones. In very rich books, artists also used gold leaf or gold paint.

Sometimes work on a book was divided between a scribe, who copied the text, and one or more artists, who did the illustrations, large initials, and other decorations. Although most books were produced anonymously, scribes and illustrators signed and dated their work on the last page, called the **colophon** (SEE FIG. 9-9). One scribe even took the opportunity to warn the reader: "O reader, turn the leaves gently, and keep your fingers away from the letters, for, as the hailstorm ruins the harvest of the land, so does the injurious reader destroy the book and the writing" (cited in Dodwell, page 247).

In the Gospel Book of Durrow the Gospel of Matthew is preceded by his symbol, the man, but a man such as to be seen only in jeweled images made by an Irish or Scandinavian metalworker. A colorful checkered pattern resembling the millefiore glass inlays of Sutton Hoo forms the rectangular, armless body. Had the artist seen Byzantine figures wearing colorful brocades, or was he thinking of gold-framed jewels? In Saint Matthew's symbol a startling unshaven face stares glumly from rounded shoulders. The hair framing the man's high forehead follows the tonsure (the ceremonial hairstyle that distinguishes monks from laymen) of the early Celtic church. The figure seems to float with dangling feet against a neutral ground, which is surrounded by a wide border filled with a curling interlacing ribbon. Although the ribbon is continuous, its color changes from segment to segment, establishing yet another pattern. On other pages the ribbons turn into serpents.

The Gospel book known as the *Book of Kells* is one of the most beautiful, original, and inventive of the surviving Hiberno-Saxon Gospel books. A close look at its most celebrated page—the page introducing Matthew (1:18–25) that begins the account of Jesus's birth (SEE FIG. 9–1)—seems at first glance a tangle of colors and lines. But for those who would "look more keenly," there is so much more—human and animal forms—in the dense thicket of spiral and interlace patterns derived from metalwork.

The Kells style is especially brilliant in the monogram page with which we opened this chapter (FIG. 9–1). The artists reaffirm their Celtic heritage with the spirals and trumpet shapes that they combine with Germanic animal

interlaces to embellish the monogram of Christ (the three Greek letters XPI, *chi rho iota*) and the words *Christi autem generatio* ("now this is how the birth of Jesus Christ came about" [Matt. 1:18]). A giant *chi* establishes the basic composition of the page. The word *autem* appears as a Latin abbreviation resembling an *h*; and *generatio* is spelled out.

The illuminators outlined each letter, and then they subdivided the letters into panels filled with interlaced animals and snakes, as well as extraordinary spiral and knot motifs. The spaces between the letters form an equally complex ornamental field, dominated by spirals. In the midst of these abstractions, the painters inserted numerous pictorial and symbolic references to Christ-including his initials, a fish (the Greek word for "fish," ichthus, comprises in its spelling the first letters of Jesus Christ, Son of God, Savior), moths (symbols of rebirth), the cross-inscribed wafer of the Eucharist, numerous chalices and goblets, and possibly in two human faces, one at the top of the page and one at the end of the Greek letter P (rho). Three angels along the left edge of the stem of the Greek letter X (chi) are reminders that angels surrounded the Holy Family at the time of the Nativity, thus introducing Matthew's story while supporting the monogram of Christ.

In a particularly intriguing image, to the right of the Greek letter *chi*'s tail, two cats pounce on a pair of mice nibbling the Eucharistic wafer, and two more mice torment the vigilant cats (FIG. 9–7). As well as being a metaphor for the struggle between good (cats) and evil (mice), the image may also remark upon the perennial problem of keeping the monks' food and the sacred Host safe from rodents.

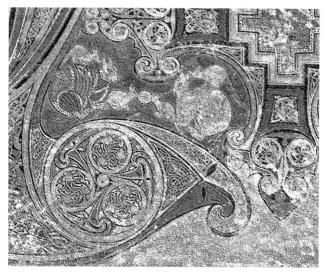

9–7 | CATS AND MICE WITH HOST, DETAIL OF FIG. 9–1 Chi Rho lota page, Book of Kells, Matt.1:18. Probably made at Iona, Scotland. Late 8th or early 9th century. Oxgall inks and pigments on vellum. $12\frac{1}{4} \times 9\frac{1}{2}$ " (325 \times 24 cm). The Board of Trinity College, Dublin. MS 58, fol. 34r.

9–8 | **SOUTH CROSS, AHENNY** County Tipperary, Ireland. 8th century. Stone.

IRISH HIGH CROSSES. Metalwork's influence is seen not only in manuscripts, but also in the monumental stone crosses erected in Ireland during the eighth century. In Irish high crosses, so called because of their size, a circle encloses the arms of the cross. This Celtic ring has been interpreted as a halo or a glory (a ring of heavenly light) or as a purely practical support for the arms of the cross. The **SOUTH CROSS OF**AHENNY, in County Tipperary, is an especially well-preserved example of this type (FIG. 9–8). It seems to have been modeled on metal ceremonial or reliquary crosses, that is, cross-shaped containers for holy relics. It is outlined with ropelike, convex moldings and covered with spirals and interlace. The large bosses (broochlike projections), which form a cross within the cross, resemble the jewels that were similarly placed on metal crosses.

THE MUSLIM CHALLENGE IN SPAIN

In 711, Islamic invaders conquered Spain, ending Visigothic rule. The invaders brought a new art as well as a new religion and government into Spain (see Chapter 8). Muslim armies swept over the Iberian Peninsula. Bypassing a small Christian kingdom on the north coast, Asturias, they crossed the Pyrenees Mountains into France, but in 732 Charles Martel and the Frankish army stopped them before they reached Paris. The Muslims retreated back across the mountains, and the Christians, led by the Asturians, slowly drove them southward. Even so, the Moors, as they were known in Spain, remained for nearly 800 years, until the fall of the last Moorish kingdom, Granada, to the Christians in 1492.

Mozarabic Art

With some exceptions, Christians and Jews who acknowledged the authority of the new rulers and paid the taxes required of non-Muslims were left free to follow their own religious practices. The Iberian Peninsula became a melting pot of cultures in which Muslims, Christians, and Jews lived and worked together, all the while officially and firmly separated. Christians in the Muslim territories were called Mozarabs (from the Arabic *mustarib*, meaning "would-be Arab").

The conquest resulted in a rich exchange of artistic influences between the Islamic and Christian communities. Christian artists adapted many features of Islamic art, creating a unique, colorful new style known as *Mozarabic*. When the Mozarabic communities migrated to northern Spain, which returned to Christian rule not long after the initial Islamic invasion, they took this Mozarabic style with them.

BEATUS MANUSCRIPTS. One of the most influential books of the eighth century was the *Commentary on the Apocalypse*, compiled by Beatus, abbot of the Monastery of San Martín at Liébana in the northern kingdom of Asturias. Beatus described the end of the world and the Last Judgment of the Apocalypse,

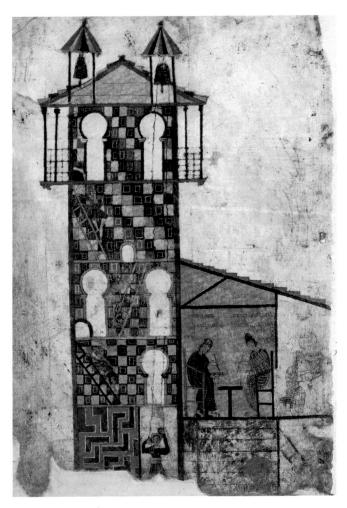

9−9 | Emeterius and Senior COLOPHON PAGE,
COMMENTARY ON THE APOCALYPSE BY BEATUS AND COMMENTARY ON DANIEL BY JEROME

Made for the Monastery of San Salvador at Tábara, León, Spain. Completed July 27, 970. Tempera on parchment, $14\frac{1}{4} \times 10\frac{1}{8}$ " (36.2 \times 25.8 cm). Archivo Histórico Nacional, Madrid. MS 1079B f. 167.v.

The colophon provides specific information about the production of a book. In addition to identifying himself and Senior on this colophon, Emeterius praised his teacher, "Magius, priest and monk, the worthy master painter," who had begun the manuscript prior to his death in 968. Emeterius also took the opportunity to comment on the profession of bookmaking: "Thou lofty tower of Tábara made of stone! There, over thy first roof, Emeterius sat for three months bowed down and racked in every limb by the copying. He finished the book on July 27th in the year 1008 [970, by modern dating] at the eighth hour" (cited in Dodwell, page 247).

as first depicted in the Revelation to John in the New Testament, which vividly describes Christ's final, fiery triumph.

In 970, the monk Emeterius and a scribe-painter named Senior completed a copy of Beatus's **COMMENTARY** (FIG. 9–9). They worked in the *scriptorium* of the Monastery of San Salvador at Tábara in the Kingdom of León. Unlike most monastic scribes at this time, Mozarabic scribes usually signed their work and occasionally offered the reader their own comments and asides (see "The Medieval *Scripto-*

rium," page 318). On the colophon (the page at the end of a book with information about its production) is a picture of the five-story tower of the Tábara monastery and the two-story *scriptorium* attached to it, the earliest known depiction of a medieval *scriptorium* and an unusual representation of a bell tower.

The tower and the workshop have been rendered in a cross section that reveals the interior and exterior of the buildings simultaneously. In the *scriptorium*, Emeterius on the right and Senior on the left, identified by inscriptions over their heads, work at a small table. A helper in the next room cuts sheets of **parchment** or **vellum** for book pages. A monk standing at the ground floor of the tower pulls the ropes attached to the bell in the turret while three other men climb ladders between the floors, apparently on their way to the balconies on the top level. Brightly glazed tiles in geometric patterns and horseshoearched openings are a common feature of Islamic architecture.

Another copy of Beatus's *Commentary* was produced five years later for Abbot Dominicus. The colophon identifies Senior as the scribe for this project. Emeterius and a woman named Ende (or simply En), who signed herself "painter and servant of God," shared the task of illustration. For the first time in the West, a women artist is identified by name with a specific surviving work of art. Using abstract shapes and brilliant colors recalling Visigothic jewel work, Emeterius and En illustrate a metaphorical description of the triumph of Christ over Satan (FIG. 9–10).

In the illustration, a peacock grasps a red and orange snake in its beak. The text tells us that a bird with a powerful beak and beautiful plumage (Christ) covers itself with mud to trick the snake (Satan). Just when the snake decides the bird is harmless, the bird swiftly attacks and kills the snake. "So Christ in his Incarnation clothed himself in the impurity of our [human] flesh that through a pious trick he might fool the evil deceiver. . . . [W]ith the word of his mouth [he] slew the venomous killer, the devil" (from the Beatus *Commentary*, cited in Williams, page 95). The Church often used such symbolic stories, or allegories, to convey ideals in combinations of recognizable images, making their implications accessible to people at any level of education. Elements of Mozarabic art lasted well into the twelfth century.

THE CAROLINGIAN EMPIRE

During the second half of the eighth century, while Christians and Muslims were creating a rich multicultural art in Spain, a new force emerged in Continental Europe. Charlemagne, or Charles the Great (*Carolus Magnus* is Latin for "Charles the Great"), established a dynasty and an empire known today as "Carolingian." The Carolingians were Franks, a Germanic people who had settled in northern Gaul (parts of present-day France and Germany) by the end of the fifth century. Under Charlemagne (ruled 768–814), the

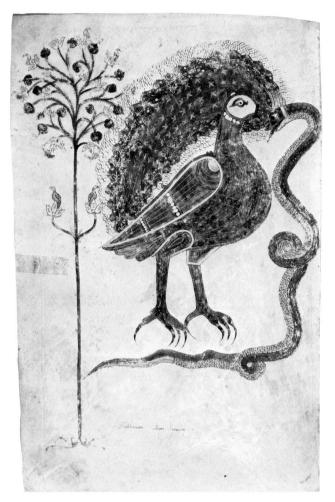

9-10 | Emeterius and Ende, with the scribe Senior
BATTLE OF THE BIRD AND THE SERPENT, COMMENTARY ON
THE APOCALYPSE BY BEATUS AND COMMENTARY ON DANIEL
BY JEROME, (DETAIL)

Made for Abbot Dominicus, probably at the Monastery of San Salvador at Tábara, León, Spain. Completed July 6, 975. Tempera on parchment, $15\frac{7}{4} \times 10\frac{7}{4}$ " (40×26 cm). Cathedral Library, Gerona, Spain. MS 7[11], fol. 18v.

Carolingian realm reached its greatest extent, encompassing western Germany, France, the Lombard kingdom in Italy, and the Low Countries (present-day Belgium and Holland). Charlemagne imposed Christianity throughout this territory. In 800, Pope Leo III (papacy 795–816) crowned Charlemagne emperor in a ceremony in Saint Peter's Basilica in Rome, declaring him the rightful successor to Constantine, the first Christian emperor. This endorsement reinforced Charlemagne's authority and strengthened the bonds between the papacy and secular government in the West.

Charlemagne sought to restore the Western Empire as a Christian state and to revive the arts and learning. As inscribed on his official seal, Charlemagne's ambition was "the Renewal of the Roman Empire." To lead this revival, Charlemagne turned to the Benedictine monks and nuns. By the early Middle Ages, monastic communities had spread

across Europe. In the early sixth century, Benedict of Nursia (c. 480–547) wrote his *Rule for Monasteries*, a set of guidelines for monastic life that became the model for monastic orders. Benedictine monasticism soon displaced earlier forms, including the Celtic monasticism in the British Isles.

Both the Benedictines and Charlemagne emphasized education, and the Benedictine monks soon became Charlemagne's "cultural army." The court at Aachen, Germany, became one of the leading intellectual centers of Western Europe. Charlemagne's architects, painters, and sculptors looked to Rome and Ravenna for inspiration, but what they created was a new, northern version of the Imperial Christian style.

Carolingian Architecture

Functional plans inspired by Roman and Early Christian architecture were widely adopted by the Carolingian builders. Charlemagne's palace complex at Aachen provides an example of the Carolingian synthesis of Roman, Early Christian, and northern styles. Charlemagne, who enjoyed hunting and swimming, built a headquarters and palace complex amid the forests and natural hot springs of Aachen in the northern part of his empire and installed his court there about 794. The palace complex included a large audience hall and a chapel facing each other across a large square (as seen in a Roman forum), a monumental gateway supporting a hall of judgment, other administrative buildings, a palace school, homes for his circle of advisers and his large family, and workshops supplying all the needs of church and state.

THE PALACE CHAPEL AT AACHEN. Directly across from the royal audience hall on the north-south axis of the complex stood the PALACE CHAPEL (FIGS. 9–11, 9–12). This structure functioned as Charlemagne's private chapel, the church of his imperial court, a place for precious relics, and, after the emperor's death, the imperial mausoleum. To satisfy all these needs, the emperor's architects created a large, central-plan building similar to the Church of San Vitale in Ravenna (FIG. 7–28), which they reinterpreted in the distinctive Carolingian style.

The westwork—church entrances traditionally faced west—is a combined narthex (vestibule) and chapel joined by tall, cylindrical stair towers. The ground-level entrance accommodated the public. On the second level, a throne room opened onto the chapel rotunda, allowing the emperor to participate in the Mass from his private throne room. (The throne is visible through the arch.) At Aachen, this throne room could be reached from the palace audience hall and hall of justice by way of a gallery. The room also opened outside into a large walled forecourt where the emperor could make public appearances and speak to the assembled crowd. Relics were housed above the throne room on the third level. Spiral stairs in the twin towers joined the three levels. Originally designed to answer practical requirements

9—II | PALACE CHAPEL OF CHARLEMAGNE Interior view, Aachen (Aix-la-Chapelle), Germany. 792–805.

Extensive renovations took place in the nineteenth century, when the chapel was reconsecrated as the Cathedral of Aachen, and in the twentieth century, after it was damaged in World War II.

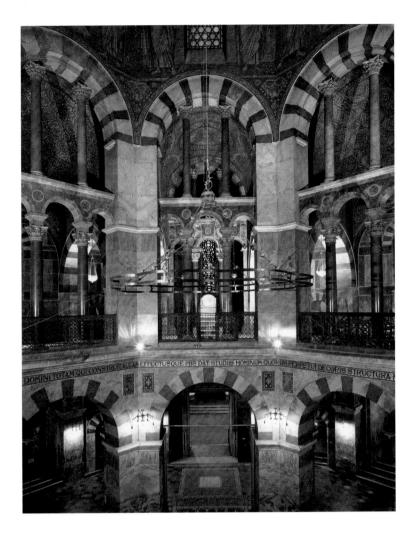

$9{-}12$ RECONSTRUCTION DRAWING OF THE PALACE CHAPEL OF CHARLEMAGNE,

Aachen (Aix-la-Chapelle), Germany. 792-805.

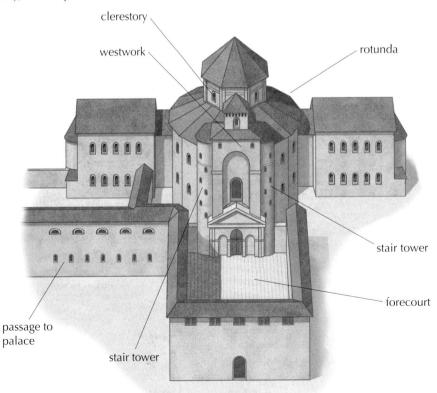

of protection and display, the soaring multitowered westwork came to function symbolically as the outward and very visible sign of an imperial building.

At Aachen, the core of the chapel is an octagon surrounded by an ambulatory and gallery in alternating square and triangular bays that produce a sixteen-sided outer wall. The central octagon rises to a clerestory above the gallery level and culminates in eight curving triangular segments that form an octagonal dome. In contrast, at the Byzantine Church of San Vitale, the central octagon was covered by a round dome and supported by half domes over the eight exedras (SEE FIG. 7-28). The chapel at Aachen has sharply defined spaces created by flat walls and angled piers. Byzantine Ravenna has curving surfaces and flowing spaces. In the gallery at Aachen, two tiers of Corinthian columns in the tall arched openings and bronze grills at floor level create a fictive wall that enhances the clarity and geometric quality of the design. The chapel's interior space is defined by eight panels that create a powerful upward movement from the floor of the central area to the top of the vault. Rich materials, some imported from Italy, and mosaics cover the walls. (The mosaic in the vault depicting the twenty-four Elders of the Apocalypse has been replaced with a modern interpretation.) This use of rich materials over every surface was inspired by Byzantine art, but the emphasis on verticality and the clear division of larger forms into separate parts are hallmarks of the new Carolingian style.

THE CHURCH OF SAINT RIQUIER. The Palace Chapel was a special building. Most Carolingian churches followed the basilican plan, often with the addition of a transept inspired by Old Saint Peter's in Rome. Charlemagne's biographer, Einhard, reported that the ruler, "beyond all sacred and venerable places . . . loved the church of the holy apostle Peter at Rome." Charlemagne's churches, however, were not simply imitations of Roman and Early Christian structures.

The Abbey Church of Saint Riquier, in the monastery at Centula in northern France, illustrates the Carolingian reinterpretation of the Early Christian basilica. Built by Angilbert, a lay abbot (781-814) and Frankish scholar at the court, the church was finished about 799. Destroyed by Viking raids in the ninth century, it is known today from archaeological evidence and a seventeenth-century engraving of a lost eleventhcentury drawing (FIG. 9–13). For the abbey's more than 300 monks, the enclosure between the church and two freestanding chapels evidently served as a cloister-cloisters are arcaded courtyards linking the church and the living and working areas of the monastery. Three kinds of church buildings are represented. Simplest is the small, barnlike chapel (at the right in the print) dedicated to Saint Benedict. The more elaborate structure, a basilica with a rotunda ringed with chapels (lower left), was dedicated to the Virgin Mary and the Twelve Apostles. The interior probably had an altar to the Virgin in the center, an ambulatory, and chapels with altars for each of the apostles against the outside walls.

The principal church, dedicated to Saint Riquier, displays a Carolingian variation of the basilica plan. The nave has side aisles and clerestory windows, and recent excavations have revealed a much longer nave than is indicated in the print. Giving equal weight to both ends of the nave are a multistory westwork including paired towers, a transept, and a crossing tower (at the left in the print), and, at the east end of the church (on the right), a crossing tower, which rises over the transept, and an extended sanctuary and apse.

The westwork served almost as a separate church. The main altar was dedicated to Christ the Savior and used for important church services. The boys' choir sang from its galleries, filling the church with "angelic music," and its ground floor had additional altars with important relics. Later the altar of the Savior was moved to the main body of the church, and the westwork was rededicated to the archangel Michael, whose chapel was usually located in a tower or other high place.

Saint Riquier's many towers would have been the building's most striking feature. The two tall towers at the crossing of the transepts soared upward from cylindrical bases through

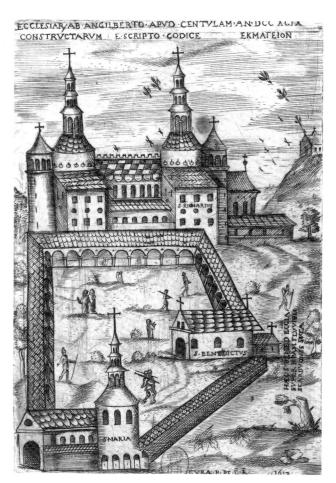

 $9 \mathbf{-} \mathbf{13}^{\top}$ abbey church of saint riquier, monastery of centula

France. Dedicated 799. Engraving dated 1612, after an 11th-century drawing. Bibliothèque Nationale, Paris.

three arcaded levels to cross-topped spires. They served a practical function as bell towers and played a symbolic role, designating an important building. Meant to be seen from afar, towers visually dominated the countryside. The vertical emphasis created by integrating towers into the basilican design was a northern contribution to Christian church architecture.

THE SAINT GALL PLAN. Monastic communities had special needs. The life of monks revolved around prayer and service in the church and work for the community. In the early ninth century, Abbot Haito of Reichenau developed an ideal plan for the construction of monasteries for his colleague Abbot Gozbert of Saint Gall near Lake Constance in Switzerland (FIG.9-14). Abbot Haito laid out the plan on a square grid, as with an ancient Roman army camp, and indicated the size and position of the buildings and their uses.

Since Benedictine monks celebrate Mass as well as the eight "canonical" hours every day, they needed a church building with ample space for many altars, indicated in the

plan as standing in the nave and aisles as well as chapels. In the Saint Gall plan, the church had large apses at both the east and west ends of the nave. North of the church were public buildings such as the abbot's house, the school, and guesthouse. The south side was private—the cloister and the complex of monastic buildings surrounding it. The dormitory was built on the east side of the cloister, and for night services the monks entered the church directly from their dormitory. The refectory (dining hall) stood on the south of the cloister, with the kitchen, brewery, and bakery attached. A huge cellar (indicated on the plan by giant barrels) was on the west side. The Saint Gall plan indicates beds for seventy-seven monks in the dormitory and space for thirty-three more elsewhere. Practical considerations for group living include latrines attached to every unit—dormitory, guesthouse, and abbot's house. (The ratio of latrine holes to beds exceeds the standards of the U.S. Army today.) Six beds and places in the refectory were reserved for visiting monks. In the surrounding buildings, monks pursued their individual tasks. Scribes and painters, for example, spent much of their day in the scrip-

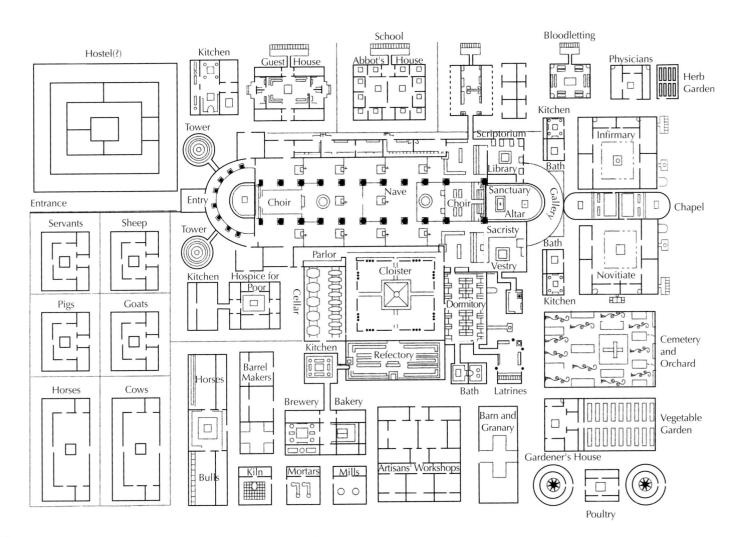

9-14 PLAN OF THE ABBEY OF SAINT GALL (REDRAWN)

c. 817. Original in red ink on parchment, 28 × 44%" (71.1 × 112.1 cm). Stiftsbibliothek, St. Gallen, Switzerland. Cod. Sang. 1092.

torium studying and copying books, and teachers staffed the monastery's schools and library. Saint Benedict had directed that monks extend hospitality to all visitors, and the large building in the upper left of the plan may indicate the guesthouse. The plan also included a hospice for the poor and an infirmary. Around this central core were the workshops, farm buildings, and housing for the lay community. Essentially self-supporting, the community needed barns for livestock, kitchen gardens (grain fields and vineyards lay outside the walls), and, of course, a cemetery. The monastery was often larger than the local villages.

The Scriptorium and Illustrated Books

Books played a central role in the efforts of Carolingian rulers to promote learning, propagate Christianity, and standardize Church law and practice. One of the main tasks of the imperial workshops was to produce authoritative copies of key religious texts, free of the errors introduced by tired, distracted, or confused scribes. The scrupulously edited versions of ancient and biblical texts that emerged are among the lasting achievements of the Carolingian period. The Anglo-Saxon scholar Alcuin of York, whom Charlemagne called to his court, spent the last eight years of his life producing a corrected copy of the Latin Vulgate Bible. His revision served as the standard text of the Bible for the remainder of the medieval period and is still in use.

Generations of copying had led to a shocking decline in penmanship. To create a simple, legible Latin script, the scribes and scholars developed uniform letters. Capitals (majuscules) based on ancient Roman inscriptions were used for very formal writing, titles and headings, and the finest manuscripts. Minuscules (now called lower-case letters, a modern printers' term) were used for more rapid writing and ordinary texts. The Caroline script is comparatively easy to read, although the scribes did not use punctuation marks or spaces between words.

Like the builders who transformed inherited classical types such as the basilican church into the new and different Carolingian monastic church, the scribes and illuminators revived and revitalized the Christian manuscript tradition. The human figure, which was absent or barely recognizable in early medieval books, returned to a central position.

Every monastic *scriptorium* developed its own distinctive forms in harmony with local artistic traditions and the books available as models in the library or treasury. The evangelist portraits (a man seated at a desk writing) in the three Gospel Books discussed here—the **GODESCALC GOSPEL LECTIONARY**, the **CORONATION GOSPELS**, and the **EBBO GOSPELS**—demonstrate the range and variety of Carolingian styles. Although the scribes intended to make exact copies of the texts and illustrations, they brought their own distinctive training to the work and so transformed the images into something new and different.

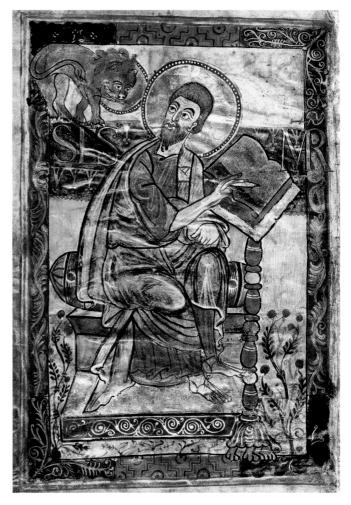

 $9{-}15$ | page with mark the evangelist, godescald gospel lectionary

Gospel of Mark. 781–83. Ink, gold, and colors on vellum, $12\,\% \times 8\,\%$ (32.1 \times 21.8 cm). Bibliothèque Nationale, Paris. MS lat. 1203, fol. 16.

THE GODESCALC GOSPEL LECTIONARY. One of the earliest surviving manuscripts in the new script produced at Charlemagne's court was the GODESCALC GOSPEL LECTIONARY (FIG. 9–15), a collection of selections from the Gospels to be read at Mass. Commissioned by Charlemagne and his wife Hildegard, perhaps to commemorate the baptism of their sons in Rome in 781, the Godescalc Gospels provided a model for later luxuriously decorated Gospel books.

The colophon indicates that the book was finished before the death of Hildegard in 783 and was made by the Frankish scribe Godescalc. This richly illustrated and sumptuously made book, with gold and silver letters on purple-dyed vellum, has a full-page portrait of the evangelist at the beginning of each Gospel. The style of these illustrations suggests that Charlemagne's artists were familiar with the author portraits of imperial Rome, as they had been preserved in Byzantine manuscripts.

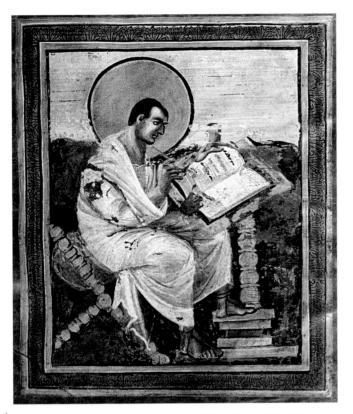

 $9\mathbf{-}16$ | page with saint matthew the evangelist, coronation gospels

Gospel of Matthew. Early 9th century. $12\% \times 9\%$ " (36.3 \times 25 cm). Kunsthistorische Museum, Vienna.

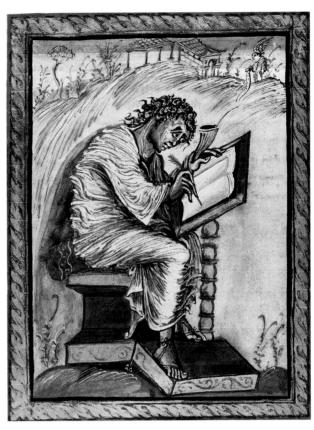

 $9-17 \perp \text{page with matthew the evangelist, ebbo}$ gospels

Gospel of Matthew. Second quarter of 9th century. Ink, gold, and colors on vellum, $10\% \times 8\%$ (26×22.2 cm). Bibliothèque Municipale, Épernay, France. MS 1, fol. 18v.

Saint Mark is in the act of writing at a lectern tilted up to display his work. He appears to be listening to the small haloed lion in the upper left corner, the source of his inspiration and the iconographic symbol by which he is known. The artist has modeled Mark's arms, hips, and knees beneath his garment and has rendered the bench and lectern to hint at three-dimensional space despite the flat, banded background. Mark's round-shouldered posture and sandaled feet, planted on a platform decorated with a classical vine, contribute an additional naturalistic touch, but the illusion of a figure in space is disrupted by the impossible position of the left knee and the reverse perspective of the furniture.

THE GOSPELS OF CHARLEMAGNE, KNOWN AS THE CORONATION GOSPELS. Classical Early Christian and Byzantine art seem very close to the style of the CORONATION GOSPELS (FIG. 9–16), in which the Carolingian painters seem to have rediscovered Roman realistic painting. Ways of creating the illusion of figures in space may have been suggested by Byzantine manuscripts in the library, or an artist from Byzantium may have actually worked at the Carolingian court. (Charlemagne had hopes of marrying the Byzantine Empress Irene.

She turned him down—in her eyes he was a barbarian.) Tradition says that the book was placed in the tomb of Charlemagne and that in the year 1000 Emperor Otto III removed it (see page 334). It was used in the coronation of later German emperors. The evangelist portraits in this book show full-bodied, white-robed figures represented in brilliant light and shade and seated in a freely depicted naturalistic landscape. The frame enhances the classical effect of a view through a window.

THE GOSPELS OF ARCHBISHOP EBBO OF REIMS. Patronage of scribes and painters continued under Louis the Pious, Charlemagne's son and successor (ruled 89–840). Louis appointed his childhood friend Ebbo to be archbishop of Reims (ruled 816–35, 840–45). Ebbo was an important patron of the arts. A portrait of Matthew from a Gospel book made for the archbishop, either in Reims or a nearby *scriptorium*, illustrates the unique style associated with Reims (FIG. 9–17). The artist interprets the author's portrait with a frenetic intensity that turns the face, drapery, and landscape into swirling expressive colored lines. The author and his angelic inspiration (the tiny figure in the upper right corner) seem to

AME FICUMCLAMARE REMINISCENTURITOON OMSPINCUISTERRAF ADEUMEXAUDIUITME. UERTENTURADDNM INCONSPECTURIUSCA APUDTILAUSMIAINIC DENTOMSQUIDESCEN UNIVERSIFINESTERRAF CLESIAMAGNA UOTA GIADORABUNIIN DUNTINTERRAM MIARIDDAMINCONS CONSCICTULIUS . GTANIMAMEAILLIUI UNIUERSAFFAMILIAE UET ITSEMENMEUM PECTUTIMENTIUEUM; EDINTPAUPERISHTSA GENTIUM SERVIETICSI TURABUNTUR ETLAU QUONIAMONIISTRIG ADNUNCIABITURDNOCF NUM HIPSIDOMINA NERATIONENTURA ET DABUNTONMQUIRE OUIRUNTIUM UI BITURGINTIUM UINTCORDATORUM MANDUCAUIRUNTIT TIÁTIUS TOPULOQUINAS INSAECULÚSAECULI ADORAUIRUNT CHURQUEHCITONS XXII PSALMUS OAUIC **VSRECITMEET VIBIL** INMEDIOUMBRAEMOR MEUSINEBRIANSQUAM MIHIDEERIT INLOCOPAS TIS NONTIMEBOMALA PRAICLARUSIST CULIBIMECOLLOCABIT etmistricordiatua QMTUMECUMES, UPFRAQUARIFICTIO CIRCATUALIBACULUSTU SUBSEQUETURME MISEDUCAUITME ANI US. ITSAMICONSOLATAST; OMNIBUSDIEBUSUI MÁMEAMCONUERTIT PARASTIINCONSPECTU LAIMIAE DEDUXITMESUTERSEMI MIOMINSÁ ADUIRSÚ GTUTINHABITIMINDO TASIUSTITIAE PROPTIR 105QUITRIBULANTME MODUL INTONG! HOMENSUUM INFINGUASTIINOLIO MUNIPULLIAN . NAMITSIABULAUTRO CAPUTMEUM ETCALIX

9-18 | page with psalm 23, utrecht psalter.

Second quarter of 9th century. Ink on vellum or parchment, $13\times 9\%$ (33×25 cm). Universiteitsbibliotheek, Utrecht, Holland. MS 32, fol. 13r.

hover over a landscape so vibrant that both threaten to run off the page. Even the golden acanthus leaves in the frame seem windblown.

The artist uses the brush like a pen, focusing attention less on the evangelist's physical appearance than on his inner, spiritual excitement as he transcribes the Word of God coming to him from the distant angel, Matthew's symbol. Saint Matthew's head and neck jut out of hunched shoulders, and he grasps his pen and inkhorn. His twisted brow and prominent eyebrows lend his gaze an intense, theatrical quality. Swept up in Matthew's turbulent emotions, the saint's desk, bench, and footstool tilt every which way, as the top of the desk seems about to detach itself from the pedestal. Gold highlights the evangelist's hair and robe, the furniture, and the landscape. The accompanying text is written in magnificent golden capitals.

THE UTRECHT PSALTER. The most famous Carolingian manuscript, the UTRECHT PSALTER, or Old Testament Book of Psalms, is illustrated with ink drawings that have the same linear vitality as the paintings in Archbishop Ebbo's Gospel book. Psalms do not tell a straightforward story and so are exceptionally difficult to illustrate. The *Utrecht Psalter* artists solved this problem by interpreting individual words and images literally. Their technique can be likened to a game of charades in which each word must be acted out.

The words of the well-known Twenty-third Psalm are illustrated literally (FIG. 9-18). "The Lord is my shepherd; I shall not want" (verse 1): The psalmist (traditionally King David) sits in front of a table laden with food; he holds a cup (verse 5). He is also portrayed as a shepherd in a pasture filled with sheep, goats, and cattle, "beside the still water" (verse 2). Perhaps the stream flows through "the valley of the shadow of death" (verse 4). An angel supports the psalmist with a "rod and staff" and anoints his head with oil (verses 4 and 5). "Thou prepares a table before me in the presence of mine enemies" (verse 5): The enemies gather at the lower right and shoot arrows, but the psalmist and angel ignore them and focus on the table and the House of the Lord. The basilica curtains are drawn back to reveal an altar and hanging votive crown: "I will dwell in the house of the Lord forever" (verse 6). Illustrations like this convey the characteristically close association between text and illustration in Carolingian art.

Carolingian Goldsmith Work

The magnificent illustrated manuscripts of the medieval period represented an enormous investment in time, talent, and materials, so it is not surprising that they were often protected with equally magnificent covers. But because these covers were themselves made of valuable materials—ivory, enamelwork, precious metals, and jewels—they were frequently reused or stolen. The elaborate book cover of gold

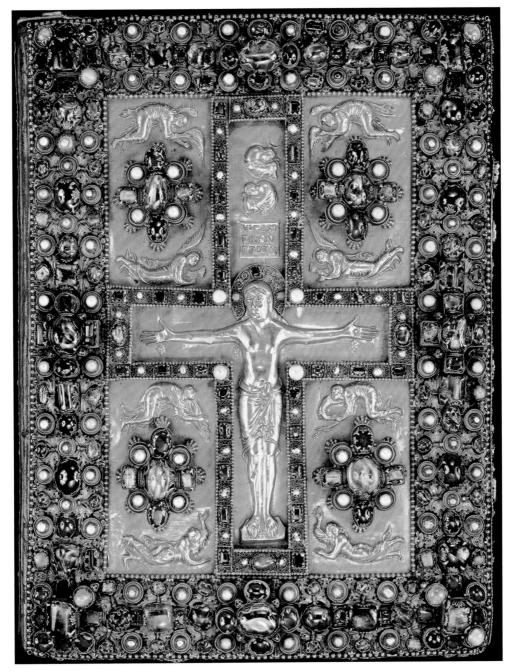

9–19 | CRUCIFIXION WITH ANGELS AND MOURNING FIGURES, LINDAU GOSPELS. Outer cover. c. 870–80. Gold, pearls, sapphires, garnets, and emeralds, $13\%\times10\%$ (36.9 \times 26.7 cm). The Pierpont Morgan Library, New York.

and jewels, now the cover of the Carolingian manuscript known as the LINDAU GOSPELS (FIG. 9–19), was probably made between 870 and 880 at one of the monastic workshops of Charlemagne's grandson, Charles the Bald (ruled 840–77). Charles inherited the portion of Charlemagne's empire that corresponds roughly to modern France after the death of his father, Louis the Pious. It is not known what book the cover was made for, but sometime before the sixteenth century it became the cover of the *Lindau Gospels*, prepared at the Monastery of Saint Gall in the late ninth century.

The Cross and the Crucifixion were common themes for medieval book covers. The Crucifixion scene on the front cover of the *Lindau Gospels* is made of gold with figures in *repoussé* (low relief produced by pounding out the back of the panel to produce a raised front) surrounded by heavily jeweled frames. The jewels are raised on miniature arcades. By raising the jewels from the gold ground, the artist allowed reflected light to enter the gemstones from beneath, imparting a lustrous glow. Such luxurious gems are meant to recall the jeweled walls of the Heavenly Jerusalem.

Angels hover above the arms of the cross. Over Jesus's head, hiding their faces, are figures representing the sun and moon. The graceful, expressive poses of the mourners—Mary, John, Mary Magdalene, and Mary Cleophas—who seem to float around the jewels below the arms of the cross, reflect the expressive style of the *Utrecht Psalter* illustrations. Jesus, on the other hand, has been modeled in a rounded, naturalistic style suggesting the influence of classical sculpture. His erect posture and simplified drapery counter the emotional expressiveness of the other figures. Standing upright and wide-eyed with outstretched arms, he announces his triumph over death and welcomes believers into the faith.

In 843, the Carolingian empire was divided into three parts, ruled by three grandsons of Charlemagne. Although a few monasteries and secular courts continued to patronize the arts, intellectual and artistic activity slowed. Torn by internal strife and ravaged by Viking invaders, the Carolingian empire came to a bloody and inglorious end in the ninth century.

THE VIKING ERA

In the eighth century seafaring bands of Norse seamen known as Vikings (*Viken*, "people from the coves") descended on the rest of Europe. Setting off in flotillas of as many as 350 ships, they explored, plundered, traded with, and colonized a vast area during the ninth and tenth centuries. Frequently, their targets were wealthy isolated Christian monasteries. The earliest recorded Viking incursions were two devastating attacks: one in 793, on the religious community on Lindisfarne, an island off the northeast coast of England, and

another in 795, at Iona, off Scotland's west coast. In France they besieged Paris in 845 and later destroyed Centula as they harried the northern and western coasts of Europe.

Norwegian and Danish Vikings raided and settled a vast territory stretching from Iceland and Greenland, where they settled in 870 and 985, respectively, to Ireland, England, Scotland, and France. The Viking Leif Eriksson reached North America in 1000. In good weather a Viking ship could sail 200 miles in a day. In the early tenth century, the rulers of France bought off Scandinavian raiders (the Normans, or North men) with a large grant of land that became the duchy of Normandy. Swedish Vikings turned eastward and traveled down the Russian rivers to the Black Sea and Constantinople, where the Byzantine emperor recruited them to form an elite personal guard. Others, known as Rus, established settlements around Novgorod, one of the earliest cities in what would become Russia. They settled in Kiev in the tenth century and by 988 had become became Orthodox Christians (see Chapter 7).

The Oseberg Ship

Since prehistoric times Northerners had represented their ships as sleek sea serpents, and as we saw at Sutton Hoo they used them for burials as well as sea journeys. The ship of a dead warrior symbolized his passage to Valhalla, and Viking chiefs were sometimes cremated in a ship in the belief that this hastened their journey. Women as well as men were honored by ship burials. A 75-foot-long ship discovered in Oseberg, Norway, and dated 815–20 served as the vessel for two women on their journey to eternity in 834 (FIG. 9–20). Although the burial chamber was long ago looted of jewelry

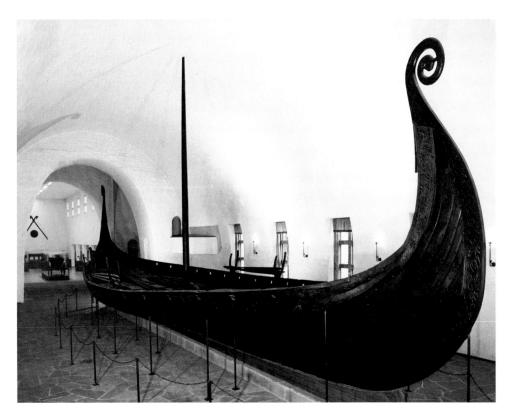

9–20 | QUEEN'S SHIP Oseberg, Norway. c. 815–20; burial 834. Wood, length 75'6" (23 m). Vikingskiphuset, Universitets Oldsaksamling, Oslo, Norway.

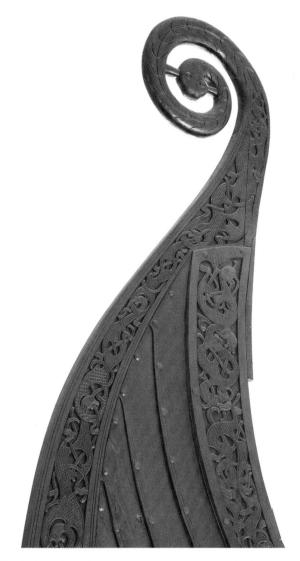

9–21 | GRIPPING BEASTS, DETAIL OF OSEBERG SHIP c. 815–20. Wood. Vikingskiphuset, Universitets Oldsaksamling, Oslo, Norway.

and precious objects, the ship itself and its equipment attest to the wealth and prominence of the ship's owner.

This vessel, propelled by both sail and oars, was designed for travel in the relatively calm waters of fjords (narrow coastal inlets), not for voyages in the open sea. The burial chamber held the bodies of two women—a queen and her companion or servant. At least twelve horses, several dogs, and an ox had been sacrificed to accompany the women on their last journey. A cart and four sleds, all made of wood with beautifully carved decorations, were also stored on board. The cabin contained empty chests that no doubt once held precious goods.

The prow and stern of the Oseberg ship rise and coil, the spiraling prow ending in a tiny serpent's head. Bands of interlaced animals carved in low relief run along the ship's bow and stern. Viking beasts are broad-bodied creatures that clutch each other with sharp claws; in fact, these animals are known as "gripping beasts" (FIG. 9–21). They are grotesque catlike

creatures with bulging eyes, short muzzles, snarling mouths, and large teeth. Their bodies are encrusted with geometric ornament. Images of these strange beasts adorned all sorts of Viking belongings—jewelry, houses, tent poles, beds, wagons, and sleds. Traces of color—black, white, red, brown, and yellow—indicate that the carved wood was painted.

All women, including the most elite, worked in the fiber arts. The Oseberg queen had her spindles, a frame for sprang (braiding), tablets for tablet weaving, as well as two upright looms. Her cabin walls had been hung with tapestries, fragments of which survive. Women not only produced clothing and embroidered garments and wall hangings, but they also wove the huge sails of waterproof unwashed wool that gave the ships a long-distance capability. The entire community—men and women—worked to create the ships, which represent the Viking's most important contribution to world architecture.

Picture Stones at Jelling

Both at home and abroad, the Vikings erected large memorial stones. Those covered mostly with inscriptions are called **rune stones**; those with figural decoration are called **picture stones**. Runes are twiglike letters of an early Germanic alphabet. Traces of pigments suggest that the memorial stones were originally painted in bright colors.

About 980 the Danish king Harald Bluetooth (c. 940–987) ordered a picture stone to be placed near the family burial mounds at Jelling (FIG. 9–22). Carved in runes on a boulder 8 feet high is the inscription, "King Harald had this memorial made for Gorm his father and Thyra his mother: that Harald who won for himself all Denmark and Norway and made the Danes Christians." (The prominent place of women in Viking society is noteworthy.) Harald and the Danes had accepted Christianity in c. 960, but Norway did not become Christian until 1015.

During the tenth century, a new style emerged in Scandinavia and the British Isles, one that combined simple foliage elements and coarse ribbon interlaces with animals that are more recognizable than the gripping beasts of the Oseberg ship. On one face of the Jelling Stone the sculptor carved the image of Christ robed in the Byzantine manner, with arms outstretched as if crucified. He is entangled in a double-ribbon interlace instead of a cross. A second side holds the runic inscriptions, and a third, a striding creature resembling a lion fighting a snake. The coarse, loosely twisting double-ribbon interlace covering the surface of the stone could have been inspired by Hiberno-Saxon art. New to the north, however, are bits of foliage that spring illogically from the animal—the Great Beast's tail, for example, is a rudimentary leaf. The Great Beast symbolizes the Lion of Judah, an Old Testament prefiguration of the militant Christ, and thus is wholly appropriate for a royal monument commemorating the conversion of the Danes and Harald's victorious dynasty.

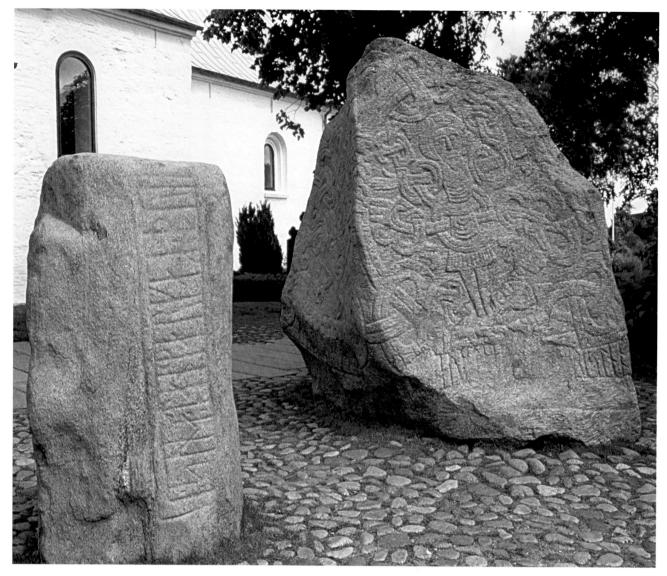

9-22 ROYAL RUNE STONES

Left: Raised by Gorm the Old to honor his wife Thyra. Right: Raised by Harald Bluetooth to honor his parents Gorm and Thyra and to commemorate the conversion of the Danes to Christianity. Jelling, Denmark, 960-985, granite, height of Harald's stone about 8' (2.44 m). The stone church in the background dates c. 1100 and replaces a series of wooden churches on the site.

THE URNES CHURCH PORTAL. The penchant for carved relief decorations seen on the Oseberg ship endured in the decoration of Scandinavia's great halls and later churches. The façades of these structures often teem with intricate animal interlace. A church at Urnes, Norway, although entirely rebuilt in the twelfth century, preserved its original eleventh century doorway (FIG. 9–23), carved with an interlace of serpentine creatures snapping at each other like the vicious little gripping beasts of Oseberg. New in the Urnes style, however, is the satin-smooth carving of rounded surfaces, the contrast of thick and very thin elements, and the organization of the interlace into harmoniously balanced patterns, which have the effect of aesthetic elegance and technical control rather than the wild disarray of earlier carving.

The images on the Urnes doorway panels suggest the persistence of Scandinavia's mythological tradition even as

Christianity spread through the country. The Great Beast standing at the left of the door, fighting serpents and dragons, continued to be associated with the Lion of Judah (as at Jelling) and with Christ, who fought Satan and the powers of darkness and paganism (like the peacock and snake image in Mozarabic art). With Christianity, the Great Beast became a positive, protective force.

Timber Architecture

In Scandinavia vast forests provided the materials for timber buildings of all kinds (FIG. 9–24). Two forms of timber construction evolved: one that stacked horizontal logs, notched at the ends, to form a rectangular building (the still popular log cabin); and the other that stood the wood on end to form a palisade or vertical plank wall, with timbers set directly in the ground or into a sill (a horizontal beam).

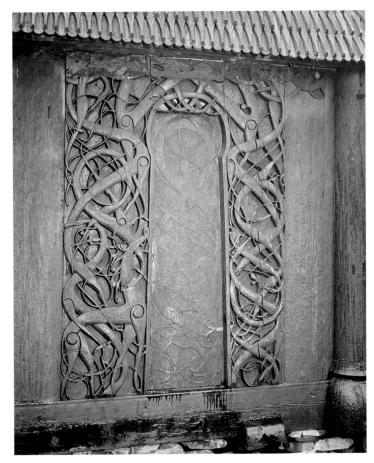

9-23 | PORTAL, SET INTO WALL OF LATER STAVE CHURCH Urnes, Norway. 11th century.

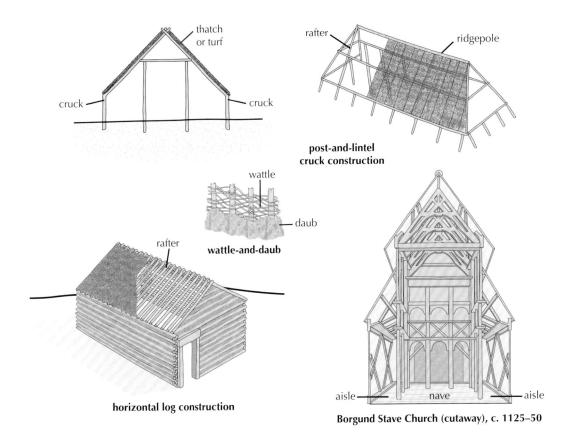

9–24 | DIAGRAMS OF WOOD BUILDINGS IN NORTHERN EUROPE
Horizontal log construction; wattle and daub used to plaster between timbers; stave church is a highly crafted version of plank wall construction.

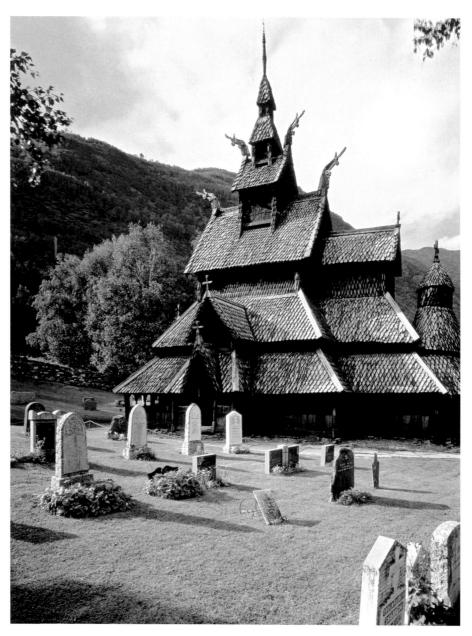

9-25 | stave church, borgund, norway c. 1125-50.

More modest buildings consisted of wooden frames filled with wattle-and-daub (woven branches covered with mud or other substances). Typical buildings had a turf or thatched roof supported on interior posts. The same basic structure was used for almost all building types—feasting and assembly halls, family homes (which were usually shared with domestic animals), workshops, barns, and sheds. The great hall had a central open hearth (smoke escaped through a louver in the roof) and an off-center door designed to reduce drafts. People secured their residences and trading centers by building massive circular earthworks topped with wooden palisades.

THE BORGUND STAVE CHURCH. Subject to decay and fire, early timber buildings have largely disappeared, leaving only post-

holes and other traces in the soil; however, a few timber churches survive in rural Norway. They are called stave churches, from the four huge timbers (staves) that form their structural core. Borgund Church, from about 1125–50 (FIG. 9–25), has four corner staves supporting the central roof, with additional interior posts that create the effect of a nave and side aisles, narthex, and choir. A rounded apse covered with a timber tower is attached to the choir. Upright planks slotted into the sills form the walls. A steep-roofed gallery rings the entire building, and steeply pitched roofs covered with wooden shingles protect the walls from the rain and snow. Openwork timber stages set on the roof ridge create a tower and give the church a steep pyramidal shape. On all the gables are both crosses and dragons to protect the church and its congregation from trolls and demons.

 $9-26 \pm 0$ otto I presenting magdeburg cathedral to Christ

One of a series of seventeen ivory plaques known as the *Magdeburg Ivories*, possibly carved in Milan c. 962-68. Ivory, $5\times4\%''$ (12.7 \times 11.4 cm). The Metropolitan Museum of Art, New York.

Bequest of George Blumenthal, 1941 (41.100.157)

The End of the Viking Era

The Vikings were not always victorious. Their colonies in Iceland and the Faeroe Islands survived, but in North America—in Canada—their trading posts eventually had to be abandoned. In Europe, south of the Baltic Sea, a new German dynasty challenged and then defeated the Vikings. During the eleventh century the Viking era came to an end.

OTTONIAN EUROPE

When Charlemagne's grandsons divided the empire in 843, Louis the German took the eastern portion. His family died out at the beginning of the tenth century, and a new Saxon dynasty came to power in lands corresponding roughly to present-day Germany and Austria. This dynasty was called Ottonian after its three principal rulers—Otto I (ruled 936–73), Otto II (ruled 973–83), and Otto III (ruled 994–1002; queens Adelaide and Theophanu had ruled as regents for him, 983–94). The Ottonian armies secured the territory by defeating the Vikings in the north and the Magyars (Hungarians) on the eastern frontier. Relative peace permitted increased trade and the growth of towns, making the tenth century a period of economic recovery. Then, in 951, Otto I gained control of northern Italy by marrying the wid-

962

owed Lombard Queen Adelaide. He was crowned emperor by the pope in 962, and so reestablished Charlemagne's Christian Roman Empire. The Ottonians and their successors so dominated the papacy and appointments to other high Church offices that in the twelfth century this union of Germany and Italy under a German ruler came to be known as the Holy Roman Empire. The empire survived in modified form as the Habsburg Empire into the twentieth century.

The Ottonian Empire was of necessity a military state. Aware of the threat of the pagan Slavs, in the 960s Otto established a buffer zone on the border with its headquarters in Magdeburg, the site of a frontier monastery. In 968 the pope made Magdeburg his administrative center in the region as well. Otto brought the relics of Saint Maurice from Burgundy, in France, to Magdeburg in 960. Saint Maurice, an African Christian commander in third century Gaul, was executed with all his troops for refusing to sacrifice to pagan Roman gods (as commander of the Theban Legion, Maurice was often represented as an African, SEE FIG. 11–37). The warrior saint became the patron of the Ottonian Empire.

THE MAGDEBURG IVORIES. The unity of church and state is represented on an ivory plaque, one of several that may once have been part of the decoration of an altar or pulpit presented to the cathedral at the time of its dedication in 968. Saint Maurice wraps his arm protectively around Otto I, who with solemn dignity presents a model of the cathedral to Christ and Saint Peter (FIG. 9–26). Hieratic scale demands that the mighty emperor be represented as a tiny, doll-like figure, and that the saints and angels, in turn, be taller than Otto but smaller than Christ. The cathedral Otto holds is a basilica with prominent clerestory windows and rounded apse that are intended to recall the churches of Rome.

Ottonian Architecture

The Ottonian rulers, in keeping with their imperial status, sought to replicate the splendors of the Christian architecture of Rome. German officials knew the basilicas well, since the German court in Rome was located near the Early Christian Church of Santa Sabina. The buildings of Byzantium were another important influence, especially after Otto II married a Byzantine princess, cementing a tie with the East. But while Ottonian patrons saw, envied, and ordered buildings to rival the sophisticated architecture of imperial Rome and Byzantium, the locally trained masons and carpenters could only struggle to comply. They built large timber-roofed basilicas that were terribly vulnerable to fire. Magdeburg Cathedral burned in 1008, only forty years after its dedication; it was rebuilt in 1049, burned in 1207, and rebuilt yet again. In 1009, the Cathedral of Mainz burned down on the day of its consecration. The Church of Saint Michael at Hildesheim was destroyed in World War II. Luckily the convent Church of Saint Cyriakus at Gernrode, Germany, still survives.

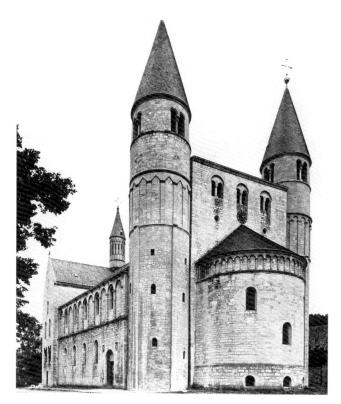

9–27 | CHURCH OF SAINT CYRIAKUS
Gernrode, Germany. Begun 961; consecrated 973.

The apse seen here replaced the original portal of the westwork in the late twelfth century.

THE CHURCH OF SAINT CYRIAKUS, GERNRODE. During the Ottonian Empire, aristocratic women often held positions of authority, especially as the leaders of religious communities. When in 961 the provincial military governor Gero founded the convent and church of Saint Cyriakus, he made his widowed daughter-in-law the convent's first abbess. The church was designed as a basilica with a westwork, an architectural feature that took on greater importance with the increasing elaboration of the liturgy (FIG. 9-27). At Gernrode, the exterior appearance of the westwork was changed in the late twelfth century by the addition of an apse, although the two tall cylindrical towers continue to dominate the skyline. At the eastern end of the church a transept with chapels led to a choir with an apse built over a crypt. This development at both the east and west ends of the nave gave the building the & "double-ended" look characteristic of major Ottonian churches. The nuns entered the church from the convent through modest side doors. Pilasters, joined by arches attached to the wall, form blind arcades, and windows also break the severity of the church's exterior.

The interior of Saint Cyriakus (FIG. 9–28) has three levels: an arcade separating the nave from the side aisles, a gallery with groups of six arched openings, and a clerestory. The flat ceiling is made of wood and must have been painted. Galleries over aisles were used in Byzantine architecture but rarely in the West, and their function in Ottonian architecture is uncertain.

Sequencing Events THE TENTH CENTURY-THE STATE OF CHRISTIANITY IN EUROPE	
910	William, Duke of Aquitaine, and his wife, Ingelborga, seeking reform in Western monasticism, give the Benedictine Order the town and manor of Cluny
911	The Viking Rolf accepts Christianity and becomes Rollo, Duke of Normandy
912-61	Muslim ruler Abd-al-Rahman, Caliph of Cordoba, pushes back Christians in northern Spain
960	Harald Bluetooth, king of Denmark and Norway, accepts Christianity
962	Supremacy of church over state proclaimed when Christian king Otto I of Germany is crowned emperor by the pope in Rome
988	Grand Prince Vladimir in Kiev, Ukraine, accepts Orthodox Christianity

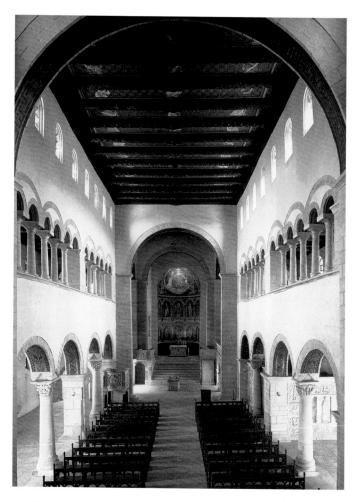

9-28 | NAVE, CHURCH OF SAINT CYRIAKUS

THE OBJECT SPEAKS

THE DOORS OF BISHOP BERNWARD

he design of the magnificent doors at Bishop Bernward's abbey church in Hildesheim, Germany, anticipated by centuries the great sculptural programs that would decorate the exteriors of European churches in the Romanesque period. The awesome monumentality of the towering doorsnearly triple a person's height-is matched by the intellectual content of their iconography. The doors spoke eloquently to the viewers of the day and still speak to us through a combination of straightforward narrative history and subtle interrelationships, in which Old Testament themes, on the left, illuminate New Testament events, on the right. Bernward must have designed the iconographical program himself, for only a scholar thoroughly familiar with Christian theology could have conceived it.

The Old Testament history begins in the upper lefthand panel with the Creation and continues downward to depict Adam and Eve's Expulsion from Paradise, their difficult and sorrowful life on earth, and, in the bottom panel, the tragic fratricidal story of their sons, Cain and Abel. The New Testament follows, beginning with the Annunciation at the lower right and reading upward through the early life of Jesus and his mother, Mary, through the Crucifixion to the Resurrection, symbolized by the three Marys at the tomb.

The way the Old Testament prefigured the New in scenes paired across the doors is well illustrated, for example, by the third set of panels, counting down from the top. On the left, we see the Temptation and Fall of Adam and Eve in the Garden of Eden, believed to be the source of human sin, suffering, and death. This panel is paired on the right with the Crucifixion of lesus, whose suffering and sacrifice redeemed humankind, atoned for Adam and Eve's Original Sin, and brought the promise of eternal life. Another example is the recurring pairing of the "two Eves": Eve, who caused humanity's Fall and Expulsion from Paradise and whose son Cain committed the first murder; and Mary, the "new Eve," through whose son, Jesus, salvation will be granted. In one of the clearest juxtapositions, in the sixth pair down, Eve and Mary are almost identical figures, each holding her first-born son; thus, Cain and Jesus (evil and goodness) are also paired.

My John M. M.

DOORS OF BISHOP BERNWARD Made for the Abbey Church of Saint Michael, Hildesheim, Germany. 1015. Bronze, height 16'6" (5 m).

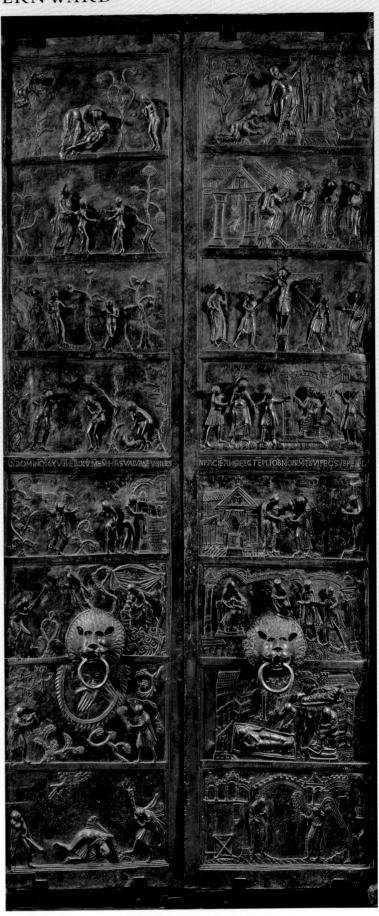

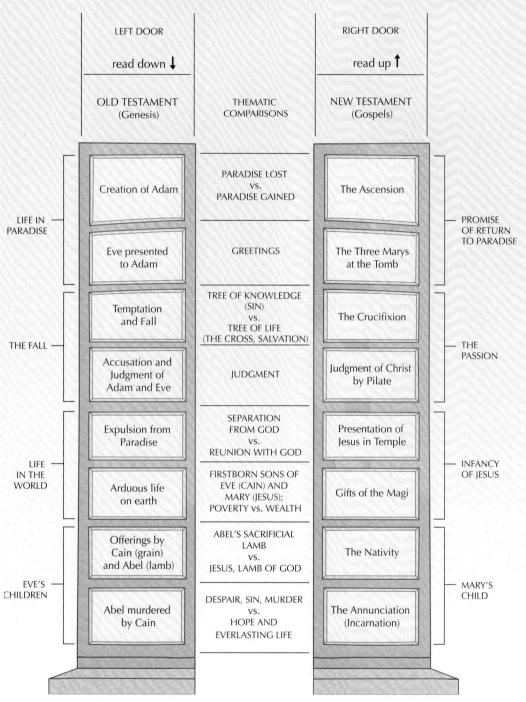

SCHEMATIC DIAGRAM OF THE MESSAGE OF THE DOORS OF BISHOP BERNWARD OF HILDESHEIM

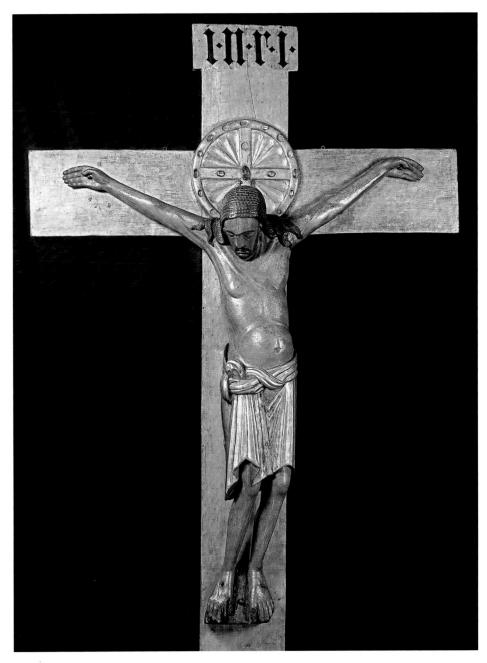

9–29 \dagger GERO CRUCIFIX Cologne Cathedral, Germany. c. 970. Painted and gilded wood, height of figure 6'2" (1.88 m).

This life-size sculpture is both a crucifix to be suspended over an altar and a special kind of reliquary. A cavity in the back of the head was made to hold a piece of the Host, or communion bread, already consecrated by the priest. Consequently, the figure not only represents the body of the dying Jesus but also contains within it the body of Christ obtained through the Eucharist.

They may have provided space for choirs as music became more elaborate in the tenth century. They may have held additional altars. They may have been simply a mark of status.

The alternation of columns and rectangular piers in Saint Cyriakus creates a rhythmic effect more interesting than that of the uniform colonnades of the Early Christian churches. Saint Cyriakus is also marked by vertical shifts in visual rhythm, with two arches on the nave level surmounted by six arches on the gallery level, surmounted in turn by three windows in the clerestory. This seemingly simple archi-

tectural aesthetic, with its rhythmic alternation of heavy and light supports, its balance of rectangular and round forms, and its combination of horizontal and vertical movement found full expression later in the Romanesque period.

Ottonian Sculpture

Ottonian artists worked in ivory, bronze, wood, and other materials rather than stone. Like their Early Christian and Byzantine predecessors, they and their patrons focused on church furnishings and portable art rather than architectural sculpture. Drawing on Roman, Early Christian, Byzantine, and Carolingian models, they created large sculpture in wood and bronze that would have a significant influence on later medieval art.

The Gero Crucifix. The Gero crucifix is one of the few large works of carved wood to survive from the early Middle Ages (FIG. 9–29). Archbishop Gero of Cologne (ruled 969–76) commissioned the sculpture for his cathedral about 970. The figure of Christ is more than 6 feet tall and is made of painted and gilded oak. The focus here, following Byzantine models, is on Jesus's suffering. He is shown as a tortured martyr, not as the triumphant hero of the *Lindau Gospels* cover (SEE FIG. 9–19). Jesus's broken body sags on the cross and his head falls forward, eyes closed. The straight, linear fall of his golden drapery heightens the impact of his drawn face, emaciated arms and legs, sagging torso, and limp, bloodied hands. In this image of distilled anguish, the miracle and triumph of the Resurrection seem distant indeed.

THE HILDESHEIM BRONZES. Under the last of the Ottonian rulers, Henry II and Queen Kunigunde (ruled 1002–24), an important artist and patron was Bishop Bernward of Hildesheim. His biographer, the monk Thangmar, described Bernward as a skillful goldsmith who closely supervised the artisans working for him. Bronze doors made under his direction for the Abbey Church of Saint Michael in Hildesheim represented the most ambitious and complex bronze-casting project undertaken since antiquity (see "The Doors of Bishop Bernward," page 336). As tutor for Otto III, the bishop had lived in Rome, where he would have seen the carved wooden doors of the fifth-century Church of Santa Sabina, located near Otto's palace.

The doors' rectangular panels recall not only Santa Sabina (SEE FIG. 7–14) but also resemble the framed miniatures in Carolingian Gospel books. The style of the sculpture is reminiscent of illustrations in manuscripts such as the *Utrecht Psalter*. Animated small figures populate spacious backgrounds. Architectural elements and features of the landscape are depicted in very low relief, forming little more than a shadowy stage for the actors in each scene. The figures stand out prominently, in varying degrees of relief, with their heads fully modeled in three dimensions. The result is lively, visually stimulating, and remarkably spontaneous for so monumental an undertaking.

Illustrated Books

Book illustration in the Ottonian period is not as varied as it is in Carolingian manuscripts, although artists continued to work in widely scattered centers, using different models or sources of inspiration. The **LIUTHAR** (or **AACHEN**) **GOSPELS** (named for the scribe or patron) were made for Otto III around 996 in a monastic *scriptorium* near Reichenau. The dedication page (FIG. 9–30) is a work of imperial propaganda

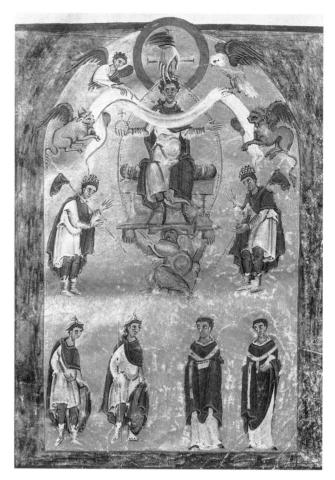

9-30 | PAGE WITH OTTO III ENTHRONED, LIUTHAR GOSPELS (AACHEN GOSPELS)

c. 996. Ink, gold, and colors on vellum, $10\% \times 8\%$ (27.9 \times 21.8 cm). Cathedral Treasury, Aachen.

meant to establish the divine underpinnings of Otto's authority and depicts him as a near-divine being himself. He is shown enthroned in heaven, surrounded by a mandorla and symbols of the evangelists. The hand of God descends from above to place a crown on his head, and Otto holds the Orb of the World surmounted by a cross in his right hand. His throne, in a symbol of his worldly dominion, rests on the crouching Tellus, the personification of earth. In what may be a reference to the dedication on the facing page—"With this book, Otto Augustus, may God invest thy heart"—the evangelists represented by their symbols hold a white banner across the emperor's breast. On each side of Otto, male figures bow their crowned heads as subordinate rulers acknowledging his sovereignty. The bannered lances they hold may allude to the Ottonians' most precious relic, the Holy Lance, believed to be the one with which the Roman soldier Longinus pierced Jesus's side. In the lower register, two warriors face two bishops, symbolizing the union of secular and religious power under the emperor.

A second Gospel book made for Otto III in the same scriptorium illustrates the painters' narrative skill. In an episode

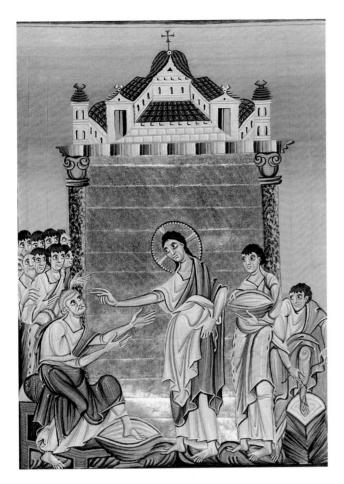

9-31 Page with Christ Washing the feet of his disciples, aachen gospels of otto III.

c. 1000. Ink, gold, and colors on vellum, approx. $8\times6''$ (20.5 \times 14.5 cm). Staatsbibliothek, Munich. Nr. 15131, Clm 4453, fol 237r.

recounted in Chapter 13 of the Gospel according to John, Jesus, on the night before his Crucifixion, gathered his disciples together to wash their feet (FIG. 9–31). Peter, who felt unworthy, at first protested. The painting shows a towering Jesus in the center extending an elongated arm and hand in blessing toward the elderly apostle. Peter, his foot in a basin of water, reaches toward Jesus with similarly elongated arms. The two figures fix each other with wide-eyed stares. Gesture and gaze carry the meaning in Ottonian painting: A disciple on the far right unbinds his sandals, and another, next to him, carries a basin of water while the other disciples look on. The light behind Jesus has turned to gold, which is set off by buildings suggesting the Heavenly Jerusalem. The painter conveys a sense of spirituality and contained but deeply felt emotion, as well as the austere grandeur of the Ottonian court.

These manuscript paintings summarize the high intellectual and artistic qualities of Ottonian art. Ottonian artists drew inspiration from the past to create a monumental style for a Christian, German-Roman empire. From the groundwork laid during the early medieval period emerged the arts of the Romanesque and Gothic periods in Western Europe.

IN PERSPECTIVE

People living outside the Roman Empire had a heritage of both imaginative abstract art and well-observed animal images. They also had an exceptionally high level of technical skill in the crafts, especially metalwork, and in wooden architecture and sculpture. The Celts, Norse, Goths, and Saxons sought to capture the essence of forms in dynamic, colorful, linear art. From astonishingly complex geometric patterns and interlaces they created imaginary creatures. They loved light and color in the form of gold and jewels. As exchanges of intellectual and artistic influences took place among the diverse groups that populated Europe, an extraordinary amalgam of ancient classical forms and Celtic and Germanic styles took place. The new narrative and figurative art that emerged was also richly decorative and expressive.

As the Western Roman Empire disintegrated, the Christian Church assumed an ever greater social as well as spiritual role. Although the Roman Empire itself was no longer a vital entity, the idea of imperial Rome—both as a secular empire and as the headquarters of the Christian Church—remained strong in people's minds. Twice, charismatic leaders gathered disparate factions together into short-lived but powerful empires—the Carolingians at the end of the eighth and beginning of the ninth centuries, and the Ottonians in the tenth century. The pope in Rome emerged as the supreme leader of the Church, and the Germanic rulers reinforced their power by supporting Rome.

Carolingian artists following ancient models brought together the classical perception of human forms, of weight and mass, with the highly developed decorative sensibility and impeccable craftsmanship of Hiberno-Saxon artisans. The arts provided a splendid and symbolic setting for the Carolingian monarchs and served to advance their imperial ambitions. This flowering of art and scholarship as well as the Christian mission came to a halt during the devastating raids of Viking adventurers. The Vikings had their own cultural and artistic traditions, dating back to their Norse ancestors. Theirs was an animal art very different from the imperial and humanistic Mediterranean arts.

Otto the Great defeated the Vikings and created a new Germanic empire in Germany and Italy. Artists served both the empire and the revitalized Church where spiritual values were considered to be superior to the material world. They created a monumental art, with images of overwhelming solemnity. Their work has a directness that often hides complex meanings. Conservative in their reference to Early Christian, Byzantine, and Carolingian art and innovative in their subordination of earlier northern styles to the new imperial ideal, Ottonian artists reaffirmed the value of art and architecture to carry powerful secular and religious messages. As they brought monumentality, dignity, and grandeur to the art of the West, they paved the way for the mature Christian art in Western Europe.

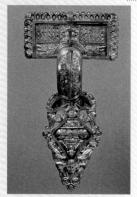

GUMMERSMARK BROOCH
6TH CENTURY

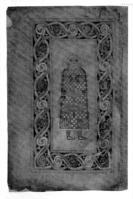

GOSPEL BOOK OF DURROW,
PAGE WITH MAN
SECOND HALF 7TH CENTURY

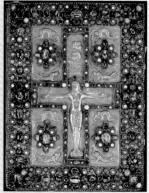

LINDAU GOSPEL COVER C. 870-80

BATTLE OF BIRD AND SERPENT,
BEATUS'S COMMENTARY

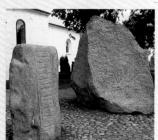

ROYAL RUNE STONE, JELLING C. 980

EARLY MEDIEVAL ART IN EUROPE

■ Rule of St. Benedict c. 530 CE

600

■ Lombards in Italy c. 568-774 CE

▼ Visigoths in Spain Adopt Western Christianity c. 589 CE

■ St. Augustine in England 597 CE

664 Syrod of Whitby

Muslims Conquer Spain 711 CE

■ Carolingian Empire c. 768-887 CE

■ Viking Raids Begin 793 CE

 Charlemagne Crowned Emperor by the Pope in Rome 800 CE

■ Cluny Founded 910 CE

■ Ottonian Empire c. 919-1024 CE

▼ Viking Settlement in North
America 1000 CE

1100

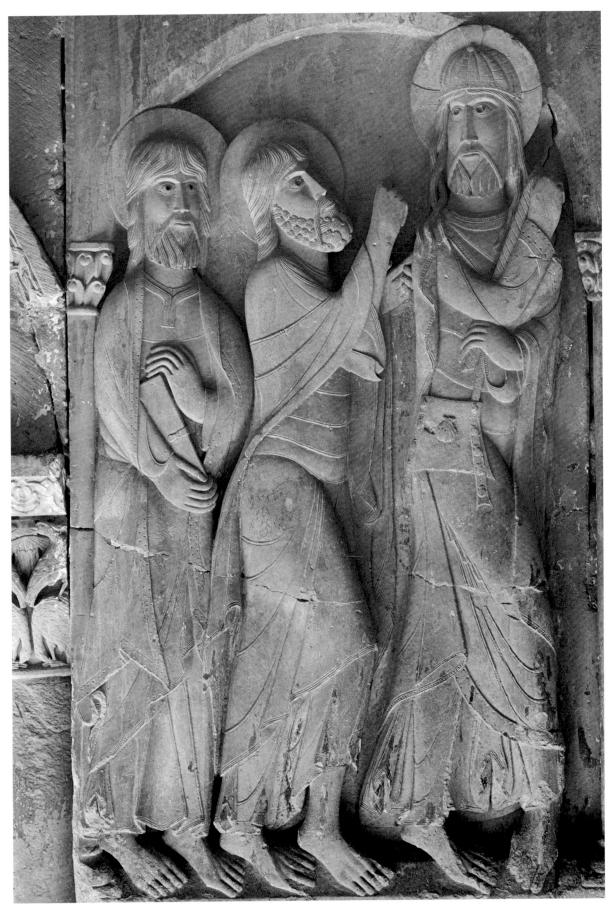

IO—I | CHRIST AND DISCIPLES ON THE ROAD TO EMMAUS | Cloister of the Abbey of Santo Domingo, Silos, Castile, Spain. Pier relief, figures nearly life-size. c. 1100.

CHAPTER TEN

ROMANESQUE ART

Three men, together under an arch supported by slender columns, seem to glide forward on tip-toe (FIG. 10–1). The leader turns back, reversing their forward movement. The men's bodies seem almost boneless, their legs cross in slow curves

rather than vigorous strides; their shoulders, elbows, and finger joints seem to melt; draperies are reduced to delicate curving lines. Framed by haloes, three bearded faces—foreheads covered by locks of hair—stare out with large wide eyes under strong arched brows. The figures interrelate and interlock without exceeding the limits of the controlling architecture.

Captivated by tranquility, the viewer only gradually realizes that this panel is more than mere decoration. The leader is identified as Christ by his large size and cruciform halo. He wears a ribbed cap and carries a satchel and a short staff. The scene depicts Christ and two disciples on the road from Jerusalem to the village of Emmaus (Luke 24: 13–35). Christ has the distinctive attributes of a pilgrim—a hat, a satchel, and a walking stick. A final surprise rewards a close examination—a scallop shell on Christ's satchel. The scallop shell is the badge worn by the pilgrims to the shrine of Saint James in Santiago de Compostela, Spain. Early pilgrims reaching this destination in the far northwestern corner of the Iberian Peninsula continued to the coast to pick up a shell as evidence of their journey. Soon shells were gathered (or made from metal as brooches) and sold to the

10

pilgrims by authorized persons—a lucrative business for both the sellers and the church. On the return home the shell became the pilgrim's passport.

The Road to Emmaus was carved on a cor-

ner pier in the cloister of the monastery of Santo Domingo de Silos, south of the pilgrimage road across Spain (see "The Pilgrim's Journey," page 350). Santo Domingo was the eleventh century abbot of Silos. The monastery had a flourishing *scriptorium* and metal smithing shops where artists as well as sculptors worked in a Mozarabic style.

The sculpture at Silos is filled with the spirit of the Romanesque. The art is essentially figurative, narrative, and didactic; it is based on Christian story and belief. It develops out of a combination of styles, not only ancient Roman art as the name might suggest. The sculpture is shaped by a new awakening. Pilgrimages to visit the scenes of Christ's life and the tombs of martyrs (those who died for their faith) inspired not only architecture and the arts. The conflict between Christians and Muslims—and the ensuing Christian Crusades to win back conquered territories and gain access to sacred places like Jerusalem—taught more than military tactics. Travel as a Crusader or a pilgrim opened the mind to a world beyond the familiar towns and agricultural villages of home. The distinctive style of the Romanesque signifies a new era in the social and economic life of Europe, an awakening of intellectual exploration.

- EUROPE IN THE ROMANESQUE PERIOD | Political and Economic Life | The Church | Intellectual Life
- ROMANESQUE ART
- **ARCHITECTURE** | The Early Romanesque Style: The "First Romanesque" | The "Pilgrimage Church" | The Monastery of Cluny in Burgundy | The Cistercians | Regional Styles in Romanesque Architecture | Secular Architecture: Dover Castle, England
- THE DECORATION OF BUILDINGS | Architectural Sculpture | Mosaics and Murals
- THE CLOISTER CRAFTS | Portable Sculpture | Metalwork | Illustrated Books
- **IN PERSPECTIVE**

EUROPE IN THE ROMANESQUE PERIOD

At the beginning of the eleventh century, Europe was still divided into many small political and economic units ruled by powerful families, such as the Ottonians in Germany (Chapter 9). The nations we know today did not exist, although for convenience we will use present-day names of countries. The king of France ruled only a small area around Paris known as the Ile-de-France. The southern part of modern France had close linguistic and cultural ties to northern Spain; in the north the Duke of Normandy (heir of the Vikings) and in the east the Duke of Burgundy paid the French king only token homage.

When in 1066 Duke William II of Normandy (ruled 1035–87) invaded England and, as William the Conqueror, became that country's new king, Norman nobles replaced the Anglo-Saxon nobility there, and England became politically and culturally allied with Normandy in France. As astute and skillful administrators, the Normans formed a close alliance with the Church, supporting it with grants of land and gaining in return the allegiance of abbots and bishops. Normandy became one of Europe's most powerful feudal domains.

In the eleventh century, the Holy Roman Empire (formerly the Ottonian empire), which encompassed much of Germany and northern Italy (Lombardy), became embroiled in a conflict with the papacy. In 1075, Pope Gregory VII (papacy 1073–85) declared that only the pope could appoint bishops and abbots; the emperor demanded the right for himself. Not only nobles, but cities took sides. In the power struggle between the Holy Roman emperor and the pope, the pope emerged victorious. The conflict persisted in the wars between the great German families, the Welfs of Saxony (known in Italy as the Guelfs), who supported the pope, and the Hohenstaufens of Swabia (or, in Italy, the Ghibellines), who backed the emperor.

Meanwhile, the Iberian Peninsula remained divided between Muslim rulers in the south and Christian rulers in the north. The power of the Christian rulers grew as they joined forces through marriage and inheritance and fought to extend their territory southward. By 1085, Alfonso VI of Castile and León (ruled 1065–1109) had conquered the Muslim stronghold of Toledo, a center of Islamic and Jewish culture in the kingdom of Castile. By this victory he acquired treasures, vast territories, and a skilled work force of Christians, Muslims, and Jews. Catalunya (Catalonia) emerged as a power along the Mediterranean coast.

By the end of the twelfth century, however, a few exceptionally intelligent and aggressive rulers began to create national states. The Capetians in France and the Plantagenets in England were especially successful. In Germany and northern Italy the power of local rulers and towns prevailed, and Germany and Italy remained politically fragmented until the nineteenth century.

Political and Economic Life

Although towns and cities with artisans and merchants gained importance, Europe remained an agricultural society, with land the primary source of wealth and power for a hereditary aristocracy. *Feudalism*, a system of mutual obligation and exchange of land for services that had developed in the early Middle Ages, governed social and political relations, especially in France and England. A landowning lord granted property and protection to a subordinate, called a vassal. In return, the vassal pledged allegiance and military service to the lord.

The economic foundation for this political structure was the manor, a self-sufficient agricultural estate where peasants worked the land in exchange for a place to live, military protection, and other services from the lord. Economic and political power depended on a network of largely inherited but constantly shifting allegiances and obligations among lords, vassals, and peasants.

THE WORCESTER CHRONICLE. The social and economic classes become vividly clear in the WORCESTER CHRONICLE, which depicts the three classes of medieval society: the king and nobles, the churchmen, and the peasant farmers (FIG. 10–2). The book is the earliest known illustrated record of contemporary events in England and was written by John, a monk of Worcester. He described the nightmares of King

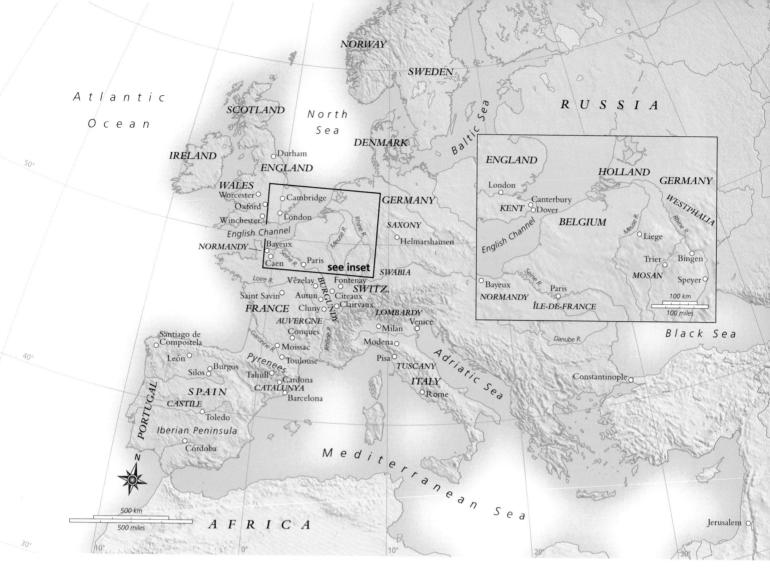

MAP IO-I | EUROPE IN THE ROMANESQUE PERIOD

Although a few large political entities began to emerge in places like England and Normandy, Burgundy, and Leon-Castile, Europe remained a land of small economic entities. Pilgrimages and crusades acted as unifying international forces. Modern names of countries have been added for convenience.

Henry I (ruled 1100–35) in 1130 in which the people demanded tax relief. On the first night, angry farmers, still carrying their shovels, forks, and scythes, hold up their list of grievances; in the second dream, armed knights confront the king; and then on the third night, monks, abbots, and bishops challenge the sleeping king, who is observed by the royal physician Grimbald. Finally, the king is caught in a storm at sea and saves himself by promising to lower taxes for a period of seven years. Speech is indicated by pointing a finger; sleep, by propping the head on a hand or arm; and royal status, by the crown worn by the sleeping king. Since the goal of the artist was to communicate clearly, not to decorate the text, the illustrations give an excellent idea of the appearance of the people.

The Church

In the early Middle Ages, church and state had forged an often fruitful alliance. Christian rulers helped insure the spread of Christianity throughout Europe and supported monastic communities with grants of land. Bishops and abbots were often their relatives, younger brothers and cousins, who pro-

vided rulers with crucial social and spiritual support and supplied them with educated administrators. As a result, secular and religious authority became tightly intertwined.

PILGRIMAGES. Reinforcing the importance of religion were two phenomena of the period: pilgrimages and the Crusades. Pilgrimages to the holy places of Christendom—Jerusalem, Rome, and Santiago de Compostela—increased, despite the great financial and physical hardships they entailed (see "The Pilgrim's Journey," page 350). As difficult and dangerous as these journeys were, rewards awaited courageous travelers along the routes. Pilgrims could stop to venerate the relics of local saints and visit the places where miracles were believed to have taken place. They also learned about people and places far removed from their isolated village life.

CRUSADES. In the eleventh and twelfth centuries, Christian Europe, previously on the defensive against the expanding forces of Islam, became the aggressor. In Spain, Christian armies of the north were increasingly successful against the

England. c. 1140. Ink and tempera on vellum, each page $12\% \times 9\%$ " (32.5 \times 23.7 cm). Corpus Christi College, Oxford. CCC MS 157, pages 382-83

Islamic south. At the same time, despite the schism within the Church (SEE Chapter 7), the Byzantine emperor asked the pope for help in his war with the Muslims. The Western Church responded in 1095 by launching a series of military expeditions against Islamic powers known as the Crusades. The word *crusade* (from "crux") refers to the cross worn by Crusaders and pilgrims.

This First Crusade was preached by Pope Urban II (a Cluniac monk and pope from 1088 to 1099) and supported by the lesser nobility of France, who had economic and political as well as spiritual goals. The Crusaders captured Jerusalem in 1099 and established a short-lived kingdom. The Second Crusade in 1147, preached by Saint Bernard and led by France and Germany, accomplished nothing. The Muslim leader Saladin united the Muslim forces and captured Jerusalem in 1187, inspiring the Third Crusade, led by German, French, and English kings. (This is the period of Richard Lionheart and Robin Hood.) The Christians recaptured some territory, but not Jerusalem, and in 1192 they concluded a truce with the Muslims, permitting the Christians access to the shrines in Jerusalem. Crusades continued to be mounted against non-Christians and foes of the papacy. Today the word crusade still implies zealous devotion to a cause.

The crusading movement had far-reaching cultural and economic consequences. The Westerners' direct encounters with the more sophisticated material culture of the Islamic world and the Byzantine Empire created a demand for goods from the East. This in turn helped stimulate trade and with it an increasingly urban society during the eleventh and twelfth centuries.

Intellectual Life

The eleventh and twelfth centuries were a time of intellectual ferment as Western scholars rediscovered the classical Greek and Roman texts that had been preserved in Islamic Spain and the eastern Mediterranean. The first universities were established in the growing cities—Bologna (eleventh century) and Paris, Oxford, and Cambridge (twelfth century). Monastic communities continued to play a major role in the intellectual life of Romanesque Europe. Monks and nuns also provided valuable social services, including caring for the sick and destitute, housing travelers, and educating the people. Because monasteries were major landholders, abbots and priors were part of the feudal power structure. The children of aristocratic families who joined religious orders also helped forge links between monastic communi-

Art and Its Context

SAINT BERNARD AND THEOPHILUS: OPPOSING VIEWS ON THE ART OF THEIR TIME

n a letter to William of Saint-Thierry, Bernard of Clairvaux wrote,

But in the cloister, under the eyes of the Brethren who read there, what profit is there in those ridiculous monsters, in that marvellous and deformed comeliness, that comely deformity? To what purpose are those unclean apes, those fierce lions, those monstrous centaurs, those half-men, those striped tigers, those fighting knights, those hunters winding their horns? Many bodies are there seen under one head, or again many heads to a single body. Here is a four-footed beast with a serpent's tail; there, a fish with a beast's head. Here again the forepart of a horse trails half a goat behind it, or a horned beast bears the hinder quarters of a horse. In short, so many and so marvellous are the varieties of divers shapes on every hand, that we are more tempted to read in the marble than in our books, and to spend the whole day in wondering at these things rather than in meditating the law of God. For God's sake, if men are not ashamed of these follies, why at least do they not shrink from the expense?

(from Caecilia Davis-Weyer. Early Medieval Art 300-1150: Sources and Documents. New Jersey: Prentice-Hall, 1971, p. 170.)

"Theophilus" is the pseudonym used by a monk who wrote an artist's handbook, On Divers Arts, about 1100. The book gives detailed instructions for painting, glassmaking, and goldsmithing. In contrast to the stern warnings of Abbot Bernard, "Theophilus" assured artists that "God delights in embellishments" and that artists worked "under the direction and authority of the Holy Spirit."

He wrote

most beloved son, you should not doubt but should believe in full faith that the Spirit of God has filled your heart when you have embellished His house with such great beauty and variety of workmanship . . . Set a limit with pious consideration on what the work is to be, and for whom, as well as on the time, the amount, and the quality of work, and, lest the vice of greed or cupidity should steal in, on the amount of the recompense.

(Theophilus, page 43).

ties and the ruling elite. The dominant order had been the Benedictines, but as life in Benedictine communities grew increasingly comfortable, reform movements arose. Reformers claimed to return to the original austerity and spirituality of earlier times. The most important for the arts was the congregation of Cluny founded in the tenth century in Burgundy (in eastern-central France) and the Cistercians in the eleventh century.

ROMANESQUE ART

The word *Romanesque* means "in the Roman manner," and the term applies specifically to eleventh- and twelfth-century European architecture and art. The word was coined in the early nineteenth century to describe European church architecture, which often displayed the solid masonry walls and the rounded arches and vaults characteristic of imperial Roman buildings. Soon the term was applied to all the arts of the period from roughly the mid-eleventh to the late-twelfth century, even though the art reflects influences from many sources, including Byzantine, Islamic, and early medieval European art.

The eleventh and twelfth centuries were a period of great building activity in Europe. Castles, manor houses, churches, and monasteries arose everywhere. As one eleventh-century monk noted, "Each people of Christendom rivaled with the other, to see which should worship in the finest buildings. The world shook herself, clothed everywhere in a white garment of churches" (Radulphus Glaber, cited in Holt, A Documentary History of Art, vol. I, page 18). Increased prosperity in spite of frequent domestic warfare made the resources available to build monumental stone architecture. The desire to glorify the house of the Lord and his saints (whose earthly remains in the form of relics kept their presence alive in the minds of the people) increased throughout Christendom.

Both inside the church and outside, especially around the entrance, sculpture and paintings illustrated important religious themes; they served to instruct as well as fascinate the faithful. These awe-inspiring works of art and architecture had a Christian message and purpose. One monk wrote that by decorating the church "well and gracefully" the artist showed "the beholders something of the likeness of the paradise of God" (Theophilus, page 79). (See "Bernard and Theophilus," above.)

10–3 | interior, church of sant vincenc, cardona 1020s–30s.

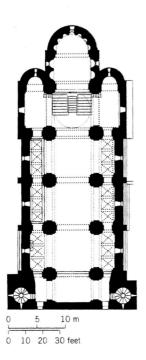

10-4 | plan of church of sant vincenc, cardona 1020s-30s.

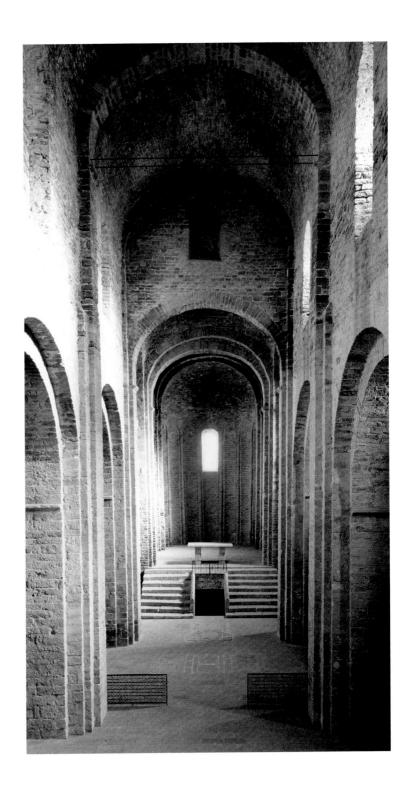

ARCHITECTURE

Romanesque architecture and art are regional phenomena. Romanesque churches were the result of master builders solving the problems associated with each individual project with the resources at hand: its site, its purpose, the building materials, the work force available, the builders' own knowledge and experience, and the wishes of the patrons who provided the funding. The process of building could be slow, often requiring several different masters and teams of masons over the years.

In general, the basic form of the Romanesque church, like that of Carolingian churches, follows the plan arrived at by the

builders of the early Christian basilicas; however, Romanesque builders made several key changes. They added apses or wide projecting transepts, creating complex sanctuaries. A variety of arrangements of ambulatories (walkways) and chapels accommodated the many altars and the crowds of worshipers. Although wooden roofs were still in widespread use, many builders adopted the stone masonry developed by Lombard and Catalan builders. Masonry vaults enhanced the acoustical properties of the building and the effect of the Gregorian chant (plainsong, named after Pope Gregory, papacy 590–604). Masonry also provided some protection against fire, a constant danger from candlelit altars and torchlight processions.

Tall towers marked the church as the most important building in the community. The two-towered west façade, derived in part from traditional fortified gateways, became not only the entrance into the church but also, by extension, the gateway to Paradise.

The Early Romanesque Style: The "First Romanesque"

By the year 1000—by which time the pope had crowned Otto III (page 334) and Radulphus Glaber commented on the rise of church building across the land—patrons and builders in Catalunya (Catalonia) in northeast Spain, southern France, and northern Italy were constructing masonry churches. Based on methods used by late Roman (SEE FIG. 6–71, Trier) and Early Christian (SEE FIG. 7–29, Ravenna) builders, the Catalan and Lombard masons developed a distinctive early Romanesque style. Many buildings still survive in Catalunya where the authorities had introduced the Benedictine Order into their territory.

THE CHURCH OF SANT VINCENC, CARDONA. One of the finest examples of these masonry buildings is the church of Sant Vincenc (Saint Vincent) in the castle of Cardona on the Catalan side of the Pyrenees Mountains (FIGS. 10-3, 10-4). Begun in the 1020s, it was consecrated in 1040. Castle residents entered the church through a two-story narrhex into a nave with low narrow side aisles that permitted windows in the nave wall. The transept had two apses and a low crossing tower that emphasized the importance of the choir, large apse, and altar. The sanctuary was raised dramatically over an aisled crypt. The different sizes of the apses, caused by the difference in the widths of the nave and the narrower side aisles, created a stepped outline that came to be called the Benedictine plan. The masons hoped to build practical, sturdy, fireproof walls and vaults. Catalan and Lombard masons used local materials—small split stones, bricks, even river pebbles, and very strong mortar-to raise plain walls and round barrel vaults or groin vaults. Today we can admire their skillful stone work both inside and out, but the builders originally covered their masonry with stucco.

To strengthen the walls and vaults the masons added bands of masonry (called strip buttresses) joined by arches and additional courses of masonry (arched corbel tables) to counter the outward thrust of the vault and to enliven the wall. Late Roman and Early Christian builders had used these techniques, but the eleventh century masons went further. They turned strip buttresses and arched corbel tables into a regular decorative system. On the interior they added masonry strips to the piers and continued these bands across the vault (a transverse arch). They added bands on the underside of the arches of the nave arcade as well. The result was a simple compound pier. The compound piers and transverse

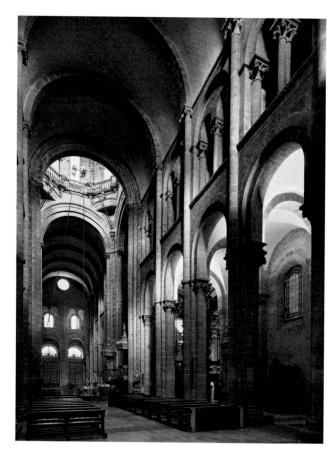

10–5 | TRANSEPT, CATHEDRAL OF SAINT JAMES, SANTIAGO DE COMPOSTELA
Galicia, Spain. View toward the crossing, 1078–1122.

arches dividing the nave into a series of bays that clarify and define the space became an essential element in Romanesque architecture.

The "Pilgrimage Church"

The growth of a cult of relics and the desire to visit shrines such as Saint Peter's in Rome or Saint James in Spain inspired people to travel on pilgrimages (see "The Pilgrim's Journey," page 350). Christian victories against Muslims also opened roads and encouraged travel. To accommodate the faithful and instruct them in Church doctrine, many monasteries on the major pilgrimage routes built large new churches and filled them with sumptuous altars and reliquaries.

THE CATHEDRAL OF SAINT JAMES IN SANTIAGO DE COMPOSTELA. One major goal of pilgrimage was the Cathedral of Saint James in Santiago de Compostela (FIG. 10–5), which held the body of Saint James, the apostle to the Iberian Peninsula. Builders of the Cathedral of St. James and other major churches along the roads leading through France to the shrine developed a distinctive church plan designed to accommodate the crowds of pilgrims and give them easy access to the relics (see "Relics and Reliquaries," page 354).

Art and Its Context

THE PILGRIM'S JOURNEY

estern Europe in the eleventh and twelfth centuries saw an explosive growth in the popularity of religious pilgrimages. The rough roads that led to the most popular destinations—the tomb of Saint Peter and the Constantinian churches of Rome, the Church of the Holy Sepulchre in Jerusalem, and the Cathedral of Saint James in Santiago de Compostela in the northwest corner of Spain—were often

Durham ENGLAND **Bury St Edmunds** Hildesheim Canterbury -Helmarshausen NORMANDY Cologne FRANCE Bingen Danube •St. Denis Paris Vézelay •Fontenay St. Savin •Autun •Cluny BURGU HOLY Limoges **ROMAN EMPIRE** Conques -- Le Puy Santiago de Compostela Milan St. Gilles-du-Gard -la-Reina Burgos León Tahull • Silos Rome CORSICA SPAIN SARDINIA Monreale Palermo SICILY **AFRICA**

crowded with pilgrims. Their journeys could last a year or more; church officials going to Compostela were given sixteen weeks' leave of absence. Along the way the pilgrims had to contend with bad food and poisoned water, as well as bandits and dishonest innkeepers and merchants.

The stars of the Milky Way, it was said, marked the road to Santiago de Compostela (SEE FIGS. 10-5, 10-6). Still, a guide-

book helped, and in the twelfth century the priest Aymery Picaud wrote one for pilgrims on their way to the great shrine through what is now France. Like travel guides today, Picaud's book provided advice on local customs, comments on food and the safety of drinking water, and a list of useful words in the Basque language. In Picaud's time, four main pilgrimage routes crossed France, merging into a single road in Spain at Puente la Reina and leading on from there through Burgos and León to Compostela. Conveniently spaced monasteries and churches offered food and lodging. Roads and bridges were maintained by a guild of bridge builders and guarded by the Knights of Santiago.

Picaud described the best-traveled routes and most important shrines to visit along the way. Chartres, for example, housed the tunic that the Virgin was said to have worn when she gave birth to Jesus. The monks of Vézelay had the bones of Saint Mary Magdalene, and at Conques, the skull of Sainte Foy was to be found. Churches associated with miraculous cures—Autun, for example, which claimed to house the relics of Lazarus, raised by Jesus from the dead—were filled with the sick and injured praying to be healed.

The great pilgrimage churches in Compostela, Toulouse, Limoges, and Conques became models of functional planning and traffic control. To the aisled nave the builders added aisled transepts with chapels leading to an ambulatory with additional radiating chapels around the apse (FIGS. 10–6, 10–7). This system of continuous aisles and ambulatory allowed worshipers to move around the church, visiting all the chapels and saying their own prayers, without disrupting services at the high altar. An octagonal windowed lantern tower over the crossing flooded the sanctuary with daylight, drawing the people forward to the shrines.

Building usually proceeded from east to west. Individual elements produce a series of simple geometric forms that express the internal arrangements of the church—chapels are attached to aisles and ambulatory; the ambulatory then circles the apse and choir, which in turn lead to the wide transept marked by a tall crossing tower. The nave culminates in western towers, an entrance porch, or a narthex. Each element of the building has a distinct geometric form; added together, they produce the powerful impression and solidity characteristic of Romanesque architecture.

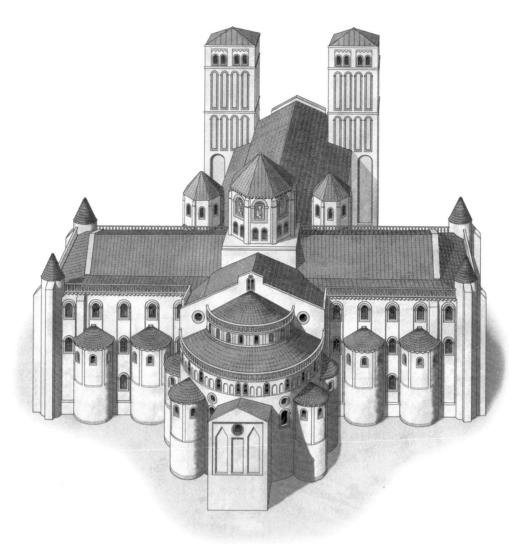

10−6 | RECONSTRUCTION DRAWING (AFTER CONANT) OF CATHEDRAL OF SAINT JAMES, SANTIAGO DE COMPOSTELA 1078–1122, western portions later.

Pilgrims usually entered the church through the large double doors at the ends of the transepts rather than through the western portal, which served ceremonial processions. Pilgrims from France entered the north transept portal; the approach from the town was through the south portal. They found themselves in a transept in which the design exactly mirrored the nave in size and structure. The nave and transept have two stories—an arcade and a gallery. Compound piers with attached half columns on all four sides support the immense ribbed barrel vault. The vaulted gallery over the aisles buttresses the nave vault for its entire length (FIG. 10-8). Quadrant vaults, each with an arc of one-quarter of a circle, strengthen the building by carrying the outward thrust of the high barrel vault to the outer walls and buttresses. The compound piers and transverse ribs give sculptural form to the interior as they mark off individual vaulted bays in which the sequence is as clear and regular as the ambulatory chapels of the choir. Three different kinds of vaults are used: ribbed

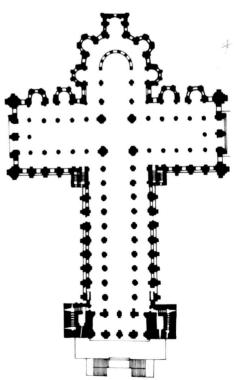

 $10-7 \mid$ plan of cathedral of saint james, santiago de compostela

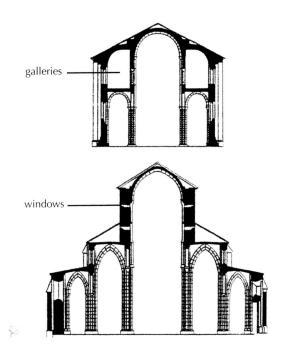

IO-8 | CROSS SECTION OF THE CATHEDRAL OF SAINT JAMES, SANTIAGO DE COMPOSTELA (DRAWING AFTER CONANT)

barrel vaults cover the nave; groin vaults span the side aisles; and half-barrel or quadrant vaults cover the galleries. Without a clerestory, light enters the nave only indirectly, through windows in the outer walls of the aisles and upper-level galleries that overlook the nave.

The building is made of local granite that has weathered to a golden brownish-gray color. In its own time, the cathedral was admired for the excellence of its construction—"not a single crack is to be found," according to the twelfth-century pilgrims' guide—"admirable and beautiful in execution . . . large, spacious, well-lighted, of fitting size, harmonious in width, length, and height . . ."

Pilgrims arrived at Santiago de Compostela weary after weeks of difficult travel through dense woods and mountains. Grateful to Saint James for his protection along the way, they entered a church that welcomed them with open portals. The cathedral had no doors to close—it was open day and night. Its portals displayed didactic sculpture, a notable feature of Romanesque churches. Santiago de Compostela was more than a pilgrimage center; it was a cathedral, the seat of a bishop and later an archbishop and consequently the administrative headquarters of the church in the northwest of the Iberian Peninsula.

The Monastery of Cluny in Burgundy

In 909 the Duke of Burgundy gave land for a monastery to Benedictine monks intent on strict adherence to the original rules of Saint Benedict. They established the reformed congregation of Cluny. From its foundation, Cluny had a special independent status; its abbot answered directly to the pope in Rome rather than to the local bishop or feudal lord. This unique freedom, jealously safeguarded by a series of long-lived and astute abbots, enabled Cluny to keep the profits from extensive gifts of land and treasure. Independent, wealthy, and a center of learning, Cluny and its affiliates became important patrons of the arts.

Cluny was a city unto itself. By the second half of the eleventh century, there were some 200 monks at Cluny and troops of laymen on whom they depended for material support. As we have seen in the Carolingian Saint Gall plan for monasteries (SEE FIG. 9–14), the cloister lay at the center of the community, joining the church with the domestic buildings and workshops (FIG. 10–9). In wealthy monasteries the arcaded galleries of the cloister had elaborate carved capitals as well as relief sculpture on piers (SEE FIG. 10–1). The capitals may even have served as memory devices to direct the monks' thoughts and prayers.

Benedictine monks and nuns observed the eight Hours of the Divine Office (including prayers, scripture readings, psalms, and hymns) and the Mass, which was celebrated after the third hour (terce). Cluny's services were especially elaborate. During the height of its power, the plainsong (or Gregorian chant) filled the church with music twenty-four hours a day. When the monks were not in the choir, they dedicated themselves to study and the cloister crafts, including manuscript production.

The hallmark of Cluny—and Cluniac churches—was their functional design that combined the needs of the monks with the desire of pilgrims to visit shrines and relics, their fine stone masonry with rich sculptured and painted decoration, and their use of elements from Roman and Early Christian art, such as fluted pilasters and Corinthian capitals. Individual Cluniac monasteries were free to follow regional traditions and styles; consequently, Cluny III was widely influential, though not copied exactly.

THE ABBEY CHURCH OF SAINT PETER. The original church, a small barnlike building, was soon replaced by a basilica with two towers and narthex at the west and a choir with tower and chapels at the east. Hugh de Semur, abbot of Cluny for sixty years (1049-1109), began rebuilding for the third time at Cluny in 1088 (FIG. 10-10). Money paid in tribute by Muslims to victorious Christians in Spain financed the building. When King Alfonso VI of León and Castile captured Toledo in 1085, he sent 10,000 pieces of gold to Cluny. The church (known to art historians as Cluny III because it was the third building at the site) was the largest church in Europe when it was completed in 1130. Huge in size—550 feet long-with five aisles like Constantine's churches in • Rome, built with superb masonry, and richly carved, painted, and furnished, Cluny III was a worthy home for the relics of Saint Peter and Saint Paul, which the monks acquired from Saint Paul's Outside the Walls in Rome.

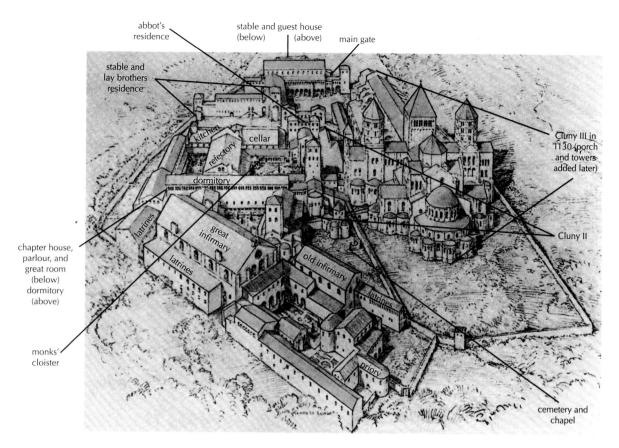

IO−9 | **RECONSTRUCTION DRAWING OF THE ABBEY AT CLUNY** Burgundy, France. 1088–1130. View from the east.

The monastery of Cluny expanded to accommodate its increasing responsibilities and number of monks. In this reconstruction, Cluny III, the abbey church (on the right), dominates the complex. Other buildings are loosely organized around cloisters and courtyards. The cloisters link buildings and provide private space for the monks; the two principal cloisters—for choir monks and for novices—lie to the south of the church.

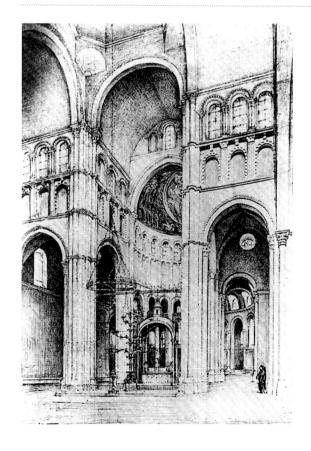

In simple terms, the church was a basilica with five aisles, double transepts with chapels, and an ambulatory and radiating chapels around the high altar. The large number of altars was required by the monks who celebrated Mass daily. Octagonal towers over the two crossings and additional towers over the transept arms created a dramatic pyramidal design at the east end. Pope Urban II, while in Burgundy in 1095 to preach the First Crusade, consecrated the high altar.

The nave of Cluny III had a three-part elevation like & Saint Peter's in Rome. In the nave arcade tall compound piers with pilasters and engaged columns supported pointed arches. At the next level a blind arcade and pilasters created a triforium that resembled a classical Roman triumphal arch, and finally triple clerestory windows let sunlight directly into the church. A ribbed vault, which rose to the daring height of 98 feet with a span of about 40 feet, was made possible by giving the vaults a steep profile (rather than being round as at Santiago de Compostela) and slightly decreasing the width of the nave at the top of the wall.

10-10 | The church choir from the transept at cluny (drawing after conant)

Art and Its Context

RELICS AND RELIQUARIES

hristians turned to the heroes of the Church, the martyrs who had died for their faith, to answer their prayers and to intercede with Christ on their behalf at the Last Judgment. In the Byzantine church people venerated icons, that is, pictures of the saints, but Western Christians wanted to be close to the actual earthly remains of the saints. Scholars in the church assured the people that the veneration of icons or relics was not idol worship. Bodies of saints, parts of bodies, things associated with the Holy Family or the saints were kept in richly decorated containers called reliquaries. Reliquaries could be simple boxes, but they might also be given the shape of the relic—the head of Saint John the Baptist, the rib of Saint Peter, the sandal of Saint Andrew.

Churches were built in cemeteries, over and around the martyrs' tombs. By the eleventh century, many different arrangements of crypts, chapels, and passageways gave people access to the relics. When the Church decided that every altar required a relic, the saints' bodies and possessions were subdivided. Ingenious churchmen came up with the idea of the *brandea*, a strip of linen that took on the powers of the relic by touching it. In this way relics were multiplied; for example, hundreds of churches held relics of the true cross.

Owning and displaying these relics so enhanced the prestige and wealth of a community that people went to great lengths to acquire relics, not only by purchase but also by theft. In the ninth century, for example, the monks of Conques stole the relics of the child martyr Sainte Foy (Saint Faith) from her shrine at Agent. Such a theft was called "holy robbery," for the new owners insisted that the saint had encouraged them because she wanted to move. In the late ninth or tenth century the monks of Conques encased their relic—the skull of Sainte Foy—in a jewel-bedecked and gilt statue whose head was made from a Roman statue. Over the centuries, added jewels, cameos, and other gifts from pilgrims enhanced the splendor of the statue.

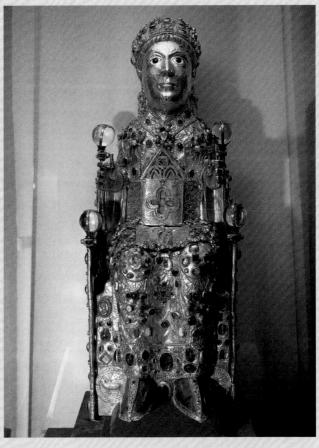

RELIQUARY STATUE OF SAINTE FOY (SAINT FAITH)
Abbey Church of Conques, Conques, France. Late 9th or 10th century with later additions. Silver gilt over a wood core, with added gems and cameos of various dates. Height 33" (85 cm). Church Treasury, Conques, France.

The Church was consecrated in 1130, but building continued at Cluny. A narthex, added at the west end of the nave, was finished at the end of the twelfth century in early Gothic style. The monastery suffered during the French Revolution, and the church was sold and used as a stone quarry. Today the site is an archeological park.

The Cistercians

New religious orders devoted to an austere spirituality arose in the late eleventh and early twelfth centuries. Among these were the Cistercians, who spurned Cluny's elaborate liturgical practices and emphasis on the arts. The Cistercian reform began in 1098 with the founding of the Abbey of Cîteaux (Cistercium in Latin, hence the order's

name). Led in the twelfth century by the commanding figure of Abbot Bernard of Clairvaux, the Cistercians advocated strict mental and physical discipline and a life devoted to prayer and intellectual pursuits combined with shared manual labor, although like the Cluniacs, they depended on the work of laypersons. To provide for their minimal physical needs, the Cistercians settled and reclaimed swamps and forests in the wilderness, where they then farmed and raised sheep. In time, their monasteries could be found from Russia to Ireland.

THE ABBEY AND CHURCH OF NOTRE-DAME AT FONTENAY. Cistercian architecture reflects the ideals of the order—simplicity and austerity—in their building. Always practical, the

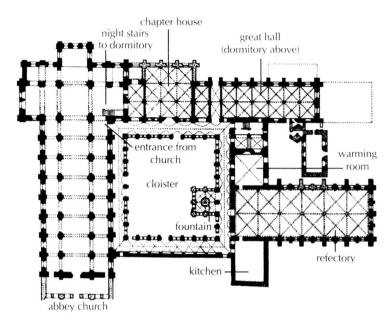

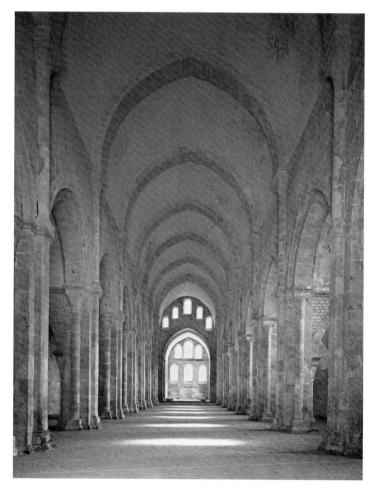

10-12 NAVE, ABBEY CHURCH OF NOTRE-DAME, FONTENAY 1139-47.

Cistercians made a significant change to the already very efficient monastery plan. They placed key buildings such as the refectory at right angles to the cloister walk so that the building could easily be extended should the community grow. The cloister fountain was relocated from the center of the cloister to the side, conveniently in front of the refectory. The monks entered the church from the cloister into the south transept or from the dormitory by way of the "night stairs."

The Cistercians dedicated all their churches to Mary, to Notre Dame ("Our Lady"). The Abbey Church of Notre-Dame at Fontenay was begun in 1139. It has a simple geometric plan (FIG. 10–11): a long nave with rectangular chapels off the square-ended transept arms and a shallow choir with a straight east wall.

A feature of Fontenay often found in Cistercian architecture is the use of pointed ribbed barrel vaults over the nave and pointed arches in the nave arcade and side-aisle bays (FIG. 10–12). The pointed arch and vault may have derived from Islamic architecture. Pointed arches are structurally more stable than round ones, directing more weight down into the floor instead of outward to the walls. Consequently, they can span greater distances at greater heights without collapsing. Pointed arches have a special aesthetic effect, for they narrow the eye's focus and draw the eye upward, an effect intended to direct thoughts toward heaven.

The Cistercians relied on harmonious proportions and fine stonework, not elaborately carved and painted decoration, to achieve beauty in their architecture. Church furnishings included little else than altars with crosses and candles. The large windows in the end wall, rather than a clerestory, provided light. The sets of triple windows reminded the monks of the Trinity. Situated far from the distractions of the secular world, the building made few concessions to the popular taste for architectural adornment, either outside or inside. In other ways, however, Fontenay and other Cistercian monasteries fully reflect the architectural developments of their time in their masonry, vaulting, and proportions.

This simple architecture spread from the Cistercian homeland in Burgundy to become an international style. From Scotland and Germany to Spain and Italy, Cistercian designs and building techniques varied only slightly. The masonry vaults and harmonious proportions influenced the development of the Gothic style in the years leading to the twelfth century (Chapter 11).

Regional Styles in Romanesque Architecture

The Cathedral of Santiago de Compostela and the Abbey church at Cluny reflect the international aspirations of the pope and the impact of the Crusades and pilgrimages, but Europe remained a land divided by competing kingdoms, regions, and factions. Romanesque architecture reflects this regionalism in the wide variety of its styles and building techniques, only a few of which will be noted here.

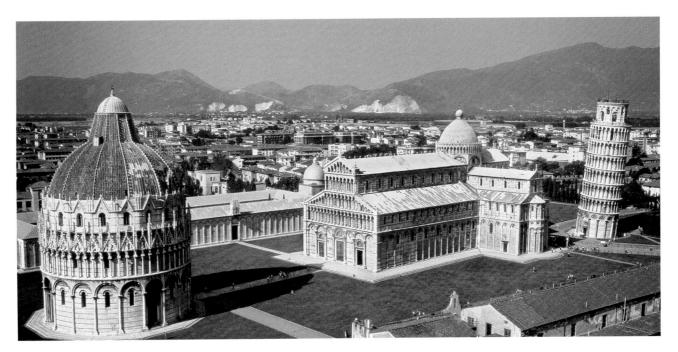

10-13 CATHEDRAL COMPLEX, PISA

Tuscany, Italy. Cathedral, begun 1063; Baptistry, begun 1153; Campanile, begun 1174; Campo Santo, 13th century.

When finished in 1350, the Leaning Tower of Pisa stood 179 feet high. The campanile had begun to tilt while still under construction, and today it leans about 13 feet off the perpendicular. In the latest effort to keep it from toppling, engineers filled the base with tons of lead.

EARLY CHRISTIAN INSPIRATION IN PISA. Throughout Italy artists looked to the still-standing remains of imperial Rome. The influence remained especially strong in Pisa, on the west coast of Tuscany. Pisa became a maritime power, competing with Barcelona and Genoa as well as the Muslims for control of trade in the western Mediterranean. In 1063, after a decisive victory over the Muslims, the jubilant Pisans began an imposing new cathedral dedicated to the Virgin Mary (FIG. 10-13). The cathedral complex eventually included the cathedral building itself, a campanile (a freestanding bell tower—now known for obvious reasons as "the Leaning Tower of Pisa"), a baptistry, and the later Gothic Campo Santo, a walled burial ground. The cathedral was designed by the master builder Busketos, who adopted the plan of a cruciform basilica. A long nave with double side aisles (the fiveaisle building always pays homage to Rome) is crossed by projecting transepts, designed like basilicas with aisles and apses. The builders added galleries above the side aisles, and a dome covers the crossing.

Unlike Early Christian basilicas, the exteriors of Tuscan churches were richly decorated with marble—either panels of green and white marble or with arcades. At Pisa, pilasters, blind arcades, and narrow galleries in white marble adorn the five-story façade. A trophy captured from the Muslims, a bronze griffin, stood atop the building until 1828 (SEE FIG. 8–19).

Other buildings in the complex soon followed the cathedral. The baptistry, begun in 1153, has arcading and galleries on the lower levels of its exterior that match those on the

cathedral (the baptistry's present exterior dome and ornate upper levels were built later). The campanile (bell tower) was begun in 1174 by the Master Bonanno. Built on inadequate foundations, it began to lean almost immediately. The cylindrical tower is encased in tier upon tier of marble columns. This creative reuse of the ancient, classical theme of the colonnade, turning it into a decorative arcade, is characteristic of Tuscan Romanesque art; artists and architects in Italy seem always to have been conscious of their Roman past.

MONTE CASSINO AND ROME; THE CHURCH OF SAN CLEMENTE, ROME.

From 1058 to 1086 Abbot Desiderius ruled Monte Cassino, the mother house of the Benedictine order. At the end of his life he was elected pope, taking the name Victor III. He rebuilt the abbey church at Saint Benedict's monastery of Monte Cassino using Saint Peter's basilica in Rome as his model—with important modifications. Since a monastic church did not have to accommodate crowds of pilgrims, single aisles and a short transept provided sufficient space. A chapel off the transept, facing each aisle, produced a distinctive stepped, triple-apse plan. The eastern portion of the church was raised above the level of the nave to accommodate an open, partially underground crypt. The church, consecrated in 1071, set the spattern for Benedictine churches thereafter.

In the late eleventh century the Benedictines turned to Desiderius's church for technical assistance and inspiration to rebuild the Church of San Clemente in Rome. The new church, consecrated in 1128, was built on top of the previous

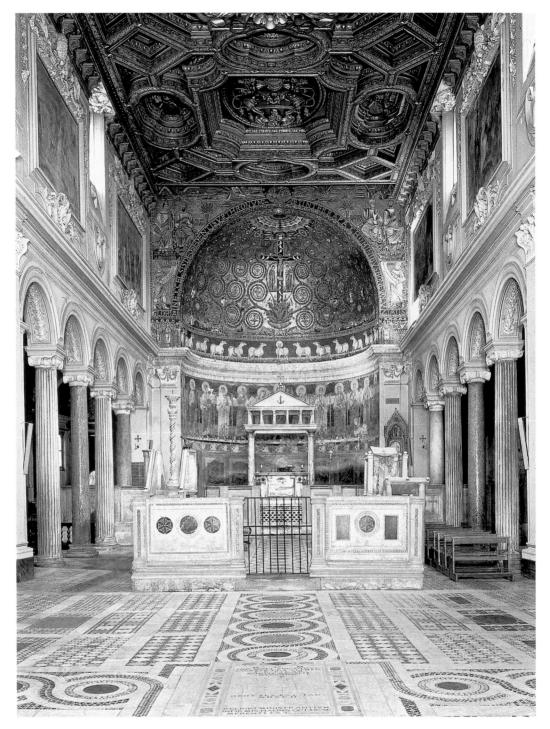

10–14 NAVE, CHURCH OF SAN CLEMENTE, ROME Consecrated 1128.

San Clemente contains one of the finest surviving collections of early church furniture: choir stalls, pulpit, lectern, candlestick, and also the twelfth-century inlaid floor pavement. Ninth-century choir screens were reused from the earlier church on the site. The upper wall and ceiling decoration are eighteenth century.

church (which had been built over a Roman sanctuary of Mithras). Although the architecture and decoration reflect a conscious effort to reclaim the artistic and spiritual legacy of the early church (FIG. 10–14), a number of features mark San Clemente as a twelfth-century building. Early Christian basilicas, for example, have parallel rows of identical columns, which create a strong, regular horizontal movement down

the nave to the sanctuary. In the new church of San Clemente, however, rectangular piers interrupt the line of Ionic columns and divide the nave into bays. (As with the columns of Santa Sabina (SEE FIG. 7–13), the columns in San Clemente are *spolia*; that is, they were taken from ancient Roman buildings.) The church had a timber roof now disguised by an ornate ceiling. The construction of

timber-roofed buildings continued throughout the Middle Ages. Its advantage of being slightly easier and cheaper to build was offset by its vulnerability to fire.

The nave and aisles at San Clemente end in semicircular apses. The central apse was too small to accommodate the increased number of participants in the twelfth-century liturgy. As a result, the choir was extended into the nave and defined by a low barrier made up of ninth-century relief panels saved from the earlier church. In early Christian basilicas, the area in front of the altar had been enclosed by a screen wall (SEE FIG. 7–13, Santa Sabina), and the later builders may have wanted to revive what they considered a glorious early Christian tradition. A **baldachin** (*baldachino* or *ciborium*), symbolizing the Holy Sepulchre, covers the main altar in the apse.

THE BARREL VAULTED CHURCH OF SAINT-SAVIN-SUR-GARTEMPE. At the Benedictine abbey church in Saint-Savin-sur-Gartempe in western France, a tunnel-like barrel vault runs the length of the nave and choir (FIG. 10–15). Supported directly by tall columns and consequently without galleries or clerestory windows, the nave at Saint Savin approaches the form of a "hall church," where the nave and aisles rise to an equal height. At Saint Savin the vault is unbroken. The continuous vault is ideally suited for paintings (see page 372, FIG. 10–31).

More often in Romanesque churches, transverse arches divide the space into bays, as at the Cathedral of Santigo de Compostela (SEE FIG. 10–5). These transverse arches provide little extra support for the vault once it is in place, but they allow the vault to be constructed in segments. They also enhance the rhythmic and "additive" aesthetic quality of the building.

FOUR-PART RIBBED VAULTS AT SANT'AMBROGIO, MILAN. About 1080, at the height of the struggles between the pope and the emperor, construction began in the city of Milan in Lombardy on a new Church of Sant'Ambrogio. The church had been founded by the city's first bishop, Saint Ambrose (d. 397), one of the Fathers of the Christian Church. This new church replaced a ninth-century building. Then, following an earthquake in 1117, masons had to rebuild the church again. This time they used a technically advanced system of fourpart rib vaulting (FIG. 10–16). With a nave wider than that of Cluny III, but, at 60 feet, only a little more than half as high, the vault presented a challenge.

Massive compound piers support three huge ribbed groin vaults over the square bays of the nave. The Romans had used groin vaults, and the Romanesque Lombard builders added diagonal and transverse ribs that had supported scaffolds during construction and now also helped to stabilize the vault. Smaller intermediate piers support the small groin vaults over the side-aisle bays, and vaulted galleries buttress the walls and vaults. Since the builders used round arches throughout the construction, in each bay the diagonal ribs had a greater diameter and therefore greater

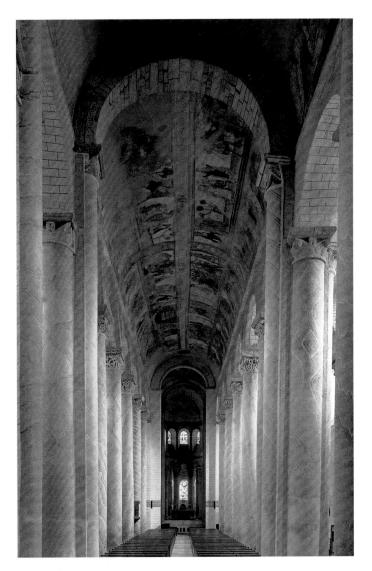

10–15 CHURCH OF SAINT-SAVIN-SUR-GARTEMPE, POITOU

France. Choir c.1060-75; nave c. 1095-1115.

height than the transverse and lateral ribs, and each bay rises up into a domical form, emphatically defining each bay. The builders did not risk weakening the structure with window openings, so there is no clerestory. The dimly lit nave makes the light streaming down in front of the altar from the lantern tower all the more dramatic. •

THE IMPERIAL CATHEDRAL OF SPEYER. Ties between northern Italy and Germany established by the Carolingian and Ottonian rulers remained strong, and the architecture of Switzerland, southern Germany, and especially the Rhine Valley is closely related to that of Lombardy. The Imperial Cathedral at Speyer in the Rhine River valley was a colossal structure rivalled only by Cluny III. The Ottonian woodenroofed church built between 1030 and 1060 was given a masonry vault c. 1080–1106 (FIG. 10–17). Massive compound piers mark each nave bay and support the transverse ribs of a vault that rises to a height of over 100 feet. These

compound piers alternate with smaller piers that support the vaults of the aisle bays. This rhythmic pattern of heavy and light elements, first suggested for aesthetic reasons in Ottonian wooden-roofed architecture (SEE FIG. 9–27, Gernrode), became an important design element in Speyer. Since groin vaults concentrate the weight and thrust of the vault on the four corners of the bay, they relieve the stress on the side walls of the building. Windows can be safely inserted in each bay (something the builders of Sant'Ambrogio dared not do). The result is a building flooded with light.

The exterior of Speyer Cathedral emphasizes its Ottonian (and even Carolingian) qualities. Soaring towers and wide transepts mark both ends of the building, although a narthex, not an apse, stands at the west. Like the arrangement of the east end first seen at Saint Riquier (SEE FIG. 9–13), a large apse housing the high altar abuts the flat wall of the choir; transept arms project at each side; a large octagonal tower rises over the crossing; and a pair of tall slender towers flanks the choir (FIG. 10–18). A horizontal arcade forms an exterior gallery at the top of the apse and transept wall. Stepped niches follow the line of the choir roof, and arched corbel tables also define

MEMORABLE ABBOTS AND POPES		
ruled 1049-1109	Hugh de Semur, Abbot of Cluny, began the Great Church of Cluny III (1088)	
ruled 1058-86	Desiderius (Benedictine), Abbot of Monte Cassino, elected Pope Victor III (ruled 1086-87)	
ruled 1073-85	Pope Gregory VII (Cluniac) asserted papal authority over political rulers; under his given name of Hildebrand, one of the great papal administrators (1048–1073)	
ruled 1088-99	Pope Urban II (Cluniac) preached the First Crusade (1095)	
ruled 1115-53	Saint Bernard (Cistercian), Abbot of Clairvaux abbey; writer and preacher; called for Second Crusade (1147)	

Sequencing Events

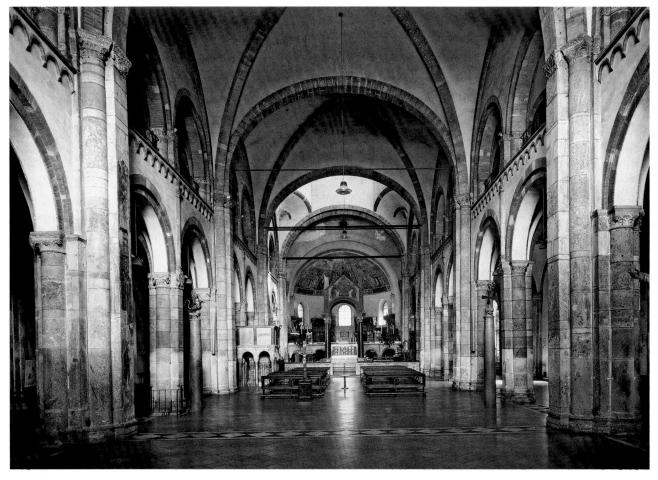

10–16 | NAVE, CHURCH OF SANT'AMBROGIO, MILAN Lombardy, Italy. Begun 1080; vaulted after an earthquake in 1117.

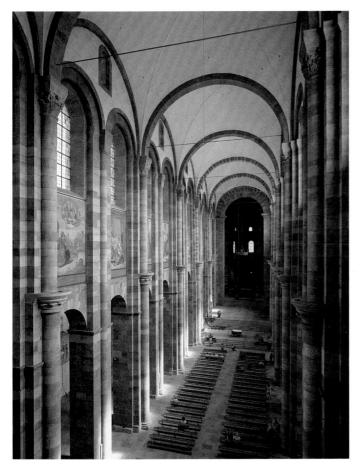

10–17 | INTERIOR, SPEYER CATHEDRAL Speyer, Germany. As remodeled c. 1080–1106.

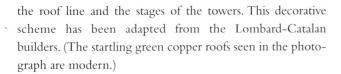

EXPERIMENTAL VAULTS IN DURHAM. In Durham, a military outpost near the Scottish border, builders were experimenting with masonry vaults. When the British turned from timber architecture to stone and brick, they associated masonry buildings—whether church, feasting hall, or castle—with the power and glory of ancient Rome and to some extent with Charlemagne and the Continental powers. As a practical matter, they also appreciated the greater strength and resistance to fire of masonry walls, although they often continued to use wooden roofs.

In Durham, one man, a count-bishop, had both secular and religious authority. For his headquarters he chose a natural defensive site where the oxbow of the River Wear formed a natural moat. Durham grew into a powerful fortified complex including a castle, a monastery, and a cathedral. The great tower of the castle defended against attack from the land, and an open space between buildings served as the bailey of the castle and the cathedral green.

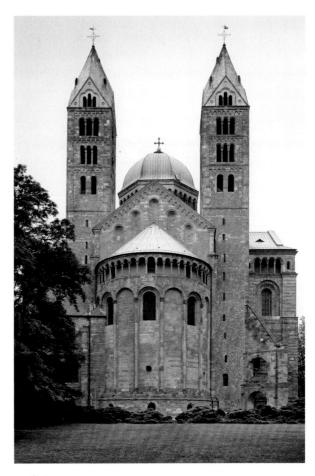

10−18 | EXTERIOR, SPEYER CATHEDRAL c. 1080–1106 and second half of the 12th century.

Durham Cathedral, begun in 1087 and vaulted beginning in 1093, is an impressive Norman church, but like most buildings that have been in continuous use, it has been altered several times (FIG. 10–19). The nave retains its Norman character, but the huge circular window lighting the choir is a later Gothic addition. The cathedral's size and decor are ambitious. Enormous compound piers alternating with robust columns form the nave arcade. The alternating circular and clustered piers establish the typical alternating rhythm. The columns are carved with chevrons, spiral fluting, and diamond patterns, and some have scalloped, cushion-shaped capitals. The arcades have multiple round moldings and chevron ornaments. All this carved ornamentation was originally painted.

Above the cathedral's massive piers and walls rise a new system of ribbed vaults and buttresses. Masons in Santiago de Compostela, Cluny, Milan, Speyer, and Durham were all experimenting with vaults—and reaching different conclusions. Unlike the masons at Sant' Ambrogio, the designers in Durham wanted a unified, well-lit space. In the vault, the Durham builders divided each bay with two pairs of diagonal crisscrossing ribs and so kept the crowns of the vaults close in height to the keystones of the transverse arches (FIG. 10–20).

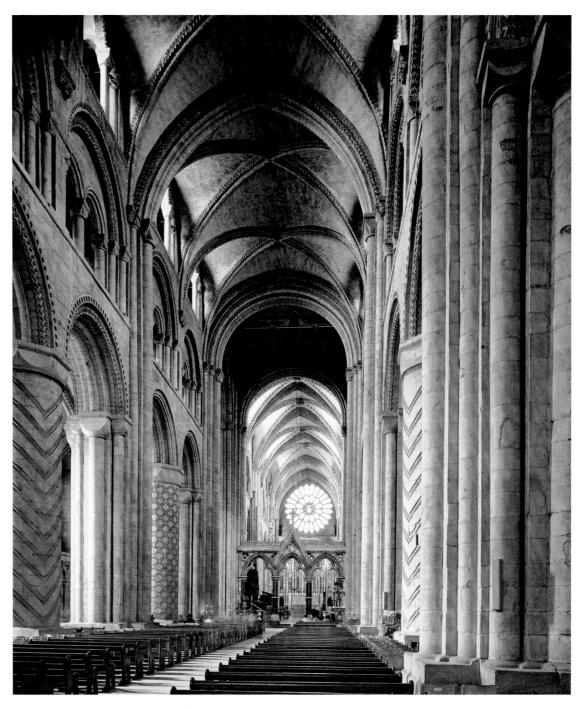

10-19 NAVE, DURHAM CATHEDRAL England. 1087-1133. Original east end replaced by a Gothic choir, 1242-c. 1280. Vault height about 73' (22.2 m).

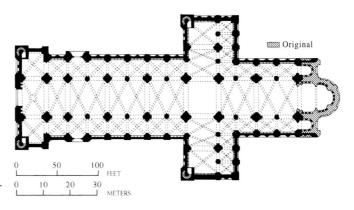

10-20 PLAN OF DURHAM CATHEDRAL Showing original east end.

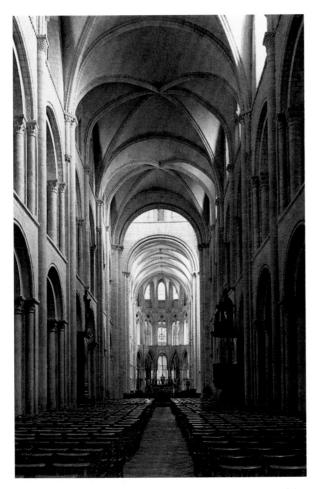

10–21 NAVE, CHURCH OF SAINT-ÉTIENNE, CAEN Normandy, France c. 1060–77; vaulted c. 1130.

The eye runs smoothly down the length of the vault. In the transept, the builders divided the square bays in two to produce four-part ribbed vaults over rectangular bays. They also experimented with buttresses that resembled later Gothic systems (see Chapter 11). Although the buttresses were not a success, the germ of the idea was there.

THE CHURCH OF SAINT-ÉTIENNE, CAEN. The Benedictine abbey church of Saint-Étienne (FIG. 10–21) in Caen was originally built as a wooden-roofed basilica nearly a generation before Durham Cathedral. William the Conqueror, while still only Duke of Normandy, had founded the monastery and had begun the construction of its church before 1066. He dedicated the church in 1077 and was buried there in 1087. His wife, Queen Matilda, established an abbey for women and built a church dedicated to the Trinity.

William's original church provides the core of the building we see today (FIG. 10–22). The nave wall has a three-part elevation (nave arcade, gallery, and clerestory) with exceptionally wide arches both in the nave arcade and the gallery. At the clerestory level, an arcade of three small arches on colonettes runs in front of the windows, creating a passageway within the thickness of the wall. On each pier, engaged columns alternate with columns backed by pilasters. They

run unbroken the full height of the nave, emphasizing its height. The walls seem designed for a masonry vault, but in fact supported a timber roof.

Sometime after 1120—perhaps as late as 1130–35—Saint-Étienne's original timber roof was replaced by a masonry vault. The masons joined two bays to form square bays defined by the heavy piers (that is, the piers with the pilaster-backed columns) and by six-part vaults. The six-part vault combines two systems—transverse ribs crossing the space at every pier and ribbed groin vaults springing from the heavy piers. To accommodate the lower masonry vault under the timber roof, the triple arches of the clerestory were reduced to two.

Soaring height was a Norman architectural goal, and the façade towers continue the tradition of church towers begun by Carolingian builders. This preference for verticality is seen in the west façade of Saint-Étienne, which was designed at the end of the eleventh century, probably about 1096–1100 (FIG. 10–23). Wall buttresses divide the façade into three vertical sections corresponding to the nave and side aisles. Narrow stringcourses (unbroken horizontal moldings) at each window level suggest the three stories of the building's nave elevation. This concept of reflecting the plan and elevation of the church in the design of the façade was later adopted by Gothic builders. Norman builders, with their brilliant techni-

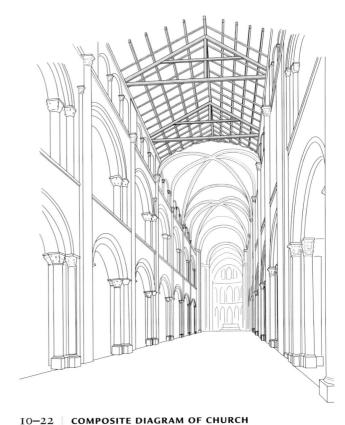

OF SAINT-ÉTIENNE, CAEN
Showing original 11th-century timber roof and later
12th-century six-part vault inserted under the roof.

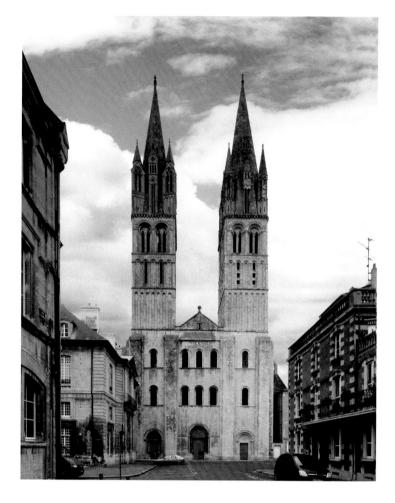

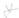

IO-23 CHURCH OF SAINT-ÉTIENNE, CAEN Normandy, France. c. 1060-77; façade c. 1096-1100; spires 13th century.

cal innovations and sophisticated designs, prepared the way for the architectural feats accomplished by Gothic architects in the twelfth and thirteenth centuries. The elegant spires topping the tall towers are examples of the Norman Gothic style.

Secular Architecture: Dover Castle, England

The need to provide for personal security in a period of constant local warfare and political upheaval, as well as the desire to glorify the house of the lord and his saints, meant that communities used much of their resources for churches and castles. Fully garrisoned, castles were sometimes as large as cities. In the twelfth century, Dover Castle, safeguarding the coast of England from invasion, was a magnificent demonstration of military power (FIG. 10-24). It illustrates the way in which a key defensive position developed over the centuries. The Romans had built a lighthouse on the point where the English Channel separating England and France narrows. The Anglo-Saxons added a church (both lighthouse and church can be seen behind the tower, surrounded by the remains of earthen walls). In the early Middle Ages, earthworks topped by wooden walls provided a measure of security, and a wooden tower signified an important administrative building and residence. The advantage of fire-resistant walls was obvious, and in the twelfth and thirteenth centuries, military engineers replaced the timber tower and palisades with stone walls. They added the massive stone towers we see today.

The Great Tower, as it was called in the Middle Ages (but later known as a keep in England, and donjon in France), stood in a courtyard (called the bailey) surrounded by additional walls. Ditches outside the walls added to the height of the walls. In some castles, ditches were filled with water to form moats. A gatehouse—perhaps with a drawbridge—controlled the entrance. In all castles the bailey was filled with buildings, the most important of which was the lord's hall, which was used for a court and for feasts and ceremonial occasions. Timber buildings housed troops, servants, and animals. Barns and workshops, ovens and wells were also needed since the castle had to be self-sufficient.

If enemies broke through the outer walls, the castle's defenders retreated to the Great Tower. The landwalls of Constantinople (SEE FIG. 7–24) had demonstrated the value of defense in depth. In the thirteenth century, the builders at Dover doubled the walls and strengthened them with towers, even though the castle's position on cliffs overlooking the sea made scaling the walls nearly impossible. The garrison could be forced to surrender only by starving its occupants.

During Dover Castle's heyday improving agricultural methods and growing prosperity provided the resources for increased building activity in Europe. Churches, castles, halls, houses, barns, and monasteries proliferated. The buildings that still stand—despite the ravages of weather, vandalism, neglect, and war—testify to the technical skills of the builders and the power, local pride, and faith of the patrons.

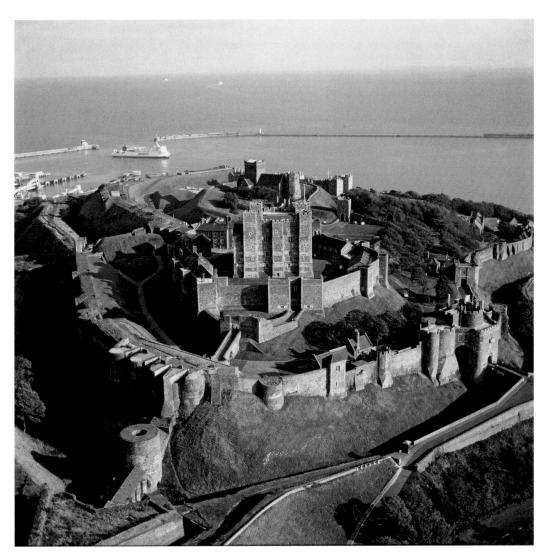

10–24 DOVER CASTLE Dover, England

Air view overlooking the harbor and the English Channel. Center distance: Roman lighthouse tower, rebuilt Anglo-Saxon church, earthworks. Center: Norman Great Tower, surrounding earthworks and wall, twelfth century. Outerwalls, thirteenth century. Modern buildings have red tile roofs. The castle was used in World War II and is now a museum.

THE DECORATION OF BUILDINGS

Like Cluny and unlike the severe churches of the Cistercians, many Romanesque churches have a remarkable variety of painting and sculpture. Christ Enthroned in Majesty in heaven may be carved over the entrance or painted in the half-dome of the apse. Stories of Jesus among the people or images of the lives and the miracles of the saints cover the walls; the art also reflects the increasing importance accorded to the Virgin Mary. Depictions of the prophets, kings, and queens of the Old Testament symbolically foretell people and events in the New Testament, but also represented are contemporary bishops, abbots, other noble patrons, and even

ordinary folk. A profusion of monsters, animals, plants, geometric ornament, allegorical figures such as Lust and Greed, and depictions of real and imagined buildings surround the major works of sculpture. The elect rejoice in heaven with the angels; the damned suffer in hell, tormented by demons; biblical and historical tales come alive, along with scenes of everyday life. All these events seem to take place in a con-

Inside the building paintings covered walls, vaults, and even piers and columns with complex imagery that combined biblical narratives and Christian symbolism with legends, folklore, and history.

Architectural Sculpture

Architecture dominated the arts in the Romanesque period—not only because it required the material and human resources of an entire community but because, by providing the physical context for sculpture and painting, it also established the size and shape of images. Sculptured façades and large and richly carved portals with symbolic and didactic images are a significant innovation in Romanesque art.

The most important imagery is usually in the semicircular tympanum directly over the door. Archivolts—curved moldings composed of the wedge-shaped stone voussoirs of the arch—frame the tympanum. On both sides of the doors, the jambs and often a central pier (called the trumeau), which support the lintel and archivolts, may have figures or columns. The jambs form a shallow porch.

WILIGELMUS AT THE CATHEDRAL OF MODENA. The spirit of ancient Rome pervades the sculpture of Romanesque Italy. The sculptor Wiligelmus may have been inspired by ancient sarcophagi still visible in cemeteries when he carved the horizontal reliefs with heavy-set figures across the west façade of Modena Cathedral, c. 1099. Wiligelmus's work is

some of the earliest narrative sculpture in Italy. He took his subjects from Genesis, beginning with the Creation and the Fall of Adam and Eve (FIG. 10–25). On the far left, God, in a mandorla supported by angels, appears in two persons as both the creator and Christ, identified by a cruciform halo. He brings Adam to life, then brings forth Eve from Adam's side. On the right, Adam and Eve cover their genitals in shame as they greedily eat the fruit of the forbidden tree, around which the serpent twists.

Wiligelmus's deft carving gives these low-relief figures a strong three-dimensionality. Adding to their tangibility is Wiligelmus's use of a miniature arcade to establish a stagelike setting. The rocks on which Adam lies, or the fatal tree of Paradise, seem like stage props for the figures. Adam and Eve stand awkwardly, with pot bellies and skinny arms and legs, but they exude a sense of life and personality that gives an emotional depth to the narrative. Bright paint, now almost all lost, increased the impact of the sculpture. An inscription reads: "Among sculptors, your work shines forth, Wiligelmus." This self-confidence turned out to be justified. Wiligelmus's influence can be traced throughout Italy and as far away as the Cathedral of Lincoln in England.

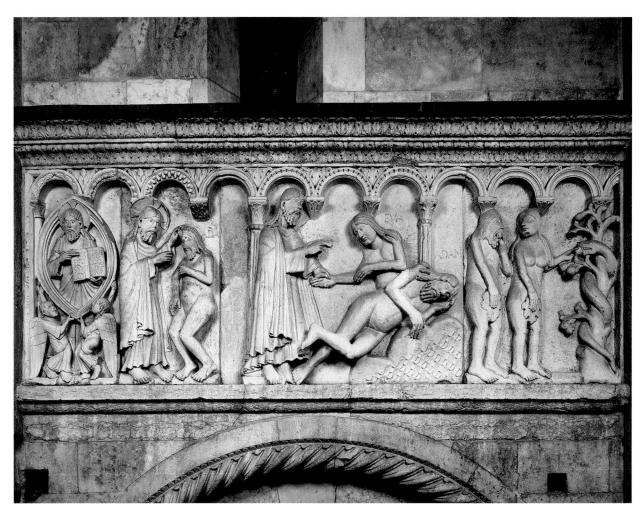

10–25 | Wiligelmus | CREATION AND FALL, WEST FAÇADE, MODENA CATHEDRAL Modena, Emilia, Italy. Building begun 1099; sculpture c. 1099. Height approx. 3' (92 cm).

THE PRIORY CHURCH OF SAINT-PIERRE, MOISSAC. The Cluniac priory of Saint-Pierre at Moissac was a major pilgrimage stop and Cluniac administrative center on the route to Santiago de Compostela. The original shrine at the site was reputed to have existed in the Carolingian period. After joining the congregation of Cluny in 1047, the monastery prospered from the donations of pilgrims and the local nobility, as well as from its control of shipping on the nearby Garonne River. Moissac's monks launched an ambitious building campaign, and much of the sculpture from the cloister (c. 1100) and the church portal and porch (1100-30) has survived. Abbot Ansquetil (ruled 1085-1115) built the cloister and portal, which must have been finished by his death in 1115, and Abbot Roger (c. 1115-31) added a porch with sculpture. The sculpture of the portal represents a genuine departure from earlier works in both the quantity and the quality of the carving.

The image of Christ in Majesty dominates the huge tympanum (FIG. 10–26). The scene combines the description of the Second Coming of Christ in Chapters 4 and 5 of the Book of Revelation with Old Testament prophecies. A

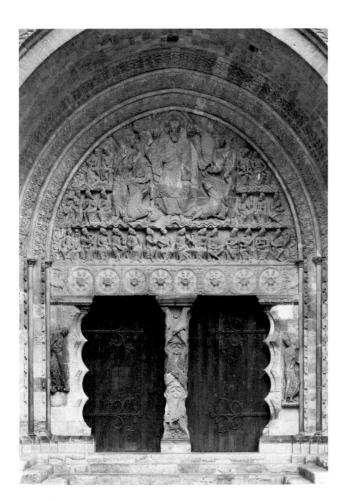

IO-26 | SOUTH PORTAL AND PORCH, PRIORY CHURCH OF SAINT-PIERRE, MOISSAC

Tarn-et-Garonne, France. c. 1115.

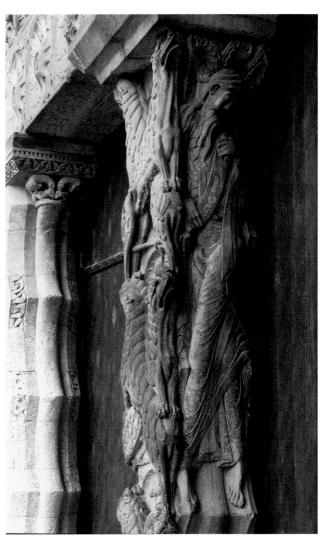

IO-27 | TRUMEAU, SOUTH PORTAL, PRIORY CHURCH OF SAINT-PIERRE, MOISSAC
Tarn-et-Garonne, France. c. 1115.

gigantic Christ, like an awe-inspiring Byzantine Pantokrator, stares down at the viewer as he blesses. He is enclosed by a mandorla, and a cruciform halo rings his head. Four winged creatures symbolizing the evangelists-Matthew the Man (upper left), Mark the Lion (lower left), Luke the Ox (lower right), and John the Eagle (upper right)—frame Christ on either side, each holding a scroll or book representing his Gospel. Two elongated seraphim (angels) stand one on either side of the central group, each holding a scroll. Rippling bands represent the waves of the "sea of glass like crystal" (Revelation 4:6), defining three registers in which twenty-four elders with "gold crowns on their heads" are seated holding either a harp or a gold bowl of incense (Revelation 4:4 and 5:8). According to the medieval view, the elders were the kings and prophets of the Old Testament and, by extension, the ancestors and precursors of Christ.

The figures in the tympanum relief reflect a hierarchy of scale and location. Christ, the largest figure, sits at the top center, the spiritual heart of the scene. The evangelists and angels are smaller, and the elders, farthest from Christ, are roughly one-third his size. Despite this formality and the limitations forced on them by the architecture, the sculptors achieve variety by turning and twisting the gesturing figures, shifting their poses off-center, and avoiding rigid symmetry or mirror images. Foliate and geometric ornament covers every surface. Monstrous heads in the lower corners of the tympanum spew ribbon scrolls, and other creatures appear at each end of the lintel, their tongues growing into ropes encircling acanthus rosettes.

Two side jambs and a central trumeau support the weight of the lintel and tympanum. These elements have scalloped profiles (a motif inspired by Islamic art) that control the design of the sculpture. Saint Peter (holding his attribute, the key to the gates of heaven) and the prophet Isaiah are carved on the jambs. Peter, a tall, thin saint, steps away from the door but twists back to look through it. His shoulder, knees, and

feet reflect the pointed cusps of the scalloped jamb; the vertical folds of his cloak repeat the framing colonettes. The trumeau depicts crisscrossing pairs of lions. A tall, thin figure of Saint Paul is on the left, and an Old Testament prophet, usually identified as Jeremiah, twists toward the viewer, with his legs crossed in the walking pose seen at Silos (FIG. 10-27). " The sculptors placed him skillfully within the constraints of the scalloped trumeau; his head, pelvis, knees, and feet fall on the pointed cusps. This decorative scalloping as well as the rosettes, lions, and ribbons reveal a knowledge of Islamic art. Moissac was on the road to Compostella. Furthermore, it was being built shortly after the First Crusade when many Europeans first encountered the Islamic art and architecture of the Holy Land. People from the region around Moissac participated in the Crusade and presumably brought Eastern objects and ideas home with them.

GISLEBERTUS AND THE LAST JUDGMENT AT AUTUN. A different pictorial style is seen in the Last Judgment at Autun on the main portal of the Cathedral of Saint-Lazare (FIG. 10–28).

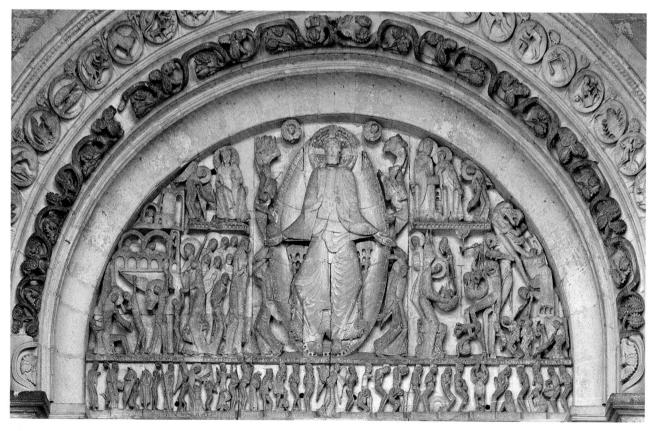

IO-28 | Gislebertus last Judgment, tympanum on west portal, cathedral (originally abbey church) of saint-lazare, autun Burgundy, France. c. 1120–30 or 1130–45.

10–29 | CAPITAL: SUICIDE OF JUDAS. CATHEDRAL OF SAINT-LAZARE, AUTUN Burgundy, France. c. 1125.

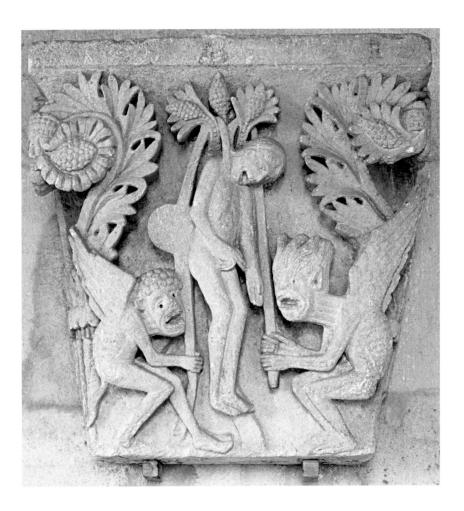

Christ has returned to judge the cowering, naked human souls at his feet. The damned writhe in torment, while the saved enjoy serene bliss. The inscribed message reads: "May this terror frighten those who are bound by worldly error. It will be true just as the horror of these images indicates" (translated by Petzold). A lengthy inscription identifies the Autun tympanum as the work of Gislebertus, who oversaw the sculpture and probably did much of the work himself.

The overall effect of the tympanum is less consciously balanced than the pattern-filled composition at Moissac. Christ dominates the composition, but the surrounding figures are arranged in less regular compartmentalized tiers than seen at Moissac. Thinner and taller, stretched out and bent at sharp angles, the stylized figures are powerfully expressive. They convey the terrifying urgency of the moment as they swarm around the magisterially detached Christ. Delicate weblike engraving on the robes seems inspired by metalwork or manuscript illumination. The scene is filled with human interest. Some angels trumpet the call to the Day of Judgment; others help the souls rise from their tombs and line up to await judgment. In the bottom register, two pilgrims—one to Jerusalem and one to Santiago de Compostela—can be identified by the cross and scallop-shell badges on their satchels. But, ominously, a pair of giant, pincerlike hands scoops up a soul at the far right of the lintel. Above these hands, the archangel Michael competes with devils for souls being weighed on the scale. Michael shelters some souls in the folds of his robe and seems to be jiggling the scales. Another angel boosts a saved soul into heaven, bypassing the gate and Saint Peter. By far the most riveting players in the drama are the grotesquely decomposed, screaming demons grabbing at terrified souls and trying to cheat by pushing down souls and yanking the scales to favor damnation.

HISTORIATED CAPITALS. An important Romanesque contribution to architectural decoration was the ingenious compression of instructive narrative scenes into the geometric confines of column capitals, a feature known as the historiated capital. Gislebertus developed this idea into a series of personalized narratives, such as **THE SUICIDE OF JUDAS** (FIG. 10–29), illustrating the Bible and the lives of the saints.

Corinthian capitals (see Introduction, Fig. 3) from among the ruins of Roman cities inspired the design of Romanesque capitals, on which spiky acanthus leaves and ribbonlike volutes surround an inverted bell shape and support a wide abacus. The Romanesque sculptors such as Gislebertus, however, turned the capital into an educational or symbolic narrative.

Art and Its Context

THE ROLE OF WOMEN IN THE INTELLECTUAL AND SPIRITUAL LIFE OF THE TWELFTH CENTURY

ne would expect women to have a subordinate position in this hierarchical, military society. On the contrary, aristocratic women took responsibility for managing estates in their male relatives' frequent absences during wars or while attending to duties at court. Among peasants and artisans, women and men worked side by side.

Women also achieved positions of authority and influence as the heads of religious communities. Convents of educated women lived under the direction of abbesses such as Hildegard of Bingen and Herrad of Landsberg, abbess of Hohenburg in Alsace. The original illuminated manuscripts containing their writings did not survive the wars of the nineteenth and twentieth centuries, but copies exist.

The Liber Scivias by Hildegard of Bingen (1098-1179) opened with a portrait of the author at work. Born into an aristocratic German family, Hildegard transcended the barriers that limited most medieval women. She began serving as leader of her convent in 1136, and about 1147 she founded a new convent near Bingen. With the assistance of the monk Volmar, she began to record her visions in a book, Scivias (from the Latin scite vias lucis, "know the ways of the light"). The opening page of this copy shows Hildegard receiving a flash of divine insight, represented by the tongues of flame encircling her head. She wrote, "a fiery light, flashing intensely, came from the open vault of heaven and poured through my whole brain." She records her visions on tablets, while Volmar, her scribe, writes to her dictation. Hildegard also wrote on medicine and natural science. A major figure in the intellectual life of her time, she corresponded with emperors, popes, and the Cistercian abbot Bernard of Clairvaux.

Herrad (1130-96), the Abbess of Hohenburg, wrote an encyclopaedia—Hortus Deliciarum (The Garden of Delights)—in which she combined a history of the world from its creation to the Last Judgment with a compendium of all human knowledge, using almost 1200 quotations from scholars as well as sermons

and poems. For example, when she told the story of the Magi following the star to Bethlehem she added a discussion of astronomy and astrology. She also devised a complex scheme of illustrations as part of her educational program. She explained her intentions: "Like a small active bee, I have extracted the sugar of the flowers of divine and philosophical literature. . ." for "my sisters in Jesus." Today, such books guide scholars who try to decode the meaning of medieval artworks.

HILDEGARD AND VOLMAR, LIBER SCIVIAS 1165–75. Facsimile frontispiece.

In the *Suicide of Judas* from Autun, flat split-leaf acanthus fronds curl up to form volutes and establish the architectural frame. Two demons string up Judas's limp ugly corpse. The strange noose they use has been identified as the bag of money Judas accepted for his betrayal of Christ or as a wrestler's belt, the symbol of useless worldly physical strength. The screaming demons with contorted faces, vicious teeth, and flaming hair embody evil. With scrawny limbs, bloated bodies, and upswept wings they reinforce the shape of the capital. The sculptors achieve a crispness and clarity by slightly undercutting the forms so that the edges are sharpened by shadows. This clarity was important when the capitals had to be seen at a distance.

Mosaics and Murals

Church interiors were not the bare expanses of stone we see today. Throughout Europe colorful murals glowed in flickering candlelight amid clouds of incense. Wall painting was subject to the same influences as the other visual arts; that is, the painters were inspired by illuminated manuscripts, or ivories, or enamels in their treasuries or libraries. Some must have seen examples of Byzantine art; others had Carolingian or even Early Christian models. During the Romanesque period, painted decoration largely replaced mosaics on the walls of churches. This change occurred at least partly because the growing demand by the greater number of churches led to the use of less expensive materials and techniques.

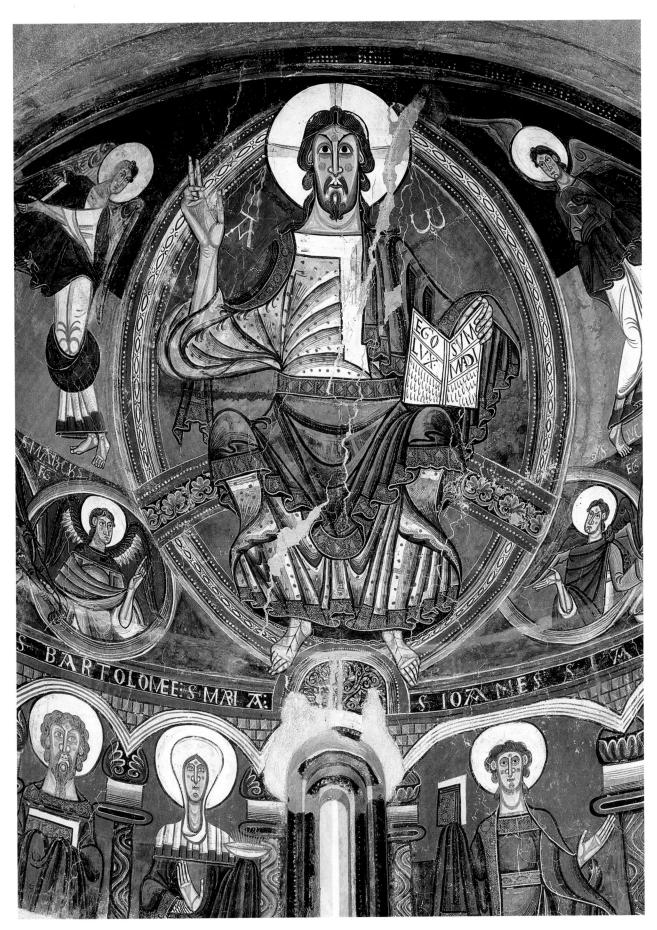

10–30 | CHRIST IN MAJESTY
Detail of apse, Church of San Climent, Taull, Catalunya, Spain.
1123. Museu Nacional d'Art de Catalunya, Barcelona.

THE Mosaics of San Clemente, Rome. The apse of San Clemente, richly decorated with colored marbles and a gold mosaic in the semidome, recalls the lost mosaics of the church at Monte Cassino, south of Rome. Abbot Desiderius built a new headquarters Church for the Benedictine Order that he intended should rival the churches of Constantinople. He brought artists from Byzantium to create mosaics and to teach the technique to his most talented monks. In Rome, where Desiderius ruled briefly as Pope Victor III, mosaics were added to a few chapels and churches in spite of the difficulty getting the expensive materials and specialized artists. In the church of San Clemente (SEE FIG. 10–14), the mosaics seem to recapture the past, with the trees and rivers of Paradise, a vine scroll inhabited by figures surrounding the crucified Christ. Mary and Saint John stand below, and twelve doves on the cross and twelve sheep represent the apostles. Stags (symbols of resurrection) drink from streams flowing from the cross, the tree of life in Paradise.

Although the iconography of the mosaic is Early Christian, the style and technique are clearly Romanesque. The artists made no attempt to create an illusion of the natural world. The hard dark outlines and bright flat colors turn the figures into ornamental patterns typical of the twelfth century. The doves on the cross, the repeated circular vine scrolls ending in bunches of leaves and flowers, even the animals, birds, and humans among the leaves are reduced to elements in a formal design. When compared with Early Christian and Byzantine mosaics (see Chapter 7), the mosaic seems evidence of a decline in standards of craftsmanship. However, the irregular setting of tesserai in visibly rough plaster is intentional and actually heightens the color and increases the glitter of the gold. Light reflects off the irregular surface of the apse, causing the mosaic to sparkle.

These rich surfaces continue through the choir and across the pavement in San Clemente. As in other Italian churches of the period, inlaid geometric patterns in marble embellish the floors in an ornamental style known as Cosmati work, after the family who perfected the technique.

MURALS IN TAULL (TAHULL), CATALUNYA, SPAIN. Artists in Catalunya brilliantly combined the Byzantine style with their own Mozarabic and classical heritage. In the Church of San Climent in Taull (Tahull), consecrated in 1123, a magnificently expressive CHRIST IN MAJESTY fills the curve of the half-dome of the apse (FIG. 10–30). Christ's powerful presence recalls the Byzantine depiction of Christ Pantokrator, ruler and judge of the world. The iconography is traditional: Christ sits within a mandorla; the Greek letters alpha and omega hang from strings beside his head. He holds the open Gospel inscribed "Ego sum lux mundi" ("I am the light of the world," John 8:12). Four lively angels, each grasping an evangelist's symbol, appear beside him. In the arcade at Christ's feet are six apostles and the Virgin Mary.

The columns with stylized capitals have wavy lines of paint indicating marble shafts.

The San Climent artist was one of the finest Spanish painters of the Romanesque period, but where he came from and where he learned his art is unknown. His use of elongated oval faces, large staring eyes, and long noses, as well as the placement of figures against flat bands of color and his use of heavy outlines, reflect the Mozarabic style .. (Chapter 9). At the same time his work shows the prevailing influence of Byzantine art, although he simplified the style. His painting technique—modeling from light to dark—is Byzantine, accomplished through repeated colored lines of varying width in three shades—dark, medium, and light. But instead of blending the colors, he delights in the striped effect. Details of faces, hair, hands, and muscles also become elegant patterns. The intensity of the colors was created by building up many thin coats of paint, a technique called glazing.

MURALS IN THE CHURCH OF SAINT-SAVIN-SUR-GARTEMPE, FRANCE. The paintings in the Church of Saint-Savin (SEE FIG. 10–15) have survived almost intact. The nave vault has scenes from the Old and New Testaments, and the lives of two local saints, Savin and Cyprian, provide

the lives of two local saints, Savin and Cyprian, provide imagery for the crypt. The narthex was also painted, as were the columns.

to have followed the masons immediately in order to use the same scaffolding. Perhaps this intimate involvement with the building process accounts for the vividness with which they portrayed the biblical story of the **TOWER OF BABEL**

The nave was built c. 1095-1115, and the painters seem

(FIG. 10-31).

According to the account in Genesis (11:1-9), God punished the prideful people who tried to build a tower to heaven by scattering them and making their languages mutually unintelligible. The tower in the painting is a medieval structure, reflecting the practice of depicting distant or legendary events in contemporary settings. Workers haul heavy stone blocks to the tower, lifting them to masons on the top with a hoist. The giant Nimrod, on the far right, simply hands over the blocks. The paintings recall the energy and narrative drama of early medieval art. God confronts the people. He steps away from them even as he turns back to chastise them. The scene's dramatic action, large figures, strong outlines, broad areas of color, and simplified modeling all help make it intelligible to a viewer looking up at it in the dim light from far below. The painters did not use the wet-plaster fresco technique favored in Italy for its long-lasting colors, but they did moisten the walls before painting, which allowed some absorption of pigments into the plaster, making them more permanent than paint applied to a dry surface. Several artists, or teams of artists, worked on the church.

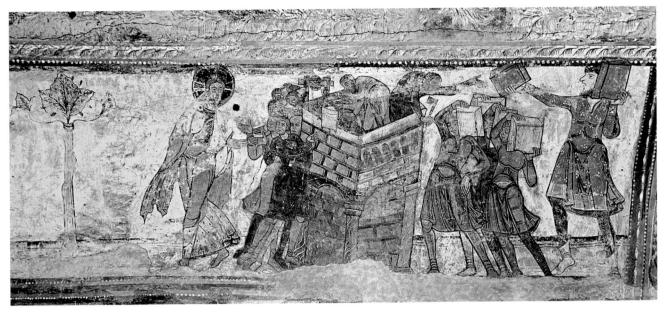

10–31 | TOWER OF BABEL

Detail of painting in nave vault, Abbey Church of Saint-Savin-sur-Gartempe, Poitou, France. c. 1115.

THE CLOISTER CRAFTS

Monastic *scriptoria* and other workshops continued to dominate the production of works of art, although more and more secular artists could be found producing high-quality pieces in the towns and in workshops attached to courts. The cloister crafts include a wide range of media from illuminated manuscripts to goldsmithing, ivory carving, and embroidery; and the designation "cloister crafts" replaces the term "decorative arts," which suggests less important work. In the Middle Ages small precious objects, as well as works in readily available material like wood, often carried profound meaning. Neither the *Mayestat Batlló* nor the *Mary as the Throne of Wisdom* can be categorized as "decorative."

Portable Sculpture

Painted wood was commonly used when abbey and local parish churches of limited means commissioned statues. Wood was not only cheap, it was lightweight, a consideration since these devotional images were frequently carried in processions.

10-32 CRUCIFIX (MAJESTAT BATLLÓ)

Catalunya, Spain. Mid-12th century. Polychromed wood, height approx. 37¾" (96 cm). Museu Nacional d'Art de Catalunya, Barcelona.

The cross was hung near the entrance or the altar and might be carried in processions.

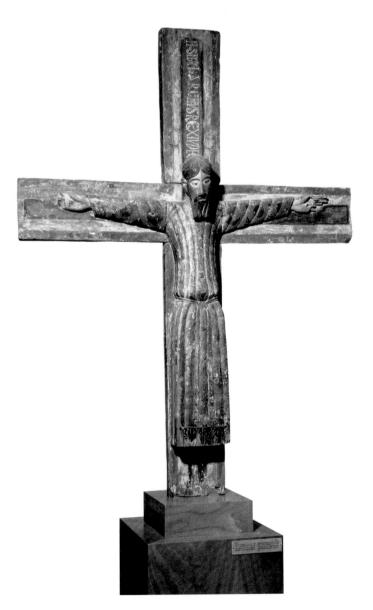

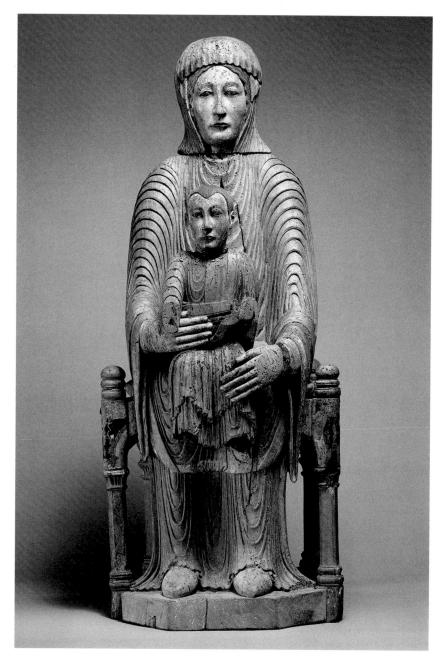

10–33 | VIRGIN AND CHILD
Auvergne region, France. Late 12th century.
Oak with polychromy, height 31"
(78.7 cm).
The Metropolitan Museum of Art,
New York.
Gift of J. Pierpont Morgan, 1916 (16.32.194)

CHRIST ON THE CROSS (*MAJESTAT BATLLÓ*). Sculptors—image makers—found sources and inspiration in Byzantine art. The image of Jesus in a mid—twelfth-century crucifix from Catalunya, known as the **MAJESTAT BATLLÓ** (FIG. 10–32), recalls the Volto Santo (Holy Face) of Lucca, thought to have been brought from Palestine to Italy in the eighth century. Legend had it that the sculpture had been carved by Nicodemus, who helped Joseph of Arimathea remove the body of Christ from the cross.

The Byzantine robed Christ, rather than the nude, tortured Jesus of Byzantine Daphni (SEE FIG. 7–43) or the Ottonian Gero Crucifix (SEE FIG. 9–29), inspired the Catalan sculptor. Christ wears royal robes that emphasize his kingship (SEE THE *Rabbula Gospels*, FIG. 7–36), although Jesus's bowed head, downturned mouth, and heavy-lidded eyes

convey a sense of deep sadness or contemplation. His long, medallion-patterned tunic has pseudo-kufic inscriptions—designs meant to resemble Arabic script—on the hem, a reminder that silks from Islamic Spain were highly prized in Europe at this time. Islamic textiles were widely used as cloths of honor hung behind thrones and around altars to designate royal and sacred places. They were used to wrap relics and to cover altars with apparently no concern for their Muslim source.

MARY AS THE THRONE OF WISDOM. Any image of Mary seated on a throne and holding the Christ Child on her lap is known as "The Throne of Wisdom." In a well-preserved example in painted wood dating from the second half of the twelfth century (FIG. 10–33), Mother and Child are frontally

THE OBJECT SPEAKS

THE BAYEUX TAPESTRY

arely has art spoken more vividly than in THE BAYEUX TAPESTRY, a strip of embroidered linen that tells the history of the Norman conquest of England. On October 14, 1066, William, Duke of Normandy, after a hard day of fighting, became William the Conqueror, king of England. The story told in embroidery is a straightforward justification of the action, told with the intensity of an eyewitness account: The Anglo-Saxon nobleman Harold initially swears his feudal allegiance to William, Duke of Normandy, but later betraying his feudal vows, he accepts the crown of England for himself. Unworthy to be king, he dies in battle at the hands of William and the Normans.

At the beginning of the Bayeux story, Harold is a heroic figure. Then events overtake him. After his coronation, cheering crowds celebrate—until a flaming star crosses the sky. (We now know that it was Halley's Comet, which appeared shortly after Harold's coronation and evidently reached astonishing brightness.) The Anglo-Saxons see the comet as a portent of disaster; the crowd cringes and gestures at this ball of fire with a flaming tail, and a man rushes to inform the new king. Harold slumps on his throne in the Palace of Westminster. He foresees what

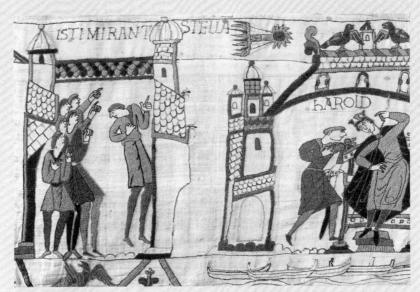

MESSENGERS SIGNAL THE APPEARANCE OF A COMET (HALLEY'S COMET), THE BAYEUX TAPESTRY Norman-Anglo-Saxon embroidery from Canterbury, Kent, England, or Bayeux, Normandy, France. c. 1066–82. Linen with wool, height 20" (50.8 cm). Centre Guillaume le Conquérant, Bayeux, France.

is to come: Below his feet is his vision of a ghostly fleet of Norman ships already riding the waves. William, Duke of Normandy, has assembled the last great Viking flotilla on the Normandy coast.

The designer was a skillful storyteller who used a staggering number of images. In the fifty surviving scenes are

more than 600 human figures; 700 horses, dogs, and other creatures; and 2,000 inch-high letters. Perhaps he or she was assisted by William's half-brother, Bishop Odo, who had fought beside William. As a man of God, he used a club, not a sword, to avoid spilling blood.

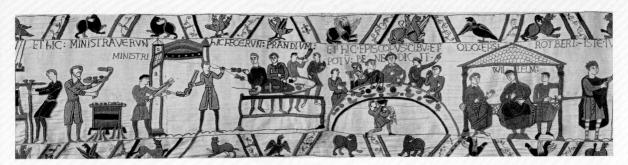

BISHOP ODO BLESSING THE FEAST, THE BAYEUX TAPESTRY

Norman-Anglo-Saxon embroidery from Canterbury, Kent, England, or Bayeux, Normandy, France. c. 1066-82. Linen with wool, height 20" (50.8 cm). Centre Guillaume le Conquérant, Bayeux, France.

Odo and William are feasting before the battle. Attendants bring in roasted birds on skewers, placing them on a makeshift table made of the knights' shields set on trestles. The diners, summoned by the blowing of a horn, gather at a curved table laden with food and drink. Bishop Odo—seated at the center, head and shoulders above William to his right—blesses the meal while others eat. The kneeling servant in the middle proffers a basin and towel so that the diners may wash their hands. The man on Odo's left points impatiently to the next event, a council of war between William (now the central and tallest figure), Odo, and a third man labeled "Rotbert," probably Robert of Mortain, another of William's half-brothers.

Translation of text: ". . . and here the servants (ministra) perform their duty. /Here they prepare the meal (prandium) / and here the bishop blesses the food and drink (cibu et potu). Bishop Odo. William. Robert."

The tragic drama has spoken to audiences over the centuries. It is the story of a good man who, like Shakespeare's *Macbeth*, is overcome by his lust for power and so betrays his king. The images of this Norman invasion also spoke to people during the darkest days of World War II. When the Allies invaded Nazioccupied Europe in June 1944, they took the same route in reverse from England to beaches on the coast of Normandy. The *Bayeux Tapestry* still speaks to us of the folly of human greed and ambition and of two battles that changed the course of history.

EMBROIDERY

The Bayeux Tapestry is really embroidery, not tapestry. In tapestry, colored threads are woven to form the image or pattern; embroidery consists of stitches applied to a woven ground. The embroiderers, probably Anglo-Saxon women, worked in tightly twisted wool that was dyed in eight colors. They used only two stitches: the quick, overlapping stem stitch that produced a slightly jagged line or outline, and the time-consuming laid-and-couched work used to form blocks of color. The embroiderer first "laid" a series of long, parallel covering threads; then anchored them with a second layer of regularly spaced crosswise stitches; and finally tacked all the strands down with tiny "couching" stitches. Some of the laid-andcouched work was done in contrasting colors to achieve particular effects. Some of the coloring was fanciful; for example, some horses have legs in four different colors. Skin and other light-toned areas were represented by the bare linen cloth that formed the ground of the work. The embroiderers of the Bayeux Tapestry probably followed drawings provided by a Norman, who may have been an eyewitness to some of the events depicted.

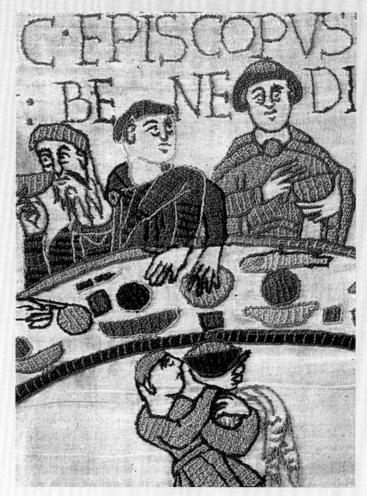

DETAIL, BISHOP ODO BLESSING FEAST, THE BAYEUX TAPESTRYNorman-Anglo-Saxon embroidery from Canterbury, Kent, England, or Bayeux, Normandy, France. c. 1066–82. Linen with wool, embroidery, height 20" (50.8 cm). Centre Guillaume le Conquérant, Bayeux, France.

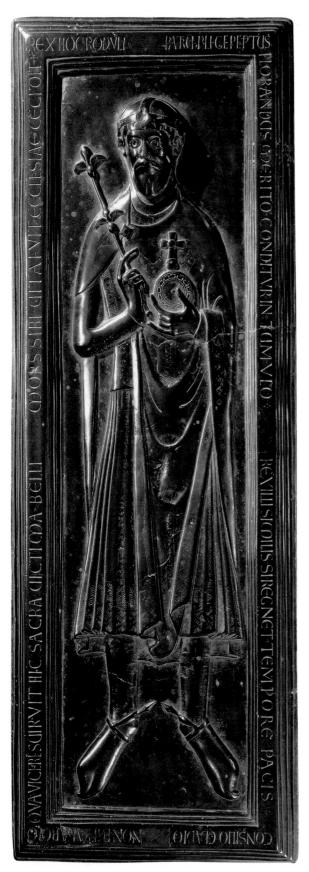

10−34 | TOMB COVER WITH EFFIGY OF RUDOLF OF SWABIA

Saxony, Germany. c. 1080. Bronze with niello, approx. $6'5\% \times 2'2\%''$ (1.97 \times 0.68 m). Cathedral of Merseburg, Germany.

erect, as rigid as they are regal. Mary's thronelike bench symbolized the lion-throne of Solomon, the Old Testament king who represented earthly wisdom in the Middle Ages. Mary, as Mother and "God-bearer" (the Byzantine Theotokos), gave Jesus his human nature. She forms a throne on which he sits in majesty. She also represents the Church. Although the Child's hands are missing, we can assume that the small but adult Jesus held a book—the Word of God—in his left hand and raised his right hand in blessing.

A statue of the Virgin and Child, like the sculpture here, could have played a role in the liturgical dramas being added to church services at that time. At the Feast of the Epiphany, which in the Western Church celebrates the arrival of the Magi to pay homage to the baby Jesus, participants representing the Magi acted out their journey by searching through the church for the newborn king. The roles of Mary and Jesus were "acted" by the sculpture, which the Magi discovered on the altar. In such simple ways theater and the performing arts returned to the West.

Metalwork

Three geographical areas—the Rhineland, the Meuse River valley, and German Saxony—continued to supply the best metalwork for aristocratic and ecclesiastical patrons. Metalworkers in these areas drew on a variety of stylistic sources, including the work of contemporary Byzantine and Italian artists, as well as classical precedents as reinterpreted by their Carolingian and Ottonian forebears.

Tomb of Rudolf of Swabia. In the late eleventh century, Saxon metalworkers, already known for their large-scale bronze casting, began making bronze tomb effigies (portraits of the deceased). The oldest known bronze tomb effigy is that of King Rudolf of Swabia (Fig. 10–34), who died in battle in 1080, having sided with the pope against the emperor during the Investiture Controversy. The spurs on his oversized feet identify him as a heroic warrior, and he holds a scepter and cross-surmounted orb, emblems of Christian kingship. Although the tomb is in the Cathedral of Merseburg, in Saxony, the effigy has been attributed to an artist originally from the Rhine Valley. Nearly life-size, it has fine linear detailing in niello, an incised design filled with a black alloy. The king's head has been modeled in high relief and stands out from his body like a detached shield.

REINER OF HUY. Renier of Huy (Huy is near Liège in present-day Belgium) worked in the Mosan region under the profound influence of ancient art as interpreted by Carolingian and Byzantine forebears. He was also influenced by the humanistic learning of Church scholars. Liege was called the "Athens of the North." Artists like Renier created a style that seems classical in its depiction of human figures with dignity, simplicity, and harmony (FIG. 10–35). Between 1107 and 1118 he cast a

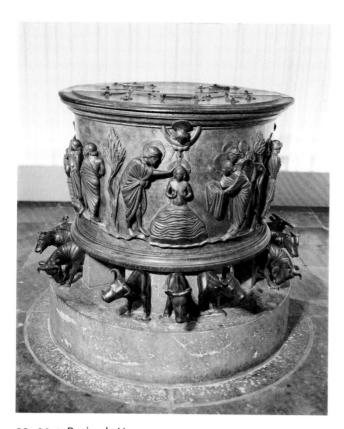

10–35 | Renier de Huy BAPTISMAL FONT, NOTRE-DAME-AUX-FONTES Liege, France. 1107–18. Bronze, Height, 23 ½" (60 cm); diameter, 31¼" (79 cm). Now in the Church of St. Barthelemy, Liège.

bronze baptismal font for Notre-Dame-aux-Fonts in Liège (now in the Church of Saint Barthelemy) that was inspired by the basin carried by twelve oxen in Solomon's Temple in Jerusalem (I Kings 7:23-24). Christian philosophers identified the twelve oxen as the twelve apostles and the basin as the baptismal font. On the sides of the font, Renier placed images of Saint John the Baptist, preaching and baptizing Christ, Saint Peter baptizing Cornelius, and Saint John the Evangelist baptizing the philosopher Crato. Renier constructs sturdy idealized bodies-nude or with clinging drapery-that move and gesture with convincing reality. His intuitive understanding of anatomy required close observation of the people around him. These figures also convey a sense of space, however shallow, where landscape is reduced to rippling ground lines, a few miniature trees used to separate the scenes, and waves of water rising (in Byzantine fashion) to discreetly cover nude figures. Renier's bronze sculptures demonstrate the survival of a classical and humanistic art in northern Europe.

Illustrated Books

Illustrated books played a key role in the transmission of artistic styles and other cultural information from one region to another. The output of books increased dramatically in the

Sequencing Works of Art PAINTING IN TWELFTH-CENTURY EUROPE

Early 12th century	The Nun Guda, <i>Book of Homilies</i> , Westphalia, Germany
c. 1100	Tower of Babel, Abbey Church of Saint-Savin-sur-Gartempe, Poitou, France
c. 1123	Christ in Majesty, Church of San Climent, Taull, Catalunya, Spain
c. 1125	Tree of Jesse from the Commentary on Isaiah, Abbey of Cîteaux, Burgundy, France
c. 1150	The Mouth of Hell, Winchester Psalter, Winchester, England

twelfth century, despite the labor and materials involved. Monastic and convent *scriptoria* continued to be the centers of production. The *scriptoria* sometimes also employed lay scribes and artists who traveled from place to place. In addition to the books needed for the church services, scribes produced scholarly commentaries, lives of saints, collections of letters, and even histories (SEE FIG. 10–2). Liturgical works were often large and lavish; other works were more modest, their embellishment confined to initial letters.

SAINT MATTHEW IN THE CODEX COLBERTINUS. The portrait of Saint Matthew from the **CODEX COLBERTINUS**, in contrast to the Hiberno-Saxon and Carolingian author portraits, is an entirely Romanesque conception. Like the sculptured pier figures of Silos (SEE FIG. 10–1), he stands within an architectural frame that controls his size and form (FIG. 10–36). A compact figure, he blesses and holds his book—rather than writing it. His dangling feet bear no weight. Blocks of color fill in outlines without giving the figure any three-dimensional quality. The evangelist is almost part of the text—the opening lines *Liber Generationes*.

The L of *Liber* (Book) is formed of plants and animals and is called a historiated initial. The L established the size and shape of the figurative panel, just as the architectural elements controlled the figures and composition in historiated capitals. The geometric underpinnings are filled with acanthus leaves and interlacing vines. Dogs or catlike animals and long-necked birds twist, claw, and bite each other and themselves while, in the center, two humans—one dressed and one nude—clamber up the letter. This manuscript was made in the region of Moissac at about the same time that sculptors were working on the abbey church.

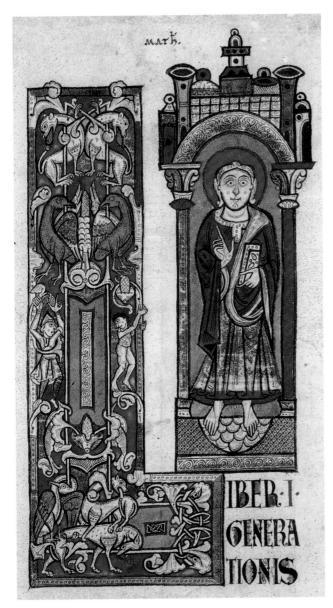

10-36 ST. MATTHEW, FROM THE CODEX COLBERTINUS c. 1100. Tempera on vellum, $7\,\% \times 4''$ (19 \times 10.16 cm). Bibliothèque National Paris.

THE GERMAN NUN GUDA. In another historiated initial, this one from Westphalia in Germany, the nun Guda has a more modest role. In a book of homilies (sermons), she inserted her self-portrait into the letter D and signed it as scribe and painter, "Guda, the sinful woman, wrote and illuminated this book" (FIG. 10-37). A simple drawing with a little color in the background, Guda's self-portrait is certainly not a major work of art. Its importance lies in its demonstration that women were far from anonymous workers in German scriptoria in the Romanesque period. Guda's image is the earliest signed self-portrait by a woman in Western Europe. Throughout the Middle Ages, women were involved in the production of books as authors, scribes, painters, and patrons.

THE HELLMOUTH IN THE WINCHESTER PSALTER. Religious texts dominated the work of the scriptorium. The WINCHESTER PSALTER, commissioned by the English king's brother, Henry of Blois, the Bishop of Winchester, contains a dramatic image of hell (FIG. 10-38). The page depicts the gaping jaws of hell, a monstrous head with dragons sprouting from its mane. Hell is filled with a tangled mass of sinners, among whom are kings and queens with golden crowns and monks with shaved heads, a daring reminder to powerful rulers and the clergy of the vulnerability of their own souls. Hairy, horned demons torment the lost souls, who tumble around in a dark void. An impassive and very elongated angel locks the door.

This vigorous narrative style had its roots in the Carolingian art of the Utrecht Psalter (SEE FIG. 9-18), a manuscript which was then in an English monastic library. Here, by comparison, the free pen work of the Utrecht Psalter has become controlled and hard. The composition of the intricate interlocking forms is carefully worked out using strong framing devices. For all its vicious energy, the page seems dominated by the ornamental frame.

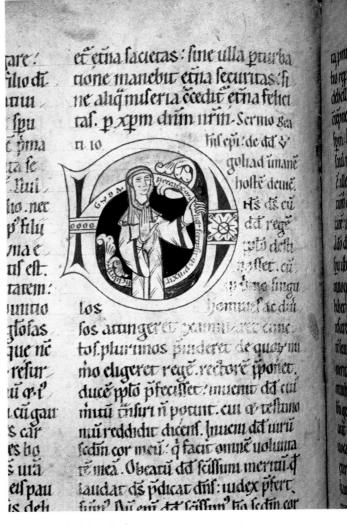

10-37 The Nun Guda BOOK OF HOMILIES West, Germany. Early 12th century. Ink on parchment. Stadtund Universitäts-Bibliothek, Frankfurt, Germany. MS. Barth. 42, folio 110v

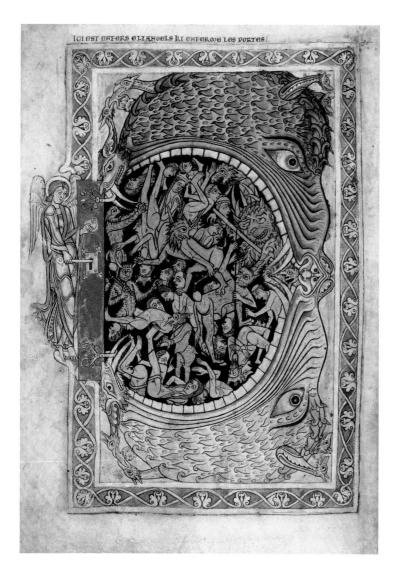

10-38 | The mouth of hell, winchester psalter

Winchester, England. c. 1150. Ink and tempera on vellum, $12\frac{1}{4} \times 9\frac{1}{8}$ " (32.5 \times 23 cm). The British Library, London.

The inscription reads: "Here is hell and the angels who are locking the doors."

There are fascinating parallels between the images of the mouth of Hell and the liturgical dramas—known in English as "mystery plays"—that were performed throughout Europe from the tenth through the sixteenth century. On stage, voracious Hellmouth props featured prominently, to the delight of audiences. Carpenters made the infernal beast's head out of wood, papier-mâché, fabric, and glitter and placed it over a trapdoor onstage. The wide jaws of the most ambitious Hellmouths, operated by winches and cables, opened and closed on the actors while emitting smoke, flames, foul smells, and loud noises. Hell scenes, with their often scatological humor, were by far the most popular parts of the plays.

Cistercian Devotion to Mary, The Tree of Jesse. The Cistercians were particularly devoted to the Virgin and are also credited with popularizing themes such as the Tree of Jesse as a device for showing her position as the last link in the genealogy connecting Jesus Christ to King David. (Jesse, the father of King David, was an ancestor of Mary and, through her, of Jesus.) Saint Jerome's **COMMENTARY ON ISA-IAH**, a manuscript made in the *scriptorium* of the Cistercian

mother house at Cîteaux about 1125, contains an image known as the **TREE OF JESSE** (FIG. 10–39).

A monumental Mary, standing on the forking branches of the tree, dwarfs the sleeping patriarch, Jesse, a small tree trunk grows from his body. The Christ Child sits on her veiled right arm. The elongated but still human figure of Mary, emphasized by the vertical lines and V-shaped folds of the drapery and the soft colors, suggests a new sense of humanity. The artist has drawn, rather than painted, with colors, the subtle tints creating an image in keeping with Cistercian restraint. Following late Byzantine and Romanesque convention, Christ is portrayed as a miniature adult with his right hand raised in blessing. His cheek presses against Mary's, a display of affection similar to that shown in Byzantine icons of the time, like the *Virgin of Vladimir* (SEE FIG. 7–39). Mary holds a flowering sprig from the tree—another symbol for Christ.

The building held by the angel on the left equates Mary with the Church, and the crown held by the angel on the right is hers as Queen of Heaven. The dove above her halo represents the Holy Spirit. The jeweled hems of Mary's robes reflect her elevated status as Queen of Heaven. In the early decades of the twelfth century, Church doctrine came

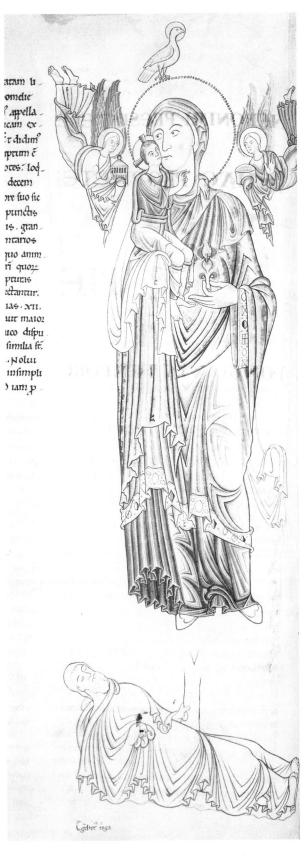

IO-39 | PAGE WITH THE TREE OF JESSE, EXPLANATIO IN ISAIAM (SAINT JEROME'S COMMENTARY ON ISAIAH) Abbey of Cîteaux, Burgundy, France. c. 1125. Ink and tempera on vellum, $15 \times 4\%$ (38 \times 12 cm). Bibliothèque Municipale, Dijon, France. MS 129, fol. 4v

increasingly to stress the role of the Virgin Mary and the saints as intercessors who could plead for mercy on behalf of repentant sinners, and devotional images of Mary became increasingly popular during the later Romanesque period.

IN PERSPECTIVE

Wiligelmus, Roger, Gislebertus, Guda, and many anonymous women and men of the eleventh and twelfth centuries created a new art that—although based on the Bible and the lives of the saints—focused on human beings, their stories, and their beliefs. The artists worked on a monumental scale in painting, sculpture, and even embroidery, and their art moved from the cloister to the public walls of churches.

The sheer size of churches, the austere majesty of their towers, their interior spaces often covered with masonry vaults, their marvelously functional plans and elevations reflect a culture that saw the church as not only the Heavenly Jerusalem but as a bulwark against the ever-present demonic forces of evil. Equally mighty castle walls stood against actual earthly enemies. A source of local and even regional pride, the cathedral, monastic church, or castle required the most creative and highest quality work, and rulers and communities contributed material resources and labor.

Many Romanesque churches have a remarkable variety of painting and sculpture. Christ enthroned in majesty may be carved over the entrance or painted in the half-dome of the apse. Scenes from the life of Christ or images of the lives and the miracles of the saints cover the walls. Romanesque art also reflects the increasing importance accorded to the Virgin Mary. The elect rejoice in heaven; the damned suffer in hell. A profusion of monsters, animals, plants, geometric ornament, and depictions of real and imagined buildings fill the spaces. While the artists emphasized the spiritual and intellectual concerns of the Christian Church, they also began to observe and record what they saw around them. In so doing they laid the groundwork for the art of the Gothic period.

CATHEDRAL COMPLEX,
PISA
CATHEDRAL BEGUN 1063

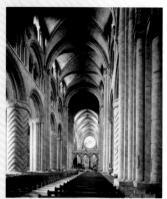

DURHAM CATHEDRAL,NAVE
1087-1133

TRUMEAU SOUTH PORTAL,
MOISSAC
C. 1115

CRUCIFIX (MAJESTAT BATLLÓ)
MID 12TH CENTURY

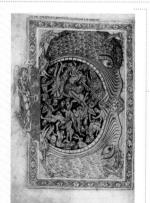

THE MOUTH OF HELL, WINCHESTER PSLATER C. 1150

ROMANESQUE ART

1050

- Henry IV Rules Germany and Holy Roman Empire 1056-1106
- William of Normandy Invades England c. 1066
- Investiture Controversy c. 1075
- First Crusade 1095-99
 Cistercian Order Founded 1098

1120

- Eleonor of Aquitaine Queen of France with Louis VII 1137-52
- Hildegard of Bingen Writes Scivias c. 1141-1151
- Second Crusade 1147-49

■ Eleanor of Aquitaine Queen of England with Henry II 1154-1189

IISC

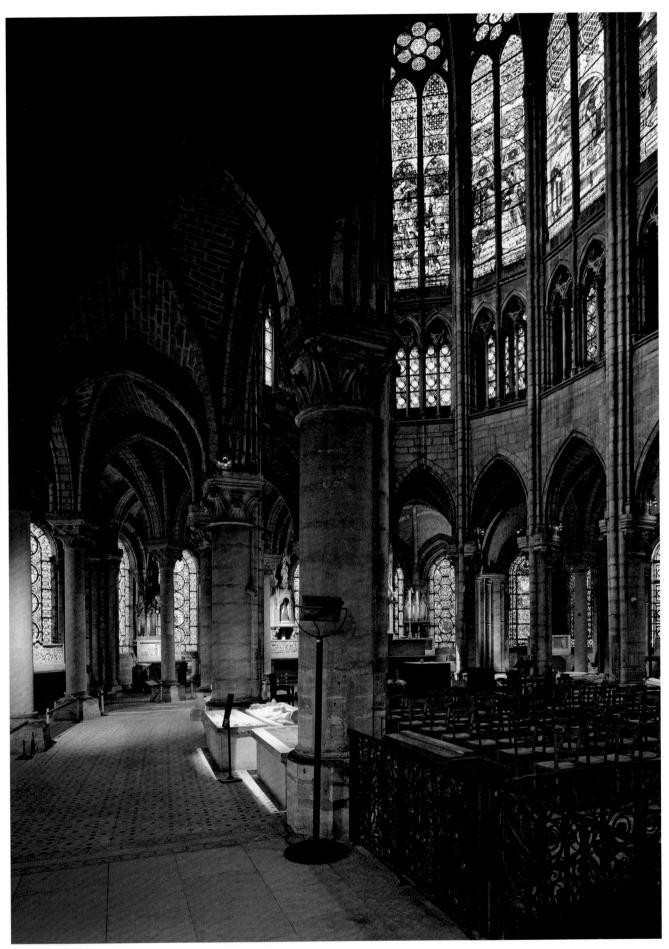

II-I | INTERIOR, ABBEY CHURCH OF SAINT-DENIS, CHOIR France. 1140-44; 1231-81.

CHAPTER ELEVEN

GOTHIC ART OF THE TWELFTH AND THIRTEENTH CENTURIES

The twelfth-century Abbot Suger of Saint-Denis (1081–1151) was, according to his biographer Willelmus, "small of body and family, constrained by twofold smallness, [but] he refused, in his smallness, to be a small man"

11

(cited in Panofsky, page 33). Educated at the monastery of Saint-Denis, near Paris, he became a powerful and trusted adviser to kings Louis VI and Louis VII. Suger governed France as regent when Louis VII and Eleanor of Aquitaine were absent from France during the Second Crusade (1147–49). He also built what many consider the first Gothic church in Europe.

After Suger was elected abbot of Saint-Denis, he was determined to build a new church to replace the old Carolingian one. He waged a successful campaign to gain both royal and popular support for his rebuilding plans. The old building, he pointed out, had become inadequate. With a touch of exaggeration, he claimed that the crowds of worshipers had become so great that women were being crushed and monks sometimes had to flee with their relics by jumping through windows.

The abbot had traveled widely—in France, the Rhineland, and Italy, including four trips to Rome—and so he was familiar with the latest architecture and sculpture of Romanesque Europe. As he began planning the new church,

he also turned for inspiration to books in the monastery's library, including the writings of a late fifth-century Greek philosopher known as the Pseudo-Dionysius, who had identified radiant light with divinity (see "Abbot Suger on the

Value of Art," page 386). Seeing the name "Dionysius," Suger thought he was reading the work of Saint Denis, also known as Dionysius the Aeropagite, the first-century convert of Saint Paul (Acts 17:34). Not unreasonably, he adapted the concept of divine luminosity into the redesign of the church dedicated to Saint Denis. In the choir of the new church, he created "a circular string of chapels by virtue of which the whole [church] would shine with the wonderful and uninterrupted light of most luminous windows, pervading the interior beauty" (cited in Panofsky, page 101).

Although Abbot Suger died before he was able to finish rebuilding Saint-Denis, his presence remained: The cleric had himself portrayed in a sculpture at Christ's feet in the central portal and in a stained-glass window in the apse. Suger is remembered not for these portraits, however, but for his inspired departure from traditional architecture in order to achieve a flowing interior space and an all-pervasive, colored interior light. His innovation led to the widespread use of large stained-glass windows that bathed the inside walls of French churches with sublime washes of color (FIG. 11–1).

- THE EMERGENCE OF THE GOTHIC STYLE | The Rise of Urban Life | The Age of Cathedrals | Scholasticism and the Arts
- GOTHIC ART IN FRANCE | Early Gothic Architecture | From Early to High Gothic: Chartres Cathedral | High Gothic: Amiens and Reims Cathedrals | High Gothic Sculpture | The Rayonnant Style | Illuminated Manuscripts
- GOTHIC ART IN ENGLAND | Manuscript Illumination | Architecture
- GOTHIC ART IN GERMANY AND THE HOLY ROMAN EMPIRE | Architecture | Sculpture
- GOTHIC ART IN ITALY | Sculpture: The Pisano Family | Painting
- IN PERSPECTIVE

THE EMERGENCE OF THE GOTHIC STYLE

In the middle of the twelfth century, a distinctive new architecture known today as Gothic emerged in the Île-de-France, the French king's domain around Paris (MAP 11-1). The appearance there of a new style and building technique coincided with the emergence of the monarchy as a powerful centralizing force in France. Soon, the Gothic style spread throughout Western Europe, gradually displacing Romanesque forms while taking on regional characteristics inspired by those forms. The term Gothic was first used by Italians in the fifteenth and the sixteenth centuries when they disparagingly attributed the style to the Goths, the Germanic invaders who had destroyed the classical civilization of the Roman Empire that they so admired. In its own day the Gothic style was simply called the "modern" style or the "French" style.

Gothic architecture sought to express the aspiration for divinity through a quest for height and luminosity. Its soaring stonework and elegance of line, and the light, colors, and sense of transparency produced by its great expanses of glass—all became more pronounced over time. The style was adapted to all types of structures—including town halls, meeting houses, market buildings, residences, synagogues, and palaces—and its influence extended beyond architecture and architectural sculpture to painting and other mediums.

The Rise of Urban Life

The Gothic period was an era of both communal achievement and social change. Although Europe remained rural, towns gained increasing prominence. Some cities were freed from obligations to local feudal lords, and, as protected centers of commerce, became sources of wealth and power for the king. Intellectual life was also stimulated by the interaction of so many people living side by side. Universities in Bologna, Padua, Paris, Cambridge, and Oxford supplanted rural monastic schools as centers of learning. Brilliant teachers like Peter Abelard (1079–1142) drew crowds of students, and in the thirteenth century a Dominican professor from Italy, the theologian Thomas Aquinas (1225–74), made Paris

the intellectual center of Europe. This period saw the flowering of poetry and music as well as philosophy and theology.

As towns grew, they became increasingly important centers of artistic patronage. The production and sale of goods in many towns was controlled by **guilds**. Merchants and artisans of all types, from bakers to painters, formed these associations to advance their professional interests. Medieval guilds also played an important social role, safeguarding members' political interests, organizing religious celebrations, and looking after members and their families in times of trouble.

A town's walls enclosed streets, wells, market squares, shops, churches, and schools. Homes ranged from humble wood-and-thatch structures to imposing town houses of stone. Although wooden dwellings crowded together made fire an ever-present danger and although hygiene was rudimentary at best, towns fostered an energetic civic life. This strong communal identity was reinforced by public projects and ceremonies.

The Age of Cathedrals

Urban cathedrals, the seats of the ruling bishops, superseded rural monasteries as centers of religious patronage. So many of these churches were rebuilt between 1150 and 1400often after fires-that the period has been called the "Age of Cathedrals." Cathedral precincts functioned almost as towns within towns. The great churches dominated their surroundings and were central fixtures of urban life (SEE FIG. 11-8). Their grandeur inspired admiration; their great expense and the intrusive power of their bishops inspired resentment. In the twelfth century, the laity experienced a decisive growth in religious involvement. In the early thirteenth century members of two new religious orders, the Franciscans and the Dominicans, known as mendicants (beggars) because they were meant to be free of wordly goods, went out into the world to preach and to minister to those in need, rather than secluding themselves in monasteries. (see "The Mendicant Orders: Franciscans and Dominicans" page 394).

Scholasticism and the Arts

The Crusades—which continued throughout the thirteenth century—and the trade that followed these military ventures

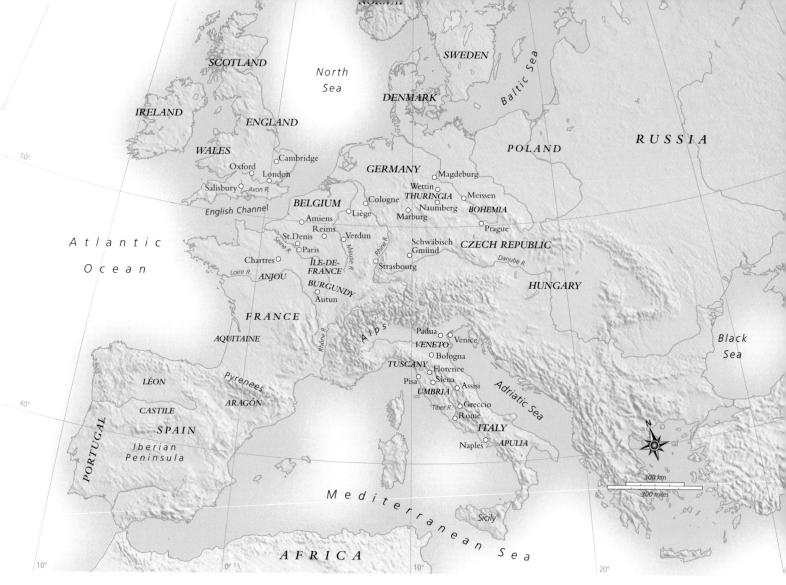

MAP II-I | EUROPE IN THE GOTHIC ERA

The Gothic period witnessed the emergence of England, France, Portugal, and Spain (Castile) as nations, while the pope wielded political as well as religious power throughout the West. The residents of cities rose to challenge the power of landed nobility.

brought Western Europeans into contact with the Byzantine and Islamic worlds, where—unlike in the West—literary works of classical antiquity had been preserved. The "rediscovery" of these works, particularly the philosophy of Aristotle, posed a challenge to Christian theology because they promoted rational inquiry rather than faith as the path to truth, and their conclusions did not always suit Church doctrine.

A system of reasoned analysis known as Scholasticism emerged to reconcile Christian theology with classical philosophy. Scholastic thinkers used a question-and-answer method of argument and arranged their ideas into logical outlines. Thomas Aquinas, the foremost Scholastic, applied Aristotelian logic to comprehend religion's supernatural aspects. His great philosophical work, the Summa Theologica, which attempted to reconcile rationalism with religious faith, has endured as a basis of Catholic thought to this day. Scholastic thinkers applied reasoned analysis to a vast range of subjects. Vincent de Beauvais, a thirteenth-century Parisian Dominican, organized his eighty-volume encyclopedia, the Speculum Maius (Greater Mirror), in which he intended to

encompass all human knowledge, into four categories: the Natural World, Doctrine, History, and Morality.

This all-pervasive intellectual approach had a profound influence on the arts. Like the philosophers, master builders saw divine order in geometric relationships and used these relationships as the underpinnings of architectural and sculptural programs. Sculptors and painters created naturalistic forms that reflected the combined idealism and analysis of Scholastic thought. Gothic religious imagery expanded to incorporate a wide range of subjects from the natural world, and like Romanesque imagery its purpose was to instruct and convince the viewer. In the Gothic cathedral, Scholastic logic intermingles with the mysticism of light and color to create for the worshiper the direct, emotional, ecstatic experience of the church as the embodiment of God's house, filled with divine light.

GOTHIC ART IN FRANCE

The initial flowering of the Gothic style took place in France against the backdrop of the growing power of the French Capetian monarchy. Louis VII (ruled 1137–80) and Philip

Art and Its Context

ABBOT SUGER ON THE VALUE OF ART

rom *De administratione*, Ch. XXVII, Of the Cast and Gilded Doors:

Bronze casters having been summoned and sculptors chosen, we set up the main doors on which are represented the Passion of the Saviour and His Resurrection, or rather Ascension, with great cost and much expenditure for their gilding as was fitting for the noble porch. . . .

The verses on the door are these:

Whoever thou art, if thou seekest to extol the glory of these doors,

Marvel not at the gold and the expense but at the craftsmanship of the work, Bright is the noble work; but being nobly bright, the work Should lighten the minds, so that they may travel, through the true lights,

To the True Light where Christ is the true door, In what manner it be inherent in this world the golden door defines:

The dull mind rises to truth through that which is material And, in seeing this light, is resurrected from its former subversion.

Panofsky, Erwin. Abbot Suger on the Abbey Church of St.-Denis and its Art Treasures. 2nd ed. By Gerda Panofsky-Soergel. Princeton, NJ: Princeton University Press, 1979, pp. 47; 49.

Augustus (ruled 1180–1223) consolidated royal authority in the Île-de-France and began to exert control over powerful nobles in other regions. Before succeeding to the throne, Louis VII had married Eleanor of Aquitaine (heiress to all southwestern France). When the marriage was annulled, Eleanor took her lands and married Henry Plantagenet—count of Anjou, Duke of Normandy—who became King Henry II of England. The resulting tangle of conflicting claims kept France and England at odds for centuries. Through all the turmoil, the French kings continued to consolidate royal authority and to increase their domains and privileges at the expense of their vassals and the Church.

Early Gothic Architecture

The political events of the twelfth and thirteenth centuries were accompanied by energetic church building, often made necessary by the fires that constantly swept through towns. It has been estimated that during the Middle Ages several million tons of stone were quarried to build some eighty cathedrals, 500 large churches, and tens of thousands of parish churches and that within a hundred years some 2,700 churches were built in the Île-de-France region alone. This explosion of building began at a historic abbey church on the outskirts of Paris.

The Abbey Church of Saint-Denis. The Benedictine monastery of Saint-Denis, a few miles north of central Paris, had great symbolic significance for the French monarchy (SEE FIG. 11–1). It housed the tombs of the kings of France and their courts, regalia of the French Crown, and the relics of Saint Denis, the patron saint of France, who, according to tradition, had been the first bishop of Paris. In the 1130s, under the direction of Abbot Suger, construction began on a new abbey church (FIG. 11–2).

Suger described his administration of the abbey and the building of the Abbey Church of Saint-Denis in three books (see "Abbot Suger on the Value of Art," above). Suger prized magnificence. Having traveled widely, he combined design ideas from many sources. Suger invited masons and sculptors from other regions, making his abbey a center of artistic exchange. (Unfortunately, Suger did not record the names of the masters he employed, nor did he give information about them.) For the rebuilding, he received substantial annual revenues from the town's inhabitants, and he established free housing on abbey estates to attract peasant workers. For additional funds, he turned to the royal coffers and fellow clerics.

Suger began the rebuilding in 1135, with a new west façade and narthex (SEE FIG. 11–2). The design combined a Norman tripartite façade design, as seen in the abbey church in Caen (SEE FIG. 10–23), with sculptured portals like those at Autun (SEE FIG. 10–28). Two towers, a round window, and narrative sculpture over not one but three portals completed the magnificent composition. Within the narthex Suger's masons built highly experimental ribbed groin vaults over both square and rectangular bays (see "Rib Vaulting," page 391). (Much of the sculpture was destroyed or damaged in the eighteenth century, and the north tower had to be removed after it was struck by lightning in the nineteenth century.)

Suger's renovation of the choir at the east end of the church represented an equally momentous departure from the Romanesque style (SEE FIG. 11–1). Completed in three years and three months (1140–44), timing that the abbot found auspicious, the choir resembled a pilgrimage church, with a semicircular sanctuary surrounded by an ambulatory and seven radiating chapels (FIG. II–3). Its large stained-glass windows, however, were new. While all the architectural elements of the choir—ribbed groin vaults springing from

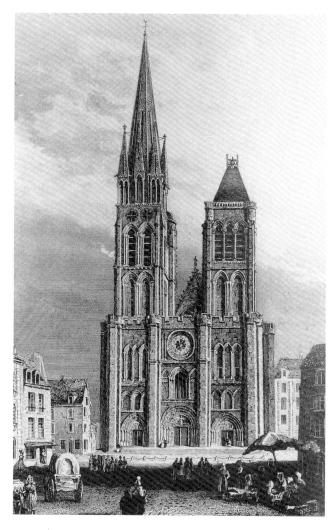

II—2 WEST FAÇADE, ABBEY CHURCH OF SAINT-DENIS France. 1135–44, engraving made before 1837.

round piers, pointed arches, wall buttresses to relieve stress on the walls, and adequate window openings—had already appeared in Romanesque buildings, the achievement of Suger's master mason was to combine these into a fully integrated architectural whole. Sanctuary, ambulatory, and chapels open into one another to create a feeling of open, flowing space. Walls of stained glass replace masonry, permitting colored light to permeate the interior. These effects rely on the masterful use of vaulting techniques, the culmination of half a century of experiment and innovation.

The choir of Saint-Denis represented a new architectural aesthetic based on open spaces rather than massive walls. Suger considered light and color to be a means of illuminating the soul and uniting it with God. For him, the colored lights of stained-glass windows, like the glint of gems and gold in the chalice he gave to his church transfixed the world with the splendor of Paradise

Louis VII and Eleanor of Aquitaine attended the consecration of the new choir on June 14, 1144. Shortly thereafter the Second Crusade became the primary recipient of royal resources, leaving Suger without funds to replace the old nave and transept at Saint-Denis. After Suger died in 1151, his church remained unfinished for another century (see page 406).

The Abbey Church of Saint-Denis became the prototype for a new architecture of space and light based on a highly adaptable skeletal framework constructed from buttressed perimeter walls and pointed arch interior vaulting with masonry ribs. It initiated a period of competitive experimentation in France that resulted in ever larger churches, enclosing increasingly taller interior spaces, walled with ever greater expanses of colored glass. These great churches, with their unabashed decorative richness, were part of Abbot Suger's legacy to France.

AN EARLY GOTHIC CATHEDRAL: NOTRE DAME OF PARIS. The Cathedral of Paris, known simply as Notre Dame ("Our Lady," the Virgin Mary), bridges the period between Abbot Suger's rebuilding of his abbey church and the High Gothic

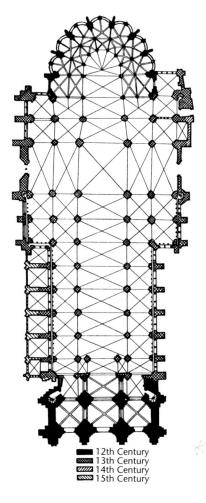

II-3 | ABBEY CHURCH OF SAINT-DENIS, PLAN West façade 1135-40; choir 1140-44; nave 1231-81.

II—4 | CATHEDRAL OF NOTRE-DAME, PARIS
Begun 1163; choir chapels, 1270s; crossing spire, 19th-century replacement. View from the south.

cathedrals of the thirteenth century (FIG. 11–4). As the city and royal court grew, Paris needed a larger cathedral. According to tradition, in 1163, Pope Alexander II laid the cornerstone of a new church.

The nave, with its massive walls and buttresses and sixpart vaults adopted from Norman Romanesque architecture (SEE FIG. 10-19), dates to 1180-1200. The nave had four stories: an arcade surmounted by a gallery and two levels of rather small windows, including both lancets and round "bull's eye" windows (SEE FIG. 11-12). To increase the window size and secure the vault, the builders built the first true flying buttresses. The flying buttress, a gracefully arched, skeletal exterior support, counters the outward thrust of the nave vault by carrying the weight over the side aisles to the ground (see "Rib Vaulting," page 391). Although the nave was huge, it must have seemed very old fashioned by the thirteenth century. After 1225, new masters modernized the building by reworking the two upper levels into the large clerestory windows we see today. The huge flying buttresses rising dramatically to support the 115-foot high vault at Notre Dame are the result of later remodeling. (The 290-foot spire over the crossing is the work of the nineteenth-century architect Eugène-Emmanuel Viollet-le-Duc.)

From Early to High Gothic: Chartres Cathedral

The structural techniques and new conception of space applied at Saint-Denis and Notre Dame in Paris were taken one step further at Chartres Cathedral. It is here that the transition from Early to High Gothic is most eloquently expressed. The great Cathedral of Notre-Dame in Chartres dominates this town southwest of Paris (SEE FIG. 11–8 and "The Gothic Church," page 392). For many people, Chartres Cathedral is a near-perfect embodiment of the Gothic spirit in stone and glass. Constructed in several stages beginning in the mid-twelfth century and extending into the mid-thirteenth, with additions such as the north spire as late as the sixteenth century, the cathedral reflects the transition from an experimental twelfth-century architecture to a mature thirteenth-century style.

FOUR HUNDRED YEARS AT CHARTRES. Chartres was the site of a pre-Christian virgin-goddess cult, and later, dedicated to the Virgin Mary, it became one of the oldest and most important Christian shrines in France. Its main treasure was a piece of linen believed to have been worn by Mary when she gave birth to Jesus. The so-called Tunic of the Virgin was a gift from the Byzantine Empress Irene to Charlemagne, whose grandson, Charles the Bald, donated it to the church in 876. The relic was kept below the high altar in a huge basement crypt. The healing powers attributed to the cloth made Chartres a major pilgrimage destination, especially as the cult of the Virgin grew in popularity in the twelfth and thirteenth centuries.

The theologians of Chartres tried to present all of Christian history in the sculpture and stained glass of their cathedral. On the west, in the Royal Portal, the sculpture is dedicated to Christ (FIG. 11–5). The north transept portal and the stained glass above it depict the world before Christ, with Saint Anne and the Virgin Mary. On the south transept, the

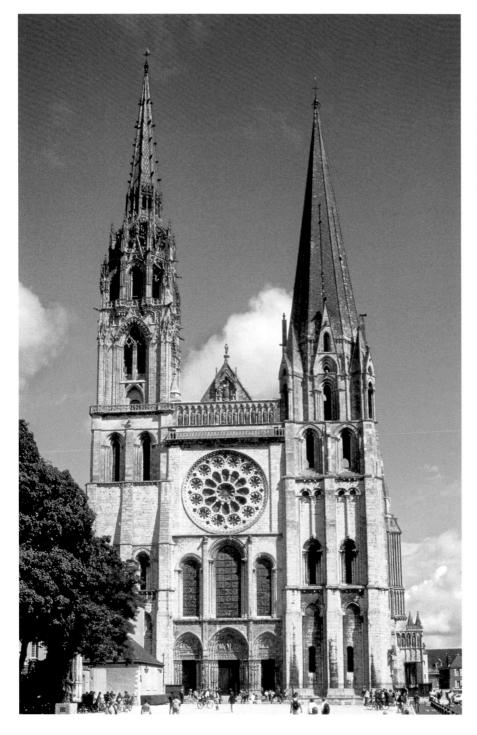

II-5 | WEST FAÇADE, CHARTRES CATHEDRAL (THE CATHEDRAL OF NOTRE-DAME)

Chartres, France. West façade begun c. 1134; cathedral rebuilt after a fire in 1194; building continued to 1260; north spire 1507-13.

viewers learn of later events in Christian history, including the lives of the saints and the Last Judgment.

Chartres' decoration also encompasses number symbolism. The number three represents the spiritual world of the Trinity, while the number four represents the material world (the four winds, the four seasons, the four rivers of Paradise). Combined, they form the perfect and all-inclusive number seven, expressed in the seven gifts of the Holy Spirit. References to three, four, and seven recur throughout the cathedral imagery. On the west façade, for example, the seven liberal arts surround the image of Mary and Jesus.

THE ROYAL PORTAL. From a distance, the most striking features of the west façade, constructed after a fire in 1134, are its prominent rose window—a huge circle of stained glass—and two towers with their spires. But up close, the western façade's three doorways—the so-called Royal Portal, inspired by the portal of the Church of Saint-Denis—capture the attention with their sculpture.

In the center of the west façade, on the central tympanum, Christ is enthroned in royal majesty with the four evangelists (FIG. 11–6). He appears imposing but more benign than at Autun. The apostles, organized into four groups of

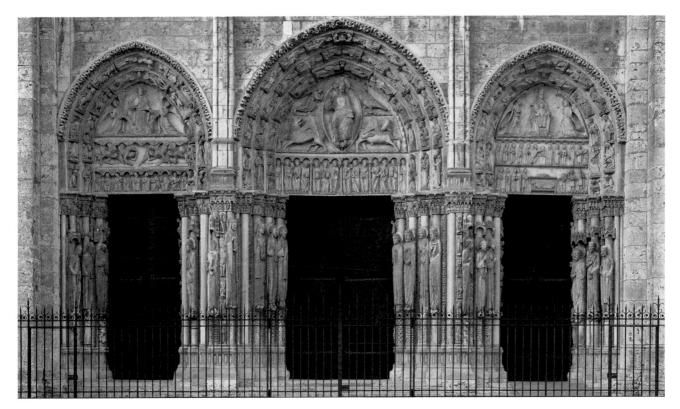

11–6 | royal portal, west façade, chartres cathedral c. 1145–55.

Right—Tympanum: Mary enthroned with Christ Child (Throne of Wisdom); Lintels: Annunciation, Visitation, Nativity and Shepherds, Presentation; Archivolts: The Liberal Arts. Center—Tympanum: The Second Coming, Christ and the Four Apostles; Lintels: Apostles; Archivolts: The Twenty-Four Elders. Left—Tympanum: Ascension; Lintels: Angels and Apostles; Archivolts: Zodiac and Labors of the Months; Capitals: Life of Christ; Statue Columns: Old Testament Kings and Queens.

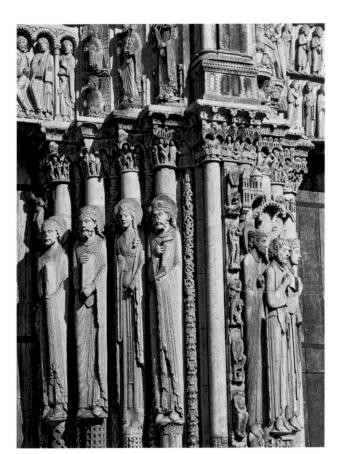

three, fill the lintel, and the twenty-four elders of the Apocalypse line the archivolts. The portal on Christ's left (the viewer's right) is dedicated to Mary and the early life of Christ, from the Annunciation to the Presentation in the Temple. On the left portal, Christ ascends heavenward in a cloud, supported by angels. Running across all three portals, storied capitals depict his earthly activities.

Flanking the doorways are monumental jamb figures (FIG. 11–7) depicting Old Testament kings and queens, the precursors of Christ. These figures convey an important message—just as the Old Testament supports and leads to the New Testament, so too these biblical kings and queens support Mary and Christ in the tympana above. They also lead the worshiper into the House of the Lord. The depiction of Old Testament kings and queens reminded people of the close ties between the Church and the French royal house. During the French Revolution, sculptures of kings and queens were removed from churches and destroyed. The Chartres figures are among the few that survived.

II−7 | ROYAL PORTAL, WEST FAÇADE, CHARTRES CATHEDRAL

Detail: Prophets and Ancestors of Christ (Kings and Queens of Judea). Right side, Central Portal, c. 1145-55.

Jamb figures became standard elements of Gothic church portals. They developed from shaftlike reliefs to fully three-dimensional figures that appear to interact. Earlier sculptors had achieved dramatic effects by compressing, elongating, and bending figures to fit an architectural framework. At Chartres, the sculptors sought to pose their figures naturally and comfortably in their architectural settings. The erect, frontal column statues, with their slender proportions and vertical drapery, echo the cylindrical shafts from which they seem to emerge. Their heads are finely rendered with idealized features. Calm and order prevails in all the elements of the portal, in contrast to the crowded imagery of the Romanesque churches.

REBUILDING CHARTRES. A fire in 1194 destroyed most of the church at Chartres but spared the Royal Portal and its windows and the crypt with its precious relics. A papal representative convinced reluctant local church officials to rebuild. He argued that the Virgin permitted the fire because she wanted a new and more beautiful church to be built in her honor. Between 1194 and about 1260, the chapter and people built a new cathedral (FIG. 11–8).

To erect such an enormous building required vast resources—money, raw materials, and skilled labor. A contemporary painting shows a building site with the masons at work (FIG. 11–9). Carpenters have built scaffolds, platforms, and a lifting machine. Master stone cutters measure and cut the stones, and in many cases sign their work with a "mason's mark." Workmen carry and hoist the blocks by hand or with a lifting wheel. Thousands of stones had to be accurately cut and placed. In the illustration a laborer carries mortar up a ladder to men working on the top of the wall, where the lifting wheel delivers cut stones.

The highly skilled men who carved capitals and portal sculpture were members of the masons' guild. Skilled stone cutters earned more than simple workmen, and the master usually earned at least twice what his men received (see "Master Builders," page 395).

Elements of Architecture

RIB VAULTING

n important innovation of Romanesque and Gothic builders was rib vaulting. Rib vaults are a form of groin vault (SEE "arch, vault, and dome," PAGE 172), in which the ridges (groins) formed by the intersecting vaults may rest on and be covered by curved moldings called ribs. After the walls and piers of the building reached the desired height, timber scaffolding to support the masonry ribs was constructed. After the ribs were set, the web of the vault was then laid on forms built on the ribs. After all the temporary forms were removed, the ribs provided strength at the intersections of the webbing to channel the vaults' thrust outward and downward to the foundations. In short, ribs formed the "skeleton" of the vault; the webbing, a lighter masonry "skin." In late Gothic buildings additional, decorative ribs give vaults a lacelike appearance.

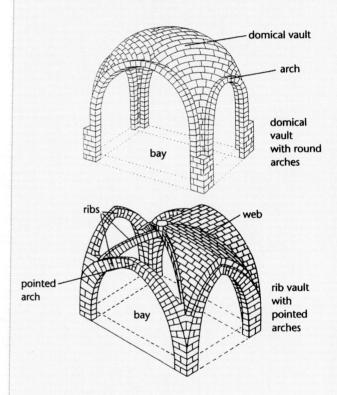

Elements of Architecture

THE GOTHIC CHURCH

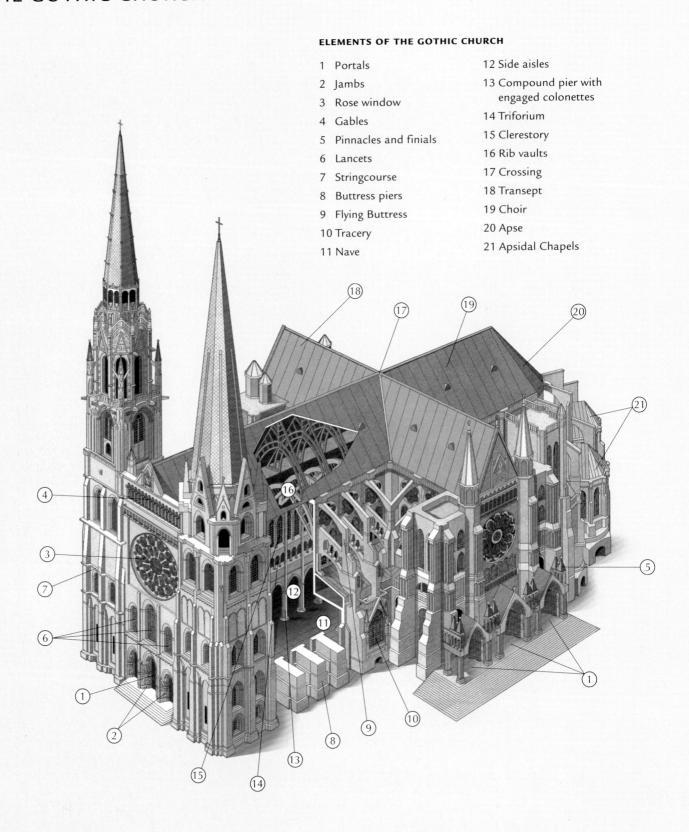

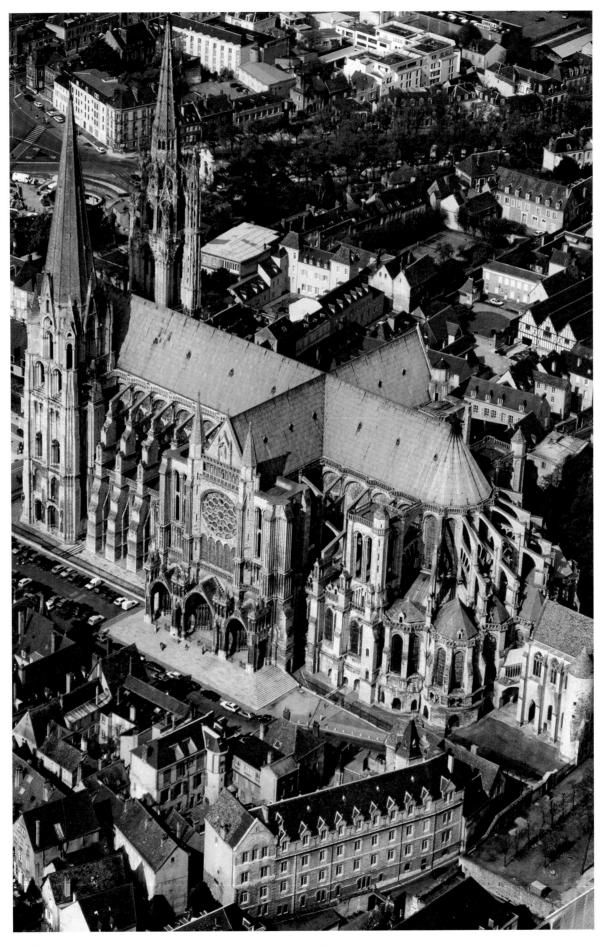

 $_{
m II}-8$ | chartres cathedral, air view from southeast

Myth and Religion

THE MENDICANT ORDERS: FRANCISCANS AND DOMINICANS

n the thirteenth century new religious orders arose to meet the needs of the growing urban population. The mendicants (begging monks) lived among the urban poor. They espoused an ideal of poverty, charity, and love, and they dedicated themselves to teaching and preaching.

The first mendicant orders were the Franciscans and Dominicans. Saint Francis (Giovanni di Bernardone, (1182-1226; canonized in 1228) was born in Assisi, the son of wealthy merchants. Sensitive to the misery of others, he gave away his possessions and devoted his life to God and the poor. He was soon joined by others who also dedicated their lives to poverty, service, and love of all creatures. His love of Christ was so intense that the stigmata, or wounds suffered by Christ on the cross, are believed to have appeared on his own body.

Saint Francis wrote a simple rule for his followers, who were called brothers, or friars (from the Latin *frater*, meaning

"brother"). The pope approved the new order in 1209-10. Franciscans can be recognized by their dark gray or brown robes tied with a rope, whose three knots symbolized their vows of poverty, chastity, and obedience.

The Dominican Order was established in 1216 by a Castilian nobleman, Domenico Guzman (1170–1221; canonized in 1234), as the Order of Friars Preachers. The Dominicans held their first general meeting in 1220. In order to combat heresy by combating ignorance, the Dominicans became teachers. Dominicans number among their members some of the greatest scholars of the thirteenth century: Vincent of Beauvais (c. 1190–1264) and Thomas Aquinas (c. 1225–74). Dominicans were also known as Black Friars because they wore a black cloak over a white tunic.

II-9 | MASONS AT WORK Morgan Library, New York. ms. M240 fol. 3

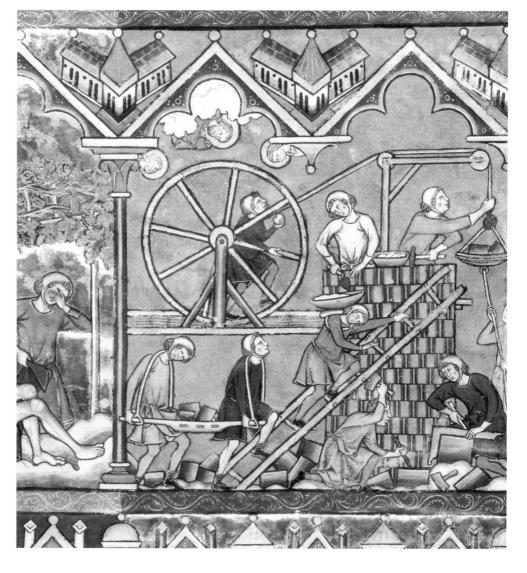

Art and Its Context

MASTER BUILDERS

aster masons oversaw all aspects of church construction in the Middle Ages, from design and structural engineering to decoration. The job presented formidable logistical challenges, especially at great cathedral sites. The master mason at Chartres coordinated the work of roughly 400 people scattered, with their equipment and supplies, at many locations, from distant stone quarries to high scaffolding. This work force set in place some 200 blocks of stone each day.

Funding shortages and technical delays, such as the need to let mortar harden for three to six months, made construction sporadic, so masters masons and their crews moved constantly from job to job, with several masters contributing to a single building. Fewer than 100 master builders are estimated to have been responsible for all the major architectural projects around Paris during the century-long building boom there, some of them working on parts of as many as forty churches. Today the names of more than 3,000 master masons are known to us, and the close study of differences in construction techniques can disclose the participation of specific masters.

Master masons gained in prestige during the thirteenth century as they increasingly differentiated themselves from the laborers they supervised. Their training was rigorous. By the standards of their time they were well read; they traveled widely.

Villard de Honnecourt SHEET OF DRAWINGS WITH GEOMETRIC FIGURES AND ORNAMENTS

From Paris. 1220–35. Ink on vellum, $9\% \times 6''$ (23.5 \times 15.2 cm). Bibliothèque Nationale, Paris.

Lodge books were an important tool of the master mason and his workshop (or lodge). Such books or collections of drawings provided visual instruction and inspiration for apprentices and assistants. Since the drawings received hard use, few have survived. One of the most famous architect's collections is the early thirteenth-century sketchbook of Villard de Honnecourt, a well-traveled master who recorded a variety of images and architectural techniques. A section labeled "help in drawing figures according to the lessons taught by the art of geometry" illustrates the use of geometric shapes to form images and how to copy and enlarge images by superimposing geometric shapes over them as guides.

They knew both aristocrats and high Church officials, and they earned as much as knights. In some cases their names were prominently inscribed in the labyrinths on cathedral floors. From the thirteenth century on, in what was then an exceptional honor, masters were buried, along with patrons and bishops, in the cathedrals they built.

The economy of Chartres revolved around trade fairs, especially cloth fairs held at the times of the church festivals honoring Mary, such as the day of her Assumption, August 15. Both merchants and the Church profited from sales and taxes at the fairs. To build the new cathedral, the bishop and cathedral officials pledged all or part of their incomes for three to five years. Royal and aristocratic patrons joined in the effort. In an ingenious scheme that seems very modern, the churchmen solicited contributions by sending the cathedral relics, including the Virgin's tunic, on tour as far away as England.

As the new structure rose higher during the 1220s, the work grew more costly and funds dwindled. But when the bishop and the cathedral clergy tried to make up the deficit by raising feudal and commercial taxes, the townspeople drove them into exile for four years. This action in Chartres was not unique; people often opposed the building of cathedrals because of the burden of new taxes. The economic privileges claimed by the Church for the cathedral sparked intermittent riots by townspeople and the local nobility throughout the thirteenth century.

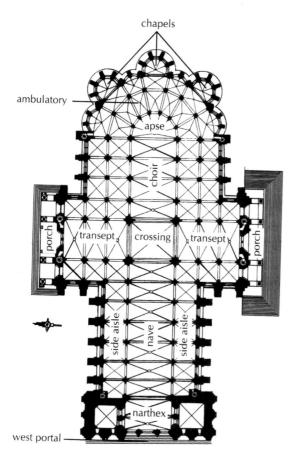

II—IO | CHARTRES CATHEDRAL, PLAN c. 1194–1220.

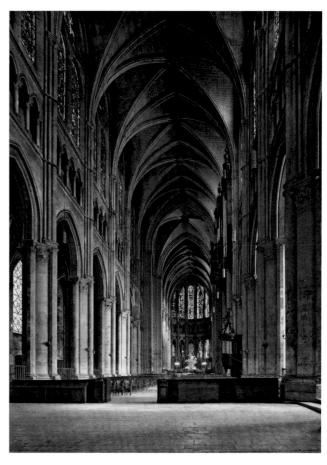

Z II—II | NAVE, CHARTRES CATHEDRAL c. 1194–1220.

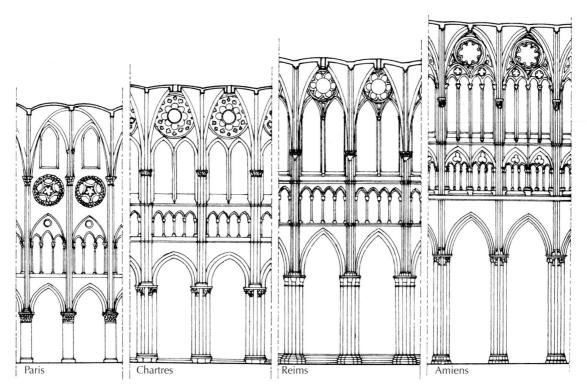

II–I2 | **COMPARATIVE CATHEDRAL NAVE ELEVATIONS**From Louis Grodecki, *Gothic Architecture*, New York, 1985. Paris, h. 115' (35 m), w. 40' (12 m); Chartres, h. 120' (37 m), w. 45' 6" (17 m); Reims h. 125' (38 m), w. 46' (14 m); Amiens, h. 144' (44 m), w. 48' (15 m).

HIGH GOTHIC ARCHITECTURE AT CHARTRES, 1194 TO 1260. Building on the concept pioneered at Saint-Denis of an elegant masonry shell enclosing a large open space, the masons at Chartres erected a church over 45 feet wide with vaults that soar approximately 120 feet above the floor. In the plan, the enlarged sanctuary with its ambulatory and chapels, a feature inspired by the church at Saint-Denis, occupied one-third of the building (FIG. II—IO). The actual cross section of the nave is an equilateral triangle measured from the outer line of buttresses to the keystone of the vault. The worshiper's gaze is drawn forward toward the choir where the high altar was situated behind a choir screen and at the same time upward to the clerestory windows and the soaring vaults (FIG. II—II).

By making the open nave arcade and glowing clerestory nearly equal in height, the architect creates a harmonious elevation (FIG. 11-12). Relatively little interior architectural decoration interrupts the visual rhythm of compound piers with their engaged shafts supporting pointed arches. Fourpart vaulting has replaced more complex systems found in churches such as Durham or Caen (SEE FIG. 10-22). The alternating heavy and light piers typical of Romanesque naves such as that at Speyer Cathedral (SEE FIG. 10-17) become a subtle alternation of round and octagonal compound piers. The gallery, now a narrow arcaded triforium passage, forms a horizontal band running the length of the nave. The large and luminous clerestory is formed by windows whose paired lancets are surmounted by small circular windows, or oculi (bull's-eye windows). The technique used is known as plate tracery; that is, holes are cut in the stone of the wall and filled with stained glass. Glass fills nearly half the wall surface. This lightening of the structure is made possible by the ingenious system of flying buttresses on the exterior.

THE GLORY OF STAINED GLASS. Chartres is unique among French Gothic buildings in that most of its stained-glass windows have survived. Stained glass is an expensive and difficult medium, but its effect on the senses and emotions makes the effort worthwhile. The light streaming in through these windows changes with the time of day, the seasons, and the movement of clouds.

Chartres was famous for its glassmaking workshops, which by 1260 had installed about 22,000 square feet of stained glass in 176 windows (see "Stained-Glass Windows," page 398). Most of the glass dates between about 1210 and 1250, but a few earlier windows, from around 1150 to 1170, survived the fire of 1194.

Among the twelfth-century works of stained glass in the west wall of the cathedral is the **TREE OF JESSE** window (FIG. 11–13). The treatment of this subject, much more complex than its depiction in an early twelfth-century Cistercian manuscript (SEE FIG. 10–39), was apparently inspired by a similar window at Saint-Denis. Jesse, the father of King David and an ancestor of Mary, lies at the base of the tree whose trunk grows out of his body, as described by the prophet Isaiah

Sequencing Works of Art

c. 1194-1220	Chartres Cathedral
1220-58	Salisbury Cathedral
1220-88	Amiens Cathedral
1235-83	Saint Elizabeth at Marburg
1243-48	Sainte-Chapelle, Paris

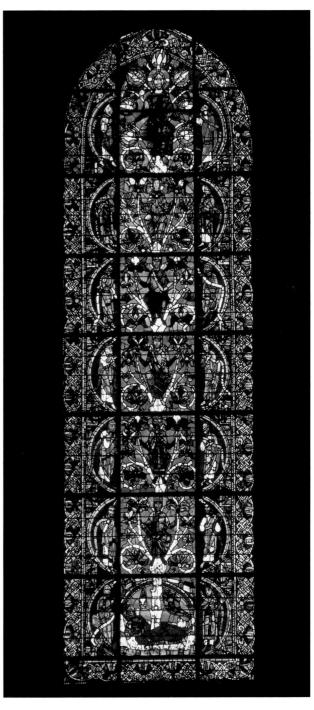

II–I3 | TREE OF JESSE, WEST FAÇADE, CHARTRES CATHEDRAL

c. 1150-70. Stained and painted glass.

Technique

STAINED-GLASS WINDOWS

he basic technique for making colored glass has been known since ancient Egypt. It involves the addition of metallic oxides—cobalt for blue, manganese for red and purple—to a basic formula of sand and ash or lime that is fused at high temperature. Such "stained" glass was used on a small scale in church windows during the Early Christian period and in Carolingian and Ottonian churches. Colored glass sometimes adorned Romanesque churches, but the art form reached a pinnacle of sophistication and popularity in the cathedrals and churches of the Gothic era.

Making a stained-glass image was a complex and costly process. A designer first drew a composition on a wood panel the same size as the opening of the window to be filled, noting the colors of each of the elements in it. Glassblowers produced sheets of colored glass, and artisans cut individual pieces from these large sheets and laid them out on the wood template. Painters added details with enamel emulsion, and the glass was reheated to fuse the enamel to it. Finally, the pieces were joined together with narrow lead strips, called **cames**. The assembled pieces were set into iron frames that had been made to fit the stonework of the window opening.

The colors of twelfth-century glass—mainly reds and blues with touches of dark green, brown, and orange-yellow—were so dark as to be nearly opaque, and early uncolored glass was full of impurities. But the demand for stained-glass windows stimulated technical experimentation to achieve new colors and greater purity and transparency. The Cistercians adorned their churches with *grisaille* windows, painting foliage and crosses onto a gray glass, and Gothic artisans developed a clearer material onto which elaborate narrative scenes could be drawn.

By the thirteenth century, many new colors were discovered, some accidentally, such as a sunny yellow produced by the addition of silver oxide. Flashing, in which a layer of one color was fused to a layer of another color, produced an almost infinite range of hues. Blue and yellow, for example, could be combined to make green. In the same way, clear glass could be fused to layers of colored glass in varying thicknesses to produce a range of hues from light to dark. The deep colors of early Gothic stained-glass windows give them a saturated and mysterious brilliance. The richness of some of these colors, particularly blue, has never been surpassed. Pale colors and large areas of grisaille glass became increasingly popular from the mid-thirteenth century on, making the windows of later Gothic churches bright and clear by comparison.

(11:1–3). The family tree literally connects Jesus with the house of David (Matthew 1:1–17). In the branches above him appear four kings of Judea (Christ's royal ancestors), then the Virgin Mary, and finally Christ himself. Seven doves, symbolizing the seven gifts of the Holy Spirit, encircle Christ, and fourteen prophets stand in the semicircles flanking the tree. The glass in the *Tree of Jesse* window is set within an iron framework visible as a rectilinear pattern of black lines.

Twelfth-century windows are remarkable for their simple geometric compositions—usually squares and circles and the intensity of the color of the glass. In the color symbolism of the time, blue signified heaven and fidelity; red, the Passion; white, purity; green, fertility and springtime. Yellow as a substitute for gold could represent the presence of God, the sun, or truth; but plain yellow could also mean deceit and cowardice. Stained-glass windows changed the color and quality of light to inspire devotion and contemplations. Their painted narratives also educated the viewers.

Most of the windows in the new church were glazed between 1210 and 1250. In the aisles and chapels where the windows were low enough to be easily seen, there were elaborate narratives using many small figures. Tracery—geometric decorative patterns in stone or wood that filled window openings—became increasingly intricate. In the clerestory windows, glaziers used single figures that could be seen at a distance because of their size, simple drawing, and strong colors. In the north transept, five lancets and a rose window (over 42 feet in diameter) fill the upper wall (FIG. 11–14).

The North transept windows may have been a royal commission, a gift from Queen Blanche of Castile (mother of Louis IX, regent, 1226–34), whose heraldic castles symbolizing the country of Castile (Spain) join the golden lilies of France in the spandrels. In the lancets, Saint Anne and the infant Mary have the place of honor. Saint Anne is flanked by Old Testament figures: the priests Mechizedek and Aaron and the kings David and Solomon. In the center of the rose window, Mary is enthroned with the Christ Child. Radiating from the holy pair are lattice-filled panels displaying four doves (the Gospels) and eight angels, the prophets, and the Old Testament ancestors of Christ.

High Gothic: Amiens and Reims Cathedrals

New cathedrals in other rich commercial cities of northern France reflected both the piety and civic pride of the citizens. The cathedrals of Chartres, Amiens, and Reims were being built at the same time, and the master masons at each site borrowed ideas from one another. Amiens was an important trading and textile-manufacturing center north of Paris. The cathedral housed relics of Saint John the Baptist. When Amiens burned in 1218, church officials devoted their resources to making its replacement as splendid as possible.

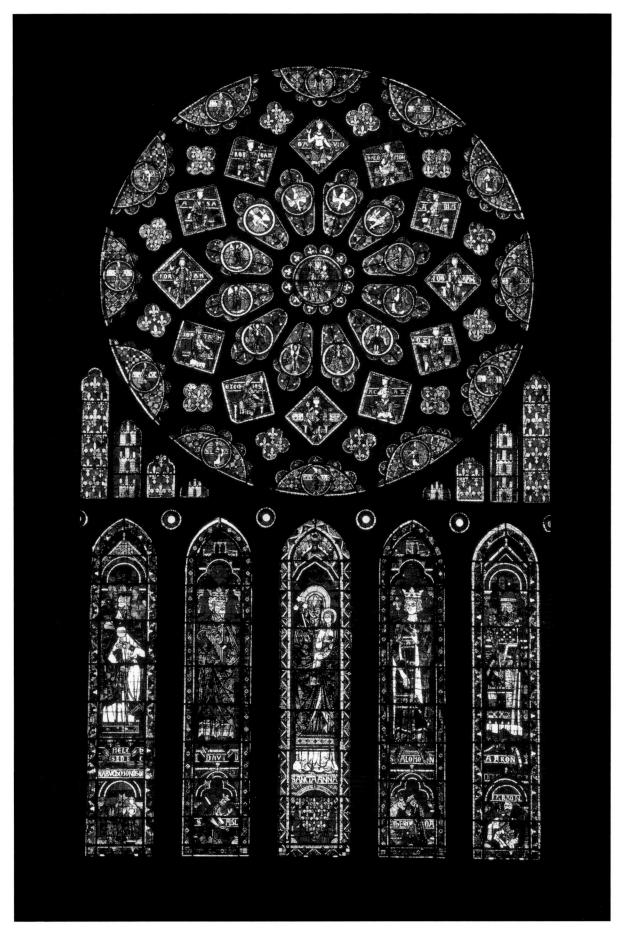

 ${\tt II-I4} \perp {\tt CHARTRES}$ cathedral, north transept, rose window and lancets, known as THE "ROSE OF FRANCE"

North transept, Chartres Cathedral. c. 1220, stained and painted glass.

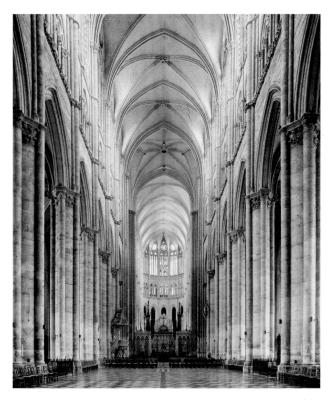

II-I5 | NAVE, AMIENS CATHEDRAL France. 1220-88; upper choir reworked after 1258.

Their funding came mainly from the cathedral's agricultural estates and from the city's important trade fairs. Construction on the new church began in 1220. The lower parts date from about 1220–36, with major work continuing until 1288. Robert de Luzarches (d. 1236) was the builder who established the overall design. He was succeeded by Thomas de Cormont, who was followed by his son Renaud.

NAVE AND CHOIR: AMIENS CATHEDRAL. The church at Amiens became the archetypical Gothic cathedral (FIG. 11-15). Robert de Luzarches made critical adjustments that simplified, clarified, and unified the plan of Amiens Cathedral as compared with Chartres Cathedral. He eliminated the narthex and expanded the transept and sanctuary (comprising the apse, ambulatory chapels, and choir), thus shortening the nave and creating a plan that seems to balance east and west around the crossing (FIG. 11-16). In the choir, chapels of the same size and shape enhance the clarity of the design. The nave elevation is also balanced and compact. Uniform and evenly spaced compound piers, with engaged half columns topped by foliage capitals, support the arcades. Tracery and colonnettes (small columns) unite the triforium and the clerestory, and together they equal the height of the nave arcade. An ornate floral molding below the triforium runs uninterrupted across the wall surfaces and the colonnettes, providing a horizontal counterpoint to the soaring verticality of the design. This sculptural detail adds an elegant note to the severe architecture.

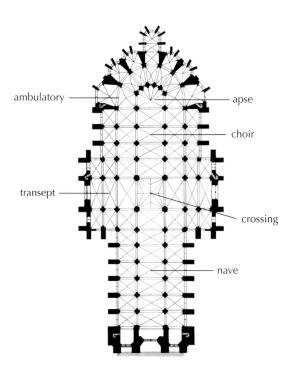

II-I6 | Robert de Luzarches, Thomas de Cormont, and Renaud de Cormont PLAN OF CATHEDRAL OF NOTRE-DAME, AMIENS 1220-88.

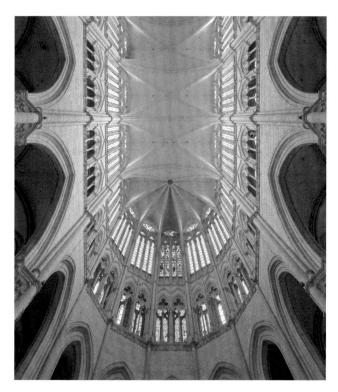

II—I7 | VAULTS, SANCTUARY, AMIENS CATHEDRAL France. Upper choir after 1258; vaulted by 1288.

Amiens is a supreme architectural statement of the Gothic desire for both actual and perceived height (FIG. 11–17). The nave, only 48 feet wide, soars upward 144 feet; consequently, not only is the nave in fact exceptionally tall, its narrow proportions (3:1, height to width) create an exaggerated sense of

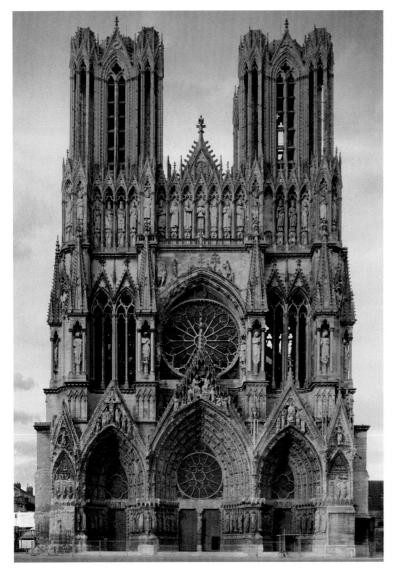

II-I8 | West façade, cathedral of notre-dame, reims

France. Rebuilding begun 1211; façade begun c. 1225; to the height of rose window by 1260; finished for the coronation of Philip the Fair in 1286; towers left unfinished in 1311; additional work 1406–28.

The cathedral was restored in the sixteenth century and again in the nineteenth and twentieth centuries. During World War I it withstood bombardment by some 3,000 shells, an eloquent testimony to the skills of its builders.

height. A comparison of Louis Grodecki's nave elevations of the cathedrals of Paris, Chartres, Reims, and Amiens—drawn to the same scale—demonstrates the change in height and design of cathedrals over time (SEE FIG. 11–12).

The lower portions of the church were substantially finished by about 1240. The vault and the light-filled choir date to the second phase of construction, directed by Thomas de Cormont, perhaps after a fire in 1258 (FIG. II–I7). The choir is illuminated by large windows subdivided by bar tracery (in bar tracery, thin stone strips, called mullions, form a lacy matrix for the glass). In the Amiens choir, the tracery divides the windows into slender lancets crowned by trefoils (three-lobed designs) and circular windows.

THE WEST FAÇADE AT REIMS CATHEDRAL. In the Church hierarchy, the bishop of Amiens was subordinate to the archbishop of Reims. Reims, northeast of Paris, was the coronation church of the kings of France and, like Saint-Denis, had been a cultural and educational center since Carolingian times. When in 1210 fire destroyed this vital building, the

community at Reims began to erect a new structure. The cornerstone was laid in 1211, and work on the cathedral continued throughout the century. The expense of the project sparked such local opposition that twice in the 1230s revolts drove the archbishop and canons into exile. At Reims five masters directed the work on the cathedral over the course of a century—Jean d'Orbais, Jean le Loup, Gaucher de Reims, Bernard de Soissons, and Robert de Coucy. If Amiens Cathedral has the ideal Gothic nave and choir, Reims Cathedral's west front takes pride of place among Gothic façades. The major portion of this magnificent structure must have been finished in time for the coronation of Philip the Fair in 1286 (FIG. 11-18). Its tall gabled portals form a broad horizontal base and project forward to display an expanse of sculpture. Their soaring peaks, the middle one reaching to the center of the rose window, unify the façade vertically. Large windows fill the tympana, instead of the sculpture usually found there. The deep porches are encrusted with sculpture that lacks the unity seen at Amiens, reflecting instead 100 years of changes in plan, iconography, and workshops.

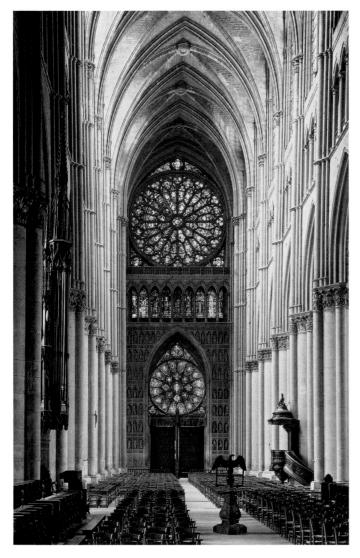

II-I9 | NAVE, REIMS CATHEDRAL Looking west. Begun 1211; nave c. 1220.

In a departure from tradition, Mary rather than Christ dominates the central portal, a reflection of the popularity of her cult. Christ crowns her as Queen of Heaven in the central gable. The enormous rose window is the focal point of the façade. The towers were later additions, as was the row of carved figures that runs from the base of one tower to the other above the rose window. This "gallery of kings" is the only strictly horizontal element of the façade.

Inside the church, remarkable sculpture and stained glass fill the west wall (FIG. 11–19), which visually "dissolves" in colored light. The great rose window fills the clerestory level; a row of lancets illuminate the triforium; and a smaller rose window replaces the stone of the tympanum of the portal. This expanse of glass was made possible by bar tracery, a technique invented or at least perfected at Reims. The circles of the two rose windows are anchored visually by a masonry grid of tracery and sculpture covering the inner wall of the façade.

Here ranks of carved Old Testament prophets and Christ's royal ancestors serve as moral guides for the newly crowned monarchs who faced them after the coronation ceremonies.

High Gothic Sculpture

Like Greek sculpture, Gothic sculpture evolved from static forms to moving figures, from formal geometric abstraction though an idealized phase, to a surface realism that could be highly expressive. As in ancient art, Gothic sculpture was originally painted and sometimes gilded. The stone surfaces were not entirely covered but subtly colored and decorated to enhance the realism of the figures. Recent cleaning at Amiens and Reims has revealed remarkable amounts of color—borders of garments painted to indicate rich embroidery, gilded angel wings, colored foliage, and chevron-patterned colonettes.

AMIENS. The worshipers approaching the main entrance—the west portals—of Amiens Cathedral encountered an overwhelming array of images. Figures of apostles and saints line the door jambs and cover the projecting buttresses (FIG. II–20). Most of them were produced by a large workshop in only twenty years, between about 1220 and perhaps 1236/40, making the façade stylistically more coherent than those of many other cathedrals. In the mid-thirteenth century, Amiens–trained sculptors traveled across Europe and carried their style into places like Spain and Italy.

The Amiens central portal is dedicated to Christ and the Apostles, with the Last Judgment in the tympanum above, surrounded by angels and saints in the voussoirs. At the right is Mary's portal, where she is depicted as Queen of Heaven. The left portal is dedicated to local saints with Saint Firmin, the first bishop of Amiens, in the trumeau. At Amiens the master designer introduced a new feature: At eye-level, on the base below the jamb figures, are quatrefoils (four-lobed medallions) containing lively illustrations of good (Virtues) and evil (Vices) in daily life, the seasons and labors of the months, the lives of the saints, and biblical stories (FIG. II–21). At last the natural world enters the ideal Christian vision.

All this imagery revolves around Christ standing in front of the trumeau of the central portal. Known as the **BEAU DIEU**, meaning "Noble (or Beautiful) God," Christ as the teacher-priest bestows his blessing on the faithful (FIG. II–22). This exceptionally fine sculpture may well be the work of the master of the Amiens workshop himself. The figure establishes an ideal for Gothic figures. The broad contours of the heavy drapery wrapped around Christ's right hip and bunched over his left arm lead the eye up to the Gospel book he holds and, following his right hand, raised in blessing, to his face, which is that of a young king. He stands on a lion and a dragonlike creature called a *basilisk*, symbolizing his kingship and his triumph over evil and death (Psalm 91:13).

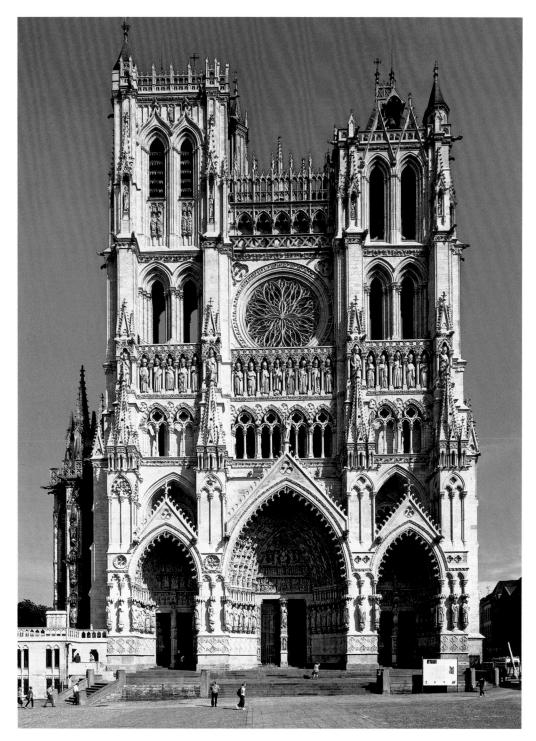

II-20 | WEST FAÇADE, AMIENS CATHEDRAL c. 1220-36/40 and continued through the 15th century.

With its clear, solid forms, elegantly cascading robes, and interplay of close observation with idealization, the *Beau Dieu* embodies the Amiens style and the Gothic spirit.

REIMS. At Reims, sculptors from major workshops, such as Chartres and Amiens, as well as local sculptors worked together for decades. Most of the sculpture was done in a

twenty-year period between 1230 and 1250, although sculpture in the upper regions of the façade may be as late as 1285.

Complicating the study of the sculpture at Reims is the fact that many figures have been moved from their original locations. On the right jamb of the central portal of the western façade, a group of four figures—depicting the *Annunciation* and the *Visitation*—illustrates three of the characteristic

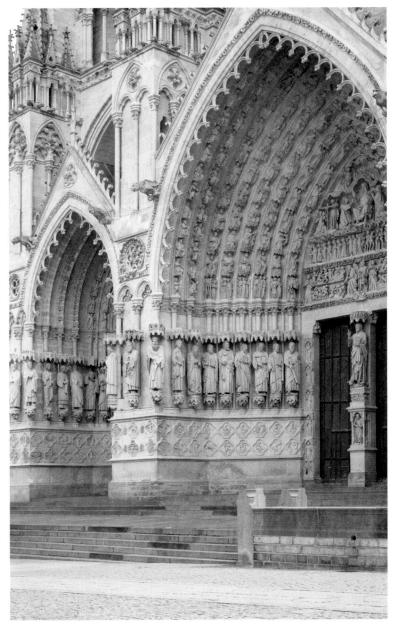

II-2I $\ \ \ \$ West façade, central and north portals. Amiens cathedral.

c. 1220-1236/40. Central portal: tympanum: Last Judgment; trumeau: Christ (Beau Dieu); jambs: Apostles. Height of figures, 7-8'.

Reims styles (FIG. 11–23). Art historians have given names to the styles: the Classical Master (or the Master of Antique Figures), the Amiens Master, and the Master of the Smiling Angels. The pair on the right, the *Visitation*, is the work of the Classical Shop, which was active as early as the 1220s and 1230s. Mary (left), pregnant with Jesus, visits her older cousin Elizabeth (right), who is pregnant with John the Baptist.

The sculptors drew on classical sources—either directly from Roman sculpture (Reims had been an important center under ancient Rome) or indirectly through Mosan metalwork (SEE FIG. 11–35). The heavy figures have a solidity seen in Roman sculpture, and Mary's full face, gently waving hair, and heavy mantle recall imperial portrait statuary. The contrast between the features of the young Mary and the older

Elizabeth recall ancient Roman sculpture (compare the portrait of the Flavian woman in FIG. 6–45). The Classical Master of Reims used deftly modeled drapery not only to provide volume, but also to create a stance in which the apparent shift in weight of one bent knee allows the figures to seem to turn toward each other. The new freedom, movement, and sense of implied interaction inspired later Gothic artists toward ever greater realism.

In the *Annunciation* two other masters were at work, one probably from Amiens and the other a new artist whose antecedents are still unknown. The Amiens Master's Mary is a quiet, graceful figure, with a slender body and restrained gestures—a striking contrast to the bold tangibility of the Classical Master's Mary. The broad planes of simple drapery suggest

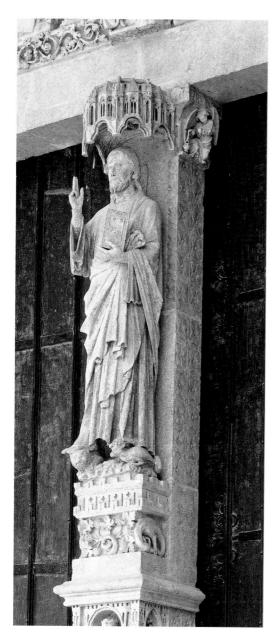

II-22 | CHRIST: BEAU DIEU
Trumeau, central portal, west façade, Amiens
Cathedral. France. c. 1220-36/40.

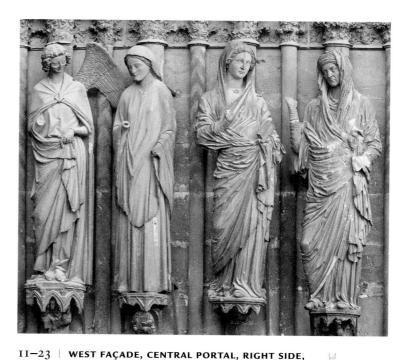

REIMS CATHEDRAL

Annunciation (left pair: Mary [right] c. 1245, angel [left] c. 1255) and
Visitation (right pair: Mary [left] and Elizabeth [right] c. 1230).

the Amiens shop, but her pinched features are the sculptor's personal style. The sculptor here was one of a large team that made most of the other sculptures of the west entrance.

The figure of the angel Gabriel is the work of the Master of the Smiling Angels. This artist created tall, gracefully swaying figures that in body type, features, pose, and gestures suggest the fashionable refinement associated with the Parisian court at mid-century. The angel Gabriel is typical. His small, almost triangular head with a broad brow and pointed chin is framed by wavy hair; his puffy, almond-shaped eyes are set under arching brows; he has a well-shaped nose and thin lips curving into a slight smile. The cocked head, hint of a smile, and mannered gestures as he draws his voluminous drapery into elegant folds suggest aristocratic,

courtly elegance. Later in the century (and during the fourteenth century), artists from Paris to Prague imitated this style, as grace and refinement became a guiding ideal in sculpture and painting (see Chapter 12).

The Rayonnant Style

In the second half of the thirteenth century artists fell under the spell of the Master of the Smiling Angels of Reims as well as the luminous west façade of Reims and choir of Amiens. They created a new variation of the Gothic style of architecture, known today as the Rayonnant (Radiant) or Court Style (referring to the Parisian court). Using this style, they finished older buildings, such as the abbey church of Saint-Denis, and added transepts and chapels to Notre Dame in Paris.

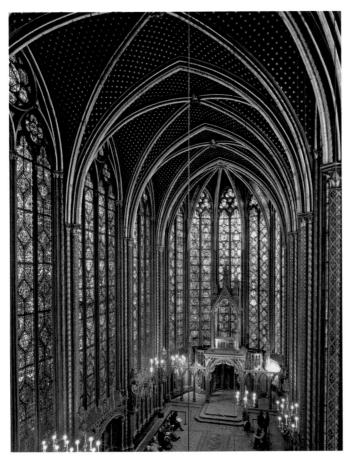

II—24 UPPER CHAPEL, SAINTE-CHAPELLE Paris. 1243–48.

At Saint-Denis (SEE FIG. 11–1), work began in 1231 to complete Abbot Suger's church. The new nave, transept, and upper part of the choir attach seamlessly to the twelfth-century narthex and lower part of the choir (SEE FIG. 11–3). Its glazed triforium and tall clerestory windows filled with bar tracery and stained glass are visually united by the continuous shafts rising from the base of clustered columns to the rib vault. The builders achieved the effects of spatial unity and an interior filled with the jewel-like colored space dreamed of by Suger.

The remodeling and construction of the transepts at Paris, the choir at Amiens, and the façade at Reims all reflect a courtly style characterized by interlocking and overlapping forms, linear patterns, and above all, spatial unity and luminosity. The Rayonnant style continued through the four-teenth and into the fifteenth centuries and influenced the Gothic art of Germany, Italy, and Spain.

THE SAINTE-CHAPELLE IN PARIS. The masterpiece of Rayonnant style is the palace chapel in Paris—the Sainte-Chapelle, or Holy Chapel—ordered by Louis IX (FIG. II–24). Louis IX (ruled 1226–70) avidly collected relics of Christ's Passion sold to him by his cousin, who was ruling Constantinople after the Fourth Crusade. In 1239 Louis acquired the crown of thorns and in 1241 other relics,

including a bit of the metal lance tip that pierced Christ's side, the vinegar-soaked sponge offered to wet Christ's lips, a nail used in the Crucifixion, and a fragment of the True Cross (or so people believed). He kept these treasures in the palace while he built a chapel to house them. Construction moved rapidly. The building may have been finished in 1246, and it was consecrated in 1248.

The Sainte-Chapelle resembles a giant reliquary, one made of stone and glass instead of gold and gems. Built in two stories, the ground-level chapel is accessible from a courtyard, and a private upper chapel is entered from the royal residence. The ground-level chapel has a nave and narrow side aisles, but the upper level is a single room with a western porch and a rounded east wall. The design of the exterior, with gables and wall buttresses framing huge windows, inspired the artist who created a psalter for the king (discussed on the facing page).

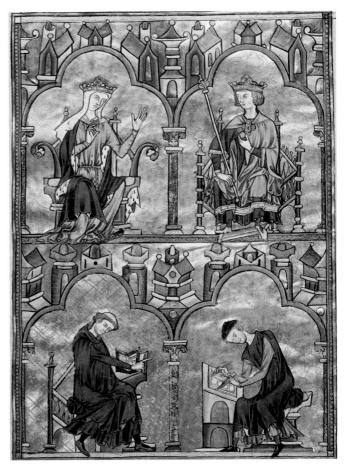

11-25 QUEEN BLANCHE OF CASTILE AND LOUIS IX, MORALIZED BIBLE

Paris. 1226–34. Ink, tempera, and gold leaf on vellum, $15\times10\%''$ (38 \times 26.6 cm). The Pierpont Morgan Library, New York.

MS. M. 240, f. 8

This page was placed at the end of the manuscript as a colophon (comparable to a title page in a modern book). Thin sheets of gold leaf were painstakingly attached to the vellum and then polished to a high sheen with a tool called a burnisher. Gold was applied to paintings before pigments.

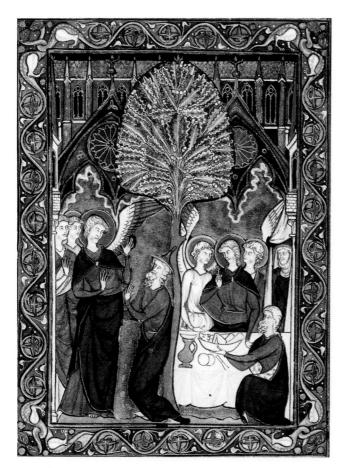

II-26 \perp abraham, sarah, and the three strangers from the psalter of saint louis

Paris. 1253-70. Ink, tempera, and gold leaf on vellum, $5 \times 3\frac{1}{2}$ " (13.6 \times 8.7 cm). Bibliothèque Nationale, Paris.

Whether entering the upper level, walking through the palace halls, or climbing up the narrow spiral stairs from the lower level, the visitor emerges into a kaleidoscopic jewel box. The walls have been reduced to clusters of slender colonnettes framing tall windows filled with shimmering glass. Bar tracery in the windows is echoed in the blind arcading and tracery decorating the lower walls. The stone surfaces are painted and gilded-red, blue, and gold-so that stone and glass seem to merge in the multicolored light. Painted statues of the twelve apostles stand between window sections, linking the walls and the stained glass. The windows contain narrative and symbolic scenes. Those in the curve of the sanctuary behind the altar and relics, for example, illustrate the Nativity and Passion of Christ, the Tree of Jesse, and the life of Saint John the Baptist. The story of Louis' acquisition of his relics is told, and the Last Judgment appeared in the original rose window on the west.

Illuminated Manuscripts

France gained renown in the thirteenth century not only for its new architecture and sculpture but also for the production

Sequencing Works of Art	
c. 1145-55	Prophets and Ancestors of Christ, Royal Portal, Chartres Cathedral
c. 1150-70	Tree of Jesse Window, Chartres Cathedral
c. 1220-36	Beau Dieu, west façade, Amiens Cathedral
c. 1226-34	Queen Blanche of Castile and Louis IX, Moralized Bible, from Paris
c. 1230	Visitation, west façade, Reims Cathedral

of books. The Court Style had enormous influence throughout northern Europe, spread by artists, especially manuscript illuminators, who flocked to Paris from other regions. There they joined workshops affiliated with the Confrérie de Saint-Jean (Guild of Saint John), supervised by university officials who controlled the production and distribution of books. These works ranged from practical manuals to elaborate devotional works illustrated with exquisite miniatures. Women played an important role in book production. Widows continued their husband's businesses; they even took oaths as commercial book producers.

LOUIS IX AND BLANCHE OF CASTILE. Paris was a major center of book production in the Gothic period, and the royal library in Paris was especially renowned. Not only the king, but his mother, Blanche of Castile, commissioned and collected books (FIG. 11–25). Blanche and the young king appear here seated on ornate thrones against a gold background. Colorful Gothic architecture suggests the royal palace, where the manuscript may actually have been made. Below, a scholar-monk dictates, and the scribe works on a page with a column of circles that will hold the illustrations. This compositional format derives from stained-glass lancets organized as columns of images in medallions. The illuminators show their debt to stained glass in their use of glowing red and blue colors and reflective gold surfaces.

THE PSALTER OF SAINT LOUIS. In the opulence, number, and style of its illustrations, the PSALTER OF SAINT LOUIS defines the Court style in manuscript illumination just as Louis' chapel does the architecture (FIG. 11–26). The book, containing seventy-eight full-page illuminations, was created for the king's private devotions, probably after his return from the Fourth Crusade in 1254. The illustrations fall at the back of the book, preceded by Psalms and other readings. Intricate scrolled borders frame the narratives, and figures are rendered in a style that reflects the sculpture of the Master of the Smiling Angels of Reims.

Depicted here is the Old Testament story of Abraham and Sarah's hospitality to three strangers, that is, God in the three persons (compare the later Byzantine icon, FIG. 7–51). Sarah watches from the entryway of their tent, while the strangers—angels representing God—tell the elderly couple that Sarah will bear a child, Isaac. The story is yet another instance of the Old Testament prefiguring the New. To the medieval reader, the three strangers were symbols of the Trinity, and God's promise to Sarah foreshadowed the angel's annunciation of the Christ Child's birth to Mary.

The architectural frame, depicting gables, pinnacles, and windows modeled on the Sainte-Chapelle, establishes a narrow stage on which the story unfolds. Wavy clouds floating within the arches under the gables indicate an outdoor setting. The oak tree, representing the biblical oaks of Mamre (Genesis 18:1), has stylized but recognizable oak leaves and acorns. The oak establishes the specific location of the story. At the same time, the angel's blessing gesture and Sarah's pres-

ence indicate a specific moment. This new awareness of time and place, as well as the oak leaves and acorns, reflect a tentative move toward the representation of the natural world that will gain momentum in the following centuries.

GOTHIC ART IN ENGLAND

Plantagenet kings ruled England from the time of Henry II and Eleanor of Aquitaine until 1485. Many of the kings, especially Henry III (ruled 1216–72), were great patrons of the arts. During this period, London grew into a large city, but most people continued to live in rural villages and bustling market towns. Textile production dominated manufacture and trade, and fine embroidery continued to be an English specialty. The French Gothic style influenced English architecture and manuscript illumination. However, these influences were tempered by local materials, methods, and artistic traditions such as an expressive use of line and an interest in surface decoration.

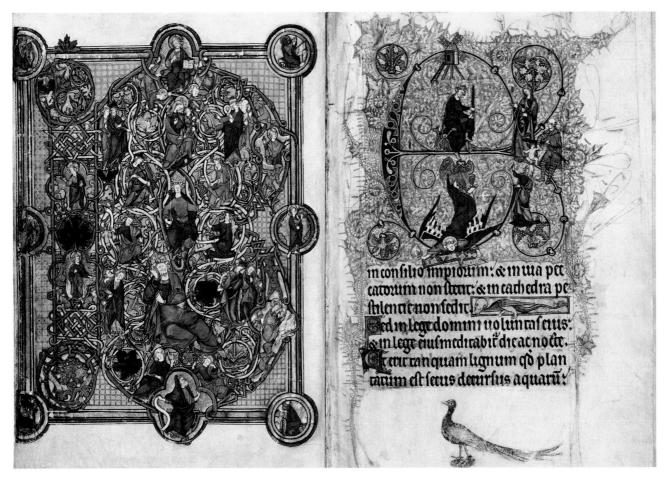

II-27 | PSALM 1 (BEATUS VIR) FROM THE WINDMILL PSALTER London. c. 1270–80. Ink, pigments, and gold on vellum, each page $12\% \times 8\%''$ (32.3 \times 22.2 cm). The Pierpont Morgan Library, New York. M. 102, f. lv-2

Manuscript Illumination

The universities of Oxford and Cambridge dominated intellectual life, but monasteries continued to house active *scriptoria*, in contrast to France, where book production became centralized in the professional workshops of Paris. By the end of the thirteenth century, secular workshops became increasingly active in England, reflecting a demand for books from newly literate landowners, townspeople, and students. These people read books for entertainment and general knowledge as well as for religious enlightenment.

The dazzling artistry and delight in ambiguities that had marked early medieval manuscripts in the British Isles reappear in the **WINDMILL PSALTER** (FIG. 11–27). The elegance of French Gothic visible in the elongated proportions and dainty heads of the figures is combined with the English tradition of draftsmanship visible in the interlaced tendrils and stylized drapery folds.

Psalm 1 begins with the words "Beatus vir qui non abiit" ("Blessed is the man who does not follow [the counsel of the wicked]," Psalm 1:1). The letter B, the first letter of the Psalm, fills the left-hand page, and an E occupies the top at the right. The rest of the opening words appear on a banner carried by an angel at the bottom of the E. The B outlines a densely interlaced Tree of Jesse. The E is formed from large tendrils that escape from delicate background vegetation to support characters in the story of the Judgment of Solomon (I Kings 3:11-27). The story, seen as a prefiguration of the Last Judgment and an illustration to the phrase "his delight is in the law of the Lord" (Psalm 1:2), relates how two women (at the right) claiming the same baby came before King Solomon (on the crossbar) to settle their dispute. The king ordered his knight to slice the baby in half and give each woman her share. This trick revealed the real mother, who hastened to give up her claim in order to save the child's life.

Realistic and surprising images appear everywhere—note how the knight hooks his toe under the cross bar of the *E* to maintain his balance. Visual puns on the text abound. The meaning of the pheasant at the bottom of the page remains a mystery, but the windmill at the top of the letter *E* (which gives the name to the *Windmill Psalter*) is typical of this new realism. It illustrates the verse that tells how wicked people would not survive the Judgment but would be "like chaff driven away by the wind" (Psalm 1:4). The imagery thus encouraged further thought on the text's familiar messages.

Architecture

The Gothic style in architecture appeared early in England under the influence of local Cistercian and Norman builders and by traveling master builders. A typical thirteenth-century English cathedral seems to hug the earth more like a Cistercian monastery (see Fontenay in Burgundy, FIG. 10–12)

than compact and vertical French cathedrals like Chartres (SEE FIG. 11–8). English builders also favored a screenlike façade that does not usually reflect the interior distribution of space, a characteristic that is at odds with the architectural logic of French Gothic.

SALISBURY CATHEDRAL. The thirteenth-century cathedral in Salisbury is an excellent example of English interpretation of the Gothic style. It had an unusual origin. The first Salisbury Cathedral had been built within the castle complex of the local lord. In 1217, Bishop Richard Poore petitioned the pope to relocate the church, claiming the wind on the hilltop howled so loudly that the clergy could not hear themselves sing the Mass. A more pressing concern was probably his desire to escape the lord's control. As soon as he moved, the bishop established a new town, called Salisbury. Material from the old church carted down the hill was used in the new cathedral, along with dark, fossil-filled Purbeck stone from quarries in southern England and limestone imported from Caen. Building began in 1220, and most of the cathedral was finished by 1258, an unusually short period for such an undertaking (FIG. 11-28).

A general comparison between the major features of French High Gothic cathedrals and Salisbury is instructive, for the builders took very different means to achieve their goal of creating the Heavenly Jerusalem on earth. In contrast to French cathedral façades, whose mighty towers flanking deep portals suggest monumental gateways to Paradise, English façades have a horizontal emphasis suggesting the jeweled walls of the celestial city.

At Salisbury, the west façade was completed by 1265. The small flanking towers of the west front project beyond the side walls and buttresses, giving the façade an increased width, underscored by tier upon tier of blind tracery and arcaded niches. Instead of a western rose window floating over triple portals (as seen in France), the English masters placed tall lancet windows above rather insignificant doorways. A mighty crossing tower (the French preferred a slender spire) became the focal point of the building. (The huge crossing tower and its 400-foot spire are a fourteenth-century addition at Salisbury, as are the flying buttresses, which were added to stabilize the tower.) The slightly later cloister and chapter house provided for the cathedral's clergy.

Salisbury has an equally distinctive plan, with wide projecting double transepts, a square east end with a single chapel, and a spacious sanctuary—like a monastic church (FIG. 11–29). The nave interior reflects the Norman building tradition of heavy walls and a tall nave arcade surmounted by a gallery and a clerestory with simple lancet windows (FIG. 11–30). The walls alone are enough to buttress the four-part ribbed vault. The emphasis on the horizontal movement of the arcades, unbroken by colonnettes,

directs worshipers' attention forward toward the altar behind the choir screen, rather than upward into the vaults, as preferred in France (SEE FIG. 11–15). The use of color in the stonework is reminiscent of Romanesque interiors: The shafts supporting the four-part rib vaults are made of dark Purbeck stone that contrasts with the lighter limestone of the rest of the interior. The stonework was originally painted and gilded.

II-28 | SALISBURY CATHEDRAL
Salisbury, England. 1220–58; west façade finished 1265; spire c. 1320–30; cloister and chapter house 1263–84.

II-30 NAVE, SALISBURY CATHEDRAL

In the eighteenth century, the English architect James Wyatt subjected the building to radical renovations, during which the remaining stained glass and figure sculpture were removed or rearranged. Similar campaigns to refurbish medieval churches were common at the time. The motives of the restorers were complex and their results far from our notions of historical authenticity today.

II-29 | SALISBURY CATHEDRAL, PLAN

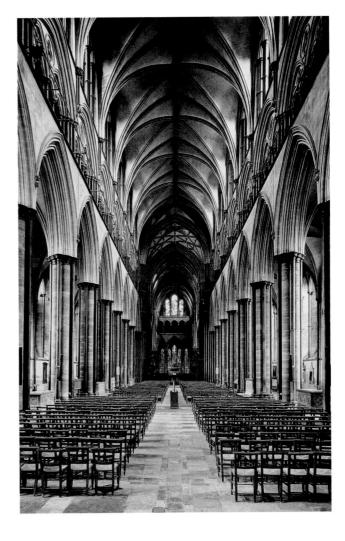

MILITARY AND DOMESTIC ARCHITECTURE. Cathedrals were not the only structures that underwent development during the Early and High Gothic periods. Western European knights who traveled east during the Crusades were inspired by the architectural forms they saw employed in Muslim castles and the mighty defensive land walls of Constantinople (SEE FIG. 7-24). When they returned home, Europeans built their own versions of these fortifications. Castle gateways now became complex, nearly independent fortifications often guarded by twin towers rather than just one. New D-shaped and round towers eliminated the corners that had made earlier square towers vulnerable to battering rams; and crenellations (notches) were added to tower tops in order to provide stone shields for more effective defense. The outer. enclosing walls of the castles were strengthened. The open. interior space was enlarged and filled with more comfortable living quarters for the lord and wooden buildings to house the garrison and the staff necessary to repair armor and other equipment. Barns and stables for animals, including the extremely valuable war horses, were also erected within the enclosure (SEE FIG. 10-24).

STOKESAY CASTLE. Military structures were not the only secular buildings outfitted for defense. In uncertain times, the manor (a landed estate), which continued to be an important economic basis in the thirteenth century, also had to fortify its buildings. A country house that was equipped with a tower and crenellated rooflines became a status symbol as well as a necessity. Stokesay Castle, a remarkable fortified manor house, survives in England near the Welsh border. In 1291 a wool merchant, Lawrence of Ludlow, acquired the property of Stokesay and secured permission from King Edward I to fortify his dwelling—officially known as a "license to crenellate" (FIG. II—31). He built two towers, including a massive crenellated south tower and a great hall. The defense walls of Stokesay are gone, but the two towers and the great hall survive.

Life in the Middle Ages revolved around the hall. Windows on each side of Stokesay's hall open both toward the courtyard and out across a moat toward the countryside. By the thirteenth century people began to expect some privacy as well as security; therefore at both ends of the hall are two-story additions that provided retiring rooms for the family and workrooms for women to spin and weave. Rooms on the north end could be reached from the hall, but the upper chamber at the south was accessible only by means of an exterior stairway. A tiny window—a peephole—let women and members of the household observe the often rowdy activities in the hall below.

Furnishings defined and dignified the rooms. Of prime importance were textiles in the form of wall hangings, cushions, and coverlets (see *Christine de Pizan and the Queen of France* for an example of a furnished room, Introduction, Fig. 21). In both layout and décor, there was essentially no

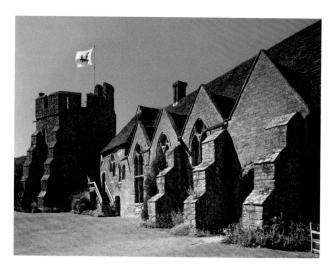

 $\mathbf{II}\textbf{-}\mathbf{3I} + \mathbf{EXTERIOR}$ of the tower and great hall, stokesay castle

Late 13th century. Royal permission to build granted in 1291.

difference between this manor far from the London court and the mansions built by the nobility in the city. A palace followed the same pattern of hall and retiring rooms; it was simply larger than a manor. The great hall was also the characteristic domestic architectural feature on the Continent.

GOTHIC ART IN GERMANY AND THE HOLY ROMAN EMPIRE

The Holy Roman Empire, weakened by internal strife and a prolonged struggle with the papacy, ceased to be a significant power in the thirteenth century. England and France were becoming strong nation-states, and the empire's hold on southern Italy and Sicily ended at midcentury with the death of Emperor Frederick II, who was also king of Sicily. The emperors—who were elected—had only nominal authority over a loose union of Germanic states. After Frederick, German lands increasingly became a conglomeration of independent principalities, bishoprics, and free cities. As in England, the French Gothic style, avidly embraced in the western Germanic territories, shows regional adaptations and innovations.

Architecture

In the thirteenth century, the increasing importance of the sermon in church services led architects in Germany to further develop the hall church, a type of open, light-filled interior space that appeared in Europe in the early Middle Ages but was particularly popular in Germany. The hall church is characterized by a nave and side aisles whose vaults all reach the same height. Large windows in the outer walls create a well-lit interior. The spacious and open design of the hall church provided accommodation for the large crowds drawn by charismatic preachers.

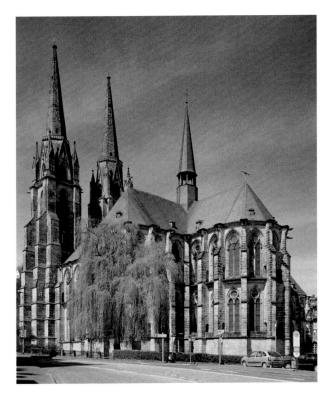

II-32 | EXTERIOR, CHURCH OF SAINT ELIZABETH Marburg, Germany. 1235-83.

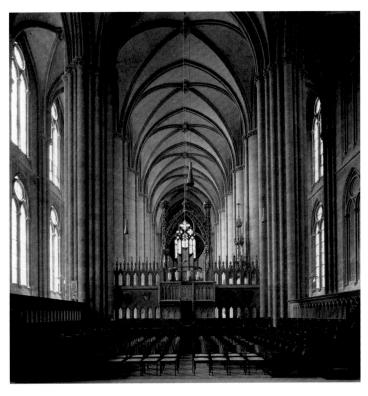

II—33 | INTERIOR, CHURCH OF SAINT ELIZABETH Marburg, Germany. 1235–83.

CHURCH OF SAINT ELIZABETH IN MARBURG. Perhaps the first true Gothic hall church, and one of the earliest Gothic buildings in Germany, was the Church of Saint Elizabeth of Hungary in Marburg (FIG. II-32). The Hungarian princess Elizabeth (1207–31) had been sent to Germany at the age four to marry the ruler of Thuringia. He soon died of the plague, and she devoted herself to caring for people with incurable diseases. It was said that she died at the age of twentyfour from exhaustion, and she was canonized in 1235. Between 1235 and 1283, knights of the Teutonic Order (who had moved to Germany from Jerusalem) built a church to serve as her mausoleum and a center of pilgrimage.

The plan of the church is an early German form, a trefoil with choir and transepts of equal size. The elevation of the building, however, is new—the nave and aisles are of equal height. On the exterior wall, buttresses run the full height of the building and emphasize its verticality. The two rows of windows suggest a two-story building, which is not the case. Inside, the closely spaced piers of the nave support the ribbed vault and, as with the buttresses, give the building a vertical, linear quality (FIG. II—33). Light from the two stories of tall windows fills the interior, unimpeded by walls, galleries, or triforia. Both the circular piers with slender engaged columns and the window tracery resemble those of the cathedral of Reims. The hall church design was adopted widely for civic and residential buildings in Germanic lands and also for Jewish architecture.

THE ALTNEUSCHUL. Built in the third quarter of the thirteenth century, Prague's Altneuschul ("Old-New Synagogue") is the oldest functioning synagogue in Europe and one of two principal synagogues serving the Jews of Prague (FIG. 11–34). The Altneuschul demonstrates the adaptability of the Gothic hall-church design for non-Christian use. Like a hall church, the vaults of the synagogue are all the same height. Unlike a basilican church, with its division into nave and side aisles, the Altneuschul has only two aisles, each with three bays. The six bays are supported by the walls and two octagonal piers. The bays have Gothic four-part ribbed vaulting to which a nonfunctional fifth rib has been added. Some say that this fifth rib was added to remove the cross form made by the ribs.

The medieval synagogue was both a place of prayer and a communal center of learning and inspiration where men gathered to read and discuss the Torah. The synagogue had two focal points, the *aron*, or shrine for the Torah scrolls, and a raised reading platform called the *bimah*. The congregation faced the *aron*, which was located on the east wall, in the direction of Jerusalem. The *bimah* stood in the center of the hall, straddling the two center bays, and in Prague it was surrounded by a fifteenth-century ironwork open screen. The single entrance was placed off-center in a corner bay at the west end. Men worshiped and studied in the principal space; women had to worship in annexes on the north and west sides.

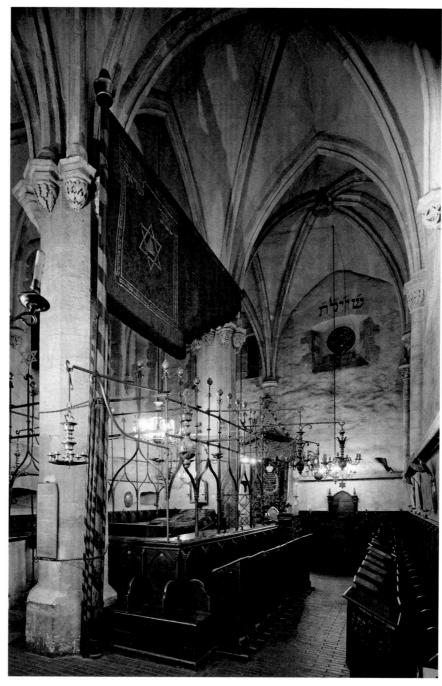

II-34 | INTERIOR, ALTNEUSCHUL
Prague, Bohemia (Czech Republic). c. late 13th century; bimah after 1483.

Sculpture

Germanic lands had a distinguished tradition of sculpture and metalwork. One of the creative centers of Europe since the eleventh century had been the Rhine River valley and the region known as the Mosan (from the Meuse River, in present-day Belgium), with centers in Liège and Verdun. Ancient Romans built their camps and cities in this area, and classical influence lingered on through the Middle Ages. Nicholas of Verdun was a pivotal figure in the development of Gothic sculpture. He and his fellow goldsmiths inspired a

new classicizing style in the arts. Masters of the Classical Shop at Reims, for example, must have known his work.

SHRINE OF THE THREE KINGS. For the archbishop of Cologne, Nicholas created a magnificent reliquary to hold what were believed to be relics of the Three Magi (c. 1190–1205/10). Called the SHRINE OF THE THREE KINGS, the reliquary has the shape of a basilican church (FIG. 11–35). It is made of gilded bronze and silver, set with gemstones and dark blue enamel plaques that accentuate its architectural

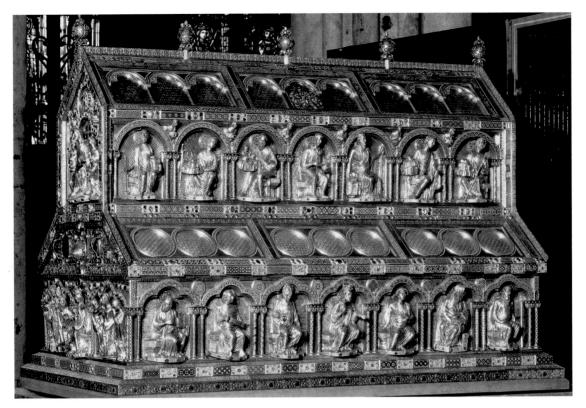

II-35 | Nicholas of Verdun and workshop SHRINE OF THE THREE KINGS Cologne (Köln) Cathedral, Germany c. 1190-c. 1205/10. Silver and gilded bronze with enamel and gemstones, $5'8'' \times 6' \times 3'8''$ (1.73 \times 1.83 \times 1.12 m).

details. Nicholas and other Mosan artists were inspired by ancient Roman art still found in the region. Their figures are fully and naturalistically modeled and swathed in voluminous but revealing drapery. The three Magi and the Virgin fill the front gable end, and prophets and apostles sit in the niches in the two levels of arcading on the sides. The work combines robust, expressively mobile sculptural forms with a jeweler's exquisite ornamental detailing to create an opulent, monumental setting for its precious contents.

STRASBOURG CATHEDRAL. At the cathedral in Strasbourg (a border city variously claimed by France and Germany over the centuries), sculpture in the south transept portal reflects the Mosan style as interpreted by Reims masters. A relief (c. 1240) depicting the death and Assumption of Mary fills the tympanum (FIG. 11–36). While Mary lies on her deathbed surrounded by distraught apostles, Christ has received her soul (the doll-like figure in his arms) and will carry her directly to heaven. The theme is Byzantine, where the subject is known as the Dormition (Sleep) of the Virgin. The apostles are dynamically expressive figures with large heads, their grief vividly rendered. Their short bodies are clothed in fluid drap-

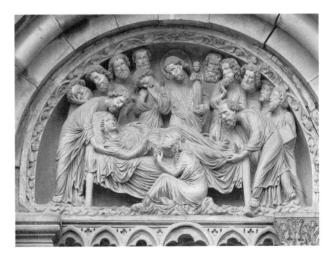

II—36 | **DORMITION OF THE VIRGIN**South transept portal tympanum, Strasbourg Cathedral, Strasbourg, France. c. 1240.

ery. Deeply undercut, each stands out dramatically in the crowded scene. Strasbourg sculpture has an emotional expressiveness unknown earlier, and this depiction of intense emotion became characteristic of German medieval sculpture.

II-37 | SAINT MAURICE
Magdeburg Cathedral, Magdeburg, Germany. c. 1240-50.
Dark sandstone with traces of polychromy.

SAINT MAURICE. In addition to emotional expressionism, a powerful current of realism runs through German Gothic sculpture. Some works suggest a living model, among them a statue of Saint Maurice in Magdeburg Cathedral, where his relics were preserved. Carved about 1240–50 (FIG. II–37), Maurice, the commander of Egyptian Christian troops in the Roman army, was martyred together with his men in 286. As patron saint of Magdeburg, he was revered by Ottonian emperors and became a favorite saint of military aristocrats. Because he came from Egypt, Saint Maurice was commonly portrayed with black African features. Dressed in a full suit of chain mail covered by a sleeveless coat of leather, he represents a distinctly different military ideal (SEE FIG. 9–26).

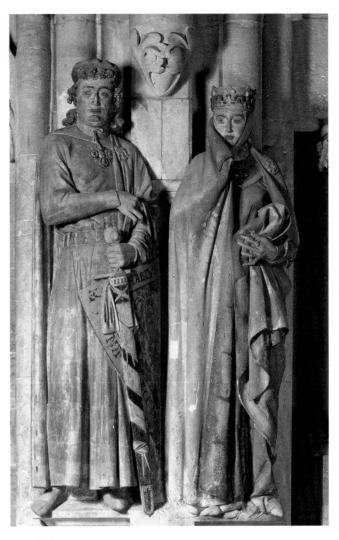

11–38 | **EKKEHARD AND UTA**West chapel, Naumburg Cathedral, Naumburg, Germany.
c. 1245–60. Stone, originally polychromed, approx. 6'2"
(1.88 m).

NAUMBURG. As portraitlike as medieval figure sculpture sometimes seems, the figures represented ideal types, not actual individuals. Such is the case in the portrayal of the ancestors of the bishop of Wettin, Dietrich II. About 1245 he ordered sculptures for the family funeral chapel, built at the west end of Naumburg Cathedral. Bishop Dietrich had lifesize statues of twelve of his ancestors, who had been patrons of the church, placed on pedestals around the chapel.

In the representations of Margrave Ekkehard of Meissen and his Polish-born wife, Uta (FIG. 11–38), the sculptor created extraordinarily lifelike and individualized figures and faces. The Margrave seems to be a proud warrior and nonnensense administrator (a *margrave*—count of the march or border—was a territorial governor whose duty it was to

THE OBJECT SPEAKS

THE CHURCH OF ST. FRANCIS AT ASSISI

hortly after Saint Francis's death, the church in his birthplace, Assisi, was begun (1228). It was nearly finished in 1239 but was not dedicated until 1253. Unusually elaborate in its design with upper and lower sections in two stories and a crypt, it is set into the hillside. Both upper and lower churches have a single nave of four square vaulted bays, and both end in a transept and a single apse. The lower church has massive walls and a narrow nave flanked by side chapels. The upper church is a spacious, well-lit hall designed to accommodate crowds. People went there to listen to the friars preach as well as to participate in church rituals, so Franciscan churches had to provide lots of space and excellent visibility and acoustics. The friars' educational mission utilized visual as well as spoken messages, so their churches had expanses of unbroken wall space suitable for educational and inspirational paintings.

Wall painting became a preeminent art form in Italy. The growing demand

for painting reflected the educational mission of the mendicant orders—the Franciscans and the Dominicans—as well as the new sources of patronage created by Italy's burgeoning economy and urban society. Art proclaimed a patron's status as much as it did his or her piety.

The Church of Saint Francis is much more richly decorated than most Franciscan churches, although the architecture itself is simple. Typical Franciscan churches were barnlike structures with wooden roofs, but in the Church of Saint Francis the nave is divided by slender clustered, engaged columns that rise unbroken to Gothic ribbed vaults. At the window level, the walls are set back to make walkways down the nave. Single two-light windows pierce the upper walls of each bay. Painting covers every surface, even the vaults where large figures float against a bright blue heaven. The amount of decoration is surprising in the mother church of a monastic order dedicated to poverty and service.

On the morning of September 27, 1997, tragedy struck. An earthquake convulsed the small town of Assisi. It shook the Church of Saint Francis, causing great damage to the architecture and paintings. The vault collapsed in two places, causing priceless frescoes to shatter and plunge to the floor. The photographer Ghigo Roli had just finished recording every painted surface of the interior when the sound of the first earthquake was heard in the basilica. As the building shook, the paintings on the vaults fell. "I wanted to cry," Ghigo Roli later wrote.

When such a disaster happens, the whole world seems to respond. Volunteers immediately established organizations to raise money to restore the frescoes, with the hope and intention of paying the costs of repairing and strengthening the basilica, reassembling the paintings from millions of tiny pieces, and finally reinstalling the restored treasures. So successful was the effort that visitors today would not guess that an earthquake had brought down the vaults only a decade ago.

Church of Saint Francis, Assisi, Italy during the 1997 earthquake. (Above) Church of Saint Francis, Assisi, Italy restored. (Right) 1228–53.

Caught by a television camera during the quake, some of the vaults and archivolts in the upper church plunged to the floor, killing four people. The camera operator eventually emerged, covered with the fine dust of the shattered brickwork and plaster, as a "white, dumbfounded phantom."

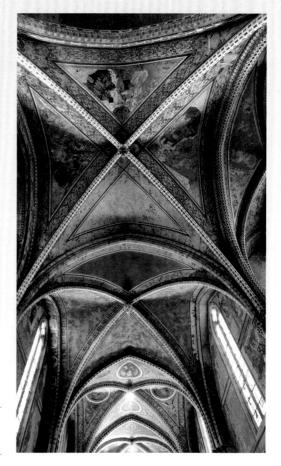

defend the frontier). Uta, coolly elegant and courtly, seems to draw her cloak artfully to her cheek. Traces of color indicate that painting added to the realistic impact of the figures. Such realism became characteristic of German Gothic art and ultimately had a profound impact on later art, both within Germany and beyond.

GOTHIC ART IN ITALY

The thirteenth century was a period of political division and economic expansion for the Italian peninsula. Part of southern Italy and Sicily was controlled by Frederick II von Hohenstaufen (1194–1250), king of Sicily from 1197 and Holy Roman emperor from 1220. Called by his contemporaries "the wonder of the world," Frederick was a politically unsettling force. He fought with a league of north Italian cities and briefly controlled the Papal States. On his death, Germany and the Holy Roman Empire ceased to be an important factor in Italian politics and culture. Instead, France and Spain began to vie for control of parts of the peninsula and the island of Sicily.

In northern Italy, in particular, organizations of successful merchants created communal governments in their prosperous and independent city-states and struggled against powerful families for control of them. Growing individual power and wealth inspired patronage of the arts. Artisans began to emerge as artists in the modern sense, both in their own eyes and the minds of their patrons. They joined together in urban guilds and independently contracted with wealthy clients and with civic and religious groups.

Sculpture: The Pisano Family

During his lifetime, the culturally enlightened Holy Roman emperor Frederick II had fostered a classical revival. He was a talented poet, artist, and naturalist, and an active patron of the arts and sciences. In the Romanesque period, artists in southern Italy had sometimes relied on ancient sculpture for inspiration. But Frederick, mindful of his imperial status as Holy Roman emperor, commissioned artists who turned to ancient Roman sculpture to help communicate a message of power. He also encouraged artists to look anew at the natural world around them. Nicola Pisano (active in Tuscany c. 1258–78), who came from the southern region of Apulia, one of the territories where imperial patronage under Frederick had flourished, became the leading exponent of the style that had developed in southern Italy.

NICOLA PISANO'S PULPIT AT PISA. An inscription identifies the marble pulpit in the Pisa Baptistry as Nicola's work (FIG. II-39). Clearly proud of his skill, he wrote: "In the year 1260 Nicola Pisano carved this noble work. May so gifted a hand be praised as it deserves." Columns topped with leafy Corinthian capitals support standing figures and Gothic

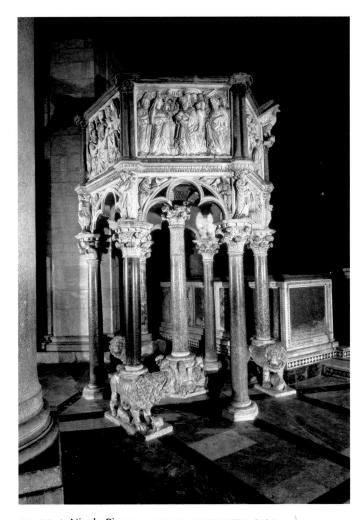

II-39 | Nicola Pisano PULPIT, BAPTISTRY, PISA 1260. Marble; height approx. 15' (4.6 m).

trefoil arches, which in turn provide a base for the six-sided pulpit. The columns rest on high bases carved with crouching figures, domestic animals, and shaggy-maned lions. The panels illustrate New Testament subjects, each framed as an independent composition.

Panels illustrate several scenes in a continuous narrative—the Annunciation, Nativity, and Adoration of the Shepherds. The Virgin reclines in the middle of the composition (FIG. 11–40). The upper left-hand corner holds the Annunciation, and the scene in the upper right combines the annunciation to the shepherds with their adoration of the Child. In the foreground, midwives wash the infant Jesus as Joseph looks on. The viewer's attention moves from group to group within the shallow space, always returning to the regally detached Mother of God. The format, style, and technique of Roman sarcophagus reliefs—readily accessible in the burial ground near the Baptistry (SEE FIG. 10–13)—may have provided models for carving. The sculptural treatment of the deeply cut, full-bodied forms is classically inspired, as are their

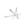

II-40 | Nicola Pisano NATIVITY Detail of pulpit, Baptistry, Pisa, Italy. 1260. Marble, $33\frac{1}{2} \times 44\frac{1}{2}$ " (85 × 113 cm).

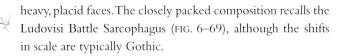

GIOVANNI PISANO'S PULPIT AT PISA. Nicola's son Giovanni (active c. 1265–1314) both assisted his father and learned from him, and he may also have worked or studied in France. By the end of the thirteenth century Giovanni emerged as a

II-4I | Giovanni Pisano NATIVITY Detail of pulpit, Pisa Cathedral, Pisa. 1302-10. Marble, $34\% \times 43''$ (87.2 \times 109.2 cm).

versatile artist in his own right. Between 1302 and 1310, he and his shop carved a huge pulpit for Pisa Cathedral that is similar to his father's in conception but significantly different in style and execution. In his **NATIVITY** panel Giovanni places graceful, animated figures in an uptilted, deeply carved landscape (FIG. 11–41). He replaces Nicola's impassive Roman matron with a slender young Mary who, sheltered by a shell-like cave, gazes delightedly at her baby. Below her, the

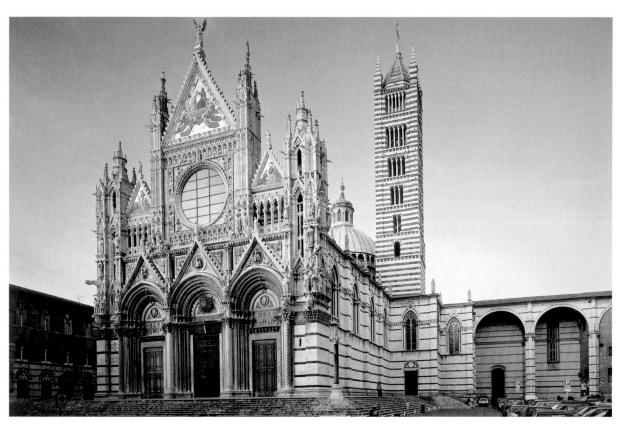

II-42 | SIENA CATHEDRAL Siena, Italy. Lower west façade, 1284-99.

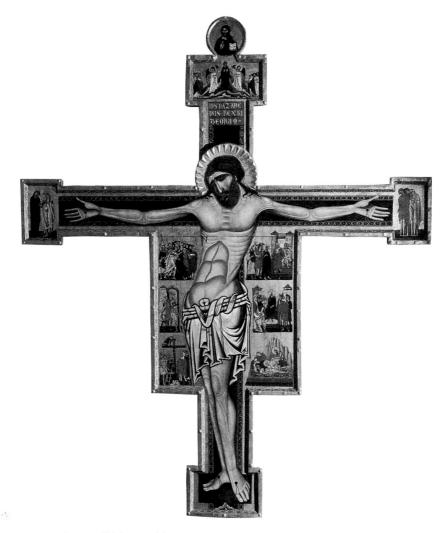

II–43 | Coppo di Marcovaldo **CRUCIFIX** Tuscany, Italy. c. 1250–70. Tempera and gold on wood panel, $9'7\%'' \times 8'1\%''$ (2.93 \times 2.47 m). Pinacoteca, San Gimignano, Italy.

midwife who doubted the virgin birth has her withered hand restored by the baby's bath water. Sheep, shepherds, and angels spiral up through the trees at the right and more angelic onlookers replace the Annunciation. Giovanni's sculpture is as dynamic as Nicola's is static.

THE CATHEDRAL FAÇADE AT SIENA. Between 1284 and 1299 Giovanni Pisano worked as architect, designer, and sculptor of the façade of the Cathedral of Our Lady in the central Italian city of Siena (FIG. 11–42). He incorporated elements of the French Style, such as Gothic gables with classical columns and moldings, to produce a richly ornamented screen independent of the building behind. High on the façade he placed figural sculptures, including dramatically gesturing and expressive prophets and sibyls. (The sculpture is now in the museum and has been replaced by copies.) Rather than the complex narrative sculptural programs typical of French Gothic façades, in Italy there was often an emphasis on architectural detailing of lintels and on narrative

door panels, as well as on figural sculpture placed across the façade. Inside, the focus was on furnishings such as pulpits, tomb monuments, baptismal fonts, and on paintings (see "The Church of Saint Francis at Assisi," page 416).

Painting

The capture of Constantinople by Crusaders in 1204 that brought relics to France also resulted in an influx of Byzantine art and artists to Italy. The imported style of painting, the *maniera greca* ("in the Greek manner"), influenced thirteenthand fourteenth-century Italian painting in style and technique and introduced a new emphasis on pathos and emotion.

A "HISTORIATED CRUCIFIX." One example, the large wooden crucifix attributed to the thirteenth-century Florentine painter Coppo di Marcovaldo (FIG. 11–43), represents the *Christus patiens*, or suffering Christ: a Byzantine type with closed eyes and bleeding, slumped body that emphasized emotional realism (SEE FIGS. 7–43, 9–29). The cross is also a "historiated

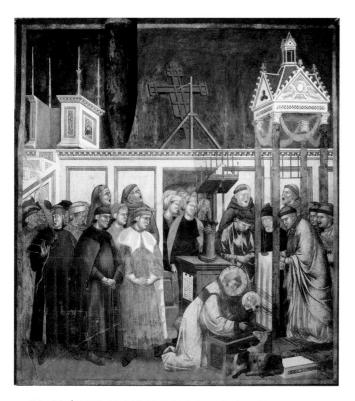

II—44 | LIFE OF SAINT FRANCIS, MIRACLE OF THE CRIB AT GRECCIO
Church of Saint Francis, Assisi, Italy. Fresco, late 13th century?

crucifix," with scenes at each side that tell the Passion story. Such crosses were mounted on the choir screen that separated the clergy in the sanctuary from the lay people in the nave (one can be seen with its wooden bracing in FIG. 11–44).

MURAL PAINTING AT ASSISI. Colorful, educational paintings covered the walls of Italian churches. The *Life of Saint Francis*, a series of narratives depicting the saint's life in the upper church of Saint Francis in Assisi, provides a vivid example of Gothic mural painting. Scholars differ on whether the murals were painted as early as 1290. Many have adopted the neutral designation of the artist as the "Saint Francis Master." THE MIRACLE OF THE CRIB AT GRECCIO (FIG. 11–44) portrays Saint Francis making the first Christmas manger scene in the church at Greccio and also vividly documents the appearance

of an Italian Gothic church. A large wooden crucifix, similar to the one by Coppo di Marcovaldo, has been suspended from a stand on top of a screen separating the sanctuary from the nave. The cross has been reinforced on the back and tilted forward to hover over people in the nave, whom we see through an open door in the choir screen. A pulpit, with stairs leading up to its entrance and candlesticks at its corners, rises above the screen at the left. An elaborate carved *baldacchino* (canopy) surmounts the altar at the right, and an adjustable wooden lectern stands in front of the altar.

Other small but telling touches include a seasonal liturgical calendar posted on the lectern, foliage swags decorating the *baldacchino*, and an embroidered altar cloth. Candles in tall candlesticks stand on the top of the screen and on wire frames above the lectern and altar. Saint Francis, in the foreground, reverently holds the Holy Infant above a plain, box-like crib next to representations of various animals that might have been present at the Nativity. The scene depicts the astonishing moment when, it was said, the Christ Child appeared in the manger. The tableau is recreated at Christmas by many families and communities today.

IN PERSPECTIVE

From its beginnings in France, Gothic art spread throughout Europe. In media as diverse as tiny book illustrations and enormous stained-glass windows, Gothic artists proclaimed the Christian message. These works were both educational and decorative. Inspired by biblical accounts of the jeweled walls of heaven and the golden gates of Paradise, Christian patrons and builders labored to erect glorious dwelling places for God and the saints on Earth. In order to intensify the effects of light and color, they constructed ever-larger buildings with higher vaults and thinner walls that permitted the insertion of huge windows. The glowing, back-lit colors of stained glass and the soft sheen of mural paintings dissolved the solid forms of masonry, while within the church the reflection of gold, enamels, and gems on altars and gospel book covers, on crosses and candlesticks, captured the splendor of Paradise on Earth. Subtle light and dazzling color created a mystical visual pathway to heaven as artists gave a tangible form to the unseen and unknowable.

ABBEY CHURCH OF ST. DENIS 1140-44; 1231-81

NICHOLAS OF VERDUN AND WORKSHOP. SHRINE OF THE THREE KINGS C. 1190–1205/10

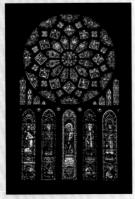

CHARTRES.

NORTH TRANSEPT, ROSE WINDOW

AND LANCETS

ABOUT 1220

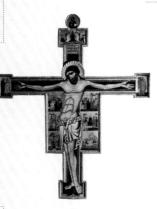

COPPO DI MARCOVALDO.

CRUCIFIX

C. 1250-1270

PSALM1 (BEATUS VIR).

WINDMILL PLASTER

C. 1270-80

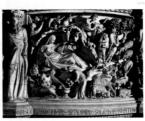

GIOVANNI PISANO.

NATIVITY, DETAIL OF PULPIT

1302–10

GOTHIC ART OF THE TWELFTH AND THIRTEENTH CENTURIES

- Second Crusade 1147-49
- Plantagenet Dynasty Ruled England 1154-1485
- **Third Crusade** 1188-92
- Fourth Crusade Takes Constantinople 1204
- Franciscan Order Founded 1209

125C

- Western Control of Constantinople
 Ends 1261
- Thomas Aquinas Begins Writing Summa Theologica 1266

1300

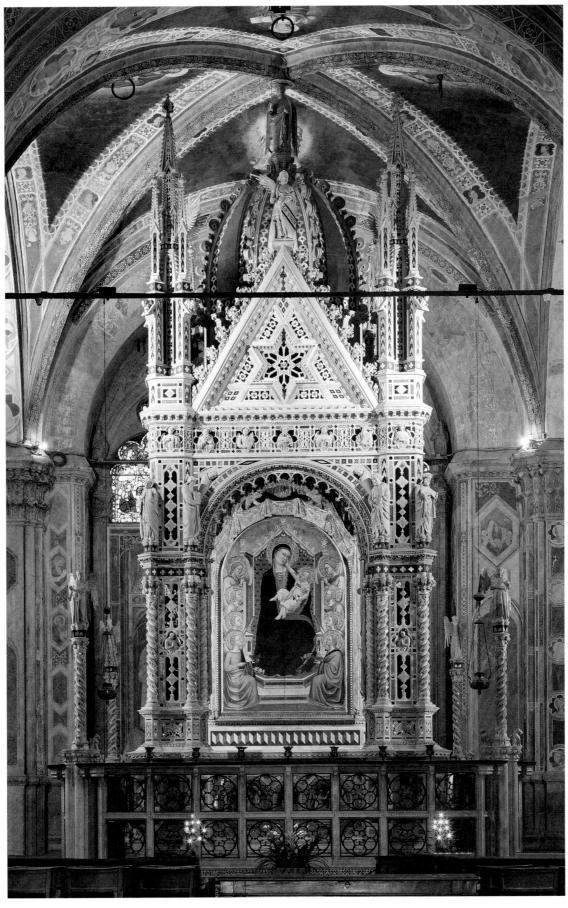

12-I | Andrea Orcagna Marble, mosaic, gold, lapis lazuli.
 Bernardo Daddi MADONNA AND CHILD 1346-7. Tempera and gold on wood panel.

CHAPTER TWELVE

FOURTEENTH-CENTURY ART IN EUROPE

One of the many surprises greeting the modern visitor to Florence is a curious blocky building with statue-filled niches. Originally a loggia (a covered, open-air gallery), today its dark interior is dominated by a huge and ornate taberna-

was built to protect the miracle-working image, and two upper stories were added to the loggia to store the city's grain reserves.

cle built to house the important MADONNA AND CHILD (FIG.

12-1) by Bernardo Daddi. Daddi was commissioned to create this painting in 1346/47, just before the Black Death swept through the city in the summer of 1348.

Daddi's painting was the second replacement of a late thirteenth-century miracle-working image of the Madonna and Child. The original image had occupied a simple shrine in the central grain market, known as Orsanmichele (Saint Michael in the Garden). The original painting may have been irreparably damaged in the fire of 1304 that also destroyed the first market loggia, built at the end of the thirteenth century. A second painting, also lost, was made sometime later, but it was believed that the healing power of the image passed from painting to painting with continued potency.

Florence grew rapidly in the late Middle Ages. By the fourteenth century two-thirds of the city's grain supply had to be imported. The central grain market and warehouse established at Orsanmichele, as insurance against famine, made that site the economic center of the city. The Confraternity (charitable society) of Orsanmichele was created to honor the image of the Madonna and Child and to collect and distribute alms to needy citizens. In 1337 a new loggia

Orsanmichele remained Florence's central grain market for about ten years after Daddi

painted the newest miracle-working Madonna and Child in 1346/47. As a reflection of its wealth and piety, the Confraternity of Orsanmichele commissioned Andrea di Cione, better known as Orcagna (active c. 1343-68), to create a new and rich tabernacle for Daddi's painting. A member of the stone- and woodworkers guild, Orcagna was in charge of building and decorating projects at Orsanmichele. To protect and glorify the Madonna and Child, he created a tour-de-force of architectural sculpture in marble, encrusted with gold and glass mosaics. In Orcagna's shrine, Daddi's Madonna and Child seems to be revealed by a flock of angels drawing back carved curtains. Sculpted saints stand on the pedestals against the piers, and reliefs depicting the life of the Madonna occupy the structure's base. The tabernacle was completed in 1359, and a protective railing was added in 1366.

Orsanmichele answered practical economic and social needs (granary and distribution point for alms), as well as religious and spiritual concerns (a shrine to the Virgin Mary), all of which characterized the complex society of the fourteenth century. In addition, Orsanmichele was a civic rallying point for the city's guilds. The significance of the guilds in the life of cities in the later Middle Ages cannot be overestimated. In Florence, guild members were not simple artisans; the major guilds, composed of rich and powerful merchants and entrepreneurs, dominated the government and were key patrons of the arts. For example, the silk guild oversaw the construction of Orsanmichele. In 1380, the arches of the loggia were walled up. At that time, fourteen of the most important Florentine guilds were each assigned an exterior niche on the ground level in which to erect an image of their patron saint.

The cathedral, the Palazzo della Signoria, and Orsanmichele, three great buildings in the city center, have come to symbolize power and patronage in the Florentine Republic. But of the three, the miraculous Madonna in her shrine at Orsanmichele witnessed the greatest surge of interest in the years following the Black Death. Pilgrims flocked to Orsanmichele, and those who had died during the plague left their estates in their wills to the shrine's confraternity. On August 13, 1365, the Florentine government gathered the people together to proclaim the Virgin of Orsanmichele the special protectress of the city.

CHAPTER-AT-A-GLANCE

- EUROPE IN THE FOURTEENTH CENTURY
- ITALY Florentine Architecture and Sculpture Florentine Painting Sienese Painting
- FRANCE Manuscript Illumination Sculpture
- ENGLAND Embroidery: Opus Anglicanum Architecture
- THE HOLY ROMAN EMPIRE | The Supremacy of Prague | Mysticism and Suffering
- IN PERSPECTIVE

EUROPE IN THE FOURTEENTH CENTURY

By the middle of the fourteenth century, much of Europe was in crisis. Earlier prosperity had fostered population growth, which by about 1300 had begun to exceed food production. A series of bad harvests then meant that famines became increasingly common. To make matters worse, a prolonged conflict known as the Hundred Years' War (1337–1453) erupted between France and England. Then, in the middle of the fourteenth century, a lethal plague known as the Black Death swept across Europe, wiping out as much as 40 percent of the population (see "The Triumph of Death," page 426). By depleting the labor force, however, the plague gave surviving peasants increased leverage over their landlords and increased the wages of artisans.

The papacy had emerged from its conflict with the Holy Roman Empire as a significant international force. But its temporal success weakened its spiritual authority and brought it into conflict with growing secular powers. In 1309, after the election of a French pope, the papal court moved from Rome to Avignon, in southern France. Italians disagreed, and during the Great Schism from 1378 to 1417, there were two popes, one in Rome and one in Avignon, each claiming legitimacy. The Church provided some solace but little leadership, as rival popes in Rome and Avignon excommunicated each other's followers. Secular rulers took sides: France, Scotland, Aragon, Castile, Navarre, and Sicily supported the

pope in Avignon; England, Flanders, Scandinavia, Hungary, and Poland supported the pope in Rome. Meanwhile, the Church experienced great strain from challenges from reformers like John Hus (c. 1370–1415) in Bohemia. The cities and states that composed present-day Germany and the Italian Peninsula were divided among different factions.

The literary figures Dante, Petrarch, and Boccaccio (see "A New Spirit in Fourteenth-Century Literature," page 431) and the artists Cimabue, Duccio, and Giotto fueled a cultural explosion in fourteenth-century Italy. In literature, Petrarch (Francesco Petrarca, 1304–74) was a towering figure of change, a poet whose love lyrics were written not in Latin but in Italian, marking its first use as a literary language. A similar role was played in painting by the Florentine Giotto di Bondone (c. 1277–1337). In deeply moving mural paintings, Giotto not only observed the people around him, he ennobled the human form by using a weighty, monumental style, and he displayed a new sense of dignity in his figures' gestures and emotions

This new orientation toward humanity, combined with a revived interest in classical learning and literature, we now designate as *humanism*. Humanism embodied a worldview that focused on human beings; an education that perfected individuals through the study of past models of civic and personal virtue; a value system that emphasized personal effort and responsibility; and a physically active life that was directed toward the common good as well as individual

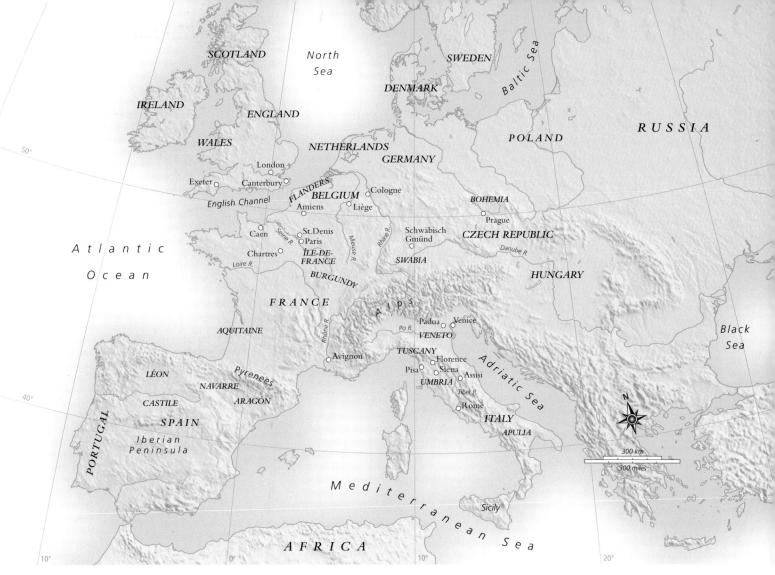

MAP 12-1 | Europe in the Fourteenth Century

Avignon in Southern France, Prague in Bohemia, and Exeter in Southern England joined Paris, Florence, and Siena as centers of art patronage in the late Gothic period.

nobility. For Petrarch and his contemporaries an appreciation of Greek and Roman writers became the defining element of the age. Humanists mastered the Greek and Latin languages so that they could study the classical literature—including newly rediscovered works of history, biography, poetry, letters, and orations.

In architecture, sculpture, and painting, the Gothic style—with its soaring vaults, light, colorful glass, and linear qualities—persisted in the fourteenth century, with regional variations. Toward the end of the century, devastation from the Hundred Years' War and the Black Death meant that large-scale construction gradually ceased, ending the great age of cathedral building. The Gothic style continued to develop, however, in smaller churches, municipal and commercial buildings, and private residences. Many churches were modernized or completed in this late Gothic period.

From the growing middle class of artisans and merchants, talented and aggressive leaders assumed economic and in some places political control. The artisan guilds—organized by occupation—exerted quality control among members and supervised education through an apprenticeship sys-

tem. Admission to the guild came after examination and the creation of a "masterpiece"—literally, a piece fine enough to achieve master's status. The major guilds included cloth finishers, wool merchants, and silk manufacturers, as well as pharmacists and doctors. Painters belonged to the pharmacy guild, perhaps because they used mortars and pestles to grind their colors. Their patron saint, Luke, who was believed to have painted the first image of the Virgin Mary (see Chapter 7, page 266), was also a physician—or so they thought. Sculptors who worked in wood and stone had their own guild, while those who worked in metals belonged to another guild. Guilds provided social services for their members, including care of the sick and funerals for the deceased. Each guild had its patron saint and maintained a chapel and participated in religious and civic festivals.

Complementing the economic power of the guilds was the continuing influence of the Dominican and Franciscan religious orders (see Chapter 11), whose monks espoused an ideal of poverty, charity, and love and dedicated themselves to teaching and preaching. The new awareness of societal needs manifested itself in the

THE OBJECT SPEAKS

THE TRIUMPH OF DEATH

he Four Horsemen of the Apocalypse—Plague, War, Famine, and Death—stalked the people of Europe during the fourteenth century. France, England, and Germany pursued their seemingly endless wars, and roving bands of soldiers and brigands looted and murdered unprotected peasants and villagers. Natural disasters—fires, droughts, floods, and wild storms—took their toll. Disease spread rapidly through a population already weakened by famine and physical abuse.

Then a deadly plague, known as the Black Death, spread by land and sea from Asia. The plague soon swept from Italy and France across the British Isles, Germany, Poland, and Scandinavia. Half the urban population of Florence and Siena—some say 80 percent—died in the summer of 1348. To people of the time the Black Death seemed to be an act of divine wrath against sinful humans.

In their panic, some people turned to escapist pleasures; others to religious fanaticism. Andrea Pisano and Ambrogio Lorenzetti were probably among the many victims of the Black Death. But the artists who survived had work to do—chapels and hospitals, altarpieces and votive statues. The sufferings of Christ, the sorrows as well as the joys of the Virgin, the miracles of the saints, and new themes—"The Art of Dying Well," and "The Triumph of Death"—all carried the message "Remember, you too will die." An unknown artist, whom we call the Master of the Triumph of Death, painted such a theme in the cemetery of Pisa (Camposanto).

The horror and terror of impending death are vividly depicted in the huge mural, THE TRIUMPH OF DEATH. In the center of the wall dead people lie in a heap while devils and angels carry their souls to hell or heaven. Only the hermits living in the wilderness escape the holocaust. At the right, wealthy young people listen to music under the orange trees, unaware of Death flying toward them with a scythe. At the left of the painting, a group on horseback who have ridden out into the wilderness discover three open coffins. A woman recoils at the sight of her dead counterpart. A courtier covers his nose, gagging at the smell,

while his wild-eyed horse is terrified by the bloated, worm-riddled body in the coffin. The rotting corpses remind them of their fate, a medieval theme known as "The Three Living and the Three Dead."

Perhaps the most memorable and touching images in the huge painting are the crippled beggars who beg Death to free them from their earthly miseries. Their words appear on the scroll: "Since prosperity has completely deserted us, O Death, you who are the medicine for all pain, come to give us our last supper!"* The painting speaks to the viewer, delivering its message in words and images. Neither youth nor beauty, wealth nor power, but only piety like that of the hermits provides protection from the wrath of God.

Strong forces for change were at work in Europe. For all the devastation caused by the Four Horsemen, those who survived found increased personal freedom and economic opportunity.

* Translated by John Paoletti and Gary Radke, Art in Renaissance Italy, 3rd ed. Upper Saddle River, New Jersey. Pearson Prentice Hall, 2005. p. 154.

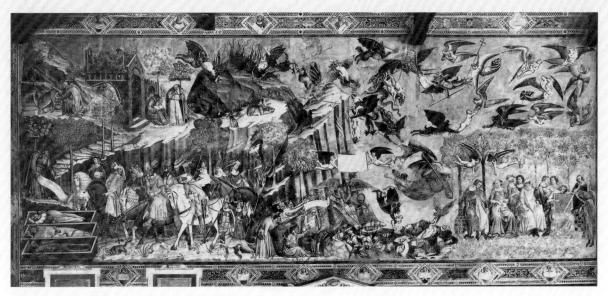

Master of the Triumph of Death (Buffalmacco?) THE TRIUMPH OF DEATH Camposanto, Pisa. 1330s. Fresco, $18'6'' \times 49'2''$ (5.6×15 m).

Reproduced here in black and white, photo taken before the fresco was damaged by American shells during World War II.

12-2 | PIAZZA DELLA SIGNORIA WITH PALAZZO DELLA SIGNORIA (TOWN HALL)
1299-1310 and LOGGIA DEI LANZI (LOGGIA OF THE LANCERS)

Florence. 1376-82. Speakers' platform and since the sixteenth century a guard station and sculpture gallery.

- Harris

architecture of churches designed for preaching as well as liturgy, and in new religious themes that addressed personal or sentimental devotion.

ITALY

Great wealth and a growing individualism promoted art patronage in northern Italy. Artisans began to emerge as artists in the modern sense, both in their own eyes and in the eyes of patrons. Although their methods and working conditions remained largely unchanged, artisans in Italy contracted freely with wealthy townspeople and nobles and with civic and religious bodies. Their ambition and self-confidence reflect their economic and social freedom.

Florentine Architecture and Sculpture

The typical medieval Italian city was a walled citadel on a hilltop. Houses clustered around the church and an open city square. Powerful families added towers to their houses both for defense and out of family pride. In Florence, by contrast, the ancient Roman city—with its rectangular plan, major north—south and east—west streets, and city squares—remained the foundation for civic layout. The cathedral stood northeast of the ancient forum. The north—south street joining the cathedral and the Piazza della Signoria followed the Roman line.

THE PALAZZO DELLA SIGNORIA. The governing body of the city (the Signoria) met in the PALAZZO DELLA SIGNORIA, a massive fortified building with a tall bell tower 300 feet (91 m) high (FIG. 12–2). The building faces a large square, or piazza, which became the true civic center. Town houses often had seats along their walls to provide convenient public seating. In 1376 (finished in 1381/82), a huge loggia was built at one side to provide a covered space for ceremonies and speeches. After it became a sculpture gallery and guard station in the sixteenth century, the loggia became known as the LOGGIA OF THE LANCERS. The master builders were Berici di Cione and Simone Talenti. Michelangelo's *David* (SEE FIG. 15–10) once stood in front of the Palazzo della Signoria facing the loggia (it is replaced today by a modern copy).

THE CATHEDRAL. In Florence, the cathedral (duomo) (FIGS. 12–3, 12–4) has a long and complex history. The original plan, by Arnolfo di Cambio (c. 1245–1302), was approved in 1294, but political unrest in the 1330s brought construction to a halt until 1357. Several modifications of the design were made, and the cathedral we see today was built between 1357 and 1378. (The façade was given its veneer of white and green marble in the nineteenth century to coordinate it with the rest of the building and the nearby Baptistry of San Giovanni.)

Sculptors and painters rather than masons were often responsible for designing Italian architecture, and as the Florence Cathedral reflects, they tended to be more concerned with pure design than with engineering. The long, square-bayed nave ends in an octagonal domed crossing, as wide as

the nave and side aisles. Three polygonal apses, each with five radiating chapels, surround the central space. This symbolic Dome of Heaven, where the main altar is located, stands apart from the worldly realm of the congregation in the nave. But the great ribbed dome, so fundamental to the planners' conception, was not begun until 1420, when the architect Filippo Brunelleschi (1377–1446) solved the engineering problems involved in its construction (see Chapter 14).

THE BAPTISTRY DOORS. In 1330, Andrea Pisano (c.1290–1348) was awarded the prestigious commission for a pair of gilded bronze doors for the Florentine Baptistry of San Giovanni. (Although his name means "from Pisa," Andrea was not related to Nicola and Giovanni Pisano.) The Baptistry doors were completed within six years and display

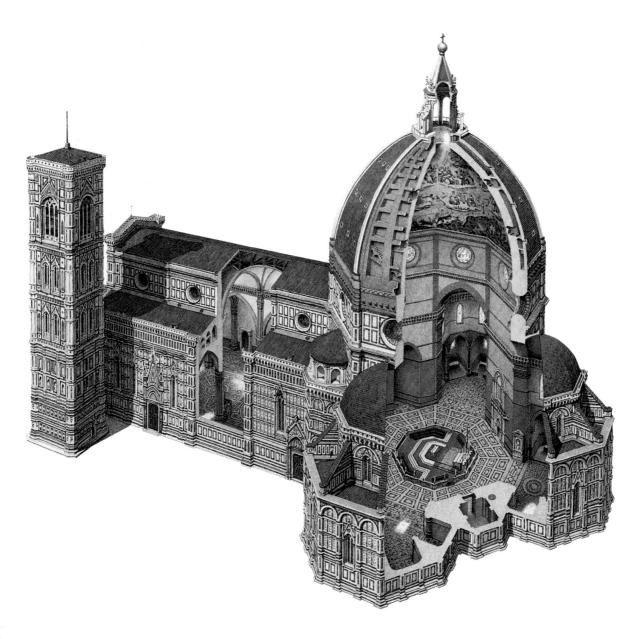

12-3 FLORENCE CATHEDRAL (DUOMO)

Plan 1294, costruction begun 1296, redisegned 1357 and 1366, drum and dome 1420-36. Illustration by Philipe Biard in Guide Gallimard Florence © Gallimard Loisirs.

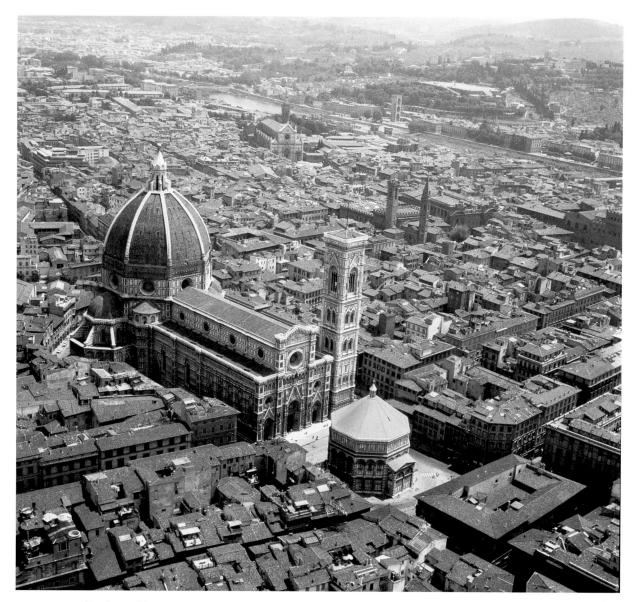

12-4 | Arnolfo di Cambio, Francesco Talenti, Andrea Orcagna, and others FLORENCE CATHEDRAL (DUOMO) 1296-1378; drum and dome by Brunelleschi, 1420-36; bell tower (Campanile) by Giotto, Andrea Pisano, and Francesco Talenti, c. 1334-50.

The Romanesque Baptistry of San Giovanni stands in front of the Duomo.

twenty scenes from the life of John the Baptist (San Giovanni) set above eight personifications of the Virtues (FIG. 12-5). The reliefs are framed by quatrefoils, the four-lobed decorative frames introduced at the Cathedral of Amiens in France (SEE FIG. 11–21). The figures within the quatrefoils are in the monumental, classicizing style inspired by Giotto then current in Florentine painting, but they also reveal the soft curves of northern Gothic forms in their gestures and draperies, and a quiet dignity of pose particular to Andrea. The individual scenes are elegantly natural. The figures' placement, on shelflike stages, and their modeling create a remarkable illusion of three-dimensionality, but the overall effect created by the repeated barbed quatrefoils is two-

dimensional and decorative, and emphasizes the solidity of the doors. The bronze vine scrolls filled with flowers, fruits, and birds on the lintel and jambs framing the door were added in the mid-fifteenth century.

Florentine Painting

Florence and Siena, rivals in so many ways, each supported a flourishing school of painting in the fourteenth century. Both grew out of the Italo-Byzantine style of the thirteenth century, modified by local traditions and by the presence of individual artists of genius. The Byzantine influence, also referred to as the maniera greca ("Greek manner"), was characterized by dramatic pathos and complex iconography and showed

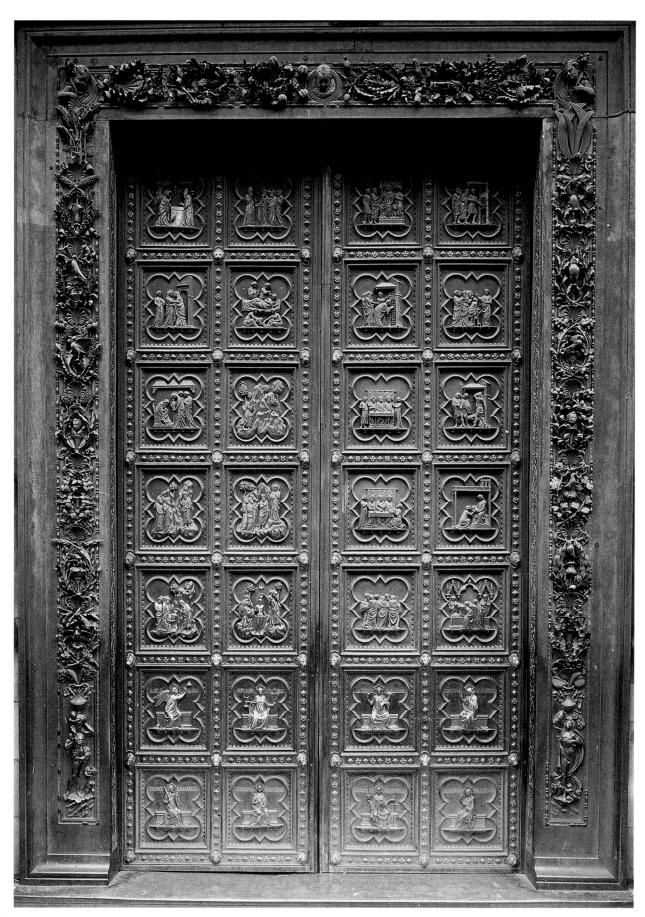

12–5 | Andrea Pisano LIFE OF JOHN THE BAPTIST South doors, Baptistry of San Giovanni, Florence. 1330–36. Gilded bronze, each panel $19\% \times 17''$ (48×43 cm). Frame, Ghiberti workshop, mid-15th century.

itself in such elements as elongated figures, often exaggerated, iconic gestures, stylized features including the use of gold for drapery folds, and striking contrasts of highlights and shadows in the modeling of individual forms. By the end of the fourteenth century, the painter and commentator Cennino Cennini (see "Cennino Cennini [c. 1370–1440] on Painting," page 434) would be struck by the accessibility and modernity of Giotto's art, which, though it retained traces of the "Greek manner," was moving toward the depiction of a humanized world anchored in three-dimensional form.

CIMABUE. In Florence, the transformation of the Italo-Byzantine style began a little earlier than in Siena. About 1280, a painter named Cenni di Pepi (active c. 1272–1302), better known by his nickname "Cimabue," painted the VIR-GIN AND CHILD ENTHRONED (FIG. 12–6), perhaps for the main altar of the Church of Santa Trinita in Florence. At almost 12 feet tall, this enormous panel painting set a new precedent for monumental altarpieces. Cimabue uses the traditional Byzantine iconography of the "Virgin Pointing the Way," in which Mary holds the infant Jesus in her lap and points to him as the path to salvation. Mother and child are surrounded by saints, angels, and Old Testament prophets.

A comparison with a Byzantine icon (SEE FIG. 7-51) shows that Cimabue employed Byzantine formulas in determining the proportions of his figures, the placement of their schematic features, and even the tilt of their haloed heads. Mary's huge throne, painted to resemble gilded bronze with inset enamels and gems, provides an architectural framework for the figures. To render her drapery and that of the infant Jesus, Cimabue used the Italo-Byzantine technique of highlighting drapery with thin lines of gold to indicate divinity. The viewer seems suspended in space in front of the image, simultaneously looking down on the projecting elements of the throne and Mary's lap, while looking straight ahead at the prophets at the base of the throne and the angels at each side. These spatial ambiguities, the subtle asymmetries within the centralized composition, the Virgin's thoughtful gaze, and the individually conceived faces of the old men enliven the picture with their departure from Byzantine tradition. Cimabue's concern for spatial volumes, solid forms delicately modeled in light and shade, and warmly naturalistic human figures contributed to the course of later Italian painting.

GIOTTO DI BONDONE. Compared to Cimabue's Virgin and Child Enthroned, Giotto's painting of the same subject (FIG. 12–7), done about 1310 for the Church of the Ognissanti (All Saints) in Florence, exhibits a groundbreaking spatial consistency and sculptural solidity while retaining some of Cimabue's conventions. The central and overtly symmetrical composition and the position of the figures reflect Cimabue's influence. Gone, however, are Mary's modestly inclined head and the delicate gold folds in her drapery. Instead, her face is

Art and Its Context

A NEW SPIRIT IN FOURTEENTH-CENTURY LITERATURE

or Petrarch and his contemporaries—Boccaccio, Chaucer, Christine de Pizan—the essential qualifications for a writer were an appreciation of Greek and Roman authors and an ability to observe and appreciate people from every station in life. Although fluent in Latin, they chose to write in the language of their own daily life—Italian, English, French. Leading the way was Dante Alighieri (1265–1321), who wrote *The Divine Comedy*, his great summation of human virtue and vice, and ultimately human destiny, in Italian. Dante established the Italian language as worthy of great themes in literature.

Francesco Petrarca, called simply Petrarch (1304–74), raised the status of secular literature with his sonnets (love lyrics) to his unobtainable, beloved Laura; his histories and biographies; and his discovery of the ancient Roman writings on the joys of country life. Petrarch's imaginative updating of classical themes in a work called *The Triumphs*—which examines the themes of Chastity triumphant over Love, Death over Chastity, Fame over Death, Time over Fame, and Eternity over Time—provided later Renaissance poets and painters with a wealth of allegorical subject matter.

More earthy, Giovanni Boccaccio (1313-75) perfected the art of the short story in *The Decameron*, a collection of amusing and moralizing tales told by a group of young Florentines who moved to the countryside to escape the Black Death. With wit and sympathy, Boccaccio presents the full spectrum of daily life in Italy. Such secular literature, including the discovery and translation of ancient authors (for some of the tales had a long lineage), written in Italian as it was then spoken in Tuscany, provided a foundation for the Renaissance of the fifteenth century.

In England, Geoffrey Chaucer (c. 1342–1400) was inspired by Boccaccio to write his own series of short stories, *The Canterbury Tales*, told by pilgrims traveling to the shrine of Saint Thomas à Becket (1118?–1170) in Canterbury. Observant and witty, Chaucer depicted the pretensions and foibles, as well as the virtues, of humanity.

Christine de Pizan (1364–c. 1431), born in Venice but living and writing at the French court, became an author out of necessity when she was left a widow with three young children and an aged mother to support. Among her many works are a poem in praise of Joan of Arc and a history of famous women—including artists—from antiquity to her own time. In *The Book of the City of Ladies* she defended women's abilities and argued for women's rights and status. These writers, as surely as Giotto, Duccio, Peter Parler, and Master Theodoric, led the way into a new era.

individualized, and her action—holding her child's leg instead of merely pointing to him—seems entirely natural. This colossal Mary seems too large for the slender Gothic tabernacle, where figures peer through the openings and haloes overlap the faces. In spite of the formal, enthroned image and flat, gold background, Giotto renders the play of light and shadow across these substantial figures to create a sense that they are fully three-dimensional beings inhabiting real space. Details of the Virgin's solid torso can be glimpsed under her thin tunic, and Giotto's angels, unlike those of Cimabue, have ample wings that fold over in a resting position.

According to the sixteenth-century chronicler Vasari, "Giotto obscured the fame of Cimabue, as a great light out-

shines a lesser." Vasari also credited Giotto with "setting art upon the path that may be called the true one [for he] learned to draw accurately from life and thus put an end to the crude Greek [i.e., Italo-Byzantine] manner" (translated by J. C. and P. Bondanella).

Giotto may have collaborated on murals at the prestigious Church of Saint Francis in Assisi (see "The Church of Saint Francis at Assisi," page 416). Certainly he worked for the Franciscans in Florence and reacted to their teaching. Saint Francis's message of simple, humble devotion, direct experience of God, and love for all creatures was gaining followers throughout Western Europe, and it had a powerful impact on thirteenth- and fourteenth-century Italian literature and art.

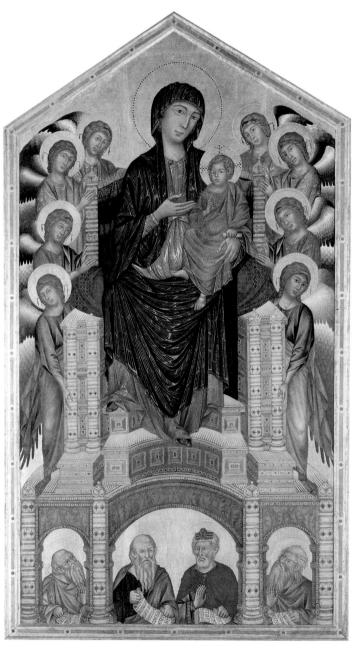

12–6 | Cimabue VIRGIN AND CHILD ENTHRONED Most likely painted for the high altar of the Church of Santa Trinita, Florence. c. 1280. Tempera and gold on wood panel, $12'17'' \times 7' 4''$ (3.53 \times 2.2 m). Galleria degli Uffizi, Florence.

Early in the fourteenth century Giotto traveled to northern Italy. While working at the Church of Saint Anthony in Padua, he was approached by a local banker, Enrico Scrovegni, to decorate a new family chapel. He agreed, and the **SCROVEGNI CHAPEL** was dedicated in 1305 to the Virgin of Charity and the Virgin of the Annunciation. (The chapel is also called the "Arena Chapel" because it and the family palace were built on and in the ruins of an ancient Roman arena.) The building is a simple, barrel-vaulted room (FIG. 12–8). As viewers look toward the altar, they see the story of Mary and Jesus unfolding before them in a series of rectangular panels. On the entrance wall Giotto painted the Last Judgment.

Sequencing Events MARCH OF THE BLACK DEATH

1346	Plague enters the Crimian Peninsula
1347	Plague arrives in Sicily
1348	Plague reaches port cities of Genoa, Italy, and Marseilles, France
1349	First recorded cases of plague in Cologne and Vienna
1350	Plague reaches Bergen, Norway, via England

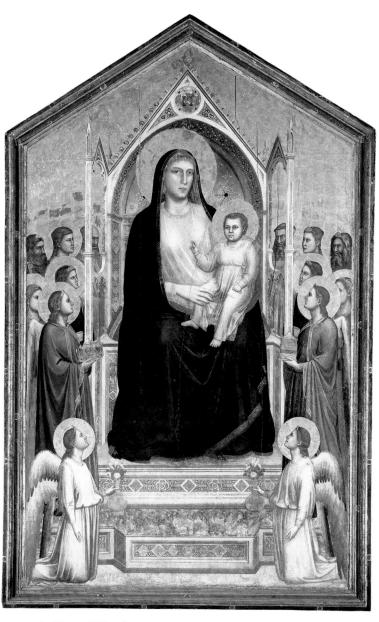

12–7 | Giotto di Bondone VIRGIN AND CHILD ENTHRONED Most likely painted for the high altar of the Church of the Ognissanti (All Saints), Florence. 1305–10. Tempera and gold on wood panel, $10'8''\times 6'~87''$ (3.53 \times 2.05 m). Galleria degli Uffizi, Florence.

Technique

CENNINO CENNINI (c. 1370-1440) ON PAINTING

ennino Cennini's *Il Libro dell' Arte (The Book of Art)* is a handbook of Florentine and north Italian painting techniques from about 1400. Cennini includes a description of the artist's life as well as step-by-step painting instructions.

"You, therefore, who with lofty spirit are fired with this ambition, and are about to enter the profession, begin by decking yourselves with this attire: Enthusiasm, Reverence, Obedience, and Constancy. And begin to submit yourself to the direction of a master for instruction as early as you can, and do not leave the master until you have to" (Chapter III).*

The first step in preparing a panel for painting is to cover its surface with clean white linen strips soaked in a **gesso** made from gypsum. Gesso provides a ground, or surface, on which to paint. Cennini specified that at least nine layers of gesso should be applied. The gessoed surface should then be burnished until it resembles ivory. The artist can now sketch the composition of the work with charcoal. At this point, advised Cennini, "When you have finished drawing your figure, especially if it is in a very valuable [altarpiece], so that you are counting on profit and reputation from it, leave it alone for a few days, going back to it now and then to look it over and improve it wherever it still needs something . . . (and bear in mind that you may copy and examine things done by other good masters; that it is no shame to you). The final version of the design should be inked in with a

fine squirrel-hair brush, and the charcoal brushed off with a feather. Gold leaf should be affixed on a humid day, the tissuethin sheets carefully glued down with a mixture of fine powdered clay and egg white, on the reddish clay ground (called bole). Then the gold is burnished with a gemstone or the tooth of a carnivorous animal. Punched and incised patterning should be added to the gold leaf later."*

Italian painters at this time worked in **tempera** paint, powdered pigments mixed most often with egg yolk, a little water, and an occasional touch of glue.

Cennini specified a detailed and highly formulaic painting process. Faces, for example, were always to be done last, with flesh tones applied over two coats of a light greenish pigment and highlighted with touches of red and white. The finished painting was to be given a layer of varnish to protect it and enhance its colors. An elaborate frame, which included the panel or panels on which the painting would be executed, would have been produced by a specialist according to the painter's specifications and brought fully assembled to the studio.

Cennini claimed that panel painting was a gentleman's job, but given its laborious complexity, that was wishful thinking. The claim does, however, reflect the rising social status of painters.

* Cennino Cennini, *The Craftsman's Handbook (II Libro dell' Arte)*. Trans. by Daniel V. Thompson. New York: Dover, 1960. pp. 3, 16, 75.

A base of faux marble and allegorical *grisaille* (gray monochrome) paintings of the Virtues and Vices support vertical bands painted to resemble marble inlay and carved relief and containing quatrefoil portrait medallions. The central band of medallions spans the vault, crossing a brilliant, lapis blue, star-spangled sky in which large portrait disks float like glowing moons. Set into this framework are the rectangular narrative scenes juxtaposing the life of the Virgin with that of Jesus (FIG. 12–9).

Both the individual scenes and the overall program display Giotto's genius for distilling a complex narrative into a coherent visual experience. The life of the Virgin Mary begins the series and fills the upper band of images. Following in historical sequence, events in the life and ministry of Jesus circle the chapel in the middle band, while scenes of the Passion (the arrest, trial, and Crucifixion of Jesus) fill the lowest band. Read vertically, however, each set of three scenes foreshadows or comments on the others.

The first miracle, when Jesus changes water to wine during the wedding feast at Cana, recalls that his blood will become the wine of the Eucharist, or Communion. The raising of Lazarus becomes a reference to Jesus's Resurrection. Below, the Lamentation over the body of Jesus by those closest

to him leads to the Resurrection, indicated by angels at the empty tomb and his appearance to Mary Magdalen in the *Noli Me Tangere* ("Do not touch me"). The juxtaposition of dead and live trees in the two scenes also becomes a telling detail of death and resurrection. Giotto used only a few large figures and essential props in settings that never distract the viewer by their intricate detail. The scenes are reminiscent of *tableaux vivants* ("living pictures"), in which people dressed in costume re-created poses from familiar works of art—scenes that were played out in the city square in front of the chapel in Padua.

Among Giotto's achievements was his ability to model form with color. He rendered his bulky figures as pure color masses, painting the deepest shadows with the most intense hues and highlighting shapes with lighter shades mixed with white. These sculpturally modeled figures enabled Giotto to convey a sense of depth in landscape settings without relying on the traditional convention of an architectural framework.

In one of the most moving works, **LAMENTATION** (FIG. 12–10), in the lowest **register** (horizontal band) of the Arena Chapel, Giotto focused the composition off center for maximum emotional effect, concentrating on the faces of Mary and the dead Jesus. A great downward-swooping ridge—its barrenness emphasized by a single dry tree, a medieval symbol of

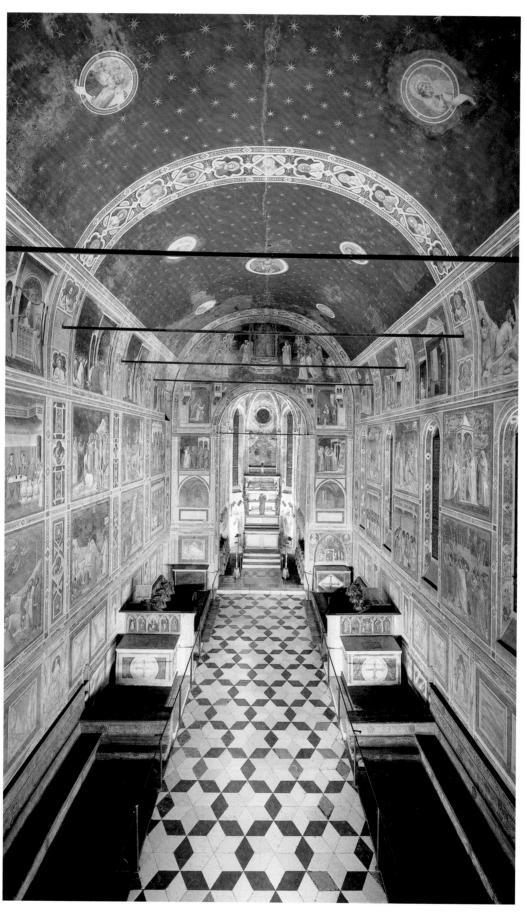

12–8 | Giotto di Bondone **SCROVEGNI (ARENA) CHAPEL**, Frescoes, Padua. 1305-6. View toward east wall.

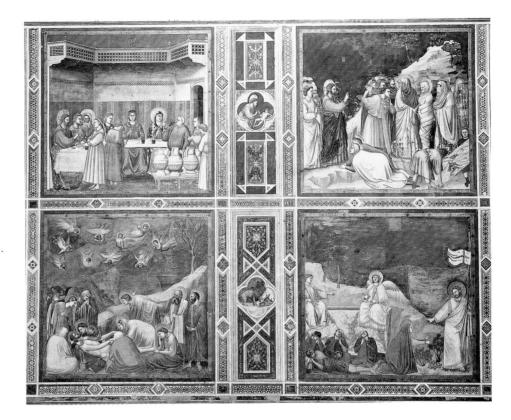

12–9 | Giotto di Bondone
MARRIAGE AT CANA,
RAISING OF LAZARUS,
RESURRECTION, and NOLI ME
TANGERE and LAMENTATION
Frescoes on north wall of
Scrovegni (Arena) Chapel,
Padua. 1305–6. Each scene
approx. 6'5" × 6' (2 × 1.85 m).

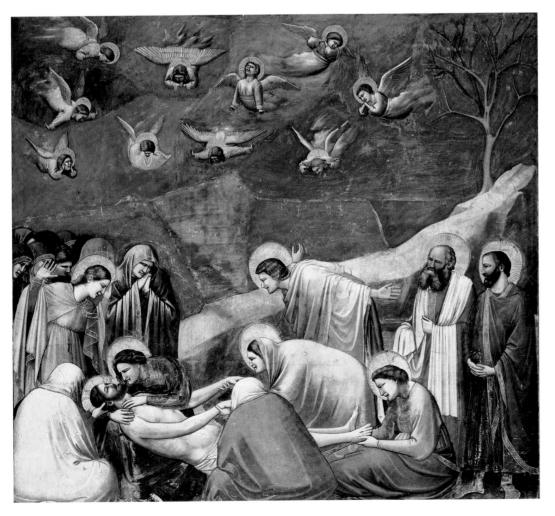

12–10 | Giotto di Bondone LAMENTATION Fresco in the Scrovegni (Arena) Chapel, Padua. 1305–6. Approx. 6′5″ × 6′ (2 x 1.85 m).

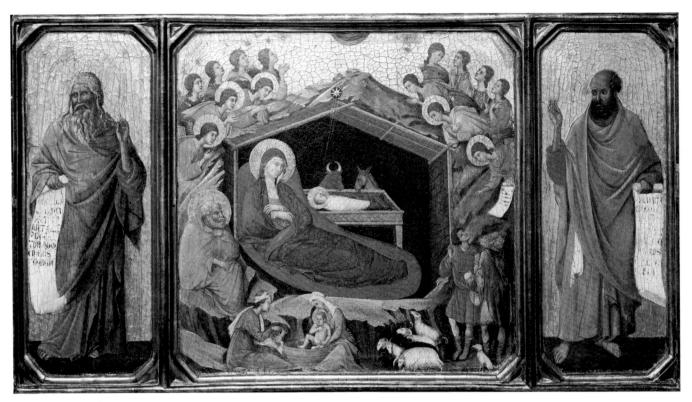

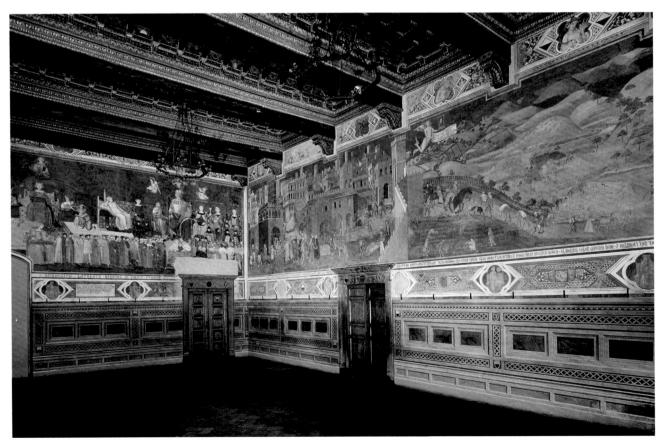

12–14 Ambrogio Lorenzetti **FRESCO SERIES OF THE SALA DELLA PACE, PALAZZO PUBBLICO** Siena city hall, Siena, Italy. 1338–40. Length of long wall about 46′ (14 m).

Creating this altarpiece was an arduous undertaking. The central panel alone was 7 by 13 ½ feet, and it had to be painted on both front and back, because it was meant to be seen from both sides. The main altar for which it was designed stood beneath the dome in the center of the sanctuary. Inscribed on Mary's throne are the words, "Holy Mother of God be thou the cause of peace for Siena and, because he painted thee thus, of life for Duccio" (cited in Hartt and Wilkins 4.2, page 104).

Mary and Christ, adored by angels and the four patron saints of Siena—Ansanus, Savinus, Crescentius, and Victor—kneeling in front, fill the large central panel. This *Virgin and Child in Majesty* represents both the Church and its specific embodiment, Siena Cathedral. Narrative scenes from the early life of the Virgin and the infancy of the Christ Child appear below the central image. The **predella** (the lower zone of the altarpiece) was entirely painted with the events in the childhood of Jesus. The back of this immense work was dedicated to scenes of his adult life and the miracles. The entire composition was topped by pinnacles—on the front, angels and the later life of the Virgin, and on the back, events after the Passion.

Duccio created a personal style that combines a softened Italo-Byzantine figure style with the linear grace and the easy relationship between figures and their settings characteristic of French Gothic. This subtle blending of northern and southern elements can be seen in the haloed ranks of angels around Mary's architectonic throne. The central, most holy figures retain a solemnity and immobility with some realistic touches, such as the weighty figure of the child; the adoring saints reflect a more naturalistic, courtly Gothic style that became the hallmark of the Sienese school for years to come. The brilliant palette, which mingles pastels with primary hues, the delicately patterned textiles that shimmer with gold, and the ornate punchwork—tooled designs in gold leaf on the haloes—are characteristically Sienese.

In 1771 the altarpiece was broken up, and individual panels were sold. One panel—the NATIVITY WITH PROPHETS ISAIAH AND EZEKIEL—is now in Washington, D.C. Duccio represented the Nativity in the tradition of Byzantine icons. Mary lies on a fat mattress within a cave hollowed out of a jagged, stylized mountain (FIG. 12-13). Jesus appears twice: first lying in the manger and then with the midwife below. However, Duccio followed Western tradition by placing the scene in a shed. Rejoicing angels fill the sky, and the shepherds and sheep add a realistic touch in the lower right corner. The light, intense colors, the calligraphic linear quality, even the meticulously rendered details recall Gothic manuscripts (see Chapter 11). The tentative move toward a defined space in the shed as well as the subtle modeling of the figures point the way toward future development in representing people and their world. Duccio's graceful, courtly art contrasts with Giotto's austere monumentality.

Technique

BUON FRESCO

he two techniques used in mural painting are buon ("true") fresco ("fresh"), in which paint is applied with water-based paints on wet plaster, and fresco secco ("dry"), in which paint is applied to a dry plastered wall. The two methods can be used on the same wall painting.

The advantage of buon fresco is its durability. A chemical reaction occurs as the painted plaster dries, which bonds the pigments into the wall surface. In fresco secco, by contrast, the color does not become part of the wall and tends to flake off over time. The chief disadvantage of buon fresco is that it must be done quickly without mistakes. The painter plasters and paints only as much as can be completed in a day. In Italy, each section is called a giornata, or day's work. The size of a giornata varies according to the complexity of the painting within it. A face, for instance, can occupy an entire day, whereas large areas of sky can be painted quite rapidly.

In medieval and Renaissance Italy, a wall to be frescoed was first prepared with a rough, thick undercoat of plaster. When this was dry, assistants copied the master painter's composition onto it with charcoal. The artist made any necessary adjustments. These drawings, known as sinopia, have an immediacy and freshness lost in the finished painting. Work proceeded in irregularly shaped sections conforming to the contours of major figures and objects. Assistants covered one section at a time with a fresh, thin coat of very fine plaster over the sinopia, and when this was "set" but not dry, the artist worked with pigments mixed with water. Painters worked from the top down so that drips fell on unfinished portions. Some areas requiring pigments such as ultramarine blue (which was unstable in buon fresco), as well as areas requiring gilding, would be added after the wall was dry using the fresco secco method.

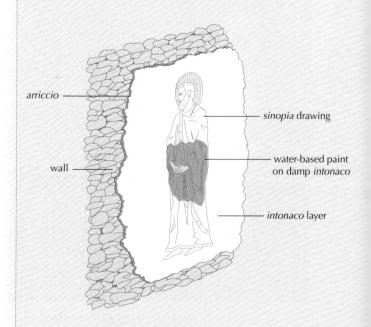

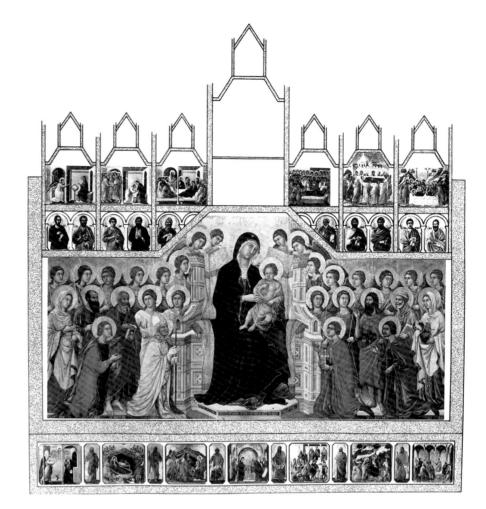

I2-I2 | PLAN OF FRONT AND BACK OF THE MAESTÀ ALTARPIECE

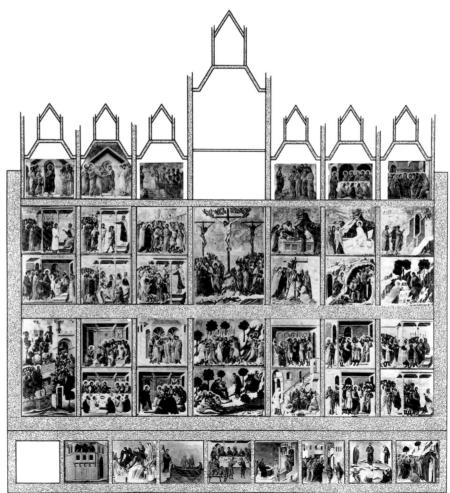

death—carries the psychological weight of the scene to its expressive core. Mourning angels hovering overhead mirror the anguish of Jesus's followers. The stricken Virgin communes with her dead son with mute intensity, while John the Evangelist flings his arms back in convulsive despair and other figures hunch over the corpse. Instead of symbolic sorrow, more typical of art from the early Middle Ages, Giotto conveys real human suffering, drawing the viewer into the circle of personal grief. The direct, emotional appeal of his art, as well as its deliberate plainness, seems to embody Franciscan values.

Bernardo Dadoi. Giotto dominated Florentine painting in the first half of the fourteenth century. His combination of humanism and realism was so memorable that other artists' work paled beside his. The artists who worked in his studio picked up the mannerisms but not the essence of his style. Bernardo Daddi (active c. 1312–48), who painted the *Madonna and Child* in Orsanmichele (SEE FIG. 12–1), typifies the group with his personal reworking of Giotto's powerful figures. Daddi's talent lay in the creation of sensitive, lyrical images rather than the majestic realistic figures. He may have

been inspired by courtly French art, which he would have known from luxury goods, such as imported ivory carvings. The artists of the school of Giotto were responsible for hundreds of panel paintings. They also frescoed the walls of chapels and halls (see "Buon Fresco," page 439).

Sienese Painting

Like their Florentine rivals, the Sienese painters at first worked in a strongly Byzantine style. Sienese painting continued to emphasize abstract decorative qualities and a love of applied gold and brilliant colors. Consequently, Sienese art often seems slightly conservative.

DUCCIO DI BUONINSEGNA. Siena's foremost painter in the later Gothic period was Duccio di Buoninsegna (active 1278–1318). Duccio knew thirteenth-century Byzantine art, with its elongated figures, stacks of angels, patterned textiles, and lavish use of gold. Between 1308 and 1311, Duccio painted a huge altarpiece for the high altar of Siena Cathedral. The **MAESTÀ (MAJESTY)** was dedicated, like the town itself, to the Virgin (FIGS. 12–11, 12–12).

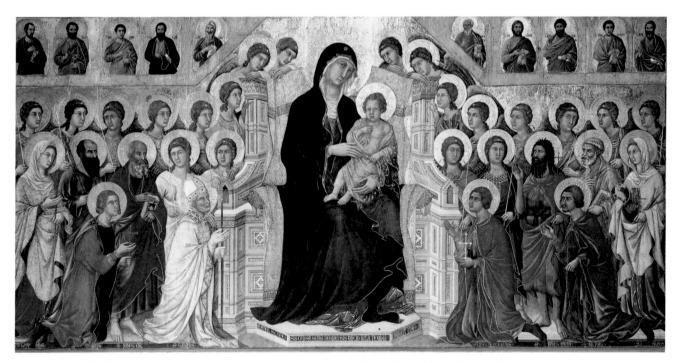

12–11 | Duccio di Buoninsegna VIRGIN AND CHILD IN MAJESTY, Central Panel from Maestà Altarpiece Siena Cathedral. 1308–11. Tempera and gold on wood panel, $7' \times 13'6''$ (2.13 \times 3.96 m). Museo dell'Opera del Duomo, Siena.

"On the day that it was carried to the [cathedral] the shops were shut, and the bishop conducted a great and devout company of priests and friars in solemn procession, accompanied by . . . all the officers of the commune, and all the people, and one after another the worthiest with lighted candles in their hands took places near the picture, and behind came the women and children with great devotion. And they accompanied the said picture up to the [cathedral], making the procession around the Campo [square], as is the custom, all the bells ringing joyously, out of reverence for so noble a picture as is this" (Holt, page 69).

AMBROGIO LORENZETTI. In Siena, a strain of seemingly native realism also began to emerge. In 1338, the Siena city council commissioned Ambrogio Lorenzetti to paint in fresco the council room of the Palazzo Pubblico (city hall) known as the SALA DELLA PACE (CHAMBER OF PEACE) (FIG. 12–14). The murals were to depict the results of good and bad government. On the short wall Ambrogio painted a figure symbolizing the Commune of Siena, enthroned like an emperor holding an orb and scepter and surrounded by the Virtues. Justice, assisted by Wisdom and Concord, oversees the local magistrates. Peace lounges on a bench against a pile

of armor, having defeated War. The figure is based on a fragment of a Roman sarcophagus still in Siena.

Ambrogio painted the results of both good and bad government on the two long walls. For the **ALLEGORY OF GOOD GOVERNMENT,** and in tribute to his patrons, Ambrogio created an idealized but recognizable portrait of the city of Siena and its immediate environs (FIG. 12–15). The cathedral dome and the distinctive striped campanile (see Chapter 16) are visible in the upper left-hand corner; the streets are filled with productive citizens. The Porta Romana, Siena's gateway leading to Rome, divides the city from the country. Over the portal

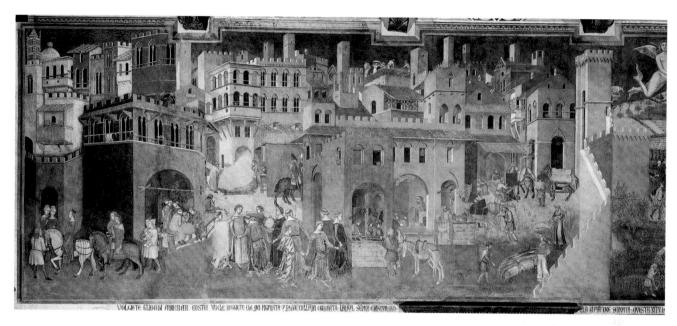

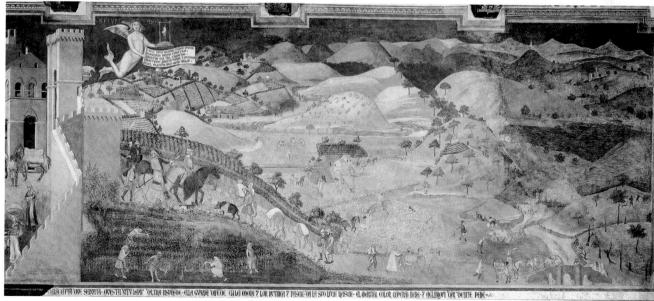

stands the statue of the wolf suckling Romulus and Remus, the legendary founders of Rome. Representations of these twin boys were popular in Siena because of the legend that Remus's son Senus founded Siena. Hovering above outside the gate is a woman clad in a wisp of transparent drapery, a scroll in one hand and a miniature gallows complete with a hanged man in the other. She represents Security, and her scroll bids those entering the city to come in peace. The gallows is a sharp reminder of the consequences of not doing so.

Ambrogio's achievement in this fresco was twofold. First, despite the shifts in vantage point and scale, he maintained an overall visual coherence and kept all parts of the flowing composition intelligible. Second, he maintained a natural relationship between the figures and the environment. Ambrogio conveys a powerful vision of an orderly society, of peace and plenty, from the circle of young people dancing to a tambourine outside a shoemaker's shop to the well-off peasants tending fertile fields and lush vineyards. Sadly, plague struck in the next decade. Famine, poverty, and disease overcame Siena just a few years after this work was completed.

The world of the Italian city-states—which had seemed so full of promise in Ambrogio Lorenzetti's *Good Government* fresco—was transformed into uncertainty and desolation by epidemics of the plague. Yet as dark as those days must have seemed to the men and women living through them, beneath the surface profound, unstoppable changes were taking place. In a relatively short span of time, the European Middle Ages gave way to what is known as the Renaissance.

FRANCE

At the beginning of the fourteenth century the royal court in Paris was still the arbiter of taste in Western Europe, as it had been in the days of Saint Louis. During the Hundred Years' War, however, the French countryside was ravaged by armed struggles and civil strife. The power of the old feudal nobility, weakened significantly by warfare, was challenged by townsmen, who took advantage of new economic opportunities that opened up in the wake of the conflict. Leadership in the arts and architecture moved to the duchy of Burgundy, to England, and—for a brief golden moment—to the court of Prague.

Gothic sculptors found a lucrative new outlet for their work in the growing demand among wealthy patrons for religious art intended for homes as well as churches. Busy urban workshops produced large quantities of statuettes and reliefs in wood, ivory, and precious metals, often decorated with enamel and gemstones. Much of this art was related to the cult of the Virgin Mary. Architectural commissions were smaller—chapels rather than cathedrals, and additions to already existing buildings, such as towers, spires, and window tracery.

In the second half of the thirteenth century, architects working at the royal court in Paris (see Chapter 11) introduced a new style, which continued into the first part of the fourteenth century. Known as the French Court style, or Rayonnant style or Rayonnant Gothic in France, the art is characterized by elegance and refinement achieved through extraordinary technical virtuosity. In sculpture and painting, elegant figures move gracefully through a narrow stage space established by miniature architecture and elements of land-scape. Sometimes a focus on the details of nature suggests the realism that appears in the fourteenth century.

Manuscript Illumination

By the late thirteenth century, literacy had begun to spread among laypeople. Private prayer books became popular among those who could afford them. Because they contained special prayers to be recited at the eight canonical "hours" between morning and night, an individual copy of one of these books came to be called a Book of Hours. Such a book included everything the lay person needed—psalms, prayers to the Virgin and the other saints, a calendar of feast days, the office of the Virgin, and even the offices of the dead. During the fourteenth century, a richly decorated Book of Hours was worn or carried like jewelry and was among a noble person's most important portable possessions.

THE BOOK OF HOURS OF JEANNE D'EVREUX. Shortly after their marriage in 1325, King Charles IV gave his queen, Jeanne d'Evreux, a tiny, exquisite BOOK OF HOURS, the work of the illuminator Jean Pucelle (FIG. 12–16). This book was precious to the queen, who mentioned it in her will. She named its illuminator, Jean Pucelle, an unusual tribute.

In this manuscript, Pucelle worked in the *grisaille* technique—monochromatic painting in shades of gray with faint touches of color (here, blue and pink). The subtle shades emphasized his accomplished drawing. Queen Jeanne appears in the initial below the *Annunciation*, kneeling before a lectern and reading, perhaps, from her Book of Hours. This inclusion of the patron in prayer within a scene conveyed the idea that the scenes were visions inspired by meditation rather than records of historical events. In this case, the young queen would presumably have identified with Mary's joy at Gabriel's message.

Jeanne d'Evreux's Book of Hours combines two narrative cycles in its illuminations. One, the Hours of the Virgin, juxtaposes scenes from the Infancy and Passion of Christ, a form known as the Joys and Sorrows of the Virgin. The other is dedicated to the recently canonized king, Saint Louis. In the opening shown here, the joy of the *Annunciation* on the

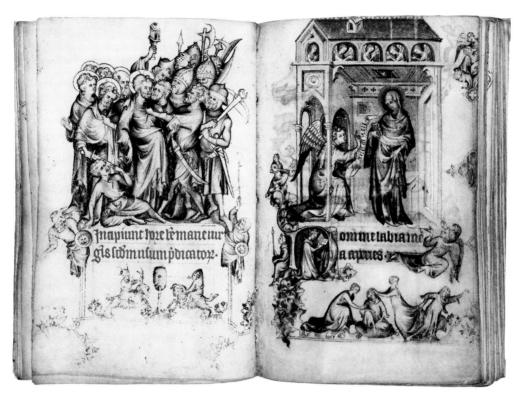

12–16 | Jean Pucelle PAGES WITH BETRAYAL AND ARREST OF CHRIST, folio 15v. (left), and ANNUNCIATION, folio 16r. (right), BOOK OF HOURS OF JEANNE D'EVREUX
Paris c. 1325–28. *Grisaille* and color on vellum, each page $3\frac{7}{2} \times 2\frac{7}{4}$ " (8.9 × 6.2 cm). The Metropolitan Museum of Art, New York. The Cloisters Collection 1954 (54.1.2).

right is paired with the "sorrow" of the Betrayal and Arrest of Christ on the left. In the Annunciation, Mary is shown receiving the archangel Gabriel in a Gothic building, while rejoicing angels look on from windows under the eaves. The group of romping children at the bottom of the page (known as the bas-de-page in French) at first glance seems to echo the joy of the angels. They might be playing "love tag," which would surely relate to Mary as the chosen one of the Annunciation. Folklorists have suggested, however, that the children are playing "froggy in the middle," or "hot cockles," games in which one child was tagged by the others. To the medieval reader the game symbolized the mocking of Christ or the betrayal of Judas, who "tags" his friend, and it evokes a darker mood by foreshadowing Jesus's death even as his life is beginning. In the Betrayal on the opposite page, Judas Iscariot embraces Jesus, thus identifying him to the Roman soldiers. The traitor sets in motion the events that lead to the Crucifixion. Saint Peter, on the left, realizing the danger, draws his sword to defend Jesus and slices off the ear of the high priest's servant Malchus. The bas-de-page on this side shows knights riding goats and jousting at a barrel stuck on a pole, a spoof of the military that may comment on the lack of valor of the soldiers assaulting Jesus.

Pucelle's work represents a sophisticated synthesis of contemporary French, English, and Italian art. From English illuminators he borrowed the merging of Christian narrative with allegory, the use of foliate borders filled with real and grotesque creatures (instead of the standard French vine scrolls), and his lively bas-de-page illustrations. His presentation of space, with figures placed within coherent architectural settings, suggests a firsthand knowledge of Sienese art: The small angels framed by the rounded arches of the attic are reminiscent of the half-length saints who appear above the front panel of Duccio's Maestà. Pucelle also adapted to manuscript illumination the Parisian Court style in sculpture, with its softly modeled, voluminous draperies gathered around tall, elegantly curved figures with curly hair and delicate features.

Sculpture

Sculpture in the fourteenth century is exemplified by its intimate character. Religious subjects became more emotionally expressive. In the secular realm, the cult of chivalry was revived just as the era of the knight on horseback was being rendered obsolete. Tales of love and valor were carved on luxury items to delight the rich, middle class, and aristocracy alike. Precious metals—gold, silver, and ivory—were preferred.

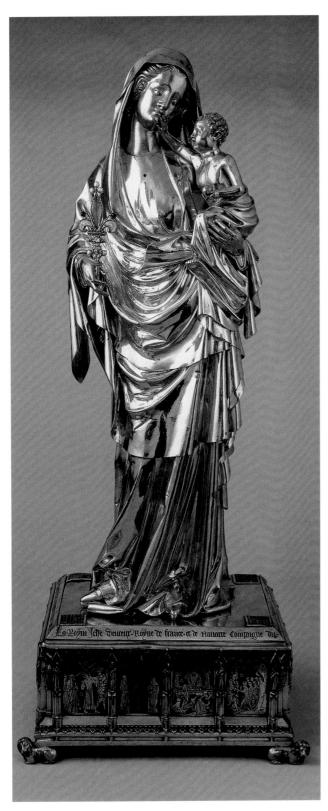

I2-I7 | VIRGIN AND CHILD c. 1339. Silver gilt and enamel, height 27% (69 cm). Musée du Louvre, Paris.

Given by Jeanne d'Evreux to the Abbey Church of Saint-Denis, France.

THE VIRGIN AND CHILD FROM SAINT-DENIS. A silver-gilt image of a standing virgin and child (FIG. 12-17) was once among the treasures of the Abbey Church of Saint-Denis (see Chapter 11). An inscription on the base bears the date 1339 and the donor's name, Queen Jeanne d'Evreux. The Virgin holds Jesus in her left arm, her weight on her left leg, creating the graceful S-curve pose that became characteristic of the period. Fluid drapery, suggesting the consistency of heavy silk, covers her body. She originally wore a crown, and she holds a scepter topped with a large enameled and jeweled fleur-de-lis, the heraldic symbol of French royalty. The scepter served as a reliquary for a few strands of Mary's hair. The Virgin's sweet, youthful face and simple clothing, although based on thirteenth-century sculpture, anticipate the so-called Beautiful Mother imagery of fourteenth-century Prague (SEE FIG. 12-25), Flanders, and Germany. The Christ Child reaching out to touch his mother's lips is babylike in his proportions and gestures, a hint of realism. The image is not entirely joyous, however; on the enameled base, scenes of Christ's Passion remind us of the suffering to come.

COURTLY LOVE: AN IVORY BOX. A strong market also existed for personal items like boxes, mirrors, and combs with secular scenes inspired by popular literature and folklore. A box—perhaps a gift from a lover—made in a Paris workshop around 1330–50 provides a delightful example of such a work (FIG. 12–18). In its ivory panels, the God of Love shoots his arrows; knights and ladies throw flowers as missiles and joust with flowers. The subject is the ATTACK ON THE CASTLE OF LOVE, but what the owner kept in the box—jewelry? love tokens?—remains a mystery.

A tournament takes place in front of the Castle of Love. The tournament—once a mock battle, designed to keep knights fit for war—has become a lovers' combat. In the center panel, women watch jousting knights charge to the blare of the heralds' trumpets. In the scene on the left, knights use crossbows and a catapult to hurl roses at the castle, while the God of Love helps the women by aiming his arrows at the attackers. The action concludes in the scene on the right, where the tournament's victor and his lady love meet in a playful joust of their own.

Unlike the aristocratic marriages of the time, which were essentially business contracts based on political or financial exigencies, romantic love involved passionate devotion. Images of gallant knights serving ladies, who bestowed tokens of affection on their chosen suitors or cruelly withheld their love on a whim, captured the popular imagination. Tales of romance were initially spread by the musician-poets known as troubadours. Twelfth-century troubadour poetry marked a shift away from the usually negative way in which women had previously been portrayed as sinful daughters of Eve.

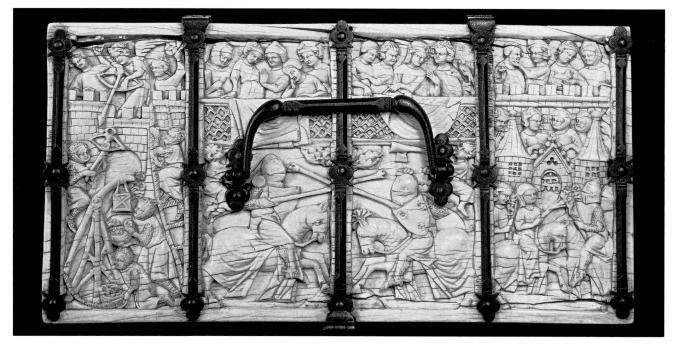

I2—I8 | ATTACK ON THE CASTLE OF LOVE Lid of a box. Paris. c. 1330–50. Ivory box with iron mounts, panel $4\% \times 9\%$ (11.5 \times 24.6 cm). The Walters Art Museum, Baltimore.

ENGLAND

Fourteenth-century England prospered in spite of the ravages of the Black Death and the Hundred Years' War with France. Life in medieval England is described in the rich store of Middle English literature. The brilliant social commentary of Geoffrey Chaucer in the *Canterbury Tales* (see "A New Spirit in Fourteenth-Century Literature," page 431) includes all classes of society. The royal family, especially Edward I—the castle builder—and many of the nobles and bishops were generous patrons of the arts.

Embroidery: Opus Anglicanum

An English specialty, pictorial needlework in colored silk and gold thread, gained such fame that it came to be called *opus anglicanum (English work)*. Among the collectors of this luxurious textile art were the popes, who had more than 100 pieces in the Vatican treasury. The names of several prominent embroiderers are known, but few names can be connected to specific pieces.

Opus anglicanum was employed for court dress, banners, cushions, bed hangings, and other secular items, as well as for the vestments worn by the clergy to celebrate the Mass (see Introduction Fig. 21, Christine de Pisan Presenting a Book to the Queen of France). Few secular pieces survive, since clothing and furnishings were worn out and discarded when fashions changed. But some vestments have survived, stored in church treasuries.

A liturgical vestment (that is, a special garment worn by the priest during mass), the red velvet **CHICHESTER-CONSTABLE** **CHASUBLE** (FIG. 12–19) was embroidered with colored silk, gold threads forming the images as subtly as painting. Where gold threads were laid and couched (tacked down with colored silk), the effect resembles the burnished gold-leaf backgrounds of manuscript illuminations. The Annunciation, the Adoration of the Magi, and the Coronation of the Virgin are set in cusped, crocketed **ogee** (S-shaped) arches amid twisting branches sprouting oak leaves, seed-pearl acorns, and animal masks. Because the star and crescent moon in the Coronation of the Virgin scene are heraldic emblems of Edward III (ruled 1327–77), perhaps he or a family member ordered this luxurious vestment.

During the celebration of the Mass, garments of *opus* anglicanum would have glinted in the candlelight amid treasures on the altar. Court dress was just as rich and colorful, and at court such embroidered garments established the rank and

Sequencing Events		
c. 1307-21	Dante writes The Divine Comedy	
1309–77	Papacy transferred from Rome to Avignon	
1348	Arrival of Black Death on European mainland	
1378–1417	Great Schism in Catholic Church	
1396	Greek studies instituted in Florence; beginning of the revival of Greek literature	

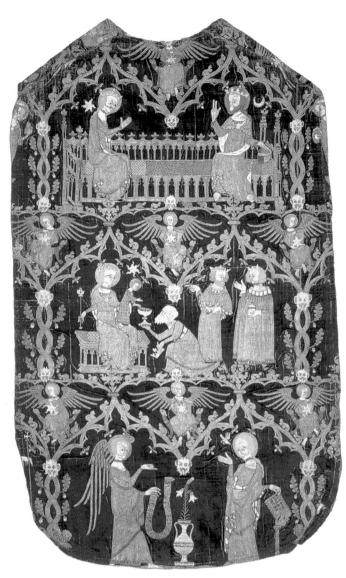

12-19 LIFE OF THE VIRGIN, BACK OF THE CHICHESTER-CONSTABLE CHASUBLE

From a set of vestments embroidered in *opus anglicanum* from southern England. 1330–50. Red velvet with silk and metallic thread and seed pearls; length 4'3" (129.5 cm), width 30" (76 cm). The Metropolitan Museum of Art, New York. Fletcher Fund, 1927 (27 162.1).

status of the wearer. So heavy did such gold and bejeweled garments become that their wearers often needed help to move.

Architecture

In the later years of the thirteenth century and early years of the fourteenth, a distinctive and influential style, popularly known as the "Decorated style," which corresponded to the Rayonnant style in France (see Chapter 11), developed in England. This change in taste has been credited to Henry III's ambition to surpass his brother-in-law, Saint Louis (Louis IX) of France, as a royal patron of the arts.

THE DECORATED STYLE AT EXETER. The most complete Decorated style building is the **EXETER CATHEDRAL.** Thomas of Witney began work at Exeter in 1313 and was the master

mason from 1316 until 1342. He supervised construction of the nave and redesigned upper parts of the choir. He left the towers of the original Norman cathedral but turned the interior into a dazzling stone forest of colonnettes, moldings, and vault ribs (FIG. 12-20). From diamond-shaped piers covered with colonnettes rise massed moldings that make the arcade seem to ripple. Bundled colonnettes spring from sculptured corbels (supporting brackets that project from a wall) between the arches to support conical clusters of thirteen ribs that meet at the summit of the vault, a modest 69 feet above the floor. The basic structure here is the four-part vault with intersecting cross-ribs, but the designer added additional ribs, called tiercerons, to create a richer linear pattern. Elaborately carved bosses (decorative knoblike elements) cover the intersections where ribs meet. Large clerestory windows with bartracery mullions (slender vertical elements dividing the windows into subsections) illuminate the 300-foot-long nave. Unpolished gray marble shafts, yellow sandstone arches, and a white French stone, shipped from Caen, used in the upper walls add subtle graduations of color to the many-rayed space.

Detailed records survive for the building of Exeter Cathedral. They extend over the period from 1279 to 1514, with only two short breaks. Included is such mundane information as where the masons and carpenters were housed (in a hostel near the cathedral) and how they were paid (some by the day with extra for drinks, some by the week, some for each finished piece); how materials were acquired and transported (payments for horseshoes and fodder for the horses); and of course payments for the building materials (not only stone and wood but rope for measuring and parchment on which to draw forms for the masons). The bishops contributed generously to the building funds. Building was not an anonymous labor of love as imagined by romantic nineteenth-century historians.

Thomas of Witney also designed the bishop's throne. Richard de Galmeton and Walter of Memburg led a team of a dozen carpenters to build the throne and the intricate canopy, 57 feet high. The canopy is like a piece of embroidery translated into wood, revealing characteristic forms of the Decorated style: S-curves, nodding arches (called "nodding ogee arches" because they curve outward—and nod—as well as upward) lead the eye into a maze of pinnacles, bursting with leafy crockets and tiny carved animals and heads. To finish the throne in splendor, Master Nicolas painted and gilded the wood. When the bishop was seated on his throne wearing embroidered vestments like the *Chichester-Constable Chasuble*, he must have resembled a golden image in a shrine rather than a living man. Enthroned, he represented the power and authority of the Church.

THE PERPENDICULAR STYLE AT EXETER. During years following the Black Death, work at Exeter Cathedral came to a

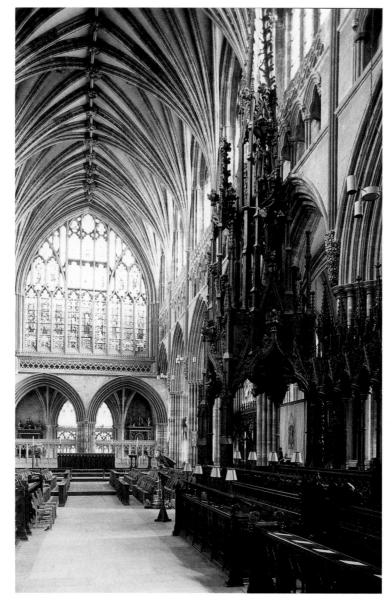

I2–20 | EXETER CATHEDRAL Exeter, Devon, England. Thomas of Witney, Choir, 14th century and Bishop's Throne, 1313–17; Robert Lesyngham, East Window, 1389–90.

standstill. The nave had been roofed but not vaulted, and the windows had no glass. When work could be resumed, taste had changed. The exuberance of the Decorated style gave way to an austere style in which rectilinear patterns and sharp angular shapes replaced intricate curves, and luxuriant foliage gave way to simple stripped-down patterns. This phase is known as the Perpendicular style.

In 1389–90, well-paid master mason Robert Lesyngham rebuilt the great East Window (FIG. 12–20), and he designed the window tracery in the new Perpendicular style. The window fills the east wall of the choir like a glowing altarpiece. A single figure in each light stands under a tall painted canopy that flows into and blends with the stone tracery. The Virgin with the Christ Child stands in the center over the high altar,

with four female saints at the left and four male saints, including Saint Peter, to whom the church is dedicated, on the right. At a distance the colorful figures silhouetted against the silver *grisaille* glass become a band of color, reinforcing the rectangular pattern of the mullions and transoms. The combination of *grisaille*, silver stain (creating shades of gold), and colored glass produces a cool silvery light.

The Perpendicular style produces a decorative scheme that heralds the Renaissance style (see Chapter 14) in its regularity, its balanced horizontal and vertical lines, and its plain wall or window surfaces. When Tudor monarchs introduced Renaissance art into the British Isles, builders did not have to rethink the form and structure of their buildings; they simply changed the ornament from the pointed cusped and

crocketed arches of the Gothic style to the round arches and ancient Roman columns and capitals of the classical era. The Perpendicular style, used throughout the Late Gothic period in the British Isles, became England's national style. It remains popular today in the United States for churches and college buildings.

THE HOLY ROMAN EMPIRE

By the fourteenth century, the Holy Roman Empire existed more as an ideal fiction than a fact. The Italian territories had established their independence, and in contrast to England and France, Germany had become further divided into multiple states with powerful regional associations and princes. The Holy Roman Emperors, now elected by Germans, concentrated on securing the fortunes of their families. They continued to be patrons of the arts, promoting local styles.

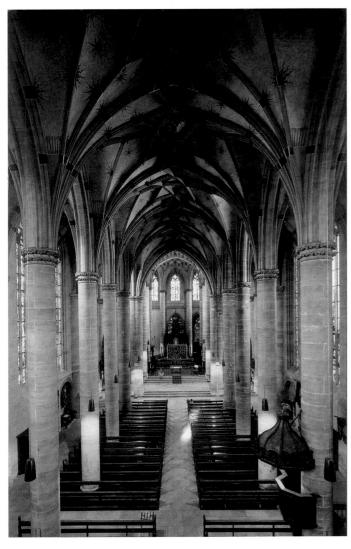

Schwäbisch Gmünd, Germany. Interior. Begun in 1317 by Henrich Parler; choir by Peter Parler begun in 1351; vaulting completed 16th century.

The Supremacy of Prague

Charles IV of Bohemia (ruled 1346–75), whose admiration for the French king Charles IV was such that he changed his own name from Wenceslas to Charles, had been raised in France. He was officially crowned king of Bohemia in 1347 and Holy Roman Emperor in 1355.

Charles established his capital in Prague, which, in the view of its contemporaries, replaced Constantinople as the "New Rome." Prague had a great university, a castle, and a cathedral overlooking a town that spread on both sides of a river joined by a stone bridge, a remarkable structure itself.

When Pope Clement VI made Prague an archbishopric in 1344, construction began on a new cathedral in the Gothic style—to be named for Saint Vitus—which would also serve as the coronation church and royal pantheon. At Charles's first coronation, however, the choir remained unfinished. Charles, deeply involved in his projects, brought Peter Parler from Swabia to complete the building. Peter came from a distinguished family of architects.

THE PARLER FAMILY. In 1317 Heinrich Parler, a former master of works on the Cologne Cathedral, designed and began building the **CHURCH OF THE HOLY CROSS** in Schwäbisch Gmünd, in southwest Germany. In 1351, his son Peter (c. 1330–99), the most brilliant architect of this talented family, joined the shop. Peter designed the choir (FIG. 12–21) in the manner of a hall church in which a triple-aisled form was enlarged by a ring of deep chapels between the buttresses

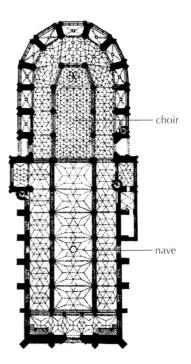

I2—22 | PLAN OF CHURCH OF THE HOLY CROSS
Schwäbisch Gmünd.

of the choir. The unity of the entire space was enhanced by the complex net vault—a veritable web of ribs created by eliminating transverse ribs and ridge ribs. Seen clearly in the plan (FIG. 12–22), the contrast between Heinrich's nave and Peter's choir illustrates the increasing complexity of rib patterns, a complexity that in fact finally led to the unified interior space of the Renaissance.

Called by Charles IV to Prague in 1353, Peter turned the unfinished Saint Vitus Cathedral into a "glass house," adding a vast clerestory and glazed triforium supported by double flying buttresses, all covered by net vaults that created a continuous canopy over the space. Photos do not do justice to the architecture; but the small, gilded icon shrine suggests the richness and elaborateness of Peter's work. The shrine stands in the reliquary chapel of Saint Wenceslas (FIG. 12–23)—once a freestanding Romanesque chapel, now incorporated into the cathedral—on the south side of the church. The chapel itself, with walls encrusted with semiprecious stones, recalls a reliquary (c. 1370–71).

Peter, his family, and heirs became the most successful architects in the Holy Roman Empire. Their concept of space, luxurious decoration, and intricate vaulting dominated central European architecture for three generations.

Sequencing Works of Art		
c. 1330	Vesperbild, Germany	
1330-36	Andrea Pisano, Life of Saint John the Baptist, Baptistry, Florence	
1338-40	Ambrogio Lorenzetti, <i>Allegory of Good Government</i> , Sala della Pace, Palazzo Pubblico, Siena	
1330-50	Life of the Virgin, Chichester-Constable Chasuble	
1339	Virgin and Child, Jeanne d'Evreux, France	

MASTER THEODORIC AND THE "BEAUTIFUL STYLE." At Karlstejn Castle, a day's ride from Prague, the emperor built another chapel and again covered the walls with gold and precious stones as well as with paintings. One hundred thirty paintings of the saints also served as reliquaries, for they had relics inserted into their frames. Master Theodoric, the court painter, provided drawings on the wood panels, and he painted about thirty images himself (FIG. 12–24). These figures are crowded into—and even extend over—the frames,

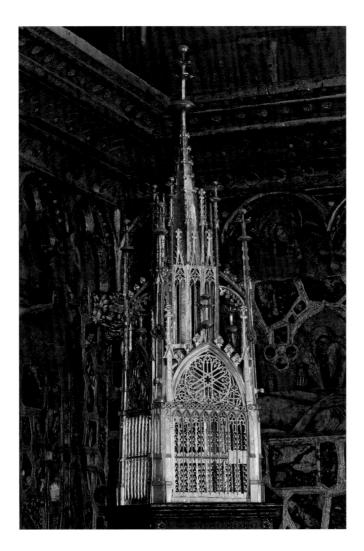

I2-23 | Peter Parler and workshop SAINT WENCESLAS CHAPEL, CATHEDRAL OF SAINT VITUS

Prague. Begun 1356. In 1370-71, the walls were encrusted with slabs of jasper, amethyst, and gold, forming crosses. Tabernacle, c. 1375: gilded iron. Height 81%" (208 cm).

The spires, pinnacles, and flying buttresses of the tabernacle may have been inspired by Peter Parler's drawings for the cathedral.

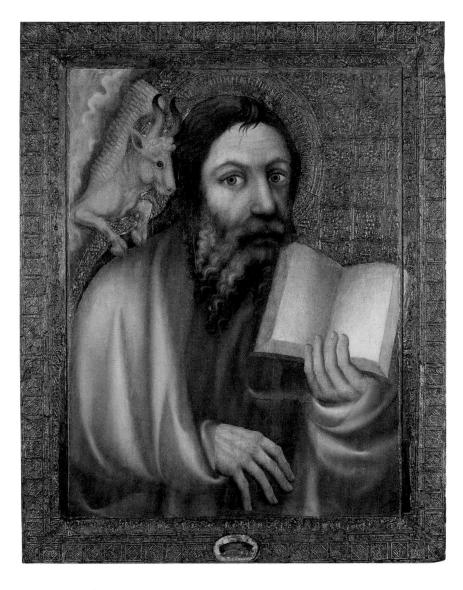

Theodoric SAINT LUKE
Holy Cross Chapel, Karlstejn Castle, near Prague.
1360-64. Paint and gold on panel. 45¼ × 37″
(115 × 94 cm).

emphasizing their size and power. Master Theodoric was head of the Brotherhood of Saint Luke, the patron saint of painters, and his painting of **SAINT LUKE**, accompanied by his symbol, the ox, looks out at the viewer, suggesting that this may really be a self-portrait of Master Theodoric. Master Theodoric's personal style—heavy bodies, oversized heads and hands, dour and haunted faces, and soft, deeply modeled drapery—merged with the French Gothic style to become what is known as the Beautiful style of the end of the century. The chapel, consecrated in 1365, so pleased the emperor that in 1367 he gave the artist a farm in appreciation for his work.

Like the architecture of the Parler family, the style created by Master Theodoric spread through central and northern Europe. Typical of this Beautiful style is the sweet-faced Virgin and Child, as seen in the "BEAUTIFUL" VIRGIN AND CHILD (FIG. 12–25), engulfed in swaths of complex drapery.

Cascades of V-shaped folds and clusters of vertical folds ending in rippling edges surround a squirming infant to create the feeling of a fleeting movement. Emotions are restrained, and grief as well as joy become lost in a naive piety. Yet, this art emerges against a background of civil and religious unrest. The Beautiful style seems like an escape from the realities of fourteenth-century life.

Mysticism and Suffering

The ordeals of the fourteenth century—famines, wars, and plagues—helped inspire a mystical religiosity that emphasized both ecstatic joy and extreme suffering. Devotional images, known as *Andachtsbilder* in German, inspired the worshiper to contemplate Jesus's first and last hours, especially during evening prayers, or vespers (giving rise to the term *Vesperbild* for the image of Mary mourning her son).

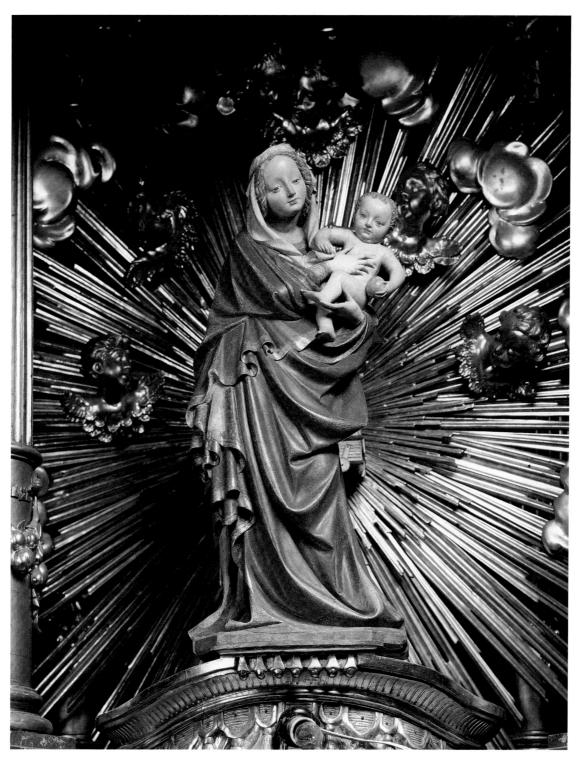

12–25 | "BEAUTIFUL" VIRGIN AND CHILD Probably from the Church of Augustinian Canons, Sternberk. c. 1390. Limestone with original paint and gilding; height 33% (84 cm).

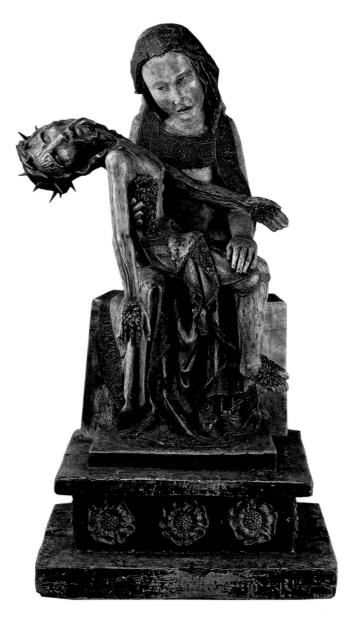

I2–26 | **VESPERBILD** From Middle Rhine region, Germany. c. 1330. Wood, height 34½" (88. 4 cm). Landesmuseum, Bonn.

Through such religious exercises, worshipers hoped to achieve understanding of the divine and union with God. In the well-known example shown here (FIG. 12–26), blood gushes from the hideous rosettes that are the wounds of an emaciated Jesus. The Virgin's face conveys the intensity of her ordeal, mingling horror, shock, pity, and grief. Such images had a profound impact on later art, both within Germany and beyond.

Prague and the Holy Roman Empire under Charles IV had become a multicultural empire where people of different religions (Christians and Jews) and ethnic heritage (German and Slav) lived side by side. Charles died in 1378, and without his strong central government, political and religious dissent overtook the empire. Jan Hus, dean of the philosophy faculty at Prague University and a powerful reforming preacher, denounced the immorality he saw in the Church. He was burned at the stake, becoming a martyr and Czech national hero. The Hussite Revolution in the fifteenth century ended Prague's—and Bohemia's—leadership in the arts.

IN PERSPECTIVE

The emphasis on suffering and on supernatural power inspired many artists to continue the formal, expressive styles of earlier medieval and Byzantine art. At the same time, the humanism emerging in the paintings of Giotto and his school at the beginning of the fourteenth century could not be denied. Painters began to combine the flat, decorative, linear quality of Gothic art with the new representation of forms defined by light and space. In Italy they created a distinctive new Gothic style that continued through the fourteenth century. North of the Alps, Gothic elements survived in the arts well into the fifteenth century.

The courtly arts of manuscript illumination, embroidery, ivory carving, and of jewel, enamel, gold, and silver work flourished, becoming ever richer, more intricate and elaborate. Stained glass filled the ever-larger windows, while paintings or tapestries covered the walls. In Italy, artists inspired by ancient Roman masters and by Giotto looked with fresh eyes at the natural world. The full impact of their new vision was not fully assimilated until the beginning of the fifteenth century.

GIOTTO DI BONDONE VIRGIN AND CHILD ENTHRONED 1305-10

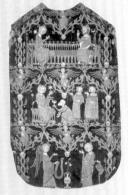

LIFE OF THE VIRGIN
BACK OF THE
CHICHESTER-CONSTABLE CHASUBLE,
SOUTHERN ENGLAND
1330–50

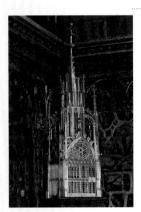

Peter Parler and Workshop. **ST. WENCESLAS CHAPEL** BEGUN 1356

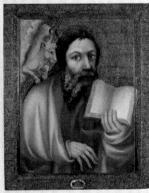

MASTER THEODORIC **ST. LUKE** 1360-64

FOURTEENTH-CENTURY ART IN EUROPE

I300

■ Papacy resides in Avignon 1309-77

1320

Hundred Years' Wars 1337-1453

1340

■ Black Death begins 1348

■ Boccaccio begins writing
The Decameron 1349-51

■ Great Schism 1378-1417

Chaucer starts work on *The Canterbury Tales* 1387

138C

1400

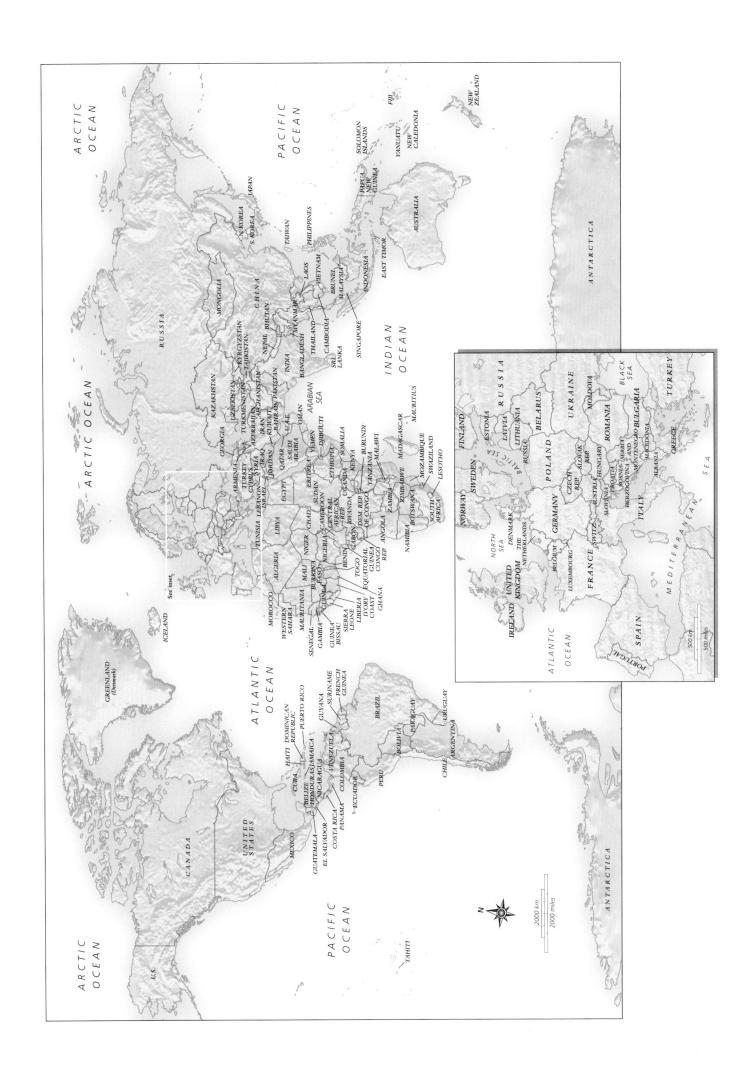

GLOSSARY

abacus The flat slab at the top of a **capital**, directly under the **entablature**.

absolute dating A method of assigning a precise historical date to periods and objects based on known and recorded events in the region as well as technically extracted physical evidence (such as carbon-14 disintegration). See also **radiometric dating**, **relative dating**.

abstract, abstraction Any art that does not represent observable aspects of nature or transforms visible forms into a stylized image. Also: the formal qualities of this process.

acropolis The **citadel** of an ancient Greek city, located at its highest point and housing temples, a treasury, and sometimes a royal palace. The most famous is the Acropolis in Athens.

acroterion (acroteria) An ornament at the corner or peak of a roof.

adyton The back room of a Greek temple. At Delphi, the place where the **oracles** were delivered. More generally, a very private space or room.

aedicula (aediculae) A decorative architectural frame, usually found around a niche, door, or window. An aedicula is made up of a **pediment** and **entablature** supported by **columns** or **pilasters**.

agora An open space in a Greek town used as a central gathering place or market. See also forum

aisle Passage or open corridor of a church, hall, or other building that parallels the main space, usually on both sides, and is delineated by a row, or **arcade**, of **columns** or piers. Called side aisles when they flank the **nave** of a church.

album A book consisting of a series of painting or prints (album leaves) mounted into book form.

all'antica Meaning, "in the ancient manner."

allegory In a work of art, an image (or images) that symbolically illustrates an idea, concept, or principle, often moral or religious.

alloy A mixture of metals; different metals melted together.

ambulatory The passage (walkway) around the **apse** in a basilican church or around the **central space in a central-plan building**.

amphiprostyle Term describing a building, usually a temple, with **porticoes** at each end but without **columns** along the other two sides.

amphora An ancient Greek jar for storing oil or wine, with an egg-shaped body and two curved handles.

aniconic A symbolic representation without images of human figures, very often found in Islamic art.

animal interlace Decoration made of interwoven animals or serpents, often found in Celtic and early medieval Northern European art.

ankh A looped cross signifying life, used by ancient Egyptians.

appropriation Term used to describe an artist's practice of borrowing from another source for a new work of art. While in previous centuries artists often copied one another's figures, motifs, or compositions, in modern times the sources for appropriation extend from material culture to works of art.

apse, apsidal A large semicircular or polygonal (and usually vaulted) niche protruding from the end wall of a building. In the Christian church, it contains the altar. Apsidal is an adjective describing the condition of having such a space.

arabesque A type of linear surface decoration based on foliage and **calligraphic** forms, usually characterized by flowing lines and swirling shapes.

arcade A series of **arches**, carried by **columns** or **piers** and supporting a common wall or lintel. In a blind arcade, the arches and supports are engaged (attached to the wall) and have a decorative function.

arch In architecture, a curved structural element that spans an open space. Built from wedge-shaped stone blocks called voussoirs, which, when placed together and held at the top by a trapezoidal keystone, form an effective space-spanning and weight-bearing unit. Requires buttresses at each side to contain the outward thrust caused by the weight of the structure. Corbel arch: arch or vault formed by courses of stones, each of which projects beyond the lower course until the space is enclosed; usually finished with a capstone. Horseshoe arch: an arch of more than a half-circle; typical of western Islamic architecture. Ogival arch: a pointed arch created by S curves. Relieving arch: an arch built into a heavy wall just above a post-and-lintel structure (such as a gate, door, or window) to help support the wall above by transferring the load to the side walls.

archaic smile The curved lips of an ancient Greek statue, usually interpreted as an attempt to animate the features.

architrave The bottom element in an **entablature**, beneath the **frieze** and the **cornice**.

art brut French for "raw art." Term introduced by Jean Dubuffet to denote the often vividly expressionistic art of children and the insane, which he considered uncontaminated by culture.

articulated Joined; divided into units; in architecture, divided intoparts tomake spatial organization intelligible.

ashlar A highly finished, precisely cut block of stone. When laid in even **courses**, ashlar

masonry creates a uniform face with fine joints. Often used as a facing on the visible exterior of a building, especially as a veneer for the **façade**. Also called **dressed stone**.

assemblage Artwork created by gathering and manipulating two and/or three-dimensional found objects.

astragal A thin convex decorative **molding**, often found on classical **entablatures**, and usually decorated with a continuous row of beadlike circles.

atmospheric perspective See perspective.

atrial cross The cross placed in the atrium of a church. In Colonial America, used to mark a gathering and teaching place.

atrium An unroofed interior courtyard or room in a Roman house, sometimes having a pool or garden, sometimes surrounded by columns. Also: the open courtyard in front of a Christian church; or an entrance area in modern architecture.

automatism A technique whereby the usual intellectual control of the artist over his or her brush or pencil is foregone. The artist's aim is to allow the subconscious to create the artwork without rational interference.

avant-garde Term derived from the French military word meaning "before the group," or "vanguard." Avant-garde denotes those artists or concepts of a strikingly new, experimental, or radical nature for the time.

baldachin A canopy (whether suspended from the ceiling, projecting from a wall, or supported by columns) placed over an honorific or sacred space such as a throne or church altar.

barrel vault See vault.

bar tracery See tracery.

bas-de-page French: bottom of the page; a term used in manuscript studies to indicate pictures below the text, literally at the bottom of the page.

base Any support. Also: masonry supporting a statue or the **shaft** of a **column**.

basilica A large rectangular building. Often built with a clerestory, side aisles separated from the center nave by colonnades, and an apse at one or both ends. Roman centers for administration, later adapted to Christian church use. Constantine's architects added a transverse aisle at the end of the nave called a transept.

bay A unit of space defined by architectural elements such as **columns**, **piers**, and walls.

beehive tomb A **corbel-vaulted** tomb, conical in shape like a beehive, and covered by an earthen mound.

Benday dots In modern printing and typesetting, the individual dots that, together with many others, make up lettering and images. Often machine- or computer-generated, the dots are very small and closely spaced to give

the effect of density and richness of tone.

bestiary A book describing characteristics, uses, and meaning illustrated by moralizing tales about real and imaginary animals, especially popular during the Middle Ages in western Europe.

biomorphic Adjective used to describe forms that resemble or suggest shapes found in nature.

black-figure A style or technique of ancient Greek pottery in which black figures are painted on a red clay ground. See also **red-figure**.

boss A decorative knoblike element. Bosses can be found in many places, such as at the intersection of a Gothic vault rib. Also buttonlike projections in decorations and metalwork.

bracket, bracketing An architectural element that projects from a wall to support a horizontal part of a building, such as beams or the eaves of a roof.

brandea An object, such as a linen strip, having contact with a relic and taking on the power of the relic.

buon fresco See fresco.

cairn A pile of stones or earth and stones that served both as a prehistoric burial site and as a marker of underground tombs.

calyx krater See krater.

came (cames) A lead strip used in the making of leaded or **stained-glass** windows. Cames have an indented vertical groove on the sides into which the separate pieces of glass are fitted to hold the design together.

cameo Gemstone, clay, glass, or shell having layers of color, carved in **low relief** to create an image and ground of different colors.

camera obscura An early cameralike device used in the Renaissance and later for recording images of nature. Made from a dark box (or room) with a hole in one side (sometimes fitted with a lens), the camera obscura operates when bright light shines through the hole, casting an upside-down image of an object outside onto the inside wall of the box.

canon of proportions A set of ideal mathematical ratios in art based on measurements of the human body.

capital The sculpted block that tops a **column**. According to the conventions of the orders, capitals include different decorative elements. See **order**. Also: a historiated capital is one displaying a narrative.

capriccio A painting or print of a fantastic, imaginary landscape, usually with architecture.

capstone The final, topmost stone in a **corbel arch** or vault, which joins the sides and completes the structure.

cartoon A full-scale drawing used to transfer the outline of a design onto a surface (such as a wall, canvas,panel,or tapestry) to be painted, carved, or woven.

cartouche A frame for a hieroglyphic

inscription formed by a rope design surrounding an oval space. Used to signify a sacred or honored name. Also: in architecture, a decorative device or plaque, usually with a plain center used for inscriptions or epitaphs.

caryatid A sculpture of a draped female figure acting as a column supporting an **entablature**.

catacomb A subterranean burial ground consisting of tunnels on different levels, having niches for urns and **sarcophagi** and often incorporating rooms (cubiculae).

cella The principal interior room at the center of a Greek or Roman temple within which the cult statue was usually housed. Also called the **naos**.

cenotaph A funerary monument commemorating an individual or group buried elsewhere.

centering A temporary structure that supports a masonry **arch** and **vault** or **dome** during construction until the mortar is fully dried and the masonry is self-sustaining.

centrally planned building Any structure designed with a primary central space surrounded by symmetrical areas on each side. For example, **Greek-cross plan** (equal-armed cross).

ceramics A general term covering all types of wares made from fired clay, including **porcelain** and **terra cotta**.

chasing Ornamentation made on metal by incising or hammering the surface.

chevron A decorative or heraldic motif of repeated Vs; a zigzag pattern.

chiaroscuro An Italian word designating the contrast of dark and light in a painting, drawing, or print. Chiaroscuro creates spatial depth and volumetric forms through gradations in the intensity of light and shadow.

chiton A thin sleeveless garment, fastened at waist and shoulders, worn by men and women in ancient Greece.

clapboard Horizontal overlapping planks used as protective siding for buildings, particularly houses in North America.

clerestory The topmost zone of a wall with windows in a **basilica** extending above the **aisle** roofs. Provides direct light into the central interior space (the **nave**).

cloisonné An enamel technique in which metal wire or strips are affixed to the surface to form the design. The resulting areas (cloisons) are filled with enamel (colored glass).

cloister An open space, part of a monastery, surrounded by an **arcaded** or **colonnaded** walkway, often having a fountain and garden, and dedicated to nonliturgical activities and the secular life of the religious. Members of a cloistered order do not leave the monastery or interact with outsiders.

codex (codices) A book, or a group of **manuscript** pages (folios), held together by stitching or other binding on one side.

coffer A recessed decorative panel that is

used to reduce the weight of and to decorate ceilings or **vaults**. The use of coffers is called coffering.

colonnade A row of **columns**, supporting a straight lintel (as in a **porch** or **portico**) or a series of arches (an **arcade**).

column An architectural element used for support and/or decoration. Consists of a rounded or polygonal vertical **shaft** placed on a **base** and topped by a decorative **capital**. In classical architecture, built in accordance with the rules of one of the architectural **orders**. Columns can be freestanding or attached to a background wall **(engaged)**.

complementary color The primary and secondary colors across from each other on the color wheel (red and green, blue and orange, yellow and purple). When juxtaposed, the intensity of both colors increases. When mixed together, they negate each other to make a neutral gray-brown.

Composite order See order.

connoisseurship A term derived from the French word connoisseur, meaning "an expert," and signifying the study and evaluation of art based primarily on formal, visual, and stylistic analysis. A connoisseur studies the style and technique of an object to deduce its relative quality and possible maker. This is done through visual association with other, similar objects and styles. See also contextualism; formalism.

contextualism An interpretive approach in art history that focuses on the culture surrounding an art object. Unlike **connoisseurship**, contextualism utilizes the literature, history, economics, and social developments (among other things) of a period, as well as the object itself, to explain the meaning of an artwork. See *also* **connoisseurship**.

contrapposto An Italian term mearing "set against," used to describe the twisted pose resulting from parts of the body set in opposition to each other around a central axis.

corbel, corbeling An early roofing and arching technique in which each course of stone projects slightly beyond the previous layer (a corbel) until the uppermost corbels meet. Results in a high, almost pointed arch or vault. A corbel table is a ledge supported by corbels.

corbeled vault See vault.

Corinthian order See order.

cornice The uppermost section of a Classical **entablature**. More generally, a horizontally projecting element found at the top of a building wall or **pedestal**. A raking cornice is formed by the junction of two slanted cornices, most often found in **pediments**.

course A horizontal layer of stone used in building.

crenellation Alternating high and low sections of a wall, giving a notched appearance and creating permanent defensive shields in the walls of fortified buildings.

crockets A stylized leaf used as decoration along the outer angle of spins, pinnacles, gables, and around **capitals** in Gothic architecture.

cuneiform An early form of writing with wedge-shaped marks impressed into wet clay with a stylus, primarily used by ancient Mesopotamians.

curtain wall A wall in a building that does not support any of the weight of the structure. Also: the freestanding outer wall of a castle, usually encircling the inner bailey (yard) and keep (primary defensive tower).

cyclopean construction or masonry A method of building using huge blocks of rough-hewn stone. Any large-scale, monumental building project that impresses by sheer size. Named after the Cyclopes (sing. Cyclops) one-eyed giants of legendary strength in Greek myths.

cylinder seal A small cylindrical stone decorated with incised patterns. When rolled across soft clay or wax, the resulting raised pattern or design (**relief**) served in Mesopotamian and Indus Valley cultures as an identifying signature.

dado (dadoes) The lower part of a wall, differentiated in some way (by a **molding** or different coloring or paneling) from the upper section.

daguerreotype An early photographic process that makes a positive print on a light-sensitized copperplate; invented and marketed in 1839 by Louis-Jacques-Mandé Daguerre.

demotic writing The simplified form of ancient Egyptian hieratic writing, used primarily for administrative and private texts.

diptych Two panels of equal size (usually decorated with paintings or reliefs) hinged together.

dolmen A prehistoric structure made up of two or more large upright stones supporting a large, flat, horizontal slab or slabs.

dome A round vault, usually over a circular

space. Consists of a curved masonry vault of shapes and cross sections that can vary from hemispherical to bulbous to ovoidal. May use a supporting vertical wall (drum), from which the vault springs, and may be crowned by an open space (oculus) and/or an exterior lantern. When a dome is built over a square space, an intermediate element is required to make the transition to a circular drum. There are two types: A dome on **pendentives** (spherical triangles) incorporates arched, sloping intermediate sections of wall that carry the weight and thrust of the dome to heavily buttressed supporting piers. A dome on squinches uses an arch built into the wall (squinch) in the upper corners of the space to carry the weight of the dome across the corners of the square space below. A half-dome or conch may cover a semicircular space.

domino construction System of building construction introduced by the architect Le Corbusier in which reinforced concrete floor slabs are floated on six freestanding posts placed as if at the positions of the six dots on a domino playing piece.

Doric order See order.

drum The wall that supports a **dome**. Also: a segment of the circular **shaft** of a **column**.

drypoint An **intaglio** printmaking process by which a metal (usually copper) plate is directly inscribed with a pointed instrument (**stylus**). The resulting design of scratched lines is inked, wiped, and printed. Also: the print made by this process.

earthenware A low-fired, opaque ceramic ware that is fired in the range of 800 to 900 degrees Celsius. Earthenware employs humble clays that are naturally heat resistant; the finished wares remain porous after firing unless glazed. Earthenware occurs in a range of earth-toned colors, from white and tan to gray and black, with tan predominating.

echinus A cushionlike circular element found below the **abacus** of a Doric **capital**. Also: a similarly shaped **molding** (usually with egg-and-dart motifs) underneath the **volutes** of an Ionic **capital**.

electron spin resonance techniques

Method that uses magnetic field and microwave irradiation to date material such as tooth enamel and its surrounding soil.

emblema (emblemata) In a mosaic, the elaborate central motif on a floor, usually a self-contained unit done in a more refined manner, with smaller tesserae of both marble and semiprecious stones.

encaustic A painting technique using pigments mixed with hot wax as a medium.

engaged column A **column** attached to a wall. See also column.

engraving An intaglio printmaking process of inscribing an image, design, or letters onto a metal or wood surface from which a print is made. An engraving is usually drawn with a sharp implement (burin) directly onto the surface of the plate. Also: the print made from this process.

entablature In the Classical orders, the horizontal elements above the columns and capitals. The entablature consists of, from bottom to top, an architrave, a frieze, and a cornice.

entasis A slight swelling of the shaft of a Greek column. The optical illusion of entasis makes the column appear from afar to be straight.

exedra (exedrae) In architecture, a semicircular niche. On a small scale, often used as decoration, whereas larger exedrae can form interior spaces (such as an apse).

expressionism, expressionistic Terms describing a work of art in which forms are created primarily to evoke subjective emotions rather than to portray objective reality.

façade The face or front wall of a building.

faience Type of **ceramic** covered with colorful, opaque glazes that form a smooth, impermeable surface. First developed in ancient Egypt.

fête galante A subject in painting depicting

well-dressed people at leisure in a park or country setting. It is most often associated with eighteenth-century French Rococo painting.

filiere Delicate, lacelike ornamental work.

fillet The flat ridge between the carved out
flutes of a column shaft. See also fluting.

finial A knoblike architectural decoration usually found at the top point of a spire, pinnacle, canopy, or gable. Also found on furniture;

fluting In architecture, evenly spaced, rounded parallel vertical grooves **incised** on **shafts** of **columns** or columnar elements (such as **pilasters**).

also the ornamental top of a staff.

foreshortening The illusion created on a flat surface in which figures and objects appear to recede or project sharply into space. Accomplished according to the rules of **perspective**.

formal analysis See formalism.

formalism, formalist An approach to the understanding, appreciation, and valuation of art based almost solely on considerations of form. This approach tends to regard an artwork as independent of its time and place of making. See also **connoisseurship**.

four-iwan mosque See iwan and mosque.

fresco A painting technique in which water-based pigments are applied to a surface of wet plaster (called **buon fresco**). The color is absorbed by the plaster, becoming a permanent part of the wall. **Fresco secco** is created by painting on dried plaster, and the color may flake off. Murals made by both these techniques are called frescoes.

fresco secco See fresco.

frieze The middle element of an **entabla- ture**, between the **architrave** and the **cornice**. Usually decorated with sculpture,
painting, or **moldings**. Also: any continuous
flat band with **relief sculpture** or painted decorations.

frottage A design produced by laying a piece of paper over a textured surface and rubbing with charcoal or other soft medium.

galleria See gallery.

gallery In church architecture, the story found above the side **aisles** of a church, usually open to and overlooking the nave. Also: in secular architecture, a long room, usually above the ground floor in a private house or a public building used for entertaining, exhibiting pictures, or promenading. *Also*: a building or hall in which art is displayed or sold. Also: **galleria**.

garbhagriha From the Sanskrit word meaning "womb chamber," a small room or shrine in a Hindu temple containing a holy image.

genre A type or category of artistic form, subject, technique, style, or medium. See also genre painting.

gesso A ground made from glue, gypsum, and/or chalk forming the ground of a wood panel or the priming layer of a canvas. Provides a smooth surface for painting.

gilding The application of paper-thin gold

leaf or gold pigment to an object made from another medium (for example, a sculpture or painting). Usually used as a decorative finishing detail.

giornata (giornate) Adopted from the Italian term meaning "a day's work," a giornata is the section of a **fresco** plastered and painted in a single day.

glaze See glazing.

glazing An outermost layer of vitreous liquid (glaze) that, upon firing, renders ceramics waterproof and forms a decorative surface. In painting, a technique particularly used with oil mediums in which a transparent layer of paint (glaze) is laid over another, usually lighter, painted or glazed area.

gloss A type of clay **slip** used in **ceramics** by ancient Greeks and Romans that, when fired, imparts a colorful sheen to the surface.

golf foil A thin sheet of gold.

gold leaf Paper-thin sheets of hammered gold that are used in **gilding**. In some cases (such as Byzantine **icons**), also used as a ground for paintings.

Grand Manner An elevated style of painting popular in the eighteenth century in which the artist looked to the ancients and to the Renaissance for inspiration; for portraits as well as history painting, the artist would adopt the poses, compositions, and attitudes of Renaissance and antique models.

Grand Tour Popular during the eighteenth and nineteenth centuries, an extended tour of cultural sites in southern Europe intended to finish the education of a young upper-class person from Britain or North America.

grattage A pattern created by scraping off layers of paint from a canvas laid over a textured surface. See also **frottage**.

Greek-cross plan See centrally planned building.

Greek-key pattern A continuous rectangular scroll often used as a decorative border. Also called a **meander pattern**.

grid A system of regularly spaced horizontally and vertically crossed lines that gives regularity to an architectural plan. Also: in painting, a grid enables designs to be enlarged or transferred easily.

grisaille A style of monochromatic painting in shades of gray. Also: a painting made in this style.

groin vault See vault.

guild An association of craftspeople. The medieval guild had great economic power, as it set standards and controlled the selling and marketing of its members' products, and as it provided economic protection, group solidarity, and training in the craft to its members.

hall church A church with a **nave** and **aisles** of the same height, giving the impression of a large, open hall.

hemicycle A semicircular interior space or structure.

henge A circular area enclosed by stones or wood posts set up by Neolithic peoples. It is usually bounded by a ditch and raised embankment.

hieratic In painting and sculpture, a formalized style for representing rulers or sacred or priestly figures.

hieratic scale The use of different sizes for significant or holy figures and those of the everyday world to indicate importance. The larger the figure, the greater the importance.

high relief Relief sculpture in which the image projects strongly from the background. See also **relief sculpture**.

himation In ancient Greece, a long loose outer garment.

historicism The strong consciousness of and attention to the institutions, themes, styles, and forms of the past, made accessible by historical research, textual study, and archaeology.

history painting Paintings based on historical, mythological, or biblical narratives. Once considered the noblest form of art, history paintings generally convey a high moral or intellectual idea and are often painted in a grand pictorial style.

hollow-casting See lost-wax casting.

hypostyle hall A large interior room characterized by many closely spaced **columns** that support its roof.

icon An image in any material representing a sacred figure or event in the Byzantine, and later in the Orthodox, Church. Icons were venerated by the faithful, who believed them to have miraculous powers to transmit messages to God.

iconoclasm The banning or destruction of images, especially icons and religious art. Iconoclasm in eighth- and ninth-century Byzantium and sixteenth- and seventeenth-century Protestant territories arose from differing beliefs about the power, meaning, function, and purpose of imagery in religion.

iconographic See iconography.

iconography The study of the significance and interpretation of the subject matter of art.

iconostasis The partition screen in a Byzantine or Orthodox church between the **sanctuary** (where the Mass is performed) and the body of the church (where the congregation assembles). The iconostasis displays **icons**.

idealism See idealization.

idealization A process in art through which artists strive to make their forms and figures attain perfection, based on pervading cultural values and/or their own mental image of beauty.

ignudi Heroic figures of nude young men.

illumination A painting on paper or **parchment** used as illustration and/or decoration for **manuscripts** or **albums**. Usually done in rich colors, often supplemented by gold and other precious materials. The illustrators are referred

to as illuminators. Also: the technique of decorating manuscripts with such paintings.

impasto Thick applications of pigment that give a painting a palpable surface texture.

impost, impost block A block, serving to concentrate the weight above, imposed between the **capital** of a **column** and the springing of an arch above.

in antis Term used to describe the position of columns set between two walls, as in a **portico** or a **cella**.

incising A technique in which a design or inscription is cut into a hard surface with a sharp instrument. Such a surface is said to be incised.

inlay To set pieces of a material or materials into a surface to form a design. *Also*: material used in or decoration formed by this technique.

installation art Artworks created for a specific site, especially a gallery or outdoor area, that create a total environment.

intaglio Term used for a technique in which the design is carved out of the surface of an object, such as an engraved seal stone. In the graphic arts, intaglio includes **engraving**, etching, and **drypoint**—all processes in which ink transfersto paper from incised, ink-filled lines cut into a metal plate.

intarsia Decoration formed through wood **inlay**.

intuitive perspective See perspective.

lonic order See order.

iwan A large, **vaulted** chamber in a **mosque** with a monumental arched opening on one side.

jamb In architecture, the vertical element found on both sides of an opening in a wall, and supporting an **arch** or lintel.

japonisme A style in French and American nineteenth-century art that was highly influenced by Japanese art, especially prints.

jasperware A fine-grained, unglazed, white **ceramic** developed by Josiah Wedgwood, often colored by metallic oxides with the raised designs ramaining white.

joggled voussoirs Interlocking voussoirs in an arch or lintel, often of contrasting materials for colorful effect.

kantharos A type of Greek vase or goblet with two large handles and a wide mouth.

keystone The topmost **voussoir** at the center of an **arch**, and the last block to be placed. The pressure of this block holds the arch together. Often of a larger size and/or decorated.

kiln An oven designed to produce enough heat for the baking, or firing, of clay.

kinetic art Artwork that contains parts that can be moved either by hand, air, or motor.

kore (korai) An Archaic Greek statue of a young woman.

kouros (kouroi) An Archaic Greek statue of a young man or boy.

krater An ancient Greek vessel for mixing wine and water, with many subtypes that each have a distinctive shape. **Calyx krater:** a bell-shaped vessel with handles near the base that resemble a flower calyx. Volute krater: a type of krater with handles shaped like scrolls.

kufic An ornamental, angular Arabic script.kylix A shallow Greek vessel or cup, used for drinking, with a wide mouth and small handles near the rim.

lamassu Supernatural guardian-protector of ancient Near Eastern palaces and throne rooms, often represented sculpturally as a combination of the bearded head of a man, powerful body of a lion or bull, wings of an eagle, and the horned headdress of a god, and usually possessing five legs.

lancet A tall narrow window crowned by a sharply pointed **arch**, typically found in Gothic architecture.

lantern A turretlike structure situated on a roof, **vault**, or **dome**, with windows that allow light into the space below.

lekythos (lekythoi) A slim Greek oil vase with one handle and a narrow mouth.

limner An artist, particularly a portrait painter, in England during the sixteenth and seventeenth centuries and in New England during the seventeenth and eighteenth centuries.

lithograph See lithography.

lithography Process of making a print (**lithograph**) from a design drawn on a flat stone block with greasy crayon. Ink is applied to the wet stone and adheres only to the greasy areas of the design.

loggia Italian term for a covered open-air. gallery. Often used as a corridor between buildings or around a courtyard, loggias usually have arcades or colonnades.

lost-wax casting A method of casting metal, such as bronze, by a process in which a wax mold is covered with clay and plaster, then fired, melting the wax and leaving a hollow form. Molten metal is then poured into the hollow space and slowly cooled. When the hardened clay and plaster exterior shell is removed, a solid metal form remains to be smoothed and polished.

low relief Relief sculpture whose figures project slightly from the background. See also **relief sculpture**.

lunette A semicircular wall area, framed by an arch over a door or window. Can be either plain or decorated.

lusterware Ceramic pottery decorated with metallic **glazes**.

madrasa An Islamic institution of higher learning, where teaching is focused on theology and law.

maenad In ancient Greece, a female devotee of the wine god Dionysos who participated in orgiastic rituals. She is often depicted with swirling drapery to indicate wild movement or

dance. (Also called a Bacchante, after Bacchus, the Roman name of Dionysos.)

majolica Pottery painted with a tin glaze that, when fired, gives a lustrous and colorful surface.

mandorla Light encircling, or emanating from, the entire figure of a sacred person.

manuscript A handwritten book or document

maqsura An enclosure in a Muslim mosque, near the mihrab, designated for dignitaries.

martyrium (martyria) In Christian architecture, a church, chapel, or shrine built over the grave of a martyr or the site of a great miracle.

mastaba A flat-topped, one-story structure with slanted walls over an ancient Egyptian underground tomb.

matte Term describing a smooth surface that is without shine or luster.

meander See Greek-key pattern.

medallion Any round ornament or decoration. Also: a large medal.

megalith A large stone used in prehistoric building. Megalithic architecture employs such stones.

megaron The main hall of a Mycenaean palace or grand house, having a columnar **porch** and a room with a central fireplace surrounded by four **columns**.

memento mori From Latin for "remember that you must die." An object, such as a skull or extinguished candle, typically found in a **vani**tas image, symbolizing the transience of life.

memory image An image that relies on the generic shapes and relationships that readily spring to mind at the mention of an object

menorah A Jewish lamp-stand with seven or nine branches; the nine-branched menorah is used during the celebration of Hanukkah. Representations of the seven-branched menorah, once used in the Temple of Jerusalem, became a symbol of Judaism.

metope The carved or painted rectangular panel between the **triglyphs** of a **Doric frieze**.

minbar A high platform or pulpit in a mosque.

miniature Anything small. In painting, miniatures may be illustrations within **albums** or **manuscripts** or intimate portraits.

mirador In Spanish and Islamic palace architecture, a very large window or room with windows, and sometimes balconies, providing views to interior courtyards or the exterior landscape.

mithuna The amorous male and female couples in Buddhist sculpture, usually found at the entrance to a sacred building. The mithuna symbolize the harmony and fertility of life.

moat A large ditch or canal dug around a castle or fortress for military defense. When filled with water, the moat protects the walls of the building from direct attack.

mobile A sculpture made with parts suspended in such a way that they move in a current of air.

modeling In painting, the process of creating the illusion of three-dimensionality on a two-dimensional surface by use of light and shade. In sculpture, the process of molding a three-dimensional form out of a malleable substance.

molding A shaped or sculpted strip with varying contours and patterns. Used as decoration on architecture, furniture, frames, and other objects.

mortise-and-tenon joint A method of joining two elements. A projecting pin (tenon) on one element fits snugly into a hole designed for it (mortise) on the other. Such joints are very strong and flexible.

mosaic Images formed by small colored stone or glass pieces (tesserae), affixed to a hard, stable surface.

mullion A slender vertical element or **colonnette** that divides a window into subsidiary sections.

muqarnas Small nichelike components stacked in tiers to fill the transition between differing vertical and horizontal planes.

naos The principal room in a temple or church. In ancient architecture, the **cella**. In a Byzantine church, the **nave** and **sanctuary**.

narthex The vestibule or entrance porch of a church.

naturalism, naturalistic A style of depiction that seeks to imitate the appearance of nature. A naturalistic work appears to record the visible world

nave The central space of a basilica, two or three stories high and usually flanked by aisles.necking The molding at the top of the shaft of the column.

necropolis A large cemetery or burial area; literally a "city of the dead."

nemes headdress The royal headdress of Egypt.

niello A metal technique in which a black sulfur alloy is rubbed into fine lines engraved into a metal (usually gold or silver). When heated, the alloy becomes fused with the surrounding metal and provides contrasting detail.

nocturne A night scene in painting, usually lit by artificial illumination.

nonrepresentational art An **abstract** art that does not attempt to reproduce the appearance of objects, figures, or scenes in the natural world. Also called nonobjective art.

oculus (oculi) In architecture, a circular opening. Oculi are usually found either as windows or at the apex of a **dome**. When at the top of a dome, an oculus is either open to the sky or covered by a decorative exterior lantern.

ogee An S-shaped curve. See **arch**.

olpe Any Greek vase or jug without a spout.one-point perspective See perspective.

opithodomos In greek temples, the entrance porch or room at the back.

oracle A person, usually a priest or priestess, who acts as a conduit for divine information. Also: the information itself or the place at which this information is communicated.

orant The representation of a standing figure praying with outstretched and upraised arms.

orchestra The circular performance area of an ancient Greek theater. In later architecture, the section of seats nearest the stage or the entire main floor of the theater.

order A system of proportions in Classical architecture that includes every aspect of the building's plan, elevation, and decorative system. Composite: a combination of the Ionic and the Corinthian orders. The capital combines acanthus leaves with volute scrolls. Corinthian: the most ornate of the orders, the Corinthian includes a base, a fluted column **shaft** with a capital elaborately decorated with acanthus leaf carvings. Its entablature consists of an architrave decorated with moldings, a frieze often containing sculptured reliefs, and a cornice with dentils. Doric: the column shaft of the Doric order can be fluted or smooth-surfaced and has no base. The Doric capital consists of an undecorated echinus and abacus. The Doric entablature has a plain architrave, a frieze with metopes and triglyphs, and a simple cornice. Ionic: the column of the Ionic order has a base, a fluted shaft, and a capital decorated with volutes. The Ionic entablature consists of an architrave of three panels and moldings, a frieze usually containing sculpted relief ornament, and a cornice with dentils. Tuscan: a variation of Doric characterized by a smooth-surfaced column shaft with a base, a plain architrave, and an undecorated frieze. A colossal order is any of the above built on a large scale, rising through several stories in height and often raised from the ground by a pedestal.

orthogonal Any line running back into the represented space of a picture perpendicular to the imagined picture plane. In linear perspective, all orthogonals converge at a single **vanishing point** in the picture and are the basis for a **grid** that maps out the internal space of the image. An orthogonal plan is any plan for a building or city that is based exclusively on right angles, such as the grid plan of many modern cities.

palace complex A group of buildings used for living and governing by a ruler and his or her supporters, usually fortified.

palmette A fan-shaped ornament with radiating leaves.

parapet A low wall at the edge of a balcony, bridge, roof, or other place from which there is a steep drop, built for safety. A parapet walk is the passageway, usually open, immediately behind the uppermost exterior wall or battlement of a fortified building.

parchment A writing surface made from treated skins of animals. Very fine parchment is known as **vellum**.

parterre An ornamental, highly regimented flowerbed. An element of the ornate gardens of seventeenth-century palaces and châteaux.

pastel Dry pigment, chalk, and gum in stick or crayon form. Also: a work of art made with pastels.

pedestal A platform or **base** supporting a sculpture or other monument. Also: the block found below the base of a Classical **column** (or **colonnade**), serving to raise the entire element off the ground.

pediment A triangular gable found over major architectural elements such as Classical Greek **porticoes**, windows, or doors. Formed by an **entablature** and the ends of a sloping roof or a raking **cornice**. A similar architectural element is often used decoratively above a door or window, sometimes with a curved upper **molding**. A broken pediment is a variation on the traditional pediment, with an open space at the center of the topmost angle and/or the horizontal cornice.

pendentive The concave triangular section of a **vault** that forms the transition between a square or polygonal space and the circular base of a **dome**.

peplos A loose outer garment worn by women of ancient Greece. A cloth rectangle fastened on the shoulders and belted below the bust or at the waist.

peripteral A term used to describe any building (or room) that is surrounded by a single row of columns. When such **columns** are engaged instead of freestanding, called pseudoperipteral.

peristyle A surrounding **colonnade** in Greek architecture. A peristyle building is surrounded on the exterior by a colonnade. Also: a peristyle court is an open colonnaded courtyard, often having a pool and garden.

perspective A system for representing threedimensional space on a two-dimensional surface. Atmospheric perspective: A method of rendering the effect of spatial distance by subtle variations in color and clarity of representation. Intuitive perspective: A method of giving the impression of recession by visual instinct, not by the use of an overall system or program. Oblique perspective: An intuitive spatial system in which a building or room is placed with one corner in the picture plane, and the other parts of the structure recede to an imaginary vanishing point on its other side. Oblique perspective is not a comprehensive, mathematical system. One-point and multiple-point perspective (also called linear, scientific or mathematical perspective): A method of creating the illusion of three-dimensional space on a two-dimensional surface by delineating a horizon line and multiple orthogonal lines. These recede to meet at one or more points on the horizon (called vanishing points), giving the appearance of spatial depth. Called scientific or mathematical because its use requires some knowledge of geometry and mathematics, as well as optics. Reverse perspective: A Byzantine perspec-

tive theory in which the orthogonals or rays of

sight do not converge on a vanishing point in the picture, but are thought to originate in the viewer's eye in front of the picture. Thus, in reverse perspective the image is constructed with orthogonals that diverge, giving a slightly tipped aspect to objects.

photomontage A photographic work created from many smaller photographs arranged (and often overlapping) in a composition.

picture plane The theoretical spatial plane corresponding with the actual surface of a painting.

picture stone A medieval northern European memorial stone covered with figural decoration. See also **rune stone**.

picturesque A term describing the taste for the familiar, the pleasant, and the pretty, popular in the eighteenth and nineteenth centuries in Europe. When contrasted with the sublime, the picturesque stood for all that was ordinary but pleasant.

piece-mold casting A casting technique in which the mold consists of several sections that are connected during the pouring of molten metal, usually bronze. After the cast form has hardened, the pieces of the mold are disassembled, leaving the completed object.

pier A masonry support made up of many stones, or rubble and concrete (in contrast to a **column shaft** which is formed from a single stone or a series of **drums**), often square or rectangular in plan, and capable of carrying very heavy architectural loads.

pietra serena A gray Tuscan limestone used in Florence.

pilaster An **engaged** columnar element that is rectangular in format and used for decoration in architecture.

pillar In architecture, any large, freestanding vertical element. Usually functions as an important weight-bearing unit in buildings.

plate tracery See tracery.

plinth The slablike **base** or **pedestal** of a **column**, statue, wall, building, or piece of furniture.

pluralism A social structure or goal that allows members of diverse ethnic, racial, or other groups to exist peacefully within the society while continuing to practice the customs of their own divergent cultures. Also: an adjective describing the state of having many valid contemporary styles available at the same time to artists.

podium A raised platform that acts as the foundation for a building, or as a platform for a speaker.

polychrome See polychromy.

polyptych An altarpiece constructed from multiple panels, sometimes with hinges to allow for movable wings.

porch The covered entrance on the exterior of a building. With a row of **columns** or **colonnade**, also called a **portico**.

portal A grand entrance, door, or gate, usually to an important public building, and often decorated with sculpture.

portico In architecture, a projecting roof or porch supported by columns, often marking an entrance. See also porch.

post-and-lintel construction An architectural system of construction with two or more vertical elements (posts) supporting a horizontal element (lintel).

potassium-argon dating Technique used to measure the decay of a radioactive potassium isotope into a stable isotope of argon, an inert gas.

potsherd A broken piece of ceramic ware.

Praire Style A style of architecture initiated by the American Frank Lloyd Wright (1867–1959), in which he sought to integrate his structures in an "organic" way into the surrounding natural landscape, often having the lines of the building follow the horizontal contours of the land. Since Wright's early buildings were built in the Prairie States of the Midwest, this type of architecture became known as the Prairie Style.

primitivism The borrowing of subjects or forms usually from non-Western or prehistoric sources by Western artists. Originally practiced by Western artists as an attempt to infuse their work with the naturalistic and expressive qualities attributed to other cultures, especially colonized cultures, primitivism also borrowed from the art of children and the insane.

pronaos The enclosed vestibule of a Greek or Roman temple, found in front of the **cella** and marked by a row of **columns** at the entrance.

proscenium The stage of an ancient Greek or Roman theater. In modern theater, the area of the stage in front of the curtain. Also: the framing **arch** that separates a stage from the audience.

psalter In Jewish and Christian scripture, a book containing the psalms, or songs, attributed to King David.

punchwork Decorative designs that are stamped onto a surface, such as metal or leather, using a punch (a handheld metal implement).

putto (putti) A plump, naked little boy, often winged. In classical art, called a cupid; in Christian art, a cherub.

pylon A massive gateway formed by a pair of tapering walls of oblong shape. Erected by ancient Egyptians to mark the entrance to a temple complex.

qibla The mosque wall oriented toward Mecca indicated by the mihrab.

quatrefoil A four-lobed decorative pattern common in Gothic art and architecture.

quincunx A building in which five **domed** bays are arranged within a square, with a central unit and four corner units. (When the central unit has similar units extending from each side, the form becomes a **Greek cross**.)

quoin A stone, often extra large or decorated for emphasis, forming the corner of two walls. A vertical row of such stones is called quoining.

radiometric dating A method of dating prehistoric works of art made from organic materials, based on the rate of degeneration of radiocarbons in these materials. *See also* relative dating, absolute dating.

readymade An object from popular or material culture presented without further manipulation as an artwork by the artist.

realism In art, a term first used in Europe around 1850 to designate a kind of **naturalism** with a social or political message, which soon lost its didactic import and became synonymous with naturalism.

red-figure A style and technique of ancient Greek vase painting characterized by red clay-colored figures on a black background. (The figures are reversed against a painted ground and details are drawn, not engraved, as in blackfigure style.) See also **black-figure**.

register A device used in systems of spatial definition. In painting, a register indicates the use of differing **groundlines** to differentiate layers of space within an image. In sculpture, the placement of self-contained bands of **reliefs** in a vertical arrangement. In printmaking, the marks at the edges used to align the print correctly on the page, especially in multiple-block color printing.

relative dating See also radiometric dating.

relief sculpture A three-dimensional image or design whose flat background surface is carved away to a certain depth, setting off the figure. Called high or low (bas) relief depending upon the extent of projection of the image from the background. Called sunken relief when the image is carved below the original surface of the background, which is not cut away.

reliquary A container, often made of precious materials, used as a repository to protect and display sacred relics.

repoussé A technique of hammering metal from the back to create a protruding image. Elaborate reliefs are created with wooden armatures against which the metal sheets are pressed and hammered.

reverse perspective See perspective.

rhyton A vessel in the shape of a figure or an animal, used for drinking or pouring liquids on special occasions.

rib vault See vault.

ridgepole A longitudinal timber at the apex of a roof that supports the upper ends of the rafters

rosette A round or oval ornament resembling a rose.

rotunda Any building (or part thereof) constructed in a circular (or sometimes polygonal) shape, usually producing a large open space crowned by a **dome**.

round arch See arch.

roundel Any element with a circular format, often placed as a decoration on the exterior of architecture.

rune stone A stone used in early medieval northern Europe as a commemorative monument, which is carved or inscribed with runes, a writing system used by early Germanic peoples.

running spirals A decorative motif based on the shape formed by a line making a continuous spiral.

rustication In building, the rough, irregular, and unfinished effect deliberately given to the exterior facing of a stone edifice. Rusticated stones are often large and used for decorative emphasis around doors or windows, or across the entire lower floors of a building. Also, masonry construction with conspicuous, often beveled joints.

salon A large room for entertaining guests; a periodic social or intellectual gathering, often of prominent people; a hall or **gallery** for exhibiting works of art.

sanctuary A sacred or holy enclosure used for worship. In ancient Greece and Rome, consisted of one or more temples and an altar. In Christian architecture, the space around the altar in a church called the chancel or presbytery.

sarcophagus (sarcophagi) A stone coffin. Often rectangular and decorated with **relief sculpture**.

scarab In Egypt, a stylized dung beetle associated with the sun and the god Amun.

school of artists An art historical term describing a group of artists, usually working at the same time and sharing similar styles, influences, and ideals. The artists in a particular school may not necessarily be directly associated with one another, unlike those in a workshop or **atelier**.

scribe A writer;a person who copies texts.

scriptorium (scriptoria) A room in a monastery for writing or copying manuscripts.

scroll painting A painting executed on a rolled support. Rollers at each end permit the horizontal scroll to be unrolled as it is studied or the vertical scroll to be hung for contemplation or decoration.

seals Personal emblems usually carved of stone in intaglio or relief and used to stamp a name or legend onto paper or silk. They traditionally employ the archaic characters appropriately known as "seal script," of the Zhou or Qin. Cut in stone, a seal may state a formal givem name, or it may state any of the numerous personal names that China's painters and writers adopted throughout their lives. A treasured work of art often bears not only the seal of its maker but also those of collectors and admirers through the centuries. In the Chinese view, these do not disfigure the work but add another layer of interest.

seraph (seraphim) An angel of the highest rank in the Christian hierarchy.

serdab In Egyptian tombs, the small room in which the ka statue was placed.

sfumato Italian term meaning "smoky," soft, and mellow. In painting, the effect of haze in an image. Resembling the color of the atmosphere at dusk, sfumato gives a smoky effect.

sgraffito Decoration made by incising or cutting away a surface layer of material to reveal a different color beneath.

shaft The main vertical section of a column between the capital and the base, usually circular in cross section.

shaftgrave A deep pit used for burial.

shoji A standing Japanese screen covered in translucent rice paper and used in interiors.

sinopia The preparatory design or underdrawing of a **fresco**. Also: a reddish chalklike earth pigment.

site-specific sculpture A sculpture commissioned and/or designed for a particular spot.

spandrel The area of wall adjoining the exterior curve of an arch between its **springing** and the **keystone**, or the area between two arches, as in an **arcade**.

springing The point at which the curve of an arch or vault meets with and rises from its support.

squinch An **arch** or lintel built across the upper corners of a square space, allowing a circular or polygonal **dome** to be more securely set above the walls.

stained glass Molten glass is given a color that becomes intrinsic to the material. Additional colors may be fused to the surface (flashing). Stained glass is most often used in windows, for which small pieces of differently colored glass are precisely cut and assembled into a design, held together by **cames**. Additional painted details may be added to create images.

stele (stelae) A stone slab placed vertically and decorated with inscriptions or reliefs. Used as a grave marker or memorial.

stereobate A foundation upon which a Classical temple stands.

still life A type of painting that has as its subject inanimate objects (such as food, dishes, fruit, or flowers).

stoa In Greek architecture, a long roofed walkway, usually having columns on one long side and a wall on the other.

stoneware A high-fired, vitrified, but opaque ceramic ware that is fired in the range of 1,100 to 1,200 degrees Celsius. At that temperature, particles of silica in the clay bodies fuse together so that the finished vessels are impervious to liguids, even without glaze. Stoneware pieces are glazed to enhance their aesthetic appeal and to aid in keeping them clean (since unglazed ceramics are easily soiled). Stoneware occurs in a range of earthtoned colors, from white and tan to gray and

black, with light gray predominating. Chinese potters were the first in the world to produce stoneware, which they were able to make as early as the Shang dynasty.

stucco A mixture of lime, sand, and other ingredients into a material that can be easily molded or modeled. When dry, produces a very durable surface used for covering walls or for architectural sculpture and decoration.

stylobate In Classical architecture, the stone foundation on which a temple **colonnade** stands.

stylus An instrument with a pointed end (used for writing and printmaking), which makes a delicate line or scratch. Also: a special writing tool for **cuneiform** writing with one pointed end and one triangular wedge end.

sublime Adjective describing a concept, thing, or state of high spiritual, moral, or intellectual value; or something awe-inspiring. The sublime was a goal to which many nineteenth-century artists aspired in their artworks.

sunken relief See relief sculpture.

syncretism In religion or philosophy, the union of different ideas or principles.

tapestry Multicolored pictorial or decorative weaving meant to be hung on a wall or placed on furniture.

tempera A painting medium made by blending egg yolks with water, pigments, and occasionally other materials, such as glue.

tenebrism The use of strong **chiaroscuro** and artificially illuminated areas to create a dramatic contrast of light and dark in a painting.

terra cotta A medium made from clay fired over a low heat and sometimes left unglazed. Also: the orange-brown color typical of this medium.

tessera (tesserae) The small piece of stone, glass, or other object that is pieced together with many others to create a mosaic.

tetrarchy Four-man rule, as in the late Roman Empire, when four emperors shared power.

thatch A roof made of plant materials.

thermo-luminescence dating A technique that measures the irradiation of the crystal structure of material such as flint or pottery and the soil in which it is found, determined by luminescence produced when a sample is heated

tholos A small, round building. Sometimes built underground, as in a Mycenaean tomb.

thrust The outward pressure caused by the weight of a vault and supported by buttressing. *See* **arch**.

tierceron In **vault** construction, a secondary rib that arcs from a **springing** point to the rib that runs lengthwise through the vault, called the ridge rib.

tondo A painting or **relief sculpture** of circular shape.

tracery Stonework or woodwork applied to wall surfaces or filling the open space of windows. In **plate tracery**, opening are cut through the wall. In **bar tracery**, **mullions** divide the space into vertical segments and form decorative patterns at the top of the opening or panel.

transept The arm of a cruciform church, perpendicular to the **nave**. The point where the nave and transept cross is called the crossing. Beyond the crossing lies the **sanctuary**, whether **apse**, choir, or chevet.

travertine A mineral building material similar to limestone, typically found in central Italy.

triglyph Rectangular block between the **metopes** of a **Doric frieze**. Identified by the three carved vertical grooves, which approximate the appearance of the end of a wooden beam.

triptych An artwork made up of three panels. The panels may be hinged together so the side segments (**wings**) fold over the central area.

trompe Poeil A manner of representation in which the appearance of natural space and objects is re-created with the express intention of fooling the eye of the viewer, who may be convinced that the subject actually exists as three-dimensional reality.

trumeau A column, pier, or post found at the center of a large portal or doorway, supporting the lintel.

tugra A calligraphic imperial monogram used in Ottoman courts.

Tuscan order See order.

twisted perspective A convention in art in which every aspect of a body or object is represented from its most characteristic viewpoint.

vanishing point In a perspective system, the point on the horizon line at which orthogonals meet. A complex system can have multiple vanishing points.

vanitas An image, especially popular in Europe during the seventeenth century, in which all the objects symbolize the transience of life. Vanitas paintings are usually of still lifes or genre subjects.

vault An arched masonry structure that spans an interior space. Barrel or tunnel vault: an elongated or continuous semicircular vault, shaped like a half-cylinder. Corbeled vault: a vault made by projecting courses of stone. Groin or cross vault: a vault created by the intersection of two barrel vaults of equal size which creates four side compartments of identical size and shape. Quadrant or half-barrel vault: as the name suggests, a half-barrel vault. Rib vault: ribs (extra masonry) demarcate the junctions of a groin vault. Ribs may function to reinforce the groins or may be purely decorative. See also corbeling.

veduta (vedute) Italian for "vista" or "view." Paintings, drawings, or prints often of expansive city scenes or of harbors.

vellum A fine animal skin prepared for writing and painting. See also parchment.

veneer In architecture, the exterior facing of a building, often in decorative patterns of fine stone or brick. In decorative arts, a thin exterior layer of finer material (such as rare wood, ivory, metal, and semiprecious stones) laid over the form.

verism A style in which artists concern themselves with capturing the exterior likeness of an object or person, usually by rendering its visible details in a finely executed, meticulous manner.

vihara From the Sanskrit term meaning "for wanderers." A vihara is, in general, a Buddhist monastery in India. It also signifies monks' cells and gathering places in such a monastery.

volute A spiral scroll, as seen on an Ionic **capital**.

votive figure An image created as a devotional offering to a god or other deity.

voussoirs The oblong, wedge-shaped stone blocks used to build an **arch**. The topmost voussoir is called a **keystone**.

warp The vertical threads in a weaver's loom. Warp threads make up a fixed framework that provides the structure for the entire piece of cloth, and are thus often thicker than weft threads. See also weft.

wash A diluted watercolor or ink. Often washes are applied to drawings or prints to add tone or touches of color.

wattle and daub A wall construction method combining upright branches, woven with twigs (wattles) and plastered or filled with clay or mud (daub).

weft The horizontal threads in a woven piece of cloth. Weft threads are woven at right angles to and through the warp threads to make up the bulk of the decorative pattern. In carpets, the weft is often completely covered or formed by the rows of trimmed knots that form the carpet's soft surface. See also warp.

white-ground A type of ancient Greek pottery in which the background color of the object is painted with a slip that turns white in the firing process. Figures and details were added by painting on or **incising** into this

slip. White-ground wares were popular in the Classical period as funerary objects.

wing A side panel of a triptych or polyptych (usually found in pairs), which was hinged to fold over the central panel. Wings often held the depiction of the donors and/or subsidiary scenes relating to the central image.

woodblock print A print made from one or more carved wooden blocks. In Japan, woodblock prints were made using multiple blocks carved in relief, usually with a block for each color in the finished print. See also woodcut.

woodcut A type of print made by carving a design into a wooden block. The ink is applied to the block with a roller. As the ink remains only on the raised areas between the carvedaway lines, these carved-away areas and lines provide the white areas of the print. Also: the process by which the woodcut is made.

ziggurat In Mesopotamia, a tall stepped tower of earthen materials, often supporting a shrine.

BIBLIOGR APHY

Susan V. Craig

This bibliography is composed of books in English that are appropriate "further reading" titles. Most items on this list are available in good libraries, whether college, university, or public institutions. I have emphasized recently published works so that the research information would be current. There are three classifications of listings: general surveys and art history reference tools, including journals and Internet directories; surveys of large periods that encompass multiple chapters (ancient art in the Western tradition, European medieval art, European Renaissance through eighteenth-century art, modern art in the West); and books for individual chapters 1 through 21.

General Art History Surveys and Reference Tools

- Adams, Laurie Schneider. Art across Time. 2nd ed. New York: McGraw-Hill, 2002.
- Barnet, Sylvan. A Short Guide to Writing about Art. 8th ed. New York: Pearson/Longman, 2005.
- Boströöm, Antonia. Encyclopedia of Sculpture. 3 vols. New York: FitzroyDearborn, 2004.
- Broude, Norma, and Garrard, Mary D., eds. Feminism and Art History: Questioning the Litany. Icon Editions. New York: Harper & Row, 1982.
- Chadwick, Whitney. Women, Art, and Society. 3rd ed. New York: Thames and Hudson, 2002.
- Chilvers, Ian, ed. The Oxford Dictionary of Art. 3rd ed. New York: Oxford Univ. Press, 2004.
- Curl, James Stevens. A Dictionary of Architecture and Landscape Architecture. 2nd ed. Oxford: Oxford Univ. Press, 2006.
- Davies, Penelope J.E., et al. Janson's History of Art: The Western Tradition. 7th ed. Upper Saddle River, NJ: Prentice Hall, 2006.
- Dictionary of Art, The. 34 vols. New York: Grove's Dictionaries, 1996.
- Encyclopedia of World Art. 16 vols. New York: McGraw-Hill, 1972-83.
- Frank, Patrick, Duane Preble, and Sarah Preble. Preble's Artforms. 8th ed. Upper Saddle River, NJ: Prentice Hall, 2006.
- Gardner, Helen. Gardner's Art through the Ages. 12th ed. Ed. Fred S. Kleiner & Christin J. Mamiya. Belmont, CA: Thomson/Wadsworth, 2005.
- Gaze, Delia, ed. Dictionary of Women Artists. 2 vols. London: Fitzroy Dearborn Publishers, 1997.
- Griffiths, Antony. Prints and Printmaking: An Introduction to the History and Techniques. 2nd ed. London: British Museum Press, 1996.
- Hadden, Peggy. The Quotable Artist. New

- York: Allworth Press, 2002.
- Hall, James. Illustrated Dictionary of Symbols in Eastern and Western Art. New York: Icon Editions, 1994.
- Holt, Elizabeth Gilmore, ed. A Documentary History of Art. 3 vols. New Haven: Yale Univ. Press, 1986.
- Honour, Hugh, and John Fleming. The Visual Arts: A History. 7th ed. Upper Saddle River, NI: Prentice Hall, 2005.
- Hults, Linda C. The Print in the Western World: An Introductory History. Madison: Univ. of Wisconsin Press, 1996.
- Johnson, Paul. Art: A New History. New York: HarperCollins, 2003.
- Kaltenbach. G. E. Pronunciation Dictionary of Artists' Names, 3rd ed. Rev. Debra Edelstein. Boston: Little, Brown, and Co., 1993.
- Kemp, Martin. The Oxford History of Western Art. Oxford: Oxford Univ. Press,
- Kostof, Spiro. A History of Architecture: Settings and Rituals. 2nd ed. Rev. Greg Castillo. New York: Oxford Univ. Press, 1995.
- Mackenzie, Lynn. Non-Western Art: A Brief Guide. 2nd ed. Upper Saddle River, NJ: Prentice Hall, 2001.
- Marmor, Max, and Alex Ross, eds. Guide to the Literature of Art History 2. Chicago: American Library Association, 2005.
- Onians, John, ed. Atlas of World Art. New York: Oxford Univ. Press, 2004.
- Roberts, Helene, ed. Encyclopedia of Comparative Iconography: Themes Depicted in Works of Art. 2 vols. Chicago: Fitzroy Dearborn, 1998.
- Rogers, Elizabeth Barlow. Landscape Design: A Cultural and Architectural History. New York: Harry N. Abrams, 2001.
- Sayre, Henry M. Writing about Art. 5th ed. Upper Saddle River, NJ: Pearson/Prentice Hall, 2006.
- Sed-Rajna, Gabrielle. Jewish Art. Trans. Sara Friedman and Mira Reich. New York: Abrams, 1997.
- Slatkin, Wendy. Women Artists in History: From Antiquity to the Present. 4th ed. Upper Saddle River, NJ: Prentice Hall, 2000.
- Sutton, Ian. Western Architecture: From Ancient Greece to the Present. World of Art. New York: Thames and Hudson, 1999.
- Trachtenberg, Marvin, and Isabelle Hyman. Architecture: From Prehistory to Postmodernity. 2nd ed. Upper Saddle River, NJ: Prentice Hall, 2001.
- Tufts, Eleanor. Our Hidden Heritage: Five Centuries of Women Artists. New York: Paddington Press, 1974.

- West, Shearer. Portraiture. Oxford History of Art. Oxford: Oxford Univ. Press, 2004.
- Wilkins, David G., Bernard Schultz, and Katheryn M. Linduff. Art Past, Art Present. 5th ed. Upper Saddle River, NJ: Prentice Hall, 2005.
- Watkin, David. A History of Western Architecture. 4th ed. New York: Watson-Guptill Publications, 2005.

Art History Journals: A Select List of Current Titles

- African Arts. Quarterly. Los Angeles: Univ. of California at Los Angeles, James S. Coleman African Studies Center.
- American Art: The Journal of the Smithsonian American Art Museum. 3/year. Chicago: Univ. of Chicago Press, 1987-
- American Indian Art Magazine, Quarterly. Scottsdale, AZ: American Indian Art Inc. 1975-
- American Journal of Archaeology. Quarterly. Boston: Archaeological Institute of America, 1885-
- Antiquity: A Periodical of Archaeology. Quarterly. Cambridge, UK: Antiquity Publications Ltd, 1927-
- Apollo: The International Magazine of the Arts. Monthly. London: Apollo Magazine Ltd, 1925-
- Architectural History. Annually. Farnham, UK: Society of Architectural Historians of Great Britain, 1958-
- Archives of American Art Journal. Quarterly. Washington, D.C.: Archives of American Art, Smithsonian Institution, 1960.
- Archives of Asian Art. Annually. New York: Asia Society, 1945-
- Ars Orientalis: The Arts of Asia, Southeast Asia, and Islam. Annually. Ann Arbor: Univ. of Michigan Dept. of Art History, 1954-
- Art Bulletin. Quarterly. New York: College Art Association, 1913-
- Art History: Journal of the Association of Art Historians. 5/year. Oxford: Blackwell Publishing Ltd, 1978-
- Art in America. Monthly. New York: Brant Publications Inc, 1913-
- Art Journal. Quarterly. New York: College Art Association, 1960-
- Art Nexus. Quarterly. Bogata, Colombia: Arte en Colombia Ltda, 1976-
- Art Papers Magazine. Bi-monthly. Atlanta: Atlanta Art Papers Inc, 1976-
- Artforum International. 10/year. New York: Artforum International Magazine Inc, 1962-
- Artnews. 11/year. New York: Artnews LLC, 1902-
- Bulletin of the Metropolitan Museum of Art.

Quarterly. New York: Metropolitan Museum of Art, 1905-.

Burlington Magazine. Monthly. London: Burlington Magazine Publications Ltd, 1903-

Dumbarton Oaks Papers. Annually. Locust Valley, NY: J. J. Augustin Inc, 1940-Flash Art International. Bimonthly. Trevi,

Italy: Giancarlo Politi Editore, 1980-Gesta. Semiannually. New York: Interna-

tional Center of Medieval Art, 1963-History of Photography. Quarterly. Abing-

don, UK: Taylor & Francis Ltd, 1976-International Review of African American Art. Quarterly, Hampton, VA: International

Quarterly. Hampton, VA: Internationa Review of African American Art, 1976-

Journal of Design History. Quarterly. Oxford: Oxford Univ. Press, 1988-

Journal of Egyptian Archaeology. Annually. London: Egypt Exploration Society, 1914-

Journal of Hellenic Studies. Annually. London: Society for the Promotion of Hellenic Studies, 1880-

Journal of Roman Archaeology. Annually. Portsmouth, RI: Journal of Roman Archaeology LLC, 1988-

Journal of the Society of Architectural Historians. Quarterly. Chicago: Society of Architectural Historians, 1940-

Journal of the Warburg and Courtauld Institutes. Annually. London: Warburg Institute. 1937-

Leonardo: Art, Science and Technology. 6/year. Cambridge, MA: MIT Press, 1968-

Marg. Quarterly. Mumbai, India: Scientific Publishers, 1946-

Master Drawings. Quarterly. New York: Master Drawings Association, 1963-

October. Cambridge, MA: MIT Press, 1976-

Oxford Art Journal. 3/year. Oxford: Oxford Univ. Press, 1978-

Parkett. 3/year. Züürich, Switzerland: Parkett Verlag AG, 1984-

Print Quarterly. Quarterly. London: Print Quarterly Publications, 1984-

Simiolus: Netherlands Quarterly for the History of Art. Quarterly. Apeldoorn, Netherlands: Stichting voor Nederlandse Kunsthistorische Publicaties, 1966-

Woman's Art Journal. Semiannually.
Philadelphia: Old City Publishing Inc,
1980-

Internet Directories for Art History Information

ARCHITECTURE AND BUILDING http://library.nevada.edu/arch/rsrce/webrsrce/ contents.html

A directory of architecture websites collected by Jeanne Brown at the Univ. of Nevada at Las Vegas. Topical lists include architecture, building and construction, design, history, housing, planning, preservation, and landscape architecture. Most entries include a brief annotation and the last date the link was accessed by the compiler.

ART HISTORY RESOURCES ON THE WEB http://witcombe.sbc.edu/ARTHLinks.html

Authored by Christopher L. C. E. Witcombe of Sweet Briar College in Virginia since 1995, the site includes an impressive number of links for various art historical eras as well as links to research resources, museums, and galleries. The content is frequently updated.

ART IN FLUX: A DIRECTORY OF RESOURCES FOR RESEARCH IN CONTEMPORARY ART http://www.boisestate.edu/art/artinflux/intro.html Cheryl K. Shutleff of Boise State Univ. in Idaho has authored this directory, which includes sites selected according to their relevance to the study of national or international contemporary art and artists. The subsections include artists, museums, theory, reference, and links.

ARTCYCLOPEDIA: THE FINE ARTS SEARCH ENGINE

With over 2,100 art sites and 75,000 links, this is one of the most comprehensive web directories for artists and art topics.

The primary searching is by artist's name but access is also available by artistic movement, nation, timeline and medium.

MOTHER OF ALL ART HISTORY LINKS PAGES http://www.art-design.umich.edu/mother/

Maintained by the Dept. of the History of Art at the Univ. of Michigan, this directory covers art history departments, art museums, fine arts schools and departments as well as links to research resources. Each entry includes annotations.

VOICE OF THE SHUTTLE

http://vos.ucsb.edu

Sponsored by Univ. of California, Santa Barbara, this directory includes over 70 pages of links to humanities and humanities-related resources on the Internet. The structured guide includes specific sub-sections on architecture, on art (modern & contemporary), and on art history. Links usually include a one sentence explanation and the resource is frequently updated with new information.

YAHOO! ARTS>ART HISTORY

http://dir.yahoo.com/Arts/Art_History/

Another extensive directory of art links organized into subdivisions with one of the most extensive being "Periods and Movements." Links include the name of the site as well as a few words of explanation.

Ancient Art in the Western Tradition, General

Amiet, Pierre. Art in the Ancient World: A Handbook of Styles and Forms. New York: Rizzoli, 1981.

Beard, Mary, and John Henderson. Classical Art: From Greece to Rome. Oxford History of Art. Oxford: Oxford Univ. Press, 2001.

Boardman, John. Oxford History of Classical Art. New York: Oxford Univ. Press, 2001.

Chitham, Robert. *The Classical Orders of Architecture*. 2nd ed. Boston: Elsevier/Architectural Press, 2005.

Ehrich, Robert W., ed. *Chronologies in Old World Archaeology*. 3rd ed. 2 vols. Chicago: Univ. of Chicago Press, 1992.

Gerster, Georg. The Past from Above: Aerial Photographs of Archaeological Sites. Ed. Charlotte Trüümpler. Trans. Stewart Spencer. Los Angeles: The J. Paul Getty Museum, 2005.

Groenewegen-Frankfort, H. A., and Bernard Ashmole. Art of the Ancient World: Painting, Pottery, Sculpture, Architecture from Egypt, Mesopotamia, Crete, Greece, and Rome. Library of Art History. Upper Saddle River, NJ: Prentice Hall, 1972.

Haywood, John. *The Penguin Historical Atlas of Ancient Civilizations*. New York: Penguin, 2005.

Lloyd, Seton, and Hans Wolfgang Muller. Ancient Architecture. New York: Rizzoli, 1986.

Milleker, Elizabeth J., ed. *The Year One:* Art of the Ancient World East and West. New York: Metropolitan Museum of Art, 2000.

Nagle, D. Brendan. *The Ancient World: A Social and Cultural History*. 6th ed. Upper Saddle River, NJ: Pearson Prentice Hall, 2006.

Romer, John, and Elizabeth Romer. *The Seven Wonders of the World: A History of the Modern Imagination*. New York: Henry Holt, 1995.

Saggs, H. W. F. Civilization before Greece and Rome. New Haven: Yale Univ. Press, 1989.

Smith, William Stevenson. Interconnections in the Ancient Near East: A Study of the Relationships between the Arts of Egypt, the Aegean, and Western Asia. New Haven: Yale Univ. Press, 1965.

Tadgell, Christopher. Imperial Form: From Achaemenid Iran to Augustan Rome. New York: Whitney Library of Design, 1998.

——-. Origins: Egypt, West Asia and the Aegean. New York: Whitney Library of Design, 1998.

Trigger, Bruce G. Understanding Early Civilizations: A Comparative Study. New York: Cambridge Univ. Press, 2003.

Winckelmann, Johann Joachim. History of the Art of Antiquity. Trans. Harry Francis Mallgrave. Texts & Documents. Los Angeles: Getty Research Institute, 2006.

Woodford, Susan. *The Art of Greece and Rome*. 2nd ed. New York: Cambridge Univ. Press, 2004.

European Medieval Art, General

Backman, Clifford R. The Worlds of Medieval Europe. New York: Oxford Univ. Press, 2003.

Bennett, Adelaide Louise, et al. Medieval Mastery: Book Illumination from Charlemagne to Charles the Bold: 800-1475. Trans. Lee Preedy and Greta Arblaster-Holmer. Turnhout: Brepols, 2002.

Benton, Janetta Rebold. Art of the Middle Ages. World of Art. New York: Thames & Hudson, 2002.

Binski, Paul. *Painters*. Medieval Craftsmen. London: British Museum Press, 1992.

- MA: Harvard Univ. Press, 2003.
- Belozerskaya, Marina, and Kenneth Lapatin. *Ancient Greece: Art, Architecture, and History*. Los Angeles: J. Paul Getty Museum, 2004.
- Boardman, John. Early Greek Vase Painting: 11th–6th Centuries B.C.: A Handbook. World of Art. London: Thames and Hudson, 1998.
- Greek Sculpture: The Archaic Period: A Handbook. World of Art. New York: Thames and Hudson, 1991.
- Greek Sculpture: The Classical Period: A Handbook. London: Thames and Hudson, 1985.
- ——. Greek Sculpture: The Late Classical Period and Sculpture in Colonies and Overseas. World of Art. New York: Thames and Hudson, 1995.
- The History of Greek Vases: Potters, Painters, and Pictures. New York: Thames & Hudson, 2001.
- Burn, Lucilla. Hellenistic Art: From Alexander the Great to Augustus. London: British Museum Press, 2004.
- Camp, John M. The Athenian Agora: Excavations in the Heart of Classical Athens.

 New York: Thames and Hudson, 1986.
- Carpenter, Thomas H. Art and Myth in Ancient Greece: A Handbook. World of Art. London: Thames and Hudson, 1991.
- Clark, Andrew J., Maya Elston, Mary Louise Hart. *Understanding Greek Vases:* A Guide to Terms, Styles, and Techniques. Los Angeles: J. Paul Getty Museum, 2002.
- De Grummond, Nancy T. and Brunilde S. Ridgway. From Pergamon to Sperlonga: Sculpture in Context. Berkeley: Univ. of California Press, 2000.
- Donohue, A. A. Greek Sculpture and the Problem of Description. New York: Cambridge Univ. Press, 2005.
- Fullerton, Mark D. *Greek Art*. Cambridge, U.K.: Cambridge Univ. Press, 2000.
- Hurwit, Jeffrey M. The Art and Culture of Early Greece 1100–480 B.C. Ithaca, NY: Cornell Univ. Press, 1985.
- ——, and Adam D. Newton. The Acropolis in the Age of Pericles. 1 v. & CD-ROM. New York: Cambridge Univ. Press, 2004.
- Karakasi, Katerina. Archaic Korai. Los Angeles: The J. Paul Getty Museum, 2003.
- Lagerlof, Margaretha Rossholm. The Sculptures of the Parthenon: Aesthetics and Interpretation. New Haven: Yale Univ. Press, 2000.
- Lawrence, A. W. Greek Architecture. 5th ed. Rev. R. A. Tomlinson. Pelican History of Art. New Haven: Yale Univ. Press, 1996.
- Martin, Roland. *Greek Architecture: Architecture of Crete, Greece, and the Greek World.* History of World Architecture.

- New York: Electa/Rizzoli, 1988. Osborne, Robin. Archaic and Classical Greek Art. Oxford History of Art. Oxford: Oxford Univ. Press, 1998.
- Palagia, Olga. ed. Greek Sculpture: Function, Materials, and Techniques in the Archaic and Classical Periods. New York: Cambridge Univ. Press, 2006.
- ——, and J.J. Pollitt., eds. *Personal*Styles in Greek Sculpture. Yale Classical
 Studies, v. 30. New York: Cambridge
 Univ. Press, 1996.
- Pedley, John Griffiths. *Greek Art and Archaeology*. 3rd ed. Upper Saddle River: Prentice-Hall, 2002.
- Pollitt, J. J. The Art of Ancient Greece: Sources and Documents. 2nd ed. Cambridge, U.K.: Cambridge Univ. Press, 1990
- Ridgway, Brunilde Sismondo. *The Archaic* Style in Greek Sculpture. 2nd ed. Chicago: Ares, 1993.
- Fifth Century Styles in Greek Sculpture. Princeton: Princeton Univ. Press, 1981.
- ——. Fourth Century Styles in Greek Sculpture. Wisconsin Studies in Classics. Madison: Univ. of Wisconsin Press, 1997.
- ——. Hellenistic Sculpture 1: The Styles of ca. 331–200 B.C. Wisconsin Studies in Classics. Madison: Univ. of Wisconsin Press, 1990.
- Stafford, Emma J. Life, Myth, and Art in Ancient Greece. Los Angeles: J. Paul Getty Museum, 2004.
- Stewart, Andrew F. *Greek Sculpture: An Exploration.* 2 vols. New Haven: Yale Univ. Press, 1990.
- Whitley, James. *The Archaeology of Ancient Greece*. New York: Cambridge Univ. Press, 2001.

CHAPTER 6 Etruscan and Roman Art

- Bianchi Bandinelli, Ranuccio. Rome: The Centre of Power: Roman Art to A.D. 200. Trans. Peter Green. Arts of Mankind. London: Thames and Hudson, 1970.
- —. Rome: The Late Empire: Roman Art A.D. 200–400. Trans. Peter Green. Arts of Mankind. New York: Braziller, 1971.
- Borrelli, Federica. *The Etruscans: Art, Architecture, and History.* Ed. Stefano
 Peccatori & Stefano Zuffi. Trans.
 Thomas Michael Hartmann. Los
 Angeles: J. Paul Getty Museum, 2004.
- Breeze, David John. *Hadrian's Wall*. 4th ed. London: Penguin, 2000.
- Brendel, Otto J. Etruscan Art. 2nd ed. Yale Univ. Press Pelican History Series. New Haven: Yale Univ. Press, 1995.
- Ciarallo, Annamaria, and Ernesto De Carolis, eds. *Pompeii: Life in a Roman Town*. Milan: Electa, 1999.
- Conlin, Diane Atnally. The Artists of the Ara Pacis: The Process of Hellenization in

- Roman Relief Sculpture. Studies in the History of Greece & Rome. Chapel Hill: Univ. of North Carolina Press, 1997.
- Cornell, Tim, and John Matthews. *Atlas of the Roman World*. New York: Facts on File, 1982.
- D'Ambra, Eve. *Roman Art*. Cambridge, U.K.: Cambridge Univ. Press, 1998.
- Elsner, Ja. Imperial Rome and Christian Triumph: The Art of the Roman Empire A.D. 100–450. Oxford History of Art. Oxford: Oxford Univ. Press, 1998.
- Gabucci, Ada. Ancient Rome: Art, Architecture, and History. Eds. Stefano Peccatori & Stephano Zuffi. Trans. T. M. Hartman. Los Angeles, CA: J. Paul Getty Museum, 2002
- —. ed. *The Colosseum*. Los Angeles, CA: J. Paul Getty Museum, 2002.
- Grant, Michael. Art in the Roman Empire. London: Routledge, 1995.
- Guillaud, Jacqueline, and Maurice Guillaud. Frescoes in the Time of Pompeii. New York: Potter, 1990.
- Haynes, Sybille. Etruscan Civilization: A Cultural History. Los Angeles: J. Paul Getty Museum, 2000.
- Holloway, R. Ross. *Constantine & Rome*. New Haven: Yale Univ. Press, 2004.
- L'Orange, Hans Peter. *The Roman Empire:* Art Forms and Civic Life. New York: Rizzoli, 1985.
- MacDonald, William L. The Architecture of the Roman Empire: An Introductory Study. Rev. ed. Yale Publications in the History of Art. New Haven: Yale Univ. Press, 1982.
- —. The Pantheon: Design, Meaning, and Progeny. Cambridge, MA: Harvard Univ. Press,
- —, and John A. Pinto. *Hadrian's Villa* and Its Legacy. New Haven: Yale Univ. Press, 1995.
- Mazzoleni, Donatella. *Domus: Wall Painting in the Roman House*. Los Angeles: J. Paul Getty Museum, 2004.
- Packer, James E., and Kevin Lee Sarring. The Forum of Trajan in Rome: A Study of the Monuments. California Studies in the History of Art, 31.2 vols., portfolio and microfiche. Berkeley: Univ. of California Press, 1997.
- Pollitt, J. J. The Art of Rome, c. 753 B.C.–337 A.D.: Sources and Documents. Upper Saddle River, NJ: Prentice Hall, 1966.
- Ramage, Nancy H., and Andrew Ramage. *Roman Art: Romulus to Constantine*. 4th ed. Upper Saddle River, NJ: Prentice Hall, 2004.
- Spivey, Nigel. *Etruscan Art*. World of Art. New York: Thames and Hudson, 1997.
- Stamper, John W. The Architecture of Roman Temples: The Republic to the Middle Empire. New York: Cambridge Univ. Press, 2005.
- Stewart, Peter. Roman Art. New York:

- Collon, Dominque. *Ancient Near Eastern Art.* Berkeley: Univ. of California Press, 1995.
- Crawford, Harriet. Sumer and the Sumerians. 2nd ed. New York: Cambridge Univ. Press, 2004.
- Curtis, J.E., and J. E. Reade, eds. Art and Empire: Treasures from Assyria in the British Museum. New York: Metropolitan Museum of Art, 1995.
- Curtis, John, and Nigel Tallis, eds. Forgotten Empire: The World of Ancient Persia. Berkeley: Univ. of California Press, 2005.
- Downey, Susan B. Mesopotamian Religious Architecture: Alexander through the Parthians. Princeton: Princeton Univ. Press, 1988.Ferrier, R. W., ed. Arts of Persia. New Haven: Yale Univ. Press, 1989.
- Frankfort, Henri. *The Art and Architecture* of the Ancient Orient. 5th ed. Pelican History of Art. New Haven: Yale Univ. Press, 1996.
- Haywood, John. Ancient Civilizations of the Near East and Mediterranean. London: Cassell, 1997.
- Lloyd, Seton. Ancient Turkey: A Traveller's History of Anatolia. Berkeley: Univ. of California Press, 1989.
- Meyers, Eric M., ed. The Oxford Encyclopedia of Archaeology in the Near East. 5 vols. New York: Oxford Univ. Press, 1997.
- Moorey, P. R. S. *Idols of the People: Miniature Images of Clay in the Ancient Near East.* The Schweich Lectures of the British Academy; 2001. New York: Oxford Univ. Press, 2003.
- Polk, Milbry, and Angela M. H. Schuster. The Looting of the Iraq Museum, Baghdad: The Lost Legacy of Ancient Mesopotamia. New York: Harry N. Abrams, 2005.
- Reade, Julian. Assyrian Sculpture. Cambridge, MA: Harvard Univ. Press, 1999.
- Roaf, Michael. Cultural Atlas of Mesopotamia and the Ancient Near East. New York: Facts on File, 1990.
- Roux, Georges. *Ancient Iraq*. 3rd ed. London: Penguin, 1992.
- Zettler, Richard L., and Lee Horne, ed. Treasures from the Royal Tombs of Ur. Philadelphia: Univ. of Pennsylvania, Museum of Archaeology and Anthropology, 1998.

CHAPTER 3 Art of Ancient Egypt

- Arnold, Dieter. *Temples of the Last Pharaohs*. New York: Oxford Univ. Press, 1999.
- Arnold, Dorothea. When the Pyramids Were Built: Egyptian Art of the Old Kingdom. New York: Metropolitan Museum of Art, 1999.
- Baines, John, and Jaromíír Máálek. Cultural Atlas of Ancient Egypt. Rev. ed.

- New York: Facts on File, 2000.
- Brier, Bob. Egyptian Mummies: Unraveling the Secrets of an Ancient Art. New York: Morrow, 1994.
- Casson, Lionel. Everyday Life in Ancient Egypt. Rev. & exp. ed. Baltimore, Md.: Johns Hopkins Univ. Press, 2001.
- Egyptian Art in the Age of the Pyramids. New York: Metropolitan Museum of Art. 1999.
- The Egyptian Book of the Dead: The Book of Going Forth by Day: Being the Papyrus of Ani (Royal Scribe of the Divine Offerings). Trans. Raymond O. Faulkner. 2nd rev. ed. San Francisco: Chronicle, 1998.
- Freed, Rita E. Sue D'Auria, and Yvonne J Markowitz. *Pharaohs of the Sun: Akhenaten, Nefertiti, Tutankhamen.*Boston: Museum of Fine Arts in assoc. with Bulfinch Press/Little, Brown and Co., 1999.
- Hawass, Zahi A. *Tutankhamun and the Golden Age of the Pharaohs*. Washington,
 D.C.: National Geographic, 2005.
- Johnson, Paul. The Civilization of Ancient Egypt. Updated ed. New York: Harper-Collins, 1999.
- Kozloff, Arielle P., and Betsy M. Bryan. Egypt's Dazzling Sun: Amenhotep III and His World. Cleveland: Cleveland Museum of Art, 1992.
- Lehner, Mark. *The Complete Pyramids:* Solving the Ancient Mysteries. New York: Thames and Hudson, 1997.
- Máálek, Jaromir. *Egypt: 4000 Years of Art.* London: Phaidon, 2003.
- Pemberton, Delia. *Ancient Egypt*. Architectural Guides for Travelers. San Francisco: Chronicle, 1992.
- Robins, Gay. *The Art of Ancient Egypt*. Cambridge, MA: Harvard Univ. Press, 1997.
- Roehrig, Catharine H., Renee Dreyfus, and Cathleen A. Keller. *Hatshepsut, from Queen to Pharaoh*. New York: The Metropolitan Museum of Art, 2005.
- Russmann, Edna R. Egyptian Sculpture: Cairo and Luxor. Austin: Univ. of Texas Press, 1989.
- Smith, Craig B. *How the Great Pyramid Was Built*. Washington, D.C.: Smithsonian Books, 2004.
- Smith, W. Stevenson. The Art and Architecture of Ancient Egypt. 3rd ed. Rev. William Kelly Simpson. Pelican History of Art. New Haven: Yale Univ. Press, 1999.
- Strudwick, Nigel, and Helen Studwick. Thebes in Egypt: A Guide to the Tombs and Temples of Ancient Luxor. Ithaca, NY: Cornell Univ. Press, 1999.
- Thomas, Thelma K. Late Antique Egyptian Funerary Sculpture: Images for this World and for the Next. Princeton: Princeton Univ. Press, 2000.
- Tiradritti, Francesco. Ancient Egypt: Art, Architecture and History. Trans. Phil Goddard. London: British Museum, 2002.

- The Treasures of Ancient Egypt: From the Egyptian Museum in Cairo. New York: Rizzoli, 2003.
- Wilkinson, Richard H. *The Complete Tem*ples of Ancient Egypt. New York: Thames & Hudson, 2000.
- ——. Reading Egyptian Art: A Hieroglyphic Guide to Ancient Egyptian Painting and Sculpture. London: Thames and Hudson, 1992.
- Ziegler, Cristiane, ed. *The Pharaohs*. New York: Rizzoli, 2002.
- Zivie-Coche, Christiane. Sphinx: History of a Monument. Trans. David Lorton. Ithaca, NY: Cornell Univ. Press, 2002.

CHAPTER 4 Aegean Art

- Barber, R. L. N. *The Cyclades in the Bronze Age.* Iowa City: Univ. of Iowa Press, 1987.
- Castleden, Rodney. The Knossos Labyrinth: A New View of the "Palace of Minos" at Knossos. London: Routledge, 1990.
- ——. *Mycenaeans*. New York: Routledge, 2005.
- Demargne, Pierre. *The Birth of Greek Art.* Trans. Stuart Gilbert & James Emmons. Arts of Mankind. New York: Golden, 1964.
- Dickinson. Oliver. *The Aegean Bronze Age*. Cambridge World Archaeology. Cambridge, U.K.: Cambridge Univ. Press, 1994
- Doumas, Christos. *The Wall-Paintings of Thera*. 2nd ed. Trans. Alex Doumas. Athens: Kapon Editions, 1999.
- Fitton, J. Lesley. *Cycladic Art*. 2nd ed. London: British Museum, 1999.
- Getz-Gentle, Pat. *Personal Styles in Early Cycladic Sculpture*. Madison: Univ. of Wisconsin Press, 2001.
- Hamilakis, Yannis. ed. Labyrinth Revisited: Rethinking 'Minoan' Archaeology. Oxford: Oxbow, 2002.
- Higgins, Reynold. *Minoan and Mycenean Art.* Rev. ed. World of Art. New York:
 Thames and Hudson, 1997.
- Hitchcock, Louise. *Minoan architecture: A Contextual Analysis*. Studies in Mediterranean Archaeology and Literature,
 Pocket-Book, 155. Jonsered: P.

 ÅÅströöms Föörlag, 2000.
- Immerwahr, Sara Anderson. Aegean Painting in the Bronze Age. University Park: Pennsylvania State Univ. Press, 1990.
- Preziosi, Donald, and Louise Hitchcock. Aegean Art and Architecture. Oxford History of Art. Oxford: Oxford Univ. Press, 1999.

CHAPTER 5 Art of Ancient Greece

- Barletta, Barbara A. *The Origins of the* Greek Architectural Orders. New York: Cambridge Univ. Press, 2001.
- Beard, Mary. The Parthenon. Cambridge,

- New York: Thames & Hudson, 2004. Gaiger, Jason, ed. Frameworks for Modern Art. Art of the 20th Century. New Haven: Yale Univ. Press in assoc. with the Open Univ., 2003.
- ——, and Paul Wood, eds. Art of the Twentieth Century: A Reader. New Haven: Yale Univ. Press, 2003
- Hamilton, George Heard. *Painting and Sculpture in Europe, 1880–1940.* 6th ed. Pelican History of Art. New Haven: Yale Univ. Press, 1993.
- Hammacher, A. M. Modern Sculpture: Tradition and Innovation. Enlg. ed. New York: Abrams, 1988.
- Harrison, Charles, and Paul Wood, eds. Art in Theory: 1900–2000: An Anthology of Changing Ideas. 2nd ed. Oxford: Blackwell, 2002.
- Hunter, Sam, John Jacobus, and Daniel Wheeler. Modern Art: Painting, Sculpture, Architecture, Photography. 3rd rev. & exp. ed. Upper Saddle River, NJ: Prentice Hall, 2004.
- Krauss, Rosalinde. *Passages in Modern* Sculpture. Cambridge, MA: MIT Press, 1977.
- Mancini, JoAnne Marie. Pre-Modernism: Art-World Change and American Culture from the Civil War to the Armory Show. Princeton: Princeton Univ. Press, 2005.
- Marien, Mary Warner. *Photography: A Cultural History*. New York: Harry N. Abrams, 2002.
- Meecham, Pam, and Julie Sheldon. *Modern Art: A Critical Introduction*. 2nd ed. New York: Routledge, 2005.
- Newlands, Anne. *Canadian Art: From Its Beginnings to 2000*. Willowdale, Ont.: Firefly Books, 2000.
- Harris, Ann Sutherland, and Linda Nochlin. *Women Artists: 1550–1950*. Los Angeles: Los Angeles County Museum of Art, 1976.
- The Phaidon Atlas of Contemporary World Architecture. London: Phaidon, 2004.
- Powell, Richard J. *Black Art: A Cultural History*. 2nd ed. World of Art. New York: Thames and Hudson, 2002.
- Rosenblum, Naomi. A World History of Photography. 3rd ed. New York: Abbeville, 1997.
- Ruhrberg, Karl. Art of the 20th Century. Ed. Ingo F. Walther. 2 vols. New York: Taschen, 1998
- Scully, Vincent Joseph. Modern Architecture and Other Essays. Princeton: Princeton Univ. Press, 2003
- Stiles, Kristine, and Peter Howard Selz. Theories and Documents of Contemporary Art: A Sourcebook of Artists' Writings. California Studies in the History of Art, 35. Berkeley: Univ. of California Press, 1996.
- Tafuri, Manfredo. *Modern Architecture*. History of World Architecture. 2 vols. New York: Electa/Rizzoli, 1986.

- Traba, Marta. Art of Latin America, 1900-1980. Washington, D.C.: Inter-American Development Bank, 1994.
- Upton, Dell. Architecture in the United States. Oxford History of Art. Oxford: Oxford Univ. Press, 1998.
- Wood, Paul, ed. Varieties of Modernism. Art of the 20th Century. New Haven: Yale Univ. Press in assoc. with the Open Univ., 2004.
- Woodham, Jonathan M. Twentieth Century Design. Oxford History of Art. Oxford: Oxford Univ. Press, 1997.

CHAPTER 1 Prehistoric Art in Europe

- Aujoulat, Norbert. Lascaux: Movement, Space, and Time. New York: H. N. Abrams, 2005.
- Bahn Paul G. *The Cambridge Illustrated History of Prehistoric Art*. Cambridge Illustrated History. Cambridge, U.K.: Cambridge Univ. Press, 1998.
- Bataille, Georges. The Cradle of Humanity: Prehistoric Art and Culture. Ed. and intro. Stuart Kendall. Trans. Michelle Kendall & Stuart Kendall. New York: Zone Books, 2005.
- Berghaus, Gunter. New Perspectives on Prehistoric Art. Westport, CT: Praeger, 2004
- Chippindale, Christopher. Stonehenge Complete. 3rd ed. New York: Thames and Hudson, 2004.
- Clottes, Jean. Chauvet Cave: The Art of Earliest Times. Salt Lake City: Univ. of Utah Press, 2003.
- ———. World Rock Art. Trans. Guy Bennett. Los Angeles: Getty Conservation Institute, 2002.
- ——, and J. David Lewis–Williams. The Shamans of Prehistory: Trance and Magic in the Painted Caves. Trans. Sophie Hawkes. New York: Harry N. Abrams, 1998.
- Cunliffe, Barry W, ed. *The Oxford Illustrated History of Prehistoric Europe*. New York: Oxford Univ. Press, 2001.
- Forte, Maurizio, and Alberto Siliotti. Virtual Archaeology: Re-Creating Ancient Worlds. New York: Abrams, 1997.
- Freeman, Leslie G. Altamira Revisited and Other Essays on Early Art. Chicago: Institute for Prehistoric Investigation, 1987
- Gowlett, John A. J. Ascent to Civilization: The Archaeology of Early Humans. 2nd ed. New York: McGraw-Hill, 1993.
- Guthrie, R. Dale. *The Nature of Paleolithic* Art. Chicago: Univ. of Chicago Press, 2005.
- Jope, E. M. Early Celtic art in the British Isles. 2 vols. New York: Oxford Univ. Press, 2000.
- Leakey, Richard E. and Roger Lewin.

 Origins Reconsidered: In Search of What

 Makes Us Human. New York: Double-day, 1992.
- Leroi-Gourhan, Andréé. The Dawn of

- European Art: An Introduction to Paleolithic Cave Painting. Trans. Sara Champion. Cambridge, U.K.: Cambridge Univ. Press, 1982.
- Lewis-Williams, J. David. *The Mind in the Cave: Consciousness and the Origins of Art.* New York: Thames & Hudson, 2002.
- Marshack, Alexander. The Roots of Civilization: The Cognitive Beginnings of Man's First Art, Symbol, and Notation. New York: McGraw-Hill. 1972.
- Megaw, Ruth, and Vincent Megaw. Celtic Art: From Its Beginnings to the Book of Kells. Rev. and exp. ed. New York: Thames and Hudson, 2001.
- O'Kelly, Michael J. Newgrange: Archaeology, Art, and Legend. New Aspects of Antiquity. London: Thames and Hudson, 1982.
- Price, T. Douglas, and Gray M. Feinman. *Images of the Past*. 3rd ed. Mountain View, CA: Mayfield, 2000.
- Renfrew, Colin, ed. *The Megalithic Monuments of Western Europe*. London: Thames and Hudson, 1983.
- Ruspoli, Mario. *The Cave of Lascaux: The Final Photographs*. New York: Abrams, 1987.
- Sandars, N. K. *Prehistoric Art in Europe*. 2nd ed. Pelican History of Art. New Haven: Yale Univ. Press, 1992.
- Sura Ramos, Pedro A. The Cave of Altamira. Gen. Ed. Antonio Beltran. New York: Abrams, 1999.
- Sieveking, Ann. *The Cave Artists*. Ancient People and Places, vol. 93. London: Thames and Hudson, 1979.
- White, Randall. *Prehistoric Art: The Symbolic Journey of Humankind*. New York: Harry N. Abrams, 2003.

CHAPTER 2 Art of the Ancient Near East

- Akurgal, Ekrem. Ancient Civilizations and Ruins of Turkey: From Prehistoric Times until the End of the Roman Empire. 5th ed. London: Kegan Paul, 2002.
- Aruz, Joan, ed. Art of the First Cities: The Third Millennium B.C. from the Mediterranean to the Indus. New York: Metropolitan Museum of Art, 2003.
- Bahrani, Zainab. The Graven Image: Representation in Babylonia and Assyria. Archaeology, Culture, and Society Series. Philadelphia: Univ. of Pennsylvania Press, 2003.
- Boardman, John. Persia and the West: An Archaeological Investigation of the Genesis of Achaemenid Art. New York: Thames & Hudson, 2000.
- Bottero, Jean. Everyday Life in Ancient Mesopotamia. Trans. Antonia Nevill. Baltimore, MD.: Johns Hopkins Univ. Press, 2001.
- Charvat, Petr. *Mesopotamia before History*. Rev. & updated ed. New York: Routledge, 2002.

- Brown, Sarah, and David O'Connor. *Glass-painters*. Medieval Craftsmen. London: British Museum Press, 1992.
- Calkins, Robert C. Medieval Architecture in Western Europe: From A.D. 300 to 1500. 1v. CD-ROM. New York: Oxford Univ. Press, 1998.
- Cherry, John F. *Goldsmiths*. Medieval Craftsmen. London: British Museum Press, 1992.
- Clark, William W., Medieval Cathedrals. Greenwood Guides to Historic Events of the Medieval World. Westport, CT: Greenwood Press, 2006.
- Coldstream, Nicola. Masons and Sculptors. Medieval Craftsmen. London: British Museum Press. 1991.
- ——. Medieval Architecture. Oxford History of Art. Oxford: Oxford Univ. Press, 2002.
- De Hamel, Christopher. Scribes and Illuminators. Medieval Craftsmen. London: British Museum Press, 1992.
- Duby, Georges. Art and Society in the Middle Ages. Trans. Jean Birrell. Malden, MA: Blackwell Publishers, 2000.
- ——-. Sculpture: The Great Art of the Middle Ages from the Fifth to the Fifteenth Century. New York: Skira/Rizzoli, 1990.
- Eames, Elizabeth S. English Tilers. Medieval Craftsmen. London: British Museum Press, 1992.
- Fossier, Robert, ed. *The Cambridge Illus-trated History of the Middle Ages.* Trans. Janet Sondheimer & Sarah Hanbury Tenison. 3 vols. Cambridge, U.K.: Cambridge Univ. Press, 1986–97.
- Hurlimann, Martin, and Jean Bony. French Cathedrals. Rev. & enlg. London: Thames and Hudson, 1967.
- Jotischky, Andrew, and Caroline Susan Hull. The Penguin Historical Atlas of the Medieval World. New York: Penguin, 2005.
- Kenyon, John. *Medieval Fortifications*. Leicester: Leicester Univ. Press, 1990.
- Labarge, Margaret Wade. A Small Sound of the Trumpet: Women in Medieval Life. London: Hamilton, 1990.
- Pfaffenbichler, Matthias. Armourers.

 Medieval Craftsmen. London: British
 Museum Press, 1992.
- Rebold Benton, Janetta. Art of the Middle Ages. World of Art. New York: Thames & Hudson, 2002.
- Sekules, Veronica. Medieval Art. Oxford History of Art. New York: Oxford Univ. Press, 2001.
- Snyder, James, Henry Luttikhuizen, and Dorothy Verkerk. Art of the Middle Ages. 2nd ed. Upper Saddle River, NJ: Prentice Hall, 2006.
- Staniland, Kay. Embroiderers. Medieval Craftsmen. London: British Museum Press, 1991.
- Stokstad, Marilyn. *Medieval Art.* 2nd ed. New York: Westview, 2004.

- ——. Medieval Castles. Greenwood Guides to Historic Events of the Medieval World. Westport, CT: Greenwood Press, 2005.
- Wixom, William D., ed. *Mirror of the Medieval World*. New York: Metropolitan Museum of Art, 1999.

European Renaissance through Eighteenth-Century Art, General

- Black, C. E, et al. *Cultural Atlas of the Renaissance*. New York: Prentice Hall General Reference, 1993.
- Blunt, Anthony. Art and Architecture in France, 1500–1700. 5th ed. Rev. Richard Beresford. Pelican History of Art. New Haven: Yale Univ. Press, 1999.
- Brown, Jonathan. *Painting in Spain:* 1500–1700. Pelican History of Art. New Haven: Yale Univ. Press, 1998.
- Cole, Bruce. Italian Art, 1250–1550: The Relation of Renaissance Art to Life and Society. New York: Harper & Row, 1987.
- Graham-Dixon, Andrew. *Renaissance*. Berkeley: Univ. of California Press, 1999.
- Harbison, Craig. The Mirror of the Artist: Northern Renaissance Art in Its Historical Context. Perspectives. New York: Abrams, 1995.
- Harris, Ann Sutherland. Seventeenth-Century Art & Architecture. Upper Saddle River, NJ: Pearson Prentice Hall, 2005
- Harrison, Charles, Paul Wood, and Jason Gaiger. Art in Theory 1648–1815: An Anthology of Changing Ideas. Oxford: Blackwell, 2000.
- Hartt, Frederick, and David G. Wilkins. History of Italian Renaissance Art: Painting, Sculpture, Architecture. 6th ed. Upper Saddle River, NJ: Prentice Hall, 2007.
- Jestaz, Bertrand. *The Art of the Renaissance*. Trans. I. Mark Paris. New York: Abrams, 1995.
- Levenson, Jay A., ed. Circa 1492: Art in the Age of Exploration. Washington: National Gallery of Art, 1991.
- McCorquodale, Charles. *The Renaissance:* European Painting, 1400–1600. London: Studio Editions, 1994.
- Minor, Vernon Hyde. Baroque & Rococo: Art & Culture. New York: Abrams, 1999.
- Murray, Peter. Renaissance Architecture. History of World Architecture. Milan: Electa, 1985.
- Paoletti, John T., and Gary M. Radke. Art in Renaissance Italy. 3rd ed. Upper Saddle River, NJ: Prentice Hall, 2006.
- Ripa, Cesare. Baroque and Rococo Pictorial Imagery: The 1758-60 Hertel Edition of Ripa's 'Iconologia.' Introd., transl., & commentaries Edward A. Maser. The Dover Pictorial Archives Series. New York: Dover Publications, 1991

- Smith, Jeffrey Chipps. *The Northern Renaissance*. Art & Ideas. New York: Phaidon Press, 2004.
- Stechow, Wolfgang. Northern Renaissance, 1400–1600: Sources and Documents. Upper Saddle River, NJ: Prentice Hall, 1966.
- Summerson, John. *Architecture in Britain,* 1530–1830. 9th ed. Yale Univ. Press Pelican History of Art. New Haven: Yale Univ. Press, 1993.
- Waterhouse, Ellis K. *Painting in Britain,* 1530 to 1790. 5th ed. Yale Univ. Press Pelican History of Art. New Haven: Yale Univ. Press, 1994.
- Whinney, Margaret Dickens. *Sculpture in Britain:* 1530–1830. 2nd ed. Rev. John Physick. Pelican History of Art. London: Penguin, 1988.

Modern Art in the West, General

- Arnason, H. Harvard. History of Modern Art: Painting, Sculpture, Architecture, Photography. 5th ed. Rev. Peter Kalb. Upper Saddle River, NJ: Prentice Hall, 2004.
- Ballantyne, Andrew, ed. Architectures: Modernism and After. New Interventions in Art History, 3. Malden, MA: Blackwell, 2004.
- Barnitz, Jacqueline. Twentieth- Century Art of Latin America. Austin: Univ. of Texas Press, 2001.
- Bjelajac, David. American Art: A Cultural History. Rev. & exp. ed. Upper Saddle River, NJ: Prentice Hall, 2005.
- Bowness, Alan. Modern European Art. World of Art. New York: Thames and Hudson, 1995.
- Brettell, Richard R. Modern Art, 1851–1929: Capitalism and Representation. Oxford History of Art. Oxford: Oxford Univ. Press, 1999.
- Chipp, Herschel Browning. Theories of Modern Art: A Source Book by Artists and Critics. California Studies in the History of Art. Berkeley: Univ. of California Press, 1984.
- Clarke, Graham. *The Photograph*. Oxford History of Art. Oxford: Oxford Univ. Press, 1997.
- Craven, David. Art and Revolution in Latin America, 1910-1990. New Haven: Yale Univ. Press, 2002.
- Craven, Wayne. American Art: History and Culture. Rev. ed. Boston: McGraw-Hill, 2003.
- Doordan, Dennis P. Twentieth-Century Architecture. New York: Abrams, 2002.
- Doss, Erika. Twentieth-Century American Art. Oxford: Oxford Univ. Press, 2002.
- Edwards, Steve, and Paul Wood, eds. Art of the Avant-Gardes. Art of the 20th Century. New Haven: Yale Univ. Press in assoc. with the Open Univ., 2004.
- Foster, Hal, et al. Art Since 1900: Modernism, Antimodernism, Postmodernism.

- Oxford Univ. Press, 2004.
- Statues in Roman Society: Representation and Response. Oxford Studies in Ancient Culture and Representation. New York: Oxford Univ., 2003.
- Strong, Donald. Roman Art. 2nd ed. rev. & annotated. Ed. Roger Ling. Pelican History of Art. New Haven: Yale Univ. Press, 1995.
- Ward-Perkins, J. B. Roman Architecture. History of World Architecture. New York: Electa/Rizzoli, 1988.
- ——. Roman Imperial Architecture. Pelican History of Art. New Haven: Yale Univ. Press, 1981.
- Wilson Jones, Mark. *Principles of Roman Architecture*. New Haven: Yale Univ. Press, 2000.

CHAPTER 7 Jewish, Early Christian, and Byzantine Art

- Age of Spirituality: Late Antique and Early Christian Art, Third to Seventh Century. New York: Metropolitan Museum of Art, 1979.
- Beckwith, John. The Art of Constantinople: An Introduction to Byzantine Art 330–1453. 2nd ed. London: Phaidon, 1968.
- ——. Early Christian and Byzantine Art. 2nd ed. Pelican History of Art. Harmondsworth, UK: Penguin, 1979.
- Carr, Annemarie Weyl. Byzantine Illumination, 1150–1250: The Study of a Provincial Tradition. Chicago: Univ. of Chicago Press, 1987.
- Cioffarelli, Ada. Guide to the Catacombs of Rome and Its Surroundings. Rome: Bonsignori, 2000.
- Cormack, Robin. *Byzantine Art*. Oxford History of Art. Oxford: Oxford Univ. Press, 2000.
- Cutler, Anthony. The Hand of the Master: Craftsmanship, Ivory, and Society in Byzantium (9th–11th Centuries). Princeton: Princeton Univ. Press, 1994.
- Demus, Otto. *The Mosaic Decoration of San Marco, Venice*. Ed. Herbert L. Kessler. Chicago: Univ. of Chicago Press, 1988.
- Durand, Jannic. *Byzantine Art*. Paris: Terrail, 1999.
- Eastmond, Antony, and Liz James, ed. Icon and Word: The Power of Images in Byzantium: Studies Presented to Robin Cormack. Burlington, VT: Ashgate, 2003.
- Evans, Helen C., ed. *Byzantium: Faith and Power (1261-1557)*. New York: Metropolitan Museum of Art, 2004.
- ——, and William D. Wixom, eds. The Glory of Byzantium: Art and Culture of the Middle Byzantine era, A.D. 843-1261. New York: Abrams, 1997.
- Fine, Steven. Art and Judaism in the Greco-Roman World: Toward a New Jewish Archae-

- ology. New York: Cambridge Univ. Press, 2005.
- Gerstel, Sharon E. J. Beholding the Sacred Mysteries: Programs of the Byzantine Sanctuary. Monograph on the Fine Arts, 56. Seattle: Published by College Art Association in assoc. with Univ. of Washington Press, 1999.
- Grabar, Andréé. *Byzantine Painting: Historical and Critical Study*. Trans. Stuart Gilbert. New York: Rizzoli, 1979.
- Jensen, Robin Margaret. Understanding Early Christian Art. New York: Routledge, 2000.
- Kitzinger, Ernst. Byzantine Art in the Making: Main Lines of Stylistic Development in Mediterranean Art, 3rd—7th Century. Cambridge, MA: Harvard Univ. Press, 1977.
- Krautheimer, Richard, and Slobodan Curcic. Early Christian and Byzantine Architecture. 4th ed. Pelican History of Art. New Haven: Yale Univ. Press, 1992.
- Levine, Lee I. and Zeev Weiss, eds. From Dura to Sepphoris: Studies in Jewish Art and Society in Late Antiquity. Journal of Roman Archaeology: Supplementary Series, no. 40. Portsmouth, R.I.: Journal of Roman Archaeology, 2000.
- Lowden, John. Early Christian and Byzantine Art. Art & Ideas. London: Phaidon, 1997.
- Maguire, Henry. The Icons of Their Bodies: Saints and their Images in Byzantium. Princeton: Princeton Univ. Press, 1996.
- Mainstone, R. J. Hagia Sophia: Architecture, Structure and Liturgy of Justinian's Great Church. London: Thames and Hudson, 1988.
- Mango, Cyril. Art of the Byzantine Empire, 312–1453: Sources and Documents.
 Upper Saddle River, NJ: Prentice Hall, 1972.
- Mathew, Gervase. *Byzantine Aesthetics*. London: J. Murray, 1963.
- Mathews, Thomas P. Byzantium: From Antiquity to the Renaissance. Perspectives. New York: Abrams, 1998.
- ——. The Clash of Gods: A Reinterpretation of Early Christian Art. Rev. & exp. ed. Princeton: Princeton Univ. Press, 1999.
- Milburn, R. L. P. Early Christian Art and Architecture. Berkeley: Univ. of California Press, 1988.
- Olin, Margaret. The Nation without Art: Examining Modern Discourses on Jewish Art. Lincoln: Univ. of Nebraska Press, 2001.
- Olsson, Birger and Magnus Zetterholm, eds. The Ancient Synagogue from Its Origins until 200 C.E.: Papers Presented at an International Conference at Lund University, October 14-17, 2001. Coniectanea Biblica: New Testament Series, 39. Stockholm: Almqvist &

Wiksell International, 2003.

- Ousterhout, Robert. Master Builders of Byzantium. Princeton: Princeton Univ. Press, 1999.
- Rodley, Lyn. *Byzantine Art and Architecture:* An Introduction. Cambridge, U.K.: Cambridge Univ. Press, 1994.
- Rutgers, Leonard Victor. Subterranean Rome: In Search of the Roots of Christianity in the Catacombs of the Eternal City. Leuven: Peeters, 2000.
- Tadgell, Christopher. *Imperial Space:* Rome, Constantinople and the Early Church. New York: Whitney Library of Design, 1998.
- Teteriatnikov, Natalia. Mosaics of Hagia Sophia, Istanbul: The Fossati Restoration and the Work of the Byzantine Institute. Washington, D.C.: Dumbarton Oaks Research Library and Collection, 1998.
- Tronzo, William. The Cultures of his Kingdom: Roger II and the Cappella Palatina in Palermo. Princeton: Princeton Univ. Press, 1997.
- Vio, Ettore. St. Mark's: The Art and Architecture of Church and State in Venice. New York: Riverside Book Co., 2003.
- Webb, Matilda. The Churches and Catacombs of Early Christian Rome: A Comprehensive Guide. Brighton, UK: Sussex Academic Press, 2001.
- Weitzmann, Kurt. Late Antique and Early Christian Book Illumination. New York: Braziller, 1977.
- ——. Place of Book Illumination in Byzantine Art. Princeton: Art Museum, Princeton Univ., 1975.
- Wharton, Annabel Jane. Refiguring the Post ClassicalCity: Dura Europe, Jerash, Jerusalem and Ravenna. New York: Cambridge Univ. Press, 1995.
- White, L. Michael. The Social Origins of Christian Architecture. 2 vols. Baltimore: Johns Hopkins Univ. Press, 1990.

CHAPTER 8

- Al-Faruqi, Ismail R, and Lois Lamya'al Faruqi. *Cultural Atlas of Islam*. New York: Macmillan, 1986.
- Atasoy, Nurhan. Splendors of the Ottoman Sultans. Ed. and Trans. Tulay Artan. Memphis, TN: Lithograph, 1992.
- Atil, Esin. *The Age of Sultan Suleyman the Magnificent*. Washington, D.C.: National Gallery of Art, 1987.
- Baer, Eva. *Islamic Ornament*. New York: New York Univ. Press, 1998.
- Baker, Patricia L. Islam and the Religious Arts. New York: Continuum, 2004.
- Barry, Michael. Figurative Art in Medieval Islam and the Riddle of Bihzââd of Herâât (1465-1535). Paris: Flammarion, 2004.
- Blair, Sheila S., and Jonathan Bloom. The Art and Architecture of Islam 1250–1800.

- Pelican History of Art. New Haven: Yale Univ. Press, 1994.
- Carboni, Stefano, and David Whitehouse. Glass of the Sultans. New York: Metropolitan Museum of Art, 2001.
- Denny, Walter B. *Iznik: The Artistry of Ottoman Ceramics*. New York: Thames & Hudson, 2004.
- Dodds, Jerrilynn D., ed. al-Andalus: The Art of Islamic Spain. New York: Metropolitan Museum of Art, 1992.
- Ecker, Heather. Caliphs and Kings: The Art and Influence of Islamic Spain. Washington, D.C.: Arthur M. Sackler Gallery, Smithsonian Institution, 2004.
- Ettinghausen, Richard, Oleg Grabar, and Marilyn Jenkins-Madina. *Islamic Art* and Architecture, 650–1250. 2nd ed. Yale Univ. Press Pelican History of Art. New Haven: Yale Univ. Press, 2001. Reissue ed. 2003.
- Frishman, Martin, and Hasan-Uddin Khan. The Mosque: History, Architectural Development and Regional Diversity. London: Thames and Hudson, 1994.
- Grabar, Oleg. The Formation of Islamic Art. Rev. ed. New Haven: Yale Univ. Press, 1987.
- —. The Great Mosque of Isfahan. New York: New York Univ. Press, 1990.
- Mostly Miniatures: An Introduction to Persian Painting. Princeton: Princeton Univ. Press, 2000.
- —, Mohammad al-Asad, Abeer Audeh, and Said Nuseibeh. The Shape of the Holy; Early Islamic Jerusalem. Princeton: Princeton Univ. Press, 1996.
- Hillenbrand, Robert. *Islamic Art and Architecture*. World of Art. London: Thames and Hudson, 1999.
- Irwin, Robert. *The Alhambra*. Cambridge, MA: Harvard Univ. Press, 2004.
- Khatibi, Abdelkebir, and Mohammed Sijelmassi. *The Splendour of Islamic Calligraphy*. Rev. & exp. ed. New York: Thames and Hudson, 1996.
- Komaroff, Linda, and Stefano Carboni, eds. *The Legacy of Genghis Khan: Courtly Art and Culture in Western Asia, 1256-1353.* New York: Metropolitan Museum of Art, 2002.
- Lentz, Thomas W., and Glenn D. Lowry. Timur and the Princely Vision: Persian Art and Culture in the Fifteenth Century. Los Angeles: Los Angeles County Museum of Art, 1989.
- Necipo lu, Güülru. The Age of Sinan: Architectural Culture in the Ottoman Empire. Princeton: Princeton Univ. Press, 2005.
- Petruccioli, Attilio, and Khalil K. Pirani, eds. *Understanding Islamic Architecture*. New York: Routledge Curzon, 2002.
- Roxburgh, David J., ed. *Turks: A Journey of a Thousand Years*, 600-1600. London: Royal Academy of Arts, 2005.
- Sims, Eleanor, Boris I. Marshak, and Ernest J. Grube. *Peerless Images: Persian*

- Painting and Its Sources. New Haven: Yale Univ. Press, 2002.
- Stanley, Tim, Mariam Rosser-Owen, and Stephen Vernoit. Palace and Mosque: Islamic Art from the Middle East. London: V & A Publications, 2004.
- Steele, James. An Architecture for People: The Complete Works of Hassan Fathy. New York: Whitney Library of Design, 1997.
- Stierlin, Henri. Islamic Art and Architecture: From Isfahan to the Taj Mahal. New York: Thames & Hudson, 2002.
- Suhrawardy, Shahid. *The Art of the Mussul-mans in Spain*. New York: Oxford Univ. Press, 2005.
- Tadgell, Christopher. Four Caliphates: The Formation and Development of the Islamic Tradition. London: Ellipsis, 1998.
- Ward, R. M. *Islamic Metalwork*. New York: Thames and Hudson, 1993.
- Watson, Oliver. Ceramics from Islamic Lands. New York: Thames & Hudson in assoc. with the al-Sabah Collection, Dar al-Athar al-Islamiyyah, Kuwait National Museum, 2004.

CHAPTER 9 Early Medieval Art in Europe

- Alexander, J. J. G. Medieval Illuminators and Their Methods of Work. New Haven: Yale Univ. Press, 1992.
- The Art of Medieval Spain, A.D. 500–1200. New York: Metropolitan Museum of Art, 1993.
- Backhouse, Janet, D. H. Turner, and Leslie Webster. *The Golden Age of Anglo-Saxon Art*, 966–1066.
 - Bloomington: Indiana Univ. Press, 1984.
- Bandman, Gunter. Early Medieval Architecture as Bearer of Meaning. New York: Columbia Univ. Press, 2005.
- Beckwith, John. Early Medieval Art: Carolingian, Ottonian, Romanesque. World of Art. New York: Oxford Univ. Press, 1974.
- Calkins, Robert G. Illuminated Books of the Medieval Ages. Ithaca, NY: Cornell Univ. Press, 1983.
- Carver, Martin. Sutton Hoo: A Seventh-Century Princely Burial Ground and Its Context. London: British Museum Press, 2005.
- Davis-Weyer, Caecilia. Early Medieval Art, 300–1150: Sources and Documents.
 Upper Saddle River, NJ: Prentice Hall, 1971.
- Diebold, William J. Word and Image: An Introduction to Early Medieval Art. Boulder, CO: Westview Press, 2000.
- Dodwell, C. R. Pictorial Arts of the West 800–1200. Yale Univ. Press Pelican History of Art. New Haven: Yale Univ. Press, 1993.
- Farr, Carol. The Book of Kells: Its Function

- and Audience. London: British Library, 1997.
- Fernie, E. C. *The Architecture of the Anglo-Saxons*. London: Batsford, 1983.
- Fitzhugh, William W., and Elisabeth I. Ward, eds. *Vikings: The North Atlantic Saga*. Washington, D.C.: Smithsonian Institution Press, 2000.
- Harbison. Peter. *The Golden Age of Irish Art: The Medieval Achievement, 600–1200.*London: Thames and Hudson, 1998.
- Henderson, George. From Durrow to Kells: The Insular Gospel-Books, 650–800. London: Thames and Hudson, 1987.
- Horn, Walter W., and Ernest Born. Plan of Saint Gall: A Study of the Architecture and Economy of and Life in a Paradigmatic Carolingian Monastery. California Studies in the History of Art, 19. 3 vols. Berkeley: Univ. of California Press, 1979.
- Lasko, Peter. Ars Sacra, 800–1200. 2nd ed. Pelican History of Art. New Haven: Yale Univ. Press, 1994.
- McClendon, Charles B. *The Origins of Medieval Architecture: Building in Europe, A.D 600-900.* New Haven: Yale Univ. Press, 2005.
- Mayr-Harting, Henry. Ottoman Book Illumination: An Historical Study. 2nd rev. ed. 2 vols. London: Harvey Miller, 1999.
- Mentréé, Mireille. *Illuminated Manuscripts of Medieval Spain*. New York: Thames and Hudson, 1996.
- Nees, Lawrence. Early Medieval Art. Oxford History of Art. Oxford: Oxford Univ. Press, 2002.
- Nordenfalk, Carl Adam Johan. Early Medieval Book Illumination. New York: Rizzoli, 1988.
- Richardson, Hilary, and John Scarry. An Introduction to Irish High Crosses. Dublin: Mercier, 1990.
- Stalley, R.A. Early Medieval Architecture. Oxford History of Art. Oxford: Oxford Univ. Press, 1999.
- Wickham, Chris. Framing the Early Middle Ages: Europe and the Mediterranean 400-800. New York: Oxford Univ. Press, 2005.
- Williams, John, ed. *Imaging the Early Medieval Bible*. The Penn State Series in the History of the Book. University Park: Pennsylvania State Univ. Press, 1999.
- Wilson, David M. Anglo-Saxon Art: From the Seventh Century to the Norman Conquest. London:Thames and Hudson, 1984.
- ——, and Ole Klindt-Jensen. Viking Art. 2nd ed. Minneapolis: Univ. of Minnesota Press, 1980.

CHAPTER 10 Romanesque Art

Armi, C. Edson. Design and Construction in Romanesque Architecture: First Romanesque Architecture and the Pointed

- Arch in Burgundy and Northern Italy. New York: Cambridge Univ. Press, 2004.
- Barral i Altet, Xavier. The Romanesque: Towns, Cathedrals and Monasteries. Taschen's World Architecture. New York: Taschen, 1998.
- Cahn, Walter. Romanesque Manuscripts: The Twelfth Century. A Survey of Manuscripts Illuminated in France. 2 vols. London: H. Miller, 1996.
- "Cloister Symposium, 1972" in *Gesta*, v.12 #1/2, 1973, pgs. v-132.
- Davis-Weyer, Caecilia. Early Medieval Art, 300–1150. Sources and Documents. Upper Saddle River, NJ: Prentice Hall, 1971.
- Dimier, Anselme. Stones Laid before the Lord: A History of Monastic Architecture. Trans. Gilchrist Lavigne. Cistercian Studies Series, no. 152. Kalamazoo, MI: Cistercian Publications, 1999.
- Evans, Joan. Cluniac Art of the Romanesque Period. Cambridge, U.K.: Cambridge Univ. Press, 1950.
- Fergusson, Peter. Architecture of Solitude: Cistercian Abbeys in Twelfth-Century England. Princeton: Princeton Univ. Press, 1984.
- Forsyth, Ilene H. The Throne of Wisdom: Wood Sculptures of the Madonna in Romanesque France. Princeton: Princeton Univ. Press, 1972.
- Gaud, Henri, and Jean-Franççois Leroux-Dhuys.
 - Cistercian Abbeys: History and Architecture. Kööln: Köönnemann, 1998
- Hawthorne, John G. and Cyril S. Smith, eds. On Divers Arts: The Treatise of Theophilus. New York: Dover Press, 1979.
- Hearn, M. F. Romanesque Sculpture: The Revival of Monumental Stone Sculptures in the Eleventh and Twelfth Centuries. Ithaca, NY: Cornell Univ. Press, 1981.
- Hicks, Carola. *The Bayeux Tapestry: The Life Story of a Masterpiece*. London: Chatto & Windus, 2006
- Kubach, Hans Erich. Romanesque Architecture. History of World Architecture. New York: Electa/Rizzoli, 1988.
- Mââle, Emile. Religious Art in France, the Twelfth Century: A Study of the Origins of Medieval Iconography. Bollingen Series. Princeton: Princeton Univ. Press, 1978.
- Minne-Sèève, Viviane, and Hervéé Kergall. Romanesque and Gothic France: Architecture and Sculpture. Trans. Jack Hawkes & Lory Frankel. New York: Harry N. Abrams, 2000.
- O'Neill, John Philip, ed. *Enamels of Limoges:* 1100-1350. Trans. Sophie Hawkes, Joachim Neugroschel, & Patricia Stirneman. New York: Metropolitan Museum of Art, 1996.
- Petzold, Andreas, *Romanesque Art.* Perspectives. New York: Abrams, 1995.
- Radding, Charles M., and William W. Clark. Medieval Architecture, Medieval

- Learning: Builders and Masters in the Age of Romanesque and Gothic. New Haven: Yale Univ. Press, 1992.
- Schapiro, Meyer. The Romanesque Sculpture of Moissac. New York: Braziller, 1985.
- Seidel, Linda. Legends in Limestone: Lazarus, Gislebertus, and the Cathedral of Autun. Chicago: Univ. of Chicago Press, 1999.
- Stones, Alison, Jeanne Krochalis, Paula Gerson, and Annie Shaver-Crandell. *The Pilgrim's Guide: A Critical Edition.* 2 vols. London: Harvey Miller, 1998.
- Swanson, R. N. *The Twelfth-Century Renaissance*. Manchester: Manchester Univ. Press, 1999.
- Toman, Rolf,ed. *Romanesque: Architecture, Sculpture, Painting.* Trans. Fiona Hulse & Ian Macmillan. Kööln: Köönemann, 1997
- *The Year 1200.* 2 vols. New York: Metropolitan Museum of Art, 1970
- Zarnecki, George, Janet Holt, and Tristam Holland, eds. *English Romanesque Art*, 1066–1200. London: Weidenfeld and Nicolson, 1984.

CHAPTER 11 Gothic Art of the Twelfth and Thirteenth Centuries

- Armi, C. Edson. The "Headmaster" of Chartres and the Origins of "Gothic" Sculpture. University Park: Pennsylvania State Univ. Press, 1994.
- Binding, Güünther. High Gothic: The Age of the Great Cathedrals. Taschen's World Architecture. London: Taschen, 1999.
- Binski, Paul. Becket's Crown: Art and Imagination in Gothic England, 1170-1350. New Haven: Yale Univ. Press, 2004.
- Bony, Jean. French Gothic Architecture of the 12th and 13th Centuries. California Studies in the History of Art. Berkeley: Univ. of California Press, 1983.
- Camille, Michael. *Gothic Art: Glorious Visions*. Perspectives. New York: Abrams, 1996.
- Cennini, Cennino. *The Craftsman's Hand-book (Il libro dell'arte)*. Trans. D.V. Thompson. New York: Dover, 1954.
- Crosby, Sumner McKnight. The Royal Abbey of Saint-Denis from Its Beginnings to the Death of Suger, 475–1151. Yale Publications in the History of Art. New Haven: Yale Univ. Press, 1987.
- Erlande-Brandenburg, Alain. *Gothic Art.* Trans. I. Mark Paris. New York: Abrams, 1989.
- —. Notre-Dame de Paris. New York: Abrams, 1998.
- Favier, Jean. The World of Chartres. Trans. Francisca Garvie. New York: Abrams, 1990.
- Frankl, Paul. *Gothic Architecture*. Rev. Paul Crossley. Yale Univ. Press Pelican History of Art. New Haven: Yale Univ. Press, 2000.

- Frisch, Teresa G. Gothic Art, 1140–c.1450: Sources and Documents. Upper Saddle River, NJ: Prentice Hall, 1971.
- Grodecki, Louis, and Catherine Brisac. Gothic Stained Glass, 1200–1300. Ithaca, NY: Cornell Univ. Press, 1985.
- Kren, Thomas, and Mark Evans, eds. A Masterpiece Reconstructed: The Hours of Louis XII. Los Angeles: The J. Paul Getty Museum, 2005.
- Moskowitz, Anita Fiderer. Nicola & Giovanni Pisano: The Pulpits: Pious Devotion, Pious Diversion. London:
 Harvey Miller Publishers, 2005.
- Murray, Stephen. Notre-Dame, Cathedral of Amiens: The Power of Change in Gothic. New York: Cambridge Univ. Press, 1996.
- Nussbaum, Norbert. German Gothic Church Architecture. Trans. Scott Kleager. New Haven: Yale Univ. Press, 2000
- Panofsky, Erwin. Abbot Suger on the Abbey Church of St.-Denis and Its Art Treasures. 2nd ed. Ed. Gerda Panofsky-Soergel. Princeton: Princeton Univ. Press, 1979.
- —. Gothic Architecture and Scholasticism. Latrobe, PA: Archabbey 1951.
- Parry, Stan. Great Gothic Cathedrals of France. New York: Viking Studio, 2001.
- Sauerlander, Willibald. *Gothic Sculpture in France*, 1140–1270. Trans. Janet Sandheimer. London: Thames and Hudson, 1972.
- Scott, Robert A. The Gothic Enterprise: A Guide to Understanding the Medieval Cathedral. Berkeley: Univ. of California Press, 2003.
- Simsom Otto Georg von. The Gothic Cathedral: Origins of Gothic Architecture and the Medieval Concept of Order. 3rd ed. Bollingen Series. Princeton: Princeton Univ. Press, 1988.
- Smart, Alastair. The Dawn of Italian Painting, 1250–1400. Ithaca, NY: Cornell Univ. Press, 1978.
- Suckale, Robert, and Matthias Weniger.

 Painting of the Gothic Era. Ed. Ingo F.
 Walther. New York: Taschen, 1999.
- Villard, de Honnecourt. The Sketchbook of Villard de Honnecourt. Ed. Theodore Bowie. Bloomington: Indiana Univ., 1960.
- Wieck, Roger S. Time Sanctified: The Book of Hours in Medieval Art and Life. New York: Braziller, 1988.
- Williamson, Paul. *Gothic Sculpture* 1140–1300. Pelican History of Art. New Haven: Yale Univ. Press, 1995.

CHAPTER 12 Fourteenth Century Art in Europe

Alexander, Jonathan, and Paul Binski, eds. Age of Chivalry: Art in Plantagenet England, 1200–1400. London: Royal Academy of Arts, 1987.

- Art from the Court of Burgundy: The Patronage of Philip the Bold and John the Fearless 1364-1419. Cleveland: The Cleveland Museum of Art, 2004.
- Backhouse, Janet. *Illumination from Books of Hours*. London: British Library, 2004.
- Boehm, Barbara Drake, and Jifiii Fajt, eds. Prague: The Crown of Bohemia, 1347-1437. New York: Metropolitan Museum of Art, 2005.
- Bony, Jean. The English Decorated Style: Gothic Architecture Transformed, 1250-1350. The Wrightsman Lecture, 10th. Oxford: Phaidon Press Limited, 1979.
- Borsook, Eve. *The Mural Painters of Tuscany: From Cimabue to Andrea del Sarto.* 2nd ed. rev. & enlg. Oxford Studies in the History of Art and Architecture. Oxford: Clarendon Press 1980.
- Branner, Robert. St. Louis and the Court Style in Gothic Architecture. Studies in Architecture, v. 7. London, A. Zwemmer, 1965.
- Bruzelius, Caroline Astrid. The 13th-Century Church at St-Denis. Yale Publications in the History of Art, 33. New Haven: Yale University Press, 1985.
- Fajt, Jifiíí, ed. Magister Theodoricus, Court Painter to Emperor Charles IV: The Pictorial Decoration of the Shrines at Karlstejn Castle. Prague: National Gallery, 1998.
- Ladis, Andrew. ed, The Arena Chapel and the Genius of Giotto: Padua. Giotto and the World of Early Italian Art, 2. New York: Garland Pub., 1998.
- Moskowitz, Anita Fiderer. *Italian Gothic Sculpture: c. 1250-c. 1400.* New York: Cambridge Univ. Press, 2001.
- Norman, Diana, ed. Siena, Florence, and Padua: Art, Society, and Religion 1280-1400. 2 vols. New Haven: Yale Univ. Press in assoc. with the Open Univ., 1995.
- Paolucci, Antonio. The Origins of Renaissance Art: The Baptistry Doors, Florence. Trans. Franççoise Pouncey Chiarini. New York: George Braziller, 1996.
- Poeschke, Joachim. *Italian Frescoes, the Age of Giotto, 1280-1400.* New York: Abbeville Press, 2005.
- Welch, Evelyn S. Art in Renaissance Italy, 1350-1500. New Ed. Oxford: Oxford Univ. Press, 2000.
- White, John. Art and Architecture in Italy, 1250 to 1400. 3rd ed. Pelican History of Art. Harmondsworth, UK: Penguin, 1993.
- Wieck, Roger S. Painted Prayers: The Book of Hours in Medieval and Renaissance Art. New York: George Braziller in assoc. with the Pierpont Morgan Library, 1997.

CHAPTER 13 Fifteenth-Century Art in Northern Europe and the Iberian Peninsula

Baxandall, Michael. The Limewood Sculptors of Renaissance Germany. New Haven Yale Univ. Press, 1980.

- Blum, Shirley. Early Netherlandish Triptychs: A Study in Patronage. California Studies in the History of Art. Berkeley: Univ. of California Press, 1969.
- Borchert, Till-Holger. Age of Van Eyck: The Mediterranean World and Early Netherlandish Painting, 1430-1530. New York: Thames & Hudson, 2002.
- Cavallo, Adolph S. The Unicorn Tapestries at the Metropolitan Museum of Art. New York: The Museum, 1998.
- Chastel, Andrèè. French Art: The Renaissance, 1430–1620. Paris: Flammarion, 1995
- Dhanens, Elisabeth. Van Eyck: The Ghent Altarpiece. New York: Viking Press, 1973.
- Flanders in the Fifteenth Century: Art and Civilization. Detroit: Detroit Institute of Arts, 1960.
- Füüssel, Stephan. Gutenberg and the Impact of Printing. Trans. Douglas Martin. Burlington, VT: Ashgate Pub., 2005.
- Kuskin, William, ed. Caxton's Trace: Studies in the History of English Printing. Notre Dame, IN: Univ. of Notre Dame Press, 2006.
- Lane, Barbara G. The Altar and the Altarpiece: Sacramental Themes in Early Netherlandish Painting. New York: Harper & Row, 1984.
- Marks, Richard, and Paul Williamson, eds. *Gothic: Art for England 1400-1547*. London: V & A, 2003.
- Meiss, Millard. French Painting in the Time of Jean de Berry: The Limbourgs and their Contemporaries. 2 vols. New York: G. Braziller, 1974
- Müüller, Theodor. Sculpture in the Netherlands, Germany, France, and Spain: 1400–1500. Trans. Elaine & William Robson Scott. Pelican History of Art. Harmondsworth, Eng.: Penguin, 1966.
- Päächt, Otto. Early Netherlandish Painting: From Rogier van der Weyden to Gerard David. Ed. Monika Rosenauer. Trans. David Britt. London: Harvey Miller, 1997
- Panofsky, Erwin. Early Netherlandish Painting. Its Origins and Character. 2 vols. Cambridge, MA: Harvard Univ. Press, 1966.
- Parshall, Peter W. and Rainer Schoch.

 Origins of European Printmaking: Fifteenth-Century Woodcuts and their Public.

 Washington, D.C.: National Gallery of Art, 2005.
- Plummer, John. The Last Flowering: French Painting in Manuscripts, 1420–1530, from American Collections. New York: Pierpont Morgan Library, 1982.
- Scott, Kathleen L. *Later Gothic Manuscripts*, 1390–1490. A Survey of Manuscripts Illuminated in the British Isles, 6. 2 vols. London: H. Miller, 1996.
- Snyder, James. Northern Renaissance Art: Painting, Sculpture, the Graphic Arts from 1350 to 1575. 2nd.ed Rev. Larry Sil-

- ver and Henry Luttikhuizen. Upper Saddle River, NJ: Prentice Hall, 2005.
- Vos, Dirk de. *The Flemish Primitives: The Masterpieces*. Princeton: Princeton Univ. Press, 2002.
- Zuffi, Stefano. European Art of the Fifteenth Century. Trans. Brian D. Phillips. Art through the Centuries. Los Angeles: J. Paul Getty Museum, 2005.

CHAPTER 14

Renaissance Art in Fifteenth-Century Italy

- Adams, Laurie Schneider. *Italian Renais*sance Art. Boulder, CO: Westview Press, 2001.
- Ahl, Diane Cole, ed. *The Cambridge Com*panion to Masaccio. New York: Cambridge Univ. Press, 2002.
- Alexander, J.J.G. The Painted Page: Italian Renaissance Book Illumination, 1450–1550. Munich: Prestel, 1994.
- Ames-Lewis, Francis. *Drawing in Early Renaissance Italy*. 2nd ed. New Haven: Yale Univ. Press, 2000.
- —. The Intellectual Life of the Early Renaissance Artist. New Haven: Yale Univ. Press, 2000.
- Baxandall, Michael. Painting and Experience in Fifteenth-Century Italy: A Primer in the Social History of Pictorial style.

 Oxford: Clarendon, 1972.
- Boskovits, Miklóós. *Italian Paintings of the Fifteenth Century*. The Collections of the National Gallery of Art. Washington, D.C.: National Gallery of Art, 2003.
- Botticelli and Filippino: Passion and Grace in Fifteenth-Century Florentine Painting. Milano: Skira, 2004.
- Brown, Patricia Fortini. Art and Life in Renaissance Venice. Perspectives. New York: Harry N. Abrams, 1997. Reissued. Upper Saddle River, NJ: Prentice Hall, 2006.
- Christianity and the Renaissance: Image and Religious Imagination in the Quattrocento. Syracuse, NY: Syracuse Univ. Press, 1990.
- Christiansen, Keith, Laurence B. Kanter, and Carl Brandon Strehlke. Painting in Renaissance Siena, 1420–1500. New York: Metropolitan Museum of Art, 1988.
- Christine, de Pisan. *The Book of the City of Ladies*. Trans. Rosalind Brown-Grant. London: Penguin Books, 1999.
- Gilbert, Creighton, ed. *Italian Art*, 1400–1500: Sources and Documents. Evanston: Northwestern Univ. Press, 1992.
- Heydenreich, Ludwig Heinrich. Architecture in Italy, 1400–1500. Rev. Paul Davies. Pelican History of Art. New Haven: Yale Univ. Press, 1996.
- Hind, Arthur M. An Introduction to a History of Woodcut. New York: Dover, 1963.
- Huizinga, Johan. *The Autumn of the Middle Ages*. Trans. Rodney J. Payton &

- Ulrich Mammitzsch. Chicago: Univ. of Chicago Press, 1996.
- Hyman, Timothy. Sienese Painting: The Art of a City-Republic (1278-1477). World of Art. New York: Thames & Hudson, 2003.
- King, Ross. Brunelleschi's Dome: How a Renaissance Genius Reinvented Architecture. New York: Walker & Co., 2000.
- Lavin, Marilyn Aronberg, ed. *Piero della Francesca and his Legacy*. Studies in the History of Art, 48: Symposium Papers, 28. Washington, D.C.: National Gallery of Art, 1995.
- Levey, Michael. Early Renaissance. Harmondsworth, UK: Penguin, 1967.
- Päächt, Otto. Venetian Painting in the 15th Century: Jacopo, Gentile and Giovanni Bellini and Andrea Mantegna. Ed. Margareta Vyoral-Tschapka & Michael Päächt. Trans. Fiona Elliott. London: Harvey Miller Pub., 2003.
- Partridge, Loren W. *The Art of Renaissance* Rome, 1400-1600. Perspectives. New York: Harry N. Abrams, 1996. Reissue Ed. Upper Saddle River, NJ: Prentice Hall, 2006.
- Poeschke, Joachim. Donatello and his World: Sculpture of the Italian Renaissance. Trans. Russell Stockman. New York: H. N. Abrams, 1993.
- Randolph, Adrian W. B., Engaging Symbols: Gender, Politics, and Public Art in Fifteenth-Century Florence. New Haven: Yale Univ. Press, 2002.
- Seymour, Charles. *Sculpture in Italy* 1400–1500. Pelican History of Art. Harmondsworth, UK: Penguin, 1966.
- Troncelliti, Latifah. The Two Parallel Realities of Alberti and Cennini: The Power of Writing and the Visual Arts in the Italian Quattrocento. Studies in Italian Literature, v. 14. Lewiston, N.Y: Edwin Mellen Press, 2004.
- Turner, Richard. Renaissance Florence: The Invention of a New Art. Perspectives. New York: Abrams, 1997. Reissue ed. Upper Saddle River, NJ: Prentice Hall, 2006.
- Walker, Paul Robert. The Feud that Sparked the Renaissance: How Brunelleschi and Ghiberti Changed the Art World. New York: William Morrow, 2002.
- Welch, Evelyn S. Art and Society in Italy, 1350–1500. Oxford History of Art. Oxford: Oxford Univ. Press, 1997.

CHAPTER 15 Sixteenth-Century Art in Italy

- Acidini Luchinat, Cristina, et al. The Medici, Michelangelo, & the Art of Late Renaissance Florence. New Haven: Yale Univ. Press, 2002.
- Andrews, Lew. Story and Space in Renaissance Art: The Rebirth of Continuous Narrative. New York: Cambridge Univ. Press, 1995.

- Bambach, Carmen. Drawing and Painting in The Italian Renaissance Workshop: Theory and Practice, 1330–1600. Cambridge, U.K.: Cambridge Univ. Press, 1999.
- Barriault, Anne B., ed. *Reading Vasari*. London: Philip Wilson in assoc. with the Georgia Museum of Art, 2005.
- Brown, Patricia Fortini. Art and Life in Renaissance Venice. Perspectives. New York: Abrams, 1997.
- Burroughs, Charles. *The Italian Renaissance Palace Facade: Structures of Authority, Surfaces of Sense.* Cambridge, U.K.: Cambridge Univ. Press, 2002.
- Cellini, Benvenuto. My Life. Trans. & notes Julia Conaway Bondanella & Peter Bondanella. Oxford World's Classics. New York: Oxford Univ. Press, 2002.
- Chastel, Andréé. *The Age of Humanism:* Europe, 1480–1530. Trans. Katherine M. Delavenay & E. M. Gwyer. London: Thames and Hudson, 1963.
- Chelazzi Dini, Giulietta, Alessandro Angelini, and Bernardina Sani. Sienese Painting: From Duccio to the Birth of the Baroque. New York: Abrams, 1998.
- Cole, Alison. Virtue and Magnificence: Art of the Italian Renaissance Courts. Perspectives. New York: Abrams, 1995. Reissue ed. Art of the Italian Courts. Prespectives. Upper Saddle River, NJ: Prentice Hall, 2006.
- Dixon, Annette, ed. Women Who Ruled: Queens, Goddesses, Amazons in Renaissance and Baroque Art. Ann Arbor: Univ. of Michigan Museum of Art, 2002.
- Franklin, David, ed. Leonardo da Vinci, Michelangelo, and the Renaissance in Florence. Ottawa: National Gallery of Canada in assoc. with Yale Univ. Press, 2005.
- Freedberg, S. J. Painting in Italy, 1500 to 1600. 3rd ed. Pelican History of Art. New Haven: Yale Univ. Press, 1993.
- Goffen, Rona. Renaissance Rivals: Michelangelo, Leonardo, Raphael, Titian. New Haven: Yale Univ. Press, 2002.
- Gröössinger, Christa. Picturing Women in Late Medieval and Renaissance Art. New York: St. Martin's Press, 1997.
- Hall, Marcia B. After Raphael: Painting in Central Italy in the Sixteenth Century. New York: Cambridge Univ. Press, 1999
- ——., ed. The Cambridge Companion to Raphael. New York: Cambridge Univ. Press, 2005.
- Hollingsworth, Mary. Patronage in Sixteenth Century Italy. London: Murray, 1996.
- Hopkins, Andrew. *Italian Architecture: From Michelangelo to Borromini*. World of Art. New York: Thames & Hudson, 2002.
- Hughes, Anthony. *Michelangelo*. London: Phaidon, 1997.

- Huse, Norbert, and Wolfgang Wolters. Art of Renaissance Venice: Architecture, Sculpture and Painting, 1460–1590. Trans. Edmund Jephcott. Chicago: Univ. of Chicago Press, 1990.
- Jacobs, Fredrika Herman. Defining the Renaissance Virtuosa: Women Artists and the Language of Art History and Criticism. Cambridge, U.K.: Cambridge Univ. Press, 1997.
- Joannides, Paul. *Titian to 1518:The*Assumption of Genius. New Haven:Yale
 Univ. Press, 2001.
- King, Ross. Michelangelo & the Pope's Ceiling. New York: Walker & Company, 2003.
- Klein, Robert, and Henri Zerner. *Italian Art*, 1500–1600: Sources and Documents.
 Upper Saddle River, NJ: Prentice
 Hall, 1966.
- Kliemann, Julian-Matthias, and Michael Rohlmann, *Italian Frescoes: High Renaissance and Mannerism*, 1510-1600. Trans. Steven Lindberg. New York: Abbeville Press, 2004.
- Landau, David, and Peter Parshall. *The Renaissance Print:* 1470–1550. New Haven: Yale Univ. Press, 1994.
- Lieberman, Ralph. *Renaissance Architecture* in Venice, 1450–1540. New York: Abbeville, 1982.
- Lotz, Wolfgang. Architecture in Italy, 1500–1600. Rev. Deborah Howard. Pelican History of Art. New Haven: Yale Univ. Press, 1995.
- Manca, Joseph. Moral Essays on the High Renaissance: Art in Italy in the Age of Michelangelo. Lanham, MD: Univ. Press of America, 2001.
- Mann, Nicholas, and Luke Syson, eds. The Image of the Individual: Portraits in the Renaissance. London: British Museum Press, 1998.
- Meilman, Patricia, ed. *The Cambridge Companion to Titian*. New York: Cambridge Univ. Press, 2004
- Mitrovic, Branko. *Learning from Palladio*. New York: W.W. Norton, 2004.
- Murray Linda. The High Renaissance and Mannerism: Italy, the North and Spain, 1500–1600. World of Art. London: Thames and Hudson, 1995.
- Olson, Roberta J. M. Italian Renaissance Sculpture. World of Art. New York: Thames and Hudson, 1992.
- Partridge, Loren W. The Art of Renaissance Rome, 1400–1600. New York: Abrams, 1996.
- Pietrangeli, Carlo, et al. The Sistine Chapel: The Art, the History, and the Restoration. New York: Harmony, 1986.
- Pilliod, Elizabeth. Pontormo, Bronzino, Allori: A Genealogy of Florentine Art. New Haven: Yale Univ. Press, 2001.
- Poeschke, Joachim. Michelangelo and his World: Sculpture of the Italian Renaissance. Trans. Russell Stockman. New York: Harry N. Abrams, 1996.

- Pope-Hennessy, Sir John. *Italian High Renaissance and Baroque Sculpture*. 3rd ed. Oxford: Phaidon, 1986.
- . Italian Renaissance Sculpture. 3rd ed. Oxford: Phaidon, 1986.
- Rosand, David. *Painting in Cinquecento Venice: Titian, Veronese, Tintoretto*. Rev. ed. Cambridge, U.K.: Cambridge Univ. Press, 1997.
- Rowe, Colin, and Leon Satkowski. *Italian Architecture of the 16th Century*. New York: Princeton Architectural Press, 2002
- Rowland, Ingrid D. The Culture of the High Renaissance: Ancients and Moderns in Sixteenth Century Rome. Cambridge, U.K.: Cambridge Univ. Press, 1998.
- Shearman, John. *Mannerism*. Harmondsworth, UK:
 Penguin, 1967. Reissue ed. New York:
 Penguin Books, 1990.
- Vasari, Giorgio. The Lives of the Artists. Trans. Julia Conaway Bondanella & Peter Bondanella. New York: Oxford Univ. Press, 1991.
- Verheyen, Egon. The Paintings in the Studiolo of Isabella d'Este at Mantua. Monographs on Archaeology and Fine Arts. New York: New York Univ. Press, 1971.
- Williams, Robert. Art, Theory, and Culture in Sixteenth-Century Italy: From Techne to Metateche. Cambridge, U.K.: Cambridge Univ. Press, 1997.

CHAPTER 16 Sixteenth-Century Art in Northern Europe and the Iberian Peninsula

- Bartrum, Giulia. Albrecht Düürer and his Legacy: The Graphic Work of a Renaissance Artist. London: British Museum Press, 2002.
- Bartrum, Giulia. German Renaissance Prints 1490-1550. London: British Museum Press, 1995.
- Buck, Stephanie, and Jochen Sander.

 Hans Holbein the Younger: Painter at the
 Court of Henry VIII. Trans. Rachel
 Esner & Beverley Jackson. New York:
 Thames & Hudson, 2004.
- Chapuis, Julien. Tilman Riemenschneider: Master Sculptor of the Late Middle Ages. Washington, D.C.: National Gallery of Art, 1999.
- Cloulas, Ivan, and Michèèle Bimbenet-Privat. *Treasures of the French Renaissance*. Trans. John Goodman. New York: Harry N. Abrams, 1998.
- Davies, David, and John H. Elliott. *El Greco*. London: National Gallery, 2003.
- Dixon, Laurinda. *Bosch*. Art & Ideas. New York: Phaidon, 2003.
- Foister, Susan. Holbein and England. New Haven: Published for Paul Mellon Centre for Studies in British Art by Yale Univ. Press, 2004.

- Hayum, Andréé. *The Isenheim Altarpiece:*God's Medicine and the Painter's Vision.
 Princeton Essays on the Arts. Princeton: Princeton Univ. Press, 1989.
- Hearn, Karen, ed. Dynasties: Painting in Tudor and Jacobean England, 1530-1630. New York: Rizzoli, 1996.
- Koerner, Joseph Leo. *The Reformation of the Image*. Chicago: Univ. of Chicago Press, 2004.
- Kubler, George. Building the Escorial. Princeton: Princeton Univ. Press, 1982
- Osten, Gert von der, and Horst Vey. Painting and Sculpture in Germany and the Netherlands, 1500–1600. Pelican History of Art. Harmondsworth, UK: Penguin, 1969.
- Price, David Hotchkiss. Albrecht Düürer's Renaissance: Humanism, Reformation, and the Art of Faith. Studies in Medieval and Early Modern Civilization. Ann Arbor: Univ. of Michigan Press, 2003.
- Roberts-Jones, Philippe, and Francoise Roberts-Jones. *Pieter Bruegel*. New York: Harry N. Abrams, 2002.
- Smith, Jeffrey Chipps. Nuremberg, a Renaissance City, 1500–1618. Austin: Huntington Art Gallery, Univ. of Texas, 1983.
- Strong, Roy C. Artists of the Tudor Court: The Portrait Miniature Rediscovered, 1520–1620. London:Victoria and Albert Museum, 1983.
- The Word Made Image: Religion, Art, and Architecture in Spain and Spanish America, 1500-1600. Fenway Court, 28.
 Boston: Published by the Trustees of the Isabella Stewart Gardner Museum, 1998
- Wheeler, Daniel. *The Chateaux of France*. New York: Vendome Press, 1979.
- Zerner, Henri. Renaissance Art in France: The Invention of Classicism. Paris: Flammarion, 2003.
- Zorach, Rebecca. Blood, Milk, Ink, Gold: Abundance and Excess in the French Renaissance. Chicago: Univ. of Chicago Press, 2005.

CHAPTER 17 Baroque Art

- Adams, Laurie Schneider. Key Monuments of the Baroque. Boulder, CO: Westview Press, 2000.
- The Age of Caravaggio. New York: Metropolitan Museum of Art, 1985.
- Allen, Christopher. French Painting in the Golden Age. World of Art. New York: Thames & Hudson, 2003.
- Alpers, Svetlana. The Making of Rubens. New Haven: Yale Univ. Press, 1995.
- Barberini, Maria Giulia, et al. Life and the Arts in the Baroque Palaces of Rome: Ambiente Barocco. Eds. Stefanie Walker

- and Frederick Hammond. New Haven: Published for the Bard Graduate Center for Studies in the Decorative Arts, New York by Yale Univ. Press, 1999.
- Blankert, Albert. Rembrandt: A Genius and his Impact. Melbourne: National Gallery of Victoria, 1997.
- Boucher, Bruce. *Italian Baroque Sculpture*. World of Art. New York: Thames and Hudson, 1998.
- Brown, Beverly Louise, ed. *The Genius of Rome, 1592-1623*. London: Royal Academy of Arts, 2001.
- Careri, Giovanni. *Baroques*. Tran. Alexandra Bonfante-Warren. Princeton: Princeton Univ. Press, 2003.
- Chong, Alan, and Wouter Kloek. Still-Life Paintings from the Netherlands, 1550-1720. Zwolle: Waanders Publishers, 1999
- Franits, Wayne E. Dutch Seventeenth-Century Genre Painting: Its Stylistic and Thematic Evolution. New Haven: Yale Univ. Press, 2004.
- Harbison, Robert. Reflections on Baroque. Chicago: Univ. of Chicago Press, 2000.
- Kiers, Judikje, and Fieke Tissink. Golden Age of Dutch Art: Painting, Sculpture, Decorative Art. London: Thames and Hudson, 2000.
- Lagerlof, Margaretha Rossholm. *Ideal Landscape: Annibale Caracci, Nicolas Poussin, and Claude Lorrain.* New Haven: Yale Univ. Press, 1990.
- McPhee, Sarah. Bernini and the Bell Towers: Architecture and Politics at the Vatican. New Haven: Yale Univ. Press, 2002.
- Millon, Henry A., ed. *The Triumph of the Baroque: Architecture in Europe, 1600-1750.* New York: Rizzoli, 1999.
- Morrissey, Jake. The Genius in the Design: Bernini, Borromini, and the Rivalry that Transformed Rome. New York: William Morrow, 2005.
- Slive, Seymour. *Dutch Painting* 1600–1800. *Pelican History of Art.* New Haven: Yale Univ. Press, 1995.
- Stratton, Suzanne L., ed. *The Cambridge Companion to Veláázquez*. New York: Cambridge Univ. Press, 2002.
- Summerson, John. *Inigo Jones*. New Haven: Published for the Paul Mellon Centre for Studies in British Art by Yale Univ. Press, 2000.
- Vlieghe, Hans. Flemish Art and Architecture, 1585–1700. Pelican History of Art. New Haven: Yale Univ. Press, 1998. Reissue ed. 2004.
- Wheelock Jr., Arthur K. Flemish Paintings of the Seventeenth Century. Washington, D.C.: National Gallery of Art, 2005.
- Wittkower, Rudolf. Art and Architecture in Italy, 1600 to 1750. 3 vols. 4th ed. Rev. Joseph Connors & Jennifer Montague.

- Pelican History of Art. New Haven: Yale Univ. Press, 1999.
- Zega, Andrew, and Bernd H. Dams.

 Palaces of the Sun King: Versailles, Trianon,

 Marly: The Chââteaux of Louis XIV.

 New York: Rizzoli, 2002.

CHAPTER 18 Eighteenth-Century Art in Europe and the Americas

- Bailey, Colin B., Philip Conisbee, and Thomas W. Gaehtgens. The Age of Watteau, Chardin, and Fragonard: Masterpieces of French Genre Painting. New Haven: Yale Univ. Press in assoc. with the National Gallery of Canada, Ottawa, 2003
- Boime, Albert. Art in an Age of Revolution, 1750–1800. Chicago: Univ. of Chicago Press, 1987.
- Bowron, Edgar Peters, and Joseph J. Rishel, eds. Art in Rome in the Eighteenth Century. London: Merrell, 2000.
- Craske, Matthew. Art in Europe, 1700–1830: A History of the Visual Arts in an Era of Unprecedented Urban Economic Growth. Oxford History of Art. Oxford: Oxford Univ. Press, 1997.
- Goodman, Elise, ed. Art and Culture in the Eighteenth Century: New Dimensions and Multiple Perspectives. Studies in Eighteenth-Century Art and Culture. Newark: Univ. of Delaware Press, 2001 Irwin, David G. Neoclassicism. Art & Ideas. London: Phaidon, 1997.
- Jarrasséé, Dominique. 18th-Century French Painting. Trans. Murray Wyllie. Paris: Terrail, 1999.
- Kalnein, Wend von. Architecture in France in the Eighteenth Century. Trans. David Britt. Pelican History of Art. New Haven: Yale Univ. Press, 1995.
- Levey, Michael. Painting in Eighteenth-Century Venice. 3rd ed. New Haven: Yale Univ. Press, 1994.
- Lewis, Michael J. *The Gothic Revival*. World of Art. New York: Thames & Hudson, 2002.
- Lovell, Margaretta M. Art in a Season of Revolution: Painters, Artisans, and Patrons in Early America. Early American Studies. Philadelphia: Univ. of Pennsylvania Press, 2005.
- Monneret, Sophie. *David and Neo-Classi-cism*. Trans. Chris Miller & Peter Snowdon. Paris: Terrail, 1999.
- Montgomery, Charles F., and Patrick E. Kane, eds.

 American Art, 1750–1800: Towards Independence. Boston: New York Graphic Society, 1976.
- Poulet, Anne L. Jean-Antoine Houdon: Sculptor of the Enlightenment. Washington, D.C.: National Gallery of Art, 2003.

- Summerson, John. Architecture of the Eighteenth Century. World of Art. New York: Thames and Hudson, 1986.
- Wilton, Andrew, and Ilaria Bignamini, eds. *Grand Tour: The Lure of Italy in the Eighteenth Century*. London: Tate Gallery, 1996.
- Young, Hilary, ed. The Genius of Wedgwood. London: Victoria & Albert Museum, 1995.

CHAPTER 19 Nineteenth-Century Art in Europe and the United States

- Adams, Steven. The Barbizon School and the Origins of Impressionism. London: Phaidon, 1994.
- Bajac, Quentin. The Invention of Photography. Discoveries. New York: Harry N. Abrams, 2002.
- Barger, M. Susan, and William B. White. The Daguerreotype: Nineteenth-Century Technology and Modern Science. Washington, D.C.: Smithsonian Institution, 1991
- Benjamin, Roger. Orientalist Aesthetics: Art, Colonialism, and French North Africa, 1880-1930. Berkeley: Univ. of California Press, 2003.
- Bergdoll, Barry. European Architecture, 1750-1890. Oxford History of Art. New York: Oxford Univ. Press, 2000.
- Blakesley, Rosalind P. Russian Genre Painting in the Nineteenth Century. Oxford Historical Monographs. New York: Oxford Univ. Press, 2000.
- Blüühm, Andreas, and Louise Lippincott. Light!: The Industrial Age 1750-1900: Art & Science, Technology & Society. New York: Thames & Hudson, 2001.
- Boime, Albert. Art in an Age of Bonapartism, 1800–1815. Chicago: Univ. of Chicago Press, 1990.
- Boime, Albert. Art in an Age of Counterrevolution, 1815–1848. Chicago: Univ. of Chicago Press, 2004.
- Butler, Ruth, and Suzanne G. Lindsay.

 European Sculpture of the Nineteenth Century. The Collections of the National Gallery of Art Systematic Catalogue.

 Washington, D.C.: National Gallery of Art, 2000.
- Callen, Anthea. The Art of Impressionism:
 Painting Technique & the Making of
 Modernity. New Haven: Yale Univ.
 Press, 2000.
- Chu, Petra ten-Doesschate. Nineteenth Century European Art. New York: Abrams, 2003.
- Denis, Rafael Cardoso, and Colin Trodd. Art and the Academy in the Nineteenth Century. New Brunswick, NJ: Rutgers Univ. Press, 2000.
- Eisenman, Stephen. Nineteenth Century

- Art: A Critical History. 2nd ed. New York: Thames and Hudson, 2002.
- Eitner, Lorenz. Nineteenth Century European Painting: David to Cezanne. Rev. ed. Boulder: Westview Press, 2002.
- Frazier, Nancy. Louis Sullivan and the Chicago School. New York: Knickerbocker Press, 1998.
- Fried, Michael. Manet's Modernism, or, The Face of Painting in the 1860s. Chicago: Univ. of Chicago Press, 1996.
- Gerdts, William H. American Impressionism. 2nd ed. New York: Abbeville, 2001.
- Greenhalgh, Paul, ed. Art nouveau, 1890-1914. London: V&A Publications, 2000.
- Grigsby, Darcy Grimaldo. Extremities: Painting Empire in Post-Revolutionary France. New Haven: Yale Univ. Press, 2002.
- Groseclose, Barbara. *Nineteenth-Century American Art.* Oxford History of Art. Oxford: Oxford Univ. Press, 2000.
- Harrison, Charles, Paul Wood, and Jason Gaiger. Art in Theory 1815–1900: An Anthology of Changing Ideas. Oxford: Blackwell, 1998.
- Herrmann, Luke. *Nineteenth Century British Painting*. London: Giles de la Mare, 2000.
- Hirsh, Sharon L. Symbolism and Modern Urban Society. New York: Cambridge Univ. Press, 2004.
- Holt, Elizabeth Gilmore, ed. *The Expanding World of Art*, 1874–1902. New Haven: Yale Univ. Press, 1988.
- Kaplan, Wendy. The Arts & Crafts Movement in Europe & America: Design for the Modern World. New York: Thames & Hudson in assoc. with the Los Angeles County Museum of Art, 2004.
- Kapos, Martha, ed. *The Post-Impressionists:* A Retrospective. New York: Hugh Lauter Levin Associates, 1993.
- Kendall, Richard. Degas: Beyond Impressionism. London: National Gallery Publications, 1996.
- Lambourne, Lionel. *Japonisme: Cultural Crossings between Japan and the West.* New York: Phaidon, 2005.
- Lemoine, Bertrand. Architecture in France, 1800–1900. Trans. Alexandra Bonfante-Warren. New York: Harry N. Abrams, 1998.
- Lochnan, Katharine Jordan. *Turner*Whistler Monet.
 London: Tate Publishing in assoc. with the Art Gallery of Ontario, 2004.
- Noon, Patrick J. Crossing the Channel: British and French Painting in the age of Romanticism. London: Tate Pub., 2003.
- Pissarro, Joachim. Pioneering Modern Painting: Céézanne & Pissarro 1865-1885. New York: Museum of Modern Art, 2005.

- Rodner, William S. J.M. W. Turner: Romantic Painter of the Industrial Revolution. Berkeley: Univ. of California Press, 1997.
- Rosenblum, Robert, and H. W. Janson. 19th Century Art. Rev. & updated ed. Upper Saddle River, NJ: Pearson Prentice Hall, 2005.
- Rubin, James H. *Impressionism*. Art & Ideas. London: Phaidon, 1999.
- Rybczynski, Witold. A Clearing in the Distance: Frederick Law Olmsted and America in the Nineteenth Century. New York: Scribner, 1999.
- Smith, Paul. Seurat and the Avant-Garde. New Haven: Yale Univ. Press, 1997.
- Thomson, Belinda. *Impressionism: Origins, Practice, Reception.* Thames & Hudson World of Art. New York: Thames & Hudson, 2000.
- Twyman, Michael. Breaking the Mould: The First Hundred Years of Lithography. The Panizzi Lectures, 2000. London: British Library, 2001.
- Vaughan, William, and Francoise Cachin. Arts of the 19th Century. 2 vols. New York: Abrams, 1998.
- Werner, Marcia. Pre-Raphaelite Painting and Nineteenth-Century Realism. New York: Cambridge Univ. Press, 2005.
- Zemel, Carol M. Van Gogh's Progress: Utopia, Modernity, and Late-Nineteenth-Century Art. California Studies in the History of Art, 36. Berkeley: Univ. of California Press, 1997.

CHAPTER 20 Modern Art In Europe And The Americas

- Ades, Dawn, comp. Art and Power: Europe under the Dictators, 1930-45. Stuttgart, Germany: Oktagon in assoc. with Hayward Gallery, 1995.
- Antliff, Mark, and Patricia Leighten. Cubism and Culture. World of Art. London: Thames & Hudson, 2001.
- Bailey, David A. Rhapsodies in Black: Art of the Harlem Renaissance. London: Hayward Gallery, 1997.
- Balken, Debra Bricker. Debating American Modernism: Stieglitz, Duchamp, and the New York Avant-Garde. New York: American Federation of Arts, 2003.
- Barron, Stephanie, ed. Degenerate Art: The Fate of the Avant-Garde in Nazi Germany. Los Angeles: Los Angeles County Museum of Art, 1991.
- Barron, Stephanie, and Wolf-Dieter Dube, eds. German Expressionism: Art and Society. New York: Rizzoli, 1997.
- Bochner, Jay. An American Lens: Scenes from Alfred Stieglitz's New York Secession. Cambridge, MA: MIT Press, 2005.
- Bohn, Willard. The Rise of Surrealism: Cubism, Dada, and the Pursuit of the Marvelous. Albany: State Univ. of New York Press, 2002.
- Bowlt, John E., and Evgeniia Petrova,

- eds. Painting Revolution: Kandinsky, Malevich and the Russian Avant-Garde. Bethesda, MD: Foundation for International Arts and Education, 2000.
- Bown, Matthew Cullerne. Socialist Realist Painting. New Haven: Yale Univ. Press, 1998.
- Brown, Milton. Story of the Armory Show: The 1913 Exhibition That Changed American Art. 2nd ed. New York: Abbeville, 1988.
- Chassey, Eric de, ed. American art: 1908-1947, from Winslow Homer to Jackson Pollock. Trans. Jane McDonald. Paris: Reunion des Musees Nationaux, 2001
- Corn, Wanda M. The Great American Thing: Modern Art and National Identity, 1915–1935. Berkeley: Univ. of California Press, 1999.
- Curtis, Penelope. Sculpture 1900–1945: After Rodin. Oxford History of Art. Oxford: Oxford Univ. Press, 1999.
- Elger, Dietmar. Expressionism: A Revolution in German Art. Ed. Ingo F. Walther. Trans. Hugh Beyer. New York: Taschen, 1998.
- Fer, Briony. On Abstract Art. New Haven: Yale Univ., 1997.
- Fletcher, Valerie J. Crosscurrents of Modernism: Four Latin American Pioneers:
 Diego Rivera, Joaquíín Torres-Garcíía,
 Wifredo Lam, Matta. Washington, D.C.:
 Hirshhorn Museum and Sculpture
 Garden in assoc. with the Smithsonian
 Institution Press, 1992.
- Folgarait, Leonard. Mural Painting and Social Revolution in Mexico, 1920-1940: Art of the New Order. New York: Cambridge Univ. Press, 1998.
- Forgáács, Eva. *The Bauhaus Idea and Bauhaus Politics*. Trans. John Báátki. New York: Central European Univ. Press, 1995.
- Frank, Patrick. Los Artistas del Pueblo: Prints and Workers' Culture in Buenos Aires, 1917-1935. Albuquerque: Univ. of New Mexico Press, 2006.
- Grant, Kim. Surrealism and the Visual Arts: Theory and Reception. New York: Cambridge Univ. Press, 2005.
- Green, Christopher. Art in France: 1900–1940. Pelican History of Art. New Haven: Yale Univ. Press, 2000. Reissue ed. 2003.
- Haiko, Peter, ed. *Architecture of the Early XX Century*. Trans. Gordon Clough. New York: Rizzoli, 1989.
- Harris, Jonathan. Federal Art and National Culture: The Politics of Identity in New Deal America. Cambridge Studies in American Visual Culture. New York: Cambridge Univ. Press, 1995.
- Harrison, Charles, Francis Frascina, and Gill Perry.
 - Primitivism, Cubism, Abstraction: The

- Early Twentieth Century. New Haven: Yale Univ. Press, 1993.
- Haskell, Barbara. *The American Century:* Art & Culture, 1900–1950. New York: Whitney Museum of American Art, 1999
- Herbert, James D. Fauve Painting: *The Making of Cultural Politics*. New Haven: Yale Univ. Press, 1992.
- Hill, Charles C. The Group of Seven: Art for a Nation. Toronto: National Gallery of Canada, 1995.
- Karmel, Pepe. Picasso and the Invention of Cubism. New Haven: Yale Univ. Press, 2003
- Lista, Giovanni. *Futurism*. Trans. Susan Wise. Paris: Terrail, 2001.
- McCarter, Robert, ed. On and by Frank Lloyd Wright: A Primer of Architectural Principles. New York: Phaidon Press, 2005
- Moudry, Roberta, ed. *The American Sky-scraper: Cultural Histories*. New York: Cambridge Univ. Press, 2005.
- Rickey, George. Constructivism: Origins and Evolution. Rev. ed. New York: G. Braziller, 1995.
- Taylor, Brandon. Collage: The Making of Modern Art. London: Thames & Hudson, 2004.
- Weston, Richard. *Modernism*. London: Phaidon, 1996.
- White, Michael. *De Stijl and Dutch Modernism*. Critical Perspectives in Art History. New York: Manchester Univ. Press, 2003.
- Whitfield, Sarah. Fauvism. World of Art. New York: Thames and Hudson, 1996.
- Whitford, Frank. *Bauhaus*. World of Art. London: Thames and Hudson, 1984.
- Zurier, Rebecca, Robert W. Snyder, and Virginia M. Mecklenburg. Metropolitan Lives: The Ashcan Artists and Their New York. Washington, D.C.: National Museum of American Art, 1995.

CHAPTER 21 The International Scene Since 1945

- Alberro, Alexander, and Blake Stimson, eds. Conceptual Art: A Critical Anthology. Cambridge, MA: MIT Press, 1999.
- Archer, Michael. *Art Since 1960.* 2nd ed. World of Art. New York: Thames and Hudson, 2002.
- Atkins. Robert. Artspeak: A Guide to Contemporary Ideas, Movements, and Buzzwords. 2nd ed. New York: Abbeville, 1997.
- Ault, Julie. Art Matters: How the Culture Wars Changed America. Ed. Brian Wallis, Marianne Weems, & Philip Yenawine. New York: New York Univ. Press, 1999.
- Battcock, Gregory. *Minimal Art: A Critical Anthology*. Berkeley: Univ. of California Press, 1995.
- Beardsley, John. Earthworks and Beyond:

- Contemporary Art in the Landscape. 3rd ed. New York: Abbeville, 1998.
- Bird, Jon, and Michael Newman, eds. Rewriting Conceptual Art. Critical Views. London: Reaktion, 1999.
- Bishop, Claire. *Installation Art: A Critical History*. New York: Routledge, 2005.
- Blais, Joline, and Jon Ippolito. At the Ege of Art. London: Thames & Hudson, 2006
- Buchloh, Benjamin H. D. Neo-Avantgarde and Culture Industry: Essays on European and American Art from 1955 to 1975. Cambridge, MA: MIT Press, 2000.
- Carlebach, Michael L. American Photojournalism Comes of Age. Washington, D.C.: Smithsonian Institution Press, 1997.
- Causey, Andrew. Sculpture since 1945. Oxford History of Art. Oxford: Oxford Univ. Press, 1998.
- Corris, Michael, ed. *Conceptual Art: The-ory, Myth, and Practice*. New York: Cambridge Univ. Press, 2004.
- Craven, David. Abstract Expressionism as Cultural Critique: Dissent during the McCarthy Period. Cambridge Studies in American Visual Culture. New York: Cambridge Univ. Press, 1999.
- Day, Holliday T. Crossroads of American Sculpture: David Smith, George Rickey, John Chamberlain, Robert Indiana, William T. Wiley, Bruce Nauman. Indianapolis, IN: Indianapolis Museum of Art, 2000.
- De Oliveira, Nicolas, Nicola Oxley, and Michael Petry. *Installation Art in the New Millennium: The Empire of the Senses.* New York: Thames & Hudson, 2003.
- De Salvo, Donna M., ed. *Open Systems:* Rethinking Art c. 1970. London: Tate, 2005.
- Fabozzi, Paul F. Artists, *Critics, Context:*Readings In and Around American Art
 Since 1945. Upper Saddle River, NJ:
 Prentice Hall, 2002.
- Fineberg, Jonathan David. Art Since 1940: Strategies of Being. 2nd ed. New York: Abrams, 2000.
- Flood, Richard, and Frances Morris. *Zero to Infinity: Arte Povera*, 1962-1972.
 Minneapolis, MN: Walker Art Center, 2001.
- Follin, Frances. Embodied Visions: Bridget Riley, Op Art and the Sixties. London: Thames & Hudson, 2004.
- Ghirardo, Diane. Architecture after Modernism. World of Art. New York: Thames and Hudson, 1996.
- Goldberg, Roselee. Performance Art: From Futurism to the Present. Rev. ed. World

- of Art. London: Thames and Hudson, 2001.
- Goldstein, Ann. A Minimal Future?: Art as Object 1958-1968. Los Angeles: Museum of Contemporary Art, 2004.
- Grande, John K. Art Nature Dialogues: Interviews with Environmental Artists. Albany: State Univ. of New York Press, 2004.
- Grosenick, Uta, and Burkhard Riemschneider, eds. *Art at the Turn of the Millennium*. New York: Taschen, 1999.
- Grunenberg, Christoph, ed. Summer of Love: Art of the Psychedelic Era. London: Tate, 2005.
- Herskovic, Marika, ed. American Abstract Expressionism of the 1950s: An Illustrated Survey: With Artists' Statements, Artwork and Biographies. New York: New York School Press, 2003.
- Hitchcock, Henry Russell, and Philip Johnson. The International Style. New York: W.W. Norton, 1995.
- Hopkins, David. After Modern Art: 1945–2000. Oxford History of Art. Oxford: Oxford Univ. Press, 2000.
- Jencks, Charles. The New Paradigm in Architecture: The Language of Post-Modernism. New Haven: Yale Univ. Press, 2002. Jodidio, Philip. New Forms: Architecture in
- Jodidio, Philip. New Forms: Architecture in the 1990s. New York: Taschen, 2001.
- Johnson, Deborah, and Wendy Oliver, eds. Women Making Art: Women in the Visual, Literary, and Performing Arts Since 1960. Eruptions, vol. 7. New York: Peter Lang, 2001.
- Jones, Caroline A. Machine in the Studio: Constructing the Postwar American Artist. Chicago: Univ. of Chicago Press, 1996
- Joselit, David. American Art Since 1945. World of Art. London: Thames and Hudson, 2003.
- Katzenstein, Inéés, ed. Listen, Here, Now!: Argentine art of the 1960s: Writings of the Avant-Garde. New York: Museum of Modern Art, 2004.
- Legault, Rééjean, and Sarah Williams Goldhagen, eds. Anxious Modernisms: Experimentation in Postwar Architectural Culture. Montrééal: Canadian Centre for Architecture, 2000.
- Lucie-Smith, Edward. *Movements in Art since 1945*. World of Art. London: Thames and Hudson, 2001.
- Madoff, Steven Henry, ed. *Pop Art: A Critical History*. The Documents of

- Twentieth Century Art. Berkeley: Univ. of California Press, 1997.
- Moos, David, ed. *The Shape of Colour:* Excursions in Colour Field Art, 1950-2005. Toronto: Art Gallery of Ontario, 2005.
- Paul, Christiane. *Digital Art*. World of Art. London: Thames and Hudson, 2003.
- Phillips, Lisa. The American Century: Art and Culture, 1950–2000. New York: Whitney Museum of American Art, 1999.
- Ratcliff, Carter. The Fate of a Gesture: Jackson Pollock and Postwar American Art. New York: Farrar, Straus, Giroux, 1996.
- Reckitt, Helena, ed. Art and Feminism. Themes and Movements. London: Phaidon, 2001.
- Risatti, Howard, ed. Postmodern Perspectives: Issues in Contemporary Art. 2nd ed. Upper Saddle River, NJ: Prentice Hall, 1998.
- Robertson, Jean, and Craig McDaniel.

 Themes of

 Contemporary Art: Visual Art after 1980.

 New York: Oxford Univ. Press, 2005.
- Robinson, Hilary, ed. Feminism-Art-Theory:
 - An Anthology, 1968-2000. Malden, MA: Blackwell Publishers, 2001.
- Rorimer, Anne. *New Art in the 60s and 70s: Redefining Reality*. New York: Thames & Hudson, 2001.
- Rush, Michael. New Media in Late 20th-Century Art. World of Art. London: Thames and Hudson, 1999.
- ——. Video Art. New York: Thames & Hudson, 2003.
- Sandler, Irving. Art of the Postmodern Era: From the Late 1960s to the Early 1990s. New York: Icon Editions, 1996.
- Shohat, Ella. Talking Visions: Multicultural Feminism
 - in a Transnational Age. Documentary Sources in Contemporary Art, 5. New York: New
- Museum of Contemporary Art, 1998. Sylvester, David. *About Modern Art.* 2nd
- ed. New Haven: Yale Univ. Press, 2001.
- Waldman, Diane. Collage, Assemblage, and the Found Object. New York: Abrams, 1992.
- Weintraub, Linda, Arthur Danto, and Thomas McEvilley. Art on the Edge and Over: Searching for Art's Meaning in Contemporary Society, 1970s–1990s. Litchfield, CT: Art Insights, 1996.

CREDITS

CREDITS AND COPYRIGHTS

The Authors and Publishers wish to thank the libraries, museums, galleries, and private collections for permitting the reproduction of works of art in their collections. Sources not included in the captions are gratefully acknowledged below. In addition, the Editors are grateful to the following correspondents: Barbara Nagelsmith,

Paris; Elizabeth Meryman, New York; Achim Bednorz, Cologne; Carla Bertini, Rome; Angela Anderson, London; Kostas Kontos, Athens.

Introduction

1 Roger Wood, London Corbis / Bettmann; 2 The Art Institute of Chicago. Wirt D. Walker Fund. 1949.585. Photograph © 2005, The Art Institute of Chicago . All Rights Reserved; 3 John Decopoulos; 4 University of Arizona, Museum of Art; 5 The University of Arizona Museum of Art. © 2007 The Georgia O'Keeffe Foundation / Artists Rights Society (ARS), New York; 6 Art Resource, NY; 7 Art Resource, NY; 8 Derechos reservados © Museo Nacional Del Prado - Madrid: 9 M. Sari / Musei Vaticani / SCALA Art Resource, NY; 10 Art Resource, NY; 11 SCALA Art Resource, NY; 12 Erich Lessing / Art Resource, NY; 13 Spencer Museum of Art, The University of Kansas; 14 The Nelson-Atkins Museum of Art, Kansas City, Missouri. Purchase, F83-55. Photograph by Mel McLean; 15 Spencer Museum of Art, The University of Kansas: Museum Purchase: Peter T. Bohan Art Acquisition Fund; 16 The J. Paul Getty Museum, Los Angeles; 17 Ghigo Roli / Index Ricerca Iconografica; 18 Robert Lehman Collection, 1975. (1975.1.794) Photograph © 1983 The Metropolitan Museum of Art; 19 Birmingham Museums and Art Gallery, Birmingham, England, U.K.; 20 By permission of The British Library; 21 Courtesy of the Freer Gallery of Art, Smithsonian Institution, Washington, D.C. F1904.61; 22 SCALA Art Resource, NY: 23 Victoria & Albert Museum. London / Art Resource, NY; BOX Catherine Ursillo / Photo Researchers, Inc.; BOX Frank Fournier.

Chapter 1

1-1 Ministere de la Culture et de la Communication. Direction Regionale des affaires Culturelles de Rhone -Alpes. Service Regional de l'Archeologie; 1-2 National Geographic Image Collection. Jack Unruh / NGS Image Collection; 1-3 K. H. Augustin, Esslingen / Ulmer Museum; 1-4 Naturhistorisches Museum, Vienna, Austria @ Photography by Erich Lessing / Art Resource, NY; 1-5 Institute of Archeology ASCR Prague; 1-6 Sisse Brimberg / National Geographic Image Collection; 1-7 Michael Lorblanchet / San Heritage Centre / Rock Art Research Centre / University of the Witwatersrand, Johannesburg; 1-8 Sisse Brimberg / National Geographic Image Collection; 1-9 Yvonne Vertut; 1-10 Sisse Brimberg National Geographic Image Collection; 1-11

Yvonne Vertut; 1-12 Reunion des Musees Nationaux / Art Resource, NY; 1-13 Marilyn Stokstad; 1-15 © David Lyons / Alamy; 1-16 Department of the Environment, Heritage and Local Government; 01-17 Aerofilms; 1-18 National Museum, Copenhagen; 01-19 National Museum, Copenhagen; 1-20 National Museum, Copenhagen; 1-21 National Museum of Ireland; BOX Erich Lessing / Art Resource, NY; BOX Erich Lessing / Art Resource, NY.

Chapter 2

2-1 Image © The Metropolitan Museum of Art; 2-02 Folco Quilici; 2-3 Peter Dorrell, Stuart Laidlaw, Dr. Gary / Prof. Nasser D Khalili; 2-04 Dr. Brian F. Byrd; 2-05 World Tourism Organization: Iraq; 2-08 Courtesy of the Oriental Institute of the University of Chicago; 2-09 Corbis / Bettmann; 2-10 National Museum of Denmark, Copenhagen; 2-11 University of Pennsylvania Museum object # B17694, (image #150848); 2-12 Image © The Metropolitan Museum of Art; 2-13 Erich Lessing / Art Resource, NY; 2-14 Herve Lewandowski © Reunion des Musees Nationaux / Art Resource, NY; 2-15 D. Arnaudet / Louvre, Paris France / RMN / Art Resource, NY; 2-16 Dagli Orti / Picture Desk, Inc. / Kobal Collection; 2-18 Courtesy of the Oriental Institute of the University of Chicago; 2-19 © The Trustees of the British Museum; 2-20 Courtesy of the Oriental Institute of the University of Chicago; 2-21 Art Resource/Bildarchiv Preussischer Kulturbesitz; 2-22 © Superstock; 2-23 © Gianni Dagli Orti / Corbis; 2-24 © Gianni Dagli Orgi / CORBIS. All Rights Reserved; 2-25 @ Ashmolean Museum, Oxford, England, U.K.; BOX Ashmolean Museum, Oxford, England, U.K.; BOX John Simmons; BOX Herve Lewandowski / Reunion des Musees Nationaux / Art Resource, NY; BOX Herve Lewandowski / Reunion des Musees Nationaux / Art Resource, NY.

Chapter 3

3-1 The Egyptian Museum; 3-2a Art Resource, NY; 3-02b Art Resource, NY; 3-05 © Archivo Iconografico / CORBIS / All Rights Reserved; 3-06 Free Agents Ltd. Corbis/Bettmann; 3-07 Harvard University Semitic Museum; 3-08 Werner Forman / Art Resource, NY; 3-09 Araldo de Luca / The Egyptian Museum, Cairo / Index Ricerca Iconografica; 3-10 Araldo de Luca Archives; 3-11 © 2006 Museum of Fine Arts, Boston. Harvard University-Boston Museum of Fine Arts. All Rights Reserved; 3-12 The Brooklyn Museum of Art; 3-13 Herve Lewandowsk Musee du Louvre / RMN Reunion des Musees Nationaux, France / Art Resource. NY; 3-14 Yvonne Vertut; 3-15 Photograph by Jamison Miller; 3-16 Yvonne Vertut; 3-17 Image © The Metropolitan Museum of Art; 3-18 Image © The Metropolitan Museum of Art; 3-19 Araldo da Luca / Image © The Metropolitan Museum of Art; 3-20 Photograph © 1992 The Metropolitan Museum of Art; 3-22 Yann Arthus-Bertrand / Corbis Bettmann; 3-25 Yvonne Vertut; 3-26 Image © The Metropolitan Museum of Art; 3-27 Petera A. Clayton; 3-30 Art Resource / Bildarchiv Preussischer Kulturbesitz; 3-31 Art Resource, NY; 3-32 Art Resource / Bildarchiv Preussischer Kulturbesitz; 3-33 Araldo de Luca Studio / Index Ricerca Iconografica; 3-34 Guillermo Aldana / The Getty Conservation Institute; 3-35 © The British Museum: 3-36 © Copyright The British Museum; BOX © The British Museum; BOX Picture Desk, Inc. / Kobal Collection; BOX: Dagli Orti Giovanni; BOX: Werner Forman Archive / Art Resource, NY; BOX @ The British Museum; BOX: © Fridmar Damm / Zefa / CORBIS All Rights Reserved; BOX: AKG-Images; BOX: Dagli Orti / Picture Desk, Inc. / Kobal Collection; BOX: Egyptian Tourist Authority.

Chapter 4

4-1 Nimatallah / National Archeological Museum, Athens Art Resource, NY; 4-2 Nicholas P. Goulandris Foundation: 4-3 Hellenic Republic Ministry of Culture; 4-4 McRae Books Srl; 4-5 @ Georg Gerster / Photo Researchers, Inc.; 4-6 © Roger Wood / Corbis; 4-7 Studio Kontos Photostock; 4-8 Archeological Museum, Irklion, Crete / Studio Kontos Photostock; 4-9 Petros M. Nomikos / Courtesy of Thera Foundations, The Archaeological Society at Athens; 4-10 Studio Kontos Photostock; 4-11 Archeological Museum, Iraklion, Crete / Studio Kontos Photostock; 4-12 Erich Lessing; Art Resource, NY; 4-13 Nimtallah / Art Resource, NY; 4-14 Nimtallah / Art Resource, NY; 4-15 SCALA Art Resource, NY; 4-16 National Archaeological Museum, © Hellenic Ministry of Culture, Archaeological Receipts Fund; 4-17 Studio Kontos Photostock; 4-19 © The Trustees of the British Museum; 4-20 Studio Kontos Photostock; 4-21 © Vanni Archive CORBIS All Rights Reserved; 4-23 Dagli Orti / Picture Desk, Inc. / Kobal Collection; 4-24 National Archaeological Museum, Athens / Hirmer Fotoarchiv, Munich, Germany; 4-25 Nimatallah / Art Resource, NY; 4-26 Nimtallah / Art Resource, NY; 4-27 Studio Kontos Photostock; BOX: Deutsches Archaologisches Institut, Athens; BOX: Studio Kontos Photostock; BOX: Studio Kontos Photostock

Chapter 5

5-2 Dagli Orti / Picture Desk, Inc. / Kobal Collection; 5-3 Archeological Museum, Eretria, Greece / Hellenic Republic Ministry of Culture; 5-4 Photograph © 1996 The Metropolitan Museum of Art; 5-5 © Metropolitan Museum of Art; 5-6 Gérard Blot / C. Jean / Musee du Louvre / RMN Reunion des Musees Nationaux, France / SCALA/Art Resource, NY; 5-7 Marco Cristofori / CORBIS-NY; 5-9 Gian Beerta Vanni / Archaelolgical Museum, Korkyra (Corfu) / Art

Resource, NY; 5-11 Studio Kontos Photostock; 5-12 Vanni / Art Resource, NY; 5-13Vanni / Art Resource, NY; 5-14 Photograph © 1997 The Metropolitan Museum of Art; 5-15 SCALA / Art Resource, NY; 5-16 Bildarchiv Preubischer Kulturbesitz; 5-17 Studio Kontos Photostock; 5-18 Studio Kontos Photostock; 5-20 Bibliotheque Nationale de France 5-21 Photo Vatican Museums; 5-22 Chateau-Musee, Boulogne-su-Mer, France Devos; 5-23 © The Metropolitan Museum of Art; 5-24 Scala / Art Resource, NY; 5-26 Studio Kontos Photostock; 5-27 Studio Kontos Photostock; 5-27 Studio Kontos Photostock; 5-28 Studio Kontos Photostock; 5-29 Bildarchiv Preussischer Kulturbesitz / Art Resource, NY; 5-30 Archeological Museum, Delphi/ Studio Kontos Photostock; 5-30 Studio Kontos Photostock; 5-31 SCALA / Museo Archeologico Naz, Italy / Art Resource, NY; 5-32 © 2005 Museum of Fine Arts, Boston. All Rights Reserved.; 5-33 © Georg Gerster / Photo Researchers Inc.; 5-34 With permission of the Royal Ontario Museum © ROM; 5-35 © Copyright The British Museum; 5-36 © The Trustees of the British Museum; 5-37 © The Trustees of the British Museum; 5-38 Reunions des Musees Nationaux / Art Resource, NY; 5-39 Studio Kontos Photostock; 5-40 Wolfgang Kaehler / CORBIS-NY; 5-40 De Agostini Editore Picture Library; 5-42 Akropolis Museum, Athens / Studio Kontos Photostock; 5-44 © 2005 Museum of Fine Arts, Boston. All Rights Reserved; 5-45 Nimatallah / National Museum Athens, Greece / Art Resource, NY; 5-48 Dagli Orti / Picture Desk, Inc. / Kobal Collection; 5-50 Archaeological Museum, Olympia / Studio Kontos Photostock; 5-51 P Zigrossi / Musei Vaticani / Vatican Museums, Rome, Italy; 5-52 © Copyright The British Museum; 5-53 Photo Vatican Museums; 5-54 Erich Lessing / Art Resource, NY; 5-55 © The Trustees of the British Museum; 5-56 © The Metropolitan Museum of Art; 5-57 SCALA / Alinari / Art Resource, NY; 5-58 Archeological Museum; 5-59 Studio Kontos Photostock; 5-60 Ruggero Vanni / CORBIS-NY; 5-61 Marvin Trachtenberg; 5-62 Araldo DeLuca / Museo Nazionale Romano, Rome / Index Ricerca Iconografica; 5-64 Bildarchiv Preussischer Kulturbesitz / Art Resource, NY; 5-65 Art Resource, NY; 5-66 Reunion des Musees Nationaux / Art Resource, NY; 5-67 Photograph © 1981 The Metropolitan Museum of Art; 5-68 Photograph © 1997 The Metropolitan Museum of Art; 5-69 Reunion des Musees Nationaux / Art Resource, NY; 5-69 Reunion des Musees Nationaux / Art Resource, NY; BOX: Ikona; BOX: Studio Kontos Photostock; BOX: The Antiquities of Athens / Gennadius Library / American School of Classical Studies at Athens; BOX: With permission of the Royal Ontario Museum © ROM; Box: Photograph by Gary Layda, The Parthenon, Nashville, Tennessee.

Chapter 6

6-1 Erich Lessing / Art Resource, NY; 6-2 © Maurizio Bellu / Ikona; 6-5 Museo Nazionale di Villa Giulia, Italy / Canali Photobank; 6-6 Nimatallah / Art Resource, NY; 6-7 SCALA Art Resource, NY; 6-8 Scala / Art Resource, NY; 06-9 Canali Photobank; 6-10 SCALA

Art Resource, NY; 6-11 Scala / Art Resource, NY; 6-11 SCALA Art Resource, NY; 6-12 NY Carlsberg Glyptotek; 6-13 American Numismatic Society of New York; 6-14 Danita Delimont Photography; 6-15 Lazio/Soprintendenza Arc. Rome / Index Ricerca Iconografica 6-16 Canali Photobank; 6-18 Roy Rainford / Robert Harding World Imagery; 6-20 Photo Vatican Museums; 6-21 A. Jemolo / Ikona; 6-22 © Andrea Jemolo / Ikona; 6-22 Andrea Iemolo / IKONA; 6-23 Vincenzo Pirozzi / IKONA; 6-24 Kunsthistorisches Museum Wien / Kunsthistorisches Museum, Vienna, Austria; 6-25 George Gerster Photo Researchers, Inc.; 6-26 Soprintendenza Archeologica di Pompei / Ikona; 6-27 The Houses of Roman Italy 100BC-AF250: Ritual Space and Decoration, by John R. Clarke, figure 28, © 1991 The Regents of the University of California; 6-28 Alberti Index Ricerca Iconografica; 6-29 Fitzwilliam Museum, University of Cambridge, England; 6-30 Canali Photobank; 6-31 Canali Photobank; 6-32 Index Ricerca Iconografica; 6-34 © The Metropolitan Museum of Art, NY; 6-35 SCALA Art Resource, NY; 6-36 Erich Lessing / Art Resource, NY; 6-36 Erich Lessing / Art Resource, NY; 6-37 Scala / Art Resource, NY; 6-38 A. Vasari / Index Ricerca Iconografica; 6-39 © Achim Bednorz, Koln; 6-39 © Achim Bednorz, Koln; 6-40 © Achim Bednorz, Koln; 6-42 Roman Architecture, Frank Sear, Cornell University Press, 1982; 6-43 Canali Photobank; 6-44 Araldo de Luca Archives / Index Ricerca Iconografica; 6-45 Ikona; 6-46 American Academy in Rome; 6-48 Dr. James E. Packer; 6-49 Scala / Art Resource, NY; 6-50 Robert Frerck / Woodfin Camp & Associates; 6-51 SCALA Art Resource, NY; 6-52 Canali Photobank; 6-54 Danita Delimont Photography; 6-56 Canali Photobank; 6-57 Biran Brake / John Hillelson Agency; 6-58 Art Resource / Bildarchiv Preussischer Kulturbesitz: 6-59 © IKONA Photo/FOTOVASARI ROMA; 6-60 Museo Capitolino / Canali Photobank; 6-61 Araldo De Luca/Musei Capitolini, Rome, Italy / Index Ricerca Iconografica; 6-62 Bildarchiv Preussischer Kulturbesitz / Art Resouce, NY: 6-63 Photograph © 1986 The Metropolitan Museum of Art; 6-66 Ikona; 6-67 Musei Vaticani, Braccio Nuovo, Citta del Vaticano, Rome / Art Resource, NY; 6-68 Fotostudio Rapuzzi; 6-69 Scala / Art Resource, NY; 6-71 @ Achim Bednorz, Koln; 6-72 © Bildarchiv Monheim GmbH / Alamy; 6-73 Capitoline Museum / Canali Photobank; 6-74 Araldo de Luca Archives / Index Ricerca Iconografica; 6-75 IKONA; 6-77 © Copyright The British Museum; 6-78 V & A Images Victoria and Albert Museum; 6-78V & A Images / Victoria and Albert Museum; 6-79 V & A Images / Victoria and Albert Museum; BOX: Musei Vaticani.

Chapter 7

7-1 Index Ricerca Iconografica; 7-2 © Soprintendenza Archeologica di Roma / Ikona; 7-3 Princeton University Press / Art Resource, NY; 7-4 Yale University Art Gallery; 7-5 Photo by David Harris, Jerusalem; 7-5 David Harris Photography; 7-7 The Cleveland Museum of Art, John L. Severance Fund. 1965.241; 7-8 Soprintendenza Archeologica di Roma / IKONA; 7-9 Yale University Art Gallery; 7-11 SCALA Art

Resource, NY; 7-12 Vincenzo Pirozzi; 7-13 Nimatallah / Index Ricerca Iconografica; 7-14 Vincenzo Pirozzi / IKONA; 7-15 Canali Photobank; 7-17 © Achim Bednorz, Koln; 7-18 Scala / Art Resource, NY; 7-19 © Vanni Archive / Corbis; 7-20 Canali Photobank; 7-21 Canali Photobank; 7-24 Sonia Halliday Photographs; 7-25 © Achim Bednorz, Koln; 7-27 Marvin Trachtenberg; 7-28 Scala; 7-30 Dagli Orti / Art Archive / Picture Desk, Inc. / Kobal Collection 7-31, 7-32 Canali Photobank; 7-33 SCALA Art Resource, NY; 7-34 © Arthur Hustwitt / eStock Photography LLC; 7-35 Bildarchiv der Osterreichische Nationalbibliothek; 7-36, 7-37 Donato Pineider, Florence / Biblioteca Medicea Laurenziana Firenze; 7-38 Studio Kontos Photostock; 7-39 SCALA / Tretyakov Gallery, Moscow / Art Resource, NY; 7-40 Bruce White © The Metropolitan Museum of Art, NY; 7-41 Dagli Orti / The Art Archive; 7-42 Bruce White / © 1997 The Metropolitan Museum of Art; 7-43 Studio Kontos Photostock: 7-44 Canali Photobank; 7-45 Musee du Louvre / RMN Reunion des Musees Nationaux, France / Daniel Arnaudet / Art Resource, NY; 7-46 © The British Museum; 7-47 Publifoto / Index Ricerca Iconografica; 7-48 Publifoto / Index Ricerca Iconografica; 7-49 Dr. Reha Gunay; 7-50 Dagli Orti / Picture Desk, Inc. / Kobal Collection / 7-51 Sovfoto / Eastfoto; BOX: Canali Photobank; BOX: Mario Carrieri Fotografo.

Chapter 8

8-1 © Kazuyoshi Nomachi / Corbis; 8-2 © Annie Griffiths Belt / Corbis; 8-4 Annie Griffiths Belt / Corbis; 8-5 Islamic Architecture, John Hoag, Harry N. Abrams, p. 308, 1977; 8-7 © Roger Wood / Corbis. All Rights Reserved; 8-8 Raffaello Bencini Fotografo; 8-9 Benini / Raffaello Bencini Fotografo; 8-10 Photograph © 1994 The Metropolitan Museum of Art, NY; 8-11 Bibliotheque Nationale de France; 8-12 Art Resource / Reunion des Musees Nationaux; 8-13 Musee du Louvre / RMN Reunion des Musees Nationaux, France / SCALA Art Resource, NY; 8-14 Werner Forman Archive Ltd; 8-15 Photograph © 1982 The Metropolitan Museum of Art; 8-16 Ronald Sheridan / The Ancient Art & Architecture Collection Ltd; 8-17 © Achim Bednorz, Koln; 8-18 Peter Sanders Photography; 8-19 Mario Carrieri Fotografo; 8-21 Photograph © 1982 The Metropolitan Museum of Art; 8-22 Museo de Telas Medievales, Monasterio de Santa Maria / Institut Amatller de Arte Hispanico; 8-23 Z. Perkins / James F. Ballard Collection / The Saint Louis Art Museum; 8-24 National Library, Egypt; 8-25, 8-26 British Library; 8-27 Sonia Halliday Photographs; 8-29 Photograph © 1980 The Metropolitan Museum of Art; 8-30 The Aga Khan Program for Islamic Architecture; BOX: Corning Museum of Glass; BOX: Library of Congress / Photo Courtesy of Gayle Garrett, Washington, D.C.

Chapter 9

9-1, 9-7 The Board of Trinity College, Dublin / The Bridgeman Art Library International; 9-02 Werner Forman / Art Resource, NY; 9-03 Rapuzzi / Index Ricerca Iconografica; 9-04 Kit Weiss / National Museum of Denmark, Copenhagen; 9-5 © Copyright The British Museum; 9-6 Trinity College Library, Dublin; 9-8 Courtesy of Marilyn Stokstad, Private Collection; 9-9 Photo: © 1994 The Metropolitan Museum of Art; 9-10 Oronoz Archivo Fotographico Oronoz, Madrid; 9-11 Achim Bednorz; 9-13, 9-15, 9-17 Bibliotheque Nationale, Paris. RMN / Art Resource, NY; 9-16 Kunsthistorisches Museum, Vienna, Austria; 9-18 Central Museum, Utrecht; 9-19 Art Resource / The Pierpont Morgan Library; 9-20 Peter Schaelichli, Zurich; 9-20 © Museum of Cultural History, University of Oslo, Norway; 9-21 Eirik Irgens Johnsen; 9-22 © Carmen Redondo / Corbis. All Rights Reserved; 9-23 Werner Forman / Art Resource, NY; 9-25 Erich Lessing / Art Resource, NY; 9-26 Photograph © 1986 The Metropolitan Museum of Art; 9-28 © Achim Bednorz, Koln; 9-29 Cathedral of Cologne / Rheinisches Bildarchiv, Museen Der Stadt Koln; 9-30 Ann Munchow Fotografin; 9-31 Bayerische Staatsbibliothek; BOX: Hessisches Landes-und Hochschulebibliothek; BOX: Frank Tomio / Dom-Museum Hildesheim.

Chapter 10

10-1, 10-5, 10-11, 10-14, 10-16, 10-17, 10-21, 10-22, 10-23, 10-25, 10-26, 10-27 Achim Bednorz 10-2 Corpus Christi College; 10-3 Archivo Fotographico Oronoz, Madrid; 10-12 Studio Folco Quilici Produzioni Edizioni Srl; 10-13 Foto Vasari / Index Ricerca Iconografica; 10-15 Canali Photobank; 10-18 © Archivo Iconografico, S.A. / Corbis, 10-19 © Erich Lessing / Art Resource, NY; 10-20 Car-

olingian and Roman Architecture, figure 78, Kenneth John Conant, Yale University Press, 1959; 10-24 Ghigo Roli / Index Ricerca Iconografica; 10-29 Scala / Art Resource, NY;10-30 Giraudon / The Bridgeman Art Library International; 10-31 © MNAC, 2001; 10-32 Photograph © 1999 The Metropolitan Museum of Art; 10-33 Constantin Beyer; 10-36 Ursula Seitz-Gray, Ffm. / Thuringer Universitats-und Landesbibliothek Jena; 10-37 The British Library; 10-38 Bibliotheque Municipale / Laboratoire Photographique, France; BOX: Wiesbaden Hessische Landesbibliothek; BOX: Centre Guillaume Le Conquerant; BOX: Achim Bednorz; BOX: Gemeinnutzige Stiftung Leonard von Matt; BOX: Musee de la Tapisserie de Bayeux.

Chapter 11

11-1 Archivo Iconografico, S.A. / Corbis. All Rights Reserved; 11-2 Yale University Press; 11-4 Corbis Royalty Free; 11-5 Herve Champollion / Caisse Nationale des Monuments Historique et des Sites; 11-6, 11-11, 11-15, 11-17, 11-18, 11-21, 11-22, 11-23, 11-24, 11-25, 11-32, 11-33, 11-36, 11-38, 11-42 Achim Bednorz; 11-7 Gian Berto Vanni / Art Resource, NY; 11-8 Sonia Halliday Photographs; 11-9 Pierpoint Morgan Library / Art Resource, NY; 11-12 Gothic Architecture, Louis Grodecki, Harry N. Abrams, p. 308, 1977; 11-13 Jean Bernard Photographe/Bordas Publication; 11-14 © Angelo Hornak / Corbis. All Rights Reserved; 11-19 Wim Swaan Collection / The Getty Research Institute; 11-20 Patric Muller / CMN Cenre des Monuments Nationaux; 1125, 11-27 The Pierpont Morgan Library / Art Resource, NY; 11-28 London Aerial Photo Library / Corbis-NY; 11-30 Aerofilms; 11-31 © Nigel Corrie / English Heritage Photo Library; 11-34 Erich Lessing / Art Resource, NY; 11-35 Hirmer Fotoarchiv, Munich, Germany; 11-37 Constantin Beyer; 11-39 Nicola Pisano / Canali Photobank; 11-43 Canali Photobank; 11-44 SCALA Art Resource, NY; BOX: Art Resource, NY; BOX: Alessandra Tarantino / AP Wide World Photos; BOX: Alberto Pizzoli / Corbis / Sygma.

Chapter 12

12-1, 12-2, 12-3, 12-5 Achim Bednorz; 12-4 © Guide Gallimard Florence, Illustration by Pilippe Biard; 12-6 Tosi Index Ricerca Iconografica; 12-7 Cimabue (Cenni di Pepi) Index Ricerca Iconografica, 12-8 Galleria degli Uffizi; 12-9, 12-10 Alinari / Art Resource, NY; 12-11Piero Codato / Canali Photobank; 12-12 Canali Photobank; 12-13 Thames & Hudson International, Ltd; 12-14 Photograph © Board of Trustees, National Gallery of Art, Washington, D.C.; 12-14, 12-16, 12-17 Scala Art Resource, NY;12-15 Canali Photobank; 12-16 Mario Quattrone / IKONA; 12-18 M. Beck-Coppola / Art Resource / Musee du Louvre; 12-19 Photography © 1991 The Metropolitan Museum of Art; 12-20 The Walters Art Museum, Baltimore; 12-21 Photograph © 1981 The Metropolitan Museum of Art; 12-23 Jan Gloc; 12-24, 12-25 © Radovnn Bocek; BOX: Canali Photobank; BOX: Alinari / Art Resource, NY.

INDEX

Italic page numbers refer to illustrations	Aeschylus, 159	Amenhotep III, 69, 74
	Aesop, 115	Amenhotep IV, 72
and maps.	Aesthetics, xxxvii–xxxviii	Amiens Cathedral, Notre-Dame cathe-
A	Agamemnon, 98	dral, 398, 400–401, 400, 402–403,
Aachen, Palace Chapel of Charlemagne,	funerary mask of, 93, 99, 102–103, 102	403, 404, 405
321, 322, 323	Agora	Amorites, 37
Aachen (Liuthar) Gospels, 339–340, 339,	Athenian Agora, 145–147, <i>146</i>	Amphiprostyle temple, 116
340	use of term, 145	Amphitheaters, Colosseum (Flavian
Abacus, 117, 118	Agriculture	Amphitheater), Rome, 202–204,
Abbasid dynasty, 285–286, 290, 294	Near East Fertile Crescent, 26	202, 203
Abbots	Neolithic, 12	Amphora, 125
See also under name of	Agrippa, Marcus Vipsanius, 184, 210	Amun, 52, 71
list of, during Romanesque period, 359	Agrippina, 198	Great Temple of, 67-69, 68, 69
Abd-al-Rahman I, 290	Ahmose, queen, 71	Anastasis, Church of the Monastery of
Abd-al-Rahman III, 291	Ain Ghazal, Jordan, 28–29, 29	Christ, Chora, Constantinople, 278,
Abelard, Peter, 384	Aisles, 242, 287	279
Abraham, Sarah, and the Three Strangers,	Ajax, The Suicide of Ajax (Exekias), 126,	Anatolia, 37, 39
Psalter of Saint Louis, 407–408, 407	126	Chatal Huyuk, 28, 28
Absolute dating, 13	Akhenaten, 72–74	Anavysos Kouros, Athens, 122, 122
Abstract art, xxxv	colossal statue of, 72, 72	Andachtsbilder, 450
Neolithic, 12–13, 13	Akhenaten and His Family, 73, 73	Angilbert, 323
Paleolithic, 6	Akkad (Akkadians), 36-37	Anglo-Saxons, 316
Abu Simbel, Rameses II temples at,	Akrotiri, "Flotilla" fresco, Thera, 82-83,	See also Normans
75–78, 76, 77	82,90	Aniconism, 284
Acanthus, 118	Alcuin of York, 325	Animals
Achaemenes, 42	Alexander II, pope, 388	cave art, 0, 1, 6–11, 7, 9, 10, 11
Achaemenids, 42–43	Alexander the Great, 46, 80, 128, 149, 157	domesticated, 12, 21
Achilles and Ajax Playing a Game (Exekias),	on a coin, 154, 155	Neolithic, 12–13, 12
126, 126	Alexander the Great (Lysippos), 154, 155	Animal style, 315
Achilles Painter, Woman and Maid, 148,	Alexander the Great Confronts Darius III at	Ankh, 52, 64
148	the Battle of Issos, Pompeii, 155, 156,	Ankhnesmeryra, queen, 61
Achilles (Spear Bearer or Doryphoros)	157	Annunciation, Book of Hours of Jeanne
(Polykleitos), 128, 128	Alexandria, Egypt, 149	d'Evreux (Pucelle), 442–443, 443
Acropolis, Athens	Alfonso VI, 344, 353	Annunciation, Reims Cathedral, Notre-
Athenian Agora, 145–147, 146	al-Hakam II, 291	Dame cathedral, 403–406, 405
description of, 136	Alhambra, Granada, Spain	Ansquetil, abbot, 366
Erechtheion, 142–144, 143	Court of the Lions, Alhambra, 298,	Anta, 116
Kritian Boy, 131, 132	299–300	Anthemius of Tralles, Hagia Sophia
model of, 137	Palace of the Lions, Alhambra, 299, 300	church, Istanbul, 255, <i>255</i> , <i>256</i> , 257,
Parthenon, 116, 136–142, 138, 139,	Ali, 284	259, 305
140, 141, 142	Allegory of Good Government in the City	Antigonus, 157
Peplos Kore, 123–124, 124	and in the Country (A. Lorenzetti),	Antoninus Pius, 204
Temple of Athena Nike, 144–145, 144	441–442, 441	Anubis, 52
Acropolis, use of term, 136	Allegory of Peace, 188–189, 188	Anu Ziggurat (White Temple), Uruk, 30, 30
Acroterion, 118	Alloy, 20	Apadana (audience hall), 44–45, <i>44</i> , <i>45</i>
Actaeon, Artemis Slaying (Pan Painter),	Alma-Tadema, Lawrence, Pheidias and the Frieze of the Parthenon, Athens, xliii,	Aphaia, temple of (Aegina), 120–121, <i>120</i>
134–135, <i>135</i>	xliii	Aphrodite, 109, 110
Adelaide, queen, 334	Altamira cave, Spain, Bison, 6, 7, 10, 10	Aphrodite of Knidos (Praxiteles), 152–153,
Adyton, 116	Altar from Pergamon, 162–163, <i>162</i>	152
Aegean Bronze Age in, 84	Altar of Augustan Peace (Ara Pacis Augus-	Aphrodite of Melos (Venus de Milo), 165,
Cycladic Islands in the Bronze Age,	tae), 187–188, 187, 188	166
84–86	Altars and altarpieces	Apollo, 109, 110, 128
map of, 85	Maestà Altarpiece (Duccio di Buonin-	sanctuary of, 110–111, 111, 132–133,
Minoan civilization on Crete, 86–95	segna), 437, 437, 438, 439, 440	133
Mycenaean (Helladic) culture, 95–104	Altneuschul, Prague, 412, 413	temple of, 111
New Palace period, 89–95	Amarna period, 72–75	Temple of Zeus, 130–131, 130, 131
Old Palace period, 86–88	Amasis Painter, Dionysos with Maenads,	Apollo (Vulca), 173–174, 175
timeline, 95	125–126, <i>125</i>	Apollodorus of Damascus, 205
Aeneid (Virgil), 179	Ambulatories, 247, 287	Apollo with Battling Lapiths and Centaurs,
Aerial (atmospheric) perspective, 195	Amenemhat I, 63, 65–66, 65	130–131, 130

Agricalers, Pour du Guard, Roman bridge, 182, 192 Aguinas, Thomas, 384, 385, 594 Arabesques, 284 Ara Pacis Augusta (Alara of Augustan Peace), 187, 189, 187, 188 Aracakes, 172, 183, 387 Archaic semich (122, 174 Anhanged Mohod chyrch, Byzantine, 203–3-24, 287, 291 203–3-24, 287, 291 203–3-24, 287, 291 204, 292, 291 205, 292, 292 21, 292 21, 292 22, 21, 292 23, 293, 294 24, 293, 294 Augusta, 193, 294 Archaic semich (122, 174 Anhanged Mohod chyrch, Byzantine, 273, 276, 276 Anhanged Mohod chyrch, Byzantine, 273, 276, 276 Anhanged Mohod chyrch, Byzantine, 273, 276, 276 Anna Paracheon, 210, 210, 211, 212 Roman Paracheon, 210, 210, 210, 210,	Apse, 242	Neo-Babylonian, 42, 42, 43	Artemis, temple of (Corfu), 119, 119
bridge, 182, 182 Aprilans, I Florans, 384, 385, 394 Arabseques, 284 Arabeques, 284 Arabeques, 284 Aracks, 172, 183, 287 Aracks, 183, 287 Aracks, 172, 184, 184, 184, 184, 192, 290, 291-294, 291, 292 Islamic, 292 Aracks, 172, 184, 184, 184, 192, 290, 291-294 Aracks, 172, 184, 184, 184, 184, 184, 184, 184, 184	•		
Aquinas, Thomas, 384, 385, 394 Arabesques, 281–189, 187, 188 Arabes, 172, 183, 287 Archais erind of Grock art. See Greek art, archaic and of Grock art. See Greek art, archaic and of Grock art. See Greek art, archaic and of Grock art. See Greek art, archaic smile, 122, 174 Archais graine, 122, 123 Archais graine, 122, 123 Archais graine, 122, 124 Archais graine, 122, 124 Archais graine, 122, 124 Archais graine, 122, 123 Archais graine, 122, 12			
Ara Pacis Augustas (Altar of Augustan Peace), 187–189, 187, 188 Ara Pacis Augustas (Altar of Augustan Peace), 187–189, 187, 188 Aradas, 172, 183, 287 Archiar period of Grock arr. See Grock art. archic archic art. archic archic art. archic archic art. archic			
Rama Books on, 179 Ara Paris Augusta (Alaro of Augustan Pace), 187-189, 187, 188 Arades, 172, 183, 287 Archais emile (122, 174 Archaise galled, 189, 246, 364 Archaise mile, 122, 174 Archaise galled, 189, 246, 364 Archaise mile, 122, 174 Archaise galled, 189, 246, 364 Archaise galled, 189, 246, 364 Archaise galled, 199, 191, 191, 246, 364 Archaise galled, 366, 367, 368, 367, 368 Archaise galled, 367, 368 Archaise galled	Arabesques, 284		
Arachsic period of Greek art. See Greek art. archaic mile, 122, 174 Archaic sprind of Greek art. See Greek art. archaic mile, 122, 174 Archaic sprind, 125, 276 Arches corbel, 171, 446 borseshoe, 291, 292 nodding agee, 446 pointed, 292 nodding agee, 446 pointed, 292, 355 round, 171, 172 transverse, 358 Archiceture Ain Ghazal, Jondan, 28, 29 Asyrina, 40–41, 42 Byzantine, middle, 267–273, 268–272 Expraintine, arily, 242–249, 242–249 Expraintine, niddle, 267–273, 268–972 Carchingina, 233, 233, 234 Chatal Huyuk, Anatolia, 28, 29 Expraintine, and 2, 242–249 Expriantine, and 2, 242–249 Expr			
Archaic period of Greek atr. See Greek atr. As archaic att. Achaic period of Greek atr. See Greek att. As archaic att. Archaic smile, 122, 174 Archaic Midde dipsych, Byzantine, 263–204, 263 Archaic gold by Spantine, 273, 276, 276 Archaic period of Greek atr. See Greek archaic mile, 122, 174 Archain and Midde dipsych, Byzantine, 273, 276, 276 Archaic period of Greek atr. See Greek archaic period, 171, 172 Carolingian, 291, 292 Idamic, 292 Indian, 292 Indian, 292 Indian, 293 Architecture Am Glazal, Jordan, 28, 29 Byzantine, Intel, 278, 279 Byzantine, middle, 267–273, 268–272 Byzantine, middle, 267–273, 268–272 Carolingian, 231–235, 232, 233, 324 Chatal Huyuk, Anatolia, 28, 29 Byzantine, Intel, 278, 279 Byzantine, middle, 267–273, 268–274 Byzantine middle, 267–273, 268–277 T5–78, 76, 77 Egyptian roperands and mastabas, 55–59, 36, 57, 58 Egyptian roperands and mastabas, 126 Byzantine middle, 267–273, 268–274 Begyptian rope of Chic, 411–412, 412, 413 Gothic, English, 409–411, 410, 411 Erroscan, 170–171, 173–174, 173 French, Gothic, 386–402, 387–402 German, Gothic, 411–412, 412, 413 Gothic, French, 386–402, 387–402 German, Gothic, 411–412, 412, 413 Gothic, French, 386–402, 387–402 Greek circy plan, orthogonal, 149–150, 199 Greek Partheron, Acropolis, 136–144, 158, 139, 143 Hellemstic, 158–160, 158, 159 Holy Roman Empire, Gothic, 411–412, 412, 413 Gothic, 181–185–100, 158, 159 Holy Roman Empire, Gothic, 411–412, 412, 413 Gothic, 181–185–100, 158, 159 Holy Roman Empire, Gothic, 411–412, 412, 413 Gothic, 181–185–100, 158, 159 Holy Roman Empire, Gothic, 411–412, 412, 413 Gothic, 181–185–100, 158, 159 Holy Roman Empire, Gothic, 416, 416 Mincan, 86–88, 87, 88 Roman Imperial, 205–212, 206–213, 242, 242, 247, 248, 247, 428, 449 Inalian, Gothic, 416, 416 Mincan, 86–88, 87, 88 Roman Insperial, 205–212, 206–221, 207–233, 246–272, 248, 246, 247, 248, 444, 445 Roman Insperial, 205–212, 206–221, 207–204, 201, 201, 202, 202, 202, 202, 202, 203 Archara Machael insperial, 205–212, 206–222, 206 Archara Mincan, 33, 33, 33, 33, 34		Roman Colosseum (Flavian Amphithe-	Ascension of Elijah, 245, 245
art. archaic Archaic mile, 122, 174 Archaingle Michael dispych, Byzantine, 273, 262–273, 226, 227, 238 Arches 276, 276 Archoged Michael cion, Byzantine, 273, 276–274 Archoged Michael cion, Byzantine, 273, 276–275 Arches 276, 276 Architecture, elements of a control, 171, 172 transverse, 386 pointed, 392, 385 round, 171, 172 transverse, 386 Architecture, elements of a control, 171, 172 transverse, 386 Architecture, elements of a control, 270, 233, 242, 242 Assyrian, 140, 141 Arthese, 342, 242, 242 Christian, early, 242–249, 242–249 Egyptian pruntich and mantahas, 55–59, 56, 57, 58 Egyptian rode-cut tombs, 63, 63 Egyptian roughes, 67–27, 68, 69, 71, 73–78, 76, 77 English, Gothic, 410–411, 410, 411 Erriscan, 170–171, 173–174, 173 French, Gothic, 386–402, 387–402 German, Gothic, 411–412, 412, 413 Gothic, English, 409–411, 410, 411 Greek (Archaic period), 116, 117–119, 176 Greek (Archaic period), 116, 117–119, 177 Greek (Archaic period), 116, 117–119, 178			
Archies amile, 122, 174 Archosed Michael dispych, Byzantine, 273, 276, 276 Archosed Michael from, Byzantine, 273, 276, 276 Archosed Michael from, Byzantine, 273, 276, 276 Arches Corbel, 171, 446 horseshoe, 291, 292 nodding agee, 446 pointed, 292, 355 round, 171, 172 transvers, 358 Architecture Ain Glazal, Jondan, 28, 29 Asyrian, 40–41, 42 Byzantine, Ine, 278, 279 Byzantine, Indie, 267–273, 268–272 Carolingian, 321–323, 322, 323, 324 Christian, cariy, 242–249, 242–249 Egyptian pyramids and imastabas, 55–39, 56, 57, 58 Egyptian rock-cut tombs, 63, 63 Egyptian temples, 67–72, 68, 69, 71, 75–78, 67, 77 English, Gorthe, 40–411, 410, 411 Engrean, 170–171, 173–174, 173 French, Corbic, 386–402, 387–402 German, Gothic, 411–412, 412, 413 Gothic, Lingish, 40–411, 410, 411 Gothic, Engish, 60–610, 116, 117–119 Greek (Archaic period), 116, 11	*		
Archanged Michael dispeych, Byzantine, 203-204, 263 Archanged Michael icon, Byzantine, 273, 276, 276 Archael corbel, 171, 146 Anneshoe, 291, 292 Balanic, 292 Tound, 171, 172 Transverse, 358 Architecture, elements of a conding age, 446 Tound, 171, 172 Transverse, 358 Architecture, elements of a conding age, 446 Tound, 171, 172 Transverse, 358 Architecture, elements of a conding age, 446 Tound, 171, 172 Transverse, 358 Architecture, elements of a conding age, 446 Tound, 171, 172 Transverse, 358 Architecture, elements of a conding age, 446 Tound, 171, 172 Transverse, 358 Architecture, elements of a conding age, 446 Tound, 171, 172 Transverse, 358 Transparent, elements of a conding age, 446 Tound, 171, 172 Transverse, 358 Transparent, elements of a conding age, 446 Transparent, eleme			The state of the s
263-264, 263 Arkalanged Midade icon, Byzantine, 273, 276, 276 Arches corbel, 171, 446 boreschoe, 291, 292 nodding ager, 446 boreschoe, 291, 292 nodding ager, 446 pointed, 292, 355 round, 171, 172 transversa, 358 Architecture, Cambridge, 171, 172 transversa, 358 Architecture, Cambridge, 171, 172 Aran Ghazal, Jordan, 28, 29 Assyrian, 40-41, 42 Byzantine, middle, 267-273, 268-272 Carolingian, 321-325, 322, 323, 324 Claud Huyuk, Anatolia, 28, 29 Christian, early, 242-249, 242-249 Elgyptain temples, 67-72, 68, 69, 71, 75-78, 77 English, Gorthic, 410-411, 410, 411 English, Gorthic, 499-411, 410, 411 Gothic, Erench, 366-402, 387-402 Gorthic, German (Holy Roman Empire, Gothic, 411-412, 413 Gothic, English, 499-411, 410, 411 Gricke (Archite period), 116, 117-119, 117 Greek (Archite pe		•	
Archive corbet, 171, 446 Nonesdow, 291, 292 Slamic, 292 Slamic, 292 Nonesdow, 291, 292 Slamic, 292 Slamic, 292 Slamic, 292 Slamic, 293 Slamic, 292 Slamic, 293 Slamic, 294 Slamic, 295 Slamic, 296 Slamic, 296 Slamic, 296 Slamic, 296 Slamic, 296 Slamic, 297 Slamic, 297 Slamic, 297 Slamic, 298 S			
276. 276 Arches corbet, 171, 446 horseshoe, 291, 292 nodding agec, 446 porneted, 292, 355 round, 171, 172 transveres, 358 Architecture Ain Ghazal, Jordan, 28, 29 Asyrian, 40–41, 42 Byzantine, early, 242–239, 242–249 Byzantine, late, 278, 279 Byzantine, late, 278, 279 Byzantine, late, 278, 279 Byzantine, late, 278, 279 Egyptian pyzantids and mastabas, 55–59, 56, 57, 58 Egyptian rock-cut tombs, 63, 63 Egyptian ro			
Arches corbel, 171, 1446 honseshoe, 291, 292 klamic, 292 nodding agec, 446 pointed, 292, 355 round, 171, 172 transverse, 358 Architecture, elements of arches, value, and domes, 172, 172 dransverse, 358 Architecture, elements of arches, value, and domes, 172, 172 dransverse, 358 Byzantine, early, 252-463, 255, 256, 258, 269-262 Byzantine, middle, 267-273, 268-272 Carolingian, 321-325, 322, 233, 324 Chatal Huyuk, Anatohia, 28, 29 Byzantine, middle, 267-273, 268-272 Carolingian, 321-325, 322, 233, 324 Chatal Huyuk, Anatohia, 28, 29 Byzantine middle, 267-273, 268-272 Carolingian, 321-325, 322, 233, 324 Chatal Huyuk, Anatohia, 28, 29 Byzantine multiple-dome plan, 275 central-plan churches, 242, 242 Carolingian, 321-325, 322, 233, 324 Chatal Huyuk, Anatohia, 28, 29 Byzantine multiple-dome plan, 275 central-plan churches, 242, 242 Carolingian, 321-325, 322, 233, 324 Chatal Huyuk, Anatohia, 28, 29 Byzantine multiple-dome plan, 275 central-plan churches, 242, 242 Carolingian, 321-325, 322, 233, 324 Chatal Huyuk, Anatohia, 28, 29 Byzantine multiple-dome plan, 275 central-plan churches, 242, 242 Carolingian, 321-325, 322, 233, 324 Chietau Huyuk, Anatohia, 28, 29 Byzantine and multiple-dome plan, 275 central-plan churches, 242, 243, 242,			
Corbel, 171, 146 Norseshoe, 291, 292 Islamic, 292 nodding agec, 446 pointed, 292, 355 round, 171, 172 transverse, 358 Architecture, elements of arches, vaults, and domes, 172, 172 archs and mugarnas, Islamic, 292, 292 Assyrian, 40–41, 42 Byzantine, andide, 267–273, 268–272 Carolingian, 321–325, 322, 323, 324 Chatal Huyuk, Anatolia, 28, 29 Christian, early, 242–249, 242–249 Egyptian pramids and mastabas, 55–59, 56, 57, 58 Egyptian rock-cut tombs, 63, 63 Egyptian rock-cut tombs, 63, 64 Egyptian rock-cut tombs, 63, 68 Egyptian rock-cut tombs, 63, 69 Tenghish, Gothic, 409–411, 410, 411 Etruscan, 170–171, 173–174, 173 French, Gothic, Sed-602, 387–402 Gothic, German, Gothic, 411–412, 412, 413 Gothic, English, Gothic, 409–411, 410, 411 Gothic, English, Gothic, 409–411, 410, 411 Gothic, French, 386–402, 387–402 Gothic, German (Holy Roman Empire, Gothic, 410–412, 412, 413 Gothic, English, 409–411, 410, 411 Gothic, English, Gothic, German (Holy Roman Empire, Gothic, 410–412, 412, 413 Gothic, English, Gothic, 410–412, 412, 413 Gothic, English, 409–411, 410, 411 Gothic, English, 409–411, 410, 411 Gothic, English, Gothic, 410–412, 412, 413 Gothic, English, 409–411, 410, 411 Gothic, E			
Sumerian, 30, 30, 33, 33, 33 Islamic, 292 nodding agec, 446 pointed, 292, 355 round, 171, 172 transverse, 558 Architecture, 2 elements of round, 171, 172 Architecture, 2 elements of received and flag timber, 331, 332, 333, 333 Architecture, 292, 242 Architecture, 2 elements of received and flag timber, 331, 332, 333, 333 Architecture, 292, 242 Architecture, 2 elements of received and flag timber, 331, 332, 333, 333 Architecture, 292, 242 Architecture, 2 elements of received and flag timber, 331, 332, 333, 333 Architecture, 292, 242 Architecture, 2 elements of received and flag timber, 331, 332, 333, 333 Architecture, 292, 242 Architecture, 2 elements of received and flag timber, 331, 332, 333, 333 Architecture, 2 elements of received and flag timber, 331, 332, 333, 333 Architecture, 2 elements of received and sequence and se	corbel, 171, 446		
Viking timber, 331, 332, 333, 333 Aten, 72 Athanadoros, Laccoon and His Som, xxxvii, 163–164 Athena, Heakes, and Atlas, 131, 131 Athena, Heakes, and, 141s, 131, 131 Athena, Heakes, and, Atlas, 131, 131 Athena	horseshoe, 291, 292	Sumerian, 30, 30, 33, 33	
pointed, 292, 355 round, 171, 172 transverse, 358 Architecture, Ain Ghazal, Jordan, 28, 29 Assyrian, 40–41, 42 Byzantine, early, 254–263, 255, 256, 258, 260–262 Byzantine, late, 278, 279 Byzantine, middle, 267–273, 268–272 Carolingian, 321–325, 322, 323, 324 Chatal Huyuk, Anatolia, 28, 29 Christian, early, 242–249, 242–249 Egyptian pryamids and mastabas, 55–59, 36, 57, 58 Egyptian rock-cut tombs, 63, 63 Egyptian formelpies, 67–72, 68, 69, 71, 75–78, 76, 77 English, fourteenth century, 446–448, 447 Gorbic, French, 366–402, 387–402 Corrman, Gothic, 410–411, 410, 411 Etruscan, 170–171, 173–174, 173 French, Gothic, 409–411, 410, 411 Gothic, French, 366–402, 387–402 Corrman, Gothic, 411–412, 412, 413 Gothic, English, 409–411, 410, 411 Gothic, French, 386–402, 387–402 Corrman, Gothic, 411–412, 412, 413 Gothic, English, 409–411, 410, 411 Gothic, French, 386–402, 387–402 Hollam, 50valudian, 410, 416 Greek (Archaic period), 116, 117–119, 117 Greek city plans, orthogonal, 149–150, 149 Holly Roman Empire, Gothic, 411–412, 412, 413 Gothic, English, 409, 411, 410, 411 Greek Parthenon, Acropolis, 136–144, 138, 139, 143 Hellenistic, 158–160, 158, 159 Holly Roman Empire, Gothic, 411–412, 412, 413 Gorek city plans, orthogonal, 149–150, 149 Holly Roman Empire, Gothic, 411–412, 412, 413 Greek Parthenon, Acropolis, 136–144, 138, 139, 143 Hellenistic, 158–160, 158, 159 Holly Roman Empire, Gothic, 411–412, 412, 413 Greek Parthenon, Acropolis, 136–144, 138, 139, 143 Hellenistic, 158–160, 158, 159 Holly Roman Empire, Gothic, 411–412, 412, 413 Greek parthely plan churches, 242, 243, 242, 243, 242, 244, 244, 244			Asturians, 319
round, 171, 172 transverse, 358 Architecture Ain Ghazal, Jordan, 28, 29 Assyrian, 40–41, 42 Byzantine, early, 254–263, 255, 256, 258, 260–262 Byzantine, late, 278, 279 Byzantine, middle, 267–273, 268–272 Carolingian, 321–325, 322, 323, 324 Chatal Huyuk, Anatolia, 28, 29 Christian, early, 242–249, 242–249 Egyptian pyramids and mastabas, 55–59, 56, 57, 58 Egyptian remples, 67–72, 68, 69, 71, 75–78, 76, 77 English, fourtcearth century, 446–448, 447 Etruscan, 170–171, 173–174, 173 English, Gottic, 409–411, 410, 411 Etruscan, 170–171, 173–174, 173 Gottic, Engenha, 366–402, 387–402 German, Gottic, 411–412, 442, 413 Gottic, Engenha, 366–402, 387–402 Gorman, Gottic, 411–412, 442, 413 Gottic, Engenha, 366–402, 387–402 Gorman, Gottic, 411–412, 442, 413 Gottic, Engenha, 366–402, 387–402 Gorman, Gottic, 1411–412, 442, 413 Gottic, Enernha, 366–402, 387–402 Gorman, Gottic, 1411–412, 442, 413 Gottic, Engenha, 360–911, 410, 411 Greek (Archaic period), 116, 117–119, 117 Greek Parthenon, Acropolis, 136–144, 138, 139, 143 Islamic, 280–292, 286–292, 295, 297–300, 297, 298, 300 Italian, fourteenth century, 427–429, 427, 428, 429 Italian, Gottic, 416, 416 Minoan, Resen, 192, 101 Athena, 109, 110 Athena, 109, 129 Athena 10s, 29, 292 Athena 10s, 150, 163 Athena 10sk, temple of, 166, 144–145, 141 Athena Atacking the Ciams, 162, 163 Athena Promaia, sanctuary of, 150–151, 150 Soc also Acropolis Athena Horakies, and 141s, 131 Athena Atacking the Ciams, 162, 163 Athena Promaia, sanctuary of, 150–151, 150 Iso			Aten, 72
Architecture Ain Ghazal, Jordan, 28, 29 Asyrtan, 40–41, 42 Byzantine, early, 254–203, 255, 256, 258, 260–262 Byzantine, middle, 267–273, 268–272 Carolingian, 321–323, 322, 323, 324 Chatal Huyuk, Anatolia, 28, 29 Christian, early, 242–249, 242–249 Egyptian pyramids and mastabas, 55–59, 36, 57, 58 Egyptian rock-cut tombs, 63, 63 Egyptian rock-cut tombs, 63, 63 Egyptian rock-cut tombs, 63, 67 Egyptian pyramids and mastabas, 55–59, 36, 57, 58 Egyptian pok-method, 240, 247 English, Gorbic, 410–411, 410, 411 Etruscan, 170–171, 173–174, 173 French, Gorbic, 386–402, 387–402 German, Gotbic, 411–412, 412, 413 Gotbic, French, 386–402, 387–402 Gotbic, German (Holy Roman Empire) 411–412, 412, 413 Gotbic, Fernch, 386–402, 387–402 Gotbic, German (Holy Roman Empire) 411–412, 412, 413 Gotbic, French, 386–402, 387–402 Gotbic, German (Holy Roman Empire) 411–412, 412, 413 Gotbic, French, 386–402, 387–402 Hollain, Julian, 416, 416 Greek (Archaic period), 116, 117–119, 177 Greek (Archaic period), 116, 117–119, 177 Greek city plans, orthogonal, 149–150, 149 Holy Roman Empire, Gotbic, 411–412, 412, 413 Gorbic, Italian, 416, 416 Greek Parthenon, Acropolis, 136–144, 138, 139, 143 Hamic, 280–292, 286–292, 295, 297–300, 297, 298, 300 Ialian, fourtienth century, 427–429, 427, 428, 429 Italian, Gotbic, 416, 416 Minoan, 86–88, 87, 88 archs and mugarnas, Islanic, 224, 242, 243, 242, 44 Gotbic church, 392, 392 Central-plan churches, 242, 242, 242 Gotbic church, 392, 392 Equital multiple-dome plan, 215 Ecentral-plan churches, 242, 242 Gotbic church, 392, 392 Greek orders, 117, 118, 118, 158–159, 158 Byathine multiple-dome plan, 215 Central-plan churches, 242, 242 Greek orders, 117, 118, 118, 158–159, 158 Byzantine, nutdile, 267–273, 268–272 Carolingian, 321–325, 322, 323, 324 Carolingian, 321–3	- In the second second		
Arbitecture Ain Ghazal, Jordan, 28, 29 Assyrian, 40–41, 42 Byzantine, early, 254–263, 255, 256, 258, 269 Byzantine, indielle, 267–273, 268–272 Carolingan, 321–325, 322, 323, 324 Chatal Huyuk, Anatolia, 28, 29 Egyptian pyramids and mastabas, 55–59, 36, 57, 58 Egyptian rock-cut tombs, 63, 63 Egyptian fook-cut, 141–412, 412 Efruscan, 170–171, 173–174, 173 English, Gothic, 409–411, 410, 411 Efruscan, 170–171, 173–174, 173 Grench, Gothic, 386–402, 387–402 German, Gothic, 411–412, 412, 413 Gothic, Engnhs, 409–411, 410, 411 Gothic, French, 386–402, 387–402 Gothic, Cerman (Holy Roman Empire) 411–412, 412, 413 Gothic, Italian, 416, 416 Greek (Archaic period), 116, 117–119, 117 Gothic, Italian, 416, 416 Greek (Archaic period), 116, 117–119, 117 Gothic, Italian, 416, 416 Greek (Archaic period), 116, 117–119, 117 Gothic, Italian, 416, 416 Greek (Archaic period), 116, 117–119, 117 Gothic, Italian, 416, 416 Greek (Archaic period), 116, 117–119, 117 Gothic, Italian, 416, 416 Greek (Archaic period), 116, 117–119, 117 Gothic, Italian, 416, 416 Greek (Archaic period), 116, 117–119, 117 Greek (Archaic period), 116, 117–11			
Ain Ghazal, Jordan, 28, 29 Asyrtian, 40–41, 42 Byzantine, early, 254–263, 255, 256, 258, 260–262 Byzantine, late, 278, 279 Byzantine, middle, 267–273, 268–272 Carolingan, 321–325, 322, 323, 324 Chatal Huyuk, Anatolia, 28, 29 Christian, early, 242–249, 242–249 Egyptian pyramids and mastabas, 55–59, 36, 57, 58 Egyptian rock-cut tombs, 63, 63 Egyptian rock-cut tombs, 63, 63 Egyptian rock-cut tombs, 63, 64 Egyptian rock-cut tombs, 63, 67 Egyptian rock-cut tombs, 63, 68 Egyptian rock-cut tombs, 63, 69 Egyptian pyramids and mastabas, 140 English, 60-411, 410, 411 Etruscan, 170–171, 173–174, 173 Eruscan, 170–171, 173–174, 173 E			
Asyrian, 40-41, 42 Byzantine, early, 254–263, 255, 256, 258, 260–262 Byzantine, late, 278, 279 Byzantine, middle, 267–273, 268–272 Carolingian, 321–325, 322, 323, 324 Chatal Huyuk, Anatolia, 28, 29 Edition, and y, 242–249, 242–249 Egyptian pryamids and mastabas, 55–59, 56, 57, 58 Egyptian rock-cut tombs, 63, 63 Egyptian frock-cut tombs, 63, 63 Egyptian fourteenth century, 446–448, 447 English, Gothic, 409–411, 410, 411 Etruscan, 170–171, 173–174, 173 French, Gothic, 386–402, 387–402 German, Gothic, 411–412, 412, 413 Gothic, English, 409–411, 410, 411 Gothic, French, 386–402, 387–402 Gothic, English, 409–411, 410, 411 Gothic, French, 386–402, 387–402 Gothic, German (Holy Roman Empire) 411–412, 412, 413 Gothic, French, 186–180, 158, 159 Holy Roman Empire, Gothic, 411–412, 413 Islamic, 286–292, 286–292, 295, 297–300, 297, 298, 300 Hellemistic, 188–160, 158, 159 Holy Roman Empire, Gothic, 411–412, 413 Islamic, 286–292, 286–292, 295, 297–300, 297, 298, 300 Italian, Gothic, 416, 416 Image and the proper of the stable and the proper of the construction, and the construction and the construction, and the construction, and the construction and the construction and the construction, and the construction and the construction and the cons			
Byzantine, early, 254–263, 255, 256, 269–262 Byzantine, late, 278, 279 Byzantine, middle, 267–273, 268–272 Carolingian, 321–325, 322, 323, 324 Chatal Huyuk, Anatolia, 28, 29 Christian, early, 242–249, 242–249 Egyptian pyramids and mastabas, 55–59, 56, 57, 58 Egyptian rock-cut tombs, 63, 63 Egyptian temples, 67–72, 68, 69, 71, 75–78, 76, 77 English, Gothic, 409–411, 410, 411 Etruscan, 170–171, 173–174, 173 French, Gothic, 409–411, 410, 411 Gothic, English, 409–411 Gothic, English, 409–410 Gothic, German (Holp) Roman Empire) 411–412, 412, 413 Gothic, English, 409–411 Gothic, English, 409–410 Arch of Titus, Rome, 199, 200, 201, 201 Arch of Titus, Rome, 199, 200, 201, 201 Arch of Titus, Rome, 199, 200, 201, 201 Arch of Titus, Rome, 199, 200, 201			
258, 260–262 Byzantine, late, 278, 279 Byzantine, middle, 267–273, 268–272 Carolingian, 321–325, 322, 323, 324 Chatal Huyuk, Anatolia, 28, 29 Christian, early, 242–249, 242–249 Egyptian pyramids and mastabas, 55–59, 56, 57, 58 Egyptian rock-cut tombs, 63, 63 Egyptian rock-cut tombs, 63, 63 Egyptian temples, 67–72, 68, 69, 71, 75–78, 76, 77 English, Gotthic, 409–411, 410, 411 Etruscan, 170–171, 173–174, 173 French, Gothic, 410–411, 410, 411 Gothic, French, 386–402, 387–402 Gothic, German (Holy Roman Empire) 411–412, 412, 413 Gothic, German (Holy Roman Empire) 411–412, 412, 413 Gothic, German (Holy Roman Empire) 411–412, 412, 413 Greek (Archaic period), 116, 117–119, 117 Greek (Archaic period), 116, 117–119, 117 Greek (27) Greek (27) Gothic, 138, 139, 143 Hellenistic, 158–160, 158, 159 Holy Roman Empire, Gothic, 411–412, 412, 413 Islamic, 286–292, 286–292, 295, 297–300, 297, 298, 300 Italian, fourtcenth century, 427–429, 427, 428, 429 Italian, Gothic, 416, 416 Minoan, 86–88, 87, 88 Gothic church, 392, 392 Greek orders, 117, 118, 118, 158–159, 167 Greek temple plans, 116, 116 mastaba to pyramid, 56 mastaba to pyramid, 56 mastaba to pyramid, 56 mastaba to pyramid, 56 mosque plans, 289, 289 pendentives and squinches, 257, 257 post-and-lintel and corbel construction, 41 and thens, 108–109, 114–115, 125, 130, 44hen, 108–109, 114–115, 125, 130, 44hen, 108–109, 114–115, 125, 130, 44hen, 109–409, 144–415, 142, 413 Gothic, French, 366–402, 387–402 Gothic, English, 409–411, 410, 411 Gothic, French, 386–402, 387–402 Gothic, German (Holy Roman Empire, Gothic, 411–412, 412, 413 Hellenistic, 158–160, 158, 159 Holy Roman Empire, Gothic, 411–412, 412, 413 Islamic, 286–292, 286–292, 295, 297–300, 297, 298, 300 Italian, fourtcenth century, 427–429, 427, 428, 429 Italian, Gothic, 416, 416 Minoan, 80–80, 27, 80, 20 Gre			
Byzantine, late, 278, 279 Byzantine, middle, 267–273, 268–272 158 150 150 150 150 150 151 150	***		
Byzantine, middle, 267–273, 268–272 Carolingian, 321–325, 322, 323, 324 Chatal Huyuk, Anatolia, 28, 29 Christian, early, 242–249, 242–249 Egyptian pyramids and mastabas, 55–59, 56, 57, 58 Egyptian rock-cut tombs, 63, 63 Egyptian rock-cut tombs, 63, 63 Egyptian rock-cut tombs, 63, 63 Egyptian temples, 67–72, 68, 69, 71, 75–78, 76, 77 English, fourteemth century, 446–448, 447 English, Gothic, 409–411, 410, 411 Etruscan, 170–171, 173–174, 173 French, Cothic, 386–402, 387–402 Gothic, English, 409–411, 410, 411 Gothic, French, 386–402, 387–402 Gothic, German (Holy Roman Empire) 411–412, 412, 413 Gothic, Italian, 416, 416 Greek (archaic period), 116, 117–119, 117 Greek Parthenon, Acropolis, 136–144, 138, 139, 143 Hellenistic, 158–160, 158, 159 Holy Roman Empire, Gothic, 416, 416 Minoan, 86–88, 87, 88 See Sabs Acrob, 257, 257 Athenian Agora, 145–147, 146 Athenian Agora, 145–147, 147, 147, 1203 Archirdray, 139 Archirdray, 139 Arch			
Chatal Huyuk, Anatolia, 28, 29 Christian, early, 242–249, 242–249 Egyptian pyramids and mastabas, 55–59, 56, 57, 58 Egyptian rock-cut tombs, 63, 63 Egyptian temples, 67–72, 68, 69, 71, 75–78, 76, 77 English, fourteenth century, 446–448, 447 English, Gothic, 409–411, 410, 411 Etruscan, 170–171, 173–174, 173 French, Gothic, 386–402, 387–402 German, Gothic, 411–412, 412, 413 Gothic, German (Holy Roman Empire) 411–412, 412, 413 Gothic, German (Holy Roman Empire) 411–412, 412, 413 Greek (Archaic period), 116, 117–119, 118, 1319, 143 Hellenistic, 158–160, 158, 159 Greek Parthenon, Acropolis, 136–144, 138, 139, 143 Hellenistic, 158–160, 158, 159 Holy Roman Empire, Gothic, 416 Greek Parthenon, Acropolis, 136–144, 138, 139, 143 Hellenistic, 158–160, 158, 159 Holy Roman Empire, Gothic, 416 Lalian, Gothic, 416, 416 Minoan, 86–88, 87, 88 mastaba to pyramids, 56 mosque plans, 289, 289 pendentives and squinches, 257, 257 post-and-lintel and corbel construction, 14 mosque plans, 289, 289 pendentives and squinches, 257, 257 post-and-lintel and corbel construction, 14 nemotives and squinches, 257, 257 Roman orders, 174, 174, 203 Roman techniques, 181–182 Tuscan order, 174, 174, 203 Architraves, 119 Architraves	Byzantine, middle, 267–273, 268–272		
Christian, early, 242–249 Egyptian pramids and mastabas, 55–59, 56, 57, 58 Egyptian pramids and mastabas, 55–59, 56, 57, 58 Egyptian pramids and mastabas, 63, 63 Egyptian prock-cut tombs, 63, 63 Egyptian temples, 67–72, 68, 69, 71, 75–78, 76, 77 English, fourteenth century, 446–448, 447 English, Gothic, 409–411, 410, 411 Etruscan, 170–171, 173–174, 173 French, Gothic, 386–402, 387–402 German, Gothic, 411–412, 412, 413 Gothic, English, 409–411, 410, 411 Gothic, German (Holy Roman Empire) 411–412, 412, 413 Gothic, Italian, 416, 416 Greek (Archaic period), 116, 117–119, 117 Greek Parthenon, Acropolis, 136–144, 138, 139, 143 Hellenistic, 158–160, 158, 159 Holy Roman Empire, Gothic, 416, 416 Greek Parthenon, Acropolis, 136–144, 138, 139, 143 Hellenistic, 158–160, 158, 159 Holy Roman Empire, Gothic, 416, 416 Greek Parthenon, Acropolis, 136–144, 12, 412, 413 Islamic, 286–292, 286–292, 295, 297–300, 297, 298, 300 Italian, Gourteenth century, 427–429, 427, 428, 429 Italian, Gothic, 416, 416 Minoan, 86–88, 87, 88 mosque plans, 289, 289 pendentives and squinches, 257, 257 post-and-lintel and corbel construction. 14 Italian, Gothic, 416, 416 Roman odrest, 174, 174, 203 Roman orders, 181–182 Tuscan order, 173, 174, 203 Arch of Constantine, Rome, 226–227, 226 Arch of Titus, Rome, 199, 200, 201, 201 Architaves, 119 Architaves, 139 Arch of Constantine, Rome, 226–227, 288, 189 Arch of Titus, Rome, 199, 200, 201, 201 Architaves, 119 Architaves, 139 Arch of Titus, Rome, 199,			
Egyptian pyramids and mastabas, 55–59, 36, 57, 58 post-and-linted and corbel construction, 14 rib vaulting, 391, 391 Attack on the Castle of Love, jewelry box lid, 441, 445 Roman orders, 174, 174, 203 Roman techniques, 181–182 Tuscan, 170–171, 173–174, 173 Trench, Gothic, 409–411, 410, 411 Erruscan, 170–171, 173–174, 173 French, Gothic, 411–412, 412, 413 Gothic, English, 409–411, 410, 411 Gothic, French, 386–402, 387–402 Gothic, German (Holy Roman Empire) 411–412, 412, 413 Gothic, Italian, 416, 416 Greek (Archaic period), 116, 117–119, 117 Greek Parthenon, Acropolis, 136–144, 138, 139, 143 Hellenistic, 158–160, 158, 159 Holy Roman Empire, Gothic, 411–412, 412, 413 Islamic, 286–292, 286–292, 295, 297–300, 297, 298, 300 Italian, fourteenth century, 427–429, 427, 428, 429 Italian, Gothic, 416, 416 Minoan, 86–88, 87, 88 Minoan, 86–88, 87, 88 Pince of the corbinal or set of the corbinal or set of the corbin or set of t			
post-and-lintel and corbel construction, 14 Atlas, Atlnea, Herakles, and, 131, 131 Atmospheric (aerial) perspective, 195 Atlas, Atlnea, Herakles, and, 131, 131 Atmospheric (aerial) perspective, 195 Atlas, Atlnea, Herakles, and, 131, 131 Atmospheric (aerial) perspective, 195 Atlas, Atlnea, Herakles, and, 131, 131 Atmospheric (aerial) perspective, 195 Atlas, Atlnea, Herakles, and, 131, 131 Atmospheric (aerial) perspective, 195 Atlas, Atlnea, Herakles, and, 131, 131 Atmospheric (aerial) perspective, 195 Attack on the Castle of Love, jewelry box lid, 444, 445 Attack on the Castle of Love, jewelry box lid, 444, 445 Attack on the Castle of Love, jewelry box lid, 444, 445 Attack on the Castle of Love, jewelry box lid, 444, 445 Attack on the Castle of Love,			
Egyptian rock-cut tombs, 63, 63 Egyptian temples, 67–72, 68, 69, 71, 75–78, 76, 77 English, fourteenth century, 446–448, 447 English, Gothic, 409–411, 410, 411 Etruscan, 170–171, 173–174, 173 French, Gothic, 386–402, 387–402 German, Gothic, 411–412, 412, 413 Gothic, English, 409–411, 410, 411 Gothic, French, 386–402, 387–402 Gothic, German (Holy Roman Empire) 411–412, 412, 413 Gothic, Italian, 416, 416 Greek (Archaic period), 116, 117–119, 117 Greek Parthenon, Acropolis, 136–144, 138, 139, 143 Hellenistic, 158–160, 158, 159 Holy Roman Empire, Gothic, 411–412, 413, 413 Islamic, 286–292, 286–292, 295, 297–300, 297, 298, 300 Italian, fourteenth century, 427–429, 427, 428, 429 Italian, Gothic, 416, 416 Minoan, 86–88, 87, 88 Islamic, 286–88, 87, 88 Atmospheric (aerial) perspective, 195 Atriun, 170, 192, 242 Attako on the Castle of Love, jewelry box lid, 444, 445 Attalos 1, 160 Attila, 21 Attalos 1, 160 Attila, 21 Attalos 1, 160 Attila, 21 Attalos 1, 160 Attila, 312 Attalos 1, 160 Attila, 21 Attalos 1, 160 Attila, 312 Attalos 1, 160 Attila, 312 Attalos 1, 160 Attila, 3, 31 Attalos 1, 160 Attila, 3, 12 Attalos 1, 160 Attila, 3, 31 Attalos 1, 160 Attila, 3, 12 Attalos			•
Egyptian temples, 67–72, 68, 69, 71, 75–78, 76, 77 English, 75–78, 76, 77 English, Gourteenth century, 446–448, 447 English, Gothic, 409–411, 410, 411 Etruscan, 170–171, 173–174, 173 French, Gothic, 386–402, 387–402 German, Gothic, 411–412, 412, 413 Gothic, English, 409–411, 410, 411 Gothic, Fench, 386–402, 387–402 Gothic, German (Holly Roman Empire) 411–412, 412, 413 Gothic, Italian, 416, 416 Greek (archaic period), 116, 117–119, 149 Greek Parthenon, Acropolis, 136–144, 138, 139, 143 Hellenistic, 158–160, 158, 159 Holy Roman Empire, Gothic, 411–412, 412, 413 Islamic, 286–292, 286–292, 295, 297–300, 297, 298, 300 Italian, Gourteenth century, 427–429, 427, 428, 429 Italian, Gothic, 416 Minoan, 86–88, 87, 88 Final vaulting, 391, 391 Roman orders, 174, 174, 203 Roman techniques, 181–182 Tuscan order, 173, 174, 203 Rodic, 181–182 Tuscan order, 173, 174, 203 Rodic, 181–182 Architraves, 119 Artialos, 1, 444, 445 Attalos 1, 404 Attalos, 1, 60 Attila, 312 Augustan sculpture, 186–190, 186, 187, 188, 189 Argois of the Covenan, 236, 236 Argois of the Covenan, 236, 236 Art of the Covenan			
Roman orders, 174, 174, 203 Roman techniques, 181–182 Tuscan order, 173, 174, 203 Idd, 444, 445 Attalos I, 160 Attalos II, 180 Attalos II, 1			
English, fourteenth century, 446—448, 447 447 English, Gothic, 409—411, 410, 411 Etruscan, 170—171, 173—174, 173 French, Gothic, 386—402, 387—402 German, Gothic, 411—412, 412, 413 Gothic, French, 386—402, 387—402 Gothic, German (Holy Roman Empire) 411—412, 412, 413 Gothic, Gerek (Archaic period), 116, 117—119, 117 Greek (ity plans, orthogonal, 149—150, 149 Greek Parthenon, Acropolis, 136—144, 138, 139, 143 Hellenistic, 158—160, 158, 159 Holy Roman Empire, Gothic, 411—412, 412, 413 Islamic, 286—292, 286—292, 295, 297—300, 297, 298, 300 Italian, Gothic, 416, 416 Minoan, 86—88, 87, 88 Roman techniques, 181—182 Tuscan order, 173, 174, 203 wood, 332, 332 Archivraes, 119 Architraves, 119 Archivraes, 129 Archof Constantine, Rome, 226–227, 206 Ared of Constantine, Rome, 226–227, 201 Area, 202—203 Area, 202—203 Area, 202—203 Ares, 109, 120 Area, 202—203 Ares, 109, 120 Area, 202—203 Augustae, 404 Augustae, 180—190, 189 Augustae, 180—190,			
## Tuscan order, 173, 174, 203 wood, 332, 332 ## Etruscan, 170–171, 173–174, 173 ## French, Gothic, 386–402, 387–402 ## Gothic, English, 409–411, 410, 411 ## Gothic, French, 386–402, 387–402 ## Gothic, German (Holy Roman Empire) 411–412, 413 ## Greek (Archaic period), 116, 117–119, 117 ## Greek Parthenon, Acropolis, 136–144, 138, 139, 143 ## Hellenistic, 158–160, 158, 159 ## Holy Roman Empire, Gothic, 411–412, 412, 413 ## Hellenistic, 158–60, 158, 159 ## Holy Roman Empire, Gothic, 411–412, 413 ## Hellenistic, 158–60, 158, 159 ## Holy Roman Empire, Gothic, 411–412, 413 ## Islamic, 286–292, 286–292, 295, 297–300, 297, 298, 300 ## Italian, Gothic, 416, 416 ## Minoan, 86–88, 87, 88 ## Tuscan order, 173, 174, 203 ## wood, 332, 332 ## Arch of Constantine, Rome, 226–227, 226 ## Arch of Constantine, Rome, 226–227, 226 ## Arch of Constantine, Rome, 290–207, 201 ## Arch of Constantine, Rome, 296–227, 226 ## Arch of Titus, Rome, 199, 200, 201, 201 ## Area, 202–203 ## Arcs, 109, 110 ## Arcs, 109			
Etruscan, 170–171, 173–174, 173 French, Gothic, 386–402, 387–402 German, Gothic, 411–412, 413 Gothic, English, 409–411, 410, 411 Gothic, French, 386–402, 387–402 Gothic, German (Holy Roman Empire) 411–412, 413 Gothic, Italian, 416, 416 Greek (Archaic period), 116, 117–119, 117 Greek (Archaic period), 116, 117–119, 149 Greek Parthenon, Acropolis, 136–144, 138, 139, 143 Hellenistic, 158–160, 158, 159 Holy Roman Empire, Gothic, 411–412, 412, 413 Islamic, 286–292, 286–292, 295, 297–300, 297, 298, 300 Italian, Gothic, 416, 416 Minoan, 86–88, 87, 88 Arch of Constantine, Rome, 226–227, 226 Arch of Cittus, Rome, 199, 200, 201, 201 Arch of Constantine, Rome, 226–227, 226 Arch of Constantine, Rome, 226–227, 226 Arch of Constantine, Rome, 290–201, 201 Arch of Constantine, Rome, 226–227, 226 Arch of Constantine, Rome, 226–227, 226 Arch of Titus, Rome, 199, 200, 201, 201 Area, 202–203 Area, 199, 110 Arisotle, xxxii, 128, 149, 385 Ark of the Covenant, 236, 236 Art defined, xxxiii history, xlvi–xlvii nature of, xxxiii nature of, xxxiii nature of, xxxiii nature of, xxxiii patrons and collectors, role of, xliii–xlvi reasons for having, xxxvii–xxxvii B Babylon (Babylonians), 31, 37, 38 neo-, 42 Bacchus, 110, 194, 229 Bailey, 363 Ballbilla, Julia, 198 Baldacchino, 420	447		
French, Gothic, 386–402, 387–402 German, Gothic, 411–412, 413, 413 Gothic, English, 409–411, 410, 411 Gothic, French, 386–402, 387–402 Gothic, German (Holy Roman Empire) 411–412, 413 Gothic, Italian, 416, 416 Greek (Archaic period), 116, 117–119, 117 Greek (Archaic period), 116, 117–119, 149 Greek Parthenon, Acropolis, 136–144, 138, 139, 143 Hellenistic, 158–160, 158, 159 Holy Roman Empire, Gothic, 411–412, 413 Islamic, 286–292, 286–292, 295, 297–300, 297, 298, 300 Italian, fourteenth century, 427–429, 427, 428, 429 Italian, Gothic, 416, 416 Minoan, 86–88, 87, 88 Archivolts, 365 Arch of Constantine, Rome, 226–227, 226 Arch of Constantine, Rome, 199, 200, 201, 201 Ara Razis Augustae (Altar of Augustas (Peace), 189–180, 189 Ara Pacis Augustae, 189–190, 189 Ara Pacis Augustae (Altar of Augustas (Peace), 187–189, 187, 188 German Augustae, 189–190, 189 Arg stron, 190, 189 Arg stron, 190, 180 Arch of Constantine, Rome, 199, 200, 201, 201 Arch of Constantine, Rome, 199, 200, 201, 201 Arch of Const			Attila, 312
German, Gothic, 411–412, 413 Gothic, English, 409–411, 410, 411 Gothic, French, 386–402, 387–402 Gothic, German (Holy Roman Empire) 411–412, 412, 413 Gothic, Italian, 416, 416 Greek (Archaic period), 116, 117–119, 149 Greek City plans, orthogonal, 149–150, 149 Greek Parthenon, Acropolis, 136–144, 138, 139, 143 Hellenistic, 158–160, 158, 159 Holy Roman Empire, Gothic, 411–412, 412, 413 Islamic, 286–292, 286–292, 295, 297–300, 297, 298, 300 Italian, Gothic, 416, 416 Minoan, 86–88, 87, 88 Arch of Constantine, Rome, 226–227, 226, 226–227, 226 Arch of Titus, Rome, 199, 200, 201, 201 Arena, 202–203 Arch of Titus, Rome, 199, 200, 201, 201 Arch of City, Rome, 199, 200, 201, 201 Arch of City, Rome, 199, 200, 201, 201 Arch of City, Rome, 199, 200, 201, 201 Arch of Titus, Rome, 199, 200, 201, 201 Arch of City, Rome, 199, 200, 201, 201 Arch of Titus, Rome, 199, 200, 201, 201 Arch of Titus, Rome, 199, 200, 201, 201 Arch of Titus, Rome, 199, 200, 201, 201 Arch of City, Rome, 199, 200, 201, 201 Arch of Titus, Rome, 199, 200, 201, 201 Arch of Ti			
Gothic, English, 409–411, 410, 411 Gothic, French, 386–402, 387–402 Gothic, German (Holy Roman Empire) 411–412, 413 Gothic, Italian, 416, 416 Greek (Archaic period), 116, 117–119, 149 Greek Parthenon, Acropolis, 136–144, 138, 139, 143 Hellenistic, 158–160, 158, 159 Holy Roman Empire, Gothic, 411–412, 413 Islamic, 286–292, 286–292, 295, 297–300, 297, 298, 300 Italian, Gothic, 416, 416 Islamic, Gothic, 416			
Gothic, French, 386–402, 387–402 Gothic, German (Holy Roman Empire) 411–412, 413 Gothic, Italian, 416, 416 Greek (Archaic period), 116, 117–119, 149 Greek Parthenon, Acropolis, 136–144, 138, 139, 143 Hellenistic, 158–160, 158, 159 Holy Roman Empire, Gothic, 411–412, 413 Islamic, 286–292, 286–292, 295, 297–300, 297, 298, 300 Italian, Gourteenth century, 427–429, 427, 428, 429 Italian, Gothic, 416, 416 Image: Arch of Titus, Rome, 199, 200, 201, 201 Gemna Augustea, 189–190, 189 Augustine, Saint, 312, 316 Augustus, 185, 205 Augustus of Primaporta, Roman, 186–187, 186 Copy with color restored, 186, 186 Aulus Metellus (The Orator), Roman, 180, 181 Autria, Woman from Willendorf, 4, 5 Autun, Burgundy, France, Saint-Lazare cathedral, 367–368, 367, 368 Babylon (Babylonians), 31, 37, 38 neo., 42 Bacchus, 110, 194, 229 Bacchus, 110, 194, 229 Bacchus, 110, 194, 229 Balley, 363 Balbilla, Julia, 198 Baldacchino, 420			
Gothic, German (Holy Roman Empire) 411–412, 413 Greek (Archaic period), 116, 117–119, 117 Greek (Archaic period), 116, 117–119, 117 Greek city plans, orthogonal, 149–150, 149 Greek Parthenon, Acropolis, 136–144, 138, 139, 143 Hellenistic, 158–160, 158, 159 Holy Roman Empire, Gothic, 411–412, 412, 413 Islamic, 286–292, 286–292, 295, 297–300, 297, 298, 300 Italian, fourteenth century, 427–429, 427, 428, 429 Italian, Gothic, 416, 416 Minoan, 86–88, 87, 88 Arena, 202–203 Arena, 202–203 Arena, 202–203 Arena, 202–203 Ares, 109, 110 Augustine, Saint, 312, 316 Augustine, Saint, 312, 316 Augustus, 185, 205 Augustus, 186 Aulus Metellus (The Orator), Augustus of Primaporta, Roman, 180, 181 Austria, Woman from Willendorf, 4, 5 Autun, Burgun			
Empire) 411–412, 412, 413 Gothic, Italian, 416, 416 Greek (Archaic period), 116, 117–119, 117 Greek (Archaic period), 116, 117–119, 117 Greek city plans, orthogonal, 149–150, 149 Greek Parthenon, Acropolis, 136–144, 138, 139, 143 Hellenistic, 158–160, 158, 159 Holy Roman Empire, Gothic, 411–412, 412, 413 Islamic, 286–292, 286–292, 295, 297–300, 297, 298, 300 Italian, Gothic, 416, 416 Minoan, 86–88, 87, 88 Ares, 109, 110 Augustus, 185, 205 Augustus of Primaporta, Roman, 186–187, 186 copy with color restored, 186, 186 Aulus Metellus (The Orator), Roman, 180, 181 Austria, Woman from Willendorf, 4, 5 Autun, Burgundy, France, Saint-Lazare cathedral, 367–368, 367, 368 B Babylon (Babylonians), 31, 37, 38 neo-, 42 Bacchus, 110, 194, 229 Bailey, 363 Balbilla, Julia, 198 Baldacchino, 420			
Gothic, Italian, 416, 416 Greek (Archaic period), 116, 117–119, 117 Greek city plans, orthogonal, 149–150, 149 Greek Parthenon, Acropolis, 136–144, 138, 139, 143 Hellenistic, 158–160, 158, 159 Holy Roman Empire, Gothic, 411–412, 412, 413 Islamic, 286–292, 286–292, 295, 297–300, 297, 298, 300 Italian, fourteenth century, 427–429, 427, 428, 429 Italian, Gothic, 416, 416 Minoan, 86–88, 87, 88 Arianism, 249 Aristotle, xxxiv, 128, 149, 385 Ark of the Covenant, 236, 236 Art defined, xxxiii history, xlvi–xlvii human figure as beauty and ideal, xxxvi–xxxvii nature of, xxxiii patrons and collectors, role of, xliii–xlvi reasons for having, xxxviii–xxxix social context and, xxxiv—xl social context and, xxxiv—xl sociopolitical intentions, xl Minoan, 86–88, 87, 88 Arianism, 249 Aristotle, xxxiv, 128, 149, 385 Ark of the Covenant, 236, 236 Art defined, xxxiii history, xlvi–xlvii human figure as beauty and ideal, xxxvi–xxxvii nature of, xxxiii patrons and collectors, role of, xliii–xlvi reasons for having, xxxviii–xxxix social context and, xxxiv—xl social context and, xxxiv—xl Babylon (Babylonians), 31, 37, 38 neo-, 42 Bacchus, 110, 194, 229 Bailey, 363 Balbilla, Julia, 198 Baldacchino, 420			
Greek (Archaic period), 116, 117–119, 117 Greek (ity plans, orthogonal, 149–150, 149 Greek Parthenon, Acropolis, 136–144, 138, 139, 143 Hellenistic, 158–160, 158, 159 Holy Roman Empire, Gothic, 411–412, 413 Islamic, 286–292, 286–292, 295, 297–300, 297, 298, 300 Italian, fourteenth century, 427–429, 427, 428, 429 Italian, Gothic, 416, 416 Minoan, 86–88, 87, 88 Ark of the Covenant, 236, 236 Art defined, xxxiii history, xlvi–xlvii nature of, xxxiii patrons and collectors, role of, xliii–xlvi reasons for having, xxxviii–xxxix social context and, xxxiii B B Babylon (Babylonians), 31, 37, 38 neo-, 42 Bacchus, 110, 194, 229 Bailey, 363 Balbilla, Julia, 198 Baldacchino, 420			
Ark of the Covenant, 236, 236 Greek city plans, orthogonal, 149–150, 149 Greek Parthenon, Acropolis, 136–144, 138, 139, 143 Hellenistic, 158–160, 158, 159 Holy Roman Empire, Gothic, 411–412, 412, 413 Islamic, 286–292, 286–292, 295, 297–300, 297, 298, 300 Italian, fourteenth century, 427–429, 427, 428, 429 Italian, Gothic, 416, 416 Minoan, 86–88, 87, 88 Ark of the Covenant, 236, 236 Art Aulus Metellus (The Orator), Roman, 180, 181 Austria, Woman from Willendorf, 4, 5 Autun, Burgundy, France, Saint-Lazare cathedral, 367–368, 367, 368 B B B B B B B B B B B B B	Greek (Archaic period), 116, 117-119,		
Greek city plans, orthogonal, 149–150, 149 Greek Parthenon, Acropolis, 136–144, 138, 139, 143 Holy Roman Empire, Gothic, 411–412, 412, 413 Islamic, 286–292, 286–292, 295, 297–300, 297, 298, 300 Italian, Gothic, 416, 416 Minoan, 86–88, 87, 88 Art defined, xxxiii history, xlvi–xlvii human figure as beauty and ideal, xxxvii–xxxviii nature of, xxxiii patrons and collectors, role of, xliii–xlvi reasons for having, xxxviii–xxxix social context and, xxxixi–xl sociopolitical intentions, xl Wins Metellus (The Orator), Roman, 180, 181 Austria, Woman from Willendorf, 4, 5 Autun, Burgundy, France, Saint-Lazare cathedral, 367–368, 367, 368 Babylon (Babylonians), 31, 37, 38 neo-, 42 Bacchus, 110, 194, 229 Bailey, 363 Balbilla, Julia, 198 Baldacchino, 420			copy with color restored, 186, 186
Greek Parthenon, Acropolis, 136–144, 138, 139, 143 Hellenistic, 158–160, 158, 159 Holy Roman Empire, Gothic, 411–412, 412, 413 Islamic, 286–292, 286–292, 295, 297–300, 297, 298, 300 Italian, Gothic, 416, 416 Minoan, 86–88, 87, 88 history, xlvi–xlvii human figure as beauty and ideal, xxxvi–xxxvii nature of, xxxiii nature of, xxxiii patrons and collectors, role of, xliii–xlvi reasons for having, xxxviii–xxxix social context and, xxxixi–xl Baustria, Woman from Willendorf, 4, 5 Autun, Burgundy, France, Saint–Lazare cathedral, 367–368, 367, 368 B Babylon (Babylonians), 31, 37, 38 neo-, 42 Bacchus, 110, 194, 229 Bailey, 363 Balbilla, Julia, 198 Baldacchino, 420	, 1		Aulus Metellus (The Orator), Roman, 180,
human figure as beauty and ideal, xxxvi-xxxvii Hellenistic, 158–160, 158, 159 Holy Roman Empire, Gothic, 411–412, 413 Islamic, 286–292, 286–292, 295, 297–300, 297, 298, 300 Italian, fourteenth century, 427–429, 427, 428, 429 Italian, Gothic, 416, 416 Minoan, 86–88, 87, 88 human figure as beauty and ideal, xxxvii and ideal, xxxviii modes of representation, xxxiii—xxxviii nature of, xxxiii patrons and collectors, role of, xliii–xlvi reasons for having, xxxviii—xxix social context and, xxxiii—xxxix social context and, xxxix—xl Babylon (Babylonians), 31, 37, 38 neo-, 42 Bacchus, 110, 194, 229 Bailey, 363 Balbilla, Julia, 198 Baldacchino, 420			
Hellenistic, 158–160, 158, 159 Holy Roman Empire, Gothic, 411–412, 412, 413 Islamic, 286–292, 286–292, 295, 297–300, 297, 298, 300 Italian, fourteenth century, 427–429, 427, 428, 429 Italian, Gothic, 416, 416 Minoan, 86–88, 87, 88 xxxvi–xxxvii nature of, xxxiii patrons and collectors, role of, xliii–xlvi reasons for having, xxxviii–xxxix social context and, xxxii–xxxix sociopolitical intentions, xl viewers, responsibilities of, xlvii xxxvi–xxxvii nature of, xxxiii patrons and collectors, role of, xliii–xlvi reasons for having, xxxviii–xxxix social context and, xxxii–xxxix sociopolitical intentions, xl viewers, responsibilities of, xlvii cathedral, 367–368, 367, 368 Babylon (Babylonians), 31, 37, 38 neo-, 42 Bacchus, 110, 194, 229 Bailey, 363 Balbilla, Julia, 198 Baldacchino, 420			
Holy Roman Empire, Gothic, 411–412, 412, 413 Islamic, 286–292, 286–292, 295, 297–300, 297, 298, 300 Italian, fourteenth century, 427–429, 427, 428, 429 Italian, Gothic, 416, 416 Minoan, 86–88, 87, 88 modes of representation, xxxiii—xxxxiii nature of, xxxiii patrons and collectors, role of, xliii—xlvi reasons for having, xxxviii—xxi search for meaning and, xxxviii—xxxix social context and, xxxix—xl Babylon (Babylonians), 31, 37, 38 neo-, 42 Bacchus, 110, 194, 229 Bailey, 363 Balbilla, Julia, 198 Baldacchino, 420			
412, 413nature of, xxxiiiBIslamic, 286–292, 286–292, 295, 297–300, 297, 298, 300patrons and collectors, role of, xliii–xlvi reasons for having, xxxviii–xlBabylon (Babylonians), 31, 37, 38Italian, fourteenth century, 427–429, 427, 428, 429search for meaning and, xxxviii–xxxix social context and, xxxix–xlBacchus, 110, 194, 229Italian, Gothic, 416, 416sociopolitical intentions, xlBalbilla, Julia, 198Minoan, 86–88, 87, 88viewers, responsibilities of, xlviiBaldacchino, 420			cathedral, 367–368, <i>367</i> , <i>368</i>
Islamic, 286–292, 286–292, 295, 297–300, 297, 298, 300 Italian, fourteenth century, 427–429, 427, 428, 429 Italian, Gothic, 416, 416 Minoan, 86–88, 87, 88 patrons and collectors, role of, xliii–xlvi reasons for having, xxxviii–xxi search for meaning and, xxxviii–xxxix social context and, xxxix–xl Babylon (Babylonians), 31, 37, 38 neo-, 42 Bacchus, 110, 194, 229 Bailey, 363 Balbilla, Julia, 198 Baldacchino, 420			В
297–300, 297, 298, 300 reasons for having, xxxviii–xl neo-, 42 Italian, fourteenth century, 427–429, search for meaning and, xxxviii–xxxix Bacchus, 110, 194, 229 427, 428, 429 social context and, xxxix–xl Bailey, 363 Italian, Gothic, 416, 416 sociopolitical intentions, xl Balbilla, Julia, 198 Minoan, 86–88, 87, 88 viewers, responsibilities of, xlvii Baldacchino, 420			
Italian, fourteenth century, 427–429,search for meaning and, xxxviii–xxxixBacchus, 110, 194, 229427, 428, 429social context and, xxxix–xlBailey, 363Italian, Gothic, 416, 416sociopolitical intentions, xlBalbilla, Julia, 198Minoan, 86–88, 87, 88viewers, responsibilities of, xlviiBaldacchino, 420		-	
427, 428, 429social context and, xxxix-xlBailey, 363Italian, Gothic, 416, 416sociopolitical intentions, xlBalbilla, Julia, 198Minoan, 86–88, 87, 88viewers, responsibilities of, xlviiBaldacchino, 420			
Minoan, 86–88, 87, 88 viewers, responsibilities of, xlvii Baldacchino, 420			
		-	
Niycenaean, 95–102, 96–102 Artemis, 109, 110, 134–135, 135 Baldachin, 358			
	Mycenaean, 95–102, <i>96–102</i>	Artemis, 109, 110, 134–135, <i>135</i>	Baldachin, 358

Queen Blanche of Castile and Louis IX Burial customs. See Funerary customs; Banner of Las Navas de Tolosa, Islamic, moralized, 406, 407 Tombs 302, 302 Burial ships Vulgate, 243, 325 Baptismal font (Reiner of Huy), Notre-Sutton Hoo, England, 316, 317 Bihzad, Kamal al-Din, 304, 305 Dame-Aux-Fonts, Liege, France, Viking, 329-330, 329, 330 Bird-Headed Man with Bison, Lascaux cave, 376-377, 377 9-10.9Busketos, 356 Baptistry of the Arians, Ravenna, 249 Buttresses, 172, 349, 362, 388 Bishop Odo Blessing the Feast, Bayeux Tapes-Baptistry of the Orthodox, Ravenna, 249, Byzantine art, early try, Norman, 374, 374, 375 Constantinople, churches in, 254-259, Bison, Altamira cave, Spain, 6, 7, 10, 10 Barrel vaults, 172, 358 Bison, Le Tuc d'Audoubert, France, 10, 11 255, 256, 258 Bar tracery, 401 Black Death, 424, 426, 445 dates for, 254 Bas-de-page, 443 icons and iconoclasm, 266-267, 266, Black-figure painted vases, 114, 115, Bases, of columns, 118 267 125-126, 125, 126 Basil I, 267 objects of veneration and devotion, Blanche of Castile, 398, 406, 407 Basil II, 268 263-265, 263, 264, 265 Boccaccio, Giovanni, The Decameron, 431 Basilica, Trier, Germany, 223–224, 223 Ravenna, churches in, 259-263, 260, Basilica of Maxentius and Constantine Bonanno, 356 261, 262 Boniface IV, pope, 212 (Basilica Nova), Rome, 227-228, Byzantine art, late Book of Genesis, 264, 264 227, 228 Book of Homilies (Guda), 378, 378 architecture, 278, 279 Basilica-plan churches, 242, 243, 242, 243 Book of Hours of Jeanne d'Evreux (Pucelle), dates for, 254 Basilicas, defined, 205-206 objects of veneration and devotion, 442-443, 443 Basilica Ulpia, Rome, 205-206, 207 278-279, 280 Book of Kells, Iona, Scotland, 310, 311, Basilica Ulpia, Rome, 206, 207 Byzantine art, middle 318, 319 Basil the Great of Cappadocia, 266 architecture and mosaics, 267–273, Book of the City of Ladies, The (Christine Baths of Caracalla, Rome, 219, 219 268-272 Baths of Diocletian, 220 de Pizan), 431 dates for, 254 Books, early forms of, 251 Battle between the Gods and the Giants, objects of veneration and devotion, Books of the Dead, 78-79, 79 Treasury of the Siphnians, Delphi, 273-274, 273, 274 Borgund stave church, Norway, 332, 333, 120, 120 in Sicily, 274-278, 277, 278 333 Battle between the Romans and the Barbar-Byzantine Empire, map of, 235 Bosses, 319, 446 ians, 222, 222 Byzantium, 254 Bowl with kufic border, Samarkand ware, Battle of Centaurs and Wild Beasts, 294, 294 Hadrian's Villa, Tivoli, 213, 213, 215 C BP (before present) designation, 2 Battle of the Bird and the Serpent (Emeterius Caen, Normandy, Saint-Étienne church, Breuil, Abbé Henri, 6 and Ende), copy of Commentary on Brinkmann, Vincenz, 187 Caen, 362-363, 362, 363 the Apocalypse (Beatus), 320, 321 Caesar, Julius, 185 Bayeux Tapestry, Normandy, France, denarius of, 181, 181 See also England; English art 374-375, 374, 375 Hadrian's wall, 212, 213 Cairn, 15 Bays, 172 Cairo, Egypt, Madrasa-mausoleum-Bronze Age BCE (before the Common Era) designamosque complex, 298, 299 tion, 2 Aegean, 84 Calchas, 177 Beatus, 319-320 prehistoric, 20-21, 21 Caliph Harun al-Rashid Visits the Turkish Bronze Foundry, A (Foundry Painter), 132, Beau Dieu, Amiens Cathedral, Notre-Bath (Bihzad), 304, 305 132 Dame cathedral, 402-403, 405 Calligraphy Bronze work Beautiful style, 449-450 Etruscan, 168-169, 169-170, 177-178, Islamic, 292-293, 293 "Beautiful" Virgin and Child, Sternberk, Calyx krater, 127-128 178 450, 451 Cambio, Arnolfo di, Florence Cathedral, Hildesheim bronze doors, 336, 336, Beauvais, Vincent de, 385, 394 428, 428, 429 337, 338 Bede, 311 Cameos, in the Middle Ages, 314 hollow-casting, 132 Beehive tombs, 99 sculpture, Classical Greek, 131-134, Cames, 398 Benedictine plan, 349 Canon of proportions, 54, 54 133, 134 Benedictines, 321, 347, 358 Brunelleschi, Filippo, Florence Cathedral Canon (Polykleitos), 129 Benedict of Nursia, 321 dome, 428, 428, 429 Canopic jars, 55 Beni Hassan, Egypt, rock-cut tombs, 63, Canopus, Hadrian's Villa, Tivoli, 212, 212 Brutus, Lucius Junius, 178, 178 63 Canterbury Tales, The (Chaucer), 431, 445 Beowulf, 316 Buffalmacco(?), The Triumph of Death, Capitals, column, 117, 118, 174 Camposanto, Pisa, 426, 426 Berlin Kore, Athens, 122-123, 123 Bull Leaping, Knossos, Crete, 91–92, 92 historiated, 368-369, 368 Bernward, Bishop, 338 Bull's-head rhyton, Knossos, Crete, 93, 94, Capstones, 15 doors of Saint Michael Church, Caracalla, 210, 218-219 Germany, 336, 336, 337, 338 Caracalla, 218, 219 Buon fresco, 90, 439 Bernard of Clairvaux, abbot, 347, 354, Caracalla, Baths of, 219, 219 Burgundians, 312 Carbon-14 dating, 13 Betrayal and Arrest of Christ, Book of Hours Burgundy Carolingian Empire, 320 abbey at, 352, 353 of Jeanne d'Evreux (Pucelle), 442-443, architecture, 321-325, 322, 323, 324 Saint-Lazare cathedral, Autun, Bur-443

gundy, France, 367–368, 367, 368

goldwork, 327-329, 328

Bible

manuscripts, 325–329, <i>325</i> , <i>326</i> , <i>327</i> , <i>328</i>	Charles V Triumphing Over Fury (Leoni), xxxvi–xxxvii, xxxvi	Greek-cross plan, 242, 275
Carpet making, Islamic, 303	Charles Martel, 319	in the Middle Ages, 323–324, <i>323</i> organization of, 239
See also Textiles	Charles the Bald, 328, 388	
		Romanesque, 350–363, 350, 351, 353–354
Carthern 170	Chartres cathedral, Notre-Dame cathe-	
Carthage, 179	dral, 388–391, <i>389</i> , <i>390</i> , <i>393</i> , 395,	stave, 332, 333, 333
Cartouches, 64, 203	396, 397–398, 397, 399	Ciborium, 244
Caryatids, 119–120, 119	Chatal Huyuk, Anatolia, 28, 28	Cimabue (Cenni di Pepi), Virgin and Chii
Castles	Chaucer, Geoffrey, The Canterbury Tales,	Enthroned, 431, 432
Dover Castle, England, 363, 364	431, 445	Cione, Berici di, Palazzo della Signoria,
Stokesay Castle, England, 411, 411	Chauvet cave, $0, 1, 7$	Florence, 427, 427
Catacomb of Commodilla, Rome, 232,	Chevrons, 102	Cistercians, 347, 354–355, 379
233–234, 239	Chichester-Constable chasuble, 445–446,	Citadels
Catacombs, 233–234, 236	446	Assyrian, 40–41, 41
paintings, 238-240, 239	Chihuly, Dale, Violet Persian Set with Red	Mycenae, 96–97, 96, 97
Cathedrals. See under name of	Lip Wraps, xli, xli	City of God, The (Augustine), 312
Cats and Mice with Host, Chi Rho Iota, page	Chi Rho Iota, page from Book of Kells,	City plans
from Book of Kells, Iona, Scotland,	Iona, Scotland, 310, 311, 318, 319	Egyptian, 66–67, 67
318, 319	Chiton, 125	Etruscan, 170
Cave art	Christ and Disciples on the Road to Emmaus,	Greek orthogonal, 149-150, 149
Altamira, 6, 7, 10, 10	Santo Domingo abbey, Silos, 342,	Roman, Republic, 190-192, 190, 191,
Chauvet, 0, 1, 7	343	192
dating techniques, 13	Christian art	Cityscape, House of Publius Fannius Synis
La Mouthe, 11, 11	architecture, 242-249, 242-249	tor, Boscoreale, 196, 197
Lascaux, 8–10, 9	basilica-plan churches, 242, 243, 242,	City-states
meaning of, 6–7	243	first, 26, 28
Paleolithic, 0, 1, 6–11, 7, 9, 10, 11	central-plan churches, 242, 242	Greek, 108, 130
Pech-Merle, 7–8, 7	house-churches, 241, 241	Classic, use of term, 128
rock-shelter art, 12–13, 12	iconography of the life of Jesus,	Classical, use of term, 129
sculptures, 10–11, 11	252–253	Classical period of Greek art. See Greek
techniques used, 8	paintings, catacomb, 238–240, <i>239</i>	
CE (Common Era) designation, 2		art, classical
	sculpture, 240–241, 240, 241, 250, 251, 254	Clement VI, pope, 448
Cella, 114, 116		Cleopatra VII, 71, 80
Celtic art, 311, 316	Christianity	Clerestory, 70, 206, 242, 323
Openwork box lid, 22, 22	early, 234, 238–239	Cloisonné, 274, 316
Centaur, Greece, 112, 112	in the Middle Ages, early, 316–319	Cloister, 323
Centering, 172	schisms, 249, 424	Cloister crafts, Romanesque, 372–
Central-plan churches, 242, 242	symbols of, 238	380, 372–380
Central-plan mosques, 289, 305–306	Christine de Pizan, The Book of the City of	Clovis, 312
Ceramics	Ladies, 431	Cluny, 347
See also Pottery	Christine de Pizan Presenting Her Book to	abbey at, 352, <i>353</i>
Aegean (Minoan), 88-89, 89, 94, 94	the Queen of France, xlv, xlv	Cluny III church, 352-354, 353
Cycladic Islands, 84–86, 85, 86	Christ in Majesty, San Climent church,	Code of Hammurabi, 38
Greek, 112–113, 113	Tahull, Spain, 370, 371	Codex, 251, 264
Islamic, 294, 294, 301–302, 301	Christ Washing the Feet of His Disciples,	Codex Colbertinus, 377, 378
Mycenaean, 104, 104	Liuthar (Aachen) Gospels, 339–340,	Coffers, 210
Neolithic, 18, 18, 19–20, 20	340	Cogul, Spain, People and Animals, 12-13,
use of term, 19, 20	Churches	12
Cerberus, 177	See also under name of	Coins
Ceremonial architecture, Neolithic,	basilica-plan, 242, 243, 242, 243	denarius of Julius Caesar, 181, 181
15–17, <i>16</i> , <i>17</i> , 19	Byzantine, in Constantinople, 255, 255,	making of, 46, 46
Ceres, 110	256, 257, 259	Persian Daric, 45, 45, 46
Cernavoda, Romania, figures of a man	Byzantine, in Greece, 269, 269, 270,	Colonnades, 116, 183
and woman, 18, 18, 19	271	Colophons, 318, 320
Cerveteri, Etruscan tombs, 176–177, 176,	Byzantine, in Kiev, 268–269, 268	Colosseum (Flavian Amphitheater),
177	Byzantine, in late period, 278–279, 279,	Rome, 202–204, 202, 203
Champollion, Jean-François, 78	280	Colum Cille, 311
Charioteer, Sanctuary of Apollo, 132–133,	Byzantine, multiple-dome plan, 275	Column of Trajan, Rome, 208–209, 208,
133		209
Charlemagne, 320, 325, 326	Byzantine, in Ravenna, 258, 259–262, 260, 261	
		Common tary on the Anacolome (Rootye)
Palace Chapel of, 321, 322, 323 Charles IV Holy Pomen emperor 448	Byzantine, in Sicily, 274–275, 277–278,	Commentary on the Apocalypse (Beatus),
Charles IV, Holy Roman emperor, 448,	277, 278 Byzantina in Vanica 271, 272, 273	319–320, <i>320</i> , <i>321</i>
Charles IV king of France 442	Byzantine, in Venice, 271, 272, 273	Commodus, 205, 217
Charles IV, king of France, 442,	central-plan, 242, 242	Commodus as Hercules, 217–218, 217
448	Gothic, French, 386-402, 387-402	Comnenian dynasty, 267

		D: 440.450
Composite capitals, 174	Cubiculum of Leonis, Catacomb of Com-	Dionysos, 110, 159
Composite order, 174	modilla, Rome, 232, 233–234, 239	Dionysos with Maenads (Amasis Painter),
Concrete, Roman use of, 182–183	Cubi XIX (Smith), xxxv, xxxv	125–126, <i>125</i>
Connoisseurship, xlvi	Cuneiform, Sumerian, 29–30, 32, 32	Diptychs, 229, 230
Constantina, 246, 247	Cupid, 110	Archangel Michael, Byzantine, 263–264,
Constantine the Great, 225–230, 242, 243,	Cybele, 179	263
246, 249, 254, 312	Cycladic Islands, 84–86	Discus Thrower (Diskobolos) (Myron), 106,
arch of, 226-227, 226	Cyclopean construction, 96	107
Basilica of Maxentius and Constantine,	Cylinder seals, 35, 35	Dish from Mildenhall, 229, 229
Rome, 227–228, 227, 228	Cyrus II, 42–43	Djoser's funerary complex at Saqqara,
Constantine the Great, Rome, 224,	Cyrus the Great, 129, 235	55–56, 56, 57
225–226	Czech Republic, Woman from Ostrava	Dolmen, 15
Constantinople, 225, 254	Petrkovice, 5, 5	Dome of the Rock, Jerusalem, 236,
	1 611801166, 5, 5	286–287, 28 <i>6</i> , 287
Hagia Sophia, 255, 255, 256, 257, 259,	D	Domes, 172
305		
walls of, 254–255, 254	Daddi, Bernardo, 437	Byzantine multiple, 275
Constantius Chlorus, 223	Madonna and Child, 422, 423	hemispheric, 172
Contextualism, xlvi–xlvii	Dado, 194	of the Pantheon, 210, 211
Contrapposto, 129	Dagger blade, Mycenae, 93, 103, 103	pendentive, 248
Coppo di Marcovaldo, Crucifix, 419–420,	Damascus, 286	Dominicans, 384, 394, 425
419	Daric, 45, <i>45</i>	Dominicus, abbot, 320
Corbel arch, 171, 446	Darius I, 43–45, 45	Domitian, 199, 204, 210
Corbel construction, 14	Darius III, 46	Domna, Julia, 218
Corbel vaults, 14, 102	Darius and Xerxes Receiving Tribute, Perse-	Donjon, 363
Córdoba, Spain, Great Mosque of,	polis, 45, <i>45</i>	Doors of Bishop Bernward, Saint Michael
290–291, 290, 291	Dating art	Church, Germany, 336, 336, 337,
Core glass, 70	problem with Aegean objects, 84	338
Corinth, Greece, 108, 114	types and techniques for, 13	Doorway panels, parish church, Urnes,
Cormont, Renaud de, 400	Daumier, Honoré, Rue Transonain, Le 15	Norway, 331, 332
Cormont, Thomas de, 400, 401	Avril 1834, xl, xl	Doric order, 117, 118, <i>118</i>
	David the Psalmist, Paris Psalter, Byzantine	Dormition church, Daphni, Greece, 271,
Cornithian capital, xxxiv, xxxiv	manuscript, 274, 274	271
Corinthian order, 117, 118, 118, 158–159,		
158	Death masks. See Funerary masks	Dormition of the Virgin, Strasbourg, France,
Cornices, 118, 174	Death of Sarpedon (Euphronios), 127–128,	414, 414
Coronation Gospels, 326, 326	127	Dove (Christian symbol), 238
Cossutius, 158	Decameron, The (Boccaccio), 431	Dover Castle, England, 363, 364
Coucy, Robert de, 401	Decorated style, 446	Drawing Lesson, The (Steen), xli, xlii
Courses, 102	Deesis, 273	Dressed stone, 87
Court (Rayonnant) style, 405–407, 442	Deir el-Bahri, funerary temple of Hat-	Drums, column, 118, 287
Courtly love, 444	shepsut at, 70-72, 70, 71	Drums, wall, 172, 257
Creation and Fall (Wiligelmus), 365,	Deir el-Medina, workers' village, 66-67,	Duccio di Buoninsegna, Maestà Altar-
365	67	piece, 437, 437, 438, 439, 440
Crenellations, 42	Delphi	Dura-Europus, 234, 236–237, 236, 237
Crete, Minoan civilization, 86-95	Sanctuary of Apollo, 110-111, 111,	Durham Castle and cathedral, England,
Crockets, 446	132–133, <i>133</i>	360, 361, 362
Croesus, king, 45, 46	Sanctuary of Athena Pronaia, 150-151,	Dur Sharrukin, 40–41, 41
Cro-Magnons, 2	150	Dutch Visitors to Rome Looking at the Far-
Cross, Christian symbol, 238	Treasury of the Siphnians, 116,	nese Hercules (Goltzius), xlvii, xlvii
Crosses	119–120, 120	Dying Gallic Trumpeter (Epigonos), 160,
Irish high crosses, 319, 319	Demeter, 110	161, 162
Lombards, 314, <i>315</i>	Demotic writing, 78	Dying Warrior, pediment of Temple of
Crucifix (Coppo di Marcovaldo), 419–420,	Denarius of Julius Caesar, 181, 181	Aphaia, 121, <i>121</i>
419	Denmark	, .=., .=.
	Gummersmark brooch, 315–316, 316	E
Crucifixion, Dormition church, Daphni,	Horse and Sun Chariot, Trundholm, 21,	Eagle brooches, Visigoths, 313–314, 314
Greece, 271, 271	21	Ebbo, 326–327
Crucifixion, Rabbula Gospels, 264–265, 265		Ecclesius, 259
Crucifixion with Angels and Mourning Fig-	Neolithic vessels, 18–20, 20	
ures, Lindau Gospels, 328–329, 328	rune stones, 330, 331	Echinus, 117, 118
Crucifix (Majestat Batilló), Catalunya,	Derrida, Jacques, xlvii	Edict of Milan, 225, 242
Spain, 372, 373	Desiderius, 314, 356, 359, 371	Edward II, king of England, 445
Cruciform, 248	Diana, 110	Edward III, king of England, 445
Cruck construction, 332	Diary (Shimomura), xl, xl	Egypt
Crusades, 345-348, 385	Dietrich II, 415	creation myths, 51–52
Crypt, 244	Diocletian, 222, 225	Madrasa-mausoleum-mosque complex
Cubicula, 239	baths of, 220	in Cairo, 298, 299

map of ancient, 51	Eriksson, Leif, 329	Flavian Amphitheater (Colosseum),
timelines, 53, 65, 73	Eros, 110	Rome, 202–204, 202, 203
Egyptian art	Etruscans	Flavians, 199–204
Early Dynastic, 50–56	architecture, 170-171, 173-174, 173	Florence
glassmaking, 70, 70, 74-75	bronze work, 168-169, 169-170,	Cathedral, 428, 428, 429
Late Period, 79–80	177–178, 178	Orsanmichele Tabernacle, 422, 423–424
Middle Kingdom, 62–67	cities, 170	painting, 429, 431-437, 432, 433, 435,
mummification, 55	civilization, 170	436
Neolithic and Predynastic, 50	temples and their decoration, 171,	Palazzo della Signoria (Cione and Tal-
New Kingdom, 67–79	173–174, 173, 175	enti), 427, <i>427</i>
Old Kingdom, 56–62	tombs, 174, 176–177, 176, 177	San Giovanni baptistry, 428–429, 430
painting, 64	Eumenes II, 163	"Flotilla" fresco, Thera, 82–83, 82, 90
pyramids and mastabas, 55–59, <i>56</i> , <i>57</i> , <i>58</i>	Euphronios, Death of Sarpedon, 127–128, 127	Flower Piece with Curtain (Van der Spelt and Van Mieris), xxxiii, xxxiii
rock-cut tombs, 63, 63	Euripides, 159	Fluted shafts, 118
sculpture, xxxii, 59-64, 59, 60, 61, 63,	Europe	Flying buttresses, 388
64, 73–74, 73, 74	See also under specific country	Flying gallop, 13
symbols, 52	map of, fourteenth century, 425	Fontenay, Notre-Dame abbey church,
temples, 67-72, 68, 69, 71, 75-78, 76,	map of, Gothic era, 385	Burgundy, France, 354–355, 355
77	map of, Middle Ages (early), 313	Foreshortening, 128
tombs, 55–56, <i>56</i>	map of, prehistoric, 3	Fortuna Primigenia, sanctuary of, 183,
Einhard, 323	map of, Romanesque period, 345	183
Ekkehard and Uta, Naumburg Cathedral,	Eusebius, 243	Forum, Roman
Germany, 415, 415, 417	Evans, Arthur, 84, 86, 87, 88	Augustus, 185, 205
Elam, 26, 28	Exedrae, 183, 212, 257	of Trajan, 205–206, 206, 207, 208, 208
Eleanor of Aquitaine, 386, 387, 408	Exekias	view of, 185
Electron spin resonance techniques, 13	Achilles and Ajax Playing a Game, 126,	Foundry Painter, A Bronze Foundry, 132,
Emblemata, 215	126	132
Embroidery	The Suicide of Ajax, 126, 126	Fountain Mosaic, Pompeii, 193, 193
Bayeux Tapestry, Normandy, France,	Exeter Cathedral, England, 446–447,	Four-iwan mosque, 289, 295, 299
374–375, <i>374</i> , <i>375</i>	447	France, Gothic era, 385–408
opus anglicanum, 445–446, <i>446</i>	Expressionism, 162	Francis, saint, 394
technique, 375	-	Franciscans, 384, 394, 395
Emeterius, copy of Commentary on the	F	Franks, 312, 320
Apocalypse (Beatus), 320, 320, 321	Façade, 114	Frederick II, Holy Roman Emperor, 411,
Emperor Justinian and His Attendants, San	Faience, 64, 70	417
Vitale church, Ravenna, 260, 261	Family of Vunnerius Keramus (Family	Freeman, Leslie G., 7
Empress Theodora and Her Attendants, San	Group), Roman, 221, 221	Freer, Charles Lang, xlv-xlvi
Vitale church, Ravenna, 260, 261	Farnese Hercules, xlvi, xlvii	Freestanding sculpture
Encaustic, 80	Fathy, Hasan	Greek Archaic, 121–125, 122, 123, 124
Ende, copy of Commentary on the Apoca-	Mosque at New Gourna, 307, 308	Greek Classical, 131, 132
lypse (Beatus), 320, 321	New Gourna Village, 307	French art
Engaged columns, 183–184	Fayum portraits, 80	architecture, Gothic, 386–402, 387–402
England, Gothic, 408–411	Felix, Julia, 198	Chauvet cave, $0, 1, 7$
English art	Fertile Crescent, 26, 27, 28	La Mouthe cave, 11, 11
architecture, fourteenth century,	Feudalism, 313, 344	Lascaux cave, 8–10, 9
446–448, 447	Fiber arts, Neolithic, 17	manuscripts, fourteenth century illumi-
architecture, Gothic, 409–411, 410, 411	Figures, Neolithic depiction of, 12–13,	nated, 442–443, 443
Dover Castle, 363, 364	12, 18, 18, 19	manuscripts, Gothic illuminated, 406,
Durham Castle and cathedral, 360, 361, 362	Figurines Ain Ghazal, Jordan, 28–29, <i>29</i>	407–408, 407
embroidery, fourteenth century,	Cycladic, 84–86, <i>85</i> , <i>86</i>	Pech-Merle cave, 7–8, 7
445–446, <i>446</i>	Greek, 113	Romanesque, 352–355, 371, 372
manuscripts, Gothic illuminated, 408,	naming, 5	sculpture, fourteenth century, 443–444, 445
409	Paleolithic, 4–6, <i>4</i> , <i>5</i> , <i>6</i>	sculpture, Gothic, 402–407, 403–406
Stonehenge, 16, 17, 17, 19	votive, 32–33, 33, 37, 37, 171	sculpture, Paleolithic, 10, 11
Entablature, 117, 118	Filigree, 93	Woman from Brassempouy, 5–6, 6
Epic of Gilgamesh, 29–30, 35	Fillets, 118	Frescoes
Epidauros, theater in, 159–160, <i>159</i>	Finding of the Baby Moses, The,	buon, 90, 439
Corinthian capital from, xxxiv, xxxiv	Dura-Europos, 237, 237	"Flotilla" fresco, Thera, 82–83, 82
Epigonos, <i>Dying Gallic Trumpeter</i> , 160, 161,	Firmans, 306	Minoan, 90–92, 90, 91, 92
162	Fish (Christian symbol), 238	Sala della Pace, Siena, <i>440</i> , 441
Equestrian statue of Marcus Aurelius, 216,	Fish-shaped bottle, Egyptian, 70, 70	Scrovegni (Arena) Chapel, Padua,
217	Five Pillars of Islam, 299	433–437, 435, 436
Erechtheion, Acropolis, 142–144, 144	Flashing, 398	secco, 90, 439

technique, 439	Glaze technique, 42	religious beliefs and sacred places,
Freud, Sigmund, xlvi	Gloss, 114	109–111
Frieze, 117, 118, 287	Glykera, 156	timelines, 113, 117
Frigidarium, 220	Gnosis, Stag Hunt, 156-157, 156	Greek art, archaic
Funerary architecture. See Tombs	Godescalc Gospel Lectionary, 325–326, 325	sculpture, freestanding, 121–125, 122,
Funerary customs	Gold foil, 93	123, 124
See also Burial ships	Gold leaf, 93, 94, 94	sculpture, pediment, 119–121, 119,
Egyptian mummification, 55	Gold work	120, 121
Etruscan, 174, 176–177, 176, 177	Aegean (Minoan), 93–94, 93, 94	temples, 116, 116, 117–119, 117, 118
Greek, 112–113	Carolingian, 327–329, 328	vases, painted, 114, 125–128, <i>125</i> , <i>126</i> ,
Viking picture and rune stones, 330,	Greek, 155, <i>155</i>	127
331	Roman, 221, 221	Greek art, classical, 111–112
Funerary masks	Goltzius, Hendrick, Dutch Visitors to Rome	Acropolis, 116, 136–142, 138, 139,
of Agamemnon, 93, 99, 102–103, 102	Looking at the Farnese Hercules, xlvii,	140, 141, 142 Athenian Agora, 145–147, 146
of Tutankhamun, 48, 49	xlvii Good Shepherd, Orants, and Story of	city plans, 149–150, 149
Funerary sculpture, Roman, 222, 222	Jonah, 239–240, 239	dates for, 128
Funerary vases, Greek, 112–113, 113	Good Shepherd (lunette), 248–249, 249	early, 128, 129–135
Furniture, Neolithic, 14–15	Good Shepherd (sculpture), 240, 240	goldsmiths, work of, 155, <i>155</i>
G	Gorgons, pediment on Temple of Artemis,	high, 128, 135–148
Galla Placidia, 312	Cofru, 119, <i>119</i>	late, 148–157
Mausoleum of, 247-249, 248, 249	Gospels	monumental tombs, 151
Galleries, 257	Coronation Gospels, 326, 326	murals and mosaics, 155–157, <i>156</i>
Gallic Chieftain Killing His Wife and	of Ebbo, 326–327, 326	painting, 148, <i>148</i>
Himself, 160, 160, 162	Godescalc Gospel Lectionary, 325–326,	Parthenon, 116, 136–142, 138, 139,
Galmeton, Richard de, 446	325	140, 141, 142
Gardens	Gospel Book of Durrow, Iona, Scotland,	Polykleitos, canon of, 128-129
Islamic chahar bagh, 299–300	317–318, <i>317</i>	sculpture, bronze, 131–134, 133, 134
Roman, 192–193, 193	Lindau Gospels, 328-329, 328	sculpture, freestanding, 131, 132
Garden Scene, Primaporta, 192, 194, 195	Liuthar (Aachen) Gospels, 339-340, 339,	sculpture, in late period, 151-155, 151,
Gauls, 160, 312	340	152, 153
Gemma Augustea, 189–190, 189, 312	Gothic, use of term, 384	sculpture, pediment, 130-131, 131
Genghis Khan, 294	Gothic art	sculpture, stele, 147–148, 147
Geometric period of Greek art, 111,	in England, 408-411	tholos, 150–151, 150
112–114	in France, 385–408	vases, 134–135, 135, 148, 148
Gerald of Wales, 311	in Holy Roman Empire and Germany,	women as artists, 157
German art	411–415, 417	Greek art periods
architecture, Gothic, 411–412, 412, 413 sculpture, Gothic, 413–415, 414, 415,	in Italy, 416, 417–420	Archaic, 111, 114–128
417	Gothic era	Classical, 111–112, 128–157
Speyer cathedral, 358–360, <i>360</i>	description of, 384–385	Geometric, 111, 112–114
Gero Crucifix, Ottonian, 338, 339	map of Europe in, 385	Hellenistic, 112, 157–166
Gilding, 93	timelines, 397, 407	historical divisions, 111–112
Gilgamesh, 29–30, 35	Goths, 312, 384	Orientalizing, 111, 114
Giornata, 439	Granada, Spain	Greek-cross plan churches, 242, 275 Greek gods and heroes, description of,
Giotto di Bondone, 424	Court of the Lions, Alhambra, 298, 299–300	110
frescoes, Scrovegni (Arena) Chapel,	Palace of the Lions, Alhambra, 299, 300	Greek manner, 429, 431
Padua, 433–437, 435, 436	Grave Stele of Hegeso, Greek, 147–148, 147	Gregory VII, pope, 346, 359
Lamentation, 434, 436, 437	Great Lyre with Bull's Head, Ur, 34–35,	Gregory of Nazianzus, 230
Marriage at Cana, Raising of Lazarus,	34	Gregory the Great, pope, 316
Resurrection and Noli Me Tangere and	Great Mosque of Córdoba, Spain,	Grid, 44
Lamentation, Scrovegni (Arena)	290–291, 290, 291	Griffin, Islamic, 300, 301
Chapel, Padua, 434, 436	Great Mosque of Isfahan (Masjid-i Jami),	Grisaille windows, 398, 434, 442, 447
Virgin and Child Enthroned, 431–432, 433	Iran, 295, 297, 297	Groin vaults, 172, 358, 391, 391
Gislebertus	Great Mosque of Kairouan, Tunisia, 288,	Groundlines, 54
Last Judgment, 367–368, 367	290, 290	Guda, Book of Homilies, 378, 378
Suicide of Judas, The, 368–369, 368	Great Schism, 424	Gudea, 37, 37
Giza, pyramids at, 57-59, 57, 58	Great Sphinx, Egypt, xxxii, xxii, 59	Guercino (Giovanni Francesco Barbieri),
Glaber, Radulphus, 349	Great Tower, Dover Castle, England, 363,	Saint Luke Displaying a Painting of the
Glass	364	Virgin, xli, xli
millefiore, 316	Greece	Guilds, 384, 425
stained, 397–398, <i>397</i> , <i>399</i>	Byzantine art in, 269, 269, 270, 271	Gummersmark brooch, Norse, Denmark,
Glassmaking	emergence of civilization, 108–112	315–316, 316
Egyptian, 70, 70, 74–75	historical background, 108–109	Guti, 37
Islamic, 296, <i>296</i>	map of ancient, 109	Guzman, Domenico, 394

н	Herakleitos, The Unswept Floor, 214, 214	Roman, Republic, 190–192, 190, 191,
Habsburg Empire, 334	Herat, 304	192
Hades, 110	Hercules (Herakles), 121	Hugh de Semur, 352, 359
Hadid, Zaha, 307	Athena, Herakles, and Atlas, 131, 131	Human development, 2
Hadrian, 158, 204, 205	Hermes, 110, 127	Human figures, Egyptian representation
Pantheon, 210, 210, 211, 212	Hermes and the Infant Dionysos (Praxiteles),	of, 52–53, 54, <i>54</i>
Villa, Tivoli, 212, 212, 213, 213	151–152, <i>151</i>	Human-Headed Winged Lion (lamassu),
Wall, Britain, 212, 213	Herodotus, 50, 51, 55	Nimrud, 24, 25
Hadrian Hunting Boar and Sacrificing to	Herod the Great, 236	Humanism, 424–425
Apollo, 215–216, 215	Herrad of Landsberg, 369	Hundred Years' War, 424, 442, 445
Hagesandros, Laocoön and His Sons, xxxvii,	Hestia, 110	Hunefer, 78–79, 79
xxxvii, 163–164	Hiberno-Saxon, 316	Huns, 312
Hagia Sophia church, Istanbul, 255, 255,	Hierakonpolis, Egypt, 50	Hus, John, 424, 452
<i>256</i> , 257, 259, 305	Palette of Narmer, 53–54, 53	Hyksos, 67
Halikarnassos, mausoleum at, 153, <i>153</i>	Hieratic scale, 36–37, 53, 334	Hypostyle hall, 68, 288, 289
Hall of Bulls, Lascaux cave, 8, 9	Hieratic writing, 78	
Hall of the Abencerrajes, Alhambra, 300,	Hieroglyphs, 53, 78, 78, 86	II 1 1 202
300	High relief. See Sculpture, relief	Ibn Muqla, 292
Hammurabi, 37	Hildegard, 325, 369	Ice Age, 11
code of, 38	Himation, 125	Iconoclasm, 266
Stele of Hammurabi, 38, 38	Hippodamos, 149, 150	Iconography, xxxvii, 35, 266–267
Hampton, James, Throne of the Third	Hippopotamus, Egyptian, 64–65, 65	of the life of Jesus, 252–253
Heaven of the Nations' Millennium	Historiated capitals, 368–369, 368	Iconostasis, 259, 266
General Assembly, xxxviii–xxxix,	Hittites, 37, 39, 75	Icons, Byzantine, 259, 266–267, 266, 269,
xxxviii	Hohlenstein-Stadel, Germany, Lion-	273–274, 273, 276, 276, 278–279,
Hanging Gardens, 42	Human figurine, 4–5, 4	280
Harald Bluetooth, Danish king, 330, 331	Hollow-casting bronze, 132	Idealism, xxxiv
Haram al-Sharif, 236, 286, 286	Holy Cross church, Schwäbisch Gmünd,	Iktinos, 136, 137, 138–139
Harbaville Triptych, Byzantine, 273, 273	Germany, 448–449, 448	Iliad (Homer), 84, 98, 103, 127 Illuminated manuscripts. See Manuscripts,
Harmony in Blue and Gold, Peacock	Holy Roman Empire, 334, 344 See also German art	illuminated
Room, for Frederick Leyland	architecture, fourteenth century,	Imhotep, 55
(Whistler), xlv–xlvi, xlv	448–449, <i>448</i> , <i>449</i>	Imperial Procession, Ara Pacis, 188, 188
Harvester Vase, Crete, 93–94, 93	architecture, Gothic, 411–412, <i>412</i> , <i>413</i>	In antis, 116
Harvesting of Grapes, Santa Costanza	painting, fourteenth century, 449–450,	Increase ceremonies, 6
church, Rome, 247, 247 Hatshepsut	450, 451	Initiation Rites of the Cult of Bacchus, Pom-
Enthroned, 70, 71	sculpture, Gothic, 413–415, 414, 415,	peii, 194–195, <i>194</i>
as a sphinx, 71	417	Inlaid, 30, 93
temple of, 71–72, 71	Homer, 84, 98, 103, 127	Intuitive perspective, 197
Hattusha, 39	Honnecourt, Villard de, 395	Iona, Scotland
Hawass, Zahi, 50	Honorius, 247	Book of Kells, 310, 311, 318, 319
Headdress	Horace, 180	Gospel Book of Durrow, 317-318, 317
nemes, 52, 72	Horemheb, tomb of, 64, 64	Ionic order, 117, 118
Head of a man, Akkadian, 36, 36	Horse and Sun Chariot, Trundholm, Den-	Iran, Great Mosque of Isfahan (Masjid-i
Head of a man (known as Brutus),	mark, 21, 21	Jami), Iran, 295, 297, 297
Roman, 177–178, 178	Horsemen, Parthenon, 141,142	Ireland
Head of Senusret III, 63, 63	Horseshoe arches, 291, 292	high (monumental) crosses, 319, 319
Helladic, use of term, 95	Hortus Deliciarum (The Garden of Delights)	Iron Age, 22, 22
Hellenistic art, 112	(Herrad), 369	New Grange, tomb interior, 15–16, 16
architecture, 158–160, <i>158</i> , <i>159</i>	Horus, 52, 53, 54	Openwork box lid, 22, 22
sculpture, 160, 160, 161, 162–165, 162,	Hosios Loukas, monastery of, Greece,	Iron Age, 21–22
163, 164, 165, 166	269, 269, 270, 271	Ishtar Gate, 31, 42, 42, 43
Helen of Egypt, 155, 157	House-churches, 241, 241	Isidorus of Miletus, Hagia Sophia church,
Hemispheric domes, 172	House of M. Lucretius Fronto, Pompeii,	Istanbul, 255, <i>255</i> , <i>256</i> , 257, 259, 305
Henges, 17	197–198, 197	Isis, 51–52, 179
T	House of Publius Fannius Synistor,	Islam, 234, 283–284
Henry I, king of England, 345	Boscoreale, 195, 195, 196, 197	Five Pillars of, 299
Henry II, king of England, 386, 408	House of the Vettii, Pompeii, 192, 193,	Islamic art
Henry II, Ottonian king, 339	193	architecture, 286-292, 286-292, 295,
Henry III, king of England, 408, 446	House-synagogue, 236–237, 236, 237	297–300, 297, 298, 300
Henry of Blois, 378	Housing	calligraphy, 292–293, <i>293</i>
Hephaistos, 110	Ain Ghazal, Jordan, 28–29, 29	ceramics, 294, 294, 301–302, 301
Hera, 109, 110	Egyptian, 66–67, 67	glass, 296, 296
Hera I, temple of, 116, 117, 117, 119	Neolithic, 13–17, 14, 15, 16, 17	manuscripts, 303–304, 304, 305
Hera II, temple of, 117	Paleolithic, 3–4, 3	metalwork, 300–301, 301

textiles, 294, 295, 302–303, 302, 303	K	Last Supper, The (Leonardo), xlii, xlii
Islamic world	Ka, 55	Last Supper, The (Rembrandt), xlii-xliii, xliii
early society, 283-285	Kaaba, <i>282–283</i> , 284	Leaning Tower of Pisa, 356, 356
map of, 285	Kahun, Egyptian town, 66	Le Corbusier, 139
Shi'ites versus Sunni, 284	Kai, 61–62, <i>61</i>	Lekythos, 148
		Leo III, emperor, 266
in Spain, 319 Italian art	Kairouan, Tunisia, Great Mosque of, 288,	Leo III, pope, 321
	290, 290	
architecture, fourteenth century,	Kalhu, 40	Leonardo da Vinci, xxxv
427–429, 427, 428, 429	Kallikrates	The Last Supper, xlii, xlii
architecture, Gothic, 416, 416	Parthenon, 136–142	Leoni, Leone, Charles V Triumphing Over
Gothic, 417–420	Temple of Athena Nike, 144-145, 144	Fury, xxxvi–xxxvii, xxxvi
painting, fourteenth century, 429,	Kamares ware jug, Crete, 88-89, 89	Leroi-Gourhan, André, 6
431–437, 432, 433, 435, 436	Karnak, temples at, 68, 69-70, 69	Lessing, xxxviii
painting, Gothic, 419-420, 419, 420	Katholikon, Monastery of Hosios Loukas,	Lesyngham, Robert, 447
Romanesque, 356–360	Greece, 269, 269, 270, 271	Le Tuc d'Audoubert, France, Bison, 10,
sculpture, Gothic, 417–419, 417, 418	Keep, 363	11
Ivory	Keystone, 172	Leyland, Frederick, xlv
Byzantine, 273, 273		Liber Scivias (Hildegard of Bingen and Vol-
	Khafre, 57–58	
French fourteenth century, 444, 444	sculpture of, xxxii, xxxii, 59–60, 59, 60	mar), 369, 369
Ottonian, 334, 334	Khamerernebty II, 60-61, 60	Life of John the Baptist (A. Pisano), panel
iwans, four-, 289, 295, 299	Khamsa (Five Poems) (Nizami), 304, 305	doors, 428–429, 430
1	Khufu, 57–58	Lindau Gospels, 328–329, 328
J	Kiev, Byzantine art in, 268–269, 268	Lion Gate, Hattusha, 39, 39
Jambs, 402	Kilns, 20, 114	Lion Gate, Mycenae, 96, 100, 100, 101
Jashemski, Wilhelmina, 192	Knossos, palace at	Lion-Human figurine, Hohlenstein-Stadel,
Jeanne d'Evreux, 442-443, 444	Old Palace period, 86–89, 87, 88	Germany, 4–5, <i>4</i>
Jefferson, Thomas, 184–185	Second Palace period, 89–95	Liuthar (Aachen) Gospels, 339-340, 339,
Jelling, Denmark, rune stones, 330, 331	Kore (korai) statues, 122–125, <i>123</i> , <i>124</i>	340
Jericho, 27, 27, 28	Kouros (kouroi) statues, 122, 123, 127	Lives of the Most Excellent Italian Architects,
Jerusalem		Painters, and Sculptors (Vasari), xlvi
Dome of the Rock, 236, 286–287, 286,	Krater, 104	Livia, 185, 189
287	Greek Geometric style, 112–113, 113	
First Temple of Solomon, 235–236	Kritian Boy, Acropolis, Athens, 131, 132	Villa of Livia, Primaporta, 192, <i>194</i> , 195
	Kritias, 148	Loculi, 239
Haram al-Sharif, 236, 286, 286	Kritios, 131	Loggia, 423
Second Temple Solomon, 201, 201,	Kublai Khan, 294	of the Lancers, 427, 427
235–236	Kufic script, 292–293, 293, 294, 294,	Lombards, 314
Jesus of Nazareth, 238–239	295	Lorblanchet, Michel, 8
iconography of the life of, 252-253	Kuyunjik, Iraq, 41	Lorenzetti, Ambrogio, 426
Jewelry	Kylix, 132, 132	Allegory of Good Government in the City
Aegean (Minoan), 89, 89	,,,	and in the Country, 441-442, 441
Egyptian, 64, 64		Sala della Pace, fresco series, 440, 441
Greek, 155, <i>155</i>	L	Lost-wax casting, 93, 155
Norse, 315–316, 316	Labyrinth, 86, 89–90	Louis VI, king of France, 383
Visigoths, 313–314, 314	•	Louis VII, king of France, 383, 385, 386,
Jewish art, early	Lactantius, 243	
Ark of the Covenant, 236, 236	Lagash, 37	387
	Lamassus, 24, 25	Louis IX, king of France, 406, 406, 407
menorahs, 201, 236, 236	Lamb (sheep) (Christian symbol), 238	Louis the German, 334
Solomon, First Temple, 235–236	Lamentation (Giotto di Bondone), 434,	Louis the Pious, 326
Solomon, Second Temple, 201, 201,	436, 437	Loup, Jean le, 401
235–236	Laming-Emperaire, Annette, 6	Ludovisi Battle Sarcophagus, 222, 222
synagogues, 236–238, 236, 412, 413	La Mouthe cave, 11, 11	Lunettes, 239
Jewish War (Josephus), 179	Lamps, Paleolithic, 11, 11	Lusterware, 301–302, 301
Joggled voussoirs, 299	Lamp with ibex design, La Mouthe cave,	Luzarches, Robert de, 400
John of Damascus, 266	France, 11, 11	Lydians, 45, 46
John of Worcester, Worcester Chronicle,	Lancets, 397, 398, 399	Lyre with Bull's Head, Ur, Great, 34–35,
344–345, <i>346</i>	Landscape painting, Minoan, 91, 91	34
Josephus, Flavius, 179	Laocoön and His Sons (Hagesandros,	Lysippos
Judaism, early, 234–235	Polydoros, and Athanadoros), xxxvii,	Alexander the Great, 154–155, 154
Judgment of Hunefer before Osiris, 79,	•	
79	xxxvii, 163–164	The Man Scraping Himself (Apoxy-
	Lapith Fighting a Centaur, Parthenon, 140,	omenos), 153, 154
Julia Domna, 218	141	
Julio-Claudians, 189–190	Lascaux cave, 8–10, 9	M
Juno, 110	Last Judgment, tympanum (Gislebertus),	Maat, 73
Jupiter, 110	Saint-Lazare cathedral, Autun,	Macedonia, 130, 149
Justinian I 254 255 260 261	Burgundy France 367-368 367	Macedonian dynasty 267

	W. I. I. E II. G. I. I. G IV.	0
Macy Jug Islamic lusterware, 301–302, 301	Mark the Evangelist, Godescalc Gospel Lec-	Sumerian, 34–35, <i>34</i>
Madonna and Child (Daddi), 422, 423	tionary, 325–326, 325	techniques, 93
Madrasa-mausoleum-mosque complex in	Marriage at Cana, Raising of Lazarus, Resur-	Visigoths, 313–314, 314
Cairo, 298, 299	rection and Noli Me Tangere and	Metamorphoses (Ovid), 179
Madrasas, 295, 297, 297	Lamentation (Giotto di Bondone),	Metopes, 117, 118
Maenads, 125	434, 436	Michelangelo Buonarroti, 220
Maestà Altarpiece (Duccio di Buonin-	Mars, 110, 179	Middle-Aged Flavian Woman, 204, 205
at the state of th		
segna), 437, 438, 439, 440	Marshals and Young Women, Parthenon, 142,	Middle Ages
Magdeburg Cathedral, Saint Maurice, Ger-	142	British Isles, 316–318
many, 414–415, <i>415</i>	Martyria, 286	Carolingian Europe, 320–329
Magdeburg ivories, 334, 334	Marx, Karl, xlvi	defined, 314
Maison Carrée (Square House), Roman	Masjid-i Jami, (Great Mosque of Isfahan),	description of, 312–313
temple, 184–185, 184	Iran, 295, 297, 297	Lombards, 314
Majestat Batilló (crucifix), Catalunya,	Masks	map of Europe in, 313
Spain, 372, 373	of Agamemnon, funerary, 93, 99,	Ottonian Europe, 334–340
Mamluk dynasty, 294	102–103, 102	Scandinavia, 314–316
	of Tutankhamun, funerary, 48, 49	
Mamluk glass oil lamp, 296, 296		Spain, 319–320
Mammoth-bone houses, 3–4, 3	Masonry, Gothic masters, 395	timeline, 335
Man and Centaur, Greece, 113–114, 113	Mastaba, 55, 56, <i>56</i>	Vikings, 329–334
Manetho, 51	Master Theodoric, Saint Luke, 449–450,	Visigoths, 313–314
Man Scrapin Himself (Apoxyomenos), The	450	Mihrab, 288, 289, 291, 297, 297, 298, 299
(Lysippos), 153, 153	Mausoleum. See Tombs	Milan, 247
Manuscripts	Mausoleum of Galla Placidia, 247–249,	Sant' Ambrogio church, Milan, 358, 359
Beatus, 319–320	248, 249	Miletos, 129
Carolingian, 325–329, 325, 326, 327,	Mausolos, 151	city plans, 149–150, <i>149</i>
328		and the second s
	Maxentius, 225	Minarets, 288
Ottonian, 339–340, 339, 340	Basilica of Maxentius and Constantine	Minbar, 290, 298, 299
Manuscripts, illuminated, 251	(Basilica Nova), 227–228, 227, 228	Minerva, 110
Byzantine, 264–265, 264, 265, 274, 274	Meander, 189	Miniatures, 251, 304
fourteenth century, French, 442–443,	Mecca, 283, 286	Minoan civilization
443	Medallion, 239	development of, 86
Gothic, English, 408, 409	Medallion rug, Ushak, 302, 302	New Palace period, 89-95
Gothic, French, 406, 407-408, 407	Medes, 42	Old Palace period, 86–89
Islamic, 303–304, 304, 305	Medici Venus, statue, xxxvi, <i>xxxvi</i>	origin of name, 86
Middle Ages, 310, 311, 317–319, 317,	Medina, 283, 286	Minos, king, 84, 86
319	Medusa, pediment on Temple of Artemis,	Minotaur, legend of, 86, 94
Ottoman, 306–307, 307	Cofru, 119, 119	Miracle of the Crib at Greccio (Saint Francis
Romanesque, 327–379, 378, 379, 380	Megalithic architecture, Neolithic, 15–17,	Master), 420, 420
scriptoria, 263, 317, 318, 320, 325,	16, 17	Miradors, 300
339–340, 372, 377–379, 409	Megaron, 95, 96–97	Mirror, Etruscan, 177, 178
Maps	Mehmed II, 279	Mithras, 179
of the Aegean, 85	Meketre, 66, 66	Mnesikles
of Byzantine empire, 235	Melos, Aphrodite of (Venus de Milo), 165,	Erechtheion, Acropolis, 142-144, 143
of Egypt, ancient, 51	166	Propylaia, 142
of Europe, in fourteenth century,	Memory images, 6, 54	Moats, 254, 360, 363, 411
425	Memphis, 80	Modeling, 10
of Europe, in Gothic period, 385	Menes, 53	Modena Cathedral, Creation and Fall (Wil-
of Europe, in the Middle Ages, 313	Menkaura, 58, 60–61, <i>60</i>	igelmus), Italy, 365, <i>365</i>
of Europe, prehistoric, 3	Menkaura and a Queen, 60–61, 60	Moissac, France, Saint-Pierre priory
of Europe, in the Romanesque period,	Menorahs, 201, 236, 236	church, 366–367, 366
345	Mentuhotep, Nebhepetre, 62	Monasteries, 316
of Greece, ancient, 109	Mercury, 110	Benedictines, 321, 347
of Islamic world, 285	Meryeankhnes, queen, 61, 61	of Centula, France, 323-324, 323
of Near East, 27	Mesolithic period. See Neolithic period	of Christ in Chora, 278, 279
of Roman Republic, 171	Mesopotamia. See Near East	Cistercians, 347, 354–355, 379
Maqsura, 290	Metalwork	Cluny, 347, 352, 353
Marathon, 129–130	Aegean (Minoan), 89, 89, 93, 94, 94–95	Dominicans, 384, 394
Marcus Aurelius, 204, 216	Byzantine, 273–274	Franciscans, 384, 394
Equestrian statue of Marcus Aurelius,	Greek, 113–114, 113, 131–134, 133,	of Hosios Loukas, Greece, 269, 269,
216, 217	134	270, 271
Marduk, 42	Islamic, 300–301, 301	of Saint Gall, 324-325, 324
Marduk Ziggurat, 42, 42	Lombards, 314, <i>315</i>	Mongols, 294
Marine style ceramics, 94, 94	Mycenaean, 93, 102–103, 102, 103	Monograms (Christian symbol), 238
Markets of Trajan, Roman, 206, 208,	Norse, 315–316, <i>316</i>	Monumental sculpture. See Sculpture,
208	Romanesque, 376–377, 376, 377	monumental
200	1.0manesque, 5/0-5/1, 5/0, 5/1	monumental

Moors, 319	Nativity pulpit (N. Pisano), 417–418, 418	Saint-Étienne church, Caen, 362–363,
Mortise-and-tenon joints, 19	Naskhi, 293	362, 363
Mosaics Byzantine, 262, 262, 269, 271, 271	Nasrids, 299 Nativity with Prophets Isaiah and Ezekiel,	Norman Palace (King Roger), Palermo, Sicily, 277–278, 278
Christian, 245–246, 246	Maestà Altarpiece (Duccio di Buonin-	Normans, 274–275, 329, 346
Greek, 155–157, <i>156</i>	segna), 439, 440	See also Normandy
Islamic, 287, 297, 297	Naturalism, xxxiii–xxxiv	Norse, 315–316
Roman, Imperial, 213–215, 213, 214	Naumburg Cathedral, Germany, 415, 415,	Norway
Roman, Republic, 193, 193	417 Name 206 242 306	burial ship, Oseberg, 329–330, <i>329</i> , <i>330</i> timber architecture, 331, <i>332</i> , 333, <i>333</i>
Romanesque, 369, 370, 371, 374	Nave, 206, 242, 396	
synagogue floor, 237–238, 237	Naxos, 84 Neanderthal, 2	Urnes, church portal, 331, 332
techniques, 215	Near East	Notre-Dame abbey church, Fontenay,
Moscow, Byzantine icons, 278–279, 280		Burgundy, France, 354–355, 355
Mosque at New Gourna (Fathy), 307, 308	Akkad, 36–37	Notre-Dame cathedral
Mosques central-plan, 289, 289, 305–306	Assyria, 25, 40–41 Babylon, 37, 38	Amiens, 398, 400–401, 400, 402–403, 403, 404, 405
defined, 285	Elam, 26	
Great Mosque of Córdoba, Spain,	fertile crescent, 26, 27, 28–29	Chartres, 388–391, 389, 390, 393, 395, 396, 397–398, 397, 399
290–291, <i>290</i> , <i>291</i>	first cities, 26, 27, 28	Paris, 387–388, 388
Great Mosque of Isfahan (Masjid-i	Hittites of Anatolia, 37, 39	Reims, 401–402, 401, 402, 403–405,
Jami), Iran, 295, 297, 297	Lagash, 37	405
Great Mosque of Kairouan, Tunisia,	map of, 27	Nubians, 79–80
288, 290, <i>290</i>	neo-Babylonia, 42	Nublans, 79–60
plans, 289, 289	Persia, 42–46	0
of Sultan Selim (Sinan), Turkey, 306,	Sumer, 29–35	Octavian, 185
306, 307	timelines, 35, 39	Octopus Flask, Crete, 94, 94
Mouth of Hell, Winchester Psalter, 378–379,	Nebuchadnezzar II, 42	Oculus, 172, 210, 397
379	Necking, 118	Odyssey (Homer), 84, 98
Mozarabic art, 319–320, 320	Necropolises, 55–59, 233–234	O'Keeffe, Georgia, Red Canna, xxxv, xxxv
Mshatta, Jordan, palace at, 288, 288	Nefertari	Old Saint Peter's basilica, Rome, 243–244,
Muawiya, 284	Making an Offering to Isis, 75, 79	243, 244
Muhammad, 283–284, 285	temples of, 75–78, 76, 77	Old Testament Trinity (Three Angels Visiting
Muhammad V, 299	Nefertiti, 72, 73, 74, 74, 84	Abraham) (Rublyov), 278–279, 280
Mullions, 401	Nemes headdress, 52, 72	Old Woman, Greece, 164–165, 165
Mummies, 80, 80	Neo-Babylonia, 42	Olga, princess, 268
preserving, 55	Neolithic period	Olpe, 114, 115
Muqarnas, 292, 295, 300, 300	architecture, 13–17, 14, 15, 16, 17, 19	Olympia
Murals	in China, 344–346	Hera I, temple of, 116, 117, 117, 119
See also Cave art	description of, 11–12	Zeus, temple of, 130–131, <i>130</i> , <i>131</i>
Greek, Classical 148, 148, 155-156, 156	in Egypt, 50	Olympic Games, 107
Minoan, 90–92, 90, 91, 92	rock-shelter art, 12–13, 12	Openwork box lid, Ireland, 22, 22
Roman, Republic, 193–198, 193–199	sculpture and ceramics, 18-20, 18,	Opithodomos, 116
Romanesque, 369, 370, 371, 374	20	Opus anglicanum, 445–446, <i>446</i>
Musical instruments	Neptune, 110	Orant figures, 239, <i>239</i>
Great Lyre with Bull's Head, Ur, 34-35,	Nero, 189, 199	Orator, The (Aulus Metellus), Roman, 180,
34	Nerva, 204	181
Paleolithic, 7	New Grange, Ireland, tomb interior,	Orbais, Jean d', 401
Muslims. See Islam	15–16, <i>16</i>	Orcagna (Andrea di Cione)
Mycenaeans	Nicholas of Verdun, Shrine of the Three	Florence Cathedral, 428, 428, 429
architecture, 95-102, 96-102	Kings, 413–414, 414	Orsanmichele Tabernacle, 422, 423-424
ceramics, 104, 104	Nicomachus Flavianus, Virius, 229	Orchestra, 160
metalwork, 102-103, 102, 103	Niello, 93, 376	Orientalizing period of Greek art, 111,
sculpture, 103–104, 103	Nike, 110	114
Myron, Discus Thrower (Diskobolos), 106,	Nike (Victory) Adjusting Her Sandal,	Orsanmichele Tabernacle, 422, 423-424
107	Acropolis, 144, 145	Orthogonal city plans, 149–150, 149
Mysticism, 450, 452	Nike (Victory) of Samothrace 163, 164	Osberg ship, Norway, 329-330, 329, 330
	Nile, 50	Osiris, 51–52, 78–79, 79, 179
N	Nimrud, 25	Osman, 305
Naming works of art, 5	Assurnasirpal II Killing Lions, 40, 40	Ostrogoths, 247, 312
Nanna Ziggurat, Ur, 33, 33	Human-Headed Winged Lion (lamassu),	Otto I, Holy Roman emperor, 334
Naos, 114, 116, 242, 257	24, 25	Otto I Presenting Magdeburg Cathedral to
Naram-Sin, 36–37, 36	Nineveh, 36, 41	Christ, 334, 334
Narmer Palette, 53-54, 53	Nizami, Khamsa (Five Poems), 304, 305	Otto II, Holy Roman emperor, 334
Narthex, 237, 242, 321	Normandy	Otto III, Holy Roman emperor, 326, 334,
Nativity pulpit (G. Pisano), 418-419, 418	Bayeux Tapestry, 374–375, 374, 375	339, 340, 349

Otto III Enthroned, Liuthar (Aachen)	Pantheon, Rome, 210, 210, 211, 212	Persia (Persians), 42–46, 128, 129–130,
Gospels, 339, 339	Papacy	149
Ottoman Empire	See also under name of pope	Perspective
architecture, 305–306, 306, 307	list of, during Romanesque period, 359	atmospheric (aerial) perspective, 195
illuminated manuscripts and tugras,	Paper, first manufactured, 292–293	intuitive, 197
306–307, 307	Parapets, 145	reverse, 262
Ottonian Empire	Parchment, 251, 292, 318, 320	twisted, 8, 54
	Paris	Perugia, 171
architecture, 334–335, <i>335</i> , 338		Peter of Illyria, 244
ivories, 334, 334	Notre-Dame cathedral, 387–388, 388	
manuscripts, 339–340, <i>339</i> , <i>340</i>	Sainte-Chapelle, 406–407, 406	Petrarch, 424, 431
sculpture, 336, 336, 337, 338–339, 338	Paris Psalter, Byzantine manuscript, 274,	Petronius, Satyricon, 214
Ovid, 179, 198	274	Pharaoh, origin of term, 67
	Parler, Heinrich, Church of the Holy	Pheidias, 136, 137, 151
P	Cross, 448–449, 448	Pheidias and the Frieze of the Parthenon,
Padua, Italy, frescoes, Scrovegni (Arena)	Parler, Peter	Athens (Alma-Tadema), xliii, xliii
Chapel, 433–437, 435, 436	Church of the Holy Cross, 448–449,	Philip Augustus, 385
Paestum, Italy, temple of Hera I, 116, 117,	448	Philip II, king of Macedon, 149
117, 119	Saint Wenceslas Chapel, 449, 449	Philip the Arab, Roman, 220, 221
Painted vases	Paros, 84	Philip the Fair, 401
black-figure, 114, 115, 125–126, 125,	Parrhasios, xxxiii	Philostratus, 221
126	Parsa, 42	Phoebus, 110
Greek, Archaic, 114, 125–128, 125,	Parthenon, Acropolis, 116	Phonograms, 32, 78
126, 127	description of, 116, 136–142, <i>138</i> , <i>139</i> ,	Pictographs, 32, 78
	140, 141, 142	Picture stones, 330
Greek, Classical, 134–135, <i>135</i> , 148,	Doric frieze, 140–141, <i>140</i>	Piers, 287, 323
148		Pilasters, 171
Greek, Geometric, 112–113, 113	pediments, 137, 140	
red-figure, 114, 126–128, 127	processional frieze, 141–142, 141,	Pilgrimages, 345, 350
standard shapes, 125	142	Pillars, 116
techniques for, 114	Parting of Lot and Abraham, mosaic, Rome,	Five Pillars of Islam, 299
white-ground, 114, 148, 148	246, 246	Pisa, Italy
Painting	Passage grave, 15–16	cathedral complex, 356, 356
See also Cave art; Mosaics; Murals; Por-	Patrons of art	Leaning Tower of, 356, 356
traiture	See also under name of	Pisano, Andrea, 426
catacomb, 238-240, 239	collectors and museums as, xlvi	Life of John the Baptist, panel doors,
Florentine fourteenth century, 429,	defined, xliiii	428–429, 430
431–437, 432, 433, 435, 436	in England, 408	Pisano, Giovanni, Nativity pulpit, Pisa,
Islamic miniatures, 304, 304	individuals as, xlv-xlvi	418–419, 418
rock-shelter, 12-13, 12	in Italy, 417	Pisano, Nicola
Roman, 198, 198	Pausanias, 100, 179, 212	Nativity pulpit, Pisa, 417-418, 418
Palace(s)	Pausias, 156	Pulpit, Pisa, 417-419, 417
Assurnasirpal II, 24, 25, 40, 40	Pech-Merle cave, Spotted Horses and	Pitcher, Corinth, 114, 115
Chapel of Charlemagne, 321, 322, 323	Human Hands, 7–8, 7	Plate tracery, 397
Dur Sharrukin, 40–41, <i>41</i>	Pectoral, of Senusret II, 64, 64	Plato, xxxiv, 128, 149
Knossos, 86–95, 87, 88	Pedestals, 174	Plinth, 174
Minoan, 86–88, 87	Pediments, 114	Pliny the Elder, 153, 155, 157, 162, 163,
	Pen box (Shazi), 300–301, 301	179, 181, 214
Mshatta, Jordan, 288, 288	Pendentive domes, 248	Pliny the Younger, 179
Nebuchadnezzar II, 42, 42, 43	Pendentives, 248, 257	Plutarch, 55, 155, 179
Pylos, 97, 97, 98, 99		Pluto, 110
Sargon II, 40–41, 41	People and Animals, Cogul, Spain, 12–13,	
Palatine Chapel, Palermo, Sicily, 277, 277	12 D. 1 122	Podium, 145, 173
Palazzo della Signoria (Cione and Talenti),	Peplos, 123	Pointed arch, 292, 355
Florence, 427, 427	Peplos Kore, Acropolis, Athens, 123–124,	Pointing, 225
Paleolithic period	124	Pollaiuolo, Antonio del, 170
architecture, 2–4, 3	Pepy II, 61	Polydoros, Laocoön and His Sons, xxxvii,
cave art, 6–11 7, 9, 10, 11	Pepy II and His Mother, Queen	xxxvii, 163–164
sculpture, 4–6, 4, 5, 6, 10–11, 11	Meryeankhnes, 61, 61	Polygnotos of Thasos, 148
Palermo	Pergamene style, 163–164, 163, 164	Polykleitos, 128, 151
Norman Palace, 277–278, 278	Pergamon, 160	The Canon, 129
Palatine Chapel, 277, 277	altar from, 162–163, 162	Spear Bearer (Doryphoros or Achilles),
Palestrina, Sanctuary of Fortuna	Perikles (Pericles), 135, 136, 142	128, 128
Primigenia, 183, <i>183</i>	Peripteral temple, 116	Pompeii
Palmettes, 146	Peristyle court, 68, 116, 117, 192	city plan, 190-192, 190, 191, 192
Pan, 110	Perpendicular style, 446–447	gardens, 192-193, 193
Pan Painter, Artemis Slaying Actaeon,	Persephone, 110, 123	House of M. Lucretius Fronto,
134–135, <i>135</i>	Persepolis, 43–45, <i>43</i> , 149	197–198, 197

134–135, 135

House of Publius Fannius Synistor, 195,	Psalm I, Windmill Psalter, England, 408,	Reims Cathedral, Notre-Dame cathedral,
<i>195, 196</i> , 197	409	401–402, 401, 402, 403–405, 405
House of the Vettii, 192, 193, 193	Psalters	Reinach, Salomon, 6
Villa of Livia, Primaporta, 192, 194, 195	Paris, Byzantine manuscript, 274, 274	Reiner of Huy, Baptismal font, Notre-
Villa of the Mysteries, 192, 192,	Psalter of Saint Louis, 407–408, 407	Dame-Aux-Fonts, Liege, France,
194–195, <i>194</i>	Utrecht, 327, 327	376–377, 377
Young Woman Writing, 198, 199	Winchester, 378–379, 379	Relative dating, 13
Pompey the Great, portrait of, 181, 181	Windmill, 408, 409	Relief. See Sculpture, relief
Pont du Guard, Roman bridge, 182, 182	Pseudo-Dionysius, 383	Religious beliefs
Poore, Richard, 409	Ptolemies, 157	See also under name of religion
Porch, 114	Ptolemy, 80	ancient Near East, 26
Porch of the Maidens, Erechtheion,	Ptolemy V, 78	Egyptian, 51–52
Acropolis, 143–144, 143	Pucelle, Jean, Book of Hours of Jeanne	Greek, 109–111
Porta Augusta, Perugia, Italy, 170, 173	d'Evreux, 442-443, 443	Paleolithic, 9–10
Portals, 242	Punchwork, 439	Roman, 179
Porticos, 116	Purse cover, Sutton Hoo burial ship, Eng-	Sumerian, 32–33, <i>33</i>
Portrait of Khusrau Shown to Shirin,	land, 316, 317	Reliquaries, 313, 354, 354
Khamsa, 304, 305	Putti, 247	Rembrandt van Rijn, xli
Portrait of Pompey the Great, 181, 181	Pylons, 68	The Last Supper, xlii-xliii, xliii
Portrait sculpture	Pylos, palace at, 97, 97, 98, 99	Remus, 169, 179
Roman Imperial, 216-217, 217, 220,	Pyramids	Repoussé (embossing), 93, 95, 328
220, 222–223, 223, 224, 225–226	constructing, 58–59	Restoration work, Warriors, Riace, Italy,
Roman Republic, 204, 204, 205	at Giza, 57–59, <i>57</i> , <i>58</i>	135
Portraiture, Roman, 198, 199	stepped, at Saqqara, 55–56, 56, 57	Reverse perspective, 262
Portunus, 183, 184	Pythian Games, 111	Revett, Nicholas, 138
Poseidon, 109, 110		Rhytons, 93–94, 93
Post-and-lintel construction, 14, 14, 15,	Q	Riace Warriors, 133-135, 134
332	Qibla, 288, 289, 298, 299	Rib vaulting, 358, 362, 391, 391
Potassium-argon dating, 13	Quadrant vaults, 351	Ridgepole, 13
Potsherds, 20	Quatrefoils, 402, 404	Rock-cut tombs, Beni Hasan, Egypt, 63,
Potter's wheel, 20	Queen Nefertari Making an Offering to Isis,	63
Pottery	75, 79	Rock-shelter art, 12-13, 12
See also Ceramics; Painted vases	Queen's ship, Osberg, Norway, 329–330,	Roger, abbot, 366
formation of, 20	329, 330	Roger II, king of Sicily, 274–275
Sumerian, 31, <i>33</i>	Queen Tiy, portrait, 74, 74	Roman Empire
use of term, 20	Quincunx, 275	Constantine the Great, 225–230
Prague	Quire, 251	emperors, list of with dates, 199
Altneuschul, 412, 413	Qur'an, 283, 284, 287	Flavians, 199–204
Saint Wenceslas Chapel, 449, 449	frontispiece, 304, 304	gods and heroes, description of, 110,
Praxiteles	page from, 292, 293	179
Aphrodite of Knidos, 152-153, 152		Julio-Claudians, 189-190
Hermes and the Infant Dionysos, 151–152,	R	origins of, 178–179
151	Ra (Re), 51, 52	religion, 179
Predella, 439	Ra-Atum, 51	Severan dynasty, 218–220
Prehistoric art	Rabbula Gospels, 264–265, 265	Tetrarchs, 222-224
Bronze Age, 20–21	Radiometric dating, 13	third century, 220–222
Iron Age, 21–22	Ramses II, 69	women, 198, 199
Neolithic period, 11–20	temples of, 75–78, 76, 77	writers on art, 179
Paleolithic period, 2–11	Ravenna	Romanesque, defined, 347
timeline, 7, 19	Baptistry of the Arians, 249	Romanesque period
Prehistoric Europe, map of, 3	Baptistry of the Orthodox, 249, 250	architecture, 350-363, 350, 351,
Priam Painter, Women at a Fountain House,	Mausoleum of Galla Placidia, 247-249,	353–354
145–146, 146	248, 249	church, 345–346
Priene city plan, 150	San Vitale church, 258, 259-262, 260,	cloister crafts, 372-380, 372-380
Priestess of Bacchus, 229, 230	261	intellectual life, 346-347
Primaporta, Garden Scene, 192, 194, 195	Rayonnant (Court) style, 405-407, 442	manuscripts, 327-379, 378, 379, 380
Princess from the Land of Porcelain	Realism, xxxiii–xxxiv	map of, 345
(Whistler), xlv	Rebecca at the Well, Book of Genesis, 264,	metalwork, 376–377, 376, 377
Procopius of Caesarea, 255	264	mosaics and murals, 369, 370, 371, 374
Pronaos, 114, 116	Red Canna (O'Keeffe), xxxv, xxxv	political and economic life, 344-345
Propylaia, Acropolis, 142	Red-figure painted vases, 114, 126–128,	sculpture, 342, 343, 365–369, 365–368
Proscenium, 160	127	timelines, 359, 377
Proserpina, 110	Redwald, 316	Romania (Cernavoda), figures of a man
Proto-Geometric, 112	Registers, 31, 434	and woman, 18, 18, 19
Proto-historic Iron Age, 21–22	Reims, Gaucher de, 401	Roman Republic

architecture, 181-185, 182, 183, 184, Saint-Denis, abbey church, France, 382, Sanctuaries, 109-110 199, 200, 201-204, 201, 202, 203 383, 386-387, 387, 444, 444 Sanctuary of Apollo, Delphi, 110–111, cities and homes, 190-193, 190, 191, Saint Elizabeth church, Marburg, Ger-111 many, 412, 412 Charioteer, 132-133, 133 early empire, 179-180, 185-204 Saint-Étienne church, Caen, Normandy, Treasury of the Siphnians, 116, gardens, 192-193, 193 362-363, 362, 363 119-120, 120 map of, 171 Saint Faith (Sainte Foy), reliquary statue Sanctuary of Athena Pronaia, Delphi, murals, 193-198, 193-199 of, 354, 354 150-151, 150 painting, still life and portraits, 198, Saint Francis, 416 Sanctuary of Fortuna Primigenia, Palest-198, 199 Saint Francis, church of, Assisi, Italy, 416, rina, Italy, 183, 183 sculpture, 180-181, 180, 181 416 Sanctuary of Zeus, 110 sculpture, Augustan, 186-190, 186, 187, Saint Francis Master, Miracle of the Crib at San Giovanni baptistry, Florence, 188, 189 Greccio, 420, 420 428-429, 430 Sant' Ambrogio church, Milan, 358, 359 sculpture, portrait, 204, 204, 205 Saint Gall monastery, Switzerland, 324-325, 324 Romans Crossing the Danube and Building a Santa Costanza church, Rome, 246–247, 246, 247 Fort, Column of Trajan, 209, 209 Saint Isidore, 313 Santa Maria Degi Angeli, 220, 220 Rome Saint James cathedral, Santiago de Com-Santa Maria Maggiore church, Rome, Arch of Constantine, 226-227, 226 postela, Spain, 349-352, 349, 351, 245-246, 246 Arch of Titus, 199, 200, 201, 201 Saint-Lazare cathedral, Autun, Burgundy, Santa Sabina church, Rome, 244-245, Basilica of Maxentius and Constantine, France, 367–368, 367, 368 244, 245 227-228, 227, 228 Saint Luke (Master Theodoric), 449-450, Santa Sophia cathedral, Kiev, 268, 269 Colosseum (Flavian Amphitheater), 202-204, 202, 203 San Vitale church, Ravenna, 258, Saint Luke Displaying a Painting of the Vir-259-262, 260, 261 Column of Trajan, 208-209, 208, 209 Forum of Trajan, 205-206, 206, 207, gin (Guercino), xli, xli Sappho, 115 208, 208 Saint Mark cathedral, Venice, 271, 272, Saqqara Pantheon, 210, 210, 211, 212 Djoser's funerary complex at, 55-56, 56, 57 sack of, 312 Saint Matthew, from the Codex Colbertinus, 377, 378 Seated Scribe, 61-62, 61 San Clemente church, 356–358, 357, Saint Matthew the Evangelist, Coronation Ti Watching a Hippopotamus Hunt, 62, 371 Rome, Imperial Gospels, 326, 326 62 architecture, 205-212, 206-213, Saint Matthew the Evangelist, Ebbo Gospels, Sarcophagi, 55 219-220, 219, 220, 223-224, 223, 326-327, 326 from Cerveteri, 176-177, 177 Saint Maurice, 334 of the Church of Santa Maria Antiqua, 226–228, 226, 227, 228 mosaics, 213-215, 213, 214 Saint Maurice, Magdeburg, Germany, 240-241, 241 sculpture, 215-218, 215, 216, 217 414-415, 415 of Junius Bassus, 250, 251, 254 sculpture, funerary, 222, 222 Saint Michael Church, doors of Bishop Ludovisi Battle Sarcophagus, 222, 222 sculpture, portrait, 216-217, 217, 220, Bernward, Hildesheim, Germany, Sargon I, 36 220, 222-223, 223, 224, 225-226 336, 336, 337, 338 Sargon II, 40-41 Saint Peter, abbey church of, 352-354 Sarsen, 17 Romulus, 169, 179 Rosetta Stone, 31, 78, 78 Saint Peter's basilica, old, 243-244, 243, Satyricon (Petronius), 214 Rosettes, 114, 115, 288 244 Saussure, Ferdinand de, xlvii Rose windows, 398, 399 Saint-Pierre priory church, Moissac, Scandinavia, in the Middle Ages, 314–316 Rotunda, 242, 323 366-367, 366 Scarab beetle, 52, 64, 84 Schliemann, Heinrich, 84, 88, 98, 100, Saint Riquier church, Monastery of Cen-Round arch, 171, 172 Roundels, 171, 215-216 tula, France, 323-324, 323 100, 102 Royal rune stone, 330, 331 Saint-Savin-sur-Gartempe abbey church, Schliemann, Sophia, 100, 100 Poitou, France, 358, 358, 371, 372 Scholasticism, 384-385 Rublyov, Andrey, Old Testament Trinity (Three Angels Visiting Abraham), Saint Vincent (Sant Vincenc) Church, Scribes, 263 278-279, 280 Cardona, 348, 349 Scriptoria, 263, 317, 318, 320, 325, Saint Wenceslas Chapel (P. Parler), Prague, 339-340, 372, 377-379, 409 Rudolf of Swabia, tomb effigy, 376, 449, 449 Scrolls, 251 376 Scrovegni (Arena) Chapel, Padua, Rue Transonain, Le 15 Avril 1834 Sala della Pace, fresco series (Lorenzetti), (Daumier), xl, xl Siena, 440, 441 433-437, 435, 436 Rules for Monasteries (Benedict of Nursia), Salisbury Cathedral, England, 409-410, Sculpture See also Figurines 321 Salisbury Plain, England, Stonehenge, 16, Ain Ghazal, Jordan, 28-29, 29 Rune stones, 330, 331 Akkadian, 36-37, 36 Running spirals, 102 17, 17, 19 Saljuqs, 294 Bronze Age, 20-21, 21 Russian art, Byzantine icons, 278–279, Samarkand ware, 294, 294 Christian, early, 240-241, 240, 241, 280 San Clemente church, Rome, 356-358, 250, 251, 254 Egyptian, xxxii, 59-64, 59, 60, 61, 63, S 357 64, 73-74, 73, 74 mosaics of, 371 Sainte-Chapelle, Paris, 406-407, 406 San Climent church, Tahull, Catalunya, French, fourteenth century, 443–444, Saint Cyriakus church, Gernrode,

Spain, 370, 371

Germany, 335, 335, 338

444, 445

French Gothic, 402-407, 403-406	Senior, copy of Commentary on the Apoca-	Spoils from the Temple of Solomon,
German (Holy Roman Empire),	lypse (Beatus), 320, 320	Jerusalem, 201, 201
Gothic, 413–415, 414, 415, 417	Senusret I, 63	Spotted Horses and Human Hands, Pech-
Gothic, French, 402-407, 403-406	Senusret II, 64, 64, 66	Merle cave, France, 7–8, 7
Gothic, German (Holy Roman	Senusret III, 63, 63	Springings, 172
Empire), 413–415, 414, 415, 417	Septimius Severus, Julia Domna, and Their	Squinches, 257, 300
Gothic, Italian, 417–419, 417, 418	Children, Geta and Caracalla, 218, 218	Stadiums, Colosseum (Flavian Amphithe-
Greek bronze, 131–134, 133, 134	Serdab, 55, 56	ater), Rome, 202–204, 202, 203
Greek freestanding (Archaic), 121–125,	Seth, 51	Stag Hunt (Gnosis), 156–157, 156
122, 123, 124	Sety I, 69	Stained glass, 397–398, 397, 399
Greek freestanding (Classical), 131, 132,	Severan dynasty, 218–220	Standing Youth (kouros), 122, 122
151–155, 151, 152, 153	Severus, Alexander, 222	Statues. See Sculpture
Greek pediment (Archaic), 119–121,	Severus, Septimius, 210, 218, 219	Stave church, Borgund, Norway, 332, 333,
119, 120, 121	Shaft graves, 99	333
Greek pediment (Classical), 130–131,	Shafts, of columns, 117, 118	Steen, Jan, The Drawing Lesson, xli, xlii
131	Shamans	Stele of Amenemhat I, 65–66, 65
Greek stele (Classical), 147–148, 147	Paleolithic, 9–10	Stele of Hammurabi, 38, 38
Hellenistic, 160, 160, 161, 162–165,	Shazi, pen box, 300-301, 301	Stele of Naram-Sin, 31, 36–37, 36
162, 163, 164, 165, 166	She-Wolf, Etrucsan/Roman, 168–169,	Stele sculpture, Greek classical, 147–148,
hollow-cast, 36, 36	169–170	147
Holy Roman Empire, Gothic, 413-415,	Shimomura, Roger, Diary, xl, xl	Stereobate, 116
414, 415, 417	Shrine of the Three Kings (Nicholas of Ver-	Still life, Roman, 198, 198
Italian, Gothic, 417-419, 417, 418	dun), 413–414, 414	Still Life, Herculaneum, 198, 198
Minoan, 92–93, 92	Shroud of Saint Josse, Khurasan, 294, 295	Stoa, 145
Mycenaean, 103–104, 103	Sicily, Byzantine art in, 274–275,	Stokesay Castle, England, 411, <i>411</i>
Neolithic, 18, 18, 19–20, 20	277–278, 277, 278	Stone Age, 2
Ottonian, 336, 336, 337, 338–339, 338	Siena Cathedral, facade, Siena, 418, 419	Stonehenge, England, 16, 17, 17, 19
Paleolithic, 4–6, <i>4</i> , <i>5</i> , <i>6</i> , 10–11, <i>11</i>	Sienese painting, 437, 437, 438, 439, 440,	Strabo, 115
Persian, 45, 45	441–442	
	Silk, 294, 295	Strasbourg Cathedral, Dormition of the Vir-
Roman Augustan, 186–190, <i>186</i> , <i>187</i> ,		gin, France, 414, 414
188, 189	Sinan, 305–306, 306, 307	Stringcourses, 362
Romanesque, 342, 343, 365–369,	Sinopia, 439	Stuart, James, 138
365–368, 372–373, 372, 373, 376	Siphnians, Treasury of the, Delphi, 116,	Stucco, 176
Roman Imperial, 215–218, 215, 216,	119–120, <i>120</i>	Stylobate, 116, 118
217	Sithathoryunet, 64, 64	Stylus, 29, 32, 114
Roman Imperial, funerary, 222, 222	Sixtus III, pope, 245, 246	Succulent (Weston), xxxiv, xxxv
Roman Imperial, portrait, 216–217,	Sixtus IV, pope, 170	Suger of Saint-Denis, abbot, 383, 386–387
217, 220, 220, 222–223, 223, 224,	Skara Brae, Orkney Islands, Scotland,	Suicide of Ajax (Exekias), 126, 126
225–226	13–15, <i>14, 15</i>	Suicide of Judas, The, capital at Saint-Lazare
Roman Republic, 180–181, 180, 181	Skopas, 153, <i>153</i>	cathedral, Autun, Burgundy, France,
Roman Republic, portrait, 204, 204,	Slip, 112, 114	368–369, <i>368</i>
205	Smith, David, Cubi XIX, xxxv, xxxv	Suleyman the Magnificent, 306
Sumerian, 30–33, 30, 33	Sobekneferu, 71	Sulpicia, 198
Sculpture, monumental	Soissons, Bernard de, 401	Sultan Hasan, 299
Irish high crosses, 319, 319	Solomon	Sumer (Sumerians), 29–35
Sculpture, relief	First Temple, 235–236	Sunken relief, 73, 73
Akkadian, 36–37, 36	Second Temple, 201, 201, 235-236	Susa, 28, 31, 43, 44
Egyptian, 59-64, 59, 60, 61, 63, 64,	Sophocles, 128, 159	Sutton Hoo burial ship, England, 316, 317
73–74, 73, 74	South Cross of Ahenny, Ireland, 319, 319	Symmachorum, 229, 230
high, 10	Spandrels, 172	Symmachus, Quintus Aurelius, 229
modeling, 10	Spanish art	Sympathetic magic, 6
Paleolithic, 4–5, <i>4</i> , 10, <i>11</i>	Alhambra, 298, 299–300, 300	Synagogues, 236–238, <i>236</i>
sunken, 73, 73	Altamira cave, 6, 7, 10, <i>10</i>	Altneuschul, Prague, 412, 413
Scythians, 42	Great Mosque of Córdoba, 290–291,	Syncretism, 239
Seals	290, 291	Syncretism, 237
impressions, Indus Valley, 312, 313, 314	in the Middle Ages, 319–320	Т
Sumerian cylinder, 35, 35	rock-shelter, 12–13, <i>12</i>	Tablinum, 192
Seascape and Coastal Towns, Villa Farnesina,	Romanesque, 351–352	Talenti, Francesco, Florence Cathedral,
Rome, 195, 195	Sparta, 108, 130, 135, 148–149	428, 428, 429
Seated Harp Player, Cyclades, 86, 86	Spear Bearer (Doryphoros or Achilles)	Talenti, Simone, Palazzo della Signoria,
Seated Scribe, Saqqara, 61–62, 61	(Polykleitos), 128, 128	Florence, 427, 427
Secco, 90, 439	Speyer cathedral, Germany, 358–360, 360	Tapestry
Seleucus, 157	Sphinx	Bayeux Tapestry, 374–375, 374, 375
Selim II, 306	Great Sphinx, Egypt, xxxii, xxxii, 59	Islamic, 303
Senbi, 65, 65	Hatshepsut as, 71	Tausret, 71

Tempera, 148	Timurid dynasty, 304	Triumphs, The (Petrarch), 431
Temples	Titus, 202, 236	Trojan War, 98
of Amun, 67–69, 68, 69	Arch of, Rome, 199, 200, 201, 201	Trompe l'oeil, 278
of Aphaia, 120–121, 120	Tivoli, Hadrian's Villa at, 212, 212, 213,	Troy, 84, 98
of Apollo, 111	213	Trumeau, 365, 366, 402 Trundholm, Denmark, Horse and Sun
of Artemis, 119, 119	Ti Watching a Hippopotamus Hunt, 62, 62	Chariot, 21, 21
of Athena Nike, 116, 144–145, 144	Tiy, queen, 74, 74	Tugras, Ottoman, 306–307, 307
complexes, Egyptian, 67–72 of the Divine Trajan, 208	Tomb of the Reliefs, 176, 176, 177	Tunisia, Great Mosque of Kairouan, 288,
Etruscan, 171, 173–174, 173, 175	Tomb of the Triclinium, 174, 176, 176	290, 290
Greek (Archaic period), 116, 117–119,	Tombs	Turkey, Mosque of Sultan Selim (Sinan),
117	beehive, 99	306, 306, 307
Greek (first ones), 114	catacombs, 233-234, 236	Tuscan order, 173, 174, 203
of Hatshepsut, 71-72, 71	Etruscan, 174, 176-177, 176, 177	Tutankhamun
of Hera I, 116, 117, 117, 119	of Galla Placidia, 247-249, 248, 249	funerary mask of, 48, 49
of Hera II, 117	at Halikarnassos, 153, 153	tomb, 75, 7 <i>5</i>
at Karnak, 69–70, <i>69</i>	Mycenaean, 99, 99, 102, 102	Tutankhaten, 75
of Nefertari, 75–78, 76, 77	Neolithic, 15–17, 16, 17	Twisted perspective, 8, 54
of the Olympian Zeus, 158–159, <i>158</i> ,	Roman, 222, 222	Two Women with a Child, Mycenae,
212	shaft, 99	103–104, 103
Pantheon, Rome, 210, 210, 211, 212	tholos, 99, 145, 149, 150–151, <i>150</i>	Tympanum, 365, 366, 367–368
of Ramses II, 75–78, 76, 77 Roman Republic, 183–185, <i>184</i>	Tombs, Egyptian complex at Saqqara, Djoser's, 55–56,	Ulu Burun, ship wreck at, 84
of Solomon, First Temple, 235–236	56, 57	Umayyad dynasty, 284–285, 286, 288, 290
of Solomon, Second Temple, 201, 201,	construction of, 58–59	Unswept Floor, The (Herakleitos), 220, 214,
235–236	decorations, 62, 62, 63–66, 64, 65	214
of Zeus, 130–131, <i>130</i> , <i>131</i>	mastabas, 55–56, <i>56</i>	Ur, 33–35
Ten Books of Architecture (Vitruvius), 179,	pyramids at Giza, 57-59, 57, 58	Urban II, pope, 348, 353, 359
185	rock-cut at Beni Hasan, 63, 63	Urnes, Norway, church portal, 331, 332
Tesserai, 155, 213, 215, 291	of Tutankhamun, 75, 75	Uruk, 29, 30–31
Tetrarchs, 222–224	Tondo, 198, 249	Vase, 31, 33
Tetrarchs, 222-223, 223	Totemistic rites, 6	Uthman, 284
Textiles	Tower of Babel, Saint-Savin-sur-Gartempe	Utrecht Psalter, 327, 327
Islamic, 294, 295, 302–303, 302, 303	abbey church, Poitou, France, 371,	Village of the Colden Mummies 40
techniques for making, 44, 409	372 Towns	Valley of the Golden Mummies, 49 Valley of the Kings, 49–50
Thatch, 13 Theaters	Egyptian, 66–67, <i>6</i> 7	Valley of the Kings and Queens, 70–72
Colosseum (Flavian Amphitheater),	Neolithic, 12, 13–17, 19	Vandals, 312
Rome 202–204, 202, 203	Tracery, plate, 397	Van der Spelt, Adriaen, Flower Piece with
Hellenistic, 159–160, <i>159</i>	Trajan, 204	Curtain, xxxiii, xxxiii
Thebes, 80	Column of Trajan, 208–209, 208, 209	Van Mieris, Frans, Flower Piece with
Theft of art, 31	forum of, 205–206, 206, 207, 208, 208	Curtain, xxxiii, xxxiii
Theodora, empress, 254, 255, 260, 261,	Transepts, 242, 244, 349	Vapheio Cup, Sparta, Greece, 93, 94-95, 95
266	Transfiguration of Christ with Saint Apolli-	Vasari, Giorgio, xlvi, 432
Theodore Metochites, 278	naris, Sant' Apollinare church, Classe,	Vase Painter and Assistants Crowned by
Theodoros, 150	262–263, 262	Athena and Victories, A, Greek, 157,
Theodosius I, 107, 247	Treasury of Atreus, Mycenae, 99, 99, 102	157
Theodosius II, 254	Treasury of the Siphnians, Delphi, 116,	Vases and vessels Greek painted (Archaic), 114, 125–128,
Theophilus, 347	119–120, 120 Tree of Jesse, Chartres Cathedral, 397–398,	125, 126, 127
Thermo-luminescence dating, 13 Theseus, 86	397	Greek painted (Classical), 134–135,
Tholos, 145, 149, 150–151, <i>150</i> , 246	Tree of Jesse, Saint Jerome's Commentary on	135, 148, 148
Treasury of Atreus, 99, 99, 102	Isaiah, Burgundy, France, 379, 380	Greek painted (Proto-Geometric),
Thomas of Witney, Exeter Cathedral,	Trefoils, 401	112–113, 112, 113
England, 446–448, 447	Trier, Germany, Basilica, 223–224, 223	Minoan, 93–94, 93, 94
Throne of the Third Heaven of the Nations'	Triglyphs, 117, 118	Mycenaean, 104, 104
Millennium General Assembly (Hamp-	Trilithons, 17	Neolithic, 19–20, 20
ton), xxxviii–xxxix, <i>xxxviii</i>	Triptychs, Harbaville, Byzantine,	painted techniques, 114
Thutmose I, 69, 71	273, 273	Sumerian, 31, <i>33</i>
Thutmose II, 71	Triumphal Procession, Titus in Chariot, 201,	Vaults
Thutmose III, 67, 69, 71	201	barrel, 172, 358
Tiberius, 189	Triumph of Death (Buffalmacco?), Cam-	corbel, 14, 102 groin, 172, 358, 391, <i>391</i>
Tiercerons, 446 Timber architecture, Viking, 331, 332,	posanto, Pisa, 426, 426 Triumph of Venice (Veronese), xxxix–xl,	quadrant, 351
333, <i>333</i>	xxxix	rib, 358, 362, 391, <i>391</i>
555,555	Preserve Comments and Comments	,,,,,

Veiled and Masked Dancer, Greece, 164, Vellum, 251, 292, 318, 320 Veneer, 183 Venice, Saint Mark cathedral, 271, 272, Venus, god, 110 Venus de Milo (Aphrodite of Melos), 165, 166 Venus (Woman) from Willendorf, Austria, 4, 5 Verism, 181 Veronese (Paolo Caliari), The Triumph of Venice, xxxix-xl, xxxix Vespasian, 189, 202 Vesperbild, Germany, 450, 452, 452 Vessels. See Vases and vessels Vesta, 110 Victor III, pope, 356, 371 Vienna Genesis (Book of Genesis), 264, 264 Vikings, 268-269, 311 burial ship, Oseberg, 329-330, 329, 330 picture and rune stones, 330, 331 timber architecture, 331, 332, 333, 333 Urnes, church portal, 331, 332 Villa at Tivoli, Hadrian's, 212, 212, 213, 213 Villa Farnesina, Rome, 195, 195 Villanovans, 170 Villa of Livia, Primaporta, 192, 194, 195 Villa of the Mysteries, 192, 192, 194-195, Violet Persian Set with Red Lip Wraps (Chihuly), xli, xli Viollet-le-Duc, Eugène-Emmanuel, Virgil, 179

Virgin and Child, Auvergne, France, 373, 373, 376

Virgin and Child, Saint-Denis, abbey church, France, 444, 444 Virgin and Child Enthroned (Cimabue),

431, 432 Virgin and Child Enthroned (Giotto di Bondone), 431-432, 433

Virgin and Child in Majesty, Maestà Altarpiece (Duccio di Buoninsegna), 437,

Virgin and Child with Saints and Angels, icon, Monastery of Saint Catherine, Egypt, 266, 266

Virgin of Vladimir, Constantinople, 266-267, 267 Visigoths, 290, 291, 312, 313-314 Visitation, Reims Cathedral, Notre-Dame cathedral, 403-405, 405 Vitruvius, 171, 173, 179, 185 Vladimir, grand prince, 268–269 Volmar, monk, 369 Volutes, 118 Votive figures, 32-33, 33, 171 Votive statue of Gudea, 37, 37 Voussoirs, 171, 172, 291, 299 Vulca, Apollo, 173-174, 175 Vulcan, 110

Wall paintings. See Murals Walter of Memburg, 446 War, art as spoils of, 31 Warka Head, Uruk, 30, 30, 31, 31 Warp, 303 Warriors, Riace, Italy, 133-135, 134 Warrior Vase, Mycenae, 104, 104 Wattle and daub, 13, 332 Weeks, Kent R., 49–50 Weft, 303 Weston, Edward, Succulent, xxxiv, xxxv Westwork, 321, 335 Whistler, James Abbott McNeill Harmony in Blue and Gold, Peacock Room, for Frederick Leyland, xlv-xlvi, xlv Princess from the Land of Porcelain, xlv White-ground painted vases, 114, 148, 148 White Temple, Uruk, 30, 30 Wiligelmus, Creation and Fall, 365, 365 Willelmus, 383 William I, 277 William the Conqueror, 344, 362, 374 Winchester Psalter, 378-379, 379 Windmill Psalter, England, 408, 409 Woman and Maid (Achilles Painter), 148, Woman from Brassempouy, France, 5-6, 6 Woman from Ostrava Petrkovice, Czech Republic, 5, 5 Woman from Willendorf, Austria, 4, 5 Woman or Goddess with Snakes, Knossos, Crete, 92-93, 92

Woman Spinning, Susa, 44, 44 Women Egyptian, 67, 70-72, 73, 73, 74, 74, 75-78, 77, 79 Greece artists, 157 Neolithic, 12-13, 17 Neolithic period and depiction of, 12-13, 12, 18, 18, 19 Roman, 198, 199 in the Romanesque period, 369 Viking, 329-330 Women artists Christine de Pizan, xlv, xlv, 431 Ende, 320, 321 Guda, nun, 378, 378 Hildegard of Bingen, 369, 369 Lin, Maya Ying, xliv, xliv O'Keeffe, Georgia, xxxv, xxxv Women at a Fountain House (Priam Painter), 145-146, 146 Worcester Chronicle (John of Worcester), 344-345, 346 Writing calligraphy, Islamic, 292-293, 293 Egyptian demotic, 78 Egyptian hieratic, 78 Egyptian hieroglyphics, 53, 78, 78 Greek alphabetic, 108 Minoan hieroglyphic and Linear A and B, 86 Sumerian cuneiform, 29-30, 32, 32

X, Y, Z

Xerxes I, 44, 45, 45, 46 Yaroslav, grand prince, 269 Young, Thomas, 78 Young Flavian Woman, 204, 204 Young Girl Gathering Saffron Crocus Flowers, Akrotiri, Thera, 90-91, 90 Young Woman Writing, Pompeii, 198, Zeus, 109, 110-111 temple of, 130-131, 130, 131 temple of the Olympian Zeus, 158-159, 158, 212 Zeuxis, xxxiii Ziggurats Assyrian, 41, 41 Marduk, 42, 42

Sumerian, 30, 30, 33, 33